Film Study

Film Study

An Analytical Bibliography

VOLUME 1

Frank Manchel

Rutherford • Madison • Teaneck
Fairleigh Dickinson University Press
London and Toronto: Associated University Presses

Associated University Presses
440 Forsgate Drive
Cranbury, NJ 08512

Associated University Presses
25 Sicilian Avenue
London WC1A 2QH, England

Associated University Presses
P.O. Box 488, Port Credit
Mississauga, Ontario
Canada L5G 4M2

The paper used in this publication meets the requirements
of the American National Standard for Permanence of Paper
for Printed Library Materials Z39.48-1984.

Library of Congress Cataloging-in-Publication Data

Manchel, Frank.
 Film study: an analytical bibliography / Frank Manchel.
 p. cm.
 ISBN 0-8386-3186-X (v. 1 : alk. paper)
 1. Motion pictures—Bibliography. 2. Motion pictures—Study and
teaching. I. Title.
Z5784.M9M34 1990
[PN1994]
016.79143—dc20 85-45026
 CIP

For Sheila,

to whom this book

and author

are dedicated.

Contents

VOLUME 1

2

4

Acknowledgments

This resource guide is the result of a lifetime of viewing films that others have made, and of reading books and articles that others have written. I would first like to thank the artists of the film, and my colleagues, whose love of film and scholarship inspired my ambition to begin writing this book. There were many times when the project seemed overwhelming. Yet I always found friends in the profession who encouraged me to see the project through to the end. At the same time, well over a hundred publishers from the mid-1970s to the present continued to supply me with their books. Although my individual debts are too vast to list in so short a space, there are obligations that deserve special accounting.

In the preparation of the first edition, I wish to express my gratitude to Professor Louis Forsdale for his initial support in this study, as well as to Professor Milton A. Kaplan for his patient advice. The Motion Picture Association of America was very helpful in supplying me with information about the Motion Picture Production Code, and I was further helped in obtaining necessary material by such wonderful aides as Judy Blanchard, Cindy Cannon, Winifred Gadue, Claire Buckley, and Phil Lyman. Typing the original manuscript was a monumental chore, and a great deal of thanks go to Evelyn Kyle, Jo Ann Cook, Jody Jarvis, Marie Schwenn, and Lynn Lanctot. I also want to express a debt owed my editor, Leslie Bialler, for giving me the extra incentive to finish.

In listing my special obligations for the preparation of this version, I would like to begin by acknowledging a special debt to my friend and colleague, Dr. Littleton Long, whose many kindnesses and outstanding editing of the manuscript often proved to be the most meaningful words of encouragement that I received during the decade-long ordeal of researching and writing this new edition. Without his help and sound advice, this book could not have been completed. He is the perfect colleague and friend. Next, I want to single out my colleague and friend, Dr. John G. Jewett, Dean of the College of Arts and Sciences of the University of Vermont from 1977 to 1988, who was responsible for getting me to do this revised edition and who made this project possible by giving me the time and financial support to do the research. I want to give a special thanks to another friend and colleague, Howard Suber, who found the words not only to keep me going, but also graciously and generously offered to put his thoughts in print. A sincere thanks also goes to my friend and colleague Dr. Virginia Clark, whose criticisms and suggestions over the years proved invaluable.

This book also benefited from the insights and criticisms supplied by my colleagues Michael A. Selig, Mark A. Stoler, Patrick H. Hutton, Deborah Clark, Betsy McLane, David Scrase, Raul Hilberg, Frank Sampson, Alan Shepherd, Nick Danigelis, Laura T. Fishman, Fred Fengler, Beth Mintz, Constance M. McGovern, Mary Beth Haralovich, Timothy M. Bates, Dennis Mahoney, Charles H. Harpole, and Rick Musty.

Two secretaries whose contributions to this study put me in their debt are Cynthia L. Radoccia and Jennifer Woyke. And then there is Mary Carol Adams who gave of her time and her heart in the most difficult of circumstances that a parent can endure. She was the best secretary a person could have for a project like this.

Special thanks also goes to work study students Ted Geiser, Kenneth Devoid, Carol Goodheart, David Nuyen, Melody Hirschbiegel, Stacey Streator, Janet Sluzenski, Jeanne Allendorf, Susan Bonn, Kathy Camisa, Wanda Heading, Donna Corson, Daryl Corcoran, Tammy Besaw, Kevin Hinch, Stacy Shields, Todd Pudvar, Leslie O'Bryan, Monica Hahn, Colette Thibodeau, Tina Neff, and Peter Hummel.

I would also like to acknowledge a sincere thanks to University of Vermont Provost John W. Hennessey, Jr., whose compassion and understanding in the final year of this project will not be forgotten; to Lynne Z. Meeks, John S. Ryder, and Roger A. Lawson of the Administrative Computing Service at the University of Vermont for their patience and indispensable advice and assistance; to Marge White of the Writers Guild of America, West, Inc., for her help in providing useful information; to the Graduate College of the University of Vermont for the grant they awarded me; to the Motion Picture Association of America for helping with statistical information; and to Phil Lyman, whose bibliographical skills once again proved to be invaluable for my scholarly efforts.

Finally, I wish to express my love and gratitude to my wife, Sheila, and to my children, Steven, Gary, and Sharon, whose consideration, patience, and encouragement made everything else possible. They alone know what this project meant to me and willingly sacrificed so that I could see it through to the end. I thank them from the bottom of my heart for understanding my needs and catering to them.

Foreword

I wish this work were *not* called FILM STUDY: AN ANALYTICAL BIBLIOGRAPHY. It is such a far more ambitious, far more detailed, and far more comprehensive work than Dr. Manchel's earlier publication, FILM STUDY: A RESOURCE GUIDE, that I feel calling it a "revision" is like saying Thomas Jefferson's draft of the Declaration of Independence was a "revision" of some line of John Locke's. It may have *begun* that way, but the first was one interesting idea among many; the second became a lasting monument.

In the development of any field of knowledge, there comes a time when all that has been done to date needs to be surveyed, not because it will mark a culmination, but because it will serve as a consolidation upon which future workers in the field advance to new plateaus of achievement. Quintilian, Pliny, Bede, and Galen provided such surveys for the antique and Pre-Renaissance worlds, and Diderot, Johnson, and Webster provided encyclopedic surveys in the 18th Century that may be seen as early markers of the beginning of the modern intellectual age.

The need for an encyclopedia that would comprehensively survey virtually every book in the English language that deals with film has been discussed for years. But it has always been assumed that such a comprehensive study would be a group work, involving many scholars who worked over many years and had the benefit of a large advance and the power of a major publishing company behind them.

That such an encyclopedic work is finally here, and that it has come from the efforts of a single individual working through a small but distinguished academic press, without benefit of either an advance or scores of collaborators is absolutely astonishing.

FILM STUDY: AN ANALYTICAL BIBLIOGRAPHY is the longest and most comprehensive work on film ever done in the English language by a single individual. Many of its individual chapters are more than twice the size of the average book in film studies. If my estimates are correct, this work has extended discussions of some five hundred books, annotations of 2,000 books, contains close to 4,000 references to books, has nearly 5,000 footnotes, and countless articles in its survey of film literature. It is so comprehensive that it requires seven different sections just to index the subjects it contains.

How, I have been asking myself, has Frank Manchel been able to do this, when the typical scholar is considered to be doing well if he or she turns out a couple of works *one-tenth* the size of this in an entire career? The answer, perhaps, has come, not from film studies, but from anthropology.

The production of encyclopedic surveys seems to come at a particular stage in the evolution of a discipline or body of knowledge, one that we might compare to the stages of evolution in the lives of individuals. Anthropologists, following the lead of Arnold van Gennep and Victor Turner, have in recent years seemed to agree that the rites of passage into maturity are marked by three stages: separation, margin, and aggregation. In the first stage, the individual (or, I would say, the discipline), having gone through a prolonged period of development, is ready to be accepted as a mature entity.

The key transitional phase in this maturation process is the one van Gennep and Turner call the Liminal Stage (from the Latin for "threshold"). In this stage, the individual leaves the community, goes off to undergo a process of contemplation and study, which requires wrestling with interior and exterior forces until a synthesis of what came before and what now is takes place.

I did not know it at the time, but Manchel was just beginning such a liminal stage when he and I got to know each other in the mid-seventies. Since I was president of the Society for Cinema Studies and he was its secretary, I was able to see at close range what qualities of organization, thoroughness, and impeccable reliability he brought to our scholarly society's operations--qualities, I see in retrospect, that were to serve him well in the unprecedented task he was then just beginning.

Burlington, Vermont, where Manchel has taught film for nearly a quarter of a century, is not generally considered the mainstream of film studies. But, for this individual--and for the field of film studies as a whole--Burlington, Vermont, has turned out to be precisely the right place to go through the Liminal Stage that both he and our field required. Because it is away from the day-to-day internecine warfare that marks the "mainstream" tribe of film scholars and academicians, Manchel was able to survey dispassionately not just this partisan quarrel or that, one favored genre or another, one contending school or its adversary, but all of them.

Since he is one of the world's most modest of men (who else would devote more than a decade to reviewing the work of others?), he would blush and protest my assertion that he is the model of the heroic scholar. The fundamental requirement of any hero, as the history of film itself proves, is firmness and courage--firmness to continue when the task is unrewarding, uncertain, and difficult; courage to continue when it seems a losing proposition and there is no external validation for what you are doing.

For more than ten years, I have watched Frank wrestle with this gargantuan task. I learned years ago that there was no point in trying to reach him in the morning, for his phone would be off the hook from four-thirty to eleven-thirty every day of the week so he could concentrate on the seemingly endless task of reading every work in English he could obtain, comparing his own reactions with those of reviewers, and then writing his own analysis of the work. Once he had put in his daily quota of seven hours of research and writing, Frank then put his phone back on the hook and went off to his job as associate dean of the College of Arts and Sciences at the University of Vermont. When the thousands of pages of text were near completion, he then took a leave from the university so he could devote full time for more than a year just to completing the manuscript and to editing the material that he had accumulated during the previous decade.

I knew that Frank was intelligent, sensitive, and perceptive; what I did not know until I saw this manuscript was that this huge work would be so engagingly written and have such overall coherence. If I have any concern about this *magnum opus*, it is not over the several passages that I would quarrel with, the few where I think I know the subject better than he, nor even the one or two that infuriated me--in a work of this scope and size such disagreements with *any* author are inevitable as rainy days in the tropics. What concerns me more is that this work, precisely because it is ten times the size of most other scholarly publications in film, will open itself up to every jealous pip-squeak who wishes he or she could have done what Manchel did, and will therefore nitpick it to death.

We film scholars tend to be a fairly parochial and insecure group anyway; I shudder to think what will happen when reviewers find that Manchel has, in their eyes, undervalued their own or their friends' contributions, either because the size of the project prevented him from devoting as much space to a specific work as the reviewer thinks he should have, or because, in comparison to the thousands of other works Manchel has read, he judged a particular favorite of someone else's to be more modest in its contribution than the critic does. Such petty disagreements are endemic to academic and scholarly reviews; by producing a work ten times the size of most others, Frank Manchel will, I'm afraid, have to accept ten times the nitpicking.

But the world belongs to those who do their homework. Manchel has clearly done his, more thoroughly than any other person in the world of film that I know of, and as a result he is now indisputably the most well-read film scholar at work in this country.

Manchel has not only read more than any of the rest of us, he has read better. While the rest of us were paying attention to our own specialties, he was paying attention to *all* of them. As a result, his breadth, his perspective, and insight stem from a far richer base than those of us who are wrapped up in one particular area or approach to film could hope to provide.

FILM STUDY: AN ANALYTICAL BIBLIOGRAPHY is, quite simply, one of the most important, most comprehensive, most intelligent, and most needed projects ever to have reached fruition in the field of film studies. It will be not only a monument to the intelligence and dedication of Manchel, it will be a monument to our field as well, providing guidance to everyone who seeks to know more about the way film functions in our world.

In this one work, film studies has taken an important evolutionary step forward. By standing on Manchel's broad shoulders, we will all be able to see farther than we have ever seen before.

Howard Suber

Preface to the New Edition

The animals other than man live by appearance and memories, and have but little of collected experience; but the human race lives also by art and reasonings. Now from memory experience is produced in men; for several memories of the same thing produce finally the capacity for a single experience . . . And in general it is a sign of the man who knows and of the man who does not know, that the former can teach, and therefore we think art more truly knowledge than experience is; for artists can teach, and men of mere experience cannot.

Aristotle, METAPHYSICS

I do not claim that this new and retitled edition of FILM STUDY: A RESOURCE GUIDE is definitive, nor do I argue that the approaches suggested and discussed are completely reflective of how I think film should be studied in the classroom. Instead FILM STUDY: AN ANALYTICAL BIBLIOGRAPHY should be seen as reflecting a maturing awareness on my part of the significant contributions made by film scholars to the ongoing, ever-changing, complex issues associated with our discipline. The growth in both quantity and quality of film materials and theories since 1973 is extraordinary. One need only scan the indices of my first edition to be struck by the absence of then-unknown and emerging researchers and theorists like Jeanne Thomas Allen, Robert C. Allen, Dudley Andrew, Bruce A. Austin, Tino Balio, David Bordwell, Larry Ceplair, Richard Corliss, David Culbert, Patricia Erens, Steven Englund, Regina K. Fadiman, Lucy Fisher, Tom Gunning, Charles H. Harpole, Jim Hillier, Beverle Houston, Annette Insdorf, Marsha Kinder, Garth S. Jowett, Larry N. Landrum, Daniel J. Leab, James M. Linton, Timothy J. Lyons, Joan Mellon, James Monaco, Charles Musser, John G. Nachbar, Bill Nichols, Nicholas Pronay, George Rehrauer, Thomas Schatz, Robert Sklar, Anthony Slide, Thomas Sobchack, Vivian C. Sobchack, Pierre Sorlin, Janet Staiger, Elizabeth Grottle Strebel, Philip M. Taylor, Kristin Thompson, David Welch, and William F. Van Wert. I mean no disrespect to the many scholar-teachers whom I have neglected to mention here. But the aforementioned individuals come most readily to mind when I think about the revisions that have occurred in this updated work. In 1973, the study of film itself was still considered a controversial subject and was not perceived by many academicians as worthy of a place in the basic curriculum. And we should not forget that film publications were often ignored or dismissed as trivial.

This new edition, therefore, attempts to place these changes in perspective. Both in the main portion of the text and in the appendexes, there is a concerted effort to show the increasing stature and quality of film study and researchers. This maturity is reflected in the burgeoning resources donated by the film industry to the academic world: e.g., the Warner Bros. collection housed at Princeton University and the University of Southern California; RKO at the University of California in Los Angeles; Disney at the studio in Burbank, California; and United Artists at the University of Wisconsin, Madison. Readers will find additional information about other new library acquisitions in Appendix V. The improvement in film scholarship is also evident in the increasing number of publishers committed to making available scholarly resources for serious students: e.g., Ablex Publishing Corporation, Associated University Presses, Gale Research, Garland Publishing, Greenwood Press, Indiana University Press, Rutgers University Press, the Scarecrow Press, Southern Illinois University Press, and UMI Research Press. Most of all, the growth in film scholarship is reflected in the quality of the publications since 1973. A new generation of scholars has taken upon itself the difficult task of re-examining almost every aspect of film history, theory, and criticism. Because their work, and indeed the issues themselves, is so exciting and because this new edition is concerned with a broad perspective on important research material, I have included in my study as much information on this research as is reasonable. In addition, I have offered more extensive book and film annotations than in the previous edition. At times, however, my commitment to completeness has resulted in minimal documentation of certain books and articles that I could not obtain through interlibrary loan. In one instance, in Chapter 7, unsurmountable problems related to computer access and cost made it financially and

26

technically impossible for me to continue with the annotations for the section on the Contemporary Cinema. Rather than end the chapter with the 1960s, I included the material from the first edition, listed the new publications and information, and provided an overview of American films from the 1970s to the present. Here, as elsewhere, I felt the existence of these works and the references to their value by other scholars justified inclusion in this revision.

This book is based on my conviction that other reference works are unsatisfactory in two specific areas. First, they fail to capture both the flavor and the insights of the material they routinely recommend. Second, teachers and students have to spend hundreds of dollars to own the basic reference works dealing with film resources. This expanded edition of FILM STUDY: AN ANALYTICAL BIBLIOGRAPHY addresses these two problems by building on the comprehensive resource guide methodology begun in 1973. No one will fail to recognize my biases in the evaluations and in the space devoted to specific authors and theories. On the other hand, my respect for and gratitude to the hardworking scholars reviewed in the following pages can never be fully stated.

To underscore the major changes in the study of film since the original 1973 edition, I have expanded considerably the variety of perspectives relating to film production, distribution, exhibition, and reception. For example, Chapter 2 not only points out the nature of film genres, but also examines in detail the historical context in which war films emerged, developed, and changed from decade to decade. The primary intent is to identify the multitude of conventions associated with narrative film formulas and to survey the sociohistoric and artistic elements that influenced their use over an eighty-year period. As in the first edition, more attention is given to description than to analysis. The latter has been done voluminously by gifted critics deeply involved in analyzing cinematic narratives. What is missing generally from such worthwhile studies is an awareness of the historical and industrial context in which these film narratives incorporated specific elements into their screen characterizations and themes. Even more to the point, film students often find that the resources available for critical study are poorly defined in scope or too fragmented. Thus Chapter 2 is subdivided into sections (e.g., genres, propaganda, history on film, and history in film). This allows me greater latitude in exploring the relationship between a specific genre, the larger context of the film industry, and American society. Chapter 3, on the other hand, explores the nature of film as a social force in society. Here the primary emphasis is on identifying the variety of attitudes and responses to the film industry's desire to maximize profits and to minimize economic risks. Again, the methodology stresses description more than analysis. Although the subsections treat different issues (e.g., ideology versus entertainment, the pleasure factor, and the multiple role of movies), the intent remains the same: to point out the historical and industrial context in which particular themes and characters originated, developed, and changed from one decade to the next. The chapters taken collectively thus provide an overview on how film history, genres, themes, narratives, characters, theories, and industrial pressures combine to form a very complex mass communication product.

A word about the indexing in this edition is necessary. Since the amount of material is voluminous and constant cross-references are made throughout the work, I have resorted to seven indexes. The Article-Title Index and the Article-Author Index contain no surprises. The Book-Author Index and the Book-Title Index, however, include the names of short story writers and playwrights, as well as the titles of short stories and plays out of which movies were made. The Film-Title Index has a listing of the English-language titles and (where appropriate) the foreign titles of the films. The Film-Personality Index contains not only the names of people connected with the film industry--e.g., producers, directors, screenwriters, and stars--but also major influences on these personalities (e.g., novelists and philosophers). With few exceptions, this is the index to use when looking for information on an individual. The Subject Index is a listing of important topics, themes, and events that relate to or affect the history and criticism of film. Whoever wants to get the fullest information on a particular personality, film, or event is advised to consult more than one index.

Although I have spent the last ten years trying to review the important developments in film, I found it impossible to cover all the areas that might be of interest to each and every reader. No doubt, you can cite a gap here or there in your favorite area. In later editions, I hope to correct many of my shortcomings. There is a limit, however, to what one book can do and to what one individual can assimilate.

A word about the manner in which this present edition was produced. From the outset the publisher Julien Yoseloff, my trusted colleague Professor Littleton Long, and my friend Dean John G. Jewett understood and recommended the use of a computer to handle the considerable amount of information involved with a new and expanded edition. While none of them warned me about the problems I would encounter, each remained supportive throughout the grueling but rewarding educational experience. The word processing system used was SCRIPT/VS, in conjunction with the IBM 6670 Information Distributor (Laser Printer) as configured at the University of Vermont. The benefits of word processing are well known by this stage in the computer revolution. Some of the problems I faced may not be. For example, in preparing indexes for this text, numbers (e.g., 11) had to be printed as "eleven." Titles of books or films could not exceed a certain length, resulting in a number of instances where only abbreviated titles are possible. Citations of facts, names, places, and thematic items had to be limited to no more than fifty to sixty page numbers for each indexed entry. In dealing with superscripted diacritical marks for French, German, Spanish, and other languages, the IBM 6670 did not have the capability for overstriking so that an ' could be printed over an a. As a result, no accent marks could be used in the text for names like Melies or Klopfer, or words like cliche. Whenever I used indented quotations, the footnotes were single-spaced at the bottom of the page, even though the format was to double-space between footnotes. At times the extensive number of footnotes on a page created a problem of white space because SCRIPT/VS could not fit that many footnotes on a single page. Most, but not all, of these problems have been resolved by the single-spacing of the entire manuscript, by judiciously selecting what would be included in the indexes, and by rewriting certain passages to accommodate the formating demands of the SCRIPT/VS and IBM 6670. In addition, I made one significant change in style from traditional formats. Instead of including to indicate the omission of one or more sentences in the midst of a quotation, I have used . . . to suggest the omitted material, using only at the end of a quotation.

In short, this book could not have been completed without the people cited in the acknowledgements, SCRIPT/VS, the IBM 6670, many generous publishers, and the scholarship of my colleagues in film. Whatever you find helpful here is in large measure a reflection of their achievements. Finally, I shall be eternally grateful for the support and understanding of my wife and children. They more than anyone else know the cost of such an undertaking. For their sakes, I hope it will be deemed worth the time and energy.

Introduction

The question of educating the public to a better more critical appreciation of the films is a question of the mental health of nations.

Bela Balazs, THEORY OF FILM

This is not a methods book on how to teach about film, though it does offer in each of its seven chapters observations on current practices. Nor is this book an attempt to list definitively the various sources or materials connected with film study, though such a work would be welcome. Rather, it is a survey designed to describe six popular approaches to the study of the cinema, along with a practical analysis of selected books, materials, and information about motion picture rentals.

It first appeared at a time when film study programs were rapidly increasing in the schools. In spite of this activity, however, most institutions still continued to relegate movies to the status of textbooks, audiovisual (A-V) aids to stimulate students to learn more about other academic subjects. Regrettably, that practice still continues today. Despite the enormous inroads made by scholars, I still find widespread use of films as "motivational devices" to interest students in sociological movements, historical events, and literary genres.

No doubt many A-V films, like textbooks, serve a variety of useful purposes. But there are also many films, like books, that are works of art and deserve special consideration. Long ago educators realized that such books exist. Now they need to understood that the same is true for the cinema.

While there is a good deal of interest--particularly among young people--in learning more about movies, few scholars are able to present useful film programs. Not only do lean budgets and poor facilities limit their efforts, but a number of professors often have only limited knowledge about movies. They have not considered the principles of film art or how these principles stem from the nature of the medium. Therefore, it should come as no surprise that film study in many institutions is unsatisfactory and that scholars need and want help in remedying the situation.

There are a number of groups and individuals trying to provide that help: workshops at national conventions and regional meetings, special summer courses, the efforts of The American Film Institute and sectional organizations, state-subsidized programs, and aggressive academic departments. But many professors are often bewildered by such offers of help. They need assistance in evaluating the quality and suitability of the programs, in understanding the procedures for joining and participating in the activities, and in following up the suggestions made at these meetings. This book tries to help film students and professors find useful sources of information about such film study aids.

There are other problems confronting confused professors. We live in a cavalier age in which irresponsible suggestions are not only available but popular. Articles and books continue to appear suggesting that anyone can teach about film. No training is necessary; all you need to do is walk into a classroom and get students "involved" with the "relevance" of film and they will have a "meaningful experience." Behind these overused and ill-defined concepts lie the false assumptions that we have nothing to learn from the past and anything new must be better than what has come before. I do not accept these assumptions. Certainly we can enjoy a film just by seeing it. Yet a knowledge of film history leads to a deeper appreciation of movies, and an understanding of film aesthetics increases our sense of enjoyment. This book reaffirms what competent scholars have always maintained: good teaching provides bridges between the past and the present that are meaningful and enjoyable. Where mediocrity and dullness exist, bad teaching does also. Here methods and materials need revision. But we should not confuse change with progress. How to improve our teaching is a complex problem. And the best that can be said about a simple solution to a complex problem was said by H. L. Mencken, "It is simple, direct and it is wrong."

In considering change, it is useful to examine where we are. This book is organized so that the six most common approaches to film study can be examined: a representative genre; stereotyping; thematic approach; comparative media; a representative period; and the history of film. None of the approaches has been

exhaustively discussed. Appropriate materials (films, books, and articles) have been suggested to help film students explore the subject further.

Each film entry, depending upon its context, is listed alphabetically and contains, in addition to its title,[1] the releasing company (country of origin), the film gauge (16mm, 8mm, or 35mm), the year of its initial release, running time in minutes, special information (black and white or color, CinemaScope prints, subtitles, etc.), and a special code abbreviation of the American distributor who has the film for rental, lease, or sale. These special codes are listed alphabetically in Appendix II.[2]

The following is a typical entry:

THE PRIME OF MISS JEAN BRODIE (Fox--16mm: 1969, 116 mins., b/w, sound, R-FNC)

Ronald Neame directed this memorable film about the Edinburgh spinster, Jean Brodie, who shocks her colleagues at a staid school for girls by snubbing the prescribed curriculum and developing her own coterie of "Brodie girls." Oscar-winning Maggie Smith is superb as the dogmatic school teacher who preaches the virtues of Mussolini and Franco, warps young minds, and ends up alone. Unfortunately, Jay Presson Allen based the screenplay on the stage play which, in turn, had been adapted from Muriel Spark's 1962 novel. The book should have been the original source since it is much stronger.

After the title comes the country of origin (or studio name when dealing with American films), the information that it is a 16mm print, first released in 1969, with a running time of 116 minutes, in black and white, with sound, and that it can be (R) rented from Films Incorporated (FNC). (S) would indicate that it is for sale, and (L) for lease. Also included is a brief description of the film and of key personalities connected with it. Usually, helpful articles dealing with the movie or its cast are footnoted on the page. Space and emphasis, however, sometimes require additional footnoting elsewhere, and readers should check the indexes for possible additional information.

In preparing the material and selecting the films, I have used the following criteria:

1. The films had to be available to schools and students.

2. The range of the films had to represent the history of motion pictures, significant genres, and important artists.

3. The films, for the most part, had to demonstrate artistic excellence as well as social relevance. I have drawn upon the judgment of recognized and respected film critics and film historians, as well as my own preferences.

4. The major emphasis is on narrative fiction films

as a result, the majority of movies chosen are well-known theatrical films from different countries.

Books, monographs, and screenplays have been, for the most part, annotated in the text proper. These annotations, chiefly critical and descriptive, suggest, in my opinion, the best of the existing English-language materials now available in libraries and book stores. Each has been read by me, and in most cases my opinions have been checked against book reviews by major scholars in reputable film periodicals. The dates given suggest the best editions to study; the publishers listed are American, whenever possible; and asterisks are used to indicate paperback editions available at the time of this writing. To keep abreast of new editions, readers

[1] In reference to foreign films, the English title is given first and the foreign title is given next. The film index provides a listing of all films under both their English and foreign titles.

[2] Extremely helpful in cross-checking this list was a very useful book edited by James L. Limbacher, FEATURE FILMS ON 8MM, 16MM, AND VIDEOTAPE. EIGHTH EDITION. A DIRECTORY OF FEATURE FILMS AVAILABLE FOR RENTAL, SALE OR LEASE IN THE UNITED STATES AND CANADA. (New York: R. R. Bowker Company, 1985).

should consult PAPERBOUND BOOKS IN PRINT. Those who wish to study these works or purchase them should consult Appendix V, which lists major archives, libraries, and rare book dealers.

Readers should also consider the advantages to their needs of video. The growing revolution in film study created by videotapes, videodiscs, and videocassette recorders reduces the problems of availability, accessibility, and rental costs. Robert Lindsey pointed out in March, 1984, that the videocassette recorder dramatically changed "the way Americans enjoy filmed entertainment since the postwar expansion of commercial television." He reported that "More than 17 million videocassette recorders are now in use, new units are being sold at a rate of more than 20,000 a day, and the film rental business is booming."[3] Three months later, David Sanger told us that the VCR industry was increasing its sales projections by twenty percent and estimating that 11.5 million more machines would be sold by the end of the year (1984).[4] The major problem, however, is that the various VCR formats dramatically affect the size and shape of the visual image and produce a viewing experience radically different from that found in a movie theater. For that matter, so does a 16mm print. At some point in the curriculum, consideration has to be given to the quality and the significance of this new but already common experience in film viewing.

On an equally controversial issue, I found it useful in the first edition to consider the art of film as a systematic ordering of images which might be said to have its own language, composition, and literature. Such metaphorical extensions of traditional terms provided me with the means of approaching a new medium in familiar terms. What I meant by language, therefore, was the audio-visual mode of expression which is characteristic of film, and yet which shares with other "languages" the traditional properties of being systematic, symbolic, socially employed, and consistently evolving under the pressure of cultural change. By composition, I referred mainly to the arrangement of filmic properties, such as images and sounds, which create the total film. And literature suggested the films which represented the outstanding achievements of the cinema.

My experiences since 1973, however, have taught me that the negatives of this approach outweigh its benefits. The end result in thinking of film in literary terms is that the uniqueness of the medium is subordinated to the biases of literary traditions. Consequently, I have altered the basic premise of this book so as to stress the nature of film as film. That is not to say that the allusions to literary traditions are insignificant. As the reader will discover, I prize them very highly. It is to say that literature and film share important characteristics, but they are also two distinct art forms.

Finally, this book is not meant as a substitute for professors and students who need to devise and develop approaches to film study which are right for them. Only they know what is best for their needs. But for too long movies have been ignored as a significant art form and as a valuable mode of expression. My hope is that you will find in the following pages materials and suggestions that will help change this situation. This book is intended as a survey which offers practical advice to serious students of film.

[3] Robert Lindsey, "VCR's Bring Big Changes in Use of Leisure," NEW YORK TIMES 1 (March 3, 1985):1. See also Hans Fantel, "Tape Changes the Home Movie Picture," ibid., 2 (April 22, 1984):26; and Geraldine Fabrikant, "Wall Street Awaits Video Wunderkind," ibid., D (September 19, 1985):1, 5.

[4] David E. Sanger, "VCR's and Disks Now Star at Show," NEW YORK TIMES D (June 3, 1985):16.

Chapter 1: Film as Film

The highest function of motion picture art is to express the people to
themselves. The voice of the screen is the voice of common humanity trying
to put into living words its thoughts and emotions, its ideals and its dreams.
William C. DeMille, HOLLYWOOD SAGA

BACKGROUND

Getting people to watch movies is not a problem. Getting them to take movies
seriously is a problem. Dealing with that challenge is what this book is all about.
Most students begin their screen education wanting to see entertaining theatrical
films. They take a film course for enjoyment and pleasure and not as their "major"
program of study. It is the "fun" course that fulfills their general education
requirements. If things go well, students may even decide to "minor" in film studies,
just for the chance to take a series of courses that "lighten" their academic load.
The more adventuresome decide to major in the discipline. At every stage, however,
it becomes clear that watching movies is not the same as appreciating them. To
appreciate films, one has to learn how to judge them. And there's the rub. For in
judging films, to further paraphrase Shakespeare's late, lamented Dane, who knows
what harm we may do to our love of films?

The challenge in studying film is how to increase one's passion for the medium
without creating linguistic and pedagogical barriers that rob us of the film experience
(seeing, hearing, and assimilating the effects of movies). To do that, to build on
student interest and enthusiasm, requires sensitivity to student needs, as well as
commitment to subject matter. There is a difference, however, between what students
perceive as their needs, and what the discipline requires for intellectual awareness.
It all hinges on how we handle analysis; i.e., how we approach the subject and allow
ourselves to experience the work of art. I begin with the assumption that film is more
than mere entertainment. By asking critical questions about why pieces of celluloid
filled with recorded images and sounds appeal so strongly to our emotions, my
students will gain a greater appreciation of film.

In particular, I feel it valuable to question not only what filmmakers offer us
about the real world, but also what is often absent from most film. For example, why
are African-Americans routinely featured in comedies and action films, but noticeably
absent in serious dramas? Why is it that women have fewer career options than men
in mainstream theatrical films? Why is it that filmmakers consistently produce sequels,
remakes, and spin-offs, rather than explore new topics and forms? How accurate are
the historical dramas that deal with legendary figures and famous battles? How
responsible is it to depict the Holocaust in film? Why is it that so many of the
commentaries on film are filled with anti-Semitic material? Why are so many of us
interested in the life-styles of movie stars? What is it about certain conventions that
they retain their hold on our imagination? Is it true that a movie is always inferior
to its literary source? Do films appeal to the lowest common denominator in our
society? Are the mass media debasing our taste and sensibilities?

Where to begin? What approach is best? How to measure success? These are
questions we will explore in this chapter. Four basic assumptions will guide my
strategy. First, I know that not everything I believe about film study will find favor
with the reader. I would like my ideas to appeal to every serious student, but my
primary goal is to advance our understanding of film. Second, I know that there is
much information about film that is omitted from this work. Third, I assume that
serious film students will become more knowledgeable as a result of reading this book
about the world of film, and the world on film. And fourth, I assume that the
discipline of film is worthy of serious study. What follows explains why.

The movies are an integral part of our culture. Seen on TV; rented or bought
as videocassettes and laserdiscs in supermarkets, video stores, or through the mail;
viewed on airplanes or in hotel rooms; studied as masterpieces or used as audio visual
aids in classrooms from pre-school to post-doctoral programs; or enjoyed as
entertainment in movie theaters, films affect the way we live, and how our society

functions. At the very least, movies represent (select, arrange, and project) a filmmaker's interpretation of the real world. By buying into that selected image of designed reality, we become vulnerable to emotional manipulation. Filmmakers thrive on getting us to identify with the screen characters and to receive pleasure from time-honored conventions recycled in narrative films. (Very rarely do we go to movie theaters to see documentaries, abstract films, and animated movies.) At the very best, the movies become an art form that enriches our quality of life. It is now axiomatic that elementary and secondary schoolchildren spend more time watching TV, where film is the basic medium, than they do studying in classrooms.[1] It should also be clear that films are more than mere entertainment. The messages they contain, the images they offer, the choices they present, and the resolutions they suggest, not only shape our daily lives, but also relate to our national ideology and future goals.

Despite film's comprehensive involvement in our lives and minds, the study of film is still in an adolescent stage. At one point in the mid-sixties, Stanley Kauffmann was celebrating the emergence of a "Film Generation: the first generation that has matured in a culture in which the film has been of accepted serious relevance, however that seriousness is defined."[2] In little more than a decade, the American Film Institute (AFI) reported that the number of colleges and universities offering film study between 1967 and 1978 had grown from 200 to 1,067. At these institutions, a 1978 study tells us,

> a total of 9,228 courses are offered in film and television . . . In the area of film, 3,655 courses are offered for undergraduates and 1116 for graduates. There are 3,360 undergraduate and 972 graduate television courses. On the undergraduate level, there are 1,087 courses combining the study of film and television; on the graduate level, there are 478. . . .
>
> At . . . [these] institutions, there are 4,220 faculty members teaching in the areas of film and television. Of these teachers, 2,830 are full-time faculty members, while 1,390 teach courses in film or television on a part-time basis.
>
> Of the 1,067 schools offering film and television coursework, 307 offer programs leading to a degree in one or both of these areas. . . .
>
> A total of 40,590 students (36,654 undergraduates and 3,936 graduate students) are currently pursuing degrees in film, television, or a closely related area . . . The number of students taking courses as nonmajors is, of course, much larger--approximately 200,000 each semester.[3]

Not only was film being studied more often than in the past, but it also was becoming a more respectable discipline. There was a widespread feeling that movies were coming of age. Whether one studied history, criticism, appreciation, production, educational media/instructional technology, or management (the six main curricular areas in film and television programs),[4] it seemed clear that film had established an irreversible foothold in academia.

The problem is the nature of the foothold. In 1986, Joan D. Lynch summarized the conclusions of three film education surveys conducted following the 1978 AFI study.[5] Her overall assessment was that our methodology and our identity were still

[1] For useful statistics, see Joan Driscoll Lynch, FILM EDUCATION IN SECONDARY SCHOOLS: A STUDY OF FILM USE IN SELECTED ENGLISH AND FILM COURSES (New York: Garland Publishing Company, 1983), pp.1-2.

[2] Stanley Kauffmann, A WORLD ON FILM: CRITICISM AND COMMENT (New York: Harper & Row, 1966), p.415.

[3] *Dennis R. Bohnenkamp et al., eds., THE AMERICAN FILM INSTITUTE GUIDE TO COLLEGE COURSES IN FILM AND TELEVISION. Princeton: Peterson's Guides, 1978), pp.11-2.

[4] Bohnenkamp, p.12.

[5] Joan D. Lynch, "Film Education Research: An Overview," TEACHING ENGLISH IN THE

evolving. More to the point, she discovered that of 546 teachers responding to a second AFI survey in 1981, no more than forty-five percent had a doctorate, fewer than twenty-two percent were working toward one, and that the largest percentage of doctoral degrees were in English (twenty-nine percent) and in communication (slightly above sixteen percent). Even more disturbing was the fact that fewer than six percent of the entire group had doctorates in cinema.[6] Lynch did qualify the last figure, however, reminding us that the statistic "could be misleading because film/video programs might be housed in departments of communication, speech, broadcasting, or humanities."[7] In addition, she points out that

> College film teachers have widely different backgrounds and divergent interests as evidenced by the degrees they hold and the organizations to which they belong. These facts, coupled with the diversity of college courses offered in film and the widely divergent placement of film courses in 12 different departments, indicate the lack of unanimity in the discipline, especially in terms of possible film/video program models. The fact that fewer than one-third of the colleges offering film and television courses have degree programs suggests that film/video study on the college level may be an ancillary to the discipline in which it is housed as it is on the high school level to the study of English.[8]

To add to the picture, the schools surveyed indicated that they intended to maintain their present course offerings, or, if possible, to expand them during the 1980s.

Equally symptomatic of the malaise in film education was Kauffmann's anecdotal observations about the current film generation. Focusing not on students who major in film, but rather on young people in general, the scholar-critic bemoaned the fact that ignorance about film history was widespread, that few people seem concerned over what movies they had missed, and that young people seemed detached from the film scene. Why? One tentative answer, he speculated, had to do with the demise of an art house environment. Twenty years earlier, foreign films had captured the imagination of the "film generation." Today, however, the art film stimulus is gone both for the public and for the American filmmaker. A second possibility is that an undergraduate degree more and more is signaling the end of intellectual curiosity for young people in general. Twenty years earlier, a commencement exercise was just that, the beginning of a continuing search for knowledge. Today, however, for many people, four years of undergraduate study is more than enough cerebral stimulation. After that, career choices and upward mobility consume the college graduates. Other possible reasons are tied to the decline of serious campus film societies, and the emergence of rock music as the central experience for young people. Kauffmann offers no solution, only lamentations.[9]

TWO-YEAR COLLEGE 13:4 (December 1986):245-53. The three surveys are Joan Driscoll Lynch, FILM EDUCATION IN SECONDARY SCHOOLS: A STUDY OF FILM USE IN SELECTED ENGLISH AND FILM COURSES (New York: Garland Publishing Company, 1983); Timothy J. Lyons, "Extent and Diversity of Degree Programs in Film and Video," A REPORT ON THE 1978 INVITATIONAL CONFERENCE AND WORKSHOP ON FILM/VIDEO AS AN ARTISTIC, PROFESSIONAL AND ACADEMIC DISCIPLINE (Los Angeles: School of Performing Arts, University of Southern California, 1979):85-118; and Calvin Pryluck and Paul T. M. Hemingway, THE AMERICAN FILM INSTITUTE SECOND SURVEY OF HIGHER EDUCATION (Los Angeles: American Film Institute, 1982).

[6] "Film Education Research: An Overview," p.246.

[7] "Film Education Research: An Overview," p.246.

[8] "Film Education Research: An Overview," p.251.

[9] Stanley Kauffmann, "After the Film Generation," NEW REPUBLIC (December 16, 1985):22-3.

Sensitive to the problems of intellectual curiosity, screen educators examine the problem of setting minimal standards for the profession. More than a decade ago, Timothy J. Lyons addressed the dilemma of increasing enrollments in graduate programs, and the lack of commonality in degree work from one institution to another. After focusing on four specific topics--"(1) academic degree structures, (2) art versus science: film/video production and study, (3) requisites for offering degrees in film and video, and (4) some comments on the future of film/video in higher education"[10]--he raised the issue of national accreditation. Lyons mentioned the issue not just for the sake of consistency or even for academic respectability. "Accreditation," he argued, "can establish minimum standards against which programs can constantly measure themselves. Through accreditation, some minimal consensus can be achieved so that programs can be formed intelligently, rather than in a vacuum."[11]

Since 1978, the profession has been wrestling with the problems of national accreditation. For example, within months of Lyons's presentation, the AFI EDUCATION NEWSLETTER had a front-page endorsement, calling the conference he attended "probably the most reasonable step that has ever been taken in bringing together screen education in our country."[12] Six years later, Lyons, now president of the University Film and Video Association, set up a national commission "to consider whether the formation of an accreditation association for the field of film and video was an appropriate and feasible step at this time."[13] In essence, the members of the commission decided that more information was needed, and recommended that a study commission be established to gather more data about the nature of the institutions where film and video are taught, and the credentials of the teachers. That report has not yet been delivered.

A word of caution. The fact that the majority of people teaching film do not have degrees in cinema is not surprising given the attitudes toward film education during the past seventy years. In my case, for example, I found it extremely difficult in the fifties to find a program that led to a doctoral degree in film teaching. Even when I tried teaching about film in the secondary schools, the only courses that I was permitted to introduce film study in were courses designed for disadvantaged students.[14] As a doctoral candidate in Columbia University's program in the College Teaching of English, life was not much easier. When I proposed the nucleus of this book for my doctoral study in the early 1960s, the review committee debated the merits of a film study project and was still debating the issue when the dissertation was finished. If not for the persuasive powers of Professors Louis Forsdale and Robert A. Bone, the committee might never have approved the project. That is not to say that my film education, primarily based on independent study, was the model route of my generation. Unquestionably I would have been better off if I had taken the "pure" cinematic route. Moreover, I remember attending the 1983 University Film and Video Association Conference held at North Texas State University, where a panel on screen education featured the distinguished scholar Raymond Fielding describing the production background that he considered necessary for a film educator. The next speaker was the equally distinguished scholar Garth S. Jowett, who stated

[10] Lyons, p.87.

[11] Lyons, p.97.

[12] Sam L. Grogg, Jr., "Standards for Film Education," AFI EDUCATION NEWSLETTER 2:1 (September-October 1978):1.

[13] Peter J. Bukalski, "A Report to the Board of Directors, University Film and Video Association, And to the Council of the Society for Cinema Studies," (June 1, 1985), p.1.

[14] Frank Manchel, "The Screen and the Book: A Solution for Slow Learners," ENGLISH JOURNAL 53:3 (March 1964):206-7.

categorically that he did not possess any of the qualifications that Fielding cited. A notable sign of relief was heard in the room.

Nevertheless, given the state of our discipline, educators, theologians, political leaders, and parents justly debate the value and role of films in public education and private life. On the negative side, film's obvious emotional and social impact has been a subject of great concern since the turn of the century, causing prominent educators, politicians, religious leaders, social reformers, and industrial giants to seek ways of controlling the content and exhibition of movies, and keeping them out of the hands of "outsiders," revolutionaries, demagogues, philistines, charlatans, sycophants, and amateurs. Film's legions of detractors have always had significant allies in literary, dramatic, and intellectual circles whose elitist views denigrate film's appeal to mass audiences and its use of hegemonic formulas and stereotypes. On the positive side, there are equally prominent scholars, artists, intellectuals, and educators who view film as the greatest art form of the twentieth century and consider it not only worthy of a place in the curriculum, but also invaluable in providing students with experiences and insights comparable to those provided by music, art, literature, drama, dance, history, and philosophy.

Even though the last twenty years have witnessed the establishment of graduate programs, important breakthroughs in how we approach the study of film, and the academic training of the most commercially successful artists in the history of world cinema, the study of film still has to defend itself. One argument against film study results from the increasing pressure for coursework to become more career-oriented and less humanistic in character. As money, material possessions, and status continue to become more important to "professionally minded" parents and students of the eighties, interest in the liberal arts and human development becomes less important to short-sighted administrators, who demand that departments and programs offer more "bread and butter" courses. As college enrollments decline, and as budgets become tighter, film courses and faculty members come under greater pressure to "account" for their content and expenses. Of course, it doesn't help to have ill-equipped teachers and "film buffs" using movies as visual aids to bolster dull classes and to maintain departmental enrollment figures. Ironically, efforts to disband weak programs and to upgrade media studies are used as general condemnations of the discipline in general, rather than as evidence of a willingness by media scholars to move mass communications to a higher standard of excellence.

Another argument against film study comes from reactionary forces who seek to eliminate popular culture from public and private schools, colleges, and universities. Although film's most recent antagonists cloak themselves in the trappings of traditional values and sacred canons, their objections are as old as the hue and cry raised against art, literature, drama, and the Bible since recorded time. Not only is there an erroneous assumption that film and TV contaminate and destroy literacy and taste, but there is also the widespread fear that intuition and emotion will undermine the central place of logic and science in our secular and industrial society. These arguments will be discussed in detail in forthcoming chapters. Suffice it to say that the debate against the modern arts is as heated today, as when it took shape with the rise of mass communication in the eighteenth century.

Thus, those scholars, teachers, students, and administrators who champion the study of film as indispensable to contemporary life and to the world of educated men and women need a perspective that allows them to unify what appear to be disparate elements. In developing this perspective, it is valuable to consider the following questions: Why teach about films at all? What do we mean by film study? My assumption--and the basic premise of this book--is that first we need to consider what we want to do and why, before we attempt to make a sensible decision concerning teaching materials, approaches, and assignments.[15] Many film educators have offered useful answers to why we should study film. For example, Tim Bywater and Thomas

[15] The strategy for this opening argument is suggested by James Knapton and Bertrand Evans, TEACHING A LITERATURE-CENTERED ENGLISH PROGRAM (New York: Random House, 1967), pp.1-31.

Sobchack stress the value of studying film criticism, arguing that it "is a process that encourages clear thinking, the weighing of alternatives, the evaluation of evidence, and the risk of having to defend judgment publicly."[16] Dudley Andrew argues that

> To me, films are both cultural objects to be mastered and experiences that continually master us. Film buffs are mere collectors of experiences (their own or those of the auteurs they worship), and film scientists protect themselves from experience by a certain technique of mastery. Education, I believe, is best served by a dialectic that forces us to interrogate films and then to interrogate ourselves in front of films. We must learn to experience, to remove ourselves from experience, to understand experience, and then to reexperience in what amounts to a perpetual internal revolution.[17]

And William Arrowsmith insists, "I know of no art with such potential for stating our problems, complexities, anxieties, and powers more naturally or comprehensively than film."[18]

In answering the question for myself, I find it helps to remember just what movies have done for me. Since my purpose in teaching is to share my passion for movies and to help students revere the aesthetic experience, I assume that what film does for me it can do for students. Thinking back over my life, I realize that movies have brought me to places I'd never been and provided experiences I'd never thought possible. They have changed my outlook on life, helped shape my career, and influenced my opinions, values, and actions. They have influenced me to investigate not only myself, but also my relationship with other people and the world in which we live. They have broadened my mode of expression and aided me in communicating with people all over the world, regardless of distance, age, or background. They have forced me to study other disciplines so that I may better understand the syncretic nature of film. While other disciplines may assume the isolated nature of their studies, mine requires an interdisciplinary approach. Film has also sensitized me to the plight of others less fortunate than myself, to the responsibility each of us has to make the world better, and to prefer conflict rather than comfort in the pursuit of excellence. That is not to say that movies are able to accomplish this feat more effectively than literature or history or philosophy or religion. It is to say that film has been central in my ongoing search for answers to what makes a person a just and responsible human being. Last but certainly not insignificant, movies have given me an incredible amount of pleasure.

Thirty years as an educator has intensified my conviction that an intelligent understanding of what movies are and how they influence our lives is essential to the mental health of nations. That is why I teach about film and argue for the inclusion of film study in school curriculums.

But none of us expects to find a method of accomplishing all of these aims within the narrow range of our influence. Nor should anyone expect it of us! After all, our budgets, training, and interests are equally varied. What's more, every time you walk into a classroom, you relate to dynamic individuals, and not to static robots. Given such a divergence, how could anyone profess to know one method that would work for everyone?

[16] *Tim Bywater and Thomas Sobchack, INTRODUCTION TO FILM CRITICISM: MAJOR CRITICAL APPROACHES TO NARRATIVE FILM (New York: Longman, 1989), p.xv.

[17] Dudley Andrew, "An Open Approach to Film Study and the Situation at Iowa," FILM STUDY IN THE UNDERGRADUATE CURRICULUM, ed. Barry Keith Grant (New York: The Modern Language Association of America, 1983), pp.43-4.

[18] William Arrowsmith, "Film as Educator," FILM AND THE HUMANITIES, ed. John E. O'Connor (New York: The Rockefeller Foundation, 1977), p.23. The article originally appeared in THE JOURNAL OF AESTHETIC EDUCATION 3:3 (1969):75-83.

This brings us to the second question: "What is film study?" Reading the opinions of respected educators in FILM STUDY IN THE UNDERGRADUATE CURRICULUM is enlightening. For example, Gerald Mast talks about film study as the examination of "humanistic texts," where one deals with questions of structure, style, contexts, and values. Minimal budgets of $25,000 are suggested, and THREE analytic projectors are deemed essential, so that instructors can review a film's key scenes and students can have repeated viewings of films housed in a central archive.[19] Ron Burnett sees film study beginning with students "unlearning" their preconceptions about movies and then "contextualizing" their film experiences. After that, the emphasis should be on understanding the basics of "perception" and their relationship to film viewing, the links between the creative act and personal values, and the importance of the audience in determining film communication.[20] Barry Keith Grant insists that film study should use art as an aesthetic experience, with the teacher demonstrating for students how they should respond to the work of art. Relying on Stephen C. Pepper's notion of "contextualism," the teacher fuels the interaction between the film and the spectator.

> The specific nature or "quality" of this experience--what Pepper called "the character, the mood, and you might say, the personality"--of the event becomes the central subject of inquiry for the contextualist, who, therefore, ultimately must consider both the physical work of art and his or her own responses in making aesthetic judgments.[21]

Paul Sharits believes that students are too rational and static in their approach to films, and argues that we should use "cinematics" as a methodology. That is, we should develop, in students, "an attitude that is both critical of natural and naive conceptions of cinema and insistently open to new definitions of the film-viewing and -making enterprise,"[22] in essence, a course of study that makes change the norm rather than the exception. Dudley Andrew rejects the idea of studying film in departments, opting instead for a film center, a clearinghouse for information and a facilty for equipment and material that incorporates film into the liberal arts curriculum, and that encourages intellectual curiosity.[23] And Bill Nichols claims that what characterizes his approach to a film studies program "is its commitment to an understanding of both the aesthetics and ideology of film communication."[24] These are just some of the approaches included in but one of dozens of books on film study.

[19] Gerald Mast, "Film Study and the University of Chicago," FILM STUDY IN THE UNDERGRADUATE CURRICULUM, pp.3-10.

[20] Ron Burnett, "The Practice of Film Teaching: Vanier College," FILM STUDY IN THE UNDERGRADUATE CURRICULUM, pp.11-6.

[21] Barry Keith Grant, "Notes on Experience and the Teaching of Film: Brock University," FILM STUDY IN THE UNDERGRADUATE CURRICULUM, p.23. See also Stephen C. Pepper, THE BASIS OF CRITICISM IN THE ARTS (Cambridge: Harvard University Press, 1965), p.59; and Barry Keith Grant, "Prolegomena to a Contextualist Genre Criticism," PAUNCH 54:5 (January 1980):138-47, rpt. JOURNAL OF MIND AND BEHAVIOR 3:4 (1982):337-44.

[22] Paul Sharits, "A Cinematic Model for Film Studies in Higher Education: Center for Media Study/State University of New York at Buffalo," FILM STUDY IN THE UNDERGRADUATE CURRICULUM, p.29.

[23] Andrew, pp.39-48.

[24] Bill Nichols, "Introducing Film Study in an Undergraduate Context: Queens University," FILM STUDY IN THE UNDERGRADUATE CURRICULUM, p.50.

Given the diversity of opinions by experienced teachers, I believe we should begin by accepting the fact that there is no one answer to what "film study" means, or what it should include. And yet, the impossibility of the answer suggests a starting point. Diversity, not uniformity, seems to be the key to film study. It follows from that position that people should be creative, experimental, and ambitious. Learning situations should provide a safe cushion for failure. Teachers should avoid using inflexible critical conclusions. Discovery should be based upon more than viewing and subjective judgments. Lectures, discussion groups, writing and reading assignments, related courses, repeated viewing sessions, and comprehensive examinations are all part of the process. And as students become more interested in history, criticism, appreciation, and production, they should have the opportunity to pursue these and other concerns. Film study, no matter what the variables are, should stimulate students' imaginations about the world of film, and then help them to explore fruitfully the many interesting possibilities. This breadth of approach was not characteristic of film study in its early years.

Although film study first appeared in the schools, mainly in English departments, in the early 1900s, teachers still fluctuated between an analytical and a humanistic approach. One of the earliest reports implies that educators considered the first motion pictures a moral and social threat.[25] To insure that students' minds would not be polluted, only instructional films from the Audio Visual Department were allowed in the classrooms. Straining to avoid the menace of a commercial product in the pure realms of academia, teachers used the instructional movie, with its major concern for transmitting information, as a substitute for the fiction film. Thus, they attempted to reduce the stigma of entertaining students with a theatrical movie during the school day, and motion pictures as teachers' aids gained a strong hold in

[25] Robert W. Neal, "Making the Devil Useful," THE ENGLISH JOURNAL 2:4 (December 1913): 658-60.

[26] One of the most exhaustive studies on the film in the secondary school, and the one thatEhis section rests most heavily on, is Stuart Selby, THE STUDY OF FILM AS AN ART FORM IN AMERICAN SECONDARY SCHOOLS (Ed.D dissertation, Teachers College, Columbia University, 1963); New York: Arno Press, 1978. In addition, the following are also useful sources: Ralph Jester, "Hollywood and Pedagogy," JOURNAL OF EDUCATIONAL SOCIOLOGY 12 (November 1938):137-41; Vlada Petric, "The Projector and the Camera: Intergrating Courses in Cinema Studies and Filmmaking," JOURNAL OF THE UNIVERSITY FILM ASSOCIATION 28:2 (Spring 1976):3-7; David Bordwell, "The National Conference on the Teaching of Film (March 24-28, University of Wisconsin at Milwaukee)," ibid., pp.33-4; Stuart Samuels, "Film as Social and Intellectual History at the University of Pennsylvania," FILM & HISTORY 2:3 (1972):14-7; James C. Curtis and J. Joseph Huthmacher, "The American Dream on Film," ibid., 3:3 (1973):17-9; Anthony Penna and Mathias von Brauchitsch, "The Design and Teaching of Dramatic Films: An Approach to Values Education," ibid., 4:3 (1976):49-55; E. Bradford Burns, "Conceptualizing the Use of Film Study to Study History: A Bibliofilmography," ibid., 4:4 (1974):6-9; William Hughes, "Proposal for a Course on Films and History," UNIVERSITY VISION 8 (1972):9-18; Michael T. Isenberg, "A Relationship of Constrained Anxiety: Historians and Film," THE HISTORY TEACHER 4:4 (1973):553-68; Peter C. Rollins, "Film and American Studies: Questions, Activities, Guides," AMERICAN QUARTERLY 26:3 (1974):245-65; E. L. Ruhe, "The Literary Approach," LITERATURE/FILM QUARTERLY 1:1 (1973):76-83; Dean Wilson Hartley, "How Do We Teach It? A Primer for the Basic Film/Literature Course," ibid., 3:1 (1975):60-9; Ruth Perlmutter, "Add Film to Rhetoric," ibid., 3:4 (1975):316-26; Claire Hirshfield, "Teaching History to the Disadvantaged College Student: A History Through Film Approach," ibid., 4:1 (1974):4-10; Michael A. Anderegg, "Shakespeare on Film in the Classroom," ibid., 4:2 (1976):165-75; Ronald Polito, "The History of Film Teaching in the American School System," SCREEN EDUCATION 31 (September-October 1965):10-18; Edouard L. de Laurot, "Audio-Visualism versus Education," FILM CULTURE 1 (Winter 1955):6-13; David C. Stewart, "Toward Film Study," FILM STUDY

institutions.[26] In the thirties, the Payne Fund Studies (to be discussed in Chapter 3) pointed out that it was the responsibility of educational institutions to teach about the harmful effects of the commercial film.

For the next thirty years, colleges, universities, and secondary schools tacitly designated that responsibility to English departments. The rationale was that this department is best at developing human ideals and positive attitudes. The English teacher in the past had done this through teaching the rudiments of language while claiming that an analysis of a literary work would lead to moral and spiritual uplift.[27] The film was viewed as a form of nonverbal communication that could transmit these values more rapidly than words and thus was a valuable adjunct to the curriculum. Far more significant than the coursework in schools, however, was the rise of film societies and archives in Europe and the United States. As will be discussed in later chapters, cineastes and film buffs encouraged the screenings of AVANT-GARDE and "classic" films. Not only did such groups provide channels of exhibition for controversial and non-traditional theatrical films outside the dominant film industry, but they also nurtured several generations of great filmmakers and critics in England, France, the Soviet Union, and the United States.

Following World War II and prior to the 1960s, teachers' attitudes reverted to the idea of film as an instructional medium, rather than as a humanistic experience. As late as 1965, one observer commented, "Today, film study in the public school still exists in scattered groups throughout the country, but only vestiges remain of the once vital film study movement of the 30's."[28] The history of film study movements, particularly the contributions of Andre Bazin, Louis Delluc, and John Grierson, will be covered in Chapters 2 and 7. Suffice it to say that film societies and "art" theaters in the postwar period became far more important centers of learning than the formal training in public schools, colleges, and universities.

[26] IN HIGHER EDUCATION, David Stewart, ed. (Washington, D.C.: American Council on the Arts, 1966),pp.1-15; Colin Young, "Films Are Contemporary: Notes on Film Education," ARTS IN SOCIETY (Winter 1966-67), pp.23-33; Frank Manchel, "The Universal Classroom," SCREEN EDUCATION 32 (January/February 1966):13-8; ___, "Film Education in Our Time," ibid., 40 (July-August 1967):6-12; ___, "For Us and By Us," THE NEW ENGLAND READING ASSOCIATION 8:2 (1972-1973):42-8; ___, "Movie's and Man's Humanity," TEACHING THE HUMANITIES: SELECTED READINGS, ed. Sheila Schwartz (New York: The Macmillan Company, 1970), pp.192-200; ___, "Film Study: NOTHING BUT A MAN," MEDIA AND METHODS 4:2 (October 1967):10-3; ___, "DR. STRANGELOVE," ibid., 4:4 (December 1967):29-32; ___, "The Archetypal American," ibid., 4:8 (April 1968):36-8, 40, 48; ___, "Volunteers for La Mancha," THE LEAFLET 47:3 (September 1968):12-9; ___, "The Tired Critics," ibid., 48:1 (February 1969):11-8; ___, "Reversing the Process," ibid., 48:3 (September 1969):8-14; ___, "Seeing and Perceiving," THE RHODE ISLAND ENGLISH JOURNAL (October 1969):3-9; ___ and Dan Ort, "Study Guide: THE HUSTLER," SCREEN EDUCATION 43 (March-April 1968):54-6, 58-62; Anthony W. Hodgkinson, "Education Comes First," ibid., pp.6-13; Helen W. Concon, "Screen Education in American High Schools," ibid., 45 (July-August 1968):6-12; William Arrowsmith, "Film as Educator," THE JOURNAL OF AESTHETIC EDUCATION 3:3 (July 1969):75-83, PERSPECTIVES ON THE STUDY OF FILM, ed. John Stuart Katz (Boston: Little, Brown and Company, 1971), pp.28-36; Robert Geller and Sam Kula, "Toward Filmic Literacy: The Role of the American Film Institute," ibid., pp.91-112; Gerald O'Grady, "The Preparation of Teachers of Media," ibid., pp.113-33, PERSPECTIVES ON THE STUDY OF FILM, pp.306-26; Paddy Whannel, "Film Education and Film Culture," SCREEN 10:3 (May-June 1969):49-59; and "Approaches to Film Teaching: A Seminar Discussion," ibid., 11:1 (January-February 1970):14-26. More recent studies will be covered in future chapters.

[27] For the most delightful disclaimer to this theory, read Pauline Kael, "It's Only a Movie," FILM STUDY IN HIGHER EDUCATION, pp.127-44.

[28] Polito, "History of Film Teaching," p. 16.

But the situation changed in the sixties. Influential groups of educators meeting at Lincoln Center, Dartmouth, Waltham, and Aspen--to name just a few places--helped define the problems and needs of film teachers.[29] Organizations like the American Film Institute and Eastman Kodak began projects designed to reduce waste and duplication in workshops, conferences, and newsletters. Teachers across the United States initiated and developed film programs at staggering rates, and movies started enjoying a status long overdue in academic circles. All this testified to the fact that film study was more important than ever before. And with all this ferment, there was an equal fervor about which was the best way to study film. Not only were new critical directions suggested in magazines like CAHIERS DU CINEMA, SCREEN, POSITIF, and MOVIE, but also new approaches through semiotics, sociology, Marxism, feminism, structuralism, psychology, and phenomenology.

Ever since the seventies, film study has taken a number of new directions, evident in periodicals like JUMP CUT, FILM QUARTERLY, QUARTERLY REVIEW OF FILM STUDIES, JOURNAL OF POPULAR FILM AND TELEVISION, WIDE ANGLE, CINEASTE, WOMEN AND FILM, CINEMA JOURNAL, CINETHIQUE, JOURNAL OF FILM AND VIDEO, CAMERA OBSCURA, FILM & HISTORY, CINETRACTS, SCREEN, and THE VELVET LIGHT TRAP. The analysis of the twists and turns that film study has taken would be a subject for another book. Here, we might only indicate two general observations. The most obvious one is that film study is still mainly the province of English departments. Although Lynch reports that at least a dozen university-level departments (e.g., communications, theater, art, education, speech, instructional media, and language arts) house film courses, the major home is still the English department. For those who view film as a distinct discipline it is frustrating to think that a majority of the teaching about film is still being done by people who believe that it is not a distinct discipline and who rely on literary methodologies to interpret the art of the film. This, I might add, is occurring at a time when the concept of film is undergoing radical changes. It is now fashionable to think of film as a generic term, rather than a specific designation, although Lynch reports that fifty-five percent of the English teachers involved in film study (as contrasted with forty-four percent of the 546 teachers responding to the 1981 AFI survey) agree with the statement, "Film is not a discipline separate from its antecedents such as literature, history, visual arts, or music."[30] The second observation is that more and more film scholars are dividing their interest between film and television study. Not only are many film magazines adding TV to their mastheads, but these journals are also devoting entire issues to television studies on the assumption that what relates to one medium relates to the other. For example, the Spring 1989 issue of the JOURNAL OF FILM AND VIDEO is devoted almost exclusively to advertising and promotion in TV, the Summer 1989 issue to TV studies on encoding research. In other words, film study today is balanced between the need for improved academic criteria AND curricular reform, and the existence of incalculable opportunities for innovative, progressive, and challenging experiences.

Each of us makes a number of important assumptions in choosing an approach to film study, but underlying every consideration should be our concern for the best possible learning experience for our students.[31] The most important factor in selecting films to study is not the age or subject of the movie, but the quality of the

[29] Accounts of these meetings are referred to in the following: *FILM STUDY IN HIGHER EDUCATION, Jane Anne Hannigan and David J. Powell, eds. THE WALTHAM CONFERENCE: SCREEN EDUCATION IN THE UNITED STATES 1975--K-12 (New York: Films Incorporated, 1968); and THE JOURNAL OF AESTHETIC EDUCATION 3:3 (July 1969).

[30] "Film Education Research: An Overview," p.247.

[31] For a general overview of educational theories on film study in the school, see Thomas F. Wylie, "Eisenstein, Kracauer and Marx: Socio-political Influence in Film Theory," JOURNAL OF THE UNIVERSITY FILM ASSOCIATION 30:2 (Summer 1978):15-8; and Laurence Behrens, "The Argument in Film: Applying Rhetorical Theory to Film Criticism," ibid., 31:3 (Summer 1979):3-11.

film. If it is a well-done movie, it will provide a worthwhile experience. That is not to say that all one has to do is show a good film, discuss it, and then move on to the next screening. Effective teaching requires more than knowing how to turn on a projector or run a bull session. It is to say that spending time, money, and effort in pursuit of a film education requires that the physical object being studied be worthy of the undertaking.

The catch of course, is what constitutes a worthwhile film.[32] When this book was first published, the choices seemed easier. The major film scholars and critics had established THE film canons. These classic films were described and analyzed in all the major books on film history. Young teachers like me were schooled in the notion that it was our job to transmit from one generation to another the manifest intentions of artists to students eager to learn what the films "meant." And years of study in literature, drama, art, music, and film had "given" us the expertise to interpret a film's meaning. We had degrees and publications to certify our "wisdom." Today, however, the idea of authors' intentions, expert pronouncements, and cinematic canons is under attack. The notion that students are passive rather than active participants in the meaning and reception of a film is discredited. The assumption that film buffs are the equivalent of film teachers and scholars is fading fast. This revisionist approach to film education will be discussed in Chapters 3 and 7. Suffice it to say that there is no sacred filmography of classic films. Each of us must decide which films suit our purposes best. But it is also necessary to have a set of standards by which our choices are explainable to others. If we are helping students develop standards, taste, and discrimination about movies, we should be able to show how films have integrity, order, and coherence.[33]

To make the process more meaningful, it helps to study the context in which films are made, to examine the elements of films, and to develop a personal perspective. In the pages that follow, I will consider first the basics of film production. The purpose is to show that films do not exist in a vacuum and that their "entertainment" value is shaped by commercial demands. Next I will consider the elements of film and how they distinguish movies from other arts. The purpose is to demonstrate the unique qualities of the medium, and the importance of not relying on literary and dramatic criteria alone in film analyses. The chapter concludes with a review of film criticism and film theories. Here, the purpose is to suggest a set of perspectives for studying film in a variety of contexts.

BOOKS

*Arnold, James W. "SEEN ANY GOOD DIRTY MOVIES LATELY?" A CHRISTIAN CRITIC LOOKS AT CONTEMPORARY FILMS. Cincinnati: St. Anthony Messenger, 1972. Illustrated. 118pp.[34]

A movie critic for INSIGHT, the Sunday magazine of the MILWAUKEE JOURNAL, takes a lively look at the problems modern movies pose for religious audiences. Rather than attacking the new freedom films gained in the late 1960s, when the film industry

[32] For useful discussions on the relationships between film and education, see the following: Manuel Gonzales Cassanova, "The Participation of Our Schools in the Defense and Diffusion of Our National Culture," JOURNAL OF UNIVERSITY FILM ASSOCIATION 29:2 (Spring 1977):3-7; Ernest D. Rose and Robert W. Wagner, "American Film and Television Schools and the Search for Cultural Identity," ibid., pp.8-11; and Robert W. Wagner, "The Needs of Film/TV Education, 1977," ibid., pp.31-8.

[33] Beginning teachers and students can get considerable help in film aesthetics by examining the work of reputable movie critics and historians. In addition to an annotated list of books on film aesthetics, see Appendix I for a list of leading film reviewers.

[34] An asterisk before an author's name indicates that the book is in paperback.

adopted its ratings system, Arnold points out how current films are more mature and less naive than films of the past. Typical of his approach are the chapter headings for the book's six entertaining and enlightened chapters: e.g., "What's Happened to the Movies?/The Response of One Christian," "Should I Let My Children Go?/Mother and Critic Debate the Movies," and "Don't People Get Married Anymore?/Sex and Love in the Movies." In addition to providing good discussion topics, Arnold offers useful film reviews. An index is included. Well worth browsing.

*Amelio, Ralph J. FILM IN THE CLASSROOM: WHY TO USE IT, HOW TO USE IT. Dayton: Geo. A. Pflaum, 1971. 208pp.
 In this short and simplistic guide to film study on the secondary school level, an Illinois high school teacher offers sample formats, lesson plans, and other related material. It is an expanded version of the WILLOWBROOK CINEMA STUDY PROJECT. Well worth browsing.

*Amelio, Ralph J., with Anita Owen and Susan Schaefer. WILLOWBROOK CINEMA STUDY PROJECT. Dayton: Geo. A. Pflaum, 1969. 84pp.
 An imaginative outline of a two-semester course on the secondary school level designed to explore the intellectual and aesthetic aspects of the film medium, the book has useful hints on writing, producing, and discussing feature-length and short films. A bibliography and filmography are included. Worth browsing.

*Beckoff, Samuel. MOTION PICTURES. New York: Oxford Book Company, 1953. Illustrated. 92pp.
 This handy little textbook, one of the best of the early approaches to film study, has fifteen short, sensible chapters for use in the secondary school. It is very similar in content to Kuhns's and Stanley's book, EXPLORING THE FILM, but not nearly so magnificently produced. Well worth browsing.

*Beckoff, Samuel. RADIO AND TELEVISION. New York: Oxford Book Company, 1952. Illustrated. 92pp.
 A charming reminder of how the public schools approached the study of advertising, programs for homemakers, sustaining programs, and the evaluation of radio and television. Beckoff offers lesson plans and study questions. Worth browsing.

*Blumenberg, Richard M. CRITICAL FOCUS: AN INTRODUCTION TO FILM. Belmont: Wadsworth Publishing Company, 1975. Illustrated. 315pp.
 What this textbook gains in scope, it loses in depth. Although emphasizing that the primary focus of the book is film, Blumberg attempts to produce a work for film courses offered by English, theater, communications, and/or art history departments. The author divides his project into five major parts: an introduction to film, the narrative film, the documentary film, the experimental film, and filmmaking activies. The chapters are coupled with lovely illustrations and useful information. The problems come in the narrative's patronizing tone and simplistic commentary. The text was aimed at a college audience. If so, it is barely adequate for college coursework. A good glossary, a weak bibliography, and a helpful index are included. Worth browsing.

*Bohnenkamp, Dennis R., et al., eds. THE AMERICAN FILM INSTITUTE GUIDE TO COLLEGE COURSES IN FILM AND TELEVISION. Princeton: Peterson's Guides, 1978. 430pp.
 The sixth edition of this valuable but defunct series, it provides a much-needed profile of the large and varied field of film and television teaching. The bulk of the book consists of a statistical overview of U. S. colleges offering courses in the two

media. Listed alphabetically by state, the material classifies colleges by types--e.g., two-year, four-year, comprehensive, and professional institution--and examines various calendar systems--e.g., semesters, trimesters, and the quarter system. Within each institutional list, brief program descriptions include the number of majors, types of degrees offered, types of financial aid, equipment and facilities available to students, names of faculty, and courses offered. Since the material is supplied by the institutions themselves, the material should be read with a sceptical perspective. It seems that some of the people who replied to the questionnaire were using the publication for publicity purposes, rather than for historical and factual data. Nevertheless, reading the book a decade after it first appeared evokes nostalgia--and some sadness--particularly when one recognizes many familiar names no longer teaching. Worth browsing.

*Brown, Roland G. A BOOKLESS CURRICULUM. Dayton: Pflaum/Standard, 1972. Illustrated. 134pp.
 A media-based curriculum designed at Ridley Senior High School in Folsom, Pennsylvania, is the heart of this adequate publication oriented toward teenagers with reading problems. Brown boasts of his success with tenth graders who now have "No required text, very little writing; just listening, seeing, doing." The book itself is little more than a series of lesson plans. If the scheme works, that's fine. One regrets, however, the lack of ability to find suitable reading materials. A bibliography and filmography are included. Worth browsing.

*Butler, Ivan. THE MAKING OF FEATURE FILMS: A GUIDE. Baltimore: Penguin Books, 1971. Illustrated. 191pp.
 Compiled from interviews with directors, performers, and technicians, this highly enjoyable book provides a fine introduction to films as commercial products created and produced by individuals steeped in their culture and its values. The focus is on filmmaking in Britain and the United States during the late 1960s. Each of the book's fifteen chapters examines a specific assignment--e.g., producing, screenwriting, directing, acting, cinematography, art design, special effects, and composing--in the film continuum. The question-and-answer format works well in illustrating the collaborative nature of the process. An index is included. Well worth browsing.

*Callenbach, Ernest. OUR MODERN ART, THE MOVIES. Chicago: Center for Liberal Education, 1955. 116pp.
 Written by the editor of FILM QUARTERLY and a long-time student of the cinema, this book is still a valuable model on how to examine motion pictures. There are eleven chapters, each on a specific movie, such as THE NAVIGATOR (1924), THE INFORMER (1935), THE RIVER (1937), THE OX-BOW INCIDENT (1943), PAISAN/PAISA (1946), and ALL THE KING'S MEN (1949). The analysis begins with general background information on the history of a particular genre or technique, and then moves into stimulating questions about the film itself. Well worth browsing.

*Carringer, Robert L., et al. FILM STUDY GUIDES: NINE CLASSIC FILMS. Champaign: Stipes Publishing Company, 1975. 130pp.
 A useful collection of essays designed for teachers, this handy booklet includes in each chapter a brief general overview of a film, information about its director, cast and technical credits, a sequence outline, and study questions. The chapters deal with Griffith's Biograph shorts, STAGECOACH (1939), CITIZEN KANE (1941), BICYCLE THIEVES/LADRI DI BICICLETTE (1949), THE SEVENTH SEAL/DET SJUNDE INSEGLET (1956), NORTH BY NORTHWEST (1959), 8 1/2/OTTO E MEZZO (1963), DR. STRANGELOVE OR: HOW I LEARNED TO STOP WORRYING AND LOVE THE BOMB (1964), and BLOW-UP (1966). A bibliography is included. Well worth browsing.

*Cooper, John C., and Carl Skrade, eds. CELLULOID AND SYMBOLS. Philadelphia: Fortress Press, 1970. 143pp.

A modest publication that seeks to bridge the chasm in theological discussions about "the knowledge of God" and "the knowledge of ourselves," this book searches for modern symbols that combine contemporary faith and modern secularism. Nine essays explore the pessimism and anxieties of the sixties manifested in films like BLOW-UP, WHO'S AFRAID OF VIRGINIA WOOLF? (both in 1966), COOL HAND LUKE, and BONNIE AND CLYDE (both in 1967), and in the works of Ingmar Bergman and Federico Fellini. Considering the fact that Cooper and Skrade are professors of philosophy (Cooper) and theology (Skrade), the book's lack of depth is disappointing. Endnotes are included. Worth browsing.

*Costanzo, William V. DOUBLE EXPOSURE: COMPOSING THROUGH WRITING AND FILM. Upper Montclair: Boynton/Cook Publishers, 1984. Illustrated. 261pp.

*Coynik, David. FILM: REAL TO REEL. Evanston: McDougal, Littell & Company, 1976. Illustrated. 216pp.

Once you get over Coynik's patronizing tone and glib perpective on film study, this nicely packaged introduction to film appreciation and filmmaking is enjoyable reading. Thirteen handsomely illustrated chapters provide useful overviews on the elements of film, genre study, and animation techniques. An index is included. Worth browsing.

*Currie, Hector, and Donald Staples. FILM: ENCOUNTER. Dayton: Pflaum/Standard, 1973. Illustrated. 272pp.

A novel attempt at using handsomely reproduced illustrations to create a sensory experience, this clever book relies heavily on the reader's willingness to make the exercise meaningful. "I know of no other work," John Howard Lawson writes in his introduction, "which so directly proposes an encounter between you and film art, between what you see and hear (your audio-visual experience) and what you think and live (your conceptual framework)." Although Lawson overstates the book's appeal, he does capture the authors' concept of using pictures and appropriate captions to illustrate the ambiguities of visual images in our culture. Worth browsing.

*Donddis, Donis A. A PRIMER ON VISUAL LITERACY. Cambridge: The MIT Press, 1973. Illustrated. 194pp.

An introductory textbook for art and design students, this analysis does a better job with illustrations than with narrative. The stiff, pedantic prose often obscures Donddis's perceptive use of pictures, drawings, and figures to develop the reader's sensitivity to the complexity of visual communication. Nine useful chapters explore the reasons why we cannot take what we see at face value. A bibliography and an index are included. Worth browsing.

*Driscoll, John P. COMMUNICATING ON FILM. Champaign: Stipes Publishing Company, 1983. Illustrated. 124pp.

A dry introduction to screenwriting, this poorly designed book relies on drawings rather than on stills to illustrate the basics of the profession. It's a shame, because the material is good. Driscoll does a nice job of identifying concepts like "shot psychology" and "planned silence," exploring the path from story idea, through building the script's form, to the final continuity script. A bibliography is included. Worth browsing.

Elliot, Godfrey M., ed. FILM AND EDUCATION: A SYMPOSIUM ON THE ROLE OF FILM IN THE FIELD OF EDUCATION. New York: Philosophical Library, 1948. 597pp.
This is one of the best of the early attempts by a host of educators to discuss the limits and potentials in the public schools of the 16mm "educational film." This term refers to any and all movies whose uses are intended to "inform, orient, or motivate its audiences to some useful end." Bibliographical material and an index are included. Well worth browsing.

*Eidsvik, Charles. CINELITERACY. New York: Random House, 1978. Illustrated. 305pp.

*Farrell, Edmund J. ENGLISH, EDUCATION, AND THE ELECTRONIC REVOLUTION. Champaign: National Teachers of English, 1967. 77pp.
Written from the perspective of a supervisor of student teachers, this book is concerned with the effects of the media on future English teachers. Five informative and brief chapters discuss the nature of the technological revolution taking place in society and suggest how computers, movies, TV, radio, and recordings can be useful in the classroom. The writing is good, the material general, and the ideas sensible. A bibliography is included. Worth browsing.

Fensch, Thomas. FILMS ON THE CAMPUS: CINEMA PRODUCTION IN COLLEGES AND UNIVERSITIES. South Brunswick: A. S. Barnes and Company, 1970. Illustrated. 534pp.
For students interested in the depth and range of various film programs across American campuses--their rationales, requirements, staff, and student body--Fensch offers a valuable and informative guide. He also includes his first-hand impressions of individuals, works-in-progress, and sample assignments. Well worth browsing.

*Feyen, Sharon, ed. SCREEN EXPERIENCE: AN APPROACH TO FILM. Dayton: Geo. A. Pflaum, 1969. Illustrated. 273pp.
Although giving an initial impression of slickness and superficiality, this nicely packaged publication reads better than it looks. Once you get over the glibness with which educators in the sixties abused the concepts of "discovery" and oversimplified film history, the reader finds helpful overviews on film genres, valuable programming tips for film series, and practical information on the elements of film. A bibliography and index are included. Worth browsing.

Fischer, Edward. THE SCREEN ARTS: A GUIDE TO FILM AND TELEVISON APPRECIATION. New York: Sheed and Ward, 1960. Illustrated. 184pp.
In his ten general and uneven chapters, this pioneer film educator discusses the essential points about writing, directing, acting, and film grammar. Although oriented toward church groups, the book presents some useful information on forming a film study group in the public schools. Worth browsing.

*Fulton, Albert R. MOTION PICTURES: THE DEVELOPMENT OF AN ART FROM SILENT FILMS TO THE AGE OF TELEVISION. Norman: University of Oklahoma Press, 1960. Illustrated. 320pp.
Although Fulton is particularly interested in the relationship between the technical and historical aspects of film, he provides some good observations on the adaptation of literary and theatrical works to the screen. Furthermore his sixteen chapters--starting with the birth of the "machine" and continuing to the present marriage betweeen it and art--are well written, useful, and enjoyable. Also valuable are his apt illustrations and short list of film credits. A glossary is included. Well worth browsing.

Gidley, M., and Stephen Wicks, eds. FILM EDUCATION: A COLLECTION OF EXPERIENCES AND IDEAS. Ontario: School Of Education, University of Exeter, 1975. 96pp.

*Gordon, Malcolm. DISCOVERY IN FILM: BOOK TWO. Paramus: Paulist Press, 1980. Illustrated. 162pp.

A teacher's sourcebook for short films, this useful reference work provides information on eighty-one movies deemed appropriate for a variety of educational settings. Gordon divides his material into thematic groupings--e.g., communication, freedom, peace, love, and happiness--and supplies brief synopses, suggested student activities, and recommended reading assignments. Two appendexes on how to make a super-8 film and a listing of distributors are included. An index is also provided. Well worth browsing.

*Grant, Barry Keith, ed. FILM STUDY IN THE UNDERGRADUATE CURRICULUM. New York: The Modern Language Association of America, 1983. 158pp.

An insightful and handy guide to film approaches, course descriptions, films, and books, this much-appreciated anthology fills in the information alluded to in AFI educational statistics. Grant divides his material into two major sections: teaching film and selected program descriptions. Both sections make for highly stimulating and enjoyable reading. Recommended for special collections.

*Hall, Stuart, et al. FILM TEACHING: STUDIES IN THE TEACHING OF FILM WITHOUT FORMAL EDUCATION--FOUR COURSES DESCRIBED. London: British Film Institute, 1964. Illustrated. 107pp.

Four authors describe their film teaching approaches, emphasizing the social effects of film, as well as the use of the medium by directors for personal expression. Particularly helpful are Roy Knight's suggestions on teacher training, and Albert Hunt's adult education program. Also valuable are four outlines of courses designed to teach the history of the cinema, film criticism, directing, and the qualities of motion pictures. Well worth browsing.

*Heyer, Robert, and Anthony Meyer. DISCOVERY IN FILM. Paramus: Paulist Press, 1969. Illustrated. 220pp.

*Hodgkinson, A. W. SCREEN EDUCATION: TEACHING A CRITICAL APPROACH TO CINEMA AND TELEVISION. New York: UNESCO. 1964. 97pp.

Based upon the international conference on Film and Television teaching held at Leangkollen, Oslo, Norway, in October 1962, this report by one of the pioneers of screen education provides a good introduction to the aims and methods of visual literacy. The monograph is short, readable, and has some informative appendexes about recommended materials. Well worth browsing.

*Hurley, Neil P. TOWARD A FILM HUMANISM. New York: Dell Publishing Company, 1970. Illustrated. 212pp.

Originally titled THEOLOGY THROUGH FILM, this book asserts that "Movies are for the masses what theology is for the elite." Hurley's major objective is to impress readers with film's psychological and pedagogical influence in our society, and to provide a primer "for a religious ethos of species-wide acceptability." The author clarifies his intriguing perspective by insisting that he is not promoting religious eclecticism, that his own Christian preconceptions do not contain the universal points of consensus demanded in the twentieth century, and that this study offers all religions the opportunity to test "their claims to universality by the potential reach

of media such as motion pictures." Eleven thoughtful chapters offer ideas on how films affect the conscience of their spectators by describing the good and evil that exist in the world. Endnotes and an index are included. Well worth browsing.

*Jones, Emily S. MANUAL ON FILM EVALUATION. Rev. edition. New York: Educational Film Library Association, 1974. 28pp.
 A manual for educators and librarians serving on selection committees, this handy booklet offers some basic ideas on how to judge non-theatrical films. Terse chapters review terms, rationales, the formation of committees, and evaluation formats. Worth browsing.

*Jones, G. William. SUNDAY NIGHT AT THE MOVIES. Richmond: John Knox Press, 1967. Illustrated. 127pp.
 A simple but helpful book for church groups who need help in initiating discussions about the interrelationship between films and religion, Jones suggests some basic steps in planning, executing, and following up film programs. He also provides a topical list of 248 approved feature films and short subjects. Worth browsing.

*Kahle, Roger, and Robert E. A. Lee. POPCORN AND PARABLE: A NEW LOOK AT THE MOVIES. Minneapolis: Augsburg Publishing House, 1971. Illustrated. 128pp.
 "The purpose of this book," Kahle and Lee explain, "is to find in feature films (as distinguished from documentary or educational films) a resource for our own faith and for our communication of religious truths to others." In addition to talking down to their audience and refusing to deal in depth with any one topic, the authors offer simplistic options for religious viewers who seek serious answers to complex issues. The book's one major value is in the questions it poses for consideration. Endnotes and a bibliography are included. Worth browsing.

Katz, John Stuart, ed. PERSPECTIVES ON THE STUDY OF FILM. Boston: Little, Brown and Company, 1971. Illustrated. 339pp.
 Stressing that the basic problems of film study today involve the importance, impact, and viability of the medium, Katz offers a variety of opinions from filmmakers, film critics, and professional educators on how to study film. The book is divided into uneven sections on "Film Study and Education," "The Film as Art and Humanities," "The Film as Communications, Environment, and Politics," and "Curriculum Design and Evaluation in Film Study." The speculations about how to study film are useful. Ffootnotes and bibliography are included. Well worth browsing.

*Kitses, Jim, with Ann Mercer. TALKING ABOUT THE CINEMA: FILM STUDIES FOR YOUNG PEOPLE. London: British Film Institute, 1966. Illustrated. 98pp.
 Another effort by the British Film Education Department to publish reports by practicing cinema teachers about their materials and methods, Kitses presents a fine introductory course on the thematic study of teenagers' images, breaking it down into week-by-week suggestions, specific films, and discussion questions. An index is included. Well worth browsing.

Kuhns, William. THEMES: SHORT FILMS FOR DISCUSSION. Dayton: George A. Pflaum, 1968. 295pp.
 For those interested in an informal, student-centered approach to the study of short films in the public schools, Kuhns offers two special sections of information. First, each description of the seventy-odd shorts mentioned is followed by a variety of suggestions for using the film in the classroom. Second, he presents clues to the

possible themes and suitable curriculum slots that the pictures might easily fit into, plus helpful comments about the discussion procedure. Worth browsing.

*Kuhns, William, and Robert Stanley. EXPLORING THE FILM. Dayton: George A. Pflaum, 1968. Illustrated. 190pp.
 Graphically, this is one of the most marvelous film study texts ever produced. It is a wonderful, quick introduction to the cinema. Teachers and students, however, need more help with the brief and very limited narrative. Recognizing this problem, Kuhns and Stanley have provided a companion book, TEACHING PROGRAM: EXPLORING THE FILM, which attempts to offer further information to the faculty about reading lists, supplementary materials, and names of distributors. Unfortunately, in an effort to avoid pretentiousness, the texts oversimplify and mislead serious students. Well worth browsing.

*Lacey, Richard A. SEEING WITH FEELING: FILM IN THE CLASSROOM. Philadelphia: W. B. Saunders Company, 1972. Illustrated. 118pp.
 Primarily an outgrowth of material that Lacey developed for several articles in MEDIA AND METHODS, the book's useful suggestions are hampered at times by glib writing and a cavalier tone. Typical of the author's style are his opening comments: "You may read this book with a grain of salt, especially when I supply recipes that sound sure-fire. However, as you read the book, ask yourself, not, 'Yes, but will it really work for me?' Rather, ask, 'How can I find a way to try it--or try something of my own that this suggests?'" Six breezy chapters discuss approaches to changing traditional approaches to film education. If you can get over the hype, some of the ideas are worth considering. A handful of appendexes provides information on books, films, and distributors. No index is included. Worth browsing.

*Langman, Larry, and Milt Fajans. CINEMA AND THE SCHOOL: A GUIDE TO 101 MAJOR AMERICAN FILMS. Dayton: Pflaum/Standard, 1975. Illustrated. 157pp.
 Intended as a source of evaluative information for secondary schools, this simplistic book rarely rises about the level of film buff information. Langman and Fajans shy away from critiquing the films, and rely instead on minimal plot synopses, characterizations of the protagonists, comments on dramatic and literary techniques, and summaries of the film's themes. Each alphabetically arranged film entry also includes one still, date of the film, color or black-and-white quality, and running time. A glossary, list of distributors, and an index are included. Worth browsing.

*Larson, Rodger, Jr. A GUIDE FOR FILM TEACHERS TO FILMMAKING BY TEENAGERS. New York: New York City Administration of Parks, Recreation and Cultural Affairs, 1968. Illustrated. 49pp.
 Intended as a resource for neophytes teaching films in the New York school system, this booklet is based upon the Larson's four years of experimental work with adolescents making their own 16mm films. The information is basic--e.g., comparion of 8mm vs. 16mm equipment, supply budgets, screenwriting, and shooting--and presented in short, summary like chapters. Worth browsing.

Lynch, Joan Driscoll. FILM EDUCATION IN SECONDARY SCHOOLS: A STUDY OF FILM USE IN SELECTED ENGLISH AND FILM COURSES. New York: Garland Publishing Company, 1983. 297pp.
 Originally written as Lynch's 1980 doctoral dissertation for Temple University, this study has three major objectives: "First, it will explore the ways that film is used by secondary school English teachers in Delaware County and Philadelphia as an adjunct to instruction. Secondly, . . . [it] will survey the number and types of courses offered in film study and filmmaking in the secondary schools of Delaware Country. Thirdly, it will compare and contrast the extent and degree of teaching about film as an artistic medium of communication by three groups: (1) Delaware

County English teachers; (2) Philadelphia film coordinators, English teachers who use a film study guide; and (3) Delaware County teachers." Lynch divides her investigation into five major sections: "The Problem," "Review of the Literature," "Method," "Results," and "Conclusions." Relying heavily on statistical analysis, the resourceful author channels her results into eleven different categories, including demographic data, obstacles to film study, sources of films, types of films used, purpose of film used by English teachers, and textbooks used and periodicals read by teachers. Thoroughness and perceptive observations characterize this useful study. A good bibliography concludes the work. Well worth browsing.

Lynch, William, S. J. THE IMAGE INDUSTRIES. New York: Sheed and Ward, 1959. 159pp.

*Mallery, David. FILM IN THE LIFE OF THE SCHOOL: PROGRAMS, PRACTICES AND NEW DIRECTIONS. Boston: National Association of Independent Schools, 1968. 53pp.
 Teachers will find this concise booklet a fast, informative, and pleasant guide to beginning film study work in the public schools. Mallary provides newcomers with some thoughtful and sensible ideas. Worth browsing.

*MacCann, Richard Dyer, ed. FILM AND SOCIETY. New York: Charles Scribners's Sons, 1964. 182pp.
 One of the great values of this anthology is that only a few of the articles are found elsewhere. Another advantage is that it helps students in doing research papers. MacCann has divided the text into seven sections. He starts with the history of film, moves through audience values, the relationship between the screen and society, censorship, and finishes with the influence of television on motion pictures. Among the thirty-nine articles are contributions by Terry Ramsaye, Richard Griffith, Arthur Mayer, Alardyce Nicoll, Mervyn LeRoy, Irving Thalberg, John Grierson, Bosley Crowther, and Jean Benoit-Levy. Well worth browsing.

*Manvell, Roger. FILM. Rev. ed. Harmondsworth, England: Penguin Books, 1946. Illustrated. 240pp.
 This book offers one of the best introductions to film study, particularly in Manvell's opening chapters on the unique characteristics of film art. Almost as good is his final section on the relationship between movies and the British public in the years following World War II. While some of the material now seems outdated, the basic principles still are useful, as is the chapter on starting a film society. An index is included. Recommended for special collections.

Manvell, Roger. THE LIVING SCREEN: BACKGROUND TO THE FILM AND TELEVISION. London: George G. Harrap and Company, 1961. Illustrated. 192pp.
 One of the first works to discuss the similarities and dissimilarities of the two screens, this book offers a nontechnical and helpful introduction to media literacy. It now appears rather stodgy, but could serve as a useful foundation upon which to build a more modern document. Worth browsing.

Manvell, Roger. WHAT IS A FILM? London: Macdonald and Company, 1965. Illustrated. 184pp.
 In this informal and nontechnical exploration of the film as an art form, Manvell begins by discussing the birth of the medium and then goes quickly into the behind-the-scenes activities of directors, producers, actors, writers, technicians, distributors, and exhibitors. He concludes his overview with some general chapters on television, documentaries, and animated films. Worth browsing.

Marcorelles, Louis, with the collaboration of Nicole Rouzet-Albagli. LIVING CINEMA: NEW DIRECTIONS IN CONTEMPORARY FILM-MAKING. Trans. Isabel Quigley. New York: Praeger Publishers, 1973. Illustrated. 155pp.

May, Mark A., et al. LEARNING FROM FILMS. New Haven: Yale University Press, 1958. 357pp.
 In 1946, the Yale Motion Picture Research Project began by "evaluating experimentally certain pilot teaching films that were produced under the sponsorship of that organization. The work . . . soon expanded to include experimental studies of problems of production and utilization." May served as the general director of the project for eight years, and his summary of the results is divided into four major parts: "The Acquisition of Knowledge from Films," "Effects of Films on Subsequent Learning Activities," "Techniques of Evaluating Instructional Films," and "The Use and Potential of Teaching Films." A bibliography and index are included. Worth browsing.

Maynard, Richard A. THE CELLULOID CURRICULUM: HOW TO USE MOVIES IN THE CLASSROOM. New York: Hayden Book Company, 1971. Illustrated. 276pp.
 "What I haven't seen before and what seems to me so crucial in . . . [this book]," states David Mallary in his foreword, "is evidence of an actual course, in which the subject matter is drawn from vital experiences and concerns and questions (marriage, ethical issues, race relations, responsibility, the impact of war . . .), and the material, the 'stuff' of the course, is films and response to film." Maynard divides his "lesson plans" into four major parts: "Bringing the Subject to Life--Film as an Independent Part of the Curriculum," "The Movies as the Message--Film as a Historical and Social Object of Study," "A Practical Guide to Teaching with Films," and "And So On . . . --Additional Filmography and Bibliography." Each of the chapters subsumed in the first three parts provides explanations of how Maynard teaches a topic--e.g., crime and punishment, marriage as an institution, movies and literature, the image of war, and movies and McCarthyism--and concludes with a selected bibliography. Generally, the bibliographies are better than the narrative. An index of film titles is included. Worth browsing.

McDonald, Bruce, et al. CREATIVE WRITING THROUGH FILMS: AN INSTRUCTIONAL PROGRAM FOR SECONDARY STUDENTS. Littleton: Libraries Unlimited, 1984. 224pp.

*McKowen, Clark et al. IT'S ONLY A MOVIE. Englewood Cliffs: Prentice-Hall, 1972. Illustrated. 188pp.
 This cleverly designed book, which attempts to introduce reluctant movie students to the excitement of film in the classroom, is high on graphics and low on written material. The authors put their faith in response-oriented teaching, but just in case you have doubts as to how it operates, a teacher's manual is available. Worth browsing.

*O'Connor, John E., ed. FILM AND THE HUMANITIES. New York: The Rockefeller Foundation, 1977. 81pp.
 On October 19, 1976, the Rockefeller Foundation's Humanities program held a conference on "Film and the Humanities," drawing on the collective talents of thirty-six people with different disciplines, in order to stimulate ideas about interdisciplinary approaches to film study and scholarly activities. The results of the New York-based conference are presented in three parts. Part 1 summarizes the day-to-day views of the participants in this conference, and identifies the basic issues raised and left unresolved. Part 2 consists of reprints of articles describing alternative approaches to film study: e.g., William Arrowsmith's "Film as Educator," John E. O'Connor's "Film Study and the History Classroom," James C. Curtis and J. Joseph Hutchmaker's "The American Dream on Film," Dean Wilson Hartley's "How

Do We Teach It? A Primer for the Basic Film/Literature Course," Jerry H. Gill's "Philosophy and Film," and Jay Ruby's "Anthropology and Film: The Social Science Implications of Regarding Film As Communication." Part 3 offers a listing of journals and organizations, a select bibliography, and a listing of bibliographies. Given the stature of the participants and the support of the Rockefeller Foundation, the working papers produced in this slim document are superficial and disappointing. Worth browsing.

*Peters, J. M. L. TEACHING ABOUT THE FILM. New York: International Documents Service, 1961. Illustrated. 120pp.
 This UNESCO publication, which emphasizes British methods, is one of the better pioneering books on screen education. Few authors approach Peters's excellent chapter on "Understanding Film Language," in which he provides thirty-three stills from David Lean's THE FALLEN IDOL (1948), a shooting script, and a well-balanced, informative narrative on how filmmakers express their ideas. He also has chapters on appreciation and criticism as well as superb practical suggestions for classroom teaching. Recommended for special collections.

*Peyton, Patricia, ed. REEL CHANGE: A GUIDE TO SOCIAL ISSUES FILMS. San Francisco: The Film Fund, 1979. Illustrated. 140pp.
 A pioneering reference work for 16mm films, videotapes, and slide presentations on social issues, this useful guide is divided into three main sections: "Directory of Titles Classified by Subject," "Films for Children," and "International Cinema Classics: Social Issue Films from the Past." The first category is subdived into ten broad subject areas: e.g., aging, gay issues, and political movements--international. Some of the other categories are subdivided even further: e.g., ethnic issues: Asian, black, Native American, and Hispanic. Each annotation includes the film title, the director's name, production time, running time in minutes, color or black-and-white quality, distributor, and price for sale or rental when available. Coding devices for identifying specific issues, suggestions for film programs, and an index are included. Well worth browsing.

*Phelan, John M. DISENCHANTMENT: MEANING AND MORALITY IN THE MEDIA. New York: Hastings House, 1980. 191pp.
 "Instead of rehearsing the familiar litany of controversial issues that pass for moral awareness in the media studies or of begeting one or more trade associations," Phelan tells us, "it seems more useful to examine three major contexts wherein communications can be related to the perennial humanistic concerns of history, philosophy, and literature." Thus the author concentrates on the treatment of minorities in the media as an example of methodology and morality, the conflict between censorship and consumerism, and the value of modern technology to morality. The writing may be dry, but the concepts are useful. A subject and author index are included. Well worth browsing.

*Poteet, G. Howard. THE COMPLEAT GUIDE TO FILM STUDY. Urbana: The National Council of Teachers of English, 1972. Illustrated. 242pp.

Rose, Ernest D. WORLD FILM & TV STUDY RESOURCES: A REFERENCE GUIDE TO MAJOR TRAINING CENTERS AND ARCHIVES. Germany: Friedrich-Ebert-Stiftung, 1974. 421pp.
 A good introduction to film and television schools in seventy-five nations, this loose-leaf guide is divided into five major sections: Europe, Africa and the Middle East, Asia and Oceania, Latin America, and North America. Short comments on the professional training in each nation are followed by addresses, phone numbers, living and educational expenses, application deadlines, and enrollments. Although the

material is now dated, it is fun to read and to compare with today's programs in the same countries. A bibliography is included. Worth browsing.

*Ross, T. J. FILM AND THE LIBERAL ARTS. New York: Holt, Rinehart and Winston, 1970. 419pp.
 The purpose of this anthology is to relate film study to the traditional college curriculum through essays concerning themes and movies. For the most part, the organization works, particularly in the sections on "Films and Rhetoric," with contributions by Andre Malraux, Andre Bazin, Stephen Crane, and James Agee; "Film and the Visual Arts," including articles by Parker Tyler, Arnold Hauser, Rudolf Arnheim, and Josef von Sternberg; and "Film and Esthetics," which includes the observations of Jean-Luc Godard, Michelangelo Antonioni, Luis Bunuel, Jack Kerouac, and J. B. Priestley. A filmography and index are included. Well worth browsing.

*Samuels, Charles Thomas, ed. A CASEBOOK ON FILM. New York: Van Nostrand Reinhold Company, 1970. 250pp.
 Recognizing the need for film students to write well, Samuels uses very effectively the casebook approach to research. He divides his text into two sections. First comes the material on the theory of film, including articles from such heavyweights as Erwin Panofsky, Arnold Hauser, Maya Deren, Andrew Sarris, V. I. Pudovkin, George Bluestone, John Simon, Robert Brustein, and Robert Warshow. Then comes the theoretical application. Students are asked to see and then write about three films: BLOW-UP (1966), THE GRADUATE, and BONNIE AND CLYDE (both in 1967). Each film assignment is preceded by model essays. For example, Samuels presents students' work on THE GRADUATE with reviews of the film by Stanley Kauffmann, Edgar Z. Friedenberg, Stephen Farber, Estelle Changas, and Jacob Brackman. A selective glossary, list of suggested projects, and bibliography are included. Well worth browsing.

*Sarris, Andrew, ed. THE FILM. New York: The Bobbs-Merrill Company, 1968. 64pp.
 This brief anthology is concerned with student writings. It contains essays that center on directors from three countries. First are Americans (Stanley Kubrick, Elia Kazan, and Jerry Lewis), second are French (Francois Truffaut, Robert Bresson, and the New Wave), and finally, there are the Italians (Michelangelo Antonioni and Federico Fellini). Sarris's format is to have critics--e.g., Pauline Kael, Eugene Archer, Hollis Alpert, and John Simon--comment on the filmmakers; then he adds a few stimulating questions for group discussion, followed by writing assignments. Worth browsing.

*Schillaci, Anthony, and John M. Culkin, eds. FILMS DELIVER: TEACHING CREATIVELY WITH FILM. New York: Citation Press, 1970. Illustrated. 348pp.
 During the late 1960s, Fordham University's National Film Study Project developed some useful and innovative materials for screen educators. The authors of this handy little book have collected the major results and presented them in four clearly defined sections: a rationale for film study ("What Films Can Do for Teachers and Students"), case studies of specific teaching units ("How It's Being Done Today"), practical tips for student filmmaking ("The Nitty-Gritty of Films in Education"), and extensive appendexes that contain annotated filmographies and bibliographies. An index is included. Well worth browsing.

*Schillaci, Anthony, O. P. MOVIES AND MORALS. Notre Dame: Fides Publishers, 1968. 181pp.
 Father Schillaci has written a good little book for religious institutions on the value of films for emotional maturity and moral development. In readable prose, he describes the place of film study in a spiritual education. Well worth browsing.

Selby, Stuart Alan. THE STUDY OF FILM AS AN ART FORM IN AMERICAN SECONDARY SCHOOLS. New York: Arno Press, 1978. 262pp.
 Originally written as Selby's 1964 doctoral dissertation for Columbia University, the purpose of this study "is to provide a chronological and critical analysis of teaching the film in American secondary schools--in order that future atempts at film teaching may be more successful and more valuable to teachers and students alike." Ellis's first of eight essentially chronological chapters explores the relationship between film and society, stressing the importance of film as an art form and as a social force. Chapter 2 discusses film's relationships to the other arts, focusing on production, distribution, and the nature of the medium. Chapters 3 through 7 take us from the entrance of film into the schools at the end of World War I, through the film study movement of the 1930s and the film appreciation era of the post-WWII period, up to film and television study in the sixties. A brief concluding chapter comments on the future of film study. In writing a new preface to this publication, Ellis revises his earlier conclusions and discusses "media study" rather than "film study." He sadly identifies the problems that undercut his predictions: "Looking backward, I would say that my optimism for the importance of film as an art form in secondary school was unfounded." An excellent bibliography concludes the study. Well worth browsing.

*Sheratsky, Rodney E. FILM: THE REALITY OF BEING. New Jersey Association of Teachers of English 1:1 (April 1969). 12pp.
 This brief monograph is a fine introduction to the study of film in the secondary school. Written by one of the best screen educators in the seventies, it presents sound advice based upon years of experience. Worth browsing.

*Sheridan, Marion C., et al. THE MOTION PICTURE AND THE TEACHING OF ENGLISH. New York: Appleton-Century-Crofts, 1965. Illustrated. 168pp.
 Ever since its publication, this volume has been the "whipping boy" of film intellectuals because of its heavy-handed literary emphasis. Nevertheless, thousands of English teachers have found its opening chapters on film technique and language helpful bridges out of a staid literary program. This is one of those books to sample rather than study. A bibliography and index are included. Worth browsing.

Starr, Cecile, ed. IDEAS ON FILM: A HANDBOOK FOR THE 16MM FILM USER. New York: Funk and Wagnalls Company, 1951. Illustrated. 251pp.
 Basically a collection of articles taken from the pages of THE SATURDAY REVIEW OF LITERATURE, where Starr had a column, this book offers some stimulating observations on understanding the attempts, in the 1940s, to bring nontheatrical films into educational circles. Among the many scholarly and well-known contributors are Rudolf Arnheim, Willard van Dyke, Arthur Knight, Pearl S. Buck, Raymond Spottiswoode, and Arthur Mayer. Here is an example where the concept is better than the execution. Worth browsing.

*Stewart, David C. FILM STUDY IN HIGHER EDUCATION. Washington, D.C.; The American Council on Education, 1966. 174pp.
 This report summarizes the work of leading film teachers who from 1964 to 1965 met first at Lincoln Center and then at Dartmouth to discuss the possible approaches to improving film study. Among its many useful materials are Jack Ellis's communication program, Arthur Knight's outline of film history materials, Hugh Gray's film aesthetics, and George C. Stoney's arguments for the art of the film. Here too is Pauline Kael's highly publicized attack on screen education. Stewart also has some valuable appendexes on professional associations and archives. A bibliography is included, but no index is provided. Well worth browsing.

*Sullivan, Sister Bede. MOVIES: UNIVERSAL LANGUAGE--FILM STUDY IN HIGH SCHOOL. Notre Dame: Fides Publishers, 1967. 160pp.
 Based on teaching experiences at Lillis High School in Kansas City, Missouri, this publication summarizes how short films used in eighteen two-hour sessions during a semester-long course brought a better understanding and appreciation of the motion picture and its "language." Sullivan groups her material into five chapters, focusing on the advantages of film to social groups, the elements of film, the differences between film and other media, the cultural influences in national cinemas, and suggested ways to teach about film. A series of appendexes related to film awards, a bibliography, a glossary, and an index are included. Worth browsing.

*Turner, Graeme. FILM AS SOCIAL PRACTICE. New York: Routledge, 1988. Illustrated. 187pp.
 Favoring the cultural rather than the aesthetic approach, Turner explains that he wants "to introduce students to film as a social practice, and the understanding of its production and consumption, its pleasures and its workings. . . ." His seven fresh and informative chapters sidestep the traditional aesthetic arguments of realism versus formalism and focus instead on the pleasure factor as a dominant force in the marketplace and theater. In addition to sections devoted to the contemporary film industry and the history of film studies, he delves into stimulating discussions on film audiences, film narratives, and film languages. A bibliography and index are included. Recommended for special collections.

Waldron, Gloria, with Cecile Starr. THE INFORMATION FILM: A REPORT OF THE PUBLIC LIBRARY INQUIRY. New York: Columbia University Press, 1949. 281pp.

Wall, James M. CHURCH AND CINEMA: A WAY OF VIEWING FILM. Grand Rapids: Eerdmans Publishing, 1971. Illustrated. 135pp.
 Written by the enlightened editor of the CHRISTIAN ADVOCATE, this slim book deals effectively with the religious school's need to analyze the place of sex and censorship in American films. Wall's emphasis is on relating content and style to the filmmaker's aesthetic and philosophical standards. Well worth browsing.

*Weiner, Janet. HOW TO ORGANIZE AND RUN A FILM SOCIETY. New York: Collier Books, 1973. Illustrated. 210pp.
 If you want the basic information on how to get a film society started and functioning, this is the book to read. Don't be deceived by the publishing date. Although the information on distributors and costs is outdated, the chapters on organization, publicity, and running the show are still useful. You might even enjoy glancing at the films people in the seventies couldn't find at the local theater or on TV. An index is included. Well worth browsing.

*Williams, Clarence, and John Debes, eds. VISUAL LITERACY. New York: Pitman Publishing Corporation, 1970.
 These uneven and provocative essays, taken from the first National Conference on Visual Literacy, discuss (1) the philosophy of the meeting, (2) related research, (3) various types of media literacy, (4) visual literacy in the schools, and (5) community projects. The fifty-six papers, concisely edited, suggest the problems and the directions for several years to come. Worth browsing.

*Wlaschin, Ken. BLUFF YOUR WAY IN THE CINEMA. London: Wolfe Publishing, 1969. 64pp.
 If you have trouble understanding all the faddish terms and cults, read this iconoclastic and delightful approach to the jargon of film. Some samples of Wlaschin's work: "Auteur--French bluffing term for O.K. director," "Cliff hanger--the

unexplained disappearance of an Antonioni heroine in the middle of a film," and "Quickie--nothing to do with sex. A cheap, hurriedly-made and usually shoddy film." Every teacher should have a copy to take to class. Recommended for special collections.[35]

THE COMMERCIAL FILM INDUSTRY

Although most film textbooks concentrate on the art of film and minimize the industrial nature of the process, it seems more prudent to begin a comprehensive study of our discipline by stressing the fact that commercial films are first and foremost products produced by people primarily concerned with profit. In short, filmmaking is a business, a very big business. The people who control the production, distribution, and exhibition of films know how to manipulate money, talent, major markets, and mass audiences. In many respects, the history of film is the story of clever and aggressive entrepreneurs and government agencies that control film technology and fight continuous battles with technicians, unions, artists, performers, censors, distributors, exhibitors, and financiers to produce, merchandise, distribute, and exhibit a film according to set standards and regulations.

The consequences of their significant struggles and strategies are explored throughout this book. For example, Chapter 2 discusses the importance of formula filmmaking in insuring that financial risks are held to a minimum during the production of theatrical films. At the same time, it takes note of the importance of novelty in keeping commercial films current with changing social values. Chapter 3 reviews the cultural influences that shape the structure of the film industry, its screen conventions and movie myths, as well as the types of economic and social controls that dictate the longevity of specific genres, distribution patterns, and exhibition practices. Attention is also drawn to the role that audiences play in maintaining or challenging standard Hollywood practices. Chapter 5 explores the problems of screenwriters in adjusting to the demands of a commercial and collaborative industry. It demonstrates the problems that arise when conflicting sets of values in story and plot development are tested in screen adaptations of works from other media. Chapter 6 highlights the origins of the current film oligopoly and cites the difficulties of film pioneers in refining the industrial nature of the filmmaking process. It illustrates how the narrative film, the rise of a star system, and the creation of a vertical system of production, distribution, and exhibition set the stage for the classical Hollywood mode of operation. Chapter 7 surveys the characteristics of national cinemas and points out the conflicts between art and entertainment in a historical context. It presents a chronological overview of how commercial filmmaking was institutionalized and then forced to adapt to changing social, political, cultural, economic, and aesthetic conditions and attitudes.

In each instance, one becomes aware of the need to understand that a film's commercial success rests more on business acumen, than on cinematic imagination and ideals. What educators must recognize is the importance of the audience in the film continuum. A careful examination of the history and structure of the theatrical film, the nucleus of the commercial film industry, reveals that economic determinants not only standardized the manufacturing, distribution, and exhibition of feature films for forty years, but also conditioned audiences and critics alike to admire certain screen conventions and styles. Nowhere is there greater evidence of the relationship between film production and audience expectations than in the centrality of sequels, spin-offs, and remakes in the contemporary cinema. As will be discussed in Chapters 5 and 7, business geniuses like George Lucas and Steven Spielberg thrive on recycling the time-honored conventions of horror, science fiction, and adventure stories. When a film trades on the public's expectations of the conventions in a Hollywood love story, comedy, thriller, and war film, journeymen reviewers applaud the finished product

[35] For a useful adjunct, see Vincent Canby, "How to Take It All Seriously (From Antonioni to Andy)," NEW YORK TIMES X (January 30, 1966):11.

and millions of people line up at the box office. When filmmakers become too "artsy" or "experimental" in updating the conventions, the same reviewers attack the film's divergence from conventional standards and theaters remain empty.

One memorable example of my naivete occurred while serving on a panel discussing IS PARIS BURNING? (1966) at the 1968 Greater Hartford Forum. I found the screen version of the liberation of Paris confusing and badly edited. Thirty years of filmgoing had conditioned me to expect historical events on film to concentrate on the actions and fate of key figures, rather than jump from one ill-defined group of protagonists to another. Serving on the panel with me was one of the film's screenwriters, a recent graduate from UCLA, named Francis Ford Coppola. Although he began by defending his contributions to the director Rene Clement's flawed picture, Coppola grew more and more annoyed with my criticisms about the bad characterizations, the weak plots, the meandering events, and the trite depiction of historical events. Finally, he admitted that he wasn't proud of the film, but that anyone working in the film industry had to make a number of bad films before getting the opportunity to make a good film. That is, one has to pay one's dues to the system. And I naively replied, "If that's how you think, then you'll never amount to anything!"

The anecdote is not only to clear my conscience and alert the reader to my failures as a young critic, but also to illustrate the training and conditioning that thirty years of filmgoing and study had produced. I still think IS PARIS BURNING? a bad film, although for different reasons. But I have also come to understand that those artists who seek alternative routes to mainstream production, distribution, and exhibition patterns run the risk not only of having their films fail commercially and critically, but also of the films' never being made. Thus, this revised edition of FILM STUDY: AN ANALYTICAL BIBLIOGRAPHY takes the position that film is a commercially collaborative enterprise based on values shared both by the people who make films and by those who watch them. This observation is not meant to discourage those who seek higher standards from the world's most pervasive form of communication, or who demand more from a medium capable of creating great works of art. Neither is it to deny that screen masterpieces exist in spite of studio tyranny, government bans, and audience oversights. It is to say that such films are the exceptions, the very rare exceptions. To deal honestly with film as art or film as a social force, one should recognize the centrality of the business deal in the production of commercial films. Moreover, it is to reinforce the notion, as David Bordwell points out, that being a collaborative art is not in itself an obstacle to art:". . . art works have been produced by collective labor for centuries (e.g., Raphael's frescoes, academic painting in the nineteenth century)."[37]

In this chapter, we note the process the film continuum takes. At the outset, the goal is to make the reader sensitive to the belief that the study of film must account for the nature of the film industry. Luckily, the basic outlines of the task have been provided by a host of film scholars. For example, Julia Lesage divides the film continuum into six stages: (1) an understanding of the economic and ideological conditions of film history that influence present and future filmmaking, (2) the collaborative nature of the filmmaking process, (3) the finished film itself, (4) the nature of the film audience, (5) the context in which films are received, and (6) the types of economic bases that determine how films are made, distributed, and seen.[38] The implications of Lesage's perspective are discussed more fully in Chapter 3.

[36] For more details, see SEVENTH ANNUAL GREATER HARTFORD FORUM (Hartford: Connecticut General Life Insurance Company, 1966).

[37] David Bordwell et al., THE CLASSICAL HOLLYWOOD CINEMA: FILM STYLE & MODE OF PRODUCTION TO 1960 (New York: Columbia University Press, 1985), p.83.

[38] Julia Lesage, "Feminist Film Criticism: Theory and Practice," JUMP CUT 5/6 (1974):13; rpt. Patricia Erens, ed. SEXUAL STRATAGEMS: THE WORLD OF WOMEN IN FILM (New York: Horizon Press, 1979), pp.144-55.

For now, we need only summarize the perspectives found in three valuable film books: AN INTRODUCTION TO FILM, FILM AS SOCIAL PRACTICE, and THE CLASSICAL HOLLYWOOD CINEMA. In the first text, Thomas and Vivien C. Sobchack begin their overview of film production by stressing that "film" is not only a specific material and medium of communication capable of generating unique values, effects, and meanings,[39] but also a commercial product economically determined through standardized and regulated practices. Next, they discuss how Hollywood, the symbol of traditional mainstream filmmaking, developed its reputation through a widely accepted set of screen conventions for the narrative film that remained in place up to the 1960s. Although the studio method of production that controlled film narratives no longer exists, the structure and ideology of the classical Hollywood narrative remains prominent. In fact, watching the Hollywood products of the eighties suggests that we may be going back to the screen values of the Eisenhower years. A major reason is that film conventions are institutionalized in a process skillfully adapted from other major American industries. That is, businessmen rely on a multitude of people with a variety of skills and interests to produce, distribute, merchandize, and exhibit a product for mass consumption.

In describing the process, the Sobchacks outline the steps a proposed film project takes from someone's originating the idea for a movie, based either on an original story or an adaptation of a work from another medium, to the preparation of a "treatment" (a summary of the idea) for purposes of convincing the right people to finance and to work on the project. Once the idea is "bought," usually with the help of an agent able to put together a "package deal" involving key performers, a director, screenwriter, distributor, producer, and investors, a screenplay is drafted and then distributed to the major people in the deal. (The types of screenplays from "treatment" to "continuity script" are described in Chapter 3 and in the glossary.) The Sobchacks make the important point that

> Creativity and quality are not necessarily the criteria upon which film financing is based. Indeed, in most instances, financial backers prefer conventional stories, plot structures, and characterizations--screenplays that basically imitate past box office successes.[40]

Once the money becomes available, many people pool their talents to give the film its physical properties. This group effort involves not only the cast and technical crew, but also travel agents, limousine services, secretaries, caterers, accountants, mail clerks, and film processors. The overriding concern is to maximize time and minimize the cost of making the film. (Information about the division of labor, cost breakdowns, and film financing will be given in Chapter 3.) The production of the film itself involves an ingenious scheduling of locations, performers, and contingency plans, all keyed to the budget. Generally, this is the stage of filmmaking that has produced the greatest number of myths about stormy battles among stars, directors, and producers. Fortunately, the Sobchacks emphasize the tedious nature of the production process, pointing out that before the director even shouts "Action!" enormous time is spent in lighting and staging a shot (the basic element in a commercial film). Once the actual shooting of the film is finished, and assuming there is no need to re-assemble the cast and crew for major retakes, the project enters the post-production stage. At this point, the Sobchacks explain the roles of the sound effects people, editors, composers, marketing experts, and publicity departments, as well as the arrangements made for distribution and exhibition. The authors conclude their useful overview of the film process with an explanation of what a film's principal and secondary credits mean. "Understanding that this system exists and

[39] *Thomas Sobchack and Vivian C. Sobchack, AN INTRODUCTION TO FILM, 2nd ed. (Boston: Little, Brown and Company, 1985), p.3.

[40] AN INTRODUCTION TO FILM, pp.24-5.

how it works," they argue, "can only help us to comprehend more fully the cultural signs and symbols and conventions that industry and system produce."[41]

In FILM AS SOCIAL PRACTICE, Graeme Turner begins his analysis by observing that "Film is no longer the product of a self-contained industry but one of a range of cultural commodities produced by large multinational conglomerates whose main interest is more likely to be electronics or petroleum than the construction of magical images for the screen."[42] Next, he discusses the changing role of theatrical films in our times, pointing out that the current emphasis on blockbuster films--"the expensive movie with high production values, big stars, and massive simultaneous release"--has affected film production on an international scale. That is, (a) fewer financiers are willing to take risks on non-conventional films, (b) independent producers have become more dependent than ever on alternative channels of distribution and exhibition, (c) marketing has become a greater factor in "selling" a film and often advertising costs are more than the production of the movie itself, (d) films tend to be released on a grand scale rather than in the prestige release patterns of the past, and (e) the major American distributors continue to tighten their control of the world film industry.[43] (Each of these points will be discussed in detail in Chapters 3 and 7.)

To appreciate how the film industry is undergoing significant changes, Turner then provides an intriguing economic view of film history. Arguing that theatrical films did not become central to the film industry until the release of THE JAZZ SINGER (1927), he interprets every important technological change in films as a result of the industry's requiring an economic boost and the public's perception of film as a realistic medium. For example, silent films lacked dialogue and thus required sound to give the images a more realistic quality. The one major misperception in the "realism" mentality, Turner notes, was the advent of color films in the 1930s.[44] Because the film industry of the thirties used it sparingly in films like LOST HORIZON (1937), THE WIZARD OF OZ, and GONE WITH THE WIND (both in 1939), audiences identified it with fantasy and spectacle, and color failed to advance film realism. (Ironically, Ted Turner is now using color to make black-and-white films more acceptable to modern audiences.) Turner's useful overview of industrial history not only highlights the aesthetic and ideological considerations that influenced the standardization and regulation of American films, but it also suggests how the current fragmentation of mass markets into specialized audiences is affecting world cinema. In concluding his introductory chapter, he emphasizes that the fate of films is linked to "a distinctive set of experiences, pleasures, and social practices" that appeal to mass audiences.[45]

As both the Sobchacks and Turner make clear, the economic health of the film industry depends on the relationship between the classic narrative film and the public. Moreover, the history of filmmaking since World War I could be described either as a reinforcement of Hollywood's traditions, or as a revolt against them. No book describes the evolution and characteristics of those traditions better than THE CLASSICAL HOLLYWOOD CINEMA: FILM STYLE & MODE OF PRODUCTION TO 1960. In the preface, the authors state their intention to study the totality of the Hollywood mode of film practice: "an integral system, including persons and groups but also rules, films, machinery, documents, institutions, work processes, and theoretical concepts."[46] Furthermore, they assert that one cannot understand the complexity of

[41] AN INTRODUCTION TO FILM, pp.42-3.

[42] *Graeme Turner, FILM AS SOCIAL CHANGE (New York: Routledge, 1988), p.1.

[43] Turner, pp.1-6.

[44] Turner, pp.17-8.

[45] Turner, p.22.

[46] THE CLASSICAL HOLLYWOOD CINEMA, p.xiii.

American film history without understanding how the process works. That is, the conditions under which films are created affect not only the images and sounds attributed to the artists, but also the structure of the film itself and the manner in which the public receives the finished product.

A mode of film practice, then, consists of a set of widely held stylistic norms sustained by and sustaining an integral mode of film production. These norms constitute a determinate set of assumptions about how a movie should behave, about what stories it properly tells and how it should tell them. about the range and functions of film technique, and about the activities of the spectator.[47]

The study of how Hollywood maintained its aesthetic norms and perfected a unifed industrial system is told skillfully by David Bordwell, Janet Staiger, and Kristin Thompson in their absorbing book.
 Particularly relevant to our present concerns is Bordwell's opening section, where he identifies the basic ingredients of the classical Hollywood film. Let me summarize what he eloquently describes. Beginning with an analysis of why the narrative film is central to the American film industry, Bordwell explains that film narrative consists of three systems: "narrative logic (definition of events, causal relations and parallelism between events), the representation of time (order, duration, repetition), and the representation of space (composition, orientation, etc.)."[48] Of the three systems, narrative logic is the dominant force. It determines not only the content and style of the film, but also the range of options filmmakers have in telling their screen stories. Although not all of the 15,000 films produced between 1917 and 1960 (the period Bordwell and his colleagues studied) embody the norms of the classical Hollywood film, most of the films have a prescribed set of recurring conventions with similar functions and relationships. While there may be periodic changes in how sets are lit, cameras positioned, or characters behave, the changes themselves are limited to specific aesthetic ranges dictated by industry and audience expectations.
 In describing the conditions under which changes are controlled by the spectator, Bordwell undersores one of the crucial elements in film study: the role of the audience in the film continuum. Hollywood banks on audience expectations. It standardizes its products to satisfy the perceived needs, desires, and expectations of its viewers. Of course, those "perceptions" frequently prove to be faulty, as evidenced by the fact that today more movies fail at the box office than ever before. However, when the perceptions meet expectations, the profits are astronomical.
 In the period from 1917 to 1960, Bordwell explains, filmmakers established a system of operation that controlled and regulated audience perceptions far more effectively than the present distributor-controlled film market. Hollywood put in place a system that utilized a division of labor to produce routinely formula films that brought people to movie theaters at least once a week. The films themselves masked any noticeable awareness that what the audience was watching was an illusion of motion (pieces of celluloid moving intermittently through a projector). The action flowed effortlessly, the actors performed naturally, and the audience willingly suspended disbelief at the artificiality of the story. As Bordwell points out, Hollywood's stylistic norms conditioned audiences from the mid-teens to the end of the fifties to expect certain conventions from a classical Hollywood movie: "causality, consequence, psychological motivations, the drive toward overcoming obstacles and achieving goals."[49] Above all, almost every film narrative focused on the leading characters and their fates. From screenwriter to spectator, the emphasis was on following the fate of the hero and heroine to their inevitable conclusion. It is quite

[47] THE CLASSICAL HOLLYWOOD FILM, p.xiv.

[48] THE CLASSICAL HOLLYWOOD CINEMA, p.12.

[49] THE CLASSICAL HOLLYWOOD CINEMA, p.13.

commonplace in film criticism to see the classical Hollywood film described as being "seamless," made with "invisible editing," and "pleasure-oriented," all in the hopes of providing audiences with "escapist" entertainment. Clearly, there were exceptions. And obviously there were differences between a Hollywood movie and a Soviet or German film.

But in the difference was the economic strength and stature of the American film industry. As will be discussed in Chapters 2, 3, 6, and 7, Hollywood gained control of world markets during World War I. At that point, its foreign competitors, devastated by economic and political conditions, no longer could threaten American film production. Seizing their opportunity, a hardy band of Eastern European Jews (more of which in Chapter 3) inaugurated a vertical system of production, distribution, and exhibition. Success depended upon being able to deliver routinely a formula film that appealed to mass audiences. Once the formulas were set in place, audiences expected and demanded that certain types of personalities perform certain acts, have certain traits, and champion certain values. The emphasis on continuity in production techniques and style gave rise not only to a a star system, but also to a dependence on stereotypes. Whether one chooses to analyze the cinematic experience as collective illusions or as the national iconography, the fact is that generation after generation of viewers who first perceived films as "escapist" entertainment came to accept Hollywood movies as a meaningful reflection of society. It was the classical Hollywood product that determined what was the "norm" for a "good" film. More to the point, the public "bought" the Hollywood product, cast, style, and message.

As will be discussed in Chapters 2, 3, and 5, Hollywood even took the position that it was responsible for uplifting America and for preserving the values of the American Dream. The thorny issue for white, Christian America was that the dream factory was run by outsiders. The relationship between a Jewish-dominated film industry standardizing and regulating the "norms" of a Christian society, and the power brokers in America who vehemently attacked Hollywood morality and values is covered elsewhere in this book. The point is that Bordwell's research makes it clear how and why standardization and regulation of the mode of film practice enabled Hollywood to gain economic control over the world's film industry and to condition audiences to accept the classical Hollywood film as the "norm" for movie aesthetics. It also focuses attention on why "Any account of the classical Hollywood film as an ideological product, a representational commodity, must recognize the specific formal operations through which classical principles reinforce dominant ideological positions."[50]

We began this chapter with an indication of how fragmented and diversified teaching, training, programs, and objectives are in film study. The initial emphasis was on explaining that these conditions do not present serious obstacles to exciting and meaningful experiences for educators or students. In fact, diversity for a young discipline may be an excellent opportunity for growth and intellectual curiosity, primarily because there are no fixed rules or rigid expectations. This book offers seven different approaches to screen education to illustrate the range of diversity in film study. Nevertheless, it does seem prudent to introduce, as early as possible, the notion that films are commercial products influenced not only by the values of the people who make them, but also by the perceptions of the society and industry in which they are created.

Romantics may treasure John Huston's comment that "Filmmaking is shadows that come together. When they part, what's left is magic!"[51] Those of us, however, who try to understand Huston's "magic" realize that filmmaking is a collaborative effort in which many people contribute to the film illusion. Building on the perspectives of the Sobchacks, Turner, and Bordwell, we appreciate not only the craft that goes into the art of filmmaking, but also the relationship between the filmmaker and the

[50] THE CLASSICAL HOLLYWOOD CINEMA, p.82.

[51] Cited in Joni Levin and Frank Marvin's documentary film, JOHN HUSTON: THE MAN, THE MOVIES, THE MAVERICK (1989).

audience. Even the novice quickly realizes how much emotional baggage a spectator brings to a formula film or to a star vehicle. For example, we expect a different experience viewing an Eddie Murphy film instead of a Meryl Streep movie, a western instead of a musical. Our expectations concerning film personalities affect the success of their films. Stars who play against our expectations sometimes grow in stature as performers: e.g., Humphrey Bogart in THE TREASURE OF THE SIERRA MADRE (1948) and THE AFRICAN QUEEN (1951), James Cagney in YANKEE DOODLE DANDY (1942), Grace Kelly in THE COUNTRY GIRL (1954), and Elizabeth Taylor in WHO'S AFRAID OF VIRGINIA WOOLF? (1966). At other times, they undercut a film's credibility by being miscast: e.g., Clark Gable in PARNELL (1937), Frank Sinatra in DIRTY DINGUS MAGEE (1970), Barbra Streisand in YENTL (1983), Bill Murray in THE RAZOR'S EDGE (1984), and Richard Gere in KING DAVID (1985). Still further, stars can be used to mislead the audience and thus add to a film's impact: e.g., Janet Leigh in PSYCHO (1960).

Of particular importance as one begins film study is the recognition that the narrative film is the cornerstone of the commercial film industry. If movies are "dream factories," then the standard product is the classical Hollywood film that uses psychologically motivated heroes and heroines to accomplish predictable and prescribed goals and wind up happily ever after. To paraphrase a line from THE MAN WHO SHOT LIBERTY VALANCE (1962), when fact comes in conflict with fantasy, Hollywood chooses the fantasy. That is not to say that Hollywood never changes its formulas. It does, but always within prescribed limits. It is not to say that the classical Hollywood film is the only influential art form in film history. It isn't. It's the most pervasive and the most influential. It is not to say that Hollywood has the best industrial system. It is to say that it is the most powerful and the richest.

Throughout this book, we will build on these assumptions. It will be argued that film is both a business and an art and that the structure of the film industry historically developed with that duality. The role of film in an evolving network of mass entertainment will be shown as part of a standardized and regulated system to satisfy widespread and multi-faceted audience needs. Drawing on the research of dedicated scholars and historians, one becomes aware of the fact that the film industry's reliance on stock situations and social types exposes significant data about ourselves and our nation. Example after example will underscore the complexity of the film process from inception to reception. The dependence of the classical Hollywood film on character motivation and audience identification will reveal important information about the price we pay for pleasure. The complexity of the film communication process should make it clear that seeing is not the same as understanding.

BOOKS

*Allen, Don, ed. THE ELECTRONIC ANTHOLOGY: PROBES INTO MASS MEDIA & POPULAR CULTURE. Dayton: Pflaum Publishing, 1975. Illustrated. 198pp.

Typical of the "hip" publications of the early seventies, this highly enjoyable anthology begins with a glib and distasteful preface that tries to show its readers that the author is "with it." Just when you're ready to discard the book, you find its six major sections have a delightful set of essays written by such stalwarts as Alvin Toffler, Tom Wolfe, Richard Schickel, Jules Feiffer, Garry Trudeau, William Goldman, Robert Warshow, Pauline Kael, Joan Baez, and E. L. Doctorow. In the process of picking a favorite author, one comes away with a good overview of the effects of the media in society. Well worth browsing.

*Boggs, Joseph M. THE ART OF WATCHING MOVIES, 2nd ed.. Palo Alto: Mayfield Publishing Company, 1985. Illustrated. 456pp.

"The underlying assumption of this book," Boggs writes, "is that there IS an art to watching films, and that special skills and techniques can sharpen and enhance the film experience." The author's analytical approach also assumes that students have little prior cinematic knowledge, and thus he moves very slowly and simply through

his fourteen chapters on film analysis, theme and focus, fictional and dramatic elements, visual elements, sound effects and dialogue, the musical score, acting, the director's style, analysis of the whole film, adaptations, sequels, other special experiences (e.g., foreign films and silent films), film censorship, and the art of watching movies on TV. Lovely illustrations nicely captioned and short thematic units in each chapter reinforce the basic concepts. Another useful feature is a set of study questions at the end of most chapters. Although footnotes appear occasionally, no bibliography is provided. One wonders what age student the author had in mind. A glossary and index are included. Worth browsing.

Bordwell, David, et al., THE CLASSICAL HOLLYWOOD CINEMA: FILM STYLE & MODE OF PRODUCTION TO 1960. New York: Columbia University Press, 1985. Illustrated. 506pp.

One of the treasures of contemporary film scholarship, this superb study challenges the notion of Hollywood as an insignificant historical institution and a wasteland for artists. Where other authors allude frivolously to the "classical Hollywood film," Bordwell, Staiger, and Thompson offer meticulous analyses of why the Hollywood product became the "norm" for film production and aesthetics. In the first of the book's seven main sections, "The Classical Hollywood Style, 1917-1960," Bordwell discusses the importance of the narrative film and the Hollywood mode of production. Part Two, "The Hollywood Mode of Production," has Staiger explaining how the system arose, the creation of standardization and differentiation, and the management style of directors and producers during Hollywood's formative years. Part Three, "The Formulation of the Classical Style, 1909-28," gives Thompson the opportunity to focus on the origins of Hollywood's classical narrative style, the continuity system, and how the process was stabilized after 1917. Part Four, "Film Style and Technology to 1930," allows each of the authors to discuss the relationship between technology and film economics. Part Five, "The Hollywood Mode of Production, 1930," gives us Staiger's perspectives on the film industry's labor relationships, producer-unit system, and package-unit methodology. Part Six, "Film Style and Technology," has Bordwell analyzing how deep-focus cinematography, Technicolor, widescreen processes, and stereophonic sound altered film styles. The concluding section, "Historical Implications of the Hollywood Cinema," provides a chance to speculate about the persistence of Hollywood's studio methods after 1960 and alternative modes of film practice. Several appendexes, endnotes, a bibliography, and an index are included. Highly recommended for all collections.

*Butler, Ivan. THE MAKING OF FEATURE FILMS: A GUIDE. Baltimore: Penguin Books, 1971. Illustrated. 191pp.

This very readable and interesting book is compiled mainly from personal interviews with famous filmmakers in the United States and Britain. Each chapter deals with specific aspects of the film continuum: production, screenwriting, directing, acting, cinematography, art design, costuming, special effects, continuity, editing, composing, sound, distribution, and censorship. No index is included. Well worth browsing.[52]

*Casty, Alan, ed. MASS MEDIA AND MASS MAN. New York: Holt, Rinehart and Winston, 1968. Illustrated. 260pp.

This is a good introduction for neophytes in film study dealing with the sight-and-sound media as originators, molders, and communicators of ideas, opinions, and values in society today. The anthology includes essays by Dwight Macdonald, Marshall McLuhan, Federico Fellini, Susan Sontag, and Pauline Kael. Worth browsing.

[52] For books on producing specific films, see Chapter 3.

*Cavell, Stanley. THE WORLD VIEWED: REFLECTIONS ON THE ONTOLOGY OF FILM.
New York: The Viking Press, 1971. 174pp. Cambridge: Harvard University Press,
1979. Enlarged ed. 253pp.
 Concerned with what makes movies so important in our lives and how to evaluate
the film's artistic merit, Cavell philosophically explores Hollywood's star system,
directors, and famous films, while at the same time he provides some stimulating
observations on major European artists. Particularly useful are his reflections on the
role of films in our society, the transformation of reality into fantasy on the screen,
and the effects that movies have on audiences. Interestingly, the author is rather
flippant about "errors of memory"--e.g., he realizes that Jean Arthur never appeared
on the Senate floor in MR. SMITH GOES TO WASHINGTON (1939), but refuses to
change the mistake in the updated version--and explains that "I am as interested in
how a memory went wrong as in why the memories that are right occur as they do."
Endnotes and an index are included. Well worth browsing.

*Dickinson, Thorold. A DISCOVERY OF THE CINEMA. New York: Oxford University
Press, 1971. Illustrated. 164pp.
 Although more than half the pages in this slim and attractive volume are devoted
to the silent film, Dickinson makes some provocative comments about what he considers
to be the four basic factors of film development--political and social climate, creative
capacity of the artist, flexibility of movie equipment, and the audience. The book
also contains recommended film viewing lists, and a brief bibliography and indexes.
Worth browsing.

Durgnat, Raymond. FILMS AND FEELINGS. Cambridge: M.I.T. Press, 1967.
Illustrated. 288pp.
 Relying on his postgraduate research at the Slade School, Durgnat spends almost
half the book developing a stimulating introduction to film styles, from THE BIRTH
OF A NATION (1915) to experimental film production in the 1960s. He is particularly
concerned with the reason why films "pose certain aesthetic problems more insistently
than other media have done" and why, "for various historical and economic reasons,
the medium generates conflicts between its function as an 'art form' and its function
as an entertainment 'dream factory.'" Film buffs may find his highly personal prose
tough going. Footnotes, a bibliography, and an index are included. Well worth
browsing.

*Edmonds, Robert. THE SIGHTS AND SOUND OF CINEMA AND TELEVISION: HOW
THE AESTHETIC EXPERIENCE INFLUENCES OUR FEELINGS. Foreword Alberto
Cavalcanti. New York: Teachers College, Columbia University, 1982. Illustrated.
235pp.
 "The purpose of this book," Edmonds explains, "is to help you judge the films
you see, or, if you are a filmmaker, the films you make." Starting with the premise
that every work of art has two major elements, "the content and the way the content
is presented," the author discusses the nature of "the aesthetic package." That is,
the qualities in a work of art that convey the author's feelings, the content of the
work. The book itself is divided into three major sections: "The Sights," dealing with
film language, frames, light, space, optics, motion, and color; "The Sounds,"
focusing on a historical overview of sound technology, music, sound effects, and
speech; and "Sight and Sounds Together: Film and Television," emphasizing styles,
imagery, and dramaturgy. The writing is thoughtful, intelligent, and challenging.
The tone may be too dry for general students. Endnotes, a bibliography, and an
index are included. Well worth browsing.

Feldman, Joseph and Harry. DYNAMICS OF THE FILM. New York: Arno Press, 1971.
Illustrated. 255pp.

Originally written in 1952, this highly readable book discusses film study in everyday terms and is an good source guide to the general understanding of film characteristics. A bibliography and index are included. Worth browsing.

*Forsdale, Louis, ed. 8MM SOUND FILM AND EDUCATION: PROCEEDINGS OF A CONFERENCE HELD AT TEACHERS COLLEGE ON NOVEMBER 8, 9, and 10, 1961. New York: Teachers College, Columbia University, 1962. 166pp.

One of the first significant studies on the technique of recording sound on a narrow magnetic strip along one edge of the film, this anthology encompasses the enthusiasm of teachers, film producers and distributors, engineers, equipment manufacturers, motion picture laboratory managers, school administrators, audio-visual directors, and librarians about 8mm sound film. Eight thoughtful sections present the hopes of the sixties in the technical, economic, and artistic potential of the minature film form. A bibliography is included. Well worth browsing.

*Jacobs, Lewis, ed. THE MOVIES AS MEDIUM. New York: Farrar, Straus and Giroux, 1970. Illustrated. 335pp.

This valiant attempt by Jacobs to collect important essays about the fundamentals of film art is another example of his excellent skill as an editor. This time he divides his anthology into four main parts: aims and attitudes of thirty-six prominent directors, the nature of film expression, the plastic elements (e.g., images, movement, time and space, color, and sound), and the plastic structure. Not only do we learn about interlocking relationships between a filmmaker's intentions and finished results, but there are also many stimulating suggestions about film criticism useful for classroom discussion. Among the contributors are Ezra Goodman, Stanley J. Solomon, Robert Gessner, Ivor Montagu, Carl Theodor Dreyer, Sergei M. Eisenstein, Bela Balazs, Kurt Weill, Arthur Lenning, and Jonas Mekas. A bibliography and index are included. Recommended for special collections.

*Kirschner, Allen, and Linda Kirschner, eds. FILM: READINGS IN THE MASS MEDIA. New York: The Odyssey Press, 1971. 315pp.

The Kirschners begin by asserting, "We believe in our films--through them we live lives far different in time, place, or circumstance from our prosaic existences. And we believe in our film heroes--they are our alter egos, exciting, romantic extensions of ourselves. We dream and we imitate. We become." Believing that films have the potential to do harm as well as good because of their hold on our collective imagination, the authors offer more than thirty essays on the history, art, and effects of film. The contributors include prominent critics and filmmakers; the essays are reprints of useful observations. To help market the anthology for schools, David Carr has prepared a teacher's guide filled with helpful suggestions and teaching activities. It's a shame that no one thought of a bibliography or an index. Well worth browsing.

*Kuhns, William, et al. THE MOVING PICTURE BOOK. Dayton: Pflaum, 1975. Illustrated. 292pp.

Here is another example of the colorful graphic designs of the Pflaum film texts of the seventies. A revision of the author's 1967 book, EXPLORING THE FILM, and intended for a similar secondary school audience, it permits Kuhn to register his disappointment with the ineffectiveness of all introductory books on film. He wants to try something new. Through a minimum of narrative and a heavy dose of visuals, he proposes "to provoke students into making their own recognition and reaching their own understanding about various terms and techniques and possibilities in movies." Twelve carefully designed chapters give it the author's best shot. Definitely not an approach that would work in structured environments, but a lovely gesture nevertheless. Film notes, a bibliographical essay, and an index are included. Well worth browsing.

*Lindgren, Ernest. THE ART OF THE FILM. New York: The Macmillan Company, 1963. Rev. ed. Illustrated. 258pp.
This useful introduction to film appreciation first appeared in 1948 and became a recommended book on every teacher's reading list by the sixties. Lindgren divides his efforts into three main sections. Part One is on the mechanics of filmmaking, including the division of labor and a brief history of film equipment complete with related comments on its value to students. Part Two deals with technique and emphasizes editing, sound, and acting. Part Three is concerned with film criticism and with some useful guidelines for teaching young people to enjoy movies. A bibliography and glossary are included. Well worth browsing.

Madsen, Roy Paul. THE IMPACT OF FILM: HOW IDEAS ARE COMMUNICATED THROUGH CINEMA AND TELEVISION. New York: Macmillan Publishing Company, 1973. Illustrated. 571pp.
"This book," Madsen explains, "represents the first attempt to define how film and television programs are organized for idea communication in their major areas of use. Its central purpose is to provide a source work to which laymen, students and professionals alike may turn to understand how the medium of cinema-television can be effectively utilized to achieve a specific purpose in drama, teaching and persuasion." The book's four major divisions deal with (1) the techniques unique to the language of film and television, (2) the basic elements of screen narratives and the important film and television genres that embody the medium's dramatic values, (3) the effects of film and television on political, social, and economic events, and (4) the recommended educational and research approaches to examining film and television. A highly ambitious undertaking that makes a useful contribution in synthesizing a range of disciplines, this work illustrates the visual literacy perspective of the early seventies. An index is included. Well worth browsing.

*Maltin, Leonard, ed. LEONARD MALTIN'S TV MOVIES AND VIDEO GUIDE. 1987 Edition. New York: New American Library, 1986. 1121 pp.
Up-to-date lists of more than 17,000 theatrical films, made-for-TV movies, and made-for-Cable TV films, this invaluable and highly entertaining resource has been praised by many major periodicals and trade papers. The running times may not always be accurate and the opinions are controversial, but I can't imagine any basic library without it. Recommended for all collections.

Manchel, Frank. MOVIES AND HOW THEY ARE MADE. Englewood Cliffs: Prentice-Hall, 1968. Illustrated. 71pp.
"This delightful book is designed for students in grades three to seven but many readers beyond those grades will enjoy it. Using a blend of line drawings and an intelligent text which is never condescending, Manchel manages to inform, teach, and entertain. Such terms as 'mass entertainment,' 'treatment,' 'associate producer,' 'unit manager,' and so on are defined and explained with economy and clarity. The book treats all of the elements of filmmaking--budgets, scripts, schedules, shooting, locations, music and preview . . . Highly recommended for intermediate and junior high grades, and others may want to consider it, too."[53]

Minus, Johnny, and William Storm Hale. THE MOVIE INDUSTRY BOOK (HOW OTHERS MADE AND LOST MONEY IN THE MOVIE INDUSTRY). Hollywood: 7 Arts Press, 1970. Illustrated. 601pp.

[53] George Rehrauer, THE MACMILLAN FILM BIBLIOGRAPHY (New York: Macmillan Publishing Company, 1982), p.642.

Designed primarily for businesspeople in film, the book points out pitfalls in contractual matters. Among the topics covered are the steps in putting together a movie package, copyright, censorship, limited partnerships, uniform commercial codes, obscenity, working forms for producers and distributors, short contracts, and magazine reviews. Although the material is dated, it's fun reading what insiders thought about deal-making in the late sixties. Well worth browsing.[54]

*Monaco, James. HOW TO READ A FILM: THE ART, TECHNOLOGY, LANGUAGE, HISTORY, AND THEORY OF FILM AND MEDIA, Rev. ed. New York: Oxford University Press, 1981. Illustrated. 553pp.

An impressive approach to studying film in the context of media in general, this detailed and stimulating book takes a global look at the complexity of the communication process. "In each of the six chapters," Monaco explains, "the intention has been to try to explain a little of how film operates on us psychologically, how it affects us politically." The author skillfully weaves concepts with diagrams, stills, and cinematic allusions to art and technique growing out of those primary concerns. For example, his opening chapter, "Film as Art," is designed to provide a historical perspective on the relationship between film and other arts, but he makes it clear in a useful teacher's guide to the book, that teachers might want to save this abstract chapter until students are more able to deal with theoretical matters. In fact, one of the book's many virtues is the author's desire to make the subject interesting, useful, and accessible to people uneasy with semiotic approaches. The effect is not only to broaden our understanding of film in the ongoing evolution of communication history, but also to provide a valuable source of information on film analysis. A bibliography, glossary, and index are included. Recommended for special collections.

*Peters, J. M. PICTORIAL COMMUNICATION. Trans. Murray Coombes. Cape Town: David Philip, 1977. Illustrated. 118pp.

*Phillips, William H. ANALYZING FILMS: A PRACTICAL GUIDE. New York: Holt, Rinehart and Winston, 1985. Illustrated. 345pp.

In comparison with other introductory books on viewing, describing, and analyzing films, this work focuses on four specific features: "It emphasizes practical criticism rather than theory and history . . . [It] is geared toward beginners, who may lack skills in viewing, analyzing, and explaining . . . [It] combines information and exercises to help viewers develop critical skills . . . The emphasis is on film viewing and viewer responses, rather than on filmmaking/filmmakers and viewer responses." Phillips divides his material into five easy-to-read and useful sections. Particularly helpful is Part Two, "Films and Examining Films," with a list of topics for discussing and examining films. A bibliography, glossary, and index are included. Well worth browsing.

*Rosenberg, Bernard, and David Manning White, eds. MASS CULTURE: THE POPULAR ARTS IN AMERICA. New York: The Free Press, 1957. 561pp.

One of the best introductions to the study of mass media, this anthology is the first comprehensive look at movies, mass literature, radio and TV programs, advertising, and popular music. Rosenberg and White judiciously select fifty-one commentators--literary critics, social scientists, journalists, and aestheticians--who are concerned with the effects of the mass media on society. The focus of the book's eight informative and entertaining sections is whether mass culture is worthy of intellectual and critical respect. While not entirely balanced, the nay-sayers are well represented. Recommended for special collections.

[54] For more inside information on Hollywood methods, see Chapter 5.

*Scheuer, Steven H., ed. MOVIES ON TV 1986-1987. 11th ed. New York: Bantam Books, 1985. 829pp.
 This is the eleventh edition of a handbook that first appeared in 1958. It briefly describes and rates over 7000 theatrical films, made-for-TV movies, and made-for-Cable TV films. Included in the alphabetically arranged reviews are production dates, credits, and a four-star ratings system. This edition also contains information about films on videocassettes, short essays on major film genres, and a selected chronology of Oscar winners. It is generally reliable and fun to read. Well worth browsing.

*Scott, James F. FILM: THE MEDIUM AND THE MAKER. New York: Holt Rinehart and Winston, 1975. Illustrated. 340pp.
 A useful introductory text on film aesthetics that emphasizes both art and technology, this work emphasizes viewing films rather than producing them. The novelty of Scott's highly informative eight chapters is that he describes the collaborative nature of film with impressive references to dozens of important films. Thus, chapters on lighting, composition, sound, acting, and screenplays anchor their explanations with specific references, rather than abstract general observations. A bibliography and index are included. Well worth browsing.

*Sharff, Stefan. THE ELEMENTS OF CINEMA: TOWARD A THEORY OF CINESTHETIC IMPACT. New York: Columbia University, 1983. Illustrated. 187pp.
 "In demonstrating the existence of uniquely cinematic elements of structure," Sharff states in his introduction, "I hope to cast light on cinema's creative processes and its aesthetic potential. While stressing the primacy of form in cinema as the foremost means for expressing content, I shall endeavor to distinguish between FILM as a medium of mass communication and CINEMA as a potential art form." The emphasis is on screen "language"; the examples are drawn from the works of important directors. The author, who studied with Eisenstein, insists that "Cinema . . . can claim to be, along with language, the only other form of communication which exists on a syntactic continuum: a sequence of signs that 'make sense' when arranged grammatically and convey meaning on both a literal and an emotional level." The attractive feature of this "technical" book on the process of film is that it is written by an intellectual filmmaker who loves his subject. A glossary and index are included. Well worth browsing.

*Slade, Mark. LANGUAGE OF CHANGE: MOVING IMAGES OF MAN. Toronto: Holt, Rinehart and Winston of Canada, Ltd., 1970. Illustrated. 186pp.
 Written with wit and insight, this book offers a good discussion of the impact that moving images have on a global community. Slade, unlike most modern critics of the communications revolution, offers some positive suggestions to the problems of information processing and outmoded learning procedures. A bibliography and filmography are included. Well worth browsing.

*Sobchack, Tom, and Vivian C. Sobchack. AN INTRODUCTION TO FILM, 2nd ed. Boston: Little, Brown and Company, 1987. Illustrated. 514pp.
 Working on the assumption that audiences go to films both for entertainment and enlightenment, the Sobchacks argue that having "a grasp of the basics of filmmaking and the context of film production will develop a respect for the complicated choices made by the artists and artisans responsible for a completed work." The book's five major sections also focus on cultural, theoretical, and historical approaches to film study. Each of the self-contained chapters provides historical overviews supplying readers with pertinent details on key technological and cultural events "so that discussions of film form and content will not occur in an historical vacuum." Part 1, "The Production of Film," emphasizes how an artifact of society emerges from an industrial setting. The focus is on the film process from screenplay to marketing

and distribution and exhibition. Part 2, "The Elements of Film," examines basic film aesthetics: film space (e.g., image, tone, composition, and movement), film time (e.g., manipulation of time, stopped time--the freeze frame, subjective time--dream, fantasy, memory, and perceptual distortion, objective time--the flashback and the flash-forward, achronological time--ambiguous time, universal time, meaning through editing--relationships between shots, and meaning with minimal editing--relationships within shots), and film sound (e.g., the human voice--dialogue, narration, sound effects--synchronous sound, asynchronous sound, music--background music, foreground music, and the artistry of sound--sound perspective, the sound bridge, sound counterpoint, and sound conventions). Part 3, "Mainstream Narrative Film," considers the development of the narrative film, film genres, nongenre narrative, and the problems of adaptation. Part 4, "The Alternative Film," offers insights into the documentary, experimental, independent, and animated films. Part 5, "A Guide to Film Analysis and Criticism," begins with a valuable overview of film reviewing, criticism, and theory; and then concludes with practical information on writing college papers about film--e.g., how to start, what to write about, research papers, manuscript preparation, and helpful hints. A bibliography, film glossary, and index are included. Recommended for undergraduate courses.

*Sohn, David A. FILM STUDY AND THE ENGLISH TEACHER. Bloomington: Indiana University Audio-Visual Center, 1968. 12pp.
 Written by a filmmaker and teacher, this terse but insightful document is wonderful for landscaping the problems and possible solutions that educators faced in the sixties. Its interesting to see whether the issues have changed in twenty years. Well worth browsing.

*Solomon, Stanley J. THE FILM IDEA. New York: Harcourt Brace Jovanovich, 1972. Illustrated. 403pp.
 Working from the basic premise that the narrative film needs to be examined independently from the traditional arts, Solomon divides his book into three main sections. Part One offers a nontechnical discussion of the basic principles of film form; Part Two examines the chronological growth of that film form; and Part Three studies a host of theories and aesthetics about film form. "The kind of analysis attempted here," the author explains, "requires a good deal of description of specific occurrences in particular films because of the difficulty of translating a largely visual event into a verbal one. The difficulty cannot be ignored by simply talking about a film's meaning, since that meaning must be derived from the specific images and events of the narrative. The questions raised in the extended analyses of various films is not 'What does a film mean?' but rather 'How is the meaning expressed?'" A glossary, selected filmography, bibliography, and index are included. Well worth browsing.

*Stromgren, Richard L., and Martin F. Norden. MOVIES: A LANGUAGE IN LIGHT. Englewood Cliffs: Prentice-Hall, 1984. Illustrated. 296pp.
 "All artists," Stromgren and Norden assert, "manipulate their material and thereby, to an extent, their audiences--not to mislead them, but to emphasize areas of importance. But audiences have a responsibility to themselves, a need to evaluate not only the effects of the art experience but the procedures and techniques the artist uses to achieve his purpose." Working on that basic premise, Solomon's six informative and lucid chapters introduce students to the evolution in film form and function, the elements of film properties and techniques, the nature of narrative conventions, the relationship between film and other media, film genres, film theories, and critical methodologies. A bibliography and index are included. Well worth browsing.

*Taylor, Theodore. PEOPLE WHO MAKE MOVIES. New York: Doubleday, 1967. Illustrated. 191pp.

An easy-to-read overview of the work behind-the-scenes is presented in this book along with some good illustrations of actual feature film productions. A glossary and index are included. Worth browsing.

*Thompson, Howard, ed. THE NEW YORK TIMES GUIDE TO MOVIES ON T.V. Introduction Bosley Crowther. Chicago: Quadrangle Books, 1970. Illustrated. 223pp.
 One of the best sources for short, witty, and insightful film reviews up to 1970, it also provides complete credits, dates, and stills from each film. Well worth browsing.

*Wead, George, and George Lellis. FILM: FORM AND FUNCTION. Boston: Houghton Mifflin Company, 1981. Illustrated. 502pp.
 Beginning with the premise that film is a complex medium of communication, Wead and Lellis divide their material into three main sections: the techniques of communication (e.g., movement, space, continuity, sound, and color, emphasizing the illusionary nature of film); the Hollywood narrative tradition (e.g., its social and artistic aspect, stressing what is the norm for the film capital); and alternatives to the Hollywood tradition (e.g., generally foreign or AVANT-GARDE films, focusing on the experimental nature of the alternative approaches). The authors define the four functions that films provide as "(1) REALIST--to document the world as closely as possible, (2) PERSUASIVE--to influence the viewer toward a particular point of view, (3) PERSONAL--to convey the filmmaker's individual vision of the world, and (4) ESTHETIC--to serve as a medium for innovative artistic expression." An index is included. Well worth browsing.

*Willener, Alfred, et al. VIDEO AND UTOPIA: EXPLORATIONS IN A NEW MEDIUM. Trans. Diana Burfield. London: Routledge & Kegan Paul, 1976. 171pp.

*Withers, Robert S. INTRODUCTION TO FILM. New York: Barnes & Noble Books, 1983. Illustrated. 264pp.
 A no-frills approach to the art, technology, language, and appreciation of film, this informative outline approach offers a good summary of traditional ideas and basic film techniques. The lack of a glossary and a meaningful bibliography limit its use as a reference tool. An index is provided. Well worth browsing.

*Whitaker, Rod. THE LANGUAGE OF FILM. Englewood Cliffs: Prentice-Hall, 1970. Illustrated. 178pp.
 Designed as a brief introduction to the study of film as a form of communication that is shaped by purposes, audience, the medium itself, and the nature of the message, this book emphasizes two main points of view: the creative and the perceptual. Central to the book's structure, Whitaker explains, "is the assumption that the film experience is composed of pure images and pure sounds, organized through narrative and artistic code structures, and lent meaning by the participation and experience of the audience member." Seven chapters offer observations on the basic elements of film. A minimum number of footnotes and the absence of a bibliography and a glossary limit the book's value. An index is included. Worth browsing.

White, David Manning, and Richard Averson, eds. SIGHT, SOUND AND SOCIETY: MOTION PICTURES AND TELEVISION IN AMERICA. Boston: Beacon Press, 1968. 467pp.
 This excellent introductory textbook for media students is divided into five well-balanced sections. Part One, "The Screen and Its Audience," consists of four sociological essays by Gilbert Seldes, Robert J. Silvey, Wilbur Schramm, and Sessue Hayakawa. The contributors are concerned with the social responsibilities of media

executives and exhibitors, the role that "play" theory has in mass entertainment, the nature of screen violence and its effects on children, and the influence that the media has on the image of minorities in our society. Part Two, "Media and Messages," has a wonderful critical piece on film aesthetics by Robert Steele. Part Three, "Sight and Sound Communicators," is about the pressures exerted by the now-defunct studio system. Part Four, "The Controversial Screen," deals with the familiar media problems of violence, censorship, and political pressures; particularly useful is Philip French's "Violence in the Cinema." Part Five, "The Expanding Image," has a superb essay by Walter J. Ong on teaching about communication in the schools, and a good survey by John Culkin on high school film teaching principles. A bibliography and index are included. Recommend for special collections.

FILM PRODUCTION

GENERAL

*Ahlers, Arvel W. THE ANSCO GUIDE TO PICTURE FUN MADE EASY. New York: Popular Library, 1963. Illustrated. 215pp.[55]

Arijon, Daniel. GRAMMAR OF THE FILM LANGUAGE. New York: Hastings House, 1976. Illustrated. 624pp.

Armer, Alan A. DIRECTING TELEVISION AND FILM. Belmont: Wadsworth Publishing Company, 1986. Illustrated. 337pp.

Bare, Richard L. THE FILM DIRECTOR: A PRACTICAL GUIDE TO MOTION PICTURE AND TELEVISION TECHNIQUES. New York: The Macmillan Company, 1971. Illustrated. 243pp.
 This practical and easy-to-read book offers a fine introduction to film and television directing. Information is provided on how to handle performers, create effective setups, and use of various types of film stock. A bibliography and index are included. Recommended for special collections.

*Bayer, William. BREAKING THROUGH, SELLING OUT, DROPPING DEAD, AND OTHER NOTES ON FILM MAKING. New York: The Macmillan Company, 1971. 227pp.
 Instead of the usual structured approach to film production, Bayer uses a dictionary format. He arranges alphabetically seventy individual topics connected with film and television making. Most unusual is his attempt to impress upon the very young filmmaker the competitive nature of the film business. Recommended for special collections.

Beal, J. David. ADVENTUROUS FILM MAKING. New York: Focal/Hastings House, 1980. Illustrated. 269pp.

*Beckman, Henry. HOW TO SELL YOUR FILM PROJECT. Los Angeles: Pinnacle Books, 1979. 313pp.

[55] This section was influenced by Raymond Fielding's excellent article, "Motion Picture Technique: A Basic Library," FILM QUARTERLY 16:3 (Spring 1963):48-9. For material on the relationship between film production and education, see Gunter Pfaff, "Buttonpusher or Partner?" JOURNAL OF THE UNIVERSITY FILM ASSOCIATION 29:2 (Spring 1971):13-6; and Bob Wilks, "Using the Partnership Model," ibid., pp.16-20.

Blanchard, Nina. HOW TO BREAK INTO MOTION PICTURES, TELEVISION, COMMERCIALS, AND MODELING. Foreword Eileen Ford. Garden City: Doubleday and Company, 1978. Illustrated. 240pp.

*Bleicher, Norman L., ed. VICTOR DUNCAN PRODUCTION EQUIPMENT GUIDE. Dallas: Victor Duncan, 1980. Illustrated. 348pp.

*Bobker, Lee R., with Louise Marinis. MAKING MOVIES: FROM SCRIPT TO SCREEN. New York: Harcourt Brace Jovanovich, 1973. Illustrated. 304pp.

Brodbeck, Emil E. HANDBOOK OF BASIC MOTION PICTURE TECHNIQUES. New York: American Photographic Book Publishing Company, 1969. Illustrated. 224pp.
 Although the basic film equipment sections are now dated, Brodbeck's useful suggestions about methods of panning, visual composition, editing, and lighting are worth investigating. Although not designed specifically for neophytes, this reference book offers more than 200 movie illustrations, drawings, and diagrams from which beginning filmmakers could learn. Well worth browsing.

Brodbeck, Emil E. MOVIE AND VIDEOTAPE: SPECIAL EFFECTS. Philadelphia: Chilton Books, 1968. Illustrated. 192pp.
 Every beginning filmmaker should examine this book's useful information on masks, filters, special lenses, mirrors, titles, sound, double exposures, backgrounds, animation, fog, smoke, water, and heat. The helpful illustrations are well chosen and well produced. An index is included. Well worth browsing.

*Cook, Michael. EXECUTIVE HANDBOOK OF BUSINESS FILM AND VIDEOTAPE. New York: Michael Cook, 1979. 79pp.

Costa, Sylvia Allen. HOW TO PREPARE A PRODUCTION BUDGET FOR FILM & VIDEO TAPE. 2nd ed.. Blue Ridge Summit: Tab Books, 1975. 192pp.

*Derks, Mik, and Steve Poster. FILM MAKING. Los Angeles: Peterson, 1977. Illustrated. 80pp.

*Dickinson, Leo. FILMING THE IMPOSSIBLE: TRAVELS IN SEARCH OF ADVENTURE. London: Jonathan Cape, 1986. Illustrated. 256pp.

Dmytryk, Edward. ON FILMMAKING. Boston: Focal Press, 1986. Illustrated. 538pp.

Ewing, Sam, and R. W. Abolin. PROFESSIONAL FILMMAKING. Blue Ridge Summit: Tab Books, 1974. Illustrated. 251pp.

Glimcher, Sumner, and Warren Johnson. MOVIE MAKING--A GUIDE TO FILM PRODUCTION. New York: Columbia University Press, 1975. Illustrated. 235pp.

*Goodell, Gregory. INDEPENDENT FEATURE FILM PRODUCTION: A COMPLETE GUIDE FROM CONCEPT THROUGH DISTRIBUTION. New York: St. Martin's Press, 1982. 323pp.

*Gregory, Mollie. MAKING FILMS YOUR BUSINESS. New York: Schocken Books, 1979. 256pp.

*Gunter, Jonathan F. SUPER 8: THE MODEST MEDIUM. New York: Unipub, 1976. Illustrated. 93pp.

Happe, L. Bernard. BASIC MOTION PICTURE TECHNOLOGY. New York: Hastings House, Illustrated. 371pp.

*Happe, L. Bernard. YOUR FILM & THE LAB. New York: Hastings House, 1974. Illustrated. 208pp.

*Harcourt, Amanda, et al. THE INDEPENDENT PRODUCER: FILM AND TELEVISION. Boston: Faber and Faber, 1986. Illustrated. 312pp.

Harris, Morgan, and Patti Karp. HOW TO MAKE NEWS & INFLUENCE PEOPLE. Blue Ridge Summit: Tab Books, 1976. 140pp.

Harrison, Helen P. FILM LIBRARY TECHNIQUES: PRINCIPLES OF ADMINISTRATION. Introduction A. William Bluem. New York: Hastings House, 1973. 277pp.

*Hodgdon, Dana H., and Stuart M. Kaminsky. BASIC FILM-MAKING. New York: Arco Publishing Company, 1981. Illustrated. 175pp.

Johnson, Albert, and Bertha Johnson. DIRECTING METHODS. Cranbury: A. S. Barnes and Company, 1970. 443pp.

Kindem, Gorham. THE MOVING IMAGE: PRODUCTION PRINCIPLES AND PRACTICES. Glenview: Scott, Foresman and Company, 1987. Illustrated. 458pp.

Klein, Walter J. THE SPONSORED FILM. New York: Hastings House, 1976. 210pp.

*Lazarus, Paul N., III. THE MOVIE PRODUCER: A HANDBOOK FOR PRODUCING AND PICTURE-MAKING. New York: Barnes & Noble Books, 1985. 209pp.

Linder, Carl. FILMMAKING: A PRACTICAL GUIDE. Englewood Cliffs: Prentice-Hall, 1976. Illustrated. 304pp.

Lipton, Lenny. FOUNDATIONS OF STEREOSCOPIC CINEMA: A STUDY IN DEPTH. New York: Van Nostrand Reinhold Company, 1982. Illustrated. 319pp.

*Lipton, Lenny. INDEPENDENT FILMMAKING. Introduction Stan Brakhage. New York: Simon and Schuster, 1972. Illustrated. 432pp.

This is a superb guide to 8mm, Super 8-Single 8 and 16mm filmmaking. It is divided into ten worthwhile and heavily detailed chapters on such things as formats, film, cameras, lens, shooting, splicing and editing, sound and magnetic recordings, preparing the sound tracks, and the laboratory's role. A valuable index is also included. Recommended for special collections.

*Lipton, Lenny. LIPTON ON FILMMAKING. Ed. Chet Roaman. New York: Simon and Schuster, 1979. Illustrated. 223pp.

*Lipton, Lenny. THE SUPER 8 BOOK. Ed. Chet Roaman. San Francisco: Straight Arrow Books, 1975. Illustrated. 308pp.

*London, Mel. GETTING INTO FILM. New York: Ballantine Books, 1977. Illustrated. 178pp.

*Lukas, Christopher. DIRECTING FOR FILM AND TELEVISION. Garden City: Doubleday, 1985. Illustrated. 194pp.

Manning, Robert N. EXPLORING CAREERS IN FILMMAKING. New York: Rosen Publishing Group, 1985. Illustrated. 128pp.

*Marner, Terence St. John, ed. DIRECTING MOTION PICTURES. New York: A. S. Barnes and Company, 1972. Illustrated. 158pp.
 This is another useful and easily readable book in a series on professional film techniques. Marner divides his text and contributors' comments into nine valuable chapters on such things as the director's role, his preparation, the script, setting up shots, graphic continuity, lens and composition, viewpoint and movement, the director and acting, and rehearsal and improvisation. Also included are two film excerpts (NOW THAT THE BUFFALO'S GONE and THIS SPORTING LIFE) as well as a helpful index. Well worth browsing.

*McClain, Bebe Ferrell. SUPER 8 FILMMAKING FROM SCRATCH. Englewood Cliffs: Prentice-Hall, 1978. Illustrated. 226pp.

*Miller, Tony, and Patricia George Miller. CUT! PRINT!: THE LANGUAGE AND STRUCTURE OF FILMMAKING. Introduction Charlton Heston. Los Angeles: Ohara Publications, 1972. Illustrated. 188pp.

*Morrow, James, and Murray Suid. MOVIEMAKING ILLUSTRATED: THE COMICBOOK FILMBOOK. Rochelle Park: Hayden Book Company, 1973. Illustrated. 160pp.

Orlik, Peter B. BROADCAST COPYWRITING. 3rd ed.. Boston: Allyn and Bacon, 1986. Illustrated. 618pp.

Petzold, Paul. ALL-IN-ONE MOVIE BOOK. Garden City: American Photographic Book, 1974. Illustrated. 224pp.

*Petzold, Paul. THE PHOTOGUIDE TO MOVIEMAKING. New York: Amphoto, 1975. Illustrated. 224pp.

Piper, James. PERSONAL FILMMAKING. Reston: Reston Publishing Company, 1975. Illustrated. 269pp.

Reynerston, A. J. THE WORK OF THE FILM DIRECTOR. New York: Hastings House, 1970. Illustrated. 256pp.
 In addition to providing an extremely worthwhile philosophy on film direction, Reynerston, in lucid and accurate prose, gives a valuable introduction to such production areas as methods, sound, composition, and acting. The illustrations in this book are valuable and plentiful. Well worth browsing.

Robertson, Joseph F. MOTION PICTURE DISTRIBUTION HANDBOOK. Blue Ridge Summit, Tab Books, 1981. Illustrated. 252pp.

Sherman, Barry L. TELECOMMUNICATIONS MANAGEMENT: THE BROADCAST AND CABLE INDUSTRIES. New York: McGraw-Hill Book Company, 1987. Illustrated. 417pp.

*Singleton, Ralph S. FILM MAKER'S DICTIONARY. Beverly Hills: Lone Eagle Publishing Company, 1986. 188pp.

*Singleton, Ralph S. FILM SCHEDULING: OR, HOW LONG WILL IT TAKE TO SHOOT YOUR MOVIE? Beverly Hills: Lone Eagle Publishing Company, 1984. 224pp.

*Singleton, Ralph S. MOVIE PRODUCTION & BUDGET FORMS . . . INSTANTLY! Beverly Hills: Lone Eagle Publishing, 1985. 132pp.

Skiles, Marlin. MUSIC SCORING FOR TV AND MOTION PICTURES. Blue Ridge Summit: Tab Books, 1976. Illustrated. 261pp.

Spottiswoode, Raymond. FILM AND ITS TECHNIQUES. Berkeley: University of California Press, 1968. Illustrated. 516pp.
 Originally published in 1951, this is one of the most compact, complete, and informative texts on making movies. More than eighty percent of the book is devoted to the needs of low-budget filmmakers. A glossary, bibliography, and index are included. Recommended for special collections.

Spottiswoode, Raymond, et al. THE FOCAL ENCYCLOPEDIA OF FILM AND TELEVISION TECHNIQUES. New York: Hastings House, 1969. Illustrated. 1100pp.
 Without question, this is one of the major texts available on basic film techniques. More than 1,600 entries, alphabetically arranged and in clear print, are concisely presented, along with many helpful charts, diagrams, and illustrations. Recommended for special collections.

Stecker, Elinor H. THE MASTER HANDBOOK OF STILL AND MOVIE TITLING FOR AMATEUR AND PROFESSIONAL. Blue Ridge Summit: Tab Books, 1979. 463pp.

Strasser, Alex. THE WORK OF THE SCIENCE FILM MAKER. New York: Hastings House, 1972. Illustrated. 306pp.

*Taub, Eric. GAFFERS, GRIPS, AND BEST BOYS. New York: St. Martin's Press, 1987. 200pp.

*Tromberg, Sheldon. MAKING MONEY MAKING MOVIES: THE INDEPENDENT MOVIE-MAKERS' HANDBOOK. New York: Franklin Watts, 1980. 204pp.

Wagner, Robert F., ed. THE EDUCATION OF THE FILM-MAKER: AN INTERNATIONAL VIEW. Washington, D. C.: The American Film Institute, 1975. Illustrated. 182pp.

Warham, John. THE TECHNIQUE OF WILDLIFE CINEMATOGRAPHY. London: Focal Press, 1966. Illustrated. 222pp.

Wise, Arthur, and Derek Ware. STUNTING IN THE CINEMA. New York: St. Martin's Press, 1973. Illustrated. 248pp.

Wordsworth, Christopher, ed. THE MOVIEMAKER'S HANDBOOK. New York: Ziff-Davis, 1979. Illustrated. 320pp.

ACTING

*Lewis, M. K., and Rosemary Lewis. YOUR FILM ACTING CAREER: HOW TO BREAK INTO MOVIES & TV & SURVIVE IN HOLLYWOOD. New York: Crown Publishers, 1983. 304pp.

*Meisner, Sanford, and Dennis Longwell. SANFORD MEISNER ON ACTING. Introduction Sydney Pollack. New York: Vintage Books, 1987. 253pp.

O'Brien, Mary Ellen. FILM ACTING: THE TECHNIQUES AND HISTORY OF ACTING FOR THE CAMERA. New York: Arco Publishing Company, 1983. Illustrated. 227pp.

ANIMATION

*Brasch, Walter M. CARTOON MONICKERS: AN INSIGHT INTO THE ANIMATION INDUSTRY. Bowling Green: Bowling Green University Press, 1983. Illustrated. 180pp.

Canemaker, John. THE ANIMATED RAGGEDY ANN & ANDY: AN INTIMATE LOOK AT THE ART OF ANIMATION--ITS HISTORY, TECHNIQUES, AND ARTISTS. Indianapolis: Bobbs-Merrill, 1977. Illustrated. 292pp.[56]

[56] The following articles are helpful: Andre Martin, "Animated Cinema: The Way Forward," SIGHT AND SOUND 28:2 (Spring 1959):80-5; Jules V. Schwerin, "Drawings that Are Alive: The Story of the Animated Film Cartoon," FILMS IN REVIEW 1:6 (September 1950:6-9; John Halas, "Tomorrow's Animation," ibid., 20:5 (May 1969):293-6; Harriet Polt, "The Death of Mickey Mouse," FILM COMMENT 2:3 (Summer

Edera, Bruno. FULL LENGTH ANIMATED FEATURE FILMS. Ed. John Halas. New York: Hastings House, 1977. Illustrated. 198pp.

Halas, John, ed. COMPUTER ANIMATION. New York: Hastings House, 1974. Illustrated. 176pp.

Halas, John, in collaboration with Roger Manvell. ART IN MOVEMENT: NEW DIRECTIONS IN ANIMATION. New York: Hastings House, 1970. Illustrated. 192pp.
This updated version of the 1959 publication contains history and factors governing animation, its uses, and the production of cartoons together with speculations about the future of the animated film. Statements from people in the field add weight to the authors' comments and make it well worth owning. Recommended for special collections.

Halas, John, and Roger Manvell. THE TECHNIQUE OF FILM ANIMATION. New York: Focal Press, 1966. Illustrated. 346pp.

Hoffer, Thomas W. ANIMATION: A REFERENCE GUIDE. Westport: Greenwood Press, 1981. 386pp.

Holman, L. Bruce. PUPPET ANIMATION IN THE CINEMA: HISTORY & TECHNIQUE. South Brunswick: A. S. Barnes and Company, 1975. Illustrated. 120pp.

Horn, Maurice, ed. THE WORLD ENCYCLOPEDIA OF CARTOONS. Two Volumes. New York: Gale Research Company, 1980. Illustrated. 787pp.

Kinsey, Anthony. HOW TO MAKE ANIMATED MOVIES: A STUDIO HANDBOOK. New York: The Viking Press, 1970. Illustrated. 95pp.
Written by an art educator, this attractively designed text is a good introduction to the basic mechanics of animation production. The reader will find many practical suggestions about equipment, techniques, and editing, along with a very readable narrative and fine illustrations. Recommended for special collections.

*Laybourne, Kit. THE ANIMATION BOOK: A COMPLETE GUIDE TO ANIMATED FILMMAKING--FROM FLIP-BOOKS TO SOUND CARTOONS. Preface George Griffin. Introduction Derek Lamb. New York: Crown Publishers, 1979. Illustrated. 272pp.

Levitan, Eli L. ELECTRONIC IMAGING TECHNIQUES: A HANDBOOK OF CONVENTIONAL AND COMPUTER-CONTROLLED ANIMATION, OPTICAL, AND EDITING PROCESSES. New York: Van Nostrand Reinhold Company, 1977. Illustrated. 195pp.

Levitan, Eli L. HANDBOOK OF ANIMATION TECHNIQUES. New York: Van Nostrand Reinhold Company, 1979. Illustrated. 318pp.

1964):34-9; and Elodie Osborn,"Animation in Zagreb," FILM QUARTERLY 22:1 (Fall (1968):46-51.

Madsen, Roy. ANIMATED FILM: CONCEPTS, METHODS, USES. New York: Interland Publishing, 1969. Illustrated. 235pp.
 Here is the one of best books on animation--one conceived and executed in an appealing manner. In fifteen informative and engaging chapters, Masden traces the history of animation, suggests novel and useful ways of making your own animated films, and provides a useful bibliography, filmography, and glossary. Recommended for special collections.

Manvell, Roger. THE ANIMATED FILM. New York: Hastings House, 1954. Illustrated. 64pp.
 This very slight but interesting book discusses animation in relation to Britain's first full-length animated film, George Orwell's ANIMAL FARM (1955). The text is filled with many fine illustrations created by John Halas and Joy Batchelor for the producer Louis de Rochemont's important movie. An index is included. Well worth browsing.

*Manvell, Roger. ART AND ANIMATION: THE STORY OF HALAS & BATCHELOR ANIMATION STUDIO 1940/1980. New York: Hastings House, 1980. Illustrated. 128pp.

*Perisic, Zoran. THE ANIMATION STAND. New York: Hastings House, 1976. Illustrated. 168pp.

*Russett, Robert, and Cecile Starr. EXPERIMENTAL ANIMATION: AN ILLUSTRATED ANTHOLOGY. New York: Van Nostrand Reinhold Company, 1979. Illustrated. 224pp.

Salt, Brian G. D. BASIC ANIMATION STAND TECHNIQUES. New York: Pergamon Press, 1977. Illustrated. 239pp.

Salt, Brian. MOVEMENTS IN ANIMATION. Two Volumes. Oxford: Pergamon Press, 1976. Illustrated. Vol.I, 220pp. Vol. II, 535pp.

*Stephenson, Ralph. ANIMATION IN THE CINEMA. New York: A.S. Barnes and Company, 1967. Illustrated. 176pp.
 A useful contribution from Peter Cowie's International Film Guide Series. This brief but important survey of the history of animation practices throughout the world is a useful guide and contains valuable information. A bibliography and filmographies are included. Well worth browsing.

*Stephenson, Ralph. THE ANIMATED FILM. New York: A. S. Barnes, 1973. Illustrated. 206pp.

Thomas, Bob. WALT DISNEY: THE ART OF ANIMATION. THE STORY OF THE DISNEY STUDIO CONTRIBUTION TO A NEW ART. New York: The Golden Press, 1958. Illustrated. 188pp.
 Strictly for children, this is a charming and worthwhile introduction to the history of animation, plus a pleasant and romantic behind-the-scenes account of the production of SLEEPING BEAUTY (1959). The illustrations are of Disney favorites like Mickey Mouse, Donald Duck, Bambi, Goofy, Pluto, and many more. Animation credits and an index are included. Well worth browsing.

White, Tony. THE ANIMATOR'S WORKBOOK. New York: Watson-Guptill, 1986. Illustrated. 160pp.

ART DIRECTION

Carrick, Edward. DESIGNING FOR FILMS. New York: Crowell-Studio Publications, 1950. Illustrated. 128pp.
This edition of a book first published in 1941 was revised and expanded to deal with color, film effects, and perspective. Handsomely printed, it offers some useful ideas about the functions of the set designer. It stresses the function of lighting in creating mood and tension. The best things about the book are its lovely illustrations.[57] Well worth browsing.

*Marner, Terence St. John, ed. FILM DESIGN. Cranbury: A. S. Barnes and Company, 1974. Illustrated. 165pp.

CINEMATOGRAPHY

Abbott, L. B. SPECIAL EFFECTS: WIRE, TAPE AND RUBBER BAND STYLE. Hollywood: The ASC Press, 1984. Illustrated. 246pp.

Alton, John. PAINTING WITH LIGHT. New York: The Macmillan Company, 1949. Illustrated. 191pp.
Although the design leaves much to be desired, this first major attempt at discussing studio camera techniques--particularly the difficulties connected with lighting interior and exterior scenes--still contains good ideas.[58] Well worth browsing.

[57] See Leo K. Kuter, "Art Direction," FILMS IN REVIEW 8:6 (June 1957):248-58; Roger Hudson, "Three Designers: Ken Adams, Edward Marshall, Richard MacDonald," SIGHT AND SOUND 34:1 (Winter 1964-65):26-31; and "Designed for Film," FILM COMMENT 14:3 (May-June 1978):25-60.

[58] Some related articles are: Charles Higham and Joel Greenberg, "North Lights and Cigarette Bulb: Conversations with Cameramen," SIGHT AND SOUND 36:4 (Autumn 1967):192-7; Paul Joannides, "The Aesthetics of the Zoom Lens," ibid., 40:1 (Winter 1970-71):40-2; Stuart M. Kaminsky, "The Use and Abuses of the Zoom Lens," FILMMAKERS' NEWSLETTER 5:12 (October 1972):20-3; Barry Salt, "Statistical Style Analysis of Motion Pictures," FILM QUARTERLY 28:1 (Fall 1974):13-22; Nick Browne, "The Spectator-in-the-Text: The Rhetoric in STAGECOACH," ibid., 19:2 (Winter 1975-76):26-44; David Bordwell, "Camera Movement and Cinematic Space," CINE-TRACTS 1:2 (Summer 1977):19-26; George Mitchell, "The Cameraman: Part I," FILMS IN REVIEW, 7:1 (January 1956):7-18; George J. Mitchell, "Part II: The Cameraman," ibid., 7:2 (February 1956):67-76; Jack Jacobs, "James Wong Howe," ibid., 12:4 (April 1961):215-32; George J. Mitchell, "The ASC," ibid., 18:7 (August-September 1967);385-97; Ralph Gerstle, "Optical Effects," ibid., 5:4 (April 1954):171-4; Patrick Ogle, "Technological and Aesthetic Influences Upon the Development of Deep Focus Cinematography in the United States," SCREEN 13:1 (Spring 1972):45-72; Edward Branigan, "The Point-of-View Shot," ibid., 16:3 (Autumn 1975):54-64; Peter Baxter, "On the History and Ideology of Film Lighting," ibid., pp.83-106; and Lee Garmes, "On Cinematography," JOURNAL OF THE UNIVERSITY FILM ASSOCIATION 28:4 (Fall 1976):15-6.
 Also see the following articles on color: James L. Limbacher, "Color's An Old Device," ibid., 10:6 (June 1959):346-50; Rudy Behlmer, "Technicolor," ibid., 15:6 (June-July 1964):333-51; William Johnson, "Coming to Terms with Color," FILM QUARTERLY 20:1 (Fall 1966):2:22; and Edward Branigan, "The Articulation of Color

*Broughton, James. SEEING THE LIGHT. San Francisco: City Lights Books, 1977. Illustrated. 80pp.

Clarke, Charles G., with Three W. Tyler, eds. AMERICAN CINEMATOGRAPHER MANUAL. 5th ed. Hollywood: American Society of Cinematographers, 1980. Illustrated. 626pp.

Dunn, Linwood, G. THE ASC TREASURY OF VISUAL EFFECTS. Ed. George E. Turner. Hollywood: American Society of Cinematographers, 1983. Illustrated. 303pp.

*Editors of Eastman Kodak. THE KODAK HOME MOVIE CAMERA GUIDE. New York: Pocket Books, 1960. Illustrated. 200pp.

*Editors of SUPER 8 FILMMAKER. FILM MAKER'S GUIDE TO SUPER 8. New York: Van Nostrand Reinhold, 1980. Illustrated. 357pp.

Fielding, Raymond. THE TECHNIQUE OF SPECIAL EFFECTS CINEMATOGRAPHY. New York: Hastings House, 1965. Illustrated. 398pp.
 This invaluable book goes to great lengths to distinguish between special photographic effects (visual and optical effects and process cinema) and mechanical effects (special sound effects, explosions, and matte shots of various types). Fielding supplies information that you won't find anywhere else. Recommended for special collections.

Finch, Christopher. SPECIAL EFFECTS: CREATING MOVIE MAGIC. New York: Abbeville Press, 1984. Illustrated. 252pp.

*Lassally, Walter. ITINERANT CAMERAMAN. London: John Murray, 1987. Illustrated. 258pp.

*Malkiewicz, J. Kris, with Robert E. Rogers. CINEMATOGRAPHY: A GUIDE FOR FILM MAKERS AND FILM TEACHERS. New York: Van Nostrand Reinhold Company, 1973. Illustrated. 216pp.

*Malkiewicz, Kris, with Leonard Konopelski. FILM LIGHTING: TALKS WITH HOLLYWOOD'S CINEMATOGRAPHERS AND GAFFERS. New York: Prentice Hall Press, 1986. Illustrated. 198pp.

*Maltin, Leonard. BEHIND THE CAMERA: THE CINEMATOGRAPHER'S ART. New York: Signet Books, 1971. Illustrated. 240pp.
 The TV critic of ENTERTAINMENT TONIGHT offers a valuable introductory essay on the history of the famous Hollywood cameramen from the beginnings of film history to the present, plus invaluable interviews with Arthur C. Miller, Hal Mohr, Hal Rossen, Lucien Ballard, and Conrad Hall. Also included are an Academy Award list for cinematography plus an index. Well worth browsing.

 in a Filmic System: Two or Three Things I Know About Her," WIDE ANGLE 1:3 (1976):20-31.

*Maple, Jessie. HOW TO BECOME A UNION CAMERAWOMAN FILM-VIDEOTAPE. New York: L. J. Film Productions, 1977. Illustrated. 86pp.

Mascelli, Joseph V., ed. THE FIVE C's OF CINEMATOGRAPHY. Hollywood: Cinne Graphic Publications, 1965. Illustrated. 251pp.
 A superb book on filmmaking, conceived from the cameraman's point of view, it deals with the basic "Cs" of the director: camera angles, continuity, cut-ups, close-ups, and composition. Mascelli not only supplies easy-to-understand definitions but also 500 clear photographs, and forty-one diagrams. An index is included. Well worth browsing.

Mathias, Harry, and Richard Patterson. ELECTRONIC CINEMATOGRAPHY: ACHIEVING PHOTOGRAPHIC CONTROL OVER THE VIDEO IMAGE. Belmont: Wadsworth Publishing Company, 1985. Illustrated. 251pp.

McDonough, Tom. LIGHT YEARS: CONFESSIONS OF A CINEMATOGRAPHER. New York: Grove Press, 1987. 258pp.

Mercer, John. AN INTRODUCTION TO CINEMATOGRAPHY. 3rd ed.. Champaign: Stripes Publishing Company, 1979. Illustrated. 197pp.
 This film-production handbook contains a wealth of useful and practical information. It seems to be aimed primarily at the low-budget filmmaker, and that makes it unique. A bibliography and index are included. Well worth browsing.

O'Connor, Jane, and Katy Hall. MAGIC IN THE MOVIES: THE STORY OF SPECIAL EFFECTS. Garden City: Doubleday & Company, 1974. Illustrated. 146pp.

*Ray, Sidney F. THE LENS AND ALL ITS JOBS. New York: Hastings House, 1977. Illustrated. 158pp.

*Samuelson, David W. MOTION PICTURE CAMERA TECHNIQUES. New York: Focal/Hastings House, 1978. Illustrated. 200pp.

Smith, Thomas G. INDUSTRIAL LIGHT AND MAGIC: THE ART OF SPECIAL EFFECTS. Introduction George Lucas. New York: Ballantine Books, 1986. Illustrated. 280pp.

Souto, H. Mario Raimondo. THE TECHNIQUE OF THE MOTION PICTURE CAMERA. Ed. Raymond Spottiswoode. New York: Hastings House, 1967. Illustrated. 263pp.
 Written by a Uruguayan filmmaker, this useful and comprehensive text deals with motion-picture cameras, not techniques. The information, however, is valuable for producing different types of movies effectively. An index is included. Well worth browsing.

Young, Freddie, and Paul Petzold. THE WORK OF THE MOTION PICTURE CAMERAMAN. Preface Michael Balcon. New York: Hastings House, 1972. Illustrated. 245pp.

DOCUMENTARY FILM PRODUCTION

Baddeley, W. Hugh. THE TECHNIQUE OF DOCUMENTARY FILM PRODUCTION. New York: Hastings House, 1963. Illustrated. 268pp.

Written by an experienced filmmaker, this is a practical introduction to the basic principles of movie-making, starting with an excellent chapter on scriptwriting. The reader will find much useful information in subsequent chapters on equipment, location work, lighting, and sound recording. A glossary and index are included. Well worth browsing.

Field, Stanley. THE MINI-DOCUMENTARY--SERIALIZING TV NEWS. Blue Ridge Summit: Tab Books, 1975. Illustrated. 249pp.

*Rabiger, Michael. DIRECTING THE DOCUMENTARY. Boston: Focal Press, 1987. Illustrated. 316pp.

EDITING

Burder, John, THE TECHNIQUE OF EDITING 16mm FILM. New York: Hastings House, 1968. Illustrated. 152pp.[59]

A short, forceful introduction to such elementary matters as film gauge, equipment and editing facilities, principles of editing, and the mechanics of sound editing. It should be a useful book for beginning filmmakers. A glossary and index are included. Well worth browsing.

Churchill, Hugh B. FILM EDITING HANDBOOK: TECHNIQUE OF 16MM FILM CUTTING. Belmont: Wadsworth Publishing Company, 1972. Illustrated. 198pp.

Rosenblum, Ralph, and Robert Karen. WHEN THE SHOOTING STOPS . . . THE CUTTING BEGINS: A FILM EDITOR'S STORY. New York: Viking Press, 1979. Illustrated. 310pp.

Reisz, Karel, and Gavin Miller, eds. THE TECHNIQUE OF FILM EDITING. New York: Hastings House, 1968. Illustrated. 411pp.

An enlarged edition of the 1953 original and the fifteenth reprinting of this highly important text, it continues to be one of the best introductions to editing for three good reasons: depth, breadth, and scholarship. An index is included. Recommended for special collections.

*Robertson, Joseph F. THE MAGIC OF FILM EDITING. Blue Ridge Summit: Tab Books, 1983. Illustrated. 277pp.

[59] For additional information, see Jean R. Debrix, "Film Editing: I" FILMS IN REVIEW 4:1 (January 1953):21-4; ___, "Film Editing II," ibid., 4:2 (February 1953):24-7; Raymond Bellour, "The Obvious and the Code," SCREEN 15:4 (Winter 1974):7-17; Jean-Pierre Oudart, "Cinema and Suture," ibid., 18:4 (Winter 1977-78):35-47; Daniel Dayan, "The Tutor-Code of Classical Cinema," FILM QUARTERLY 28:1 (Fall 1974):22-31; and Folmer Blangsted, "On Film Editing," JOURNAL OF UNIVERSITY FILM ASSOCIATION 28:4 (Fall 1976):11-4.

Walter, Ernest. THE TECHNIQUE OF THE FILM CUTTING ROOM. New York: Hastings House, 1969. Illustrated. 282pp.

Written by a very knowledgeable and experienced film editor, this text discusses in detail the basic responsibilities of the editor and his assistants, and the various stages of editing. In addition to many helpful diagrams and illustrations, the book's eleven chapters are divided into numerous subtopics for quick information. A glossary and index are included. Well worth browsing.

FILM MUSIC

Eisler, Hans. COMPOSING FOR THE FILMS. New York: Oxford University Press, 1970.[60] 165pp.

Based upon his creative work in the forties, the famed composer's book is an informative and readable discussion of his personal approach to film music. Well worth browsing.

Foort, Reginald. THE CINEMA ORGAN: A DESCRIPTION IN NON-TECHNICAL LANGUAGE OF A FASCINATING INSTRUMENT AND HOW IT IS PLAYED. Vestal: Vestal Press, 1971. Illustrated. 199pp.

Originally published in 1932, this book was mainly a music text covering the history of the organ in movie houses, instructions on how to play it, and suggestions on musical scores. The new edition brings the story forward to the end of the sixties. Well worth browsing.

Manvell, Roger and John Huntley. THE TECHNIQUE OF FILM MUSIC. New York: Hastings House, 1967. Illustrated. 299pp.

[60] Two of the best articles on film music up to the 1970s are William Johnson, "Face the Music," FILM QUARTERLY 22:4 (Summer 1969):3-19; and Douglas W. Gallez, "Theories of Film Music," CINEMA JOURNAL 9:2 (Spring 1970):40-7. For the most complete bibliography on Hollywood musicals, see Jane Feuer, "The Hollywood Musical: An Annotated Bibliography," GENRE: THE MUSICAL, ed. Rick Altman (Boston: Routledge & Kegan Paul, 1981):208-15. See also John Broeck, "Music of the Fears," FILM COMMENT 12:5 (September-October 1976):56-60; Claudia Gorbman, "Teaching the Sound Track," QUARTERLY REVIEW OF FILM STUDIES 1:4 (November 1976):446-52; Jeffrey Embler, "The Structure of Film Music," FILMS IN REVIEW 4:7 (August-September 1953):332-5; Jack Jacobs, "Alfred Newman," ibid., 10:7 (August-September 1959):403-14; Harry Haun and George Raborn, "Max Steiner," ibid., 12:6 (June-July 1961):338-51; Edward Jablonski and William R. Sweigart, "Harold Arlen," ibid., 13:10 (December 1962):605-14; Dennis Lee Galling, "Arthur Freed," ibid., 15:9 (November 1964):521-44; Anthony Thomas, "Hugo Friedhofer," ibid., 16:8 (October 1965): 496-502; Ken Doeckel, "Miklos Rozsa," ibid., 16:9 (November 1965):536-48; Rudy Behlmer, "Erich Wolfgang Korngold," ibid., 18:2 (February 1967):86-100; Page Cook, "Bernard Herrmann," ibid., 18:7 (August-September 1967):398-412; ____, "Franz Waxman," ibid., 19:7 (August-September 1968):415-30; ____, "Ken Darby," ibid., 20:6 (June-July 1969):335-56; Douglas W. Gallez, "Theories of Film Music," CINEMA JOURNAL 9:2 (Spring 1970):40-47; Jean-Francois Hauduroy, "Writing for Musicals: Interview With Betty Comden and Adolph Green," CAHIERS DU CINEMA IN ENGLISH 2 CdC:174 (January 1966):42-8; Patrick Brion, "Filmography," ibid., 49-50; William Alwyn, "Composing for the Screen," FILMS AND FILMING 5:6 (March 1959):9, 34; Richard Fothergill, "Putting Music in Its Place," ibid., 10-11, 33; Lionel Godfrey, "The Music Makers: Elmer Bernstein and Jerry Goldsmith," ibid., 12:12 (September 1966):36-40; and Elmer Bernstein, "On Film Music," JOURNAL OF UNIVERSITY FILM ASSOCIATION 28:4 (Fall 1976):7-9.

Except for two historical chapters on the development of film music, Manvell and Huntley concentrate on the scores of the 1950s. Although this is heavy reading, their comments on the function of music in talkies as well as the musicians' responsibilities are important considerations. Well worth browsing.

MAKE-UP

Buchman, Herman. FILM AND TELEVISION MAKEUP. New York: Hastings House, 1973. Illustrated. 224pp.

Kehoe, Vincent J.R. THE TECHNIQUE OF FILM AND TELEVISION MAKE-UP. New York: Hastings House, 1969. Illustrated. 260pp.
One of the major early books, written by a practical and experienced artist in the field, its information is heavily oriented to British practices. An index is included. Well worth browsing.

SCREENWRITING

*Brady, John. THE CRAFT OF THE SCREENWRITER: INTERVIEWS WITH SIX CELEBRATED WRITERS. New York: Simon and Schuster, 1981. Illustrated. 462pp.

Bronfeld, Stewart. WRITING FOR FILM AND TELEVISION. Foreword Delbert Mann. Englewood Cliffs: Prentice-Hall, 1981. 144pp.

*Edmonds, Robert. SCRIPTWRITING FOR THE AUDIO-VISUAL MEDIA: RADIO, FILMS, TELEVISION, FILMSTRIPS, SLIDEFILMS. New York: Teachers College Press, Columbia University, 1978. 185pp.

*Field, Sy. SCREENPLAY: THE FOUNDATIONS OF SCREENWRITING. New expanded ed. New York: Dell Publishing Company, 1982. 246pp.

Giustini, Rolando. THE FILMSCRIPT: A WRITER'S GUIDE. Englewood Cliffs: Prentice-Hall, 1980. Illustrated. 243pp.

Halas, John, et al. VISUAL SCRIPTING. New York: Hastings House, 1976. Illustrated. 144pp.

*Hayward, Stan. SCRIPTWRITING FOR ANIMATION. New York: Hastings House, 1977. Illustrated. 160pp.

Herman, Lewis. EDUCATIONAL FILMS: WRITING, DIRECTING AND PRODUCING FOR CLASSROOM TELEVISION AND INDUSTRY. New York: Crown Publishers, 1965. 338pp.
For those who want an informal but knowledgeable guide to practical filmmaking this book may be just the thing.[61] Recommended for special collections.

[61] Some related articles are: Elia Kazan, "The Writer and Motion Pictures," SIGHT AND SOUND 27:1 (Summer 1957):20-4; Tom Milne, "The Difference of George Axelrod," ibid., 37:4 (Autumn 1968):164-9; John Springer, "Charles Brackett," FILMS IN REVIEW 11:3 (March 1960):129-40; DeWitt Bodeen, "Frances Marion: Part I," ibid.,

*Herman, Lewis. A PRACTICAL MANUAL OF SCREEN PLAYWRITING FOR THEATER AND TELEVISION FILMS. New York: World Publishing Company, 1952. Illustrated. 294pp.

In spite of the date, this book is a valuable resource for most of the aspects of writing screenplays, particularly when it comes to visual aids. Well worth browsing.

Lawson, John Howard. THEORY AND TECHNIQUE OF PLAYWRITING AND SCREENWRITING. New York: G. P. Putnam's Sons, 1960. 313pp.

Here is a persuasive and useful approach to the fundamentals of dramatic writing for the screen. It comes as an outgrowth of Lawson's original study, written in 1935 and regarded by many theater people as a basic text. A new introduction adds to the book's value. Well worth browsing.

*Miller, Pat P. SCRIPT SUPERVISING AND FILM CONTINUITY. Boston: Focal Press, 1986. Illustrated. 190pp.

*Rowlands, Avril. SCRIPT CONTINUITY AND THE PRODUCTION SECRETARY IN FILM AND TV. New York: Hastings House, 1977. Illustrated. 166pp.

*Stempel, Tom. SCREENWRITING. San Diego: A. S. Barnes and Company, 1982. Illustrated. 160pp.

Straczynski, J. Michael. THE COMPLETE BOOK OF SCRIPTWRITING. Cincinnati: Writer's Digest Books, 1982. 267pp.

Vale, Eugene. THE TECHNIQUE OF SCREENPLAY WRITING: AN ANLYSIS OF THE DRAMATIC STRUCTURE OF MOTION PICTURES. Rev. and enlarged ed. New York: Grosset and Dunlap, 1972. 306pp.

Yoakem, Lola Goelet, ed. TV AND SCREENWRITING. Berkeley: University of California Press, 1958. 124pp.

This practical collection of seventeen essays written by the members of the Writers Guild of America is a delightful source of information about approaches to genres, screen adaptations, and marketing of scripts. Among the many useful contributors are Hugh Gray, Jesse L. Lasky, Jr., Frank Gruber, Ivan Tors, Erik Barnouw, and Lois Jacoby. Well worth browsing.

20:2 (February 1969):71-91; ____, "Frances Marion: Part II," ibid., 20:3 (March 1969):129-52; Stephen Farber, "The Writer in American Films," FILM QUARTERLY 21:4 (Summer 1968):2-13; ____, "The Writer II: An Interview With Alexander Jacobs," ibid., 22:2 (Winter 1968-69):2-14; Robin Bean, "Through the Looking Glass: Frank Pierson," FILMS AND FILMING 15:12 (September 1969):29-31; Richard Corliss, "The Hollywood Screenwriter," FILM COMMENT 6:4 (Winter 1970-71):4-7; Carl Foreman, "Confessions of a Frustrated Screenwriter," ibid., 22-5; Sam Fuller, "Ben Hecht: A Sampler," ibid., pp.32-9; Gary Carey, "Written on the Screen: Anita Loos," ibid., pp.50-5; Paul Jensen, "The Career of Dudley Nichols," ibid., pp.56-63; Michael Dempsey, "They Shaft Writers Don't They?: Interview With James Poe," ibid., pp. 64-73; and "Screenwriters Symposium," ibid., pp.86-100. For more recent studies, see Chapter 5.

SOUND RECORDING

Alton, Stanley R. AUDIO IN MEDIA. 2nd ed.. Belmont: Wadsworth Publishing Company, 1986. Illustrated. 612pp.

Cameron, Ken. SOUND AND THE DOCUMENTARY FILM. London: Pitman and Sons, 1947. Illustrated. 150pp.
 Although out-of-date and difficult to obtain, this fascinating and lucid approach to mixing, by a respected documentary filmmaker, is a worthwhile overview of sound editing. Well worth browsing.

Collins, W. H. THE AMATEUR FILMMAKER'S HANDBOOK OF SOUND SYNC & SCORING. Blue Ridge Summit: Tab Books, 1974. Illustrations. 210pp.

*Editors of Eastman Kodak. HOW TO MAKE GOOD SOUND MOVIES. Rochester: Eastman Kodak Company, 1975. Illustrated. 99pp.

*Everest, F. Alton. HANDBOOK OF MULTICHANNEL RECORDING. Blue Ridge Summit: Tab Books, 1975. Illustrated. 322pp.

*Frater, Charles B. SOUND RECORDING FOR MOTION PICTURES. New York: A. S. Barnes and Company, 1979. Illustrated. 210pp.

Frayne, John G., and Halley Wolfe. ELEMENTS OF SOUND RECORDING. New York: John Wiley and Sons, 1949. Illustrated. 686pp.
 At one time or another, this important text on the use of sound and its various production principles should be consulted. For many years, it was the number one book in the field. Well worth browsing.

Honore, Paul M. A HANDBOOK OF SOUND RECORDING: A TEXT FOR MOTION PICTURE AND GENERAL SOUND RECORDING. Foreword and Final Chapter Hal Honore. South Brunswick: A. S. Barnes and Company, 1980. Illustrated. 213pp.

Nisbett, Alec. THE TECHNIQUE OF THE SOUND STUDIO: FOR RADIO, TELEVISION, AND FILM. 3rd ed.. New York: Hastings House, 1962. Illustrated. 559pp.
 This is another book that demonstrates the interrelationship among the mass media. Although the emphasis here is definitely on broadcasting, filmmakers should find many valuable suggestions for sound movies. A glossary and index are included. Recommended for special collections.

Pellegrino, Ronald. THE ELECTRONIC ARTS OF SOUND AND LIGHT. New York: Van Nostrand Reinhold Company, 1983. Illustrated. 256pp.

Wysotsky, Michael Z. WIDE-SCREEN CINEMA AND STEREOPHONIC SOUND. Trans. Raymond Spottiswoode. New York: Hastings House, 1971. Illustrated. 282pp.
 First issued in the Soviet Union in 1965, this impressive work discusses all aspects of widescreen and sound usage from the professional's point of view. The text is helped considerably by the excellent illustrations and diagrams. A bibliography and index are included. Recommended for special collections.

STUDENT FILMMAKING

Andersen, Yvonne. MAKE YOUR OWN ANIMATED MOVIES: YELLOW BALL WORKSHOP FILM TECHNIQUES. Boston: Little, Brown and Company, 1970. Illustrated. 102pp.
 Strictly for children, this clever and well-illustrated book offers many valuable suggestions. It condenses much of Anderson's method by successfully taking novices step-by-step through the exciting experience of making original films. Recommended for special collections.

Andersen, Yvonne. TEACHING FILM ANIMATION TO CHILDREN. New York: Van Nostrand Reinhold Company, 1970. Illustrated. 112pp.
 Teachers with next to no experience in filmmaking and animation should benefit greatly from this straightforward text for public schools. The stills are worthwhile, the explanations are clear, and the practical advice is invaluable. Recommended for special collections.

Bourgeois, Jacques. ANIMATING FILMS WITHOUT A CAMERA. New York: Sterling Publishing Company, 1974. Illustrated. 48pp.

Bowskill, Derek. ALL ABOUT CINEMA. Levittown: Transatlantic Arts, 1976. Illustrated. 142pp.

Callaghan, Barry. MANUAL OF FILM-MAKING. New York: Van Nostrand Reinhold Company, 1973. Illustrated. 164pp.

*Campbell, Russell, ed. PHOTOGRAPHIC THEORY FOR THE MOTION PICTURE CAMERAMAN. New York: A.S. Barnes and Company, 1970. Illustrated. 160pp.
 Despite Campbell's claim that the book is designed for readers just beginning film production, you might start with easier texts and then come back to this technical but useful discussion of film stock, processing, sensitometry, image formation and tone rendering, grain structure and definition, printing, color photography and color balance. An index is included. Worth browsing.

*Campbell, Russell, ed. PRACTICAL MOTION PICTURE PHOTOGRAPHY. Introduction Walter Lassally. New York: A. S. Barnes and Company, 1970. Illustrated. 192pp.
 Beginners will find this a useful text in which to read about light meters, exposure controls, filters, and color rendering. A special feature of the book is the section on aerial and underwater filming. A bibliography and index are included. Well worth browsing.

Carrier, Rick, and David Carroll. ACTION! CAMERA! SUPER 8 CASSETTE FILM MAKING FOR BEGINNERS. New York: Charles Scribner's Sons, 1972. Illustrated. 78pp.

Catling, Gordon, and Richard Serjeant. MOVIE MAKING FOR THE YOUNG CAMERAMAN. New Rochelle: Leisure Time, 1965. Illustrated. 128pp.

*Caunter, Julien. HOW TO MAKE MOVIE MAGIC IN AMATEUR FILMS. Philadelphia: Chilton Books, 1971. Illustrated. 348pp.
 This study originally consisted of two books entitled HOW TO DO TRICKS, and HOW TO DO THE SIMPLER TRICKS. Caunter has combined and revised them into a useful introduction to special effects filmmaking. Among the many things discussed

are simple effects--including exposure, focusing, lens, diffusion, distortion, filter, and dissolves--and more sophisticated techniques, including camera speed, reverse action, stop motion, animation, editing, and directing. Recommended for special collections.

Cleaue, Alan. CARTOON ANIMATION FOR EVERYONE. New York: Morgan & Morgan, 1973. Illustrated. 132pp.

Colman, Hila. MAKING MOVIES: STUDENT FILMS TO FEATURES. New York: The World Publishing Company, 1969. Illustrated. 192pp.
 Strictly for children, this lightweight introduction into various careers in filmmaking and the reasons why some of the professionals have succeeded should help motivate youngsters to learn more about film opportunities. Colman has an interesting behind-the-scenes section on the making of ALICE'S RESTAURANT, plus some good appendexes on sample training programs. An index is included. Well worth browsing.

*Coynik, David. MOVIE MAKING: A WORKBOOK FOR SUPER 8 FILM PRODUCTION. Chicago: Loyola University Press, 1974. Illustrated. 240pp.

*Editors of Eastman Kodak. MOVIES WITH A PURPOSE. Rochester: Eastman Kodak, 1968. Illustrated. 28pp.
 This brief, informative booklet is one of the best bargains for beginning student filmmakers. In clear and precise terms, the Kodak people describe the basic elements of Super 8 film production, and offer practical guidelines. Well worth browsing.

Ferguson, Robert. HOW TO MAKE MOVIES: A PRACTICAL GUIDE TO GROUP FILMMAKING. New York: The Viking Press, 1969. Illustrated. 88pp.
 In this valuable introduction to beginning filmmaking, Ferguson surveys all aspects of production, from movie equipment and scripting to practical advice on sight and sound filming techniques. Extremely useful are the nicely conceived and creatively displayed illustrations. A bibliography and index are included. Well worth browsing.

*Gaskill, Arthur L., and David A. Englander. HOW TO SHOOT A MOVIE STORY: THE TECHNIQUE OF PICTORIAL CONTINUITY. New York: Morgan & Morgan, 1960. Illustrated. 135pp.
 In simple, straightforward language, this cogent study takes you from a basic sequence right through the important steps of build-up, script, shooting and editing. Despite the somewhat dated illustrations, this work still remains a good introduction to filmmaking procedures. Well worth browsing.

*Gessner, Robert. THE MOVING IMAGE: A GUIDE TO CINEMATIC LITERACY. New York: E. P. Dutton and Company, 1968. Illustrated. 444pp.
 Written by one of the best-known film pioneers, this worthwhile text first discusses the principles, patterns, and structures of film art and then offers practical steps for student film production. In thirteen sensible, informative, and progressively more useful chapters, Gessner leads students through important stages of film production. The five appendexes include one on various tests for "plastic sensitivity, visual memory, and visual intelligence." An index is included. Well worth browsing.

*Goldstein, Laurence, and Jay Kaufman. INTO FILM. New York: E. P. Dutton and Company, 1976. Illustrated. 607pp.

Gordon, George N., and Irving A. Falk. YOUR CAREER IN FILM MAKING. New York: Julian Messner, 1969. Illustrated. 224pp.

Strictly for children, this book, to be skimmed quickly, offers a hasty overview of the various careers open to young people in filmmaking. Its twelve uneven chapters are often disappointing discussions of important subjects. Considering the audience, Gordon and Falk have done a particularly poor job with illustrations. A bibliography and index are included. Approach with caution.

Helfman, Harry. MAKING PICTURES MOVE. New York: William Morrow and Company, 1969. Illustrated. 48pp.

One of the finest books ever designed and executed for elementary school students. Helfman, imaginatively and with excellent help from his illustrator Willard Goodman, suggests nine animation projects, all very valuable for understanding the fundamentals of animation and for having a good time. Every youngster should have a copy. Recommended for special collections.

Hobson, Andrew, and Mark Hobson. FILM ANIMATION AS A HOBBY. New York: Sterling Publishing Company, 1975. Illustrated. 46pp.

Horvath, Joan. FILMMAKING FOR BEGINNERS. New York: Thomas Nelson, 1974. Illustrated. 162pp.

*Kemp, Jerrold E., et al. PLANNING AND PRODUCING AUDIO-VISUAL MATERIAL. San Francisco: Chandler Publishers, 1957. Illustrated. 169pp.

Don't be alarmed by the title. A good portion of this valuable resource book deals with useful discussions on shooting, composition, and sound recording. The suggestions are practical, adaptable to various situations, and supplemented with important appendexes. Worth browsing.

Kennedy, Keith. FILM MAKING IN CREATIVE TEACHING. New York: Watson-Guptill, 1972. Illustrated. 128pp.

*Kuhns, William, and Thomas F. Giardino. BEHIND THE CAMERA. Dayton: Geo. A. Pflaum, 1970. Illustrated. 178pp.

This publication provides a good introduction to 16mm film production in the secondary schools, and useful information about equipment, techniques, and time-saving methods. In addition, readers should enjoy reading the diary account of a student-made film entitled SPARROW. Well worth browsing.

Larson, Rodger, with Ellen Meade. YOUNG FILMMAKERS. New York: E. P. Dutton, 1969. Illustrated. 190pp.

Larson, a former painter, reports on his film teaching project with African-American and Puerto Rican slum children in New York City, and provides practical information on budgets, equipment, and techniques for making student films in the sixties. This book offers something to adult and child alike on how movies are made. A glossary and index are included. Well worth browsing.

Lewis, Jerry. THE TOTAL FILM-MAKER. New York: Random House, 1971. Illustrated. 208pp.

Taken from more than 500,000 taped feet of his lectures at the University of Southern California, this book quickly covers the general problems confronting the beginning filmmaker: production and post-production. Lewis, unfortunately, gives little thought to editing his comments. He is at his best in discussing comedy and at offering hints on how to handle crew and actors. No index is included. Worth browsing.

Lidstone, John, and Don McIntosh. CHILDREN AS FILM MAKERS. New York: Van Nostrand Reinhold Company, 1970. Illustrated. 111pp.
Starting with the simple premise that children can enjoy making films and at the same time learn a great deal, Lidstone and McIntosh design a program and then suggest, show, and comment on what occurs. This is one of the clearest, best illustrated, and most readable texts on the student-made film for children. A bibliography and index are included. Recommended for special collections.

*Livingston, Don. FILM AND THE DIRECTOR: A HANDBOOK AND GUIDE TO FILM MAKING. New York: Capricorn Books, 1969. Illustrated. 207pp.
In ten straightforward chapters, this reissue of a sensible 1953 guide through the basic techniques of cutting, motion, acting, sound, and editing techniques provides students with an inexpensive source of useful information. A bibliography and index are included. Well worth browsing.

Lowndes, Douglas. FILM MAKING IN SCHOOLS. New York: Watson-Guptill Publications, 1968. Illustrated. 128pp.
Secondary schoolteachers in the sixties found this one of the most worthwhile books in their film library, primarily because Lowndes orients his material to their questions, needs, and varied situations. Here are valuable, concise, and accurate answers to problems about methods, equipment, and materials. The illustrations are well selected and well printed. Well worth browsing.

Manoogian, Haig P. THE FILM-MAKER'S ART. New York: Basic Books, 1966. Illustrated. 340pp.
In lucid prose, this experienced film teacher offers practical suggestions on filmmaking procedures. First he considers the principles of film art, and then he introduces intelligent and valuable steps to production practices, aided by several appendexes of actual student work. Very helpful for novices in film teaching. Well worth browsing.

Marino, T. J. PICTURES WITHOUT A CAMERA. New York: Sterling Publishing Company, 1974. Illustrated. 48pp.

*Miklos, Mark, and Gunther Hoos. HANDBOOK OF SUPER 8 PRODUCTION. New York: United Business Publications, 1976. Illustrated. 314pp.

Monier, Pierre. THE COMPLETE TECHNIQUE OF MAKING FILMS. New York: Ballantine Books, 1968. Illustrated. 304pp.
Beginners in film production may be put off by this book's amazing ignorance of Super 8 film. But in almost every other area, Monier provides useful, accurate information. Well worth browsing.

*Pincus, Edward, with Jairus Lincoln. GUIDE TO FILMMAKING. Chicago: Henry Regnery Company, 1972. Illustrated. 258pp.

This is the best handbook for beginning students in filmmaking, simply because it is still valuable, comprehensive, and well designed. Furthermore, this inexpensive paperback has several valuable appendexes that teachers should own and have close by. Recommended for special collections.

Proviser, Henry. 8MM/16MM MOVIE MAKING. New York: American Publishing Company, 1970. Illustrated. 272pp.
Readers will find the illustrations in this beginner's handbook extremely useful. Well worth browsing.

Rilla, Wolf. A-Z OF MOVIE-MAKING. New York: The Viking Press, 1970. Illustrated. 128pp.
Teachers should delight in this useful book that deals with the specifics of filmmaking: terms, planning stages, technical matters, use of live performers, and post-shooting techniques. Well worth browsing.

*Roberts, Kenneth H., and Win Sharples, Jr., A PRIMER FOR FILM MAKING: A COMPLETE GUIDE TO 16MM AND 35MM FILM PRODUCTION. New York: Pegasus, 1972. Illustrated. 546pp.
For those who want a sound, useful, and accurate guide to 16mm and 35mm filmmaking, this book is one of the best around. Being professional filmmakers themselves, Roberts and Sharples provide important technical but sensible information about raw film stock, lighting, costs, scripts, editing, optical effects, sound and music. The book also offers many useful and accurate illustrations plus superb appendexes. Recommended for special collections.

*Rynew, Arden. FILMMAKING FOR CHILDREN: INCLUDING MOTION PICTURE PRODUCTION HANDBOOK. Dayton: Pflaum/Standard, 1971. Illustrated. 117pp.

Schiff, Lillian. GETTING STARTED IN FILM-MAKING. New York: Sterling Publishing Company, 1978. Illustrated. 96pp.

*Smallman, Kirk. CREATIVE FILM-MAKING. New York: Collier Books, 1969. Illustrated. 245pp.
This text is a quick and uneven account of film equipment and techniques that should be used gingerly. Approach with caution.

*Trojanski, John, and Louis Rockwood. MAKING IT MOVE. Dayton: Pflaum/Standard, 1973. Illustrated. 151pp.

Yulsman, Jerry. THE COMPLETE BOOK OF 8mm MOVIE MAKING. New York: Coward, McCann & Geoghegan, 1972. Illustrated. 224pp.

TELEVISION PRODUCTION

Englander, A. Arthur, and Paul Petzold. FILMING FOR TELEVISION. Preface Kenneth Clark. New York: Hastings House, 1976. Illustrated. 266pp.

Keirstead, Phillip O. JOURNALIST'S NOTEBOOK OF LIVE RADIO-TV NEWS. Blue Ridge Summit: Tab Books, 1976. Illustrated. 252pp.

Knecht, Kenneth. DESIGNING & MAINTAINING THE CATV & THE SMALL TV STUDIO. 2nd ed.. Blue Ridge Summit: Tab Books, 1976. Illustrated. 287pp.

Kybett, Harry. THE COMPLETE HANDBOOK OF VIDEOCASSETTE RECORDERS. Blue Ridge Summit: Tab Books, 1977. Illustrated. 280pp.

*Marsh, Ken. INDEPENDENT VIDEO: A COMPLETE GUIDE TO THE PHYSICS, OPERATION, AND APPLICATION OF THE NEW TELEVISION FOR THE STUDENT, THE ARTIST, AND FOR COMMUNITY TV. San Francisco: Straight Arrow Books, 1974. Illustrated. 212pp.

Millerson, Gerald. EFFECTIVE TELEVISION PRODUCTION. New York: Hastings House, 1976. Illustrated. 192pp.

Millerson, Gerald. THE TECHNIQUE OF LIGHTING FOR TELEVISION AND MOTION PICTURES. 2nd ed. New York: Hastings House, 1982. Illustrated. 391pp.
 This is the best work in the seventies on creative lighting techniques. Written by an engineer with twenty years of experience with the BBC, the text is divided into twelve excellent sections starting with the basic principles to the art of lighting, and moving to more advanced levels of theory and methodology. In addition, Millerson offers the readers a wealth of useful and clear illustrations. An index is included. Well worth browsing.

Millerson, Gerald. THE TECHNIQUE OF TELEVISION PRODUCTION. 10th ed. New York: Hastings House, 1979. Illustrated. 447pp.
 Although the emphasis is clearly on TV production, Millerson suggests many useful ideas on techniques directly applicable to film, e.g., visual continuity, lighting, camera placement, composition, and sound recording. Recommended for special collections.

Millerson, Gerald. VIDEO CAMERA TECHNIQUES. Boston: Focal Press, 1983. Illustrated. 160pp.

Millerson, Gerald. VIDEO PRODUCTION HANDBOOK. Boston: Focal Press, 1987. Illustrated. 216pp.

*Oringel, Robert S. AUDIO CONTROL HANDBOOK: FOR RADIO AND TELEVISION BROADCASTING. New York: Hastings House, 1963. New York: Hastings House, 1983. Illustrated. 313pp.
 One of the few books on the subject that is both accurate and readable, this fifth edition includes all of the major changes in surrounding audio control and electronics in the past decade. A glossary and index are included. Recommended for special collections.

*Peck, William A. ANATOMY OF LOCAL RADIO-TV COPY. 4th ed. Blue Ridge Summit: Tab Books, 1976. 95pp.

*Robinson, J. F., and P. H. Beards. USING VIDEOTAPE. New York: Hastings House, 1976. Illustrated. 163pp.

Veith, Richard. TALK-BACK TV: TWO WAY CABLE TELEVISION. Blue Ridge Summit: Tab Books, 1976. Illustrated. 238pp.

Westmoreland, Bob. TELEPRODUCTION SHORTCUTS: A MANUAL FOR LOW-BUDGET TELEVISION PRODUCTION IN A SMALL STUDIO. Foreword Charles N. Hockman. Norman: University of Oklahoma Press, 1974. Illustrated. 265pp.

Zettl, Herbert. TELEVISION PRODUCTION HANDBOOK. 3rd ed. Belmont: Wadsworth Publishing Company, 1976. Illustrated. 534pp.

FILM FORM AND FUNCTION

Having reviewed the business of making films, we now turn to the art of making films. Here, the concern is with aesthetic principles that determine the complex set of relationships that constitute a theatrical film. The purpose is to try to understand how one begins to appreciate the actual techniques that produce a popular film, a work of art, or a memorable film experience. The questions of taste and standards will be discussed later. For now, let us consider the elements of film. Even in the weakest moving picture, the filmmaker has indicated a certain familiarity with camera angles and distances, lighting problems and framing, and editing techniques and sound mixing. A more charitable opinion might even credit the filmmaker with knowing something about character development, plot motivation, dramatic irony, and thematic intentions. No matter what type of film--e.g., fiction or nonfiction--almost every filmmaker thinks about the form that the work will take, and the various functions of the elements within the total film. Often the aesthetic differences among the film types lie in the economic and social conditions under which the films take shape and the expectations of the filmmakers. That is not to say that beauty and art are dependent upon money and traditional values. Clearly, they are not. Each of us can cite examples of films that not only were made on minimal budgets, but that also violated standard cinematic techniques and went against the STATUS QUO. It is to say that creating a competent film requires an understanding of how disparate elements of sight and sound are put together to communicate an idea or feeling. If we are to study films, we surely must go beyond the stage of liking films and progress to the stage where we examine why a particular film appeals to us, or why we reject it. If there is any value to film study, it is in broadening our perspectives, refining our tastes, and enlarging our experiences in the world of film.

We begin with the obvious: there is more to films than the literary conventions of plot, story, theme, character development, denouement, conflict, irony, allegory, atmosphere, exposition, and symbol. Nearly every filmmaker is aware that a set of non-literary elements--e.g., camera settings, lights, costumes, props, sets, editing techniques, lens, filters, and film widths--exist that can be used to make a commercial film. Which of those elements are used effectively depends upon resources, judgment, and talent.

The finished film, however, has a form. That is, the filmmaker has arranged the materials--literary and technical elements--to produce a desired effect. There are no specific rules. There are no fixed forms. Films can be slow-moving or action-packed. They can be westerns or domestic dramas. They can be original works or screen adaptations of stage plays and novels. They can be domestic dramas or historical epics. They can be structured like the classical Hollywood film or in the AVANT-GARDE tradition of European artists. They can even be in a form heretofore unknown in film history. The only aesthetic requirement is that the form satisfy the needs of the filmmaker. The only commercial requirement is that its form appeal to a mass audience. For our purposes, therefore, form represents not only the organization of a film, but also the principles that govern the structure of a film.

Most introductory books on film appreciation offer insights into the nature of cinematic form (the complex set of relationships that constitute a completed film), the separate functions that each element plays in a total film relationship, and the steps leading to an evaluation of film form. Few books, however, provide a better overview on the nature of film form and functions than is found in David Bordwell and Kristin Thompson's FILM ART: AN INTRODUCTION. For our purposes, let me summarize its approach to the significance of film form.[62]

After establishing that an overall pattern exists in a commercial film, Bordwell and Thompson dismiss the notion that "form" (the complete set of relationships in a total film) and "content" (what a film "contains") are separate entities. They view every element in a film as contributing to the total film. Next, the authors discuss how form directs the audience's cinematic experience. Pointing out that both filmmakers and audiences assume not only that there is a method to how a film is made, but also that the filmmaking process adds a new dimension to the way we view people and events in the film, the authors show how those expectations operate through the filmmaking continuum and in the form the released film takes. It is a point that will be discussed in detail in Chapter 3, where we explore how audiences and filmmakers rely on the notion that people first define and then see. Bordwell and Thompson next examine how the film industry merchandizes traditional expectations into film conventions that then can be used in novel ways to involve the audience in the film experience. That is, the imaginative filmmaker manipulates our expectations to produce specific emotions. Whether the manipulation results in the desired emotion that the filmmaker intended depends upon many complex factors related to the effective functioning of the film elements and to the criteria by which audiences interpret films. "Very often," the authors tell us, "the most relevant prior experience for perceiving form is not everyday experience, but previous encounters with works having similar conventions."[63]

Like many contemporary critics, Bordwell and Thompson stress the importance of emotion in making and evaluating films. Not only are film elements primarily used to play on our emotions (as opposed to our intellect), but also our expectations affect our emotional reactions to the film. It is not unusual, for example, to hear people confusing their liking a film, with their judgment of the film's merits. One is a psychological reaction, the other is an intellectual exercise.[64] The former is personal; the latter is a statement of judgment and requires a set of standards. For Bordwell and Thompson, complexity and originality are crucial criteria in any objective evaluation of a film. Furthermore, the authors reject the idea that there is "one" desired reaction to a film, or that a film's perceived "meaning" is more important than other elements in the total film system: "Instead of asking, 'What does this film mean?' we can often usefully ask, 'How do ALL the film's meanings interrelate formally?'"[65] In determining the set of interrelationships in a total film, Bordwell and Thompson suggest five questions: (1) what function does an element perform in the total film? (2) What patterns are repeated throughout the film? How and why? (3) In what ways are patterns differentiated and contrasted? (4) What changes have occurred in

[62] For more details, see *David Bordwell and Kristin Thompson, FILM ART: AN INTRODUCTION (Reading: Addison-Wesley Publishing Company, 1979), pp.27-46. Unfortunately, I received the second edition of this fine book just as this chapter was completed and was not able to comment on the new material the authors had included in their revised work.

[63] FILM ART: AN INTRODUCTION, p.32.

[64] Robert Gessner put the case somewhat differently when he wrote, "Seeing is an optical capacity, while perception is an awareness, involving visual intelligence and visual sensitivity." See Robert Gessner, THE MOVING IMAGE: A GUIDE TO CINEMATIC LITERACY (New York: E. P. Dutton, 1968), p.20.

[65] FILM ART: AN INTRODUCTION, p.35.

relationships between the start and end of a film? and (5) Is there a unity to the total film? If so, why? If not, why not?[66]

The major drawback with this approach is its reluctance to evaluate films. It is true that most of us lack objectivity in developing criteria for judging a film's merits. It is also true that we will never get consensus on what makes a film "great" or what it "means." Still further, an overreliance on taste often results in a discussion of everything but the set of relationships in the film supporting that evaluation. On the other hand, I have always found it useful to explore not only what a film "means" and how one arrives at that decision, but also to ask: "So what?" That is, knowing what went into the film and how effectively the elements function is not necessarily the crucial issue for those people who have serious reservations about racist and sexist content. The issue of a film's message and role in society and its impact on society, will be covered more thoroughly in Chapters 2, 3, and 6. Suffice it to say that the concept of "art for art's sake" is only one of many valid approaches to film analysis.

Given the history of film education, it is not surprising that another popular approach to film form and function is through the medium of language. Since all technological media are referred to as "new languages," a common assumption is that this metaphor indicates a naive comparison between a very complex print-oriented system and loose, simple, visual communications. Whatever film is, it is not simple. Before we describe the difficulties with the metaphor, let us first consider the basic reasons why some film educators feel the urge to study film as a language. As summarized by Anthony Hodgkinson, the premises are the following:

1. Human beings express themselves and communicate with each other in a variety of modes (speech, writing, pictures, actions, etc.). Each of these modes may be called "a language." 2. Films and television, taken as essentially similar (in that they both present moving pictures on a screen accompanied by sounds), constitute a particularly rich and complex "language" (mode of expression and communication), embracing elements of most other languages--notably mime and gesture, speech, pictures, music, sounds. 3. Communication is only possible when agreement is reached between communicator(s) and receiver(s) on the meaning to be attached to the symbols used and the manner in which they are used. . . . We call these conventions of a language VOCABULARY and GRAMMAR. 4. These agreed conventions derive from human usage of the language and are subject to variation from time to time, place to place, person to person, except where language is dead (e.g., Latin) or is artifically and arbitrarily constructed (e.g., Volapuk). 5. Although the BASIC conventions of the mother-tongue and non-verbal "universal" languages (e.g., facial expressions, pictures) are learned outside the formal education system by exposure (this also applies, of course to the screen language, to which children are informally exposed almost from birth), it is generally accepted that the schools have the responsibility to formalize and develop knowledge of vocabulary and grammar, and the recognition and practice of individual styles of use of language. 6. Because of the strongly print-oriented nature of Western society since Gutenberg, our schools tend to limit their responsibilities largely to one mode of communication--printed or written words. Other modes--speech, mime, picture, etc.,--are relegated to minor positions in the curriculum, if indeed they are taught at all.[67]

In essence, the assertion is that just as print-oriented literacy requires a recognition of words and patterns, so film literacy requires a recognition of pictures. The form and function of these images in relation to sound and movement require analysis if an idea or emotion is to be meaningfully communicated. Furthermore, if it is true,

[66] FILM ART: AN INTRODUCTION, p.44.

[67] Anthony Hodgkinson, "Teaching the Screen Language: A Basic Method," SCREEN EDUCATION YEARBOOK (London: UNESCO 1965):57-8.

as many modern teachers of mass communication claim, that the print-oriented society of the past 500 years is being replaced by a multi-media culture, then we need to think seriously about developing visual literacy. The steps taken by semiologists, critics who apply linguistic principles to analyze film language as a form of communicating ideas, will be discussed later. Here, we are concerned with a more general use of the concept of film language.

Metaphorically, the "grammar" of the film refers to theories that describe visual forms and sound combinations and their functions as they appear and are heard in a significant relationship during the projection of a film. Thus, film grammar includes the elements of motion, sound, picture, color, film punctuation, editing, and montage. Although this metaphor tries to assess more effectively the relationship among the various mass-media languages, it has disadvantages as well as advantages. Simplifications are always distortions and the disadvantages need to be noted so that we may be reminded of the dangers of overgeneralizing.

First, each medium limits the effectiveness of its communication by the nature of the medium's structure. Print can do things that film cannot. But the reverse is also true. What we need to understand is what each can do best. Far too often we refuse to consider the limitations of either and exploit them for selfish reasons. In making an analogy between languages and their grammars, the teacher helps to describe a significant code of a particular language and to compare it with other codes used by the older media. As James Monaco points out, "An education in the quasi-language of film opens up greater potential meaning for the observer, so it is useful to use the metaphor of language to describe the phenomenon of film."[68]

Second, what are the characteristics of film language that many people take for granted? Since the cinema was born in the current industrial age, it presents us with the only language of known origin, except artificial languages like Volapuk, Esperanto, and Interlingua. That language has now advanced to the point where it holds a prominent place in society. However, we still know very little about film language and grammar, and they are nowhere as defined as the more established languages. But knowing the limitations of the analogy does not override the fact that studying film language definitely increases our ability to understand and to appreciate how films are structured and function aesthetically and culturally.

Third, film grammar mainly describes what has taken place on the screen; it does not present a formula for making films. This may be because we try to verbalize about a medium that is basically nonverbal. Primarily, the film is concerned with conveying gestures, thoughts, and feelings rather than words. While it is true, as Monaco observes, that ". . . it is impossible to be ungrammatical in film" and that one need not master a film vocabulary,[69] it is also clear that the patterns used in organizing sights and sounds bear a strong resemblance to the patterns used in more formal languages. That is not to say that film language has a fixed structure. As Robert S. Withers explains, film expression communicates emotions more effectively than abstract ideas. While languages like English, Swahili, or Fortran have fixed rules that allow us to examine how meanings are arranged, film expression does not "have such fixed rules of grammar, and does not even have the kind of separate, consistent bits of meaning that could be organized by such rules."[70] Moreover, he points out that film is a "mediate expression." While other languages permit users to express themselves simply, directly, and almost immediately as a thought arises, film expression requires the filmmaker to rely on technology, economics, and collaborative

[68] *James Monaco, HOW TO READ A FILM: THE ART, TECHNOLOGY, LANGUAGE, HISTORY, AND THEORY OF FILM AND MEDIA, rev. ed. (New York: Oxford University Press, 1981), p. 121.

[69] HOW TO READ A FILM, p. 121.

[70] *Robert S. Withers, INTRODUCTION TO FILM: A GUIDE TO THE ART, TECHNOLOGY, LANGUAGE, AND APPRECIATION OF FILM (New York: Barnes and Noble Books, 1983), pp. 12-3.

efforts to communicate an emotion or idea to an audience.[71] Nevertheless, as Withers argues, "Film may be said to have a grammar in that there are certain conventions of shooting and editing that are often followed to evoke particular emotional responses or to create an illusion of continuous action in time and space."[72]

Fourth, the classification that follows is not meant to be definitive. Its main value is in enabling us to generalize about the alternatives that have been open to filmmakers so that when we come to evaluating the finished product, we can indicate and appreciate the ingenuity, creativeness, and craftsmanship in theatrical films.

In this chapter we began with the assumption that movies are an integral part of our culture and proceeded to discuss why it is important to study how films are made and received. Working on the premise that there is no single way to study films and reacting to the history of screen education, we suggested that it was important to stress the complex nature of the film continuum. The focus was on the industrial and collaborative nature of filmmaking, the significance of film formulas in maximizing profits and minimizing risks, and the role that audiences perform in the preproduction, production, and postproduction aspects of the filmmaking process. Having discussed one side of how films are made, we raised the issue of film as a language. Despite its limitations, the metaphor is useful in discussing the elements of film that operate collectively in a total work. Thus, we turn to an overview of the system and the way it functions.

For our purposes, the "grammar" of film indicates the possible forms cinematic units of meaning can take, and is thus an aid to understanding film communication.[73] That is, the total film is divided into elements of sight and sound. The film frame focuses our attention on how filmic space is used. The visual aspect centers around the shot, which in turn is subdivided into fixed shots and motion shots. Fixed shots are determined by the distance from the subject and by the angle of the camera. Included in this category are long, medium, and close shots. Motion shots are those that suggest movement to the spectator. Typical are shots that pan, zoom, tilt, dolly, travel, and boom. All of these shots can be shown in slow, normal, and fast motion.[74]

The concept of size is related to shots. Since it is the camera that directs the viewer's eyes, the filmmaker manipulates the dimensions and proportions of people, places, and things for creative purposes. Thus, small-scale models, properly constructed and photographed, can substitute for actual people or objects. In science-fiction films, for example, individuals can appear in contrast as giants or as minute insects.

Both shots and sizes are influenced by framing. The restriction of a predetermined screen ratio limits directors in what they can and cannot show. Framing helps the filmmaker to select only those images that are important to the artistic presentation of the subject. It allows directors to organize and arrange the various elements of lights, shadows, and objects (people included) in each shot. And by limiting what can be seen by the audience, framing controls our attention and provides a unity to the film. Different kinds of framing--dramatic, split, and oblique--are used to increase the action and suspense in films. In simplified terms, filmmakers compose much in the style of the painter or the photographer, only the filmmakers' arrangements are basically mobile. The motion both into and from shots provides the dynamic aspects uncommon in the static arts.

[71] Withers, pp.14-5.

[72] Withers, p.13.

[73] Although all books on film appreciation in varying degrees include the information summarized, the author wishes to acknowledge a special debt to *Ralph Stephenson and J. R. Debrix, THE CINEMA AS ART, rev. ed. (Baltimore: Penguin Books, 1969) for the strategy in this section.

[74] For definitions of these terms and others, see the Glossary.

Framing also allows for the advantages of filmic space. Because of the camera's mobility and speed, film can multiply, divide, add, and fragment space. It can create new objects from old ones, reshape present perspectives, and control almost every appearance that we see on the screen.

What film can do to space it can also do to time. Flexibility is always the key word. Movies are able to involve us in a continuous present tense,[75] while at the same moment and without any observable visual contrast, show past, current, and future time. A useful way of labeling filmic time is suggested by the terms "physical," "psychological," and "dramatic." Physical time involves the duration of the actual scene along with its projection time while we watch the movie; dramatic time is the manipulation of the natural time necessary for the scenes presented. Like filmic space, filmic time tends to mix a variety of its many possibilities within a single motion picture. As a result, filmmakers use slow, fast, and stopped motion along with flashbacks to repeat, extend, shorten, or change the action in a movie.

Another way of manipulating reality is by optical distortions. Through the use of soft-focus, filmmakers idealize their romantic and epic heroes, provide symbolic representations, and create an impression of fantasy. Soft-focus may also be used to suggest dizziness, dreamlike states of consciousness, flashbacks, and depth perception within a particular shot. Similarly, double-exposures help the artistic quality of a film. They are useful for suggesting the supernatural, the internal states of mind, screen metaphors, and the fusion of the present and the past. A third optical distortion is the negative image, which is useful for evoking the mysterious, the fantastic, and the unnatural. Like other elements of film grammar, the success of optical distortions depends upon their context within the film itself, and not as separate entities.

In addition, filmmakers have learned how to create unique effects with settings. Not only can they manipulate dimensions, but technical experts have developed rare methods of artificially creating a specific atmosphere through the use of such techniques as glass, mirror, and matte shots, optical printing, rear and front projection, and miniatures.[76] Naturally, the creative use of costumes and make-up also contributes to the artistic effect of the scene.

Lighting is another consideration. More important to artists than illuminating the scene is what kind and how much light they should use. With the help of lens openings, filters, reflectors, and setups, the film presents a mood or tone, suggests significant details, provides objects and performers with specific characteristics, and also creates an emotional state. Often there are many subtleties and nuances that the spectator views, but rarely perceives. One of the most frequent types of lighting is high key, generally employed with comedies and musicals where the intent is to suggest a bright and optimistic mood. Color provides an added dimension to lighting. In the hands of experts, it can increase the symbolic and dramatic effects of a shot, scene, or film. It can help establish emotion, feeling, and thought. As is the case with any aspect of film grammar, lighting, except in rare cases, is ineffective if it calls attention to itself and does not blend with the other aspects in the movie.

Film punctuation is yet another factor. Like artists in the traditional narrative arts, the filmmaker manipulates time by starting a new episode, a new scene, and a new point of view. Here, camera techniques other than straight cuts can be used to suggest transitions: e.g., fades, dissolves, wipes, mixes, iris-out and iris-in, turnovers, and titles. By such means, artists can suggest sadness, the passing of time, or a change in mood. They can also eliminate unnecessary material and space, move the story in any direction they choose, make comparisions and contrasts, create suspense, and establish important relationships.

[75] Stephenson and Debrix, p.90.

[76] Lengthier discussions of these terms are available in Raymond Fielding, THE TECHNIQUE OF SPECIAL EFFECTS CINEMATOGRAPHY (New York: Hastings House, 1965); and Raymond Spottiswoode et al., THE FOCAL ENCYCLOPEDIA OF FILM AND TELEVISION TECHNIQUES (New York: Hastings House, 1969).

Sound also has a number of important subdivisions, the most common being music, speech, natural sounds, and sound effects. Sound provides an added dimension to the film experience because it brings another sense into play. Music, since it is married to the sound film itself, needs to be carefully constructed, arranged, and controlled. Used effectively, it can heighten visual effects, stress moods, recall prior events, and foreshadow dramatic situations. Every type of music has proven successful in the cinema at some time or other. Suitability is in every instance the determining factor. Not only can traditional scores be used, but the filmmaker, by virtue of his control over sound recording, can create new musical sounds electronically, most commonly through amplification or by making marks on the sound track directly.

As with visual distortions, so with sound manipulations: by creatively reproducing desired sound effects, artists can increase the film's emotional impact. They can select, multiply, intensify, and invent the sounds we hear. And depending upon their skill, they can orchestrate them into the precise mood of the movie. Various sounds, like visual images, can act as transitional devices, generally in the form of a recurrent melody.

Speech is another asset. Not only does it liberate the image to work with visual ideas alone, but it also allows filmmakers to choose appropriate dialogue and sounds to create a more artistic effect. They therefore have one further device for controlling our emotions and attention. Interestingly, the absence of sound is also useful for the very same reasons.

A basic principle in filmmaking is that sound should not dominate the visual composition. In either sight or sound, artists are judged by their ability to select, shape, and unify the various elements of film grammar.

Like expressions of spoken and written languages, film expressions have denotations and connotations. The meanings are constantly changing in tune with changes in our culture and experiences. It is difficult to discuss, however, whether a "cut" is good or bad unless we first agree that it is a "cut." In this respect, students can help in developing a basic film vocabulary. The most effective way to help them is by extensive screenings of films, and not by lists of specific terms. If you want to kill someone's love for movies, turn the projection of a film into a vocabulary drill. Although those who have grown up with television and film will already have an extensive knowledge of key terms, it might help, at the appropriate moment, to discuss the current meanings of such words as "distortion," "reality," "fantasy," "genre," "theme," "structure," "filmic time and space," "content," "function," "setting," "character," "illusion," "irony," and "symbol." As is the case with all vocabulary, the word is not an end in itself, and it is always wise to anchor your definition to a particular scene or film.

We turn now to editing. Although many viewers realize that movies are a collaborative art, they sometimes ignore the contributions of individuals in composing the shots, scenes, sounds, and sequences of the cinema. A better understanding of what is involved in the making of a film should heighten a viewer's appreciation of a well-composed motion picture.

In most instances, a film is organized to convey an emotion, feeling, or concept to an audience. Grammar is used to select, arrange, and codify that meaning. Thus, every shot and sound generally is integrally arranged and timed to make as clear as possible the intention of the scene in its relative position to preceding and following shots. Essentially, the technique is called "editing" or "montage." The latter is an older term, originating from the efforts of the great Russian filmmakers of the twenties. They tried to distinguish between joining various elements of film together, and the creative cutting of separate shots into an artistic whole. Today, their basic ideas have been expanded to include a variety of approaches. The original intention still persists--that of developing significant effects by joining two separate images together to create a new concept that is greater than the sum of its parts.[77]

[77] See Chapter 7 for a list of books by Pudovkin and Eisenstein dealing with montage.

The differences in theoretical approaches to editing range from ridiculing the advent of sound and color, to claiming that montage allows film to become the most significant form of communication in the world today. It is pointless to maintain that the theories of montage derived from V. I. Pudovkin, Sergei M. Eisenstein, Bela Balazs, or Rudolf Arnheim are supreme, nor is it wise to ignore the aesthetic treatises of Siegfried Kracauer, John Howard Lawson, or Ivor Montagu, or the documentary influences of Robert Flaherty and John Grierson. A more useful position is to study each of them and to extract the most helpful ideas. In addition, a comparison between literary composition and film editing should show that selection, organization, and development are necessary for both. Each is concerned with a point of view, coherence, meaningful symbolic content, rhythm, and forceful, unobtrusive grammar.

Stephenson and Debrix refer to the theories of Marcel Martin: narrative and expressive montage. The former joins individual shots into a chronological scheme for the purpose of presenting a story. The latter joins disjunctive shots in order to create a specific, sudden effect when the two unrelated images clash.[78]

Another interesting approach to montage is presented in an involved but important discussion of synchronization by Kracauer. He divides his significant concepts into three major categories: (a) Synchronism--asynchronism, (b) parallelism--counterpoint, and (c) actual and commentative sound. Synchronism represents the normal union of sight and sound we find in our natural lives (we hear and speak to an individual simultaneously). Asynchronism represents a union of sight and sound not found in our natural lives, in which the source of a sound is not visual (we stare at a book and hear the words of someone not present who often spoke about the book). Parallelism refers to a situation where sight and sound duplicate each other's actions, a form of tautology. This redundancy can be either synchronous or asynchronous. Counterpoint represents the creative union of two different aspects of sight and sound with both forming a single significant effect (a smiling, friendly salesperson is shown as a hypocrite). This relationship can also be either synchronous or asynchronous. The last contrast is between naturalistic sounds that fit into the screen story (actual) and those that talk over the visuals (commentative), most evident in documentaries. The sum total of Kracauer's argument is twofold: (1) the better films are those where sight, not sound, predominates; and (2) images that reinforce verbalizations tend to flaw a movie's pace and effect.[79]

Such theories of editing make it clear that the movement in each shot needs to be arranged to control the effect. Consequently, not all motion that would occur in real life need or should appear in the filmed version. Only movement that relates specifically to the continuation of the desired impression is necessary. Obviously, the filmmaker needs to be selective. Movements are tied to motivations, and motivations should be shown by relating them to a theme as well as to a plot. That relationship is set up to correspond to the filmmaker's point of view. Thus, the content of a shot often contains a careful, complex arrangement of sounds, movements, and subjects, which, when scrutinized, will reveal a significant contribution to the total effect of the film.

Relationships can also be established by parallel editing and referential crosscutting. In both cases, by alternating the shots between simultaneous actions, the editor allows the audience to witness both events. By showing the connection between the two events, parallel editing interprets the actions and heightens the emotional tension of the film. Referential cross-cutting involves a psychological comment. Where the traditional narrative arts use words to reveal the innermost thoughts of an individual, the filmmaker can depict abstract thought graphically through shots showing the action and reaction of performers to a given

[78] Stephenson and Debrix, pp.130-1.

[79] For other points of view, see Richard Corliss, "The Limitations of Kracauer's Reality," CINEMA JOURNAL 10:1 (Fall 1970):15-22; Brian Henderson, "Two Types of Film Theory," FILM QUARTERLY 24:3 (Spring 1971):33-42; and ___, "The Long Take," FILM COMMENT 7:2 (Summer 1971):6-11.

situation--without verbalization. In somewhat similar fashion, a film depicts a naturalistic interpretation of an environment by decomposition. Where the novelist lists specific characteristics, the filmmaker presents specific images.[80]

Rhythm is present in one form or another in all works of art: in film editing we have timing. The shorter the shots, the quicker the time. By alternating the length of the film strip, the duration of the movie is modified, which in turn affects the vital time-space relationship. A shot, action, or emotion can be controlled for emphasis, depending upon the effect the artist wants to achieve. The right length depends on a relationship among the image's form, content, and duration.[81] This is similar to the choice of a word, the arrangement of a sentence, the length of a paragraph, and the development of an idea in prose.

An analogy can be drawn between precise diction in a literary work, and correct typecasting in film. Typecasting approximates the physical characteristics suggested by the script, and the performers objectify these traits on the screen. For some, casting is a photographic art, requiring special talents. For others, casting is not photography but the creative use of individuals stereotyped by previous appearances or roles into visual symbols. Whether they are stars or supporting actors, they can be used frequently as visual icons in much the same way that certain symbols like a swan, rose, or mountain were used by William Butler Yeats, Dylan Thomas, or James Joyce. Each player becomes not only an actor, but also a way of life.

Analogies between movies and the oral or written languages are also useful in suggesting the similarities between scenes and paragraphs, shots and sentences, actors and words, and cuts and commas. But it is important to remember that they are only analogies. Film has its own unique form of expression and we should not lose sight of that.

BOOKS

Barsam, Richard Meran. IN THE DARK: A PRIMER FOR THE MOVIES. New York: The Viking Press, 1977. Illustrated. 216pp.

An attractively designed book with basic information on film history, the commercial aspects of filmmaking, and film criticism, this classroom text seems too general to compete with recent publications. The level of difficulty appears geared to junior high school classes and the bibliography is too general for most college courses. Only the stills continue to be enjoyable to look at. An index is included. Worth browsing.

*Benoit-Levy, Jean. THE ART OF THE MOTION PICTURE. Trans. Theodore R. Jaeckel. New York: Coward-McCann, 1946. Illustrated. 263pp.

Divided into two main sections (education and entertainment), the book provides the general reader with interesting ideas on the basic categories of film and how to study them in the classroom. Although dated, it serves as a valuable reminder of how far we have come since the post-WWII period. Worth browsing.

*Bobker, Lee R. ELEMENTS OF FILM. New York: Harcourt, Brace and World, 1974. 2nd ed. Illustrated. 272pp.

"The emphasis throughout," Bobker explains, "is on the relationship between the techniques of filmmaking (the HOW-to-do it) and their creative application (WHY-to-do-it). I have designed the book to appeal to both the serious student of film who wishes to pursue a career in filmmaking and to the general reader who wishes to learn more about this most dynamic of art forms." Bobker, a knowledgeable film teacher, follows the filmmaking process in organizing his book. The first six of his

[80] For more information on this aspect of film editing, see Joseph and Harry Feldman, DYNAMICS OF THE FILM (New York: Hermitage House, 1952), pp.74-102.

[81] *Ivor Montagu, FILM WORLD (Baltimore: Penguin Books, 1964), p.130.

eight chapters deal with scripting, imagery, sound, editing, directing, and acting. The last two chapters discuss the contemporary cinema and the nature of film criticism. Each chapter begins with a theoretical point of view, followed by a practical application, and then concludes with lists of suitable films for screening, plus a supplementary bibliography. An index is included. Recommended for special collections.

*Boggs, Joseph M. THE ART OF WATCHING FILMS. 2nd ed. Palo Alto: Mayfield Publishing Company, 1985. Illustrated. 456pp.
 Designed for students who may have no prior knowledge of film, this analytically oriented text focuses on basic information related to "film techniques, current practices, and basic principles of film art." Each of the book's fourteen lucid and attractively designed chapters concludes with study questions challenging readers to apply the ideas covered therein. Like many recent publications on the subject, the emphasis is on student involvement and flexible organization. Clearly labeled topic headings allow readers to pick and choose areas for study, rather than requiring them to move sequentially through the book. A notable change from the first edition is the inclusion of numerous examples to illustrate the concepts of film elements and analysis. The book has all the features of the standard introductory text: i.e., a clear set of principles for film analysis. A glossary and index are included, but no bibliography. Well worth browsing.

*Bordwell, David, and Kristin Thompson. FILM ART: AN INTRODUCTION. Reading: Addison-Wesley Publishing Company, 1979. Illustrated. 339pp.
 Designed for beginning film study students, this highly enjoyable and very unusual text limits its focus to the basic elements of film. It is directed "at the person interested in how the film medium may give us experiences akin to those offered by painting, sculpture, music, literature, theater, architecture, or dance." No attempt is made to survey the range of film theories concerned with the art of the film. Moreoever, Bordwell and Thompson emphasize "THE WHOLE FILM," arguing that this is how audiences measure their experiences rather than by analyzing snippets of dialogue or action. "The approach we have chosen," the authors explain, "emphasizes the film as an artifact--made in particular ways, having a certain wholeness and unity, existing in history." Through the book's well-organized and insightful ten chapters, the experienced screen educators stress the importance of film principles. One of the many pleasures in this skills-centered approach is the use of frame enlargements instead of production stills. Another joy is the "Notes and Queries" section at the end of each chapter, where the authors provide not only valuable bibliographical information but also raise significant issues. What makes this book stand ahead of many of its competitors is its refusal to talk down to students. An index is included. Highly recommended for special collections.

*Casebier, Allan. FILM APPRECIATION. New York: Harcourt Brace Jovanovich, 1976. Illustrated. 207pp.
 A modest and unassuming text that sensitively explores complex issues, this intelligent introductory book seeks to draw on the reader's experiences with the traditional arts. "Those coming to the study of film with a background in drama," Casebier astutely observes, "emphasize its commonalities with the theatre--acting, dialogue, MISE EN SCENE; historians of art see the film largely in terms of balance, proportion, rhythm, textures; and literary critics apply to films the linguistic and symbolic systems of interpretation they use in analysis of fiction and poetry." The author then notes that film goes beyond these links and "is a particular result of wedding the traditional elements of actor, setting, dialogue, costume, and music to the new possibilities generated by the camera and the editing process." The first section deals with the elements of film. The second section concentrates on film's depiction of reality and unreality. The final section focuses on specific film styles

and offers useful tips on film criticism. A bibliography/filmography, list of film distributors, and index are included. Recommended for special collections.

*Casty, Alan. THE DRAMATIC ART OF THE FILM. New York: Harper & Row, 1971. Illustrated. 192pp.
 By studying the film from the point of view of technique and dramatic function, Casty offers some valuable insights into the art of motion pictures. "My approach to defining and explaining the basic elements of film art," the author writes, "has been shaped by two basic beliefs: In its major directions and accomplishments the film is a dramatic art, and different applications of its techniques are influenced by different views of both dramatic art and life itself. The cinematic devices fulfill in form the dramatic content, just as the dramatic content fulfills the human context from which the work arises." Casty's early chapters stress how films are created through the use of the camera, the arrangements of shots, and editing. Later chapters explore how technology and drama interact with sound, color, and lighting. The concluding section treats the fusion of cinematic elements into various film styles. An index is included. Well worth browsing.

*DeNitto, Dennis. FILM: FORM & FEELING. New York: Harper & Row, 1985. Illustrated. 544pp.
 "In writing this volume," DeNitto explains, "I gave high priority to three objectives. The first was clarity of expression without oversimplification of concepts . . . Equally important to me . . . was organizing my material to integrate generalizations and specific examples . . . [and] The third . . . was to supply background material so that a reader will consider a film more than an isolated entity." In many respects DeNitto has his worthy objectives dulled by the poor book design and weak visual reproductions. Dividing his ambitious project into three major sections--"Foundations," "Film Movements," and "Film Genres"--and trying to satisfy the needs of courses in film history, introduction to film, and film genres, the author valiantly goes through the basic elements in each area. The information compares favorably with other works, but is presented in a lackluster format. One can read about the components of film for several pages without seeing a single visual. Then when the frame enlargements appear, they seem poorly chosen and reproduced. For example, the tiny reproduction of a sequence from SHANE (1953) is too blurry to know whether its the funeral scene (if it is, then the author has mislabeled it in calling it an early sequence). Here is a well-intentioned author who deserved better editorial help. A fine bibliography, and four indexes--film terms, subject, names, and film titles--are included. Well worth browsing.

*DeNitto, Dennis, and William Herman. FILM AND THE CRITICAL EYE. New York: Macmillan Publishing Company, 1975. Illustrated. 543pp.
 Frustrated by an inability to obtain detailed analyses of important films, DeNitto and Herman decided to examine fourteen separate films and provide critical essays for use in classroom situations. "Each essay is comprehensive, so that every aspect of a cinematic work from story to the style and approach of the director is explored. We believe this type of analysis gives a critical viewer many advantages. If he [sic] has not seen the film, our essay will supply points to look for. After he has seen the film, he will find our analysis helpful in minimizing confusions resulting from the vagaries of individual memory (the analysis is especially valuable when members of a group are comparing impressions). Finally, a viewer can challenge or confirm his own insights and interpretation with those offered in our text." As you might imagine, this is a book that suffers from overinflated ambitions. For example, the authors do a fine job of calling attention to the narrative and visual qualities of the thirteen foreign films and one Hollywood movie selected. I don't mind that the only American film choosen for analysis is THE GOLD RUSH (1925). I don't even mind that the notes they provide on an additional six films include only one English-language film, THE SERVANT (1963). But these authors claim in their cursory opening sections on film interpretation and language that they do not intend to offer prescriptive judgments.

They write that "We have intentionally avoided the subject of judging a film, for we feel if an individual views a film with discrimination, concentration, and background knowledge that we recommend, any judgment he [sic] makes will be judicious and worthy of a respectful hearing." Yet in the fifty years since the sound revolution these authors can't find a single American sound film worthy of a classroom exercise with American students who want to expand their understanding of narrative films. A bibliography, glossary, biographies/filmographies, and an index are included. Worth browsing.

*Dick, Bernard F. ANATOMY OF FILM. New York: St. Martin's Press, 1978. Illustrated. 211pp.
 This book, Dick asserts, "examines the exterior and the interior of the narrative film--its outer form and its inner structure--in order to isolate its parts and study their functions, to explore what happens on the screen of the theater and on the screen of the imagination, and to determine what critical approaches should be taken to the medium." The author moves quickly through his ten well-organized chapters starting with the nature of film, then turning to the elements of film language, editing, narrative and literary devices, the film subtext, and the total film, and concludes with discussions of film authorship and criticism. Particularly effective are the four types of film allusions used for explaining principles: "classic" films, movies shown frequently on TV, films that have published screenplays, and current box-office hits. The book's one drawback is an oversimplification of complex ideas. On the other hand, here is an introductory work by someone whose love of teaching and movies is apparent. A bibliography, filmography with film distributors, and index are included. Well worth browsing.

*Fell, John L. FILM: AN INTRODUCTION. New York: Praeger Publishers, 1975. Illustrated. 274pp.
 Although seeing the benefits from studying film as a unique medium, Fell argues for a broader context. "By 'broad context,'" he explains, "we refer to the several realms of experience (financial and social, but even more important, psychological and cultural) that overlap the movie image, however faintly." Fell insists that "The study of film . . . cannot be divorced from the culture in which film was nurtured, from the circumstances of its production, and from the requirements imposed by its audience." Dividing his introductory text into five major sections, the knowledgeable scholar begins with understanding film's relationship to us and other media, then moves to the elements of film, how films are made, film theory and criticism, and concludes with observations on the future of the medium. Although the author uses illustrations sparingly, his modest writing style and sensitive approach to his topic hold the reader's attention. Here is a case where quality prevails. Endnotes, a set of appendexes on important reference sources, and index are included. Recommended for special collections.

*Giannetti, Louis D. UNDERSTANDING MOVIES. 4th ed. Englewood Cliffs: Prentice-Hall, 1987. Illustrated. 482pp.
 Starting with the basic premise that movies consist mainly of images and sound, Giannetti structures his realism-formalism approach around the "various language systems and spectrum of techniques used by filmmakers in conveying meaning." The book's lucid and informative twelve chapters begin with a focused discussion on cinema and photography, and then proceed to more complex and abstract ideas on MISE EN SCENE, movement, editing, sound , acting, drama, literature, documentary, the AVANT-GARDE, and theory. The concluding chapter on CITIZEN KANE (1941) functions as a synthesis of the principles covered throughout the book. Like most recent introductory texts, this one stresses a flexible format, with chapters that can be read out of sequence, boldfaced technical terms, and topical subheadings embedded in each section. Unlike other books, Giannetti's has a superb ability to generalize about technology and history, to apply the concepts to the traditional film classics

AND modern works, to illustrate the applications with lovely frame enlargements, and to maintain interest and excitement in the material. Along with Bordwell and Thompson's FILM ART: AN INTRODUCTION, this book is ahead of the field. Endnotes, a glossary, and index are included. Highly recommended for special collections.

*Johnson, Lincoln F. FILM: SPACE, TIME, LIGHT, AND SOUND. New York: Holt, Rinehart and Winston, 1974. Illustrated. 340pp.

Concerned primarily with the film as it appears on the screen, this book focuses on the filmmaker's four basic materials, the methods of organizing them for effective communication, and the existing technical processes for implementing the method chosen. Eleven heavily illustrated and clearly written chapters take us from a simple discussion of film's unique qualities, to detailed examinations of space, time, light, sound, film forms, genres, and important filmmakers. Particularly impressive is the ease with which Johnson uses examples from the traditional arts and famous films to explain his generalizations. The only limitation of this intelligent and reliable book is its time references. An updated bibliography and filmography, expanded glossary, and more current visuals would make it a first-rate textbook for contemporary classrooms. An index is included. Well worth browsing.

*Johnson, Ron, and Jan Bone. UNDERSTANDING THE FILM. Skokie: National Textbook Company, 1976. Illustrated. 248pp.

This is a book whose time has past. Although Johnson and Bone fail to identify their audience, I assume it's the secondary school. Note the tone in the following excerpt from the book's introduction: "First, as you will see, we feel that in order for you to develop the kind of interest in movies we would like, this book cannot deal only with the 'oldies' even though they are classics. And so, we have given contemporary movies equal or greater 'billing.' Second, we feel that in order to really understand the film, you have got to know more about how movies are made. And so we have presented one scene from THE STING (1973) from the actual script right through to the editing." Twelve breezy chapters take us from "The Most Popular Art Form" and "The World of Film," through film language and a case study, to "Evaluating Film: You Be the Judge" and "The Moviemakers: Great Directors and Their Films." A dismal bibliography and no index only add to the book's problems. Approach with caution.[82]

*Kawin, Bruce F. HOW MOVIES WORK. New York: Macmillan Publishing Company, 1987. Illustrated. 574pp.

This book," Kawin tells us, "is addressed to the filmgoer who wants to know more about the art, to the prospective filmmaker, and to the critic/student, in school or not. The movies are their own school, and most readers will aready have learned a great deal there before ever opening this book." Kawin divides his material as follows: "Film and the Physical World," "From Shot to Sequence," and "The Film Artist and the Movie Business." Although well-designed, the book has stylistic and pedagogical problems. For example, the author frequently bombards you with information rather than developing an idea. The details are fine, but the writing style is choppy and dull. Equally disconcerting is Kawin's approach to learning. He shows no interest in student involvement and thus offers no study questions. A cursory annotated bibliography offers a smattering of suggestions for future study, but it would be far more useful if appropriate titles appeared at the end of specific chapters. To his credit, Kawin adds a section for instructors at the end of the book on suggested films, probable costs, and sources for information on rentals. In short, this is a good book to peruse, but not for a classroom setting. An index and bibliography are included, but no footnotes. Well worth browsing.

[82] The third edition of this book, published in 1987, arrived too late for review.

Manvell, Roger. THE LIVING SCREEN: WHAT GOES ON IN FILMS AND TELEVISION. London: George G. Harrap & Company, 1961. Illustrated. 192pp.

An early study comparing the relationship between TV and film, this theoretical overview describes the possibilities that the new medium offers film. Five general chapters touch on the nature of the two industries and on the role that audiences play in the finished product. There is nothing exciting or novel about the material. A bibliography and index are included. Worth browsing.

*Perkins, V. F. FILM AS FILM: UNDERSTANDING AND JUDGING MOVIES. Baltimore: Penguin Books, 1972. 198pp.

One of the few well-written and insightful books on criteria for evaluating films, this provocative work argues for a synthetic approach to film analysis. "The examples discussed," Perkins explains, "are not drawn from the (rightly or wrongly) accepted classics of Film Art nor from the fashionable 'triumphs' of the past few years, but generally from films which seem to represent what the Movies meant to their public in the cinema's heyday." The author builds his arguments through a historical survey of film theories from the silent era to the late sixties. By the middle of the book, he is arguing that "matters of balance and coherence are crucial to our appreciation of Cinema." He effectively demonstrates the difficulties filmmakers face in bringing their initial ideas to fruition. "A film (other, perhaps, than a cartoon which might be a one-man product)," he writes, "cannot be made in the mind and then transferred to celluloid precisely as conceived. One of the prime requirements for a film-maker is flexibility to improvise, and to adjust his [sic] conceptions to the ideas and abilities of his co-workers, to the pressures of circumstance, and the concrete nature of the objects photographed." Perkins concludes his literate study by championing the director as AUTEUR and by defining the fiction film "as a synthetic process whose conventions allow the creation of forms in which thought and feeling are continually related to our common experience of the world." Particularly relevant to current film theories is his admonition that "any theory (and particularly the one I have presented) should be disregarded the moment it seems to obstruct rather than promote understanding and discourse." My one major complaint is the weak binding in the paperback edition. An index in included. Recommended for special collections.

*Sohn, David A. FILM: THE CREATIVE EYE. Dayton: George A. Pflaum, 1970. Illustrated. 178pp.

This book is a good introduction to learning about visual literacy. Through the use of an excellent graphic text, cogent and brief interviews, and outstanding short films, Sohn develops insights into creativity in filmmaking. Well worth browsing.

*Spottiswoode, Raymond. A GRAMMAR OF THE FILM: AN ANALYSIS OF FILM TECHNIQUE. Berkeley: University of California Press, 1962. 328pp.

This early work, originally published in 1935 and somewhat dated today, is still an invaluable introduction for establishing the basic language and grammar of film. It is particularly helpful in illustrating and describing specific movie devices and forms. Recommended for special collections.

*Stephenson, Ralph, and J. R. Debrix. THE CINEMA AS ART. rev. ed. Baltimore: Penguin Books, 1969. Illustrated. 270pp.

Even though somewhat dated, this book is still one of the best-organized and most lucid introductions to the art of the film for beginning students. Stephenson, a former employee of the British Film Institute, and Debrix, formerly from the Institut des Haute Etudes Cinematographiques in France, combine decades of European scholarship with modern insights to provide a readable, valuable, and important text on motion picture aesthetics. The nine chapters, which begin with a discussion of

the film as art and end with a summary on reality and artistic creation, include names of films that illustrate abstract theories. The book also has more than fifty well-chosen stills. A bibliography, index of directors and films, and general index are included. Recommended for special collections.

Zettl, Herbert. SIGHT, SOUND, MOTION: APPLIED MEDIA AESTHETICS. Belmont: Wadsworth Publishing Company, 1973. Illustrated. 401pp.

Heavily illustrated and filled with detailed technical discussions, this challenging book is not for beginners. Zettl works hard at building one's understanding of "five principal interconnected aesthetic fields: (1) light and color, (2) space: area, (3) space: volume, (4) time-motion, and (5) sound." Excellent use is made of paintings and colored illustrations, but the emphasis on technical terms makes the reading slow-moving and tedious. A glossary and index are included. Well worth browsing.

FILMS

THE ART OF THE FILM (Janus--16mm: 1975, sound, R-JAN)

A series of twelve films, each running approximately twenty-five minutes, this valuable teaching aid includes individual prints on screenwriting, the camera, performance, music and sound, the edited image, the director, vintage Hitchcock, Alec Guinness, the chase, the role of women in film, and Charlie Chaplin.[83]

BASIC FILM TERMS: A VISUAL DICTIONARY (Adams-Renan--16mm: 1970, 15 min., color, sound, R-PYR/S-PYR)

Sheldon Renan directed this delightful and very useful movie about film syntax, which shows the uses and effects of various lenses, camera angles, and editing.

THE NARRATIVE FILM

To paraphrase Lewis Carroll, the time has come to speak of many forms, of narrative and non-narrative films, of theories and approaches, and what we mean by MISE EN SCENE, and whether literary theories inhibit serious film criticism. Ever since most of us watched our first film, we discovered there were many types of movies. In my youth, for a quarter, you could get into a movie theater and see a cartoon, serial, newsreel, and two narratives films. Each of these types had its own set of conventions and used the elements of film differently. But I never had any trouble in distinguishing the different forms. Only as I matured did it become evident that classifying films was not as easy as I thought.

Because much of film study has its roots in literary and theatrical traditions, it is commonplace to categorize films as in "genres." The classification can be on a very broad scale--e.g., narrative and non-narrative films--or in slightly less general categories--e.g., the narrative, animated, non-fiction, and AVANT-GARDE film--or as special types--e.g., westerns, comedies, cartoons, and documentaries. On the surface, it is not a bad idea. Following the practices of literary critics, screen educators discuss the "rules" that apply to each category and how they are used in various examples of the genre.

The problem is that the "rules" used in literary genres aren't always applicable to film "genres." Let me cite two examples. (I focus on theatrical films because they are the most common in film history and have the widest appeal.) First, in literary circles, a reliance on stereotyping and stock characters is considered an artistic blemish. The emphasis is on originality and creativity. Because almost no one or nothing comes between the author and the published work, the emphasis on these

[83] A more extensive list of films useful for teaching purposes is compiled by *Robert W. Wagner and David L. Parker, A FILMOGRAPHY OF FILMS ABOUT MOVIES AND MOVIE-MAKING (Rochester: Eastman Kodak Company, 1974).

characteristics is reasonable and possible. In film circles, however, a great deal comes between filmmakers and the released film. As we have seen, film is a collaborative art that relies on technology and business patterns. Collaboration forces artists to alter their intentions to meet both the technical requirements of the medium, and the tastes of the times. More to the point, the film industry's reliance on presumed audience expectations as a means of reducing considerable financial risk almost always mandates the use of stereotypes and stock characters in a film. Second, the "rules" of a literary genre are applied according to a writer's talents and time. What to include in a psychological or a picaresque novel depends on the author's inclinations. Not so in a theatrical film. Before a project can even get started, someone has to persuade potential financial backers that a film has enough familiar material to attract sizable audiences. Even when backing is obtained, the look and form of the completed film will be affected by such factors as budget, equipment, and "star" requirements. For instance, most anti-war films will not have the scope or size of patriotic war films, mainly because our government does not offer much assistance to such films. In other words, film is a mediated art. And mediation requires that films have their own set of "rules."

The issue of whether to rely on literary methods for film analysis appears frequently in this work and in most serious studies of film. On the one hand, as Kristin Thompson argues,

> Leaving aside romantically derived interpretive procedures, much critical methodology has been based on general New Critical approaches. That is, the critic defines a context for analysis and interpretation . . . New Criticism itself placed great emphasis on style; it was not simply an interpretive tool for exacting meaning. With literature this was possible because a set of terms and concepts had been developed over centuries to characterize literary style But the direct application to film of systems derived from New Criticism has not proved successful in most cases. This is because film critics did not have the necessary theoretical knowledge of the film medium; they could only apply New Critical concepts to films by treating them as works of literature. Hence the main products of their "readings" would be interpretations, with a simple grasp of stylistic elements serving primarily to determine the meaning of any given technique . . . Since this approach consists mainly of paraphrasing cinematic meanings into words, reductivism inevitably results. Often the contextual film critic (and by now we are far from the sophistication of true New Criticism) resorts to "literacizing" films by basing interpretations on metaphorical descriptions of filmic techniques.[84]

On the other hand, as discussed earlier, the background of many people who study film is rooted in literary traditions. Moreover, as R. Barton Palmer points out,

> Most films are narratives. Indeed Christian Metz, the leading theorist of cinesemiotics, argues that film as LANGUAGE has developed in response to the need to tell a story. As a result, many uniquely cinematic properties, the constituents of what has been aptly termed the "classic grammar" of film are analogous in their function (if not in their functioning) to the devices of literary narrative. Cineliteracy, that appropriate term for film viewer competence, calls attention in its very formation to that analogy.[85]

It is not our intention to resolve the issue here or in this book. I not even sure it can be resolved, given the divergence of academic settings and curricular objectives.

[84] *Kristin Thompson, EISENSTEIN'S "IVAN THE TERRIBLE": A NEOFORMALIST ANALYSIS (Princeton: Princeton University Press, 1981), p.19.

[85] *R. Barton Palmer, "Editor's Comment," STUDIES IN LITERARY IMAGINATION 16:1 (Spring 1983):2.

My major purpose is to call attention to the debate over the appropriateness of applying literary concepts to an analysis of film narratives, and to point out that it is a heated topic--one worthy of serious consideration. More to the point, the goal of this resource guide is to provide information for those students who choose to explore the issue in greater detail.

The pros and cons of film classifications will be covered in Chapter 2. It generates almost as much heat as the literature-film debate. Almost every book you read on the subject has an opinion on genre and non-genre films. Whatever position one takes, it seems reasonable to expect not only an understanding of the history of a film form, but also an appreciation of the context in which films are made, distributed, and exhibited. It also requires knowing when and what literary concepts are applicable to film analysis. For our purposes now, we will focus on the nature of the theatrical narrative film, the fiction movie that tells a story about characters caught in a structured set of circumstances and controlled by the filmmaker.

In order to debate whether a narrative film is good or bad, well made or poorly constructed, complex or simple, we first have to agree that it is a narrative film. What are the essential ingredients? First, it must have a structure, a pattern to unify cinematic principles and commercial objectives discussed earlier. Since film narratives (story films) have their fictional roots in time-honored literary and dramatic traditions, it helps to understand how literary critics define "structure." For example, Marlies K. Danziger and W. Stacy Johnson explain that

> Although this idea has been interpreted in several rather special senses, it means, fundamentally, that each work is a highly complex organization and that its many components or facets are interrelated in such a way that the whole is greater than its parts. Used in this sense, the term does not refer only to the formal aspects--the parallels or contrasts of scenes, the climactic or anticlimactic ordering of the plot--but includes the whole of a literary work. In other words, each work not only has a structure but is a structure. In the romantic period, a similar idea was expressed by saying that a poem, novel, or drama has "organic form," thereby comparing it with a living organism, none of whose parts can be destroyed without crippling the rest. But since pieces of literature do not grow or develop as plants and animals do, it seems better to use the other metaphor--provided we think of structure not just as a mechanical putting together of assorted ingredients but as a vital and dynamic interrelationship of plot, character, tone, style, and all the other components. [86]

The idea of a work being greater than its parts is important. It forces one to explain why a particular interpretation is relevant, and why another perspective is not. Having to defend one's judgment by reference to a specific element and its relationships to other parts in the work helps discipline our imagination. Moreover, as Blaze O. Bonazza and Emil Roy point out, "In studying a work of literature from a structural point of view one may deal with these parts separately, but the ultimate objective is to see the work as a whole and to become aware of how the parts are fitted together to produce a unified effect."[87]

The idea that structure is what unifies a literary work has obvious benefits for appreciating film narratives. Far too often, reviewers and film buffs ignore the structure of a film and indulge in star worship and/or personal moralizing about film content. Conceiving of film as having a structure and being a structure opens up the possibility of experiencing films beyond the initial screening. It brings home the fact that there is more to the film than the plot. Indicative of a useful approach to film narratives is Dennis DeNitto's observation that

[86] *Marlies K. Danziger and W. Stacy Johnson, AN INTRODUCTION TO LITERARY CRITICISM (Boston: D. C. Heath and Company, 1961), p.14.

[87] *Blaze O. Bonazza and Emil Roy, STUDIES IN FICTION (New York: Harper & Row, 1965), p.3.

A film, whether solely entertainment or also a work of art, should possess an organic unity. For example, when experiencing a sound narrative film, we are exposed to various types of stimuli, often simultaneously, even within a few moments of footage. There can be visual images (perhaps in color), words that are spoken and occasionally written (as in signs or a letter shown in a close-up), background music, actors in costumes, settings and props, and other means by which the medium of cinema conveys emotions and ideas to an audience. While these elements of a film may not always be fully integrated, they are organically related in that each component depends on the others to fulfill its functions.[88]

Lee R. Bobker makes a similar point, insisting that "Most current motion pictures of artistic merit are based on scripts that contain a recognizable form and structure. The sequential ideas are clearly present and the shots. scenes, and sequences define the form of the film."[89] I'm not suggesting, nor are DeNitto and Bobker, that we turn screen education into fact-finding expeditions about the organic unity of each scene and sequence. I am suggesting that we anchor interpretations about the meaning and worth of a film within the context of the film itself. So long as we understand that film narratives are not just verbal structures, the literary metaphor of a pattern being imposed on disparate elements functions well in film appreciation.

How narrative structures function in films is described in most introductory film textbooks. Particular attention is given at the outset to defining certain key terms: e.g., "story," "plot," "theme," "narration," "narrative," "characters," "causal relations," "motivation," "parallelism," and "conflict." Thus we are taught that stories are descriptions of the action that occur in the film, while plots provide the details of that action. For example, KRAMER VS. KRAMER (1979) is a story about a man whose wife leaves him, and he has to learn how to take care of himself and their young son. The plot shows us how the husband (Dustin Hoffman) behaves toward his estranged wife (Meryl Streep), their son (Justin Henry), and other important people in their lives. Instead of a narration (an offscreen commentary), we are presented with a linear narrative that illustrates how an ambitious advertising executive ill-at-ease with domestic responsibilities gradually adapts to being a parent and a provider. The fact that we never see him become a responsible husband is secondary to the director-screenwriter Robert Benton's objectives in treating the emotional problems of the three major characters. Each of these three characters--husband, wife, and child--has certain traits that motivate (compel) them to do certain things, behave in a certain way, and react accordingly. Benton structures his narrative to allow them to progress from a state of confusion at the beginning of the narrative, to a state of stability at the end of the narrative. For example, a parallel set of breakfast scenes illustrates the changing relationships between father and son. Through a series of conflicts with friends, business associates, lawyers, and each other, the characters discover new things about themselves, and about their relationships to each other.

Of course, KRAMER VS. KRAMER is not the only type of narrative structure in films. Nor is it an original screenplay. It is just one example of how filmmakers adapt material from another medium (in this case, a novel by Avery Corman). The film does, however, illustrate Bruce F. Kawin's useful observation that

The makers of narrative films often rely on classical precepts about what constitutes a "good story." These can be summarized as follows: There ought to be one or more major characters. They ought to be in some kind of conflict. That conflict ought to be acted out (dramatized). Some degree of tension ought to accumulate as the events proceed, until that tension peaks and is released

[88] *Dennis DeNitto, FILM: FORM & FEELING (New York: Harper & Row, 1985), p.3.

[89] *Lee R. Bobker, ELEMENTS OF FILM, 2nd ed. (New York: Harcourt Brace Jovanovich, 1974), p.37.

at the climax. The climax should be followed by a resolution that wraps up the threads of the story. Both the characters and the meaning of the events ought to be clarified and advanced by this progression from exposition, complication, reversal (or twist), and climax to resolution.[90]

In many respects, Kawin is describing the literary qualities of the classical Hollywood film. With rare exceptions, it characterizes the history of American filmmaking between World War I and the Vietnam War. Elwood Goulart suggests another way of approaching film narrative structures:

> Basic to all dramatic narrative entertainment are these salient generic features which delineate specific areas of a story in which ideas can be shaped in a rhetorical process: conflict and crisis--narrative element which provides the impetus for dramatic protagonist/antagonist interaction; principal characters--those who are the central focus of a narrative; supporting characters--those who augment the roles of the principal characters; dramatic resolution of conflict--narrative element which usually has three parts, (a) introduction of some problem with which to be dealt in the narrative, (b) establishment of conflict between protagonist(s) and antagonist(s) to suggest that the problem is insoluble at first, (c) action that provides a path to some solution nevertheless . . . ; climax and outcome--narrative element concerning what happens as a result of such choices; and theme--the overall philosophical or intellectual issue addressed in the narrative.[91]

Kawin and Goulart (along with the authors of most introductory textbooks on film) are helpful in outlining the main literary features of a narrative work on screen. In calling attention to traditional elements in storytelling, they remind us again of the synthetic nature of the film medium.

There is more to narrative films, however, than literary precepts. In Chapter 2, we will see how Hollywood discovered, refined, and maintained one specific narrative formula--the war film--for eighty years. In Chapter 3, we will discuss how narrative films are economically driven and rely on audience identification, stereotypes, and the pleasure principle. In Chapter 4, we will suggest various ways in which narrative films can be analyzed thematically. In Chapter 5, we will explore some of the similarities between film narratives and their literary antecedents. In Chapter 6, we will review the contributions of major artists who set in motion the conventions of film narratives. And in Chapter 7, we will survey the development of narrative and non-narrative films in the history of motion pictures, calling attention to the alternative strategies proposed by artists who rejected the traditions of the classical Hollywood film. The purpose of this cursory overview is to suggest the complexity of a narrative film, touch on the idea of structure, and point out the possibilities for combining the principles of filmmaking discussed earlier with literary traditions.

Knowing about how a film takes shape helps us understand its style: the way in which a work is put together. In that regard, it useful to make a distinction between style and structure. The latter refers to specific relationships between elements of film; the former, to the way in which those relationships capture the filmmaker's broad intentions. For example, in KRAMER VS. KRAMER, the structure relates to how Benton uses kitchen utensils to create confusion in the father's first attempt to make breakfast for his son. Benton's style is revealed in the way in which he organizes the action to achieve the effect of confusion. Another director would have staged the scene differently. Another way of identifying differences in style

[90] *Bruce F. Kawin, HOW MOVIES WORK (New York: Macmillan Publishing Company, 1987), p.63.

[91] Elwood Goulart, A CRITICAL EXAMINATION OF RHETORICAL ARGUMENT IN NARRATIVE ENTERTAINMENT ON TELEVISION: A CASE STUDY OF SELECTED DRAMATIC PROGRAMS (Unpublished Doctoral dissertation, Indiana University, 1979), pp.9-10.

is to contrast several versions of the same plot. Consider the three versions of A STAR IS BORN (1937, 1954, and 1976). Although the basic story is the same, each film has a unique style. In analyzing the differences, one readily sees the changes in plotting, characterizations, and point of view.[92] The chapters that follow will review the different film styles that have evolved over the history of film, and the ramifications they have had for the art of the film. Our purpose here is to suggest the importance of style and structure in doing film analyses.

One facet of film style, however, deserves special attention: MISE EN SCENE. A French term, borrowed from dramatic criticism and literally translated as "putting into the scene," it has special significance for film analysis. As Bordwell and Thompson explain,

> Film scholars, extending the term to film direction as well, use the term to signify the director's control over what appears in the film frame. As you would expect from that term's theatrical origins, mise-en-scene includes those aspects that overlap with the art of the theater: setting, lighting, costume, and the behavior of the figures. In controlling the mise-en-scene, the director STAGES THE EVENT for the camera.[93]

Thomas and Vivian C. Sobchack point out that "The filmmaker who uses mise-en-scene tries to hide the art, the manipulation of the photographed images in order to present an illusion of reality. In other words, mise-en-scene is a style of REALISM."[94] The concepts of film authorship and "realism" will be discussed later. Suffice it to say that central to both explanations of MISE EN SCENE is the notion that filmmakers use the shot rather than the shot's relationship to other shots to express the meaning of the action.

Another way of looking at the importance of MISE EN SCENE is to think of it in relationship to DECOUPAGE, a French term for the pre-production work on the shooting script. As Noel Burch explains, DECOUPAGE deals with

> the final form of a script, incorporating whatever technical information the director feels is necessary to set down on paper to enable a production crew to understand his intention and find the technical means with which to fulfill it, to help them plan their work in terms of his. By extension, . . . decoupage also refers to the more or less precise breakdown of a narrative action into separate shots and sequences BEFORE FILMING.[95]

Examining the relationship between DECOUPAGE and MISE EN SCENE increases our appreciation of how individual directors use the visual image to communicate with mass audiences. The study of the variations is a delightful way to explore not only the art of the film, but also film history.

Just as the filmmaker has considerable latitude in structuring a film, so do the critics in evaluating the finished product. As we move from a look at the nature of narrative film and turn to the basics of film criticism and theory, it's helpful to remember the debt that narrative films owes to literary traditions. As Sarah Kozloff points out,

[92] For more information, see Chapter 5.

[93] FILM ART: AN INTRODUCTION, p.75.

[94] AN INTRODUCTION TO FILM, p.156.

[95] Cited in Lutz Bacher, THE MOBILE MISE EN SCENE: A CRITICAL ANALYSIS OF THE THEORY AND PRACTICE OF LONG-TAKE CAMERA MOVEMENT IN THE NARRATIVE FILM (New York: Arno Press, 1978), p.3. The original source is Noel Burch, THEORY OF FILM PRACTICE (New York: Praeger Publishers, 1973), p.3.

It is not insignificant that Robert Scholes and Robert Kellog start their wide-ranging study of the nature of narrative with oral storytelling and end with film. Narrative cinema's roots spring from the same soil (fertilized by folktales, myths, epics, romances, histories, chronicles, and autobiographies) as those of the novel.[96]

It's one thing to insist on individuality and independence. It's another thing to forget one's heritage.

BOOKS

Armes, Roy. THE AMBIGUOUS IMAGE: NARRATIVE STYLE IN MODERN EUROPEAN CINEMA. Bloomington: Indiana University Press, 1976. Illustrated. 256pp.
A useful approach to the study of "modernism" in contemporary films, this book describes how important filmmakers have rejected both the search for realism, and the classical Hollywood narrative traditions in favor of a search for a narrative style that involves audiences in abstract problems as defined not by specific situations, but by the dialogue and imagery. That is, the films ask questions about universal issues (e.g., the meaning of racism and the nature of justice) rather than offer solutions to particular situations and incidents (e.g., the "happy ending" of the classical Hollywood film). Armes focuses on the work of European directors like Luis Bunuel, Jean-Pierre Melville, Michelangelo Antonioni, Robert Bresson, Ingmar Bergman, and Jean-Luc Godard. His divides his discussion of their radical approaches in three major sections entitled "Roots," "Fusions," and "Dissolutions." The most frustrating aspect of the study is the lack of any clear-cut definition of just what "modernism" means. Endnotes, a bibliography, and index are included. Well worth browsing.

Bacher, Lutz. THE MOBILE MISE EN SCENE: A CRITICAL ANALYSIS OF THE THEORY AND PRACTICE OF LONG-TAKE CAMERA MOVEMENT IN THE NARRATIVE FILM. New York: Arno Press, 1978. 304pp.
"In the films of many of the greatest directors," Bacher writes, "one often finds scenes which continue uninterrupted by cuts for up to several minutes. Even with little subject movement and no camera movements, such scenes have a tendency to 'pull the audience in,' to have them become more intimately involved with the dramatic action. But when they also feature interrelated subject and camera movements, with those movements creating rhythms which, ideally, are supported by matching musical rhythms, such scenes can achieve a fluid atmosphere that is sheer magic." Bacher then proceeds to survey film history for notable examples of how the "long take" or "mobile MISE EN SCENE" has been used by famous directors. Originally written as the author's 1976 doctoral dissertation at Wayne State University, this intriguing analysis emphasizes the importance of viewing camera movement as consisting of two separate components--"narrative expressiveness and formal expressiveness"--that eventually function together in a total film. Endnotes and an index are included. Well worth browsing.

Bordwell, David. NARRATION IN THE FICTION FILM. Madison: The University of Wisconsin Press, 1985. Illustrated. 370pp.
Arguing that the work of Russian formalist critics of the 1920s presents the most significant theories about narrative since Aristotle, Bordwell argues that their study of aesthetics "encourages the breaking of arbitrary boundaries among theory, history, and criticism." The author's dissatisfaction with the current literature on film narrative serves as the basis of the book's three major sections. Part One, "Some Theories of Narration," explores current narrative theories on perspective, point of

[96] Sarah Kozloff, INVISIBLE STORYTELLERS: VOICE-OVER NARRATION IN AMERICAN FICTION FILM (Berkeley: University of California Press, 1988), p.127.

view, and enunciation. Part Two, "Narration and Film Form," allows Bordwell first to establish his THEORETICAL poetics, and then to turn to the role of the spectator in film's "dynamic, perceptual-cognitive process." He stresses the importance of two key formal systems in narrative films: "syuzhet" (the plot, or more specifically, the "actions, scenes, turning points, plot twists") and style (the way in which a filmmaker creates a desired effect that is "at once perceptual, affective, and cognitive"). Next, he demonstrates how this conceptual framework operates in a total film. The section ends with an emphasis on the role of space and time in narrative films. Part Three, "Historical Modes of Narration," offers examples of how Bordwell's theory functions in analyzing the formal and stylistic conventions of the classic Hollywood film, art-cinema, and Soviet films. Although the ideas are fascinating and carefully argued, the book's scholarly tone limits its audience to serious students. A bibliography and index are included. Recommended for special collections.

Browne, Nick. THE RHETORIC OF FILM NARRATION. Ann Arbor: UMI Research Press, 1982. Illustrated. 108pp.
 A revision of Browne's 1976 Harvard Ph.D. dissertation, this first-rate study is an examination of three films: John Ford's STAGECOACH (1939), Alfred Hitchcock's THE 39 STEPS (1935), and Robert Bresson's BALTHAZAR/AU HASARD BALTHAZAR (1966). "Study of the presentation of film by the act of narrating events to a spectator," Browne explains, "is different from the study of the narrative itself. This book describes the structures of filmic narration by means of detailed analysis of instances of film 'texts.' Because a text implies, as we show, a position for viewing, an analysis of narration calls for a study of the determinations that structure the relations among narrator, character, and spectator. Through an anlysis of contrasting forms of rhetoric exemplified by selected film sequences, I have outlined an approach to the analysis of film narration as a problem of mediation of functions." Although some of the material has already appeared in FILM QUARTERLY, the chance to examine in one volume Browne's ideas on how film meanings are produced and structured is much appreciated. Not only does it allow the author to contrast various rhetorical structures in several unusual films, but it also illustrates the importance of point of view "as the central structuring and integrating function that determines and coordinates the multiple levels of the text and arbitrates the relation of the spectator to the text." Even though the semiological orientation of the book may be offsetting to general students, Browne's graceful writing style and the book's brevity make it appealing to most audiences. A bibliography is included, but no index. Well worth browsing.

*Chatman, Seymour. STORY AND DISCOURSE: NARRATIVE STRUCTURE IN FICTION FILM. Ithaca: Cornell University Press, 1978. Illustrated. 277pp.
 "There are few books in English on the subject of narrative in general," Chatman asserts, "though libraries bulge with studies of specific genres--novels, epics, short stories, tales, fabliaux, and so on. Beyond the analysis of generic differences there lies the determination of what narrative is IN ITSELF. Literary critics tend to think too exclusively of the verbal medium, even though they costume stories daily through films, comic strips, paintings, sculptures, dance movements, and music. Common to these artifacts must be some substratum; otherwise we could not explain the transformation of 'Sleeping Beauty' into a movie, a ballet, a mime show." Chatman's structuralist approach to these inquiries is to focus on the concepts of "story" and "discourse." The former relates to events, characters, and setting; the latter, to the way in which the story is communicated. Five challenging chapters explore in linguistic prose the general theory of narrative. The appeal is more to specialists than to the general reader. Footnotes and an index are included. Well worth browsing.

Clifton, N. Roy. THE FIGURE IN FILM. Newark: University of Delaware Press, 1983. Illustrated. 394pp.

A thoughtful and detailed study on the figures of rhetoric, this unusual work is more a reference book than a continuous narrative. Filled with scholarly allusions and images from the history of motion pictures, it is filled with intriguing definitions and imaginative assertions. One of the problems is getting into the subject. Consider Clifton's opening paragraph: "A TROPE is said to be a way of using words that alters the common meaning of the words used, their inwardness, while a SCHEME changes the common way of putting words together, their outer arrangement. But writers have disagreed on the meanings of the terms, and some doubt if the distinction is valid or even valuable, for can any change in arrangement be quite without effect upon the meaning? Especially in the phrase FIGURES OF RHETORIC, FIGURE has been used as including both TROPE and SCHEME. Not only is this convenient; it is a route round a distinction of little value in film." If you can get past this type of approach, the book's seven major sections should provide valuable insights into how meaning is translated to viewers. But if this type of prose is offsetting, this is not the work where "the best is yet to be." A bibliography, endnotes, and two indexes are included. Worth browsing.

Cohen, Keith. FILM AND FICTION: THE DYNAMICS OF EXCHANGE. New Haven: Yale University Press, 1979. Illustrated. 216pp.

Seeking a way to combine a love for literary studies and film studies, the author decided to write about the influence of cinematic expression on modern fiction. The focus is on the late nineteenth and early twentieth century, starting with the works of impressionistic painters and the rise of moving pictures, and then charting the inroads made by nineteenth century theorists among the arts up to 1925. Cohen's emphasis is on showing the transformation of artists from a position of independence, to one of interdependence. While he does not claim that film "is solely responsible for this cutoff or aesthetic swerving, or that it is the exclusive factor in the radically new formulations of the twentieth-century novel," he does insist "that among the many factors brought to bear upon the novel, the movies, that new contraption of dubious artistic status, became a unique source of inspiration for the modern novelist's revamping of traditional form." Cohen divides his material into two major sections: "Convergence" and "Exchange." Part 1 explores how language and narrative conventions bridged the gap between film and the other arts. Part 2 discusses how the novel began assimilating cinematic techniques. An index is included. Well worth browsing.

Fell, John L. FILM AND THE NARRATIVE TRADITION. Norman: The University of Oklahoma Press, 1974. Illustrated. 283pp.

"This study, "Fell explains, ". . . collects a number of experiences from industry, art, and commerce, and tries to point up a culmination of the storytelling impulses when these techniques finally find their secure home in nickelodeon. In this respect the book is perhaps radical because it denies disciplinary conventions for the sake of less apparent formal ones." The experiences the resourceful author finds are in nineteenth-century novels, early comic strips, magazine illustrations, cubist and impressionistic paintings, popular literature, and theatrical events on stage, in fairgrounds, and in parlors. To Fell's credit, he doesn't play the "up-manship" game, but seeks instead to discover who and what were the major influences and why. Organizing his material into three major sections--"Verbal Arts," "Graphic Arts," and "The Movies," the author focuses on the twin themes of melodrama and mechanics, pointing out how each shaped the works that used them. In clear and highly entertaining prose, Fell charts the legacy of a hundred years of narrative tradition that movies inherited and restructured. A bibliography and index are included. Recommended for special collections.

Harpole, Charles Henry. GRADIENTS OF DEPTH IN THE CINEMA IMAGE. New York: Arno Press, 1978. Illustrated. 293pp.

Arguing that gradients of depth in pictorial compositions are a significant aspect of films that have been ignored in most books on film, Harpole sets out to trace the history of pictorial depth in film. By "depth," the author means "the arrangement of objects or people within the film frame in such a way that there is some important distance between those things in the foreground and the things in the background of the space presented." Since "distance" becomes an issue in discussing a filmmaker's use of depth, Harpole employs the concept of "gradient": the degree of the variations of usage, rather than the kinds. Eleven well-organized chapters explore issues related to perception, technology, and aesthetic concerns. Originally written as the author's 1976 New York University doctoral dissertation, the book surprisingly minimizes academic jargon and awkward prose. Among the many useful conclusions is that depth usage occurred in the very early films and was prominent in some films of the teens, that it was used especially in exterior scenes, and the usage was not limited to a particular national cinema. Those authors still citing CITIZEN KANE (1941) as the origin of deep-focus photography will need to rethink their position if they read Harpole's work. An appendix chronicling film stocks from 1889 to 1954 and a bibliography are included. Well worth browsing.

*Kawin, Bruce F. MINDSCREEN: BERGMAN, GODARD, AND FIRST-PERSON FILM. Princeton: Princeton University Press, 1978. Illustrated. 242pp.
"This book," Kawin explains, "is an attempt to address one of the central problems of film theory: who narrates a narrative film? The classic assumption is that all film narration is third person--and must be, since the camera can record and present only ITS. What I hope to show is that although a camera does not have consciousness, and cannot therefore literally be an I, it is possible to encode the image in such a way that it gives the impression of being perceived or generated by a consciousness." Kawin draws on a wide range of American and Europeans films from the history of motion pictures to test his ideas on dream theory. In the process, he makes good use of his literary background. Endnotes, a bibliography, and index are included. Recommended for special collections.

Kozloff, Sarah. INVISIBLE STORYTELLERS: VOICE-OVER NARRATION IN AMERICAN FICTION FILM. Berkeley: University of California Press, 1988. Illustrated. 167pp.
Originally written as Kozloff's 1984 Standfod University doctoral dissertation, this highly informative study focuses on nearly sixty years of American and British filmmaking that has used "voice-over narration." the author emphasizes the importance of the three words in her definition of the term: "VOICE determines the medium: we must hear someone speaking . . . OVER pertains to the relationship between the source of the sound and the images on the screen: the viewer does not see the person who is speaking at the time of hearing his or her voice . . . [and] NARRATION relates to the content of the speech: someone is in the act of communicating a narrative--that is, recounting a series of events to an audience." For those who think there isn't much to say about the types of voice-over narrations, this book will surprise you. Not only does the clever author point out how often the technique has been misused and why it is so valuable in scores of films, mostly Hollywood products, but she also challenges the worn-out theories about sound having ruined the art of the film. Particularly impressive in her five delightful chapters is the way she demonstrates that the technique owes as much to the mass media as it does to literary traditions.[97] After reading this engrossing study, one wants to re-view the great

[97] In this connection, readers might find it useful to study Robyn R. Warhol's ingenious ideas about the "engaging narrator" in nineteenth-century literature. Simply put, she argues that certain novelists (primarily women) "used engaging narrators to encourage actual readers to identify with the 'you' in the texts." See Robyn R. Warhol, "Toward a Theory of the Engaging Narrator: Earnest Interventions in Gaskell, Stowe, and Eliot," PMLA 101 (1986):811-8.

films--e.g., HOW GREEN WAS MY VALLEY (1941), ALL ABOUT EVE (1950), ANNIE HALL (1977), and PLATOON (1986)--which have employed the technique. Endnotes, a filmography, a bibliography, and index add to the book's value. Recommended for special collections.

Luhr, William, and Peter Lehman. AUTHORSHIP AND NARRATIVE IN THE CINEMA: ISSUES IN CONTEMPORARY AESTHETICS AND CRITICISM. New York: G. P. Putnam's Sons, 1977. Illustrated. 320pp.

This book is really two works in one. Using material from their respective doctoral dissertations, Luhr and Lehman gamely try to channel their shared perspective on the director's being the controlling personality in a film production into a study of how best to evaluate films. Part 1, "Authorship," contains Lehman's thoughts on the importance of aesthetics ("the way in which the work functions as an artistic unit") in film criticism. Using John Ford's THE MAN WHO SHOT LIBERTY VALANCE (1962) and THE SEARCHERS (1956) as the touchstone for judging works of art, Lehman argues that "The relation of formal and thematic patterns in the two films to similar patterns in his career should indicate the worth of directorial construct but the point remains that the examination of the man's oeuvre is worthwhile primarily because he was able to produce complex and self-contained works, works that show a thorough comprehension of the cinematic form." Four useful chapters comment on the author's misgivings about the state of film criticism up to the mid-1970s and suggests that we concentrate in the future on analyzing how cinematic elements function in a total film. Part 2, "Narrative," presents Luhr's perspective on narrative and Victorian literature and their application in films. His prime examples are five screen adaptations of Robert Louis Stevenson's DR. JEKYLL AND MR. HYDE: John Robertson's DR. JEKYLL AND MR. HYDE (1920), Rouben Mamoulian's DR. JEKYLL AND MR. HYDE (1932), Victor Fleming's DR. JEKYLL AND MR. HYDE (1941), Terence Fischer's THE TWO FACES OF DR. JEKYLL/THE HOUSE OF FRIGHT (1960), and Jerry Lewis's THE NUTTY PROFESSOR (1963). Luhr's three informative chapters point out how each of the directors uses similar material, stressing identifiable narrative elements and their contribution to a director's style. The upshot of the concluding section is to discredit the notion that screenwriters can be AUTEURS. Endnotes, filmographies, and an index conclude this formalist approach. Well worth browsing.

Prats, A. J. THE AUTONOMOUS IMAGE: CINEMATIC NARRATION AND HUMANISM. Lexington: The University Press of Kentucky, 1981. 178pp.

"In the widest possible sense," Prats explains, "this study is an assessment of the movies as contributors to one of the most creative revolutions in Western history." Focusing on the role that movies play in reshaping our visions of ourselves and our world, the author explores the values communicated in four films: Federico Fellini's FELLINI: DIRECTOR'S NOTEBOOK/BLOCK-NOTES DI UN REGISTA (1969) and THE CLOWNS/I CLOWNS (1970), Lina Wertmuller's SEVEN BEAUTIES/PASQUALINO SETTEBELEZZE (1976), and Michelangelo Antonioni's BLOW-UP (1966). Each of the four films functions as "a specific MODEL of narration" that illustrates the contrasts between reality and illusion, right and wrong, good and evil, beauty and ugliness. I'm not terribly troubled that Prats uses four Italian films as the examples of liberated imagery in the contemporary cinema. Nor do I quarrel with his thesis that certain modern narrative films add considerably to our need for more humanistic values in our world. I do take exception, however, to a humanistic analysis of SEVEN BEAUTIES/PASQUALINO SETTEBELEZZE that ignores the film's exploitation of Holocaust material. Endnotes and an index are included. Well worth browsing.

*Rosen, Philip, ed. NARRATIVE, APPARATUS, IDEOLOGY. New York: Columbia University Press, 1986. Illustrated. 539pp.

"This anthology," Rosen writes, "finds its rationale in the complicated tissue of cross-references and debates which flowered during late 1960s and 1970s." No attempt is made in the book's four major sections to provide a unified theoretical

position. Rather, the author includes commentaries by semioticians, pyschoanalytic textual theorists, feminists, historical materialists, and neo-Formalists. The value of the enterprise is in demonstrating the division of thought that characterizes modern film theory. Although one gets a sense of common assumptions--e.g., the importance of linguistics to film analysis, the role of signification in narrative films, the perceptions of what modern audiences consider "normal" in narrative films, the role of the spectator in determining a film's "meaning," how filmmakers structure a film's appeal to mass audiences, the relationship between sociocultural elements and narrative structure, how gender functions in theatrical filmmaking, and the significance of cultural politics in the film continuum, nevertheless, the primary value of this extremely informative volume is in its making readily acccessible many of the thoughts of leading film theorists in recent years. For example, the opening section on the structures of film narrative includes essays by David Bordwell, Christian Metz, Raymond Bellour, Nick Browne, Peter Wollen, Kristin Thompson, and Deborah Linderman. Section Two, "Subject, Narrative, Cinema," includes works by Roland Barthes, Colin MacCabe, Laura Mulvey, Paul Willemen, Kaja Silverman, and Julia Kristeva. Section Three, "Apparatus," has articles by Jean-Louis Baudry, Pascal Bonitzer, Mary Ann Doane, and Teresa de Lauretis. The final section, "Textuality as Ideology," has essays by Stephen Heath, Jean-Louis Comolli, Noel Burch, Linda Williams, and Thomas Elsaesser. Each section includes a valuable introduction not only to the topic but also to positions taken by the contributors. Recommended for special collections.

Siska, William Charles. MODERNISM IN THE NARRATIVE CINEMA: THE ART FILM AS GENRE. New York: Arno Press, 1980. 149pp.
 Originally written as Siska's 1976 Northwestern University doctoral dissertation, this study identifies the characteristics of "art-movies" as having themes that contain abstract problems ("raised" problems) openly discussed and thus distinguishes them from the popular theatrical narrative that deals with concrete problems ("lived" problems). Siska points out that "In art movies, the foregrounding of abstract themes through dialogue and direction of the viewer to the image constitutes a departure from the Aristotelian poetics that governs the structure of the traditional narrative." Noting that the break with the past occurred near the end of the nineteenth century and is described as modernism, Siska explains that the value of the term for analyzing art films is found in the key concepts of modernism: "subjectivity, point of view, reflexivity, and open texture." Endnotes and a bibliography are included. Well worth browsing.

Stam, Robert. REFLEXIVITY IN FILM AND LITERATURE: FROM DON QUIXOTE TO JEAN-LUC GODARD. Ann Arbor: UMI Research Press, 1985. Illustrated. 285pp.
 Originally written as Stam's 1976 University of California-Berkeley doctoral dissertation, this study "deals with the 'other tradition' in literature and cinema: the tradition of reflexivity as embodied in novels, plays, and films which break with art as enchantment and point to their own factiousness as textual constructs." The author explains that "The texts discussed here interrupt the flow of narrative in order to foreground the specific means of literary and filmic production. To this end, they deploy myriad strategies--narrative discontinuities, authorial intrusions, essayist digressions, stylistic virtuosities. They share a playful, parodic, and disruptive relation to established norms and conventions. They demystify fictions, and our naive faith in fictions, and make of this demystification a source for new fictions." An introduction and five extremely well-written and absorbing chapters explore the rise of modernism, the complicity of the reader-spectator in creating illusion, the process of production, current anti-illusionist traditions, and the importance of Bertolt Brecht to reflexivity in film and literature. Endnotes, a bibliography, and index are included. Recommended for special collections.

Wilson, George M. NARRATION IN LIGHT: STUDIES IN CINEMATIC POINT OF VIEW. Baltimore: The John Hopkins University Press, 1986. Illustrated. 223pp.

"The concept of point of view, as a construct of interpretation," Wilson explains, "is more familiar to us from literary theory and, admittedly, that concept is not as sharply delimited as one might wish. In film theory the situation is much worse. Nevertheless, if there is one useful core concept to be discerned in both domains, then it is one that covers the different ways in which a form of narration can systematically structure an audience's overall epistemic access to narrative." The author then proceeds to identify three categories of narrational assumptions: the common-sense picture of the world we share with a film, the complex set of inferences a film makes about narrative developments, and "the relations between the information that the audience progressively acquires concerning dramatic issues in the film and the information that one or several characters is shown to possess about the same topic." Although he enlarges on these three categories throughout the book's ten thought-provoking chapters, the author argues that these are the crucial elements in analyzing a film's point of view. To illustrate his "RHETORIC of narration," Wilson selects five films: Fritz Lang's YOU ONLY LIVE ONCE (1937), Alfred Hitchcock's NORTH BY NORTHWEST (1959), Max Ophuls's LETTER FROM AN UNKNOWN WOMAN (1948), Josef von Sternberg's THE DEVIL IS A WOMAN (1935), and Nicholas Ray's REBEL WITHOUT A CAUSE (1955). These classic Hollywood film narratives provide Wilson with persuasive examples of how the categories of film narration ("epistemic distance, reliability, and alignment") relate to audience reception. Endnotes and an index are included. Recommended for special collections.

FILM CRITICISM AND THEORY

Thus far we have reviewed the nature of film education, the commercial and collaborative base of the film industry, the form and function of film elements, and the role that structure and style play in theatrical narrative films. In this final section, we turn to the evaluation of this synthetic medium. Why is one film better than another? What does it tells us about humanity? Why is it even necessary to judge films? There is no shortage of answers. Everyone has an opinion on what the standards should be, how they should be applied, what a film means, and what constitutes the art of the film.

Our purpose here is to put the major critical ideas in a historical context, point out the job of critics, and highlight the principles they use. The survey will also comment briefly on the theories themselves. Summaries of difficult and controversial ideas, however, are oversimplifications that may mislead readers into glib conclusions about the virtues or vices of these complex ideas. That is clearly not my intention. Rather, the assumption is that an introductory approach to film study requires a familiarity with the theories and concepts used for analyzing films in a variety of historical, philosophical, and aesthetic contexts. By calling attention to the major theories already available in English-language publications, I am suggesting a starting point for further study. The emphasis is on identifying important resources that define the major approaches, describe the leading theories, and review the history of film criticism. The chapters that follow provide examples of how these complex and controversial concepts are applied and debated.[98]

[98] Although the material in this section draws upon the thousands of articles and books reviewed in this study, I wish to acknowledge a special debt to the following works: *Dudley Andrew, THE MAJOR FILM THEORIES: AN INTRODUCTION (New York: Oxford University Press, 1976); ___, CONCEPTS IN FILM THEORY (New York: Oxford University Press, 1984); Joseph Dalton Blades, Jr., A COMPARATIVE STUDY OF SELECTED AMERICAN FILM CRITICS, 1958-1974 (New York: Arno Press, 1976); *Tim Bywater and Thomas Sobchack, INTRODUCTION TO FILM CRITICISM: MAJOR CRITICAL APPROACHES TO NARRATIVE FILM (New York: Longman, 1989); *Dennis DeNitto, FILM: FORM & FEELING (New York: Harper & Row, 1985); *Louis Giannetti, UNDERSTANDING MOVIES, 4th ed. (Englewood Cliffs: Prentice-Hall, 1987); Brian Henderson, A

 A sensible way to begin film criticism is by defining some terms. In this book,
"criticism" and "critique" will be used interchangeably. "Film criticism," however,
means more than judging a film. It is the process of examining how movies communicate
ideas and emotions through internal and external cinematic and human relationships.
"Film theory" relates to the formulating and testing of general concepts about parts
or all of the medium. As Tim Bywater and Thomas Sobchack point out, it seeks
answers to four primary questions: "(1) the relationship of the medium to raw
materials, the technological aspects of cinema; (2) the relationship to its subject
matter, the aesthetic considerations; (3) the relationship to its mode of production,
the economic matrix; and (4) the relationship to the social and political contexts, the
ideological elements."[99] As we will see, the answers to these theoretical questions
affect an individual's judgment on a specific film's merits, its role in society, and the
nature of the medium.
 In a valuable review of the historic uses of the terms "critique," "criticism,"
and "theory," Brian Henderson identifies a variety of ways film theory has been
applied in intellectual contexts and cultural periods. While finding that
"Film-theoretical writings are utterly determined by and absorbed by the larger
philosophic positions they express," he takes the position that ". . . film theory
is a site, a realm of discourse, that it exhibits regularities of structure, assumptions,
propositions, and concepts."[100] Henderson notes that although some film theories are
perceived as "systems" that allow for extrapolations from explicit positions to implicit
ones, he argues to the contrary. He insists that not only are the important theories
of film fragmented, contradictory, and paradoxical in significant ways, but that such
inconsistencies "characterize" the field of film theory.[101] His position, and one that
I find extremely useful, is to view film theory as "a realm of discourse comprised
entirely by the texts of film theory as they stand."[102] Where Henderson and I part
company is in his assertion that we view "film theory as a single structure capable
of various investments rather than as a group of opposing whole theories."[103] As
will be evident throughout this book, I believe in an eclectic approach that benefits
from many points of view. That is not to denigrate Henderson's elegant arguments.
It is to say that the nature of screen education in a pluralistic society requires a
variety of approaches, rather than one method for all situations.
 In beginning a study of film theory, it is useful to consider first the broader
area of film criticism: reviews, critiques, and theories that apply to the analysis of
specific films. The focus is on the context in which the film is made and received.
The premise is that a film does not originate in a vacuum. In that regard, DeNitto
suggests using the concept of "matrix" ("that which gives origin or form to a thing")
to describe the influences--"small and large, external or internal"--that occur during
the film continuum.[104] By becoming familiar with the various interrelated and
interdependent matrixes--e.g., biographical, economic, social, political, technological,

CRITIQUE OF FILM THEORY (New York: E. P. Dutton, 1980); Myron Osborn Lounsbury,
THE ORIGINS OF AMERICAN FILM CRITICISM 1909-1939 (New York: Arno Press, 1073);
*Thomas Sobchack and Vivian C. Sobchack, AN INTRODUCTION TO FILM, 2nd ed.
(Boston: Little, Brown and Company, 1987); and Raman Selden, A READER'S GUIDE
TO CONTEMPORARY LITERARY THEORY (Lexington: The University of Kentucky Press,
1986).

[99] Bywater, p.164.

[100] Henderson, p.x.

[101] Henderson, pp.xi-xii.

[102] Henderson, p.xii.

[103] Henderson, p.xiii.

[104] DeNitto, p.83.

and religious--that a critic uses in analyzing a film, we appreciate and evaluate not only what a critic does, but also a critic's principles. In Chapter 3, I will discuss useful models for analyzing the influences on film from the pre-production stages, to audience reception. Suffice it to say that there is more to a film than meets the eye.

Simply put, film criticism involves an individual's subjective reactions to the experiences created by viewing moving pictures. As the Sobchacks point out, these reactions can be in the form of a review, a critical essay, or a theoretical proposition. "Each kind," we're told, "presupposes a specific audience and a specific aim."[105] In general terms, the reviewer's job is to describe and judge a film the public is not familiar with, and advise us on its merits. What's the film about, is it worth seeing, and why? The critic examining the same film assumes that we are familiar with the film but may not fully understand its content, structural relationships, or social relevance. Unlike the reviewer, the critic is concerned more with analyzing the film than with providing general and immediate feedback to a lay audience. A theorist's analysis may slight the film altogether and focus instead on broader issues about film as a medium. Rather than asking how good the film is, the theorist may deal with problems related to making the film and address issues raised by the filmmakers themselves. Having said that, let me quickly add that there are times when the distinctions among reviewers, critics, and theorists are not readily apparent. For example, noted reviewers like Richard Corliss, Pauline Kael, Stanley Kauffmann, Andrew Sarris, Richard Schickel, and John Simon often go beyond mere reporting to analyzing the social, aesthetic, and historical characteristics of a particular film.[106] For the most part, however, film criticism falls into these three general areas. The media reviewer rarely goes beyond short, crisp reviews. The journal critic focuses on extended, analytical evaluations of film and its role in society. And the theorist offers abstract and pragmatic propositions about the film to a sophisticated and specialized audience.

Even so, what qualifies someone to be a reviewer, critic, or theorist? I did say that criticism was subjective. I'll go further and state that critics have biases. Why, then, is one person's opinion better than another person's? The simple answer is that some individuals have better judgment than others. It isn't just a matter of having seen more films or read more books about the subject or even having a facility with words that distinguishes the professional from the amateur. As much as anything, it is an attitude that separates one from the other. The professional works at film criticism, the amateur plays at it. The professional believes that it is important to analyze films, the amateur simply enjoys them. A more complex answer is that while there are clinkers in every profession, first-rate film reviewers, critics, and theorists have specific standards that they use to support their judgments. That is, they recognize the possibilities that films offer filmmakers, and they examine critically how the medium has been used and to what end. A professional critic puts more emphasis on knowledge than on prejudice. Unlike an amateur, a professional defends his or her judgment through an analysis of a film, rather than hiding behind sweeping generalities.

But isn't it true, you may rightly ask, that the "experts" disagree strongly about the merits of a film or the nature of the medium itself? Absolutely! That is what distinguishes one critic from another: a point of view, an area of emphasis, a unique perspective. It is the nature of the major disagreements among critics that defines the state of film criticism. Respected critics don't disagree over trivial matters. They fight over important political, social, and aesthetic issues. Take, for example, GONE WITH THE WIND (1939). One critic examines the film for the contributions of the various screenwriters who prepared the script. What role did each of them play in adapting Margaret Mitchell's book to the screen? A second critic is concerned with screen adapations and contrasts the book with the film. Are the two media compatible? A third critic examines the performances of Clark Gable and

[105] AN INTRODUCTION TO FILM, p.412.

[106] For a good overview of the journalistic approach, see Bywater, pp.3-23.

Vivien Leigh in relation to the film's success. How important is the star system to a commercial venture? A fourth critic analyzes the commercial nature of the total film production. Was this film atypical of the products made in the Hollywood studio system? A fifth critic approaches the analysis from the point of view of genres. In what way does this film represent Hollywood's conventions on the Civil War? A sixth critic is concerned about stereotypes. Do the images of African-Americans in the film encapsulate what white Americans felt about blacks prior to World War II? A seventh critic focuses on authorship and on who is responsible for this seminal film in commercial film history: the producer, the credited director, or a combination of people both behind and in front of the camera? An eighth critic examines the class struggle depicted in the film. Does the film illustrate how capitalism exploits the underprivileged and weak in American society? A ninth critic cares mostly about the style of the film. How are the cinematic elements structured and how effectively are cinematic relationships developed? Although each critic takes a different tack, they are all concerned with going beyond the surface of the film. The battles and combatants may change from one generation to the next; the function of criticism remains constant.

The study of film theory, however, is more than the study of any one film. As mentioned earlier, it focuses on the basic questions of technology and technique, aesthetic considerations, economic concerns, and social or ideological issues. It argues that it is important to raise questions about the talent of an artist, the structure of a work, the role of an audience, and the nature of the medium. In many respects, film theory is the most difficult task in film criticism. Unlike the reviewer or the critic, the theorist takes a global view of film and struggles to find a comprehensive approach to the medium itself. "Traditionally," as Louis Giannetti explains, "theorists have focused their attention on three areas of inquiry: (1) the work, (2) the artist, and (3) the audience."[107] To understand the nature of film theory, let us first look briefly at how film criticism and theory evolved, the controversies that emerged, and the links between opposing positions. After that, we will conclude this chapter with a review of current film criticism and theory.

Throughout the first sixty years of film criticism, there was little serious debate about the nature of the medium. Starting with the first English-language review of Edison's Kinetoscope at Koster & Bial's Music Hall on April 24, 1896, film criticism and theory were preoccupied with the issue of form. Those who favored the works of the Lumiere brothers in France emphasized the realistic power of the medium to record actual events. Those who admired the works of storytellers like Edwin S. Porter and David Wark Griffith emphasized the medium's ability to restructure reality. The battles between the "realists" and the "formalists" took center stage in film criticism and theory.

At first, the press was content in reporting new releases and to provide plot summaries. Few people considered film worthy of any further notice. It was a toy, a novelty, a mere distraction. If anything, people discussed what the film was about and whether it was entertaining. More socially minded observers worried about its effect on the poor and on the uneducated. The people in the burgeoning industry concerned themselves with issues of production, distribution, and exhibition. They rarely considered their products as anything other than goods to be manufactured and sold for profit. Whether a film was a mechanical record of an actual event or a made-up story was secondary to what the public liked.

That pragmatic approach to film criticism took root in America and England and became a distinguishing characteristic separating English-language critics from critics on the continent. As discussed in Chapters 3, 5, and 7, theoretical discussions about the nature of the medium became more the preoccupations of French, German, and Russian critics than of American and British ones.

There was, however, a need at the turn of the century to bring respectability to this profitable amusement. The commercially motivated industry quickly realized that the best way to fend off censorship and increase box-office revenues was to

[107] Giannetti, p.362.

publicize the "merits" of film productions. Those individuals who saw in film the possibilities of a great art form felt the need to jettison its ties to the traditional arts and establish principles unique to film. The eventual appearance of trade periodicals and newspapers, starting in 1906-07 (e.g., VIEWS AND FILM INDEX, THE MOVING PICTURE WORLD, and MOVING PICTURE NEWS), signaled not only the growing importance of the film industry, but also a mutually satisfactory relationship between filmmakers and the press for evaluating the film products offered for sale and exhibition. Soon other trade publications like VARIETY, BILLBOARD, and THE DRAMATIC MIRROR joined the fold. Publishers realized that stories about film sold papers. As will be discussed in Chapters 3 and 6, the film industry developed an unholy alliance between the media and film publicity departments and their advertising agencies for merchandising stars, films, and gossip about the movies. This gave rise to fan magazines, gossip columns, and "authorized" biographies of film personalities and studios. For many people, this form of film propaganda remains the most interesting "criticism" about films. The public never seems overly concerned that publishers (and later radio and TV executives) worry that an unfavorable review or feature story might jeopardize revenues. And more than one critic has lost his or her job because integrity became more important than job security.

The period from 1908 to 1919 contains the first serious approach to film criticism. For example, Frank E. Woods, the medium's first prominent critic, made his debut in THE NEW YORK DRAMATIC WRITER in 1908. Known to the public only as "The Spectator," Woods became the prototype of media cheerleaders for the art of the film. He attacked films that merely recorded events and places. These "documentaries," "newsreels," "staged productions," and "actualities" ignored the unique qualities of film. He insisted that film was not the handmaiden of the traditional arts, but an art form equal in stature to the traditional arts. Fearful of the growing numbers of people wanting to censor films and excited about the enormous social and aesthetic possibilities of the new medium, he tried to create a more sophisticated audience for the movies. "Motion pictures," he argued, "are at last gaining recognition as an institution of immense value to mankind."[108] Over the next five years, Woods wrote about the role of a film critic and the nature of film as art. He clarified his views on the distinctions between film and the stage, the importance of film as a medium of communication, the responsibility of filmmakers, and the central role of the director in the creative process.[109] His discussions about the rise of a universal language that would enrich our lives inspired industry insiders, who knew that Woods was one of Griffith's major screenwriters. Other journalist-critics like Heywood Broun, Epes Winthrop Sargent, and Kenneth Macgowan followed his lead.

By 1908, famous stage performers who had once shunned the low-brow medium began appearing in longer films, and drama critics started turning their attention to the "photoplay." The issue of film versus drama became a hotly debated topic in prestigious publications. Whatever side was taken, it became clear that film had emerged as a medium to be reckoned with. The appearance of THE BIRTH OF NATION (1915) opened the debate further, raising the issues of social responsibility and the freedom of expression. At the very moment film was gaining respectability as an art form, its mode of operation was being seriously threatened. The debate spread to social and political arenas, as well as to the world of aesthetics.

The most eloquent defender of film in those early days was the poet Vachel Lindsay. In his book, THE ART OF THE MOVING PICTURE (1915), he passionately championed the film as a work of art. He admonished the public to open its eyes to the way scenes are composed, action created, and emotions communicated. Lindsay praised in particular the spectacle of film, comparing it favorably to the illusion of reality found in books and on the stage. While also noting the intellectual weaknesses in the material dramatized in the new medium, this pioneering book on film theory encouraged the mass audience to see and discuss films as a visionary force for

[108] Frank Woods, "Spectator's Comments," NEW YORK DRAMATIC MIRROR (May 1, 1909):38. Cited in Lounsbury, p.8.

[109] Lounsbury, pp.12-28.

uplifting civilization. "It has come, this new weapon of men, and by faith and a study of the signs we proclaim that it will go on and on in immemorial wonder."[110] As Kauffmann points out, Lindsay's hyperbolic style was characteristic of the man himself. Nevertheless, he finds his predecessor on THE NEW REPUBLIC to have published an "astonishing" book of "analysis and vision."[111]

The second major book on film theory appeared the following year: Hugo Munsterberg's THE PHOTOPLAY: A PSYCHOLOGICAL STUDY. A German psychologist practicing at Harvard University, the eminent scholar stated, "The art of the photoplay has developed so many new features of its own, features which have not even any similarity to the technique of the stage that the question arises: is it not really a new art which long since left behind the mere film reproduction of the theater and which ought to be acknowledged in its own esthetic independence?"[112] Like Lindsay, Munsterberg stressed the uplifting and imaginative possibilities of the new art form. Again like Lindsay, he argued that what made film art was the manner in which it reshaped reality to suit film's purposes.

> A work of art may and must start from something which awakens in us the interests of reality and which contains traits of reality, and to that extent it can not avoid imitation. But IT BECOMES ART JUST IN SO FAR AS IT OVERCOMES REALITY, STOPS IMITATING AND LEAVES THE IMITATED REALITY BEHIND IT. It is artistic just in so far as it does not imitate reality but changes the world, selects from it special features for new purposes, remodels the world and is through this truly creative. To imitate the world is a mechanical process; to transform the world so that it becomes a thing of beauty is the purpose of art. The highest art may be furthest removed from reality.[113]

What distinguished the two pioneering theorists was Munsterberg's concern with film's psychological effects on audiences. He explained how viewers actively participated in the film experience, called attention to the ways in which their emotions were stimulated by cinematic techniques, and emphasized that film was first and foremost a visual art. In years to come leading theorists like Rudolf Arnheim would follow Munsterberg's lead and argue forcefully that the silent screen, the highest form of cinematic expression, was debased by extraneous elements like dialogue, sound effects, and music.

In essence, the theories of Lindsay and Munsterberg, along with the film criticism of journalists like Woods, had made form and subject matter the primary tests for the art of the film. If all the filmmaker did was record reality, the film was merely imitative. If the film only reproduced the conventions of the stage, it failed to achieve its unique potential. And if film content neglected moral values, it abandoned it social responsibilities. At the same time, as Bywater and Sobchack observe, they were "humanist" critics: people who "see film as an art like other arts, and film criticism as a general human activity practiced by the educated, cultured person." More to the point, the humanist approach to film criticism "attempts to make sense of the

[110] *Vachel Lindsay, THE ART OF THE MOVING PICTURE (New York: The Macmillan Company, 1915), p.289. Rpt. New York: Liveright, 1970. Introduction Stanley Kauffmann. The quotations cited in this chapter are from the 1915 edition. See also Lounsbury, pp.50-8.

[111] Kauffmann, THE ART OF THE MOVING PICTURE, pp.x, xiv.

[112] *Hugo Munsterberg, THE PHOTOPLAY: A PSYCHOLOGICAL STUDY (New York: D. Appleton and Company, 1916). Rpt. New York: Dover Publications, 1970. Foreword Richard Griffith. All quotations cited in this chapter are from the 1970 edition. See also Lounsbury, pp.58-67; and THE MAJOR FILM THEORIES, pp.14-26.

[113] Munsterberg, p. 62.

individual's emotional and intellectual experience of a film (it always begins with that personal encounter with the work), to draw conclusions about the value of that experience, and then to communicate that value to others."[114]

The hopes and dreams of the pioneering critics were dashed during the 1920s. With the emergence of Hollywood and a vertical system that centralized production, distribution, and exhibition in the hands of mostly Eastern European Jewish immigrants, American film criticism abandoned its optimistic tone, and critics concentrated on attacking the commmercial values of the film industry. As will be discussed in Chapters 3, 5, 6, and 7, part of the problem was the scandal-ridden Hollywood community, its penchant for publicity, and the presumed harm that cinematic scenes of sex and violence were having on young and impressionable audiences. Part of the problem also was the fact that "foreigners" were using the film to justify the virtues of the American Dream at a time that the American establishment felt that the "outsiders" were threatening the soul of the American way. Whatever the problems, former defenders like Lindsay withdrew their support of film. It was during this period that the notion of film as entertainment became the rallying cry of the film industry. Give the public what it wants and send the messages by telegrams.

In Europe, however, film as a serious art form was on the rise. Artists everywhere were in rebellion against traditional aesthetics. The European film community was part of that uprising. It was a time of "movements," of filmmaking that was characterized by shared values of stylistic themes and techniques.[115] As will be discussed in Chapter 7, the Germans applied the theories of expressionism to new forms of psychological screen dramas; the French published manifestos about the poetic qualities of film and experimented with non-narrative productions; and the Soviets offered new perspectives on the relationships between film and the goals of the state. Film societies emerged in these nations, along with academic programs to study the art of the film.

One noted theoretician of the period was the Hungarian filmmaker Bela Balazs. In a work like THE VISIBLE MAN, OR FILM CULTURE (1923), the first European critic to write a daily column argued for the importance of examining the structure of film form. As Herbert Marshall points out,

> The significant thing that Bela Balazs makes clear is the importance of theory and the lack of appreciation of this in relation to "the only new art"--the film It is an art that could only have been born in an industrial civilization and the universality of the film is primarily due to economic causes.[116]

In his writings, Balazs, a Marxist critic, hammered away at the organization of the film industry, pointing out that the demand for novelty constantly required filmmakers to improve their techniques and to discover fresh approaches to popular formulas. Although he acknowledged that there were many roads filmmakers could travel in satisfying the needs of a vast public, Balazs found only the art of the film worthy of serious examination. Just before his death in the early 1950s, Balazs summarized his thirty years of analyzing the medium in THEORY OF THE FILM: CHARACTER AND GROWTH OF A NEW ART. Two decades later, Andrew referred it as "one of the first and unquestionably one of the best introductions to the art."[117]

[114] Bywater, p.25.

[115] DeNitto, p.88.

[116] Herbert Marshall, "Preface," THEORY OF THE FILM: CHARACTER AND GROWTH OF A NEW ART, by Bela Balazs, trans. Edith Bone (London: Dennis Dobson, 1952), p.11. See also THE MAJOR FILM THEORIES, pp.76-101.

[117] THE MAJOR FILM THEORIES, p.76.

The most influential formalist theories of the silent era were in the Soviet Union. Committed to a revolutionary approach to aesthetics and determined to serve the new social and political order, starved for equipment and raw materials, and cut off from the intellectual stirrings in other parts of the world, the Soviet filmmakers set about developing a "scientific" approach to filmmaking. The details of their formalist approach to filmmaking will be discussed in Chapter 7. Here we will only touch on the highlights. Rather than dwell on the scarcity of raw materials, the Soviet filmmakers made it their ally. Using existing footage of films in their possession, they experimented with the notion that subject matter was less important than the way it was structured. They concentrated on how ideas and meanings were created and communicated. Instead of being concerned with stars and stories, they focused on technique and style. Film was perceived as a unique language that gained force through the editing process. The function of the film artist was to communicate emotions rather than to record reality. Like all theorists, they accepted the idea that a reproduction of life was essential to the art of film. How it was reproduced, however, became the test of an artist, and not what was reproduced. It didn't matter if the viewer noticed the filmmaker's techniques, that the action seemed contrived, or the meaning blatant. The Soviet filmmakers argued persuasively that any type of character, event, or message could be accepted by the audience once it accepted the filmmaker's intentions. The skill was in getting the audience to accept the premise of the shot, the scene, and the sequence. Everything the filmmaker did, as Andrew points out, had four functions: "practical, theoretic, symbolic, and aesthetic."[118] These functions became the overriding principles in silent Soviet films.

While there were many filmmakers theorizing and working in the Soviet cinema, two deserve special mention: Sergei M. Eisenstin and Vsevolod I. Pudovkin. Their published works will be discussed in Chapter 7. Here we need only suggest the significant similarities and differences in their theoretical approaches to film. Both were concerned with the ability of film to shape elements of reality to meet the needs of the state. Both believed in the concepts of filmic time and space, and that these cinematic features could be manipulated in any way that suited the purposes of the filmmaker. Context not content was the key ingredient. And both believed that editing determined the pattern of how space and time could best communicate the filmmaker's intentions.

There were major differences, however, in the way the men applied these principles. For example, Eisenstein described his approach as "montage," the theory that the basic unit of film construction was the "shot." The way in which it was constructed and the relationships between it and other shots in a scene or a sequence was at the core of his films. Working on the premise that each element in film had an equal role to play in the total film, he searched for psychological combinations (e.g., a dialectical combination of thesis, antithesis, and new thesis) that captured the viewer's emotions and imagination. Pudovkin, on the other hand, argued that the shot, properly constructed, already had the necessary information to evoke the desired audience response. It wasn't necessary to have shots clash with each other to produce a specific effect. What the filmmaker needed to do was to conceal the effect by linking shots together and by letting the story carry the viewer forward. Although changes in Soviet politics would affect the careers of both men and mandate certain limitations in applying these principles, the theories themselves are still held in high regard.

The coming of sound films in the late 1920s forced a reconsideration of critical and theoretical positions. Now that dialogue, sound effects, and music (later also color) added to the realistic possibilities of the medium, analysts debated anew the nature of the medium and on the value these technological breakthroughs have for film. Aiding considerably in the debate was the appearance of serious film journals like CLOSE UP and EXPERIMENTAL CINEMA.[119] Not surprisingly, the Depression and

[118] THE MAJOR FILM THEORIES, p.79.

[119] For more information, see Lounsbury, pp.225-323.

the rise of Fascism stimulated a trend toward social and political film criticism. Among the major film critics of the era were Alan Bakshy, Iris Barry, Otis Ferguson, Lewis Jacobs, Pare Lorentz, Dwight Macdonald, Harry Alan Potamkin, Gilbert Seldes, Robert Sherwood, William Troy, and Herman G. Weinberg. Their erudite debates ran the gamut of opinions on the nature of the medium and its role in society. By the advent of World War II, sound had become an indispensable part of film theory, and film criticism had become a fixture in the daily press and in specialized film periodicals.

The two major theoretical events of the thirties were the documentary movement in England, and the publication of Rudolf Arnheim's seminal study, FILM AS ART. The former will be discussed in detail in Chapter 2. Suffice it to say that the British, led by the indomitable John Grierson, proposed that non-fiction filmmakers use the lives of working-class people as alternative subject matter to compete with mainstream cinema. Arnheim's book argued that we look back at the virtues of the silent film, rather than embrace the new technological developments in film. Published in 1933, FILM AS ART summarized the crucial formalist positions of the past two decades. "It is worth while," Arnheim argued, "to refute thoroughly and systematically the charge that photography and film are only mechanical reproductions and that they therefore have no connection with art--for this is an excellent method of getting to understand the nature of film art."[120] Thus while Grierson was calling for a more realistic approach to filmmaking, Arnheim was cataloging the reasons why film art had very little to do with what we perceived as "reality."

The value of the formalistic approach to film criticism is still being debated today. Those who support its principles focus on analyzing cinematic techniques in judging a film's strengths and weaknesses. Attention is paid to a filmmaker's style, pointing out the way he or she structures the subject matter, creates a specific mood, and presents a point of view. Those who reject the formalist approach claim that it doesn't work well with films that emphasize realism, often results in a theoretical film vocabulary drill, and is too mechanistic.

World War II set the stage for still other dramatic shifts in film criticism and theory. One change in the constant barrage of attacks on Hollywood's destruction of talent and its crass values was noticeable in the writings of James Agee, Bosley Crowther, Manny Farber, and Robert Warshow, who treated film as an art form worthy of serious examination. These prominent social critics also began talking about film genres, overlooked "B" films, and neglected directors. In the decade to follow, other critics would build on these ideas and create influential theories that would revolutionize approaches to film criticism. A second change during the war years was a revisionist attitude toward film and reality. Some film historians credit Orson Welles's CITIZEN KANE (1941) with the resurgence of interest in realistic filmmaking. Other authorities point to the British documentary movement and the non-fiction propaganda films produced by the Allied and Axis powers between 1935 and 1945. Most critics agree, however, that the Italian neo-realists during the early and mid-1940s made the theory attractive and persuasive. The importance of practitioners like Cesare Zavattini, Roberto Rossellini, and Vittorio de Sica in developing a cinema of social responsibility based on realistic filmmaking will be discussed in Chapter 7. Suffice it to say the neo-realistic movement embraced many of the ideals of the documentary movement.

To illustrate briefly the difference between the Realist and Formalist approaches, let's consider the intrinsic nature of neo-realism. Giannetti divides the characteristics of the Italian movement into two parts: ideology and style. The former includes

(1) a new democratic spirit, with emphasis on the value of ordinary people;
. . . (2) a compassionate point of view and a refusal to make facile judgments; (3) a preoccupation with Italy's Fascist past and its aftermath of

[120] *Rudolf Arnheim, FILM AS ART (Berkeley: University of California Press, 1960), p. 9.

wartime devastation; . . . a blending of Christian and Marxist humanism;
and (5) an emphasis on emotions rather than abstract ideas.[121]

Among the major stylistic characteristics of neo-realism are

(1) an avoidance of neatly plotted stories in favor of loose, episodic structures
that evolve organically from the situations of the characters; (2) a documentary
visual style; (3) the use of actual locations . . . rather than studio sets;
(4) the use of nonprofessional actors; . . . (5) an avoidance of literary
dialogue in favor of conversational speech; . . . and (6) an avoidance of
artifice in the editing, camerawork, and lighting in favor of a simple "styleless"
style.[122]

Using Giannetti's summary of neo-realism, we can see that the realists reject the idea
that subject matter is subordinate to form and that the art of the film requires any
suggestion that film is imitating life. To the contrary, the realists emphasize the
necessity of recording reality as accurately and as unobtrusively as possible and
presenting it as honestly as a mediated medium allows. In particular, the notion of
carefully crafted films relying on meticulously developed plots as the basis of cinematic
art was soundly rejected. A new age demanded that films respond to the experiences
of world wars and universal suffering. Far more important to the visionary role of
film in a modern world was a commitment to social responsibility and to educating the
public to its role in making the world a more humane and just place to live and work.
 Italian neo-realism had a short but memorable life. Before it disappeared in the
early 1950s, it had inspired many influential critics and filmmakers into calling for a
new direction for the commercial cinema. Nowhere did this take hold more firmly than
in postwar France. Although the French cinema of the period was committed to
carefully crafted films that relied heavily on elegantly written screenplays, many
French intellectuals and aspiring filmmakers envisioned a revolutionary approach both
to criticism and to theory. As will be discussed in Chapter 7, a number of
factors--e.g., film study movements, a series of manifestos, the appearance of critical
journals, the re-emergence of Henri Langlois's CINEMATEQUE FRANCAISE, and
significant government subsidies--contributed to the intellectual climate of the French
film community. As a result of the critical and theoretical ferment, two men in
particular were chiefly responsible for changing the direction of world cinema: Andre
Bazin and Francois Truffaut. The former was a brilliant critic who helped found
CAHIERS DU CINEMA; the latter was his protege, a gifted critic who wrote a seminal
article on film authorship and then went on to become one of the greatest directors
in film history. Their specific contributions are described later in a historical context.
Here, we need only indicate the nature of those contributions.
 Although Bazin never put together a comprehensive theory on film, his published
and edited books have placed him at the head of realist film theorists. During his
short life (he died of tuberculosis at age forty in 1958), he commanded enormous
respect from the public, colleagues, and the film community for his attempt to
establish a viable aesthetic for film. "Without any doubt," writes Hugh Gray, "the
whole body of Bazin's work is based on one central idea, an affirmation of the
objectivity of the cinema in the same way as all geometry is centered on the properties
of straight lines."[123] Twenty-six of Bazin's essays based on his four-volume work
QU'EST-CE QUE LE CINEMA? have been translated and collected in two books
annotated later. In them, we discover the brilliant critic's admiration for the
psychological, technical, and mythical qualities of the Hollywood film; his rejection

[121] Giannetti, p.366.

[122] Giannneti, pp.366-7.

[123] *Hugh Gray, "Introduction," WHAT IS CINEMA? by Andre Bazin, trans. Hugh Gray,
 Foreword Jean Renoir (Berkeley: University of California Press, 1967), p.4.

of montage[124] in favor of techniques that "saw the cinema as a total and complete representation of reality" and did not try to reconstruct it scientifically;[125] his affection for neo-realism; the value of perceiving films as genres; the crucial differences between film and theater; and his unwavering commitment to humanistic values.

Guided by Bazin's theories on film, Truffaut wrote an essay in 1954, entitled "A Central Tendency of the French Cinema." Beginning as an attack on the French postwar cinema and its "Tradition of Quality," it called for a cinema of "AUTEURS." The details of this critical approach will be discussed in Chapter 7. Here, we need only point out that Truffaut spoke for many militant young filmmakers and critics who saw in the works of Hollywood and some national cinemas evidence of a personal style of filmmaking that went beyond the mechanics of studio control and government interference. Blending the basic tenets of earlier formalist theories into a new framework that stressed the role of a guiding force, the director, in the creation of a work of art, Truffaut challenged critics to study the "signature" of a director throughout his or her career, rather than focus on a single film. Central to this AUTEUR theory were film genres. No longer should they be perceived as mere film formulas, but rather as examples of how great directors, AUTEURS, overcame conventions and stamped their own vision on traditional material and techniques. True, only a small number of people in the history of film had the strength and the talent to make their identity known in the work they did for the commercially run cinema. But it was precisely those directors who did put their mark on film content and style who were responsible for the art of the film. How can you identify them? Study their use of MISE EN SCENE, editing techniques, and thematic emphases throughout their careers, the AUTEUR theorists argued, and you will discover not only what is important in filmmaking, but also why their works earn a special place in film history.

Jean-Luc Godard, also a critic for CAHIERS DU CINEMA, added his voice to the call for change in film criticism and filmmaking. Throughout his career as a film critic during the 1950s, but especially in 1959, he argued for a more moral and politically motivated cinema that abandoned artificial differences between formalists and realists. Instead, he insisted on getting the audience more involved in how film communicates meaning and influences values. As will be discussed in Chapter 7, he gradually worked toward building a cinema that made the spectator a participant in the filmmaking process. Although he praised Hollywood's classical narrative style and its abilty to affect audiences emotionally, Godard would abandon that tack in the sixties and seek to find a way to involve the audience more directly and politically in the film process. By the end of the fifties, however, he argued forcefully for films that relied on artistic spontaneity and fluid camerawork, rather than on meticulously plotted and crafted story films.

Although these revolutionary ideas made little impression on the mainstream filmmaking industry, they did affect the attitudes of serious critics and emerging filmmakers throughout the world. The emphasis on analyzing film styles and creating free-wheeling socially committed films could not be ignored, especially as it grew more visible in "art houses" and international film festivals. Not only did critics scramble to identify who the "real" AUTEURS were, but they also called attention to new forms of filmmaking evident in France's "New Wave" and England's "Free Cinema." As will be discussed in Chapter 7, these were not monolithic movements. Rather, they consisted of talented filmmakers who experimented with the conventions of the

[124] Bazin considered montage "the creation of a sense of meaning not proper to the images themselves but derived exclusively from their juxtaposition." See Andre Bazin, "The Evolution of the Language of Cinema," WHAT IS CINEMA?, p.25. He argued that that we should be concerned "not with the form but with the nature of the recital of events--or to be more precise with a certain independence of nature and form." See Andre Bazin, "The Virtues and Limitations of Montage," WHAT IS CINEMA?, p.50.

[125] Andre Bazin, "The Myth of Total Cinema," WHAT IS CINEMA?, p.20.

narrative film, de-emphasized "seamless, invisible editing," and shot on location, rather than on a studio lot. Critics began turning away from time-honored views about the purposes of popular entertainment in favor of the need for greater freedom of expression, more realistic settings and action, and a commitment to undermining Hollywood's standards of technique and social values.

As the battle lines were being drawn, Siegfried Kracauer published his seminal work on film realism: THEORY OF FILM: THE REDEMPTION OF PHYSICAL REALITY, in 1960. The most comprehensive and detailed examination of realistic film theory to date, it is based on what Kracauer calls "MATERIAL aesthetics." The emphasis is on content. "It rests," he explains, "upon the assumption that film is essentially an extension of photography and therefore shares with this medium a marked affinity for the visible world around us. Films come into their own when they record and reveal physical reality."[126] So long as filmmakers use the camera to record life "on the wing," they create cinematic art. Those who try to imitate life by staging reality are ignoring the essence of the medium. That is not to rule out all narrative filmmaking. It is, however, to state priorities among the two major forms story films can take: the theatrical story ("so-called because its prototype is the theatrical play")[127] and the "found story" (a term that "covers all stories found in the material of actual physical reality").[128] Weak cinema (theatrical films, particularly screen adaptations) occurs when technology is used to reshape reality. Strong cinema (the found story, especially its episodic structure) results from filmmakers' taking their material from the world itself, depicting life's uncertainties, relying on the raw materials of nature and actual locations, and avoiding artificial effects to restructure reality.

The value of the realist approach to film criticism continues to be a lively topic, as it was in the entire earlier history of film. Those critics who support "the window on the world" concept applaud the necessity of comparing films with reality, of focusing on what a film reveals about ourselves and the world we live in, and of dealing with humanity honestly. Those critics who feel that the cinematic window shuts us off from art argue that it is too limited in scope to be of use to the commercial film industry, it fails to appreciate that all filmmaking is mediated, and it falsely separates content from form.

Also surfacing during this militant, revolutionary period in film criticism was the growing importance of Marxist ideas. A detailed look at the evolution of Marxist theory is beyond the scope of this book. Here we need only point out that first, Marxists want to change the world, not just analyze it; and second, Marxists claim that only by changing our social being can we bring about true reform. The basic tenets of Marxist film criticism were developing during the political struggles of the Soviet filmmakers in the silent era. As will be discussed in Chapter 7, the Soviets veered away from works that put the emphasis on content and steered their films toward an awareness of how films illustrated the conditions that were necessary to reform society. The emphasis was on raising public consciousness about the economic and political ideological chains that prevented the existence of a free and just society. At the same time, there was an awareness of the crucial role that art played in bringing about social and political revolution. By the late 1940s, one of the most contentious champions of Marxist theory was Bertolt Brecht. Arguing that it was important to make audiences conscious of how bad art co-opts the individual into accepting the STATUS QUO, he argued that the best works show us that we do not have to accept our lot in life, our future is not predetermined, and present conditions are not divinely sanctioned. Moreover, great artists call attention to these issues by making the audience aware of the artificial barriers between the work and the

[126] Siegfried Kracauer, THEORY OF FILM: THE REDEMPTION OF PHYSICAL REALITY (New York: Oxford University Press, 1960), p.ix.

[127] THEORY OF FILM, p.216.

[128] THEORY OF FILM, p.245.

audience. Every effort should be made, he insisted, to destroy the illusion of reality and to get the spectator to see how the story and the characters operate. In short, involve the audience in the artist's attempt to overthrow the STATUS QUO.

Clearly, such oversimplications about Marxist theory are filled with glaring omissions. It should be noted, therefore, that Marxist film criticism is not monolithic. For example, as Giannetti points out, "All Marxists believe that a given country's wealth and resources should be equitably shared, but they differ radically in how this idea should be implemented."[129] The point here is that by the advent of the sixties, film movements like neo-realism, the New Wave, and the Free Cinema included formidable filmmakers who believed in many of the Marxist principles. Film had become more than a source of popular entertainment. It had also become an ideological battleground. As will be discussed in Chapter 5, nowhere were the artistic and commercial battle lines more clearly drawn than in the United States. Judging a film was no longer limited to issues of realism, formalism, or entertainment. A film's "message" often determined its right to be made, let alone to be shown.

In 1960, the editors of two leading film periodicals questioned the current direction of film criticism. Speaking for the highly influential British periodical, SIGHT AND SOUND, Penelope Houston took issue with the changing critical standards, espoused by left-wing periodicals like CAHIERS DU CINEMA, which put a greater emphasis on the director and aesthetics than on a film's literary qualities. "Cinema is about the human situation, not about 'spatial relationships.'"[130] Outraged by the new critics' appetite for the sensational and their distaste for the slow and the sentimental, she lashed out at their divorcing morality from art in film criticism. Reared on literary and intellectual traditions, Houston insisted that

> Film Criticism is in search of an aesthetic, which will not be found in the narrower issues of committed versus anti-committed attitudes; and . . .
> this debate ceases to be illuminating when both sides are forced into taking up extremist positions. The unattractive truth, of course, is that there is plenty of reviewing and not nearly enough criticism (and a magazine such as this must accept its share of the guilt); that the film, because it can not be taken home and studied like a novel or a play, invites reactions and impressions rather than sustained analysis; that there has never really been an aesthetic of the sound cinema, and that most of the standard textbooks are useful only for those who still believe that cinema history virtually stops with BLACKMAIL and THE BLUE ANGEL.[131]

For those who were bewildered by the conflicting theories and the extremist positions, Houston insisted that "In the long run, the critic is still on his own, confronted with the work of art. His tools: his sensibility, his knowledge, his judgment, and his apparatus of values."[132] In essence, she was arguing for the "liberal" tradition in film criticism, a tradition "which looked to the cinema to extend our range of ideas rather than confirm pre-conceived assumptions. . . ."[133]

[129] Giannetti, p.379.

[130] Penelope Houston, "The Critical Question," SIGHT AND SOUND 29:4 (Autumn 1960):163.

[131] Houston, p.164.

[132] Houston, p.164.

[133] Houston, p.165. Interestingly, Richard Roud took an opposing position in the same issue. Typical of his position was his anecdote about a conversation between Degas and Mallarme. The former complained that "although he had lots of ideas he was finding it very difficult to write a poem." Mallarme's immediate response was, "But Degas, poems aren't made with ideas; they're made with words." See Richard Roud, "The French Line," SIGHT AND SOUND 29:4 (Autumn 1960):171.

Speaking for the American periodical, FILM QUARTERLY, Ernest Callenbach presented a different perspective. While admiring Houston's humanistic principles, he disagreed with her assessment of film criticism. He had no problem with the idea that film is a "social art" involving people in a variety of social contexts that have profound effects on society. "Any critic who attempted to write about films without a consciousness of the SERIOUSNESS of the medium, in this sense," Callenbach argued, "we should indeed dismiss as an irresponsible critic."[134] He also took issue with Houston's statement on the literary tools of analysis and her emphasis on the rhetoric of film. It wasn't that her "liberal" views were false. They weren't. The problem was that the methods of the "liberal" critic were too simple and inappropriate for modern times. What was needed instead, Callenbach argued, was a "'textual' criticism: criticism which sticks much closer to the actual work itself than is usual."[135] Moreover, the existence of 16mm prints for review and study had made the old arguments about accessibility and availability outmoded. In essence, he advocated a middle ground between the polemics of form versus content.

Not surprisingly, the sixties, the age of "the film generation," was also the age of the greatest collection of American film critics since the thirties. Not only did they have enough profound issues to discuss, but also they had the intelligence and the wit to deal with these issues forcefully and skillfully. These were the days in which Andrew Sarris magnificently expounded on the AUTEUR theory, Pauline Kael brilliantly defended film pluralism, John Simon's scholarship set aesthetic standards the gods had difficulty achieving, Stanley Kauffmann taught people the true value of taste, and Dwight Macdonald's sociological criticism captured the imagination of a restless generation intent on reforming not just America, but the world. It wasn't only that these critics wrote well. It was that we read what they wrote, debated it in terms of the movies we saw, and studied it in the classes we took. Although these critics collectively published many books, they constructed no comprehensive theories. They were too busy just keeping up with the latest technical, social, economic, political, and cultural changes to give us anything but their educated thoughts on current films. But no film criticism in all of film history captures as well the context in which films were made and seen than does the work of these five extraordinary critics.

While Sarris was publishing his pantheon of AUTEURS first in FILM CULTURE in 1962, and six years later in book form in THE AMERICAN CINEMA: DIRECTORS AND DIRECTIONS, 1929-1968, Jean Mitry in France was putting out a two-volume work, ESTHETIQUE ET PSYCHOLOGIE DU CINEMA (1963-1965), which synthesized film theory. A scholarly work by a dedicated theoretician whose roots extended back to AVANT-GARDE silent films, and whose incredible knowledge of the arts, philosophy, and film history had helped found and shape the CINEMATEQUE FRANCAISE, this massive systematic and sweeping study analyzed and reviewed the history of film theory. The details of that painstaking project and how Mitry uses phenomenology (the study of how we become aware and what awareness means and the shapes it takes)[136] are discussed admirably by Dudley Andrew and Brian Lewis. The former remarked that Mitry's scholarship made film study academically

[134] Ernest Callenbach, "The Critical Question: Another View," FILM QUARTERLY 14:2 (Winter 1960):2.

[135] Callenbach, p.3.

[136] For more information on phenomenology and film, see N. Patrick Peritore, "Descriptive Phenomenology and Film: An Introduction," JOURNAL OF THE UNIVERSITY FILM ASSOCIATION 29:1 (Winter 1977):3-6; John L. Fell, "Dear Dean Korzybski," ibid., 31:3 (Summer 1979):45-50; and David A. Daly, "Films for the Classroom: Pedagogical Luxury or Rental Rip-Off?" ibid., pp.61-5.

[137] See THE MAJOR FILM THEORIES, pp.185-211; and Brian Lewis, JEAN MITRY AND THE AESTHETICS OF THE CINEMA

respectable. It took it out of the salons and the coffee houses and put it onto college campuses and into credited courses. As Andrew aptly states, "Cinema is not something to be understood instantly or argued about ideologically. It is an enormous field of inquiry which only patient and controlled study can progressively illuminate. This is the spirit of modern film study."[138] Lewis's assessment of Mitry's extraordinary study, is that "In all of the ways discussed--as a description of the film experience, as a paradigm and a problem-solver in the literature of film theory, as a theory of symbol, and as a theory of criticism--Jean Mitry's great aesthetic and psychology of the cinema invites detailed analysis."[139]

The most significant shift in contemporary critical thinking about film occurred during 1968. Along with editorial changes on key film magazines and on artists' experimenting with narrative conventions, the student uprisings in France solidified the desire of critics, filmmakers, and scholars to develop a "scientific" approach to film criticism and theory. As will be discussed in Chapters 3 and 7, CAHIERS DU CINEMA and different factions of LA NOUVELLE VAGUE led the way in drawing attention away from classical Hollywood narratives, and toward examining a "new cinema" influenced by Brecht's Marxist, materialist ideas.

At the same time, years of research in the study of language as a sign system inspired Christian Metz to publish ESSAIS SUR LA SIGNIFICATION AU CINEMA in 1968. By the time it was translated into English four years later as FILM LANGUAGE: A SEMIOTICS OF THE CINEMA, Peter Wollen had already begun to disseminate the concepts of semiology to English-language audiences with his seminal work, SIGNS AND MEANING IN THE CINEMA. What startled the film community was not only that the new approach brought film study back into the linguistic arena, but also that many of its advocates claimed that semiology made previous theories about film inoperative.

The strengths and weaknesses of semiology are covered in detail by theorists like Andrew and Henderson. Here, we need only skim the surface to illustrate the methodology. In essence, Metz in his first set of essays, and other writings that followed the 1968 publication, applied the theories of noted scholars like Ferdinand de Saussure, Sigmund Freud, and Carl Jung to a film theory based on the study of signs and codes. Instead of looking at influences external to the actual film, Metz and his followers scrutinize the film elements themselves to see how meaning is formed and communicated. The idea is to examine how filmmakers symbolically channel information. We are asked to study the raw material of the film. As Andrew points out, these include

1. images which are photographic, moving and multiple
2. graphic traces which include all written material which we read off the screen
3. recorded speech
4. recorded music
5. recorded noise or sound effects.[140]

The film semiologist concentrates on these elements, examining, for example, how the SIGNIFIED--a specific concept and reference point (the idea of a car)--is communicated--the SIGNIFIER, or message carrier (showing the car). Drawing parallels with more formal languages, the semiologist analyzes the connotations and denotations of the SIGNIFICATION (the relationship between the SIGNIFIED and the SIGNIFIER). Clearly there is a difference between how we define literally a Ford station wagon, and the social significance of owning one.

[138] THE MAJOR FILM THEORIES, p.188.

[139] Lewis, p.7.

[140] THE MAJOR FILM THEORIES, p.218.

The images of the SIGNIFIER are interpretated as units of meaning created by the filmmaker to influence our perceptions and reactions. As Peter Wollen explains Metz's approach, we discover "how the problem of the relationship of language, symbolism and iconography to the cinema is essentially the inverse of the problem of realism."[141] That is, in response to questions about how film reproduces reality or how it communicates through artificial and arbitrary means, Metz answers "that cinema can heighten natural expressivity and it can (indeed, almost must) inscribe it within a fictional 'story' which, as it were, transposes natural expressivity into a different key."[142]

When the relationship between a SIGNIFIED and a SIGNIFIER goes beyond a literal meaning to a symbolic one, it is labeled a TROPE. A series of related signs is called a CODE. As DeNitto explains, there are three basic codes:

> The first is societal: derived from a cultural environment (for example, the way characters in a motion picture dress). Another type of code includes the signs that cinema shares with other media, such as natural signs in a play, a film, and an opera. Finally, there are codes unique to cinema; visual montage is an example. No matter what the type, codes are not formulae that a filmmaker follows in creating a motion picture. They are critical constructs that enable the student of cinema to explore how what appears on the screen is perceived intellectually and emotionally by viewers.[143]

Semiologists also subdivide codes into smaller units. Attention is paid as well to morphological structures (e.g., linguistic units that deal with inflections, derivations, and word-forming/image-forming relationships). The emphasis, however, is on connotations and denotations.

As you may surmise, semiology's ties to structural linguistics are considerable. And therein lie its appeal and its drawbacks. While many modern critics and scholars who have their basic training in literature and language-based educational programs find semiotics invaluable in analyzing film, many other critics and scholars find the jargon and pseudo-scientific approach gibberish that obfuscates both the symbolic meaning of a film and the film experience.

Ever since Metz's ground-breaking ideas, film theory and film criticism have divided into three major camps. One camp is committed to classical film theory, arguing that the theories of Eisenstein, Bazin, and Kracauer are as relevant today, as in any period in film history. A second camp argues just the reverse. Skeptical of classical film theory, the contemporary school seeks to demystify film altogether. Building on the work of twentieth-century linguistics and applying the theories of modern scholars like Louis Althusser, Roland Barthes, Jacques Lacan, and Jacques Derrida, the opponents of classical film theory pursue the effect of film on individuals and society. The third camp are the eclectics, those theorists and critics who argue that the diversity of film demands a plethora of approaches rather than a single perspective. The names of the popular critics and the important journals that debate these issues are listed in Appendix I.

Approaching the warring camps without an understanding of the issues and points of departure is not only bewildering, but also frustrating. Fortunately, several recent books (to be described later) are now available. One of the best overviews of the current state of film theory is Dudley Andrew's CONCEPTS IN FILM THEORY. That is not to ignore its shortcomings, especially in the area of feminist criticism and theory. The contributions of the feminist movement will be discussed

[141] *Peter Wollen, READINGS AND WRITINGS: SEMIOTIC COUNTER-STRATEGIES (London: Verso Editions, 1982), p.5. To be precise, Wollen refers specifically to Metz's article "Le Cinema: Langue ou Langage?"

[142] Wollen, p.5.

[143] DeNitto, p.92.

in Chapter 3. Suffice it to say that Andrew's unwillingness to give it more visibility in his important overview of film theory indicates a weakness in his discussion of the structuralist and poststructuralist approaches to film. That being duly noted, his book is the most useful starting point for learning the basics about ahistorical theories that focus on the production of film texts, techniques for analyzing ideology in films, new interpretations about narrative structures, ideas about reception theories, and the widespread skepticism that pervades current interpretations of all previous studies on film history and audience analysis. These approaches will be discussed in the chapters that follow. Here we only want to highlight Andrew's frustration with current approaches that limit analysis to one overriding issue, whatever that issue is: e.g., stereotypes, structure, ideology, commerce, or reception. "How have we gotten into this state of affairs," he asks, "where direct approaches to the field are unfeasible, where theory aims at explanation or 'picturing' rather than at 'prediction' and 'verification' as it does in the sciences and social sciences?"[144] His descriptions of antihumanists who attack traditional theories on film, society, and aesthetics, while availing themselves of current developments in the general intellectual community have a ring of truth.

Nevertheless, the debates that have taken place over the past fifteen years have significantly altered my perspective on film. When the first edition of this book appeared, I firmly believed that film should be studied as a new language and that the best expressions of that language should be deemed "film literature." Why not? "Best" meant to me the representation on film of certain values, truths, attitudes, assumptions, and ethical judgments concerning humanity. Filmmakers were creative individuals who fashioned raw materials into significant works of art. And the study of film as literature represented an invaluable opportunity for students intent on becoming educated.

Moreover, I came armed with ammunition on why literature was not the sole province of the written word. For example, John Steinbeck wrote that

> . . . I run into people who seem to feel that literature is all words and that words should preferably be a little stuffy. Who knows what literature is? The literature of the Cro-Magnon is painted on the walls of the caves of Altamira. Who knows but that the literature of the future will be projected on the clouds? Our present argument that literature is the written word in poetry, drama, and the novel has no very eternal basis in fact. Such literature has not been with us very long, and there is nothing to indicate that it will continue with us very long (at least at the way it is going). If people don't read it, it just isn't going to be literature.[145]

Lennox Grey put it another way:

> It is conceivably historical accident that printing came before any other kinds of art reproduction, and that literature became a matter of letters instead of pictures.[146]

In short, film as literature made very good sense to an inexperienced film educator grounded in literary traditions and teaching in an English Department.

My discussion of film literature was predicated on three key assumptions. First, film is a new form of literature, one that represents the period in which it is created; it is uneven in quality, it has certain limitations, restrictions, and conventions, and

[144] *Dudley Andrew, CONCEPTS IN FILM THEORY (New York: Oxford University Press, 1984), p.4.

[145] John Steinbeck, quoted by *Neil Postman, TELEVISION AND THE TEACHING OF ENGLISH (New York: Appleton-Century-Crofts, 1961), p.40.

[146] Lennox Grey, "Communication and the Arts," THE COMMUNICATION OF IDEAS, Lyman Bryson, ed. (New York: Harper and Brothers, 1948), p.130.

it requires a certain selectivity when presented in the schools. The comparison between film and traditional literature is not meant to emphasize the dramatic and narrative qualities of film to the neglect of cinematic terms, but to show metaphorically the relationship of film to literature. The artist's situation with regard to film literature, for example, is similar to that of the artist who uses traditional literary language. The poet must write in terms of poetry; the dramatist in terms of drama; and the novelist in terms of narrative fiction. So, the filmmaker must work in terms of film. While filmmakers are creators of a new type of art form, it would be a mistake to disassociate the new form completely from traditional literature and from its purposes.

Second, the value of film goes beyond the realm of entertainment. Motion pictures have an effect upon the values and mores of mankind. As Erwin Panofsky writes:

> Whether we like it or not it is the movies that mold more than any other single force, the opinions, the taste, the language, the dress, the behavior, and even the physical appearance of a public comprising sixty per cent of the population of the earth. If all the serious lyrical poets, composers, painters and sculptors were forced by law to stop their activities, a rather small fraction of the general public would become aware of the fact and a still smaller fraction would seriously regret it. If the same thing were to happen with the movies, the social consequences would be catastrophic.[147]

Since English departments traditionally had been the repositories of taste and critical standards, they seemed the natural place to pursue a "literacy" in film.

Third, there is a need for teaching film in the colleges and public schools. It is a valuable and stimulating art form that communicates ideas and emotions of vital consequence to students and faculty alike. It influences our culture and our lives. If there is any possibility that education and art combined can improve our condition, we would be insane not to bring the art of the film into our classrooms.

The problems with that critical perspective return us to the issues that began this chapter. Having studied film theory for the past fifteen years, I have come to the conclusion that to perceive film as anything other than film is to misunderstand the unique qualities of film. While there are many useful links between film and all the arts, approaching film in anything other than its cinematic elements is not only counter-productive, but also naive. The second major point concerns the "best" or "masterpiece" approach. Although it is self-serving to boast that film is the equal of any art form, the fact is that the overwhelming majority of films WE see (not just the masses) are popular commercial products produced for profit. The quantity in no way matches the number of poor plays, books, and other works we are exposed to. They are certainly out there, but we are far more discriminating with them, than we are with film and television. Another dimension to the "masterpiece" argument is the issue of standards. Making room in the curriculum to study current theories on perception, representation, and identification helps considerably in rethinking the "masterpiece" route. For these reasons alone, it is important to study film as a commercial product that sometimes becomes art. Film as literature doesn't quite capture the idea. Third, films borrow from all the arts, not just literature. And as we become more comfortable with current theories on systems and ideologies, they offer valuable insights into how creation occurs and art results. Thus, to narrow our interest to literary analyses is to become as much reductionists as those who see film only as forms of ideology or representation. Fourth, the history of film is tied inexplicably to technology. It is important, therefore, to investigate how films are affected by technological development, a concept not made clear by referring to film as literature. Finally, current emphases on material determination, repressive

[147] Erwin Panofsky, "Style and Medium in the Moving Pictures," CRITIQUE 1:3 (January-February 1947). Rpt. FILM: AN ANTHOLOGY, ed. Daniel Talbot (New York: Simon and Schuster, 1959), pp.16-17.

ideology, the production of meaning, narrative structures, the positioning and questioning of the spectator, signification, and representation, all work well with literature in general. It is more helpful, however, to determine what is unique about film in relation to these topics, rather to than lump film with all the arts.

Having covered the reasons for film study, the commercial and collaborative nature of the film industry, its basic elements for communicating with the public, and the theories that are used to evaluate the works that artists and hucksters have produced for mass consumption, I offer, in the following chapters, six ways to examine the topics frequently discussed in the history of film study. There is no necessity to read those chapters sequentially. What is important is that you appreciate the complexity of the film experience and recognize that there are many gifted scholars working hard to advance our understanding of this unique medium. As for the best approach to film study, the one that I think offers the greatest advantages both to educators and to students, I honestly don't know. The more I have studied the writings of my gifted colleagues, the more I realize how little I know. Perhaps T. S. Eliot had the best advice about criticism, "The only method is to be very intelligent."

BOOKS

FILM CRITICISM

GENERAL

*Bellone, Julius, ed. RENAISSANCE OF THE FILM. New York: The Macmillan Company, 1970. Illustrated. 366pp.

This anthology is a collection of opinions by thirty-three critics about noteworthy films since 1940, and can used either for general reading, or for an introductory classroom text. Among the commentators are Eric Rhode, Andrew Sarris, Robert Brustein, James Agee, Pauline Kael, Jonas Mekas, Stanley Kauffmann, Norman H. Holland, and Vernon Young. Well worth browsing.

Blades, Joseph Dalton, Jr. A COMPARATIVE STUDY OF SELECTED AMERICAN FILM CRITICS, 1958-1974. New York: Arno Press, 1976. 227pp.

This is a straightforward and informative analysis of six "serious, competent film critics": John Simon, Pauline Kael, Stanley Kauffmann, Andrew Sarris, Judith Crist, and Vincent Canby. While some serious film student might debate the inclusion of Canby, almost every academic I checked is stunned by the appearance of Crist. To Blades's credit, he makes a valiant effort to show why the popular and trendy Crist is worthy of such distinguished company. Each critic is given a separate chapter and subjected to the same evaluative criteria: e.g., elements of style, special areas of concern, analysis of cinematic technique in reviews, and methods of persuading the reader. The concluding chapter does a nice job of summarizing the similarities and differences among the six critics. A bibliography is included. Well worth browsing.

*Boyum, Joy, and Adrienne Scott. FILM AS FILM: CRITICAL RESPONSES TO FILM ART. Boston: Allyn and Bacon, 1971. 397pp.

Emphasizing that their book offers a chance to study and practice good film criticism, Boyum and Scott explain that film exists only when it functions in tandem with its audience. "The perfect film," they argue, "is the one which makes everyone's work of art the same work of art in that it is so finely fashioned, so in charge of its own possibilities, that it precisely structures the shape of the film which the partnership will produce. From this point of view, the worst film is that which allows the viewer the greatest possible freedom in the realization of his work of art." Boyum and Scott divide their anthology into two parts: Theory and Practice. Section One explores the problems of treating film as an art; Section Two offers an excellent collection of critical reviews by popular critics on twenty-five important films: e.g., BLOW-UP (1966), BONNIE AND CLYDE (1967), 8 1/2/OTTO E MEZZO (1963), THE

GRADUATE (1967), JULES AND JIM/JULES ET JIM (1961), ROME, OPEN CITY/ROMA, CITTA APERTA (1945), THE SEVENTH SEAL/DET SJUNDE INSEGLET (1956), and VIRIDIANA (1961). A bibliography is included. Well worth browsing.

*Bywater, Tim, and Thomas Sobchack. INTRODUCTION TO FILM CRITICISM: MAJOR CRITICAL APPROACHES TO NARRATIVE FILM. New York: Longman, 1989. Illustrated. 238pp.

A valuable book for teaching the basics of film criticism, the practical authors organize their materials into individual chapters on the seven basic techniques of film criticism: journalistic, humanistic/theoretical, genre, social science, historical, and ideological/theoretical. The book, Bywater and Sobchack explain, "is organized on the basis of complexity of approach and the nature of the intended audience. It moves from the simplest approaches to the most difficult, from material aimed at the general reader and filmgoer to that written for specialists in film study." Particularly impressive is the frequent use in each chapter of capsule comments. For example, in the chapter on "The Auteurist Approach," we begin with terse comments about the audience ("General reader interested in film craftsmanship; film students and film scholars"), move to its functions ("Identify the person most responsible for the creation of a film. . . ."), subject ("Body of films attributable to a single individual. . . ."), writers ("Freelance professionals: film scholars"), and conclude with publications ("Highbrow journals. . . ."). Following a useful general discussion, the chapter ends with guidelines for writing AUTEURIST film criticism. Sample student papers, a chronology of film reviewing, criticism, and theory, bibliography, glossary, and index are included. Recommended for special collections.

Cadbury, William, and Leland Poague. FILM CRITICISM: A COUNTER THEORY. Ames: The Iowa State University Press, 1982. Illustrated. 304pp.

A complex and involved set of essays based on aesthetics and general linguistics, this speculative and challenging study works on the thesis that "aesthetic objects exist in some 'phenomenally objective' sense and that human minds are capable of understanding such works, including films, in a very active, productive, yet nonsubjective way." The combative authors are out to prove that not only is there an aesthetic experience, but also that perception can be uncoded and objective. Dividing their material into two major sections on "Film, Language, and Criticism," and "Authorship, Meaning, and Interpretation," Cadbury and Poague argue for cartesian aesthetics--that "which is neither impressionistic nor semiological, but rather symbolic in a sense, following Dan Sperber, theoretical but not scientific, grounded in a psychology to which psychologists themselves might assent." Particularly stimulating are the authors' ideas on the nature of film audiences. Endnotes, a bibliography, and index are included. Well worth browsing.

*Cardullo, Bert. INDELIBLE IMAGES: NEW PERSPECTIVES ON CLASSIC FILMS. Lanham: University Press of America, 1987. Illustrated. 289pp.

An ambitious collection of essays written mainly between 1980 and 1985, the anthology is arranged by subjects--e.g., "Literature into Film," "Comic Visions," "Tragic Variations," "Film as the Characterization of Space"--and offers perspectives on eighteen films from WAY DOWN EAST (1920), to NASHVILLE (1975). The brevity of the essays works against Cardullo's desire to provide insightful observation on complex issues. A filmography is included, but no footnotes, bibliography, or index. Approach with caution.

Cooke, Alistair, ed. GARBO AND THE NIGHT WATCHMAN: A SELECTION FROM THE WRITINGS OF BRITISH AND AMERICAN FILM CRITICS. London: Cape, 1937. 352pp. New York: McGraw-Hill Book Company, 1971. Illustrated. 285pp.

One of the legendary anthologies on film criticism, this collection incorporates the views of nine literate and elegant critics--Robert Herring, Don Herold, John Marks, Meyer Levin, Alistair Cooke, Robert Forsyte, Graham Greene, Otis Ferguson, and Cecelia Ager--and offers a provocative set of perspectives on the state of film during the Depression. Originally intended as "a casual chronicle of pleasure and pain in the movies" written by "people who earn their bread and butter by dashing from meals to movies," it has become a model of first-rate criticism by individualists who "have a personal point of view and the ability to express it crisply, or passionately, or drolly or entertainingly, but above all intelligently." In addition to the work's historical value, it contains some of the most savage criticism ever assembled in one volume prior to the critical writings of the 1950s. An index is included. Highly recommended for special collections.

*Denby, David, ed. AWAKE IN THE DARK: AN ANTHOLOGY OF AMERICAN FILM CRITICISM, 1915 TO THE PRESENT. New York: Vintage Books, 1977. 397pp.
An enjoyable collection of various approaches to American film criticism, this book contains examples of the writings of the most famous critics in film history. Arranged chronologically, the material is divided into seven major sections: "In Defense of a Popular New Art Form," "Film as High Art," "Critical Method," "Genres," "Directors," "Performers," and "Entertainment." The best part, however, is Denby's intelligent overview of film criticism. The editor points out a number of serious charges against American film journalism--e.g., "critics want to be media stars; .
. . they have an insatiable need to dominate public opinion or seduce public approval; . . . their bouts of squabbling are tiresome and unilluminating--mere personal quarrels masked as conflicts of principle; . . . they spend too much time dramatizing themselves and not enough time reviewing the movie at hand; . .
. when they finally get around to the movie they don't stick to the point but bring in 'irrelevant' sociological or political speculations; . . . [and] American criticism is congenitally shallow and intellectually feeble--that it lacks an 'intellectual center.'" Denby's response to these complaints and his reasons for structuring the book as he does are well worth reading. Recommended for special collections.

English, John W. CRITICIZING THE CRITICS. New York: Hastings House, 1979. 240pp.
An overlooked and informative analysis of the history and functions of critics in architecture, the arts, and dining out, this useful study suffers from a matter-of-fact tone and dry prose. Nevertheless, anyone browsing though English's six intelligent chapters on the multiple roles that critics assume and the effects of their criticism should be impressed by his commonsense study of the critic's job, and the challenges it offers. Particularly interesting is the author's discussion of the ethical traps critics can fall into. An index is included. Well worth browsing.

*"The Film Issue," ARTS IN SOCIETY 4:1 (Winter 1966-67).
This is a useful and critical collection of articles by such respected writers as Ernest Callenbach, Richard Dyer MacCann, Colin Young, Willard van Dyke, George Amberg, and Robert Steele. In addition, there is some wonderful material on Robert Rossen, the early years of movies, and a symposium on film by thirteen motion picture directors. The book is beautifully illustrated. Well worth browsing.

*Hochman, Stanley, ed. FROM QUASIMODO TO SCARLETT O'HARA: A NATIONAL BOARD OF REVIEW ANTHOLOGY 1920-1940. Introduction. Robert Giroux. New York: Frederick Ungar Publishing Company, 1982. Illustrated. 432pp.
Ever since 1909, the National Board of Review of Motion Pictures has been championing the art of the film. The original plan was to use quality as an argument against censorship. Thus, every film distributed with the board's seal, "Passed by the National Board of Review," in the opening frames of the movie helped ward off local, state, and national interference in the film industry. By the twenties, however,

Hollywood established its own form of censorship and the National Board of Review turned to publishing its views. This anthology presents the judgments of the board reviewers, many of them prominent critics like Alistair Cooke, Gilbert Seldes, Iris Barry, Jay Leyda, Richard Griffith, and Harry Alan Potamkin. Cast credits, plot summaries, and critical commentaries were the core of THE NATIONAL BOARD OF REVIEW MAGAZINE. An index is included. Well worth browsing.

*Hughes, Robert, ed. FILM: BOOK 1--THE AUDIENCE AND THE FILMMAKER. New York: Grove Press, 1959. Illustrated. 185pp.
 A rich collection of essays on cinematic art in a commercial film industry, this valuable anthology contains provocative essays written by Siegfried Kracauer, Arthur Knight, Frances Flaherty, George Stoney, Federico Fellini, James Agee, Cesare Zavattini, and Jonas Mekas. The best piece, however, is a symposium of leading American and European filmmakers discussing their problems. Recommended for special collections.

*Hughes, Robert, ed. FILM: BOOK 2--FILMS OF PEACE AND WAR. New York: Grove Press, 1962. Illustrated. 255pp.
 One of the most praised critical anthologies of the 1960s, this book contains candid discussions of the problems that filmmakers have in making war movies. In addition to hearing from filmmakers like Francois Truffaut, Jean Renoir, Stanley Kramer, Dore Schary, and John Huston, Hughes provides the complete scripts of Huston's then-banned World War II documentary LET THERE BE LIGHT (1945), and Alain Resnais's NIGHT AND FOG/NUIT ET BROUILLARD (1955). Highly recommended for special collections.

*Huss, Roy, and Norman Silverstein. THE FILM EXPERIENCE: ELEMENTS OF MOTION PICTURE ART. New York: Harper & Row, 1968. Illustrated. 172pp.
 The authors' intentions are to increase the filmgoer's perception through three critical methods: (1) a discussion of AUTEUR directors such as D. W. Griffith, Jean-Luc Godard, and Akira Kurosawa, and the development of their techniques; (2) an analysis of the social significance evident in specific movies; and (3) an evaluation of the effect that films create. In eight well-written chapters dealing with the important elements in film technique, Huss and Silverstein effectively use stills, diagrams, a graphic storyboard presentation, and a host of fine filmic examples to illustrate many abstract concepts. An index is included. Well worth browsing.

*Jacobs, Lewis, ed. INTRODUCTION TO THE ART OF THE MOVIES: AN ANTHOLOGY OF IDEAS ON THE NATURE OF MOVIE ART. New York: The Noonday Press, 1960. Illustrated. 302pp.
 Jacobs's purpose is to survey the nature of film art through a collection of thirty-six articles written from 1920 to 1960. Particularly noteworthy are essays by Herman G. Weinberg, Dorothy B. Jones, Jay Leyda, Seymour Stern, Dwight Macdonald, Paul Goodman, Maya Deren, Dudley Nichols, Hans Richter, and Slavko Vorkapich. Well worth browsing.

*Jacobs, Lewis, ed. THE EMERGENCE OF FILM ART: THE EVOLUTION AND DEVELOPMENT OF THE MOTION PICTURE AS AN ART FROM 1900 TO THE PRESENT. New York: Hopkinson and Blake, 1969. Illustrated. 453pp.
 Don't be deceived by the title of this book, which suggests a heavy emphasis on historical matters. Jacobs skips quickly from country to country with little chronological transition, and after the early 1930s the selections are almost all theoretical and not bound to a specific period. But it is a superb collection of essays on the art of the cinema as seen through the eyes of some outstanding film critics. Especially noteworthy are articles by Lewis Jacobs, Seymour Stern, Sergei M.

Eisenstein, Alberto Cavalcanti, John Howard Lawson, Robert Flaherty, Earl Anderson, Harold Benson, Ingmar Bergman, Andrew Sarris, Pauline Kael, Donald Richie, Michelangelo Antonioni, Vernon Young, Jonas Mekas, and Stanley Kauffmann. An index is included. In light of the new edition, skip this one and buy the second edition. Worth browsing.

*Jacobs, Lewis, ed. THE EMERGENCE OF FILM ART: THE EVOLUTION AND DEVELOPMENT OF THE MOTION PICTURE AS AN ART FORM FROM 1900 TO THE PRESENT. 2nd ed. New York: W. W. Norton & Company, 1979. 544pp.
 A hundred pages more of a good thing, this new edition brings the historical overview up to the end of the seventies. Among the new material are articles about Yasujiro Ozu, Jean-Luc Godard, Luis Bunuel, Robert Bresson, and the Czech New Wave. Recommended for special collections.

Khatchadourian, Haig, ed. MUSIC, FILM, AND ART. New York: Gordon and Science Publishers, 1985. 222pp.
 A collection of thirteen essays on aesthetics and on the philosophy of the arts, this stimulating book raises worthwhile questions about AVANT-GARDE films. "The first nine essays," as Khatchadourian explains, "deal with important aesthetic issues in a number of major art forms and genres: music, painting and sculpture, literature, dance, theatre, and film. The central issues are the identity--or ontological status--and the nature--or some important features and aspects--of the particular art form or genre." The remaining four essays explore problems related to all the arts. An index is included. Well worth browsing.

*Kinder, Marsha, and Beverle Houston. CLOSE-UP: A CRITICAL PERSPECTIVE ON FILM. New York: Harcourt Brace Jovanovich, 1972. Illustrated. 395pp.
 Kinder and Houston, in a cleverly designed book on film aesthetics, base their inductive approach "on the assumption that critical words can broaden the range of films one can respond to, and ultimately lead to an intensification of subjective response." Nine thought-provoking chapters emphasize the importance of leaving the definition of art open-ended. The many film examples and intelligent discussions reinforce the authors' premise that we should be receptive to breakthroughs in filmmaking and not be rigid about what constitutes the art of the film based on prior experiences. A basic assumption the authors have of cinema "is that its power as a medium derives from its unique capacities to represent the external, objective world and to express the subjective reality of a personal vision." One section of the books offers cinematic examples from the silent era. A second section focuses on the documentary and genres. A third section deals with film technology and underground filmmaking. A fourth section discusses three cinematic movements of realism. A listing of the films cited and their 16mm distributors plus an index adds to the book's value for classroom use. Recommended for special collections.

*Kauffmann, Stanley, with Bruce Henstell, eds. AMERICAN FILM CRITICISM: FROM THE BEGINNINGS TO "CITIZEN KANE." New York: Liveright, 1972. 443pp.
 A fascinating approach to collecting the writings of American critics on American and foreign films, Kauffmann and Henstell arrange the material chronologically by film title, rather than by the name of the critic. "The plan," Kauffmann explains, "was to trace a way through the early years of American criticism using memorable films as guideposts, rather than the names of unremembered critics remembered otherwise." Most of all, the authors want to establish that there WAS serious film criticism before James Agee. The anthology concludes with CITIZEN KANE (1941) "because it came at the right time for the second purpose and because it is a peak that contrasts dramatically with the beginning." Endnotes, a bibliography, and index are included. Recommended for special collections.

Linden, George W. REFLECTIONS ON THE SCREEN. Belmont, Calif.: Wadsworth Publishing Company, 1970. Illustrated. 297pp.
Central to understanding this book is Linden's premise that films have a dual nature that synthesizes a variety of life experiences, which are discussed in terms of contrasting relationships such as outer-inner worlds and objective-subjective experiences. If you can get by some of the verbosity, you'll find it very helpful in exploring film in relation to the more traditional arts. Worth browsing.

Lounsbury, Myron Osborn. THE ORIGINS OF AMERICAN FILM CRITICISM 1909-1939. New York: Arno Press, 1973. 547pp.
Originally written as Lounsbury's 1966 University of Pennsylvania doctoral dissertation, this valuable study provides a detailed look at the evolution of serious film criticism from 1909, when the issue of aesthetic standards first became a topic of public discussion, to 1939, the publication of Lewis Jacobs's classic study on American film. "More specifically," the author explains, "the study examines the evolution of the body of literature to determine the extent to which 'liberal' attitudes and matters of aesthetic form have entered into serious motion picture evaluation and analysis. . . ." Thus, little attention is paid to trade publications and fan magazine pronouncements. Instead, the author combs the pages of serious publications aimed at the general public for evidence of significant film criticism. At the same time, the book's five detailed chapters indicate important factors outside of film criticism that influenced the debates on the nature of the medium: e.g., censorship, technological breakthroughs, economic crises, and stylistic developments in foreign countries. Particularly effective is Lounsbury's technique of letting the critics speak for themselves, allowing us to appreciate not only their style, but also the growth of a vocabulary for discussing film. An extensive bibliography and index are included. Recommended for special collections.

*MacCann, Richard Dyer, ed. FILM: A MONTAGE OF THEORIES. New York: E. P. Dutton and Company, 1966. 384pp.
This well-organized anthology contains thity-nine stimulating essays written by important filmmakers and critics. MacCann, hoping to shed some light on the controversies surrounding the art of the film, has grouped conflicting and valuable points of view under five main titles: "The Plastic Material," "Film and the Other Arts," "The Cinematic Essence," "Dream and Reality," and "An Evolving Art." Particulary enjoyable are the observations of Parker Tyler, Hollis Alpert, Rudolf Arnheim, George Bluestone, V. I. Pudovkin, Rene Clair, Dudley Nichols, Mack Sennett, Pauline Kael, and Francois Truffaut. Well worth browsing.

Manvell, Roger. WHAT IS A FILM? London: Macdonald & Company, 1965. Illustrated. 184pp.
A dry introduction to the history and nature of filmmaking, this introductory book reads more like an extended essay, than a serious examination of the medium. Manvell tries to lead an unsophisticated audience through the stages of film production and to explain how the film industry operates. An index is included. Worth browsing.

*Montagu, Ivor. FILM WORLD: A GUIDE TO CINEMA. Baltimore: Penguin Books, 1964. Illustrated. 327pp.
Although this is another politically biased treatise--avowedly pro-Soviet and anti-West--Montagu provides some excellent chapters on the art of the film and gives invaluable suggestions for beginning students on what to look for in film analysis. Of the four uneven chapters, the most practical and useful section is the third, on film as a commodity. The first two demonstrate Montagu's Aristotelian urge to list, and the last chapter on film as a vehicle for communicating reality can easily be avoided. An index is included. Well worth browsing.

Murray, Edward. NINE AMERICAN FILM CRITICIS: A STUDY OF THEORY AND PRACTICE. New York: Frederick Ungar Publishing Company, 1975. 248pp.
 A fine summary and critique not only of prominent critics, but also of current critical practices, this absorbing book reads extremely well and contains valuable insights into the work of James Agee, Robert Warshow, Andrew Sarris, Parker Tyler, John Simon, Pauline Kael, Stanley Kauffmann, Vernon Young, and Dwight Macdonald. The best parts are those that compare and contrast the critics to each other. Murray has a gift for making complex ideas readily accessible and for synthesizing years of reviewing into perceptive summary paragraphs. In addition, he provides a marvelous appendix about filmmakers reacting to critics.[148] One of my favorites is Lindsay Anderson's observation that "The more vicious a critic is in print, the more cowardly in person." An index is included. Recommended for special collections.

Schickel, Richard, and John Simon, eds. FILM 67/68: AN ANTHOLOGY OF THE NATIONAL SOCIETY OF FILM CRITICS. New York: Simon and Schuster, 1968. 320pp.
 The first in a series of annual anthologies containing the best reviews and essays by the members of the National Society of Film Critics, it provides a valuable perspective on sixty-one films covered in 1967. The organization was founded in 1966 and, as Stanley Kauffmann explains, has four specific purposes: (1) to honor the best film, the best director, the best leading performers (male and female), and the best screenplay, (2) to promote outstanding films, (3) to voice opposition to industry practices considered injurious to the public interest or to films, and (4) to develop a collegial attitude among critics. Decisions on the first three functions are determined by majority vote. The awards in 1967 went to Ingmar Bergman's PERSONA for Best Film, Bergman for Best Director, Rod Steiger (IN THE HEAT OF THE NIGHT) for Best Actor, Bibi Anderson (PERSONA) for Best Actress, Gene Hackman (BONNIE AND CLYDE) for Best Supporting Actor, Majorie Rhodes (THE FAMILY WAY) for Best Supporting Actress, and David Newman and Robert Benton (BONNIE AND CLYDE) for Best Screenplay. In addition to the stimulating reviews, the book contains essays on the underground film, the notable events of the year, and a symposium on the future of film. An index is included. This volume and the successive volumes are recommended for special collections.

Slide, Anthony, ed. SELECTED FILM CRITICISM 1951-1960. Metuchen: The Scarecrow Press, 1985. 186pp.
 Part of a six-part series that begins with film criticism written in 1896, this concluding anthology contains the last set of selected contemporary reviews of the more than 1,100 films released in America between 1896 and 1960. The one thing you can always count on in a work by Slide is that it will contain information not found anywhere else. Here he has selected reviews from AMERICA, COMMONWEAL, CUE, FILM CULTURE, FILMS IN REVIEW, FORTNIGHT, LIBRARY JOURNAL, MCCALL'S, THE NEW YORKER, and NEWSWEEK that have not been anthologized elsewhere. The views of the 128 critics or reviewers, selected for their historical significance, are printed in their entirety. An index of reviewers and an index of film titles are included. Well worth browsing.

*Solomon, Stanley J., ed. THE CLASSIC CINEMA: ESSAYS IN CRITICISM. New York: Harcourt Brace Jovanovich, 1973. Illustrated. 354pp.
 An effective teaching tool for film appreciation courses, this book tries to downplay controversy, and to stress film analysis. Solomon chooses fourteen films, most of them fairly recent, that "REPRESENT the classic tradition in the cinema or,

[148] For examples of playwrights reacting to critics, see Mel Gussow, "When Writers Turn the Tables Rather than the Other Cheek," NEW YORK TIMES H (July 16, 1989):5-6.

more specifically, the Western World's part in that tradition." The selections are based not only on film quality, but also on the reputation of the filmmakers, and on the films' value in discussing "distinctive styles and historical developments within the major tradition in narrative film." Each film is treated separately with cast and credit information followed by an introduction and then a trio of critical essays. You can judge the book's value by considering the films chosen: BATTLESHIP POTEMKIN/BRONENOSETS POTEMKIN (1925), THE GOLD RUSH (1925), THE PASSION OF JOAN OF ARC/LA PASSION DE JEANNE D'ARC (1928), M (1931), THE RULES OF THE GAME/LA REGLE DU JEU (1939), CITIZEN KANE (1941), BICYCLE THIEVES/LADRI DI BICICLETTE (1948), THE SEVENTH SEAL/DET SJUNDE INSEGLET (1957), VERTIGO (1958), RED DESERT/IL DESERTO ROSSO (1964), BELLE DE JOUR (1967), and FELLINI SATYRICON (1969). A filmography, bibliography, and index are included. Well worth browsing.

Sontag, Susan. AGAINST INTERPRETATION AND OTHER ESSAYS. New York: Farrar, Straus and Giroux, 1966. 304pp.
 Only six of twenty-six chapters are directly about motion pictures, but Sontag's first two chapters are quite effective in cautioning us against overanalyzing a work of art to the point where it destroys our interest or love for the opus itself. Also useful reading is her highly praised essay "Notes on 'Camp.'" Well worth browsing.

*Talbot, Daniel, ed. FILM: AN ANTHOLOGY. New York: Simon and Schuster, 1959. 651pp.
 Although there is an abridged paperback edition of this splendid anthology available from the University of California Press, it is worth paying the extra money to get this complete collection of superb essays. The first section--"Aesthetics, Social Commentary and Analysis"--has some of the most significant articles ever published on film, including Erwin Panofsky's "Style and Medium in the Moving Pictures," Allardyce Nicoll's "Film Reality: The Cinema and the Theater," Susanne Langer's "A Note on the Film," James Agee's "Comedy's Greatest Era," and Robert Warshow's "The Westerner." In the other two sections, the reader will find equally important essays by V. I. Pudovkin, Bela Balazs, Rudolf Arnheim, Sergei M. Eisenstein, Rene Clair, Jean Cocteau, Paul Rotha, Lewis Jacobs, Siegfried Kracauer, and Georges Sadoul. An index is included. Highly recommended for special collections.

Thomson, David. MOVIE MAN. New York: Stein and Day, 1967. Illustrated. 233pp.
 Here is a good discussion of the complexities of film expression by the use of literary analogies and sociological speculations. For those who are already into serious film study, Thomson provides some useful insights into the works of Alfred Hitchcock, Fritz Lang, Howard Hawks, Jean Renoir, Jean-Luc Godard, Anthony Mann, and Joseph Losey. Well worth browsing.

*Youngblood, Gene. EXPANDED CINEMA. Introduction R. Buckminster Fuller. New York: E.P. Dutton and Company, 1970. Illustrated. 432pp.
 Arguing as a post-McLuhanite, Youngblood claims that new technological extensions of film have become mandatory. Consequently, he offers an unusual and perceptive account of such advanced breakthroughs as computers, films, television experiments, laser movies, and multiple-projection environments. A bibliography and index are included. Well worth browsing.

FILM CRITICS

RENATA ADLER

Adler, Renata. A YEAR IN THE DARK: JOURNAL OF A FILM CRITIC 1968-69. New York: Random House, 1969. 355pp.

Born in Milan, Italy, reared in Danbury, Connecticut, trained in comparative literature, and from January 1968 to March 1969, the film critic for THE NEW YORK TIMES, Adler is a good case study of what can happen to a person who goes too far in criticizing mainstream films. Her elitist approach is most clearly shown in this enjoyable collection, but particularly her analysis of STAR! (1968). The two-paragraph review that appeared on October 23, 1968, begins with Adler stating that Julie Andrews "is not at her best" in depicting the life of Gertrude Lawrence. After noting the clash in style between Andrews's "special niceness and innocence," and the director Robert Wise's attitude toward the film biography, the critic knocks the dialogue, the film's emphasis on infidelity, and the music. Adler then points out that "The movie, with intermission (by some convention that makes it possible to charge theater prices for mammouth musicals), is three hours long and it has the rickety structure of a movie within a movie." She then concludes by acknowledging that those people who like old-fashioned musicals might enjoy this film, "But people who like Gertrude Lawrence had better stick with their record collections and memories." You can just tell readers of a major newspaper to stay home so many times before the advertising folks pick up the phone and explain the "facts" of the film industry to the boss. While there are reasons why Adler's matter-of-fact reviews usually don't appeal to serious readers on a steady basis, this collection illustrates why she deserves more attention than she has gotten. Regrettably, no index is included. Worth browsing.

JAMES AGEE

Agee, James. AGEE ON FILM, VOLUME ONE: REVIEWS AND COMMENTS. New York: Grosset & Dunlap, 1967. Illustrated. 433pp.

During the 1940s, Agee wrote reviews for TIME and THE NATION. His wide-ranging perspectives and marvelous imagination influenced both the public and filmmakers on the unique possibilities of films for art and social reform. Included in this collection of reviews and critical pieces are many memorable articles, including the seminal essay, "Comedy's Greatest Era." An index is included. Recommended for special collections.

Agee, James. AGEE ON FILM, VOLUME TWO. Foreword John Huston. New York: Grosset & Dunlap, 1967. 489pp.

Agee's enthusiasm for film extends beyond criticism to screenwriting. This valuable publication provides his scenarios for NOA NOA (a script Agee was working on at the time of his death in 1955), THE AFRICAN QUEEN (1951), THE NIGHT OF THE HUNTER (1955), THE BRIDE COMES TO YELLOW SKY (1952), and his first script, THE BLUE HOTEL (written in 1948-49). Recommended for special collections.

Barson, Alfred T. A WAY OF SEEING: A CRITICAL STUDY OF JAMES AGEE. Amherst: The University of Massachussets Press, 1972. 218pp.

"I have attempted," Barson explains, "to identify the sources of Agee's art in his life and his times and to trace its development and decline." Wrestling with the scope and size of his work--e.g., poetry, journalism, screenwriting, social commentary, and novels--the author focuses primarily on Agee's books: LET US NOW PRAISE FAMOUS MEN (1941), A DEATH IN THE FAMILY (published posthumously in 1957), and THE MORNING WATCH (1951). Interestingly, Barsam, who began this project as a doctoral dissertation, views Agee's departure from TIME in 1948 and his turning to screenwriting from that time until his death on May 16, 1955, as a period of decline. According to Barson, ". . . while I believe Agee was working harder

in his last years, with even more discipline, I also believe that he was not working any better." The problem, as the author describes it in his provocative analysis, stemmed from Agee's efforts to fit into the Hollywood mode. Endnotes and an index are included. Well worth browsing.

Madden, David, ed. REMEMBERING JAMES AGEE. Baton Rouge: Louisiana State University Press, 1974. Illustrated. 172pp.
 "Few writers," Madden writes, "have been as obsessed as Agee was with analyzing the difficulties of the creative process, and in the works of few writers has the suffering of the artist's vision been so much the subject of the work." To illustrate that thesis, the author presents twelve touching and objective perspectives by Agee's wife, friends, and associates covering the critical periods of his life. Included as well is a collection of rare photographs of Agee. A chronology of his life and works concludes the nostalgic anthology. Well worth browsing.

Snyder, John J. JAMES AGEE: A STUDY OF HIS FILM CRITICISM. New York: Arno Press, 1977. 229pp.
 Orginally written as Snyder's 1970 St. John's University doctoral dissertation, this valuable study on one of America's legendary critics examines Agee's film criticism from 1941 to 1948 in a variety of contexts. "It is compared and contrasted," the author explains, "with the theories and practices of other critics, theorists, and film-makers." The historical developments in cinematic theory and practice, which took place before and after Agee's tenure as movie reviewer, are also examined. Finally, Agee's criticism is placed in the context of his entire non-critical writings, from the earlier FORTUNE articles to the script of NOA NOA, one of his last works." Particular attention is paid to Agee's attacks on Hollywood, the Motion Picture Code, and the tastes of the general movie audience; to his forging an aesthetic compromise between realism and fantasy exemplified by, but not limited, to the "poetic realism" found in neo-realism; to his prioritizing humanistic values evident in theme, story, characters, setting, and style over the mechanics of filmmaking; to his arguing for the value of sound in the art of the film; and to his passionate prose stye. A bibliography is included. Recommended for special collections.

HOLLIS ALPERT

Alpert, Hollis. THE DREAMS AND THE DREAMERS: ADVENTURES OF A PROFESSIONAL MOVIE GOER. New York: The Macmillan Company, 1962. 258pp.
 One of the unrecognized influential critics of the late 1950s and sixties, Alpert was the film critic for THE SATURDAY REVIEW during the time of great changes in the film industry. The material anthologized in this book consists of a series of essays about filmmaking and about the people who capture the spotlight. The emphasis is on impressions rather than on a systematic analysis. Although Alpert's work lacks a coherent structure and borders on superficiality, it is very useful in capturing the flavor of the period. Worth browsing.

PETER BOGDANOVICH

Bogdanovich, Peter. PIECES OF TIME. New York: Arbor House, 1973. 269pp.
 One of the few collections of criticism by a prominent American director, this anthology presents Bogdanovich's pieces for ESQUIRE during the sixties and early seventies. The insights he provides from a director's perspective are better than his prose style, and represent a brashness that is typical of the youthful filmmaker (most of the pieces were written before he was thirty). Although they often seem to be cheering Hollywood more than is usual for a serious critic, the essays collectively give us lively opinions about controversial films, and even more controversial personalities. For example, "Selznick's contribution to American movies was important but he was not an artist. He never went all the way. Capra was and did."

Or "They say television has replaced the B-Movie, but it's not true. The reason why the 'second feature' was so often able to achieve such vigor and interest is that it was made, so to speak, while no one was looking." And just for good measure, "John Wayne's performances in . . . [films directed by Howard Hawks and John Ford between 1947 and 1962] rate with the finest examples of movie acting." An index is included. Well worth browsing.

JUDITH CRIST

Crist, Judith. THE PRIVATE EYE, THE COWBOY AND THE VERY NAKED GIRL: MOVIES FROM CLEO TO CLYDE. New York: Holt, Rinehart and Winston, 1968. 292pp.
 A critic popular with the general public and a specialist in fast, no-nonsense reviews, Crist is someone who gives you a quick, clever reaction rather than a serious film analysis. She's fun to read and always ready with a gutsy opinion. The anthology consists of five amusing sections of reviews, filled with clever quips and controversial judgments on foreign filmmakers. An index is included. Well worth browsing.

SIDONIE-GABRIELLE COLETTE

*Colette. COLETTE AT THE MOVIES: CRITICISM AND SCREENPLAYS. Eds. Alain and Odette Virmaux. Trans. Sarah W. R. Smith. New York: Frederick Ungar Publishing Company, 1975. Illustrated. 213pp.
 "One of the great writers of her generation," Smith points out, "the French novelist Colette through her early film criticism and screenwriting had as important a role in the development of cinema as its first defender in America, Vachel Lindsay, or her great co-workers in France, Louis Delluc and Germaine Dulac." She began her defense of film in 1914 and had a hand in educating the public to the gifts of noted directors. After World War II, Colette succumbed to the literary snobbery of her day and downplayed the value of her earlier writings on movies. She even omitted her reviews from a 1948 edition of her collected works. Fortunately, this volume corrects that regrettable decision and offers us almost all of Colette's ideas on movie stars and popular films. In addition, we get two of her screen scenarios, a tongue-in-cheek piece entitled, "A Short Manual for the Aspiring Scenario Writer," and a Colette filmography. Well worth browsing.

BOSLEY CROWTHER

Beaver, Frank Eugene. BOSLEY CROWTHER: SOCIAL CRITIC OF FILM 1940-1967. New York: Arno Press, 1974. 187pp.
 Originally written as Beaver's 1970 University of Michigan doctoral dissertation, this useful study covers the work of the man who has had the most extensive film reviewing career in journalism. For twenty-seven years (1940-1967), Crowther was the most powerful critic on the American scene, explaining to readers of THE NEW YORK TIMES why film was a popular art form, but also an important social force. Two assumptions, according to Beaver, were at the heart of Crowther's reviews: "First, the screen can reveal the realities of life through the camera's unique ability for showing things as they are. Films can, potentially, both please and teach. Second, motion picture audiences are impressionable and, therefore, films can play a part in shaping filmgoer attitudes by the views and values contained in motion pictures." Those biases are apparent throughout the critic's career and help explain why he fought so hard to gain freedom of expression for the movies. Beaver does a good job in summarizing Crowther's strengths and weaknesses as a critic, often pointing out why the reviewer objected so strongly to the increasing use of violence and explicit sex in contemporary films. In addition to a useful bibliography, the book includes Crowther's annual lists of "Ten Best" films. Well worth browsing.

MANNY FARBER

Farber, Manny. NEGATIVE SPACE: MANNY FARBER ON THE MOVIES. New York:
Praeger Publishers, 1971.288pp. Published in paperback as *MOVIES. New York:
Hillstone, 1971. Illustrated. 288pp.
 This important anthology brings together twenty-five years of film criticism of
a highly influential American critic who dealt superbly with the appeal of "B" films
made by such then-unrecognized directors as Sam Fuller, Howard Hawks, and Don
Siegel--the same man who taught the general public to recognize the virtues of
"underground cinema" (a term he coined). "Space," Farber explains in the book's
significant introduction, "is the most dramatic stylistic entity . . . How an artist
deploys his space, seldom discussed in film criticism, but already a tiresome word
of the moment in other art, is an anathema to newspaper editors, who believe readers
die like flies at the sight of esthetic terminology." He then adds that "If there were
a textbook on filmic space, it would read: 'There are several types of movie space,
the three most important being: (1) the field of the screen, (2) the psychological
space of the actor, and (3) the area of experience and geography that the film
covers.'" Farber's highly personal style and imaginative insights are then revealed
in perceptive essays on underground films, now noted directors, and the film
industry. An index is included. Recommended for special collections.

OTIS FERGUSON

Wilson, Robert, ed. THE FILM CRITICISM OF OTIS FERGUSON. Foreword Andrew
Sarris. Philadelphia: Temple University Press, 1971. 475pp.
 Ferguson, the film critic for THE NEW REPUBLIC from 1934 to 1941, was an
extremely influential commentator. His obvious love of the movies and his witty,
perceptive observations made him a favorite with critics and the public. Following
his tragic death at age thirty-six in 1943, Ferguson's work disappeared from public
scrutiny. Therefore, except for the occasional reference by an informed historian or
by a generous colleague who paraphrased one of his ideas, the modern generation
knew little about him. Thus there was much to applaud when Wilson gathered nearly
eighty percent of Ferguson's writings into a single volume. The significance of the
anthology is underscored by Sarris's pronouncements that Ferguson "is the one
American movie critic who most closely resembles Bazin" and that he may be "the
writer of the best and most subtly influential criticism ever turned out in America."
Two indexes are included. Recommended for special collections.

PENELOPE GILLIATT

Gilliatt, Penelope. THREE-QUARTER FACE: REPORTS & REFLECTIONS. New York:
Coward, McCann & Geoghegan, 1980. 295pp.
 Novelist, short story writer, and screenwriter, Gilliatt has been a film and
theater critic for more than twenty years. Her most notable criticism has been for
THE OBSERVER and THE NEW YORKER. In this anthology of conversations with many
of the world's leading filmmakers, she offers controversial opinions about the art of
the film and the problems of working in a commercial industry. The major drawback,
however, is the author's emphasis on meaningless information. Consider this example:
"Woody Allen lay down in a commando position with a BB gun on his New York East
Side terraces, outside a pair of French windows, and took potshots at some pigeons
that fondly think he wants them there and that he emphatically does not. Feathery
things seem to bother him: dowagers' fussy hats, bouffant hairdos, pigeons most of
all. His penthouse duplex is a pigeon heaven, and nothing he tries seems to turn it
into a purgatory for them." I really expected more from an artist whose memorable
screenplay, SUNDAY, BLOODY SUNDAY (1971), received a much deserved Oscar
nomination. An index is included. Worth browsing.

Gilliatt, Penelope. UNHOLY FOOLS--WITS, COMICS, DISTURBERS OF THE PEACE: FILM & THEATER. New York: The Viking Press, 1973. 373pp.

Here is Gilliatt at her best, writing clever, insightful, and highly entertaining pieces about actors, film, and genres. The essays are from various American and British periodicals she has contributed to over a thirteen year period (1960-1973) and are divided into ten major sections pretentiously labeled "Marooned," "Cogitators," "Last-Ditch Wits," "Physicists," "Farce-Makers," "Scamps," "The Dandies, The Bunglers of Taste," "Disrupters," "Rotten-Jokes," and "Prodigals." As you may glean from this list, her focus is mainly on comedy. Fortunately, the comments often explore the history of comedy and not just the works of the sixties. Although some attention is given to theatrical reviews, the primary emphasis is on films. An index is included. Recommended for special collections.

PAULINE KAEL

*Kael, Pauline. DEEPER INTO MOVIES. Boston: Little, Brown and Company, 1973. 458pp.

Few critics in film history have expressed a greater love for films, been more perceptive about the art of the film, or been more idolized by their readers than this author. Her work is characterized by a superb grasp of film history, a razor sharp wit, a marvelous autobiographical writing style, and a deep commitment to popularizing the art of American film. At times, Kael's intense dislike of elitist views leads her into rash judgments and outrageous pronouncements that result in heated and vitriolic battles with her fellow critics. Except for her tainted scholarship in the publication of material on Orson Welles's contributions to the screenplay of CITIZEN KANE (1941),[149] she has had a long and distinguished career as one of the world's legendary film critics. She began writing about film in the early 1950s and gained national prominence in the mid-1960s. She eventually became a featured film critic for THE NEW YORKER in 1967. This collection of her reviews from that periodical covers the period from September 1969 to March 1972. What emerges most clearly is Kael's violent reaction to cultural snobbery and her unwavering belief that movies do not have to pander to the lowest common denominator in order to be popular entertainment. For example, in comparing ALICE'S RESTAURANT to BUTCH CASSIDY AND THE SUNDANCE KID (both in 1969), she states that "In formal terms, neither is very good. But ALICE'S RESTAURANT is a groping attempt to express something, and BUTCH CASSIDY is a glorified vacuum. Movies can be enjoyed for the QUALITY of their confusions and failures, and that's the only way you can enjoy some of them now." The anthology won the 1973 National Book Award, the only work of film criticism to be so honored. An index is included. Recommended for special collections.

*Kael, Pauline. GOING STEADY. Boston: Little, Brown and Company, 1970. 304pp.

A collection of the author's work from January 1968 to March 1969, this anthology presents not only Kael's first reviews for THE NEW YORKER, but also her assessment of a critic's difficulties in a business that depends so heavily on timid editors and film industry advertising. "To be a casual critic of movies," she explains in the foreword, "is to be no critic at all, and for one whose interest is more than casual, it's painful to write about movies just occasionally, or to order. What is missing is the connection--or context--in which movies are a continuing art. In such frustrating circumstances each review one writes has to take for granted a whole succession of unwritten reviews that would have established the basis for one's criticism." Grateful for the opportunity to have a regular weekly column (Kael shared the NEW YORKER job with Penelope Gilliatt, with each critic working for six consecutive months of the year), she thanked her editor William Shawn both for the opportunity and for never saying "those obscene words: 'Our readers won't be interested in all that.'" Although there are many outstanding examples of Kael's blunt attacks on "art house" aesthetics,

[149] See Chapters 5 and 7 for comments on her approach to THE CITIZEN KANE BOOK: RAISING KANE, THE SHOOTING SCRIPT, BY HERMAN J. MANKIEWICZ AND ORSON WELLES.

the anthology contains her famous piece, "Trash, Art, and the Movies." It is one of the few seminal articles in film history that defends the joy of watching movies without relying on the proviso that the films being watched had anything to do with art. "Movie art," she argues, "is not the opposite of what we have always enjoyed in movies, it is not found in a return to that official high culture, it is what we have always found good in movies only more so." Later she adds, "Keeping in mind that simple, good distinction that all art is entertainment but not all entertainment is art, it might be a good idea to keep in mind also that if a movie is said to be a work of art and you don't enjoy it, the fault may be in you, but it's probably in the movie." An index is included. Recommended for special collections.

*Kael, Pauline. I LOST IT AT THE MOVIES. Boston: Little, Brown and Company, 1965. 323pp.
 This is the book that catapulted Kael into the national consciousness. It contains her major work prior to her becoming the controversial resident film reviewer for MCCALL'S (a one-year assignment that ended in her being fired for her savage reviews of popular films). Here are her famous attacks on the AUTEUR theory, objective criticism, unified theoretical approaches to film, fellow critics, and elitist film criticism. I remember especially the storm of controversy that swept through the "film generation" when she wrote, "There is more energy, more originality, more excitement, more ART in American kitsch like GUNGA DIN, EASY LIVING, the Rogers and Astaire pictures like SWINGTIME and TOP HAT, in STRANGERS ON A TRAIN, HIS GIRL FRIDAY, THE CRIMSON PIRATE, CITIZEN KANE, THE LADY EVE, TO HAVE AND HAVE NOT, THE AFRICAN QUEEN, SINGIN' IN THE RAIN, SWEET SMELL OF SUCCESS, or more recently, THE HUSTLER, LOLITA, THE MANCHURIAN CANDIDATE, HUD, CHARADE, than in the presumed 'High culture' of HIROSHIMA MON AMOUR, MARIENBAD, LA NOTTE, THE ECLIPSE, and the Torre Nilsson pictures. As Nabokov remarked, 'Nothing is more exhilarating than Philistine vulgarity." An index is included. Highly recommended for all collections.

*Kael, Pauline. KISS KISS BANG BANG. Boston: Little, Brown and Company, 1968. 404pp.
 In her second collection of criticism, Kael presents the material she wrote at MCCALL'S and at THE NEW REPUBLIC. In addition, she gives us thumbnail reviews on 280 movies gleaned from the program notes she wrote during her formative years in California running film in an art house and doing radio commentaries on film. Among the many interesting pieces on film psychology and audience tastes are her memorable put-downs of films like THE SOUND OF MUSIC (1965)--she calls it "The Sound of Money"--and BORN FREE (1966)--"Unfortunately for BORN FREE, the art of film was not born yesterday." Here, too, are examples of her love for directors like Jean Renoir, the early Jean-Luc Godard, Carl T. Dreyer, and Orson Welles; her emphasis on content and motivation rather than on style and technique; and, most often, the way movies affect her and the public. Two especially noteworthy essays are Kael's first NEW YORKER essay, "Movies on TV," and her detailed discussion of Sidney Lumet's THE GROUP (1966). An index is included. Recommended for special collections.

*Kael, Pauline. REELING. Boston: Little, Brown and Company, 1976. 497pp.
 The fifth book of Kael's collected criticism and the first to draw bad reviews from once friendly quarters, it deals with the material she wrote between 1972 and 1975. The complaints center on her controversial social psychology, constant defense of trashy movies, and hyperbolic prose. For me, however, the critic was as good as ever, including in her seventy-four essays a first-rate discussion of LAST TANGO IN PARIS (1973), an insightful look at "blaxploitation" films, and a bold analysis of contemporary films. An index is included. Recommended for special collections.

*Kael, Pauline. THE STATE OF THE ART. New York: E. P. Dutton, 1985. 404pp.
 This latest book in the Kael critical anthology collection represents not only a
change in the author's populist approach but also a decline in her general appeal.
Between June 1983 and July 1985, the scope of this collection, she seems to lose the
energy level that characterized her defense of highly questionable Hollywood products
and takes up arms against popular films like FLASHDANCE, THE RIGHT STUFF (both
in 1983), STAR TREK III: THE SEARCH FOR SPOCK, THE KILLING FIELDS,
STARMAN (all in 1984), and WITNESS (1985). On the other hand, depite the
lackluster prose and the absence of unique perceptions, her love for movies is still
struggling to survive. It's just that the author seems tired. An index is included.
Well worth browsing.

*Kael, Pauline. WHEN THE LIGHTS GO DOWN. New York: Holt, Rinehart and Winston,
1980. 592pp.
 The fourth and most controversial of all Kael's critical anthologies, it epitomizes
her strengths and weaknesses as a popular critic. Those readers who fault her vicious
attacks on stars, resent her outrageous defense of second-rate films, object
strenuously to her abuse of high-brow art, dismiss her pop sociology, insist she lacks
depth, and cringe at her autobiographical musings have more than enough material
to support their arguments.[150] Nevertheless, one can still find in this collection of
material written between 1975 and 1980, the brutally honest opinions of a serious critic
who feels compelled to share her personal reactions in the hope that we will better
understand the effect of movies on our times. The methods may be more crude than
are necessary, but the feelings remain genuine and heartfelt. An index is included.

STANLEY KAUFFMANN

Kauffmann, Stanley. A WORLD ON FILM: CRITICISM AND COMMENT. New York:
Harper & Row, 1966. 437pp.
 Kauffmann, a born and bred New Yorker with extensive experience as an actor,
director, novelist, and drama critic, has been writing film criticism for the politically
conscious magazine , THE NEW REPUBLIC since 1958. His "high-brow" reputation
reflects not only a highly literate background and an insider's appreciation of
stagecraft, but also a willingness to challenge the reader's intellectual strengths.
Although he contributes to other periodicals and has taken an ocasional leave from
THE NEW REPUBLIC (e.g., a Ford Foundation Fellowship and a brief stint as THE
NEW YORK TIMES drama critic in 1966), the majority of his reviews collected in his
five books on film criticism are from the politically conscious magazine. A WORLD ON
FILM covers the first eight years of his work at THE NEW REPUBLIC and isolated
essays written for periodicals like THEATRE ARTS and SHOW. The book's four major
sections--"Subjects," "Countries," "Events," and "The Film Generation"--highlight
his principles and prejudices. For example, "Subjects" deals with war films,
spectacles, acting, and adaptations, illustrating Kauffmann's belief that film criticism
should be rooted in the context of the film's unique qualities (e.g., how images are
created and used, the demands that film places on acting, the importance of realism
in film narratives) and that a filmmaker's perspective is central to the film's worth
as entertainment and art. Particularly noteworthy is his position that filmmakers have
no obligation to recreate faithfully a novel or a play on the screen. In reviewing
THE DOCTOR'S DILEMMA (1958), for example, Kauffmann writes, "Now language is,
if not the enemy, at least the burden of the motion picture. In good pictures the
words are good, but the picture does not rely on them in the way that Shaw or
Shakespeare or Marlowe relied on them. Admittedly, in plays as well as films, one
wants not a single word more than necessary; but language is central to the classical
theater, and to film it is supplementary." On the other hand, critics have a different
function. "A recurrent debate about criticism of films and plays," he writes in his

[150] For an example of a highly questionable attack on Kael, see Renata Adler, "The
 Perils of Pauline," NEW YORK REVIEW OF BOOKS (August 14, 1980):26, 31-5.

review of THE SOUND AND THE FURY (1959), "is whether adaptations ought to be considered in relation to their originals or as entities in themselves. Where the original is a work of little importance the question can be begged. Otherwise, in my view, reference to the original is unavoidable." In Part Four, "The Film Generation," Kauffmann gives us his definition of "taste," explaining that "It is not my purpose to lay down an artistic credo: I can always think of too many exceptions. Taste is a matter of instances, not precepts. One forms an idea on another's taste--or of one's own--from the perspective of many instances of judgment and preference, and even then, general deductions must be drawn delicately." The one complaint I have of all of Kauffmann's writings is that they aren't long enough. An index is included. Recommended for special collections.

Kauffmann, Stanley. BEFORE MY EYES: FILM CRITICISM AND COMMENT. New York: Harper & Row, 1980. 464pp.

In his fourth collection of critical reviews (written between 1974 and 1979), Kauffmann provides a chronological presentation of his reactions to the New German Cinema, the rise of America's most commercially successful filmmakers in history, the recent works by established masters of the film, books on film, and selected film classics. The standards remain constant, only the names of the players change. He still is tough on actors who don't act well or look right in a part. For example, in reviewing NEW YORK, NEW YORK (1977), Kauffmann writes, "The first trouble is the look of the thing. Laszlo Kovacks doesn't know how to photograph his two stars. Robert De Niro, hair plastered down and parted in the middle, is supposed to be attractively menacing; he kept reminding me of Faulkner's Popeye, whose face had 'that vicious depthless quality of stamped tin.' And Liza Minnelli, difficult to like at best, comes out looking like a giant rodent en route to a costume ball." He still focuses on the nature of the film experience. In analyzing THE DEER HUNTER (1978), he states that ". . . experientially the picture drags, from one detailed examination to another, without culmination: moving from intensity to incredibility to protracted finish." For me, the most fascinating comments in the anthology are Kauffmann's views on treating the Holocaust in art. Defending Lina Wertmuller's depiction of concentration camps in SEVEN BEAUTIES/PASQUALINO SETTEBELEZZE (1976), Kauffman insists there are three options open to the artists: "The first is to leave the subject completely alone, to leave it to historians and documentarians. I'll confess to a prejudice in favor of that choice. The second, almost always foolish or disgusting, is to try to treat it mimetically, like the recent television series about the holocaust. I have never felt more like Plato in Book X of THE REPUBLIC, the famous rejection of mimesis as degradation, than watching what I could endure of that television series . . . There is a third possible way to handle the subject, the only one I can think tolerable . . . Deny, if you like, that a film-maker has the right to make fiction films on this subject at all. But if you do not deny it, then Wertmuller's method can be seen as a means of making us LOOK at the experience, an attempt to fill the Brechtian idea of presentation, instead of giving us the luxury, the quasi-refuge, of tears." An index is included. Recommended for special collections.

*Kauffmann, Stanley. FIELD OF VIEW: FILM CRITICISM AND COMMENT. New York: PAJ Publications, 1986. 316pp.

The most recent collection of THE NEW REPUBLIC's distinguished film critic (covering 1979-1984), it demonstrates that Kauffmann's critical skills and hard-fast principles are still going strong after thirty years of exposure to mass entertainment. For those who think that film debases taste, Kauffmann's criticism demonstrates otherwise. He maintains a good sense of humor: in reviewing MONTY PYTHON'S THE MEANING OF LIFE (1983), he writes "It's time to take Monty Python seriously. This may sound ungratefully grim, but these six men have brought it on themselves." He still rails against misguided screen adaptations: in his analysis of THE TIN DRUM/DIE BLECHTROMMEL (1979), he asks, "Why do people adapt important novels, about which there is no special best-seller incentive, without (a) a way to reproduce the novel

cinematically or (b) a way to deconstruct it and reconstruct it authentically in cinematic terms?" He still gets outraged when artists abuse their talents: in commenting on Woody Allen's STARDUST MEMORIES (1980), he begins by feelin compassion for the writer-director-star--"How desperately he wants to be more than he is"--and then gets angry because "Allen's view of the world is egotistical, "a hypersensitivity that breeds insensitivity. . . ." An index is included. Recommended for special collections.

Kauffmann, Stanley. FIGURES OF LIGHT: FILM CRITICISM AND COMMENT. New York: Harper & Row, 1971. 297pp.
 The second collection of Kauffmann's writings (covering 1967-1970), this anthology includes material on some of the most exciting works and events in modern film history. Kauffmann's perspective on the revolutions in style, acting, content, and morality reveal not only his skill as a critic, but also his impressive scholarship. For example, in reviewing WINNING (1969), he takes note of the way that film cannibalizes high art to pander to pop tastes. "I'm not worrying about desecration," he explains. "Who wants to protect art that can't take care of itself? (Remember those silly protests some years ago against the jazzing up of Bach?) I merely note that a mission has been accomplished: the new, affluent, university-trained middle class has sent its forces into the world of entertainment to wrest pop art from vulgarians and to lacquer it with chic." An index is included. Recommended for special collections.

Kauffmann, Stanley. LIVING IMAGES: FILM CRITICISM AND COMMENT. New York: Harper & Row, 1975. 404pp.
 The third collection of Kauffmann's writings (covering 1970 to 1974), this fine anthology not only gives us comments about the important films and filmmakers of the era, but also reconsiderations of six classic films and two extended pieces on the film-theater debate and on the interchange between American and foreign films throughout motion picture history. One of my all-time favorite Kauffmann lines is included here in his review of Sam Peckinpah's talent in THE GETAWAY (1972): "He is quite clearly a madman with, among other gifts, an extraordinary talent for murder, so powerful that it makes us enjoy blood." An index is included. Recommended for special collections.

PARE LORENTZ

*Lorentz, Pare. LORENTZ ON FILM: MOVIES FROM 1927 TO 1941. New York: Hopkinson and Blake, 1975. 228pp.
 Lorentz is best known for his magnificent romantic and poetic documentaries--THE PLOW THAT BROKE THE PLAINS (1936) and THE RIVER (1937)--made for the U. S. Department of Resettlement Administration. The success of those films resulted in the creation of the short-lived U. S. Film Service, a government program dedicated to "films of merit" that dealt with important social issues. Although it existed only for only a few years (1938-1940), the Film Service made a number of memorable movies, including Lorentz's first feature-length work, THE FIGHT FOR LIFE (1940). What is generally overlooked in Lorentz's career is his journalist background and the tasteful and witty film reviews he wrote during the Depression. His blunt, perceptive observations about Hollywood and the filmmaking experience are effectively recalled in this nostalgic and informative anthology. An index is included. Recommended for special collections.

DWIGHT MACDONALD

Macdonald, Dwight. DISCRIMINATIONS: ESSAYS & AFTERTHOUGHTS 1938-1974. New York: Grossman Publishers, 1974. 466pp.
 Irreverent and free-wheeling, the superb essayist began writing about film almost immediately after he graduated from Yale University in 1928. The former writer for FORTUNE (1929-1936), editor for PARTISAN REVIEW (1937-1943), and editor and

publisher for POLITICS 1944-1949) did his best film criticism for THE NEW YORKER (1951-1965) and ESQUIRE (1960-1966). This book contains almost no material on film but is worth reading for insights into Macdonald's strong political views and the reasons why he waged such a long and memorable battle against the intellectual vacuum in the film world. By way of enticement, I offer Macdonald's comment on the film LONELYHEARTS (1958): "If the epigram of [Nathanael] West's novel [MISS LONELY HEARTS] might be Dostoevsky's "Hell is the inability to love," that of the film might be William Dean Howells' observation to Edith Wharton: 'What the American public always wants is a tragedy with a happy ending.'" Well worth browsing.

Macdonald, Dwight. ON MOVIES. Englewood Cliffs: Prentice-Hall, 1969. 492pp.
 The only substantive collection of the influential social critic's film criticism, this anthology contains fine examples of Macdonald's powerful attacks on film mediocrity written over a forty-year period in publications like THE MISCELLANEY, PROBLEMS OF COMMUNISM, ENCOUNTER, POLITICS, ESQUIRE, AND THE PARTISAN REVIEW. In the book's Forenotes, he explains how he once tried to objectify his standards for judging films by synthesizing them into five critical principles: "(1) Are the characters consistent, and in fact are there characters at all? (2) Is it true to life? (3) Is the photography cliche, or is it adapted to the particular film and therefore original? (4) Do the parts go together; do they add up to something; is there a rhythm established so that there is form, shape, climax, building up tension and exploding it? (5) Is there a mind behind it; is there a feeling that a single intelligence has imposed his own view on the material?" Macdonald then completely rejects the first two principles, claims the third is sound, and admits that the last two have some sort of ambiguous meaning. Dividing his reviews into six major sections, he then advises casual readers to look at the last section, "Trims and Cuts" first because it is his favorite. If Macdonald has one major drawback as a critic, it is that he is better at telling us what is bad about a movie, than in pointing out its merits. An index is included. Recommended for special collections.

WILLIAM S. PECHTER

Pechter, William S. MOVIES PLUS ONE: SEVEN YEARS OF FILM REVIEWING. New York: Horizon Press, 1982. 246pp.
 Born and educated in New York, Pechter has been writing film criticism for academic journals since 1960. During most of the seventies, he was the film critic for COMMENTARY. "This book," he explains, "documents the experience of some regular movie-going during the first seven years of the seventies, an experience about which the recurring questions asked are: what takes place--on our screens, in our heads, and in that charged space of interchange between--when we see a movie?" His writing lacks the flair and energy of the major film critics, while his judgment remains conservative. That is, the films you'd expect a serious critic to like, he likes. He also has a tendency to talk around a film rather than about it. For example, in discussing Mike Nichols's direction of CATCH-22 (1970), Pechter states "CATCH-22 is this year's White Elephant Movie, a lumbering vehicle hauling its tiny cargo of humanistic piety from one end of two hours to the other." Two paragraphs later, he is writing, "Beyond this, it would hardly matter that the director of CATCH-22 has for several years been mounting Neil Simon farces on Broadway if those years hadn't so evidently taken their toll." Despite the limited number of films reviewed, this volume reveals a good mind thinking about the state of film and offering some valuable insights. An index is included. Well worth browsing.

Pechter, William S. TWENTY-FOUR TIMES A SECOND: FILMS AND FILM-MAKERS. New York: Harper & Row, 1971. 324pp.
 The first volume of Pechter's reviews, this book covers ten years of film criticism about topical issues, important directors, and significant events. The author divides his material into five sections: "Practice," "Films," "Film-Makers," "Spectators," and

"Theory." More often than not, the critic's judgment is rendered in dry, slow-moving sentences. The only reason to keep reading is because he raises important issues and frequently provides thoughtful perspectives. Whatever reservations one may have about his opinions about specific films, it helps to remember that Pechter's reflective comments add fresh insights not only about contemporary films, but also about film history. An index is included. Well worth browsing.

HARRY ALAN POTAMKIN

Jacobs, Lewis, ed. THE COMPOUND CINEMA: THE FILM WRITINGS OF HARRY ALAN POTAMKIN. New York: Teachers College, Columbia University, 1977. Illustrated. 641pp.

A poet who embraced Marxism during the twenties and became one of America's premier ideological critics for more than decade, Potamkin displayed a unique talent for analyzing the role of film in society. "The majority of the essays and reviews assembled in this book," Jacobs explains, "are relatively unknown today. These articles originated in the late 1920s and early '30s in many diverse and often specialized publications. A large number originated in fugitive, obscure, and out of print magazines no longer available, difficult to find, and in the main neglected by periodical indexes." Dividing Potamkin's writings into two major sections--"Film as Art (1920-1930)" and "Film and Society (1930-1933)"--Jacobs allows us to appreciate the critic's sensitive and socially conscious insights into the contributions being made by American and European filmmakers during the end of the silent era and during the early days of talkies. Here is an example of how technical analysis is skillfully blended with social commentary. A bibliography and three indexes are included. Recommended for special collections.

REX REED

Reed, Rex. BIG SCREEN, LITTLE SCREEN. New York: The Macmillan Company, 1971. 433pp.

Strip away the celebrity image and the knack for silly arguments, and you discover in this second volume of collected criticism a very sensitive and bright journalist. He not only knows how to get your attention, but also how to give you useful information about a film's plot and the strengths and weaknesses of the performances. Most of the essays come from his regular columns for WOMEN'S WEAR DAILY and HOLIDAY. There are even a few thrown in from THE NEW YORK TIMES. The problem is that you are so amused by his outrageous prose that you tend to ignore the skill with which he composes his popular reviews. He may not be a profound commentator, but he is certainly one of the wittiest in the business. Two examples should suffice. In describing Francois Truffaut's THE WILD CHILD/1'ENFANT SAUVAGE (1969), he labels it ". . . THE MIRACLE WORKER with escargot on its breath. . . ." And then there is "PAINT YOUR WAGON is a monument to unparalleled incompetence." An index is included. Recommended for special collections.

ANDREW SARRIS

*Sarris, Andrew. CONFESSIONS OF A CULTIST: ON THE CINEMA, 1955/1969. New York: Simon and Schuster, 1971. 480pp.

For many people who only think of Sarris as the foremost American promoter of the AUTEUR theory and have missed the full import of the film reviews he has been writing for THE VILLAGE VOICE ever since the summer of 1960, this first volume of his influential essays is a treasure box. It contains the thoughts of an outstanding film historian, critic, and journalist who may well be the most widely read and discussed scholar-critic in the second half of the twentieth century. Born and educated in New York, he is an avid moviegoer who writes candidly and perceptively about his feelings, and who continually and constantly finds himself embroiled in serious debates and controversies about the state of film art, the worth of major directors and performers, and the views of his fellow critics. Rarely does one read

a Sarris review and not find a provocative thought, a scholarly insight on film history, or a refreshing perspective on a topical issue. That is not to say that he doesn't have blind spots or stylistic weaknesses. He does. His unwavering commitment to the AUTEUR theory and his less-than-elegant prose often intrude on his otherwise incisive and blunt assessments. It is to say that his analysis of a film's form and content is the equal of any critic who has ever written a regular column in the popular press. In this work we get an autobiographical introduction explaining Sarris's interest in film, followed by a year by year collection of his reviews. An index is included. Highly recommended for special collections.

Sarris, Andrew. POLITICS AND CINEMA. New York: Columbia University Press, 1978. 215pp.
 In the book's valuable introduction, Sarris discusses how he first thought in political rather than artistic terms when analyzing films. At the same time, he explains, he maintained a healthy skepticism about what "political messages," films communicated. "For the past half century," he writes, "these political claims have been mostly liberal, leftist, anarchistic, and even methodically Marxist. Rightists, by and large, have preferred to express their opposition to the alleged redness of movies with the blue pencil of censorship. Religious people have tended to mistrust the medium itself as the work of the devil rather than turn it to their own uses. That is not to say that a classically reactionary cinema has not always existed, particularly in Hollywood. But the terms in which even this cinema was discussed presupposed a generally leftward orientation in both the writer and the reader." After illustrating the types of questions these "political" analysts have raised about film, Sarris argues that ". . . if D. W. Griffith be deemed a racist and a bigot, so was Shakespeare. As for social significance it is quite clear that UNCLE TOM'S CABIN changed more hearts and minds than MOBY DICK, but Harriet Beecher Stowe does not therefore rise above Herman Melville in our literary estimations." Sarris then goes on to explain why it is necessary to evaluate and reevaluate films constantly in a variety of contexts. He acknowledges the importance of his New York "disaffected" heritage in shaping his views of film ideology and the role that French critics like Andre Bazin and Jean-Luc Godard played in getting him to appreciate that an anaylsis of form cannot be ignored or the filmmaker's political choices in characters, actions, and options. He admits that he prefers a capitalist cinema to a Marxist one, to being driven "by the imperatives of my politics toward a relatively pluralistic aesthetic in which the very diversity of artistic styles is counted a blessing." The material anthologized in this fascinating book then proceeds to explore the way contemporary films have dealt with many of the most explosive issues in the second half of the twentieth century. An index is included. Highly recommended for general collections.

Sarris, Andrew. THE PRIMAL SCREEN: ESSAYS ON FILM AND RELATED SUBJECTS. New York: Simon and Schuster, 1973. 337pp.
 This anthology of Sarris's important film reviews functions as a summary of his concerns as an emerging critic. The nature of those concerns is apparent in the book's six major sections: "Critical Credos and Causes," "Personal Styles," "Genres," "Politics," "Odes and Obits," and "Arts and Letters." Readers interested in discovering the basic Sarris should start with this work. An index is included. Recommended for special collections.

RICHARD SCHICKEL

Schickel, Richard. SECOND SIGHT: NOTES ON SOME MOVIES, 1965-1970. New York: Simon and Schuster, 1972. 351pp.
 A collection of reviews from the author's stint as the film critic for LIFE, this anthology is a mixed bag of lightweight analyses, nasty observations and second thoughts about eighty-four films. The book begins with an autobiographical introduction that attacks film scholarship--"it is mostly a joke--a thin mixture of

pedantry and buff books and cheesy journalism, out of which one would be hard pressed to create a decent reading list for a freshman survey course in movies"--and explains what he tried to do in a regular weekly column--"To be on the lookout for the rare work of art, to deflate the more common phenomena, films that substituted pretension and good intention for actual achievement, to try to pick and choose rather carefully among the genre films that still (as of 1965-66) composed the bulk of theatrical programming and to ignore (unless their offenses were particularly egregious) the routine films that never managed to transcend their origins as purely commercial ventures--these were my intentions." What went wrong, the problems film criticism generates, and how he feels about the films of the late sixties are alluded to in the film reviews themselves. In reading Schickel's current film reviews in TIME, one gets a sense of how much he has matured since the LIFE days. The earlier reviews are more personal than perceptive, more personable than probing. An index is included. Worth browsing.

JAY SCOTT

*Scott, Jay. MIDNIGHT MATINEES: MOVIES & THEIR MAKERS 1975-1985. New York: Ungar, 1987. 266pp.
 The only three-time winner of the Canadian National Newspaper Award for criticism, Scott became the film critic for THE TORONTO GLOBE AND MAIL in 1978. His first collection of reviews is divided into two parts. The first section consists of a series of behind-the-scene essays, two informal histories on teen films and Canadian films, and a seven-year journal of watching movies and people at the Cannes Film Festival. The second part covers the essays he wrote for his newspaper between 1978 and 1985. Unlike most daily reviews, Scott's work displays a chatty and critical perspective that reveals a sensitive critic with a good eye and a probing mind. One gets an insight into the times and the artist as well as the film and the performers. This anthology is fun reading and very stimulating. An index is included. Recommended for special collections.

GILBERT SELDES

Seldes, Gilbert. THE GREAT AUDIENCE. New York: The Viking Press, 1950. 299pp.
 One of the greatest critics of popular art in this century, Seldes not only wrote well, but thoughtfully. "In gratitude for the pleasures I had [from popular entertainment]," he writes at the beginning of this book, "I made large assertions about those arts; what I regret now is my excessive modesty." Grandly including movies, television, and radio, he takes up the challenge of defending them against their social and critical enemies. In a chatty but informative tone, he discusses the structure of the three industries, the nature of their products, and the problems they need to overcome if they are to fulfill their social responsibilities. Well worth browsing.

Seldes, Gilbert. AN HOUR WITH THE MOVIES AND THE TALKIES. Philadelphia: J. B. Lippincott, 1929. 156pp.
 "No other form of entertainment has so loudly called itself an art," observes Seldes, "and to none has the name of art been so vigorously denied. Its existence depends upon a machine and the people who have made colossal fortunes out of it have been obviously ignorant of the nature and capacity of the machine they were working." The ex-music and drama critic does a charming hatchet job on film history up to the end of the twenties, finding praise mainly for Charlie Chaplin and expressing remorse over what film can achieve but rarely pursued. In talking about the potential that sound brought to movies, Seldes often sounds like an impatient schoolteacher. Well worth browsing.

Seldes, Gilbert. THE MOVIES COME FROM AMERICA. Preface Charles Chaplin. New York: Charles Scribner's Sons, 1937. Illustrated. 120pp.

"This book," Seldes writes, "is written by an American who has seen more pictures than most people and therefore has suffered more than most from the stupidities and monotony, the uninventiveness and the timidity of American pictures; nothing could be more pleasing to him than the thought of a powerful rival to Hollywood which would go where Hollywood led only when Hollywood led in the right direction; and would avoid its banalities--even if it substituted some of its own. It is with considerable regret that I record a setback to those hopes." Seldes than gives us another perspective of critical film history up to the mid-1930s, taking potshots at almost everyone and everything about the film business. Yet on the last page he shows his true colors by stating "That it would be a satisfactory conclusion to many of us if the people of the world would overthrow their dictators in order to protect their movies." An index is included. Well worth browsing.

*Seldes, Gilbert. THE PUBLIC ARTS. New York: Simon and Schuster, 1956. 305pp.
Reflecting on the changes television has brought about in mass media entertainment, the incisive popular critic takes a nostalgic and analytical look at the direction the public arts--radio, movies, and TV--have taken and the one they should take. The book's first five chapters focus on the movies. "Looking forward gratefully," Seldes concludes, "we can afford to forget the blunders and the bad taste and the stupidity that have attended the movies in the past. We can even say that these less engaging qualities had their share, as surely as talent and devotion had theirs, in making the movies what they have been and may again be, the great lovely art of our time." Worth browsing.

WILFRID SHEED

Sheed, Wilfrid. THE MORNING AFTER: SELECTED ESSAYS AND REVIEWS. Foreword John Leonard. New York: Farrar, Straus & Giroux, 1971. 304pp.
A noted commentator who has written for NEW AMERICAN REVIEW, THE NEW YORK TIMES BOOK REVIEW, ENCOUNTER, THE ATLANTIC, COMMONWEAL, THE NEW YORK REVIEW OF BOOKS, LIFE, SPORTS ILLUSTRATED, and ESQUIRE, Sheed has something to say about almost everything. In this collection of fifty entertaining and high-brow essays written between 1963 and 1970, he includes only a sprinkling of material on foreign and esoteric films. Nevertheless, Sheed's scholarly and idiosyncratic style is stimulating enough to warrant reading the other material on theater and politics. Well worth browsing.

JOHN SIMON

Simon, John. ACID TEST. Introduction Dwight Macdonald. New York: Stein and Day, 1963. 288pp.
In a field where its hard to get people to agree on anything, there is almost universal agreement that John Simon is the most controversial critic on the national scene. Macdonald describes him in the introduction as "a good complainer." He also points out that "Humility has never been Mr. Simon's problem, nor has he eschewed either trenchancy or learnedness. He is acerb and cold-eyed . . . But he is also a fair-minded judge . . . who has all the precedents to hand and can bring them to bear on a contemporary work." A Yugoslav by birth, a polished multi-linguist, a Harvard Ph.D., and a critic for magazines like ESQUIRE, NEW YORK, THE NEW LEADER, and, most frequently, the NATIONAL REVIEW, he goes for the jugular in reviewing films, talking about fellow critics, and discussing the film community. Not surprisingly, his allusions and writing style call as much attention to his erudition, as they do to the subject being discussed. At the very least, he is an acquired taste. At the very best, Simon puts films in the perspective of their time, their past, and their relationship to the traditional arts. For example, in commenting about stage adaptations of literary works, he writes, "There is a simple law governing the dramatization of novels: if it is worth doing, it can't be done; if it can be done, it isn't worth it." He is not interested in helping someone decide which film to see.

Moreover, he doesn't seem to have much use for the majority of people who see or make films. He is an elitist who scorns popular art and works tirelessly to set a higher standard for filmmaking and for the public. Although the focus in his first published collection of writings is mainly on the author's literary and theater reviews, there are four film essays that suggest his high-brow approach to reviewing. Worth browsing.

Simon, John. MOVIES INTO FILM: FILM CRITICISM 1967-1970. New York: The Dial Press, 1971. 448pp.
 "I consider film inferior to no art," writes Simon in the introduction to his third volume of film reviews, "but neither do I make the dangerous assumption widely held by illiterate film critics (or whatever the opposite of 'bookish' ones may be) that film is superior to all the other arts. A critic may be a lover; he must not become an idolater." The essays, taken from his weekly output as film critic of THE NEW LEADER, are filled with wonderful one-liners and lethal opinions. For example, in critiquing Franco Zeffirelli's THE TAMING OF THE SHREW (1967), Simon quips, "If Zeffirelli's idiosyncrasy is fancy production values and disrespect for the work of art, Elizabeth Taylor's is godawful acting"; on LeRoi Jones's DUTCHMAN (1966), "One kind of play that need not be put on screen is the kind that was already rotten on stage"; and Stanley Kubrick's 2001: A SPACE ODYSSEY (1968): "The slab, of course, is never explained, leaving 2001, for all its lively visual and mechanical spectacle, a kind of space-SPARTACUS and, more pretentious still, a shaggy god story." What surprises the reader are the many films that Simon likes and recommends. Although reading his full-length study of Ingmar Bergman demonstrates the depth of Simon's critical powers, one can appreciate in this book his precision with language and his talent for linking film to the traditional arts. An index is included. Recommended for special collections.

Simon, John. PRIVATE SCREENINGS: VIEWS OF THE CINEMA OF THE SIXTIES. New York: The Macmillan Company, 1967. 316pp.
 In his second volume of reviews, Simon presents his critical credo: "The most important thing to remember about film criticism is that it is not fundamentally different from any other kind of criticism." He points out that ". . . to the critic to whom art is important, sacred, and ultimately, coextensive with life itself, to produce bad art and to condone it--and thereby give rise to further bad art and finally drive out the good--are the two most heinously dangerous sins imaginable. And the most destructive . . . [In choosing a critical method] The critic's words are his tool, or weapons, and he would be foolish and incompetent if he did not use them to the utmost of his, and their, ability." The bad critic is the reviewer, one who merely tells someone what film to see. The good critic, however, is a teacher, an artist, and a thinker. He then goes on to describe a film critic's responsibilities and speculate on the characteristics of the ideal critic. "To speak only of American criticism," he explains, "I should like an ideal critic to acquire the passionate scrupulousness, the constant soul-searching enthusiasm of James Agee, the modesty and social awareness of Robert Warshow, the background information and scrappiness of Pauline Kael, the gentlemanly dignity of Stanley Kauffmann, and the idiosyncratic raciness of Dwight Macdonald." Whether Simon is better at describing the ideal critic than being one depends somewhat on how you feel about a director like Orson Welles. That is, is it good criticism in dismissing Welles's direction of THE TRIAL/LE PROCES (1963) to mock the director by asserting "There is nothing about Orson Welles to convince us that he has ever felt humanity or love anywhere except in front of a mirror." On the other hand, Simon's ability to build a critical case based on comparisons with other films and the traditional arts in general is impressive. The essays in this edition are filled with ammunition for both sides of the issue. An index is included. Recommended for special collections.

Simon, John. REVERSE ANGLE: A DECADE OF AMERICAN FILMS. New York: Clarkson N. Potter, 1982. 466pp.

In his third volume of collected criticism, Simon begins by explaining what he thinks film criticism is all about: "Critics are after something harder and more elusive [than guidance and product approval]: pursuing their own reactions down to the rock bottom of their subjectivity and expressing them with the utmost artistry, so that what will always elude the test of objective truth will at least become a kind of art: the art of illumination, persuasion, and good thinking and writing." In showing us how he functions as a critic trying to stimulate thought, Simon offers a decade of criticism on American film directors, performers, and cinematographers. Among his more memorable comments are those about JESUS CHRIST SUPERSTAR (1973): "As a body who considered the rock opera mostly throwaway din, and the Broadway show a throwback to the megatherium, I would say the movie version--although in many ways odious and in all ways absurd--better than either of those." A close second is his review of the sequel to TRUE GRIT (1978): "ROOSTER COGBURN is a sentimental journey into nausea." As always, the reader comes away thoroughly surprised at how many films appeal to Simon. An index is included. Recommended for special collections.

Simon, John. SOMETHING TO DECLARE: TWELVE YEARS OF FILMS FROM ABROAD. New York: Clarkson N. Potter, 1983. 442pp.
 In his fourth and latest volume of collected criticism, Simon focuses on foreign films he reviewed between 1970 and 1982. "The problem with the better foreign films," the author explains, "is that--unlike the majority of American movies, even the superior ones--they have something to declare, something to say. They are not devices for killing a couple of hours. They do not merely entertain but also, by provoking thought, sustain." One of Simon's purposes in this book is to generate interest in, and appreciation of, superior foreign films. At the same time, he is not averse to attacking pretension and superficiality. Despite critics who attack Simon's elitist criticism as being glib and not particularly penetrating on serious themes, this book may be the most important collection of film criticism Simon has yet published. There is ample evidence of his approach to complex films and his use of language to deal with serious issues. One also gets an excellent opportunity to evaluate Simon's knowledge of film elements and his appreciation of screen acting. An index is included. Recommended for special collections.

ROBERT WARSHOW

*Warshow, Robert. THE IMMEDIATE EXPERIENCE: MOVIES, COMICS, THEATRE, AND OTHER ASPECTS OF POPULAR CULTURE. New York: Doubleday, 1962. 212pp.
 Written by a former editor of COMMENTARY magazine and a man who dearly loved the popular arts, this book is a remarkable collection of essays by a legendary film critic. Although he died at age thirty-seven in 1955, this posthumous publication offers immediate access to some of the best sociological criticism on film. "The movies--and American movies in particular," he wrote, "stand at the center of that unresolved problem of 'popular culture' which has come to be a kind of nagging embarrassment to criticism, intruding itself on all our efforts to understand the special qualities of our culture and define our relation to it." In using movies to measure the psychological state of society, Warshow produced a number of seminal articles on the western and gangster films, as well as major commentaries on film aesthetics and American popular culture. Included in this valuable anthology are his memorable essays on film genres, as well as fine pieces on MONSIEUR VERDOUX (1947), and THE BEST YEARS OF OUR LIVES (1946). Highly recommended for special collections.

HERMAN G. WEINBERG

Weinberg, Herman G. SAINT CINEMA: SELECTED WRITING, 1929-1970. Preface Fritz Lang. New York: Drama Book Specialists, 1970. 354pp. New York: Frederick Ungar Publishing Company, 1980. Illustrated. 366pp.

A devout lover of films and an unforgiving foe of those who treated them lightly, Weinberg not only wrote reviews and books on films for over forty years, but he also lectured extensively, taught film courses, had a regular column ("Coffee, Brandy, and Cigars") in FILM CULTURE, served on international film juries, and wrote titles for more than forty foreign films. Dwight Macdonald reportedly referred to him as 'The Boswell of the movies." Above all, Weinberg was a sophisticated man who reveled in allusions to the traditional arts and in name-dropping about the famous artists he knew. In this much-appreciated anthology, his specialized tastes and rambling literary style provide a welcome reminder of how a maverick intellectual and critic fought all his life for the art of film. One of my favorite Weinberg anecdotes is his quoting THE NEW YORK TIMES eulogy on Josef von Sternberg by referring to the director's quote from Goethe at the end of von Sternberg's autobiography: "The greatest happiness of man is to explore that which is explorable and to revere that which is unexplorable." That is the Weinberg touch. An index is included. Recommended for special collections.

VERNON YOUNG

Young, Vernon. VERNON YOUNG ON FILM: UNPOPULAR ESSAYS ON A POPULAR ART. Chicago: Quadrangle Books, 1972. 428pp.
 Born in London, Young lived for a time in America, and worked as a literary and film critic for THE HUDSON REVIEW beginning at the end of the 1940s. Young was also an actor, novelist, and stage director. He returned to England in 1957 and maintained his reputation as a distinguished international critic. In this collection of film essays written over a twenty-year period, the lucid, knowledgeable, and intellectual critic treats us to a broad and fascinating range of cultural comments about film and society. Young displays wit, good standards, and an impressive acquaintance with a wide variety of movies. Teachers should find his extensive comments on short films useful for the classroom. An index is included. Recommended for special collections.

FILM THEORY

GENERAL

*Andrew, Dudley. THE MAJOR FILM THEORIES: AN INTRODUCTION. New York: Oxford University Press, 1976. 278pp.
 The best book surveying the history of film theory from Hugo Munsterberg to Jean Mitry, this lucid and well-organized study "sets off the major theorists one against the other, forcing them to speak to common issues, making them reveal the basis of their thought." The theorists chosen are those who conceived of film in sweeping terms, rather than theorists who only explored film occasionally. Priority is also given to those indidividuals whose work is available in English-language publications. Arranged chronologically, the material is divided into three major sections: Part 1, "The Formalist Tradition," includes analyses of Munsterberg, Arnheim, Eisenstein, and Balazs; Part 2, "Realist Film Theory," discusses Kracauer and Bazin; and Part 3, "Contemporary French Film Theory," examines Mitry, Metz, Amedee Ayfre, and Henri Agel. Endnotes, a bibliography, and index are included. Highly recommended for special collections.

*Andrew, Dudley. CONCEPTS IN FILM THEORY. New York: Oxford University Press, 1984. 239pp.
 A controversial sequel to THE MAJOR FILM THEORIES: AN INTRODUCTION, this important study covers the progress of film theory since 1965. Andrew's major concern here is "to express, through a dialogue with the theories of the day, my own views on each particular concept and, more ambitious still, my own sense of the interdependence of these concepts." Noticeably different about this second survey is the emphasis on theories rather than theorists, a highly sceptical approach to these schools of theory rather than a "laying on of hands" discussion, and the changes in

Andrew's views on previous theories. The material is divided into ten chapters, focusing on areas like perception, representation, signification, narrative structure, adaptation, genres and AUTEURS, identification, figuration, and interpretation. One of the most intriguing areas is the author's perspective on film theory and the Academy. The most disappointing aspect of the study is Andrew's decision to subsume analyses of the feminist movement and Marxist approaches in his discussions on the poststructuralist material. Endnotes, a bibliography, and index are included. Recommended for special collections.

*Andrew, Dudley. FILM IN THE AURA OF ART. Princeton: Princeton University Press, 1984. Illustrated. 207pp.
 An absorbing and insightful study of works by major filmmakers (D. W. Griffith, Friedrich W. Murnau, Jean Vigo, Frank Capra, Jean Delannoy, Robert Bresson, Laurence Olivier, Orson Welles, and Kenji Mizoguchi), this superb set of imaginative essays is the result of Andrew's "distrust of pure film theory." Five years of studying films that shaped his views on film theory convinced him "that film theory, at least those aspects of it that have always fascinated me, progresses only to the extent that it pursues problems uncovered in the close study of fertile films." An index is included. Recommended for special collections.

Armes, Roy. FILM AND REALITY: AN HISTORICAL SURVEY. Baltimore: Penguin, 1974. 254pp.

Biro, Yvette. PROFANE MYTHOLOGY: THE SAVAGE MIND OF THE CINEMA. Trans. Imre Goldstein. Bloomington: Indiana University Press, 1982. 148pp.
 "This study," Biro explains, "attempts to delineate the intellectual countenance of the film and to seek out its characteristics and limits, its cognitive and cognitive aesthetics. The methodology used is not from the world of classical aesthetics. It has been proved countless times that neither literature's, nor the theaters', nor even the fine arts' refined methods of investigation can AUTOMATICALLY be applied to film. " The author then argues that ". . . today's film marches in one ambitious direction: it tries to take possession of human consciousness, to rule the total, bustling life of our conscience." In six complex and technical chapters, Biro discusses how film functions to take control of our thoughts. Interesting theory, but hardly persuasive. Endnotes, a bibliography, and index are included. Worth browsing.

Carroll, Noel. MYSTIFYING MOVIES: FADS & FALLACIES IN CONTEMPORARY FILM THEORY. New York: Columbia University Press, 1988. 262pp.

Caughie, John, ed. THEORIES OF AUTHORSHIP. Boston: Routledge & Kegan Paul, 1981. Illustrated. 316pp.
 A collection of thiry-two valuable essays on the AUTEUR theory, this British Film Institute anthology provides, in one volume, many of the best comments on the subject by Edward Buscombe, Andrew Sarris, Louis Marcorelles, Lindsay Anderson, Robin Wood, Peter Wollen, Jean-Louis Comolli, Jean Narboni, Nick Browne, Roland Barthes, and Stephen Heath. The material is divided into three major sections: "Auteurism," "Auteur-Structuralism," and "Fiction of the author/author of the Fiction." A glossary, bibliography, and index are included. Recommended for special collections.

*Deleuze, Gilles. CINEMA 1: THE MOVEMENT-IMAGE. Trans. Hugh Tomlinson and Barbara Habberjam. Minneapolis: University of Minnesota Press, 1986. 250pp.

Giannetti, Louis D. GODARD AND OTHERS: ESSAYS ON FORM. Rutherford: Fairleigh Dickinson University Press, 1975. Illustrated. 184pp.

Consisting of four extended essays that are loosely linked to issues related to issues in film aesthetics, this book focuses on "cinematic form, or the technical means by which ideas and emotions are expressed in movies." The first article, "Godard's MASCULINE-FEMININE: The Cinematic Essay," explores the filmmaker's rejection of plot, and his search for alternative narrative structures. The second, "The Aesthetics of the Mobile Camera," examines the symbolic use of "all vehicular--dolly and crane--movements, and those crane shots that are obviously meant to suggest the camera moving through space. . . ." The third, "Cinematic Metaphors," focuses on screen adaptations and their presumed parameters. The final essay, "ALICE'S RESTAURANT and the Tradition of the Plotless Film," provides a historical perspective on alternative narrative structures that coalesced in Arthur Penn's 1969 film. An index is included. Well worth browsing.

Henderson, Brian. A CRITIQUE OF FILM THEORY. New York: E. P. Dutton, 1980. 233pp.

A challenging and absorbing critique of major film theories since the silent era, this detailed and provocative study is divided into two major sections. Part 1 deals with classical film theory, focusing on three film theorists: Sergei M. Eisenstein, Andre Bazin, and Jean-Luc Godard. The emphasis is on comparing basic issues common to all three theorists: "the relations between film and reality, the relations between film and narrative, and the question whether film is a language and, if so, what kind of language." Part 2 examines film semiotics and cine-structuralism. Interestingly, Henderson does not directly pursue the issues raised in Part 1. Rather, he critically explores the impact of semiotics on traditional film theories. Although much of the material in both sections was previously published in FILM QUARTERLY, it is a pleasure to have it available in one volume. Regrettably, no index is included. Recommended for special collections.

*Houston, Beverle, and Marsha Kinder. SELF AND CINEMA: A TRANSFORMALIST PERSPECTIVE. Pleasantville: Redgrave Publishing Company, 1980. Illustrated. 371pp.

"Transformalism," Houston and Kinder explain, "is a method of criticism that explores the ways in which artistic and cultural conventions are transformed in the context of individual works, creating a unique combination of the new and the familiar. Rooted in formalism and phenomenology, it attempts to integrate three sets of polarities: (1) the tension between centripetal meanings that are created within the individual work and centrifugal meanings deriving from and influencing other works and the outside world; (2) the tension between the subjective experience of the artist and audience and the objective experience of the artifact and the society that produced it; (3) the relationship between the individual text and the structural systems and codes of meanings it expresses." Houston and Kinder point out that these three bipolarities "center on the relations between the one and the many, the individual and the community, the self and the other." They then go on to describe the six key assumptions of transformalism: (1) the primacy of practical criticism, (2) the necessity for multiple conceptual frameworks, (3) the value of discovering and creating meaning, (4) the inevitability of evaluation, (5) the necessity of attending to the emotive qualities of the work, and (6) the value of evocative, detailed description of the film's surface. The major portion of the book contains six extended essays, one for each of the six key assumptions, and covers fourteen films. The writing is clear, informative, and perceptive. Endnotes are included, but no bibliography. Recommended for special collections.

Jarvie, Ian C. PHILOSOPHY OF THE FILM: EPISTEMOLOGY, ONTOLOGY, AESTHETICS. New York: Routledge & Kegan Paul, 1987. 392pp.

*Klinge, Peter, and Sandra Klinge. EVOLUTION OF FILM STYLES. New York: Lanham, 1983. Illustrated. 277pp.

*Lawson, John Howard. FILM: THE CREATIVE PROCESS: THE SEARCH FOR AN AUDIO-VISUAL LANGUAGE AND STRUCTURE. Preface Jay Leyda. New York: Hill and Wang, 1964. Illustrated. 380pp.
 Written in Russia by a blacklisted American screenwriter, this book has more than its share of acrimony against Hollywood movies and an overemphasis on Soviet achievements. But when it comes to a theoretical discussion of film as art, Lawson is magnificent. He bases his critical position on the importance of movies in helping rational people know the truth about themselves, and the world, so that humans can control their destiny. Although the book has five sections, readers might do better to skip 1 and 2 on history and begin with his important chapters on film language, theory, and structure. An index is included. Well worth browsing.

Lynch, F. Dennis. CLOZENTROPY: A TECHNIQUE FOR STUDYING AUDIENCE RESPONSE TO FILMS. New York: Arno Press, 1978. 127pp.
 Originally written as Lynch's 1972 University of Iowa doctoral dissertation, this study is concerned with "the development of a new test instrument with which we can explore the interaction among different kinds of film (or audio-visual messages), different kinds of audiences, and expectations about what is going to happen next in films." After reviewing the material on information theory and on audience response, Lynch discusses how to measure audience uncertainty, perception, and expected outcomes. Using the methods developed by Donald Darrell for the analysis of language patterns, he explains that "Clozentropy related a standard measure of comprehension and language aptitude, cloze procedure, with 'an entropy measure derived from information theory which indexes compatability of an individual's response with those of a selected criterion group.'" This book is strictly for specialists. Questionnaires, tables, footnotes, and a bibliography are included. Worth browsing.

*Lotman, Jurij. SEMIOTICS OF CINEMA. Trans. Mark E. Suino. Ann Arbor: University of Michigan, 1976. 106pp.

Mast, Gerald. FILM/CINEMA/MOVIE: A THEORY OF EXPERIENCE. New York: Harper & Row, 1977. Illustrated. 299pp.
 An eclectic approach to film aesthetics, this book is divided into two main sections. "The first," Mast explains, "begins with a critical summary of current film thinking: of theories and critical attitudes that have dominated the writing and reasoning about cinema. It is, clearly, a 'negative' section that questions and refutes extant views and principles. I restate the theories of others summarily, rather than in detail, assuming the reader's awareness of the major ideas about cinema that already exist." Mast then proceeds to general speculations about film as art, and the artistic pleasures it offers. "The second section," he points out, "is much more specific, a detailed discussion of the immensely varied ways that cinema can affect and manipulate our responses." The book's eight chapters provide a lackluster set of film analyses and have not inspired any great interest in academia. Endnotes, a bibliography, and an index are included. Worth browsing.

*Mast, Gerald, and Marshall Cohen, eds. FILM THEORY AND CRITICISM: INTRODUCTORY READINGS. 3rd ed. New York: Oxford University Press, 1985. Illustrated. 852pp.
 One of the best anthologies on critical film writings, this current edition contains fifty-three selections (from 1916 to the present) on classical and contemporary film theories. Mast and Cohen divide their indispensable collection into seven major

sections: "Film and Reality," "Film Image and Film Language," "The Film Medium," "Film, Theater, and Literature," "Film Genres," "The Film Artist," and "Film: Psychology, Society, and Ideology." A bibliography is included. Highly recommended for general collections.

Mendelson, Lois. ROBERT BREER: A STUDY OF HIS WORK IN THE CONTEXT OF THE MODERNIST TRADITION. Ann Arbor: UMI Research Press, 1981. Illustrated. 168pp.

Nilsen, Vladimir. THE CINEMA AS GRAPHIC ART (ON A THEORY OF REPRESENTATION IN THE CINEMA). Trans. Stephen Garry. New York: Hill and Wang, 1959. Illustrated. 227pp.

*Ray, Robert B. A CERTAIN TENDENCY OF THE HOLLYWOOD CINEMA, 1930-1980. Princeton: Princeton University Press, 1985. Illustrated. 411pp.

Russell, Sharon A. SEMIOTICS AND LIGHTING: A STUDY OF SIX MODERN CAMERAMEN. Ann Arbor: UMI Press, 1981. 177pp.
 Originally written as Russell's 1978 Northwestern University doctoral dissertation, this analysis is concerned with the style of visual images created by cinematographers. "The first part of the theoretical section of this study," the author explains, "reviews approaches to style in general and those few statements made about film style. But ultimately new ways of dealing with the problem must be found. This study proposes an approach for isolating one aspect of the larger problem by dealing specifically with the stylistic contribution of the cinematographer. . . ." The six cinematographers---Henri Decae, Ghislain Cloquet, Willy Kurant, Nestor Almendros, Jean Rabier, and Edmond Richard--are seen as representative of different backgrounds and approaches. Endnotes, a bibliography, and index are included. Well worth browsing.

Samuels, Charles Thomas. MASTERING THE FILM AND OTHER ESSAYS. Knoxville: University of Tennessee Press, 1977. 228pp.

*Silverman, Kaja. THE SUBJECT OF SEMIOTICS. New York: Oxford University Press, 1985. 304pp.

*Tudor, Andrew. THEORIES OF FILM. New York: The Viking Press, 1974. Illustrated. 168pp.
 Filled with many provocative ideas that are obscured by a weak focus, this concise and straightforward overview of the history of film theory provides six chapters on important theorists (e.g., Eisenstein, Grierson, Bazin, and Kracauer), the AUTEUR theory, and genres. More a handbook than a full-fledged study, it just seems to throw out ideas to consider rather than organize them into a forceful analysis. A bibliography is included. Well worth browsing.

Weiss, Paul. CINEMATICS. Carbondale: Southern Illinois University Press, 1975. 227pp.
 A novel approach to a traditional analysis of film, the noted philosopher divides his speculations into three major sections: the art of the film (e.g., script, performers, cinemakers, montagists, directors, and five varieties of art film), a philosophical interlude (e.g., elicited emotions, appearance, and realities), and films with a purposes (e.g., education, documentary, and experimental films). The charming novelty of Weiss's reflective study is that he frequently interrupts his

narrative with comments by film scholars--e.g., Robert Thom, Eric Sherman, Joseph Williman, Arthur Knight, and David Slavitt--who have have reacted to earlier drafts of his manuscript. For example, in asserting that it is rare for a film to "have shots or scenes or sequences as its units," Weiss interjects in the next few lines statements by Knight ("I find myself constantly remembering or appreciating shots and sequences far more than the film as a whole") and Thom ("And yet a film may be remembered, be significant, because of a particular scene or sequence. The stabbing in the shower in PSYCHO opened up to modern consciousness, a violence which has since become street knowledge, banal, frightening"). Although the narrative itself is dry and offsetting to beginning students, advanced readers will find Weiss's insights into propaganda and escapism intriguing. A bibliography, endnotes, and an index are included. Well worth browsing.

*Williams, Christopher, ed. REALISM AND THE CINEMA: A READER. London: Routledge & Kegan Paul, 1980. 285pp.
 Another fine anthology from the British Film Institute series focusing on single issues in contemporary film studies, this useful collection offers information on the significant realist positions, ideological patterns, and the relationship between realist theories and technology. Particularly useful is an analysis of Robert Flaherty's work as an example of a realist filmmaker. A bibliography, list of 16mm distributors in Britain, and index are included. Well worth browsing.

FILM THEORISTS

RUDOLF ARNHEIM

*Arnheim, Rudolf. ART AND VISUAL PERCEPTION: A PSYCHOLOGY OF THE CREATIVE EYE. Berkeley: University of California Press, 1966. Illustrated. 485pp.
 Originally published in 1954, this fascinating study on the reasons why we view art as we do is beautifully organized and clearly written. Arnheim is a master at taking complex theories about aesthetics and at breaking them down into useful categories that can be read and appreciated by the lay public and professionals. In this instance, ten straightforward chapters explain balance, shape, form, growth, space, light, color, movement, tension, and expression in art. A bibliography and index are included. Recommended for special collections.

*Arnheim, Rudolf. FILM AS ART. Berkeley: University of California Press, 1960. 230pp.
 Originally published in 1933, this book is the first full-length discussion of the relationship between film technique and audience reactions. Arnheim, writing during the early days of sound, considered both sound and color liabilities to the art of the cinema, and thus parts of the treatise are defensive statements about the value of the silent screen. Nevertheless, much of what the distinguished theorist observes about cinematic technique is invaluable for understanding the formalist view of film art. Recommended for special collections.

BELA BALAZS

*Balazs, Bela. THEORY OF THE FILM: CHARACTER AND GROWTH OF A NEW ART. Trans. Edith Bone. London: Dennis Dobson, 1952. Illustrated. 292pp.
 Written by a filmmaker and pioneer motion picture theorist, this posthumous book presents an important aesthetic and psychological analysis of film development. "One of the aims of this book," Balazs writes, "is precisely to prove that the deeply rooted old conceptions and valuations of an artistic culture nurtured on the old arts was the greatest obstacle to the development of film art in Europe." The work's twenty-six

chapters seem more like a collection of ideas, than a linear narrative. Balazs offers us opinions on everything from technique to subject matter. Although overly critical of American films and favorably disposed toward Russian movies, he provides one of the best studies ever written on the artistic qualities possible in the cinema. An index is included. Recommended for special collections.

ANDRE BAZIN

Andrew, Dudley. ANDRE BAZIN. Foreword Francois Truffaut. New York: Oxford University Press, 1978. 253pp.

"More than once," Andrew writes, "Bazin has been called the Aristotle of film for trying to formulate principles in all regions of this unexplored field. His ideas are available and in many cases well known. Like all ideas they are both disputed and supported. But what is neither available nor well known and what lies beyond dispute is the organic relation of those ideas to the milieu within which he lived." The life and times of this brilliant critic and theorist is captured eloquently by one of America's foremost authors on film aesthetics. This first full-length biography recounts the man's total commitment to the cinema, his influence on great filmmakers, his role in the development of one of the world's most influential film periodicals, and the nature of his work. Endnotes and an index are included. Recommended for special collections.

*Bazin, Andre. WHAT IS CINEMA? Volume I. Essays selected and trans. Hugh Gray. Foreword Jean Renoir. Berkeley: University of California Press, 1967. 183pp.

Bazin's first collection of essays, translated and published ten years after his untimely death, represent the work of the most important postwar critic in France. We are given a good understanding of the thoughts and feelings of this influential editor of CAHIERS DU CINEMA whose love for Hollywood so affected rising directors like Francois Truffaut, Alain Resnais, and Jean-Luc Godard that a "New Wave" of filmmakers revitalized the French cinema. Two impeccable selections, "The Myth of Total Cinema" and "The Evolution of the Language of Cinema," are excellent examples of Bazin's ability to use films as a springboard for his stimulating theories of movies in general. An index is included. Highly recommended for all collections.

*Bazin, Andre. WHAT IS CINEMA? Volume II. Essays selected and trans. Hugh Gray. Foreword Francois Truffaut. Berkeley: University of California Press, 1971. 200pp.

Taken from the last two volumes of Bazin's QU'EST-CE QUE LE CINEMA?, these valuable translations deal with the great French critic's views on the western, on Chaplin, and on neorealism. There are also two charming and witty articles on pin-up girls and THE OUTLAW. An index is included. Recommended for special collections.

NOEL BURCH

Burch, Noel. THEORY OF FILM PRACTICE. Trans. Helen R. Lane. Introduction Annette Michelson. New York: Praeger Publishers, 1973.

A complex and difficult book on the relationship between film theory and filmmaking, this work comes out of CAHIERS DU CINEMA's militant phase between the late 1960s and mid-1970s. The emphasis is on recognizing the physical possibililies and limitations in the medium itself. Burch has fresh and creative ideas, but he demands a great deal of patience and prior knowledge from his audience. Well worth browsing.

STEPHEN HEATH

*Heath, Stephen. QUESTIONS OF CINEMA. Bloomington: Indiana University Press, 1981. Illustrated. 257pp.

A seminal work by a young writer trying to establish a foothold in Academia for semiotics, Marxism, and psychoanalysis in the first days of contemporary film theory, this book contains many of the articles that Heath wrote for the influential British periodical, SCREEN. Eleven chapters present his important perspectives on film and ideology, narrative space, suture, film performance, and the cinematic apparatus. The nice thing about this collection is that you have many of Heath's much-discussed essays in a single volume. Three indexes on films, names, and terms and themes are included. Recommended for special collections.

*Heath, Stephen, and Patricia Mellencamp, eds. CINEMA AND LANGUAGE. Los Angeles: The American Film Institute, 1983. 179pp.

De Lauretis, Teresa, and Stephen Heath, eds. THE CINEMATIC APPARATUS. New York: St. Martin's Press, 1980. 213pp.

SIEGFRIED KRACAUER

*Kracauer, Siegfried. THEORY OF FILM: THE REDEMPTION OF PHYSICAL REALITY. New York: Oxford University Press, 1960. Illustrated. 364pp.
This is one of the most significant studies of film art yet written. Kracauer, concerning himself primarily with black-and-white film, discusses the development of film aesthetics as an outgrowth of photography, and argues that motion pictures achieve greatness only when they record and reveal the visible world around us. "I assume," he writes, ". . . that films are true to the medium to the extent that they penetrate the world before our eyes." Not only does Kracauer offer one of the most profound discussions on film every written, but the book also has a certain timelessness about it. Divided into three major sections, it covers the general characteristics of film, important areas and elements of emphasis in film study, and the significant film forms. Endnotes, a bibliography, and index are included. Highly recommended for special collections.

VACHEL LINDSAY

*Lindsay, Vachel. THE ART OF THE MOVING PICTURE. New York: The Macmillan Company, 1915. New York: Liveright, 1970. Introduction Stanley Kauffmann. 324pp.
"This book," Lindsay writes, "tries to find that fourth dimension of architecture, painting, and sculpture, which is the human soul in action, that arrow with wings which is the flash of fire from the film, or the heart of man, or Pygmalion's image when it becomes a woman." The well-known American poet divides his thoughts on how to judge film into two sections: (1) a basis for "photoplay" criticism and (2) speculations. Although the prose suffers from a sentimental excess, and the specifics of film art are dated, Lindsay does provide a worthwhile commentary on the state of the motion picture between 1912 and 1915. It remains the major tribute by a literary mind to the then-new art. Well worth browsing.

CHRISTIAN METZ

Metz, Christian. FILM LANGUAGE: A SEMIOTICS OF THE CINEMA. Trans. Michael Taylor. New York: Oxford University Press, 1974. 268pp.
This is the book that launched a thousand articles on semiotics and film. First published in France in 1968, it is Metz's clearest and most accessible discussion on the characteristics of film as a language. The material is divided into four main sections: "Phenomenological Approaches to Film," "Problems of Film Semiotics," "Syntagmatic Analysis of the Image Track," and "The Modern Cinema: Some Theoretical Problems." Endnotes are included. Recommended for special collections.

Metz, Christian. THE IMAGINARY SIGNIFIER: PSYCHOANALYSIS AND THE CINEMA. Trans. Celia Britton et al. Bloomington: Indiana University Press, 1982. 327pp.
A complex and difficult book that synthesizes Metz's earlier studies on psychonalysis, this work is a collection of four earlier texts that the author had written between 1973 and 1976. The material is divided into four major parts: "The Imaginary Signifier," "Story/Discourse (A Note on Two Kinds of Voyeurism)," "The Fiction Film and Its Spectator: A Metapsychological Study," and "Metaphor/Metonymy, Or The Imaginary Referent." Among the many important contributions the book makes to contemporary film theory is a chance to study the author's theoretical progress from 1968 to 1976. Endnotes and an index are included. Recommended for special collections.

Metz, Christian. LANGUAGE AND CINEMA. Trans. Donna Jean Umiker-Sebeok. Paris: Mouton, 1974. 304pp.
Another complex and technical discussion of semiotics, this highly regarded book analyzes language as a system. Metz makes a scholarly case for the study of signs and codes as the basis of cinematic language analysis. Among the material discussed in detail are the plurality of cinematic codes, textual systems, the nature of the paradigmatic and syntagmatic, the problem of distinctive units, and the relativity of the classification used. A list of references and three indexes are included. Recommended for specialists.

JEAN MITRY

Lewis, Brian. JEAN MITRY AND THE AESTHETICS OF THE CINEMA. Ann Arbor: UMI Research Press, 1984. Illustrated. 140pp.
Originally written as Lewis's 1980 University of Iowa doctoral dissertation, this informative and valuable examination of Mitry's ESTHETIQUE ET PSYCHOLOGIE DU CINEMA is a valuable companion piece to Andrew's earlier analysis in THE MAJOR FILM THEORIES: AN INTRODUCTION. The ease with which the author deals with complex and difficult ideas is impressive. For example, in a few short pages Lewis skillfully summarizes the reasons why Mitry was a lifelong, self-confessed "cinema addict" and how he channeled his love for films into a remarkable range of activities. Then on a single page, Lewis summarizes the five major aspects of Mitry's comprehensive aesthetics of film, noting the central role that phenomenological traits play in defining the film experience: "These 'basic structures' include the photographic image and the frame in their multiple psychological aspects, and the rapid succession of separate images, which evoke the illusion of movement, cinematic narrative, and cinematic discourse." Acknowledging the difficulties associated with Mitry's prose style, Lewis first organizes the major ideas in the two-volume work and then proceeds to discuss their importance to film theory and study. Endnotes, a bibliography, and index are included. Recommended for special collections.

HUGO MUNSTERBERG

*Munsterberg, Hugo. THE FILM: A PSYCHOLOGICAL STUDY. New York: D. Appleton, 1916. New York: Dover, 1970. Foreword Richard Griffith. 232pp.
This is the first major attempt by a distinguished psychologist to explain the relationship between film techniques and the movie audience. It has not dated. His treatment of depth, movement, attention, and emotions is thorough, and his brilliant observations on the "phi phenomenon" (the psychological reaction that contributes to the illusion of moving pictures) are excellent in defining the limitations of the vision concept of film. The summarized lectures of Slavko Vorkapich, a specialist in montage editing, lovingly recorded by Barbara L. Kevles in FILM CULTURE 38 (Fall 1965), are a good follow-up. Recommended for special collections.

BILL NICHOLS

*Nichols, Bill. IDEOLOGY AND THE IMAGE: SOCIAL REPRESENTATION IN THE CINEMA AND OTHER MEDIA. Bloomington: Indiana University Press, 1981. Illustrated. 334pp.

Centering on the relationship between patterns and images in film and how they affect us individually and collectively, Nichols asks a series of questions: "What does a society make of images--especially in relation to its need to reproduce the existing relations of production? Why do certain patterns in the selection and arrangement of images afford pleasure? Is that pleasure innocent or does it. . . bear some necessary, but variable, relation to ideology?" Drawing upon a variety of approaches--e.g., Marxism, psychoanalysis, semiotics, and structuralism--to analyze fiction and non-fiction film genres, the author makes us sensitive to the types of messages that can be communicated in film. Eight intriguing chapters raise a number of controversial issues relating to ideological values in the film industry. A bibliography, endnotes, and an index are included. Recommended for special collections.

*Nichols, Bill, ed. MOVIES AND METHODS: AN ANTHOLOGY. Berkeley: University of California Press, 1976. Illustrated. 640pp.

"This anthology," the author explains, ". . . will examine a range of critical methods applicable to film study, and will provide examples of how these methods can be applied to the study and appreciation of actual films. It sets older traditions alongside newer ones, throwing light on the limits of methods that were once pervasive and establishing a historical context for methods that are still being formulated. The emphasis will be on methods rather than on classic film repertory. . . ." The book is divided into three major sections: "Contextual Criticism" (political and genre criticism), "Formal Criticism" (AUTEUR criticism and MISE EN SCENE criticism), and "Theory" (film theory and structuralism-semiology). A glossary and index are included. Recommended for special collections.

PARKER TYLER

*Tyler, Parker. THE HOLLYWOOD HALLUCINATION. Introduction Richard Schickel. New York: Simon and Schuster, 1970. 246pp.

A strange and offsetting style characterize the writings of this prolific and myth-oriented film critic. Most of the time it is difficult to understand where he is heading, let alone what he means. Although the films discussed in this book, and most other works by Tyler, are from Hollywood's "golden age," he considers films films and makes no effort to relate to a particular period or time frame. As far as he is concerned, movies are myths, not art. He has no interest in standard evaluations. He wants to study the unconscious ideas that emerge from the different roles film personalities play in Hollywood films. More to the point, Tyler argues that film is made up of three parts: "art," "dream," and "cult." Each is distinguished from the others. "At the same time," he explains, "since most of the films I shall discuss here start with the premise of being fiction and thus 'art,' the dream and the cult can never be wholly isolated from the art: organically, they remain interrelated. Hence the classifications in this book represent emphases, and not categories, viewpoints and not final definitions." First published in 1944, this original and controversial commentary on American filmmaking in the 1930s offers the reader a chance to study a form of dream theory criticism that tries to explain the complex relationship between movies and their audiences. Well worth browsing.

*Tyler, Parker. MAGIC AND MYTH OF THE MOVIES. Introduction Richard Schickel. New York: Simon and Schuster, 1970. 283pp.

Admitting a peculiar, indeed fatal attraction to the works of Tyler, Schickel writes in his introduction that the author's critical daring consists of two major elements: "a willingness to risk overinterpretation of specific objects (the popular films and film stars that catch his endlessly roving eye) and the courage to build on these fragile and transitory creations a towering theoretical structure (a structure from which, it should be added, one can gain a unique view of the way one of our most significant cultural institutions actually works--or used to work at the height of its powers--on us)." This book on how Hollywood manipulates our minds through a star system both on and off the screen was originally published in 1947. In it Tyler continues his controversial and perplexing analysis of the movies as the folk art of the American people. The primary emphasis is on discussing the 1940s as commercial myths. Well worth browsing.

*Tyler, Parker. THE SHADOW OF AN AIRPLANE CLIMBS THE EMPIRE STATE BUILDING: A WORLD THEORY ON FILM. Garden City: Doubleday, 1973. 300pp.
Tyler weaves his most tangled web in this rambling, disorienting, and outrageous theoretical exercise. Sample this opening statement for a clue to where the myth-oriented critic is heading: "A world theory of film must be as much about the world as about film; else it is only a stab at a theory, a shadow of one. We cannot aim at a perfectly secure, a really satisfying and broadly based theory of film, therefore, without taking into account all our problems as a human society today, especially that aspect that involves the value and limits of the aesthetic position as such. Film, as so widely useful a medium (TV is also film), one so often involved with elements only journalistic, carries an immense technical burden and a corresponding moral responsibility. Obviously, then, it is impossible to propose a theory of film without examining a number of historical qualities." And so it goes page after confusing page. I think the book is about art, life, and mimesis. An index is included. Approach with caution.

Tyler, Parker. THE THREE FACES OF THE FILM: THE ART, THE DREAM, THE CULT. New York: Thomas Yoseloff, 1960. Illustrated. 150pp.
By this stage in his critical journeys, the eccentric but fascinating critic had synthesized his writings on film and dream to present a good discussion of the cultural and aesthetic relevance of movies in our lives. In discussing the critical significance of this book, Tyler writes, "Suddenly. . . it then struck me that the very basis of my own attitude toward the movies is that the value of any one film, considered as unique, is signally less than its value as a 'specimen,' something with its tentacles clearly marked in various moral, mental and aesthetic strata; for me that is to say, a film (whatever else it may be) is predominantly the token of a stream of consciousness, dipping waywardly into the unconscious and just as waywardly connecting itself with the unceasing life of the mind and body as this life is part of daily experience and as it also enjoys other arts." His division of the material into "art," "dream," and "cult" continues his exploration of dream, myth, and hallucination in the film world. An index is included. Well worth browsing.

PETER WOLLEN

*Wollen, Peter. READINGS AND WRITINGS: SEMIOTIC COUNTER-STRATEGIES. London: Verso Editions, 1982. 228pp.
"This book," Wollen writes, "collects together essays and fictions written during the period from 1968 to 1982 and published in a variety of magazines and journals, of which the most significant for me personally were SCREEN and BANANAS." The seventeen pieces grouped in four untitled sections reflect not only changes in Wollen's thinking about the nature of semiotics, Marxism, and aesthetics, but also his reactions to the power of the medium to influence behavior and values. Particularly refreshing about the filmmaker-theorist is his ability to pursue new ideas without rigid preconceptions. Endnotes and an index are included. Well worth browsing.

*Wollen, Peter, SIGNS AND MEANING IN THE CINEMA. Bloomington: Indiana
University Press, 1969.
 This is the first English-language book on film theory dealing with the
relationship between film and the other arts to apply the principles of semiology to
screen language. In clear and straightforward prose, Wollen discusses how a system
of signs functions in cinematic communication. Where later works make access to the
system of signs difficult and frustrating for non-linguists, this book is sensitive to
the needs of would-be semiologists. For beginners who need and value a useful survey
of Eisenstein, the AUTEUR theory, and a linguistic-oriented discussion of major
directors, Wollen's well-written, concise, and enjoyable text is first rate.
Recommended for special collections.

Chapter 2: A Representative Genre of the Film

. . . . no attempt was ever made before the movies began to please young and old, men and women, rich and poor, learned and ignorant, well-bred and vulgar, urban and provincial, cleric and peasant, by the same means. Everything that is strong and everything that is weak in the moving pictures must have its source in this same attempt at being universal--its wealth in money, its poverty in taste, its splendid achievements, and its disastrous failures.

Gilbert Seldes, THE MOVIES COME FROM AMERICA

At some point in film study it is important to distinguish among the wide variety of movie genres--e.g., documentaries and fiction films--together with their numerous subdivisions. It is also valuable to know something about the history, conventions, and outstanding examples of a particular genre if one is to develop critical standards in viewing films.[1] This background tells a student about film precedents, what is unique about the movies, and where the innovations seem to be heading. In addition, as Thomas Schatz observes, it provides a much needed critical and theoretical framework for understanding how the film industry operates in terms of a producer-audience process. That is, movies are seen primarily as a commercial venture using successful formulas in a standardized manner to maximize profits.[2] The formulas move along in routine fashion until a "revolutionary" film appears. Its success produces not only a shift in the traditional images, but also a host of imitations made by other filmmakers eager to profit by giving the public more of what it enjoys.

At the core of most traditional genre studies is a recognition of the complex relationship that exists among the artist, the film, and the audience. Tom Ryall, in his overview of genre studies, states, "The master image for genre criticism is the triangle composed of artist/film/audience. Genres may be defined as patterns/forms/styles/structures which transcend individual films, and which supervise both their construction by the filmmaker, and their reading by the audience."[3] Schatz sees "the studio's reliance on standardized techniques and story formulas--on established SYSTEMS OF CONVENTION--. . . [as] not merely a means of economizing the material aspects of production, but also of responding to the audience's collective values and beliefs."[4] Specific studies of major genres continually stress the close links between filmmakers and their intended audiences. In discussing westerns, for example, Jim Kitses argues that the neutrality of the concept "westerns" assumes "an area of agreement between audience and artist with reference to the form which his art will take. . . ." He then goes on to identify the key interrelated aspects of "genre" as being history, themes, archetypes, and icons.[5] Andrew Tudor concurs. He insists that the best approach to explaining and defining a genre is "to lean on a common cultural consensus as to what constitutes a 'Western' and then go on to

[1] For a useful updating of recent studies, see Larry N. Landrum, "Recent Work in Genre," JOURNAL OF POPULAR FILM AND TELEVISION 13:3 (Fall 1985):151-8.

[2] *Thomas Schatz, HOLLYWOOD GENRES: FORMULAS, FILMMAKING, AND THE STUDIO SYSTEM (Philadelphia: Temple University Press, 1981), p.viii.

[3] Tom Ryall, "Teaching Through Genre," SCREEN EDUCATION 17 (Winter 1975/76):28.

[4] Thomas Schatz, OLD HOLLYWOOD/NEW HOLLYWOOD: RITUAL, ART, AND INDUSTRY (Ann Arbor: UMI Research Press, 1983), p.12. See also David Nord, "An Economic Perspective on Formula in Popular Culture," JOURNAL OF AMERICAN CULTURE 3:1 (Spring 1980):17-31.

[5] Jim Kitses, HORIZONS WEST: Anthony Mann, Budd Boetticher, Sam Peckinpah--Studies of Authorship Within the Western (London: Thames and Hudson, 1969), pp.24-5.

analyze it in detail."[6] Colin McArthur, in his examination of the gangster film, responds to those critical of genre studies with the argument that "genre, with its obvious analogies with a sign system, an agreed code between filmmaker and audience, would seem on the face of it a fruitful starting point for investigating the semiology of the cinema."[7] Even Stephen Neale, who takes exception to most traditional genre criticism because of the lack of "conceptual means" for analysis, agrees in his attack on Ryall's thesis that "while an interrelationship central to an understanding of genre is clearly located, i.e. the triangle 'artist/film/audience,' there are no conceptual means offered for its analysis."[8] Kathryn Kane makes a further elaboration. She points out that "Though little research has been done on . . . [audience expectations], it seems apparent that audience recognition of a film as generic is most immediate on the level of visual imagery." Kane goes on to say that "An image which recurs over and over and by this repetition builds up its own set of independent meanings is called an icon."[9] Thus, success breeds repetition and repetition forms audience input and expectations. Recognizing the importance of the producer-audience process is, therefore, essential to the study of film genres.

Equally important is the awareness that economic conditions vis-a-vis the film process do not constitute a simple, straightforward explanation for a standardized product. Market conditions, political and social constraints (e.g., industry self-censorship), budgetary concerns, and individual artistic inclinations do not operate in the same way as in other mass-produced products. Neale, for example, perceptively points out that while the profit motive influences the series of films produced by the industry, it does not account for the existence of genre films. That is, "in contrast to other, non-artistic commodities, each film, of whatever variety, kind or genre has in some way to be different, unique in order to guarantee regimes of pleasure and meaning. . . ."[10] In addition, Neale theorizes that film audiences, unlike those who purchase cars, never buy a film product at the box office, only the right to see a film. And that, furthermore, unlike the conventional consumer who takes away a product for a price, the film audience takes home not a film but a memory.[11] In other words, those who study film genres need to understand that while the film industry operates as a business processing expectations for a mass audience, the profit motive demands that diversity and repetition function in each film as the basis for a successful product.

The simultaneous demand for both novelty and tradition helps explain the overwhelming narrative emphasis in commercial films. That emphasis is directly related to the filmmaker's skill in using a story to provide both entertainment and ideological messages for a mass audience. In fact, "Narrative art," as Robert Scholes and Robert Kellogg surmise, "requires a story and a story-teller. In the relationship between the teller and the tale, and that other relationship between the teller and the audience, lies the essence of narrative art."[12] Filmmakers base much of their

6 Andrew Tudor, "Genre: Theory and Malpractice," SCREEN 3:6 (November/December, 1970):37.

7 Colin McArthur, UNDERWORLD USA (New York: The Viking Press, 1972), p.20.

8 *Stephen Neale, GENRE (London: The British Film Institute, 1980), p.7.

9 *Kathryn Kane, VISIONS OF WAR: HOLLYWOOD COMBAT FILMS OF WORLD WAR II (Ann Arbor: UMI Research Press, 1982), pp.7-8.

10 Neale, p.52.

11 Neale, p.53. In fairness to Neale, he made that statement before the advent of the videocassette, videotape, and videodisc era.

12 *Robert Scholes and Robert Kellogg, THE NATURE OF NARRATIVE (New York: Oxford University Press, 1966), p.240.

storytelling power on an ability to imbue their tales with psychological and social relevance. Thus, gangster films exploit society's dilemma between conforming to a social code and the need for individual assertiveness. Westerns incorporate into their action-packed dramas the debate between the appeal of the wilderness and the security of civilization. Clearly, the close ties between storytelling and ideology are not unique to films.[13] For example, the relationship between myth and storytelling in American literature, to be discussed in Chapter 5, illustrates how the new nation used its physical being and enterprising population to fashion an image not only of our national character, but also of our national destiny. One has only to read the writings of Erastus Beadle, James Fenimore Cooper, Mark Twain, and Walt Whitman to get a sense of the way in which myths about the frontier became conventions in a growing body of material that used literature to shape and coalesce the nation's hopes and dreams. Henry Nash Smith brilliantly explained how our literary heritage emphasized the importance of the Western frontier, the celebration of democracy, and the doctrine of a manifest destiny. "A new intellectual system was requisite," Smith points out, "before the West could be adequately dealt with in literature or its social development fully understood."[14]

Just as myth-making is not unique to films, America's attitudes toward its national mythology are not unique to its myth-making process. As Richard Slotkin explains,

> The mythology of a nation is the intelligible mask of that enigma called the "national character." Through myths the psychology and world view of our cultural ancestors are transmitted to modern descendants, in such a way and with such power that our perception of contemporary reality and our ability to function in the world are directly, often tragically affected.[15]

The study of how these myths move through stages from oral traditions to legends and folk tales and eventually become part of our literary and cinematic traditions is beyond the scope of this study. For now, what is important is an awareness that narratives often articulate a collective consciousness. Will Wright summarized their basic value, stating that "Stories (myths) relieve boredom, permit escape, relate custom and history, enrich experience, reinforce values, relieve psychological conflict, produce social cohesion, create social conflicts (Leach), strengthen status demands, teach children violence. . . ."[16]

It's not not surprising, therefore, that the movie industry relies so heavily on narrative traditions in selling its product to the public. Nor is it unusual for critics like Kane to state that the underlying feature of genre is its everyday subject matter. That is, "Subject matter makes itself the central issue of the films through the primary narrative aspects of film: theme, form--especially setting, character and plot--and visual imagery."[17] Schatz takes a similar tack, insisting that a genre is much more than a collection of narrative conventions: "It represents the way artists

[13] For a good introduction to the relationship between film history and myth, see Philip Beck, "Orson Welles and John Ford: History and Myth in Film," JOURNAL OF THE UNIVERSITY FILM ASSOCIATION 28:3 (Summer 1976):13-7.

[14] *Henry Nash Smith, VIRGIN LAND: THE AMERICAN WEST AS SYMBOL AND MYTH (New York: Vintage Books, 1950), p.305.

[15] *Richard Slotkin, REGENERATION THROUGH VIOLENCE: THE MYTHOLOGY OF THE AMERICAN FRONTIER, 1600-1860 (Middletown: Wesleyan University Press, 1974), p.3.

[16] Will Wright, SIXGUNS AND SOCIETY: A STRUCTURAL STUDY OF THE WESTERN (Berkeley: University of California Press,1975), p.192. The reference to "Leach" is related to "The Story of Asdiwal," in *THE STRUCTURAL STUDY OF MYTH AND TOTEMISM, ed. Edmund Leach (London: Tavistock Publications, 1967).

[17] Kane, p.3.

and audiences feel and think about their culture: about their art, politics, storytelling, perceptions, social values, institutions, individuality, and so on."[18] In the movie industry, filmmakers also rely on contemporary cultural conflicts and recent technological developments as the primary sources for modernizing familiar and popular screen narratives. As Bill Nichols points out, it is the method which most closely ties "internal, formal patterns to external phenomena--the western film and the frontier ethic, the gangster film and outlaw capitalism, the musical and Hollywood as a dream factory, horror films and psychological patterns. . . ."[19] In this respect, the filmmaker is very similar to the nineteenth century popular writer who "abandons his own personality and identifies himself with the reveries of his readers."[20]

Most important, the study of film types helps us, better than any other approach, to categorize, compare, and contrast motion pictures. When to begin the analysis of film genres can be determined only by specific instructors and their students, and depends upon the group's age, experience, and interest.

LIMITATIONS

As already indicated, genre study poses a number of methodological problems including those of workable definitions, sensible classifications, meaningful iconographic characteristics, and accurate historical trends.[21] Richard Griffith's concern, for example, with relating genres like the topical, gangster, and confessional films to their historical setting in the Depression Era gives us a useful perspective on the intricate links between movies and society, but obscures the way superior films with similar themes or topics differ from lesser films within the same genre. For example, knowing that SMART MONEY and THE SECRET SIX were both gangster movies made in 1931 does not tell us anything about either their quality or their commercial success. A second problem surfaces when Griffith de-emphasizes aesthetic values in favor of contextual criticism, making clear that one's likes and dislikes are less important than understanding the films themselves. This focuses attention on identifying sociological issues of a society at a particular time when gangsters were popular heroes, audiences sentimentalized unrestrained violence, and small towns with their aversion to morbid movies dealt a death blow to crime films. Griffith's intention is to reduce the negative influence that cyclical value systems have on genre film analysis.[22] An educated sensibility, however, is a useful critical tool, particularly when one rummages through the history of popular film genres. Andrew Tudor is another film theorist who champions genre study as a detailed and responsible critical tool. He sees its major value as shifting "thought on film . . . away from theoretical interests [and] toward discussion of the methodology of analysis." [23] Yet

[18] Schatz, OLD HOLLYWOOD, p.233.

[19] *Bill Nichols, "Genre Criticism," MOVIES AND METHODS: AN ANTHOLOGY, ed. Bill Nichols (Berkeley: University of California Press, 1976), p. 107.

[20] Smith, p.101.

[21] Other sources for criticism include Edward Buscombe, "The Idea of Genre in the American Cinema," SCREEN 11 (March/April 1970):33-45; Tom Ryall, "The Notion of Genre,"ibid., pp. 22-32; Leland A. Poague, "The Problem of Film Genre: A Mentalistic Approach," LITERATURE/FILM QUARTERLY 6:2 (Spring 1978):152-161; and Edward S. Small, "Literary and Film Genres: Toward a Taxonomy of Film," ibid., 7:4 (1979):290-9.

[22] Richard Griffith, "Cycles and Genres," MOVIES AND METHODS: AN ANTHOLOGY, ibid., pp. 111-8.

[23] Andrew Tudor, "Genre and Critical Methodology," MOVIES AND METHODS: AN ANTHOLOGY,

Tudor reminds us that genre methodology is based on many untested assumptions concerning commonly agreed-upon definitions, mass audience expectations, and the sociological relationship between films and society. For example, defining a film as a "western" often gives the false impression that all such labeled films share the same basic elements. They don't. Furthermore, Tudor shows how critics use the term far more narrowly than does the public. Even then, he points out, critics disagree among themselves on whether it is best to categorize films according to the film's attributes or intentions. To guard against the flaws in these genre hypotheses, both Griffith and Tudor insist genre analysis needs to be as rigorous as possible. In that way, the final judgments have more validity, can be tested by others, enhance the viewing experience, and increase the potential for further discoveries.

Additional problems arise when film teachers, sensing that most American and many foreign films are adapted from books and plays, base their genre study programs too mechanically on the traditional approaches to classifying literary types. In those instances, the results are negligible. However, when imagination is substituted for rote thinking, the analogy has considerable merit. Nearly all instructors recognize the importance of the narrative and its critical antecedents in the commercial cinema. For the past two centuries, literary scholars have been studying fiction, poetry, and drama as art forms deeply influenced by myths and symbols. Here, as suggested earlier, the concern has been with the manner in which abstract ideas have been given concrete forms that transmit, influence, and reinforce the attitudes and values of society. Jerome Bruner, for example, recognized in myths an "aesthetic device for bringing the imaginary but powerful world of preternatural forces into a manageable collaboration with the objective facts of life in such a way as to excite a sense of reality amenable to both the conscious mind and the unconscious passions."[24] Claude Levi-Strauss asserts that "myths are communications from a society to its members,"[25] and Roland Barthes argues that "myth is a type of speech."[26]

The judgments reached over the past two hundred years, therefore, are of great value because they often represent the same concerns that film criticism reveals about story development, theme, characterizations, setting, conflict, and irony. Such works, as Northrop Frye demonstrates, share universal qualities of wish fulfillment found most frequently in mythical romances. That is, influential people in every age project their ideals into some form of romance, "where the virtuous heroes and beautiful heroines represent the ideals and the villains the threat to their ascendancy."[27] Such qualities are relevant to the film producer/product/audience triangle, where the key elements are adventure, and the romance predictably appears as a sequential and consecutive form. The types of characterization found in a film-literature romance concentrate on a quest resulting in a climactic battle between the hero and the villain. Throughout the narrative, the author/filmmaker strives to maintain a close audience identification with the hero, his/her values, and their relationship to worldly concerns.[28] In other words, as Frye states elsewhere,

ibid., pp.118-26. See also *Andrew Tudor, THE MAJOR FILM THEORIES: AN INTRODUCTION (New York: Oxford University Press, 1976).

[24] Jerome Bruner, "Myth and Identity," DAEDALUS 88:2 (Spring 1959). Cited in Carlos Boker, JORIS IVENS, FILM-MAKER: FACING REALITY (Ann Arbor: UMI Research Press, 1981), p.34.

[25] Quoted in Edmund Leach, CLAUDE LEVI-STRAUSS (Middlesex: Penguin Books, 1970), pp.58-9.

[26] Roland Barthes, MYTHOLOGIES, trans. Annette Lavers (New York: Hill and Wang, 1972), p.109.

[27] *Northrop Frye, ANATOMY OF CRITICISM: FOUR ESSAYS (New York: Atheneum, 1968), p.186.

[28] Frye, p.186.

"literature belongs to the world man constructs, not to the world he sees; to his home, not his environment. Literature's world is a concrete human world of immediate experience."[29]

Obviously, the narrative and its literary antecedent blend easily with the film industry's methods and interests. In discussing epic war films like THE DEER HUNTER (1978) and APOCALYPSE NOW (1979), for example, John Hellmann indicates their links to two of Hollywood's most enduring genres of American pulp literature: the western and the hard-boiled detective novel. He then goes on to argue that because "both formulas are genres of romance, they provide the directors with the 'mythic, allegorical, and symbolistic forms' that Richard Chase has traced as the main strategy of the American literary tradition for encountering the contradictions and extreme ranges of American culture and experience, of which Vietnam is a recent and particularly traumatic example."[30] Kathryn Kane in her study of World War II combat films concurs. She argues against viewing such movies in the context of intelligent, reasoned, and coherent considerations of men and war. "It is much more to the point," she asserts, "to see these films in terms of Romance, of twentieth century myth."[31] Consequently, teaching strategies that rely on literary precedents present widespread benefits and countless pitfalls. Before looking at the benefits, we should first understand the pitfalls.

The most obvious drawbacks in the literary-film analogy, discussed in Chapters 1, 5 and 7, concern the differences in production and audience. Literary works generally result from the efforts of a single author or limited team of collaborators working in relative solitude; films are much more collaborative ventures often produced in populated areas and are mass experienced. To study out of context individual contributions to a single film [as evident in AUTEUR criticism] would be to distort seriously how films are made and to misunderstand grossly various elements within the film itself. The differences in authorship, however, need not be a major problem in genre film study. As long as researchers recognize that a genre's conventions are not dependent on any one filmmaker for their existence or meaning, they can successfully use the AUTEUR method of analysis. When specific directors, stars, writers, producers, or cinematographers spend considerable time and effort on a particular formula, an analysis of their individual input proves useful, but only as a second step to the primary purpose of genre analysis. As Stuart Kaminsky puts it, "In general, one must first consider a work in terms of understanding its genre, and the work's relationship to that genre before attempting to discern what the creator of the work has added to the genre--or given it beyond its accumulated historical-cultural definition."[32] Furthermore, a literary author is less bound by mass audience expectations of storytelling conventions, seasonal marketing conditions, or production costs.[33]

[29] *Northrop Frye, THE EDUCATED IMAGINATION (Bloomington: Indiana University Press, 1964), p.27.

[30] John Hellmann, "Vietnam and the Hollywood Genre Film: Inversions of American Mythology in THE DEER HUNTER and APOCALYPSE NOW," AMERICAN QUARTERLY 34:4 (Fall 1982):419. The reference to Chase relates to *Richard Chase, THE AMERICAN NOVEL AND ITS TRADITION (Baltimore: Johns Hopkins University Press, 1957), p.13.

[31] Kane, p.147.

[32] *Stuart M. Kaminsky, AMERICAN FILM GENRES: APPROACHES TO A CRITICAL THEORY OF POPULAR FILM (Dayton: Pflaum Publishing, 1974), p.7.

[33] In fairness to filmmakers, literary authors are not always of the magnitude of D. H. Lawrence and Ernest Hemingway. Thus, they are as much bound by commercial pressures and editorial interference as the average filmmaker.

A more serious barrier to the analogy is the long-standing literary prejudice against the popular/commercial arts, the assumption that there is a difference in quality of content, audience, and skill between high and low culture. "The problem," as Hal Himmelstein explains, "begins with the presupposition that mass culture and popular art can only signify crass, formulaic, superficial works that correspond to a certain 'level of taste' in the audience for such works; the audience for mass culture and popular art is said to be large in number and underdeveloped in its aesthetic sensibility."[34] Unfortunately, the effect of such overgeneralizations is to discount altogether individual artistic achievements and the function that mass culture performs in an industrial society. The false assumption is that only high culture offers enlightenment; low culture, mindless escape and entertainment. In addition, it ignores individual works and focuses criticism on a falsely perceived mass audience.

Since genre films epitomize for many people the best of the film industry's formulaic approach to escapist entertainment, their reliance on conventions works against them in the mass culture/high culture debate. Ever since the romantic period, for example, literary critics have had an intellectual preference for originality and disdain for conventions, stereotyped characters, familiar settings, predictable endings, and repetition. Schatz believes that the transformation from the Old to the New World precipitated a reevaluation of what was meant by CULTURE. The result was a privileged status attributed to the "high arts," those forms of communication that enjoyed the patronage of "the economic and educational elite." Thanks in part to the efforts of opinion-makers like Matthew Arnold, Alexis de Tocqueville, and Henry Adams, the attempts in the industrial society to make art more democratic were deemed detrimental to humanity because they did away with elitist standards. "With industry and commerce," explained Schatz, "came our mass society, with its mass production, mass marketing, and mass consumption of goods by and for the masses."[35] The prejudices born in one century have been brought forth almost intact to the next century. "Genre films especially are criticized," Leo Braudy discovers, "because they seem to appeal to a pre-existing audience, while the film 'classic' creates its own special audience through the unique power of the filmmaking artist's personal creative sensibility."[36] The traditional scholar's prejudice against imitative forms in general and genre films in particular both overemphasizes poetic imagination and misunderstands the art of genre films. Critics who have neither the solid background needed to interpret the history of a particular genre or who prefer subjective judgments find aesthetic analyses easier to use in terms of both time and effort. That is not to deny the value of aesthetics. As stated earlier, an educated sensibility is indispensable to serious film study, but not as a substitute for identifying the birth, growth, and maturing of a successful film tradition.

It is equally true that the popular arts produce inferior works, frequently ignore imagination in favor of mechanical reproduction, and prefer profits to art. To say the same is often true of the literary arts, as well as dance, music, architecture, theater, and painting does not really address the problem, although it suggests the issue is not as simple as traditional scholars would prefer. Modern film scholars take a different approach. Kaminsky, for example, stresses the nonqualitative approach used by many serious film genre students. Their method is to examine "popular forms . . . in an attempt to understand, not 'sell' films or directors."[37] Himmelstein, in the debate over the essence and value of mass culture and the popular arts (i.e., Dwight MacDonald, Edward Shils, and C. Wright Mills), pinpoints many of the elitists' theoretical fallacies. For example, overgeneralizations about a body of films are not

[34] *Hal Himmelstein, ON THE SMALL SCREEN: NEW APPROACHES IN TELEVISION AND VIDEO CRITICISM (New York: Praeger, 1981), p.2.

[35] Schatz, OLD HOLLYWOOD, pp.4-6.

[36] *Leo Braudy, THE WORLD IN A FRAME: WHAT WE SEE IN FILMS (Garden City: Doubleday, 1977), p.104.

[37] Kaminsky, p.4.

a valuable substitute for aesthetic judgments on a film-by-film basis. Nor is it true that serious artists avoid working in the mass media. Many gifted people employ their talents in a variety of media, including film and television. It is just as misleading to argue that the falsely perceived mass media audience is made up of only the uneducated and less sophisticated. The cultural elite clearly use the mass media for enlightenment and entertainment. And most significant, the overall debate itself sheds few worthwhile insights about the aesthetic and mythic qualities of genre films.[38] Thus, critics like Kaminsky and Himmelstein deplore elitist attacks on the audience. Just the opposite is important to them. They want an explanation of why the films and the contributors evoke such strong, immediate, and long term audience reactions. Braudy goes further, saying, " Genre films . . . arouse and complicate feelings about the self and the society that more serious films, because of their bias toward the unique, may rarely touch. Within film the pleasures of originality and the pleasures of familiarity are at least equally important."[39] He argues that genre films are best seen in terms of what they accomplish. That is, "The joy in genre is to see what can be dared in the creation of a new form or the creative destruction and complication of an old one."[40]

Another constructive response to those opposed to an analysis/discussion of the conventions of the popular arts evident in film genres is to examine the recent approaches to the study of television put forth by scholars such as David Thornburn,[41] John R. Cashill,[42] and Peter H. Wood.[43] These theorists are quite willing to accept the fact that television is a popular art form that uses a standard product where frequently the formula is too sentimental, focuses on exaggerated incidents or actions at the expense of subtle characterizations, makes sensational appeals to the audience's emotions, and ends with the central characters living happily ever after. What these theorists are not willing to accept is that these reassuring qualities of a popular art form as entertainment are bad. They may in fact provide us with meaningful insights into our communal lives--our identity, our potential for the future. These insights are gained by delving beneath the surface level of the formula's reassuring characteristics.

The basic thrust of these popular culture theories and their relationship to mass culture in general and genre films in particular is that there are times when too much attention is paid to traditional aesthetics and not enough to the realization that there are other criteria for evaluating art. As Thornburn indicates in his essay "Television Melodrama," the crucial point "is the way in which the old dispraised attributes of melodrama are understood, the contexts to which they are returned, the respectful scrutiny they are assumed to deserve."[44] This approach encourages us to see melodrama (and possibly other popular visual narratives) as fantasies of reassurance, which then allow the narrative to act as a forum for the forces of tradition to interact with those of change and contingency. Cashill, in his probing of the relationship

[38] Himmelstein, pp.3-12.

[39] Braudy, p.105.

[40] Braudy, p.109.

[41] David Thornburn, "Television Melodrama," TELEVISION AS A CULTURAL FORCE, eds. Douglass Cater and Richard Adler (New York: Praeger, 1976), pp.77-94.

[42] John R. Cashill, "Packaging Pop Mythology," THE NEW LANGUAGES, eds. Thomas H. Ohlgren and Lynn M. Berk (Englewood Cliffs: Prentice-Hall, 1977), pp.79-90.

[43] Peter H. Wood, "Television as a Dream," TELEVISION AS A CULTURAL FORCE, pp.17-35.

[44] Thornburn, p.78.

between myth and media, wants to see if there is "a mass of beliefs, values, fears, and dreams which may not decipher Americans' relationship to the universe, but which do shape the gritty clay of their everyday existence."[45] His strategy is to explore popular myths like manifest destiny, racism, anti-intellectualism, and cleanliness in order for us to better understand how the medium works and how we respond. Wood suggests looking at the medium as a form of collective perceptions. He wonders what would happen if we accepted the notion that TV affects the dream life of individuals. Could we then "entertain the thought that TV may also CONSTITUTE --in some unrecognized way--part of the collective dream life of society as a whole? Is there room, in other words, for THE INTERPRETATION OF TELEVISION AS DREAM?"[46] Each theorist, therefore, turns long standing prejudices against the popular arts into constructive models for serious examination while indirectly strengthening the case for genre studies.

THE EHRENPREIS MODEL

The fact that so many teachers use literary traditions as an aid to film study illustrates the widespread support the approach has for contemporary classrooms. In this respect, I find the best source for reviewing these current practices is a doctoral study, done more than forty years ago, that directed its attention to answering the problems of why and how to study genres.[47] The same arguments are basically true for film categories. Ivin Ehrenpreis found that one approach is to set up platonic types toward which all authors (filmmakers) strive but rarely reach. A second approach is to use traditional types, a procedure that may discourage the recognition of new types. (This is the great weakness for film study in two ways: first, it prevents people from recognizing film as a new art form; second, it limits the creative and original movie, which is outside the traditional scope of the categories.) A third approach is to erect a hierarchy of types and thereby establish a ranking system for major and minor genres. But no one, either in Ehrenpreis' examination or in current film study, thinks of these categories as permanent and immutable forms of communication into which films are classified by means of rigid and inflexible criteria. The characteristics of a specific genre or approach should be defined in terms of a definite context. In that way films are classified by a cultural-historical process, underscoring the importance of relating a particular interpretation to a specific time, purpose, group, and place.

It comes as no surprise that the most frequent reasons given for studying genres in the schools are those of convenience and organization. By arranging blocks of time to examine various types, students are able to (1) gain explicit recognition of literature (film) itself; (2) move easily from an individual work to a number of works of the same type; (3) surmount various kinds of reading difficulties, or, in the case of film, visual illiteracy; (4) appreciate how individual attitudes are reflected by the themes continually used in a culture; (5) compare works of art; and (6) gain a basis for appreciating a work in relation to a particular category.

Ehrenpreis notes that there are three implicit factors connected with these reasons for teaching genres. First is the value of teaching literature as literature (films as film) and not as historical and biographical material. Second is the value in knowing that there are specific types of literature (film) and what these types are.

[45] Cashill, p.79.

[46] Wood, p.19.

[47] Ivin Ehrenpreis, "The Types Approach to Literature" (Doctor of Education Project Report. New York: Teachers College, Columbia University, 1943).

And third is the value accruing from teaching the appreciation of literature (film) through the study of types.[48]

FILM CLASSIFICATION

As for the question of how to classify films, four general methods seem most popular. One approach is to compare different genres in order to discern respective characteristics; here the emphasis is primarily on those particular features of one genre that set it off from others. A second approach is the historical one, in which the students study the development of certain genres--westerns, musicals, and comedies, for example. A third approach is to study a single genre as a way to define principles for the selection of certain plots, characters, and a type of film such as a western, musical, or comedy. A fourth approach is to perceive Hollywood film genres as mythmaking rituals for maintaining and reevaluating American mores and values; the emphasis here is on showing the links between the genre's narrative-social conventions and mass audience appeal.

A practical approach that combines both history and mythmaking, suggested by John G. Cawelti, offers a simple but effective methodology: label the popular film types formulas, not genres.[49] This labeling forces us to consider the complexity of a body of films that have as their primary goal the synthesizing of aesthetic elements with social and psychological implications. No single factor is identified as the justification for a particular formula. Instead, students discover how skillfully a formula adapts to a variety of interpretations and changing societal pressures. The focus is on the manner in which westerns, Biblical epics, romances, and other conventional narrative forms with their mythic qualities engage in specific cultural functions. "We could best define these formulas," Cawelti argues, "as principles for the selection of certain plots, characters, and settings, which possess in addition to their basic narrative structure the dimensions of collective ritual, game and dream."[50] To put it another way, he is trying to redefine mythmaking in more popular, twentieth century terms. Starting with his basic premise about narrative film structures, he analyzes "how the additional dimensions of ritual, game and dream have been synthesized into the particular patterns of plot, character and setting which have become associated with the formula."[51] Cawelti's method is to view each formula--e.g., westerns, musicals, horror films--as having conventions and inventions. The former includes those elements shared equally by the creator and the audience: e.g., the favorite plots, the stereotyped characters, the accepted ideas, and the commonly known metaphors. Inventions, on the other hand, are the elements

[48] Ehrenpreis, pp.83-5.

[49] Cawelti makes four important assumptions about the links between formulaic literature and popular culture: (1) "Formula stories affirm existing interests and attitudes by presenting an imaginary world that is aligned with these interests and attitudes." (2) "Formulas resolve tensions and ambiguities resulting from the conflicting interest of different groups within a culture or from ambiguous attitudes toward particular values." (3) "Formulas enable the audience to explore in fantasy the boundary between the permitted and the forbidden. . . ." (4) ". . . literary formulas assist in the process of assimilating changes in values to traditional imaginative constructs." See John G. Cawelti, ADVENTURE, MYSTERY, AND ROMANCE (Chicago: University of Chicago Press, 1976), pp.34-6.

[50] *John G. Cawelti, THE SIX-GUN MYSTIQUE (Bowling Green: Bowling Green University Popular Press, 1970), p.33.

[51] Cawelti, p.33.

[52] Cawelti, p.27.

that are unique to the individual artist: new characters, for example, or new ideas.[52]

The emphasis in Cawelti's approach is on contrasting and comparing the historical development of a formula--its conventions--with the inventions found in a particular film or period of film history. His methodology places its greatest weight on the cultural functions performed by conventions and inventions. The conventions would be perceived as symbolizing society's shared values; inventions as giving us new perceptions.[53] Consider, for example, the two versions of INVASION OF THE BODY SNATCHERS. In the original 1956 film, the story takes place in a small California community. Thus the problem of credibility that director Phillip Kaufman faced in the 1978 film was different from that encountered by director Don Siegel. The latter had no difficulty in convincing 1950s audiences that pod-like creatures could easily take over Santa Mira and cut off escape. Kaufman's dilemma was how to entrap the citizens of San Francisco and make it believable. This required a different set of characters, more contemporary problems, and a denouement in keeping with the pessimism of the late 1970s. Consequently, the idea of using large cities in place of isolated communities is just one invention filmmakers use to update the genre and take advantage of contemporary cultural conflicts and recent technological developments.[54]

Valuable as it is, the Cawelti method has several weaknesses. First, the distorted notions of "convention" and invention" as being antonyms offend linguists. "Convention" comes from the Latin CONVENTIO meaning "assembly" and "agreement"; "inventions," from the Latin IN VENIRE meaning "to come on." Nevertheless, the catchy use of the terms works well with popular culture audiences. Second, any attempt to ignore quality in film study does a disservice to the art of the film and to the intelligence of serious film students. But by altering slightly Cawelti's emphasis as well as the quantitative judgments in all the aforementioned film genre approaches so as to highlight significant films (i.e., commercially successful, critically acclaimed), we can avoid the pitfalls of fluctuating values and still show the important relationships among film, society, and market conditions. A third problem results from not paying attention to what Maurice Merleau-Ponty termed "perceptual faith." That is, audiences tend to believe that what they see is reality, not an illusion. Genre study must examine the context in which a film was initially screened to grasp how the era helped shape not only the content but also the reception of the movie in its own time. Our exploration of people's perceptions, therefore, allows us to better understand our world view, as well as ourselves.[55]

The most troublesome aspect of Cawelti's formula theory concerns his discussion of myths. Although making clear the misperceptions currently associated with the widespread use of the concept--e.g., confusion between theme and myth, its use as a synonym for a false belief, its long-standing link with ancient stories and heroes--he mistakenly uses myths as an embodiment of both universal archetypes and specific cultural patterns. However, a particular formula delineated by its unique position in time and place cannot simultaneously fit into a universal mode. Cawelti, in effect, is offering us a description of myth, not an explanation of how it functions as a means of social communication. Either its significance is all-embracing, depending on the specific culture only for parochial symbols to translate the sweeping message, or the culture itself is responsible for determining how the formula's

[53] Cawelti, p.28.

[54] For an invaluable introduction to the visual and verbal puns in the Siegel film, see the videodisc release by the Voyager Press. Maurice Yacowar's insightful audio essay is followed by the film's original trailer, the reprint of Stuart Kaminsky's interview with Siegel, a fascinating demonstration of the problems in transferring Videoscope productions to TV formats, and a useful bibliography.

[55] Maurice Merleau-Ponty, THE VISIBLE AND THE INVISIBLE, translated by Alphonso Lingis (Evanston: Northwestern University Press, 1968), p.28. Useful in this connection is a good application of the theory found in J. P. Telotte, "Faith and Idolatry in the Horror Film," LITERATURE/FILM QUARTERLY 10:3 (1982):143-55.

structure and substance symbolize a specific society's conflicts, fears, and values. Universality fails as a definition of permanence for a formula that has undergone considerable changes from Bronco Billy to Clint Eastwood.

In this regard, Will Wright's study of the western genre provides a more reasonable alternative to Cawelti's treatment of myths. He too is preoccupied with the genre's popularity, with the manner in which it reinforces or appeals to a society while still mediating between the individual and a totality. But the two scholars differ significantly on the psychological perspective. Wright states that "the central problem with the psychological approach is that it either ignores or denies the fact that the Western, like other myths, is a social phenomenon."[56] That being true, neither the social nor psychological methods can justify theories that assume shared concerns, which when experienced produce widespread unsettling results. Audiences consist of individuals who interpret the events in unique ways. Conflicts do arise, emotional catharses do occur, but there is no one meaning, no single perspective. "Cultural forms such as myths," Wright reminds us, "help the individual to live with these conflicts."[57] The key point is that the formula approach works well as a description of genres, not an explanation for them.

Where Cawelti relies heavily on the works of Freud and Frye, Wright opts for the structural tribal myth studies of Claude Levi-Strauss, the theories about the social structure of literature formulated by Kenneth Burke, the investigations involving Russian folktales developed by Vladimir Propp, and the philosophical analyses of history developed by Arthur Danto. The stress is on order and communication, a methodology designed to show "how the myths of a society, through their structure, communicate a conceptual order to the members of that society a myth [that] orders the everyday experiences of its hearers (or viewers) and communicates this order through a formal structure that is understood like language."[58] Put another way, Cawelti is concerned with modernizing universal mythmaking elements; Wright, with the way in which the myths of a society order the everyday experiences of individuals and communicate those messages formally to members of the society. Wright's structural approach differs significantly from that of his mentor Levi-Strauss: the former emphasizes the cognitive qualities of myth to enable one to learn more about the mechanism of ordering human thoughts and the symbolic form as applied to social interaction; the latter is concerned with using myths to discover more about the structure of the mind. "The elements of myth," become for Wright, ". . . the images and actions of the narrative, and the structure that orders them, like the structure of language, is determined by the general properties of symbolic consciousness--that is, by the psychological resources of the mind and the laws of symbolic meaning."[59] Simply put, a myth's formal structure contains symbolic messages that have social significance. We react to the plot, characters, setting, and action not only with enjoyment but also with an unconscious understanding that what transpires relates to our lives and our times.[60]

Whether or not structural film studies with their complex methods are more valuable than humanistic approaches is not our concern here. That is an issue determined by such variables as staffing, resources, individual leanings, and future goals. For now, we need only recognize the potential problems in an uncritical

[56] Wright, p.8.

[57] Wright, p.9.

[58] Wright, p.17.

[59] Wright, p.11.

[60] Nichols makes a similar point, arguing that "Narrative shares with ideology a set of structural mechanisms to generate apparent unity and coherence. It proposes a sense of closure; it provides a sense of ending." See *Bill Nichols, ed., IDEOLOGY AND IMAGERY (Bloomington: Indiana University Press, 1981), p.78.

application of Cawelti's general principles. By being aware of the limitations of his approach, we can concentrate on how the filmmaker uses conventions and inventions as indicators of specific achievements artistically, socially, and historically. It thus gives us a valuable tool for studying the complexities of film genres.

Another valuable aid to the serious student of film is the Beograd Institute's system[61] that has as its aim the fixing of a complete and inclusive series of terms for existing genres, of defining these types, and of suggesting a procedure for interlocking the various kinds. The following is the Beograd scheme:

FILM GENRES

-Scheme-

DIVISION ACCORDING TO CRITERIA OF STRUCTURE AND TECHNIQUE	DIVISION ACCORDING TO CRITERIA OF AIM AND THEME
Documentary	Newsreel
Fiction film	Magazine
Cartoon	Report
Graphic film	Propaganda film
Puppet film	Advertising film
Silhouette film	Trailer
Collage	Scientific-research film
Film with models	Popular science film
	Educational film
	Cultural film
	Industrial film
	Film on economics
	Film on art
	Nature film
	Travelogue
	Ethnographical film
	Social film
	Psychological film
	Melodrama
	Biographical film
	Historical film
	War film
	Adventure film
	Criminal film
	Spy film
	Thriller
	Western
	Phantasy film
	Science fiction
	Horror film
	Fairy tale
	Fable
	Burlesque
	Comedy
	Parody
	Satire
	Music film
	Opera

[61] *Beograd Film Institute, FILM GENRES: AN ESSAY IN TERMINOLOGY AND DETERMINATION OF FILM GENRES (Belgrade: Beograd Film Institute, 1964), pp.3-4.

Operetta
Musical
Ballet
Film poem
Film critic
Abstract film
Free theme film

One of the most useful ways to explain the Beograd scheme is to apply it to a genre that is now widely patronized by the American public: war films. Two points should be made clear at the outset. First, types are selected for a particular purpose, both by the artists who work with them and by the viewers who see them. What may be suitable for one group may not be so for another. Secondly, genres that are now popular with the public may become unpopular. Our attitudes change. It is not my intention to prescribe a particular genre to study in the classroom but simply to show a representative approach to the study of genres. Any one of these strategies will acquaint students with the reasons for the study of movie categories and the methods connected with it.

BOOKS

*Beograd Film Institute. FILM GENRES: AN ESSAY IN TERMINOLOGY AND DETERMINATION OF FILM GENRES. Beograd: Film Institute, 1964. 46pp.
 A special commission of the Beograd Film Institute spent over a year and a half trying to design a practical terminology for determining film genres and fixed notations for those already in existence. No attempt is made to go beyond the complicated task of identifying the terms, defining each of them, and establishing a methodology for interlocking the results into an all-inclusive system. "The definitions," explains the monograph, "do not pretend to be of general theoretic or scientific character; they will fulfill their purpose if they explain, in context, the matter presented." In other words, the definitions work only when used in connection with the other definitions and only in the context of the system established. Four useful criteria are established and arranged in two groups: the first focusing on structure and technique; the second, aim and theme. Following brief explanations of the terminology, the monograph explains in awkward prose how the system should be used. Thanks to two invaluable appendexes, we see the options initially considered but later rejected by the group, as well as domestic and foreign classifications used earlier. Recommended.

*Braudy, Leo. THE WORLD IN A FRAME: WHAT WE SEE IN FILMS. Garden City: Doubleday, 1977. 274pp.
 Sensitively written and with no didactic answer to how movies can best be studied, this extended essay charts an intelligent introduction to a coherent examination of film categories. It begins with the basic idea of art, "not as a controller and former of images and principles, but art as a place of testing experience." This focus reverses the negative judgments heretofore associated with film--e.g., commercially oriented, collaborative in nature, mechanically conceived--and makes them characteristic of the medium's potential for greatness. Movies become the art form that has the potential for lifting a technological world out of the mass audience's individual anonymity and frustration. In studying film, therefore, the theorist has to take everything into consideration, assuming nothing to be extraneous. "And the test of a great film artist," argues Braudy, "is the test of any great artist--the coherence in object and effect of all . . . conscious, unconscious, and subconscious choices." To this end, he divides his book into three major sections.
 The first section--"Varieties of Visual Coherence"--considers the role of objects in films and the diverse means by which they gain significance. Instead of viewers' accepting what they see in films as realistic and representative of the world, Braudy

suggests we perceive the objects in a movie as being selected and shaped by their context in a particular film, much the way traditional art forms chose and transform material. In other words, each filmmaker has his own style of reality. Film history then becomes a record of two distinguishing structures and styles--the opened and the closed: Renoir vs. Lang, theatrical vs. novelistic, pictorial vs. architectural. The dichotomy offers rich possibilities mainly because it forces us to deal directly with the imaginative process filmmakers employ in creating their films. The closed film, for example, demands that every object, every element perform a specific purpose. The open film does not, preferring the momentary frame only as a comment around an ongoing reality. Lang's METROPOLIS (1926) illustrates the former; Renoir's THE GOLDEN COACH/LE CARROSSE D'OR (1954) the latter. Neither type is better than the other, just different in strategy and structure. Wisely, Braudy does not insist that every filmmaker falls neatly into these categories, only that from a theoretical point of view such divisions help focus attention on how films are created.

Section two--"Genre: The Conventions of Connection"--examines the influence of conventions and traditions on film formulas and the unique types of themes and characters they have established. Starting with the premise that understanding genre films is a special case of understanding film in general (i.e., critical discussion too frequently focusing on the audience and not the filmmaker), Braudy makes a useful distinction between genre and "classic" films. That is, genre films basically rely on precedents; classic films, on denying them. He then moves on to showing why genres, with their sensitivity to audience expectations and needs, use conventions as a means of commenting on societal problems. "The very relaxing of the critical intelligence of the audience," Braudy explains, "the relief that we need not make decisions--aesthetic, moral, metaphysical--about the film, allows the genre film to use our expectations against themselves, and, in the process, reveal to us expectations and assumptions that we may never have had." As a result, genre films function like closed films, with one major change: they are closed primarily by conventions. This association, he notes, does not apply to experimental films. There the filmmaker expects the audience to knowingly expect changes. Genre filmmakers, on the other hand, delight in reshaping and challenging the traditional form and content. Serious students should readily enjoy the diversity of Braudy's humanistic summary of film genres through the past decades and his expansive tastes for many different types of films, especially his treatment of westerns and musicals.

Section three--"Acting and Characterization: The Aesthetics of Omission"--concentrates on the links audiences make with famous film personalities and well-known physical characteristics. Braudy starts by showing that film, contrary to popular belief, can produce complex characterizations through the act of omission, "the omission of connective between appearances, of reference to the actor's existence in other films, of inner meditation, in short, of all possible other worlds and selves except the one we see before us." The actor thus becomes more important than either the script or the director, mainly because the performer's physical image is what most makes the audience comfortable. This emphasis also serves to heighten the distinction between silent and sound films: silent film characterizations relying heavily on theatrical techniques of staging, costumes, and clothes; the sound film amalgamating the visual/theatrical world with the added dimension of voice, music, and sound effects. Readers will find the subsections on stage/screen acting, role-playing/type-casting, the metaphysic of the body, and actors/objects particularly stimulating. In every instance, Braudy takes pleasure in using the arguments against film as examples of the medium's strength. For example, he sees the film's stress on physical appearances--e.g., healthy bodies, beautiful looks --as a means of extending, not limiting, a performer's role from film to film, of using fan magazine gossip not as a distraction but as a means of enhancing the subtleties of story and character. In fact, Braudy suggests that the entire history of film might be perceived as a history of a society's changing attitudes as reflected in the physical images they admired and disliked from one decade to the next. Similarly, a director's treatment of actors or objects illustrates the changing priorities in the development of film: e.g., Lang and Hitchcock, Hawks and Lubitsch, Renoir and Rossellini. Braudy concludes his searching study by arguing that movies enrich our lives as much as they reflect them. The task before us is to understand how that special filmic structuring occurs and works. Highly recommended.

*Cawelti, John G. THE SIX-GUN MYSTIQUE. Bowling Green: Bowling Green University Popular Press, 1975. 138pp.
 Although nominally an extended essay on the western, this remarkable publication does for contemporary genre studies what Robert Warshow's seminal articles on the western and the gangster film did for his generation. Cawelti, as discussed earlier, is concerned with the key differences among "genres," "myths," and "formulas." Using an interdisciplinary approach that draws heavily on the writings of Freud, Marx, and Frye, he tries valiantly to explain and interpret popular culture from the perspective of social and psychological functions. The latter works on the dual premise that art appeals vicariously to audiences seeking wish fulfillment and a resolution to their disturbing unresolved psychic conflicts. Thus literature and film perform the similar symbolic function that Freud ascribed to dreams, a form of repetition compulsion in which "unconscious impulses find expression sometimes in dreams, sometimes in neurotic behavior and sometimes in art." Cawelti does not minimize the difficulties in such an analogy. He does, however, demonstrate the substantial advantages of relating popular films to specific cultural functions: e.g., audience identification; the nature of enjoyment; the possibilities of viewers' being both deeply affected by the aesthetic experience, yet remaining detached from the action and events; and a good plot model for explaining why, what, and how characters, setting, and events are organized differently from formula to formula. His judgments are descriptive, rather than qualitative. He concentrates on the organizing principles that permit filmmakers rare opportunities to deal meaningfully with cultural needs.
 The discussion of the western serves as an excellent illustration of how the theory operates. Game strategies with their paradigms of excitement, suspense, and release are easily translated into formula patterns of conflicts involving stereotyped characters, costumes, settings, and predictable resolutions. Specific eras mirror America's constant dilemma over the paradoxes connected with the dream of success and progress and the reality that most Americans rarely understand, let alone benefit from, the cost of success and progress. The one interesting omission in Cawelti's entire essay is his failure to cite Douglas Fairbanks, Sr., as the epitome of a classic type, "a dude come West who duplicates the metamorphosis of the cowboy into a pioneer in reverse." Other than that, Cawelti's choice of films, his explanations of conventions, and the force of his arguments make excellent reading.
 Serious students will find the nine appendexes, which include by-now dated bibliographies and filmographies, good starting points for more in-depth research. Regrettably, there is no index and no illustrations. Required reading.

*Earley, Steven C. AN INTRODUCTION TO AMERICAN MOVIES. New York: New American Library, 1978. Illustrated. 337pp.
 Set against a quick overview of American movies from the penny peepshows up to 1976, this breezy text provides a nonscholarly, nontechnical thumbnail sketch on the growth, development, and relationship between film history and its most popular genres. It's aimed more at novices than at serious students. The writing is general, crisp, and straightforward.
 The first and most satisfying of the two main parts reworks the major currents and attitudes well known to film historians. The comments are generally noncontroversial, with the crucial movies, industrial leaders, and personalities dutifully mentioned. Each subchapter summarizes a significant struggle between warring elements--e.g., art vs. business, cinema vs. theater, entertainment vs. message, national vs. international--or highlights the seminal contributions of creative filmmakers like Griffith, Sennett, and Chaplin. The stress throughout is on issues of creativity, psychological effects, story innovations, and important historical contributions.
 More disappointing and truly for neophytes is Part Two on American film genres. While no attempt is made to be all-inclusive, the author identifies thirteen categories: e.g., the gangster film, FILM NOIR (black cinema), the epic/spectacular, the horror film, the science fiction film, the musical, the comedy film, the war film, the western, the romance, novels into film, the documentary/direct cinema, and experimental

cinema/the avant-garde. Heading the long list of problems is a failure to identify at the outset what he means by genre. Only by consulting the brief glossary does one discover the weak definition, which simply states that genres are "types of film which include certain established conventions of that particular style of film, i.e., westerns. . . ." The individual chapters do little to flesh out what is meant by "conventions" or "style of film." The section on gangster films, for example, identifies mostly well-known Hollywood pictures, famous stars and directors, as well as highly visible sources for the film mobsters like Al Capone, but demonstrates no original research or risky disagreements. In fact, the omissions are often more interesting than the terse summaries. One three-sentence paragraph, for example, covers the years from 1940 to 1967. THE RISE AND FALL OF LEGS DIAMOND (1960) is cited as an "excellent" film, with no reasons given; but in the chapter's concluding list of outstanding gangster films and directors no mention is made of the movie. Earley also asserts that "The genre may have exploited brutality and viciousness in its stories, but at least these movies made audiences aware of the important sociological problems that existed in their contemporary world." Why, how, and how accurately do not seem his concern. He wants merely to heighten audience awareness of the links between film and society, while at the same time suggesting what the genre directors are trying to do. Unfortunately, he confuses perceptions with insights. The result is an overview that neither enhances appreciation nor reduces the misunderstanding over the art of genre films.

Rounding out this once-over-lightly narrative are four trivial appendexes: a glossary of film terms, bibliography, suggested reading list, and a list of major 16mm film distributors. Worth browsing.

*Grant, Barry Keith, ed. FILM GENRE READER. Austin: University of Texas, 1986. Illustrated. 425pp.

An extensively revised and updated edition of the author's 1977 study, the new anthology is a decided improvement over the original. Twenty-three essays written by scholars like John G. Cawelti, Thomas Elsaesser, Paul Schrader, Thomas Schatz, and Robin Wood offer perspectives in the book's two major sections: "Theory" and "Selected Genre Criticism." An extensive bibliography and index are included. Well worth browsing.

Grant, Barry K., ed., FILM GENRE: THEORY AND CRITICISM. Metuchen: The Scarecrow Press, 1977. 249pp.

One of the few truly disappointing volumes from this significant press, the anthology suffers from an inflexible commitment to literary precedents. Defining film genres is difficult enough without the added burden of forcing the categories to conform to classical patterns, and if the intention of this text was to act as both a basic source book and an introduction to the study of film genres, the collection runs into serious trouble throughout its fifteen chapters.

Of its two major parts, Section One is the more annoying since the theoretical issues raised about what film genres are and how they are experienced creates more confusion than clarification. In Frank D. McConnell's opening essay, for example, he insists that film is the heir to the last two centuries of art and poetry, positing the argument that an adversary relationship exists between the genre and the creator, which, in turn, elevates the AUTEUR theory to a primary role in genre criticism. This overemphasis on personalization detracts seriously from the study of genre structure and the audience/genre/industry relationship. Andrew Tudor follows with an essay critical of genre studies that places an emphasis on both attributes and intentions. Rather than offering a better methodology, Tudor is content to attack obvious weaknesses in existing approaches without shedding any light on their positive contributions. Edward Buscombe, in the third and best essay in the section, gives a much needed perspective on the drawbacks to forcing film genre study into a rigid literary mold. Pointing out that literary critics are valuable for the warnings they give us about being too rigid in classifying types, he accurately observes that, "One does not have to set up a platonic ideal, to which all particular examples try vainly to aspire, even to say that the closer any individual film comes to incorporating

all the different elements of the definition, the more fully it will become a western, or gangster picture, or musical." The key element is description, not prescription. He succinctly points out the problems inherent in AUTEUR criticism, while introducing useful terms like "inner" and "outer" forms as a means of understanding how genres function: primarily as a means of allowing good directors to be better. Unfortunately, Thomas Sobchack's analysis fails to benefit from Buscombe's erudition and rigidly prescribes what should be the subject matter (story) of a genre. He insists that genre analysis be conducted along literary traditions since "Genre films operate on the same principal . . . [imitation of prior story material as deduced by Aristotelian criticism]," and that one of the most important elements of classical analysis has been the concern with form. Particularly disturbing in Sobchack's strained approach is the failure to recognize that the best modern films are exactly the opposite of his theory that genre films leave little room for ambiguity. It's the ambiguity that distinguishes one director's contributions from another, as for example with crime films like THE GODFATHER (1972) and CHINATOWN (1974). Judith W. Hess continues the section's weak discussion by arguing that "Genre films produce satisfaction rather than action, pity and fear rather than revolt; they serve the interests of the ruling class by assisting in the maintenance of the status quo and they throw a sop to oppressed groups who, because they are unorganized and therefore afraid to act, eagerly accept the genre's absurd solution to economic and social conflicts." Not to be outdone by such inflated rhetoric, Jean-Loup Bourget concludes the theoretical section with the less-than-startling idea that a Hollywood director's freedom is measured more by what the individual can imply about our society than by what that person can do within the system.

Section Two, while not as disappointing, remains just as lightweight an exercise. Examinations of such film genres as screwball comedies, disaster movies, epics, horror films, musicals, monster films, sports movies, and westerns are merely cursory. The writings generally ignore film developments after the middle 1960s, place too great an emphasis on the famous studio iconography associated with stars and character actors of the thirties and forties, and refuse to take into account the impact that the revised American production code of the late sixties had on film content. A selected bibliography, long on pages but short on new material, plus a useful index closes out this marginal anthology.

*Kaminsky, Stuart M. AMERICAN FILM GENRES: APPROACHES TO A CRITICAL THEORY OF POPULAR FILM. Dayton: Pflaum Publishing, 1974. Illustrated. 232pp.

Ambitious in scope, limited in execution, this stimulating analysis goes beyond the standard superficial observations to provide useful generalizations on film formulas. "Genre study in film," explains Kaminsky, "is based on the realization that certain popular narrative forms have both cultural and universal roots, that the Western of today is related both to archetypes of the past 200 years in the United States and to the folk tale and the myth." Rather than play the film-buff, he wants to know how we relate to these film genres, what makes the various forms popular, adds to their enduring nature, and links them to older traditions. His approach to a popular form of entertainment does not substitute aesthetics or mysticism for in-depth analysis. The focus is where it's needed: on the genres' roots in a variety of areas like religion, mythology, the social sciences, the literary traditions, and "the fabric of existence itself." Regrettably, the treatment is neither exhaustive nor intensive. Equally troublesome is the lack of a rigorous definition for what he means by a genre. Much more instructive are Kaminsky's thoughts on how to begin an analysis of a film genre: e.g., looking at a specific movie and illustrating its unique contributions to a particular genre, comparing and contrasting an individual film to its sources. The emphasis throughout the text is on methodology and application rather than on AUTEUR criticism and qualitative judgments. Not that he finds the latter insignificant. On the contrary, he believes that AUTEURISM and aesthetics shed considerable light on the milieu in which genre films gain their enormous appeal. Such studies, however, too often limit analysis of popular entertainment forms. Kaminsky is after concepts related to understanding more than evaluation. Although he proposes more than he achieves, the effort exceeds the work done by his competitors.

The main text is divided into ten sections, each illustrating a valuable approach to American film genres: the individual film as exemplified by LITTLE CAESAR (1930) and gangster movies; comparative forms, the Samurai film and the western; literary adaptations and changes, THE KILLERS (1946); contemporary problems, the white-hot violence of the 1970s; variations on a major genre, the big caper movie; psychological considerations, horror and science fiction movies; performing arts, the musical (by Jerome Delamater); history and social change, comedy and individual expression; the genre director, the films of Donald Siegel; and the genre director, character types in the films of John Ford. Each chapter includes comparative, historical, and analytical comments, in addition to a useful filmography and a brief suggested reading list. Particularly outstanding are a handful of charts strategically placed at the end of several chapters which both summarize the major ideas and categorize the significant films. For example, the discussion on LITTLE CAESAR ends with a chart entitled "Observations on American Gangster Film History Since 1930." Under each of six headings--1930-1933, 1934-1938, 1939-1945, 1946-1959, 1960-1970, 1971-present (roughly up to 1973)--Kaminsky annotates not only the key films, but also thumbnail comments on context: 1930-1933: "Start of Depression. Rise of Unions. Uncertainty of American Dream in literature. Fear of immigrant."--Primary Form--"The rise and fall of the lower class gangster"--Era--"The 1920s"--Protagonist--"Grotesque, small urban, lower class ethnic background, tough, ironic"--Protagonist's goals--"Business success, to see self and others accepted and see him as successful"--Problems--"Little man in society, American Dream vs. American Reality, Ambivalence between audience's identification with criminal and need to reject him"--Icons and Settings--"Guns, machines guns, flashy suits, black limousines, cigars, tuxedos, blondes (women) as acquisitions like liquor; settings: offices, night clubs, lower class homes." Summaries such as these are helpful for beginning film students and can be found nowhere else in such a short, readable, and accurate form. While Kaminsky admits that much of what he argues is open to debate and controversy, he clearly has done a first-rate job in providing us with a basis for more exhaustive research. Highly recommended for special collections.

*Kaminsky, Stuart M. AMERICAN FILM GENRES. 2nd ed. Chicago: Nelson-Hall, 1985. Illustrated. 238pp.
Reflecting the changes that have taken place in American genres since the mid-1970s, the author omits his chapters on the caper-film and the musical, replacing them with chapters on ONCE UPON A TIME IN AMERICA (1985), Kung Fu films, the screen adaptation of B. Traven's THE TREASURE OF THE SIERRA MADRE (1948), and Sergio Leone's westerns. Kaminsky also provides his reactions to the debate over realism in film, Mel Brooks, and Woody Allen. Fresh illustrations and slightly updated bibliographies complete the touchup. An index is included. Well worth browsing.

*Mallery, David. THE SCHOOL AND THE ART OF MOTION PICTURES: A CHALLENGE TO TEACHERS WITH A DISCUSSION OF NEW AND OLD FILMS AVAILABLE IN THEATRES AND IN 16MM. FILM RENTAL LIBRARIES. Boston: National Association of Independent Schools, 1964. 101pp.
This valuable, but somewhat outdated monograph offers a practical, simplified guide to film study in the public schools. Divided into two parts, the first section briefly covers issues generally confronted by teachers unfamiliar with critical sources for reviews, arguments helpful in explaining the function of film in a traditional school curriculum, and ways of using community resources effectively. Part Two begins with a good introduction to the problem of film rentals and then quickly provides comments, titles, and sources for examining film genres like novel/stage adaptations, Shakespearean films, biographies, westerns, war movies, mystery-thrillers, adventures, and musicals. Since no real explanation justifies the various categories, the selections seem more a matter of convenience than serious interpretation. But since I find most of the choices good films, the guidebook approach is more than satisfactory on a beginning level. Teachers, however, will need to consult new film rental sources and updated bibliographies to maximize the intended purpose of the monograph. Novices in film study might enjoy browsing through this succinct primer.

*Neale, Stephen. GENRE. London: The British Film Institute, 1980. 74pp.
 In what may be the most uneven study of film genres, this terse booklet offers both obtuse semiotic strategies for educators and remarkable insights into the process of film formulas. The announced intention was "to construct film as a coherent discipline that would be introduced into schools, colleges and universities. . . ." Making no concessions to the unconverted, it demands that the reader be conversant with the theories of Christian Metz and assumes the primary audience to be school teachers working in England. Neale ignores the significant contributions of American theorists like Cawelti and Warshow, choosing instead to concentrate on contributors to the publications of The British Film Institute (i.e., SCREEN). The pedantic prose has almost no concern with aesthetics or entertainment and puts enormous pressure on the reader not to just discard the material after only a few pages. Nevertheless, persistent students will find the effort valuable, if not particularly enjoyable.
 The opening "Presentation" by Paul Willemen, the editor of this British Film Institute series, is somewhat misleading. Beginning with a schematic, reductive overview of film criticism in England during the late 1960s and early 1970s, Willemen regrets the distractions to film genre study created by the sudden interest in textual construction and related issues. We get the impression, therefore, that this text, although admittedly tentative and brief, will clear away the debris, set out some crucial parameters. The impression is that educators will discover much-needed strategies for viewing film study as a process whereby a mainstream, commercial product in a narrative form tied to audience and artistic expectations operates in a systematic and ideological framework.
 Neale's introductory chapter reinforces that point of view. Using essays by Tom Ryall and Ed Buscombe, as well as Jim Kitses's HORIZONS WEST and Colin McArthur's UNDERWORLD USA, the phlegmatic author announces his intentions first to excoriate proponents of traditional genre theories and then offer a revised theory based on semiological principles. In Chapter 1, Neale argues that the above-mentioned authors fail to provide a conceptual apparatus for speculating on how the industry, artist, and audience function as self-consistent, autonomous subjective entities. He attacks their methodologies on the supposition that they foreclose rather than expand the possibilities for innovation and creativity. Neale is particularly critical of theories that fail to understand how cinematic narratives, iconography, self-expression, fetishism, and sexuality operate for all film genres, not just in terms of a single genre. The issues he raises are both valid and vital, even if his solutions, sketched poorly in Chapter 2, are less than satisfying and sound. For example, it is true that "The cinema is not simply an industry or set of individual texts." Films do involve a plurality of operations and processes; each of these does not have equal social weight; it is not simply a matter of repetition. It is also true that his semiotic emphasis on psychological and phenomenological principles fails to account for the crucial influence of socio-historical factors. It is even more significant that his prose, if it is indicative of his classroom strategy, illustrates how the love of film can be atrophied. Neale, for example, comments on the comedy styles of the Marx Brothers and Chaplin, never once demonstrating why they were effective, only how the material theoretically was conceived. His approach is dry, detached, devoid of enthusiasm--an indication of a mechanical rather than an innovative, exciting, and stimulating teacher. To his credit, in Chapter 3 Neale does a good job of citing similarities among genres, highlighting how studying genres together rather than individually produces valuable insights into the systematic process of combining novelty with repetition. He further provides provocative examples of how the economic aspect and sets of expectations influence the different functions of mainstream cinema. The booklet concludes with two negligible appendexes on sexuality and teaching materials, plus a minimal bibliography. Recommended only for specialized collections.

Pickard, Roy. A COMPANION TO THE MOVIES: FROM 1903 TO THE PRESENT DAY. New York: Hippocrene Books, 1972. Illustrated. 287pp.
 This concise reference guide claims more than it delivers, but is not without some value. Because no satisfactory explanation is given for the various groupings--e.g., comedy, fantasy, thriller and crime, western, musical, romance,

epic, war, swashbuckler, adventure, novels into film, and plays into film--the oversimplified text serves more as a film-buff exercise than a serious discussion of film categories. Each section-chapter consists of two parts: an historical overview of the critical/influential movies followed by a Who's Who listing of significant actors, directors, writers, cameramen, etc. Filmographies related only to that particular category are credited to individuals, although those artists who have made important contributions get an additional filmography in concluding appendexes on cameramen, composers, original screenplays, and Academy Awards.

Readers can judge for themselves the value of this dictionary-like approach by the following sample, which begins the chapter on westerns:

THE IRON HORSE 1924
A large-scale (160 minute) western about the construction of the Union Pacific railroad that relies more on its individual action sequences than its thin story line about the search by a son for his father's murderer. The climax, when hordes of Indians attack a derailed train, is superbly handled and gives ample evidence of the experience gained by John Ford in directing his earlier 48 B westerns, many of which starred Harry Carey, Hoot Gibson and Tom Mix. The film was shot almost entirely on location in the Nevada desert and made use of several real-life props, including Wild Bill Hickok's original vest-pocket Deringer revolver.

Production Company	Fox
Direction	John Ford
Screenplay	Charles Kenyon
from a story by	
Kenyon and John Russell	
Photography	George Schneiderman, Burnett Guffey
Leading Players:	George O'Brien, Madge Bellamy,
	Judge Charles, Edward Bull,
	William Walling, Fred Kohler,
	Cyril Chadwick, Gladys Hulette,
	J. Farrell McDonald

In this particular chapter, only nine other landmark westerns are listed--STAGECOACH (1939), RED RIVER (1948), SHE WORE A YELLOW RIBBON (1949), BROKEN ARROW (1950), HIGH NOON (1952), SHANE (1953), THE MAGNIFICENT SEVEN (1960), THE WILD BUNCH (1969), BUTCH CASSIDY AND THE SUNDANCE KID (1969)--revealing both the author's traditional tastes and limited amount of original, useful information. Worth browsing.

*Schatz, Thomas. HOLLYWOOD GENRES: FORMULAS, FILMMAKING, AND THE STUDIO SYSTEM. Philadelphia: Temple University Press, 1981. Illustrated. 297pp.
Concerned primarily with the Hollywood studio system's "classic era" (1930 to 1960), the entertaining but not highly original narrative attempts to "lay the historical and theoretical groundwork for genre study in the American screen arts, encompassing not only literary and filmic concerns, but cultural, socio-economical, industrial, political, and even anthropological concerns as well." The major assumption is that genre analysis is the best way to examine American films and understand the dynamics of the film industry and audience exchange. A secondary assumption, less compelling and often disconcerting, is that the American preoccupation with genres went into sharp decline with the demise of the studio system at the end of the fifties.
Schatz begins with a theoretical discussion in general terms of the basic characteristics and cultural role of genre filmmaking. His oversimplified definition of a genre film--"essentially one-dimensional characters acting out a predictable story pattern within a familiar setting"--sets the tone for the controversies to follow. He argues, for example, that any American film that traces "the development of a 'central character' or protagonist" automatically becomes a "non-genre film." Plots that avoid traditional patterns and standardized conclusions are also non-genre films. Thus films like THE GRAPES OF WRATH (1940), THE LOST WEEKEND (1945), MONSIEUR

VERDOUX (1947), and THE GODFATHER (1972) are excluded from Schatz's flawed system. He accurately sees the AUTEUR theory as making a significant contribution to genre study. Praising it, despite the theory's well-known limitations, as "the single most productive concept in film study over the past quarter century," Schatz argues that the theory successfully identifies those filmmakers who work best within the genre system. A problem that he noticeably neglects, particularly in his discussion of the musical, is the fact that many of the genre's best films are made by heretofore unappreciated directors like Charles Walters and Mark Sandrich. He's particularly impressed by the "structure" methodology used in AUTEUR analysis, whereby "deep structure" (the directorial personality) acts to evaluate and interpret "surface structure" (the director's films). Thus both AUTEURISM and genres serve as the basis of the best in the Hollywood studio system. Together they act as a social force in reinforcing the values and ideals of the mass audience. As a result, box office receipts operate in a ritualistic way, allowing the various studios to refine popular formulas through an evolutionary process. Using Henri Focillon's system as a model,[62] Schatz discusses how a form moves through an EXPERIMENTAL stage (conventions set up), a CLASSIC stage (conventions mutually agreed upon by artist and audience alike), an age of REFINEMENT (formal and stylistic details embellish the conventions), and finally the genre reaches the BAROQUE stage (the stylized conventions become the substance of the form). It's an interesting theory, but doubtful in practice because movies, both as an art form and as an industry, are very young and still evolving. It also becomes clear once an intense study of genres is made that applying classical models to the popular arts is not always productive or appropriate. A case in point is the author's discussion of westerns, calling those released in 1981 "the richest and most enduring genre in Hollywood's repertoire," although they have been in disfavor with the public for almost a decade. Time and again, Schatz's rigidity is at odds with the facts. Genres in his system come down to only two types: Order--those that center on a redeeming hero in the midst of a specific setting of contested space (e.g., westerns, gangsters, detectives); and Integration--those that focus on collaborative heroes (usually couples) set in more civilized settings that demand social integration into the community (e.g., musicals, screwball comedies, and family melodramas). If Schatz made fewer assertions and looked more closely at his material, he would more readily see the need for greater flexibility. For example, in the Order category, why must prosocial war films be the norm for the genre and anti-war films made after a conflict be relegated to a subgenre status? Why, in fact, is time anything more than an indication of how the genre is responding to modern social conflicts and technological developments?

Section Two contains six chapters, each of which examines a specific genre: the western, gangster, hardboiled detective, screwball comedy, musical, and family melodrama. Each chapter is then subdivided into an historical survey of the genre and a critical discussion of the major films. Westerns, for example, are first given a brief overview, followed by an analysis of four John Ford films: STAGECOACH (1939), MY DARLING CLEMENTINE (1946), THE SEARCHERS (1956), and THE MAN WHO SHOT LIBERTY VALANCE (1962). Here again rigidity is the problem, with films made after 1960 appearing more and more as non genre movies. The one major contribution of this section is the first-rate discussion of family melodramas, with its convincing case for a serious reexamination of the 1950s as a period of serious film art. This excellent essay plus an adequate bibliography, appropriate illustrations, and a useful index salvage the otherwise uneven narrative and provide readers with a provocative text. Above average, but not required reading.

Schatz, Thomas. OLD HOLLYWOOD/NEW HOLLYWOOD: RITUAL, ART, AND INDUSTRY. Ann Arbor: UMI Research Press, 1983. Illustrated. 318pp.

[62] Henri Focillon, THE LIFE OF FORMS IN ART (New York: George Wittenborn, 1942), p. 10.

A revised edition of Schatz's 1976 University of Iowa Ph.D. thesis, the challenging text is filled with exciting and exasperating perspectives. The difficulty results from the author's lack of precision in developing his arguments. "The primary aim of this study," we are told, "is to reconcile the dominant approaches to American cinema--i.e., film as art, as industry, and as a national mythology--and to integrate these approaches into a coherent and reasonably comprehensive theory of commercial filmmaking in America." In discussing the disparity of these approaches, Schatz makes a valiant effort to outline how commercialism capitalized on the nation's collective dreams. His insightful summaries tracing the country's "ideological transition from rural-agrarian to urban-industrial America" skillfully link the transformation of high culture to popular entertainment. Throughout ten provocative chapters, the text builds an impressive case for films as "a marvelous hybrid of high culture and low, of private and public experience, of art work and mythmaking, of individual expression and calculated industry, of the sacred and the profane."

At the heart of his hypothesis is the historical role, form, and development of genres. Schatz has no qualms in arguing forcefully that formula film making relies more on economics than it does on anthropology. Standardization rests on what he calls the "economic principle." That is, neither the public nor the producer is the sole determinant in the manufacturing of social meaning in films. The creative system of conventions that characterize film genres results from the filmmaker "successfully REinventing sensibilities and appeals to the audience's desire for innovation without violating their expectations." This reinventing process is rooted in the nature of film narrative. It allows the Hollywood filmmaker to "confront certain contradictions inherent in our culture, resolve those cultural conflicts in favor of the community, and consequently ritualize our collective cultural ideas." To demonstrate how various genres perform those functions, Schatz selects westerns, gangster films, and hardboiled detective movies to illustrate his theory of "determinate space" (a "symbolic 'arena' of action") and the role of the individual hero. The science fiction film and the war film illustrate how determinate space and the collective hero thematically perpetuate basic cultural values. Musicals, screwball comedies, and family melodramas exemplify how "indeterminate space" (not a prescribed setting but rather "a complex system of character relationships and codes of behavior") and collective heroes treat cultural oppositions that are resolved creatively through ritualistic patterns. Although his semiotic findings make for dry reading, his perceptive analyses suggest the way many Hollywood film genres used conventions to establish, animate, and resolve specific cultural conflicts--i.e., social order versus anarchy (westerns), society's anxieties toward technological progress (science fiction films), and America's paradoxical attitudes toward success (musicals). Thus what made classic Hollywood such a brilliant system, according to Schatz, is the manner in which it maintained and nurtured "constant contact with the public." This practice resulted primarily in films that relied on "'invisible' narration and 'passive' viewing." What most distinguishes the New Hollywood from the Old is the elimination of those "classic principles." Mass production and formula filmmaking are now replaced by an innovative system of production, distribution, and exhibition that allows for greater freedom but operates much more conservatively. The sections in which Schatz reviews the rise of the new Hollywood are filled with wonderful collections of facts, examples, and biographical sketches. Unlike the semiotic material, these pages convey a sense of love and enthusiasm for the subject.

But what detracts considerably from this otherwise admirable study is the author's lack of historical depth in genre study and a host of problems related to definitions and scholarly inflexibility. Schatz runs into trouble early on by not adequately defining the "classic Hollywood tradition." Instead of getting a firm grasp on the silent era as well as the rise of the studio system in the 1920s, he focuses his attention almost exclusively on the production process from 1930 to 1960 and the "tension between subjective identification and objective detachment, between participation in the action and the observation of it." The result is highly controversial definitions for most of his illustrative genres. No gangster film prior to 1930, for example, is seen as related to the genre. And how does one reconcile films like DEAD END (1937) and ANGELS WITH DIRTY FACES (1938) with his assertion that "The ultimate conflict with the gangster film is not between the gangster and his environment"? Must there even be an "ultimate conflict" in each genre? War films

only come into being for him during the advent of World War II. The concept of time or change rarely intrudes on his groupings of films, nor is there any awareness of how changes in the genre occur within the same time frame. A case in point is his lumping of war films like STALAG 17 (1953), THE GREAT ESCAPE (1963), and VON RYAN'S EXPRESS (1964). What they each have in common is the Nazis as the enemy and a general disregard for superior officers. However, Schatz makes no attempt to differentiate between these films and those depicting prisoners of war in Japanese camps--i.e., THE BRIDGE ON THE RIVER KWAI (1957) and KING RAT (1965). If he did, he would quickly see the differences in the way war film conventions about the Japanese treated heroes and villains from the manner in which the anti-Nazi films operated. Furthermore, if he did his homework, he would see the debt that both sets of villains owed to the war films made before, during, and after World War I. In talking about science fiction films, he mentions how Americans reacted to scientific and technological advances without ever recognizing the debt we owed to British and German science fiction films in the silent era. One gets the impression that Hollywood developed the science fiction film in a vacuum. His discussion on the post-1950s western gives the impression that outlaw collectives operated uniformly. In fact, often what distinguishes Butch and Sundance or Pike Bishop and Dutch Engstrom from their fellow outlaws is a belief in traditional values that are not shared by other members of their gangs. Equally unsettling is Schatz's reluctance to introduce standards by which to distinguish films with similar themes or topics. Potboilers are lumped together with works of art with no serious effort made to demonstrate how his "economic principle" functions successfully. Here, as in many other nonqualitative approaches, little recognition is given, for example, to the fact that BUTCH CASSIDY AND THE SUNDANCE KID and THE WILD BUNCH (both in 1969) treat a similar topic in very different ways and with very different audiences in mind. Adding to the superficiality of his flawed conclusions is his heavy dependence on narrow genre research. For example, his references in the eight genres cited are limited frequently to just one or two film critics. And then they are used repeatedly as if they alone were the final authority on the subject. This constant oversimplification of complex issues undercuts what could have been a masterly study. It also results in a series of specious pronouncements that occur far too often in a scholarly work. For example, the observation that Woody "Allen's early comedies are closer to the slapstick tradition of Buster Keaton." In fact, Allen's early comedies compared to Keaton's classic skills seem more noteworthy for their lack of artistic control and visual brilliance. In talking about the "woman's film" of the 1970s, Schatz refers to the "return to the kind of prominence it held in the fifties." No mention is ever made of the crucial role "women's films" in the twenties and thirties.

If this had been a work that wanted to introduce the general patterns Hollywood used in its eighty-year love-hate relationship with the public, Schatz would deserve considerable praise. He could have convinced less demanding readers that his generalizations were meant to be examples rather than definitive statements about genre filmmaking. He certainly would have impressed everyone with the seriousness of his undertaking. But as an attempt to reconcile disparities and offer a comprehensive theory it lacks depth and credibility. A bibliography and index are provided. Well worth browsing.

*Solomon, Stanley J. BEYOND FORMULA: AMERICAN FILM GENRE. New York: Harcourt Brace Jovanovich, 1976. Illustrated. 310pp.
Building on a common sense, matter-of-fact approach to film scholarship, this stimulating and refreshing book challenges many modern day theorists. Solomon accepts critical analysis as a valid exercise but rejects the current stress on "faddish critical tendencies of sociology and of cultural archeology. . . ." He reminds such critics that (1) the assumed standard visual and dramatic elements of a genre are not necessarily the essential binding characteristics of the genre; (2) whatever the essential characteristics are, they are not negligible or trite but artistic insights belonging to gifted directors; and (3) THE MOST GENERIC WORKS--the most typical examples--never do what the established critical rules prescribe as necessary for intellectual and artistic success. In fact, they do just the opposite. Furthermore,

he chastises critics who rely heavily on the ICONOGRAPHY of a genre but only examine the literal surface and never what those images or visual symbols REPRESENT. It's the deeper meaning, not the surface reality, that contains the art of the genre. He, therefore, has little interest in classifying a genre's literal surfaces. It's how they are used artistically, not what they are, that becomes for him the crucial test. While admitting the importance of even minor occurrences of a convention to help in comprehending the nature of a genre, he counters that genre study itself is too young to let iconographic design take precedence over major narrative patterns. He sees the emphasis on repetition as responsible for the widespread attack on genres as being unoriginal. Genre artists, unlike film hacks who merely repeat a formula's conventions, he sees as endowing the basic elements of a genre with new insights into human behavior and motivation. This infusion of new meanings can sometimes blur the difference between studying a film as a genre or as an example of popular culture. The former concentrates on "traditional values of art as they happen to appear in a group of related works"; the latter "describe, categorize, and analyze in regard to the sociological and psychological phenomena apparent in films." Despite the obvious overlap between the two methods, he values genre study because of its more meaningful emphasis on a film's art. Solomon admits that he can offer no specific set of cinematic qualities for genre analysis, cannot conceive of any method for classifying a genre of comedy, and rejects FILM NOIR or concepts (e.g., politics in film, sex in the cinema) as genres because they ignore art in favor of ideology. "Broadly put," he states, "a genre film is one in which the narrative pattern, or crucial aspects of that pattern, is visually recognizable as having been used similarly in other films." The purpose of his book is to examine the aspects of specific genres in relation to their specific cores. Simply put, he wants to know why traditional characters, like the private eye in detective films, behave the way they do, and why a particular visual environment (a sense of place) unifies all westerns.

The six chapters that follow the stimulating introduction focus on major genres: westerns, musicals, horror movies, criminal films, investigation movies, and war films. First he explores the relevant categories of the genre--e.g., the western is broken down into landscape, movement, the romance of the west, the lonely hero, sheriffs and marshals, and the outlaw--followed by a collection of brief, mostly unsatisfying essays on works of art that typify the best examples of the genre--e.g., STAGECOACH (1939), WINCHESTER '73 (1950), SHANE (1953), JOHNNY GUITAR (1954), THE SEARCHERS (1956), COMANCHE STATION (1960), THE WILD BUNCH and BUTCH CASSIDY AND THE SUNDANCE KID (both in 1969). It isn't just Solomon's aesthetic criteria that weakens his critical arguments, but also his inability to implement his concept of narrative cores to specific film analyses that undercuts the book's value to serious students. Once you get by the enjoyable general discussions, you learn almost nothing new about the films themselves. This praiseworthy introduction to the study of film genres is marred by the lack of a summary that would tie together the book's arguments against the current emphasis on sociological, psychological, and semiological examinations. In addition, an extensive section on bibliographical sources turns out to be more a matter of repeating the usual titles rather than introducing and extending outdated lists. Two indexes conclude the text. Recommended.

Wright, Will. SIX GUNS AND SOCIETY: A STRUCTURAL STUDY OF THE WESTERN. Berkeley: University of California Press, 1975. 217pp.

In one of the most ambitious and ponderous examinations of film genres, an enterprising young scholar tries to reinterpret the structural studies of Claude Levi-Strauss so that the myths of modern society can be seen as similar to those of primitive communities. Levi-Strauss had argued that myths acted as intellectual mediators for explaining the various contradictions in a tribal society. The more popular the myth, the more it symbolized a reinforcement of individual values as well as social institutions and community attitudes. That function, as well as the myths themselves, was replaced in modern times by history and science. Wright disagrees. He believes that modern man not only has contemporary myths that can be fruitfully analyzed by structural means, but also that these myths are similar to those used in

primitive communities. To support his theory, Wright sets out to prove that "the Western is a myth of contemporary American society . . . and contains a conceptual analysis of society that provides a model of social action." His two flawed assumptions are that his methodology is scientific (i.e., replicable and predictable) and that his analysis of why westerns are meaningful to us is valid.

Wright first sets up four structural binary oppositions characteristic of the primary people found in the western myth: inside society/outside society; good/bad; strong/weak; and wilderness/civilization. These provide the abstract structure by which the public, through the film myth, orders the conflicts in society. He then proceeds to use sixty-four films from 1930 to 1972 as a basis for dividing the genre into four basic patterns. Most of these films constitute the initial category: the Classical Plot. Here the solitary, good, and strong hero (associated with a wilderness that is pure and noble) wages a ceaseless stuggle to rescue society from those intent on destroying it and its values (symbolized by property, friends, family, peace, and freedom from domination). Each film in the category is analyzed and found to contain specific narratives that have three properties--e.g., explaining a change in a situation, explaining what cannot be challenged, and showing how everything in the narrative underscores the explanation. Collectively, these narratives perform sixteen functions (e.g., the society is safe, the society accepts the hero). Typical examples of the formula that existed, according to Wright, from the 1930s until the end of the Eisenhower years are DODGE CITY (1939), CANYON PASSAGE (1946), and SHANE (1953). The second category, the Vengeance Variation, indicates the first significant changes in the Classical formula. No longer as simple and straightforward a hero as in the Classical Plot (although Wright reduces the identifiable functions to thirteen), the vengeance hero disdains society rather than joining it in settling a personal score. The community neither needs his help nor can it aid in his revenge. In addition, he stops fighting in order to protect the values of the community, whereas in the Classical Plot the hero starts fighting to protect those same values. Typical examples of this plot variation, running predominantly from 1949 to the mid-1960s, are STAGECOACH (1939), THE MAN FROM LARAMIE (1955), ONE-EYED JACKS (1961), and NEVADA SMITH (1966). The third category, the Transitional Theme, is limited primarily to the 1950s and operates mainly as an inversion of the Classical Plot. The hero shares his fate with a heroine, and both end up seeing civilization as oppressive and corrupt. The central examples are BROKEN ARROW (1950), HIGH NOON (1952), and JOHNNY GUITAR (1954). The final category, the Professional Plot, bears a strong resemblance to the Classical Plot: a solitary gunfighter outside of society comes to the defense of a weak community terrorized by villains. Two very significant differences, however, are that the heroes now work for pay or for the enjoyment of fighting, not for any abstract concepts; and society itself becomes irrelevant, its social values to be ignored rather than desired. Starting with RIO BRAVO (1959), the formula (which has only twelve structural functions) produced such examples as THE PROFESSIONALS (1966), THE WILD BUNCH and BUTCH CASSIDY AND THE SUNDANCE KID (both in 1969).

After establishing the four categories with their binary sets, Wright proceeds to make a fascinating argument for interpreting westerns on the basis of economic American history. Theorists like John Kenneth Galbraith, Jurgen Habermas, and C.B. MacPherson are cited for their analyses of the shift in the United States from market to corporate capitalism, the consequences of that shift on our social institutions and public ideology, and the specific impact on the western in terms of the basic plots and the binary sets. In the Classical Plot, for example, the divisions between hero and society are seen as symbolic of the need for individualism in market-oriented communities. The Professional Plot, on the other hand, reflects the necessity for organizational rather than competitive relationships favored by corporate capitalism.

Marring this otherwise resourceful study are minor problems in editing, the absence of a much-needed glossary for students not familiar with semiotics, plus more serious problems in the author's lackluster writing style, key omissions, basic plot interpretations, and a confusion between scientific thought and rationalizations. For example, Wright selects films based upon the MOTION PICTURE HERALD's reported box office figures of the top grossing westerns of each year since 1930 ($4,000,000

or more rental in the United States and Canada). Putting aside the obvious problems of inflation and the knowledge that for decades Hollywood annually released well over a hundred westerns, the fact that important films such as MY DARLING CLEMENTINE (1946), THE GUNFIGHTER (1950), THE MAGNIFICENT SEVEN (1960), and THE MAN WHO SHOT LIBERTY VALANCE (1962) are omitted seriously undermines the value of Wright's selection process. More trouble develops when Wright awkwardly pigeonholes seminal films into arbitrary categories. Consider the case of HIGH NOON (1952), placed in the Transitional Period. While it is true that the good/bad dichotomy shows a shift in society from the ideal to the reprehensible, it is a rationalization, not a scientific fact, that self-interest and betrayal are synonyms, or that the town symbolizes a higher evil than the murderous Miller gang. Also in Wright's debatable analysis, he claims that the wilderness/civilization motif does not appear. That just isn't true. Marshall Kane makes his decision to return and fight outside the town, in the wilderness, and, at the end, he and his bride leave the town, heading into the wilderness. The treatment of BROKEN ARROW (1950) is another illustration of a film being jammed into a predetermined analysis. Wright claims that westerns in the Transitional mode feature society as taking over the functions traditionally associated with villains. The fact is that there have always been individuals within all the films who are bad, just as there have been decent, law-abiding citizens. Because white men kill Tom Jefferds' Indian bride, it does not follow that the entire white society is evil. If that were true, the peace between them and Cochise could never work. One additional example concerns BUTCH CASSIDY AND THE SUNDANCE KID (1969). In talking about his final classification, the Professional Plot, Wright argues that "the heroes are workers whose job happens to be fighting, whether for the law or against it." Yet it strains credibility to associate the bandit characterizations in THE PROFESSIONALS (1966) and THE WILD BUNCH (1969) with those found in BUTCH CASSIDY AND THE SUNDANCE KID (1969). On the simplest level, the former are much more violent and action-oriented, while the two lone protagonists wander aimlessly from one location to another. On a more complex level, those opposing the former represent a deterioration in what once were considered the ideal symbols of society, while those opposing Butch and Sundance (except for the Bolivian bandits) are doing their jobs in a lawful manner. Even the Bolivian army, although vastly superior in numbers, is in no significant way similar to the military forces in the other two films.

Despite the book's methodological problems, it does establish the myriad possibilities that structural analysis offers the study of film genres. Wright is particularly effective in getting us to think about the important relationships yet to be established among myth, ritual, and film analysis. Recommended for serious film students.

DEFINITION

Considering the problems identified with film classifications, it is not surprising that Julian Smith describes the war film genre as a less than clearly definable formula. Unlike the western, he finds,

The war film would seem to lack such formal boundaries, but a survey of the successful and influential films of the last quarter century suggests that the war film is properly limited to "modern war"--specifically World War II--with its potential for mobility and mass killing. [63]

How the plots develop, from Smith's point of view, depends more on the history of the war film than on the various wars themselves. That is, conventions take

[63] Julian Smith, LOOKING AWAY: HOLLYWOOD AND VIETNAM (New York: Charles Scribner's Sons, 1975), p.23.

precedence over inventions in the war film genre. The Beograd Film Institute, however, approaches the formula from a different perspective. It states that a war film "treats war events either on the front or behind enemy lines, and can be produced in any technique."[64] Russell Earl Shain basically agrees, describing the genre as "one dealing with the roles of civilians, espionage agents, and soldiers in any aspects of war (i.e., preparation, cause, prevention, conduct, daily life, and consequences of aftermath)."[65] Both the Beograd Film Institute and Shain remind us that war films are not restricted to combat zones or military actions. Their definitions restate the major war issues needing amplification and identified by President Franklin D. Roosevelt in his 1942 State of the Union address. Those six vital issues, categorized by Dorothy B. Jones in her definition, are "the Issues of the War; the Nature of the Enemy; the United Nations and Peoples; Work and Production; the Home Front; and the Fighting Forces."[66] A fifth classification, developed by members of Fordham's National Film Study Project, is to group war movies under four general categories: (1) war: the immediate threat, (2) war: the historical perspective, (3) what causes war? and (4) the effects of war.[67] For the most part, those artists who depict war on film greatly simplify the issues. As Basil Wright observes,

> Issues are no longer in doubt, or at any rate are not seen to be so. One knows
> what to do. Wartime films are therefore ideologically and emotionally very
> simple. Their value in later times tends to be historical rather than
> aesthetic.[68]

While all generalizations are in need of qualifications, Wright's observation that "the great war films are made when the wars are over"[69] is true.

 For our purposes this chapter will define a war film according to its aim, treatment, structure or technique, and will deal with the issues and participants that constitute the subject matter of war films. Since it is not my intention to describe definitively the war film genre, the major emphasis will be limited to Hollywood movies and those mainly concerned with the First and Second World Wars, although references will be made to the Korean and Vietnam Wars. I hope in this section to illustrate how the film industry in its constant efforts to attract and keep mass audiences through an emphasis on meaning and pleasure uses a specific genre, its conventions and inventions, to satisfy both the industry's and the audience's need for repetition and novelty. It should further demonstrate how a specific genre functions as a totality tied to a variety of producer-audience expectations, as well as highlighting specific strengths and weaknesses of the mass media as a form of entertainment, education, and art.

 Before discussion of the documentary and fiction movies, the two major categories of the war film, it would be useful, because of their relevance to the subject, to consider the concept of propaganda in relation to war films and the value of genre

[64] Beograd Film Institute, p.12.

[65] Russell Earl Shain, AN ANALYSIS OF MOTION PICTURES ABOUT WAR RELEASED BY THE
 AMERICAN FILM INDUSTRY, 1930-1970 (New York: Arno Press, 1976), p.20.

[66] Dorothy B. Jones, "Hollywood War Films: 1942-1944," HOLLYWOOD QUARTERLY 1:1
 (October 1945):2.

[67] David Sohn, Henry F. Pusch, and Rev. A. Schillaci, O. P., "Perspectives on War:
 A Teaching Unit of Films," MEDIA AND METHODS 4:4 (December 1967):8-15, 18. Rpt.
 *Anthony Schillaci and John M. Culkin, eds., FILMS DELIVER: TEACHING CREATIVELY
 WITH FILM (New York: Citation Press, 1970), pp.145-62.

[68] Basil Wright, THE LONG VIEW (London: Secker & Warburg, 1974), p.153.

[69] Wright, p.153.

films for historical evidence.

PROPAGANDA

The term "propaganda" has many different definitions. Harold D. Lasswell, for example, defined it as "the management of mass communication for power purposes."[70] Robert T. Holt and Robert W. van de Velde described propaganda as the "attempt to influence behavior . . . by affecting through the use of the mass media of communications, the manner in which a mass audience perceives and ascribes meaning to the material world."[71] On the other hand, Paul Weiss observes that "A propaganda film does not seek to satisfy the emotions it elicits, but to have those emotions vitalize activities which are to be carried out after the viewing is over Propaganda makes one attend emotionally to what the film does not present."[72] Aldous Huxley stressed that "Propaganda gives force and direction to the successive movements of popular feeling and desire; but it does not do much to create these movements. The Propagandist is a man who canalises an already existing stream. In a land where there is no water, he digs in vain."[73] Erik Barnouw draws a distinction between propaganda and information. In writing about his experiences during World War II, the distinguished broadcaster explained that "Propaganda was what the others did, especially the Germans. Our work had other names . . . What I did for the Office of War Information . . . was by definition information."[74]

The thread subtly woven through each definition is that propaganda is in essence a means to subordinate the intellect to the emotions. Its purpose is to discourage debate, to create widespread acceptance of a particular point of view, and to rationalize where necessary the doubts audiences may have over a controversial policy. Two popular misconceptions about propaganda, as Welch points out, need to be recognized before such a study takes place:

> There is a widely held belief that propaganda implies nothing less than the art of persuasion, which serves only to change attitudes and values. This is undoubtedly one of its aims, but often a limited and subordinate one. More often, propaganda is concerned with reinforcing existing trends and beliefs; to sharpen and focus them. A second basic misconception is the entirely erroneous conviction that propaganda consists only of lies and falsehood. In fact it operates with many different kinds of truth--from the outright lie, the half truth, to the truth out of context . . . In all political systems policy must be explained, the public must be convinced of the efficacy of government decisions, and rational discussion is not always the most useful means of doing this, particularly in the age of "mass man." Therefore, in any body politic,

[70] Harold D. Lasswell, "The Strategy of Soviet Propaganda," in THE PROCESS AND EFFECTS OF MASS COMMUNICATION, ed. Wilbur Schramm (Urbana: University of Illinois Press, 1954), p.538.

[71] *Robert T. Holt and Robert W. van de Velde, STRATEGIC PSYCHOLOGICAL OPERATIONS AND AMERICAN FOREIGN POLICY (Chicago: University of Chicago Press, 1960), pp.26-7.

[72] Paul Weiss, CINEMATICS (Carbondale: Southern Illinois University Press, 1975), p.171.

[73] Aldous Huxley, "Notes on Propaganda," HARPER'S MAGAZINE 174:1 (December 1936):32-41.

[74] Cited in K. R. M. Short, ed., FILM AND RADIO PROPAGANDA IN WORLD WAR II (Knoxville: The University of Tennessee Press, 1983), p.1.

propaganda is not, as often supposed, a malignant growth, but it is an essential part of the whole political process.[75]

Modern propagandists have always considered film genres as one of the most important forms of entertainment for manipulating the emotions of mass audiences. Not only do genre films have the ability to attract and maintain mass audiences, but also through the use of conventions and inventions, genre films are excellent at rationalizing changes taking place in society. Yet no agreement exists among the books dealing with war films on how to make the emotions dominate the intellect. The unstated consensus is that filmmakers use propaganda as a means to justify their ends, the difference often being only one of degree.

Intentionally or not, every film is propaganda in the sense that each of us is personally affected by what we see and hear. This is no accident. Filmmakers deliberately try to influence our emotions and attitudes by their creative handling of images and sounds, as well as by catering to our presumed desires. John Grierson, for example, believed that movies were more than mere entertainment and that film propaganda played an essential role in modern day society:

> Cinema is neither an art nor an entertainment: it is a form of publication, and may publish in a hundred different ways for a hundred different audiences. There is education to serve; there is the new civic education which is emerging from the world of publicity and propaganda; there is the new critical audience of the film circles, the film societies and the specialized theatres. All these fields are outside the commercial cinema.
> Of these, the most important by far is propaganda.[76]

Especially during times of conflict, filmmakers through their war films give the public what the public believes is a valid reflection of the nation's mission and national honor. Propaganda also becomes, as David Welch points out, "a means of maintaining the status quo, of reinforcing already held beliefs, by way of various psychological defense mechanisms."[77] Our combat troops, for example, are never shown as less than heroic. War itself becomes a crusade against the forces of evil. Our opponents do the same with their film genres. The films, therefore, use propaganda not only to persuade but also to reinforce the justness of the national cause.[78] On the other hand, they can just as easily be used as a weapon of terror and fear. In Nazi Germany, for example, Hitler used propaganda as a warning to nations he intended to invade. His newsreels showing triumphant troops in action were meant to intimidate other countries. In Germany itself, once the mood of optimism turned to one of pessimism, propagandists warned the German people that the nation's downfall was synonymous with their destruction.[79] Consequently, "If one regards propaganda,"

[75] *David Welch, ed., NAZI PROPAGANDA: THE POWER AND THE LIMITATIONS (Totowa: Barnes and Noble Books, 1983), p.2.

[76] *Forsyth Hardy, ed., GRIERSON ON DOCUMENTARY, abridged ed. (London: Faber and Faber, 1979), p.68.

[77] David Welch, PROPAGANDA AND THE GERMAN CINEMA 1933-1945 (New York: Oxford University Press, 1983), p.55.

[78] For an example of how the film THE LIFE AND DEATH OF COLONEL BLIMP (1943) was used by the British Minstry of Information to influence American attitudes toward the war, see Nicholas Pronay and Jeremy Croft, "British Film Censorship and Propaganda Policy During the Second World War," BRITISH CINEMA HISTORY, eds. James Curran and Vincent Porter (Totowa: Barnes and Noble Books, 1983), pp.144-64.

[79] For a good overview of how Goebbels used the genre to obtain mass approval for

according to Michael T. Isenberg, "as the 'organized dissemination of interested information' which shows the 'good side of one side of the question and the bad side of the other sides,' one is forced to regard every motion picture, no matter what its degree of objectivity, as propaganda."[80]

The debate on how to differentiate among propaganda, education, and entertainment in genre films becomes especially sensitive during crisis periods in national and international affairs. It is at such times that an insecure society, uncertain of its future and forced to make sacrifices, is most vulnerable to bigoted solutions to complex problems. For example, the official policy of the United States prior to December 1941 was to remain neutral in the European conflict. Isolationist congressmen led by Senators Burton K. Wheeler, Gerald P. Nye, and Benjamin Champ Clark felt that Hollywood films like CONFESSIONS OF A NAZI SPY (1939),[81] SERGEANT YORK, and MAN HUNT (both in 1941) not only violated government policy, but also had a dangerous influence on public sentiment. The basic arguments of these influential senators against Hollywood were summarized in an issue of LIFE magazine:

(1) Though movie houses are losing money on war films, an industry controlled by "foreign-born" producers persisted in making pictures calculated to drag the U. S. into a European conflict.

(2) Government officials have asked the movies to do this.

(3) Film makers had a stake in a British victory because British rental fees often made the difference between profit and loss on U. S. movies.

(4) The movies are a "tightly controlled monopoly" exercising a rigid censorship that turns 17,000 theaters into "daily and nightly mass meetings for war."[82]

Weakening the isolationist position of the AD HOC Senate committee, however, were its members' obvious race-baiting statements--e.g., "If anti-Semitism exists in America," Senator Nye reportedly said, "the Jews have themselves to blame"--and the fact that most of the critics hadn't bothered to see the films they were condemning.[83] Nevertheless, in an effort to prevent Hollywood from continuing its

Hitler's plans, see David Welch, "Nazi Wartime Newsreel Propaganda," FILM AND RADIO PROPAGANDA IN WORLD WAR II, pp.210-9. See also Richard Traubner, "The Sound and the Fuhrer," FILM COMMENT 14:4 (July-August 1978):17-23; and "Berlin II. The Retrospective," AMERICAN FILM 4:7 (May 1979):67-9.

[80] Michael T. Isenberg, WAR ON FILM: THE AMERICAN CINEMA AND WORLD WAR I, 1914-1941 (Rutherford: Associated University Presses, 1981), pp.13-1. Isenberg's references to "good" and "bad" are credited to ideas suggested by Richard Dyer MacCann, DOCUMENTARY FILM AND DEMOCRATIC GOVERNMENT: AN ADMINISTRATIVE HISTORY FROM PARE LORENTZ TO JOHN HUSTON (Ph.D. diss., Harvard University, 1951), pp.13-4. Isenberg also adds the sensible point that there are obviously varying degrees of "goodness" and "badness."

[81] For a good introduction to the film, see Eric J. Sandeen, "Confessions of a Nazi Spy," AMERICAN STUDIES (April 1979):69-81.

[82] "Senate Isolationists Run Afoul of Willkie in 'Warmonger' Hearings," LIFE 11 (September 22, 1941):21. For additional information, see *Larry Ceplair and Steven Englund, THE INQUISITION IN HOLLYWOOD: POLITICS IN THE FILM COMMUNITY 1930-1960 (New York: Anchor Press/Doubleday, 1980), pp.158-61; and Bernard F. Dick, THE STAR-SPANGLED SCREEN: THE AMERICAN WORLD WAR II FILM (Lexington: The University Press of Kentucky, 1985).

[83] Anti-Semitism vis-a-vis war films also was apparent during the pre-World War I period. Producer Charles Urban reported the problems he faced trying to gain sympathy for Britain in 1915. Since many American theaters were operated by German, Polish, or Russian Jews, "British propaganda in America had cast suspicion on all Jews, declaring that their primary loyalty was to the

prowar efforts, the United States Senate in October of 1941 passed Resolution 152, which authorized a congressional investigation into the film industry's alleged propaganda efforts "to influence public sentiment in the direction of participation by the United States in the . . . European War." Although the issue was never resolved because of America's entry into the war two months later, a similar attack on alleged Hollywood propaganda resurfaced in 1947 with the House Un-American Activities Committee investigation of Communism in motion pictures.[84] In light of the anxiety related to war films, it is sensible to consider and identify the forms and purposes propaganda can take in the genre.

One method is to understand the qualities unique to propaganda. Jacques Ellul, for example, insists that it is a technique rather than a science, "But it is a MODERN technique--that is based on one or more branches of science."[85] It is modern because of the propagandist's reliance on the scientific application of psychological and sociological principles. By methodically taking advantage of our understanding of human beings, their needs, desires, and socialization processes, the propagandist manipulates us according to the techniques developed by group psychologists and sociologists. It is also scientific in the fact that propaganda techniques rely on specific rules, tested and refined by experts. Those who hope to shape our responses for the best possible results systematically analyze both the groups themselves and the environments in which these groups function. The essential point is that propaganda is not applied randomly, but specifically to a particular group and situation. And in keeping with a modern scientific orientation, as Ellul explains, "the propagandist is no longer content to have obtained, or to believe he has obtained, a certain result; he seeks precise evidence."[86]

Ellul cautions us not to be misled by the fact that the propagandist works with groups. While it may be true that individual reactions are always tested against mass reactions (e.g., it is too costly, inefficient, and difficult to identify individual responses), to be effective the propagandist must always create individual responses within the crowd.[87] Put another way, the difference between advertising and propaganda is that "advertising turns to ME, propaganda plays on US."[88] The real test of effective propaganda is in making every person feel as if the message being sent responds directly to individual feelings, needs, and values. "Thus," Ellul concludes, "all modern propaganda profits from the structure of the mass, but

fatherland." Cited in Kevin Brownlow, THE WAR, THE WEST AND THE WILDERNESS (New York: Alfred A. Knopf, 1979), p.53.

[84] Often overlooked is the fact that the House Un-American Activities Committee (HUAC) was instituted in 1938, under the chairmanship of Texas Congressman Martin Dies. Anti-Semitic and extremely right wing in character, HUAC first investigated Hollywood's alleged communist activities in 1938-1940, but was soundly rebuffed by the film industry. After America's entry into World War II and our joining with the Soviet Union as a wartime ally, HUAC became dormant. Following its highly publicized attack on Hollywood in 1947, HUAC again investigated the film industry in 1951 and then focused attention on the television industry until 1956. For more information, see chapters 5 and 7.

[85] *Jacques Ellul, "Characteristics of Propaganda," PROPAGANDA ON FILM: A NATION AT WAR, ed. Richard A. Maynard (Rochelle Park: Hayden Book Company, 1975), p.1. Ellul's important text PROPAGANDES, published in 1962, has been translated by *Konrad Kellen and Jean Lerner: PROPAGANDA: THE FORMATION OF MAN'S ATTITUDES (New York: Vintage Books, 1973).

[86] Ellul, p.2.

[87] Ellul, pp.3-4.

[88] Leif Furhammar and Folke Isaksson, POLITICS AND FILM (New York: Praeger Publishers, 1968), p.186.

exploits the individual's need for self-affirmation; and the two actions must be conducted jointly, simultaneously."[89] Genre films operate on much the same basis, using conventions to reaffirm traditional values, and using inventions as a means of responding to current needs. In addition, the knowledge that propaganda is tied to specific individual attitudes in a particular period and environment is an invaluable reminder that as individual tastes change, so does the effect of a particular film--especially the war film--, and with it the reactions of critics and audiences.

By today's standards, for example, the racist, hate-filled films of World War I appear childlike and primitive. The poorest type even by comparison with the standards of the era were the propaganda movies. Nevertheless, as two Swedish commentators observed, "contemporary assessments of their effectiveness were so positive that most of the warring countries sooner or later made propaganda pictures."[90] Kevin Brownlow assessed the impact of these films differently, stating:

> The propaganda films cast a dark shadow across the cinema's history; they aroused hatred from the audience and disapproval from the White House. Nevertheless, by the time the conflict was over, the film had become a social force. It had grown out of the stage of a mild diversion and into an era when life without it was unthinkable.[91]

To fully appreciate a film's impact, therefore, we must always keep in focus the time of its initial release and the critical climate of the period.

Adolf Hitler had his own theories on what was effective propaganda.[92] In MEIN KAMPF, for instance, he devoted considerable space to the lessons World War I had taught him about psychological conflicts. Again and again, he hammered at the idea that propaganda to be effective had to be simple, direct, and easy to assimilate. Baird summarized those theories into two basic points:

> First, propaganda should always be directed to the uneducated masses, not to questioning intellectuals; the larger the crowd, the lower the intellectual level of the speech. Secondly, propaganda should always appeal to the emotions and not to reason; simple themes should be repeated time and again. Material based on objective truth was worthless since the nation "is not composed of diplomats and professors of international law, nor even people capable of reasonable

[89] Ellul, p.4. Elsewhere, Ellul explains that a major difference between historical and contemporary societies is that in earlier times images posing as facts played a much less important role than in modern times. As a result, we face an interesting paradox: ". . . the more technology develops the diffusion of information (and notably of images), the more it provides the means of mastering the constructed meaning under the appearance of the given meaning." In simplified terms, what, according to Ellul, motivates individuals into political and social action is not facts but propaganda. This manipulation of public opinion flows not only from authoritarian sources but also from among everyday sources in society. Thus, one always has to be aware that we react to events with already predispossed and conditioned attitudes. See Jacques Ellul, THE POLITICAL ILLUSION, trans. Konrad Kellen (New York: Alfred A. Knopf, 1967), pp.113-28.

[90] Furhammar and Isaksson, p.10.

[91] Brownlow, p.3.

[92] For a useful introduction into the preconditions necessary to mythologizing history, see *David Desser, THE SAMURAI FILMS OF AKIRA KUROSAWA (Ann Arbor: UMI Research Press, 1983), p.18.

judgment, but of grown-up children with a predilection for irresolution, doubt, and insecurity."[93]

Hitler's precepts laid the basis for communicating Nazi ideology, and films showing his speeches reveal how closely he practiced what they preached. His oratory is a model of the irrational.

Particularly relevant for our purposes is the fact that genre films in Nazi Germany established conventions based on Hitler's propaganda theories and then used inventions as a means of rationalizing war-related issues. A case in point was the 1933 film HITLER YOUTH/HITLERJUNGE QUEX, an early but highly significant integration of Nazi filmmaking, myth, and history. "This work, celebrating the life and death of a symbolic Hitler youth, became," as Baird explains, "an integral part of Nazi ideology and played a role in influencing millions of young Germans to be prepared to sacrifice their lives for Fuhrer, Volk, and Fatherland.[94] HITLER YOUTH like its imitators lent credibility to the way in which propaganda based on historical distortions could influence mass audiences.

Fiction films were not the only cinematic evidence of Hitler's propaganda. Siegfried Kracauer's World War II analysis of direct Nazi war propaganda concentrated on two types on nonfiction films: the weekly newsreels, including a compilation of newsreels entitled BLITZKRIEG IN THE WEST/BLITZKRIEG IM WESTEN (1940); and feature-length campaign films, including BAPTISM OF FIRE/FEUERTAUFE (1940) and VICTORY IN THE WEST/SIEG IM WESTEN (1941).[95] The Nazis insisted on three principles in relation to their newsreels: (1) realism; (2) adequate length, usually forty minutes; and (3) speed, enabling the films to follow closely upon the events recorded. Building upon their expertise in manipulating the basics of film (e.g., commentary, visuals, and sound), the Nazi war films continually glorified Germany as a dynamic nation, not only in the present but throughout the centuries. The point of this propaganda technique was to show how the Western democracies have tried throughout history to destroy Germany. "The whole myth," as Kracauer explained, "was to give the impression that Germany's war and triumph were not accidental events, but the fulfillment of an historic mission, metaphysically justified."[96] The purpose of the strategy, according to Josef Paul Goebbels, Hitler's minister for Popular Entertainment and Propaganda, "was to win the heart of the people and keep it."[97]

John Grierson, who classified propaganda as "the art of public persuasion," provided a classic essay on how scientifically the Nazis used Hitler's techniques during World War II. He pointed out that the Germans gave propaganda top priority "as the very first and most vital weapon in political management and military achievement--the very first."[98] They used it behind the enemy lines as a

[93] Jay W. Baird, THE MYTHICAL WORLD OF NAZI WAR PROPAGANDA, 1939-1945 (Minneapolis: University of Minnesota Press, 1974), pp.17-8.

[94] Jay W. Baird, "From Berlin to Neubabelsberg: Nazi Film Propaganda and Hitler Youth Quex," JOURNAL OF CONTEMPORARY HISTORY 18:3 (July 1983):495.

[95] Siegfried Kracauer, PROPAGANDA AND THE NAZI WAR FILM (New York: Museum of Modern Art, 1942). Reissued as a supplementary section in *FROM CALIGARI TO HITLER: A PSYCHOLOGICAL HISTORY OF THE GERMAN (Princeton: Princeton University Press, 1947), pp.274-331.

[96] Kracauer, p.288.

[97] Kracauer, p.299.

[98] *John Grierson, "The Nature of Propaganda," GRIERSON ON DOCUMENTARY, ed. and comp. Forsyth Hardy; American Notes Richard Griffith and Mary Losey (New York: Harcourt, Brace and Company, 1947), p.202.

psychological means of "confusing and confounding" their opposition. Hitler stressed its ability cheaply to demoralize and terrorize his foes. But propaganda had other purposes. It could divide and conquer one's enemies internally:

> The principal point to take is that, when Germans put propaganda on the offensive in war, their psychological opportunities were rich and widespread. They appealed to men's thwarted ambitions; they offered salvation to disappointed and disheartened minorities; they preyed on the fears of capitalist groups regarding socialism; they preached controlled capitalism and a socialist state to the socialist minded. They harped on the weaknesses of democracy of which democratic citizens are only too well aware: the verbiage of its parliamentary debates, the everlasting delays of its committees, the petty bourgeois ineffectiveness of its bureaucracy . . . Everything was grist to their mill, so long as they divided the enemy and weakened his belief in himself.[99]

Grierson then proceeded to contrast the way in which Britain employed propaganda, not in a "very scientific" manner but based on a humanistic tradition stressing information and education. His goal from the start was always to prevent wars by making peace exciting. "Simple notion as it is," he wrote in 1926, "--that has been my propaganda ever since--to make peace exciting."[100]

Grierson's evaluation of the Nazi propaganda strategy ignores the crucial disagreement between Hitler and Goebbels.[101] As Erwin Leiser explains:

> Hitler wanted to exploit film entirely for propaganda purposes, but "in such a way that every filmgoer will know: today I am going to see a political film." Goebbels preferred a different method. Of the approximately 1,150 feature films produced during the Third Reich,[102] only about one-sixth were straight political propaganda. But every film had a political function. The entertainment films made during the Third Reich did not feature even the Nazi salute, because it was simpler to let a non-political audience go on believing that the old, cosy idyll still prevailed. There was much talk of realism, but a realistic portrayal of everyday life was avoided. That might have been dangerous: people were to be manipulated without being shown the direction in which they were being led. Which explains why Goebbels was not particularly interested in explicit glorification of the Nazi movement in films. No one must be allowed to get the impression that the revolution was over.[103]

Thus, for men like Goebbels, the function of an entertainment film bore a striking resemblance to certain Hollywood precepts.[104] That is, its external purpose was to

[99] Grierson, abridged version, p.103.

[100] John Grierson, "Review of MOANA," THE NEW YORK SUN (February 8, 1926). Rpt. *Lewis Jacobs, ed., THE DOCUMENTARY TRADITION, 3rd ed. (New York: Norton and Company, 1979), pp.25-6.

[101] David Welch identifies another disagreement between the two propagandists. Hitler saw propaganda as declining in its value as the Nazi Party grew stronger. Goebbels, however, thought it should increase in importance in order to maintain enthusiasm for the party. See Welch, PROPAGANDA, pp.41-42.

[102] Most sources claim that the number of feature films produced in the Third Reich were 1,097.

[103] Erwin Leiser, NAZI CINEMA, trans. Gertrud Mander and David Wilson (New York: Macmillan Publishing Company, 1974), p.12.

[104] John Gillett, "Germany A Lost Decade," SIGHT AND SOUND 4:4 (Autumn 1972):225-6.

distract audiences away from reality.[105] He constantly saw feature film genres as
being able to romanticize war as well as being an inexpensive form of escapist
entertainment.[106] The major difference, obviously, was in the conscious effort by the
Nazis to use the film as part of a comprehensive plan of thought control.[107] Or, as
Baird believes, "Nazi propaganda was unique in the way it merged the practical and
political with the mythical."[108] Worth noting in this connection is that Soviet
filmmakers had an easier time in mobilizing public opinion than did the Nazis. "The
Communists," as Peter Kenez perceptively observes, "were in a better position. Their
long-term monopoly over all forms of media had prepared the Soviet people to accept
whatever was given to them."[109]

The Swedish film commentators Leif Furhammar and Folke Isaksson have provided
a valuable overview of the principles of propaganda, starting first with the importance
of the psychological over the artistic. They base their summary on the concepts
formulated, analyzed, and developed by the early Soviet filmmakers.[110] As a result,
montage becomes the crucial factor in audience manipulation.[111] A second principle
of propaganda is to distort the audience's perception of reality, thereby providing a
new framework for the ideas presented. Thus the third principle, the use of
half-truths, can work just as effectively as truth itself. For example, Frank Capra's
WHY WE FIGHT series (1942-1945) made effective use of captured German newsreels,
by extracting specific images and then placing them in a different context in his films.

[105] Illustrative of how strongly Hollywood insiders felt about the movie theater as
an escape from reality are the comments made in 1945 by Terry Ramsaye, the noted
editor of the MOTION PICTURE HERALD. Complaining about hard-hitting newsreel
pictures of the Nazi death camps at Dachau and Buchenwald, he argued that "The
news obligation of the newsreel is happily trivial . . . No one goes to the
theater to get the news." Cited in THE AMERICAN NEWSREEL, pp.222-223. Also of
interest is David H. Mould, "Historical Trends in the Criticism of the Newsreel
& Television News 1930-1955," JOURNAL OF POPULAR FILM AND TELEVISION 12:3 (Fall
1984):118-26.

[106] A fascinating result, according to Short (pp.8-9), was the postwar conclusion
by the Allied Forces' film censors that of the seven hundred feature films and
twenty-five hundred short subjects released in Germany between 1933 and 1945,
"all but 141 feature and 254 short films were devoid of the taint of Nazi
propaganda."

[107] Other major differences, as Short (pp.4-5) points out, had to do with (1) the
war situation's effect on individual national film styles, (2) the propaganda
of one-party states versus multiparty political systems; and (3) power struggles
carried on within democratic societies.

[108] Baird, p.3.

[109] Sergei Drobashenko and Peter Kenez, "Film Propaganda in the Soviet Union,
1941-1945: Two Views," FILM AND RADIO PROPAGANDA IN WORLD WAR II, p.114.

[110] Furhammar and Isaksson, pp.152-86.

[111] The techniques conceptualized by the Soviets and used by propagandists ever since
are described in such books as *V. I. Pudovkin, FILM TECHNIQUE AND FILM ACTING,
memorial ed., trans. and ed. Ivor Montagu (London: Vision Press, 1954); Vladimir
Nilsen, THE CINEMA AS GRAPHIC ART (ON A THEORY OF REPRESENTATION IN THE CINEMA),
With an Appreciation by S.M. Eisenstein, trans. Stephen Garry, with editorial
advice from Ivor Montagu (New York: Hill and Wang, 1959); *Vladimir Nizhny,
LESSONS WITH EISENSTEIN, trans. and ed. Ivor Montagu and Jay Leyda (New York:
Hill and Wang, 1962); and *Sergei Eisenstein, FILM FORM: ESSAYS IN FILM THEORY
and *THE FILM SENSE, ed. and trans. Jay Leyda (New York: Meridian Books, 1957).

A fourth principle is that to get the maximum propaganda effect the director needs to stimulate the audience's emotions. The most successful method employs the elements found in melodramas--e.g., surprise, danger, adventure, love, death, and eroticism. For example, Mary Pickford, "America's Sweetheart" during the silent era, was menaced by lecherous Huns in Cecil B. De Mille's inflamatory film THE LITTLE AMERICAN (1917);[112] Soviet seamen are shown rebeling because of a "spoonful of soup" in Sergei M. Eisenstein's BATTLESHIP POTEMKIN (1925);[113] and hatred for the North Vietnamese is generated by an extended sequence of "Russian roulette" in Michael Cimino's THE DEER HUNTER (1978). In each film, perception takes precedence over truth, while the propagandist stirs up the viewer's indignation. A sixth principle stresses the importance of crowd scenes, evident in the works of such diverse filmmakers as Griffith, Eisenstein, Riefenstahl, and Capra. The seventh principle underscores the importance of music in manipulating an audience's emotions, noticeable in movies such as GRAND ILLUSION/LA GRANDE ILLUSION (1937), BLITZKRIEG (1939), and YANKEE DOODLE DANDY (1942). The eighth principle points out the importance of the star system for audience manipulation. A popular World War II personality like John Wayne, for example, could easily affect audiences' emotions in the 1940s. By the 1960s, however, Wayne's by-now controversial image and his "hawkish" film THE GREEN BERETS (1968) produced division rather than a desired consensus. The ninth principle of propaganda identified by the Swedish critics is the use of stirring appeals. Variations of that technique can be found in Chaplin's speech in THE GREAT DICTATOR (1940), Robert Taylor's dying words in BATAAN (1943), and Wayne's pep talk at the end of THE GREEN BERETS. The tenth principle, and perhaps the most potent, stresses the importance of contrasts, of creating in the audience's minds a "them" versus "us" mentality: wrong versus right, the cowardly versus the heroic. In their summation, Furhammar and Isaksson remind us again of the propagandist's psychological emphasis on simplifying the issues, and that "Politics are thus reduced to a magic game in which unequivocal moral signals are substituted for ideologies and where there is no room for rational arguments among the emotional manipulation."[114]

By studying the qualities unique to propaganda, film students discover how genres are propagandistic regardless of the filmmaker's stated intentions. The choice of a star, the emphasis on repeating one convention and excluding another, the musical selections,[115] and the appeal to the audience's emotions all contribute to both the success of a film and the effectiveness of its propaganda.[116]

[112] Brownlow, pp.131-4.

[113] Interestingly, BATTLESHIP POTEMKIN (1925) was one of Goebbels's favorite films, and he constantly exhorted Nazi filmmakers to model their propaganda techniques after Eisenstein's masterpiece. (The closest they ever came was OHM KRUGER/UNCLE KRUGER.) When the great Russian director heard about Goebbels's exhortations, he sent an open letter on March 22, 1934 to the propaganda minister, saying, "How dare you of all people talk about life--you who are inflicting death and exile on all things living and good in your country. . . ." Cited in Leiser, pp.13-4.

[114] Furhammar and Isaksson, p.168.

[115] Jay Leyda points to an undated Japanese World War II film, OCCUPATION OF SUMATRA, as a fine example of how music could be used for propagandistic purposes: ". . . Haydn is used for the camouflage of planes, DIE WALKURE for parachuting arms and troops, Tchaikovsky for the wrecking of an airfield, Dukas through the jungle grass, MEISTERSINGER for the finale of destruction." See Jay Leyda, FILMS BEGET FILMS (New York: Hill and Wang, 1964), p.61. A particularly useful essay on how Germany used music for propaganda during World War II is Michael Meyer, "The Nazi Musicologist as Myth Maker in the Third Reich," JOURNAL OF CONTEMPORARY HISTORY 10:4 (October 1975):649-65.

[116] In connection with propaganda techniques, teachers may find it useful to point

Another suggestion for studying the relationship among propaganda, censorship (antipropaganda),[117] and war films is to examine the history of the concept itself. Originally coined by Pope Gregory XIII in the sixteenth century, propaganda was put to use by a commission of cardinals to negate the teachings of the Protestant Reformation. A century later, Pope Gregory XV institutionalized the "Sacra Congregatio de Propaganda Fide," a specially established Roman Catholic College of Propaganda created to train priests for missionary work. Thus, from the outset, the concept represented a planned attack on converting nonbelievers to an alternative point of view. Yet up to World War I, "propaganda," usually identified with religious teachings and public declarations to encourage conversion and faith, was not looked upon as a sinister force in domestic or international relations.

But beginning in 1914, because of its use by demagogues, the press, and governments to persuade masses of people to controversial "patriotic" and populist positions, the word had shifted its meaning to connote treachery and subversion. Many people now began using it as a term for something repulsive. Of particular concern for intellectuals was the callous pleasure that many filmmakers and exhibitors derived from audience reactions to "faked" war films. In addition, the American film industry by 1914 found its profits increasing because such violent films proved popular. Government authorities, on the other hand, maintaining a neutralist policy, worried about the interventionist effect such movies were having on public opinion. The following year, "hawks" became disturbed about the number of pacifist films being released. They saw such films as bad for morale and undermining the need for national mobilization. Brownlow cites numerous examples of other types of problems created by films depicting the war in Europe: e.g., fights in local theaters between different nationalistic communities, fear arising from the depiction of new weapons like submarines and aeroplanes, and the growing terror of an impending invasion from the Kaiser's armies.[118]

Horace C. Peterson and Gilbert C. Fite also allude to the changing role of propaganda in the American media prior to World War I. Once we were part of the conflict, the government insisted that the media stand solidly behind the war effort. Systematically attempting to repress unfavorable points of view, the authorities decreed that no pacifist, anti-enlistment, or other message critical of our allies would be tolerated. Films like THE BATTLE CRY OF PEACE (1915),[119] WAR BRIDES (1916), and CIVILIZATION (1916), all with pacifist slants, were banned for the duration of World War I. Typical of what followed was Vitagraph's act of recalling all its prints of THE BATTLE CRY OF PEACE. They were reedited, retitled, and then rereleased as THE BATTLE CRY OF WAR.[120] Simplification of the issues became the custom,

out methods of combating negative messages. A good source for information is Eunice Cooper and Maria Jahoda, "The Evasion of Propaganda: How Prejudiced People Respond to Anti-Prejudice Propaganda," THE JOURNAL OF PSYCHOLOGY 23 (January 1947):15-25.

[117] Nicholas Pronay explains that censorship functions as antipropaganda in at least three ways: (1) it prevents alternative ideas to existing policies; (2) it prevents alternative explanations to the causes of existing problems; and (3) it prevents "alternative solutions, alternative methods and alternative aims to those projected by the government. . . ." See Nicholas Pronay, "The Political Censorship of Films in Britain Between the Wars," PROPAGANDA, POLITICS AND FILM, 1918-45, ed. Nicholas Pronay (London: The Macmillan Press, 1982), p.109.

[118] Brownlow, pp.22-36.

[119] For useful information, consult James R. Mock, CENSORSHIP 1917 (Princeton: Princeton University Press, 1941), p.175; and Jack Spears, "Nazimova," CIVIL WAR ON THE SCREEN AND OTHER ESSAYS (Cranbury: A. S. Barnes and Company, 1977), pp.117-63.

[120] Brownlow, pp.30-8.

with the enemy negatively stereotyped while the allied powers were deified and their cause made undeniably just and heroic (a pattern followed in psychological warfare ever since). "Hate-the-Hun" movies incited such race hatred among the general public that many intelligent Americans, including President Wilson, were embarrassed by the movie's grotesque stereotypes. Unfortunately, not enough concerned citizens existed at the time to prevent the violent and vicious crimes committed by an aroused public determined to punish indiscriminately anyone considered "pro-German." Almost any historical account of the era can supply examples of vigilante attacks on farmers or beatings of pacifists and socialists. As a result, Peterson and Fite had some justification for their claim that "The [American] moving picture industry was one of the greatest instruments for propaganda in the war. It must be given some responsibility for the hysteria and repressive activities of 1917 and 1918."[121]

Propaganda also took its toll on the morale of the various military forces as well as on the home front. Philip M. Taylor, for example, argues that Britain's Ministry of Information did a splendid job not only of demoralizing the Central Powers in Europe but also of drawing the United States into the European war.[122] The Central Powers, in turn, believed that Allied propaganda had been responsible for the internal collapse of support for the war. "Whether or not the work of allied propaganda organizations did or did not help much to win the War," writes Nicholas Pronay, "is immaterial for our purposes here: the important point is that it was believed at the time by those who had been in charge of the armies of the Central Powers and by those who were in charge of the propaganda offensive mounted against them."[123] Nonetheless, by 1914, no one doubted that propaganda was now a basic ingredient in modern warfare. Its role during peacetime, however, was still very much a matter of controversy.

The British, for their part, worried that populist messages in American films inflamed the English working classes against the British class system.[124] Prime Minister Herbert Henry Asquith also worried that his government's policies were not well understood by other nations. As a result, within days of declaring war on Germany, Asquith instructed one of his cabinet members, Charles F. G. Masterman, to set up a secret British propaganda bureau in Wellington House, Buckingham Gate, London.[125] "Instead of providing news stories--the job of the Press Bureau--,

[121] Horace C. Peterson and Gilbert C. Fite, OPPONENTS OF WAR, 1917-1918 (Madison: University of Wisconsin Press, 1957), p.93.

[122] Philip M. Taylor, "Propaganda in International Politics, 1919-1939," FILM AND RADIO PROPAGANDA IN WORLD WAR II, pp.17-47.

[123] Nicholas Pronay, "The First Reality: Film Censorship in Liberal England," FEATURE FILMS AS HISTORY, ed. Kenneth M. Short (Knoxville: The University of Tennessee Press, 1981), p.114.

[124] Worth remembering, as Nicholas Pronay points out, is "that the first British government of the twentieth century (elected 1900) rested on 1.8 million votes including those of the pluralists and the whole Mother of Parliaments on the votes of 3 1/2 million people out of a population of 41 million." While Pronay credits Britain's leaders with a willingness to extend eventually voting rights to all their citizens, he insists that "The arrival of the mass-male-electorate, with a startling suddenness in 1918 and its then inevitable extension to women was, at best, thought to open the door to demagogues and Press-Power." See Pronay and D.W. Spring, p.6.

[125] For more information, see Horace C. Peterson, PROPAGANDA FOR WAR: THE CAMPAIGN AGAINST AMERICAN NEUTRALITY, 1914-17 (Norman: University of Oklahoma, 1939); Arthur Prosonby, FALSEHOOD IN WARTIME (London: George Allen and Unwin, 1928); James Morgan Read, ATROCITY PROPAGANDA, 1914-1919 (New Haven: Yale University Press, 1941); and James Duane Squires, BRITISH PROPAGANDA AT HOME AND IN THE UNITED STATES FROM 1914 TO 1917 (Cambridge: Harvard University Press, 1935).

Wellington House," according to Brownlow, "concentrated on the production, translation, and distribution of books, pamphlets, and speeches, and the placing of extracts and articles in the world's newspapers and magazines."[126] In 1916, Lloyd George replaced Asquith as prime minister, Lieutenant Colonel Jack Buchan (author of the novel THE THIRTY-NINE STEPS) took over the propaganda bureau from Masterman, and Wellington House was transformed into the Department of Information. This resulted in a complete overhaul of the manner in which propaganda was conducted.[127]

By 1917, as Nicholas Reeves discovered, "domestic enthusiasm had begun to wane, and they [the propaganda agency] turned their attention to public opinion at home as well.[128] The effects were so devastating that in 1918, Lloyd George reconstituted the Department of Information as the Ministry of Information, with Lord Beaverbrook presiding. At the same time, Lord Northcliffe was placed in charge of the Department of Enemy Propaganda at Crewe House.[129] The primary but highly controversial mission was to influence and shape the way the British working class thought and reacted to events in the postwar period. In fact, as Pronay explains, gaining control of the opinions and perceptions of working people "came to be seen by the political leaders of postwar Britain as the most essential step upon which everything else depended, including survival of the political system itself."[130] Although the Ministry of Information and the Department of Enemy Propaganda were both disbanded by the end of 1918, the British Foreign Office continued efforts to use propaganda to preserve the STATUS QUO in England and its policies abroad. The most acceptable use, discussed below, was in the area of commerce. Overall, however, "The British government . . . regarded propaganda," Taylor documented, "as . . . politically dangerous, financially unjustifiable and morally unacceptable in peacetime."[131]

Other nations during this time also took precautions against possible political instability. The Weimar Republic, for its "protection," encouraged self-censorship in the German film industry beginning in May 1920. Attempts during World War I to ban foreign films maligning the national image had failed badly. But the new German censors did not do much better in banning any film that "endangers public order and safety . . . or endangers the German image or the country's relationship with foreign states."[132] The Soviet Union, meanwhile, put propaganda to work popularizing Marxist doctrines. Soon after the Russian Revolution had established the Bolsheviks as the new government, Lenin proclaimed the following policy concerning national culture in PRAVDA, his official news agency:

[126] Brownlow, p.6.

[127] Brownlow, p.54.

[128] Nicholas Reeves, "Film Propaganda and Its Audience: The Example of Britain's Official Films During the First World War," JOURNAL OF CONTEMPORARY HISTORY 18:3 (July 1983):463.

[129] For more information, see Campbell Stuart, SECRETS OF CREWE HOUSE (London: Hodder and Stoughton, 1920); and M. L. Sanders and Philip M. Taylor, BRITISH PROPAGANDA IN THE FIRST WORLD WAR (London: The MacMillian Press, 1982).

[130] Pronay and Spring, p.9.

[131] Taylor, p.24.

[132] Welch, PROPAGANDA, p.19. See also David Welch, "The Proletarian Cinema and the Weimar Republic," HISTORICAL JOURNAL OF FILM, RADIO AND TELEVISION 1:1 (1981):3-18.

> Political propaganda in the country must be conducted for both illiterates and the literates . . . The cinema theatre, concerts, exhibitions, etc., as much as they will penetrate to the country, and towards this end all forces must be applied, must be used for Communist propaganda directly . . . General education . . . must be closely linked with Communist propaganda.[133]

Thus the function of "expressive realism," the Soviet name for the new aesthetics, was to use the arts to educate politically the Russian population. The revolutionary editing techniques developed and perfected by Sergei M. Eisenstein, V. I. Pudovkin, Dziga Vertov, Esther Shub,[134] and Alexander Dovzhenko produced powerful visual weapons to win people to the Soviet point of view. At the same time, however, the international class-based ideology propagandized in the Soviet films continued to pose a threat to the stability of industrialized nations.[135]

American movie messages posed other problems for foreign nations. Despite the Armistice in November 1918, for example, American filmmakers remained determined to release revenge movies against the horrible "Huns." Among the most inflammatory were THE KAISER'S FINISH, WHY AMERICA WILL WIN, AMERICA MUST CONQUER (KING OF THE HUNS), and DAUGHTER OF DESTINY (all in 1918). The effect of these "Hang-the-Kaiser" films was to offset President Wilson's peacetime aims. He thus "instructed the Creel Committee to try to stop the atrocity pictures because they made the job of securing a just peace yet more hazardous."[136] Even run-of-the-mill Hollywood films in the years that followed created problems for the industry. England's Lord Lee of Fareham, for example, told visiting Americans in 1925

> that the American movie is a positive menace to the world. It gushes . . . It spills over with cheap sentiment. It is wholly unrepresentative of life in the United States. It is used by Bolsheviks to stir up trouble. "From your point of view as well as ours," he said, with his face turned toward America, "to send us trash of this description is fraught with terrible consequences not only in this country but in every country in the world.[137]

Alarmist outbursts like this notwithstanding, it is clear that films in general and war films in particular reflected the ideology and mythology of their individual countries. Their aim went far beyond entertainment, and their impact involved more than escapism.

Such practices contributed to the fact that "propaganda" no longer was considered a neutral term. It came eventually to mean, as one commentator said, "The controlled dissemination of deliberately distorted notions in an effort to induce action favorable to predetermined ends of special interest groups."[138] As such a negative

[133] *Jay Leyda, KINO: A HISTORY OF THE RUSSIAN AND SOVIET FILM (New York: The Macmillan Company, 1960), p.139.

[134] For more information, see Vlada Petric, "Esther Shub: Cinema is My Life," QUARTERLY REVIEW OF FILM STUDIES 3:4 (Fall 1978):429-48; and ___, "Esther Shub's Unrealized Project," ibid., pp.449-56.

[135] For recent overviews, see "Part IV: The Projection of the Soviet Union," PROPAGANDA, POLITICS AND FILM, 1918-45, pp.249-92; and Drobashenko and Kenez, pp.94-124.

[136] Brownlow, pp.158-61.

[137] Cited in Charles Merz, "When The Movies Go Abroad," HARPER'S MAGAZINE 152:2 (January 1926):159.

[138] Michael Choukas, PROPAGANDA COMES OF AGE (Washington: Public Affairs Press, 1965), p.37.

force increased in size and importance, governments continued their efforts to counterbalance its harmful ideological and political effects.

During the next two decades, the British documentary movement led the way in trying to restore the original meaning referred to in Grierson's definition of propaganda as "the art of public persuasion."[139] The center of the documentary movement in the early 1930s was at the Empire Marketing Board (EMB). Set up in 1926 by the British government to encourage trade with the Commonwealth, the EMB in 1927 hired Grierson. One social historian would later write that Grierson was to the documentary movement "what J. S. Mill was to nineteenth-century liberalism."[140] Within a year, he had convinced Stephen Tallents to form a film production unit. The purpose of that unit was to produce nontheatrical films that operated as effective government propaganda.[141] Its value to film history centers on the theories developed by Grierson to promote film propaganda and on the young people whom Grierson attracted to the EMB--e.g., Basil Wright, Paul Rotha, Stuart Legge, Harry Watt, and Arthur Elton.

With very few exceptions, however, the first films made by the EMB were undistinguished technically. Their great significance was in their revolutionary emphasis on a new type of film production, a new direction for film sponsorship, a new use for the film medium, and a new attitude toward the working class. Before the appearance of movies like DRIFTERS (1929) and INDUSTRIAL BRITAIN (1933), for example, the British working class was used primarily in the commercial cinema for comic relief. The documentary movement dramatically changed that public perception. Nevertheless, by 1933, the EMB found itself under attack not only from government critics but also from members of the commercial film industry. The arguments most often made against Grierson's productions were that they represented unfair competition for the film industry and that the filmmakers themselves were politically suspect. These complaints plus the bad economic conditions in England caused the demise of the EMB. The film unit, however, was shifted to the public relations section of the General Post Office (GPO).[142] It was both at the EMB and the GPO that the importance of using propaganda in nontheatrical films for achieving government ends had its greatest artistic success.[143]

[139] Another prominent film trend using the British cinema for propaganda in the period between the two world wars involved the Workers' Film Movement. For more information, see Bert Hogenkamp, "The Workers' Film Movement in Britain, 1929-39," PROPAGANDA, POLITICS AND FILM, 1918-45, pp.144-70; and Trevor Ryan, "'The New Road to Progress': The Use and Production of Films by the Labour Movement, 1929-39," BRITISH CINEMA HISTORY, pp.113-28.

[140] Peter Stead, "The People and the Pictures. The British Working Class and Film in the 1930's," PROPAGANDA, POLITICS AND FILM, 1918-45, p.84.

[141] It is useful to consider the often-used assertion that "morality" plays a key role in differentiating the factual film from the fictional film. For a good introduction, see James M. Linton, "The Moral Dimension in Documentary," JOURNAL OF THE UNIVERSITY FILM ASSOCIATION 28:2 (Spring 1976):17-22.

[142] Credit for the transfer goes to Stephen Tallents. Not only had he been in charge of the EMB and the man who had appointed Grierson head of the film unit, but also Tallents had been chosen as the person in charge of public relations at the GPO.

[143] It's worth noting that the ideas received more respect than the people who promoted them. The documentary movement, according to Harry Watt, did not gain respectability until World War II. "The trade, the whole of the film business," claimed Watt, "had no respect for documentary." Cited in Elizabeth Sussex, THE RISE AND FALL OF BRITISH DOCUMENTARY: THE STORY OF THE FILM MOVEMENT FOUNDED BY JOHN GRIERSON (Berkeley: University of California Press, 1975), p.61.

Documentary filmmakers, led by Grierson, Rotha, and Alberto Cavalcanti,[144] stressed innovative techniques that made nonfiction films absorbing to watch and invaluable instruments for social progress.[145] They disagreed among themselves, however, on the best means for achieving these ends.[146] Paul Rotha, for example, divided the value of documentary techniques into two categories: (1) for "incidental background" material; and (2) for a "specifically designed" purpose.[147] Rotha's emphasis, as summarized by Richard Meran Barsam, was always humanistic. That is, "He favor[ed] films which illuminate the past, explain the present, and enrich the future."[148] Both Grierson and Rotha, unlike Cavalcanti, put propaganda above aesthetics. They saw the end result of such priorities as making it possible for a better life for everyone.

In the meantime, the British establishment continued to be disturbed by the working class emphasis in the films. In fact, as Watt recalled, the entire GPO film unit was viewed suspiciously by certain government officials who regretted ever having established a film unit: "To start with, we were left-wing to a man. Not many of us were Communists, but we were all socialists, and I'm sure we had dossiers because we demonstrated and worked for the Spanish War."[149] The British establishment was well aware of the problems created by World War I propaganda and

[144] Although the Brazilian filmmaker Cavalcanti had distinguished himself with silent films made in France like RIEN QUE LES HEURES (1926) and EN RADE (1928), he joined the "lowly" GPO in 1934 in order to experiment with sound techniques. His impact on the GPO was second only to that of Grierson.

[145] Grierson's major contributions were more in film theory than in film production. By the time he left the GPO in 1937 to assist in the formation of the Film Centre in London, Grierson had directed only one respected film of his own--DRIFTERS (1929). He had, on the other hand, written and lectured extensively on the significance of the documentary film movement. It should be remembered, however, that Grierson discouraged giving individual credits for camera work, editing, and directing during the EMB-GPO days. Teamwork, not individual achievements, was what distinguished the early documentary movement, and Grierson had played a critical role in the production of almost all films made by the EMB and GPO film units. In addition, Grierson had nurtured the film careers of Basil Wright, John Taylor, Edgar Anstey, Paul Rotha, Arthur Elton, Harry Watt, Alberto Cavalcanti, and Stuart Legge. Informative biographies on Grierson's life are *Gary Evans, JOHN GRIERSON AND THE NATIONAL FILM BOARD: THE POLITICS OF WARTIME PROPAGANDA (Toronto: University of Toronto Press, 1984); Forsyth Hardy, JOHN GRIERSON: A DOCUMENTARY BIOGRAPHY (London: Faber and Faber, 1979); and James Beveridge, JOHN GRIERSON FILM MASTER (New York: Macmillan Publishing Company, 1978). Also helpful are Jack C. Ellis, "The Grierson Movement," JOURNAL OF FILM AND VIDEO 36:4 (Fall 1984):41-9; ___, "John Grierson's First Years at the National Film Board," CINEMA JOURNAL 10:1 (Fall 1970):2-14; and Stuart Hood, "John Grierson and the Documentary Film Movement," BRITISH CINEMA HISTORY, pp.99-112.

[146] Rotha worked at EMB only for six months in 1931. He disagreed with Grierson's group approach to filmmaking and was fired. He then made documentaries for independent commercial sponsors. In 1941, he set up his own production company, Paul Rotha Productions. Although the two men found working together very difficult, they remained lifelong friends.

[147] Quoted in Robert Vas, "Sorcerers or Apprentices: Some Aspects of Propaganda Films," SIGHT AND SOUND 32:4 (Autumn 1963):200.

[148] Richard Meran Barsam, NON-FICTION FILM: A CRITICAL HISTORY (New York: E. P. Dutton and Company, 1973), p.9.

[149] Sussex, p.77.

felt more comfortable with censorship policies that protected them from subversive ideas.[150] Although this position created problems for the members of the documentary movement, the theory that propaganda should be tied to education and information stayed with many British filmmakers, even during the Second World War.[151] Actually, as Wright points out, "By the nature of their work the documentarists were expert in matters of propaganda, and it was not unusual for the feature filmmakers to turn in their direction."[152] A declaration of principle printed in the DOCUMENTARY NEWSLETTER OF BRITAIN[153] stated,

> True propaganda should be firstly concerned with the dissemination of knowledge and thereby linked with education; secondly, its aim should be persuasion and not imposition; thirdly, it should be regarded as a science which is largely useless unless it can operate over the surface of the whole globe, and unless it can use those media with the widest and most immediate coverage, such as radio, film, and printing. There is only one other requisite--that it must be operated by experts, and in the interest of humanity at large.[154]

The fact that the British government did not immediately follow the advice of its documentary filmmakers is well documented.[155] Just as well documented is the proof that once documentary filmmakers like Harry Watt, Alberto Cavalcanti, Humphrey Jennings,[156] Ian Dalrymple, and Paul Rotha were allowed to make the type of films they wanted, the British were provided with excellent wartime propaganda.[157] Thanks to production groups like the Crown Film Unit (formerly the GPO) at Pinewood

[150] For a good overview, see Nicholas Pronay, "The Political Censorship of Films in Britain Between the Wars," PROPAGANDA, POLITICS AND FILM, 1918-45, pp.98-125.

[151] Baird offers a valuable summary of the psychological warfare waged by England and Germany during the "Phony War," from the defeat of Poland in 1939 to Germany's attack on Norway and Finland in April 1940. See Baird, pp.57-83.

[152] Wright, p.177.

[153] The DOCUMENTARY NEWSLETTER OF BRITAIN (1940-1947) was an outgrowth of the CINEMA QUARTERLY (1932-1935) and WORLD FILM NEWS (1936-1938).

[154] Roger Manvell, FILMS AND THE SECOND WORLD WAR (South Brunswick: A. S. Barnes and Company, 1974), p.78.

[155] See Forsyth Hardy, "British Documentaries in the War," TWENTY YEARS OF BRITISH FILMS 1925-1945, ed. Michael Balcon et al. (London: Falcon Press, 1947), pp.45-80. Rpt. NONFICTION FILM THEORY, pp.167-72; and in THE DOCUMENTARY TRADITION, pp.205-10. See also Paul Rotha, DOCUMENTARY DIARY: AN INFORMAL HISTORY OF THE BRITISH DOCUMENTARY FILM, 1928-1939 (New York: Hill and Wang, 1973), pp.232-40; and Nicholas Pronay, "'The Land of Promise: The Projection of Peace Aims in Britain," FILM AND RADIO PROPAGANDA IN WORLD WAR II, pp.51-77.

[156] Lindsay Anderson, "Some Aspects of the Work of Humphrey Jennings," SIGHT AND SOUND 24:2 (April-June 1954). Rpt. THE DOCUMENTARY TRADITION, pp.236-43.

[157] For a good overview of British propaganda during World War II, see "Part III: Film Propaganda in Britain in World War II," PROPAGANDA, POLITICS AND FILM, 1918-45, pp.173-245.

[158] In 1939, the GPO film unit was transferred to the resurrected Ministry of Information. It offically became the Crown Film Unit in 1940. Tallents was the head of public relations. For more information, see Ian Dalrymple, "The Crown Film Unit, 1940-43," PROPAGANDA, POLITICS AND FILM, 1918-45, pp.209-20.

Studios,[158] inspired documentaries were made that effectively explained to the English public what was happening in the war and what was needed by the British government to win the fight against the Axis powers.

Not much has changed since then. The controversy over how scientific propaganda is, under what conditions it is most effective, the dangers it poses to political stability, and what should be the stated or covert objectives of the propagandist still remain areas of controversy. It is also true that Europeans think of propaganda differently from the way Americans do. "Propaganda can be honest," as summarized in the arguments by the noted Dutch filmmaker Joris Ivens, "but it's a question of language. Propaganda for . . . the American public . . . has a very bad smell, no? It doesn't sound very good, you see. But for us in Europe the word propaganda is more honourable. If you have a good cause, and you speak freely and frankly out for it. . . ."[159] What seems clear, however, is that propagandists have as their ultimate aim the unquestioning acceptance of their ideas; and that propaganda itself is an integral part of genre films.[160]

Some illustrations of the problems "propaganda" presents for those studying the war film concern movies made by individuals sympathetic to or reflecting a national policy. In reviewing Hollywood's World War II movies, for example, Furhammar and Isaksson concluded that "The patriotic films were often noisily heroic, grotesque and naive, sometimes foolish, often filled with highly threatening fantasies in the manner of horrid fairy-tales, and, just occasionally, compassionate, perceptive or brilliant."[161] Julian Smith makes pointed references to actual World War II movies as an example of how American filmmakers refused to deal with contemporary issues. In highlighting Hollywood's traditional emphasis on how war affects Americans to the exclusion of other nationalities, Smith argues that the profit-minded film industry instead of making movies about the Vietnam War turned away from the controversy and produced new, safer films dealing with World War II. One of the examples he cites is the film version of SLAUGHTERHOUSE FIVE (1972),

> which attempted to treat the horrors of strategic bombing [a major policy of both the Johnson and Nixon administrations in regard to North Vietnam] from ground level but somehow forgot to point out the primary sufferers in the infamous Dresden raid were GERMANS; by focusing on an American character, the film fell right in step behind THE PURPLE HEART and THIRTY SECONDS OVER TOKYO, in which Yanks are shown to suffer tremendously following raids upon the enemy.[162]

Japanese war productions, not surprisingly, also stressed the effect of war on the individual, because, as Wright points out, "the military government's policy was the glorification of home and family."[163]

[159] Gordon Hitchens, "Joris Ivens Interview, November 20, 1968, American Documentaries," FILM CULTURE 53-55 (Spring 1972):210. For another perspective, see Philip M. Taylor, "British Official Attitudes Towards Propaganda Abroad, 1918-39," PROPAGANDA, POLITICS AND FILM, 1918-45, pp.23-49.

[160] Fielding makes a special case for newsreels. While admitting that they frequently and openly distorted events, he finds no overt evidence that newsreels ever intentionally manipulated their content for political purposes. He does, however, provide considerable evidence of the numerous charges made by the genre's critics that it was filled with blatant propaganda. See THE AMERICAN NEWSREEL, pp.246-8.

[161] Furhammar and Isaksson, p.66.

[162] Smith, p.201.

[163] Wright, p.214.

Revisionist film historians commenting on the Vietnam War films constantly criticize the values, attitudes, and stereotypes inherited from World War II filmmakers. They label such films as "guts and glory" movies that obfuscate the real issues, are extremely self-righteous, propagate racist views, and revel in mindless violence. For example, Gilbert Adair in his analysis of THE DEER HUNTER (1978) comments on the fact that neither director Michael Cimino nor his protagonists question why we're in Vietnam, although

> Cimino does indirectly raise a fundamental issue: How far should an artist be free to deform the "truth" in the pursuit of avowedly aesthetic aims? The problem is especially thorny where Vietnam is concerned, AS THE CRUDE RACISM AND POLITICAL OBFUSCATION OF MANY WORLD WAR II MOVIES, EVEN IF NOT CONSTRUCTED INSTRUMENTS OF PROPAGANDA, WERE FOUNDED ON THE CONSENSUS OF AMERICAN, WESTERN, AND, INDEED, ALMOST GLOBAL OPINION. [Emphasis mine] The Japs and the Krauts WERE the bad guys. As such, they deserved to be held up to the good guys' scorn.[164]

James Wilson indirectly credits the lingering influence of the traditional Hollywood war film for the media distortions found in the television coverage of the Vietnam War: "Whether television wanted to or not, it gave the American public a fictionalized, Hollywood version of America at war, ignoring the racism and the brutality of Vietnam."[165]

Obviously, the propagandist in one generation cannot be judged solely by another generation's values. Not having the hindsight granted to those in the present, the unsophisticated, war-torn audiences of yesteryear took what they saw to be if not realistic, at least reassuring in terms of the national values and mission. Just as obviously, film is a business where profits, not cultural standards, dominate decisionmaking. However, filmmakers do not operate in a vacuum, and therefore must be held accountable for their symbolism; they do bear some responsibility for the effect those images have on future generations. How to judge accountability is, of course, extremely difficult. Veit Harlan, for example, was the Nazi director responsible for the insidious 1940 film JEW SUSS/JUD SUSS. He was twice tried after the Second World War and both times acquitted. No one was able to prove satisfactorily what effect his loathsome films had on people and how the principle of free speech was abused.

Several critics have tried to solve the question of knowing how to identify a film that changes from being patriotic to being propagandistic in the pejorative sense. Leo C. Rosten, for example, argues that "A movie which dramatizes the prevailing civic emotions about our country, its institutions or national heroes, is a patriotic film. But a movie made for the PURPOSE of changing attitudes about, say, American foreign policy . . . would be a propaganda film."[166] Isenberg disagrees, calling Rosten's reasoning "semanticism . . . at its worst." Pointing out that cases are rarely that simple, he asks, "Where for example does one put Riefenstahl's TRIUMPH OF THE WILL?"[167]

Film historians are also fond of identifying ironic examples where censoring bodies have drawn the line on "propaganda" in war films. Mussolini's film censors, for example, in the 1930s "banned THE CHARGE OF THE LIGHT BRIGADE, LIVES

[164] Gilbert Adair, VIETNAM ON FILM: FROM THE GREEN BERETS TO APOCALYPSE NOW (New York: Proteus Books, 1981), p.138.

[165] *James C. Wilson, VIETNAM IN PROSE AND FILM (Jefferson: McFarland and Company, 1982), p.33.

[166] Leo C. Rosten, "Movies and Propaganda," ANNALS OF THE AMERICAN ACADEMY OF POLITICAL AND SOCIAL SCIENCES 254 (November 1947):118.

[167] Isenberg, p.230.

OF A BENGAL LANCER, LLOYDS OF LONDON, and CLIVE OF INDIA on the grounds they contained 'British propaganda'."[168] Darryl F. Zanuck's A YANK IN THE RAF (1941), conversely, originally had its hero (Tyrone Power) killed defending Britain, but the producer gave in to a request by the British Air Ministry that Power be allowed to live because showing "Americans getting killed in defense of Britain would make poor propaganda. . . ."[169] Nazi Germany went so far as to wage a commercial war against American films. In 1936, for example, Hitler ordered "the films of Mae West, Johnny Weissmuller, Francis Lederer, Fred Astaire, Ginger Rogers, Warner Oland and George Arliss . . . prohibited from exhibition" in Germany on the mistaken assumption that each of these performers was Jewish.[170] (Not that it changes anything, but for the record only Weissmuller, Lederer, and Oland were Jewish.) Hitler's "insanity" continued in 1939, as V. F. Calverton reported that Berlin had declared "'the American film industry stands under predominating Jewish influence,' and today there is not a single first-run theatre in Berlin which is showing an American picture."[171] What the Nazi propaganda did not report was that German audiences had not only shown disdain since the mid-1930s for Goebbels's film policies, but also had demonstrated support for American films. In fact, even weak Hollywood movies were preferred to most local productions.[172]

The American Catholic Church was also worried about Hollywood's political values, but for different reasons. Early in the 1930s, the Legion of Decency, the censoring body of the American Catholic Church, set out to monitor the film industry's self-regulatory code of moral standards, which included, in addition to its guidelines for presenting sex and crime on the screen, instructions on presenting political values: "The history, institutions, prominent people and citizenry of other nations shall be represented fairly." Thus when Hollywood began making movies like BLOCKADE (1938), which favored the Loyalist position in the Spanish Civil War--an anticlerical position understandably repugnant to Catholic groups not only in the United States--the Legion of Decency found itself in a quandary.[174] "If it should rate the picture as objectionable [a less serious penalty]," explained Paul W. Facey, "it would seem to countenance support for a group which was connected with immoral doctrines and practices. If it should condemn the film [a far more serious penalty], it would seem to others to be rating the picture on the basis of political, rather than

[168] Colin Shindler, HOLLYWOOD GOES TO WAR: FILMS AND AMERICAN SOCIETY 1939-1952 (London: Routledge and Kegan Paul, 1979), p.2.

[169] Smith, p.182.

[170] Shindler, p.2.

[171] V. F. Calverton, "Cultural Barometer," CURRENT HISTORY 50:1 (March 1939):46.

[172] David Stewart Hull, FILM IN THE THIRD REICH: A STUDY OF THE GERMAN CINEMA 1933-1945 (Berkeley: University of California Press, 1969), p.126.

[173] Paul W. Facey, THE LEGION OF DECENCY: A SOCIOLOGICAL ANALYSIS OF THE EMERGENCE AND DEVELOPMENT OF A SOCIAL PRESSURE GROUP (New York: Arno Press, 1974), pp.119-20.

[174] Loyalists throughout Spain were charged with burning and closing most of the country's churches because of the support shown for the Nationalist cause. What's interesting is that several years later, as Marjorie A. Vallaeu points out, the Legion of Decency mounted no formal pressure against the film FOR WHOM THE BELL TOLLS (1943), also supporting the Loyalist position, and based upon Hemingway's novel that the church authorities considered anti-Catholic. *Marjorie A. Valleau, THE SPANISH CIVIL WAR IN AMERICAN AND EUROPEAN FILMS (Ann Arbor: UMI Press, 1982), p.36. For a fascinating summary of the progressive reaction to BLOCKADE, see Ceplair, pp.307-10. See also Larry S. Ceplair, "The Politics of Compromise in Hollywood: A Case Study," CINEASTE 8:4 (Summer 1978):2-7.

moral values."[173] In a classic example of political jargon, the group gave BLOCKADE no rating, put it in a special classification, and issued a statement that said, "Many people will regard this picture as containing foreign political propaganda in favor of one side in the present unfortunate struggle in Spain."

Even in cases where filmmakers intend a film to have a specific message, the results can be confusing. Film classics heralded as anti-war films, for example, are often not that in fact. And from the vantage point of the present they seem mild and romantic. Robert Hughes points out:

> The two best-known anti-war films of the past, ALL QUIET ON THE WESTERN FRONT and GRAND ILLUSION, are concerned with the basic, well-known contradictions of war: men fight other men who are like themselves. Effective as they still are, both pictures are romantic in their idealization of the so-called good side of war, the camaraderie. But in a world of "total war," where mass extermination is a fact, whether in concentration camps or obliterated cities, they seem strangely dated. War and killing today are much more efficient and outrageously absurd. But there is almost no reflection of this fact in present day movies.[175]

It seems to many intelligent viewers like Hughes that movies that try to portray the evils of war actually glorify them. Consider, for example, THE BRIDGE ON THE RIVER KWAI (1957), which was intended as an anti-war film. Both Hughes and James Baldwin have commented on the same point, namely that the film shows individuals who are deranged placed in positions of authority, and the system itself, the military command in particular, is never seriously questioned; nor is the extent of the madness ever explored. "And speaking of absurdity," Hughes exclaims, "what of an 'anti-war' film [THE BRIDGE ON THE RIVER KWAI] which inspired at least one of its big audiences to scream at one point: 'kill him! kill him!'"[176] I have seen the same reaction twice in public schools where the film has been shown to large groups. Gordon Gow, taking note of the audience's misplaced and excessive sympathy, placed some of the blame on Alec Guinness's performance. He found it to be too "straight." The book's author, Pierre Boulle, described Colonel Nicholson (Guinness) as the prototype of the legendary Indian Army officer "who provokes in those around him alternating bouts of anger and affection." Guinness, in creating the screen role, won more loyalty for a soldier's allegiance to duty than for the destructive nature of such a blind obedience. As Gow points out, Sam Spiegel, the film's producer, was well aware of the intellectual conflict, "Man came into this world to build, and not to destroy. Yet he's thrown into the necessity of destroying, and his one everlasting instinct is to try to save himself from having to destroy."[177] David Lean gave a somewhat different perspective. He worried in his discussions with screenwriter Carl Foreman whether Colonel Nicholson's actions in leading the Japanese to the demolition charges would be perceived by the British public as an act of treason. In an interview with Steven Jay Rubin, Foreman explained that "Being British, David was quite sensitive about the impression Nicholson would give to an audience. In my opinion, it was never treason. But it was the ultimate insanity."[178] Lean's response to Rubin confirmed Foreman's explanation: "In most movies about war, people are conceived and conceived of as heroes. Aren't they wonderful. There was no question that

[175] Robert Hughes,"Murder: A Big Problem," FILM: BOOK 2--FILMS OF PEACE AND WAR, ed. Robert Hughes (New York: Grove Press, 1962), p.8.

[176] Robert Hughes and James Baldwin, "Mass Culture and the Creative Artist: Some Personal Notes," DAEDALUS 89:2 (Spring 1960):375.

[177] *Gordon Gow, HOLLYWOOD IN THE FIFTIES (New York: A. S. Barnes and Company, 1971), pp.79-81.

[178] Steven Jay Rubin, COMBAT FILMS 1945-1970 (Jefferson: McFarland, 1981), p.160.

Nicholson was a very brave man, but wasn't he also a fool who in the end became a blithering idiot?"[179] Nevertheless, audiences were divided on whether they saw the action in terms of a search for justice, an ironic commentary, or a just a thrilling finale. It may well be, as Isenberg pointed out, that "The themes of nationalism, honor, duty, and heroism are all common to war adventure genres. Plots threaded with them cannot make a coherent anti-war or pacifist statement, since the focus of such themes is individualistic rather than situational."[180]

Sometimes, however, the filmmaker achieves his intentions. Stanley Kauffmann, for instance, argues that GRAND ILLUSION (1937) is one of the most powerful anti-war films ever made:

Couched in terms of individual confrontation--a man with a man, rather than bloc against bloc or two hemispheres competing for outer space-- GRAND ILLUSION remains a towering film. By now it has attained the state of all good art that has lived some time among men: it moves us more than ever because it no longer surprises us.[181]

John Clellon Holmes is another commentator who writes how he and many like him were affected by anti-war movies, in particular, ALL QUIET ON THE WESTERN FRONT (1930):

It has always astonished me that almost no one has perceived that one reason why we went through the war [World War II] so laconically, with so little rhetoric, and with our eye out mainly for personal survival (not only against the enemy, but against the military system itself) was that we knew that all wars were basically frauds, even just wars. After all, hadn't we learned precisely that in our local theatre?[182]

Marjorie A. Valleau offers us one further important observation on anti-war films even when such movies end on an unrealistic emphasis of heroism. Using BLOCKADE (1938) to illustrate how the traditional Hollywood film can unintentionally disturb mass audiences, she explains how

Humanitarian values are paramount in the film. The dignity of human life is reinforced by showing how senseless suffering can ruin persons and land. Morality is not merely a question of morale among soldiers or civilians; rather it is a means of showing concern for those who are being hurt by war. While the film concludes on an unrealistic heroic note, nevertheless its chief effect is not to reassure but to trouble the audience and question their attitudes toward the Spanish Civil War.[183]

While BLOCKADE is not often seen as comparable to ALL QUIET ON THE WESTERN FRONT, it is worth noting that the former may well have been a more courageous film

[179] Rubin, p.160.

[180] *Michael T. Isenberg, "The Great War Viewed from the Twenties: THE BIG PARADE (1925)," AMERICAN HISTORY/AMERICAN FILM: INTERPRETING THE HOLLYWOOD IMAGE, ed. John E. O'Connor and Martin A. Jackson (New York: Frederick Ungar Publishing Company, 1979), p.28.

[181] Stanley Kauffmann, A WORLD ON FILM: CRITICISM AND COMMENT (New York: Harper & Row, 1966), p.3.

[182] John Clellon Holmes, "Fifteen Cents Before 6:00 P.M.: The Wonderful Movies of the 'Thirties,'" HARPER'S MAGAZINE 231:1 (December 1965):53.

[183] Valleau, pp.28-9.

to make, coming as it did during the days of the Spanish Civil War and not after a war as the Milestone movie did in 1930.

The point is that while propaganda does enter into filmmaking, the intentions and the effects often depend not so much on the movie itself as on the perception of the viewer as well as the filmmaker's ability to tap the national subconsciousness. In the end, cinematic techniques and film rhetoric can affect audiences in ways not intended by the filmmaker.[184]

An excellent illustration of how misperceptions can occur is provided by the controversy surrounding the 1967 BBC documentary THE WARSAW GHETTO. Intended, according to Annette Insdorf, as a condemnation of the way Germans mistreated Jews during World War II, the 1967 compilation film using Nazi film footage had the opposite effect on many viewers.[185] Holocaust historian Lucy Dawidowicz, for example, argued that the original Nazi film footage was meant to present a false image of the Germans being generous to the Jews of the Warsaw Ghetto. The Jews selected by the Nazis for the propaganda scenes, however, were chosen for their approximation of the hideous racist stereotypes perpetuated by the Nazis. Dawidowicz's argument against the BBC film, therefore, rested on the belief that a compilation movie using distorted photographs and footage could not be historically accurate. That is, "the faces of the Jews we see during most of the film definitely conform to those racist stereotypes." She goes on to remind us that the Nazis made no visual records of the many secret activities carried on by the Jews. These activities included not only attempts to preserve Jewish heritage, but also to organize militant resistance against the Nazi massacre of Jews. Insdorf takes the controversy one step further, emphasizing that there are three major obstacles that everyone faces in trying to overcome the ignorance that exists concerning the Holocaust:

(1) active resisters risked their lives as a matter of course, and few survived. There is consequently a lack of written or photographic records of their work. Moreover, as Terrence Des Pres notes, "Certainly it is not true that they did not revolt; to live was to resist, every day, all the time, and in addition to dramatic events like the burning of Treblinka and Sobibor there were many small revolts in which all perished";

(2) countless Jewish survivors of Auschwitz admit to having had no knowledge of the organized political network that existed in the camp. Indeed, political prisoners enjoyed comparatively more mobility and access to information than Jews, who were programmed for extermination. Accounts of individual survival have therefore paid scant attention to group solidarity;

(3) almost all the existing photos and newsreels of the ghettos and camps were taken by German cameras. A documentary like Frederic Rossif's THE WITNESSES (1962) is thus able to trace with poignancy the destruction of the Jews in the Warsaw Ghetto by re-cutting original Nazi footage, but it cannot show what those cameras would not, or could not record. How can one reconstruct images or activities that were secret even to the Ghetto inhabitants? Thus, we see thousands of starving and humiliated Jewish faces that elicit sympathy, but few defiant ones to command respect.[187]

[184] For a useful introduction to distortions in TV docu-dramas, see Bill Davidson, "TV's Historical Dramas: Fact or Fiction?", TV GUIDE (March 20, 1977). Rpt. THE DOCUMENTARY TRADITION, pp.557-62.

[185] *Annette Insdorf, INDELIBLE SHADOWS: FILM AND THE HOLOCAUST (New York: Vintage Books, 1983), p.126.

[186] Lucy Dawidowicz, "Visualizing the Warsaw Ghetto: Nazi Images of the Jews Refiltered by the BBC," SHOAH I, 1, p.5. Cited in Insdorf, p.126.

[187] Insdorf, p. 126. The quotation cited by Insdorf is from *Terrence Des Pres, THE

In other words, cinematic techniques used by an earlier generation of filmmakers can still influence the content and effect of a compilation film, even though the intentions of the latter day filmmaker are different from those of the film footage being used.

A third method for sensitizing audiences to the forms and purposes propaganda can take is to examine how governments themselves have difficulty in determining how, when, and where to use propaganda in films. Consider, for example, the United States government.[188] In World War I, it began exerting influence on the film industry prior to entering the war.[189] Not only did "hawkish" members of Congress pressure certain Hollywood producers to withdraw their pacifist, anti-war films, but as Timothy J. Lyons described, they also counselled filmmakers on the appropriateness of national types.[190]

The most notorious case involved Robert Goldstein's THE SPIRIT OF '76, a film made before April 6, 1917 (the day the United States declared war on Germany), which in the course of telling its story detailed British cruelty during America's fight for independence. Unfortunately, the film ran into serious problems during its Los Angeles premiere in November of 1917, at a time when war fever reached hysterical proportions nationally. Because the film and its director tarnished the image of an ally during World War I, the Los Angeles district attorney had Goldstein, an American Jew of German origins, arrested and tried under Title XI of the Espionage Act. Goldstein was found guilty and sentenced to ten years' imprisonment as well as fined five thousand dollars.[191] On appeal, the sentence was commuted to three years.[192]

The most evident official influence, however, was in the formation of duly constituted government agencies. For example, on April 14, 1917,[193] the Committee on Public Information (CPI), under the chairmanship of George Creel, a crusading journalist, was created to advise and administer the propagation and dissemination of war propaganda.[194] Since neither President Wilson nor Creel had much respect for the film industry, relations between the government and Hollywood went badly at first. It soon became apparent, however, that the CPI needed the film industry's

SURVIVOR: AN ANATOMY OF LIFE IN THE DEATH CAMPS (New York: Pocket Books, 1977), p.181.

[188] England had the Ministry of Information; Germany, the Ministry of Popular Enlightenment and Propaganda; France, the Commissariat General a L'Information; Japan, the Central Information Bureau; Russia, the Communist Party Central Committee. For a good overview of how these organizations operated, see FILM AND RADIO PROPAGANDA IN WORLD WAR II.

[189] Peter Soderbergh, "Aux Armes!: The Rise of the Hollywood War Film, 1916-1930," SOUTH ATLANTIC QUARTERLY 65:4 (Autumn 1966):509-22.

[190] Timothy J. Lyons, "Hollywood and World War I, 1914-1918," JOURNAL OF POPULAR FILM I:1 (Winter 1972):25.

[191] Brownlow suggests there might have been an element of anti-Semitism, because during World War I many people considered "German" and "Jewish" synonymous. See Brownlow, p.80.

[192] Michael Selig, "United States v. Motion Picture Film THE SPIRIT OF '76: The Espionage Case of Producer Robert Goldstein (1917)," JOURNAL OF POPULAR FILM AND TELEVISION 10:4 (Winter 1983):168-74.

[193] The Division of Film was initiated on September 25, 1917.

[194] For further information, consult Michael T. Isenberg, WAR ON FILM: THE AMERICAN CINEMA AND WORLD WAR I, 1914-1941 (Rutherford: Fairleigh Dickinson University Press, 1981); James R. Mock and Cedric Larson, WORDS THAT WON THE WAR: THE STORY ON THE COMMITTEE OF PUBLIC INFORMATION, 1917-1919 (Princeton: Princeton University Press, 1939); and George Creel, HOW WE ADVERTISED AMERICA (New York: Harper and Brothers, 1920).

expertise in matters of production and distribution. As a result, Creel established the War Co-operating Committee, made up of movie moguls like Jesse L. Lasky, Carl Laemmle, Adolf Zukor, and Marcus Loew, as well as D. W. Griffith. In return for the government's promise not to censure or limit distribution of their films--e.g., no film could be exported unless approved by the CPI--the commercial film industry "volunteered" its resources for government service. Stars participated in Liberty Bond drives, short subjects produced privately by the film industry represented CPI positions, and commercial feature films sensitized the public to issues the government wanted explained and accepted.

How effectively the CPI did its job is a matter of controversy. Historians like James R. Mock and Cedric Larson write disparagingly of "the first propaganda ministry," while film scholar Raymond Fielding viewed negatively the film coverage of World War I. Calling the efforts of combat photographers "thin and inadequate," Fielding summarized a number of factors for the medium's failures:

> the novelty of the motion picture as a journalistic medium and the failure of government officials to accord cameramen the same privileges given newspapermen; the hesitancy of front-line military authorities to allow photography for fear of attracting enemy fire; the failure of the government to develop an efficient production and distribution system for war film; the exclusion of highly competitive civilian cameramen from front-line areas during most of the war; lack of equipment suited to battleground cinematography; and, most limiting of all, the presence of rigorous censorship by zealous representatives of the Creel Committee and the military services.[195]

Lyons, on the other hand, concluded that "Hollywood presented the war in terms that the American public could not only understand but, more important, absorb. In this way, Hollywood LEGITIMATED--i.e., explained AND justified the objectionable social situation [war], the remote battlefield, and reduced the situation into terms which could be--in fact, WERE--readily accepted."[196]

Historians agree, however, that the policies of both the CPI and Hollywood had a profound influence not only on the manner in which the United States government operated its propaganda-making activities during future wars, but also on war films in particular. As Richard Dyer MacCann aptly stated:

> Most of the film work of the CPI was done too late to have much effect--whether negatively or affirmatively--in what Creel called "the world fight for public opinion." The motion picture only barely began to carry "the call of the country to every community in the land and . . . inform and enthuse the peoples of Allied and neutral nations." Yet the intentions and plans were all there as a pattern for a later war. The discrepancy in film technique and in mood--epitomized in such titles as PERSHING'S CRUSADERS and RECLAIMING THE SOLDIERS' DUDS--should not hide the fact that all the major film activities of World War II were used in World War I: newsreel distribution, nontheatrical showings, features and shorts for commercial theaters, and films for overseas, accomplished through government advice, then government sponsorship and, finally, government production.[197]

From this period on, filmmakers knew the worth of stereotyping the enemy, simplifying the issues, and manipulating the attitudes, values, and behavior of the audience both for commercial and political purposes.

[195] THE AMERICAN NEWSREEL, pp.124-5.

[196] Lyons, p.27.

[197] Richard Dyer MacCann, THE PEOPLE'S FILMS: A POLITICAL HISTORY OF U. S. GOVERNMENT MOTION PICTURES (New York: Hastings House, 1973), p. 123.

Following the end of World War I and the dissolution of the CPI in 1919, the public's interest in film propaganda focused on the film industry's morals. A number of Hollywood scandals involving sex crimes, dope addiction, and murder forced the film industry to create the Motion Picture Producers and Distributors of America, an organization designed to enforce "proper codes of conduct" for all aspects of the movie business.[198] Included in its concerns was the fear that insensitive film treatments might not only offend foreign countries and thus cause an international problem, but more importantly diminish profits from a foreign market. To head this self-regulatory agency, the movie moguls appointed William Harrison Hays, the postmaster-general of the United States.[199] During the remainder of the 1920s, Hays worked to overcome the objections posed by the film industry's critics, and established a "Don'ts and Be Carefuls" list to guide filmmakers. Of particular relevance was the resolution that read:

> special care . . . [should] be exercised in the manner in which the following subjects are treated to the end that vulgarity and suggestiveness may be eliminated and that good taste be emphasized: . . . International relations (avoiding picturizing in an unfavorable light another country's religion, history, institutions, prominent people, and citizenry). . . .[200]

Over the next two decades, various self-regulating groups under the auspices of the Hays office wrestled continuously with the implications of that political issue.

It was, however, the California gubernatorial race of 1934 that once again focused attention on Hollywood's use of propaganda for political purposes.[201] Candidate Upton Sinclair, the muckraking socialist journalist, captured the Democratic

[198] In England, a similar trade group called the British Board of Film Censors (BBFC) was formed in 1912. Its original function was to pass on the suitability of commercial feature films. But as a result of the propaganda in nonfiction films during World War I, the BBFC increased its role to include film reporting. For a helpful summary, see Paul O'Higgins, CENSORSHIP IN BRITAIN (London: Nelson, 1972); Dorothy Knowles, THE CENSOR, THE DRAMA AND THE FILM (London: Allen and Unwin, 1934); J. Richards, "The British Board of Film Censors and Content Control in the 1930s, I: Images of Britain," HISTORICAL JOURNAL OF FILM, RADIO AND TELEVISION 1:2 (1981):95-117; and ___, "II: Foreign Affairs," ibid., 2:6 (1982):39-49. For a good account of censorship worldwide, the following books are useful: Ira H. Carmen, MOVIES, CENSORSHIP AND THE LAW (Ann Arbor: University of Michigan Press, 1966); Neville March Hunnings, FILM CENSORS AND THE LAW (London: George Allen and Unwin, 1967); Guy Phelps, FILM CENSORSHIP, Introduction Alexander Walker (London: Gollancz, 1975); and *Richard S. Randall, CENSORSHIP OF THE MOVIES: THE SOCIAL AND POLITICAL CONTROL OF A MASS MEDIUM (Madison: University of Wisconsin Press, 1968).

[199] How much actual power Hays wielded is a matter of controversy. Most historians, however, agree that the appointment itself was politically motivated. That is, a close associate of the then Republican administration would be advantageous for thwarting a congressional movement to censor films.

[200] The British Board of Film Censors followed a similar policy. Among its more than ninety-five operating rules were those forbidding references to controversial politics, relations between capital and labor, scenes disparaging public characters and institutions, realistic horrors of war, and scenes and incidents calculated to afford information to the enemy. By the late-1920s, the rules included censorship against any film "likely to wound the just susceptibilities of Friendly nations."

[201] For examples of how American avant-garde groups used film for propaganda purposes, see Russell Campbell et al., "Film and the Photo League: Radical Cinema in the 1930s," JUMP CUT 14 (March 1977):23-33. Examples of similar attempts

nomination in a stunning primary upset, and campaigned on a New Deal-Socialist platform so terrifying to Louis B. Mayer and his Republican-oriented movie moguls that they waged a covert film war against him. Studio employees were coerced into giving campaign contributions to Sinclair's Republican opponent, Frank E. Merriam.[202] But the most significant factor was the "doctored" newsreels exhibited in California movie theaters, showing thugs being transported into the state to cause labor unrest or illegal immigrants being smuggled across the Mexican border to reduce farm wages.[203] Although Sinclair lost the election, the political shenanigans backfired on the movie moguls. From 1934 on, the film industry splintered into various political factions, not only into Democratic-Republican party lines, but also along political divisions originating abroad: e.g., anti-Fascists, anti-Communists, and anti-Nazis. Thus when congressional isolationists, citing the 1935 Neutrality Laws, began taking official note of Hollywood's prowar movies at the end of the thirties, the politicians could point to the various organizations that for several years had been arguing for our international intervention in Spain, China, Italy, and Germany.

What these politicians did not realize was the enormous dilemma faced by the film industry: should it pursue profits or purpose? The foreign markets, particularly in Europe, were vital to the economic success of the big studios. They depended on these markets for their major profits.[204] Jack L. Warner, for example, recalled in his autobiography the pressure he received from powerful Hollywood producers who were furious with him for going ahead with the exhibition of CONFESSIONS OF A NAZI SPY (1939): "Look, Jack," one studio boss told him, "a lot of us are still booking pictures in Germany, and taking money out of there. We're not at war with Germany, and you're going to hurt some of our own people there."[205]

The irony of the 1939 anecdote is that ever since the Nazi Party had come to power in 1933, Jews had systematically been removed from the German film industry.[206] According to one Nazi sympathizer's gross exaggeration, Jews working

abroad can be found in Elizabeth Grottle Strebel, "French Social Cinema and the Popular Front," JOURNAL OF CONTEMPORARY HISTORY 12:3 (July 1977):499-519; and ___, "Political Polarization and the French Cinema," PROPAGANDA, POLITICS AND FILM, 1918-45, pp.157-69.

[202] A number of Hollywood celebrities actively fought against the so-called "Merriam" tax. Among the leaders were Jean Harlow, James Cagney, Gene Fowler, Jim Tully, Frank Scully, and Morrie Ryskind. See Rosten, HOLLYWOOD: THE MOVIE COLONY, p.136.

[203] See Harry Pringle, "The Movies Swing an Election," NEW YORKER (April 14, 1936):28; Bosley Crowther, HOLLYWOOD RAJAH: THE LIFE AND TIMES OF LOUIS B. MAYER (New York: Henry Holt, 1960), pp.225-8; *Samuel Marx, MAYER AND THALBERG: THE MAKE-BELIEVE SAINTS (New York: Random House, 1975), pp.235-6; Gary Carey, ALL THE STARS IN HEAVEN: LOUIS B. MAYER'S M-G-M (New York: E. P. Dutton, 1981), pp.185-8; Bob Thomas, THALBERG: LIFE AND LEGEND (Garden City: Doubleday and Company, 1969), pp.268-9; Ceplair, pp.89-94; and Rosten, HOLLYWOOD: THE MOVIE COLONY, pp.134-8.

[204] The importance of foreign markets for the American film industry can not be underestimated. In 1983, for example, American movies earned more than $1.25 billion dollars a year, or 30 percent of their revenues from overseas sources. See Peter Kerr, "Foreign 'Piracy' of TV Signals Stirs Concern," NEW YORK TIMES 1(October 13, 1983):1. A good source for the importance of overseas markets in the 1920s is C. J. North, "Our Foreign Trade in Motion Pictures," AMERICAN ACADEMY OF POLITICAL AND SOCIAL SCIENCES ANNALS 128 (November 1926):100-8.

[205] Jack L. Warner, with Dean Jennings, MY FIRST HUNDRED YEARS IN HOLLYWOOD (New York: Random House, 1964), p.262.

[206] Warner Bros. also battled with the highly regarded MARCH OF TIME organization. The studio refused to show in its theaters the MARCH OF TIME's INSIDE NAZI

in the German film industry during the early 1930s accounted for eighty percent of the scripts, fifty percent of the completed films, and ninety percent of film distribution.[207] In addition, by July 12, 1933, as documented by David Stewart Hull, a law had been passed that stated that "Workers desiring any kind of film job would have to present proof that both their parents and grandparents were 'Aryans.'"[208] The fact that major American producers, the majority of whom were Jewish, for primarily business reasons[209] as late as 1939 tried to pressure Warner against upsetting the Nazi government is both shocking and indicative of the importance they attached to the German film revenue.[210] It was, however, all in vain. By April 1940, Goebbels had banned all American films,[211] MGM's offices in Germany were forced to close on August 14, 1940; and Paramount had its distribution ties severed by Nazi decree on September 7, 1941.[212] The effect, at least according to Fritz Heppler, Goebbels's man in charge of film in the Propaganda Ministry, was that the American film industry lost "40 percent of its income from foreign countries."[213]

Once European markets were lost as a result of the ANSCHLUSS and German occupation, the same Hollywood producers willingly joined with Warner in testing the "political" possibilities of using heretofore taboo international themes. "It was not only in blatant propagandistic films that Hollywood attempted to underline the danger of the fascist menace," argued Garth Jowett, "but films such as John Ford's THE GRAPES OF WRATH (1939), Frank Capra's MEET JOHN DOE (1940), and the series of biographical studies on Zola, Curie, Juarez, and Lincoln, popular in the 1930s,

GERMANY--1938. Warner Bros. considered the extremely controversial film pro-Nazi. See Raymond Fielding, THE MARCH OF TIME, 1935-1951 (New York: Oxford University Press, 1978), p.199. For a useful overview of the political, cultural, and economic forces shaping THE MARCH OF TIME, see Stephen E. Bowles, "And Time Marched On: The Creation of the MARCH OF TIME," JOURNAL OF THE UNIVERSITY FILM ASSOCIATION 29:1 (Winter 1977):7-13. See also John Davis, "Notes on Warner Brothers Foreign Policy, 1918-1948," THE VELVET LIGHT TRAP 4 (Spring 1972):23-33.

[207] Curt Belling, DER FILM IN STAAT UND PARTEI (Berlin, 1936), pp.15-6. Cited in Welch, p.15. For another perspective, see M. S. Phillips, "The Nazi Control of the German Film Industry," JOURNAL OF EUROPEAN STUDIES 1:1 (March 1971):37-68; and ___, "The German Film Industry and the New Order," THE SHAPING OF THE NAZI STATE, ed. Peter D. Stachura (Totowa: Barnes and Noble, 1978), pp.257-81.

[208] Hull, p.26.

[209] Rosten makes a good point (pp.161-2) that many filmmakers had relatives and friends in occupied or soon-to-be-occupied countries. To increase tensions or dramatize horrors may have been emotionally troubling to these cautious and worried filmmakers.

[210] For valuable insights into what was being projected on French screens in the interwar period, see Pierre Sorlin, "Jewish Images in the French Cinema of the 1930s," HISTORICAL JOURNAL OF FILM, RADIO, AND TELEVISION 1:2 (October 1981):139-50.

[211] Professor David Scrase of the Department of German and Russian at the University of Vermont believes that Hollywood films continued to be shown in Germany well into 1941. Interview with the author, October 18, 1983.

[212] Hull, p.178.

[213] Cited in Thomas Decker, "Movies to Sell the Reich," THE NATION 153:1 (July 5, 1941):14. Interestingly, Rosten (p.160) claimed that Hollywood in general lost 35-40 percent of its foreign revenues, while specific studios and producers may have lost as much as 50 percent of their income from abroad.

all attempted to reinforce a belief in the democratic tradition."[214] Leo C. Rosten astutely reminded us what were the reactions to these types of films:

> When Hollywood released THE GRAPES OF WRATH, the simpletons of reaction cried "Communist!" (because of the picture's content) and the simpletons of revolution cried "Fascist!" (because of the picture's ending). When Hollywood produced CONFESSIONS OF A NAZI SPY, the Nazis cried "Bolsheviks!" When it produced NINOTCHKA, the Communists cried "Fascists!" When it produced MR. SMITH GOES TO WASHINGTON, the Bourbons cried "Trouble-Makers!" When it produced MAYTIME, the liberals cried "Escapists!"[215]

In addition, up to our actual entry into World War II in December of 1941, the American public remained deeply divided over the issues of interventionism versus isolationism. Confusing the situation in the pre-World War II days was the Nazi-Soviet Non-Aggression Pact of 1939 and the Russian-Japanese Non-Aggression Pact of 1941. Thus, as Robert Sklar observed, American attitudes toward the Soviets were in a state of confusion because "In 1940 and 1941, the dominant question in American political life was whether to intervene in the European war, and the Communists for much of this period joined ranks with the right-wing isolationists."[216] In sum, the various government investigations into the propaganda activities of the film industry dealt with very complex issues almost impossible to separate in terms of profit motivation, propaganda, and high-minded ideals.[217]

World War II did not resolve the issue of how democratic governments should use the film medium for political propaganda. A prime example of the dilemma was the Office of War Information (OWI). As Clayton R. Koppes and Gregory D. Black explain,

> During the war the government, convinced that movies had extraordinary power to mobolize public opinion for war, carried out an intensive, unprecedented effort to mold the content of Hollywood feature films. Officials

[214] Garth Jowett, FILM: THE DEMOCRATIC ART (Boston: Little, Brown and Company, 1976), p.300. Other nations also searched for historical subjects suitable for wartime propaganda. Germany, for example, relied heavily on Frederick the Great, while both Germany and the Soviet Union reached back to the 1812 heroes who fought against Napoleon.

[215] See Rosten, p.78.

[216] *Robert Sklar, MOVIE-MADE AMERICA: A SOCIAL HISTORY OF AMERICAN MOVIES (New York: Vintage Books, 1976), p.245. Interestingly, German and Soviet propagandists faced a similar problem during the same period. Evidence exists showing that the German people considered Hitler's pact with Stalin to be merely a tactical maneuver prior to an inevitable war with Russia. Ever since 1924, the Nazis had been waging an anti-Bolshevik propaganda campaign. Goebbels, therefore, didn't know what type of propaganda to use in terms of the Soviets, let alone what would be effective. The Russians, for their part, had produced so much anti-Nazi propaganda prior to 1938 that they found it nearly impossible to reverse the Soviet audiences' long-standing animosity toward the Germans. See Baird, pp.147-8; Furhammar and Isaksson, p.24.

[217] Baird provides an excellent account of the issues, techniques, and problems besetting Nazi officals responsible for wartime propaganda. More broadly based than OWI, the OBERKOMMANDO DER WEHRMACHT/ABTEILUNG FUR WEHRMACHTPROPAGANDA (Supreme Command of the Armed Forces/Section for Wehrmacht Propaganda), or OKW/WPR, supervised the information coming from the front, as well as which war correspondents went where and when, or if they went at all. Furthermore, it had censorship powers concerning any materials bearing on military matters, a power that extended to the mass media and even advertisements. See Baird, pp.33-4.

of the Office of War Information, the government's propaganda agency, issued a constantly updated manual instructing the studios in how to assist the war effort, sat in on story conferences with Hollywood top brass, reviewed the screenplays of every major studio (except the recalcitrant Paramount), pressured the movie makers to change scripts and even scrap pictures when they found objectionable material, and sometimes wrote dialogue for key speeches. OWI attained considerable influence with the Office of Censorship, which issued export licenses for movies, and it controlled the exhibition of American films in liberated areas.[218]

Established by executive order on June 13, 1942, the OWI consolidated a variety of prewar informational agencies.[219] Its primary mission was "not only to disseminate information and to clarify issues but also to arouse support for particular symbols and ideas."[220] Its director was Elmer Davis, an aggressive radio commentator, who recruited liberal New Dealers like Archibald MacLeish, Robert Sherwood, and Milton S. Eisenhower to his staff.[221] A subsection, the Bureau of Motion Picture Affairs (BMPA), headed by Lowell Mellett, according to many historians was "one of the agency's more important and controversial activities."[222]

At first, OWI and Hollywood disagreed on the most effective methods for getting the desired message to the American people.[223] Hollywood had set up the War Activities Committee, an organization of filmmakers from producers to labor leaders,

[218] Clayton R. Koppes and Gregory D. Black, HOLLYWOOD GOES TO WAR: HOW POLITICS, PROFITS, AND PROPAGANDA SHAPED WORLD WAR II MOVIES (New York: The Free Press, 1987), pp.vii-viii.

[219] The two major branches of the OWI were the Coordinator of Information's Foreign Information Service, responsible for overt propaganda, and the Office of Strategic Services, responsible for covert propaganda. For the best summaries of the OWI's activities with Hollywood, see Clayton R. Koppes and Gregory D. Black, HOLLYWOOD GOES TO WAR: HOW POLITICS, PROFITS AND PROPAGANDA SHAPED WORLD WAR II MOVIES (New York: The Free Press, 1987); and A. M. Winkler, THE POLITICS OF PROPAGANDA, THE OFFICE OF WAR INFORMATION, 1942-1945 (New Haven: Yale University Press, 1978).

[220] Clayton R. Koppes and Gregory D. Black, "What to Show the World: The Office of War Information and Hollywood, 1942-1945," JOURNAL OF AMERICAN HISTORY 64:1 (June 1977):88. See also Clayton R. Koppes and Gregory D. Black, "OWI Goes to the Movies: The Bureau of Intelligence's Criticism of Hollywood, 1942-1943," PROLOGUE 6 (Spring 1974):42-57.

[221] In 1950, according to Erik Barnouw, Senator Joseph McCarthy led an attack on members of the OWI who had started working after the war in the State Department. The films, broadcasts, and other media-based products designed for foreign consumption and emanating from the State Department were labeled as "Communist-inspired" and resulted in a new wave of purges and loyalty oaths. See Erik Barnouw, DOCUMENTARY: A HISTORY OF THE NON-FICTION FILM (New York: Oxford University Press, 1974), p.222. Of particular importance was the attempt to prove (unsuccessfully) that American films glorifying the "Common Man" were part of a Communist conspiracy. Kanfer, for example, reports that Ayn Rand in her attack on Communists published a pamphlet entitled SCREEN GUIDE FOR AMERICANS, with a section extorting readers not to "Deify the Common Man." See *Stefan Kanfer, A JOURNAL OF THE PLAGUE YEARS (New York: Atheneum, 1973), p.82.

[222] Koppes, p.89.

[223] See Richard Dyer MacCann, pp.152-72; and Philip Dunne, "The Documentary and Hollywood," HOLLYWOOD QUARTERLY 1:2 (January 1946):166-72. Both articles have been reprinted in NONFICTION FILM THEORY, pp.136-57 and pp.158-66 respectively.

who sought to cooperate with the government in needed morale-oriented projects. The film community stressed conventional formulas over message-oriented products, assuming that a passive-minded audience always preferred avoiding controversy in favor of escapist entertainment.[224] The OWI insisted that message-oriented movies get the point across that "the war was not merely a stuggle for survival but a 'people's war' between fascism and democracy. . . ."[225]

Clearly, the OWI had the upper hand in the debate. In addition to their aforementioned advantages, the OWI determined how much, if any, film stock and construction materials filmmakers could use during wartime. To survive economically, the film industry had to make many concessions, including giving the Pentagon script approval over war-related films. In the end, a compromise was worked out in which the OWI and the filmmakers obfuscated the real issues in favor of stressing the nation's will to endure and its democratic ideals.[226] And, as hindsight reveals, the relationship between the government propaganda agency and the American dream factory "offers insights into America's war ideology and the intersection of politics and mass culture in wartime."[227]

Government influence on Hollywood films continued after World War II,[228] primarily through a seemingly innocent arrangement. Much as had been the case throughout the century, the Pentagon during peacetime provided "technical" assistance to filmmakers. The assistance, as Russell E. Shain reported, could be anywhere from permitting filmmakers "access to film clips to allowing studios use of military bases and equipment. Hollywood has filmed at relatively low cost jets, bombers, submarines, carriers and other technological hardware."[229] Requests for such assistance, starting in 1948, went to the Motion Picture Production section of the Department of Defense Public Affairs Office. Donald Baruch, the only person to head that area, was appointed in 1949.[230] Up until the early 1960s, according to Lawrence H. Suid, Baruch acted primarily as a go-between for filmmakers working with the individual services:

[224] The demand by the general public for escapist films was not unique to the United States. In Norway, for example, the film industry fell into Nazi hands in 1940. The Norwegian Resistance movement then twice tried to organize a boycott of the "Nazi" films shown in Norway. Both attempts failed because the public had a passion to see films, and "that escapist urge was not to be denied." In fact, movie business reached a new high. See Furhammar and Isaksson, p.127.

[225] Koppes, p.91.

[226] For a good introduction to the documentary and nonfiction films produced by the OWI, consult Barsam, pp.216-9.

[227] Koppes, p.87. Interestingly, Culbert in his analysis of MISSION TO MOSCOW claims that the OWI never had the President's confidence. The freedom with which Ambassador Davies controlled the way his memoirs were transformed into a propaganda film is cited as a case in point. See Culbert, p.137.

[228] Readers may also find valuable information about the effects of World War II propaganda techniques on postwar American information services abroad. See Richard Dyer MacCann, "Film and Foreign Policy: The USIA, 1962-1967," THE PEOPLE'S FILMS, pp.173-200. Rpt. NONFICTION FILM THEORY, pp.173-202.

[229] Russell E. Shain, "Effects of Pentagon Influence on War Movies, 1948-70," JOURNALISM QUARTERLY 49:4 (Winter 1972):641-2.

[230] As of December 1985, Donald Baruch was still working for the Defense Department. His new title, however, is Special Assistant for Audio-Visual in the office of the assistant Secretary of Defense for Public Affairs.

In this capacity, the office could recommend that a service provide assistance, could help with the negotiations between a filmmaker and a service, or could refuse to approve cooperation on a film that was not in the best interests of the military. But it could not require a service to assist on a movie, and once the office approved a project, it had no involvement in the cooperation process. Consequently, throughout the 1950s, the services had virtually a blank check to provide assistance, much as they had from the earliest days of their relationship with the film industry. Film-makers received as much help on any movie as a service's public affairs office in Washington and its commanders in the field decided was in its best interest.[231]

As long as the filmmakers conformed to Pentagon standards, the arrangement worked well.[232] Particularly interesting are those cases where disagreements arose--e.g., THE STEEL HELMET (1951), FROM HERE TO ETERNITY (1953), PRISONER OF WAR (1954), ON THE BEACH (1959), and WAR HUNT (1962).[233] In each instance, one discovers how the military used the film industry for propaganda purposes, while in its own behalf the industry exploited the enormous resources of the Pentagon to produce "realistic" films.

The turning point came as a result of a relatively insignificant congressional request in 1961 for information about military assistance given to a Jack Paar television show near the Berlin Wall. Shortly thereafter further inquiries were made concerning the amount of time, equipment, and military personnel assigned to Darryl F. Zanuck's then-in-production THE LONGEST DAY (1962). One memorandum led to another, the use of the military for entertainment purposes became more controversial, and before a year was out the Pentagon had issued a "new series of strictly enforced regulations [which] deeply affected the course of future military cooperation with the motion picture industry."[234]

The result was that fewer and fewer films received Pentagon support,[235] and the image of the military in films switched dramatically from a positive to a negative one--e.g., FAIL-SAFE, DR. STRANGELOVE OR: HOW I LEARNED TO STOP WORRYING AND LOVE THE BOMB, and SEVEN DAYS IN MAY (all in 1964), CATCH-22 (1970), and CINDERELLA LIBERTY (1973). One need only contrast these films with those receiving support--e.g., A GATHERING OF EAGLES (1963), THE GREEN BERETS (1968), TORA! TORA! TORA! and PATTON (both in 1970)--to understand the transformation of the military image after 1962.

The question, of course, is whether, given the era, the film image of the military

[231] *Lawrence H. Suid, GUTS AND GLORY: GREAT AMERICAN WAR MOVIES (Reading: Addison-Wesley Publishing Company, 1978), pp.112-3.

[232] "When Hollywood Asks the Pentagon For Help," NEW YORK TIMES C (August 29, 1984):21.

[233] The best sources for such information are *Lawrence H. Suid, GUTS AND GLORY: GREAT AMERICAN WAR MOVIES; *Steven Jay Rubin, COMBAT FILMS 1945-1970; Russell Earl Shain, AN ANALYSIS OF MOTION PICTURES ABOUT WAR RELEASED BY THE AMERICAN FILM INDUSTRY, 1939-1970; and Julian Smith, LOOKING AWAY: HOLLYWOOD AND VIETNAM. Smith, in particular, has two appendexes on the Department of Defense's cooperation with Hollywood: "An Approximate List of Commercial Motion Pictures on which The Department of Defense Rendered Assistance 1949-1968" and "Extracts from Department of Defense Instruction 5410.15 (November 3, 1966): 'Delineation Of DoD Audio-Visual Public Affairs Responsibilities and Policies.'"

[234] Rubin, p.76.

[235] Ironically, the years from 1962 to 1967 saw an increase in the number of United States Information Agency films produced at home and distributed abroad. Congressional fears about the films being politically dangerous kept them from being shown to American audiences. See MacCann, "Film and Foreign Policy," p.174.

would have changed anyway.[236] Judging from recent reports, Baruch's control and policies remain firmly entrenched. For example, Rod Lurie points out that only TV shows that portray the military positively get the support of the Department of Defense. In the case of the 1988/89 TV season, only one series, the weekly CBS drama TOUR OF DUTY, benefits from the hardware owned and operated by the military. "'We support the show because it shows it [the life of an infantry unit in the Vietnam War] like it was,' says Baruch. 'And please note that it's not all flattering. There may be one episode here and there that deals with racism within the unit. We're ready to accept that if the theme of the series itself shows the army in a light that doesn't discredit us.'"[237] In reviewing the history of the Pentagon-Hollywood relationship, Shain spoke for most scholars when he concluded, "The military did influence its own portrayal by the American film industry. The result was not a complete perversion of how the movies would have portrayed the military without assistance. However, the intrusion of the Pentagon into movie making does raise certain ethical questions and does provide an example of what can happen when a mass medium relinquishes editorial control in return for economic favors."[238]

In line with the propagandist function of the war film is Hollywood's treatment of heroes. American war heroes usually follow the prototypes of the cowboy or gangster hero.[239] Herbert Jacobson described the war hero as an outsider who was defending the community, much the same way as the western hero is usually portrayed as a scout, a guide, or a soldier. The war hero fits into the pattern of the cowboy whose inventiveness, marksmanship, and perseverance always will win out, given enough time. No matter how many people are involved in the conflict, in the final showdown the decision will depend upon one man's courage and fortitude.[240]

The male leads' bravado is surpassed only by their indestructibility.[241] However, John Howard Lawson saw American war heroes as gangsters who glorify, on the screen, sex and murder.[242] American officers, according to Lawson, portray fascist leaders. The men are seen accepting war and killing, reasoning that it is a game of kill or be killed. No one questions the orders of superiors; there are no discussions on morality or the purpose of war. Officers expect their men to be killed, and the men have as their aim "to accomplish the greatest possible destruction before they die."[243]

[236] For an interesting discussion on why Hollywood may have perpetuated the image of World War II films more than twenty years after V-J day, see Peter A. Soderbergh, "The War Films," DISCOURSE 11:1 (Winter 1968):87-91. For an interesting account of how war films are prepared, see "Supplying the Props for War Films," NEW YORK TIMES C (August 20, 1987):14.

[237] Rod Lurie, "Hollywood and the Pentagon: When the Military Assists a Production," SATELLITE TV PRE-VUE (January 8-14, 1989):115.

[238] Shain, "Pentagon Influences," p.647.

[239] For an interesting variation on this theme, see Richard W. Steele, "The Greatest Gangster Movie Ever Filmed: PRELUDE TO WAR," PROLOGUE 11:4 (Winter 1979):221-36.

[240] Herbert L. Jacobson, "Cowboy, Pioneer and American Soldier," SIGHT AND SOUND 22:4 (April-June 1953):189-90.

[241] The Editors of LOOK, MOVIE LOT, p.58.

[242] In view of Lawson's almost unanimous praise of Russian filmmaking, it would have been interesting to learn his views of the Russian movie war hero, something that he did not discuss in his writings.

[243] John Howard Lawson, FILM IN THE BATTLE OF IDEAS (New York: Masses and Mainstream, 1953), pp.23-5.

In studying how the propaganda war films familiarize their audience with the effects of oppression, Arthur Knight describes how Hollywood used these movies as a device for exploiting the public's fascination with terror, horror, and sadism. He points out that the films often depicted the savage Nazis as mentally disturbed beasts who took great pleasure in inflicting their inhuman tortures. The typical American hero, on the other hand, never resorted to such brutality; he was just a clean-cut youth caught in a troubled world.[244] Quite a different picture is presented after the war, particularly in films like THE VICTORS (1963), THE NAKED AND THE DEAD (1958), and THE DIRTY DOZEN (1967). Parker Tyler, reviewing the formulas of war movies, points out the tendency to portray an individual who, regardless of his rank or popularity with his comrades, will achieve success against the maniacal enemy. He cites A WALK IN THE SUN (1945) as the archetype of the Hollywood war film. It presents soldiers as average Americans, "nearly all former clerks," who are transformed into fighting men in a "stinking" war. With no choice except to do their duty and finish the dirty business at hand, they are reduced to a corps of soldiers who recognize as their one goal in life, killing the enemy and capturing a farmhouse that they are to hold until relieved by a larger force.[245] Kathryn Kane, in her analysis of twenty-four American World War II fiction combat films, concluded that "The American may be summed up as a creature of moderation and control; he believes in rules of government, of personal behavior, of natural order, of cosmic order. The enemy is a creature of chaos; believing himself superhuman, he behaves bestially, slavishly obedient to the will of patently unworthy leaders, vicious in his own behavior. . . ."[246] Thus the American combat films serve as a twentieth century depiction of an heroic myth typifying the struggle between Humanity and Chaos.

For our purposes, therefore, Ruth A. Inglis's explanation of "propaganda" is the most useful:

> If by "propaganda" is meant something deceitful or misleading, then, of course, the movie must have none of it. If we mean by "propaganda" any content which might change the ideas, sentiments, or values of those exposed to it, the motion picture can not in any conceivable way avoid being propagandistic. Movies necessarily carry images of people and implications regarding ideas and ideals which have relevance to the community at large.[247]

Her definition neatly summarizes the way propagandists use films to convert an audience and reinforce its values and points of view. As well, Inglis's explanation reminds us once more that the propagandist's goal is to simplify issues so as to shape the national will to a desired end more easily.

In the context of this chapter, a propaganda war film is one created specifically to persuade the audience on matters of social, political, and economic ends and accomplishments connected with war, whether the techniques are documentary, fiction, animation, or whatever. Like Inglis, I don't find the concept of a propaganda war film necessarily offensive if two basic ingredients are present. First, the propaganda war film can serve a valuable function if its aim is to boost morale. But to do that, as Walter Wanger explained in 1941, "The movies and the men who make movies . . . [must be] soldiers in the ranks of democracy; they need leaders who can inspire and explain, so that they can inspire and explain to the enormous

[244] *Arthur Knight, THE LIVELIEST ART: A PANORAMIC HISTORY OF THE MOVIES (New York: The Macmillan Company, 1957), pp.246-7.

[245] Parker Tyler, MAGIC AND MYTH OF THE MOVIES, Introduction by Richard Schickel, (New York: Simon & Schuster, 1970), pp.132-74.

[246] Kane, p.14.

[247] Ruth A. Inglis, FREEDOM OF THE MOVIES: A REPORT ON SELF-REGULATION FROM THE COMMISSION ON FREEDOM OF THE PRESS (Chicago: University of Chicago Press, 1947), p.13.

public which loves films."[248] Sometimes that works; sometimes not. Richard Schickel, for example, found that during the Second World War the motion picture's "greatest contribution was to the morale of the fighting men ."[249] The fact that later film efforts in terms of morale (e.g., the Vietnam War) met with far less success may well be attributed to the failure of the United States government to explain its foreign policy adequately and/or to inspire Hollywood filmmakers. Particularly relevant to our study of the war film are the problems raised by the Nazi's tactics for boosting morale. Baird finds evidence, for example, that Hitler's propagandists had one common goal "to rally to their leader's side a people who were 'true believers, united, confident, and absolutely reliable,' a people who would fanatically believe in the final victory."[250] How well the Nazi propaganda machine worked remains a debatable issue among those who have studied Hitler's twelve years in power. Second, propaganda war films are not offensive if the public is aware that they are specifically designed as propaganda and not solely as entertainment. Unfortunately, the public isn't always conscious of how subtly propaganda operates. For that reason, it's useful to remember Welch's general distinction between a film's political intentions and its actual content: "In a highly politicized society, even the a-political becomes significant in that the so-called 'entertainment films' tend to promote the official world view of things, and reinforce the existing social and economic order."[251]

In sum, the study of propaganda provides further insights into the complex relationship that exists among the artist, film, and the audience. By delving into the way propagandists structure their messages, we better understand how various patterns, structures, forms, and styles are used to transform a particular film. We see more clearly the potential problems that exist between a filmmaker's intentions and an audience's reception of the film.

BOOKS

Baird, Jay W. THE MYTHICAL WORLD OF NAZI WAR PROPAGANDA,1939-1945. Minneapolis: University of Minnesota Press, 1974. Illustrated. 329pp.

Scholarly and challenging, this carefully researched narrative gives a fascinating analysis of "the development of Nazi propaganda during World War II as a function of Party ideology" and the detailed disintegration of that ideology as it "failed to survive in a world of objective reality." The thesis maintains that Hitler was consumed with myths and symbols, and that Nazi propaganda predicated its messages on an ethos based on race. Under Goebbels's guidance, the propaganda reinforced deep-seated German prejudices with patriotism and Party ideological motifs. Jews, for example, became the target for Germany's collective fears; National Socialism offered an alternative in a sense of renewed German pride; a Fuhrer cult paralleled Hitler with Jesus Christ; war offered Germans the chance for immortality through personal sacrifice and death; Bolshevism was synonymous with Jewry; and a British "plutocracy" conspired with Jews to suppress Germany's need for LEBENSRAUM (living-space). Baird makes extensive use of original documents from Goebbels's propaganda ministry and its various reporting agencies to illustrate how the major propaganda campaigns were staged and the uneven effects that resulted. These World War II campaigns either focused on a boisterous victory announcement or on a subtle, delayed explanation of a defeat described "in the reassuring fog of myth."

[248] Walter Wanger, "The Role of Movies in Morale," THE AMERICAN JOURNAL OF SOCIOLOGY 40:7 (November 1941):383.

[249] Richard Schickel, MOVIES: THE HISTORY OF AN ART AND AN INSTITUTION (New York: Basic Books, 1964), p.138.

[250] Baird, p.23.

[251] Welch, PROPAGANDA, pp.44-5.

What is best about this highly readable narrative is its straightforward approach. Without the chatty, gossipy tone of Hull's text, the sixteen chapters provide absorbing behind-the-scenes information about the major figures. Goebbels's decision-making process, for example, is credited to three factors: working class origins, a clubfoot, and a sharp, penetrating mind. His sinister genius is shown as the result of an incredible ability to identify with the psyche of the German people. Goebbels's favorite propaganda technique--e.g. a "whisper" or person-to-person campaign--is presented as both revolutionary for its time and extremely effective. And we learn that the minister prided himself on a strategy of propaganda control, not day-to-day administration. Baird is also remarkably effective in reporting the problems Goebbels faced with Otto Dietrich, Alfred Rosenberg, Heinrich Himmler, and Hitler himself. Chapter after chapter looks into the various jurisdictional disputes among the various offices and the countless mistakes made by the propagandists, leading eventually to a situation where the German people relied for their information more on foreign news broadcasts than on those of their own country. Among the highlights of the book are the author's wonderful anecdotes recounting the miserable propaganda campaigns involving the alleged Nazi sinking of the English aircraft carrier ARK ROYAL, the British sinking of the GRAF SPEE, the Soviet invasion of Finland, the condition of German troops on the Eastern Front, the image of the Vichy government, and the Battle of Britain. This is not to say Baird treats Goebbels as a complete fool. We see the minister's enormous propaganda successes in reporting Dunkirk, the fall of France, and the British attack on the French fleet at Mers-el-Kebir. But no one will ever view Nazi propaganda the same way after reading Baird's balanced reports. Nor will they underestimate the effectiveness of Allied propaganda and the problems it created for the Nazis. Equally fascinating is the amount of detail showing the shift in Goebbels's strategy away from factual-mythical propaganda prior to the Battle of Stalingrad to one emphasizing irrational themes in lieu of factual reporting, beginning with the German watershed defeat at the hands of the Russians. Baird goes so far as to state that, "In many respects, the entire propaganda campaign following Stalingrad was as much an anti-Jewish as an anti-Bolshevik crusade." Baird's narrative, unlike those in both the Hull and Leiser books, suggests that the German people turned away from Hitler not because he was a tyrant, but because he failed to deliver on his promise for a "Thousand-Year Reich." Another positive feature of this carefully written study is the opportunity it provides for drawing comparisons between the propaganda machines in England and the United States. When we, for example, were concerned with racial tolerance, Goebbels exploited German prejudice against the Jews, blacks, and Asian people. Where we produced positive images of our allies, Goebbels fluctuated between positive and negative images of the Russians, the Italians, and the Japanese.

Baird's book, however, does have several drawbacks. First is the omission of any discussion concerning the annihilation of millions of Jews and other Europeans. It's mystifying why a text that talks so much about cover-ups ignores the biggest cover-up of all. What is also missing is the use of films in Goebbels's propaganda war. Considerable time is spent on discussing propaganda in general terms, but very few specifics are given of how the myths and distortions operated in the individual media. Finally, Baird provides no summation about the Nazi propaganda machine--whether or not he perceived Goebbels as effective in spite of his situation or as a failure whose techniques were doomed from the start.

On balance, however, the book's extensive notes, strong bibliography, and helpful index make the text an invaluable source for studying not only the Nazi era, but also how propaganda operates and its role in World War II films. Highly recommended for special collections.

Besas, Peter. BEHIND THE SPANISH LENS: SPANISH CINEMA UNDER FASCISM AND DEMOCRACY. Denver: Arden Press, 1985. Illustrated. 291pp.

Part of Arden House's FILM: THE FRONT LINE series encouraging a critical-political dialogue in which individual authors debate the major points of film theory and practice, this intriguing book chronicles the work of filmmakers like Carlos Saura, Jose Luis Borau, and Victor Erice in two major sections, is tied to his cultural portrait of life under Franco's fascist reign, and discusses how artists interpreted

their experiences in the decade following the dictator's death on November 20, 1975. The material is informative, documented, and provocative. Filmographies of the key directors, a selected bibliography, an English-translation title index, and general index are included. Well worth browsing.

*Dower, John W. WAR WITHOUT MERCY: RACE AND POWER IN THE PACIFIC WAR. New York: Pantheon Books, 1986. Illustrated. 399pp.
An indispensible account of the propaganda war between the United States and Japan over two decades, this absorbing book discloses a host of information dealing with the power struggle that evolved since the turn of the century. Dower divides his material into three riveting sections: "Enemies," "The War in Western Eyes," and "The War in Japanese Eyes." The author's epilogue, "From War to Peace," summarizes both the optimistic and pessimistic lessons to be learned from the Pacific War. Written with great skill and keen insights, this important study is fully documented and impressively researched. Endnotes, a bibliography, marvellous illustrations, and an index are included. Highly recommended for special collections.

*Evans, Gary. JOHN GRIERSON AND THE NATIONAL FILM BOARD: THE POLITICS OF WARTIME PROPAGANDA. Toronto: University of Toronto Press, 1984. Illustrated. 329pp.

Furhammar, Leif, and Folke Isaksson, POLITICS AND FILM. Trans. Kersti French. New York: Praeger Publishers, 1971. Illustrated. 257pp.
In an incisive study focusing on movies designed to reach and influence mass audiences, this book, first published in Sweden in 1968, provides a valuable introduction to the complex relationship between society and filmmakers. The collection of thirty-five essays, divided roughly into three sections, gives special attention to the fact that certain movies "have a clear political purpose . . . as a weapon of propaganda." While considerable time is devoted to American, Soviet, and Nazi filmmakers, the authors also direct attention to the manner in which filmmakers respond to political pressures and the way covert messages appear in run-of-the-mill movies.
The first section concentrates on an historical overview of political films, emphasizing the patterns cultivated in America, England, Russia, and Germany. The United States, for example, is credited with being the first country officially to establish and coordinate a propaganda unit (The Creel Committee), while the Soviet Union gets recognition for its revolutionary cinema--unique in not promoting middle class aims and values in its propaganda. The weakest essays deal with German films from 1920 to 1925, merely revisiting the ground covered by Kracauer, and offering surprisingly unsophisticated treatment of the Nazi propaganda created by Goebbels. In the latter case, for example, the propaganda minister is erroneously accused of relying on "jack-boot" cinema that failed to make an impact on foreign countries. The false assumption is made that there was little difference between the exported films and those shown in Nazi Germany. And the authors mistakenly credit Goebbels's initial film policies with improving the lot of the German film industry. On the other hand, Furhammar and Isaksson in their synoptic essay on "Hollywood and the World" provide a good survey of the political in-fighting the American film industry waged with its political foes. The same can be said concerning their intelligent treatment of British films made during World War II. What distinguishes it from summaries found elsewhere is the Swedish critics' knowledge of film technique, not just narrative conventions. Rounding out the book's largest section are helpful historical commentaries on Italian and Brazilian movies, which highlight the major filmmakers, their various ideologies, and the important films.
The second section takes an uneven look at specific films through reviews too short to be helpful. Two cases in point are the comments on TRIUMPH OF THE WILL (1935) and HITLER YOUTH. The one exception to this general criticism concerns the analysis of the anti-Semitic 1940 Nazi film THE ETERNAL JEW. The authors, for

example, raise an issue not touched on in most studies, namely, the apparent inconsistency of the propagandist's message throughout the film to a large German audience who by 1940 seemed unable to identify with the debased Jewish image. Another noteworthy essay is a succinct, fascinating account of Mikhail Romm's ORDINARY FASCISM/OBYKONOVENN FASCHISM (1965). After reading about this sixteen-part film lecture, you're left with the disturbing feeling that it's important to see, but horrifying to experience.

The third section offers essays on the principles of propaganda in film and their relationship to politics that alone are worth the price of the book. Not only is there a first-rate discussion of aesthetics, but also numerous examples of how historical figures are distorted in films, the various ways nations are stereotyped during wartime, and the techniques used for manipulating a nation's myths for political purposes. Near the end of the section, the authors make the intelligent observation that we tend to take too negative an attitude toward propaganda. "Possibly," they argue, "we should, at least in the context of film, talk more about edification than about conversion and stress psychological defense rather than psychological attack."

What makes this book stimulating reading is that Furhammar and Isaksson take enormous risks in the positions they espouse. Hardly an essay fails to challenge the reader on some point of history or aesthetics. The 150 illustrations liberally included throughout the text heighten the commentary and more than compensate for the sometimes heavy-handed translation that often becomes tiresome to read. Fortunately, an index is included for shortcuts. Highly recommended for special collections.

*Hardy, Forsyth, ed. GRIERSON ON DOCUMENTARY. Abridged ed. London: Faber and Faber, 1979. 232pp.

Republished during the fiftieth anniversary of DRIFTERS, this classic collection of Grierson's writings recalls not only the birth and growth of the movement he founded, but also his passionate commitment to harnessing the power of the documentary film for the betterment of society. No attempt is made to be critical of the new genre or its filmmakers. Just the reverse is the case. Grierson takes every opportunity to extol the documentary film as an important means of propaganda and a revolutionary form of education. Throughout his writings, he stresses that an industrialized society can not depend on outmoded traditions to compete and to survive in a modern world. "I look on the cinema as a pulpit," he wrote, "and use it as a propagandist." As a devoted friend and admirer, Hardy takes the same public relations approach in his selection of Grierson's writings. All of the slim volume's contents--e.g., film reviews, journal articles, essays--reveal how Grierson insisted that art and entertainment be married to social purpose. Hardy arranges the material chronologically, rather than by subject, thereby allowing us to see how Grierson's ideas matured over a period of time. The purpose, no doubt, is to have the book appeal to more than just the film community.

Most stimulating are the insights into the great film pioneer's values and ideas. Early on, for example, he writes, "What I know of cinema I have learned partly from the Russians, partly from the American westerns, and partly from Flaherty, of NANOOK." Very soon, however, we see Grierson discarding Flaherty's approach because it does not come "to grips with the more modern factors of civilization." He then proceeds to wrestle with the term "documentary," finding it "clumsy," but better than any concept around. After defining the basic principles for the new movement, Grierson next struggles to separate the documentary ideas from those of the commercial cinema. He is careful, however, to represent Hollywood as both a good and bad world force. That is, it may be undisciplined but still able to have a keen wit "and its types have more honest human gusto than their brothers and sisters of the stage and the popular novel." He is particularly ecstatic when the MARCH OF TIME appears and sees it, unlike the "thin glitter of the newsreels," as an indispensable forum for revitalizing good citizenship. When war comes to Europe, Grierson renews his fight for making the film as important as the radio and the newspaper in providing information and inspiration to the public. He vigorously attacks the false assumption that the modern citizen can learn through traditional educational modes how to function effectively either in a peaceful or war-torn society. It isn't that the old ways are bad or of no use at all. It's just that they are not

enough and can not do what the film can do. As always, his arguments are logical, stressing practical considerations instead of making negative criticisms. He insists that film be viewed in political, not just educational terms. Thus, it is important that the state not only take an active role in making films, but also in using them to disseminate vital information. However, he warns the state against making the type of hideous propaganda produced in World War I. That proved counterproductive. Instead, the emphasis should be on facts, goals, and results. Only then will the films be taken seriously and be effective. Of course, he points out that the models for how to make the best propaganda are the documentary films made in the 1930s by the EMB and GPO film units. By the end of this stimulating collection, Grierson is meshing his principles of art, entertainment, and documentary with those of propaganda and education. He adds in a postscript to the original edition published in 1966, "Hardy emphasizes the long struggle to build a documentary movement and the intensity of effort it sometimes demanded . . . On the other hand, difficulties have been incidental to the fact that the British government supported us throughout and over that long and necessary period which permitted us to mature our ideas as well as our techniques and our teams."

Once readers recognize the purposes to which Grierson's writings were directed, the noncritical tone is understandable. The book's contributions, therefore, are in documenting the spirit and intelligence of the movement's leading figure. This paperback edition also puts the stirring essays in an inexpensive format, making it all the more accessible to students. Together with a new introduction by Hardy and a valuable index, the collection is a welcome addition to any serious film library. Recommended for special collections.

*Hull, David Stewart. FILM IN THE THIRD REICH: A STUDY OF THE GERMAN CINEMA 1933-1945. Berkeley: University of California Press, 1969. Illustrated. 291pp.

Important, well-researched, and highly provocative describe this comprehensive history, which its detached author modestly calls a preliminary attempt to answer "the most common questions asked about films made in the Third Reich . . . 'What was made?' and 'Who made these films--how did it happen that these artists lent their services to the Nazi regime?'" Hull spent nine years viewing hundreds of films, interviewing key personalities, and investigating heretofore undisclosed sources that would provide insights into the Nazi film propaganda machine. The results more often than not justify the efforts.

On the positive side, we get first an intriguing, albeit gossipy tale of the continuous warfare between the German filmmakers and Goebbels. The minister, initially labeled by many in the industry as "Mickey Mouse" and who by 1940 had become known as a "rat," is portrayed as a devout lover of movies and an enthusiastic supporter of Hitler. These two factors influenced the insecure Goebbels to set up the repulsive, elaborate cultural bureaucracy that determined how films and the arts operated in Germany from conception to exhibition and criticism. Throughout, Hull weaves an engrossing but low-key summary of how the film industry never stopped fighting against Nazi propaganda, the petty in-fighting of Hitler's cronies, and the "Little Doctor's" anti-Semitism. Some of the text's most poignant moments document the tragic destinies of artists who refused to follow Goebbels's policies: e.g., Herbert Selpin, Renate Muller, Harry Baur, and Joachim Gottschalk. Hull also provides an objective commentary when critiquing the German films made over the twelve years that Hitler was in power, frequently praising neglected works of well-known Third Reich directors like Veit Harlan and Hans Steinhoff, or ignored filmmakers such as Frank Wysbar and Curt Oetel. TRIUMPH OF THE WILL (1935) gets an incredibly balanced review, while at the same time Hull goes out of his way to attack Budd Schulberg for defaming Leni Riefenstahl "in a scurrilous and irresponsible article for the SATURDAY EVENING POST in 1946." The emphasis mainly is on fairness, behind-the-scenes anecdotes, resourceful footnotes, extensive plot synopses and quotations--all proof that Hull himself is a lover of films. In that regard, the chronological survey clearly makes a major contribution to film scholarship.

What weakens this text, however, is the author's refusal to take a stand on controversial issues or come to grips, as do Erwin Leiser and David Welch, with what propaganda is and how it operates. In fact, Hull never really does give a satisfactory answer to why a number of major artists did what they did. We learn almost nothing, for example, of why Pola Negri returned to Germany following her failure to make the transition to sound movies in America, why Goebbels denied her permission to work, but an audience she had with Hitler reversed his minister's edict. Why did she come back? Why did Hitler publicly insult his loyal subordinate? Why did she leave for the United States just before the start of World War II? Why did Emil Jannings, another artist well known to world audiences, work so enthusiastically for the Nazis? Why has the most famous Nazi filmmaker of them all, Leni Riefenstahl, been properly criticized for her work in the 1930s if all Hull's fairminded explanations about an unlucky artist are true? It is highly debatable, for example, that TRIUMPH OF THE WILL (1935) was financed by Riefenstahl and its only ties to the Nazi party were those of distribution. It's particularly interesting that in the report about the films that disagree with the National Socialist position we're told only about the staged demonstrations and protests. What we don't get is the audience reaction to those films blatantly supportive of the Nazi regime. Another interesting omission involves the gossip concerning Goebbels's near-fatal affair with the Czech actress Lida Baarova. No mention is made of Frau Goebbels's dalliance with her husband's subordinate Karl Hanke, or the reasons why he helped in alerting the Fuhrer to his boss's indiscretions. Highly questionable as well is Hull's thesis that as a result of Hitler's forcing Baarova to leave Germany in 1938, the minister began his program of anti-Semitic movies. And what about the infamous JUD SUSS (1940)? Considerable space is provided in the text for director Harlan's explanations of how he and his cast were forced into making the film, even at the threat of losing their lives. But no mention is made of the fact, reported in Baird's book, that the actors who played the Jewish roles asked Goebbels to announce publicly that the players were good Aryans, not Jews. Were the actors, in fact, more worried about their standing in the Nazi community or their unconscionable roles? In short, Hull makes us wonder as much about his acts of omission as those of commission.

No one should ignore this original history, which, for its time and pioneering research, is outstanding. On the other hand, no one should forget that its "preliminary" conclusions suffer from a naive understanding of propaganda and a failure to understand the mythical underpinnings of the Nazi films. Recommended.

Jones, Stephen G. THE BRITISH LABOUR MOVEMENT AND FILM, 1918-1939. London: Routledge & Kegan Paul, 1987. Illustrated. 248pp.

During the twenties and thirties, many segments of the British public became avid filmgoers. The British Labour movement, as the author explains, "encompassing the main Socialist parties, trade unions and co-operative societies, . . . spawned a vibrant cinema movement" during the inter-war years. Its main objective "was of course political, to change the social and economic system. But it should be emphasized . . . that because the film medium had recreational and aesthetic qualities, entertainment pleasure and critical comment were always important concerns." Seven detailed and intriguing chapters explore the ideology of the Labour Movement; trade unionism in the British film industry; the relationships among labor, film, and the state; and the Communist movement and film. Jones concludes that the British Labour Movement's "approach to film in the inter-war years was wide-ranging." Endnotes, a bibliography, and an index are included. Recommended for special collections.

*Jowett, Garth S., and Victoria O'Donnell. PROPAGANDA AND PERSUASION. Beverly Hills: Sage Publications, 1986. Illustrated. 244pp.

Intrigued by the lack of interest in the study of propaganda as well as the absence of suitable classroom material for a systematic study of the subject, the authors offer "an overview of the history of propaganda as well as a review of the social scientific research on its effects and an examination of its applications." The eight informative and useful chapters combine the talents of Jowett (a communications

history scholar) and O'Donnell (a persuasion and rhetoric expert). O'Donnell authors the material on "What is Propaganda and How Does It Differ From Persuasion?" "Propaganda and Persuasion Examined," and "How to Analyze Propaganda." Jowett is responsible for the chapters on "Propaganda Through the Ages," "Propaganda Institutionalized," and "Propaganda and Psychological Warfare." The concluding chapters on "Propaganda in Action: Five Case Studies" and "How Propaganda Works in Modern Society" are joint efforts. A strong bibliography and a good index are included. Recommended for special collections.

Leiser, Erwin. NAZI CINEMA. Trans. Gertrud Mander and David Wilson. New York: Macmillan Publishing Company, 1974. Illustrated. 179pp.
 Intended as a follow-up to the author's 1968 documentary on propaganda in the Third Reich--WAKE UP, GERMANY!/DEUTSCHLAND, ERWACHE!--the straightforward narrative documents how a totalitarian state abused the mass media. Leiser goes beyond a mere listing of feature films and overt propaganda to analyze the crucial themes of the Nazi film output: e.g., the glory of dying for Germany, the struggle for the German soul between National Socialism and Communism, the readiness of the masses to expect miracles from Hitler and to submit unconditionally to his will, the Fuhrer's will as law because it represents the will of the people, German heroes presented with all or nothing options, the crafty Jew being defeated by the heroic Aryan, propaganda for euthanasia, a love-hate relationship with England, Germany's great artists and heroes as prototypes for Hitler, and mass murder as a tribute to German glory. Leiser wants to show as clearly as possible "the mechanics by which film became part of the propaganda machine." For the most part, he succeeds, although the definitive story is yet to be written.
 In ten succinct chapters, we discover how the Nazis, primarily through the minister of Popular Enlightenment and Propaganda, Josef Paul Goebbels, began their stranglehold on the German film industry starting in 1933. (The actual nationalization occurred between 1936 and 1942.) The emphasis was on aligning the arts to the political objectives. Leiser claims that behind-the-scenes coordination deceived outside observers who failed initially to see how films were licensed, casts selected, financing obtained, and direct intervention at all levels was orchestrated by Goebbels. That may have been true in Germany, but doubtful worldwide. What makes the author's perspective questionable here is the wealth of information in the Hull book, pointing out the German film industry's early, strong resistance to Goebbels's decrees. In addition, many artists fled from Germany, films having any relationship to Jews (actors, writers, directors) were banned, booed, and savaged in Nazi state-controlled film publications, and the German film industry's relationship with foreign film representatives was poor. Leiser does document how the specific characteristics of Nazi propaganda appeared eventually as cliches. We learn, for example, about Nazi euphemisms for murder ("Special treatment"), the contributions of the major directors--Veit Harlan (JUD SUSS, DER GROSSE KONIG, KOLBERG), Karl Ritter (UNTERNEHMEN MICHAEL, PATRIOTEN, URLAUB AUF EHRENWORT, UBER ALLES IN DER WELT), Hans Steinhoff (HITLERJUNGE QUEX, OHM KRUGER), and Leni Riefenstahl (TRIUMPH DES WILLENS, OLYMPIADE). The latter, in particular, is given more coverage than most, even to the point of appended material that refutes her arguments that she privately financed OLYMPIADE. The most poignant section, as might be expected, covers the anti-Semitic films. But Leiser never tries to inflame his readers. Instead, he shows considerable restraint while objectively describing, for example, how Nazi camera crews manipulated actual events in the Warsaw Ghetto to mislead an unsuspecting world audience.
 Serious students will find quotations from Party memoranda, diaries, illustrated program booklets, autobiographies, film criticism of the period, and press releases. Unfortunately, since no specific pages are cited, it is difficult for researchers to investigate the sources listed in the author's fine bibliography. For example, Leiser cites the oft-quoted policy of Goebbels--that "the essence of any propaganda is to win people over to an idea which is so profound and so vital that in the end they fall under its spell and cannot escape from it"--but tells us only that it was contained in a speech the minister gave to theater managers on May 8, 1933. No mention is made

anywhere else about where the document can be found or how others might study the comments in context. Another problem is the text's neglect of the German audience for whom these films were made. The question that never gets answered is "Could these films have been made if the audience rejected them?" Leiser continually reminds his readers that Goebbels is concerned with results, that he is getting secret reports on how the films are being received. He points out that the anti-Semitic films were used to soften up the viewers for the eventual, monstrous annihilation of the European Jews. Particularly interesting is the absence of any documentation, amply available in the Hull book, on the German audience's early reactions to Nazi propaganda films and the fact that by 1935, the negative effects of Goebbels's policies had nearly destroyed film production and German audiences were demanding more foreign films be shown, specifically American movies. Is the implication that the author wants to leave with us that Hitler and his ministers were merely giving the German people what they wanted?

Given the book's size, its objectivity, and the clear narrative, Leiser has performed a valuable service. For the uninitiated, this is a basic source of information on the Nazi film. It comes with a filmography and a much-needed index. Highly recommended for special collections.

*Maynard, Richard A., ed. PROPAGANDA ON FILM: A NATION AT WAR. Rochelle Park: Hayden Book Company, 1975. Illustrated. 147pp.

The stated purpose of this disappointing collection is "to explore many of the issues concerning the uses of modern propaganda." By concentrating on the historical relationship between film and political propaganda, Maynard proposed in his four-part anthology to trace the growth of the film as a medium of mass persuasion, the distortions practiced by totalitarian states, and the educational approaches used by democratic nations. The various parts include excerpts from the published works of important film personalities, social and critical essays, contemporary film reviews, and script extracts. Maynard intended with this assorted material to illustrate both the uses and impact of film propaganda.

The book's overriding problem is one of identity. If its intended audience is at the secondary school level, the material collected lacks appeal and interest. If its audience is at the college level, the anthology fails for lack of depth and breadth. Part One, for example, does a good job of introducing the concepts of propaganda, thanks to an excellent excerpt from Jacques Ellul's marvelous book, *PROPAGANDA: THE FORMATION OF MAN'S ATTITUDES, and a useful reprint of Robert Vas's 1963 SIGHT AND SOUND article entitled "Sorcerers or Apprentices: Some Aspects of Propaganda Films." Part Two, with its emphasis on early Soviet and Nazi propaganda, continues to provide good material, but in a much more abbreviated form and with limited general use. The selections on BATTLESHIP POTEMKIN/BRONENOSETS POTEMKIN (1925), TRIUMPH OF THE WILL/TRIUMPH DES WILLENS (1935), and the excerpt from Hull's book don't adequately cover the topics--e.g., either they're too short or too general. The one exception is a reprint of John Grierson's essay on Nazi propaganda. Unfortunately, Robert Warshow's critical comments on re-viewing Soviet films, given their new context, seem out of place in what amounts to an introductory text. Part Three, "American Propaganda Films," is a potpourri of rambling film reviews, most of which tell us more about the critics than either the films or the times. The section's one saving grace is an extended excerpt from Frank Capra's THE NAME ABOVE THE TITLE. At this point, you want to drop Maynard and read the rest of Capra. Part Four gives us a cursory look at the cold war, offering interesting reminiscences of I WAS A COMMUNIST FOR THE FBI (1951), MY SON JOHN (1952), and NIGHT PEOPLE (1954). The reprints from the writings of Pauline Kael and Robert Warshow are helpful, but fail to satisfy the needs of readers and viewers new to the issues or those familiar with the period who want to know more.

Regrettably, this anthology doesn't deliver what it promised and exhibits a lack of intellectual cohesion and a clear sense of purpose. Browse, don't read.

*Petley, Julian. CAPITAL AND CULTURE: GERMAN CINEMA 1933-45. Champlain: University of Illinois Press, 1985.

*Pronay, Nicholas, and D. W. Spring, eds. PROPAGANDA, POLITICS AND FILM, 1918-45. Atlantic Highlands: Humanities Press, 1982. 302pp.

This cogent anthology consists of articles by American, Dutch, and Russian scholars on the significant role and political impact of the mass media during the period from 1918 to 1945. In addition, there are contributions by distinguished participants--e.g., Ian Dalrymple (Crown Film Unit), Lady Helen Forman (Ministry of Information), Tom Harrison (Mass Observation), Sergei Drobashenko (Film Art Institute of the State Film Archive of the USSR)--that add another dimension to the growing amount of valuable information disseminated lately by the InterUniversity History Film Consortium of England. More than a decade ago, thanks to the prodding of its executive secretary, Nicholas Pronay, the consortium began organizing conferences and sponsoring research and publications that would further our understanding of twentieth century history and the complex relationship between communication techniques and politics or international relations. The current publication results from two such conferences held in 1973 and in 1979 at the Imperial War Museum. Each of the twelve contributors works on the basic assumption that the new media and the new techniques of communication had profound political repercussions during the twenty-seven-year period under review. Interestingly, the reasons why have as much to do with perception as reality. That is, "Men act according to their perceptions," observes Pronay in his fine Introduction. "What politicians believe to be prime political factors and therefore prime concerns for them, become important factors in the making of political decisions while the perception lasts--whether it be 'religion' or 'unemployment.' So it was in the interwar period with 'propaganda.'" The book's four sections offer complex and detailed explanations for how those troublesome perceptions arose and operated.

Part I--"The Projection of Britain"--consists of two essays. Philip M. Taylor's excellent "British Official Attitudes Towards Propaganda Abroad, 1918-39" is masterly at revealing the basic assumptions on which the English conducted their overseas propaganda, the deep-rooted prejudices resulting from the British experience in World War I, and the steps taken toward "psychological rearmament" in anticipation of World War II. Far less satisfying is David W. Ellwood's dull essay, "'Showing the World What It Owed to Britain': Foreign Policy and 'Cultural Propaganda,' 1935-45."

Part II--"Film Propaganda in Britain and France between the World Wars"--offers five stimulating perspectives on how governments and societies interacted. For example, Peter Stead's "The People and the Pictures. The British Working Class and Film in the 1930's" is remarkable for its revisionist thesis that Hollywood did a better job of projecting working class expectations than did English filmmakers. Rarely in British publications does one find a comment like "There was no British Renoir because no British filmmaker knew enough about his medium or knew enough about his country and its people." Also rewarding in terms of information and stimulation are the articles by Nicholas Pronay (dealing with political censorship), Bert Hogenkamp (concerning how films affected the British labor movements and the radical left), and Elizabeth Grottle Strebel (focusing on the influence of film during the Popular Front years in France). Overall, this section argues that people got what they deserved. Not caring enough about what propaganda was or how to use it effectively, the public was not in a position to stop its elected officials from proceeding in any direction the officials chose.

The rest of the anthology then discusses the role of specific British agencies in action during wartime, and goes on to offer a comparison with the propaganda techniques in Soviet Russia. Part III--"Film Propaganda in Britain in the Second World War"--uses four essays on wartime "persuasion" techniques to illustrate how the English mobilized their psychological defenses at home and abroad. Pronay's opening paper on the news media provides a splendid backdrop for the first-hand experiences then reported by Dalrymple, Forman, and Harrison. Part IV--"The Projection of the Soviet Union"--has two essays exploring how the Russians were as adept at manipulating their citizens as were the English and French. Deputy Director Drobashenko's explanation of the Soviet documentary film up to 1940 reveals how the Soviet government tied the development of the medium to its power to "educate" the

public to its "moral" responsibilities. D. W. Spring effectively concludes the book with an analysis of Russian newsreels and their crucial role in mobilizing civilians, maintaining morale, and encouraging cultural exchanges.

Besides a handful of editorial mistakes, what is disappointing about this important anthology is its narrow perspective. Almost no attention is given to the United States, Nazi Germany, Fascist Italy, and Japan. To appreciate fully the uniqueness of what the English or Soviets achieved, it would have been helpful to compare and contrast what other major participants in World War II were doing in the same timeframe. No doubt, Grierson's supporters will be annoyed with the trivial recognition accorded by these contemporary historians, while film historians will be disturbed by the failure to treat film as film rather than as mere historical documents. As Paul Smith aptly stated in his review of the book, "Film suited the politics of unreason best, the politics of comfortable inertia next, and the politics of earnest progressivism not at all. Or so one might argue; but whether accurately or not is hard to say from this symposium, where the nature of the relationship between political persuasion and filmic expression is scarcely examined."[252]

What is notable about this serious undertaking, however, is the considerable research that its authors undertook and communicated with conviction. The extensive endnotes and useful index add to the book's value. Well worth browsing.

Rotha, Paul. DOCUMENTARY FILM: AN INFORMAL HISTORY OF THE BRITISH DOCUMENTARY FILM, 1928-1939. New York: Hill and Wang, 1973. Illustrated. 305pp.

A first-hand account of the revolutionary documentary film movement in England during the 1930s, the purpose of this descriptive narrative is to identify "the main aims, influences, and achievements, as well as . . . the mistakes and the failures, in those formative years." We get, therefore, not only a much-needed critical examination of the origins and development of the genre in England, but also an insightful account of the author's personal experiences in and reactions to the misunderstood period. In the past, activists like Grierson and Rotha allowed their enthusiasm for the new directions in which films were heading to overshadow questions of art or quality. They sensed, perhaps justifiably, that it was more important to give the daring innovations encouragement and visibility than to criticize their shortcomings. Anyone scanning film publications of the 1930s will be struck by the attention the movement's advocates paid to the genre's revolutionary techniques in contrast to a serious examination of the warring philosophical positions of the filmmakers themselves. Rotha, in this post-World War II edition, still emphasizes the heroic uniqueness of the documentary movement initiated by Grierson, but understates the contributions to the genre made by Flaherty and other individual filmmakers prior to 1928. At the same time, he enlivens his fact-filled text by pointing out many of the often ignored controversies connected with the movement. Earlier commentaries, for example, overstated the excitement generated by films like DRIFTERS (1929), GRANTON TRAWLER (1934), and NORTH SEA (1938). This text explains why many exhibitors considered the documentary movement a synonym for bad box office, and why a number of filmmakers who broke with Grierson in 1935 tried to distinguish their efforts from his by substituting "realist" for "documentary" in their organizational name--i.e., the Associated Realist Film Producers. Despite Rotha's emphasis on the positive aspects of the new genre, he constantly reminds us that the two fundamental disagreements within the movement involved the individual versus the group approach and creative interpretation versus a stress on using film propaganda to benefit society. To illustrate the types of artistic, social, and economic issues behind the British documentary movement, the author provides us with statistical reports, quotes heavily from public and private documents, and relies on his personal observations. Considerable space is also given to the genre's early critics, most notably the British Film Institute as well as SIGHT AND SOUND. In addition, Rotha makes clear that an underlying purpose in his history is to educate a new generation of film students

[252] Paul Smith, "Persuasion at the Pictures," TIMES LITERARY SUPPLEMENT (October 1, 1982):1054.

who are "salivating over the Hollywood years of whoredom [1920s-1940s]." He finds men like William Fox, Harry Cohn, Adolph Zukor, Louis B. Mayer, David O. Selznick, Nicholas Schenck, and Harry Warner to be social parasites. They used the film, Rotha argues, much the way gangsters used drugs and alcohol to exploit an unsuspecting society. Thus the book is written as much to correct a false impression of Hollywood's values as it is to champion the British documentary movement. While the author's passion often results in overstatements, his perspective contrasts nicely with those who exaggerate the case for Hollywood's achievements.

The best sections in the text concern the work done at the EMB and the GPO. Both Professor Charles Edward Merriam and Walter Lippmann are credited with influencing Grierson's desire to make propaganda films, while the support given to the movement by Stephen Tallents is spelled out in considerable detail. The latter's relationship with Grierson, for example, results in film being considered as more than entertainment, government funding acting as an alternative to commercial sponsorship, the film medium being recognized as an important form of communication, and creative artists discovering a new outlet for their talents. Of particular value in the early chapters is Rotha's hard-hitting analysis of the films and the filmmakers. For example, DRIFTERS (1929) gets very bad reviews for its technical and aesthetic qualities, and no claims are made for Grierson's skills as an artist. Rotha does, however, revere the film for its unique qualities--e.g., a revolutionary approach to film production and a unique attitude about the way films can be used. Even more praise is reserved for Grierson's skills as a propagandist, an administrator, and a man of vision. We are given a rare analysis of the difficulties that the EMB and GPO film units faced in terms of political interference, limited budgets, difficult working conditions, poor equipment, and personnel problems. Especially noteworthy is the way Rotha objectively describes his dismissal by Grierson from the EMB. Commenting on his being the only one fired from the film unit in September 1931, the author merely states that his boss considered him "in the Courtly tradition." That is, Grierson always favored the importance of people working together on a film, while Rotha took a more AUTEUR approach. This brief explanation highlights the confusion over who did what at the EMB and the GPO. Because Grierson insisted on everyone's being involved in each production, many latter-day controversies emerged over what specific contributions were made by men like Jennings, Cavalcanti, and Watt. Rotha naturally takes sides in the various debates, arguing at one point that in the years from 1933 to 1937 only four films made by the GPO were outstanding and each was indebted to "the professional skill and imaginative ideas of Cavalcanti." The author also provides useful insights into the reasons for the formation of other significant documentary groups--e.g., Strand Films, the Associated Realist Film Producers, the Film Centre, and the Shell Film Unit. Each in its own fashion contributed to a better understanding of what documentary films were and what they could do. They assisted as well in opening new channels of distribution and identifying new sponsors. Interspersed between the history of the EMB and the GPO are valuable observations about the author's own films--e.g., CONTRACT (1932-1933), SHIPYARD (1934), THE FACE OF BRITAIN (1935), and THE FOURTH ESTATE (1939-1940)--and the conditions under which they were made. In his concluding chapter, Rotha discusses the mixed blessings of having to create under government sponsorship. He reminds us of the debate about trying to make films that were both acceptable politically and valuable socially. Most enjoyable are his speculations on why the documentary movement declined in importance after 1939, the philosophical disagreements he had with Grierson, the in-fighting between documentary filmmakers and the British government over what constituted good propaganda during wartime, and his great love for nonfiction films.

Those readers most likely to be disappointed by Rotha's history are supporters of the British Film Institute, Robert Flaherty, and Humphrey Jennings. Rotha's savage account of the methods and purposes of the national group prior to 1940 is only surpassed by his disdain for the Hollywood film industry. The comments on Jennings are so minimal that one questions either the claims that authors like Manvell and Hodgkinson make for the filmmaker's early successes or wonders why Rotha deliberately minimized the importance of Jennings' work at the GPO. Flaherty's advocates will no doubt be disturbed by the unpleasant anecdotes of the great

filmmaker's behavior during the making of INDUSTRIAL BRITAIN (1933), and by Rotha's claims that the film produced owes as much to Grierson's painstaking editing as it does to Flaherty's photography.

Anyone interested in documentary filmmaking, the philosophical debates over government-sponsored propaganda, and the revolutionary role that Britain played in nurturing a new film genre will find Rotha's account good reading. General students, however, may be disappointed by too much emphasis on bureaucratic issues and not enough on aesthetics and individual contributions to the documentary film movement. While the book's bibliography is outdated, the three indexes plus the small but valuable illustrations are very helpful. Recommended for special collections.

Rotha, Paul, in collaboration with Sinclair Road and Richard Griffith. DOCUMENTARY FILM: THE USE OF THE FILM MEDIUM TO INTERPRET CREATIVELY AND IN SOCIAL TERMS THE LIFE OF THE PEOPLE AS IT EXISTS IN REALITY. 3d ed. New York: Hastings House, 1952. Illustrated. 412pp.

Originally published in 1935 and regarded as the first major treatise on the documentary movement, this absorbing text remains a vital commentary on the aims, methods, and struggles faced by young, revolutionary filmmakers. Rotha's intention, stated in the book's first foreword, is to have the narrative replace the earlier theoretical discussions in his history book, THE FILM TILL NOW (1930). Addressed neither to filmmakers nor serious film students exclusively, the narrative successfully conveys "something of the social and economic basis upon which . . . [the documentary movement was built in order] to fulfill certain purposes at . . . [a particular] moment of political apprehension and social disintegration." The author's strategy is to illustrate how documentary films rather than entertainment films required greater craftsmanship, possessed more profound ideas, and contributed more significantly to our society than did Hollywood movies. Unlike story films, Rotha sees the documentary enhancing human understanding and increasing our knowledge of the issues confronting us in our daily lives. In essence, he makes the argument that critics must judge the new genre differently from the entertainment film, placing the emphasis on social values instead of on aesthetics or amusement. At the same time, Rotha remains acutely aware that film activists are open to suspicion because they challenge traditional values, and thus he concentrates in the text on the aims of the documentary film as a propagandist and social instrument. In his foreword to this third edition, Rotha reminds his readers that documentary filmmakers held true to their humanistic ideals during the Second World War and refused to make war propaganda alone. He also recognizes the problems that the term "documentary" created and argues that the best definition, formulated at the June 1947 World Union of Documentary meeting, is worth restating: "By the documentary film is meant all methods of recording on celluloid any aspect of reality interpreted either by factual shooting or by sincere and justifiable reconstruction, so as to appeal either to reason or emotion, for the purpose of stimulating the desire for, and the widening of, human knowledge and understanding, and of truthfully posing problems and their solutions in the spheres of economics, culture and human relations." Although lamenting the demise of the World Union of Documentary, Rotha remains optimistic about the documentary film movement, pointing with pride to the foothold it has established in countries all over the globe. The third edition, therefore, makes very few changes in the text of earlier versions. Thanks to Road, the British period from 1939 to 1951 is updated, while Griffith provides a useful survey of documentary filmmakers in North and Latin America.

Among the book's many significant contributions to our understanding of the British documentary film movement are Rotha's discussions on theoretical issues. Like Grierson, he feels strongly that the filmmaker must function as an educator in modern society. The test of a good versus a bad film, therefore, is whether or not the film "deadens the social and civil conscience of the audience." Unlike Grierson, however, Rotha places greater emphasis on a documentary method than on documentary as a genre. He refuses to let the debate merely be defined as a choice, on one side, by DRIFTERS (1929), and, on the other side, by NANOOK OF THE NORTH (1922). Using films like HOUSING PROBLEMS (1935) and COAL FACE (1936) as examples, Rotha stresses not merely the introduction to the documentary of story, characterization,

and studio shooting, but also the more significant methodological intentions of the socially and politically motivated filmmakers. More important than the observations of people, places, and things are the ends to which these observations are used. Above all is his concern that the documentary reflect contemporary problems and realities. Interestingly, Rotha makes no argument for documentary films being truthful either in theme or incident. He dismisses that possibility because of the technical problems inherent in filmmaking and the fact that what's occurring is a dramatization. The vital role of the filmmaker, for Rotha, is in determining the approach to the subject, but not the subject itself. In judging the final film, therefore, we evaluate how the dramatization functions vis-a-vis the issues and events, and not its factual accuracy. That is, truth is determined by the state of mind created by the film, not by how realistically the events are portrayed. Thus Rotha gives bad marks to TRIUMPH OF THE WILL/TRIUMPH DES WILLENS (1935) and high marks to THE RIVER (1937). He also warns against prescriptive principles for producing documentaries. In another subtle distinction between Grierson and himself, the author insists on the importance of individual styles and techniques. Nevertheless, in Section IV of the book's six sections, he lists the elements that most documentaries have in common and what distinguishes the genre from that of the story film. Central to his argument is the relationship between the filmmaker's intentions and the needs of society.

Not surprisingly, Rotha's impassioned prose has its share of controversies. While less vitriolic against the Hollywood film than in DOCUMENTARY DIARY, he nonetheless is more critical of film distortions in entertainment films than in documentary films. For example, he finds almost nothing negative to say about Flaherty's documentaries and the Soviet film movement in the 1920s, while attacking the efforts of the early British newsreels and regretting the lack of opportunity in Britain in the mid-1930s for viewing the political films of the Nazi and Italian fascist film industries. One moment art-for-art's sake is deplored; the next, acceptable. Another inconsistency is his principle that film documentaries should be concise and wherever possible avoid trained actors. Not only does this principle violate his nonprescriptive attitude, but also it mitigates against masterpieces like THE SORROW AND THE PITY/LE CHAGRIN ET LA PITIE (1970) and his consistent praise for THE MARCH OF TIME series. Rotha also periodically violates his theory that function not fact should determine a documentary's value. In commenting on THE NEGRO SOLDIER (1944), for example, he ignores its revolutionary place in American film history and describes the film as "a rather tame picture . . . reduced to a somewhat childish level because it could not refer to the position of the civilian negro [sic] in U. S. life."

Anyone serious about documentary films, their history, and guiding production principles, should study this book closely. Its arguments about the role the genre should play in society are fascinating, while its insights about Britain's attitude toward film propaganda in the 1930s are second only to those found in Grierson's text. In addition, the comments about the filmmakers themselves add a valuable dimension to those observations recorded by Elizabeth Sussex, Erik Barnouw, and Richard Meran Barsam. Also valuable are the book's three appendexes on films used by the American military, one hundred important documentary films, and a selected bibliography. Three helpful indexes, plus many excellent illustrations round out the book's considerable contributions to film theory and history. Highly recommended for special collections.

Short, K. R. M., ed. FILM AND RADIO PROPAGANDA IN WORLD WAR II. Knoxville: The University of Tennessee Press, 1983. 341pp.
The result of a 1982 conference on "Film and Radio Propaganda in World War II: A Global Perspective" sponsored by the HISTORICAL JOURNAL OF FILM, RADIO AND TELEVISION, this anthology contains some of the best essays on wartime propaganda and the worst editing job in recent memory. The sixteen contributors (including the book's editor and Erik Barnouw, the conference chairperson) suggest the range of perspectives currently emanating from the United States, Japan, Germany, the Soviet Union, France, England, Switzerland, and the Netherlands. Four intriguing sections provide readers with significant information on what were the essential propaganda

aims of the belligerent powers and how the propaganda experts targeted their messages for specific audiences during World War II.

Section One is devoted entirely to Philip M. Taylor's invaluable overview of propaganda in international politics from the end of World War I to 1939. In tracing the growth and development of a method for disseminating and manipulating information, the author reviews its value both for peacetime diplomacy and for maintaining the domestic policies of governments in power. He makes clear that there were three reasons why the concept became a fixture of international relations between the two world wars: "(1) a general increase in the level of popular interest and involvement in political and foreign affairs as a direct consequence of World War I; (2) technological developments in the field of mass communications which provided a basis for rapid growth in propaganda as well as contributing toward the increased level of popular involvement in politics; and (3) the ideological context of the inter-war period . . . in which an increased employment of international propaganda could profitably flourish." Although frequent references are made to American interests, the focus is on the European powers.

Following this excellent introduction, Section Two examines how the Allies handled propaganda. Nicholas Pronay explores how left-wing documentary filmmakers affected Britain's Ministry of Information. Remy Pithon analyzes the problems facing the French counterpart of the MOI, Commissariat General A L'Information (Department of Information). Sergei Drobashenko describes what were the essential war themes in film propaganda put out by the Soviet Information Bureau. Peter Kenez explains the reasons why and how Soviet propaganda differed from that of its allies. Thomas Cripps and Kenneth Short critique America's problems with racial projections dealing with blacks and Jews in World War II. David Culbert details the reasons why Frank Capra's WHY WE FIGHT series remains the greatest achievement of the army's Morale Branch, or the Information and Education Division (I&E), and Erik Barnouw concludes with a brief essay on what made Radio Luxembourg such an extraordinary propaganda phenomenon in Europe during the Second World War.

Section Three shifts attention to how Fascist Europe responded to the campaign to win the minds of the world to their cause. David Welch surveys why the Nazi newsreels, with their close ties to the military, failed to instill in the German nation what Coleridge termed a "willing suspension of disbelief." David Ellwood explores how Fascist Italy tied its propaganda techniqes to populist perspectives, while Gianni Rondolino analyzes the role of Italian documentary-style war films that were designed "to present war in a politically attractive and ideologically exciting way." Pierre Solin's excellent essay on the effect of Vichy propaganda makes a convincing argument that the four-year period established the importance of broadcasting as a source for entertainment and information in France. Elizabeth Strebel's follow-up essay then explores whether or not the French cinema during this period shaped and reflected the existing sociopolitical attitudes; and whether or not the French filmmakers aided the aims of either the Vichy or Nazi occupiers.[253]

The final section concentrates on Japanese propaganda. Gordon Daniels's significant chronicle on the historical ties between Japanese censorship and control and its effect on World War II broadcasting provides an invaluable framework with which to compare different societies and their approach to propaganda. And Namikawa Ryo's concluding essay on NIPPON HOSO KYOKAI (NHK), the Japan Broadcasting Corporation, presents an insider's perspective of the problems faced by Japanese propagandists from the mid-1930s to the end of the war.

Although there is much to praise in this broad perspective on wartime propaganda, readers should be aware of two specific problems. First, by trying to do too much in a slight volume, the editor allows for considerable oversights on wide-ranging issues. For example, few authors really come to grips with how

[253] Readers interested in pursuing this subject should also read Elizabeth G. Strebel, "French Cinema, 1940-1944, and Its Socio-Psychological Significance: A Preliminary Probe," HISTORICAL JOURNAL OF FILM, RADIO AND TELEVISION 1:1 (January 1981):33-46; and Evelyn J. Ehrlich, CINEMA OF PARADOX: FRENCH FILMMAKING UNDER THE GERMAN OCCUPATION (New York: Columbia University Press, 1985).

entertainment films can use propaganda covertly during wartime. Pronay slights Grierson's contributions to the development of British film propaganda, just as Kenez mistakenly assumes that the Nazi-Soviet Pact of 1939 created no ideological problems for Russian film propagandists. Cripps tries too hard to condense racial problems before and after World War II in order to provide a setting for what happened in America between 1940 and 1945. There is also a problem with focus. Short's attack on Hollywood's handling of anti-Semitism is a case in point. He demonstrates admirable values for the mistreatment of Jewish images, but almost no sensitivity for the racist images of the Japanese in films like GUADALCANAL DIARY, BATAAN (both in 1943) and THE PURPLE HEART (1944). Second, the proofreading of these isolated but highly useful essays is depressing. Not only are there numerous typographical errors, but also Cripps's essay repeats almost two full paragraphs within two pages of the introduction.

If the next edition could correct the editing problems and fill in a number of historical gaps, this would be among the best books on introducing the subject of wartime propaganda. An index is included. Well worth browsing.

Sussex, Elizabeth. THE RISE AND FALL OF BRITISH DOCUMENTARY: THE STORY OF THE FILM MOVEMENT FOUNDED BY JOHN GRIERSON. Berkeley: University of California Press, 1975. Illustrated. 219pp.

Iconoclastic and absorbing, this superb reconsideration of the revolutionary British film movement presents the most formidable recollections of what actually was attempted and achieved by Grierson and his followers. Its purpose is neither to praise nor to condemn what occurred during the 1930s, but rather to correct the distortions created by the earlier publications of men like Grierson, Hardy, and Jacobs, which exaggerated the accomplishments and preferred propaganda to facts. The assumption is that by recognizing the genre's weaknesses, future generations will be able to evaluate more effectively the benefits of these initial stages of the movement. "The attraction of British documentary in its early years," the author shrewdly observes, "was not that it achieved success but that it achieved the freedom to stumble in a number of interesting directions almost by accident." Among the many false myths she attacks are those dealing with the documentary breakthroughs in sound technique, which are considered today more notable for what was attempted with primitive equipment in the mid-1930s than for what was actually produced. Another significant contribution that the text makes to film scholarship is an analysis of the reasons why the movement failed, thereby warning would-be pioneers of the problems inherent in any revolutionary movement. Being a filmmaker herself, Sussex employs a method akin to that used by documentary filmmakers. She interviews twelve of the movement's leading figures--e.g., Grierson, Rotha, Wright, Elton, Watt, and Cavalcanti--and then edits their tape-recorded memories into a chronological, composite picture of what transpired at a particular time in film history. This results in an immediate awareness that not only did the participants disagree strongly about the direction that the Grierson-led movement took, but also about the interpretations given to the films and individual contributions. While admitting that her method makes her, and not the people she interviewed, responsible for the book's conclusions, Sussex's purpose "is to provide enough documentary evidence to enable readers to reach their own conclusions."

The text's most skillful sections are those that separate truth from legends, intentions from achievements. In discussing the output of the EMB film unit, for example, she acknowledges the enthusiasm of its pioneering filmmakers, but states categorically that "none of those interviewed would be likely to take serious offense at the allegation that none of the EMB films is actually a masterpiece. Certainly none is." Sussex even questions the group's alleged respect for the British working class, arguing convincingly that while working people are shown to be noble at their jobs, no attempt is made to portray the people in an honest and accurate light. That is, the working class is either heroic or it is almost not the working class. The picture we get of Grierson confirms what many observers allude to in their books and articles, but never really develop: e.g., a ruthless, obstinate, and inspiring politician who had few equals when it came to fighting administrative wars and achieving his goals.

We learn in concise terms his cynical attitudes toward those who opposed him, and his justifiable pride in his monumental achievements, most importantly the establishment of the National Film Board of Canada. We discover as well that the pioneers were just as snobbish and antagonistic toward their critics as the critics were toward them, and that Grierson's browbeating tactics intimidated his filmmaking subordinates frequently because the subordinates "didn't have the guts . . . to stand up to him enough." Sifting through all the testimony, Sussex concludes that the movement reached its peak between 1934 and 1937. Acknowledging the brilliant work done at the GPO, she feels that films like SONG OF CEYLON (1934), NIGHT MAIL (1936), and COAL FACE (1936) all demonstrate unique artistic talent that rarely surfaced again. Interestingly, she identifies Humphrey Jennings's links to NIGHT MAIL, comments on the fact that he alone progressed in new directions during the war, and then adds the observation that "Grierson never liked Jennings and never claimed him as one of his proteges." The reason generally given is that Jennings was another maverick who preferred an individualistic rather than a group approach to filmmaking. Nevertheless, Sussex admits that the camaraderie among the major documentary filmmakers during this period was extraordinary. By 1939, however, Grierson was in Canada and the movement was beginning to split up into warring factions. The Second World War delayed the dissolution of the British documentary, and even resulted in some of its best work--e.g., TARGET FOR TONIGHT (1941), WORLD OF PLENTY, FIRES WERE STARTED, and DESERT VICTORY (all in 1943), and THE TRUE GLORY (1945). The postwar period brought an end to the pioneering efforts, according to Sussex, because "realism" had successfully integrated with the entertainment film, making the documentary less unique, poor economic conditions had shrunk the number of sponsors, and a number of the filmmakers themselves had left the movement. Most of all, it seemed as if the passion for nonfiction films was no longer there.

The problems, of course, with relying heavily on the memories of the combatants themselves are accuracy and prejudice. Harry Watt, for example, admits to a long-standing bitterness toward Grierson as a result of the latter not giving him "proper" directorial credits for NIGHT MAIL. He therefore credits Cavalcanti for much of the artistic advances made by the GPO film unit. Cavalcanti, for his part, talks about Grierson as someone "difficult to work with" and a "confused" sort of administrator. In addition, none of the people interviewed remembers clearly why Grierson resigned from the GPO in 1937, or why such hard feelings developed between Grierson's closest associates and other documentary people at this junction. Thus we learn very little about why the Film Centre felt it necessary to usurp the already established functions of the Associated Realist Film Producers. Interestingly, Humphrey Jennings gets high praise for his wartime films, but sharp criticism for his postwar work--e.g., A DEFEATED PEOPLE (1945), A DIARY FOR TIMOTHY (1946), and THE CUMBERLAND STORY (1947). Also coming in for their share of controversial commentary are Alexander Korda, the British Film Institute, and SIGHT AND SOUND.

Overall, the composite picture left by the survivors of the British documentary movement is both engaging and challenging. It brings a much-needed new perspective to the issues as well as to the personalities. Aided by excellent illustrations and a strong index, the book should be required reading. Highly recommended for special collections.

*Vaughan, Dai. PORTRAIT OF AN INVISIBLE MAN: THE WORKING LIFE OF STEWART MCALLISTER, FILM EDITOR. London: British Film Editor, 1983. Illustrated. 210pp.

*Welch, David. PROPAGANDA AND THE GERMAN CINEMA 1933-1945. New York: Oxford University Press, 1983. Illustrated. 352pp.

In this important examination of Nazi film propaganda as a reflection of National Socialist ideology, the author attempts not only to trace the origins of the ideology back to eighteenth century romanticism (the VOLKISCH tradition) but also to provide a better understanding of the films produced in Germany for German audiences. The result is a sweeping analysis advancing the work started by Hull and earlier writers.

Welch makes an interesting, although not entirely convincing argument that Nazism was not a temporary aberration, and that any attempt to understand how Nazi propaganda impacted on the German people must go beyond the economic and social framework of the Third Reich. One guarded limitation he sets for his ambitious study is to avoid quantifying the effects of the Nazi home-based films, primarily because he finds the available measuring techniques inadequate. For example, Goebbels began in 1940, by means of confidential weekly SD reports (SICHERHEITSDIENST DER SS) issued by Reich Security Main Office, to evaluate public opinion about the various films shown in Germany. The value of those reports then and now continues to be a source of controversy, but since they represent the best existing documentation, Welch uses them whenever available. They serve as the underpinnings for his conclusions on Nazi film genres such as the STAATSAUFTRAGSFILME (state-commissioned movies) and DEUTSCHE WOCHENSCHAUEN (German newsreels), as well as for his value judgments on the "Film Hour for the Young" (JUGENDFILMSTUNDEN). Consequently, the book's seven chapters and concluding essay are more a matter of subjective rather than objective judgments. The background material, however, represents admirable scholarly research.

Beginning with an outstanding interpretation of the history and organization of the German film industry, the author demonstrates that many policies and actions credited to Goebbels might better be ascribed to his associates or adversaries. A case in point is Hans Hinkel, who had the responsibility for the ENTJUDUNG (removal of the Jews and other undesirables from the German film industry). While not much is discussed of Hinkel's methods or the ironic use of his name by Chaplin in THE GREAT DICTATOR (1940), the fact is that he was able at the same time to persecute Jews in the film industry and still retain large numbers of stars, directors, and writers. Thus where other books have stressed the breakdown in the German film industry, this source argues that "of all the film stars who emigrated between 1933 and 1939 only 32 per cent of the seventy-five most popular actors and actresses left Germany to work abroad." He further demonstrates that in the first few years of Goebbels's control of the FILMWELT (German film world) the film industry made an impressive recovery, although the figures are admittedly misleading because of the serious decline in film exports. And unlike other sources, this one states "that when war came in 1939, the German cinema had attained an expertise and technical mastery that was unequalled in Europe." The author also takes a strong stand against Riefenstahl's claims after the war that she was innocent of political ties to Hitler. Culling the evidence available, he documents the fact that contrary to what she reported about OLYMPIA (1938) being commissioned by the International Olympic Committee, it was commissioned, financed, and carefully assisted by the Third Reich. The so-called "Olympia Film Gmbh" was only "a dummy company" established by the Nazis because "it was thought 'unwise for the government itself to appear as producer'. . . ." Welch offers many comments such as these, all suggesting rich possibilities for further research. He next analyzes the content and aim of the so-called TENDENZFILME (the state-supported propaganda films that received special treatment and funds), illustrating how films were manipulated for political purposes "in an attempt to shape and direct mass feeling toward specific 'facts' in accordance with the ambitions of the Nazi Party at different periods of time." The chapters that follow focus on the themes of comradeship, heroism, and Party loyalty; blood and soil (BLUT UND BODEN); the leadership cult (FUHRERPRINZIP); the military image during the war; and the way in which the enemies of the Third Reich were stereotyped. The actual films are then discussed as reflections of the way Nazi archetypes were idealized, the manner in which they were produced, and the purposes for which they were made as well as the audience targeted. Welch continually reminds us that throughout the twelve-year period Goebbels fluctuated in his film output between using Hitler's idea of making movies that were a "direct lie" (obvious propaganda films devoid of art) and those that were an "indirect lie" (far more subtle in style and overt political statements). Among the many intriguing observations on the ground well-traveled by others are those dealing with the uncertainty with which Nazi propagandists faced their tasks, their reliance on the myth of an "international Jewish conspiracy," the manner in which the German revolution based its cultural foundations on an abstract concept of a pure Aryan race, the Nazi inability to keep their stereotypes consistent (except

for the Jewish image) that then reduced their effectiveness, and how, during the last two years of the war, Goebbels used films like KOLBERG (1945) to raise the morale of the German people rather than for an attack on the enemy.

Despite the impressive bibliography that Welch used in preparing his arguments, several sections of the text offer no new insights and a number of issues remain unanswered. Welch's discussion on TRIUMPH OF THE WILL/TRIUMPH DES WILLENS (1935), for example, merely reworks material found elsewhere, and his plot synopses could be trimmed without doing damage to his extended analyses. More effort could have been given to determining audience reactions and to possible explanations of why the FILMWELT supported the Nazis as well as it did. Noticeably missing are explanations for the infamous behavior of noted film personalities or reactions to Goebbels's policy of using films for putting fear into the German people. Curiously, the text often refers back to the antecedents of National Socialist ideology, but never observes that anti-Semitism was not unique to the German people either in the eighteenth or twentieth century. Another curiosity is the author's reticence to draw parallels between propaganda in Germany and the other warring nations. For example, Welch points out that in the early 1940s the Nazis turned away from "direct lie" feature films to escapist genres like love stories and musicals. The United States did likewise starting in 1943, but the reasons were both similar and dissimilar. It would have been fascinating to explore how one strategy interacted with another, particularly since Goebbels always kept up with films being made by other countries. It might also have corrected the author's misperceptions that "barbarically exaggerated" stereotypes were limited only to totalitarian propaganda.

Overall, Welch should be complimented on the manner in which he has translated his 1979 doctoral thesis at the London School of Economics into a straightforward narrative where facts are clearly stated and arguments forcefully made. It's a rare treat to come upon footnotes at the bottom of the page, a useful glossary, interesting illustrations, and an index all in the same text. Finally, Welch proves once again the wisdom of Le Bon's maxim: "the improbable does not exist for the crowd." Recommended for special collections.

Welch, David, ed. NAZI PROPAGANDA: THE POWER AND THE LIMITATIONS. Totowa: Barnes and Noble Books, 1983. 228pp.

A first-rate anthology on the theory and practice of Nazi propaganda, this collection makes no claims for comprehensiveness or for revealing the reasons why the Nazis were successful in their efforts. "The aim of this book," the editor writes, "based on detailed examinations of specific aspects of Nazi propaganda, is to enhance our understanding of National Socialism by revealing both its power and limitations." Lothar Kettenacher's "Hitler's Impact on the Lower Middle Class" discusses why Goebbels's polices reinforced the image of Hitler accepted by the petit-bourgeoisie (KLEINBURGERTRUM). Richard Taylor's "Goebbels and the Function of Propaganda" explores the relationship between the Propaganda Ministry and Hitler's regime. Jochen Thies's "Nazi Architecture--A Blueprint for World Domination" analyzes why Hitler's illogical ideas on art and culture resulted in the building program that symbolized Nazi ideology. Welch's "Educational Film Propaganda and the Nazi Youth" underscores how the Nazi combined show business and propaganda in the schools to minimize dissent and to encourage a national consensus. Stephen Salter's "Structures of Consensus and Coercion: Workers' Morale and the Maintenance of Work Discipline, 1939-1945" analyzes how that propaganda program worked in the trade unions. Jill Stephenson's "Propaganda, Autarky and the German Housewife" discusses how the consensus approach failed with housewives because they couldn't apply it to their everyday needs. Gerhard Hirschfeld's "Nazi Propaganda in Occupied Western Europe: The Case of the Netherlands" shows the problems that Goebbels had in transporting his ideolgy outside of Nazi Germany. Francois Garcon's "Nazi Film Propaganda in Occupied France," the least successful of the essays, also highlights the problems of exporting propaganda, arguing that the French artists avoided any Nazi influence in their films. In concluding this splendid antholgy, Ian Kershaw's "How Effective was Nazi Propaganda?" draws the by-now widely accepted view that the propaganda approach only worked when it matched its ideology with the audience's prejudices. A bibliography and an index are included. Recommended for special collections.

Zucker, Joel Stewart. RALPH STEINER: FILMMAKER AND STILL PHOTOGRAPHER.
New York: Arno Press, 1978. Illustrated. 453pp.

HISTORICAL EVIDENCE

We come now to another major issue: Whether or not films in general and war
films in particular are valid historical documents. If film study is to remain a serious
academic pursuit, then it must be more than an examination of mere entertainment.
And if genres really represent their times, they should be just as valuable as the
other arts in documenting "historical facts" worthy of close examination by historians.
Few would deny that genre films concentrate on contemporary conflicts and seek to
satisfy the perceived attitudes, values, and ideals of a mass audience. The question,
however, is whether such films are reasonable and effective sources of historical
evidence, or are they fleeting commercial products produced by crass businessmen
with little concern for facts and reality? Are they just propaganda made obsolete and
worthless by the passing of time? Another concern is what methodology is reliable
and valid for twentieth century historians using film as a historical document?[254] Is
it reasonable, for example, to analyze the motion picture along traditional lines--e.g.,
indicating the date of origin, authorship, individual perspective, validity, reliability,
the path of causation, the degree of influence--or is it more appropriate, allowing

[254] As the result of a graduate seminar entitled "The Philosophy of History and the
Writing of Film History" conducted at the University of Iowa during the summer
of 1983, a series of papers was published in a special issue of the JOURNAL OF
FILM AND VIDEO 37:1 (Winter 1985). Guest edited by Robert C. Allen, the key
articles are Philip Beck, "Historicism and Historism in Recent Film
Historiography," pp.5-20; Patrice Petro, "Discontinuity and Film History: The
Case of Heidegger and Benjamin," pp.21-35; Robert Arnold, "The Architecture of
Reception," pp.36-47; Greg Easley and Pieter Pereboom, "Realism and Film
Historical Practice," pp.48-54; Ana Lopez, "A Short History of Latin American
Film Histories," pp.55-69; and Richard Pena, "College Course File: Film as
History," pp.70-6. Other useful essays to consult are Bradford E. Burns,
"Conceptualizing the Use of Film to Study History," FILM AND HISTORY 4 (December
1974):1-11; Robert Brent Toplin, "The Making of Denmark Vesey's Rebellion,"
ibid., 12 (September 1982):49-56; Daniel J. Leab, "Writing History with Film:
Two Views of the 1937 Strike Against General Motors by the UAW," LABOR HISTORY
21 (Winter 1979-80):102-12; Daniel Walkowitz, "Visual History: The Craft of the
Historian Filmmaker," THE PUBLIC HISTORIAN 7 (Winter 1985):53-64; Edward
Buscombe, "A New Approach to Film History," 1977 FILM STUDIES ANNUAL, PART II
(West Lafayette: Purdue University, 1978):1-8; ___, "Introduction: Metahistory
of Films," FILM READER 4 (1980):11-5; ___, "Notes on Columbia Pictures Corp.,
1926-41," SCREEN 16 (Autumn 1975):65-82; Gerald Mast, "Film History and Film
Histories," QUARTERLY REVIEW OF FILM STUDIES 1:3 (August 1976):297-314; Geoffrey
Nowell-Smith, "Facts About Films and Facts of Films," ibid., pp.272-5; Michael
T. Isenberg, "Toward an Historical Methodology for Film Scholarship," THE ROCKY
MOUNTAIN SOCIAL SCIENCE JOURNAL 12:1 (January 1975):45-57; Arthur Elton, "The
Film as Source Material for History," ASLIB PROCEEDINGS 7 (1955):207-39; Karsten
Fledelius, "Film Analysis: The Structural Approach," POLITICS AND THE MEDIA, ed.
M. J. Clark (New York: Oxford University Press, 1979), pp. 105-26; I. C. Jarvie,
"Seeing Through Movies," PHILOSOPHY OF THE SOCIAL SCIENCES 8:4 (December
1978):374-9; Charles F. Altman, "Towards a Historiography of American Film,"
CINEMA JOURNAL 16:1 (Spring 1977):1-25; Eileen Bowser et al., "Symposium on the
Methodology of Film History," CINEMA JOURNAL 14:2 (Winter 1974/75):1-79; and
"Historians and Movies: The State of the Art," JOURNAL OF CONTEMPORARY HISTORY
18:3 (July 1983):357-532.

for the medium's technical characteristics, to critique movies much the way historians analyze literature--e.g., identifying the circumstances surrounding its origin, creation, and reception; as well as how technological, sociological, and economic factors influencing the work reflect the age in which it was produced. A second issue relates to whether one type of film--e.g., fiction, documentary, newsreel--is more appropriate than another as a historical artifact. A third issue, assuming film's acceptance as a valid historical document, concerns the availability and accessibility of adequate film archives and whether such sources are financially prohibitive to researchers.

To determine the value of film as historical evidence and its relevance to movie genres, we need to accept several assumptions. Short, for example, has stated two of them:

> the historian must be prepared . . . to adopt the hypothesis that feature-length movies, despite being almost exclusively fictitious in nature, have the ability to reflect historical realities in a useful, if not unique manner. Its corollary is that feature films have a significant and demonstrable impact upon their audiences either in confirming an existent value-system or in contributing to its modification with political, social or economic basic assumptions.[255]

Short's arguments on behalf of feature films can be pleaded as well for nonfiction films, particularly documentaries and newsreels. Another basic assumption, put forth by Anthony Aldgate, is that since film is an art, it means "that all the biographical materials which are ordinarily useful in the study of the other arts are useful in the study of film. Thus papers, letters, diaries, memoranda, all provide insights into the personalities of the filmmakers and help to reveal the educational, social, political and psychological elements from which the film was fashioned."[256] Still another major supposition is Arthur Elton's thesis that "Fiction films are today's folklore, and will be as useful to the historian, or at least to the anthropologist, as the ballad and the fairy tale."[257] Neatly synthesizing these basic assumptions is Marc Ferro's argument that

> Grasping film in its relation to history requires more than just better chronicles of the works or a description of how the various genres evolved. It must look at the historical function of film, at its relationship with the societies that produce and consume it, at the social process involved in the making of the works, at cinema as a source of history. As agents and products of history, films and the world of films stand in a complex relationship with the audience, with money and with the state, and this relationship is one of the axes of its history.[258]

Serious film students need, therefore, to study how these various assumptions relate to the growth and development of film both as an art form and as an industry.

These assumptions need to be buttressed with an awareness of the problems films generally present to researchers. First, the viewer must understand what film is (a series of shots on celluloid that have been edited to create a specific effect for a multitude of reasons) and how it can be manipulated by producers, distributors, and

[255] Kenneth R. M. Short, "Introduction," FEATURE FILMS AS HISTORY, ed. Kenneth R. M. Short (Knoxville: University of Tennessee Press, 1981), p.31.

[256] *Anthony Aldgate, CINEMA AND HISTORY: BRITISH NEWSREELS AND THE SPANISH CIVIL WAR (Atlantic Highlands: Humanities Press, 1979), p.14.

[257] Eaton, p.208.

[258] Marc Ferro, "Film as an Agent, Product and Source of History," JOURNAL OF CONTEMPORARY HISTORY 18:3 (July 1983):358.

exhibitors. Second, there are often several versions of the same film. That is, the original film made by a director may have been reedited, censored, or mutilated over a period of time. One need only consult detailed discussions on films like THE BIRTH OF A NATION (1915), TRIUMPH OF THE WILL/TRIUMPH DES WILLENS (1935), or GRAND ILLUSION/LA GRANDE ILLUSION (1937) to find examples of how existing versions of these films need to be scrutinized before arriving at conclusions about their meaning or value as historical evidence. These may seem like obvious first steps. In practice, however, they are often overlooked or ignored.

It is also necessary to make the distinction between history ON film and history IN film. The former refers to historical motion pictures that attempt either to recreate or preserve the memories of important events--e.g., THE LONGEST DAY (1962), IS PARIS BURNING? (1965), TOBRUK (1966)--or well-known personalities--e.g., WILSON (1944), PATTON (1970), and MACARTHUR (1977). History in film, however, involves the medium's relationship to society: how it reflects and affects people in a particular time, place, and period of history. For example, what does THE LONGEST DAY tell us about the values, attitudes, and ideas that the filmmaker communicated concerning this historical event, and what did the communication mean to the audiences who watched it in 1962 and afterwards? History on film is justifiably scorned for its lack of insights, historical inaccuracies, and cheapening of national cultures, while history in film is gaining long overdue recognition for the historic value of its symbolic content and the conceptual framework imbedded in film characterizations, dialogue, settings, plots, props, sound effects, and themes.

Historians have some justification for their conservative attitudes toward using the medium for historical evidence.[259] The nature of the film process clearly demonstrates that when restaging history on film the reliability and availability of "historical facts" in movies are often inferior to those found in printed sources of evidence.[260] Feature films are not alone to blame for the historian's distrust. Film history books are filled with stories about the "fakery" and distortions in nonfiction films. Raymond Fielding, for example, notes that faking a news film was a practice "as much the rule as the exception in the newsreel business."[261] For those who falsely assumed that such shenanigans were only for silent film newsreels, Fielding reminds us that "If the opportunities for journalistic fraud were great during the silent newsreel days, the addition of sound doubled them, inasmuch as manipulation of content could be executed in both dimensions."[262] In fact, film distortions became so disturbing that in the early 1930s at an international meeting of historical scientists

[259] Arthur Schlesinger, Jr., "The Fiction of Fact--and the Fact of Fiction," SHOW (January 1964). Rpt. THE DOCUMENTARY TRADITION, pp.383-5. For additional insights, see Louis Van Den Ecker, "A Veteran's View of Hollywood Authenticity," HOLLYWOOD QUARTERLY 4:4 (Summer 1950):323-31; and Mary Field, "Making the Past Live: Inaccuracy in Historical Films," SIGHT AND SOUND 4:15 (Autumn 1935):23-4.

[260] George MacDonald Frazer argues that "Hollywood is not a school for teaching history; its business is making money out of entertainment, and history needs considerable editing and adaptation (which can, in some cases, justifiably be called distortion and falsification) before it is submitted to the paying public. This is something from which writers, directors and producers have seldom flinched. In this they are not necessarily more culpable than many serious historians who, if they seldom deliberately falsify, are often inclined to arrange, shape, select, emphasize, and omit in order to prove a case, or confound a rival, or make propaganda, or simply present what they wish to believe is the truth." See George MacDonald Frazer, THE HOLLYWOOD HISTORY OF THE WORLD: FROM "ONE MILLION B. C." TO "APOCALYPSE NOW" (New York: William Morrow and Company, 1988), p.xv.

[261] THE AMERICAN NEWSREEL, p.8.

[262] THE AMERICAN NEWSREEL, p.240.

a resolution was passed stating that the term "historical film" could be used justifiably only in connection with those movies that "record a person or period from the time after the invention of cinematography and without dramaturgical or 'artistic' purposes: those films which present a visual record of a definite event, person, locality, and which presuppose a clearly recognisable historical interest inherent in the subject matter."[263] Obviously, the resolution is inaccurate in failing to understand how nonfiction films can distort as much as any fiction films.[264] And just as obvious is the fact that audiences far less sophisticated than those that attended the meeting of the historical society take what is shown on the screen to be "truthful" to some degree.[265] The study of film genres must address those issues whether they be in documentaries,[266] newsreels,[267] westerns, gangster movies, war films, or in historical dramas. Clearly too much oversimplification and "poetic license" for dramatic effect are found in genre movies, especially in historical films.[268]

The public constantly needs to be reminded about what in a movie is or is not historically true, how the film/audience relationship operates, and what are a filmmaker's intentions. "A historical film," as Pierre Sorlin nicely states, ". . .

[263] Aldgate, pp.5-6.

[264] For a good discussion on how the difference between a fiction and a nonfiction film may depend only on the degree of distortion, see S. Tretyakov et al., "Symposium on Soviet Documentary," THE DOCUMENTARY TRADITION, pp.29-36.

[265] Readers interested in a striking example of how troublesome film distortions can be for audiences should read *Daniel J. Boorstin, THE IMAGE: A GUIDE TO PSEUDO-EVENTS IN AMERICA (New York: Atheneum Publishers, 1961; Rpt., 1978).

[266] Many documentary filmmakers believe strongly in Grierson's argument that they are first propagandists and then artists. Philip Dunne (p.159) has summarized that position best, stating, ". . . most documentaries have one thing in common: each springs from a definite need; each is conceived as an idea-weapon to strike a blow for whatever cause the originator has in mind. In the broadest sense the documentary is almost always, therefore, an instrument of propaganda."

[267] Pronay explores a variety of reasons why British newsreels maintained credibility at home and abroad during World War II, while noting that Nazi newsreels did not. See Nicholas Pronay, "The News Media War," PROPAGANDA, POLITICS AND FILM, 1918-45, pp.173-208. Another perspective is provided by David Welch, who reviews why Goebbels decided to use propaganda in newsreels rather than in feature films. See David Welch, "Nazi Wartime Newsreel Propaganda," FILM AND RADIO PROPAGANDA IN WORLD WAR II, pp.201-19.

[268] Historical films going back several decades present as great a problem of credibility as works going back thousands of years. Consider the case of MISSISSIPPI BURNING (1988). The story deals with the murder of three civil rights workers in 1964. Although the popular film has received considerable commericial and critical success, a number of intellectuals and sensitive critics have attacked the way that the filmmakers have distorted the role of Afro-Americans and the FBI in this period of the civil rights movement. For more information, see Wayne King, "Fact Vs. Fiction in Mississippi," NEW YORK TIMES H (December 4, 1988):15, 20; "Civil Rights Burned," ibid., A (December 30, 1988):30; "Mississippi Theater Bans Film on Death of Rights Workers," ibid., A (January 10, 1989):20; Dorothy M. Zeller, "F.B.I. is a Strange Hero for MISSISSIPPI BURNING,"ibid., A (January 13, 1989):30; James Alan McPherson, "Burning Memories, Mississippi 1964," ibid., A (January 14, 1989):25; Bill Minor, "Image in Film Worries Mississippians," ibid., A (January 15, 1989):16; Walter E. Ritter, "Fictious Justice," ibid., E (January 15, 1989):26; and Richard Corliss et al., "Fire This Time," TIME (January 9, 1989):56-62.

[becomes] a reconstruction of the social relationship which, using the pretext of the past, reorganizes the present."[269] In comparing modern history on film with the genre's previous attempts, Arthur M. Schlesinger reinforces Sorlin's definition, commenting, "It seems to me the current crop [1983] has a rather more ironic tone. They do not regard history as teaching great truths. It is, rather, illustrating the ambiguity and uncertainty of life. These sardonic and ironic films express about the past the feelings we have about the present."[270] The irony is even greater once we realize that the basis for all Nazi historical films was that they "were only relevant if they exploited contemporary themes in a historical context commenting on the 'great men' in Germany's past who embodied aspects of the National Socialist WELTANSCHAUUNG."[271] Furthermore, Goebbels specifically exploited historical feature films for morale purposes and left the newsreels and the documentaries to act as fear-producing genres for film audiences.[272] Thus a basic assumption that conservative scholars make, and the reason they are so cautious in their approach to film study, is that filmmakers will distort historical events to suit their questionable goals.[273]

Jowett, for example, surveyed Hollywood's treatment of historical concepts in over three thousand films during the 1950s. He noted not only that most war films definitely lack "historical fact," but also that Hollywood had a definite attitude toward historical themes:

 1. Hollywood has consciously devised certain plot formulations which tend to emphasize certain aspects of history, while de-emphasizing or ignoring those which may not be commercially viable. Thus areas which require interpretation, or are subject to emotional response are seldom used as thematic material. Instead "safe" historical topics are used so frequently that they have become the paradigms for the public's concept of these topics. "History as conceived by Hollywood" is a major influence on concept-formation in the United States.

 2. American-made films seldom, if ever, give an accurate historical interpretation, as far as such an interpretation is possible. In order to make films more commercially "interesting," plots are altered so as to distort known historical facts. In their analysis of the material culture of any period, films tend to be more sensitive because film is, of course, first and foremost a visual medium; thus props, sets and costumes are usually more historically accurate, especially in the bigger-budget productions.

 3. Films made for the commercial market seldom deviate very far from those social values which are basic to American society. . . .[274]

Jowett's conclusions indirectly remind us that often the criticisms leveled against film for its vulgarization of history are in fact the very reasons why it serves as such a valuable historical document. That is, the film industry's insistence on catering to

[269] Pierre Sorlin, THE FILM IN HISTORY: RESTAGING THE PAST (Totowa: Barnes and Noble, 1980), p.80.

[270] Cited in Stephen Harvey, "Why Today's Films Turn to History," NEW YORK TIMES C (August 28, 1983):1.

[271] Welch, p.165.

[272] Welch, p.257.

[273] Ernst Wolfgang, "DIStory: Cinema and Historical Discourse," JOURNAL OF CONTEMPORARY HISTORY 18:3 (July 1983):397-409.

[274] Garth Jowett, "The Concept of History in American Produced Films: An Analysis of the Films Made in the Period 1950-1961," THE JOURNAL OF POPULAR CULTURE 3:4 (Spring 1970):812.

popular points of view both in terms of historical recreations and film biographies of important personalities makes the industry's products valuable sources of historical evidence because of what these products communicate of the filmmaker's values as well as a mass audience's preconceived attitudes.

To guard against superficial analyses that note only that war films rely heavily on conventions, we must see how the repetition of images becomes crucial to analyzing contemporary treatments of those images, how such images provide evidence of changing values, new interpretations, and shifting points of view.[275] Hull, for example, in a model review of a number of Nazi youth-oriented films, noticed a recurring image of "a recalcitrant hero (but never a heroine) who has to be brought around to believing ideas which he does not initially support."[276] The conclusion that Hull drew was that the films might well indicate how the alleged cooperation between the government and German youths fell far short of what the Party expected and wanted. Peter A. Sonderbergh offers another example. He discovered in his examination of American war films from 1925 to 1965, that on the surface there was not much difference between the 1949 war film cycle started by BATTLEGROUND and the cycle started in 1925 by THE BIG PARADE:

> BATTLEGROUND did not deviate from the romantic pattern established by THE BIG PARADE, nor have the majority of war films made since 1949. The enemy has to be rehumanized and forces have been busy once more trapping peaceful men in bloody circumstances not of their own choosing, much as they had been in the 1926-1930 series of films.[277]

Sonderbergh, of course, then went on to identify significant differences. Even if no differences had been discovered, however, the intellectual historian would have benefited from the analysis. At the very least, it would have demonstrated a new generation's reluctance to free itself from the conventional thinking of another age. A more fruitful analysis can produce evidence of factors ranging from racial attitudes, political values, and class structure to sexual mores, fashions, and linguistic conventions. A third example concerns English film audiences prior to the Second World War where there was a vast difference between what people verbalized in opinion polls and what they actually felt as evidenced when they watched newsreels. Thus, just prior to Prime Minister Neville Chamberlain's resignation, he received good ratings in the polls, but theater audiences demonstrated a noticeable lack of enthusiasm each time he appeared on the screen.[278] What is important in each of these examples is not whether the images are "truthful" or merely similar to those of the past, but how they affect the audience, what they tell us about the genre's characteristics and the filmmaker's style, as well as what they reveal about their historical age.

Put another way, the question concerns what influence the context in which the film was made has had on the film's iconography and conventions. How has that context affected both the filmmaker's behavior and the behavior of the audience? Clearly, proving a film's influence is difficult. It is not, however, impossible. For example Marc Ferro points out that

> We know that JUD SUSS . . . was a great success in Germany above and beyond Goebbels's order that it be widely shown. We also know that just after it was shown in Marseilles, Jews were molested. We can note, too, that the

[275] R. C. Raack, "Historiography as Cinematography: A Prolegomenon to Film Work for Historians," JOURNAL OF CONTEMPORARY HISTORY 18:3 (July 1983):411-38.

[276] Hull, p.191.

[277] Peter A. Sonderbergh, "On War and the Movies: A Reappraisal," CENTENNIAL REVIEW 11:3 (Summer 1967):408.

[278] Aldgate, p.61.

success of anti-Nazi films and films exalting patriotic solidarity in the United States were successful only if they did not glorify either the Resistance in occupied countries, or the struggle against legal institutions in Germany; and if, on the pretext of better coordinating production following Roosevelt's appeal, they didn't question the free initiative of every undertaking.[279]

The important link is between behavior and meaning. Or, as Goebbels speculated early in 1933, whether or not films that have the power to influence attitudes also have the power to change people's behavior? If so, by isolating your audience in a totalitarian system could you force the public into becoming more obedient, disciplined, and subordinated to the will of an Adolf Hitler?[280]

Here again no definitive answer has been reached. Kenneth E. Boulding, for example, argues that "behavior depends on the image."[281] And images evolve, they don't just exist. What we need to do in using film as evidence, therefore, is distinguish between an "image" and a "message." In Boulding's terms, "The messages consist of INFORMATION in the sense that they are structured experiences. THE MEANING OF A MESSAGE IS THE CHANGE WHICH IT PRODUCES IN THE IMAGE."[282] Consequently, even when war films start off appearing to be the same, their final reception is determined by the context in which they are shown and seen. Scholars generally agree that Hollywood and American society function in tandem, and thus produce messages that influence each other's values, beliefs, and attitudes. What the scholar needs is an understanding of the genre's conventions in order to contrast the present with the past accurately. In that way, the analysis reveals the values of cliches, stereotypes, and film conventions as a reinforcement of long-standing audience perceptions, while the film inventions highlight the particular messages of a new generation and serve as historical evidence of that change.

Intellectual historians, with their overriding concern with "how and why specific human experiences have followed one another in time,"[283] derive substantial benefits from examining the film process and its unique products. It should be clear now why they begin by subordinating aesthetics to an emphasis on the product itself, a stress on historical construction rather than on artistic evaluation. It is similar, as Isenberg observes, to not confusing "visual details with the stuff of history."[284] In other words, the intellectual historian recognizes the suitability of film analysis for deciphering ideologies, identifying propaganda, and questioning rationalizations. And, according to John Higham, the intellectual historian's primary concern is "not culture, politics, society or art, but states of mind [that] make up the foreground of interest and the focus of curiosity."[285] One feature of such a concern is a description of the attitudes and ideas present in films.[286] What, for example, does THE BEST YEARS

[279] *Marc Ferro, CINEMA AND HISTORY, trans. Naomi Greene (Detroit: Wayne State University Press, 1988), p.16.

[280] Welch, p.46.

[281] *Kenneth E. Boulding, THE IMAGE: KNOWLEDGE AND LIFE IN SOCIETY (Ann Arbor: University of Michigan Press, 1961), p.6.

[282] Boulding, p.7.

[283] *John Higham, "American Intellectual History: A Critical Appraisal," THE AMERICAN EXPERIENCE: APPROACHES TO THE STUDY OF THE UNITED STATES, ed. Hennig Cohen (Boston: Houghton Mifflin, 1968), p.351.

[284] Isenberg, p.32.

[285] Higham, p.351.

[286] For two interesting perspectives, see Harold Putnam, "The War Against War

OF OUR LIVES tell us about the problems of returning veterans in 1946? How does this differ from films made about returning Vietnam veterans--e.g., HEROES and ROLLING THUNDER (both in 1977), and COMING HOME (1978)?[287] The intellectual historian's inquiry recognizes film as a valuable source of evidence because of the communication that occurs between influential opinion-makers and a major portion of society; it also provides a more democratic description and explanation of the spirit of an age. Besides, as Paul Smith aptly states, "Film, after all, is a fact, which historians can ignore no more than other facts."[288]

In Hollywood's defense against those who see only its commercial concerns, it has sometimes responded to patriotic calls and still been castigated. A case in point is Warner Bros.' MISSION TO MOSCOW (1943).[289] Following the Nazi invasion of Russia on June 22, 1941, the United States government through various channels, as David Culbert points out,[290] asked Hollywood studios to produce pro-Soviet films. These movies had as their purpose offsetting the widespread resentment against our now awkward but necessary wartime ally.[291] The Warner Bros. film purported to be an accurate account of Ambassador Joseph E. Davies's diplomatic mission in Russia from 1936 to 1938. To insure the public perception that such was the case, Davies not only meticulously supervised the film's production from start to finish, but also appeared in the film's Prologue to assure audiences that what they were about to see was factual. But truth had nothing to do with this production. The wholesale distortions that followed--e.g., the condensing of the four Soviet purge trials into one, the lies about Trotsky, the benign depiction of Stalin--are now adequately exposed. And as of 1978, the film's producer, Robert Bruckner, has sheepishly admitted the movie itself "was an expedient lie for political purposes."[292] Whether or not the pro-Soviet films ever changed the public's attitude toward Russia is debatable. At the very least, however, the films curtailed the flow of anti-Soviet propaganda. Nevertheless, as Culbert objectively observed:

Movies," EDUCATIONAL SCREEN 2 (May 1943):162-3, 175; and Peter A. Soderbergh, "The Grand Illusion: Hollywood and World War II," UNIVERSITY OF DAYTON REVIEW 5:3 (Winter 1968):13-22.

[287] For three interesting perspectives, see Lisa M. Heilbronn, "Coming Home a Hero: The Changing Image of the Vietnam Vet on Prime Time Television," JOURNAL OF POPULAR FILM AND TELEVISION 13:1 (Spring 1985):24-30; Martin F. Norden, "The Disabled Vietnam Vet in Hollywood Films," ibid., pp.16-23; and Leonard Quart and Albert Auster, "The Wounded Vet in Postwar Film," SOCIAL POLICY 13:2 (Fall 1982):24-31.

[288] Paul Smith, "Introduction," THE HISTORIAN AND FILM (New York: Cambridge University Press, 1976), p.5.

[289] The decision to make MISSION TO MOSCOW was in part based on the success Warner Bros. had with the film of Ambassador James W. Gerard's memoir MY FOUR YEARS IN GERMANY during World War I. The film version, which premiered in March 1918, not only was a box office hit, but also helped establish the studio on a solid financial basis. See also Brownlow, pp.135-41.

[290] *David Culbert, "Our Awkward Ally: MISSION TO MOSCOW (1943)," AMERICAN HISTORY/AMERICAN FILM: INTERPRETING THE HOLLYWOOD IMAGE, ed. John E. O'Connor and Martin A. Jackson (New York: Frederick Ungar Publishing Company, 1979), pp.121-45; and *MISSION TO MOSCOW, ed. and introduction David Culbert (Madison: University of Wisconsin Press, 1980).

[291] Melvin Small, "Buffoons and Brave Hearts: Hollywood Portrays the Russians," CALIFORNIA HISTORICAL QUARTERLY 52 (Winter 1973):326-37.

[292] Culbert, p.126.

Because the film is the most extreme example of official attempts to create support by distorting history, it commands the serious attention of those interested in propaganda and wartime censorship . . . The story of the making of the film provides small comfort for those who see conspiracy wherever they look--there is no cast of villains; rather we see a tale of zeal gone awry, of misplaced enthusiasm, of government officials at cross-purposes, a story of the buck never stopping anywhere.[293]

In short, here was an example of a studio that made a movie out of purpose rather than for profit--the film never made back its costs--and was condemned by certain leading intellectuals like John Dewey[294] at the time of the movie's release as well as by the industry's later critics. It illustrates as well the use of film for historical evidence in spite of its distortions and aesthetic failure.[295]

That the arts themselves qualify as sources of evidence for historical analysis should no longer be a matter of controversy. They certainly circulate ideas through the various levels of society. What has not been generally accepted by some historians is that the popular arts deserve the same serious consideration traditionally accorded more aristocratic forms of culture. This issue as it pertains to high culture versus popular culture was discussed earlier. We need now only indicate its relevance to film as a source of historical evidence.

Obviously, film operates like other mass media art forms in communicating society's values. Barry Ulanov, for example, clarifies the issue in terms of how the traditional historian perceives the difference between high culture and popular culture. The former has always been considered the repository of intellectual nuggets of evidence dealing with a society's values, ideals, and attitudes. Not until this century, however, has popular culture been considered a fit area of inquiry for intellectual historians. In the past, it did not appear to influence either the national tone or direction. But Ulanov and other modern scholars argue the need to examine the diversity of subcultures that exist in a national culture:

In the modern world . . . a world of masses and mass media and a world of more specialized and individual tastes, there is always a popular culture and a private culture. Each has its own set of arts, popular arts and private arts, each dedicated to different purposes, each making use of different skills.[296]

Ulanov's thesis is that neither private nor popular art has a monopoly on historical truth, that neither "set of endowments, adaptations, skills, or temperamental qualities

[293] Culbert, p.122.

[294] Culbert, p.134.

[295] According to recent reports, the "disenchantment with the prospects of propaganda films because of Warner Brother's [sic] experience with MISSION TO MOSCOW in 1943" contributed to the decision by that studio not to produce a film on Charles de Gaulle scripted by William Faulkner. What makes the report even more fascinating is that President Roosevelt is alleged to have suggested the idea to Jack Warner. Warner then presumably gave the writing chores to Faulkner, who began the assignment the first day he reported for work at Warner Bros. For more information, see Edwin McDowell, "Books: Faulkner Scripts for Film on De Gaulle," NEW YORK TIMES C (October 30, 1984):13; and *William Faulkner, THE DE GAULLE STORY--VOLUME THREE OF FAULKNER: A COMPREHENSIVE GUIDE TO THE BRODSKY COLLECTION, eds. Louis Daniel Brodsky and Robert W. Hamblin (Jackson: University Press of Mississippi, 1984).

[296] Barry Ulanov, THE TWO WORLDS OF AMERICAN ARTS: THE PRIVATE AND THE POPULAR (New York: The Macmillan Company, 1965), p.11.

is necessarily good or bad." To be fair, "This is neutral ground, morally and aesthetically."[297] Patrick H. Hutton has found that French intellectual historians recently have also become interested in the same democratization of historical research. Called the "history of mentalities," the new perspective "considers the attitudes of ordinary people toward everyday life. Ideas concerning childhood, sexuality, family, and death, as they have developed in European civilization--these are the stuff of this new kind of history."[298] No doubt as the "mentalities" methodology develops, the history of European films will play a major role in explaining the culture of the common person. A good starting point, of course, would be Siegfried Kracauer's FROM CALIGARI TO HITLER: A PSYCHOLOGICAL HISTORY OF THE GERMAN FILM. As the historian discards his scholarly prejudices toward film and popular culture, historical research shows how movies helped shape national policies, influenced public opinion, and reflected changes in a society's attitudes and values.

Consider, for example, Marc Ferro's skillful analysis of the Russian film TCHAPAEV (1934) as an illustration of Stalinist ideology.[299] He begins with the premise that fiction films are more valuable than either newsreels or documentaries to the historian

thanks to the analysis of critical reactions, to the study of the number of cinema attendances, to a variety of information on the conditions of production, it is possible to get an idea of at least some of the relations of the film to society, whereas one cannot always say as much for the newsreel or the documentary.[300]

Ferro then goes on to cite four specific procedures for analyzing a fiction film: "(1) the transmitting or receiving society, (2) the work itself, (3) the relation between the authors of the film, society and the work . . . (4) after its production, the filmic work has a history of its own. . . ."[301] Using TCHAPAEV, a film about the Soviet Civil War in 1919, the imaginative historian discovers it is a paradigm for Bolshevik values as well as a partial inversion of the revolutionary values expounded in 1917. That is, "TCHAPAEV shows that heroes make mistakes, that spontaneity leads to errors, that individuals die, while the party sees straight, does not make mistakes and never dies."[302] Through his careful study, Ferro illustrates how historical analysis functions within the context of a fiction film.

Another benefit of Ferro's procedures is the reminder of how valuable the filmmaker-audience model is to historians. Sometimes ignored is the fact that many of the screenwriters, producers, and directors based their films on firsthand experiences. For example, in World War I William Wellman (WINGS, LAFAYETTE ESCADRILLE) was a pilot; Jean Renoir (GRAND ILLUSION) served both as an infantryman and a pilot; James Whale (JOURNEY'S END) was a German prisoner of

[297] Ulanov, p.12.

[298] Patrick H. Hutton, "The History of Mentalities: The New Map of Cultural History," HISTORY AND THEORY 20:3 (October 1981):237.

[299] Marc Ferro, "The Fiction Film and Historical Analysis," THE HISTORIAN AND FILM, pp.80-94; Rpt, "Stalinist Ideology Seen Through CHAPAYEV," CINEMA AND HISTORY, pp.53-67. The quotations are from the essay. Another useful study in this area is Richard Taylor, "A 'Cinema for the Millions': Soviet Socialist Realism and the Problem of Film Comedy," JOURNAL OF CONTEMPORARY HISTORY 18:3 (July 1983):440-61.

[300] "The Fiction Film and Historical Analysis," p.80.

[301] "The Fiction Film and Historical Analysis," p.83.

[302] "The Fiction Film and Historical Analysis," p.83.

war; and Lewis Milestone (ALL QUIET ON THE WESTERN FRONT, NORTH STAR, THE PURPLE HEART, A WALK IN THE SUN, PORK CHOP HILL) served in the Signal Corps. Among the many notables serving in World War II were Samuel Fuller (FIXED BAYONETS, THE STEEL HELMET, MERRILL'S MARAUDERS, THE BIG RED ONE); Sy Bartlett (TWELVE O'CLOCK HIGH, PORK CHOP HILL, STRATEGIC AIR COMMAND, THE OUTSIDER); and Darryl F. Zanuck (WILSON, TWELVE O'CLOCK HIGH, THE LONGEST DAY). "Whatever their background or obsessions," as Rubin points out, "they all fought the same creative battle with studio executives, the financial backers, the advertising and promotion departments and the scoffers who constantly demanded entertaining, money-making films."[303] Historians searching for evidence of a causal relationship between the attitudes, values, and ideals of a society and their reflection in movies of the period will find the biographies, autobiographies, and records of these filmmakers valuable historical documents.

Ferro's procedures further point out the importance of examining how war films directly relate to the prevailing attitudes and the economic, political, and social conditions in the country in which they are made. Very often by examining these films we can learn about the opinions of the nation and the direction in which it is heading. Lewis Jacobs, for example, in discussing World War I movies, noted that the films reflected the change in public opinion during the First World War from tolerance to intolerance, from progressivism to reaction, and from pacifism to militarism.[304] Jack Spears, another respected film historian, described how a prowar feeling started in America after Germany's march into Belgium, but it did not reach any great heights until after Woodrow Wilson's 1916 reelection on the slogan "He kept us out of war." Then the movies became more militant as war became more "unavoidable," and films like CIVILIZATION (1916) declined in popularity.[305] Brownlow disagrees, arguing instead that the turning point in public opinion came after the sinking of the LUSITANIA in May 1915.[306] Michael A. Selig contends, however, that such interpretations are fallacious because they ignore the real historical circumstances in the industry. The visibility of Goldstein's case, and his imprisonment, would surely dissuade any Hollywood filmmaker from producing pictures with any tinge of antiwar sentiment, public opinion and filmmaker's sentiments not withstanding.[307]

For commercial, social, and political reasons, war films constantly change their attitudes toward the enemy and allies alike, depending on when the films are made.[308] One of the most graphic examples of how films change in their treatment of war issues and enemies can be seen in Hollywood's treatment of the German people.[309] War films prior to America's entry into World War II began to educate the

[303] Rubin, p.xii.

[304] *Lewis Jacobs, THE RISE OF THE AMERICAN FILM: A CRITICAL HISTORY WITH AN ESSAY "Experimental Cinema in America 1921-1947" (New York: Teachers College Press, 1968), p.261.

[305] Jack Spears, "World War I on the Screen: Part I," FILMS IN REVIEW 17:5 (May 1966):274; Part II, ibid., 17:6 (June-July 1966):347-65. Also see Lyons, pp.15-30.

[306] Brownlow, p.29.

[307] In an interview with Professor Michael A. Selig, September 12, 1983.

[308] For a useful overview of how different countries stereotype the enemy, see Furhammar and Isaksson, pp.201-17.

[309] Two good sources for information are Larry N. Landrum and Christine Eynon, "World War II in the Movies: A Selected Bibliography of Sources," JOURNAL OF POPULAR FILM 1:1 (Spring 1972):147-52; and Arthur F. McClure, "Hollywood at War: The American Motion Picture and World War II, 1939-1945," ibid., pp.122-35.

general public on what was to be the image of their future enemy. In describing this development, Knight uses Hitchcock's FOREIGN CORRESPONDENT (1940) to illustrate Hollywood's more menacing mood, especially the abrupt conclusion in which the film's hero, Joel McCrea, radios America from a blitzed London: "The lights are going out in Europe! Ring yourself around with steel, America!"[310] There are other examples as well. The previous year, Warner Bros. had produced the archetypal German espionage story, CONFESSIONS OF A NAZI SPY. The film, based upon a sensational German spy trial in New York City, charged that German-American Bunds were centers for espionage, destruction, and anti-American activities, that German diplomatic missions were merely subterfuges for undermining our country. According to one source:

> The effect was electric. Actors and directors received murder threats. German Charge d'Affaires Thomsen screamed "Conspiracy!" The picture was banned by many countries anxious not to offend Germany. In the United States, however, it made a profound impression.
> . . . what CONFESSIONS OF A NAZI SPY said was nothing new. But the picture dramatized the dangers of Nazism, brought them vividly home to the American people. Isolationists began to charge Hollywood with being one-sided about the war in Europe. The charges mounted as more screen dramas told their stories against the backdrop of Nazi terror--THE MORTAL STORM, ESCAPE, FOUR SONS.[311]

During the war years, Hollywood set its patterns on how Germans should be treated. They were to be stereotyped on two levels; either as brutes, in the form of the Gestapo, SS troops, and hired henchmen, or as German intellectuals trapped by their inability to deviate from a preconceived idea. William K. Everson describes the stereotype best:

> The World War II German villain . . . At the highest level was a man of supreme intellect and culture, placidly listening to Wagner while his storm-troopers tried to beat a confession out of the hero. He was resolutely dedicated to his cause, given to fanatic speeches, and a mastermind at keeping several jumps ahead of the opposition. But like all Germans (according to Hollywood), he was a methodical and regimentalized man, and it was this discipline that finally tripped him up when, at the crucial moment, he was unable to outguess the less intellectual, more emotional representative of the democracies.[312]

It is interesting to note that the German stereotype in Hollywood war films made during World War II did not deviate much from the patterns set in World War I.[313] Then the image was of a hideous Hun, usually embodied by Erich von Stroheim, George Siegmann, or Walter Long. In some of the war's most outrageous propaganda, "The Germans--the Boches, the Huns--were represented as sliteyed, mustachioed,

[310] Knight, p.243.

[311] Editors of LOOK, MOVIE LOT TO BEACHHEAD: THE MOTION PICTURE GOES TO WAR AND PREPARES FOR THE FUTURE. With a Preface by Robert St. John (New York: Doubleday, Doran and Company, 1945), p.5. Interestingly, Rosten (p.327) reports the American film audiences of the period were apathetic about such movies. The polls conducted by Dr. George Gallup concluded that political films attacking Hitler and the Nazis had their greatest success mainly with New York viewers.

[312] *William K. Everson, THE BAD GUYS: A PICTORIAL HISTORY OF THE MOVIE VILLAIN (New York: The Citadel Press, 1964), p.130.

[313] Some of the most obnoxious "Hang-the-Kaiser" films are described in Brownlow, pp.171-6.

lecherous devils whose every instinct was geared toward rape and vandalism."[314] The stories involving these stereotypes are generally the same. We fight fairly, while the enemy almost always uses cowardly and despicable tactics, despite, as Everson points out, "overwhelming numerical superiority that makes such tactics rather superfluous anyway."[315]

After the Second World War, Hollywood's treatment of Germans changed. In films like THE DESERT FOX (1952), THE SEA CHASE (1955), and THE ENEMY BELOW (1957), we were suddenly told that the real enemy was only a limited group in the now-conquered German nation. In an excellent analysis of post-World War II movies dealing with Nazi Germany, Martin Dworkin points out how films have tried to show that the ordinary German soldier was really "not to blame" for what happened. "It is the politicians who are--and they happen to be the Nazis."[316] Forgotten is the fact that Hitler and his party in 1932 had a plurality of seats in the Reichstag; emphasized is the misunderstanding over what the war was all about; glorified are the Nazi generals who, having realized they were losing the war because a madman was leading them, tried to kill Hitler; and romanticized are the German youths who goosestepped into the devastated countries of Africa and Europe. Dworkin emphasizes that these films show that the German youths, who were portrayed as no different from our American boys, were outside of politics as was the "good scientist of the present . . . outside responsibility. . . ."[317]

The reason why Hollywood war films become more liberal toward the enemy and more critical of the allies after the real war has ended is basic to the process of the film industry. First, the former enemy nations become sizeable markets for movies, and the industry tries to secure as much popularity there as at home. Second, returning veterans relate the horrors and atrocities committed at the front by both sides and are quite cynical about romanticized and idealized versions of war. Finally, as loyalties change, we need the friendship and cooperation of our former enemies in case of a new war with new antagonists.

Sometimes the protests against the war and chauvinistic films begin during the war itself, as in the example of an advertisement printed in MOTION PICTURE MAGAZINE in February 1916:

> Strangely enough, these pictures have not presented to our view the actual proof of the toll of war. They have not shown us the millions of widows and the millions of orphans that are the results of this conflict. They have not proven to us the hopelessness, the despair, the hunger and suffering that have been inevitable consequences of the War. And--having failed to present these consequences . . . --these pictures have not been logical arguments in favor of Peace. They have been military--they have been martial in the extreme. . . .[318]

Almost fifty years later, David Robinson reaffirmed the same unrealistic approach to the early war films, commenting that many of the photographers were former cameramen for popular magazines. Consequently, the pictures taken during World

[314] Furhammar and Isaksson, p.8.

[315] Everson, p.125.

[316] Martin Dworkin, "Clean Germans and Dirty Politics," FILM COMMENT 3:1 (Winter 1965):37. Also see Leslie Halliwell's two-part article, "Over the Brink," FILMS AND FILMING 14:12 (September 1968):54-60; and 15:1 (October 1968):58-62, 64.

[317] Dworkin, p.41.

[318] Quoted from Lewis Jacobs, THE RISE OF THE AMERICAN FILM, p.253.

War I have a stilted effect, as if the soldiers were posing or inadvertently getting in the camera's eye.[319]

Serious students, therefore, who use war films as historical evidence will find content analysis and the nature of the film industry itself as the best methods for deciding on issues of validity and reliability. Intangibles will, however, remain. As will be discussed in Chapter 3, these methods will not be able to determine precisely an audience's composition, why a particular film did well or poorly at the box office, or specific causal relationships between a film and society. Nevertheless, the research will illustrate the importance of conventions and inventions; the role that the medium performs as a purveyor of national attitudes; the values of those who write, direct, and produce movies; what were the circumstances surrounding the production of the film; what was the reaction at the time to specific motion pictures and themes; and the advantage of using genres as the best example for gauging consistently popular film formulas with their cliches and stereotypes.

This overview illustrates how the study of genres as historical evidence reveals the complex relationship among the artist, film, and the audience. Just as an examination of propaganda strengthens our understanding of technique and structure, so an awareness of what films tell us about their times and the artist's choices increases our perception of the close links between the artist and the intended audience. The war film thus becomes a valuable example of how economic factors alone do not determine what types of films are made. It makes abundantly clear that movies are far more than entertainment and that their basic value to a society is the way in which they not only reaffirm traditional beliefs, but also produce social cohesion and relieve our psychological conflicts. The study of the war film serves an additional value by reminding us how individuals through the manipulation of the genre can distort a society's history, customs, and values.

The last question remaining from our initial agenda involves the availability and accessibility of adequate film archives, and the expense to scholars of doing historical film research. Students just beginning film research need to understand the problems long associated with the unreliability of film books in general, the absence of a good, interlibrary network for locating films and their associated documentation, the costs involved with viewing films, and the confusion that exists with different versions of the same film as a result of prints made for foreign export as well as reconstructed versions.[320]

The two most obvious conclusions are that not enough archives exist, let alone adequate ones; and that costs in rentals, projection expenses, and actual visits to film repositories run too high. It is just as obvious that since this resource guide was first published in 1973, the situation has improved considerably.[321] The book annotations that follow will address specific situations as do Appendices V and VI, which list the major sources for film study in the United States as well as primary foreign archives and libraries.

BOOKS

*Aldgate, Anthony. CINEMA AND HISTORY: BRITISH NEWSREELS AND THE SPANISH CIVIL WAR. Atlantic Highlands: Humanities Press, 1979. Illustrated. 239pp.

Based upon the author's doctoral research, this scholarly book boldly stakes out three areas of inquiry: (1) a historical review of the debate among British historians concerning the usefulness of film as a primary source for the study of history, (2) an examination of the "British newsreel during the 1930s as a medium

[319] David Robinson, "The Old Lie," SIGHT AND SOUND 31:4 (Autumn 1962):203-4.

[320] For a good, practical introduction, see FEATURE FILMS AS HISTORY, pp.16-36.

[321] A good discussion about the range of documentary material available for integrating film into traditional historiography is available in Nicholas Pronay, "The 'Moving Picture' and Historical Research," JOURNAL OF CONTEMPORARY HISTORY 18:3 (July 1983):365-95.

of mass communication and as a means for the dissemination of news," and (3) an in-depth investigation of the treatment of the Spanish Civil War by the British newsreel companies from 1936 to 1939. Although Aldgate's major concern is with area three, he does not neglect a detailed examination of the first two. In fact, the book's most glaring flaw is its author's inability to connect persuasively the three relevant sections. In the Introduction, for example, he stresses both the ease with which one can prove that film has a mass audience and the difficulties in evaluating the messages movies send and the ways in which they are received. While he sees no problem in isolating and identifying the messages themselves, Aldgate recognizes the enormous problems that surface when attributing motives to those who send the messages. Yet when his study of how the British newsreels covered the Spanish War is completed, Aldgate convinces us only that his theories are fascinating. He never satisfactorily proves why the newsreel companies did what they did. Also weakening the text's impact is the author's handling of the background material. Unlike Marjorie A. Valleau's approach, Aldgate jams the film analyses alongside the political and philosophical material. The nonhistorian, therefore, has no difficulty understanding that British newsreels are reacting to domestic pressures and to the nation's fear that a general war might follow the Spanish conflict, but what's actually going on in Spain, why, when, and where, often gets confusing. The author's doctoral audience obviously was more attuned to the issues involved in the conflict than are the general film students who will read it. Overall, however, Aldgate's study has many impressive features.

The first chapter examines the issue of film as a primary source. Beginning with why film first attracted historians and the kinds of questions raised, the text concentrates on the basic debate over primary and secondary sources. Arthur Elton, Christopher Rhoads, and John Grenville get the credit for showing that movies do provide direct evidence, despite the fact that movies reflect the biases of their writers, directors, camera crews, and editors. Aldgate insists that we should ignore the manipulation in favor of studying those who do the manipulating. His thesis rests on the premise that the primary evidence that film can present relates to the attitudes of the people involved in depicting the events, the actual geographical and physical representations of people and places in the films, and the distinction between the film's information (denotation) and its message (connotation).

After a brief historical look at the rise of newsreels in Britain, Chapter Two examines the organizational structure of the five newsreel companies--Pathe, Movietone, Gaumont, Paramount, and Universal--that covered from the English point of view the Spanish Civil War, their personnel and production techniques, and the nature of the technology and technicians at their disposal. Aldgate clearly proves that these companies had a virtual monopoly on news reporting within the film industry and were relatively independent from their parent companies. He argues persuasively that the newsreels had a greater chance of remaining solvent in the 1930s than did full-length fiction films because the former provided their producers with prestige and advertising, while the latter were more closely dependent on profits for survival. What he never proves is how the backgrounds of the single commentators at Gaumont (E. V. H. "Ted" Emmett), Universal (R. E. Jeffrey), Pathe (Roy de Groot), or the multi-commentators at Movietone and Paramount influenced their reporting or increased the newsreels' value as primary sources. No causal relationship is established between the commentators and/or their bosses or crews-in-the-field that even remotely offers persuasive direct evidence on how to interpret better the messages Aldgate identifies in their respective newsreels.

Chapter Three presents similar difficulties. It begins with a skillful summary of the characteristics of British film audiences in the 1930s--e.g, mainly urban working class--and identifies through attitudinal surveys what the audiences liked and disliked about newsreels, cartoons, short subjects, and fiction films. Misperceptions about the provinciality of the newsreels are corrected, and we learn as well how newsreels received their share of criticism, when investigators report of "repeated cases where the newsreels have alienated people by their political bias, by their treatment of emotional topics, by the commentaries (which are often unsympathetic to ordinary people), and have shown by numerous indications that they are sometimes out of touch with the feelings of the moment and even, sometimes, with

the permanent feelings of housewives or labourers." A strong argument is made both against those who consider newsreels the same as documentaries and those who feel the former should be more creative in their treatment of reality. But when Aldgate later turns his attention to the book's major focus, he provides almost no meaningful information about audience reactions to the depiction of the two and half year Spanish Civil War. So what was the point? Having built an excellent case for the importance of measuring audience reaction to movie messages, Aldgate falls back on speculations rather than on direct evidence.

Except for the book's tenuous conclusions, Chapters Four through Seven offer a very impressive examination of the newsreel coverage of the Spanish Civil War. The evidence seems overwhelming that the five companies manipulated the news to favor General Francisco Franco's position, stressed the inhumanity of war, emphasized Britain as a peace-loving nation, faked battle reports from Spain, and often closed their lenses to violations of the agreement reached by the Non-Intervention Committee of 1936. Aldgate's excellent analysis of the Gaumont newsreel issue 274, "The Blonde Amazon," by itself provides a reason for getting the book. While one can find the usual problems associated with validating a decoder's impressions, this author painstakingly documents his judgments with footage allocated and, where appropriate, printed film commentary. Unfortunately, Aldgate never ties the messages he identifies with the alleged motives of the filmmakers or the impact on the audience. It does no harm to speculate that by following official government policy the newsreels were patriotic and compassionate in reassuring a concerned British audience that it was better off at home than were other foreign countries. But whether or not those are the real reasons that the five companies reported what they did is never determined by the author.

In the end, Aldgate can justly claim that newsreels for the British working class were a major source of information on the Spanish Civil War and on Britain's movement toward national defense, but that they offered almost nothing on the nations involved in the Spanish tragedy or their roles in the tragic conflict. He provides us as well with an invaluable bibliography, filmography, and index on the subject. And despite his failure to make a definitive case for his interpretations, the study remains a first-rate job of speculation. Recommended for special collections.

Isenberg, Michael T. WAR ON FILM: THE AMERICAN CINEMA AND WORLD WAR I, 1914-1941. Rutherford: Fairleigh Dickinson University Press, 1981. Illustrated. 273pp.

Modestly billed "as an exercise in the use of the motion picture as historical evidence," this disjointed text offers a wealth of information buried amidst its tedious prose. Isenberg's reasons for choosing World War I as his film focus are the large amounts of historical material already available, the changes the conflict produced in American intellectual life, and the "hundreds of movies which revealed significant ideas, attitudes, and values regarding the war." On the latter point, he stresses that although such views were commonly held by the audience, the films dealing with World War I were few (356 in this study) compared with Hollywood's total film production. The fact that 1941 is chosen as the cutoff date for the exercise, Isenberg candidly admits, is more because of the size of his manuscript than because of historical validity. Nevertheless, he does include material on such important later films as PATHS OF GLORY (1957) and LAWRENCE OF ARABIA (1962). No serious attempt is made to study the economics and the aesthetics of the film industry itself, nor is there any concern shown for looking at the biographies of the screen personalities. He makes no attempt to reshape the existing scholarship on the First World War or to champion the movies as the important step in the evolution of historical research. Most surprisingly, given the subject, he has only a superficial interest in analyzing the film audiences that watched these films. He just wants to examine as many films as possible to prove how the film can be used as evidence. The result is a collection of roughly related chapters that lack the statistical force of Shain's research or the intellectual imagination of the Baird and Welch books. Within each chapter, however, Isenberg crams mountains of invaluable footnotes, observations, and raw data that when thoroughly digested will more than repay the effort spent in laboring through the text.

The fact-filled introduction sets the tone for what follows. It begins by impressing the reader with statistics as a means of positing a theory unique to American films: "film was the major avenue for the dissemination of the national culture." Before examining that hypothesis, however, Isenberg feels compelled to devote the first of his five sections (each containing a minimum of two chapters) to a detailed discussion on the use of film as history. He lists the standard harangues against historians of World War I who have failed to see that the film plays a role "in presenting (advocating, explaining, exculpating, dramatizing, castigating) the conflict to the American mass public." He reviews the disadvantages historians face in trying to study films as historical documents, laments the deterioration of writings on the film, and points out how difficulties are compounded when one tries to investigate the film personalities themselves. From here Isenberg moves on to a discussion of the relationship among history, aesthetics, and film. He argues persuasively that traditional historians by ignoring film ignore practical examples of ideas in action. Despite the dull prose, it's difficult not to admire the author's convictions and his wide-ranging scholarship. He may not be the most effective writer, but he works very hard at locating primary and secondary sources to bolster his position. By the time Isenberg concludes his opening arguments for a historical methodology for film scholarship, the reader, persuaded or not, is saturated with ideas about the importance of content analysis in film study.

Section Two covers the issue of film reality and the false myths about the camera's alleged "objectivity." He correctly attacks the premise that documentaries and newsreels have a monopoly on "truth," dismisses the idea that propaganda doesn't exist in most films, surveys how the shifting attitudes of the United States government are evident in their sponsored films from 1917 on, and closes with the argument that the surviving war footage is overwhelming evidence of the film's plastic qualities. The straightforward commentary rarely breaks new ground, nor is it easy reading. Isenberg seems oblivious to the problems faced by documentary and newsreel cameramen, and to the difficulties posed by the equipment itself. He treats the films as if they merely exist to transport the ideas of special interest groups. Thus, the reader benefits enormously from the facts the author has accumulated, but learns little about film as a medium.

The final three sections, however, provide many insights into the relationship between films and historical documentation. Isenberg does demonstrate, for example, how certain movies about World War I were intellectually causative in themselves, providing members of the audience with models of behavior or acting as reflections and reinforcements of the national consciousness. We see how, once America entered the war, most films equated manhood with patriotism and a willingness for battle, castigated pacifists, while superficially touting war as the great leveling force to eradicate class differences. After the conflict, as Isenberg effectively records, the crude democratic ideals slowly began to disappear in movies about "the war to end all wars," and war themes fluctuated between extremes of bitterness and escapist adventures. In two exceptionally fine chapters on the themes of commitment, sacrifice, and adventure, the author expertly chronicles how films like THE BATTLE CRY OF PEACE (1915), CIVILIZATION (1916), THE BIG PARADE (1925), WHAT PRICE GLORY? (1926), WINGS (1927), and THE DAWN PATROL (1930) captured the shifting values of the American public, even if only a few of all the total number of war movies produced approached the intellectual power of their literary sources. Isenberg also deserves considerable praise for his study of the stereotypes associated with World War I films. He explains, for example, that often in such movies "Americans became heroes when they performed acts identical to those that, committed by Germans, were the apex of villainy . . . [thus] It was not the deed that determined the degree of criminality or immorality involved, but the nationality of its perpetrator." Anyone wishing to study how our friends and enemies were treated in World War I movies should first start with Isenberg's three strong chapters on the subject. Unfortunately, the same can not be said for his discussions on either women or humor in the same films. His bibliographical entries, for example, on women are shallow and dated, and his overall outlook remains superficial.

Fortunately, his concluding essay is mercifully short and makes only modest judgments about the film's primary role in disseminating popular information. He ignores here as he does throughout the text the variety of ways that filmmakers subtly treat the complex issues connected with war. As a result, this book should encourage very few people to analyze films in depth. It will, however, serve as an impressive resource for future research topics. In addition to a general filmography and a valuable bibliography, the author includes a much-needed index. Recommended.

*Ferro, Marc. CINEMA AND HISTORY. Trans. Naomi Greene. Detroit: Wayne State University Press, 1988. Illustrated. 176pp.

A translation of most of the French historian's essays in his 1977 Paris edition of CINEMA ET HISTOIRE, these revised works explore a sweeping range of film periods. Unifying the work, as Greene points out, are three central questions: "What can cinema tell us about the spirit, or 'mentalite,' of an era? In what ways does cinema constitute a valuable document for the study of history, a document long overlooked by 'official' historians? Finally, in what zones and modes do cinema and history intersect?" The material is divided into four major sections: film as a source of history; film as an agent of history; society which produces, society which receives; and modes of action of cinematographic language. Collectively, the sixteen stimulating essays provide a useful starting point for historians interested in using film as "an agent and source of history." A bibliography and index are included. Well worth browsing.

Fraser, George MacDonald. THE HOLLYWOOD HISTORY OF THE WORLD: FROM "ONE MILLION B. C." TO "APOCALYPSE NOW." New York: William Morrow and Company, 1988. Illustrated. 268pp.

This is a fun book to read. Its overiding premise is that Hollywood's virtues far outweigh its poetic distortions of history. Fraser, best known for his Flashman novels, and for his screenplays for THE THREE MUSKETEERS (1974) and OCTOPUSSY (1983), is irreverent, eccentric, and clever. For all those readers who harbor thoughts about Hollywood's venial distortions of history, here is the best defense yet on the film capital's reasons and behavior. "What is overlooked," the unrestrained Fraser tells us, "is the astonishing amount of history Hollywood has got right, and the immense unacknowledged debt which we owe to the commercial cinema as an illuminator of the story of mankind." Elsewhere, he insists that "It is worth remembering that the oft-despised film moguls were the greatest patrons of the arts since time began; Hollywood employed more scholars and experts and diverse talents than any philanthropic or learned institution--and incidentally paid them better." Now wait, don't dismiss this guy because he takes such wild leaps of logic. Fraser not only offers well-researched information, but also shows considerable wit in presenting it. For example, he quotes James Thurber, allegedly reacting to DeMille's 1956 version of THE TEN COMMANDMENTS, by saying, "'It makes you realize what God could have done if He'd had the money.'" And there is the delightful anecdote about the late Alan Badel's screenwriting problems on an unspecified biblical epic. In complaining that the words of Jesus had been badly distorted, Badel was told by his boss, "'Well, you see, Alan, we thought Jesus sounded just a bit cocky in there.'" Fraser's chronological examination of how Hollywood has treated history may infuriate mass media critics, but it will evoke outbursts of laughter from less uptight readers as they follow his arguments about who created a more impressive Moses, Michelangelo or Charlton Heston? A bibliography and index are included. Well worth browsing.

Maeder, Edward, ed. HOLLYWOOD AND HISTORY: COSTUME DESIGN IN FILM. New York: Thames and Hudson, 1987. Illustrated. 256pp.

Mould, David H. AMERICAN NEWSFILM 1914-1919: THE UNDEREXPOSED WAR. New York: Garland Publishing, 1983. 308pp.

*O'Connor, John E., and Martin A. Jackson, eds. AMERICAN HISTORY/AMERICAN FILM: INTERPRETING THE HOLLYWOOD IMAGE. Foreword Arthur M. Schlesinger, Jr. Expanded and updated. New York: Frederick Ungar Publishing Company, 1988. Illustrated. 306pp.
 The updating process involves mainly Lawrence W. Lichty and Raymond L. Carroll's essay on PLATOON (1986) and a few new bibliographical entries. Still recommended for special collections.

*O'Connor, John E., and Martin A. Jackson, eds. AMERICAN HISTORY/AMERICAN FILM: INTERPRETING THE HOLLYWOOD IMAGE. Foreword Arthur M. Schlesinger, Jr. New York: Frederick Ungar Publishing Company, 1979. Illustrated. 290pp.
 "Evidence," claims Schlesinger in his eloquent foreword, "is, of course the lifeblood of history . . . [and just as obviously] American movies have been dedicated to the reinforcement of middle-class morality. Certainly they have done their share to strengthen capitalism, chauvinism, racism, sexism, and so on." For those who have scorned the motion picture as a valuable source of evidence, this highly useful anthology succeeds in its intention of convincing fair-minded readers that the Hollywood film is "a valid and respectable subject for research." The format, using historical chronology as a guideline, avoids sweeping generalities about genres or periods of film history in favor of specific film analysis. The best essayists demonstrate how the film process relates to the spirit of the age. In addition, all the contributors--eleven historians, including the authors, one professor of English, and film historian Robert Sklar--use documentation and annotation techniques to illustrate how traditional historical scholarship applies to film research. Two fundamental themes link the collection and the essays together: (1) an understanding of each film's relationship to the period and people, and (2) an awareness of the film's place in the movie industry's technical, aesthetic, and economic growth. Because of the book's brevity, no definitive conclusions were attempted or reached. Collectively, however, the authors do suggest how conclusions based upon film scholarship meaningfully can be incorporated into intellectual histories about America in the twentieth century.
 The outstanding essays, for example, capture how films impact on society despite political and financial pressures, respond positively to technological developments, and still remain entertaining works of art. Sklar's masterly analysis of RED RIVER (1948) reveals how film critics overlook a film's social criticism about America's expansionist ideology because the film itself on the surface functions as a conventional western. Lawrence H. Suid details how DR. STRANGELOVE OR: HOW I LEARNED TO STOP WORRYING AND LOVE THE BOMB (1964) captures the 1960s' fears about nuclear catastrophe.
 Equally readable, if somewhat less persuasive, are essays probing films that grew out of a culture's basic insecurities. Thomas Cripps's defense of the black independent film THE SCAR OF SHAME (1929), while not a convincing case for the movie's artistic merits, is a skillful argument for viewing the movie as a reflection of minority values, attitudes, and problems. John O'Connor's research on DRUMS ALONG THE MOHAWK (1939) offers a starting point for linking a cycle of Revolutionary War films in the late 1930s to the growing national unrest over events in Europe. Isenberg's interpretation of what THE BIG PARADE (1925) suggests about post-World War I attitudes, and Jackson's observations on THE BEST YEARS OF OUR LIVES (1946) in relation to post-World War II values outline the basic steps in using films for historical research. David Culbert's objective treatment of MISSION TO MOSCOW (1943) demonstrates the variety of sources invaluable to a serious study of the film as a historical document. Garth Jowett's stimulating examination of the effect that THE PUBLIC ENEMY (1931) had on the growth of film censorship during the 1930s neatly summarizes what is already available in traditional film history texts.
 The least satisfying contributions--June Sochen on feminism in WAY DOWN EAST (1920); Peter C. Rollins, nostalgia in STEAMBOAT 'ROUND THE BEND (1935); Paul J. Vanderwood, the cold war in VIVA ZAPATA! (1952); Stuart Samuels, paranoia in INVASION OF THE BODY SNATCHERS (1956); Lawrence L. Murray, nihilism in BONNIE AND CLYDE (1967); and Daniel J. Leab, the blue collar ethic in ROCKY (1976)--are disappointing more for what they don't say than for what is written. They

tend to generalize far more than the evidence allows. And frequently their interpretations are jarring rather than satisfying. One gets the feeling that these authors could have done more, gone further with the material available.

For the most part, however, serious students will find this pioneering work replete with extensive footnotes, challenging points of view, and highly readable essays. Recommended for special collections.

*Rollins, Peter C., ed. HOLLYWOOD AS HISTORIAN: AMERICAN FILM IN A CULTURAL CONTEXT. Lexington: University Press of Kentucky, 1983. Illustrated. 276pp.

Almost ninety years have passed since the birth of the movies, and still the historian's disdain for popular art persists; the reliance on traditional documentation continues, despite the obvious, pervasive influence of the mass media in society. But there are signs that the times are changing. This collection, the latest and the best American attempt to demonstrate how movies communicate deep-seated truths about the periods in which they are made, should make a difference. The emphasis is on producing research papers that are themselves models for future scholars. While the scope of such a slight anthology does not permit sweeping perspectives, the attempt by the contributors to show how filmmakers influence society is refreshing. The twelve interdisciplinary essays, all linked thematically to the multiple roles Hollywood performs in American history, are arranged chronologically, although each approaches its task differently. The major issues treated in the sixteen films covered range from racial and sexual stereotyping to film censorship, comedy as a subversive technique, and the relationship between historical figures and their screen counterparts.

Despite the editor's grating hyperboles about his contributors (e.g., "superior interdisciplinary scholarship" and "excellent example of conscientious research"), the essays themselves represent a significant advance over those found in previous anthologies. Thomas Cripps and David Culbert, for example, skillfully describe how the need for a government-sponsored World War II film on racial tolerance resulted in sociologists, filmmakers, and the United States government working in concert to produce THE NEGRO SOLDIER. Even if one doubts the overemphasis on the causal relationship between it and the 1949 cycle of Hollywood racial films, the reader remains impressed by the meticulous original research done on the war years. Equally impressive is the rare instance of technical insights provided by Vivian C. Sobchack in her analysis of THE GRAPES OF WRATH. Despite all arguments for approaching film study in the context of the medium's unique characteristics, few scholars demonstrate Sobchack's gift for relating nonverbal messages to a movie's value as historical evidence. Also worthy of praise are essays by Ira S. Jaffe (an examination of Chaplin's social criticism in CITY LIGHTS, MODERN TIMES, THE GREAT DICTATOR), Leslie Fishbein (a revisionist look at the negative Freudian messages in THE SNAKE PIT), Kenneth R. Hey (an investigation of the political and multiple artistic influences affecting ON THE WATERFRONT), Charles Marland (a review of the Freudian and political currents imbedded in DR. STRANGELOVE OR: HOW I LEARNED TO STOP WORRYING AND LOVE THE BOMB), and Leonard J. Leff (a behind-the-scenes look at the censorship problems facing the makers of WHO'S AFRAID OF VIRGINIA WOOLF?). Collectively, however, their scholarship does not answer definitively the nagging questions about what constitutes valid and reliable audience research, or even responsibility for final film products. But their superior efforts offer strong encouragement to the progress being made.

The remaining essayists illustrate the major problems plaguing current research on history in film. Everett Carter, for example, in his flawed analysis of THE BIRTH OF A NATION overlooks much of the considerable scholarship published elsewhere by Cripps. Thomas J. Knock in his zeal for showing the value of WILSON as historical evidence fails to explain why a movie that did badly at the box office had a significant influence on the public.[322] Philip Dunne, for example, who was a close associate of

[322] Fred Lawrence Guiles offers a contrasting opinion, pointing out that WILSON appeared on almost every prestigious 1944 "ten best films of the year" list;

Zanuck, claimed that the studio head "always mourned the failure of his WILSON, a picture in which he poured all his idealism and energy."[323] Clearly, the confusion over cause and effect is unresolved. Other methodological difficulties--e.g., factual versus subjective information, unsupported generalizations, the absence of new perspectives on currently existing data--beset the essays by Douglas Gomery (an overview of sound's evolution from an invention to its role in the patent wars involving Theodore Case, Earl Sponable, Lee De Forest, and William Fox), Peter C. Rollins (an illustration of how the New Deal tried to influence American voters through government documentaries), and William M. Hagen (a thesis that the television news coverage of the Vietnam War had a major aesthetic impact on the artistic conception of APOCALYPSE NOW).

In sum, the end result of this far-ranging collection is a solid body of material that elevates the standard by which the future study of film as history can be measured. Rollins may not have succeeded totally in providing us with the best ways to approach film scholarship, but what he gives us is far better than what generally passes for historical research. Highly recommended for special collections.

Shindler, Colin. HOLLYWOOD GOES TO WAR: FILMS AND AMERICAN SOCIETY 1939-1952. London: Routledge and Kegan Paul, 1979. Illustrated. 152pp.

Part of a series designed to link films to the societies that produce them, this vastly underrated text looks at movies primarily as historical evidence of the American public's preoccupation with escapist entertainment, while both the government and the industry were using the same films as propaganda weapons. Shindler, an English social historian who did his Ph.D. thesis on Hollywood and the Great Depression, makes no attempt to write a definitive history of the Hollywood World War II film genre. He is concerned with writing only about the films that interested him and about their filmmakers who "were shaped by and responded to various social, political and ideological stimuli and [how] in their work they helped to intensify those feelings which were transmitted to their audience." Noticeably missing from this social history are useful references to serials, short subjects, and documentaries. Nevertheless, each of the book's eleven fact-filled chapters depicts clearly that filmmakers don't function in an "intellectual vacuum."

The richly illustrated narrative begins with a broad summary of the problems faced by Hollywood as a result of the world political situation prior to World War II. Shindler shows, for example, the international diplomatic problems created by American films like THE DEVIL IS A WOMAN (1935), THE LAST TRAIN FROM MADRID (1937), and GUNGA DIN (1939). Unlike other writers, however, who stress Hollywood's eagerness to get embroiled in American foreign policy, he argues that most of the film industry through the 1930s was "overwhelmingly isolationist." He further points out that such a policy provided many satisfying results, not the least of which was being in the mainstream of American thought. As a result, film personalities like Walter Wanger, John Howard Lawson, the Warner brothers, and the small group of influential British exiles living in California (e.g., David Niven, Laurence Olivier, Ray Milland) are singled out as the exceptions rather than the norm for the period. We see how this situation changes once President Roosevelt moves cautiously toward our involvement in the European war, and Hollywood begins a stream of service comedies and dramas like ARISE, MY LOVE (1940) and BUCK PRIVATES (1941). Shindler's comments eschew film analysis in favor of demonstrating how the movies reveal the social values of the times. We learn, for example, that THE GREAT DICTATOR (1940) fares badly at the box office, but the changing political climate a year later turns prowar films like A YANK IN THE RAF, CAUGHT

received an Oscar nomination, as did its star, Alexander Knox, for best actor. For a more detailed discussion, see Fred Lawrence Guiles, HANGING ON IN PARADISE (New York: McGraw-Hill Book Company, 1975) p.225.

[323] Philip Dunne, TAKE TWO: A LIFE IN MOVIES AND POLITICS, Foreword Anthony Lewis (New York: McGraw-Hill Book Company, 1980), p.57.

IN THE DRAFT, and DIVE BOMBER into commercial hits. We discover that a "B" movie like REAR GUNNER (1942), made at the alleged request of General "Hap" Arnold, increased substantially the recruitment of rear gunners; or that child star Margaret O'Brien's emotionally compelling role in JOURNEY FOR MARGARET (1942) made possible the adoption of many more English war orphans. Furthermore, he reminds us that Hollywood began an economic boom in 1941 that continued until 1946, suggesting again how closely politics and profits are related. Among the major contributions the narrative makes to our understanding of the war films themselves are the terse summaries of various film formulas (e.g., the typical American platoon consisting of "the tough Sergeant, the rich kid, the ex-con, a Jew, a Polish-American, an Italian-American, and a Black"), the perceptive observations concerning the industry's effective wartime propaganda and its postwar consequences (e.g., Hollywood's efforts to rework Russia's image in 1943 films like MISSION TO MOSCOW and NORTH STAR), the highly significant examples of how World War II provided enormous benefits for the future of American films (e.g., the training and development of filmmakers, as well as breakthroughs in the treatment of sensitive themes), and the manner in which Hollywood films boosted morale by stressing emotions in lieu of realism in their home front films (e.g., the 1943 drama SINCE YOU WENT AWAY). The material covered in this sweeping chronology, which ends surprisingly in 1952, is presented in a witty, straightforward, and captivating style.

That's the good news. The bad news is that much of what Shindler states is highly subjective and very debatable. For example, he argues that MGM in 1940 took greater risks with its production of THE MORTAL STORM, than Warner Bros. did with its productions of the same time period. No evidence is given to prove that statement, nor is there any documentation for the charge that Lawson's 1940 rewrite of the 1928 film FOUR SONS was a result of the screenwriter's "dutifully following the Communist Party line." Readers may also be disturbed by the way in which Shindler's biases intrude on his objectivity, particularly in his attacks on Leo McCarey, Fritz Lang, John Howard Lawson, and David O. Selznick. Troubling as well is the author's failure to account for the effect that the 1939-1940 HUAC investigations had on filmmakers, the nature of the film code in relation to Hollywood war film productions, the restricting nature of the OWI on filmmaking, and the role of television in the postwar period. Historical reconstructionists will no doubt object to Shindler's comments on Eisenhower, MacArthur, and Truman, while social historians will criticize him for his disregard of theoretical constructs. And, of course, there will be those film scholars who censure him for his refusal to address film aesthetics.

Given the paucity of material treating individual film genres and the manner in which they mirror national values, plus the handsomely illustrated narrative and its highly readable prose, I find this history-oriented text to be more than worth the reader's time and interest. With all its admitted faults, I thoroughly enjoyed Shindler's point of view and the many risks he took in compiling one person's interpretation of film history. Recommended for special collections.

Short, Kenneth R. M., ed. FEATURE FILMS AS HISTORY. Knoxville: The University of Tennessee Press, 1981. 192pp.

Committed to the pragmatic more than to the theoretical, this slim volume gives seven traditional historians the opportunity to demonstrate how films can be used as historical documents. The premise is "If the conclusions of these examples are credible then one might reasonably expect the case for using feature films in historical research to be proven." The articles themselves cover American, English, French, German, and Russian films from about 1924 to 1945.

Most, if not all of the essays, provide stimulating ideas and explore provocative issues. Short, in his thoughtful Introduction, points out that feature films aid historians in two ways: either as evidence in their analyses of political, social, and economic history; or, as a topic worthy of study just like theses concerned with an examination of the Depression or World War II. He then summarizes important projects that have identified how an influential elite manipulated newsreels for propaganda purposes, the problems to be wary of in reading traditional film literature, and the value in approaching film study through an examination of film censorship. D. J. Wenden's intriguing comparison of the mutiny and events in Odessa with those

recorded in BATTLESHIP POTEMKIN clearly illustrates how traditional scholarly methods work well in using film as historical evidence. The author makes abundant use of primary and secondary sources to point out Eisenstein's distortions of the facts, the efforts taken to construct many of the actual events, and the reasons why an unsuccessful mutiny has emerged as one of the most famous uprisings both in history and in the history of film. Paul Monaco's article on the psychological links between films and German-French consciousness in the 1920s, while lacking a tightly knit narrative, challenges its readers to consider visual and symbolic content in doing historical research. He explains, for example, that movies are nonlinear and unlike traditional historiography, which is linear, analytical, and rational. His advice, therefore, is that historians think of films much as they do of myths, as a "'fantastic' story told in an especially powerful way . . . [and requiring] the release of more energy than could be possessed by any individual psyche." Once historians grasp the idea of movies behaving as a collective national consciousness, the idea of movies functioning as historical evidence becomes indisputable. How you mine that resource is, of course, a far more difficult feat. Both Monaco and Elizabeth Grottle Strebel in her fascinating essay on two of Jean Renoir's Popular Front films (LE CRIME DE MONSIEUR LANGE and LA MARSEILLAISE), have difficulty in their argumentation, but offer extremely stimulating perspectives. Far more traditional is the evidence presented by Tony Aldgate in his treatment of how an ideological consensus rather than a confrontational policy was achieved in British feature films from 1935 to 1947. The most valuable essay, however, for persuading reluctant scholars to use film for historical purposes is Nicholas Pronay's masterly analysis of British film censorship. It demonstrates not only how ideas originated and were implemented, but also what the implications were for the industry and society. He clearly proves that "the processes of film production and distribution do generate records and therefore we can establish an historic reality within which the artistic element of film making operated."

General readers should find most enjoyable the two articles written by Thomas Cripps and Short himself, primarily because of the controversies they engender. Cripps, for example, uses the concept of "Conscience-liberalism" (a loosely defined phrase for a brand of American political faith in the 1940s and 1950s that worked its way into public policy) as a yardstick for measuring the progress made in the film images of blacks in American movies like CASABLANCA (1942), TENNESSEE JOHNSON (1942), and THE NEGRO SOLDIER (1944). Serious students who have followed Cripps's seminal work on racial issues will enjoy comparing his ideas here with his more recent writings on THE NEGRO SOLDIER. Short, on the other hand, is stimulating to read because of the way in which his concluding essay on Hollywood's fight against anti-Semitism ignores material covered in the anthology's previous essays. His opening paragraph, for example, contradicts Cripps's conclusion that American filmmakers in the 1940s were creating a better climate for black images. Interesting as well is the manner in which Albert Maltz is characterized as a "Communist screenwriter," but not Edward Dmytryk as a Communist director. A similar curiosity occurs in Short's discussion of screen adaptations. He makes a point, for example, of explaining that the homosexual victim in Richard Brooks's novel THE BRICK FOXHOLE was turned into a Jewish victim in CROSSFIRE (1947), but fails to mention that the Jewish patient in Arthur Laurent's play was transformed into a black patient in the movie version of HOME OF THE BRAVE (1949). In fact, both the Cripps and Short articles raise questions about acts of omission. Why, for example, is little said about the events prior to World War II that set the stage for the film breakthroughs during and after the war? Cripps, in particular, misses an opportunity to explain more fully the reason why World War II movies improved the image of black people; namely, because of the low morale generated by many black soldiers' being relegated to secondary roles (e.g., cooks and shoe polishers) in the military, while their civilian counterparts in several major American cities were rioting in protest against racial discrimination at home.

Despite these minor reservations, plus a poorly prepared index and some sloppy textual editing, the fact-filled volume succeeds in what it set out to do. Social and cultural historians will find the issues of methodology and resources amply discussed and the rich collection of footnotes extremely useful for further research. In addition,

the issue of how filmmakers manipulate feature films for propaganda purposes is very well documented. Recommended for special collections.

Smith, Paul, ed. THE HISTORIAN AND FILM. Cambridge: Cambridge University Press, 1976. 208pp.

This British-oriented introduction to using film as source material gives a much-needed overview of the problems involved with deciphering films, using them in history classes, and making movies for academic purposes. The book's basic premise is that film has broad evidential value just by the fact that it exists, as do the circumstances of its production, exhibition, and reception. A fake film provides a sense of reality, according to Smith, because "it is a real fake, the result of real events, mental as well as physical, composed of elements individually genuine, and can be usefully analyzed in that sense." But Smith does not minimize the complex methodological problems involved with determining the meaning of a film, what it reveals of its creators or audience, and the factors surrounding its production, exhibition, or reception. Instead, he asks eleven film archivists and investigators--mostly British--to suggest solutions. Their answers are grouped into four uneven sections.

Section One--"The Raw Material"--focuses on film resources and preservation. Lisa Pontecorvo surveys how historians can locate films through identifying the sponsor and purpose, as well as using the aesthetic form and length to help in teaching and historical research. Particularly valuable for neophytes are her practical comments on how filmmakers target audiences; the differences among a commercial film production library, state-subsidized archives, a television or newsreel company library, film archives, and film repositories; the types of film collection guides available; and what sorts of paper documentation exist. Pontecorvo also provides a much-needed warning that without an intellectual orientation--e.g., an awareness of how various types of films and the technical and financial support systems all reflect the age in which the movies were made--the serious student will miss the research value of films. Clive Coultass follows up with what can be found in film archives and sensitizes us to the difficulties of maintaining and preserving these precious collections. Students just beginning film study will benefit considerably from this section, although the heavy orientation on British resources limits immediate practical application. Another serious limitation, mentioned in an extended review of the book, is the less than candid assessment of the problems researchers encounter when they find out, for example, that a recommended Paris repository is a private foundation with specific limits to its access; that requests to some European institutions may take up to eighteen months to get; or that copyright problems make one repository extremely difficult to use for a host of purposes.[324]

Section Two--"Film as Historical Evidence"--offers the best material for experienced investigators. William Hughes is particularly good at pointing out what sets film apart from more traditional forms of documentation, as well as surveying film types and indicating the value of each for historical evidence. For example, he finds that the typical message-oriented film of the 1940s provides "a relatively accurate impression of the way things looked in the forties--the clothes, the buildings, the cars, the furniture." On the other hand, Hughes explains that such films are not of much value in regard to the problem being treated. Marc Ferro's analysis of TCHAPAEV (1934) details how fiction films can play a conscious role in factually recording events, policies, and processes of an age, material that is crucial to intellectual historians. No one should doubt the wealth of evidence available in fiction films after reading these two scholarly articles.

Section Three--"Film as Historical Factor"--is devoted exclusively to Nicholas Pronay's excellent essay on newsreels. He argues persuasively that the newsreel throughout its three stages of development--i.e., birth, the establishment of an elaborate international structure, and its emergence as a major news medium--provides rich sources of evidence for the values, beliefs, and attitudes of the ordinary citizen.

[324] Jerry Kuehl, "The Historian and Film," SIGHT AND SOUND 45:2 (Spring 1976):118-9.

Taking advantage of his skills as a filmmaker, the author reviews the difference between "authenticity" and the illusion of authenticity in newsreels. And like the highly regarded writings of Raymond Fielding, Pronay's historical overview should be required reading.

The last section--"Film in the Interpretation and Teaching of History"--spoils an otherwise exemplary text. Four of the five essays on how historians can become filmmakers, teach film in the classroom, and view feature films and television documentaries are boring, unconvincing, and pedantic. The one exception is Arthur Marwick's sensible discussion of how the cinema can be useful in traditional history courses. While he doesn't exhaust the range of possibilities, Marwick does an effective job of reviewing the most often used approaches to integrating movies into mainstream teaching at the university level.

In addition to an abundance of footnotes suggesting further research options, Smith includes an extensive bibliography, a limited list of organizations involved with film and history, and a helpful index. Recommended for special collections.

Sorlin, Pierre. THE FILM IN HISTORY: RESTAGING THE PAST. Totowa: Barnes and Noble Books, 1980. Illustrated. 226pp.

Based upon a lecture series given at St. Antony's College, Oxford, in 1976, this intriguing but laborious study lobbies for the importance of examining fiction films as historical documents. Sorlin begins by outlining his subject. The first step, he argues, is to dismiss our knowledge of the historical periods being examined. In that way, "we will be able to understand what the people who made these films, and the people who saw them, thought of as 'history.'" His prime example is the treatment accorded THE BIRTH OF A NATION (1915). It's an unfortunate choice for the University of Paris professor. Lacking a firm grasp of how American slavery operated, he loses credibility when arguing against historians who dissect the film for its historical inaccuracies. His judgments on how blacks are depicted in the film fails to account for the distinctions made between field and house servants or for the use of comedy in the first half of the film to stylize racist attitudes. Thus his analysis of the treatment of blacks in the film undermines his theory that the job of historians analyzing film "should not involve bestowing marks for accuracy, but describing how men living at a certain point understood their own history." Clearly if Sorlin had the benefit of the former, his position would have been more tenable. His second recommendation is to sensitize historians to the fact that narrative is only one of many means of expression open to filmmakers. The point is well taken, even though the author's prose has the effect of discouraging readers from believing that such analyses are productive. One has only to compare Marc Ferro's essays with the material presented in Sorlin's eight chapters to discover the difference between what is said and how it is said. The latter knows what to do; the former, how to do it.

Where the text helps interested readers is in the formulation of concepts related to understanding "how, why and for what purpose the past has been and is restaged by the cinema." In the first of the book's three sections, Sorlin effectively explains his methodological approaches and what he means by cinema as "a document of social history." Americans may bristle at his labeling the film as "audiovisual material," but appreciate the manner in which he gives a good introduction to the basics of film analysis and historiography. Particularly important are his four rules for selecting films for analysis: "the originality of a film, its relationship to current events, its favorable reception by the public and the fact of its being produced and distributed during a time of crisis." My one major reservation is the omission of film genres. One would have to know what had preceded a specific film to determine what made it original. Comparing "one or two themes and see[ing] how they are treated throughout the film" is helpful but fails to determine whether the filmmaker is following the conventional or the inventive route.

It's in the second section--"The Reference Periods"--that Sorlin faces his greatest problems. Having successfully identified three kinds of information found in films--i.e., the people, the events, the dates--the author proceeds to illustrate how "these data assert an intrinsic meaning which arises from a predetermined cultural consensus. . . ." But the analyses of films like THE BIRTH OF A NATION,

OCTOBER/OKTIABR/TEN DAYS THAT SHOOK THE WORLD (1928), GRAND ILLUSION/LA GRANDE ILLUSION (1937), GONE WITH THE WIND (1939), THE LEOPARD/IL GATTOPARDO (1963), 1860 (1933), and LA MARSEILLAISE (1937) are more noteworthy for their lackluster prose than for insightful commentaries on imagery, historical diversions, and cultural biases. For example, Sorlin makes the assumption that "a historical period cannot be pictured if audiences do not feel disposed . . . to take an interest in it." Disposition may affect specific box-office receipts, but American production is more closely aligned to historical trends. That is, we get more films about the Civil War than the Revolutionary War because historically the latter does poorly at the box office and there exists the myth about the South as a major source of revenue. It is true, as Sorlin suggests, "that films by manufacturing a fanciful history, occasionally disclose carefully concealed problems." The challenge, however, is to determine accurately what those problems are and how they are concealed. The author's assertions that Griffith's racist epic hinges on a change in leadership midway through the film and a denial of economic factors as the basis for race hatred are fascinating. So too are his discussions of the family relationships between and in the Stoneman and Cameron households. But to conclude that the marriage between Elsie Stoneman and Ben Cameron "is not the association of two families but the reproduction of the existing family" and that the upshot of the film "is not to endorse the old rural slave society" strains the author's credulity. Adding to the problem is the absurd statement that "Until 1960 the American cinema avoided showing black characters altogether--in a favorable or critical light." If the author had done his homework and used books by Thomas Cripps, Donald Bogle, and Daniel J. Leab instead of those authored by Peter Noble and Jim Pines, his judgments would have been altered noticeably. I will leave to other critics the validity of Sorlin's assertions about France's treatment of the French Revolution, the Soviet Union's idealization of the Russian Revolution, and Italy's depiction of the RISORGIMENTO.

The book's final section--"The History of Yesterday"--begins on a strong note. Moving beyond the previously established relationships concerning the past and the present, the author points out the importance of understanding how history is conceived. That is, the "framework of knowledge . . . defined at a certain point." The trouble, once again, is in the selection of a film--GRAND ILLUSION/LA GRANDE ILLUSION--that is covered with decades of significant criticism. Sorlin almost seems masochistic in his desire to take on traditional evaluations. In itself, the challenge is formidable and necessary for scholars. But one must be able to do so with skill and depth. What the author here wins by imagination, he loses by discipline. For example, he does a fine job of suggesting the image that "women" symbolize in drawing distinctions between the various Russian, English, German, and French troops. But then he fails to indicate forcefully that Renoir repeatedly argues in the film that nationalities by themselves are artifical. Within each nation, there are differences; and those differences are what align one class with another, regardless of national boundaries. Thus to argue that "the English are feminized, and the Russians are the victim of a woman. . . ." puts further strains on Sorlin's dubious critical judgments. The failure to account for these class distinctions throws considerable doubt on his theory that GRAND ILLUSION/LA GRANDE ILLUSION is more an isolationist, than either a defeatist or pacifist, film.

In the end, the attempt to discuss both film and history proves too difficult for the author. His many relevant points about historical prejudices, the need to have theoretical concepts to understand how history is restaged, and the importance of film for historical documentation are blurred by forced and unpersuasive conclusions about the films in question. A brief filmography and bibliography are provided, along with a helpful index. Approach with caution.

*Valleau, Marjorie A. THE SPANISH CIVIL WAR IN AMERICAN AND EUROPEAN FILMS. Ann Arbor: UMI Research Press, 1982. 207pp.
Designed originally as a doctoral study, this important text compares the treatment of the Spanish Civil War in twelve American and European narrative films to discover what differences exist between them in terms of their ideological content and cinematic modes of representation. The author's concern with how films

communicate leads her into the areas of structural linguistics, semiology, and structuralism. Unlike other scholars who lose their general readers in such highly technical terrain, Valleau skillfully sets up an informal taxonomy that aids not only our understanding of her conclusions, but also increases our appreciation of the method. "Ideological content," for example, refers to the way in which filmmakers signify the film's major conflicts and predicaments, the political questions emerging from the dialogue, the roles assigned the various characters, the political results accruing from the actions, the style of reality in each film, the relationship between the thematic content and the "myths of oppression" that support the film's political position, and how the films end. "Cinematic modes of representation" refers to elements like camera work, editing, the organization of space and movement within a shot, sound and image relationships, and lighting. Valleau limits her investigation to those fiction films using the tragic conflict as the main subject or setting. Thus movies like THE FALLEN SPARROW (1943) and I AM CURIOUS: YELLOW (1968) are excluded because they do not make the Spanish Civil War central to their themes, characters, and/or settings. Also excluded are those films for which the author could find no prints available in the United States or which were released too late for the original study--e.g., LOVE UNDER FIRE (1937) and GUERNICA--THE TREE OF LIBERTY (1976). The author's basic premises are that films represent "one of the most significant manifestations of the popular culture of an era and . . . [that] the Spanish Civil War, a complex, significant, and tragic event, was . . . richly reflective of various social and political attitudes. . . ." Valleau first analyzes in chronological order six American films--i.e., THE LAST TRAIN FROM MADRID (1937), BLOCKADE (1938), FOR WHOM THE BELL TOLLS (1943), THE CONFIDENTIAL AGENT (1945), THE ANGEL WORE RED (1960), and BEHOLD A PALE HORSE (1964). Next, she analyzes six European films: i.e., SIERRA DE TERUEL (1938), ALKAZAR (1940), THE WAR IS OVER/LA GUERRE EST FINIE (1966), THE SEA/LE MER (1967), THE GARDEN OF DELIGHTS (1970), and VIVA LA MUERTE (1970). After comparing and contrasting the two sets of films, the author ends her significant examination by summarizing her conclusions on how the fiction film approaches a political event and the differences between the methods used by American and European filmmakers.

Valleau's research offers many excellent insights for serious film students. The most obvious one is in giving us the first major study of the Spanish Civil War in fiction films. Nowhere else can one find the information on how American and European filmmakers thematically focused in their "political" movies on the attempts of civilians, with or without military aid, to overthrow the enemy. We are shown how individuals more than groups in these movies (ten of which take the Republican side) are responsible for the film's political activity, and we discover major differences between American and European filmmakers. The former, for example, stress the protagonist's personal life to help audiences indentify with him, while the latter are just as content to let political issues rather than the personal lives of the characters take center stage. All twelve films, however, offer us perspectives on how filmmakers examine political issues like civil war, political prisoners, religion, and betrayal; visualize the conflict as a tragic struggle between poorly armed Republican peasants and well-equipped Nationalist warriors; avoid the sweeping military struggles common to other war films; and end very pessimistically. The striking differences between the American and European perspectives are summarized in an absorbing four-page conclusion comparing and contrasting Sam Wood's FOR WHOM THE BELL TOLLS with Andre Malraux's SIERRA DE TERUEL. Rarely in such studies does one find an author so passionate yet so imaginative in her analysis. Another major contribution of this challenging study is the recognition of films generally overlooked or downplayed by film historians and teachers. It's hard to picture someone who's never seen THE CONFIDENTIAL AGENT, SIERRA DE TERUEL, LE MUR, and THE GARDEN OF DELIGHTS reading the author's commentaries and not wanting to see those movies.

Several of Valleau's glaring weaknesses even make valuable contributions to film study. One of her scholarly limitations reminds us what happens when you can't separate your politics from your analysis. Despite a recognized need for a decoder to remain objective, the author frequently fails to distance herself both from the political and social messages in specific movies and from her all-too-obvious distaste for Hollywood films. In praising director Carlos Saura's THE GARDEN OF DELIGHTS,

for example, she describes it as a "parable which cracks the surface vitality of modern Spain and offers a glimpse of its underlying rottenness." Few scholars after detecting that biased slip would then trust Valleau's encoding methods on the controversial issues in these message-oriented movies to be either fair or objective. The problem is compounded by the author's failure to define what she means by "heroism," "personal freedom," "exciting melodrama," and "honest portrayal of war." Consider as well her comments criticizing Paramount Pictures' failure to mass market VIVA LA MUERTE by director Fernando Arrabal. Valleau states that the studio found the film's subject matter too shocking for a mass audience, although "it is acceptable [for American films] to delve into spiritualism and personifications of evil (THE EXORCIST and THE OMEN, for example), but harmful and too unsettling to tap the roots of sexual repression and the institutions that feed on this: home, church, and state." Besides confusing the issues of distribution and film content, Valleau seriously errs by not fully understanding Hollywood's reliance on genre filmmaking and that modern American horror films are concerned primarily with issues of sexual repression. In fact, the author's biases against Hollywood entertainment films almost turns her important conclusions on fiction films about the Spanish Civil War into a simplistic argument that European films are better than Hollywood movies because they are made independently, stress the filmmaker's personal convictions, delight in innovative film techniques, have almost no commercial value, and are never seen by very many people. Conversely, highly successful commercial movies like FOR WHOM THE BELL TOLLS are to be pitied because they were made by big studios that forced profit-motivated authors like Ernest Hemingway to sacrifice literary emphases in favor of film conventions tapping national values and attitudes in order to entertain and influence the behavior of vast middle class audiences. That's not completely fair to Valleau, but it gives you a sense of the text's underlying tone. Another mistake that authors need to avoid is substituting assertions for historical evidence. The author's narrative is riddled with comments like "It is a truism to say that films reflect the values and attitudes of society." Saying something and proving it, however, are very different matters. Illustrative of Valleau's methodological problems is her assertion that "Frequently, the American director appears to see filmmaking as a job or an occupation while his European counterpart views movie production as an artistic endeavor created out of personal concern and commitment." Since her study is based on twelve American and European films made over a thirty-three year period (1937-1970), this is nothing less than the tired debate on high versus popular culture shifted to film. It could have been avoided if she took more time to understand the complexities of the American film industry or relied on more than one source to justify her stimulating interpretations. For example, Valleau adores James Agee's reviews, but always finds Bill Nichols's interpretations very suspect. In addition, she rarely makes use of primary materials like autobiographies, diaries, or interviews to investigate the events and personalities involved in the production process. Even secondary sources in the case of Graham Greene could have added further to her already sensitive and impressive interpretation of THE CONFIDENTIAL AGENT. Finally, the narrative itself is occasionally hurt by weak editing. Valleau in her analysis of THE LAST TRAIN FROM MADRID continually refers to Vigo as both a colonel and a general. In the same analysis, she creates unnecessary distractions by comparing the film to BLOCKADE, rather than finishing the initial review and then doing the comparisons in the analysis of BLOCKADE that follows.

Even with these weaknesses, this narrative serves as a good introduction to the study of politics in film and how to use one specific event as a means for analyzing the style and content of individual films. Valleau has a sharp eye for detail and a gift for provocative prose. She also provides us with a helpful bibliography and a useful index. Even if I can't agree with everything she says, I appreciate the honest, straightforward way in which she presents her arguments. Recommended for special collections.

THE DOCUMENTARY WAR FILM

With this background in mind, we can turn to the major categories of the war film.[325] By beginning with the form that a movie may take--that is, its basic structure--we can see that since 1914, war films fall primarily into two subgenres: documentary[326] or fiction. And the majority of these moving pictures, intentionally or not, were prowar, as Richard Whitehall accurately notes.[327] Isenberg's careful research has proven that a change did occur, but "Not until 1930, and then in only a very few films, did moviemakers come to realistic grips with modern war in a mood of disillusionment which approached that of literature."[328]

A documentary war film can be defined as a movie that relates and creatively interprets "facts" of real life by trying to preserve authentic features dramatically, either by showing them as they actually occur in real life or as they appear in published works such as newspapers and factual books.[329] A fiction war film generally presents some contrived action performed by professional actors. For the most part, movies made during the war are not so good as those made afterwards, the main exception being documentary films, which we turn to now.

The documentary war film can be classified under the following subgroups: magazine, propaganda, newsreel, training, and report.

The magazine war films deal mainly with news reports of general or specific interest, often held together by a common theme; they are released in a series, and imitate the style of popular publications. Two major American series[330] used during World War II were the MARCH OF TIME and THE ARMY-NAVY SCREEN MAGAZINE.

[325] As discussed throughout this chapter, categorizing films is a hazardous occupation. Suffice it to say that what is offered here is only one perspective. Its purpose is not to limit the subject but to provide a basis for discussion and for information about war films as a film genre. For another approach, see Jeanine Bassinger, THE WORLD WAR II COMBAT FILM: ANATOMY OF A GENRE (New York: Columbia University Press, 1986).

[326] For help in tracing the history of the documentary and the various opinions about forms and purposes, see Ann S. Utterback, "The Voices of the Documentarist," JOURNAL OF THE UNIVERSITY FILM ASSOCIATION 29:3 (Summer 1977):31-5; Jay Ruby, "The Image Mirrored: Reflexivity and the Documentary Film," ibid., 29:4 (Fall 1977):3-11; Richard M. Blumenberg, "Documentary Films and the Problem of 'Truth'," ibid., pp.19-22; and Seth Feldman, "Viewing, Viewed: A Critique of Subject-Generated Documentary," ibid., pp.23-6, 35-6.

[327] Richard Whitehall, "One . . . Two . . . Three . . . : A Study of the War Film," FILMS AND FILMING 10:11 (August 1964):8.

[328] Isenberg, pp.114-5.

[329] Raymond Fielding makes the point that after more than half a century no satisfactory definition for "documentary" exists. "The only thing that everyone seems to agree upon," he observes, "is that 'documentary' film is supposed to be 'true' and seems to have something to do with 'reality.'" THE MARCH OF TIME, p.69.

[330] Two other series worth considering, time permitting, would be RKO-Pathe's THIS IS AMERICA and the National Film Board of Canada's THE WORLD IN ACTION. The former's emphasis over a ten year period was on the American way of life in peace and war. See Richard Meran Barsam, "THIS IS AMERICA: Documentaries for Theaters, 1942-1951," CINEMA JOURNAL 12:2 (Spring 1973):22-38. Rpt. NONFICTION FILM THEORY, pp.115-35. THE WORLD IN ACTION, a monthly series that ran from 1942 to 1945, was produced by John Grierson and written and directed by Stuart Legge. Modeled after the MARCH OF TIME, it carried Canada's wartime perspective abroad while its counterpart CANADA CARRIES ON handled issues domestically. "For what they had to say," stated Richard Griffith, "THE WORLD IN ACTION series stands

The former, which began in 1935 by Time-Life, Inc. under the direction of Louis De Rochemont, used a new means of screen journalism to inform the public on current events. With the help of talented impersonators, the controversial film unit reconstructed important happenings in order to give mass audiences the impression that the MARCH OF TIME was both omnipotent and fearless in its imaginative coverage of the news. That distinctive quality gradually disappeared during the war years, with the filmmakers putting more emphasis on stock footage and didactic messages than on originality and provocative issues.[331] THE ARMY-NAVY SCREEN MAGAZINE, on the other hand, was a biweekly series prepared for the servicemen wherever they were stationed to show them what was happening at home and abroad. These films were used by the government to boost morale and to provide combat troops with up-to-date information on the war.

The propaganda film was designed to let the people know what the war was about and why we were involved in it. One of the best examples of this type was the WHY WE FIGHT series, under the supervision of Frank Capra. As Dorothy B. Jones pointed out,

These films were designed to make the men in our Armed Forces acutely aware of the dangers of totalitarianism and of the outstanding contributions and sacrifices of our allies in the global struggle. Composed primarily of newsreel clips and stock-library footage, these pictures were widely shown in the United States and overseas; and they were carefully studied and admired by Soviet filmmakers, ever conscious of the great propaganda powers of the motion picture.[332]

No doubt what made one of the biggest impressions on propagandists was the skill with which Capra's highly emotional history lessons took captured enemy film footage and manipulated it for completely different purposes than those originally intended by the Axis filmmakers.[333]

In contrast to American propaganda films were the more elaborate Nazi war propaganda movies.[334] As early as 1933, Goebbels had recognized the importance of newsreels and documentaries as a means to enslave the minds of the German people.

among the most remarkable films made at any time. In striking contrast to other forms of news-interpretation, they rarely over-simplified." See Griffith, DOCUMENTARY FILM, p.334.

[331] THE MARCH OF TIME, p.277. See also Raymond Fielding, "Time Flickers Out: Notes on the Passing of THE MARCH OF TIME," THE QUARTERLY OF FILM, RADIO, AND TELEVISION 11:4 (Summer 1957):354-61; and ___, "Mirror of Discontent: THE MARCH OF TIME and Its Politically Controversial Film Issues," WESTERN POLITICAL QUARTERLY 12:1 (March 1959):145-52

[332] Dorothy B. Jones, "Hollywood War Films: 1942-1944," p.13. See also William Thomas Murphy, "The Method of WHY WE FIGHT," THE JOURNAL OF POPULAR FILM 1:3 (Summer 1972):185-96; and William J. Blakefield, "A War Within: The making of KNOW YOUR ENEMY--JAPAN," SIGHT AND SOUND 52:2 (Spring 1983):128-33.

[333] For an excellent discussion of the problems connected with the production of the WHY WE FIGHT series, see *Frank Capra, THE NAME ABOVE THE TITLE: AN AUTOBIOGRAPHY (New York: Macmillan, 1971), pp.326-50; and Thomas William Bohn, AN HISTORICAL AND DESCRIPTIVE ANALYSIS OF THE WHY WE FIGHT SERIES (New York: Arno Press, 1977).

[334] For those readers interested in studying how the Soviet government used film propaganda in World War II, a good overview is provided by Sergei Drobashenko and Peter Kenez, "Film Propaganda in the Soviet Union, 1941-1945: Two Views," FILM AND RADIO PROPAGANDA IN WORLD WAR II, ed. K. R. M. Short (Knoxville: The University of Tennessee Press, 1983), pp.94-124. For viewing purposes, readers should consult the Soviet documentary film library in the Axelbank Collection of the Hoover Archives, Stanford, California.

Starting at first with Eisenstein's BATTLESHIP POTEMKIN/BRONENOSETS POTEMKIN (1925) as his model and then abandoning its fictional emphasis, Goebbels saw the advantage of reediting actual documentary footage so that a specific point could be made; in a sense, both he and Capra tried rewriting history.[335] The propaganda minister also used his newsreels (WOCHENSCHAU) to give the German nation a false sense of security. In fact, as Welch explains, the Nazi cinema, whether it featured documentaries or fiction films, was always seen by Goebbels as a means to open the door for escapism or WIRKLICHKEITSFLUCHT.[336] He attached so much importance to this concept that "he created administrative machinery to reopen cinemas as quickly as possible after air raids--with the obvious intention of diverting people's minds from the present political and human reality of war and building up their morale."[337] In this respect, Goebbels used good judgment. Most observers give the Nazi cameramen high marks for their visual imagination and cinematic originality in making documentary propaganda films. As an example, Peter Kenez points out the striking contrast in the early days of World War II between Nazi and Soviet filmmakers: "The biggest difference between the early German (such as BAPTISM BY [sic] FIRE and VICTORY IN THE WEST) and Russian documentaries was that the Germans showed victorious, fast-moving armies and skipped over the images of human suffering, while the Russians made it clear that war was hell."[338] Where the Nazi filmmakers proved vulnerable was in their unrealistic reporting. This became fatal after the Nazi defeat at Stalingrad, where their lack of objectivity cost them their credibility with audiences worldwide.

No documentary formula had as many mixed blessings from World War II as did the newsreels.[339] Produced, directed, and distributed by filmmakers and government agencies all committed to patriotic and propagandistic excellence, newsreels enjoyed an enormous popularity with mass audiences. Much of their World War II footage is still being used in many of the documentary and fiction films seen today. Usually scenes from them are spliced into the story lines of war films to provide a sense of realism. One of the most important aspects of wartime newsreels was that they gave the people on the home front, for the first time, the chance to hear and see the war in action. As the editors of LOOK explained:

> Since Pearl Harbor four-fifths of newsreel footage has dealt with some aspect of the total war. Newsreel cameras have accompanied bombers and fighters on thousands of plane raids; roved the Pacific with our naval task forces; portrayed historic landings in Africa, Italy and Normandy; revealed events of immense significance--raids on Tokyo, war in China, battles in the malarial slime of Jap-infested islands.[340]

[335] To explore this concept further, see Penelope Houston, "The Nature of Evidence," SIGHT AND SOUND 36:2 (Spring 1967):88-92; and Robert Vas, "Sorcerers or Apprentices," ibid., pp.199-204. To learn something about the Japanese approach, read Leona Protas Schecter, "World War II on Japanese Screens: A Documentary of US and Japanese Newsreel Clips Elicited Pacifistic--and Other--Reactions," FILM IN REVIEW 8:3 (March 1957):108-10.

[336] For another perspective, see Daniel M. Kimmel, "Goebbels' Work," FILM COMMENT 22:6 (December 1968):74-5.

[337] Welch, p.43.

[338] Kenez, pp.110-11.

[339] Julien Bryan, "War Is, Was, and Always Will Be, Hell," THE DOCUMENTARY TRADITION, pp.167-74.

[340] LOOK, MOVIE LOT, p.26.

Out of these newsreel accounts filmmakers created some of the best documentaries on war. Unfortunately, as Fielding has documented, the newsreel also experienced a number of significant changes in World War II that eventually led to its decline.[341]

Another subgenre of the documentary war film is the training movie, the purpose of which is to teach our servicemen the techniques of war. At the outbreak of World War II, as Richard Shale points out, training films were an unexplored field, for

> No one quite knew what an ideal training film should consist of. What was the optimum length? Should the films have humor or be all business? Should they be designed for multiple screenings? Was color worth the added cost? Should the films conclude with a review session? The only value that everyone agreed on, especially for the top secret films for strategic warfare, was quick production.[342]

Using the elements of story, music, sound effects, and color, the producers of these films combined the appeals of the commercial film with those of the audiovisual movie. Inexperienced civilians were taught a range of skills through the motion picture, including how to use weapons, understand military discipline, and identify enemy aircraft. One example of such training films is Walt Disney's FOG (1943). This animated movie was designed to orient pilots to the problems of aerial navigation. It is also a fine example of Disney's educational cartoons made for the war effort.

The reportage documentary is a more elaborate documentary survey of a particular event presented from a first-person point of view. These films constitute the best wartime documentaries. Some outstanding American examples of this type are John Ford's THE BATTLE OF MIDWAY (1942), John Huston's BATTLE OF SAN PIETRO, Louis De Rochemont's THE FIGHTING LADY, and William Wyler's MEMPHIS BELLE (all in 1944). Notable British examples include Harry Watt's TARGET FOR TONIGHT (1941), Humphrey Jennings's FIRES WERE STARTED (1943), and Paul Rotha's WORLD OF PLENTY (1944).

One approach to studying the war film is to compare and contrast those particular features that are unique to the documentary and fiction films. This section and the next with their various tables are, in part, arranged to help in such an analysis. The contrast-comparison approach takes into account a theoretical producer-audience process typical of film industry operations. It also goes beyond the simplistic assumption that movies are only commercial ventures using successful formulas in a standardized fashion to maximize profits. The value of such an approach comes in showing that even though patterns transcend individual films, uniqueness and repetition in genres are not incompatible concepts. This perspective on the war film further reinforces the concept that filmmakers rely on contemporary cultural conflicts and recent technological developments as primary sources for modernizing familiar and popular screen traditions. It demonstrates as well the validity of Julian Smith's assertion that "the treatment of WAR in a nation's films provides a crucial index to popular concepts of patriotism, national purpose, and relationships with the rest of the world."[343]

The patterns of World War II documentaries and their effects upon other types of film, for example, have been the source of an interesting analysis by Douglas W. Gallez. Defining documentary movies as "those factual films that inform the public about the doings of men in wartime,"[344] his study examines some of America's best wartime documentaries, among them the WHY WE FIGHT series (1942-1945), REPORT

[341] THE AMERICAN NEWSREEL, pp.294-6.

[342] Richard Shale, DONALD DUCK JOINS UP: THE WALT DISNEY STUDIO DURING WORLD WAR II (Ann Arbor: UMI Research Press, 1982), pp.24-5.

[343] Julian Smith, p.5.

[344] Douglas W. Gallez, "Patterns in Wartime Documentaries," THE QUARTERLY OF FILMS, RADIO AND TV 10:2 (Winter 1955):125.

FROM THE ALEUTIANS (1943), BATTLE OF SAN PIETRO, THE FIGHTING LADY, and
MEMPHIS BELLE (all in 1944), and LET THERE BE LIGHT (1946).
 Although not intended as an analysis of cliches in fiction war films, Gallez's
study provides an excellent review of how the documentary film influenced fiction
movies. He points this out through discussion of significant scenes that have been
used again and again: soldiers waiting for the enemy's attack, the American flag still
flying after the battle is over, and heroic fliers returning to the bases of operation
after successful raids on the enemy. The sound tracks are punctuated with machine
gun fire, the sputtering of engines, the explosions of downed planes and of bombs.
In addition, there are many scenes of bombing missions, beginning with the fueling
and loading of the bombers, the briefing of the crews, the overloaded jeeps carrying
the men to their planes, and the planes one by one leaving their bases. During the
flight to their destination, the crews are seen as human beings with personal
problems. Once over the target, there are the sounds of anti-aircraft guns, the
fights with enemy planes, and the dropping of bombs. When the mission is completed,
the planes return home, and we have the scenes of anxious officers and ground crews
tensely waiting for the crippled ships to return. Suddenly there is the sound of the
first returning bombers, then the counting of the planes, the stationing of emergency
landing vehicles for the damaged ships, the emergency landings, and the depiction
of fatigue. Almost always there are close-ups of the tired and weary men who fight
the dirty war. In addition, there are often scenes of the battles, with the weather
and the terrain as enemies that plague the foot soldier as well as the pilots. These
are usually exemplified by showing men building airstrips or fighting in jungles. And
finally, there are often shots of the men themselves: lonely but somehow existing,
finding joy where they can, particularly in mail from home.
 Gallez, in summarizing the patterns emerging from these standard elements,
makes three major points. First, the filmmakers emphasized the personal touch by
trying to let the audience identify with the combat troops. Second, every effort was
made to stress the importance of teamwork in winning the war; no one individual was
more important than another. And third, the war documentaries propagandized the
religious and moral righteousness of our fight. We were the men of peace, forced into
combat to preserve justice. Once the battle ended, we would return to our quiet
and gentle lives.[345]
 Richard Meran Barsam adds to Gallez's research by approaching the patterns
of World War II American and English documentaries from the perspective of functions.
Indicating that the subgenres can take various forms (e.g., training films,
propaganda films, reconnaissance films), he identifies the broad way in which
documentary films adapt to audience needs, production requirements, and specific
tasks assigned to them by their sponsors. His one additional caveat is that
documentary films made during the final stages of the conflict--e.g., LET THERE
BE LIGHT and REUNION/LE RETOUR (both in 1946)--illustrate the human cost of the
war in physical and psychological terms, as well as the steps necessary to rebuild
the peace.[346]
 A second and more comprehensive method for analyzing the war film is to study
chronologically the growth and development of the genre through the four major wars
America was involved in during the twentieth century. In this section, five historical
tables on documentary war films are provided for such a purpose. The shifting
emphasis in World War I, for example, from pacifism to preparedness to actual combat
(See TABLE 1) illustrates how filmmakers handled the complex issues of film
propaganda, historical accuracy, and government control. In examining these films,
it's worth contrasting Fielding's view that vigorous newsreel censorship resulted in
little that was visually interesting,[347] with Brownlow's assertion that the documentary

[345] Gallez, pp.134-35.

[346] NONFICTION FILM, pp.163-4.

[347] THE AMERICAN NEWSREEL, pp.109-10.

material from this period contains invaluable data.[348] The historical evidence clearly demonstrates how the films of the era tried to subordinate the intellect to the emotions, how debate was discouraged, how widespread acceptance of a particular point of view was developed, and how controversial issues were oversimplified. Even the most minimal review should demonstrate the importance of the war film genre not only for its ability to attract and maintain mass audiences, but also for the use of its conventions and inventions for rationalizing changes taking place in society. Equally significant is an awareness of how the formula, through its conventions and inventions, operates as a means of reassuring and comforting audiences concerned about the changes and traumas taking place in society.

TABLE 1

SELECTED WORLD WAR I FILMS

DOCUMENTARY

Year	Movie
1915	GERMANY IN WARTIME
1916	AMERICA UNPREPARED; THE BATTLE OF THE SOMME; GERMANY ON THE FIRING LINE
1918	AMERICA'S ANSWER
1919	THE LOG OF THE U-35
1921	ZEEBRUGGE
1922	YPRES
1926	THE ATTACK ON ZEEBRUGGE
1927	FIGHTING FOR THE FATHERLAND/THE WORLD WAR AS SEEN THROUGH GERMAN SPECTACLES/DER WELTKRIEG
1931	HEROES ALL
1932	THE CRY OF THE WORLD
1933	HELL'S HOLIDAY, FORGOTTEN MEN, THIS IS AMERICA
1934	THE FIRST WORLD WAR, THE GERMAN SIDE OF THE WAR
1935	BILDDOKUMENTE
1940	THE RAMPARTS WE WATCH
1963	CBS'S GREAT WAR (TV SERIES)
1965	OVER THERE, 1914-1918
1972	GOODBYE BILLY--AMERICA GOES TO WAR 1917-18
1977	MEN OF BRONZE

The World War II documentaries (See TABLE 2) contain the most carefully analyzed and critically discussed films in the subgenre. For that reason, it may be the most valuable era by which to begin an in-depth study of the documentary war film from a global perspective. By contrasting and comparing the films of the Allied and Axis powers, researchers can demonstrate the complex relationship between myth and the media. That is, hindsight provides us with the ability to see in a nation's films its wartime values, beliefs, fears, and aspirations as presented and interpreted by a specific generation of filmmakers.

[348] Brownlow, p.3.

TABLE 2

SELECTED WORLD WAR II FILMS

DOCUMENTARY

Year	Movie
1935	TRIUMPH OF THE WILL
1938	CRISIS; THE FOUR HUNDRED MILLION
1939	SPAIN/ISPANIYA; LIGHTS OUT IN EUROPE; SIEGE
1940	THEY ALSO SERVE; LONDON CAN TAKE IT; MEN OF THE LIGHTSHIP; BAPTISM OF FIRE/FEUERTAUFE
1941	TARGET FOR TONIGHT; FRANKLIN D. ROOSEVELT: DECLARATION OF WAR
1942	LISTEN TO BRITAIN; MOSCOW STRIKES BACK/THE DEFEAT OF THE GERMAN ARMIES NEAR MOSCOW/RAZGROM NEMETZKICH VOISK POD MOSKOVI; OUR RUSSIAN FRONT; LENINGRAD AT WAR/LENINGRAD V. BORBE; UNITED WE STAND; THE WORLD AT WAR; SCORCHED EARTH; WE ARE MARINES
1943	FIRES WERE STARTED; THE SILENT VILLAGE; DESERT VICTORY; STALINGRAD; THE BATTLE OF RUSSIA (WHY WE FIGHT); THE BATTLE OF BRITAIN (WHY WE FIGHT); THE NAZIS STRIKE (WHY WE FIGHT); AT THE FRONT; VICTORY THROUGH AIR POWER; REPORT FROM THE ALEUTIANS
1944	THE NEGRO SOLDIER; THE BATTLE OF MIDWAY; THE BATTLE OF SAN PIETRO; THE FIGHTING LADY; MEMPHIS BELLE; THE BATTLE OF CHINA (WHY WE FIGHT); WORLD OF PLENTY; WESTERN APPROACHES (THE RAIDER); WITH THE MARINES AT TARAWA; TUNISIAN VICTORY; ATTACK! THE BATTLE OF NEW BRITAIN; THE BATTLE FOR THE MARIANAS; BEACHHEAD FOR BERLIN
1945	THE TRUE GLORY; FIGHT FOR THE SKY; RUSSIA AT WAR; WAR COMES TO AMERICA; NAZI CONCENTRATION CAMPS; BERLIN; BROUGHT TO ACTION; THE FIGHTING LADY; FURY IN THE PACIFIC; TO THE SHORES OF IWO JIMA; THE FLEET THAT CAME TO STAY; APPOINTMENT IN TOKYO
1946	REUNION/LE RETOUR; LET THERE BE LIGHT; YANKS BOMB TOKYO
1947	TWO DECADES OF HISTORY
1949	THE NUREMBERG TRIALS
1951	FIGHTERS FOR DEMOCRACY
1952	HOTEL DES INVALIDES; BATTLE FOR LEYTE GULF; DESIGN FOR PEACE: SURRENDER OF JAPAN AND AFTERMATH OF WAR; THE FATE OF EUROPE--BLACK SEA, SOUTH OF FRANCE, SURRENDER; GUADALCANAL, MIDWAY IS EAST. . . .; JAPANESE VICTORIES AND THE BATTLE OF MIDWAY; NORMANDY D-DAY; ROAD TO MANDALAY: CHINA, BURMA, INDIA AND INDIAN OCEAN; ROMAN RENAISSANCE: SICILY AND THE ITALIAN CAMPAIGN; SEA AND SAND: INVASION OF NORTH AFRICA 1942-1943; TARGET SURIBACHI: IWO JIMA; DWIGHT D. EISENHOWER: FROM SOLDIER TO PRESIDENT; SUICIDE ATTACK
1954	VICTORY AT SEA
1956	WORLD WAR II; PROLOGUE U. S. A.
1957	BATTLE OF BRITAIN (CBS); HITLER INVADES POLAND; PACIFIC PATTERN; SCUTTLING OF THE GRAF SPEE; VICTORY IN EUROPE
1958	TWISTED CROSS; NIGHTMARE IN RED
1959	FDR: THIRD TERM TO PEARL HARBOR; LAND OF LIBERTY, PART 5; MINISTER OF HATE; MUSSOLINI; THE WEEK THAT SHOOK THE WORLD
1960	MEIN KAMPF; FOCUS ON 1941: AMERICA GOES TO WAR; FROM KAISER TO FUEHRER; GERMANY TODAY; GOERING; TRIAL AT NUREMBERG (CBS); MILESTONES OF THE CENTURY
1961	EICHMANN AND THE THIRD REICH/EICHMANN UND DAS DRITTE REICH; THE LIFE OF ADOLF HITLER/DAS LEBEN ADOLF HITLER; GENERAL GEORGE C. MARSHALL; FIGHTING MAN: THE STORY OF GENERAL GEORGE S. PATTON; AFTER MEIN KAMPF

1962	AFTERMATH OF WORLD WAR II: PROLOGUE TO THE COLD WAR; CZECHOSLOVAKIA: FROM MUNICH TO MOSCOW; VICTORY IN THE SOUTH PACIFIC; WE'LL BURY YOU!; D-DAY; SMASHING OF THE REICH; KAMIKAZE
1963	DECEMBER 7th--DAY OF INFAMY; BEACH HEAD AT ANZIO; FRANKLIN D. ROOSEVELT, PART 2: THE WAR YEARS (WOLPER); HITLER: NAZI-SOVIET WAR: PARTISAN; TRIUMPH OF THE AXIS; WORLD WAR II: BACKGROUND AND CAUSES; WORLD WAR II: 1939-1941; WORLD WAR II: 1942-1945
1964	BATTLE OF BRITAIN (WOLPER); FOCUS ON 1939: EUROPE GOES TO WAR; FOCUS ON 1945; NINETEEN THIRTY-NINE: EUROPE GOES TO WAR; OLD SOLDIER: DOUGLAS MACARTHUR; THE OLD SOLDIER: DUTY, HONOR, COUNTRY; TRIAL AT NUREMBERG (CBS), TRIAL AT NUREMBERG, BLOOD ON THE BALCONY, THE FINEST HOURS
1965	DECISION TO DROP THE BOMB; AGE OF THE ATOM, WORLD WAR II: 1935-1965; GENERAL GEORGE PATTON; GENERAL GEORGE MARSHALL; HALSEY VS. YAMAMOTO: TURNING POINT; JAPAN: A NEW DAWN OVER ASIA; THE NISEI: THE PRIDE AND THE SHAME; ROOSEVELT VS. ISOLATION; WARSAW GHETTO
1966	ORDINARY FASCISM/OBYKONOVENN FASCHISM; THE LION AND THE EAGLE, PARTS 1 & 2; VICTORY AT SEA; THE BATTLE OF THE BULGE--THE BRAVE RIFLES, THE EAST IS RED
1967	ATLANTIC PARTNERSHIP, 1939-1941; THE PACIFIC BOILS OVER--PEARL HARBOR, DECEMBER 7, 1941
1968	TRIUMPH OVER VIOLENCE
1969	HITLER: ANATOMY OF A DICTATORSHIP; WORLD WAR II: TOTAL WAR
1970	HIROSHIMA--NAGASAKI, AUGUST 1945; GUADALCANAL--ISLAND OF DEATH, PART I & II; WORLD HISTORY FROM 1917 TO PRESENT, 5 FILMS: THE RISE OF HITLER, HITLER'S WAR, THE NEW EUROPE, BRITAIN AND EUROPE, STALIN'S REVOLUTION
1972	GUILTY BY REASON OF RACE; AMERICA: A PERSONAL HISTORY OF THE UNITED STATES, NO. 11--THE ARSENAL, PARTS 1 & 2; GOTTERDAMMERUNG: FALL OF THE THIRD REICH; NAZI GERMANY: YEARS OF TRIUMPH
1973	THE AMERICAN PEOPLE IN WORLD WAR II; HISTORY OF U. S. FOREIGN RELATIONS, PART 3--THE RELUCTANT WORLD POWER
1974	INSIDE THE THIRD REICH; FRANKLIN ROOSEVELT: THE WAR YEARS (HISTORY MAKERS); FRANKLIN ROOSEVELT: WAR COMES TO AMERICA; GERMANY--THE ROAD OF RETURN; HARRY S. TRUMAN: SUDDENLY, MR. PRESIDENT; HISTORY BOOK, VOLUME 7--THE COMING OF DARKNESS; ROOSEVELT AND U. S. HISTORY (1930-1945); THE WORLD AT WAR (26 FILMS)
1975	THIS IS EDWARD R. MURROW
1976	LOWELL THOMAS REMEMBERS: (6 FILMS, 1939-1944)
1979	TO REMEMBER THE FALLEN: CONFLICT IN JAPAN; EDWARD TELLER--AN EARLY TIME
1980	WORLD WAR TWO: GI DIARY; LIFE AND TIMES OF ROSIE THE RIVETER
1982	A WAR STORY
1984	THE DAY AFTER
1985	THREADS; NORMANDY TO BERLIN: A WAR REMEMBERED (PBS); THE TOKYO TRIAL; LE TEMPS DETRUIT/TIME DESTROYED; UNFINISHED BUSINESS

Students can also draw upon the previous discussions concerning distortions and censorship to evaluate how valuable and reliable documentaries are as a source of historical evidence. At the same time, they can compare and contrast the films of the

Cold War (See TABLE 3) and the Vietnam War (See TABLE 4) to other records of political history, particularly in the areas of historical results and reactions. Much is known about the intentions of filmmakers concerning morale and propaganda, but not much solid information exists about the effectiveness of such efforts. Here would be a good starting place to examine how values in films changed and which new interpretations most clearly captured the spirit of the age.

TABLE 3

SELECTED COLD WAR FILMS

DOCUMENTARY

Year	Movie
1959	JOSEPH MCCARTHY
1961	SECRET WAYS
1963	FORGOTTEN IMPERIAL ARMY/WASURERAETA KOGUN
1964	RING OF TREASON; POINT OF ORDER
1965	DECISION TO DROP THE BOMB
1973	PUEBLO AFFAIR; I. F. STONE'S WEEKLY
1974	UNQUIET DEATH OF JULIUS AND ETHEL ROSENBERG
1975	MISSILES OF OCTOBER; BETTER ACTIVE TODAY THAN RADIOACTIVE TOMORROW; FEAR ON TRIAL; LOVEJOY'S NUCLEAR WAR
1976	HOLLYWOOD ON TRIAL
1978	WAR WITHOUT WINNERS
1979	SURVIVAL . . . OR SUICIDE; AN AMERICAN ISM: JOE MCCARTHY; PAUL ROBESON: TRIBUTE TO AN ARTIST; PAUL JACOBS AND THE NUCLEAR GANG
1980	FIRST STRIKE; DAY AFTER TRINITY; J. R. OPPENHEIMER AND THE ATOMIC BOMB; A GOOD EXAMPLE; LAST EPIDEMIC
1981	EIGHT MINUTES TO MIDNIGHT: A PORTRAIT OF DR. HELEN CALDICOTT; END OF INNOCENCE; CASE OF THE LEGLESS VETERAN: JAMES KUTCHER; NICK MAZZUCO: BIOGRAPHY OF AN ATOMIC VET
1982	NO PLACE TO HIDE; SURVIVORS; DARK CIRCLE; THE ATOMIC CAFE; TO DIE, TO LIVE: THE SURVIVORS OF HIROSHIMA; IF YOU LOVE THIS PLANET; AMERICA--FROM HITLER TO MX; THE WEAVERS: WASN'T THAT A TIME; BUTTON, BUTTON: A DREAM OF NUCLEAR WAR; GODS OF METAL; THE TIME HAS COME
1983	PROPHECY, SL1
1984	BIRDY
1985	ON THE 8TH DAY

Although the films about the various wars, as G. R. Elton pointed out, will shed little light on planning or decision making, they will in the case of the Vietnam War have visually "recorded some of the major consequences and reactions to . . . [those decisions], both on the streets and campuses of the United States and in the jungles of Southeast Asia."[349] That is, the film records will provide us with examples of political rhetoric, the physical trappings of authority, as well as the dynamics of popular opinion. Students can evaluate how the documentaries represented political ideology and the values of those who made the films, while analyzing the relationship

[349] Cited in THE HISTORIAN AND FILM, p.61.

between the filmmaker and society. In that way, a determination can be made about the important distinction between documentaries that report the facts and those that faithfully reflect the facts.

TABLE 4

SELECTED VIETNAM WAR FILMS

DOCUMENTARY

Year	Movie
1955	VIETNAM
1965	QUIXOTE; WHY VIETNAM?; NGUYEN HUN THO SPEAKS TO THE AMERICAN PEOPLE; THE WAY TO THE FRONT; WITH A SOUTH VIETNAMESE MARINE BATTALION
1966	MONDO BIZARRO; A PILGRIMAGE FOR PEACE: POPE PAUL VI VISITS AMERICA; VIETNAM IN TURMOIL
1967	INSIDE NORTH VIETNAM; SONS AND DAUGHTERS; 23RD PSALM BRANCH; THE SEVENTEENTH PARALLEL/LE DIX-SEPTIEME PARALLELE; HANOI; TUESDAY THE 13TH; LAOS, THE FORGOTTEN WAR; PILOTS IN PYJAMAS: FAR FROM VIETNAM/LOIN DU VIETNAM; MORLEY SAFAR'S VIETNAM; THE ANDERSON PLATOON; FACES OF IMPERIALISM; TIME OF THE LOCUST
1968	A FACE OF WAR; FOR LIFE; AGAINST THE WAR; NO VIETNAMESE EVER CALLED ME NIGGER; FIRE; INSIDE VIETNAM; THE DEMONSTRATION; THE BATTLE OF CHICAGO; IN THE YEAR OF THE PIG
1969	HIGH SCHOOL; SOME EVIDENCE; SEVENTY-NINE SPRINGTIMES; ARTS VIETNAM; TERRY WHITMORE, FOR EXAMPLE
1970	SKEZAG; SAD SONG OF YELLOW SKIN; THE BACK-SEAT GENERALS, THE PEOPLE AND THEIR GUNS/LE PEUPLE ET SES FUSILS; NAPALM
1971	INTERVIEW WITH MY LAI VETERANS; THE SELLING OF THE PENTAGON
1972	WINTER SOLDIER
1973	VIETNAM EPILOGUE
1975	HEARTS AND MINDS
1976	SEARCH FOR GREEN EYES
1977	VIETNAM: PICKING UP THE PIECES; THE CLASS THAT WENT TO WAR
1979	VIETNAM: AN AMERICAN JOURNEY
1980	THE WAR AT HOME; AGENT ORANGE: A STORY OF DIGNITY AND DOUBT; FRONTLINE
1981	WARRIORS' WOMEN; VIETNAM DOCUMENTARY
1982	VIETNAM REQUIEM; THE SILENCE; GOING BACK: A RETURN TO VIETNAM
1983	VIETNAM: A TELEVISION HISTORY
1988	DEAR AMERICA: LETTERS HOME FROM VIETNAM

No study of the war film, however, would be complete without an examination of the tragic and incomprehensible events examined in Holocaust films (See TABLE 5). Not only do the various attempts to record the Nazi genocide against six million European Jews defy our imagination, but also they make us examine the essential issues of history on and in film. Documentary films made by survivors as well as those of later generations have stirred enormous controversies over whether or not the arts have the ability to capture the essence of the horror itself. Men like Elie Wiesel and Bruno Bettleheim understand the paradox of wanting to speak out on the Holocaust, but knowing that any attempts by artists to represent the enormity of what took place is essentially futile. They point out that what happens instead in many of these works

TABLE 5

SELECTED HOLOCAUST FILMS

DOCUMENTARY

Year	Movie
1944	MAJDANEK
1945	JASENOVAC
1946	JUDGMENT OF THE NATIONS/SUD NARADOV
1947	THE ILLEGALS
1948	NUREMBERG/NURNBERG
1955	NIGHT AND FOG/NUIT ET BROUILLARD
1960	KAPO
1962	THE WITNESSES/LA TEMPS DU ONETTO
1964	SIGHET, SIGHET
1970	THE SORROW AND THE PITY/LE CHAGRIN ET LA PITIE
1973	L'CHAIM--TO LIFE!
1975	SHADOW OF DOUBT/EEN SCHISN VAN TWIJFEL; THE 81st BLOW
1976	THE MEMORY OF JUSTICE
1977	THE WORLD AT WAR: THE FINAL SOLUTION
1978	OUR HITLER, A FILM FROM GERMANY/HITLER, EIN FILM AUS DEUTSCHLAND; IN DARK PLACES: REMEMBERING THE HOLOCAUST; THE LAST CHAPTER
1979	THIRTY-FOUR YEARS AFTER HITLER: TOP SECRET--THE HISTORY OF THE GERMANS; THE LAST SEA
1980	AS IF IT WERE YESTERDAY/COMME SI C'ETAIT HIER; KITTY: RETURN TO AUSCHWITZ; DANZIG-1939; OUR TIME IN THE GARDEN; AUSCHWITZ STREET/LAGERSTRASSE AUSCHWITZ; IMAGE BEFORE MY EYES
1981	RETURN TO POLAND; NOW . . . AFTER ALL THESE YEARS/JETZT . . . NACH SO VIELEN JAHREN; WHO SHALL LIVE AND WHO SHALL DIE?; THE ALIEN'S PLACE; GENOCIDE; THE STORY OF CHIAM RUMKOWSKI AND THE JEWS OF LODZ
1982	THE PARTISANS OF VILNA
1983	YEARS OF DARKNESS; YOU ARE FREE; THE DR. JOHN HANEY SESSIONS
1984	THE LAST SEA; OPEN SECRETS
1985	SHOAH; THE SPIES WHO NEVER WERE
1986	THE LIBERATION OF AUSCHWITZ
1987	TRANSPORTS OF DEATH
1988	HOTEL TERMINUS: THE LIFE AND TIMES OF KLAUS BARBIE; GOD DOESN'T BELIEVE IN US ANYMORE; SANTA FE; FAULKENEAU, THE IMPOSSIBLE: SAMUEL FULLER BEARS WITNESS; GOLUB
1989	LODZ GHETTO; VOICE FROM THE ATTIC; WEAPONS OF THE SPIRIT

is a trivialization and a vulgar distortion of a monstrous part of history.[350] A case in point is Laurence Jarvick's WHO SHALL LIVE AND WHO SHALL DIE? (1981). The ninety-minute film made by an American Jew in his mid-twenties attacks American Jews

[350] Elie Wiesel, "Art and the Holocaust: Trivializing Memory," trans. Iver Peterson, NEW YORK TIMES H (June 11, 1989):1, 38. See also Joshua Sobol, "The Holocaust: Of Plays and Playwrights," NEW YORK TIMES H (July 2, 1989):3.

and their organizations during World War II for failing to help rescue the European Jews.[351] Historian Lucy Dawidowicz's response to such a film is that "To anyone familiar with the history of the American Jewish community, the imputation of inaction is at once laughable and outrageous."[352] Political scientist Raul Hilberg, on the other hand, disagrees. He believes that "The leadership of the American Jewish Community psyched itself into a posture of impotence."[353] Artists argue, meanwhile, that silence is worse; and according to Michiko Kakutani, leads "to indifference and cynicism--the very things that . . . [led] to Hitler's rise."[354]

Of all the material treated by the war film, none will test the issues of historical accuracy, dramatic license, and film propaganda more than the various interpretations provided by documentary and fiction filmmakers.

The presumption in this section, therefore, is that documentary war films present the public with complex and controversial ideas that need to be discussed and understood both from the point of view of genres and of history. In addition, four wars in this century have given national film industries incredible opportunities not only to advance their art, but also to reexamine their aims and obligations.

BOOKS

GENERAL

*Barnouw, Erik. DOCUMENTARY: A HISTORY OF THE NON-FICTION FILM. New York: Oxford University Press, 1974. Illustrated. 332pp.

Drawing on a 1971-1972 odyssey to twenty countries, Barnouw gives us a wide-ranging descriptive history synthesizing what he learned from visiting important film archives, interviewing influential documentary filmmakers, viewing over seven hundred films from the early days of the cinema to the end of the 1960s, and scanning a substantial amount of printed material. The book's purpose is as much a public relations gesture as it is a much-needed survey of the documentary movement. Barnouw has spent a lifetime advocating the media's vital role in civilized society and takes this opportunity to encapsulate his ideas on who and what are essential to understanding the nonfiction film. He divides the story into five sections, providing a convenient taxonomy of the various roles the documentary filmmaker can assume: e.g., prophet, explorer, reporter, painter, advocate, bugler, prosecutor, poet,

[351] For more information, see *David S. Wyman, THE ABANDONMENT OF THE JEWS: AMERICA AND THE HOLOCAUST, 1941-1945 (New York: Pantheon Books, 1984); and *Haskel Lookstein, WERE WE OUR BROTHERS' KEEPERS? THE PUBLIC RESPONSE OF AMERICAN JEWS TO THE HOLOCAUST, 1938-1944 (Bridgeport: Hartmore House, 1986).

[352] Lucy Dawidowicz, "American Jews and the Holocaust," NEW YORK TIMES MAGAZINE (April 18, 1982):46.

[353] An interview with Professor Raul Hilberg of the Department of Political Science at the University of Vermont on January 3, 1984.

[354] Michiko Kakutani, "40 Years After, Artists Still Struggle With The Holocaust," NEW YORK TIMES 2 (December 5, 1982):1,16,17. See also Lawrence L. Langer, "The Americanization of the Holocaust on Stage and Screen," FROM HESTER STREET TO HOLLYWOOD: THE JEWISH-AMERICAN STAGE AND SCREEN, ed. Sarah Blacher Cohen (Bloomington: Indiana University Press, 1983), pp.213-30; John Corry, "Does the Holocaust Defy Dramatization?" NEW YORK TIMES 2 (April 12, 1987):27; Caryn James, "Critic's Notebook: 4 Films at Once on Holocaust Offer a Dialogue," ibid., C (November 1, 1988):17, 19; and Thomas Friedmann and Owen Shapiro, "Their Holocaust, Upon Watching Ours: THE DR. JOHN HANEY SESSIONS and OPEN SECRETS," JUMP CUT 34 (March 1989):64-72.

chronicler, promoter, observer, catalyst, and guerrilla. What the narrative lacks in critical insights is overshadowed by its illuminating mosaic of worldwide patterns. Although published a decade ago, it still remains the only text available that presents a meaningful global study of the nonfiction film. And despite the oversimplified transitions from one historical period to another, Barnouw is excellent at suggesting the scope of the genre's appeal. Neophytes, therefore, will find the book the best general introduction to the subject, while serious students should enjoy it as a nostalgic reminder of significant film history.

Barnouw's skillful blending of biography and film scholarship works best when applied to the genre's growth and development. For example, the distinguished scholar credits scientists like the French astronomer Pierre Juels Cesar Janssen and the English-born Eadweard Muybridge with inaugurating the cinema's fascination with films as a document. But it is Louis Lumiere whom he acknowledges as the true father of the nonfiction film. Unlike the materialistic Edison who produced the first marketable equipment, Lumiere is pictured as a pioneering genius whose prophetic insights about the new technology made nonfiction films practical and profitable. By rejecting the traditional arts as a model for the new medium, Lumiere established the future directions the documentary film could and would pursue. That direction, Barnouw reminds us, placed more value initially on imagination and ingenuity than on truth and ethics. "Faking" news stories was justified as being the enterprising thing to do, and "deceitful" films escaped criticism because of promotional phrases explaining the events depicted as "reconstitutions." Such questionable methods, plus the rise of the multi-reel film, are cited as the reasons nonfiction films soon declined in popularity. By 1910, however, the only notable achievement for the genre was the introduction of semiweekly newsreels. That perspective highlights the enormous breakthrough in documentary films started in 1922 by Flaherty. Barnouw portrays him as the premier explorer-documentarist celebrating the struggle of human beings against nature, but deeply troubled by the fact that his presence signaled the beginning of the end of the natives' traditional life styles. More important for Barnouw than the romantic distortions Flaherty presented of vanishing cultures were the permanent images he recorded of people and values alien to an industrialized society. The noncontentious nature of Flaherty's films as well as those of painters-as-documentarists like Hans Richter, Walther Ruttmann, Alberto Cavalcanti, Jean Vigo, and Joris Ivens are seen being subverted in the 1930s as the result of ideological struggles brought about by worldwide economic troubles. Grierson emerges as an inspired advocate-as-documentarist whose brilliant theories gave birth to a new generation of filmmakers with a missionary zeal to lead the industrialized nations to a better way of life for their citizens. Interestingly, Barnouw acknowledges the criticisms that men like Grierson and Rotha leveled against Flaherty, but takes no sides in the controversy. We are simply told that the influence of the latter's "reactionary return to the worship of the heroic," (Rotha's opinion), was superseded in the 1930s by Grierson's emphasis on exploring the vital social issues of the era. The author is careful, however, not to credit Grierson with politicizing the documentary. That distinction is given to the Nazi filmmakers, led by Goebbels and exemplified by Riefenstahl. A third type of advocacy-in-documentary approach Barnouw finds highly significant was that staged by the much-ignored Workers Film and Photo League, which began in New York City in 1930. That loosely organized arrangement with its socially conscious documentaries foreshadowed the work done later in the decade by better known production groups like Frontier Films and The March of Time. Particularly useful are the links that Barnouw draws between the work done by Lorentz for the Resettlement Administration, the protest ideology of documentary American filmmakers in the 1930s, and the tensions between Hollywood and government agencies. Even with the narrative's insistence on brief, broad comments, we get enough information on President Roosevelt's propaganda techniques to see why informed members of Hollywood and Congress were reluctant to give the White House too much film support too quickly and without reservations. The narrative is at its best during the periods of the 1930s and 1940s, pointing out how documentary filmmakers throughout the world faced problems similar to those encountered in England, America, and Germany. With Barnouw assuming Grierson's role as a latter-day advocate for the nonfiction film, we rediscover the pressures put

on documentary filmmakers to maintain their humanistic concerns while still remaining loyal to national goals. During the 1940s, for example, he concludes that "the documentary had seldom been subtle or profound, but it had had power, and had assumed central importance. It had often outdrawn the fiction film. The documentarist had moved among world leaders." The new directions the genre took in the post-World War II era are interpreted as a direct result of a radical change in economic theories, a view expounded as well by Wright's SIXGUNS AND SOCIETY: A STRUCTURAL STUDY OF THE WESTERN. Just as the new role of corporations in society led to the Cold War era in politics, so it also led to a revolutionary change in the content and style of documentary films. Dissent now became the filmmakers' primary concern and conflict both with sponsors and audiences, a way of life. The filmmakers Barnouw admires most--e.g., Frederick Wiseman, Louis Malle, Jean Rouch, and George C. Stoney--are those who destroyed harmful stereotypes, who used their cameras as a powerful educational force for reform. In his summary chapter, the author eloquently argues that the plausibility of the nonfiction film, "its authority, is the special quality of the documentary--its attraction to those who use it, regardless of motive--the source of its power to enlighten or deceive."

All the anticipated problems you might expect from such a sweeping overview are present in the text. No mention is made, for example, of the abuses of the documentary film during wartime, while the distinguished Canadian productions of THE WORLD IN ACTION are ignored. Credit for inventions and theories is stated matter-of-factly, leaving the impression that the issues are noncontroversial. A case in point is W. K. L. Dickson. Barnouw's astonishing assessment of him as only "Edison's aide during KINETOSCOPE days" makes one very suspicious of the "facts" reported throughout much of his very entertaining narrative. That suspicion becomes equally apparent in the author's numerous errors concerning the production of Riefenstahl's films. Here, Barnouw's liberal leanings interfere with his critical judgments. He errs, as well, in thinking that newsreels appeared weekly, not biweekly, during the 1930s, or that TARGET FOR TONIGHT was made primarily during a real-life bombing run over Germany. Even when he summarizes a particular film's notable virtues, Barnouw sometimes fails to understand just what point of view the filmmaker is espousing. NIGHT AND FOG/NUIT ET BROUILLARD, for example, through its blurring of the distinctions Nazis made between Jews and other concentration camp inmates--e.g., political prisoners, Gypsies, homosexuals--makes a formidable statement on Nazi atrocities, but confuses the relationship between the Holocaust and other special victims of Hitler.

Many of the book's weaknesses can be understood in light of the author's purpose and ground-breaking efforts. He did not intend the text to be either definitive or critical. As long as readers are sensitive to the problems, they will find the narrative very fast reading and useful. The handsome illustrations, the international flavor of the subject, and the mass of material offer a useful beginning to the study of the nonfiction film. An extensive bibliography and index are included. Recommended for special collections.

*Barsam, Richard Meran. NONFICTION FILM: A CRITICAL HISTORY. Foreword Richard Dyer MacCann. New York: E. P. Dutton and Company, 1973. Illustrated. 332pp.

Much more limited in scope than Barnouw's history but with greater depth, this provocative survey deals almost exclusively with the growth and development of American and British nonfiction films. One reason for its limited focus is that Barsam rightly believes a book of this size could not deal realistically with the social, political, and economic factors that influence the production and distribution of nonfiction films. Another reason is that he feels students would find it frustrating to read about foreign films that could not then be viewed because the films are not readily available for rental from American and British film distributors. Thus only those early European films that have a direct influence on Anglo-American documentary film history are examined. Regrettably omitted are discussions of those films produced by the United States Information Agency and the National Film Board of Canada, on the shaky assumption that other books have covered the topic sufficiently. Barsam makes clear that he wants his focus to be on "idea" films--"films

which present solutions to major problems"--and on proving to readers that alternative solutions to those presented by the filmmakers exist. Recognizing the difficulty with making objective evaluations about problem-centered films, he sets as his primary goal the evaluation of such films "in the larger social context out of which the problems arose." His technique, however, offers a dubious distinction between content and form. Barsam stresses his concern with "what the films say, not on how they say it, because, for the most part, the technique of a nonfiction film is less important than its content." His opening chapter, therefore, concentrates on explaining why all documentaries are nonfiction films, but not the reverse. The argument that "nonfiction film" is a more flexible concept than "documentary" may not be an exciting discovery, but his analysis of the basic distinctions--e.g., sociopolitical purposes, journalistic biases, commercial goals--are valuable observations. The author's concern with the problems in terminology as well as in approaches and techniques underscores his considerable debt to Rotha's DOCUMENTARY FILM and the limitations caused by Barsam's own theoretical flaws. He claims, on one hand, to be updating the earlier work by dealing in more detail with the two great Flaherty-Grierson traditions of documentary, while on the other hand he remains rooted in the traditional categories set by Rotha: e.g., naturalist (romantic), realist (continental), newsreel, and propagandist.

Barsam's major contributions are more in the area of interpretation than in history. Unlike Barnouw, he ignores biographical blurbs and frequent illustrative material in mapping out the evolution of the nonfiction film. When discussing the cinematic influences on DRIFTERS (1929), for example, he argues that the film owes a greater debt to Eisenstein than to Cavalcanti or Ruttmann, but neglects the fact that Grierson had come from a four-year stint in America where he was influenced by the writings of Lippmann and Merriam. What's surprising is that this more detailed study does not provide a more significant history. The facts we get are available in other texts, where they are more handsomely presented. Barsam's critical style, however, and his process of synthesization are very valuable. He points out, for example, that while Grierson's approach to documentary filmmaking lacked the consistency needed to be called a philosophy, his revolutionary zeal made an immeasurable contribution by stimulating people and ideas about the value of the documentary film to society. The disagreements between Flaherty and Grierson are balanced more in favor of the romantic tradition, with the author arguing that the English movement failed to observe human beings as "intimately or as wisely as Flaherty did." Rotha's socially conscious perspective, while considered somewhat naive, is credited with steering the movement toward a more meaningful union of art and social purpose. The fact that filmmakers have often failed to meet Rotha's expectations is judged more a fault with them than with Rotha. Particularly noteworthy is the author's discussion of Cavalcanti's role in the documentary movement. While most authors pay lip service to the Brazilian's influence, few explain in sufficient detail how Cavalcanti differed from Grierson and Rotha in emphasizing the interrelationship of social, political, and technical factors. Barsam's brief discussions of European filmmakers also provide useful observations. He finds, for example, that the so-called political distinctions between Grierson and Ivens were of degree only, although he admits that the former never allowed politics to dominate his films while the latter almost always did. The author's comments on the distinctions between Capra's wartime films and those of Watt prove equally challenging, suggesting Capra saw the "war as a vast struggle between forces of right and wrong," whereas Watt viewed the "war in human not global terms." Barsam then goes on to explain that Watt's perspective is characteristic of most British wartime documentaries, "where people, not battles, are the concern, where defense planning, not propaganda, is the focus, and where the war effort is a sense of mission, not destiny." The book's strongest section deals with the new nonfiction film forms in the 1960s and early 1970s. It's here that Barsam passionately wrestles with the terminolgy that tries to make distinctions between nonfiction and fiction films. Students should find his

criticism of concepts like "direct cinema" very useful.[355] By the time one finishes reading the author's socially conscious narrative, you discover that he's almost always prepared to believe the worst about society's leaders and to admire those who document the problems best.

Given such a strong social conscience, Barsam is vulnerable on many fronts. He can readily be accused of being overly biased toward humanistic filmmakers like Flaherty, Rotha, and Wiseman, while less tolerant of wartime films by Vertov and Capra. It comes as a big surprise, therefore, when he lavishes excessive praise on the Riefenstahl Nazi films. Commenting on TRIUMPH OF THE WILL/TRIUMPH DES WILLENS (1935), for example, he writes, "It should be studied not as propaganda only, but also art of the highest order; no film has been more vilified for its subject matter, yet no film has been more misunderstood." That comment is but one small illustration of the thematic inconsistencies that permeate Barsam's historical outlook. He stresses throughout his pioneering study the need to view non-fiction films as a source for solving the world's vital problems, but then often extols those that either confuse the issues, or worse, compound them.

Serious students will find much in this narrative troublesome and disappointing, but necessary to discuss and debate. It represents a major effort to resolve long-standing controversies over issues, personalities, and events. The fact that it falls short of its objectives reveals not only the magnitude of the undertaking, but also the daring of the author. If nothing else, we owe him a debt of gratitude for putting the discussion on a scholarly level. A list of film sources, a bibliography, a filmography, and an index are included. Recommended for special collections.

*Barsam, Richard Meran, ed. NONFICTION FILM THEORY AND CRITICISM. New York: E. P. Dutton and Company, 1976. 382pp.

Focusing on British and American non-fiction films, this valuable anthology consisting of twenty-six uneven essays divides into four sections. The opening section offers perspectives on the basic ideas and definitions of the genre. Included are the pioneering principles of documentary proposed by Grierson and Rotha, as well as theories developed by Sir Stephen Tallents ("The Documentary Film"), Lindsay Anderson ("Free Cinema"), and A. William Bluem ("The Documentary Idea: A Frame of Reference"). The second section stresses both the relationships between non-fiction films and the specific contexts in which they are produced. The primary emphasis is on matters related to World War II, with significant research being supplied not only by experts like Grierson and Hardy, but also by essayists such as Richard Dyer MacCann ("World War II: Armed Forces Documentary" and "Film and Foreign Policy: The USIA, 1962-1967") and Philip Dunne ("The Documentary and Hollywood"). The third section presents critical evaluations of important filmmakers like Flaherty (Helen Van Dongen, Richard Corliss), Cavalcanti (Emir Rodriguez Monegal), Riefenstahl (Richard Meran Barsam), Jennings (Lindsay Anderson), Van Dyke (Harrison Engle), and Wiseman (Ira Halberstadt, David Denby). The final section offers behind-the-scenes accounts of non-fiction filmmaking by four directors: i.e., Van Dyke, Riefenstahl, Robert Gardner, and Ivens.

Professionally assembled and reasonably priced, the collection serves as an important resource for comparing and contrasting major theories and assumptions. Section One, for example, offers a good comparison of the Rotha-Grierson approaches, while calling attention to the often unacknowledged influences that the early John Ford movies had on the EMB and GPO filmmakers. It's also useful for outlining the broken-but-undeniable link between the early British documentary movement and modern-day television. Section Two is by far the most stimulating area for reviewing the effect of World War II on non-fiction films. Rarely in one source have the arguments for studying movies in the context of their time been more persuasively presented. Of particular value is the opportunity to contrast and compare the goals

[355] For another perspective on "direct cinema," see Vivian C. Sobchack, "NO LIES: Direct Cinema as Rape," JOURNAL OF UNIVERSITY FILM ASSOCIATION 29:4 (Fall 1977):13-8.

and policies of the United States government-made films with those of The National Film Board of Canada and The March of Time. Robert T. Elson's outdated essay on The March of Time, however, is one of the anthology's more questionable selections. Filled with factual errors about Henry Luce and Roy Larsen, misinterpretations concerning the films' being analogous to newsreels, and oversimplifications about the enterprise itself, it should be consulted only after reading Fielding's book-length study. Weaknesses in the collection become even more noticeable in Section Three, as the editor strains to include Riefenstahl in his roster of important divergent filmmakers who "are committed to the particular truth that distinguishes their art." The insidious Nazi director is without doubt significant for what she did, but to claim that her work "enriched film history" or that her "regrettable mistake" is mainly that of placing "ambition ahead of everything else" poses more problems than Barsam's essay solves. To Barsam's credit, he includes in this section Van Dyke's evaluation of Riefenstahl's Nazi films as "slick, superficial." The problem is compounded, however, in Section Four when the editor leaves unchallenged Riefenstahl's outright lies that neither Goebbels nor any other Nazi group "had any influence on the Olympic Games or on the production or shaping of the Olympic films." As a reference tool, therefore, the collection poses serious problems. But as a stimulus to provocative discussions, the book is well worth a serious student's time.

Because much of the material contained in this anthology is of such high quality and difficult to obtain easily elsewhere, Barsam deserves praise for the undertaking. What problems exist are as much a reflection of the disagreements surrounding non-fiction films as they are evidence of questionable editorial judgments. Given what now exists for students, this text gets a priority rating. One hopes that new editions will have a much-needed index. Well worth browsing.

Brownlow, Kevin. THE WAR, THE WEST AND THE WILDERNESS. New York: Alfred A. Knopf, 1979. Illustrated. 602pp.

Magnificently designed and expertly written, this highly original study is enamored with the idea of history on and in film. Brownlow confines his research to the silent era and demonstrates how the early film pioneers became unconsciously significant cultural historians. The basic thesis is that shooting outside the studios and on actual worldwide locations turned the era's feature films and documentaries into important historical evidence about the first third of the twentieth century. To bolster his arguments, the author located and interviewed many of the major personalities involved, including not just stars and directors, but also camera crews, technical advisors, stunt men, and editors. His exhaustive research using letters, diaries, and hitherto ignored public documents allowed him to reconstruct the mood and emotion that made filmmaking a risky and exciting enterprise. Furthermore, he makes abundantly clear that documentary films are not synonymous with truth. In fact, he writes near the end of his rich study that "A comment of Flaherty's should be stamped upon the front of every documentary film script: 'One often has to distort a thing to catch its true value.'" Brownlow also credits the spirit of Theodore Roosevelt as the guiding force that links the era and the book's three equally rewarding sections together. His roles as soldier, cowboy, and explorer conveyed Roosevelt's charisma to Americans at the turn of the century and help explain the events the author skillfully describes in his narrative.

The most absorbing material for our purposes (although all sections are first-rate) is found in the section on World War I. Brownlow makes clear that the movies not only came of age during this period, but also that their propaganda films "cast a dark shadow across the cinema's history." He details how military and civilian censors systematically eliminated scenes that MIGHT deter military recruiting or aid spies and saboteurs. He explains how an extended ban by Allied governments on war correspondents and their heavy one-hundred-pound camera equipment, transported by carts, bicycles, and backs, made actual combat footage difficult to obtain. (The Central Powers relaxed their restrictions, once they recognized the value of newsreel footage for morale purposes.) Nevertheless, Brownlow finds that a handful of maverick cameramen defied the authorities and recorded valuable World War I footage that still exists in such great quantities that viewing it all is nearly

impossible. What emerges from the material he viewed is a sense of irony concerning the emphasis that propagandists placed on "tales of simple barbarism, when weapons of indescribable ferocity were being used by both sides." The rationalization was that no one at the time realized the unimaginable horrors of war, thus the need for stories of familiar horror like rape and mutilation. The same callousness surfaces in the reactions of American filmmakers to the outbreak of the war in Europe. Rather than being alarmed, they rejoiced in the effect that battle and violence would have on foreign film competition. Lest someone assume that only filmmakers were opportunistic, the author states that the sinking of the LUSITANIA was justified militarily, since British officials had turned it into "a floating arsenal," and America was looking for an excuse to enter the war. Even Roosevelt was not above using his vast influence to insure the success of a propreparedness mood in the nation by secretly aiding the success of a film like THE BATTLE CRY OF PEACE (1915). The narrative also fills in a number of blind spots in silent film history. Chaplin fans, for example, will find sensitive and revealing Brownlow's brief analysis of the English comic's problems with his British critics, who accused him of cowardice during the war. Especially valuable is the material on Front Line Cinemas. A regular feature of life at the front by 1915, they were first proposed by wealthy French citizens to entertain the boys in combat. Any existing building in the war zones that could quickly be converted into a movie house was supplied with the most readily available and up-to-date films, which invariably played to packed audiences. Brownlow states that the British sector by mid-1916 had twenty such cinemas. Of all the exciting material here presented, however, none is more remarkable than the day-to-day accounts the author offers of the maverick cameramen themselves. From the exploits of Geoffrey Malins and James Douglas (British war correspondents) to those of Edwin F. Weigle and Donald Thompson (American war correspondents) and Oskar Messter and Franz Seldte (German war correspondents), we get a feel for the dangers of combat photography. Interested readers will also find the adventures of daring cameramen like Phil Tannura fascinating, particularly the story of his filming of mistreated Bolshevik prisoners of war almost turning into a real-life execution staged for the benefit of the movies. Those readers interested in the star system, fiction films, and movie propaganda will find the narrative helpful, particularly in the material on the Creel Committee, as well as on the making of MY FOUR YEARS IN GERMANY (1918), THE BIG PARADE (1925), WHAT PRICE GLORY? (1926), WINGS, BARBED WIRE (both in 1927), and ALL QUIET ON THE WESTERN FRONT (1930). If he does not restore all the lost glory to the golden age of silent films, Brownlow at least makes clear its enormous historical value for cultural and social historians.

A pioneering undertaking of such magnitude invariably creates a modicum of controversy. Aside from the obvious ones created by the author's comments on the LUSITANIA, there is Brownlow's indictment of Ambassador James W. Gerard's simple-minded filmed autobiography. The negative attitudes it created about the cinema's ability to deal honestly with history, according to the author, made charges of mass murders by the Nazis in World War II difficult to believe, since similar charges had been filmed in the World War I Gerard film. I respect the author's feelings, but cannot accept the speculative causal relationship. It is highly improbable that many viewers in World War II would have known about the earlier misleading film stereotypes. Just as debatable are the author's speculations on von Stroheim's background and Griffith's reasons for making HEARTS OF THE WORLD (even though the speculations carry the impressive endorsement of Russell Merritt).

None of these minor points can detract from Brownlow's excellent historical study. His brilliant visual recreation of the war, westerns, and wilderness films make this book the yardstick by which future studies on the subject will be judged. The 350 stunning photographs and illustrations are accompanied by a generous number of footnotes and an extensive index. Highly recommended for special collections.

Cohn, Lawrence. MOVIETONE PRESENTS THE 20TH CENTURY. Introduction Lowell Thomas. New York: St. Martin's Press, 1976. Illustrated. 381pp.

An affectionate pictorial survey of the famous 20th Century-Fox newsreel, the six hundred illustrations offer a delightful contrast to the disappointing text and inconsiderate book design (neither page numbers nor an index are provided). Cohn

states that he spent close to a year viewing several million feet of Fox's Movietone News film footage in order to select the best frame enlargements for inclusion in this history. In addition, he made extensive use of five thousand continuity sheets plus millions of index cards and dope sheets to insure that what he reported about the years from 1919 to 1963 was accurate. By the time Cohn had finished, he had naively discovered that despite Movietone's international and extensive coverage, "the filming of certain areas of human behavior was unavoidably not all-encompassing. This is quite evident in the field of sporting events, boxing in particular." What was reported, however, is handsomely arranged in chronological order in seven intriguing categories: i.e., Twentieth Century Personalities, Fashions, War in the Twentieth Century, The Human Side, The Great News Stories, Sports, and Marvels of Technology. Intelligently captioned and fascinating to study, the reproduced film frames present a unique and stimulating account of film history.

Unfortunately, the slim introductory text creates an initial negative impression. Lowell Thomas, who did such a memorable job as the voice of Movietone, for example, exhibits a less-than-satisfactory memory of what newsreel cameramen could and could not do during World War I. He talks about the accuracy and authenticity of the coverage, even while acknowledging that "Some battle scenes and other exciting events were staged and then presented as reality." This totally ignores the restrictions placed on camera crews (Fielding in his history of the American newsreel comments that most World War I footage was shot by military cameramen "and much of what they photographed never reached the screen"), the political censorship that existed, and the fact that latter-day film historians have documented the seemingly limitless distortions and prejudice propagated by the newsreels of World War I. Fielding may have summed up the situation best when he said, "Newsreel coverage of the war was sketchy and inadequate by any standards. . . ." Thomas also praises justifiably Movietone's many famous scoops--e.g., the explosion of the Hindenberg, the Japanese surprise attack on Pearl Harbor, the assassinations of King Alexander I and Jean Louis Barthou, the prime minister of France--but ignores the fact that Movietone was the last, not the first, of the four major American newsreels to appear in the silent era. Thomas's one interesting caveat is a reference to Movietone's sending eleven sound crews to Spain in 1936 "to record the action on both sides" in the Spanish Civil War. Neither Fielding's nor Aldgate's books make mention of large-scale newsreel crews covering the war. If such footage exists, it should have significant historical value. Cohn's own thumbnail chronology of Movietone adds to the amount of misinformation concerning newsreel history. He claims, for example, that the Fox-Case Corporation was founded in 1927, whereas Fielding reports July 23, 1926. Cohn gives 1926 as the date that Fox News became Fox Movietone News; Fielding, 1927. Cohn gives the impression that the silent newsreels ran between ten and fifteen minutes, while Fielding states they rarely exceeded ten minutes. Cohn identifies 460 West Fifty-fourth Street as the headquarters of Movietone News, ignoring altogether the original residence at 3 West Sixty-first street. The irony of the Cohn-Fielding discrepancies is that Cohn acknowledges the "informational assist" he received from Fielding's meticulous research in THE AMERICAN NEWSREEL, 1911-1967.

Once we get into the visual chronology, however, Cohn's research is splendid. He shows great skill both in his choice of frame enlargements and his caption commentaries. In particular, the material on WAR IN THE TWENTIETH CENTURY testifies to the enormous ingenuity of the more than one thousand men and women who worked for Movietone news. While what is shown represents mainly nonbattle conditions, the personalities visiting front-line positions as well as the types of scenes depicted provide considerable information about the context and attitudes surrounding the wars themselves. The frame enlargement of officials visiting the Maginot Line in 1940, prior to the German BLITZKRIEG, for example, recalls the narration in the actual newsreel that talked about "the extensive French fortifications." The pictures of the damage done by the attack of the Japanese at Pearl Harbor are another good example, as are the shots of Chinese Nationalists executing "Chinese Reds" in the streets of Shanghai. The latter is especially interesting, given the attention paid to the infamous television report nearly twenty years later showing a similar picture of a Vietnamese soldier with his hands tied behind his back being executed in the streets

of Vietnam. The book's one striking omission is the newsreel coverage of the atomic bombings on Hiroshima and Nagasaki.

Anyone with even a passing curiosity about over fifty years of newsreel history should find this collection a pleasure to view. Ignore the introductory material and you will find the candid shots of famous and not so famous people exciting as well as nostalgic. Worth browsing.

*Fanshel, Susan. A DECADE OF CUBAN DOCUMENTARY FILM: 1972-1982. New York: Young Filmakers Foundation, 1982. Illustrated. 48pp.

A good start in providing information about the Cuban film industry, this helpful text not only summarizes the results of a film series held in New York City, but also provides an overview of Cuba's efforts through films to present its society to the world. The Cuban Institute of Cinematographic Art and Industry (ICAIC) was inaugurated on March 24, 1959, three months after the Castro government came to power. In the twenty-five years that followed, ICAIC developed from a primitive organization to a significant body of filmmakers. Its 1981 catalogue lists more than seventy feature films, 670 documentaries, and 138 animated shorts. Fanshel points out that ICAIC also has produced 1,196 newsreels, "one every week for twenty-three years." As a veteran filmmaker, she took advantage of her connections to spend five weeks in Cuba to review the quality and extent of this wealth of material. The results of her conversations with members of ICAIC and her private screenings are encapsulated in this slim publication. Among the contents are transcribed interviews with Jorge Fraga, Santiago Alvarez, Jesus Diaz, Melchor Casals, and Carlos Galiano. The twenty films shown in the New York festival are then listed, with appropriate credits, synoses, and brief commentaries from the directors. Well worth browsing.

*Fielding, Raymond. THE AMERICAN NEWSREEL, 1911-1967. Norman: University of Oklahoma Press, 1972. Illustrated. 392pp.

This absorbing book is more than an instructive history from the birth of American newsreels starting in Europe and the United States to their demise in the late sixties when television news replaced them. Fielding's lucid and informative narrative is a critical indictment of a film genre that failed to take advantage of economic circumstances and advanced technology. The decade-long study originated because of the author's affection for the movie newsreel and his concern about its veracity. But very soon the research was expanded to "embrace speculations about the newsreel's role in society, its function in the motion picture industry, its survival for more than half a century, and its ultimate demise." After viewing millions of feet of film, interviewing many movie pioneers, and sifting through reams of conflicting information, Fielding's affection turned to hostility when he finally realized that the genre never reached maturity as an art form. His text is filled with interesting anecdotes and facts about the problems, personalities, and events that made newsreels a key part of the local weekly movie program for five decades.

The significance of Fielding's scholarship lies in the issues it raises as well as the conclusions the author reaches. He states, for example, that by 1900--four years after the commercial birth of movies and at least five before they became a fixed entertainment phenomenon--the first news-film producers had explored virtually "every TYPE of subject matter which was to characterize the newsreel for the next sixty years: catastrophe, international celebrities, pageantry and ceremony, sports, political and military events, technology, and spectacle and novelty." Such diversity plus the importance of the genre in establishing the commercial film has led many people into believing an unflagging audience loyalty existed and newsreel producers had few problems in selling their product. Fielding's research dispels both false myths. Much of the book's focus is on the operation of the five major American newsreels, four of which were functioning by 1918: i.e., Pathe News (later, Warner-Pathe News), Hearst International Newsreel (later, Hearst Metrotone News,

then News of the Day),[356] Universal News, and Fox Movietone News. (Paramount News began its successful run in 1927.) Fielding documents how the economic fallout from World War I wiped out foreign competition and gave American filmmakers unparalled opportunities for international leadership. Hopes were never higher for the artistic and commercial success of newsreels. Fielding explains why those ambitions were never realized, despite the fact that by the mid-1920s somewhere "between 85 and 90 percent of the eighteen thousand theaters in the United States exhibited one of the six newsreels then available to a weekly audience in excess of forty million people." Part of the problem lay in the complex process of making and distributing the newsreels. Each of the major organizations, for example, had more than a hundred cameramen scattered all over the globe. These men were then given backup support by full-time employees in key areas both foreign and domestic, in addition to the fifteen hundred stringers working on a free-lance basis. The physical and financial costs of such operations were enormous, and Fielding's research reveals the many competitive risks taken by filmmakers and producers to report the news in the local theaters. Nevertheless, newsreels entered the thirties as a handy, hardy, and mainly unprofitable film genre. It no longer had a drawing attraction for audiences, its artistic integrity had declined sharply, and exhibitors kept it on the program mainly for the purpose of having "a complete show" for moviegoers accustomed to quasi-journalistic attractions. Especially interesting is the author's discovery that newspapers and periodicals held silent newsreels in high regard, but became disillusioned with the genre when sound was introduced. Why such trust existed at all baffles Fielding, because he finds no justification for trusting newsreels more in one period than another. He does find, however, that each major newsreel organization had a distinctive structure and style of presentation. In addition to a first-rate explication of those styles, Fielding gives us an evenhanded comparison of American and Nazi newsreels, observing at one point that "In the late 1930's the Nazi German government introduced a different sort of newsreel--DIE DEUTSCHE WOCHENSCHAU (THE GERMAN NEWSREEL)--that, despite the purpose to which it was put, provided a much more intellectually exciting and cinematically appropriate model for newsreel production." That is, the American newsreels led off with their most exciting material, while the Nazi newsreels built to an exciting, emotional climax. As the public and the media became more critical, they lost interest in the novelty of American sound newsreels. At the same time, film censorship increased. This was followed by what Fielding labels "the introduction of journalistically unhealthy production innovations during World War II." What the author primarily is objecting to is the wartime establishment of government-regulated rota pools (i.e., one cameraman, or a restricted crew to cover a single event) to cover the global events. Fielding believes this method destroyed intercompany competition, already on the wane by the end of the 1930s. While he credits the war with making newsreels more mature, the author blames the rota pools for making one newsreel story on an event indistinguishable from another in its subject matter, length, and controversy. Thus by 1950, with the advent of commercial television and its aggressive news-reporting potential, the American newsreel was all but through. But Fielding is too enterprising a scholar to leave the matter there. He goes on to show the more complex reasons why Warner-Pathe folded in 1956; Paramount News, 1957; Fox Movietone News, 1963; Hearst's News of the Day and Universal News, both in 1967.

 Serious students will find little that is controversial about the book's conclusions. They will wonder, however, why Fielding didn't find the early fight films "stained with scandal and criticism," when boxing matches themselves were subject to raging public debates. On a much more serious level is the merit of Fielding's arguments concerning authenticity in films. He accurately states that three of the most basic philosophical questions are "What is reality? What is truth? What is ethically right?" Yet he gives no reasonable answers, except to explain why newsreel reporters, given geographic and time constraints, did what they did. It's a position

[356] For additional information, see Walter Goodman, "Film: Hearst Newsreels in a 100-Minute Feature," NEW YORK TIMES C (May 6, 1987):18.

Fielding returns to in his study of THE MARCH OF TIME, with the same disappointing results.

This first and only satisfactory study of the genre gives meaning to Oscar Levant's often quoted definition of the newsreel as "A series of catastrophes, ended by a fashion show." Its magnificent illustrations, as good as in any book on non-fiction films, add to Fielding's extensive footnoting contributions, as do the excellent bibliography and index. Highly recommended for special collections.

Fielding, Raymond. THE MARCH OF TIME, 1935-1951. New York: Oxford University Press, 1978. Illustrated. 359pp.

One of the most dynamic and controversial production units in film history is impressively chronicled in this readable, scholarly book. Based upon extensive interviews, countless screenings, and in-depth research, the narrative begins by explaining how TIME, THE WEEKLY NEWS MAGAZINE (introduced in 1923) had very little conceptually to do with either the radio or film versions of THE MARCH OF TIME. The one major connection with Henry Luce's powerful organization, outside of underwriting the costs for promotional reasons, was Roy Edward Larsen, "initially circulation manager and then general manager of TIME, later publisher of LIFE, for many years president of Time, Incorporated, and in the long history of the corporation the most influential and important figure after Luce." It was Larsen who convinced Luce that ventures into other media would benefit the corporation's image and publications. Given both encouragement and a relatively free hand, Larsen first brought TIME's high tension techniques to radio news broadcasting. By 1931, he had perfected the highly successful CBS radio show, THE MARCH OF TIME (on the air until 1945). Three days each week, for fifteen minutes each show (occasionally once a week for thirty minutes), millions of listeners tuned in to hear recreated news reports using professional actors and impersonators, dramatically supported by sound effects technicians and a complete studio orchestra. Larsen's plans for a film version of THE MARCH OF TIME also began in 1931, but did not reach fruition until a propitious meeting with Louis de Rochemont in the spring of 1934. Producer of a unique film series for Columbia Pictures, THE MARCH OF THE YEARS (a succession of film recreations of historical events inspired by the radio shows of THE MARCH OF TIME), de Rochemont impressed Larsen as the man to head a March Of Time film production unit. A corporation, separate from but controlled by Time, Incorporated, was established that same year, with Larsen as president and treasurer. Larsen stayed in that position for two years (he left in late 1936 to become publisher of LIFE), while de Rochemont remained with the corporation until August 23, 1943 (he went on to have a distinguished career as a feature film director, responsible for films like THE HOUSE ON 92ND STREET, BOOMERANG, and LOST BOUNDARIES). Louis was replaced by his brother Richard, who until then had been head of the corporation's European operations. These three men collectively over a period of sixteen years were responsible for nearly three hundred issues of THE MARCH OF TIME. None of these strikingly different individuals was by nature a radical or a leftist, yet the monthly twenty-minute films introduced on February 1, 1935 and produced under Louis's tutelage were consistently "liberal, progressive, and militantly antifascist at a time when it took courage to attack 'prematurely' the totalitarian adventures then under way in Germany, Italy, Spain, and Japan." This new form of "pictorial journalism" narrated by the compelling voice of (Cornelius) Westbrook Van Voorhis had little to do with the newsreel format. It made no attempt at up-to-the-minute news reports, confined its attention to a limited set of topics, ran ten minutes longer than the average newsreel, was discursive in treatment, was far more expensive than any newsreel released, placed a greater emphasis on "staged" and recreated materials, thrived on controversy, and was openly partisan. An amalgam of documentary, dramatic, and newsreel features, THE MARCH OF TIME series not only had a major impact on movie audiences of its day, but also was widely imitated by filmmakers around the world. Nevertheless, it was, at best, a break-even operation for Time, Incorporated. The skill with which this story unfolds, along with the reasons given for the demise of THE MARCH OF TIME, mark one of the high points in research on the non-fiction film.

Fielding's gift for not letting his admiration overwhelm his critical judgments is put to excellent use in his evaluation of the personalities guiding the fortunes of THE MARCH OF TIME. He portrays Louis de Rochemont, for example, as a liberal filmmaker who in his day-to-day relations with peers was "a driven man, inspired but insecure; a dreamer who was painfully uncommunicative and contradictory in his relations with other human beings; a bully who was impossibly demanding of both himself and his associates; an oftentimes hard and humorless man who could be unpredictably generous in helping loyal workers." The biographical sketches of "The Men Who Made Time March" reveal the author's fine evenhandedness in dealing with contentious personalities. Of particular merit are Fielding's comments about key personnel like Jack Glenn, Lothar Wolff, Tom Orchard, and Albert Sindlinger. The latter, for example, had an intense dislike for Louis de Rochemont, but found himself in the ironic position of having to publicize him. The author also provides fascinating factual summaries on this journalistic phenomenon, which almost always interpreted events in terms of the personalities depicted. From 1935-1942, for example, Fielding's content analysis reveals that "approximately 24 percent of all episodes dealt with war or the threat of war." Readers curious about the charges Jack Warner leveled against the issue INSIDE NAZI GERMANY--1938 will find Fielding's chapter on the film itself an insightful and persuasive defense. The debate with exhibitors and producers over how best to examine the insidious Nazi "racial purification" program, the author reasons, may have stemmed more from an industry desire to limit exposure of Hitler's ideas and an unwillingness to show controversial subjects than from a condemnation of the film's point of view. In effect, Fielding believes that "Journalistically speaking, the March Of Time earned a first-class reputation for calling the shots accurately, just ahead of events, and for hard-headed, accurate judgments of the military capabilities of foreign nations." He does admit, however, that when THE MARCH OF TIME made mistakes, they were big ones--e.g., the reports that the island on which Pearl Harbor was located was "impregnable to attack."

If Fielding's substantive study is open to any serious criticism, it is in the author's judgments concerning THE MARCH OF TIME'S methods. While acknowledging that the production unit had many faults, he concludes that "it was always dynamic, positive, and self-confident." The issue is whether that was enough to justify the distortions the series promulgated. In other words, do the ends justify the means? To be fair, Fielding cites the caustic comments by liberal critic George Dangerfield, who argued that THE MARCH OF TIME issues "have no conviction in them, they are thrillers. That, I submit, is the real evil in THE MARCH OF TIME. It is neither candid nor passionate nor partisan, merely excitable. . . .; it is almost completely irresponsible." But while Fielding gives due recognition to Grierson's views on the subject, he fails to recognize the charges brought by Rotha against THE MARCH OF TIME. In fact, as reported in DOCUMENTARY DIARY, Rotha found the series in one way a very bad influence on the British documentary movement: "Its string of images, usually thrown together with unrelated editing, its strident, staccato, one-level voice delivery, made a powerful impact all right but it was an impact quickly to become dulled . . . What was seen and said was all too soon forgotten." Thus what Fielding gives us is an excellent summary of a provocative organization, but not a definitive interpretation of its value to film history.

No disagreement over emphasis can diminish the significant contributions that this insightful narrative has made to film scholarship. As always, Fielding's selection of stills is chosen with an eye for the unique as well as the important. The text is packed with bibliographical information, and has an excellent filmography and a complete index. Credit also should go to Oxford University Press for the book's beautiful production values. Highly recommended for special collections.

*Jacobs, Lewis, ed. THE DOCUMENTARY TRADITION. 2d ed. New York: W. W. Norton and Company, 1979. Illustrated. 594pp.
Originally published in 1971, this ground-breaking text is more propagandistic than analytical. It represents the first serious "public relations" attempt to chronicle in anthology format the development of the documentary over a seventy-year period. "Its central aim," states the highly respected and overly ambitious film historian, "is

to define the convention that came to be called 'documentary'; to trace its growth and its major exponents; to provide analyses and interpretations of the classic and transitional achievements; to indicate the varied trends, movements, and schools that have made this genre one of the most representative forms of social and artistic expression, and finally to offer an insight into the present state of documentary's rich and living tradition." Despite such global aims, Jacobs sensibly attempts no comprehensive or definitive history. He is content to rely heavily on American contributors (close to one hundred filmmakers and critics) for beginning the much-needed synthesis of material on the genre. The book itself is divided into five chronological sections, each covering a single decade, starting in the 1920s and ending in the late 1970s. In addition to a very mixed assortment of short essays, the sections also include a filmography of the decade's most noteworthy films and a smattering of familiar illustrations. No attempt is made to include information about sponsored films that have as their main purpose increasing sales, providing educational content, or improving public relations. The exclusive concern is with those artistic and socially conscious films that have influenced and advanced the documentary. The author, however, avoids a chronological approach when dealing with the major filmmakers. He wisely reasons that an examination of achievements in relation to the emerging genre and its changing times would be more valuable than a survey focusing on the development of important directors. Of special interest is the fact that at the time the volume was first printed, many of the contributors, films, and directors were unknown to serious film students. As a result, we are able to measure how much film scholarship has changed within the last decade.

One indication of the change is that the book's value now lies in its containing many esoteric essays more important to specialists than to the general reader. Among the best are brief but notable film reviews by John Grierson (MOANA), Harry Alan Potamkin (DRIFTERS), Marie Seton (SONG OF CEYLON), Parker Tyler (OLYMPIA), William K. Everson (TRIUMPH OF THE WILL), Basil Wright (LAND WITHOUT BREAD and THE SPANISH EARTH), Pare Lorentz (THE RAMPARTS WE WATCH), Janet Handelman (THE SELLING OF THE PENTAGON), Arthur Knight (THE SORROW AND THE PITY), and Peter Biskind (HEARTS AND MINDS). Another change is that the opinions of many contributors survive more as curiosity pieces rather than as invaluable sources of information. Cases in point are Robert T. Elson's comments on THE MARCH OF TIME, Evelyn Gerstein's analysis of English documentary films, Virginia Warner's reaction to THE NEGRO SOLDIER,[357] and Parker Tyler's observations on documentary techniques in fiction films.

The most disturbing change since the anthology first appeared is the growing awareness of the misinformation contained in the author's introductory essays to each of the book's five sections. For example, in commenting on the early days of the newsreels, Jacobs mistakenly claims that Fox entered the newsreel field in 1912 (it was 1919), while making a serious error in assuming that the newsreels during this period "were a worthy rival of the newspapers." The general public may have thought this, but not scholars, as Fielding has demonstrated. Jacobs's judgments on the British documentary film movement are even more disappointing. Long since discredited are his assumptions that Grierson "turned out pictures aimed at exposing injustices inflicted on working men." Portraying the working class as 'heroic' is not the same as picturing them being mistreated. What the author is describing is more the paranoia of the British establishment than the attitudes of the documentary filmmakers.

Far below Jacobs's usual high standards, this collection needs a careful reediting in order for it to become once more an invaluable classroom text. Recommended only for very special collections.

Leyda, Jay. FILMS BEGET FILMS. New York: Hill and Wang, 1964. 176pp.

[357] For more information on the subject see Thomas Cripps and David Culbert, "THE NEGRO SOLDIER (1944): Propaganda in Black and White," AMERICAN QUARTERLY 31:5 (Winter 1979):616-40.

Straightforward and matter-of-fact, this slim publication does an above-average job of compressing the history of the "compilation film" from the birth of the movies through two world wars and the controversial TV documentaries of the early sixties. It begins with the author's stating his dislike of terms like "documentary" and "Archive films" as a means of describing the mysterious processes for transcribing newsreel footage into documentary films, for analyzing so-called historical reconstructions, and for interpreting how filmmakers manipulate actual events for purposes of propaganda. He admits that "compilation film" as a term is not much more precise, but argues that it more intelligently calls attention to the idea that filmmakers use any means available to them to force spectators to view familiar footage as if they had never seen it before. What's more, the term sensitizes us to the fact that the filmmakers force on the viewers a new interpretation of old material. Having defined the issues, Leyda uses his seven fact-filled chapters both to criticize the evolution of the genre and to identify many important but obscure films that deserve recognition.

Because the author is a distinguished scholar and filmmaker, his observations on who pioneered these compilation films, what were the best examples, and what problems they have created constitute the book's major contributions. For example, we don't learn very much about Boleslaw Matuszewski, but the important Polish thinker is given credit for being among the first scholars to recognize the validity of film as historical evidence. Picking up, however, on Matuszewski's mistaken belief that films could not be retouched in the way that photographs are redone, Leyda goes on to explain why actuality footage becomes important for acts of omission as well as those of commission. This leads into many rewarding discussions on why compilation films are concerned mainly with propaganda and ideas, as opposed to being historical records or entertainment films. His observations on Esther Shub reveal how badly the significant Soviet filmmaker has been ignored by other commentaries on documentary film. We are often told that future generations benefitted from the revolutionary techniques of the Soviet cinema during the twenties, but Leyda is one of the few critics to show the influence that Shub's experiments with newsreels and the American serials featuring Pearl White, Eddie Polo, and Ruth Roland, had on more prominent Soviet filmmakers like Eisenstein, Vertov, and Pudovkin. Her three precedent-forming films--FALL OF THE ROMANOV DYNASTY and THE GREAT ROAD (both in 1927) and THE RUSSIA OF NIKOLAI II AND LEV TOLSTOY (1928)--are praised for their ingenious montage techniques, showing how effectively ideas can be built on contrasting materials. Readers who are familiar with propaganda films between World War I and the post-World War II period will find Leyda's capsule comments on American, English, Soviet, and German products informative and interesting. He writes honestly about his likes and dislikes, admits when his reactions are based upon the observations of others, and tries to put everything into a historical perspective. For example, in commenting about Laurence Stallings, who collaborated so effectively with King Vidor on THE BIG PARADE (1925) and Maxwell Anderson on WHAT PRICE GLORY (1926), Leyda reminds us that Stallings's most memorable observations may have been "his half-romantic book of photographs called THE FIRST WORLD WAR" and the compilation film made from it for Fox Movietone News (1934). If Leyda feels that the compilation film owes its greatest debt prior to the 1950s to the montage school of filmmaking, Leyda believes that the modern school has gained enormously from the efforts of German filmmakers like Andrew and Annelie Thorndike. Through films like DU UND MANCHER KAMERAD/YOU AND OTHER COMRADES (1956), OPERATION TEUTONIC SWORD (1958), and HOLIDAY ON SYLT (1959), the Thorndikes are credited with advancing the techniques first established by Shub, Vertov, Cavalcanti, Capra, and Dovzhenko. What worries the author, however, is that society is becoming less able to understand when deliberate forgeries are put forward as truths. Just as troublesome is the fact that a new generation of filmmakers seem extremely careless in distinguishing reconstructed footage from actual fact. For example, Leyda accuses the CBS series THE GREAT WAR (1963) of using "as documents the reconstructions that were staged for THE RAMPARTS WE WATCH--less than twenty years before."

Ironically, the book's major problems center on the author's unwillingness to look more closely at his own material. If anyone has deliberately misled viewers into thinking that what they see accurately represents fact, it's Alain Resnais in NIGHT AND FOG/NUIT ET BROUILLARD (1955), a film Leyda believes is based on "horrifying footage made at Auschwitz by both Nazis and liberators." Not only does Resnais's film contain footage from other death camps, but Resnais is doing more than just getting us to change our awareness of what happened at one death camp. He is trying to obscure the distinction between what happened to six million Jews who were murdered and other Nazi victims. That is not to denigrate Resnais's remarkable film. It is to remind readers that Leyda's passion for the montage school and his favorite films are not the entire story.

The book concludes with helpful appendexes on the film series THE WORLD IN ACTION, the television series THE TWENTIETH CENTURY, I AM IRELAND/MISE EIRE (1959), and films using the compilation form. It also contains useful footnotes and an index. Recommended for very special collections.

MacCann, Richard Dyer. THE PEOPLE'S FILMS: A POLITICAL HISTORY OF U. S. GOVERNMENT MOTION PICTURES. New York: Hastings House, 1973. Illustrated. 238pp.

The story of American government filmmaking through three wars and five presidents receives an intelligent analysis in this dry, informative text. Based upon the author's 1951 doctoral dissertation, it conceptualizes the interest many film historians have in United States agencies making films, as well as the dramatic changes in production levels between the time MacCann first did his work at Harvard, and the early seventies when the rewritten and expanded thesis was published. The book's focus, however, remains the same: to chart the government's policies and practices from 1908 and the films made by the Department of Agriculture, to the modern day efforts of the National Aeronautics and Space Administration and the Department of Defense. As stated in his initial preface, "This thesis deals mainly with the public relations process in the Federal government--specifically, with the medium of the documentary film." The four questions that most concern the author are how many factual films were made by the government, when, how, and why. His three-fold general assumptions are that a communications crisis exists, that democracies need a free-flowing exchange of ideas between experts and citizens, and that government agencies have an "immediate moral responsibility for action." Unfortunately, scant attention is paid to the way in which Russian directors or Nazi propaganda impacted on American filmmakers and government policy. The topics covered in MacCann's ten uneven chapters include an overview of public relations vis-a-vis the documentary film, the rise of the documentary in England and Canada, the early days of United States Government films, Pare Lorentz, The United States Film Service, World War II and the Office of Information, armed forces documentaries in World War II, the USIA, the relationship between the presidency and Congress toward televison, and directions for the documentary in the early 1970s.

Most useful about this pioneering study are the questions it raises about responsibilities, accountability, and directions. In exploring American documentary film history, for example, the author asks us to be concerned about the propriety and purposes of a federal agency's seeking "to express, rather than to direct, the popular will." In essence, what limits should be placed on government propaganda? Like Grierson, MacCann is strongly influenced by Walter Lippmann's 1922 PUBLIC OPINION essay describing a human being's limited capacities for absorbing facts. Ordinary people are described as unable to fathom "the complexities of great issues." The decision-making burdens, therefore, fall more and more on the federal government. And the concern seriously raised by MacCann is how much creativity should we expect from factual filmmakers working for government agencies? He criticizes CINEMA VERITE, for example, because it "tends to revert to the worst disadvantages of the primitive newsreel." That is, too many false claims are made about the technique's ability to record the "truth," while the "sync-sound" of the technique places an inordinate emphasis on shock and entertainment, on recording exciting and controversial events. MacCann correctly reminds us that CINEMA VERITE "is simply a way of getting closer to the emotional or decision-making fabric of life."

The issues of responsible reporting, rational representation, and journalistic integrity are just as valid for CINEMA VERITE filmmakers as they are for any other artists working in the mass media. The author's admirable concern with subject matter, not method, as the litmus test for "truth" and "integrity" in documentary films results in many astute observations about government film productions. He states, for example, that the most important socially conscious film contributions are found in industry rather than in government-sponsored films. An excellent reason why is offered in his brief but valuable analysis of what happened to the National Film Board of Canada after World War II. Equally valuable is the author's insightful discussion of the perpetual dilemma between a documentary producer and an operating bureaucrat. He superbly pinpoints the difficulties as coming between those who want "intensity and distillation" and those who prefer "balance and dilution." His penetrating explorations raise the ultimate question whether it is possible for the federal government to make honest documentary films.

MacCann's passion for wrestling with the elusive issues of "truth" and "authenticity" in documentary films creates a number of problems for him. It is one thing to praise NANOOK OF THE NORTH and THE MARCH OF TIME because they placed "authenticity of results" above "authenticity of materials"; quite another to use that principle as the basis for all documentary films, especially when no adequate definitions of "truth" and "authenticity" are provided by the author. Who determines what is accurate and truthful? A case in point is the author's unsophisticated assumption that "The story of America is also the story of THE TOWN [1943], directed by Josef von Sternberg, a film which described in 'simple, sparse,' language and straightforward pictures an average midwestern town, with its mixed population, its differing religions, its many styles of architecture, all carrying on certain cultural traditions from the old world into a free synthesis of live-and-let live." That view may have been possible during World War II, but hardly stands up in light of modern day sociological studies or after a single viewing of a fiction film like BAD DAY AT BLACK ROCK (1955). MacCann also has a tendency to oversimplify or omit pertinent information concerning the history of documentary filmmaking. His most glaring errors relate to the British sector. He claims mistakenly that Grierson and Flaherty shared directorial responsibility for INDUSTRIAL BRITAIN (1933), ignores the federal government's harassment in 1947 of Grierson because of his alleged "Communist" leanings, and totally avoids any discussion of the political problems faced by the EMB and the GPO film units.

Serious students will find many of the book's best chapters reprinted elsewhere, but not MacCann's excellent questioning techniques. Consequently, the book merits a close reading. It contains a wealth of useful bibliographic material and a good index. Recommended for special collections.

Shale, Richard. DONALD DUCK JOINS UP: THE WALT DISNEY STUDIO DURING WORLD WAR II. Ann Arbor: UMI Research Press, 1982. Illustrated. 185pp.

A welcome addition to the slim material on Disney's wartime activities, this revised 1976 doctoral dissertation challenges many of the time-honored views of the man, his studio, and its accomplishments during World War II. Agee's classic 1949 essay, "Comedy's Greatest Era," for example, established the prevalent opinion that Disney "had lost his stride during the war and has since regained it only at moments." Seldes, augmenting Agee's assessment, argued in his 1951 book, THE GREAT AUDIENCE, that Disney never returned to "the brilliant techniques of his military work." Both these debatable points of view come under critical attack in Shale's methodical study, as do the controversies surrounding many of the films made by Disney for various government agencies. The author limits his focus to the years from 1941 to 1945, ignoring a historical overview--found in other published sources--in favor of a close examination of a crisis period for both the nation and the Disney Studio. Shale's major concern, therefore, is with explaining why and how each of the Disney films was made. Fortunately, the Disney Studio possesses a remarkable film archive, which provided the author a rare opportunity to study invaluable primary sources--e.g., letters, memoranda, and contracts. The conclusions he reaches after viewing almost every Disney wartime entertainment feature, short, and nonmilitary

government film are fresh, provocative, and fascinating. Although the dry writing style detracts from the author's stimulating ideas, the narrative provides an engrossing summary of the style and content of over a thousand movies. Particularly helpful at the outset are Shale's linguistic precautions. He makes clear that the term "cartoons" refers only to entertainment or humorous elements, and thereby allows the concept of "animation" to be used for serious descriptions. He also makes an important distinction between military and government films, reminding us that while the former are made by government agencies, not all agency films are military films. Thus in this study government films are equated with educational films, military films with training films.

Each of the book's ten tightly written essays contains original material found nowhere else. In the opening chapter, for example, Shale goes beyond a predictable survey of Disney history, studio techniques, and technological breakthroughs to point out how film animators did not suffer from wartime shortages of film materials in the way in which other members of the industry were affected. Chapter 2 reveals how crucial events in 1941 united Grierson and Disney in the production of Canadian film propaganda, an association that paved the way for Disney's much-needed orientation toward educational and training films. As Shale documents, neither the federal government nor the Disney Studio could have been as effective or as efficient if not for the earlier alliance with Canada. And equally valuable is the author's candidness about Disney's motives. While patriotism clearly contributed to Disney's action, so did financial considerations. By the end of 1941, for example, the Disney Studio not only had suffered a debilitating strike over the issue of unionization (settled in favor of the union), but also the Disney organization had failed to show a profit since 1939 (the first upturn would be in 1943). All the stories printed since the 1930s about Disney making government and military films "without profit," therefore, need rethinking. Shale's careful review of the economics of the Disney Studio is not intended to undermine the enormous contributions, financial or otherwise, by Disney to the war effort. The material is important, however, for understanding the crucial difference between the concepts of "without profit" and "out-of-pocket costs." Lively debates will no doubt result among Disney scholars who henceforth will use Shale's financial analyses to question how much the studio did or did not benefit from the war years. Chapters 3 through 5 reopen the controversies over Disney's Treasury Department film THE NEW SPIRIT (1942), his highly publicized 1941 trip to South America sponsored by the Coordinator of Inter-American Affairs (headed by Nelson Rockefeller), and the four propaganda films contracted by that agency. Chapter 6 takes a detailed look at VICTORY THROUGH AIR POWER (1943), a feature-length propaganda film that stirred up the most critical debate among Disney reviewers during the 1940s. The next three chapters review studio projects that never appeared, as well as observations on how the war itself affected Disney cartoons and entertainment films, especially THE THREE CABALLEROS (1945). Shale's concluding essay briefly summarizes the effect that the wartime films had on Disney's postwar productions and how all his efforts related to the filmmaker's dominant interest in the film medium as a force in education.

Serious students will fault the author for not taking a more balanced approach to Disney's motives and philosophy. For example, Shale's dislike of Richard Schickel's iconoclastic, flawed biography of Disney is understandable, but not his reasons for ignoring Schickel's observations about the movie mogul's problems with key government officials and the methods they used in taking over his studio or dictating policy. We're tantalized by the information that Disney's identification films (i.e., the WEFT series, an acronym for Wings, Engine, Fusilage, and Tail) were canceled at the navy's request before the maximum footage was shot and referred to jokingly as "Wrong Every Fucking Time," but get very few insights into the problems. We're told very little about Disney's relations with his employees, or even about the major battles over studio policy during the war years. Another glaring omission involves the arguments surrounding VICTORY THROUGH AIR POWER. Shale is willing to review the debate concerning strategic long-range bombing, but refuses to take a stand on its merits. The impression he leaves is that it is more important to document Disney's efforts rather than to comment on the filmmaker's intellect or misguided intentions. And since an underlying theme of the narrative is Disney's fascination

with the film's value to educators, why is there no discussion on the very same theories so strongly advocated by Grierson?

In short, this book provides an important study of the unprecedented liaison between the federal government and the Disney Studio between 1941 and 1945. Its value for understanding what, how, and why such films were made is substantial. Shale's bibliography, film listings, and index add to the book's overall worth. The fact that the author draws back from a critical discussion of Disney himself can be viewed more as a disappointment than as a serious limitation. Recommended for special collections.

Ward, Larry Wayne. THE MOTION PICTURE GOES TO WAR: THE U. S. GOVERNMENT FILM EFFORT DURING WORLD WAR I. Ann Arbor: UMI Research Press, 1985. Illustrated. 176pp.

Originally written as the author's 1981 dissertation at the University of Iowa, the initial idea "was to chronicle and analyze the government's use of motion pictures in the Great War." As Ward progressed, however, "it became clear that the government's wartime film program was inextricably linked to the contributions of the private film industry." Describing how the government's objectives coincided with dramatic changes in the film industry, Ward argues that Hollywood and the government found it mutually beneficial to work together, particularly in the area of "propaganda." The author uses the term in its WWI context: "spreading or extending a doctrine or idea." The book's five intriguing chapters cover the two-and-half years before America entered the war and concludes with the government and the film industry being satisfied with its accomplishments up to 1918. Ward's exemplary research and lucid prose result in a first-rate examination of a valuable period of filmmaking. Endnotes, a bibliography, and an index are included. Recommended for special collections.

Watt, Harry. DON'T LOOK AT THE CAMERA. New York: St. Martin's Press, 1974. Illustrated. 198pp.

Although not a detailed history of the British documentary movement, this irreverent, highly personal account is the most candid memoir to date of what a " bunch of enthusiastic kids" were trying to do with documentary film in England during the 1930s and the 1940s. Its author, who describes himself as "a brash, overbearing, cheeky and opinionated youngster who unexpectedly got the chance to make films," has little patience with facts, statistics, or footnotes. Watt also wants to distance himself from other accounts that vastly overrate the quality of the films produced, or simply ignore the fact that the young filmmakers "bubbling with ideas but making thousands of mistakes" learned their craft through a prolonged period of trial and error. He just wants, in his own idiomatic way, to set the record straight about what were the intentions of the EMB and GPO film units, where they succeeded and where they failed, as well as what happened to the genre in the postwar years.

Once we get past the dreary tales about Watt's early years and arrive in 1931 at the EMB section, the narrative presents a wonderful mixture of revealing anecdotes and filmmaking philosophy. The most stimulating material relates to the author's relationship and disagreements with Grierson. Acknowledging Grierson as "one of the strongest, most compelling personalities" that he had ever met, Watt goes on to portray him as an evangelist with "a strange, ambivalent character," and "a brilliant, but erratic boss." Grierson's prophetlike leadership is credited with starting the British documentary on the road to social significance, but the visionary Scotsman himself is accused of deserting the movement before it succeeded in its goal to "influence cinema as a whole." Watt takes strong exception to the theory that Grierson left the GPO in 1937 because he wanted to try to make films that would reach millions of people who never went to the commercial cinema. The real reason, according to Watt, was Grierson's thirst for power, his missionary zeal for new converts to the documentary film. Cavalcanti, on the other hand, is credited as the true filmmaking genius of the thirties. As Watt puts the argument, "the idea and inspiration of the British documentary movement came from Grierson, its style and quality came from

Cavalcanti." The author's impish comments on fellow filmmakers are just as provocative. Arthur Elton, for example, is described as a technical genius who "obviously disliked people"; Basil Wright, a film poet who "had the misfortune to become rich"; and Stuart Legge, a filmmaker who was "brilliant, skillful and dull." We also learn that his experiences with Flaherty were not as productive as other sources have suggested. Granting the great filmmaker his due as an artist as well as a fabulous storyteller and drinking partner, Watt nevertheless considered Flaherty a difficult man to work with and quit his job on MAN OF ARAN (1934) because he felt the film to be a dishonest documentary. Among the autobiography's most enjoyable pages are those describing the problems the inexperienced filmmakers faced as they battled against ignorance, poverty, and government interference. After reading the solemn accounts presented by documentary historians, it's reassuring to learn that the masters of the genre admit to weaknesses. For example, Watt always considered his film dialogue flat, felt that he was a bad cameraman who concentrated more on the action than on the mechanics, and admitted to being a poor editor because he was "too clumsy and impatient." Equally enjoyable are the author's candid comments on controversial issues. For example, in confronting modern-day critics who denounce the "political timidity in our work," he concedes that "in the greatest Depression of all time, . . . [the movement was] mostly showing workers bravely carrying on their wonderful skills, and hardly ever mentioning that they were underpaid, underfed and appallingly housed." Rather than hide behind the standard defense that these 1930s films gave a new perspective to the dignity of the working class, Watt simply states that real social criticism would have cost them their jobs and so they compromised in order to survive. But he also makes clear that, along with artists like Cavalcanti and Jennings, he made documentary films commercially acceptable and thereby fulfilled the movement's original goal. How this was done is lovingly told in his stories about the making of such memorable Watt productions as NIGHT MAIL (1936), NORTH SEA (1938), LONDON CAN TAKE IT (1940), and TARGET FOR TONIGHT (1941). In each instance, he takes care to credit cameramen, musicians, producers, and colleagues with helping make the films successful. While admitting that his generation had its share of flaws, he makes it clear that contemporary filmmakers have some problems of their own. A case in point is filmmakers' using CINEMA VERITE. Rather than seeing their theories about spontaneity and unrehearsed behavior as epitomizing the essence of real truth, he calls the movement "as phony as a four-dollar bill" and some of its products examples of "lazy, unprofessional film-making."

No doubt, Grierson's defenders will lead the assault on Watt's memoirs, challenging not only his interpretations but also his biases. The suggestion that Grierson's sink-or-swim attitude toward filmmaking, for example, "could have led . . . to disaster with too much amateurism and lack of polish . . . [and that what] saved . . . [the film units] was the arrival of Cavalcanti" ignores the fact that Grierson hired Cavalcanti almost five years after the movement had started. Just as important was Grierson's ability to capitalize on Cavalcanti's skills, without detracting from the purposes of these government-sponsored films. Watt's comments about Jennings and Dalrymple will create some problems for their defenders. Those who admire Jennings generally compliment his producer. Watt, on the other hand, claims that Dalrymple was to him "cold, distant, and generally discouraging," while denying Basil Wright's charges that Jennings remained aloof from the workers he filmed. Of course, no supporting evidence is provided for any of the author's opinions.

What we are left with in this often overlooked book is an entertaining, narrow summary of the British documentary movement. It provides no filmography, bibliography, or scholarly footnotes. The helpful index makes it easy to identify particular material that serious students might wish to consult. Don't look for anything factual, and you will be pleasantly surprised. Recommended for specialized collections.

BRITISH DOCUMENTARIES

*Ballantyne, James, ed. RESEARCHER'S GUIDE TO BRITISH NEWSREELS. Bath: British Universities Film and Video Council, 1983. Illustrated. 119pp.

Based upon the RESEARCHER'S GUIDE TO BRITISH FILMS & TELEVISION COLLECTIONS (1981), pioneered by the staff of the Slade Film History Register, this companion volume serves as an invaluable reference document. The annotated abstracts, in chronological order from 1901 to 1982, include first, books, pamphlets, reports or letters; and second, periodical articles (season, followed by month, then by date). In this way, active researchers can be aware of the problems newsreels faced in their evolutionary stages until their demise during the mid-1950s. (The two exceptions are PATHE NEWS and BRITISH MOVIETONE NEWS, which lasted until the 1970s.) Ballantyne wisely includes in his important resource popular and trade notices as well as information on the ways various companies operated and the prevailing attitudes toward the newsreels themselves. No attempt is made here to be definitive. The essentials, however, are provided. Particularly useful is a separate "Chronological Chart," that can be carried by the student. It lists nearly fifty newsreel series, together with archive addresses and location notes. Only someone sensitive to a researcher's problems and needs could have produced such a handy reference tool. Recommended for special collections.

HOLOCAUST

*Avisar, Ilan. SCREENING THE HOLOCAUST: CINEMA'S IMAGES OF THE UNIMAGINABLE. Bloomington: Indiana University Press, 1988. Illustrated. 212pp.

"The present study," the author writes, "rests on two assumptions: first, that the Holocaust was a unique or an unprecedented historical experience; and second, that as such it poses new kinds of problems and challenges to those who seek to reflect upon and transmit its singular character. These special challenges lead to a new and distinct Holocaust discourse, which is nevertheless closely interrelated with the entire cultural discourse of the post-Auschwitz era." Avisar passionately defends cinema's ability and responsibility to document, communicate, interpret, and assess the Holocaust. In five thought-provoking and moving chapters, his eclectic approach performs two specific tasks: "first, to highlight theoretical issues of representation and presentation; and second, to provide critical analysis of significant films, many of which have been neglected." Leaving the comprehensive story to Insdorf's INDELIBLE SHADOWS: FILM AND THE HOLOCAUST, Avisar concentrates on a more limited number of European and American pictures: e.g., NIGHT AND FOG/NUIT ET BROUILLARD (1955), THE DAMNED/LA CODUTA DELGI DEI (1969), THE GREAT DICTATOR (1940), THE DIARY OF ANNE FRANK (1959), THE SHOP ON MAIN STREET/OBCHOD NA KORZE (1965), THE GARDEN OF THE FINZI-CONTINIS/IL GIARDINO DEI FINZI-CONTINI (1970), and MR. KLEIN (1976). In explicating the films, the author tries to discover what they tell us about the Holocaust. He is particularly concerned with the categories of representation, presentation, and comprehension. "The first," he explains," involves the aesthetic problem of achieving an adequate representation of the original reality. The second category is more political in nature, referring to the need to present correctly the role and the identity of the participants in the historical drama. The third involves the challenge of trying to understand why it happened, how it was allowed to happen, and the profound implications of the unsettling experience to our human culture." Given the valuable perspective that Avisar provides, the book should be read as a companion piece to the Insdorf book. Endnotes, a bibliography, a filmography, and index are included. Recommended for special collections.

*Insdorf, Annette. INDELIBLE SHADOWS: FILM AND THE HOLOCAUST. New York: Vintage Books, 1983. Illustrated. 234pp.

In an extraordinary survey, Insdorf explains the conflicting demands of artistic integrity and historical accuracy, as well as the delicate critical balance between film scholarship and moral concerns. The author, a child of Holocaust survivors, sets as her basic task, "finding an appropriate language for that which is mute or defies visualization." While acknowledging Elie Wiesel's position that literature about the Holocaust is by definition a contradiction in terms, she refuses to remain silent about the various ways filmmakers communicate the complexities of cinematically representing the destruction of six million Jews. She begins by making clear that contemporary audiences exhibit an inability to understand even what is meant by the term "Holocaust." It is not, as some people assume, a catchall phrase to describe Nazi brutality and atrocities during World War II. In its most precise use, the Holocaust refers not only to the Nazi plan to annihilate European Jewry, but also to eradicate any historical traces of the Jewish people. Surprisingly, the one glaring omission in this otherwise impressively researched study is any reference in the text to Raul Hilberg's monumental work, THE DESTRUCTION OF THE EUROPEAN JEWS, which is included in the bibliography. The reason may be the author's dependence on the research done by Holocaust scholars like Lucy Dawidowicz and Terrance Des Pres, who place a greater emphasis than does Hilberg on documenting organized Jewish resistance to the Nazi war machine. Insdorf's focus is on documentary and fiction films, primarily those produced in America, France, Poland, Italy, and Germany. Her selections are based on the fact that these nations have produced the most significant treatments, and that they provide the most accessible and available films. Hopefully, a follow-up study will examine the growing number of Holocaust films emerging from Eastern Europe (included in the book's excellent filmography), but which are not easy to obtain and view. That limited focus is the only short cut Insdorf takes.

Rather than follow a standard chronological or nationalistic analysis, she takes the more difficult approach of channeling nearly 150 films into four major thematic concerns. The first section explores the cinema's search for an appropriate language to deal with the awesome subject. This allows the author to compare and contrast Hollywood's melodramatic conventions with the dialectical montages of European filmmakers. Included in this section are films like the TV miniseries HOLOCAUST (1978) and THE WALL (1982), as well as feature films like KANAL (1957), THE DIARY OF ANNE FRANK (1959), JUDGMENT AT NUREMBERG (1961), HIGH STREET/RUE HAUTE (1976), and THE SERPENT'S EGG/ORMENS AGG (1977). This section also explores the unique attempts by filmmakers to express the horror of the Holocaust through savage satires--e.g., TO BE OR NOT TO BE (1942), SEVEN BEAUTIES/PASQUALINO SETTEBELEZZE (1975). The next section investigates the narrative strategies that concentrate on Jewish children and adolescents. In films like THE TWO OF US/LE VIEIL HOMME ET L'ENFANT (1966), THE GARDEN OF THE FINZI-CONTINIS/IL GIARDINO DEI FINZI-CONTINI (1970), BLACK THURSDAY/LES GUICHETS DU LOUVRE (1974), LACOMBE, LUCIEN (1974), and THE BOAT IS FULL/DAS BOOT IST VOLL (1981), Insdorf discusses the depictions of wealthy and attractive Jews who thought assimilation would protect them against Nazi genocide, of the families that went into hiding in order to survive, and of the guilt passed on to later generations by the failure of parents to behave morally during the Holocaust. The third section tackles the controversial issue of political resistance to the Nazis during World War II. In selecting films like ASHES AND DIAMONDS/POPIOL I DIAMENT (1958), GENERAL DELLA ROVERE/IL GENERALE DELLA ROVERE (1959), THE SHOP ON MAIN STREET/OBCHOD NA KORZE (1965), THE TIN DRUM/DIE BLECHTROMMEL (1979), and MEPHISTO (1981), the sensitive author grapples not only with the operations of organized leftist groups, but also with issues like Zionism, the political activities of the Polish Church, and "the political resistance of rightists who applauded (silently) the extermination of Jews while fighting against Nazi invaders of their homeland." Insdorf is particularly concerned in this thematic area with the guilt-ridden responses "ranging from profound guilt to perverse fascination" produced by contemporary German filmmakers like Werner Herzog, Rainer Werner Fassbinder, Wim Wenders, and Volker Schlondorff. The book's concluding section considers a new form of filming--neither documentary nor fiction--that organizes the tragic material into personal statements by the survivors of the Holocaust. The films selected as the most representative of the "personal genre," closer to the memoir or

journal, include THE SORROW AND THE PITY/LE CHAGRIN ET LA PITIE (1970), KITTY: RETURN TO AUSCHWITZ (1980), and RETURN TO POLAND (1981).

The major question that can be asked of such a difficult study is how well did the author balance her aesthetic and moral judgments? Does she, for example, in explicating HOLOCAUST (1978), place a greater emphasis on the filmmaker's intentions or on the technique? She does neither. Instead, Insdorf judiciously points out how a "phenomenon of superficiality" can also heighten the awareness of a mass audience and take the Holocaust out of the realm of a specialized subject. Does she overcompensate for repugnant, exploitative films like THE NIGHT PORTER/IL PORTIERE DI NOTTE (1974) by stressing the novelty of showing the repressed guilt of a Nazi war criminal? She does. Many readers who resent deeply the trivialization resulting from films depicting the Holocaust--e.g., CABARET (1972), SEVEN BEAUTIES/PASQUALINO SETTEBELEZZE (1975), MARATHON MAN (1976), THE BOYS FROM BRAZIL (1978), VICTORY (1981)--will find her remarkable restraint profoundly disturbing. On the other hand, the author's courageous interpretations of films like THE MAN IN THE GLASS BOOTH (1975), THE MEMORY OF JUSTICE (1976), and PLAYING FOR TIME (1980) should earn her the gratitude of a new generation of students ignorant of the artistic merits of these controversial films. Potential readers may also ask whether Insdorf's personal involvement in the subject persuades her that the Holocaust " 'belongs' to--or is the domain of--one set of victims more than another." It absolutely does not. She states unequivocally her conviction that "films not only commemorate the dead but illuminate the price to be paid for unquestioned obedience to governmental authority."

In essence, Insdorf has provided us with a major text on a much ignored and very difficult subject. She has very firm ideas on why maudlin and relentless depictions of the Holocaust are bad films, and why the most noteworthy attempts stress a sparse or stylistic excellence. The films she most admires present us with a provocative group of works that illuminate the Nazi horror and keep it meaningfully visible in our times. Together with valuable illustrations, a list of sources for renting Holocaust films, and a useful index, the author has made a significant contribution to film scholarship. Highly recommended for special collections.

JORIS IVENS

Boker, Carlos. JORIS IVENS, FILM-MAKER: FACING REALITY. Ann Arbor: UMI Research Press, 1981. 211pp.

Originally a 1978 Ph.D. thesis at the University of Iowa, this intriguing study promises more than it delivers. Boker suggests at the outset his interest in examining "a period of time that started before the rise of fascism in Germany and continues today." It's an era that Dutch documentarist Joris Ivens captured in his films about Soviet Russia, Nazi Germany, Castro's Cuba, and Communist China. The plan, therefore, was to "show the continuity of Ivens' political and social commitment, and the correspondence between his aesthetics and his politics." The promise was an insight into the "consistency" of Ivens's positions on worldwide struggles for the liberation of the oppressed and "the validity of his interpretations of history." For the sake of convenience, Boker sets up three categories of films for analysis: six war documentaries--i.e., THE SPANISH EARTH (1937), THE FOUR MILLION (1938), PEOPLE IN ARMS/PUEBLO ARMADO (1960-61), THE SKY AND THE EARTH/LE CIEL LA TERRE (1965), 17TH PARALLEL/LE DIX-SEPTIEME PARALLELE (1967), PEOPLE AND THEIR GUNS/LE PEUPLE ET SES FUSILS (1968-69); four work documentaries--i.e., BORINAGE/MISERE AU BORINAGE (1933), NEW EARTH/NIEUWE GRONDEN (1934), SONG OF HEROES/HELDENLIED or KOMSOMOL (1932), CARNET DE VOYAGE/CARNET DE VIAJE (1960-61); and four poetic films--i.e., THE SEINE HAS MET PARIS/LA SEINE A RECONTRE PARIS (1957), BEFORE SPRING (1958), A VALPARAISO (1963), SONG OF THE RIVERS/DAS LIED DER STROME (1954). He then goes on to analyze the films in the first two categories according to story, form, presentation of the forces of good and evil, the elements of the struggle, the issues, and the aesthetics. After demonstrating the parallels in both categories, Boker makes the persuasive argument that the films are really documentaries on peace where war

is "an extraneous element." In a somewhat less convincing fashion, he argues that the poetic films also continue Ivens's ideological and aesthetic principles. The author's holistic position runs parallel to that of Ivens's beliefs. Thus Boker's analysis gives content precedence over form. It also attempts to demonstrate that a consistency and unity of contents in Ivens's work results in a "unity of aesthetics." The emphasis throughout is on proving that the films are dialectic statements symbolically represented as a primeval myth. That is, "the documentary is an epic in which man-the-builder is confronted by the forces of destruction, or of darkness; these can be colonialism, imperialism, or untamed nature. Man is the everyday hero, and has to pass through an ordeal of suffering (inflicted, not by fate, but by regressive forces in society and history); he will emerge triumphant, showing each time the victory of light over darkness, of good over evil, of progress over fascism." Boker's scheme has considerable merit. Not only is there no comprehensive and current study in English about Ivens, but also those that do exist reflect primarily a Marxist point of view that is concerned with reinforcing a limited interpretation of global issues. The attempt to place Ivens with his social commitments in the general framework of contemporary history is long overdue.

The problem comes in the author's literal adherence to showing only the continuity in the filmmaker's work and not in studying how effective or valid were Ivens's cinematic interpretations. It's difficult to understand why such a study, stressing ideology and aesthetics, would not examine the merits of the filmmaker's "truth" or its mythological forms. Even with the barriers imposed by his thesis committee, the enterprising scholar should have done more than just recognize the important issues contextual criticism defines. How valid, for example, is it to identify the relationship between Ivens's aesthetics and ideology but not evaluate sufficiently the depth of Ivens's aesthetics or ideology? Why not go beyond introducing what the filmmaker meant when he says that his main interest is "revolution"; his main concern, "social change"? If Ivens admonishes other documentary filmmakers for producing boring films, why not explain how audiences and critics reacted to his theories that film is "a dialectic play," that there is little difference between the documentary and the fiction film, and that political commitments give birth to his aesthetics? Unfortunately, Boker's five chapters are content only to establish what Ivens's work represents and to set him adrift in an ideological framework.

The disappointment with the book is as much the result of the many fine ideas the author offers as with its acts of omission. A lesser effort would have produced fewer disappointments. A case in point is Boker's chapter on Ivens's social and political values. He expertly discusses the filmmaker's attitudes toward the reconstruction of events in the documentary, the fact that social reality can be effectively presented in both factual and nonfactual films, the problems that prevent documentary filmmakers from reaching the mass audiences where the most converts to a cause can be found, and why cinema is an incidental form that Ivens uses to record the change in the structure of society. Then suddenly we're given a list of negative reactions to the films by such formidable critics as Francois Truffaut--e.g., "Joris Ivens who has filmed in his career nothing but rain, bridges, mud, corn and beets happens to be the official filmmaker of East Europe"--and no serious response is provided by the author. Saying only that different people have different reactions is hardly the scholarly route to take. If the central point of the thesis is to show that Ivens believes that a change in the structure of society will allow a more just social order to emerge, then how well did the films he made represent his purposes? Was every film successful? If not, why not? What were the differences between the two categories? After all, the filmmaker in his autobiography goes to great lengths to discuss his strengths and weaknesses. He prides himself on responding to constructive criticism, especially when it comes from people who take his work seriously. And as Boker aptly explains, the debate over form and content is subordinate to Ivens's rhetorical aims.

Adding to the book's problems are the author's choppy prose and weak editing. THE SPANISH EARTH (1937), for example, is frequently referred to as SPANISH EARTH, and on one page alone "documentary" is misspelled twice. What helps salvage this praiseworthy effort are valuable appendexes containing interviews with Ivens, an excellent bio-filmography, a superb bibliography, and a useful index. What Boker

has done is introduce anew the importance of Ivens as a major filmmaker and lay the groundwork for a more substantial investigation. Well worth browsing.

*Ivens, Joris. THE CAMERA AND I. New York: International Publishers, 1969. Illustrated. 280pp.

Digressive and disjointed, this trouble-filled autobiography nevertheless presents an absorbing picture of a significant documentary filmmaker.[358] It passes quickly over the years from 1898 (when Ivens was born at Nymegen, Holland) to 1927 (when Ivens, who had taken over the family photographic business, decided to become a filmmaker). Moving almost immediately to technical and aesthetic concerns, the author shows us the steps that led him from helping operate one of the world's first successful film societies, Filmliga, to becoming initially a filmmaker interested in form, and then, following a three-month visit to Russia in 1929, a socially committed artist of the documentary film.

He credits Pudovkin's film MOTHER/MAT (1926) with inspiring him to experiment with composition in his first film THE BRIDGE (1928), but singles out Dovzhenko as the filmmaker who influenced him most in his lifelong concerns with worldwide social revolutions. Ivens's recollections about the strengths and weaknesses of his initial film output are refreshing and valuable. He explains how and why people reacted to documentaries devoid of story or social links. Even if readers doubt the naive claims that laymen provided more constructive criticism than skilled film critics, you can appreciate Ivens's passion for the world of social action. The rambling discussions about the production problems associated with INDUSTRIAL SYMPHONY/PHILIPS-RADIO (1931), SONG OF HEROES/HELDENLIED, KOMSOMOL (1932), BORINAGE/MISERE AU BORINAGE (1933), THE FOUR HUNDRED MILLION (1938), and POWER AND THE LAND (1939) offer perceptive examples of the problems and issues dedicated filmmakers face in presenting their ideas. For example, Ivens gives considerable attention to the critical issue of reenactments in a straight documentary film. While acknowledging Vertov's arguments that only the actual event should be filmed in actuality movies, Ivens finds reenacted events prefectly valid if they deepen a film's content. However, there is a danger in going too far. That occurs when studio shots replace actual locations, professional actors substitute for those who participated in the events. Then authenticity is lost, and it becomes "not only a matter of matching light and movement . . . [but] also a matter of matching style and attitude."

Indicative of the book's pluses and minuses is the section covering the production of THE SPANISH EARTH (1937). Ivens begins by explaining what brought him to the subject ("filming a war where ideas of Right and Wrong were clashing in such clear conflict"), how he assembled his key personnel (Helen van Dongen, John Ferno), the reasons why Contemporary Historians produced the film (information and fund-raising purposes), and how his initial script was unsuited for the task (it bore no relationship to what was taking place in the war and failed to encompass what occurs during combat filming). His digressions about what combat photographers must go through as they film are excellent, as are his explanations of how editors can deepen the meaning of the footage by concentrating on psychological and emotional factors rather than on physiological images and sounds alone. Where Ivens falters is in his discussion of Hemingway's commentary, choosing to praise the great writer's efforts rather than give us a fuller picture of how Hemingway worked. Even more disappointing is the author's simplistic reaction to the arguments raised by critics and censors against the film: e.g., propaganda, lack of objectivity, lack of information. It is one thing to state that no sensitive filmmaker can be indifferent to fascism, and that choosing sides is natural and understandable. It is another thing to ignore the charges that he reduced the complexities of the conflict to childlike explanations of the issues; or that in being so involved in the action, he took too

[358] For an update, see Peter B. Flint, "Joris Ivens, 90, Dutch Documentary Film Maker," NEW YORK TIMES A (June 30, 1989):14.

much for granted in presenting the issues. In either case, the artist and the audience encounter more problems than necessary.

The second half of the autobiography shifts without warning to diarylike accounts of Ivens's worldwide filming activities and remains interesting mainly to those who have seen films like THE FOUR HUNDRED MILLION and POWER AND THE LAND. It offers a limited perspective on how to deal with military censorship and combat photography. Not much useful information is provided on Ivens's post-World War II films. Part of the reason is the fact that the original book was written during the forties, and only a minimum amount of updated material is included in the brief addenda. Interesting illustrations and a useful filmography are provided, but not an index. Worth browsing.

HUMPHREY JENNINGS

Hodgkinson, Anthony W., and Rodney E. Sheratsky. HUMPHREY JENNINGS: MORE THAN A MAKER OF FILMS. Foreword Roger Manvell. Hanover: University Press of New England, 1982. Illustrated. 205pp.

In this, the first full-length study of the distinguished British filmmaker, the authors use any pretext to praise Jennings's creative activity, whether in films, poetry, sociology, or painting. In addition, as Manvell states in his supportive and sentimental foreword, "the authors . . . see him as a unique interpreter during the 1930s and the 1940s of British cultural tradition and of life in England during those troubled prewar and wartime years." Both Manvell and Hodgkinson knew Jennings, and that partly explains the loving care with which they protect his memory. Nevertheless, Jennings's detractors point out that what made him "unique" was his upper-class consciousness that remained steadfast, despite his participation in the British documentary movement with its emphasis on dignifying the working class. Sheratsky, however, is a distant American admirer who presumably was chosen to coauthor the book because of his talented film criticism and a much-recognized need for objectivity. That may explain the shift in emphasis once the narrative nears the postwar period. Up to that point, we're presented with an image of a Renaissance man who was intent on becoming famous and could do little wrong in his seventeen years as a filmmaker.

The picture the authors paint of this remarkable individual is useful to film historians. Born on August 19, 1906 in Walberswick, Suffolk, Jennings from birth possessed an exceptional intellect and a passion for independence. His comfortable circumstances permitted him a wide range of interests, which his progressive parents willingly encouraged. His classmates at Cambridge--e.g., Jacob Bronowski, William Empson, Kathleen Raine, and Charles Madge--shared the young man's love of moving pictures, negative attitude toward the modern mechanized world, and undying respect for the classics. Jennings and his friends particularly enjoyed experimenting in the arts, whether it be with revolutionary stage designs or innovative literary magazines. No matter how erratic the young man's results, admirers always praised his energy and his enthusiasm. The narrative gets a little muddy once Jennings arrives at the GPO and begins working on sets for Cavalcanti films like PETT AND POTT (1934) and COAL FACE (1935). More critical commentators might be satisfied to indicate that these exercises gave the youngster a much-needed experience in the nature of film production. Our devoted authors, however, are soon talking about his "editing trilogy." They cite comments by the formidable Rachel Low that Jennings "may have directed" some of the shooting of COAL FACE. Interestingly, the comments expressed by Cavalcanti, and recorded in Sussex's book, are omitted. The reason may be because on the same page that Cavalcanti expresses his admiration for Jennings as a "film poet," Basil Wright is criticizing the young man's "sneering attitude towards the efforts of the lower class groups to entertain themselves," and Grierson is referring to Jennings as "a minor poet" who was "a very stilted person." Later on, when the authors get to the early stages of World War II, they slip in the comment that Wright "was almost consistently hostile to Jennings's wartime films," but offer no satisfactory explanations for Grierson's hostility. This emphasis on the positive to the neglect of serious critical evaluation sets the tone and the direction for the next third of the biography. We learn that Madge and Jennings spearheaded the

formation in 1937 of MASS OBSERVATION, a group concerned with scientifically surveying the culture of British islanders. How effective were the results, what were the problems, and why it went under seem of little concern to the authors. We learn mainly that the group's ideas were expressed in Jennings's highly significant film SPARE TIME (1939). Where Hodgkinson and Sheratsky are very helpful is in capsulating what many viewers admire in Jennings's films: i.e., complex ideas poetically clarified, emotional imagery, and an obsession for glorifying English culture. Where they stumble badly is in presenting the complex issues that divided British documentary filmmakers in World War II. The attacks on Jennings by the authors of DOCUMENTARY NEWSLETTER (Elton, Anstey, and Wright) cannot be dismissed as based only on "bias." Nor can the claims of what he did or did not contribute to specific films between 1939 and 1945 be so quickly glossed over. Here again, Sussex's book is helpful. Hodgkinson and Sheratsky acknowledge her observation that she found no evidence that Jennings codirected with Harry Watt the stunning LONDON CAN TAKE IT (1940). They do not refer, however, to Sussex's additional comments that it "should always be remembered that, for Jennings, . . . [his] formative experience went back to the work of the GPO film unit." For our authors to do so would be to acknowledge the importance of Grierson, and this they systematically downplay. A case in point is the treatment of Jack Beddington, a key figure at Shell's International Marketing branch and at the Ministry of Information. Beddington and Grierson maintained a love-hate professional relationship during their careers, and this underlies our authors' unqualified admiration for his work. That is not to say he did not deserve high praise for his work on documentary films. He did. My point is that the "enemies" of Jennings are also the "enemies" of our authors. Surprisingly, the narrative turns critical at the point when most film critics agree on Jennings's magnificent wartime films: e.g., LISTEN TO BRITAIN (1942), FIRES WERE STARTED, and THE SILENT VILLAGE (both in 1943). THE SILENT VILLAGE in this study, for example, emerges as flawed because of noticeable government interference and is labeled the "grimmest of all Jennings' films." The narrative ends, however, on the same note with which it began. Despite the fallow years from 1947 to 1949, the authors are still praising Jennings's intellect, his creative ideas, and his enormous energy. And for those critical of the artist's elitist values, we're given the statement that "The acceptance of hierarchy, of the natural authority of certain classes of people, was (and to a lesser degree still is) a basic British habit, developed over centuries of a monarchic and aristocratic tradition. It is difficult for Americans, whose culture is founded on revolt and the constant QUESTIONING of authority, to appreciate this." This position tells us more about the authors than it does about their subject. Maybe if Jennings had not died tragically in 1950, still in his early forties, the story might have been different.

Once readers become acclimated to the authors' point of view, the book's value increases. The many fine illustrations, the useful filmography, extensive notes, and competent index synthesize a diverse collection of material. This biography, along with the volume of essays and excerpts from the book by Jennings's daughter, should serve as the basis for a serious study of an important filmmaker. Well worth browsing.[359]

*Jennings, Mary-Lou, ed. HUMPHREY JENNINGS: FILM-MAKER/ PAINTER/POET. London: British Film Institute with Riverside Studios, 1982. Illustrated. 76pp.

Produced in conjunction with the 1982 Jennings exhibition at Riverside Studios in London, this attractive booklet illustrates the many facets of Humphrey Jennings's creative life as a filmmaker, as a photographer, and as a writer. The films, primarily produced for sponsors, represent his work for the British government (the General Post Office film unit, which became the Ministry of Information's Crown Film Unit in

[359] A useful essay to read in connection with this book is Geoffrey Nowell-Smith, "Humphrey Jennings: Surrealist Observer," ALL OUR YESTERDAYS: 90 YEARS OF BRITISH CINEMA, ed. Charles Barr (London: British Film Institute, 1986), pp.321-33.

1941, and, finally, the Central Office of Information in 1946), and Ian Dalrymple's Wessex Films. The paintings, drawings, collages, and photographs are drawn from the private collections of his family. Also included are tributes to Humphrey Jennings, composed after his tragic death, by Charles Madge and Kathleen Raine; Lindsay Anderson's noteworthy essay "Only Connect: Some Aspects of the Work of Humphrey Jennings"; and critical commentaries by David Mellor and Dai Vaughan. Mary-Lou Jennings concludes the text with a useful filmography and bibliography. Recommended for special collections.

MARCEL OPHULS

Johnston, Mireille, trans. THE SORROW AND THE PITY: A FILM BY MARCEL OPHULS. Introduction Stanley Hoffman. Biographical and Appendix Material Mireille Johnston. New York: Outerbridge and Lazard, 1972. Illustrated. 194pp.
 One of the finest documentary films ever made is translated effectively into an important film script for study and reflection. Ophuls's intention in his masterpiece on France from 1939 to 1945 was, according to Hoffman, "to show the discrepancy between present testimonies and past reality, the distortions of memory and the soothing role of oblivion for many souls that need to find peace." Now we are given a printed copy of Ophuls's superb success, along with a thoughtful commentary, plus appendexes on the Massilia episode, the British bombardment at Mers-el-Kebir, and the Resistance, plus a history of French governments since 1940, a chronology of events from 1940 to 1945, and a glossary of the names and terms used in the film.
 Hoffman's thoughtful introduction summarizes the major issues associated with the production and exhibition of the four-and-a-half hour movie. It proves once again that there are no substitutes for what the cinema can show us about individuals in terms of what they looked like, how they spoke, and the impact of their gestures. Ophuls's film, for example, clearly meant to take the side of the Resistance; and thus the physical appearance of people who deny their anti-Semitism, who refuse to admit their support for the Vichy government, and who rationalize their horrendous immorality during the Nazi occupation of France negates their long-winded and self-serving protests to the contrary. But Hoffman reminds us that the film, which was originally made for Swiss and German television, is more than an attack on a false myth about what took place during World War II. It is also an example of political censorship, of a filmmaker's message sometimes interfering with his judgment, and of a reminder of how the past and the present treat the "truth." What makes the film invaluable for serious students is not only the picture of human beings trapped by their fears and prejudices, but also a portrait of what a conquered nation experiences both in defeat and liberation. That is, the film provides us with "a way of learning without indoctrination." Highly recommended for special collections.

LENI RIEFENSTAHL

*Barsam, Richard Meran. FILMGUIDE TO "TRIUMPH OF THE WILL." Bloomington: Indiana University Press, 1975. 82pp.
 Extremely useful for its factual contents, this slim study guide presents a number of problems when it comes to analysis and balance. The author's views on Riefenstahl's propaganda documentary reinforce his comments elsewhere. What we get, therefore, is a synthesis of why the thirty-one-year-old director did what she did as well as the tired arguments about her intentions and the false impressions the finished film made on those who saw it. What is found nowhere else, however, is the care with which Barsam builds his case. He includes a biographical sketch and filmography of Riefenstahl, a useful outline of TRIUMPH OF THE WILL/TRIUMPH DES WILLENS (1935), a provocative overview of the film's production problems, and a controversial essay on "The Paradox of Propaganda." The latter, for example, acknowledges "TRIUMPH OF THE WILL as a superb example of political propaganda even as we are repelled by its vision," but argues that the film's critics "have paid less attention to its artistic achievement than to its politics." Barsam then goes on to identify the three major responses critics have had to the film. First, he attacks those critics who have allowed their moral and political values to interfere with their

critical judgments (i.e., Kracauer). Second, he identifies critics like Grierson who understood and even appreciated the film's skill in using film as propaganda. And third, Barsam reminds us that there are critics like Ken Kelman who appreciate the film's artistic merit in spite of its politics. Whether or not the author fairly represents the various critics he selects is secondary to the important issues he raises. Informed readers will find Barsam's arguments challenging and worth engaging.

Regrettably, the book fails to give us either illustrative material or an index. Nevertheless, it does give us a useful companion piece to the film. Well worth browsing.

Graham, Cooper C. LENI RIEFENSTAHL AND OLYMPIA. Metuchen: The Scarecrow Press, 1986. Illustrated. 323pp.

Gleaned from the author's NYU dissertation, this fascinating study is the most exhaustive documentation on the filmmaker's collaboration with the National Socialist regime in making the controversial film about sports and propaganda. An excellent place to begin the study of Riefenstahl's art and objectives. Endnotes, appendexes, a bibliography, and an index are included. Highly recommended for special collections.

Hinton, David B. THE FILMS OF LENI RIEFENSTAHL. Metuchen: The Scarecrow Press, 1978. Illustrated. 168pp.

Infield, Glenn B. LENI RIEFENSTAHL: THE FALLEN FILM GODDESS. New York: Thomas Y. Crowell, 1976. Illustrated. 278pp.

FILMS

NEWSREEL ANTHOLOGIES

OVER THERE, 1914-1918 (France--16mm: 1963, 90 mins., b/w, English narration, sound, R-BUD)

Jean Aurel's production, based upon clips from various newsreels and official government documentaries, records World War I from the individual infantryman's perspective.

LIFE AND TIMES OF ROSIE THE RIVETER (Field--16mm: 1978, 65 mins., b/w, sound, R-DCL)

This inventive revisionist look at World War II concentrates on the way in which working women on the home front helped the war effort. Interviews with articulate participants from the era are mixed with personal photographs and 1940s newsreel footage to provide an absorbing record of the way in which women were integrated into the work force during the war and then summarily discarded during the postwar period in order to make room for returning veterans. Directed and produced by Connie Field, the compilation film reveals how newsreels can be used for historical evidence on the attitudes and values of a specific period.

A TRIP DOWN MEMORY LANE (Canada--16mm: 1966, 12 mins., b/w, sound, R-CON)

Arthur Lipsett's National Film Board collection of newsreel clips since the early days of moving pictures presents a brief, incisive, and memorable history of stupidity and inhumanity, particularly in the war scenes.

VIVRE (France--16mm: 1959, 8 mins., b/w, English subtitles, sound, R-CON)
 Carlos Vilandebo's French film, using well-chosen newsreel scenes shot all over the globe during the last forty years, poignantly visualizes the misery and horror that war spawns. No dialogue is used or needed.

SPANISH CIVIL WAR

THE SPANISH EARTH (Spain--16mm: 1937, 54 mins., b/w, sound, English narration, R-FNC)
 Directed by Joris Ivens,[360] the emotionally propagandistic plot contrasts life in Madrid where people are being terrorized by bombing raids from German and Italian planes, with the peaceful existence of peasants in the small village of Fuenteduena, where the major concern is finding enough water to cultivate crops. Ivens claimed that the film's general theme "was working the earth and fighting for the earth."[361] Ernest Hemingway's commentary makes no attempt to explain why the war is taking place, what the issues are, and who the participants are. The film itself illustrates how Americans committed to helping the Loyalist position in the Spanish Civil War relied heavily on patriotic sound and imagery to help raise funds for an antifascist cause. But Ivens's first revolutionary war film is more than just a reaction to fascism and to events in Spain from 1936 to 1939. "SPANISH EARTH," as Carlos Boker stated, "only pretended to call attention to fascist aggression, and then to collect money to buy ambulances for the Republic; today it is an indictment against aggression and fascism, as well as a prophecy of the Second World War."[362]

THE SPANISH TURMOIL (BBC--16mm: 1967, 64 mins., b/w sound, R-FNC/S-FNC; video:S-FNC)
 This excellent documentary traces the rise of Franco's power and the succession of political crises that led to the Spanish Civil War, and eventually to World War II.

TO DIE IN MADRID/MOURIR A MADRID (Spain--16mm: 1963, 90 mins., b/w, English narration, sound, R-FNC)
 One of the finest documentary films ever made, director Frederic Rossif's depressing picture of the Spanish Civil War is brilliant in technique, delivery, and impact.

MARCH OF TIME

THE RAMPARTS WE WATCH (Time, Inc.--35mm, 16mm: 1943, 60 mins., b/w, sound, R-FNC, MAC, UMI, SUF/S-MAC)
 Under Louis de Rochemont's direction and with authentic newsreel footage from World War I laced with fictionalized scenes, this film propagandizes for America's entry into the European conflict. Its basic message was that our democratic way of life was being threatened by foreign powers and their devastating military forces.[363]

[360] Joris Ivens, "Spain and THE SPANISH EARTH," NONFICTION FILM THEORY, pp.349-75; Sidney Meyers and Jay Leyda, "Joris Ivens: Artist in Documentary," THE DOCUMENTARY TRADITION, pp.158-66.

[361] *Joris Ivens, THE CAMERA AND I (New York: International Publishers, 1969), p.124.

[362] Boker, p.4.

[363] THE MARCH OF TIME, pp.244-72.

MUSIC IN AMERICA (Time, Inc.--16mm: 1943, 17 mins. b/w, sound, R-MMA)
 An example of how entertainers boosted the morale of the servicemen during the
war, it contains good shots of Glenn Miller, Perry Como, Marian Anderson, and Art
Tatum.

THE ARMY-NAVY SCREEN MAGAZINE

ARMY-NAVY SCREEN MAGAZINE HIGHLIGHTS (United States Government--16mm:
1943-1945, 62 mins., b/w, sound, S-NAC)
 The National Audio Visual Center has put together an entertaining,
representative compendium of the highlights of episodes produced during the last
three years of World War II. Among the selected segments are examples of the songs
and humor by some of Hollywood's most famous stars, the "By Request" news features
about the war, and the Private Snafu short entitled "Spies."[364] The program is also
available in both the Beta and the VHS formats.

THE WAR-ISSUE--10 (1945). BURMA OUTPOST--ISSUE 22 (1945). BATTLE OF THE
UNITED STATES--ISSUE 42 (1945).
 Each of these twenty-minute, folksy films, available from the Museum of Modern
Art, was heavily influenced by the attitudes and desires of the troops themselves.
They were intended more as entertainment than as propaganda. In particular, the
emphasis was on authoritative, first-hand reporting, with a snappy, everyday
commentary delivered in a matter-of-fact voice. Other interests in this diverse screen
series, as Barsam reports, included "cartoons (Private Snafu); quick, factual
instructions on various subjects; and more serious reports (such as J. Edgar Hoover's
narration of Nazi espionage in the United States)."[365]

WHY WE FIGHT

THE NAZIS STRIKE (War Department--16mm: 1942, 41 mins., b/w, sound, R-BUD,
IMA, KIT, MMA, TWY/S-CIE, REE; video:S-NAC)
 Capra and Anatole Litvak directed this account of the German invasion and defeat
of Austria and Poland. It illustrates how the series used the combat footage of other
nations--Allied and Axis--as well as other sources to make propaganda statements in
the context of history. It also reveals that greater attention was paid to telling us
what was needed from the nation for the war to be won rather than to showing us
what was happening. This technique was in keeping with Capra's mission of attacking
isolationist objections to America's entering the war, strengthening the image of
American military power, and praising the courage of our allies.[366]

DIVIDE AND CONQUER (War Department--16mm: 1943, 58 mins., b/w, sound, R-FES,
IOW)
 Capra and Litvak again on the German war machine, this time attacking Denmark,
Norway, and France. We are shown the British defeat at Dunkirk and the French
being conquered by the Nazis. Among its many fascinating features are the use of

[364] For more information, see David Culbert, "Walt Disney's Private Snafu: The Use
 of Humor in World War II Army Film," PROSPECTS 1 (December 1975):80-96.

[365] NONFICTION FILM, p.192.

[366] For a good overview of how the army used this series to justify the war effort,
 see David Culbert, "Social Engineering for a Democratic Society at War," FILM
 AND RADIO PROPAGANDA IN WORLD WAR II, pp.173-91.

animated maps prepared by the Disney studios[367] and the script written by novelist Eric Knight.

NAZI FILMS

PROPAGANDA FILMS II (1933-1937). BLEEDING GERMANY/BLUTENDES DEUTSCHLAND (excerpt) (1933). HANS WESTMAR (excerpt) (1933). ONE OF MANY/EINER VON VIELEN (excerpt) (1934). FOR US/FUR UNS (1937).(Germany--16mm: 27 mins., b/w, sound, R-MMA)
 The concept of rebirth through life in the Nazi Party, a recurrent theme in the Nazi movies of the period,[368] is graphically depicted in the two excerpts showing first a newsreel account of the Nazi funeral of Horst Wessel and next a fictionalized version. FUR UNS is an homage to early members of the party killed in the 1923 "beer hall putsch."

TRIUMPH OF THE WILL/TRIUMPH DES WILLENS (Germany-(16mm: 1935, 120 mins., b/w, sound, no English subtitles. R-BUD, ICS, IOW, KIT, PNX, ILL, UTA, WCF/S-CIE, NCS, PNX, IMA, REE. Subtitled version, R-CTH, IMA, JAN, TWY, WCF. Abridged 52-min. version, R-IMA/S-IMA CIE, NCS, PNX, REE; The Museum also has a 40-min. version, with English titles, R-MMA).
 Leni Riefenstahl's technically brilliant film was a deliberate attempt to influence public attitudes favorably toward the Nazi Party both in Germany and the rest of the world.[369] The movie centers on the 1934 Nuremberg rally; the major emphasis is on showing Hitler as the savior of the German people.[370]

[367] For a useful discussion of the relationship between Disney and Capra during the Second World War, see Shale, pp.38-40.

[368] William G. Chrystal, "Nazi Party Election Films, 1927-1938," CINEMA JOURNAL 15:1 (Fall 1975):28-47.

[369] For useful information on the films of Leni Riefenstahl, see the following: Richard Meran Barsam, "Leni Riefenstahl: Artifice and Truth in a World Apart, FILM COMMENT 9:6 (November-December 1973):32-37; a special issue of FILM COMMENT 3:1(Winter 1965):1-31; Arnold Berson, "The Truth about Leni," FILMS AND FILMING 11:7 (April 1965):15-9; David Gunston, "Leni Riefenstahl," FILM QUARTERLY 14:1 (Fall 1960):4-19; Hans Barkhausen, "Footnote to the History of Riefenstahl's OLYMPIA," ibid., 28:1 (Fall 1974):8-12; Siegfried Kracauer, FROM CALIGARI TO HITLER: A PSYCHOLOGICAL HISTORY OF THE GERMAN FILM (Princeton: Princeton University Press, 1947); David Stewart Hull, FILM IN THE THIRD REICH: A STUDY OF THE GERMAN CINEMA 1933-1945 (Berkeley: University of California Press, 1969); Michel Delahaye, "Leni and the Wolf: Interview With Leni Riefenstahl," CAHIERS DU CINEMA IN ENGLISH 5, CdC: 170 (June 1966):48-55; Ken Kelman, "Propaganda as Vision--TRIUMPH OF THE WILL," FILM CULTURE 56:7 (Spring 1973):162-7; Rena Andrews, "Hitler's Favorite Filmmaker Honored at Colorado Festival," NEW YORK TIMES 2 (September 15, 1974):1, 15; Amos Vogel, "Can We Now Forget the Evil that She Did?", ibid., (May 13, 1973):19; "TV Mailbag: 'Leni Could Have Said No'," ibid. 2, (June 3, 1973):17, 33; David B. Hinton, "TRIUMPH OF THE WILL: Document or Artifice?," CINEMA JOURNAL 15:1 (Fall 1975):48-57; and Susan Sontag, "Fascinating Fascism," NEW YORK REVIEW OF BOOKS 22:1 (February 6, 1975):23-30, Rpt. Karyn Kay and Gerald Peary, eds., WOMEN AND THE CINEMA (New York: E. P. Dutton, 1977), pp.35-76.

[370] In addition, there are a number of articles on Nazi propaganda films: Helmut Blobner and Herbert Holben, "Jackboot Cinema: The Political Propaganda Film in

REPORTAGE FILMS

AMERICAN

BATTLE OF SAN PIETRO (War Department--16mm, 1944, 61 mins., b/w, sound, R-MMA/S-NAC)
 Directed by John Huston, this deeply moving film records the events leading up to and the capture of an isolated Italian village in the Liri Valley. No attempt is made to ignore the human cost of the military action on American infantrymen or the villagers themselves. The film is also valuable for depicting the problems faced by combat photographers who recorded many of the events as they were actually taking place.[371]

MEMPHIS BELLE (War Department--16 mm: 1944, 43 mins., color, sound, R-BUD, IMA, IOW, KIT, REE)
 Fascinating not only for its documentary footage, but also for its personalized account of men in combat, the story of the final mission of this Flying Fortress over Germany illustrates the documentary film cliches reported by the previously discussed research. Particularly noteworthy is the manner in which director William Wyler mixed actual combat scenes with the dubbed dialogue of the crew commenting on the battle.[372]

BRITISH

TARGET FOR TONIGHT (England--16mm: 1941, 48 mins., b/w, sound, R-BUD, EMG, KIT/S-FES, KIT)
 Useful to compare and contrast with MEMPHIS BELLE, this record of a routine bombing raid by British fliers over Germany emphasizes what type of men fly these missions. Because the acting is so impressive, many viewers today have trouble believing that director-screenwriter Harry Watt did not use professional actors in a number of the key scenes. In addition, the distinguished film represents the first major attempt by the British to switch from "we-can-take-it" documentaries to those showing them "hitting-back."[373]

FIRES WERE STARTED (England--16mm: 1943, 62 mins., b/w, sound, R-IMA/S-IMA)

the Third Reich," FILMS AND FILMING 9:3 (December 1962):13-9; Herbert G. Luft, "Shadow of the Swastika," ibid., 7:2 (November 1960):10-1; Pom, "The Nazis Return," ibid., 12:7 (April 1966):36-9; Peter John Dyer, "The Rebels in Jackboots," ibid., 5:6 (March 1959):13-5, 32-3, 35; and David Stewart Hull, "Forbidden Fruit: The Nazi Feature Film, 1933-1945," FILM QUARTERLY 14:4 (Summer 1961):16-30.

[371] For useful information, see Gerald Pratley, THE CINEMA OF JOHN HUSTON (South Brunswick: A. S. Barnes and Company, 1977), pp.52-7; and Stuart Kaminsky, JOHN HUSTON: MAKER OF MAGIC (Boston: Houghton Mifflin Company, 1978), pp.39-43.

[372] For useful information, see Michael A. Anderegg, WILLIAM WYLER (Boston: Twayne Publishers, 1979), pp.123-6; and Axel Madsen, WILLIAM WYLER: THE AUTHORIZED BIOGRAPHY (New York: Thomas Y. Crowell Company, 1973), pp.237-40.

[373] Harry Watt, DON'T LOOK AT THE CAMERA (New York: St. Martin's Press, 1974), pp.146-55.

One of Humphrey Jennings's best wartime films, it surprises you with its apparently straightforward subject: a typical day in the life of British firemen during the London blitz. The visuals, however, are anything but matter-of-fact. The scenes of men living, working, and dying in the midst of war poignantly record the heroism of the English nation during the uncertain days of World War II.[374]

THE SILENT VILLAGE (16mm: 1943, 33 mins., b/w, sound, R-MMA)
Humphrey Jennings's film about Nazi vengeance in a Czechoslovak village that was entirely destroyed is another example of the documentary film's use for propaganda purposes.

WORLD OF PLENTY (16mm: 1943, 45 mins., b/w, sound, R-MMA)
Paul Rotha's documentary propaganda masterpiece about the end of the war and what was to come is an example of the way in which movies were used in time of war.

CO-BRITISH AND AMERICAN PRODUCTIONS

DESERT VICTORY (Fox--16mm: 1943, 62 mins., b/w, sound, R-BUD, MMA, TWF, WEL, WIL)
An outstanding effort by the combined crews of the army and Royal Air Force film units, this memorable documentary recorded England's first important victory over the Nazis. It covers the military campaign in North Africa, from the blockade at El Alamein against Rommel's forces to his eventual defeat early the following year. Singled out for exceptional merit are Ray Boulting's editorial contributions and William Alwyn's music.

THE TRUE GLORY (Columbia--16mm: 1945, 85 mins., b/w, sound, R-BUD, FNC, IMA, KIT; S-REE)
Codirected by Carol Reed and Garson Kanin, the film was a joint product of the MOI and the OWI. It chronicles the events from the Allied landing at Normandy to the eventual surrender of Germany. The emotional impact created by the parallel editing of combat footage and the personal perspective of the soldiers involved, along with Alwyn's stirring music, resulted in the film's being awarded the 1945 Oscar for best documentary film.

HOLOCAUST FILMS

MEMORANDUM (Canada--16mm: 1966, 58 mins., b/w, sound, R-IMA, KIT)
Donald Brittain produced and directed this National Film Board movie that contrasts the Bergen-Belsen concentration camp in the sixties and the forties. By focusing attention on Bernard Laufer, a survivor who returns to the modern tourist attraction, we get a sense of horror and frustration as film clips taken from German and British documentary footage are edited into the present-day scenes.

NIGHT AND FOG/NUIT ET BROUILLARD (France--16mm: 1955, 30 mins., color, sound, English subtitles, R-BUD, IMA)
Alain Resnais's classic film contrasts the past with the present in such extermination camps as Buchenwald, Treblinka, and Auschwitz. The screenplay by Jean Cayrol, a survivor from the death camps, provides one of the most terrifying accounts of genocide ever made, and few young people are able to sit through the scenes that detail the atrocities that occurred in those hell holes. According to James

[374] A good summary of the film is provided in Hodgkinson, pp.140-7.

Monaco, the French government banned the film from the 1956 Cannes Film Festival because it might be offensive to a participating government and because the film raised the provocative (and then surpressed) question of what role France played in the "extraordinary crime of the death camps."[375]The film's one major failure is the director's striking distortion in presenting all the camps and their helpless occupants as representative of a single, inhuman design.[376] Resnais seems to be analyzing the events as though he were doing a case study on factory economics: what was needed, how was it done, and what were the results.

THE SORROW AND THE PITY/LE CHAGRIN ET LA PITIE (France--16mm: 1972, 260 mins., b/w, English narration, sound, R-CIV, FES/L-CIV)

Marcel Ophuls, following in the superb tradition of his father, Max, directed this fascinating documentary about Germany's World War II occupation of France and the rise of the French underground. One comes away realizing, if one did not know before, that determined men will stop at absolutely nothing to gain their ends and that time will make it all seem understandable, if not forgivable.

THE MEMORY OF JUSTICE (Paramount--16mm: 1976, 278 mins., b/w-color sequences, sound, R-FNC)

Surrounded with controversy, this remarkable film[377] draws a provocative parallel between the Holocaust and the Vietnam War. The title, attributed to Plato's conviction that mortals in a less than perfect world must be governed by the primeval memory of Justice and Virtue, acted as a guide to the director's investigation of the nature of war crimes.

THE COLD WAR

THE ATOMIC CAFE (Archives Project Inc.--35mm: 1982, 88 mins., b/w, sound, R-NYF; video:R-DCL)

This explosive little documentary was made over a ten-year period by three filmmakers who examined ten thousand hours of government informational films on the atomic bomb. Some of the edited footage depicting how Americans were kept informed about the subject is funny; most of it is shocking and disgraceful. Without any new commentary, Kevin Rafferty, Jayne Loader, and Pierce Rafferty allow us to see how our soldiers were misled into believing they had nothing to fear from participating in atom bomb tests. We watch in disbelief the excerpts from the government-produced films suggesting that survival in an atomic attack amounts to little more than taking minimal precautions. The film is especially nostalgic for viewers who lived through the 1940s and 1950s when these films were being made.[378]

[375] *James Monaco, ALAIN RESNAIS (New York: Oxford University Press, 1979), p.22.

[376] For helpful information, see *Paul A. Schreivogel, NIGHT AND FOG (NUIT ET BROUILLARD): A FILM STUDY (Dayton: George A. Pflaum Publishers, 1970), p.3-22; *Roy Armes, THE CINEMA OF ALAIN RESNAIS (New York: A. S. Barnes and Company, 1968), pp.48-58; and *John Ward, ALAIN RESNAIS, OR THE THEME OF TIME (Garden City: Doubleday and Company, 1968), pp.141-7.

[377] Frank Manchel, "A War Over Justice: An Interview With Marcel Ophuls," LITERATURE/FILM QUARTERLY 6:1 (Winter 1978):26-47.

[378] Vincent Canby, "Film: Documentary on Views about the Atom Bomb," NEW YORK TIMES C (March 17, 1983):16; Robin Herman, "They Turned Old Movies into a Timely Film about Nuclear War," NEW YORK TIMES C (May 16, 1982):1,23; and J. Hoberman, "White Light, White Heat," VILLAGE VOICE 27:12 (March 23, 1982):50.

EIGHT MINUTES TO MIDNIGHT: A PORTRAIT OF DR. HELEN CALDICOTT (Caldicott Project--16mm: 1981, 60 mins., color, sound, R-DIC/L-DIC)
Nominated for a 1981 Oscar for its compelling portrait of Dr. Helen Caldicott's public campaign against the dangers of nuclear war, the filming covers the years between 1978 and 1980. Director Mary Benjamin effectively captures the outspoken pediatrician conveying to her audiences then and now the dangers that atomic and nuclear radiation have not only on our bodies, but also on future generations.

THE VIETNAM WAR

HEARTS AND MINDS (BBS--16mm: 1974, 112 mins., color, sound, R-FNC, UMI)
Winner of the 1974 Oscar for the best documentary film, this controversial film takes full advantage of the medium's resources to make a powerful antiwar statement about America's involvement in Vietnam.[379] Director Peter Davies dramatically contrasts hawks and doves, combatants from the North and South Vietnam forces, and the survivors both home and abroad to show the human cost of the tragic conflict. No matter what your politics, you will find yourself deeply affected by the sound track and the visuals.

THE FICTION WAR FILM

The fiction war film tends, as can be expected, to glorify battles and struggles. But the issues themselves are rarely explored with any concern for a social or historical point of view. Men die, women weep, and children are orphaned. Millions are maimed, tortured, and raped, while nations are leveled. Yet most of the fiction war films have a happy ending.
It is particularly sad that no intelligent perspective is presented in motion pictures made during wartime, but the anxiety of the people often misleads filmmakers, and political censorship discourages filmmakers from delving into the complex issues or the reasons for the conflict itself. A distraught country, mobilized both at home and abroad, searches in its leisure moments for some escape and distraction from long working hours, nerve-racking headlines, and overwhelming loneliness. The film industry, on the one hand patriotic and willing to serve the nation's needs, produces a stream of movies designed to bolster the audience's morale. On the other hand, this same industry, commercially based and tending toward exploitation, greedily makes any kind of film that a maximum-wage working force will blindly pay to watch. Even when the war is over, the same type of film retains its popularity at the box office, or as Robin Bean puts it, "like the Western, the war setting is almost a reliable proposition for a producer, providing it is not too moralistic about its subject."[380]
One way to understand the fiction war film is to examine how it reflects the times in which it was made. A chronological approach allows you to study why and when certain types of conventions were popular, and what influence technology as well as social, political, and economic factors had on the genre. The films of World War I, for example, are useful for showing how the commercial cinema moved from pacifist messages to ardent support of the war to feelings of disillusionment (See TABLE 6). National ideals, stated simply at first, become transformed into complex icons in the movies made during the 1930s and after. Images originally conceived for purposes of reassurance during periods of crisis become stereotypes perpetuating narrow and confining expectations. Former enemies like the Germans, for example, are given

[379] For useful information about the film propaganda carried on by both sides, see "Propaganda Films about the War in Vietnam," FILM COMMENT 4:1 (Fall 1966):4-39.

[380] Robin Bean, "The War Makers," FILMS AND FILMING 12:5 (February 1966):63.

atrocious characteristics that are solidified in the impressionable minds of future generations. Questions of patriotism are transformed into issues of conscience. And as nations seek to bind their wounds in postwar periods, the portrayal of former enemies as sympathetic characters in revisionist film plots meets with questionable results.

TABLE 6

SELECTED WORLD WAR I FILMS

NARRATIVE

Year	Movie
1915	THE BATTLE CRY OF PEACE; THE COWARD; A SUBMARINE PIRATE
1916	CIVILIZATION; WAR BRIDES
1917	THE LITTLE AMERICAN; THE SPIRIT OF '76; THE SPY
1918	HEARTS OF THE WORLD; MY FOUR YEARS IN GERMANY; SHOULDER ARMS; THE KAISER--BEAST OF BERLIN
1920	HUMORESQUE
1921	THE FOUR HORSEMEN OF THE APOCALYPSE
1924	ISN'T LIFE WONDERFUL
1925	THE BIG PARADE
1926	WHAT PRICE GLORY?; THE STRONG MAN; THE ROAD TO GLORY; TELL IT TO THE MARINES
1927	WINGS; HOTEL IMPERIAL; SEVENTH HEAVEN; BARBED WIRE
1928	LILAC TIME; FOUR SONS
1929	THE COCKEYED WORLD; SHE GOES TO WAR
1930	ALL QUIET ON THE WESTERN FRONT; THE DAWN PATROL; HELL'S ANGELS; JOURNEY'S END; YOUNG EAGLES
1931	MATA HARI; DISHONORED; THE LAST FLIGHT; HELL DIVERS
1932	BROKEN LULLABY (THE MAN I KILLED); A FAREWELL TO ARMS
1933	CAVALCADE; TODAY WE LIVE; THE EAGLE AND THE HAWK; I WAS A SPY
1934	THE LOST PATROL; HERE COMES THE NAVY
1935	THE DARK ANGEL; SHIPMATES FOREVER
1936	THE ROAD TO GLORY; SUZY
1937	SEVENTH HEAVEN; GRAND ILLUSION (LA GRANDE ILLUSION); THREE COMRADES; SEA DEVILS
1938	THE DAWN PATROL; SUBMARINE PATROL
1939	SPY IN BLACK; WINGS OF THE NAVY
1940	THE FIGHTING 69TH
1941	SERGEANT YORK; I WANTED WINGS
1942	YANKEE DOODLE DANDY; RANDOM HARVEST; THE BUGLE SOUNDS
1944	WILSON
1947	GOLDEN EARRINGS
1952	WHAT PRICE GLORY?
1955	COURT MARTIAL OF BILLY MITCHELL
1957	THE SUN ALSO RISES; A FAREWELL TO ARMS
1958	PATHS OF GLORY; LAFAYETTE ESCADRILLE
1961	THE GREAT WAR
1962	THE FOUR HORSEMEN OF THE APOCALYPSE; LAWRENCE OF ARABIA
1964	THE YANKS ARE COMING, 633 SQUADRON; THE SECRET INVASION
1965	DOCTOR ZHIVAGO
1966	BLUE MAX; KING AND COUNTRY; KING OF HEARTS/LE ROI DE COEUR
1969	OH! WHAT A LOVELY WAR; DARLING LILI
1971	JOHNNY GOT HIS GUN
1977	MEN OF BRONZE
1978	THE WAR IS OVER
1981	REDS; GALLIPOLI
1983	THE RETURN OF THE SOLDIER

TABLE 7

SELECTED WORLD WAR II FILMS

AFRICA

NARRATIVE

Year	Movie
1941	SUNDOWN
1942	CASABLANCA; SUBMARINE RAIDERS;
1943	SAHARA; IMMORTAL SERGEANT; FIVE GRAVES TO CAIRO; DESTINATION GOBI
1951	THE DESERT FOX
1953	THE DESERT RATS; PARATROOPER
1957	BITTER VICTORY
1960	DESERT ATTACK/ICE COLD IN ALEX
1965	TAXI FOR TOBRUK; THE HILL
1967	TOBRUK
1969	PLAY DIRTY
1971	RAID ON ROMMEL
1978	THE WILD GEESE

World War II fiction films, when viewed chronologically, allow for an even broader study of the genre in context. For example, contrasting the conventions used in movies about combat in Africa (See TABLE 7) with those depicting the conflict in Europe (See TABLE 8) and Asia (See TABLE 9) heightens our understanding of how racial stereotypes were used to reinforce national values. The Japanese are portrayed in films made during the war as "sneaky," "mad dogs," "monkeys," and "rapists," while Americans are shown as just and honorable.[381] Even when we resort to using the same tactics as the enemy, we are justified on the grounds that war forces us to meet the enemy on his own terms. Shain's invaluable research offers extensive examples of demographic breakdowns--i.e., sex, age, class, marital status, education, nationality, occupation--contrasting and comparing the Allies and the enemies, not only in World War II, but also in the Korean and Vietnam Wars. Kane's more limited approach fleshes out how these images were used in twenty-four American fiction feature films. Other studies use AUTEUR theories to explain how individual filmmakers used the genre's conventions either to clarify or confuse the issues of war, patriotism, and justice.

Despite the fact that the subject matter is basically the same, World War II films fall into many diverse categories. In classifying Hollywood feature films, Dorothy B. Jones analyzed 1,313 pictures produced from 1942 to 1944 and found that three out of every ten were related to some aspect of the war.

. . . it may surprise some people that only one-fourth to one-third of Hollywood's output was concerned with the conflict. However, to those who are

[381] For examples of the Japanese counterparts to our theatrical films, see Leslie Bennetts, "Another Side's Views of World War II," NEW YORK TIMES C (February 4, 1987):21.

familiar with the nature of the industry's product, who know the proportion of formula westerns, murder mysteries, domestic comedies, and musicals that go to make up the bulk of pictures turned out each year, it would appear that Hollywood gave a remarkably large proportion of its output to war topics.[382]

First, Jones, head of the Research and Analysis section of the OWI, working on the assumption that there were relatively few people in America who understood what World War II was about, concentrated on motion pictures that explained the United States's role in the war. She found that forty-three war films treated this topic. These films explained our stake in the war, and at the same time justified our way of life. She concluded that generally these movies were superficially made and added little to our understanding of the issues.

Second, Jones explored the war films dealing with the enemy, a group that constituted the major number of films made: 107, or 28.16 percent of the total. Most of the films released in 1942 covered stories about sabotage or espionage; only one of sixty-four films did not. This proved, in her opinion, to be an unfortunate emphasis, particularly at the start of the war.

TABLE 8

SELECTED WORLD WAR II NARRATIVE FILMS

EUROPE

Year	Movies
1939	CONFESSIONS OF A NAZI SPY; BEASTS OF BERLIN/GOOSE STEP/HELL'S DEVILS
1940	FOREIGN CORRESPONDENT; FOUR SONS; THREE FACES WEST; ARISE, MY LOVE; SKI PATROL; FLIGHT COMMAND; MYSTERY SEA RAIDER/SUBMARINE ZONE; ENEMY AGENT
1941	A YANK IN THE RAF; PIMPERNEL SMITH; MAN HUNT; SOMEWHERE IN FRANCE; THEY DARE NOT LOVE; UNDERGROUND; DIVE BOMBER; PARACHUTE BATTALION; I WANTED WINGS; WOMEN IN WAR; INTERNATIONAL LADY; ONE NIGHT IN LISBON; CONFIRM OR DENY; PARIS CALLING; INTERNATIONAL SQUADRON; BUCK PRIVATES; IN THE NAVY; KEEP 'EM FLYING; CAUGHT IN THE DRAFT
1942	MRS. MINIVER; THIS ABOVE ALL; SABOTEUR; JOE SMITH, AMERICAN; DESPERATE JOURNEY; IN WHICH WE SERVE
1943	ACTION IN THE NORTH ATLANTIC; CASABLANCA; HANGMEN ALSO DIE; HITLER'S CHILDREN; KEEPER OF THE FLAME; MISSION TO MOSCOW; THE MOON IS DOWN; SONG OF RUSSIA; STAGE DOOR CANTEEN; WATCH ON THE RHINE; ABOVE SUSPICION; HOSTAGES; EDGE OF DARKNESS; FOR WHOM THE BELL TOLLS; THIS IS THE ARMY; NONE SHALL ESCAPE; MARGIN FOR ERROR; FOREVER AND A DAY; EAGLE SQUADRON; DESTROYER

[382] Dorothy B. Jones, "Hollywood War Films," p.2. Both Bernard F. Dick and Garth S. Jowett critcize Jones's influential essay on the grounds that she used this opportunity to strike back at Hollywood for its refusal to go along with many of her suggestions. I cite it in some detail mainly because of its frequent use in film accounts of World War II. For more information, see THE STAR-SPANGLED SCREEN: THE AMERICAN WORLD WAR II FILM, pp.274, 278-9; and Jowett, FILM: THE DEMOCRATIC ART, p.319.

1944 HAIL THE CONQUERING HERO; LIFEBOAT; NORTH STAR (ARMORED ATTACK);
 PASSAGE TO MARSEILLES; TENDER COMRADE; WING AND A PRAYER; THE
 SEVENTH CROSS; WHITE CLIFFS OF DOVER; TO HAVE AND HAVE NOT;
 THE SULLIVANS; SUNDAY DINNER FOR A SOLDIER;
 SINCE YOU WENT AWAY; SEE HERE, PRIVATE HARGROVE; WESTERN
 APPROACHES/THE RAIDER

1945 A BELL FOR ADANO; ROME, OPEN CITY (ROMA, CITTA APERTA); THE
 STORY OF G. I. JOE; THE WAY TO THE STARS; HOTEL BERLIN; RAILWAY
 BATTLE; WHAT NEXT, CORPORAL HARGROVE?

1946 THE BEST YEARS OF OUR LIVES; A WALK IN THE SUN;
 SHOESHINE (SCIUSCIA);
 THIRTEEN RUE MADELEINE; TILL THE END OF TIME; NOTORIOUS;
 STAIRWAY TO HEAVEN; PAISAN (PAISA); THE MURDERERS AMONG US

1947 CAPTIVE HEART; DEAD RECKONING

1948 KEY LARGO; FOREIGN AFFAIR; THE SEARCH; COMMAND DECISION;
 HOMECOMING; FIGHTER SQUADRON

1949 BATTLEGROUND; TWELVE O'CLOCK HIGH

1950 THE THIRD MAN; THE MEN; THE BIG LIFT; BREAKTHROUGH

1951 TERESA; GO FOR BROKE; FORCE OF ARMS; THE TANKS ARE COMING

1952 FORBIDDEN GAMES (LES JEUX INTERDITS); DECISION BEFORE DAWN;
 RED BALL EXPRESS; EIGHT IRON MEN

1953 STALAG 17; THE CRUEL SEA

1955 TO HELL AND BACK; DIVIDED HEART

1956 ATTACK!; THE BOLD AND THE BRAVE; D-DAY, THE SIXTH OF JUNE

1957 ONE THAT GOT AWAY; THE ENEMY BELOW

1958 DUNKIRK; THE YOUNG LIONS; ASHES AND DIAMONDS (POPIOL I DIAMENT);
 THE NAKED AND THE DEAD; ORDERS TO KILL; DARBY'S RANGERS; KINGS GO
 FORTH; A TIME TO LOVE AND A TIME TO DIE; THE LAST BLITZKREIG

1960 TWO WOMEN; SINK THE BISMARCK

1961 JUDGMENT AT NUREMBERG; TOWN WITHOUT PITY; THE GUNS OF NAVARONE;
 ARMORED COMMAND; THE BRIDGE; TWO WOMEN; INVASION QUARTET

1962 THE LONGEST DAY; HELL IS FOR HEROES; THE COUNTEFEIT TRAITOR;
 FIVE FINGER EXERCISE; THE PASSWORD IS COURAGE

1963 THE VICTORS; THE GREAT ESCAPE; THE DAY AND THE HOUR/LE JOUR ET
 L'HEURE; THE WAR LOVER; THE AMERICANIZATION OF EMILY; CAPTAIN
 NEWMAN, M. D.

1965 THE BATTLE OF THE BULGE; OPERATION CROSSBOW; MORITURI/THE
 SABATOUR: CODE NAME--MORITURI; THE TRAIN; UP FROM THE BEACH;
 VON RYAN'S EXPRESS; THIRTY-SIX HOURS; OPERATION SNAFU

1966 THE HEROES OF TELEMARK; IS PARIS BURNING?; WHAT DID YOU DO IN
 THE WAR, DADDY?; WEEKENDS AT DUNKIRK; IT HAPPENED HERE

1967 THE NIGHT OF THE GENERALS; THE DIRTY DOZEN; THE 25th HOUR;
 HOW I WON THE WAR; TRIPLE CROSS

1968 THE YOUNG WARRIORS; THE DEVIL'S BRIGADE; THE LONG DAY'S DYING;
 ATTACK ON THE IRON COAST; ANZIO; COUNTERPOINT

1969 WHERE EAGLES DARE; CASTLE KEEP; THE BATTLE OF BRITAIN; THE
 BRIDGE AT REMAGEN; SUBMARINE X-1; THE SECRET OF SANTA VITTORIA

1970 PATTON; CATCH-22; DARLING LILI; KELLY'S
 HEROES; HORNET'S NEST; MOSQUITO SQUADRON; THE LAST ESCAPE; THE
 MCKENZIE BREAK; WHICH WAY TO THE FRONT?

1971 MURPHY'S WAR

1972 SLAUGHTERHOUSE FIVE

1973 EAGLES OVER LONDON; HITLER: THE LAST TEN DAYS

1975 UNDERCOVER HERO

1977 JULIA; CROSS OF IRON; A BRIDGE TOO FAR

1978 BREAKTHROUGH; FORCE TEN FROM NAVARONE; BRASS TARGET

1979 YANKS; HANOVER STREET

1980 THE BIG RED ONE; THE SEA WOLVES

1981	MEPHISTO; THE NIGHT OF THE SHOOTING STARS (LA NOTTE DI SAN LORENZO); LILI MARLEEN; THE BOAT/DAS BOOT
1982	INSIDE THE THIRD REICH
1983	THE WINDS OF WAR; TO BE OR NOT TO BE; GERMANY PALE MOTHER
1985	OVERLORD
1986	NAZI HUNTER: THE BEATE KLARSFELD STORY; THE ASSAULT
1987	DESTINY; HOPE AND GLORY
1988	HISTORY

Frightened and misguided citizens became suspicious of foreigners living in America (film spies spoke with foreign accents and innocent-looking people often turned out to be dangerous aliens).[383] No one knew how many actual spies were living in the country, and isolated events became accepted as widespread occurrences. Not only did this help the Axis cause but it also helped divide the nation itself. Screen exaggerations, therefore, presented a serious threat and a disservice at the outset. As Jones notes, these films contained the greatest examples of distortions in war films made during this period.

Third, she turned her attention to films depicting our Allies. These movies, she found, provided Americans with a general understanding of our friends. Some of the countries depicted were Russia, China, France, and England. These films in many respects were Hollywood's most intriguing war movies. What is surprising is that the people who wrote, produced, starred in, and directed these movies knew very little about the citizens and countries they were depicting. No amount of research could overcome their lack of first-hand knowledge. And authentic costumes were no substitute for a perceptive understanding of the customs and values of individuals in Allied nations. The only useful purpose the films served was to link Americans to friendly powers abroad.

Fourth, Jones investigated the films covering American war production, and found that relatively few films in this area were made--twenty-one in all. Not only were they few in number, but they were also poorly made. There seems to be no doubt that Hollywood failed deplorably in presenting the contribution of management and labor in the winning of the war.

Fifth, she analyzed movies made about the home front; there were only forty films made in this category. Some of the home-front problems portrayed on the screen were housing shortages, civilian defense activities, life in wartime Washington, and juvenile delinquency. She concluded that the Hollywood feature film failed to dignify the efforts of the home-front war or to interpret its value to the total war effort. Just the reverse occurred. These movies ridiculed, exaggerated, or sensationalized the dilemma. And the group most adversely affected by these exploitative films was the domestic audience itself.

Finally, Jones evaluated the war films showing our servicemen in action, a total of ninety-five films, or twenty-five percent of the total war film production. The themes of these movies centered on such areas as the fighting man, his development in boot camp, his adventures in battle, and his leaves. Although she found some good films made in this category, Jones believes that most of the pictures were undesirable and unfortunate. Musicals and comedies of the period, often done in poor taste, minimized the seriousness of the war. Melodramas, complete with arrogant, swashbuckling American heroes who ALONE delivered the crucial blow that brought victory, were seriously criticized by our Allies for downplaying their role in the war by exaggerating the United States's contribution. These films minimized the teamwork

[383] The film BAD DAY AT BLACK ROCK treats an aspect of this problem. Robert Ryan and some of his cronies kill a Japanese-American tenant farmer to prove their patriotism.

TABLE 9
SELECTED WORLD WAR II NARRATIVE FILMS
PACIFIC

Year	Movies
1942	ACROSS THE PACIFIC; WAKE ISLAND; STAND BY FOR ACTION; FLYING TIGERS; FLYING FORTRESS; EAGLE SQUADRON; A YANK ON THE BURMA ROAD; MANILA CALLING
1943	A GUY NAMED JOE; AIR FORCE; CRY HAVOC; GUADALCANAL DIARY; BATAAN; CHINA; CRASH DIVE; SO PROUDLY WE HAIL; GUNG HO!
1944	DESTINATION TOKYO; THE PURPLE HEART; THIRTY SECONDS OVER TOKYO; MARINE RAIDERS; A WING AND A PRAYER; THE FIGHTING SEABEES
1945	BACK TO BATAAN; BLOOD ON THE SUN; PRIDE OF THE MARINES; GOD IS MY CO-PILOT; THEY WERE EXPENDABLE; OBJECTIVE BURMA!
1947	THE BEGINNING OR THE END
1949	SANDS OF IWO JIMA; MALAYA; HOME OF THE BRAVE; TASK FORCE
1950	AMERICAN GUERRILLA IN THE PHILIPPINES; THREE CAME HOME; HALLS OF MONTEZUMA
1951	THE FROGMEN; FLYING LEATHERNECKS; OPERATION PACIFIC; FIGHTING COAST GUARD
1952	THE WIDE BLUE YONDER; FLAT TOP
1953	FROM HERE TO ETERNITY; THUNDERBIRDS
1954	THE CAINE MUTINY; BEACHHEAD
1955	THE PURPLE PLAIN; MISTER ROBERTS; BATTLE CRY
1956	THE BURMESE HARP; THE PROUD AND THE PROFANE; THE TEA HOUSE OF THE AUGUST MOON; AWAY ALL BOATS; BETWEEN HEAVEN AND HELL; BATTLE STATIONS
1957	THE BRIDGE ON THE RIVER KWAI; SAYONARA; HEAVEN KNOWS, MR. ALLISON; HELLCATS OF THE NAVY
1958	RUN SILENT, RUN DEEP; SOUTH PACIFIC; TORPEDO RUN; THE DEEP SIX; CHINA DOLL
1959	FIRES ON THE PLAIN/NOBI; HUMAN CONDITION; UP PERSICOPE; BATTLE OF THE CORAL SEA
1960	THE GALLANT HOURS; NEVER SO FEW
1961	JUNGLE FIGHTERS; BRIDGE TO THE SUN
1962	P. T. 109; NO MAN IS AN ISLAND; DESERT PATROL; JUNGLEFIGHTERS
1964	THE THIN RED LINE; MAN IN THE MIDDLE; FATHER GOOSE; ENSIGN PULVER
1965	KING RAT; NONE BUT THE BRAVE; IN HARM'S WAY; AMBUSH BAY; THE WALLS OF HELL
1967	BEACH RED; FIRST TO FIGHT
1968	HELL IN THE PACIFIC
1969	THE EXTRAORDINARY SEAMAN
1970	TORA! TORA! TORA!; TOO LATE THE HERO
1976	MIDWAY; FAREWELL TO MANZANAR
1977	MACARTHUR
1980	THE FINAL COUNTDOWN
1986	WOMEN OF VALOR
1987	EMPIRE OF THE SUN; THE LAST EMPEROR
1988	TOO YOUNG THE HERO

that in fact won the war, not individual heroism. Jones concluded her research by finding that "most of the war films produced by Hollywood were inconsequential, misleading, or even detrimental to the war program."[384]

In addition to Jones's classifications, we can add the subgenre of the Holocaust films (See TABLE 10). Not only is it useful to contrast and compare these fiction films with their documentary counterparts, but it is also valuable to discuss whether one category or the other is more suited for artistic interpretations. What criteria should be used to determine when a film has trivialized, even falsified, the facts for commercial purposes? How much weight should be given to issues of aesthetics in relation to those of morality? The study of such films also makes clear how history on film often makes use of the past to comment on the present. It sharpens the need to minimize the errors in judgment and understanding that result when a subject becomes distant and misunderstood, when memory is clouded by fantasy.

TABLE 10

SELECTED HOLOCAUST FILMS

NARRATIVE

Year	Movie
1937	PROFESSOR MAMLOCK
1940	THE GREAT DICTATOR; ESCAPE; THE MAN I MARRIED
1941	SO ENDS OUR NIGHT
1942	TO BE OR NOT TO BE
1947	CROSSFIRE
1948	THE LAST STOP/OSTANTI ETAP
1955	I AM A CAMERA
1957	KANAL
1958	ASHES AND DIAMONDS/POPIOL I DIAMENT
1959	THE DIARY OF ANNE FRANK; GENERAL DELLA ROVERE/IL GENERALE DELLA ROVERE
1960	EXODUS; CONSPIRACY OF HEARTS
1961	JUDGMENT AT NUREMBERG; SAMSON; THE GOLD OF ROME/L'ORO DI ROMA
1962	AMBULANCE; THE PASSENGER; THE CONDEMNED OF ALTONA/I SEQUESTRATI DI ALTONA; LISA
1965	THE PAWNBROKER; SANDRA/VAGHE STELLE DELL'OREA, THE SHOP ON MAIN STREET/OBCHOD NA KORZE
1966	THE TWO OF US/LE VIEIL HOMME ET L'ENFANT; RETURN FROM THE ASHES; THE FIFTH HORSEMAN IS FEAR
1969	THE DAMNED/LA CADUTA DELGI DEI
1970	LANDSCAPE AFTER BATTLE/KRAJOBRAZ PO BITWIE; THE GARDEN OF THE FINZI-CONTINIS/IL GIORDINO DEI FINZI-CONTINI
1972	CABARET
1973	LES VIOLONS DU BAL
1974	BLACK THURSDAY/LES GUICHETS DU LOUVRE; LACOMBE, LUCIEN; THE NIGHT PORTER/IL PORTIERE DI NOTTE; QB VII
1975	SEVEN BEAUTIES/PASQUALINO SETTEBELEZZE; THE EVACUEES; THE MAN IN THE GLASS BOOTH; THE CONFESSIONS OF WINIFRED WAGNER
1976	HIGH STREET/RUE HAUTE; MR. KLEIN; VOYAGE OF THE DAMNED; MARATHON MAN
1977	THE SERPENT'S EGG/ORMENS AGG

[384] Jones, "Hollywood War Films," p.13.

1978	HOLOCAUST; THE BOYS FROM BRAZIL; IN DARK PLACES: REMEMBERING THE HOLOCAUST; JACOB, THE LIAR/JACOB, DER LUGNER
1979	DAVID; THE TIN DRUM/DIE BLECHTROMMEL; THE CHILDREN FROM NUMBER 67/DIE KINDER AUS NO. 67
1980	PLAYING FOR TIME; THE LAST METRO/LE DERNIER METRO; THE FIANCEE/DIE VERLOBTE
1981	VICTORY; THE BOAT IS FULL/DAS BOOT IST VOLL; LILI MARLEEN; MEPHISTO
1982	THE WALL; SOPHIE'S CHOICE; SKOKIE
1983	FROM OUT OF THE ASHES; TO BE OR NOT TO BE; THE REVOLT OF JOB; THE WELL; A GENERATION APART
1985	FORBIDDEN; WALLENBERG: A HERO'S STORY; BASTILLE
1987	ESCAPE FROM SOBIBOR; FLAMES IN THE ASHES; THE WANNSEE CONFERENCE
1988	GOODBYE MY CHILDREN/AU REVOIR LES ENFANTS; THE BOXER AND DEATH; UNDER THE WORLD/DEBAJO DEL MUNDO; WAR AND REMEMBRANCE; THE HOUSE ON CARROLL STREET
1989	HANUSSEN; TRIUMPH OF THE SPIRIT

Films of the Cold War (See TABLE 11), with their emphasis on a worldwide Communist conspiracy and the dangers of a nuclear catastrophe, signal the changes taking place not only in American foreign policy but also in the nature of war itself.[385] A greater stress is placed on specialists who best know how to manage the highly sophisticated new weaponry. Filmmakers are confronted with the problems of transforming the images of former enemies into ones that are positive and reassuring. World War II Allies like the Russians and Chinese are given negative images in keeping with their new roles as the enemy. More subtle are the arguments justifying the Cold War itself and the reasons for increased military budgets. Ways have to be found to explain why the nation should risk a possible nuclear disaster in the growing awareness that the very existence of a nuclear arsenal threatens the human race with extinction.

Films about the Korean War (See TABLE 12) demonstrate dramatically the shifts in national values and the way in which the conventions of the war film genre were beginning to break down. The professional warrior replaces the common man as the bulwark of our defenses. In the process, the previously accepted American virtues of duty, honor, and fair play depicted in World War I and World War II movies are reexamined. For example, the killing of innocent civilians becomes an acceptable act of war when such civilians are used as hostages by the enemy while advancing on Allied positions. The authority of military leaders is no longer accepted blindly, and servicemen who challenge their commanders are sometimes shown as justified for being insubordinate. At the same time, the films themselves struggle to maintain the conventions of a group effort in combat. Abstract ideas about fighting for our way of life and our families still obfuscate the complex issues surrounding the war, but now they appear less convincing as audiences grow more critical about the actual events that the films represent.

The films of the Vietnam War effectively tie together all the issues of historical evidence, studying genre movies in context, the AUTEUR theories of criticism, and the model of film-producer-society relationships (See TABLE 13). They begin in the 1960s by question the competence of the military leadership. No longer is the predominant image one of a film protagonist primarily concerned with protecting his country or the folks back home. The foreign terrain is still hostile to American forces;

[385] For a contemporary perspective, see Vincent Canby, "Revenge Fuels the Cold War Movies of the 80's," NEW YORK TIMES 2 (December 8, 1985):21-2.

TABLE 11

SELECTED COLD WAR FILMS

NARRATIVE

Year	Movie
1946	THE STRANGER
1948	IRON CURTAIN
1951	I WAS A COMMUNIST FOR THE FBI; THE DAY THE EARTH STOOD STILL
1952	DIPLOMATIC COURIER
1954	NIGHT PEOPLE
1956	INVASION OF THE BODY SNATCHERS; NINETEEN EIGHTY-FOUR; BATTLE HELL
1957	THE D. I.; THE WINGS OF EAGLES; THREE BRAVE MEN
1959	ON THE BEACH; OUR MAN IN HAVANA
1963	THE UGLY AMERICAN
1964	FAIL-SAFE; SEVEN DAYS IN MAY; DR. STRANGELOVE OR: HOW I LEARNED TO STOP WORRYING AND LOVE THE BOMB
1965	THE SPY WHO CAME IN FROM THE COLD; THE BEDFORD INCIDENT
1966	THE RUSSIANS ARE COMING, THE RUSSIANS ARE COMING
1968	ICE STATION ZEBRA
1969	TOPAZ, THE CHAIRMAN
1976	THE FRONT
1983	DANIEL; KENNEDY; MISSILES OF OCTOBER; THE DAY AFTER; TESTAMENT

the enemy, just as treacherous and stereotyped; and the basic unit, still a cross section of Americans doing a dirty job. Only now, the hero has his own self-interest as his paramount concern. In place of the distilled images of warfare, evident in the earlier genre films, are the graphic scenes of violence and destruction. Most significantly, the films openly confront national policies that led to our involvement in the war itself.[386] By the late 1980s, however, America began rationalizing its role in the Vietnam War and the war film once more became an ideological battleground. As Harvey Greenberg points out, "Focus has gradually shifted from the war's causes, from actual compromises by our leadership in its conduct, to imaginary failures of the nerve, the shameful treatment of veterans, or the fate of MIAs. Whether the

[386] For some helpful overviews, see Harvey R. Greenberg, "Dangerous Recuperations: Red Dawn, Rambo, and the New Decaturism," JOURNAL OF POPULAR FILM AND TELEVISION 15:2 (Summer 1987):60-70; Peter McInerney, "Apocalypse Then: Hollywood Looks Back at Vietnam," FILM QUARTERLY 33:2 (Winter 1979-80):21-32; Larry Suid, "Hollywood and Vietnam," FILM COMMENT 15:5 (September-October 1979):20-5; Vincent Canby, "Hollywood Focuses on Vietnam at Last," NEW YORK TIMES D (February 19, 1978):1,13; Samuel G. Freedman, "The War and the Arts," NEW YORK TIMES MAGAZINE (March 31, 1985):50-1, 54-7; Lawrence D. Thompson et al., "A Vietnam Filmography," JOURNAL OF POPULAR FILM AND TELEVISION 9:1 (Spring 1981):61-7; and John Hellmann, "Vietnam and the Hollywood Genre: Inversions of American Mythology in THE DEER HUNTER and APOCALYPSE NOW," AMERICAN QUARTERLY 34:4 (Fall 1982):418-39.

TABLE 12

SELECTED KOREAN WAR FILMS

NARRATIVE

Year	Movie
1951	THE STEEL HELMET; A YANK IN KOREA; FIXED BAYONETS; I WANT YOU; SUBMARINE COMMAND
1952	ONE MINUTE TO ZERO; BACK AT THE FRONT; RETREAT, HELL!; JAPANESE WAR BRIDE; SUBMARINE COMMAND; BATTLE ZONE; TORPEDO ALLEY
1953	BATTLE CIRCUS; THE GLORY BRIGADE; SABRE JET; TAKE THE HIGH GROUND; CEASE FIRE!; MISSION OVER KOREA
1954	MEN OF THE FIGHTING LADY; FLIGHT NURSE; PRISONER OF WAR; THE BRIDGES AT TOKO-RI
1955	THE BAMBOO PRISON; BATTLE TAXI; THE MCCONNELL STORY; TARGET ZERO; LOVE IS A MANY-SPLENDORED THING; TO HELL AND BACK
1956	THE RACK; HELL'S HORIZONS
1957	MEN IN WAR; BATTLE HYMN; TIME LIMIT
1958	THE HUNTERS; JET ATTACK
1959	PORK CHOP HILL
1960	ALL THE YOUNG MEN
1961	SNIPER'S RIDGE; MARINES, LET'S GO!; THE BATTLE AT BLOODY BEACH; OPERATION BOTTLENECK
1962	WAR HUNT; THE MANCHURIAN CANDIDATE; PERIOD OF ADJUSTMENT
1963	THE YOUNG AND THE BRAVE; THE HOOK
1964	WAR IS HELL
1968	SERGEANT RYKER
1970	M*A*S*H
1976	COLLISION COURSE
1982	INCHON

United States should have become bogged down in an Asian land conflict seems beside the point."[387]

Indicative of the debate on recent Vietnam War films was a series of articles in the September 8, 1987, issue of VILLAGE VOICE. Leo Cawley takes the position that Americans, preoccupied about being virtuous and moral, have difficulty resolving their perceptions of our behavior in Vietnam. Complicating matters is that many of the Vietnam War films share a number of premises found in World War II movies (movies that epitomize the best memories of a just war in which we behaved heroically): e.g., wars are for us crusades, in which we, as individuals, discover truths about ourselves unavailable elsewhere; foreigners symbolize the evils we face and reveal not only that we are better as a nation than those we fight against but also that when the going gets rough no one is more fierce than an aroused American. "Because of its marked unwillingness to face the question of the war's justification," Cawley writes, "the Vietnam film differs sharply from WWII movies in that it shows the rise of 'lesser' loyalties, which supplant older causes like anti-Communism or

[387] Greenberg, pp.62-3.

democratic principle."[388] He goes on to discuss why the Vietnam film stresses "the personal anguish of individuals" as they discover the horrors of war and thus the films lose "any connection with reality."[389] J. Hoberman feels that America's embarrassing role in and flight from Vietnam has created an "impossible longing for a satisfactory conclusion [that] tempts each Viet film to sell itself as definitive."[390] Citing HAMBURGER HILL (1987) as an example of a movie that favors "grit rather than hallucination," he describes how the American perspective is constantly being refined and sentimentalized.

In the same VOICE issue, Andrew Sarris masterfully explains why war movies in general and Vietnam films in particular are so popular today. The former mask their love of violence under the cloak of social significance, while the latter thrive on showing an incompetent chain of command reviled and ridiculed by "grunts" (foot soldiers) who find the War "messy, disillusioning, and inconclusive."[391] Especially fascinating is the class distinction that Sarris finds in conflicting sets of Vietnam films. On the one hand, he sees movies like FIRST BLOOD (1982) and RAMBO: FIRST BLOOD PART II (1985) preoccupied with officers missing in action (MIA's). Almost always fliers, the MIA's personify "a dedicated, educated class, one in which military service was a career and a cause."[392] On the other hand, films like THE DEER HUNTER (1978) and PLATOON (1986) deal with grunts who for the most part are high school dropouts, minorities, and blue collar workers. Interestingly, Sarris highlights the racist nature of most war films toward Orientals but fails to note that despite the disproportionate number of Hispanics and Blacks in the Vietnam War they are almost relegated to backdrops in the Vietnam War films. He does make the important point, however, that many of the Vietnam films try to redeem the honor of Vietnam veterans by leveling recriminations "against people over here, safely shielded from the carnage, exulting in their moral superiority."[393]

Like the documentary war film, the fiction war film can be divided into a number of subcategories: biographical, those based on branches of the armed services, adventure, spy films, prisoner-of-war pictures, socially conscious films, those having to do with civilian life and with rehabilitation, films emphasizing comedy or history.

The biographical war film, for example, has a plot based upon the life of some important individual, and the treatment generally allows many liberties with the facts (TABLE 14). The overall tendency is to show how great a man we had among us, to present his qualities as godlike traits, and to depict his actions as the outgrowth of divine destiny. Despite the cinematic depiction of four major wars over the past seventy years, few good biographical films about Americans involved in the wars have been produced. The best such movies have centered around two personalities from World War I, President Woodrow Wilson and Sergeant Alvin York, and one from World War II, General George S. Patton.

[388] Leo Cawley, "Refighting the War: Why the Movies are in Vietnam," VILLAGE VOICE 32:36 (September 8, 1987):20.

[389] Cawley, p.20.

[390] J. Hoberman, "Hollywood on the Mekong," VILLAGE VOICE 32:36 (September 8, 1987):57.

[391] Andrew Sarris, "The Screen at the End of the Tunnel," VILLAGE VOICE, p.19.

[392] Sarris, p.29.

[393] Sarris, p.54.

TABLE 13

SELECTED VIETNAM WAR FILMS

NARRATIVE

Year	Movie
1947	SAIGON; A YANK IN INDOCHINA
1957	CHINA GATE; THE QUIET AMERICAN
1964	A YANK IN VIETNAM
1965	OPERATION CIA
1966	TO THE SHORES OF HELL; LOST COMMAND
1967	BORN LOSERS
1968	ANGELS FROM HELL; THE GREEN BERETS; GREETINGS; WINDFLOWERS: THE STORY OF A DRAFT DODGER
1969	THE ACTIVIST; HAIL, HERO!; FEEL IT COMING; MEDIUM COOL; ALICE'S RESTAURANT; HI, MOM!
1970	CAPTAIN MILKSHAKE; COWARDS; GETTING STRAIGHT; HOMER; THE STRAWBERRY STATEMENT; THE LOSERS; THE RAVAGER; SUMMERTREE
1972	SLAUGHTER; A JOURNEY THROUGH ROSEBUD; LIMBO; WELCOME HOME, SOLDIER BOYS
1973	P. O. W.
1974	THE TRIAL OF BILLY JACK
1976	TAXI DRIVER; TRACKS
1977	ROLLING THUNDER; TWILIGHT'S LAST GLEAMING; HEROES
1978	THE BOYS IN COMPANY C; COMING HOME; GO TELL THE SPARTANS; WHO'LL STOP THE RAIN; BIG WEDNESDAY; THE DEER HUNTER; GOOD GUYS WEAR BLACK
1979	MORE AMERICAN GRAFFITI; APOCALYPSE NOW; FRIENDLY FIRE; HAIR
1980	A RUMOR OF WAR; TWINKLE, TWINKLE KILLER KANE/THE NINTH CONFIGURATION
1981	SOME KIND OF HERO
1982	HONOR GUARD; FIRST BLOOD
1983	UNCOMMON VALOR; STREAMERS
1984	THE PURPLE HEART; MISSING IN ACTION; THE KILLING FIELDS
1985	MISSING IN ACTION II; RAMBO: FIRST BLOOD PART II; BIRDY; ALAMO BAY; CEASE FIRE
1986	UNNATURAL CAUSES; PLATOON
1987	GARDENS OF STONE; FULL METAL JACKET; THE HANOI HILTON; HAMBURGER HILL; KARMA; GOOD MORNING, VIETNAM
1988	BAT 21; DISTANT THUNDER
1989	JACKNIFE; 84 CHARLIE MOPIC; CASUALTIES OF WAR; IN COUNTRY; WELCOME HOME

TABLE 14

SELECTED FILM BIOGRAPHIES[394]

War	Year	Person	Movie
WWI	1941	Sergeant Alvin York	SERGEANT YORK
	1944	President Woodrow Wilson	WILSON
WWII	1949	General K. C. Dennis	COMMAND DECISION
	1951	Field Marshal Rommel	THE DESERT FOX
	1952	Col. Paul Tibbetts, Jr.	ABOVE AND BEYOND
	1955	Admiral John M. Koskins	THE ETERNAL SEA
	1955	General Billy Mitchell	THE COURT MARTIAL OF BILLY MITCHELL
	1957	Admiral Frank Wead	THE WINGS OF EAGLES
	1959	Captain Audie Murphy	TO HELL AND BACK
	1960	Werner von Braun	I AIM AT THE STARS
		Guy Gabaldon	HELL TO ETERNITY
	1961	Chancellor Adolf Hitler	THE LIFE OF ADOLF HITLER
	1960	Admiral William F. Halsey	THE GALLANT HOURS
	1962	General Frank Merrill	MERRILL'S MARAUDERS
	1963	President John F. Kennedy	P. T. 109
	1970	General George S. Patton	PATTON: A SALUTE TO A REBEL
	1973	Prime Minister Winston Churchill	YOUNG WINSTON
	1976	President Franklin D. Roosevelt	ELEANOR AND FRANKLIN: THE WHITE HOUSE YEARS
	1977	General Douglas MacArthur	MACARTHUR
	1977	Chancellor Adolf Hitler	HITLER--A CAREER

BOOKS

Adair, Gilbert. VIETNAM ON FILM: FROM THE GREEN BERETS TO APOCALYPSE NOW. New York: Proteus Books, 1981. Illustrated. 192pp.
 Focusing on the eleven-year period between the 1968 John Wayne adventure melodrama and the 1979 Francis Ford Coppola epic, this very opinionated survey examines nearly seventy movies dealing with the Vietnam War. The emphasis is on American works of fiction, because Adair, a British film critic, believes they "offer up a far richer vein of ideology than documentaries. . . ." His concern is with discovering why, even when its intentions were well motivated, Hollywood failed to incorporate the Vietnam War successfully into the conventions of the popular war film genre. Part of the reason, the author suggests, springs from the film industry's penchant for self-censorship. Although American involvement in Vietnam affairs dates back to the late 1940s, Hollywood filmmakers found the subject to be like the issue of nudity, too risky a subject to deal with honestly. By the late 1960s, however, American producers began taking an oblique approach to the Vietnam War. Exploitation bike films like ANGELS FROM HELL (1968) and SATAN'S SADISTS (1969)

[394] Usually portrayed as hagiography or as scandal-mongering.

indirectly reminded audiences how combat skills learned in Vietnam were used to commit crimes back home. TAXI DRIVER (1976) drew a striking comparison between the moral deprivation of an ex-Vietnam veteran named Travis Bickle and the physical squalor in Manhattan. The western genre, as Adair observes, frequently allegorized the Vietnam War in movies such as SOLDIER BLUE (1970) and ULZANA'S RAID (1972). This oblique technique has led many people to believe that there aren't enough Hollywood films on the subject to justify a book and to theorize that "every American feature film made during the decade of 1965-75 must directly or indirectly reflect some aspect of its political makeup. . . ." Adair obviously disagreed, although he does acknowledge that these arguments contain elements of truth. What's truthful about them we never discover since he avoids any detailed examination of causal relationships and relies heavily on subjective judgments recorded impressionistically. But the six chapters that make up this bellicose narrative prove that there are indeed enough movies about the Vietnam War to make a worthwhile study.

Adair begins his stimulating history by speculating on why Hollywood treated the last of America's four major wars in the twentieth century so differently from the first three. For example, he believes that Hollywood never considered World War I an "'American' affair at all," and that's why the film industry poorly defined the geopolitical frontiers and gave negative racial stereotypes to any enemy not resembling America's majority WASP (white Anglo-Saxon Protestant) population. These false myths became essential conventions for the genre and potential problems for filmmakers from the late 1940s on. Why a predominantly Jewish-controlled industry in which many of the key personnel emigrated from Germany and Russia would have difficulty with the geographical and racial characteristics of that area of the world is never considered, nor is the possibility that what happened occurred for political and commercial purposes. Nor does Adair, who insists that the pre-1920 war films reflected a pacifist attitude toward World War I, show much interest in recent research documenting how pacifism played a relatively minor role in American war movies between 1917 and 1930. World War II with its clear-cut issues, however, puts him squarely in touch with standard interpretations of the genre. He sees movies on this conflict as unique, encompassing an almost limitless range from farce to tragedy. Nevertheless, he views the World War II movies as uncharacteristic of contemporary films about modern warfare because they fail to examine the complex moral issues of war. Furthermore, the World War II movies ignore completely the frustration ensuing from attempts at political rather than military resolutions. Adair justifiably gives considerable importance to the way in which American movies on World War II reinforced racial prejudices against the Japanese, arguing that except for films like THE TEAHOUSE OF THE AUGUST MOON (1956) and A MAJORITY OF ONE (1962), Hollywood refused to humanize the image of the Japanese or even make distinctions among Koreans, Chinese, Japanese, and Vietnamese in movies set in Asia. While informed film historians can cite Adair's factual errors--e.g., THREE STRIPES IN THE SUN (1955), JOE BUTTERFLY (1957), SAYONARA (1957), and BRIDGE TO THE SUN (1962)--it's difficult to disagree with his conclusions, primarily because of the popularity of World War II movies and the frequent revivals of those made during the 1940s and shown constantly on television. Films about the Korean War add further strength to Adair's position. Hollywood, acting as a microcosm for middle America's prejudices, automatically identified the spread of Communism in Southeast Asia with the motives of "'barbaric' Asian peoples (among which, of course, are included the Russians)." But by the 1950s the film industry was approaching war films, Communism, and political issues very carefully. The lessons learned from the pro-Soviet films in the early 1940s as well as the infamous HUAC hearings had terrified many American filmmakers. Gripped by fear, preoccupied with domestic priorities, and blind to the virtues of other cultures, Hollywood found the Korean War too complex to understand, and the American public lost a valuable chance to comprehend better the changes occurring in international warfare. Adair concludes his background review with the thesis that the images created by the previous wars--e.g., pacifism, high adventure, and a communist conspiracy in Korea--gave

Hollywood unlimited opportunities for which it didn't "simply pass the buck, it tried to bury it."

The ensuing analysis offers an extremely provocative discussion of the manner in which the racist conventions of the pre-1960 war films affected the movies dealing with the Vietnam War. Among the Zeitgeist movies getting special treatment are THE GREEN BERETS (1968), EASY RIDER (1969), TAXI DRIVER (1976), THE BOYS IN COMPANY C (1977), COMING HOME, THE DEER HUNTER, and GO TELL THE SPARTANS (all in 1978), FRIENDLY FIRE and APOCALYPSE NOW (both in 1979). The author takes every opportunity to condemn the film industry for its naive, pretentious, and exploitative productions. He's particularly caustic about the new wave of Hollywood "movie brats" who became film directors during the 1970s--e.g., Francis Ford Coppola, Brian De Palma, George Lucas, John Milius, Steven Spielberg, Martin Scorsese, and Paul Schrader. Pointing out that "while it would be self-righteously puritanical to censure them for failing to seize the opportunity of becoming the spokesmen of their contemporaries drafted to (and sometimes killed in) Vietnam," Adair states, "it can't be denied that their record on the matter is disappointing to say the least." Yet in dealing with other controversial targets, Adair gives them a measure of dignity, noting in the case of THE GREEN BERETS that no matter how repugnant he found the film it still remains "the ONLY Hollywood movie to have tackled the issues of the war head on (even if with heavily loaded arguments) and from an ideological standpoint that endorses without flinching (even if its anti-communism is of the Pavlovian variety)." Overall, the author's impressionist arguments serve as the best source to date of film information helpful in comparing and contrasting the Vietnam War films with their three earlier counterparts in this century.

In addition to the author's combative prose, serious students should enjoy the book's fast pace, excellent illustrations, basic filmography, and useful index. Here's one more good example of a book's apparently trivial format concealing a worthwhile experience. Recommended for special collections.

Baker, M. Joyce. IMAGES OF WOMEN IN FILM: THE WAR YEARS, 1941-1945. Ann Arbor: UMI Research Press, 1980. Illustrated.

*Basinger, Jeanine. THE WORLD WAR II COMBAT FILM: ANATOMY OF A GENRE. New York: Columbia University Press, 1986. Illustrated. 373pp.

In a hands-on approach to defining a genre, the author, after watching hundreds of combat World War II films, presents a history of these films, "tracing their origin and evolution and indicating important information about the system that produced them, the individuals that created them, and the technological developments that changed them." Basinger's basic assumptions are that the WWII combat film is a genre, not a subgenre; that it is a representative genre; and that the process she follows illustrates the difficulty in defining genres. For example, she argues that the WWII combat film genre went through three stages in reaching its basic definition: the introductory stage (December 7, 1941 to December 31, 1942), the emergence of the basic definition (1943), and the repetition of the definition (January 1, 1944 to December 31, 1945). That is, until World War II, elements of the combat genre existed and only after a transitional period did the genre itself come into being.

Although Basinger's research is broader than the material found in the Kane and Rubin books on combat films, the results are roughly the same. In other words, the arguments are fascinating but not conclusive. The author's two key films in defining the WWII combat film genre are are WAKE ISLAND (1942) and BATAAN (1943). The former contains the "old" conventions that would be incorporated into the "new" genre: e.g., adversary relationships between two characters, internal conflicts on the Allied side, a desire by one character not to re-enlist, the appearance of a tough, new commanding officer, an off-limits fist fight and a coverup to prevent the C.O. from learning the facts about the illegal fight, one character's attachment to a dog who functions as a mascot, a disastrous climax where the characters are

killed in battle, assurances through a patriotic opening frame that the events seen are true, a "last stand" situation reminiscent of "Custer" and "Alamo" westerns, a group of soldiers differentiated by rank and backgrounds, a sentimental burial at night, and a pilot who sacrifices his life for the cause. BATAAN acts as the coalescing film, breathing "new" life into these war film conventions. The "new" generic conventions include the democratic ethnic mix, the hero whose leadership responsibilities temporarily separates him from the group, a specific objective the group has to achieve, the internal battles among group members, the faceless enemy, the almost non-existence of women, the dangers in thinking too much about the folks back home, the standard war imagery of two forces in conflict, the "message" about why we are fighting this dirty war, the day-to-day routines of men waiting for the action to begin, and the death of heroes. Basinger fleshes out her definition with charts, outlines, detailed discussions, and post-mortems on films made during and after World War II. Her five informative chapters also indicate how the Korean and Vietnam Wars affected the genre and its conventions. In addition to an annotated, chronological filmography on the combat films of World War II and Korea, she provides a filmography on selected titles relevant to prior history of World War II combat films, endnotes, a bibliography, and an index. Recommended for special collections.

Butler, Ivan. THE WAR FILM. South Brunswick: A. S. Barnes and Company, 1974. Illustrated. 191pp.
 Not intended as a social or political treatise, this highly subjective overview covers chronologically the main trends in American and British fictional war films from the early days of movies up to the 1971 production of Dalton Trumbo's harrowing screenplay JOHNNY GOT HIS GUN. It serves primarily as a good excuse for one of England's most prolific film commentators to record his memories of the actual impact that movies like WHAT PRICE GLORY? (1926) had on the audiences of their day. The book also serves as an opportunity to challenge the unacknowledged opinions about the movies circulated by other war film historians. In his Introduction, for example, Butler wisely reminds these critics that for pacifist movies like Lewis Milestone's version of ALL QUIET ON THE WESTERN FRONT (1930) to be truly "courageous" productions, they need to be made during the middle of the battle, and not during a period where pacifism is profitable. The author knows full well the difficulties artists face in the commercial cinema, but he feels strongly that the history of war films demonstrates the importance of true artists' not losing their independence. Butler defines war films as those "concerned either directly with the actual fighting, or very closely with the effects and aftermath of a conflict." Thus peripheral areas such as the Cold War or prewar periods generally are excluded. In nine feisty chapters, he arbitrarily displays a preference for British rather than American films and seems to enjoy immensely disagreeing with his colleagues.
 The discussion on the silent era allows his pungent wit free rein. Admonitory works like AN ENGLISHMAN'S HOME (1909) are put in the "see-what-will-happen-if-you-don't-watch-out school of drama," while antiwar movies like THE HORRORS OF WAR (1914) are shown at variance with "rally-round-the-flag-boys trumpetings of earlier years." In defending Herbert Brenon's impassioned pacifist film WAR BRIDES (1916), he taunts the defenders of free speech who suppressed the movie once England entered the war. One can almost picture Butler poised with his poison pen as he thinks back on the war films he detested: e.g., CIVILIZATION (1916), "competently made, but nauseatingly dishonest"; THE BATTLE CRY OF PEACE (1915), based on a story by a writer of "machine-gun fame"; and THE LITTLE AMERICAN (1917), technically outstanding, but "blatantly opportunistic."
 Butler's insights into the years from 1915 to 1941 offer few startling revelations. He agrees, however reluctantly, with the conclusions reached by historian Jack Spears that of all the war films made between 1914 and 1918, only Chaplin's comedies have an enduring quality. Germany, England, and America are credited with being able to produce just one significant war film each during the 1920s: G. W. Pabst's

THE JOYLESS STREET (1925), George Pearson's REVEILLE (1924), and King Vidor's THE BIG PARADE (1925). Lesser movies like THE FOUR HORSEMEN OF THE APOCALYPSE (1921) are cited as valuable historical documents, precisely capturing the mood of the age in which they were produced but of extremely limited quality. WINGS (1927) is praised for its spectacular air footage, but dismissed for its trite story and pious platitudes. Besides the well-known hits of the 1930s, Butler calls attention to underrated movies like JOURNEY'S END (1930) and THE MAN I KILLED/BROKEN LULLABY (1932). No serious analyses to back up his decisions are presented, and readers must settle for his personal and civilized convictions.

The Second World War provides Butler with an opportunity not only to champion the resurgence of the British cinema, but also to contrast its achievements with America's allegedly inferior wartime productions. We discover, for example, that English films like 49th PARALLEL and NEXT OF KIN (both in 1941) and THE FIRST OF THE FEW (1942) were splendid films that bolstered British morale; but Hollywood productions like WAKE ISLAND (1942), A WING AND A PRAYER, and THE PURPLE HEART (both in 1944) are part of a "worthless crop of feature war films." American documentaries fare better, although the contributions of master filmmakers like Humphrey Jennings and Alberto Cavalcanti receive far more space and praise than do Frank Capra and John Huston. Here, as elsewhere, a smattering of other national cinemas get the once-over-lightly treatment with disappointing results.

The postwar period to the Vietnam War synthesizes Butler's by-now obvious biases against prowar films, a great love of English thrillers, and a surprisingly intolerant view of American escapist movies. For example, Carol Reed's THE THIRD MAN (1949) is acclaimed as the finest film of the late 1940s; American films in the Cold War period give Butler the impression "that those responsible were uncertain which way to face--apart from the box-office"; and epic war films like IN HARM'S WAY (1965) exemplify stories that "say in 167 minutes what is scarcely worth saying in eighty." As you might guess, among his favorite films during the last thirty years are KING AND COUNTRY (1964), OH! WHAT A LOVELY WAR (1969), and JOHNNY GOT HIS GUN (1971). The text ends with the observation that "we are left, after seventy years' hard labour in the field of war, with a handful of great films, a couple of handfuls of fine ones, and fistfuls of mediocrity, or worse." As if to prove his point anew, Butler gives us a chronological filmography divided into the major conflicts beginning with the Napoleonic Wars.

Anyone looking for controversy will adore this book. The critical comments rarely do justice to the films attacked, while those praised are better treated in other books. Butler's decision to follow a chronological format rather than a topical one never quite succeeds in resurrecting the mood of the era in which the films were released. None of his assertions is documented, and in several cases--e.g., the claim that Robert Goldstein spent ten years in jail--are clearly faulty. Having said that, I must admit to a certain pleasure in reading an educated critic's caustic outbursts in an area where scholars far too often remain detached. Worth browsing.

*Culbert, David, ed. MISSION TO MOSCOW. Madison: University of Wisconsin Press, 1980. Illustrated. 277pp.

This absorbing text exemplifies the significant contribution to film scholarship that is being made by the Wisconsin Center for Film and Theater Research. In his detailed introduction and annotation of the 1943 Warner Bros. screenplay, Culbert critically examines the development of the film from the period when Ambassador Davies first had the idea for publishing his ghost-written memoirs to the audience reaction of the Soviet Union to the released version (only one of twenty-four American movies allowed in Russia between 1939 and 1945) shown during the final years of World War II. Careful attention is given to explaining the different contributions to the final shooting script made by Erskine Caldwell, Howard Koch, and Davies himself. The author's analysis of their interpretations of how best to portray Davies's experiences in Russia between 1936 and 1938 is anchored in the context of the studio's patriotic zeal and President Roosevelt's need to prove to an anxious Stalin that the United States was "experiencing a change of heart" toward its awkward wartime ally. Taking

full advantage of the rich resources on Warner Bros. available to film scholars at the University of Wisconsin, Princeton University, and the University of Southern California, Culbert points out the important production roles played by the film's technical advisor Jay Leyda, editor Don Siegel, director Michael Curtiz, producer Robert Bruckner, and studio boss Jack Warner. Extensive footnotes guide the reader to deletions, distortions, and controversies in both the screenplay and the actual film release. Fifteen intriguing documents in the book's splendid Appendix provide supporting evidence on Davies's flip-flop judgments on the Soviet purge trials, the attitudes of the Office of War Information toward the project, the heated public debate that followed the film's initial release, the behind-the-scenes controversy over Stalin's personal reaction to the film, and the deep-seated resentment Bruckner felt toward the Ambassador's continued interference with the day-to-day production of the movie.

Of special value to film historians is Culbert's treatment of a specific film used during wartime for propaganda purposes. One benefit accrues from comparing the author's attitude toward propaganda--e.g, "the controlled dissemination of deliberately distorted notions in an effort to induce action favorable to predetermined ends of special interest groups"--with the views held by critics like John Dewey, who claimed MISSION TO MOSCOW "is the first instance in our country of totalitarian propaganda for mass consumption--a propaganda which falsifies history through distortion, omission or pure invention of facts." Another value resides in the questions Culbert raises but never satisfactorily answers: e.g., how effective was the Office of War Information considering its behavior during the production of the film; how sensible is it for a studio to risk its reputation in making a blatantly propagandistic film; what should be the rights of the government to distort the truth in the interests of preserving wartime solidarity; and when does a film go beyond using dramatic license for effect and become a dishonest motion picture?

My only reservations about Culbert's fine analysis concern his treatment of Ambassador Davies. Considerable space is devoted to revealing how the diplomat cared primarily for collecting art while in Moscow, did not have the confidence of the State Department when it came to his political judgments, had almost no regard for accuracy, and often allowed his vanity to disrupt the hard work of serious filmmakers. The problem with these positions is not that they are false, but that they fail to present a balanced perspective on Davies. He may not, as the author concludes, have predicted the outcome of "every foreign crisis" from 1936-1941, but he was one of the few influential Americans to predict in 1941 that the German invasion of Russia would fail. And while his expertise may indeed have been valued "by few," those few included Presidents Franklin D. Roosevelt and Harry S. Truman, as well as the Soviet leadership. (In this regard, it is important to note that Roosevelt held the State Department experts in as low regard as they held Davies.) For all his shortcomings, Davies was thus a very important and highly valued diplomat whose belief in Soviet-American cooperation had a major and positive impact on American foreign policy during World War II. The breakdown of this cooperation after the war, and the eventual rejection of Davies's suggestions, in no way diminish his previous contributions and importance.[395]

This criticism aside, Culbert deserves considerable praise for documenting how the federal government, a major film studio, and wartime pressures resulted in the most notorious example of commercial film propaganda in World War II. Highly recommended for special collections.

[395] An interview with Professor Mark Stoler, Department of History, The University of Vermont, on October 12, 1983. For a more balanced assessment of Davies, Professor Stoler suggests consulting Daniel Yergin, SHATTERED PEACE: THE ORIGINS OF THE COLD WAR AND THE NATIONAL SECURITY STATE (Boston: Houghton Mifflin Company, 1977), pp.32-4, 417-8.

Dick, Bernard F. THE STAR-SPANGLED SCREEN: THE AMERICAN WORLD WAR II FILM. Lexington: The University Press of Kentucky, 1985. Illustrated. 294pp.

A valuable contribution to the study of war films, this informative, idiosyncratic history begins in 1933 with Hollywood's early explorations with fascist film ideology and takes us through the Second World War, finishing with flourishes about post-WWII films. The focus is on the studio system, how it manufactured war films, and how the public responded to them. In the author's judgment, the "most memorable World War II films" came in the 1940s and by the mid-1950s "the war had become a mythico-historical event to be approached in the way a historical novelist might approach the past." He further asserts that "Most of the post-1940s World War II films either recreate history at the expense of plot (THE LONGEST DAY, THE BATTLE OF THE BULGE) or sacrific history for the sake of plot (THE SEA CHASE, HANOVER STREET)." According to Dick, "The American World War II film . . . transforms history into plot, inventing boldly, sometimes rashly, but at least inventing. Although that transformation is sometimes naive, it is still a true transformation; there is never that jarring separation of fact and fiction that occurs in A BRIDGE TOO FAR and BATTLE OF THE BULGE." It is intriguing to read how Dick uses concepts like "truth," "fiction," and "inventing."

Given his highly debatable assertions, one might wonder what makes the book so valuable to the study of World War II war films. First, Dick does a splendid job of tracing the "paper trail" of the production process of the major films in the genre. His exploration of archival material provides numerous new insights into the workings of directors, producers, publicity departments, and government agencies. Particularly impressive is his handling of Hollywood's treatment of the Spanish civil war, the making of CONFESSIONS OF A NAZI SPY (1939), and the infamous workings of isolationist senators in the early 1940s. He is careful to note his sources and almost all of the information is accurate (i.e., a reference to John Davis's article on Warner Bros.'s foreign policy gives the wrong year and issue number of the magazine and then cites a quotation on page 20, although the article itself begins on page 23). Secondly, the book is very stimulating reading. Dick is not timid about stating his positions and one often is taken back by his personal reactions and positions. For example, in describing the problems that filmmakers faced in working with the Breen Office, Dick comments that the head of the Production Code Administration "felt it was his solemn duty to sanitize movie sex so Americans would not be copulating in department store windows. . . ." And what about the assertion that "Anyone who could decode a movie about adultery or dreamed murder could decode a movie about the Spanish civil war." And third, this account of World War II movies does a lovely job of relating the war film to other Hollywood genres. Thus reading Dick's interpretations about Hollywood's history of the Third Reich, the European Resistance movement, the Battle of Britain, the role of the Japanese in the Pacific War, and American combat forces in action results in a lively, challenging, and eye-opening experience.

On the down side, the author gets a little too glib when it comes to some of his material and conclusions. For example, he refers to BATTLESHIP POTEMKIN as POTEMKIN, generally ignores the effect of the star system on screen imagery, and downplays the economic factors that influence a final version of a film. Informed readers, for example, may take issue with Dick's assertion that Jack Warner's refusal to hire Nazis and Communists in his studios during World War II "inadvertently set the stage for the blacklist that began seven years later," particularly since "blacklisting" in various forms appeared throughout the history of Hollywood and the policy of Warners Bros. in the mid- to late 1940s was influenced by labor battles in the postwar period. Perhaps the most serious problem with Dick's approach is his failure to deal boldly with the racist imagery of the World War II films. He may find that THE PURPLE HEART "leaves only memories of violence," but others remember more the horrible stereotyping of the Japanese.

On balance, the book serves as a good companion piece to Suid's study and an excellent reminder of the types of films the studio system produced. Endnotes, a bibliographical essay, and an index are included. Well worth browsing.

Editors of LOOK. MOVIE LOT TO BEACHHEAD: THE MOTION PICTURE GOES TO
WAR AND PREPARES FOR THE FUTURE. Preface Robert St. John. Garden City:
Doubleday, Doran and Company, 1945. Illustrated. 292pp.

Characteristic of the national euphoria following the end of World War II, this
hyperbolic survey of the film industry's role in wartime production provides a unique
perspective on the years from 1939 to 1945. It has both an open and a hidden agenda.
The former is to present primarily through pictures the enormous contributions made
by the American movie industry to the winning of the war. The hidden agenda is to
defend Hollywood against decades of cynical attacks. The book's more than three
hundred pictures effectively capture the size of the undertaking and impressively
document the range of activities the film industry undertook. The flag-waving
narrative, despite its useful statistics, provides a disingenuous account of what
filming in war is all about.

Divided into twelve interesting chapters, the unnamed editors of LOOK summarize
the various roles stars, directors, producers, technicians, musicians, and bit players
did for the war effort. From the vantage point of 1945, the commentators praise the
daring Hollywood films (approximately fifty out of a thousand produced) for taking
an antifascist position from 1939 to 1941. The narrative goes on to show how the five
major American newsreel companies (Fox Movietone, News of the Day, Paramount,
Pathe, Universal) provided nearly 520 reels each year to the screen's news reports.
Such extensive coverage gave Americans at home scenes of battle never before
witnessed by civilians far from the front lines. If the Vietnam War can justifiably be
called the first war brought into our living rooms, then it can be said that World
War II was the first war seen and heard in our movie theaters. Another major change
noted by the text is the effect that the war had on government filmmaking. About
thirteen hundred training films--e.g., how-to movies--were made between 1942 and
1944 as compared to only sixty-three made by the military in World War I, and those
coming only in the closing months of the conflict. Combat photography also became
a top government priority both for propaganda and military reasons. This effort
resulted in the establishment of three key schools--i.e., Long Island City, New York
(Army Signal Corps), Pensacola, Florida (Navy), and Quantico, Virginia (Marine
Corps)--where not only Hollywood talent was transformed into combat photographers,
but also hundreds of unskilled people learned how to become cameramen, directors,
writers, editors, and sound technicians. And the OWI, realizing how important it
was to counteract Axis film propaganda, began making in 1942 a series of short
subjects extolling the American way of life, explaining from our point of view what
the war was all about, and glorifying the sacrifices made by civilians in occupied
nations. Aided by the Motion Picture Committee Co-operating for National Defense (an
industry-based group of film leaders), the OWI had direct access to Hollywood's
massive distribution, transportation, and exhibition channels. For propaganda outside
the United States, the OWI had an overseas branch headed by Hollywood
producer-writer Robert Riskin. Its function was to provide regular shipments of
newsreels, short subjects, and full-length narrative films that presented America in
a favorable light. Other fascinating features of this pictorially invaluable text are
shots of the famous Hollywood stars and directors in uniform--e.g., Clark Gable,
David Niven, Douglas Fairbanks, Jr., Louis Hayward, George Montgomery, Victor
Mature, Frank Capra, William Wyler, Tyrone Power, James Stewart, and Lew Ayres
(who served honorably as a conscientious objector). Useful, too, are the reminders
of the famous stars who entertained the troops overseas, in the USO clubs, and who
raised enormous sums of money for war bonds, blood donations, and wartime charities:
e.g., Bob Hope, Joe E. Brown, Ann Sheridan, Al Jolson, Dinah Shore, Irving Berlin,
Charles Laughton, Humphrey Bogart, Greer Garson, John Garfield, Ingrid Bergman,
and Carole Lombard (who died in a plane crash returning from a war bond rally in
1942). "By the end of 1944," the narrative states, "fully 2,000 performers (about
one in six was a 'big name' working without compensation) had gone on USO tours
outside the United States." These credits and substantial contributions made by the
movie colony are duly recorded and handsomely illustrated.

The problem for serious students is the book's uncritical analysis. For example, mention is made of the fact that one day after the bombing of Pearl Harbor, Japanese employees at the big studios were laid off and never got their jobs back. No other discussion on this subject follows, nor is there any interest in the racial stereotypes propagated by either the government or the American film industry. Another example of intellectual flabbiness is the attitude the editors take toward Capra's meritorious WHY WE FIGHT series. Even for 1945, it's hard to believe that informed people could state, "Purpose of this series is to give soldiers the background of World War II, showing events leading up to our participation. Avoiding propaganda, the series uses only combat footage, documentaries, other factual film." One last example relates to the book's reproduction of selected shots from an OWI short film entitled THE TOWN (1943). Rather than indicating how the agency is using propaganda to mask America's domestic problems to other nations, the captions reinforce the misrepresentation that American towns are absolutely spotless, populated only by Caucasians who are healthy, well-fed, and religious.

Once you get over the narrative's myopic point of view, the book is very entertaining, nostalgic, and fun to browse. Approach with caution.

*Hallin, Daniel C. THE UNCENSORED WAR: THE MEDIA AND VIETNAM. New York: Oxford University Press, 1986. 285pp.

The best book to-date on the history of the media's approach to reporting the Vietnam War, this study offers many valuable perpectives about America's attitudes toward our growing involvement in Vietnam, the war itself, and the aftershock. The author relies on the complete coverage of the conflict as told by the NEW YORK TIMES. Endnotes, a bibliography, an index are included. Well worth browsing.

Jones, Ken D., and Arthur F. McClure. HOLLYWOOD AT WAR: THE AMERICAN MOTION PICTURE AND WORLD WAR II. South Brunswick: A. S. Barnes and Company, 1973. Illustrated. 320pp.

In a concise introduction to this pedestrian volume, the authors extol the enduring popularity of war films while claiming that readers seeing the films in the early 1970s discovered a "source of consolation amidst the cruelness of the contemporary world." The wholesale distortions about people, places, and events in such movies are dismissed because of all "kinds of good things" that can be found in a war not as confusing as the Vietnam conflict: e.g., nostalgic recollections about individualism, a chance to reevaluate national values, an opportunity to see quality productions, renewed recognition for our armed forces and the valiant contributions made by the home front, the chance to examine how propaganda functions in wartime, and the role of Hollywood in helping to win the war. If Jones and McClure had explored critically these various topics, they might have made a more persuasive argument for their lackluster efforts. As presented, however, the comments demonstrate an atrocious lack of sensibility.

The pictorial-credits survey that follows provides only a very limited list of the casts performing in each of over four hundred movies. Technical credits extend to just the distributor and director; also the individual running times of the films are misleading. Each film has a still for illustrative purposes, with the names of the actors dutifully mentioned, but no indication is given as to whether it was used for publicity purposes or actually reflects the film itself.

Given the book's minimal ambitions, it is too easy to attack the authors' obvious failures or misunderstandings. The one useful value in picking it up is to prove to unsophisticated readers that there really are people who publish such drivel and retain such dubious judgments. Approach with caution.

*Kagan, Norman. THE WAR FILM. New York: Pyramid Publications, 1974. Illustrated. 160pp.

Don't be deceived by this book's nonscholarly format, which relies on lots of illustrations, impressionistic evaluations, and unsupported claims. Its highly intelligent narrative succeeds in giving patient readers an impressive response to the basic question, "Are war films ever true?" Kagan uses that question as an excuse to examine a range of absorbing issues. For example, he's concerned with whether or not Gary Cooper's depiction of Sergeant Alvin York tells us anything truthful about either the man or World War I. Do films like ALL QUIET ON THE WESTERN FRONT (1930) and THE DIRTY DOZEN (1967) distort the principles, causes, and effects of battle? Are there techniques that make one type of film propaganda more effective than another? In what ways do war films reflect the times in which they are made, and what is the relationship between film and the traditional arts? Obviously, this terse history provides only minimal answers to such basic concerns. What's surprising, however, is that despite the book's brevity, it offers a formidable challenge to the far more extensive commentaries provided by Suid, Manvell, and Butler. Instead of using the standard chronological approach, Kagan varies his nine stimulating chapters to include examinations of the films about specific wars to those about subgenres like comedy and antiwar films.

The analysis is at its best when summarizing war film conventions and speculating on their relationship to the society that produces them. Kagan, for example, begins with the argument that two films--THE BIRTH OF A NATION (1915) and SHOULDER ARMS (1918)--contain "the archetypal themes, plot ideas, story incidents, characters, and cultural assumptions which define the next half century of U. S. combat stories depicted on the screen." He backs up this controversial assessment by commenting on the by-now recurring images of massive, cruel armies creeping insect-like across barren battlefields, gallant heroes dying needlessly during senseless suicide attacks against nameless enemies, rebellious soldiers frustrated by their sense of alienation, and the false myth in American films that "the right man at the right time can solve everything." He offers a much-needed balance to British publications that deplore Hollywood's pre-World War II fiction films, stating forcefully that films like FOUR SONS, THE MORTAL STORM, and ESCAPE (all in 1940) were "high-level" melodramas that followed the patterns set during the First World War and reemerged during the days of the Cold War in movies like THE IRON CURTAIN (1948), WHIP HAND (1951), and BIG JIM MCLAIN (1952). Not content just to summarize, the author notes important watersheds in the genre's development. Unlike Suid's too-quick dismissal of the Pentagon's role in the production of Robert Aldrich's ATTACK! (1956), Kagan points out just why the government objected to the startling transformation of Cold War themes about men in battle and the problems of command. "ATTACK!," he explains, "is the first postwar film to connect the new brutality of war with confusion, corruption, and incompetence of American leadership and American motives--in this sense it is the first Cold War anti-war film." What's refreshing in the narrative is that unlike the stances taken by Manvell and Butler, Kagan is evenhanded in his treatment of the war films he dislikes. He rebukes, for example, many critics who initially condemned John Wayne's THE GREEN BERETS (1968) for being "hysterically negative," while reminding everyone that the movie used many of the war film conventions we had supported for the past fifty years. Even more commendable is that Kagan's narrative in one of the rare instances in the study of war films not only recognizes the importance of comedy war films, but is willing also to risk making qualitative as well as quantitative judgments. At long last Hollywood films like STALAG 17 (1953) and THE AMERICANIZATION OF EMILY (1964) are given serious consideration, while overrated productions like CATCH-22 (1970) earn applause for their intentions, not their achievements.

Kagan loses his audience, however, when he ventures into areas of historical evidence and stereotyping. He claims, for example, that THE BIG PARADE (1925) was made in part as an attempt "to scoop" Raoul Walsh's WHAT PRICE GLORY? (1926), but offers no proof. The author speculates elsewhere that films like THE DAMNED (1971) and CABARET (1972) are inspired perhaps "by our own feelings of decadence and decay," but no persuasive reasons are provided. He extols Howard Hawks's masterly morale-building techniques in AIR FORCE (1943), but fails to acknowledge

the role played by the military in its preparation. In essence, Kagan is ignoring the relationship between political and social institutions and the precise ways in which they influence film productions. He also demonstrates an unwillingness to criticize the racist images produced in World War II films, preferring instead to justify them on the grounds that they reflect the conditions of the time. As a result, Kagan, unlike more sensitive modern film historians, continues to give unqualified praise to disturbing movies like CRY HAVOC (1943) and THE PURPLE HEART (1944). He even goes to considerable pains to debunk the revisionist post-World War II film THE DESERT FOX (1951), citing it as an example of the "whitewashing of the Nazis from diabolical, genocidal fiends into noble fighters who really hated Der Fuehrer." No attempt is made to set the transformations in context or discuss the problems that every commercial filmmaker faces once a war is over.

The fact that Kagan never succeeds in resolving his questions about the "truthfulness" of war films should not surprise anyone. We're compensated by a delightful introduction to the genre from a film generalist who has strong opinions and is not afraid to state what he believes. Adding to the book's entertaining text are a superb collection of illustrations, a filmography, bibliography, and index. Recommended for special collections.

*Kane, Kathryn. VISIONS OF WAR: HOLLYWOOD COMBAT FILMS OF WORLD WAR II. Ann Arbor: UMI Research Press, 1982. Illustrated. 174pp.

Originally written as a 1972 Ph.D. thesis at the University of Iowa, this curious study exhibits a range of scholarly strengths and weaknesses. A relatively small block of American-made, fiction feature films produced between 1942 and 1945 is selected for an examination of the way in which Hollywood presented America's involvement in World War II. These films are defined as "combat movies" and given genre status because of their similar subject matter: they concentrate on uniformed American troops battling uniformed enemy troops on foreign soil. Interestingly, nineteen of the twenty-four films concern action in the Pacific, emphasizing the unique nature of the enemy, environment, and warfare. All the films, however, are highly conventional and are seen as an excuse for a reexamination of American values. Their well-known conventions of setting, characters, and plot allude to real events, but make no effort to be historically accurate. That is, the images in each film are "specific, limited and recurrent." To prove her thesis, Kane analyzes six films in detail in her chapters on setting, character, and plot. For example, she uses AIR FORCE (1943) and OBJECTIVE BURMA! (1945)[396] to illustrate how American combat troops are portrayed as extremely alienated in foreign settings. BATAAN (1943) and THE STORY OF G.I JOE (1945) depict how the cluster of central characters acts as a metaphor for America and its purpose in fighting World War II. GUADALCANAL DIARY (1943) and THEY WERE EXPENDABLE (1945) demonstrate the combat films' concern not only with military action, but also with revealing American behavior before, during, and after battles with the enemy. By effectively choosing her selections and focusing on their conventions, the author establishes their striking similarities. Nevertheless, the problems she creates for herself are formidable. Kane wants, on one hand, "to expand upon the critical and historical possibilities of examining individual films in terms of groupings: to reveal elements of an individual film which would go unnoticed or be misunderstood without comparison to other, similar films and to reveal subtleties and complexities hidden in what would otherwise appear to be repetitious or cliched material." On the other hand, she makes no serious attempt to understand the filmmaking process or put in perspective the social, political, and economic pressures Hollywood faced during World War II.

[396] For another perspective, see Ian C. Jarvie, "Fanning the Flames: Anti-American Reaction to OPERATION BURMA (1945)," HISTORICAL JOURNAL OF FILM, RADIO, AND TELEVISION 1 (1981):117-37.

Kane's difficulties stem, in part, from her superficial treatment of genre analysis. Limiting herself only to the models provided by Kitses, Cawelti, Warshow, Bazin, and McArthur, she mistakenly decides on a far-too-narrow fourfold plan of interpretation, each layer of which shows a serious defect. First, there is no attempt to link real events with their representation in the films. As a result, the author makes a number of glaring omissions. For example, she repeatedly refers to the manner in which the combat films stress "the diversity that exists among men and affirming the fundamental unity that underlies this diversity." She constantly reminds us that the films dwell on a "hoped-for unity of common people all over the world." Yet never once does Kane explain why those specifically developed conventions exist. A minimum amount of research on the OWI would have produced the fact that the government had convinced Hollywood to have as its central theme in wartime films the idea that America through the common man was fighting a just war against the forces of evil. Ironically, the author eventually asserts that the combat films are a twentieth century version of the mythic forces of Humanity waging war against the forces of Chaos. She just doesn't explain why. Secondly, Kane makes conventions the key by which to unlock a genre's hidden meanings. She does an outstanding job of setting up a basic dichotomy that separates the Americans/Allies from the Japanese/Germans. The former are characterized, for example, as democratic, peaceful, tolerant, honorable, and sentimental; the latter, as totalitarian, bellicose, oppressive, treacherous, dispassionate, and ruthless. Yet Kane never considers it important to discuss why such complex issues are reduced to simplistic imagery, or how propaganda impinges on commercial products during wartime. She does make the point that by the last reel the combat films resolve the various conflicts among American servicemen arising from differences in ethnicity, race, regionality, age, social and educational backgrounds, military rank, and attitudes. But why blacks or Jews are stereotyped the way they are in films from 1942 to 1945 is secondary to the fact that they are stereotyped in a specific way. Third, her plan reveals and relates the levels of similarities that combat films contain in terms of complexities of meanings and iconography. The fact that in these films military decisions made by officers and top-ranking government leaders are shown as correct, or that dissidents and lone wolves are seen as endangering the success of a military mission is duly noted, but not why such images are mandated by political and social necessities. Granted, Kane did her study before the publications by Shain, Suid, or Rubin. But the current publication is heralded as a "revised thesis." It should have taken into account, for example, how the military influenced the making of AIR FORCE (1943) and A WALK IN THE SUN (1945). In that way, perhaps, Kane would have found the latter more than just an "extremely neurotic film." Her study surely should have made clear why such images are transformed once the war is over. It's as if all these highly developed conventions came out of nowhere, with no reference to other wars or audience expectations. Fourth, Kane builds a thematic construction for the genre: the Hollywood combat films have as their major concerns justifying America's involvement in World War II, validating the purpose of the war, and graphically portraying its events. In doing so, she acknowledges the fact that genre and AUTEUR studies complement each other. Yet not once in the study are we made aware of the importance to the conventions of movie stars like John Wayne, Robert Taylor, and Errol Flynn; or of directors like Howard Hawks, William Wellman, and John Ford. Kane ignores the audience-director-star relationships and their emotional implications for the genre because she feels the research of sociologists and communication researchers has yet to "yield any substantial results."

In fairness to the author, the value of the study depends in large measure on what the reader is looking for and what the author is attempting to do. Her extremely limited focus turns up a wealth of recognizable conventions useful to generations not born during the 1930s and 1940s. She explains the paradox of the American combat soldier who fought for a society that protected his individuality, but at the cost of his ability to think independently. She demonstrates how the filmmakers were not content to articulate the importance of values like unity, domesticity, love, and loyalty. Every film had to give the combat soldier the opportunity to test those values

and prove their worth. If "the home" symbolized security, peace, and stability--what made the war worth fighting--then Kane superbly discusses why women represented the most important aspect of the home. She also calls attention to the difficulty the combat film had in verbalizing the issues of the war. Noting that the combat films put more importance on the moral than on the intellectual reasons, the author carefully details the technique of having negative images of the enemy define the reasons for war. That is, he is vicious and treacherous in combat, while we always play by the rules. And if the characters in these films have difficulty understanding abstractions like freedom and honor, there is always the concept of duty. What makes Kane's fact-finding expedition palatable is her gifted writing style and her lucid plot synopses. For example, her plot summary of AIR FORCE demonstrates clearly how technology is used as a metaphor for America. We understand the value of "the warship" as a symbol of why airplanes, in particular, stood for American skills and technology, and why the film characters always viewed it as a haven from hostile environments as well as a source of strength in combat.

In short, this well-intentioned study is another example of an author's gathering facts as an end in themselves. No historical perspective is provided, and thus what could have been a major contribution to the study of the war film turns out to be a competent exercise in content analysis. An index is provided. Well worth browsing.

Koppes, Clayton R., and Gregory D. Black. HOLLYWOOD GOES TO WAR: HOW POLITICS, PROFITS, AND PROPAGANDA SHAPED WORLD WAR II MOVIES. New York: The Free Press, 1987. Illustrated. 374pp.

The book to begin the study of the relationship between Hollywood and the OWI, this highly informative and very lucid text is real find for anyone interested in the way the film capital got into the business of producing wartime propaganda. The authors superbly demonstrate that patriotism was hardly the only incentive for the filmmakers. This study, Koppes and Black explain, deals "with the enduring question of the appropriateness of governmental coercion and censorship of private media, the ways in which American society was mobilized for war, and the consequences of these methods for peace." Using archival material as well as public documents, the authors detail the paradox of Hollywood at the height of its popularity being "controlled by a tight corporate oligarchy and a rigid code of censorship." Eleven fact-filled chapters discuss the roles played Elmer Davis, Robert E. Sherwood, and Archibald MacLeish in the Office of War Information, the relationship between Hollywood and the government in producing pro-Soviet film propaganda, the now-obnoxious racism developed for projecting Japanese images in war films, the attempts to obfuscate class conflict in domestic dramas about America and Britain, the approaches taken to minimize images of racism in America, and the steps taken to shape up Hollywood's partiotic posture. Endnotes, a bibliographical essay, and an index are included. Highly recommended for special collections.

Manvell, Roger. FILMS AND THE SECOND WORLD WAR. South Brunswick: A. S. Barnes and Company, 1974. Illustrated. 388pp.

Designed as a sweeping overview, this ambitious survey examines a cross-section of films made by the principal nations in World War II to shape and reflect public opinion before, during, and after the global conflict. The major emphasis is on re-reviewing movies produced between 1939 and 1945, although significant films made up to the early 1970s are included. Manvell's plan provides thumbnail sketches of the historical background against which countries like Britain, the United States, Russia, Japan, Germany, Italy, and France waged their intensive film propaganda battles. No attempt is made to analyze individual movies, although the distinguished author did reviews of many of the British films at the time they first appeared and frequently quotes large portions of those reviews in the text. Instead, the narrative defines a period of history, proceeds to cursory observations about the wartime restrictions various filmmakers faced, and then offers broad generalizations about changing national images, and how each depiction reflected the specific country's attitudes

toward heroism, patriotism, cowardice, and the reasons for the war itself. Manvell structures his comments to show how the socially and politically motivated cinematic portraits moved from initial simple images typical of wartime propaganda that obfuscate important social issues to more complex characterizations as a result of postwar conditions and a need for better international relationships. A careful reading of the book reveals its author is more concerned with reliving important moments in his life and in illustrating how the principal nations see themselves vis-a-vis World War II than in breaking new ground in the study of war films. The book, therefore, functions more as a synthesis of previously published material on the genre than as an original commentary on more than eight hundred feature-length fiction and factual films.

Manvell's opening chapter on the events that led to World War II sets the tone for his humanistic, nostalgic study. Important dates and events are crammed into brief fact-filled paragraphs showing how nations edged toward confrontation. The notable film-producing countries are criticized for their unwillingness to affront the new dictators emerging in Europe and Asia. Factual films (e.g., documentaries, newsreels, magazine films) are praised as generally superior to fiction films. For example, each of the major nations has its product summarized in terms of films produced, attitudes presented, and overall image revealed. Impressionism takes center stage, not depth. Thus in the subsections on the United States, considerably more space is given to reporting how the monthly releases of THE MARCH OF TIME (1935-1954) covered the tragic events in Europe and Asia in a manner that was different from earlier and more detailed pre-1940 Hollywood fiction films. Dates of particular releases are provided, along with useful plot synopses. But there the value of the commentary stops. No attempt is made to assess the accuracy or purpose behind such monthly presentations. No significant distinctions are made between the economic and social pressures facing the two genres. In discussing THE SPANISH EARTH (1937), Manvell becomes even more impressionistic in his criticism, enthusiastically commending the film's sponsors (e.g., Hemingway, Hellman, Dos Passos, MacLeish) both for striking a major blow against dictatorship and for producing one of the most brilliant documentaries of the 1930s. What is most disconcerting is that his discussions change focus from one country to another. His comments on French filmmaking prior to 1940, for example, stress the industry's preoccupation with pessimistic and fatalistic themes, while allowing the author the opportunity to make caustic references about Jean Renoir (leftist filmmaker) and French film historians Maurice Bardeche and Robert Brasillach ("penchant for the fascist film"). The overview of Nazi Germany before 1939, however, concentrates on Goebbels's control of the right-wing German film industry and the manner in which propaganda was manufactured. Japanese filmmaking, on the other hand, is reviewed from the perspective of its strong prewar economic base, and fiction filmmakers exposing social evils in Japan are commended. In effect, Chapter I represents a valuable collection of interesting data randomly assembled by a very moralistic critic who badly needed editorial guidance.

The other five chapters dealing with the various phases of the war and its aftermath reinforce these initial impressions. Many excellent comments are included about early World War II films' being modeled on pre-1940 precedents, Britain's aversion to using fascist propaganda techniques, the contrast between England's controversial and vacillating propaganda policies and the behavior of the German propaganda system, the enthusiasm with which Allied filmmakers depicted the Axis powers once the war freed them from film censorship concerning foreign governments, the negative impressions created by Hollywood's chauvinistic movies from 1940 to 1945 in the audiences of Allied nations, the rise of a "new realism" in British documentary films that "matched the quietly determined mood of the middle years of the war," and the often-ignored roles important filmmakers like Roberto Rossellini played in fascist film propaganda. Particularly endearing is Manvell's affection for British filmmakers who risked their lives to present honestly and realistically the determination of the English people under fire. Among those receiving special commendations are Ian Dalrymple, Humphrey Jennings, and Harry Watt. Manvell also exhibits considerable pride in recalling the wartime contributions of the Ealing studio, with its "production

of relatively low-budget war films derived from the actual wartime incidents, reconstructed and dramatized," as well as the emotional uplift provided by memorable British fiction films like ONE OF OUR AIRCRAFT IS MISSING and IN WHICH WE SERVE (both in 1942). In essence, Manvell's greatest strengths are not only his personal recollections but also his ability to comment on both fiction and factual films in the same volume.

Far less effective, however, are the frequent cases where the author's judgment is marred by prejudice or shallow aesthetic judgments. For example, dismissing Renoir's THE LOWER DEPTHS (1936), JUDAS WAS A WOMAN (1938), and THE LONG NIGHT because they "made a virtue out of defeat" and were too "pessimistic" does a disservice to Manvell's humanistic standards and underestimates Renoir's perspectives. Another evident weakness surfaces when Manvell reviews Hollywood thrillers and distinguishes between American and European directors: e.g., Alfred Hitchcock's FOREIGN CORRESPONDENT (1940) and Fritz Lang's MAN HUNT (1941) are unqualified successes; Mervyn LeRoy's ESCAPE, Frank Borzage's THE MORTAL STORM, and Archie Mayo's FOUR SONS (all in 1940) are "seriously intended dramas," but with specific problems that are ignored in movies Manvell likes. Another example of the author's anti-Hollywood bias is his attack on "romance" as a staple in making fiction film propaganda more effective. In criticizing SINCE YOU WENT AWAY (1944), Manvell finds it "a form of indecency that men still living in the comforts of Hollywood should devise such an entertainment at such a time in American history. . . ." He does acknowledge, however, that the film did provide millions of women separated from their loved ones with considerable consolation. The author's failings are also evident in his reluctance to explain why documentaries had greater freedom to explore controversial issues than did fiction films, and the need to explain more adequately assertions like the claim that MISSION TO MOSCOW was "a magnificent propaganda exercise," and his final conclusion that "The majority of the films that have appeared so far do little to bring new, contemporary understanding of the significance of what happened, except in a purely factual, historical context." Much as I admire the author's humanistic concerns, they seem unfair and unreasonable as a prescription for what is or is not significant film history.

If Manvell meant this volume to examine critically the manner in which the principal nations portrayed themselves, their friends, and their enemies in movies about World War II, the results are disappointing. But if the intention was to describe one person's personal reactions to World War II and what he both admired and resented about various filmmakers' interpretations of the significant events, the end result is a fascinating narrative which is helpful and entertaining. The book includes a basic bibliography and a much-needed index. Worth browsing.

Renov, Michael. HOLLYWOOD'S WARTIME WOMAN: REPRESENTATION AND IDEOLOGY. Ann Arbor: UMI Research Press, 1988. Illustrated. 275pp.

A challenging and intriguing examination on very limited period in Hollywood film history (1942-43), this Marxist cultural history analyzes "the issues in the charting of historical determinancy for Hollywood films . . . [and attempts to answer] the question 'In what ways can a piece of popular culture be said to respond to--to shape and be shaped by--its historical moment?'"The author focuses on a group of films that he sees as representing the film industry and the government's concerns the image of women. Renov divides his scholarly analysis into two major sections: "History and Ideology" and "Texts and Texuality." His provocative interpretations and revisionist history deserve serious consideration, but the author's academic prose will make the reading difficult for beginning students. Four appendexes categorizing the films and the distribution policies of their respective studios add to the book's value for serious students. Endnotes, a bibliography, and an index are included. Well worth browsing.

*Rubin, Steven J. COMBAT FILMS 1945-1970. Jefferson: McFarland, 1981. Illustrated. 233pp.

A breezy, behind-the-scenes approach, this disappointing study explores the story of battle in thirty American combat movies from the perspective of the filmmakers who played a major role in their production. The author bases his findings mainly on personal interviews with over forty screenwriters, novelists, directors, producers, cinematographers, and actors, all of whom worked on important movies between the end of World War II and 1970. Rubin claims that "The interesting common denominator is that they each have a unique story to tell, a story of creative frustration, of artistic perseverance, and of final victory." Instead of trying to discuss all thirty movies in detail, the author selects eight major films--e.g., A WALK IN THE SUN (1945), BATTLEGROUND (1949), TWELVE O'CLOCK HIGH (1949), THE BRIDGE ON THE RIVER KWAI (1957), HELL IS FOR HEROES (1962), THE LONGEST DAY (1962), THE GREAT ESCAPE (1963), and PATTON (1970)--and uses the attitudes and experiences associated with these movies as a means of understanding other combat films. The anthology's eight commentaries are placed into three arbitrary sections, which neither add to Rubin's observations nor sharpen the book's focus. In fact, the author's terse introductory remarks call attention to his unscholarly methodology; and throughout the book, Rubin's unwillingness to define his terms or grapple seriously with the issues he is investigating points out serious problems in his oral history and historical research.

The first and longest section presumes to discuss the filming of history, not heroics. Starting with the last World War II combat film, A WALK IN THE SUN, for example, Rubin synthesizes the information he received from novelist Harry Brown, director Lewis Milestone, producer Samuel Bronston, and screenwriter Robert Rossen. No attempt is made to question either the individual recollections of the people interviewed or the historical accuracy of what finally emerged in the film. That is not to say the essay is valueless. The information about script changes, the insights into why the film is so "talky," and the problems created by the military prior to the productions are interesting. But the reader has no way of knowing whether such information is accurate or self-serving. A case in point is the essay on BATTLEGROUND. Rubin claims that the 1949 film gave the public a new point of view on war--e.g., the GI's perspective--and that the movie's dialogue was checked personally by Brigadier General Anthony McAuliffe (the officer who gave the famous reply of "Nuts!" to the Germans at Bastogne). Besides the fact that the GI point of view had been a Hollywood staple, at least since THE BIG PARADE, or that a general's grasp of what it's like to be a lowly infantryman has a questionable validity, there is the unfounded assumption that screenwriter Robert Pirosh (who was at the battle and as an infantryman) remembered the events and interpreted them accurately. Rubin may be right in recalling that 1949 audiences came away from the film with a sense of the GI's essential humanity, but he totally fails to notice how much the film romanticizes the reality of war and vastly oversimplifies the Battle of the Bulge. Still another example of heroics not history, the reverse of Rubin's theme for this section, is the essay on THE LONGEST DAY. Darryl F. Zanuck, the film's producer, is quoted as wanting to make a movie that "will hate the institution of war and yet be fair about it." Rubin never comments on what finally emerged or about the absurdity of a star-packed war film's even coming close to such a noteworthy goal. Thus the author's many charming anecdotes and quotations from the filmmakers themselves prove disappointing when compared to the amount of information found in a similar undertaking by Lawrence Suid's GUTS AND GLORY: GREAT AMERICAN WAR MOVIES.

The anthology's other two sections only reinforce Rubin's weaknesses and strengths as a film commentator. In dealing with film history, for example, he mentions the importance of THE DAWN PATROL (1938), but overlooks the 1930 version, which many critics consider a better movie. The chapter on TWELVE O'CLOCK HIGH (1949) provides an enjoyable overview of the filmmaking process, but surprisingly ignores the military use of that movie in training officers for command positions. Finally, Rubin frequently misses excellent opportunities to relate his valuable personal interviews to central themes in war movies. For example, he talks about screenwriter (mistakenly referred to in a caption as "Director") Francis Ford Coppola's intense concern for making the setting accurate in PATTON, yet never

comments on the importance in World War II movies of showing the conflict as a "just war" fought by "the common man" against "the forces of evil." More than anything else, this distinction is what clearly separates World War II movies from those dealing with the Korean and Vietnam Wars.

Rubin may be right in referring to his book as "a story of a group of film makers who set out to achieve the impossible. . . ." As history it has serious flaws, but as the recollections of extremely influential filmmakers it makes for interesting reading. The anthology includes a filmography and index. Worth browsing.

Shaheen, Jack G., ed. NUCLEAR WAR FILMS. Forword Marshall Flaum. Carbondale: Southern Illinois University Press, 1978. Illustrated. 193pp.

Socially rather than aesthetically oriented, this well-intentioned anthology wants to be more than a collection of twenty-five critical essays by twenty-one concerned film commentators on thirty-two of the most significant nuclear war films produced between 1946 and 1975. The movie discussions by teachers, reporters, and filmmakers act as a launch pad for attacking the distortions and lies propagated by people who defend the use of nuclear deterrents as well as those members of the audience whose psychological, social, and political conditioning misleads them into believing nuclear wars are winnable. "The book is designed," according to its editor, "to encourage a reasoned and thoughtful understanding of nuclear films, to convey not only the diversity of genre themes but a sense of the fragility of human life." The commentators, who represent a cross section of backgrounds and perspectives, stress one major idea: nuclear technology is inherently evil and unless controlled will become even more devastating than it already is. "Inherent in most nuclear feature films," states Shaheen, "is one basic warning--man should not rely on technology at the expense of humanity and civilization." He then goes on to point out the irony of the 1960s, where the number of nuclear films declined in proportion to the expanding arms race. No attempt is made to put the essays into a critical context that illuminates the filmmaking process or explains the involved producer-audience relationship. Subjective and philosophical discussions take precedence over statistical, analytical, and historical methods. Generalities rather than specifics characterize the treatment used in most of the articles.

The first of the book's two sections concentrates on feature films exploiting the bomb's awesome power. Two different emphases serve as a link for the eleven essays chronologically arranged. The major focus is on the survival theme, evident in FIVE (1951); THE WORLD, THE FLESH AND THE DEVIL; ON THE BEACH; and HIROSHIMA MON AMOUR (all in 1959); PANIC IN YEAR ZERO (1962); and LADYBUG, LADYBUG (1963). Ernest Martin's superficial analysis of FIVE illustrates how most of the contributors consciously ignore the complex issues surrounding genre filmmaking in favor of sounding the alarm over the dangers of nuclear proliferation. For example, Martin states at the outset, "The importance of FIVE to the nuclear war genre is not in the cinematic virtuosity of the director, not the contrived plot, not the allegory on racial tensions. The importance is the influence of FIVE in the development of the cinematic attitude toward atomic war." The remainder of the very brief essay sketches Hollywood's basic approach to nuclear films--e.g., pessimism about the world's future in an atomic age, fatalism when it comes to technology and humanism's being able to coexist peacefully--and draws parallels between Arch Oboler's melodramatic attempts to mislead the public about the reality of nuclear survival with similar distortions in Jim McBride's GLEN AND RANDA (1971), Ranald MacDougall's THE WORLD, THE FLESH, AND THE DEVIL, and Norman Taurog's THE BEGINNING OR THE END. One of the book's few good models for combining a strong social consciousness with intelligent film criticism can be found in H. Wayne Schuth's perceptive comments on HIROSHIMA MON AMOUR. Without neglecting the seriousness of the nuclear dilemma, Schuth critically examines Alain Resnais's haunting film from its stress on the rebirth of both a woman and a city, telling us why war destroys both victor and vanquished. The results do more to achieve the anthology's stated aims--e.g., to "enhance our ability to perceive, criticize, and appreciate the nuclear film in a disciplined and creative manner"--than other essays that substitute good intentions for serious film

analysis. The section's second theme centers on society's inability to control its technology. Among the films discussed--e.g., THE BEGINNING OR THE END (1946), THE DAY THE EARTH CAUGHT FIRE (1962), FAIL-SAFE (1964), DR. STRANGELOVE OR: HOW I LEARNED TO STOP WORRYING AND LOVE THE BOMB (1964), and THE BEDFORD INCIDENT (1965)--only George W. Linden's essay on Stanley Kubrick's satiric masterpiece offers fresh new insights. He shrewdly reinterprets the nuclear war comedy as an all-out assault on America's pornographic love of power, "our propensity to substitute violence for love." For the most part, however, the initial essays merely identify the illogical film plots and then warn us about the dangers of nuclear war. One long well-written essay by gifted critics like Schuth and Linden would have done the job better.

The same cannot be said about the anthology's other section on documentaries and short films. While the essays themselves do little to enlighten and educate us about critical film values, the invaluable reminder about a vast body of ignored films provides an important service. Educators planning programs about the dangers of nuclear war will want to know about movies like A SHORT VISION (1956), A THOUSAND CRANES: CHILDREN OF HIROSHIMA, H-BOMB OVER U. S., and THE HOLE (all in 1962), SKIDOO (1964), COUNTDOWN TO ZERO and THE WAR GAME (both in 1966), FOOTNOTES ON THE ATOMIC AGE (1969), HIROSHIMA-NAGASAKI--AUGUST 1945 (1970), RUMOURS OF WAR, ARMS AND SECURITY: HOW MUCH IS ENOUGH, and ONLY THE STRONG (all in 1972), AND WHEN THE WAR IS OVER: THE AMERICAN MILITARY IN THE 70'S (1973), and TO DIE, TO LIVE (1975). Each of these documentaries, educational short films, and television reports gives us a much-needed perspective on the social, historical, and scientific issues associated with nuclear war.

Summing up, the anthology is overloaded with personal opinions that vastly oversimplify the filmmaking process and thus don't help very much in developing a critical awareness about movie distortions. The weak results are understandable, given editor Shaheen's humanistic concerns. One hopes the idea for such an important project will be tried by others whose purpose will be as noble, but whose methods will be more scholarly. Worth browsing.

Shain, Russell Earl. AN ANALYSIS OF MOTION PICTURES ABOUT WAR RELEASED BY THE AMERICAN FILM INDUSTRY 1930-1970. New York: Arno Press, 1976. 448pp.

Indispensable for any serious examination of the genre, this remarkable doctoral study provides the most thorough statistical evaluations of fictional, feature-length war films from the end of the 1930s to 1970. Its author makes extensive use of historical perspectives and content analysis, skillfully combining objective scholarship with subjective judgments while never allowing the gathering of statistics about 815 films to become an end in itself. Purists might fault Shain for not seeing every movie mentioned and for basing some of his conclusions on representive samples viewed on televison and relying frequently on published plot synopses, but the fact is that many of the films no longer exist and the cost of such an undertaking for a young scholar is prohibitive. Other critics may challenge his methodology (modeled after George Gerber's content analysis approach in studying mass communication) in which the focus is divided between impressions of the entire film and those of the major character. In such cases, the issues of the coder's reliability and the validity of the published material present serious limitations. To his credit, Shain acknowledges the problems and does a creditable job in offering safeguards for any errors that result. The study itself is divided into four jam-packed fact-filled sections, focusing on the content and environment affecting the films, as well as on the imagery that these American war films have produced and the clues they provide for scholars interested in determining a society's attitudes toward war. "However," as Shain points out, "the relationship between individual and film should not be interpreted as one which the individual enters with the purpose of forming opinions." He acknowledges that many people go to the movies for relaxation, but in the process they are "partaking of a cultural product."

Part one concentrates on a statistical analysis of the environmental influences associated with war film productions. In particular, considerable attention is given to the complex relationship between the film industry and the government, the undeniable importance of economic conditions, and the crucial role that cultural and social conditions play in formulating film policies. As a result of his quantitative research, Shain discovers that in the years from 1939 to 1947 Hollywood provided us with an accurate picture, albeit stereotyped, of dominant American values. For example, he concludes that although movies like THE MORTAL STORM, ESCAPE, FOREIGN CORRESPONDENT, and THE GREAT DICTATOR (all in 1940), A YANK IN THE RAF and INTERNATIONAL SQUADRON (both in 1941) constituted only a fraction (3.4 percent between 1939 and 1941) of the film industry's total output, these films did provide a rough approximation of American opinion regarding our potential involvement in World War II. The anti-Nazi films of those days--e.g., CONFESSIONS OF A NAZI SPY (1939)--are described as a deviation from Hollywood's standard procedures, primarily because the industry went against the mainstream of American thought that was "vocally isolationist and pacifist." The years from 1948 to 1962 demonstrate how Hollywood became the scapegoat for right-wing attacks on movies that suffered from the changing social and political shifts brought about by the Berlin blockade, the widespread fear of Communism, and the Korean War. Cold War films like THE IRON CURTAIN (1948), MAN ON A TIGHTROPE (1953), and NIGHT PEOPLE (1954) illustrate how American filmmakers, with mixed results, tried to "pacify the political sector while . . . [adjusting] to new economic realities." Interestingly, in one of his rare omissions, Shain ignores the serious economic impact that the influx of foreign films and the transfer of "B" productions to television had on the film industry. The last part of this section covers the years from 1963 to 1970, pointing out that for the first time since the pre-World War II days Hollywood filmmaking was not "primarily the consequence of political influence or coercion." He describes the shift as one in which national chauvinism was replaced in war films with an emphasis on the importance of the professional military as well as an audience interest in action for its own sake, evident in films like A GATHERING OF EAGLES (1963) and THE DIRTY DOZEN (1967). Major exceptions like FAIL-SAFE (1964) and THE GREEN BERETS (1968) are explained as the work of independent filmmakers or studios, now freed from the old vertical film industry practices (production-distribution-exhibition concentrated in a few hands) and benefiting from the demise of the old motion picture code. Shain's conclusions, therefore, lend strong support to Will Wright's analysis of the western genre and the relationship between genre study and American social history. They also underscore the weaknesses found in film genre studies that ignore the institutional influences on film production. Shain's discoveries in this section are neither new nor revolutionary, but they do reinforce past interpretations, and the statistical explanations provide for fascinating summaries.

Section two examines the changing concept of American war heroes. Here Shain begins a close examination of individual films, pointing out how Hollywood portrayed the major character's aspirations, beliefs, and behavior, as well as demographic representations. The same three time periods serve as a basis for contrasting and comparing the various American heroes as a cultural indication of the nation's shifting attitudes toward war from 1939 to 1970. For example, the heroes of war films both from 1939 to 1947 and 1948 to 1962 are shown as "socially responsible characters" (almost exclusively men) who saw themselves performing clear-cut patriotic missions in an attempt to prevent future wars. Where the former were generally civilians or civilians-turned-soldiers, the latter were professional warriors who had an unswerving devotion to duty. The American film heroes from 1963 to 1970, however, were much different. They differed in their attitudes toward life, the methods they used to achieve their goals, and in the results that followed. According to Shain's statistics, the typical American film hero now became an uncaring figure whose personal objectives were "sex, money, status, and survival."

In section three, the enterprising author turns his attention to the changing concepts of our allies and enemies. Unlike the ease with which filmmakers adopted the image of American war heroes to the shifts in political and social currents, international images proved more difficult. For example, allies like Russia and China

who were friends during the 1939 to 1947 period became political enemies in the two decades that followed. In addition, our World War II enemies--e.g., Germany and Japan--became our friends in the late 1940s. Thus, American filmmakers had the problem not only of transforming the images of these various former allies and enemies, but also in persuading the audience to accept new conventions about the interpretation of what occurred in World War II.[397] Shain is especially astute in evaluating how the transformations occurred, the problems they presented, the distinguishing characteristics of the changes taking place, and the difficulties for filmmakers in reevaluating the war contributions of the various groups in post-World War II movies. For instance, in the 1939-1947 period American war films distinguished between the barbarism practiced by the Germans and the Japanese. The insidious actions of the former were attributed to fascists and Nazis, not the German nation itself. Japanese attrocities, however, were presented as being committed by the entire nation, not just its leaders. The same films also called attention to the contributions and sacrifices made by our allies. These conventions changed in the American war films made in the 1948-1962 period. As a consequence of our national realignments, Hollywood turned the Germans into super patriots fighting to overthrow Hitler, while the Japanese suddenly lost their barbaric behavior and became very sensitive, polite people victimized by the war. In fact, the distinguishing difference between allies and enemies became not their actions but their primary goals. The 1963-1970 era blurred the distinctions further, placing the importance more on individual actions than on national objectives. Anyone wishing to know the statistics can consult Shain's massive data in demographic breakdowns by sex, age, class, marital status, education, nationality, and occupation.

The final section explores in even greater detail not only Hollywood's views on America's wartime behavior--e.g., its justifications, methods, and the consequences of warfare--but also how the Defense Department through its assistance program influenced American film content. Among the significant conclusions reached are that the professional warrior replaced the everyday soldier in Hollywood war films after 1947 because war itself became associated more with specialists than with noble causes, no nation was shown as devoid of brutality, and America could no longer use moral justification for sending its armed forces into combat. Especially interesting is Shain's conclusion that the Pentagon gave more aid to filmmakers who made war movies about the navy and the air force than those about the army because those services needed extensive propaganda justifying their enormous capital outlay for expensive technology.

Unfortunately, not everything in this competent study is either compelling or persuasive. Shain may be strong in statistical analysis, but his critical skills present some problems. He mistakenly reports that "Prior to World War II, Hollywood had little reputation as a social critic," fails to mention how production lags influenced filmmakers' production policies in the last few years of World War II, places too great an emphasis on the industry's financial problems in the late 1940s and not enough on political and social issues, too superficially accounts for the consequences of right wing-left wing Hollywood factions on American filmmaking, and vastly oversimplifies the relationship between filmmakers and the Production Code. He also demonstrates an annoying habit of referring to important literary figures as if they were personal friends--e.g., Charles Greene instead of Graham Greene, Bert Brecht instead of Bertolt Brecht. In addition, readers will find his writing style typical of the laborious prose identified with doctoral dissertations.

[397] For an interesting perspective, see Robert C. Reimer, "Nazi-Retro Films: Experiencing the Mistakes of the Ordinary Citizen," JOURNAL OF POPULAR FILM AND TELEVISION 12:3 (Fall 1984):112-7.

These minor criticisms aside, Shain's study remains the major source of information analyzing statistically the objective content of war films and the context in which they are produced. My one major regret is that no index is provided. Highly recommended for special collections.

Smith, Julian. LOOKING AWAY: HOLLYWOOD AND VIETNAM. New York: Charles Scribner's Sons, 1975. Illustrated. 236pp.

A meandering, well-intentioned survey, this deeply felt narrative comments "on thirty years of war films in which Hollywood, by affirming certain values and reinforcing certain fears, helped to create the state of mind that led to Vietnam." The book's title suggests Smith's central concern, that Hollywood refused to see what was happening in Vietnam. His thesis is that the film industry, like the nation itself, became disoriented by the war we couldn't win or abandon. As a result, filmmakers conditioned by the rigidity of pre-Vietnam War movies and their emphasis on action and technique found the Asian conflict a monstrosity to depict. Similarly, moral justification so uncontroversial in past movies became confusing to the people making Vietnam War films. Thus no clear-cut iconography emerged inspiring the industry with the names of heroes or places to exploit in a film title such as had been done in World War II movies like BACK TO BATAAN (1945) and SANDS OF IWO JIMA (1949). We also got "no movies about aircraft carriers in the South China Seas. No comedies about boys on furlough in Japan or Hawaii or Australia. No spies or saboteurs. No bomber crews sweating out a run on Hanoi or Haiphong. . . ." What Hollywood did give us, according to Smith, was war films void of a chauvinistic religious spirit that created the overall impression that "God seems to have forsaken America." Smith's emotional study rests on more tenuous grounds than the shaky psychological assumptions of Kracauer's FROM CALIGARI TO HITLER, asserting not only that a nation's films reflect its mentality more directly than do other art forms, but also that they provide a crucial index to national values and are best analyzed by investigating the images in full-length commercial fiction films. The author restricts his research, therefore, to American movies made for mass audiences and ignores documentaries, short films, and underground films.

The very subjective analysis works best when speculating on Hollywood's methods in using other film genres and movies about past wars to comment indirectly on the Vietnam War. THE SAND PEBBLES (1966), for example, is interpreted as providing Americans with images of what it's like to fight in the civil war of a foreign country where you are ignorant of its language, customs, and national goals. THE FRENCH CONNECTION (1971) reveals the dangers of domestic drug dealing and of innocent people being killed by "justifiable" violence to stop it, a metaphor for our actions in Vietnam. STRAW DOGS (1971), based on Gordon Williams's novel THE SIEGE OF TRENCHER'S FARM, has its overtly political statements about Vietnam turned into a violent visual metaphor in the movie when an American college professor living in England finally realizes that he can't avoid defending himself against ignorant savages irrationally determined to kill him and those he holds dear. Korean War films demonstrate Hollywood's failure to adjust the genre's conventions for depicting a new era of international conflict. Smith makes an especially good case for viewing movies like THE STEEL HELMET (1951), FIXED BAYONETS (1951), RETREAT, HELL! (1952), ONE MINUTE TO ZERO (1952), BATTLE CIRCUS (1953), THE BRIDGES AT TOKO-RI (1954), PORK CHOP HILL (1959), and M*A*S*H (1970) as a "shadow history" of what was to occur later in Vietnam, where Hollywood had difficulty treating such controversial subjects as killing innocent civilians to protect a military position or motivating dissident combat troops to fight for a cause they can't comprehend. Equally stimulating are the observations about the American film industry's early history of movies dealing with Vietnam, starting with SAIGON and ROGUE'S REGIMENT (both in 1948), moving through the fifties with A YANK IN INDOCHINA (1952), CHINA GATE and THE QUIET AMERICAN (both in 1957), and up to the 1960s with such far-ranging films as THE UGLY AMERICAN (1963), A YANK IN VIETNAM (1964), THE LOST COMMAND (1966) and THE GREEN BERETS (1968). Smith is very effective in using these films as an opportunity to explain how they affected him and others

growing up in America from the late 1940s to the 1970s. He states, for example, that THE MANCHURIAN CANDIDATE (1962) and the assassination of President John F. Kennedy are "irrevocably" linked in his mind; and that "the 'presidential' films in the early sixties were classical portents of what lay ahead for presidents, the presidency, and the nation." Such comments illustrate the text's major focus and appeal.

The obvious weakness in Smith's book is its subjective conclusions. No evidence is ever presented that remotely justifies many of the assertions the author makes. Since no useful plot synopses or detailed analyses of the films are provided, the reader first needs to be conversant with the movies and then has to decide whether or not Smith's comments are valid, given the social, political, and economic pressures of the period. It's hard to understand how people not well versed in the films of either Audie Murphy or John Wayne will relate to the author's criticisms of these stars or their impact on men like William Calley, John F. Kennedy, and Richard M. Nixon. Furthermore, only experienced viewers will be able to locate the errors in Smith's otherwise insightful comments about movies concentrating on the role of the air force in war. For example, he claims erroneously that the film version of SLAUGHTERHOUSE FIVE (1972) ignores the suffering of the German people during the infamous Dresden bombing raid.

As one person's deeply disturbing memories about growing up with American war films, the book is an excellent reminder of how movies can affect individuals. But as an analysis of Hollywood's responsibility for what occurred in Vietnam, the text loses its credibility. The emotional arguments are stirring; the logic is not. Well worth browsing.

*Suid, Lawrence Howard, ed. AIR FORCE. Madison: The University of Wisconsin Press, 1983. Illustrated. 224pp.

In his excellent introduction to the screenplay, the editor reviews not only the evolution of the production but also the love-hate relationship between the military and Hollywood during World War II. Suid pays particular attention to the historical context in which AIR FORCE was conceived and to the unique talents of director Howard Hawks in creating an aesthetically pleasing film as well as a piece of important propaganda to bolster the nation's spirits following the attack on Pearl Harbor and the fall of the Philipines. Cast, production credits, and a host of useful stills are included. Well worth browsing.

*Suid, Lawrence H. GUTS AND GLORY: GREAT AMERICAN WAR MOVIES. Reading: Addison-Wesley Publishing Company, 1978. Illustrated. 357pp.

Concentrating exclusively on the American military image in Hollywood feature films, this unusual book makes no attempt to be either comprehensive or definitive. Suid is fascinated by the relationship between Hollywood filmmakers and the American military establishment from 1915 to the late 1970s and thus explores in chronological order the behind-the-scenes events affecting more than thirty major American war films. His method is to focus on how certain filmmakers received Pentagon support during the production of many of their films, as well as the reasons why other individuals were denied similar assistance. Comparisons are then made as to the image of the military presented by both groups, and the way those different types of images developed over a sixty-year period. What is most surprising is that he makes no attempt to question the legitimacy of the Pentagon's influence on war films, stating simply that such a relationship is authorized by Congress with the stipulation that no expense is to be incurred by the taxpayer. Whether the regulations have been followed, abused, or ignored he finds difficult to assess and therefore avoids the issue. Instead, he applauds the Department of Defense's involvement in commercial film productions, arguing that such efforts cost less than letting the military make its own "message" movies and that they provide the Pentagon with much larger audiences than are possible with its service-produced films. To avoid unnecessary

confusion, he makes a distinction between a war film and a military film. The former is defined "as one in which men are portrayed in battle in a recognizable military action or in which they are directly or indirectly influenced by actual combat." Military films, on the other hand, are those "in which military men are portrayed in training situations during peacetime or performing duties intended to preserve the peace." In addition to this curious and dubious distinction, Suid's study holds other surprises. It has little concern with issues of dramatic quality and avoids commenting on any films not presenting an illusion of military reality--e.g., war comedies or musicals. However, the author criticizes the genre as being different from other film types. The latter generally include good movies that make comments on the human condition. War films rarely take that tack, according to Suid, preferring instead "to create their dramatic impact through noise, spectacular combat scenes, and violence." Given this debatable assortment of values, limitations, and historical perspective, the narrative's fifteen chapters are filled with controversial, challenging, and intriguing observations.

On the positive side, Suid's fluid writing style presents a highly readable description of the war film's developing sophistication and freedom from the hate-filled days of World War I to the overwhelming cynicism of APOCALYPSE NOW (1979). His early chapters on the way in which war movies up to the mid-1960s reflected myths about American ideals offer interesting speculations on why Americans failed to be more critical about our involvement in the Vietnam War. He reminds us of how films like producer Walter Mirisch's MIDWAY (1976) were made for patriotic as well as commercial reasons, how such movies helped justify war and the use of violence for achieving national objectives, as well as the various debates about whether or not the film reenactments of actual combat conditions are realistic from the Pentagon's perspective. We are given glimpses of the military assistance tendered important productions like THE BIG PARADE (1925), WHAT PRICE GLORY? (1926), and WINGS (1927), in addition to explanations extracted from the author's private interviews with the directors of these films. As long as we ignore Suid's refusal to question the validity of the statements made by the people interviewed and the absence of conflicting testimony, the material raises a host of valuable opinions about purposes, propaganda, exploitation, individual responsibility, and censorship. Particularly enjoyable are the discussions purporting to explain what impact the military intended films like AIR FORCE (1943), SAHARA (1943), BATTLEGROUND (1949), and THE BRIDGES AT TOKO-RI (1954) to have on the American public. Unlike the Butler book's caustic comments about Hollywood's World War II films, for example, Suid applauds movies like WAKE ISLAND (1942), BATAAN, and AIR FORCE (both in 1943) for not only providing American audiences of the day with much needed antidotes for the early setbacks following the attack on Pearl Harbor, but also for reassuring the viewers that in the end we will be victorious. The general reader will also find Suid's comments on the links between John Wayne and the Pentagon over a twenty-year period very enjoyable. For example, Wayne in his countless film roles is credited with extolling "the simple virtues of doing right and feeling useful." Nonetheless, Suid goes on to argue that not only did the "Duke" reflect in such roles "the desire in Americans to solve problems simply and directly," but also he represented "the use of violence rather than reason to solve problems." More sophisticated readers will appreciate the insights gleaned from the author's interviews with William Wellman (WINGS, THE STORY OF G. I. JOE), Fred Zinnemann (FROM HERE TO ETERNITY), Darryl F. Zanuck (THE LONGEST DAY), Donald Baruch (chief of the Pentagon's Motion Picture Bureau),[398] General Curtis LeMay (father of the Strategic Air Command), Frank McCarthy (PATTON), and Andrew Marton (THE LONGEST DAY, CATCH-22). Whether you accept or reject their interpretations of why and what happened in the making of specific films, you will not find anywhere else their points

[398] Appointed in 1949, Baruch is now the Special Assistant for Audio-Visual in the Office of the Assistant Secretary of Defense for Public Affairs.

of view so succinctly and objectively reported. For this and many other data collecting services, Suid gets high marks.

Where the author runs into serious problems is in the area of analysis. Almost nothing in his many film reviews differs significantly from previously published evaluations. We gain no new interpretations about the films themselves, the eras in which they were made, and the impact they had on their audiences. The testimony recorded by Suid acts more as a self-serving rationalization by the filmmakers than evidence on a controversial interpretation by an objective scholar. For example, the author presents a realistic depiction of tensions and conflicts in the peacetime air force in A GATHERING OF EAGLES (1963), but ignores the film's dismal dramatic impact. The problems that Max Youngstein had with the Pentagon in the production of ATTACK! (1956) are presented, but no discussion of the charges that the military clandestinely worked against the film are raised. In discussing THE LAST DETAIL (1973), Suid is more preoccupied with pointing out how the Navy was mistreated by the film, than with the problems created by military roadblocks the filmmakers faced in producing the movie. Finally, he makes a serious effort to discredit Francis Ford Coppola's argument that the Pentagon tried everything possible to stop the production of APOCALYPSE NOW. The questions continually surfacing as Suid makes his extended case for the military involvement in such productions is, "For whom was this book written and why?" For example, when Suid finds a film that contains an authentic image of war, he goes to considerable lengths to discuss it in detail. Conversely, those films that fail to represent reality are treated perfunctorily with negative critical comments. He rarely considers the possibility that the message might just be a more important commentary on war than an accurate representation of high technology.

GUTS AND GLORY may not be the ideal book that a more critical historian will eventually supply us with. It is, nevertheless, a very readable story that presents an extremely rare point of view, and one which, in fairness to its subject, deserves consideration. In addition, many of the stills superbly illustrate the author's fast-paced text, which comes loaded with extensive footnotes and an excellent index. Recommended for special collections.

*Syberberg, Hans-Jurgen. HITLER: A FILM FROM GERMANY. Preface Susan Sontag. Trans. Joachim Neugroschel. New York: Farrar, Straus and Giroux, 1982. Illustrated. 268pp.

"Our aim," Syberberg stated in explaining his seven-hour epic film, "is the irony of the diabolical enlightenment: to discover horror in the banal, to confront the hugeness of evil with ever-lurking triviality and carry it to absurdity; our aim is the sad knowledge that for victims and perpetrators, as for the spectators of history, this crisis of human existence has an attractive demonic quality." But the film is much more than an attempt to portray Hitler as the culmination of Germanic traditions dating back to the romantic age. It is also a remarkable artistic achievement that testifies to the intellectual power of film to treat complex issues in a profound manner. We are asked not only to reexperience the scope of Hitler's crimes, but also to understand the German nation's complicity in the spiritual catastrophe that engulfed the world during this tragic historical period. Syberberg sees his project as having a special significance for modern day Germans. He claims that as a result of the nation's refusal to accept its role in Germany's Satanic past and a refusal to mourn for its sins, Germany cannot rediscover its identities, be healed, and be saved. Thus this work of mourning (TRAUERARBEIT) becomes an opportunity for a new generation to expiate its collective responsibility for the past. Susan Sontag, in her opening remarks (excerpted from the essay "Syberberg's Germany," penned in 1979 and anthologized in the 1980 book UNDER THE SIGN OF SATURN published by Farrar, Straus and Giroux), points out that the filmmaker's monumental work recalls the art of Thomas Mann and James Joyce. That is, it "belongs in the category of noble masterpieces which ask for fealty and can compel it."

Along with the film script and many striking illustrations, the engrossing text provides a valuable glossary on names and references used in the film. Surprisingly, no information is given on where the film can be rented either in 35mm. or 16mm. Recommended for special collections.

*Wilson, James C. VIETNAM IN PROSE AND FILM. Jefferson: McFarland and Company, 1982. 130pp.

By far the most sensitive and balanced introduction to the role of the arts vis-a-vis the Vietnam War, this well-written narrative is critical not only of the United States's foreign policies toward the small Asian nation, but also of the press, novelists, and filmmakers for allowing us to both deny and evade our guilt rather than forcing us to face what we had done and thus learn from our mistakes in Vietnam. The author has no intention of forgetting what happened or blurring responsibility for the national tragedy. He is not, however, interested in a purely formalistic analysis; rather, as Wilson writes, "I am interested in this body of literature and film for what it tells us about ourselves and our culture." He goes on to say, "For these works reflect the difficulties we have in comprehending the war: our evasions, our distortions, our denials." In the best books and films are to be found the unequivocal testimony of the steps we have begun taking "toward facing the unpleasant truth of an unpleasant war."

Despite the book's brevity and the relatively limited space devoted to movies about the war, its narrative provides film students with a superb overview of the ideological issues relating to Vietnam War movies. Wilson's stirring introduction, for example, recaps the government's standard reasons for our involvement--e.g., the domino theory, safeguarding democracy and freedom, national defense, protecting our allies, American prestige--and the significant arguments against these official rationalizations found in major works by Michael Herr (DISPATCHES), Gloria Emerson (WINNERS AND LOSERS), Charles Durden (NO BUGLES, NO DRUMS), Philip Caputo (A RUMOR OF WAR), and Ron Kovic (BORN ON THE FOURTH OF JULY). Wilson reminds us that during the 1960s the American public and its elected officials strongly supported the war and thus set up formidable commercial dangers for anyone having the courage to produce dissenting opinions in multi-million-dollar movies. The first text studied in detail, Graham Greene's seminal novel THE QUIET AMERICAN (1955), is justly praised as the prototype for future fiction works and as a harbinger of how American leaders eventually misrepresented our actions in Vietnam to the American people. Greene refers in the book to "mental concepts," preconceived ideas or abstractions, that have the power to shape reality and explain why perceptions can often be more powerful than truth in determining the course of history. Alden Pyle, Greene's American protagonist sent by his government on a covert mission to Vietnam, becomes in Chapter 3 of Wilson's study the symbol of our distorted perceptions of what led us into the Vietnam War. Pyle ignored the differences between his social, cultural, and political values and those of the Vietnamese. He refused to challenge official interpretations of what was occurring in Asia and what his proper response should be. He became confused by the misleading propaganda emanating from the mass media. And thus "Like Alden Pyle, . . ." Wilson concludes, "the Americans got hold of an idea and altered every situation to fit the idea."[399] Chapters 4 and 5 effectively describe how broadcasters and literary people mirrored the distortions perpetuated by government policies. Obvious parallels between the French and American Indochinese Wars were ignored, the racist nature of the conflict was never revealed, and the brutality of American behavior in Vietnam was masked by the media reports. Novelists reinforcing government distortions included Robin Moore (THE GREEN BERETS), Winston Groom (BETTER TIMES THAN THESE), James Park Sloan

[399] For an intriguing analysis of what went wrong in the film version of THE QUIET AMERICAN, see *Kenneth L. Geist, PICTURES WILL TALK: THE LIFE AND FILMS OF JOSEPH L. MANKIEWICZ (New York: Charles Scribner's Sons, 1978), pp.267-78.

(WAR GAMES) and Joe W. Haldeman (WAR YEAR). Although Wilson doesn't make direct references to Hollywood in these opening chapters, he indirectly draws comparisons between the reliance of the media and novelists on conventions and the patterns followed by filmmakers. It's important to remember that the 1960s was a period in which the film industry was taken over by many conglomerates primarily interested in profits not art. While maverick producers dabbled in controversial subjects, the major producers avoided controversy. Their "mental concepts" insisted on seeing the Vietnam War as no different from previous wars; as a result, conventional interpretations proliferated until the late 1970s. Chapters 6 through 9 introduce many of the major themes treated first in the Vietnam War novels and later adapted to the screen: e.g., the massive drug problem, rock-and-roll music as an escape from reality, the surrealistic behavior of the conflict, the unreliability of the government and the media in reporting the truth about the Vietnam War, widespread confusion on what was happening and why, and a growing sense of disillusionment and apathy at home and abroad. All the works Wilson discusses blame America's political and economic priorities for the war in Vietnam. "Even more," he argues, "these books blame government, military, and corporate executives who sold the war to increase their own power and profit, and who 'wasted' a generation of Americans and millions of Vietnamese by pursuing their own self-interest." Regrettably, Chapter 10, dealing with Hollywood movies, is the weakest section in the text. While Wilson accurately characterizes the film industry's fickle relationship with the Vietnam issue as proceeding from a too-hot-to-handle position in the 1950s and 1960s to a major commercial opportunity in the late 1970s, he mistakenly assumes that movies, novels, and television all operated the same way in selling the public "a simplistic, sentimental, soap opera version of American [sic] in Vietnam." Once Wilson abandons his ideological perch and begins analyzing the film industry, he runs into serious problems. Hollywood simplified the Vietnam War not just for the reasons Wilson thinks but also because it relied on conventions rather than on novelty to satisfy the public's mental concepts. Film versions of THE QUIET AMERICAN (1957), THE GREEN BERETS (1968), and DOG SOLDIERS, retitled WHO'LL STOP THE RAIN (1978), didn't distort their sources to deliberately soft-pedal the controversial material, although avoiding controversy no doubt played a role. The producers were giving the audience what they felt the viewers wanted. In other words, entertainment, not messages, remains Hollywood's top priority. HEARTS AND MINDS (1975), on the other hand, was a documentary not bound by audience expectations, although it clearly simplified the issues to make its antiwar position more accessible to the public and won an Academy Award for the year's best documentary. Filmmakers were not just playing it safe, but trying to survive in a very competitive business where good intentions count for very little. Furthermore, most of the movies Wilson alludes to were made during the Vietnam War when governments traditionally exert enormous pressure on the mass media to follow official lines. That is not to condone the products produced; it is to put the criticisms in context. Wilson is quite right, however, in summarizing what conventions Hollywood used in presenting the Vietnam War: e.g., cowboys versus Indians, good versus evil, an American not a Vietnamese tragedy, a reincarnation of World War II's mythical interracial platoon of dogface soldiers, and the racist values of the war film genre. Out of the more than seventy films made on the subject, he finds only two to be important--HEARTS AND MINDS (1975) and APOCALYPSE NOW (1979). In fact, he finds that "Even more than the literature, the Vietnam movies generally have derealized Vietnam to the point of unrecognizability." The validity of that elite versus popular culture argument is still to be determined. Nonetheless, the book's conclusion poignantly recalls how the various novels, histories, autobiographies, articles, broadcasts, and movies documented the insanity of our involvement in the Vietnam War. It reminds us again that America had set the seeds for its depraved behavior by its long-standing overemphasis on consumer consumption, and that the war only contributed to reinforcing the decline in our human values and human morality.

In addition to a valuable chronology of events from 1873 to 1975, Wilson includes an important bibliography, filmography, and index. Highly recommended for special collections.

FILMS

BIOGRAPHICAL WAR FILMS

AMERICAN

PATTON (Fox--16mm: 1970, 171 mins., color, sound, R-FNC, WIL)
Franklin J. Schaffner directed what is probably the best war biography to date.[400] Based upon a number of books, the screenplay starts in 1943 when General George S. Patton (George C. Scott) assumes command of a demoralized tank battalion and defeats Rommel's Afrika Corps. From then on we get to see Patton's ego take on General Bradley, Field Marshal Montgomery, and General Eisenhower. Balanced against Patton's negative characteristics are his military successes. So ambivalent is the drama that one is torn between bitterness and admiration for what must have been a very disturbed man. Scott is brilliant. A well-deserved Oscar went to him; to Francis Ford Coppola and Edward H. North for their screenplay; to art and set decorators Urie McCleary, Gil Parrondo, Antonio Mateos, and Pierre-Louis Thevent; to soundmen Douglas Williams and Don Bassman; and to film editor Hugh S. Fowler.

SERGEANT YORK (Warner Bros.--16mm: 1941, 134 mins., b/w, sound, R-MGM)
Gary Cooper gives a creditable but overrated Oscar-winning performance as the ex-Tennessee pacifist who single-handedly captured more than a hundred Germans. Howard Hawks does his best directing in the first thirty minutes, before he gets to moralizing about supermen.[401] A well-deserved Oscar went to film editor William Holmes.

WILSON (Fox--16mm: 1944, 120 mins., color, sound, R-FNC, TWY)
Henry King's treatment of President Woodrow Wilson (Alexander Knox) begins with the Princeton professor's entry into politics and stays with him until the disastrous defeat of his plan to have his country participate in the League of Nations, which he helped found. At the time the movie was made, it served to show a parallel

[400] For a listing of ten good tapes about war, see John Powers, "Bringing the War Home," AMERICAN FILM 10:4 (January-February 1985):62-6. Also useful is Jeanine Basinger, "Living-Room War: VCR-Day--World War II Combat Films on Tape," AMERICAN FILM 10:10 (September 1985):63-6.

[401] The most useful information is available in George Carpozi, Jr., THE GARY COOPER STORY (New Rochelle: Arlington House, 1970); *Homer Dickens, THE FILMS OF GARY COOPER (New York: Citadel Press, 1970); and Robin Wood, HOWARD HAWKS (New York: Doubleday, 1968). See also John Henley, "Program Notes: SERGEANT YORK," CINEMATEXAS PROGRAM NOTES 14:2 (February 27, 1978):15-22. The screenplay, written by Abem Finkel, Harry Chandlee, John Huston, and Howard Koch, is available at the Wisconsin Center for Theater Research.

between Wilson's failure and Roosevelt's attempts to help form the United Nations.[402] Nominated for ten Oscars, including Best Picture, Best Actor (Knox), Best Director, Best Screenplay (Lamar Trotti), Best Scoring of a Dramatic or Comedy Picture (Alfred Newman), and Best Special Effects (Photographic: Fred Sersen; Sound: Roger Heman), it won the award for Best Color Cinematography (Leon Shamroy), Best Interior Decoration (Wiard Ihnen and Thomas Little), Best Sound Recording (E. H. Hansen), and Best Film Editing (Barbara McLean).

GERMAN

THE DESERT FOX (Fox--16mm: 1951, 91 mins., b/w, sound, R-FNC)
 Director Henry Hathaway's romanticized account of Field Marshal Rommel weaves various military scenes and episodes of his domestic life together in an attempt to create sympathy for individual German officers who considered themselves apart and aloof from the Nazi war machine. In spite of James Mason's strong performance, the film itself is stiff and Nunnally Johnson's screenplay is distasteful.[403]

I AIM AT THE STARS (Columbia--16mm: 1960, 107 mins., b/w, sound, R-FNC, NFS, WEL)
 Probably the most sympathetic treatment of Wernher von Braun's life up to the Korean War, director J. Lee Thompson's pseudodocumentary film tries to pacify critics of the scientist's war work for Hitler by suggesting that he had no other choice. Jay Dratler's screenplay even makes a vulgar attempt at praising Americans for having gotten better Nazi scientists than those who fled to Russia.

FICTION FILMS ON THE MILITARY BRANCHES

ARMY

APOCALYPSE NOW (United Artists--16mm: 1979, 153 mins., color, sound, R-FES, MGM; Anamorphic version, R-MGM)
 Taking a script by John Milius based loosely on Joseph Conrad's HEART OF DARKNESS, director Francis Ford Coppola used the Vietnam War as the basis for an epic film about war, American society, and our traditional values. Almost every convention from the past is shown in reverse: the wisdom of field commanders, the

[402] For more useful information see James Agee, "Wilson," AGEE ON FILM: Vol. 1-REVIEWS AND COMMENTS (New York: McDowell, Obolensky, 1958), pp.110-3; Thomas J. Nock, "History with Lightning: The Forgotten Film WILSON," AMERICAN QUARTERLY 28 (1976):525-34; Leonard J. Leff and Jerold Simmons, "WILSON: Hollywood Propaganda for World Peace," HISTORICAL JOURNAL OF FILM, RADIO, AND TELEVISION 3 (1983):3-18; and Alexander Knox, "On Playing Wilson," HOLLYWOOD QUARTERLY 1:1(October 1945):110-1. The script of WILSON is available in BEST FILM PLAYS 1943-1944, ed. John Gassner and Dudley Nichols (New York: Crown, 1944).

[403] For a recent overview of Hathaway's career, see Jean-Louis Ginibre and Tony Peyser, "Power Yesterday: A Conversation With Henry Hathaway," THE HOLLYWOOD REPORTER 54th ANNIVERSARY ISSUE 284:42 (1984):22-4, 26, 28, 32.

commitment to protecting the nation and its principles, the solidarity of the combat unit, only WASPs reaching positions of authority, and the protagonist as a clean-cut, honest hero. Excellent performances are turned in by Martin Sheen and Robert Duvall. Oscars went to the film for its sound (Walter Murch, Mark Berger, Richard Beggs, and Nat Boxer), and cinematography (Vittorio Storaro).[404] Nevertheless, the film has been severely criticized for its racist imagery.

THE BIG PARADE (MGM--16mm: 1925, 125 mins., b/w, music and sound effects only, R-MGM)
 King Vidor's classic World War I film is told from the perspective of the infantrymen. John Gilbert, Tom O'Brien, and Karl Dane play three soldiers who serve in France and find tragedy, camaraderie, and romance. Laurence Stallings wrote the screenplay based upon his own experiences as a doughboy. The film is often credited with turning MGM into a major studio and establishing Gilbert as a star. The scenes depicting the troop convoy heading for the front and the men going into combat are exceptional.[405]

THE DEER HUNTER (Universal--16mm: 1978, 183 mins., color, sound, R-FES, SWA)
 The most controversial film about the Vietnam War has been attacked for its alleged racism and historical inaccuracies,[406] while being praised by others as a masterpiece. In many ways the story about three friends (Robert De Niro, John Savage, Christopher Walken) from the Pennsylvania steel town of Clairton who fight in the Vietnam War bears a strong relationship to James Fenimore Cooper's THE DEERSLAYER.[407] Of special interest is the manner in which director Michael Cimino and co-screenwriter Derec Washburn rework the genre's fascination with men in combat and male camaraderie.[408] An important issue to discuss is whether the final scene of the film, where the group sings "God Bless America," is a cop-out or a fine metaphor for American values. In 1978 Oscars went to the film for Best Picture,

[404] Brooks Riley, "Heart Transplant," FILM COMMENT 15:5 (September-October 1979):26-7; Marsha Kinder, "The Power of Adaptation in APOCALYPSE NOW," FILM QUARTERLY 33:2 (Winter 1978-79):12-20; Diane Jacobs, "Coppola Films Conrad in Vietnam," *THE ENGLISH NOVEL AND THE MOVIES, ed. Michael Klein and Gillian Parker (New York: Frederick Ungar Publishing, 1981), pp.211-7; Charles Higham, "Coppola's Vietnam Movie Is a Battle Royal," NEW YORK TIMES D (May 18, 1977):13, 25; and *Eleanor Coppola, NOTES (New York: Simon and Schuster, 1979).

[405] Roi A. Uselton, "Renee Adoree," FILMS IN REVIEW 19:6 (June-July 1968):345-57; Joel Greenberg, "War, Wheat and Steel: King Vidor Interviewed," SIGHT AND SOUND 37:4 (Autumn 1968):192-97; and Charles Higham, "King Vidor," FILM HERITAGE 1:4 (Summer 1966):14-25.

[406] Aljean Harmetz, "Oscar-Winning DEER HUNTER Is under Attack as 'Racist' Film," NEW YORK TIMES C (April 26, 1979):15; John Pilger, "The Gook-Hunter," NEW YORK TIMES A (April 26, 1979):23; and "Film Mailbag: On THE DEER HUNTER," NEW YORK TIMES D (March 25, 1979):6.

[407] David Axeen, "Eastern Western," FILM QUARTERLY 32:4 (Summer 1979):17-8; Colin Westerbeck, "Peace with Honor: Cowboys and Viet Cong," COMMONWEAL 106:4 (March 2, 1979):115-7; and John Hellmann, pp.418-29.

[408] *Robin Wood, HOLLYWOOD FROM VIETNAM TO REAGAN (New York: Columbia University Press, 1986), pp.270-97; Andrew Britton, "Sideshows: Hollywood in Vietnam," MOVIE 27/28 (Winter-Spring 1980/1):2-23; and Leticia Kent, "Ready for Vietnam? A Talk with Michael Cimino," NEW YORK TIMES D (December 10, 1978):15, 23.

Best Supporting Actor (Walken), Best Director, Best Film Editing (Peter Zinner), and Best Sound (Richard Portman, William McCaughey, Aaron Rochin, and Darin Knight).

FROM HERE TO ETERNITY (Columbia--16mm: 1953, 118 mins., b/w, sound, R-BUD, CHA, FNC, IVY, KIT, MOD, NFS, ROA, TWY, VCI, WEL, WHO, WIL)
 Fred Zinnemann directs this well-made version of novelist James Jones's cynical account of Army life at the Schofield Barracks, Honolulu, in the days just before the attack on Pearl Harbor. In addition to Daniel Taradash's forceful screenplay, there are commendable performances by Frank Sinatra (Oscar for the year's Best Supporting Actor), Montgomery Clift, Burt Lancaster, and Donna Reed.[409] The film also won Oscars for Best Picture, Best Supporting Actress (Reed), Best Directing, Best Screenplay, Best Cinematography (Burnett Guffy), Best Sound Recording (John P. Livadary), and Best Film Editing (William Lyon).

PLATOON (Orion--16mm: 1986, 113 mins., color, sound, R-SWA)
 Written and directed by Oliver Stone, this Oscar-winning film stars Charlie Sheen as a young man who loses his innocence in an infantry outfit presided over by a fanatical sergeant (Tom Berenger) who will stop at nothing to win the war. Much of the interest focuses on the symbolic struggle between the evil sergeant (Berenger) and his saintly counterpart (Willem Dafoe) as they battle to survive in a savage environment. In addition to an outstanding depiction of combat violence, the film is a fine illustration of personal crises in war.[410] Oscar nominations for Best Supporting Actor went to Berenger and Dafoe (they lost to Michael Caine in HANNAH AND HER SISTERS), to Stone for Best Director and Screenwriter (he won for direction; lost to Woody Allen for HANNAH AND HER SISTERS), to Claire Simpson for Best Film Editing (she won), and to John Grenzbach and Simon Kaye for Best Sound (they won).

THE VICTORS (Columbia--16mm: 1963, 147 mins., b/w, sound, R-BUD, CHA FNC, MOD, TWY, KIT; anamorphic version, R-KIT)
 Carl Foreman produced, wrote, and directed this uneven and sweeping picaresque journey of a squad of American infantrymen marching through Europe in

[409] For some good background information read Bob Thomas, KING COHN: THE LIFE AND TIMES OF HARRY COHN (New York: G. P. Putnam's Son, 1967). Also helpful is Daniel Taradash, "Into Another World," FILMS AND FILMING 5:8 (May 1969):9, 33; and *Brandon French, ON THE VERGE OF REVOLT: WOMEN IN AMERICAN FILMS OF THE FIFTIES (New York: Frederick Ungar Publishing Company, 1978), pp.48-60.

[410] David Halberstam, "Two Who Were There View PLATOON: The Correspondent," NEW YORK TIMES II (March 6, 1987):21, 38; Bernard E. Trainor, "Two Who Were There View PLATOON: The Marine Officer," ibid., pp.21, 38; Richard A. Sorgen, "The Morality of PLATOON," ibid., II (April 12, 1987):13; Aljean Harmetz, "Unwanted PLATOON Finds Success as U.S. Examines the Vietnam War," ibid., C (February 9, 1987):13; Louise Tanner, "Oliver Stone," FILMS IN REVIEW 38:3 (March 1987):153-5; J. Hoberman, "At War With Ourselves," VILLAGE VOICE (December 23, 1986):79, 82; and Pat McGilligan, "Point Man: Oliver Stone Interviewed," FILM COMMENT 23:1 (February 1987):11-4, 16-20, 60.

World War II. Surprisingly good performances by George Peppard and George Hamilton.[411]

A WALK IN THE SUN (Fox--16mm: 1945, 117 mins., b/w, sound, R-BUD, EMG, FES, FNC, IMA, KIT, NFS, ROA, VCI, WHO; Super 8 Sound-S-KIT)
 Director Lewis Milestone, using Robert Rossen's well-written, well-conceived script, creates a semirealistic film about a Texas platoon in an infantry division in Italy. One of Richard Conte's better roles. Interestingly, this quintessential portrait of the World War II infantry squad was ignored at Oscar time in favor of THE STORY OF G. I. JOE.

THE YOUNG LIONS (Fox--16mm: 1958, 167 mins., b/w, cinemascope, sound, R-FNC)
 Based upon Irwin Shaw's best selling novel about people in war, director Edward Dmytryk and screenwriter Edward Anhalt present on an epic scale the story of three men: an uncommitted socialite (Dean Martin), an ill-fated Jew (Montgomery Clift), a misguided Nazi (Marlon Brando). Although the screenplay is flabby, Clift gives a strong performance as a Jew caught in an anti-Semitic platoon.[412]

NAVY

DESTINATION TOKYO (Warner Bros.--16mm: 1944, 135 mins., b/w, sound, R-MGM)
 Delmer Daves co-authored the screenplay with Albert Maltz and directed this restrained but propagandist adventure yarn about a submarine mission into Tokyo Harbor to blow up ships and cargo. Strong performances by Cary Grant and John Garfield.

TASK FORCE (Warner Bros.--16mm: 1949, 117 mins., b/w, sound, R-MGM)
 Again Daves directs and writes, only this sea yarn about the birth of naval aircraft is too spread out and unevenly edited. There are, however, some good newsreel shots and fine examples of mixing actual footage with a fictional narrative starring Gary Cooper and Jane Wyatt.

THEY WERE EXPENDABLE (MGM--16mm: 1945, 136 mins., b/w, sound, R-MGM)
 Director John Ford, working with Frank Wead's screenplay, fashioned this memorable film as a tribute to the PT boats in action in the Pacific. Lots of blood and thunder, typical of war films in general, but with respectable acting from John Wayne and Robert Montgomery. Oscar nominations deservedly went to Douglas Shearer (Best Sound Recording) and to Donald Jahraus, R. A. MacDonald, and Michael Steinore (Best Special Effects).

[411] Carl Foreman, "The Road to THE VICTORS," FILMS AND FILMING 9:12 (September 1963):11-2.

[412] Romano Tozzi, "Edward Dmytryk," FILMS IN REVIEW 13:2 February 1962):86-101.

AIR FORCE

AIR FORCE (Warners--16mm: 1943, 124 mins., b/w, sound, R-MGM)
Using a script by Dudley Nichols (and dialogue by William Faulkner), Howard Hawks directed this classic World War II film about the adventures of a Flying Fortress crew at the outbreak of hostilities in the Pacific. It is a textbook production for studying not only the relationship between Hollywood and the military, but also the conventions of aviation war films during the forties and fifties.

COMMAND DECISION (MGM--16mm: 1948, 111 mins., b/w, sound, R-MGM)
Director Sam Wood does a good job of adapting this hit Broadway play about the psychological pressures on the military chiefs who decide how many lives they are willing to sacrifice to achieve their objectives. The George Froeschel-William R. Laidlaw screenplay does a good job of showing the day-to-day pressures of planning strategic bombing missions. The overlooked and unappreciated film has an all-star cast, headed by Clark Gable, Walter Pidgeon, Van Johnson, and Charles Bickford.

THIRTY SECONDS OVER TOKYO (MGM--16mm: 1944, 135 mins., b/w, sound, R-MGM)
The combination of Dalton Trumbo's screenplay and Mervyn LeRoy's direction make this film, based upon Captain Ted Lawson's diary, a patriotic interpretation of the first bombing mission over Tokyo.[413] At Oscar time, it was nominated for Best Black-and-White Cinematography (Robert Surtees and Harold Rossen), and won for Best Special Effects (A. Arnold Gillespie, Donald Jahraus, Warren Newcombe, and Douglas Shearer).

TWELVE O'CLOCK HIGH (Fox--16mm: 1949, 133 mins., b/w, sound, R-FNC)
Henry King directs what was to be the prototype of the popular 1960s television series in this drama of a general's torment as he sends his men on dangerous missions. In adapting their novel to the screen, Sy Bartlett and Beirne Lay, Jr., stressed the dangers a commanding officer faces when he identifies too strongly with his men. Nominated for four Oscars, including Best Picture and Best Actor (Gregory Peck), it won for Best Supporting Actor (Dean Jagger) and Best Sound Recording (20th Century Sound department).

WINGS (Paramount--16mm: 1927, 130 mins., b/w, music, sound effects only, R-FNC; silent 16mm version, R-FNC)
Directed by William Wellman, this classic film, scripted by Hope Loring and Louis D. Lighton, focuses on two American fliers (Charles "Buddy" Rogers and Richard Arlen) who battle the Germans in World War I for glory and each other for the love of Clara Bow. It is most noted for the expertly created flying stunts,[414] for winning Hollywood's first Oscar for best film, and for a brief but memorable scene by the then-unknown Gary Cooper as a doomed pilot.

[413] The script is available in BEST FILM PLAYS, 1943-44, eds. John Gassner and Dudley Nichols (New York: Crown, 1945).

[414] Rudy Behlmer, "World War I Aviation Film," FILMS IN REVIEW 18:7 (August-September 1967):413-33.

THE MILITARY IN FOREIGN COUNTRIES

ALL QUIET ON THE WESTERN FRONT (Universal--16mm: 1930, 103 mins., b/w, sound, R-FES, SWA)

This Lewis Milestone masterpiece is based upon Erich Maria Remarque's great novel about young Germans who learn that dying for the Fatherland in 1918 is without glory or honor. Scripted by Maxwell Anderson, Del Andrews, George Abbott, and Milestone, the pacifist film magnificently illustrates how the causes of war are ignored in the midst of patriotic fervor and serves as a brilliant example of the torment suffered by a nation at war. Lew Ayres gives a moving portrayal of Paul Bauner, the disillusioned patriot. One caution: only poor prints are available.[415]

THE BALLAD OF A SOLDIER/BALLADA O SOLDATE (Russia--16mm. 1960, 89 mins., b/w, English subtitles, sound, R-BUD, COR, EMG, FES, FNC, IMA, KPF/S-REE, TIF/L-COR; video:R-TIF)

Director Grigori Chukrai composes a series of impressive images of a soldier on leave who falls in love on the way home to see his mother. Particularly impressive is the photography of Vladimir Nikolayev and Era Savaleva.[416]

THE BURMESE HARP/THE HARP OF BURMA/BIRUMA NO TATEGOTO (Japan--16mm: 1956, 116 mins., b/w, subtitles, sound, R-BUD, FNC)

Director Kon Ichikawa presents a long, terrifying epic of a Japanese soldier in the Burmese campaign of 1943-44 and the responsibility this one man felt after the war to bury the dead as expiation for his sins. An outstanding performance by Shoji Yasui.

THE CRUEL SEA (Britain--16mm: 1953, 121 mins., b/w, sound, R-BUD, KIT, TWY)

Director Charles Frend puts together this graphic adventure of the officers and men of the COMPASS ROSE, whose job it was to hunt down Japanese submarines in World War II.

IN WHICH WE SERVE (Britain--16mm: 1942, 114 mins., b/w, sound, R-BUD, IMA, KIT, TWY)

Noel Coward produced, wrote, directed, and starred in this impressive account of people, adrift on a life raft, who recall their past experiences. David Lean codirected.

KING AND COUNTRY (Britain--16mm: 1964, 86 mins., b/w, sound, R-FNC, IVY)

Joseph Losey does a remarkable job of bringing John Wilson's stage play to the screen. Tom Courtenay plays the sensitive and simple soldier who decided to walk away from war and now faces a court-martial. Dirk Bogarde is the arrogant and pitiful officer who refuses to face the horror of his own military organization. A brutal visual

[415] For a good analysis of this film see John Cutts, "Classics Revisited: ALL QUIET ON THE WESTERN FRONT," FILMS AND FILMING 9:7 (April 1963):55-8. Also useful is Jack Spears, "Louis Wolheim," FILMS IN REVIEW 23:3 (March 1972):158-77.

[416] There is a script extract from the film available in FILMS AND FILMING 7:10 (July 1961):22-3; 38-9; 41.

picture of World War I in the English trenches, it illustrates the obfuscation of class differences in the war films shot during World War II.[417]

PATHS OF GLORY (United Artists--16mm: 1957, 87 mins., b/w, sound, R-FES, MGM)
 This is one of Stanley Kubrick's most outstanding films and remains one of the greatest anti-war films ever made. Using a brilliant script, written by Calder Willingham and Jim Thompson and adapted from Humphrey Cobb's novel, Kubrick presents the cynical account of a World War I French Army Division being exploited by its officers. Adolphe Menjou portrays the vicious general, while Kirk Douglas turns in a splendid performance as the outraged officer who sees the injustice of certain military procedures.

THE ADVENTURE WAR FILM

CASABLANCA (Warner Bros.--16mm: 1942, 102 mins., b/w, sound, R-FES, MGM)
 Director Michael Curtiz presents a good example of how Hollywood takes the usual adventure yarn,[418] with its emphasis on dramatic scenes filled with the unexpected, and often set in exotic places, and adapts these conventions to Vichy-France-ruled North Africa. The all-star cast consists of Humphrey Bogart, Ingrid Bergman, Claude Rains, Sydney Greenstreet, and Peter Lorre. In this film Dooley Wilson plays the memorable song, "As Time Goes By."[419] Oscars that year went to the picture, director, and screenwriters (Julius J. Epstein, Philip G. Epstein, and Howard Koch). It's worth a chuckle to check who beat out Bogart, Bergman, and Rains.

SPY WAR FILMS

FIVE FINGERS (Fox--16mm: 1952, 108 mins., b/w, sound, R-FNC)
 Director Joseph L. Mankiewicz gives this conventional tale of espionage some superb moments of suspense, and James Mason is splendid as "Cicero," World War II's famous German spy who operated as a valet to the British emissary in Turkey. Nominated for two Oscars, Best Director and Best Screenplay (Michael Wilson), the overlooked film still is an engrossing experience.

[417] See James Leahy, THE CINEMA OF JOSEPH LOSEY (New York: A. S. Barnes and Company, 1967); and Tom Milne, LOSEY ON LOSEY (New York: Doubleday, 1968). Also Gilles Jacob, "Joseph Losey, or the Camera Calls," SIGHT AND SOUND 35:2 (Spring 1966):62-7.

[418] Gordon Gow, "Thrill a Minute: Adventure Movies of the 60's," FILMS AND FILMING 13:4 (January 1967):4-11.

[419] There is an excellent selection of articles on CASABLANCA in *Joseph McBride, ed., PERSISTENCE OF VISION: A COLLECTION OF FILM CRITICISM (Madison: The Wisconsin Film Society Press, 1968), pp.93-110. See also Jack Edmund Nolan, "Michael Curtiz," FILMS IN REVIEW 21:9 (November 1970):525-48; and Leonid Kinskey, "CASABLANCA: It Lingers Deliciously in Memory 'As Time Goes By,'" MOVIE DIGEST 1:5 (September 1972):118-33.

HOUSE ON 92ND STREET (Fox--16mm: 1945, 89 mins., b/w, sound, R-FNC)
Henry Hathaway gets the credit for this semidocumentary account of how the FBI broke up a Nazi spy ring operating in New York. Particularly interesting is some wartime footage made and used by the Federal Bureau of Investigation. Charles G. Booth's script synthesized the conventions of the World War II spy film and in the process won the Oscar for Best Screenplay (Original Writing). At the time, no recognition was given to the screenplay's co-authors, Barre Lyndon and John Monks, Jr.

THE MALTESE FALCON (Warner Bros.--16mm: 1941, 100 mins., b/w, sound, R-FES, MGM)
John Huston's classic "private eye" film about Dashiell Hammett's Sam Spade is an excellent illustration of how the gangster film slowly was transformed during the Second World War. As Stuart M. Kaminsky points out, the third movie version in its first wartime appearance "presented situations that Huston would return to again and again. Spade is the obsessed professional, a proud man who will adhere to principle until death. Women are a threat, temptations that can only sway the hero from his professional commitment."[420] This version also helped lead the way into FILM NOIR and starred such stalwarts as Humphrey Bogart, Peter Lorre, and Elisha Cook, Jr. Moreover, it introduced Sidney Greenstreet and provided Mary Astor with her best performance.[421]

THE MAN WHO NEVER WAS (Fox--16mm: 1956, 104 mins., cinemascope, color, sound, R-FNC)
This English spy film, directed by Ronald Neame and scripted by Nigel Balchin (from a book by Julian Symonds), is an engrossing story about a clever device by British Intelligence to keep the Germans from finding out about the Normandy Invasion. A fine performance by Clifton Webb.

THE THIRTY-NINE STEPS (Britain--16mm: 1935, 80 mins., b/w, sound, R-BUD, EMG, FES, FNC, IMA, IVY, JAN, KIT, ROA, VCI, WEL, WHO/S-KIT, REE, TIF; video:R-IVY, TFF/S-IVY)
Hitchcock's classic spy film, starring Robert Donat and Madeleine Carroll, melodramatically presents an innocent young man trying to catch German spies before they or the police put an end to him. Avoid the remake of 1960.

[420] Stuart M. Kaminsky, "THE MALTESE FALCON," THE INTERNATIONAL DICTIONARY OF FILMS AND FILMMAKERS: VOLUME 1--FILMS, eds. Christopher Lyon and Susan Doll (Chicago: St. James Press, 1984), p. 276

[421] Peter B. Flint, "Mary Astor, 81, Is Dead+ Star of MALTESE FALCON," NEW YORK TIMES (September 26, 1987):34. For a helpful analysis read Eugene Archer, "The Hemingway Tradition in American Film," FILM CULTURE 19 (1959):66-101; ___, ""Taking Life Seriously: A Monograph on John Huston, Part 1--A Touch of Hemingway," FILMS AND FILMING 5:12 (September 1959):13-4, 28, 33; ___, "Small People in a Big World: A Monograph on John Huston, Part 2--A Touch of Melville," ibid., 6:1 (October 1959):9-10, 25, 34; Allen Eyles, "Great Films of the Century: THE MALTESE FALCON," ibid., 11:2 (November 1964):45-50; Gordon Gow, "Pursuit of the Falcon," ibid., 20:6 (March 1974):56-8; Penelope Houston, "The Private Eye," SIGHT AND SOUND 26:1 (Summer 1956):22-4, 55; John Russell Taylor, "John Huston and the Figure in the Carpet," ibid., 38:2 (Spring 1969):70-3; and James Naremore, "John Huston and THE MALTESE FALCON," LITERATURE/FILM QUARTERLY 1:3 (Summer 1973):239-49.

THE PRISONER-OF-WAR FILM

THE BRIDGE ON THE RIVER KWAI (Columbia--16mm: 1957, 161 mins., color, sound, R-BUD, COR, FES, FNC, IMA, IVY, KIT, ROA, SWA, TWY, VCI, WEL, WHO, WIL; anamorphic version R-COR, IMA, KIT, TWY)
 David Lean's highly acclaimed and controversial movie concerns a warped, resolute British colonel (Alec Guinness) who defies the Japanese prison commander (Sessue Hayakawa), and uses the construction of a bridge as a method of restoring his men's morale. William Holden plays an American officer who escapes, only to return with commandos to destroy the bridge.[422] Oscars that year went to the picture, actor (Guinness), director, screenplay (politically awarded to Pierre Boulle), cinematography (Jack Hildyard), film editing (Peter Taylor), and musical scoring (Malcolm Arnold).

THE GREAT ESCAPE (United Artists--16mm: 1963, 172 mins, color, sound, R-MGM)
 Director John Sturges took charge of this epic-like adventure of a mass escape by hundreds of prisoners held inside Germany during World War II and what happened to them. The W. R. Burnett-James Clavell screenplay synthesizes the conventions of the POW escape film in the sixties. Particularly good are James Garner, Richard Attenborough, and Steve McQueen.[423] Nominated for Best Editing, it lost the Oscar to HOW THE WEST WAS WON.

KING RAT (Columbia--16mm: 1965, 133 mins., b/w, sound, R-BUD, FNC, IVY, KIT, SWA, TWY, WHO)
 Bryan Forbes directed this underrated version of James Clavell's novel about life in Changi, a notorious Japanese prisoner-of-war camp that held over ten thousand soldiers. Strong performances by George Segal, Tom Courtenay, James Fox, and James Donald.

STALAG 17 (Paramount--16mm: 1953, 120 mins., b/w, sound, R-FNC, WHO)
 Billy Wilder wrote the screenplay and directed this bitter-comic film adapted from the Broadway hit about life in a POW camp. Although attacked in some circles as a tasteless satire minimizing Nazi treatment of American prisoners, the farcical story does a good job of humanizing the problems of men cutoff from the world. Oscar-winning William Holden is outstanding as Sefton, the wheeler-dealer who most of the men suspect is a traitor. Nominated for Oscars were Robert Strauss (Best Supporting Actor) and Wilder (Best Director). This movie set the pattern for the popular TV series HOGAN'S HEROES.

[422] There is an interesting article by Sessue Hayakawa, who plays the Japanese commandant, discussing his feelings about the film. See Sessue Hayakawa, "Nazis and Japs," FILMS AND FILMING 8:5 (February 1962):21, 45; and Gordon Gow, "Potential: The Mirisch Brothers," FILMS AND FILMING 18:6 (March 1972):41-4.

[423] Michael Ratcliffe, "The Public Image and the Private Eye of Richard Attenborough," FILMS AND FILMING 9:11 (August 1963):15-7.

SOCIALLY CONSCIOUS WAR FILM

CROSSFIRE (RKO--16mm: 1947, 65 mins., b/w, sound, R-FNC; L-FNC)
 Director Edward Dmytryk developed this story, based upon a Richard Brooks novel THE BRICK FOXHOLE, about an anti-Semitic soldier who becomes a killer, into a strong, sensitive film filled with suspense. Although nominated for four Oscars, including Best Picture, Best Supporting Actor (Robert Ryan), Best Director, Best Screenplay (John Paxton), it was overshadowed by the more popular film on racism, GENTLEMAN'S AGREEMENT.

HOME OF THE BRAVE (United Artists--16mm: 1949, 88 mins., b/w, sound, R-BUD, CHA, FNC, IVY, KIT, VCI, WHO, WIL)
 Director Mark Robson, screenwriter Carl Foreman, and producer Stanley Kramer combined talents to adopt Arthur Laurents's successful Broadway play about anti-Semitism and to change it into the story of a black man (James Edwards) suffering from his prejudices about his white comrade (Lloyd Bridges).[424]

SAHARA (Warners--16mm: 1943, 97 mins., b/w, sound, R-BUD, FNC, IMA, KIT, MOD, TWYWES, WEL, WHO)
 Director Zoltan Korda, working with a script he co-authored with Sidney Buchman and John Howard Lawson, fashioned this adventure story of members of a racially troubled American tank crew who wander, lost, through the desert and eventually take on an entire German division--and win. Bogart and Rex Ingram give the movie some good moments.[425]

REHABILITATION

THE BEST YEARS OF OUR LIVES (Goldwyn--16mm: 1946, 170 mins., b/w, sound, R-FNC, IVY, MAC; L-MAC)
 Acting, directing, screenwriting, and photography all meshed effectively to make this the best example of the problems of returning WWII-veterans as they try to readjust to civilian life.[426] William Wyler directed; Robert E. Sherwood did the script; Greg Toland handled the camera; and Fredric March, Myrna Loy, Dana Andrews, and Teresa Wright excelled.[427] Among the Oscars won that year were for the Best Picture, Best Actor (March), Best Supporting Actor (Harold Russell), Best Director, Best Screenplay, Best Film Editing (Daniel Mandell), and Best Scoring of a Dramatic Picture (Hugo Friedhofer).

[424] Herbert G. Luft, "Mark Robson," FILMS IN REVIEW 19:5 (May 1968):288-97.

[425] For more information, see Theodore Kornweibel, Jr., "Humphrey Bogart's SAHARA: Propaganda, Cinema and the American Character in World War II," HISTORICAL JOURNAL OF FILM, RADIO, AND TELEVISION 1 1981):117-37.

[426] For a good discussion of the rehabilitation films, see Frank Fearing, "Warriors Return: Normal or Neurotic?" HOLLYWOOD QUARTERLY 1:1 (October 1945):97-109; Roy E. Grinker and John P. Spiegel, "The Returning Soldier: A Dissent," ibid.,1:3 (April 1946):321-6; and Frank Fearing, "A Reply," ibid., pp.326-8.

[427] See Abraham Polonsky, "The Best Years of Our Lives: A Review," HOLLYWOOD QUARTERLY 2:3 (April 1947):257-60; and French, pp.xviii-xxi.

COMING HOME (United Artists--16mm: 1978, 127 mins., color, sound, R-MGM)
 Directed by Hal Ashby and filled with music from the Beatles and the Rolling Stones, this was the first major attempt by the American film industry to examine the issues of returning Vietnam veterans. It took almost a decade for Nancy Dowd's original script, titled "Buffalo Ghost," to make it to the screen (rewritten in large measure by Waldo Salt and Robert C. Jones), but thanks to the memorable performances of Jon Voight and Jane Fonda, the sense of emotional crises stemming from the war received worldwide attention. Nominated for seven Oscars, including Best Picture, Best Supporting Actor (Bruce Dern), Best Director, and Best Film Editing (Don Zimmerman), it won for Best Actor (Voight), Best Actress (Fonda), and Best Screenplay Written Directly for the Screen (Down, Salt, and Jones). Today, the trite love affair between an Army wife and paraplegic victim overshadows the impact the film had when it premiered.[428]

THE MEN (United Artists--16mm: 1950, 85 mins., b/w, sound, R-BUD, CHA, ICS, IVY, KIT, TWY, WEL, WIL)
 Producer Stanley Kramer, director Fred Zinnemann, and screenwriter Carl Foreman combined talents to create this poignant and penetrating film about the adjustment of paralyzed war veterans to civilian life. Teresa Wright and Jack Webb gave good support to Marlon Brando in his first film. Foreman's Oscar-nominated story and screenplay lost out that year to the authors of SUNSET BOULEVARD.

THE CIVILIAN WAR FILM

BLOCKADE (United Artists--16mm: 1936, 84 mins., b/w, sound, R-BUD, FNC, KIT, VCI)
 Directed by William Dieterle, the John Howard Lawson screenplay shows the effect of the Spanish Civil War on people forced to side with either the Republicans or the Nationalists. More important than the story itself is the controversy generated over the picture's favoring the Republican position at a time when most vocal Americans wanted to maintain an isolationist position.[429] Particularly interesting are the problems Dieterle and Lawson have in trying to reconcile their attacking totalitarianism while endorsing methods similar to those they despise.

THE BOAT IS FULL/DAS BOOT IST VOLL (German--16mm: 1980, 100 mins., color, sound, R-FNC)
 Written and directed brilliantly by Markus Imhoof, this poignant film recounts what happened in 1942 to Jewish-German refugees seeking sanctuary in Switzerland. The Swiss bureaucracy had decided the nation needed new regulations to protect itself against too large an influx of immigration. With stark simplicity Imhoff shows how "racial grounds" no longer were considered sufficient reasons to harbor terrified

[428] Jack Kroll, "Vietnam Hero Worship," NEWSWEEK 91:8 (February 20, 1978):89-90; and Kirk Honeycutt, "The Five-Year Struggle to Make COMING HOME," NEW YORK TIMES C (February 19, 1978):13, 15.

[429] John Howard Lawson, "Comments on Blacklisting and BLOCKADE," FILM CULTURE 50/51 (Fall/Winter 1970):28-9; and Valleau, pp.20-9.

Jews, and the difficult choices the Swiss people had to make between breaking the law and yielding to feelings of human compassion.[430]

FORBIDDEN GAMES/LES JEUX INTERDITS (France--16mm: 1952, 90 mins., b/w, English subtitles, sound, R-FES, FNC)
 Rene Clement's sensitive and disturbing film about an orphaned girl befriended by a poor family during World War II. She and the youngest boy explore the problems of growing up, and there are many poignant scenes of innocence. The Francois Boyer-Jean Aurenche-Pierre Bost-Rene Clement screenplay then injects one of the most devastating of all conclusions. The film received an Honorary Oscar for the Best Foreign Film of the Year (the regular category was instituted in 1956).

JUDGMENT AT NUREMBERG (United Artists--16mm: 1961, 186 mins., b/w, sound, R-MGM)
 Director Stanley Kramer took Abby Mann's classic TV production of the same name and fashioned it into a memorable tableau of the Nazi war crimes trials in Nuremberg. The cast--Spencer Tracy, Burt Lancaster, Richard Widmark, Montgomery Clift, Judy Garland, and particularly Maximilian Schell--helped create one of the most important fiction films about World War II and its implications for our time. Schell won both the Oscar and the New York Film Critics' Award for the year's Best Actor; Mann won the the Oscar for Best Screenwriting; while WEST SIDE STORY beat the film out in the Academy Award races for Best Picture, Best Supporting Actor (Clift), Best Supporting Actress (Garland), Best Direction, and Best Film Editing (Frederic Knudtson).

LACOMBE, LUCIEN (France--16mm: 1974, 141 mins., sound, color, subtitles, R-FNC)
 Directed memorably by Louis Malle and starring Pierre Blaise as a seventeen-year-old hero, the title alludes to the hero's frequently replying to an official's request by giving his last name first. The plot concerns what happens to Lucien when, rejected by the Resistance in 1944, he becomes a Fascist collaborator. Like Ophuls's THE SORROW AND THE PITY/LE CHAGRIN ET LA PITIE, the film is one more attack on how some Frenchmen behaved during the days of Occupation.[431]

THE NIGHT OF THE SHOOTING STARS/LA NOTTE DI SAN LORENZO (Italy--16mm: 1983, 106 mins., color, English subtitles, sound, R-MGM/UA/S-TFF)
 Written and directed by Paolo and Vittorio Taviani, the story is filled with astonishing human insights and superb visual images. A middle-aged mother, trying to comfort her young child, tells through a flashback what happened forty years before when as a six year old she lived under German occupation. The compelling account of how a caravan of ordinary people tries to escape from the Nazis and locate the advancing liberating American armies can be seen as a political and religious metaphor. It can also be enjoyed on another level as a tale of people confronted with incredible dilemmas, soul-searching choices, and extraordinary human challenges.[432]

[430] Annette Insdorf, "A Swiss Film Bares Another Chapter of the Holocaust," NEW YORK TIMES D (October 18, 1981):1, 15.

[431] *Louis Malle and Patrick Modiano, LACOMBE, LUCIEN, trans. Sabine Destree (New York: The Viking Press, 1975).

[432] Vincent Canby, "NIGHT OF THE SHOOTING STARS from Italy," NEW YORK TIMES C (September 29, 1982):19; Arthur Knight, "Film Review: NIGHT OF THE SHOOTING

ROME, OPEN CITY/ROMA, CITTA APERTA (Italy--16mm: 1945, 103 mins., b/w, English subtitles, sound, R-FNC)
Roberto Rossellini's film about Italy's final days under German occupation is one of the most artistic films ever made about the lives of civilians at war. This prototype of neo-realistic movies, the screenplay by Sergio Amidei, Federico Fellini, and Rossellini centers on a priest (Aldo Fabrizi) who works with the underground in the final days of Nazi rule in Rome. Anna Magnani gives a brilliant performance as the woman who dies fighting to protect her husband.

MRS. MINIVER (MGM--16mm: 1942, 135 mins., b/w, sound, R-MGM)
William Wyler directed this propagandistic yet entertaining movie about the English populace and their lives during the Second World War. There is an especially moving scene portraying the evacuation from Dunkirk aided by a flotilla of private small craft.[433] Nominated for eleven Oscars, including Best Actor (Walter Pidgeon), Best Supporting Actor (Henry Travers), Best Sound Recording (Douglas Shearer), Best Film Editing (Harold F. Kress), and Best Special Effects (Photographic: A. Arnold Gillespie and Warren Newcombe; Sound: Douglas Shearer), it won for Best Picture, Best Director, Best Actress (Greer Garson), Best Supporting Actress (Teresa Wright), Best Screenplay (George Froeschel, James Hilton, Claudine West, and Arthur Wimperis), and Best Black-and-White Cinematography (Joseph Ruttenberg).

THE SHOP ON MAIN STREET/OBCHOD NA KORZE (Czechoslovakia--16mm: 1965, 128 mins., b/w, subtitles, sound, R-FNC)
Jan Kadar and Elmar Slos directed this memorable film that starts off as a comedy about a simple man who is made the "Aryan manager" of a Jewish button shop. Brtko (Josef Kroner) runs up against the old Jewish lady (Ida Kaminska) who not only doesn't understand what his title means, but also doesn't concern herself with making money. The two develop an unusual relationship that is put to the severest test when it is announced that all Jews are being deported. An unforgettable film with amazing performances by its stars. The film won the Oscar for Best Foreign Film.

TWO WOMEN (Italy--16mm: 1961, 105 mins., b/w, subtitles, sound, R-FNC)
Vittorio de Sica's story of a mother and daughter who try to stay alive in Italy toward the end of World War II. Sophia Loren is outstanding in her best (and only Oscar-winning) role.

COMEDY WAR FILM

KELLY'S HEROES (MGM--16mm: 1970, 145 mins., color, sound, R-MGM; anamorphic color: R-MGM)
Brian Hutton directed this tongue-in-cheek war movie about a discouraged platoon led by the smooth-talking Kelly (Clint Eastwood), who in the course of interrogating a captured German colonel discovers that a French bank in occupied territory close by contains a fortune in gold bars. So the resourceful Kelly convinces

STARS," HOLLYWOOD REPORTER 275:33 (February 15, 1983):3, 28; and Andrew Sarris, "THE NIGHT OF THE SHOOTING STARS," VILLAGE VOICE 28:6 (February 8, 1983):39.

[433] The film script is available in TWENTY BEST FILM PLAYS, eds. John Gassner and Dudley Nichols (New York: Crown, 1943), pp.192-332.

the tough sergeant Crapgame (Telly Savalas) to help Kelly and a far-out renegade tank commander (Donald Sutherland) to pull a "bank robbery" in the name of war and personal profit. All in all, the film is good, fast, and clever entertainment.

M*A*S*H (Fox--16mm: 1970, 116 mins., color, sound, R-FNC; video: S-BLA)
 In one of the wildest, most irreverent, and hysterically funny films about war, Hawkeye Pierce (Donald Sutherland), Duke Forrest (Tom Skerritt) and Trapper John McIntyre (Elliott Gould)[434] join up with the 4077th Mobile Army Surgical Hospital in Korea, and divide their time between operating in surgical crises and destroying any semblance of military discipline. The funniest scenes in the film, however, center around the virile males' attack on the moral and physical scruples of a new senior nurse (Sally Kellerman), soon known to all as "Hot Lips." While not completely an antiwar film, the movie goes a long way in showing the horrors of combat. Nominated for five Oscars, including Best Picture, Best Supporting Actress (Kellerman), Best Director (Robert Altman), and Best Film Editing (Danford B. Greene), it won for Best Screenplay Based on Material from Another Medium (Ring Lardner, Jr.)[435] It also inspired the brilliant TV series of the same name.

HISTORICAL WAR FILM

AN OCCURRENCE AT OWL CREEK BRIDGE (16mm: 1961, 29 mins., b/w, sound, R-CON)
 Robert Enrico directed this impressive adaptation of Ambrose Bierce's short story about a Confederate spy's hanging by a Union platoon. The movie is beautifully created and provides a terrifying comment on war.[436]

A TIME OUT OF WAR (16mm: 1954, 22 mins., b/w, sound, R-CON)
 Denis Sanders directed this Civil War film about a momentary truce between two Union soldiers and a Confederate who for one brief afternoon decide to lay down their arms and share their thoughts.

THE WAR IS OVER/LA GUERRE EST FINIE (France--16mm: 1966, 121 min., b/w, subtitles, sound, R-FNC; English language version, R-FNC)
 Alain Resnais directed this outstanding and emotionally taut Spanish Civil War story of Diego (Yves Montand), a doomed Spanish patriot who plays out his last days in contemporary Spain and France in a series of events involving love and politics. Although it tends to be prosaic in comparison with the French director's other films, Montand is first-rate as the ruthless old soldier fighting a losing battle.[437]

[434] Richard Warren Lewis, "Playboy Interview: Elliott Gould," PLAYBOY 17:11 (November 1970):77-94, 262, 264.

[435] John Cutts, "M*A*S*H, McCloud and McCabe: An Interview With Robert Altman," FILMS AND FILMING 18:1 (November 1971):40-4; and Kenneth Geist, "The Films of Ring Lardner Jr.," FILMS COMMENT 6:4 (Winter 1970-71):44-9.

[436] Paul A. Schreivogel, A VISUAL STUDY GUIDE (Dayton: George A. Pflaum, 1969); and David Sohn et al. "Perspectives on War," p.12.

[437] Michael Caen, "The Times Change," CAHIERS DU CINEMA IN ENGLISH 8:174 (January 1966):58-61; Andrew Sarris, "Ode to the Old Left," ibid., p.62; *LA GUERRE EST

As one examines the war films in all categories, one comes to the realization that the film in treatment and emphasis responds to the economic, political, historical, technological, and social pressures of its time. And because films are first and foremost products of a mass media industry, endings are often contrived, characters are stereotypes, and prevailing attitudes of the public are reinforced. Rarely do we have a film that represents an unpopular viewpoint or situation. Especially, during periods of great conflict, war itself is scarcely examined for its significance and its importance. This chapter may help illustrate not only the various types of categories films may fall into, but also how movies are more than mere entertainment.

OTHER STUDIES ON GENRES

AVIATION FILMS

*Orriss, Bruce W. WHEN HOLLYWOOD RULED THE SKIES: THE AVIATION FILM CLASSICS OF WORLD WAR II. Hawthorne: Aero Associates, 1984. Illustrated. 219pp.
 One of the most enduring and popular Hollywood genres, the aviation film is an area generally glossed over by most studies on film genres. This entertaining and heavily illustrated book provides a superficial look at the flying films of World War II, from the pre-war recruiting days to the patriotic movies of World War II itself, and the hard-hitting vehicles in the immediate postwar period, concluding with the more reflective films of the late 1950s to the present. The author's goal is to "study the radical changes in aim and purpose that these films have undergone in the past forty-two years . . . [and to] give special emphasis not only to the stories that these aviation films depicted but also the stories behind their making and the people that made them." Orriss divides his chronological study into four major sections, worthwhile mainly for their cast and production credits, illustrations, and plot summaries. Endnotes, a bibliography, and an index are included. Worth browsing.

Pendo, Stephen. AVIATION IN THE CINEMA. Metuchen: The Scarecrow Press, 1985. Illustrated. 402pp.
 A well-researched and in-depth examination, this chronological study "deals with feature motion pictures, made-for-television films, and television series that feature some aspect of aviation." The author's twelve enjoyable chapters function primarily as opportunities to comment in short paragraphs on hundreds of productions. The one major drawback is the absence of an annotated filmography to obtain cast and production credits. On the other hand, Pendo's extensive bibliography and endnotes open up numerous sources for future investigations. An index is included. Well worth browsing.

THE DETECTIVE FILM

*Everson, William K. THE DETECTIVE IN FILM. Secaucus: The Citadel Press, 1972. Illustrated. 247pp.
 The first comprehensive study of the detective genre suffers from weak organization and detailed information. Everson deserves credit, however, for establishing a framework in which to investigate films about Sherlock Holmes, Philo Vance, Charlie Chan, Bulldog Drummond, Sam Spade, Philip Marlowe, Ellery Queen,

FINIE: TEXT BY JORGE SEMPRUN FOR THE FILM BY ALAIN RESNAIS, trans. Richard Seaver. (New York: Grove Press, 1967).

Boston Blackie, Perry Mason, Nero Wolfe, and Miss Marple. His thirteen chapters raise fascinating questions about conventions, industry-related problems with the formula, and the quality of the many screen stars and directors who interpreted the famous detectives in entertaining films of questionable quality. A rich assortment of stills adds to the book's well intentioned pioneering effort and remains the publication's most important contribution to film scholarship. No bibliography or filmography accompanies the adequate index. Nevertheless, Everson's work has yet to be surpassed. Worth browsing.

Eyles, Allen. SHERLOCK HOLMES: A CENTENARY CELEBRATION. New York: Harper and Row, 1986. Illustrated. 144pp.

Reading this beautifully illustrated book one wonders if Arthur Conan Doyle ever realized that writing fictional stories about a detective would result in the idolatry found among his readers today. At the beginning, the fledging Scottish doctor needed something to do to pass the time until patients found their way to his Southsea door. Eyles, however, approaches the literary and mass media phenomenon of the masterly Baker Street sleuth with considerable admiration and respect. The enterprising author regales us with eleven chapters packed with stunning illustrations, anecdotes about the numerous performers who have impersonated Sherlock Holmes and his friends and enemies, and delightful bits of information about the evolution of the great detective from print to stage to screen. An appendix listing the sixty Holmes stories, a bibliography, and an index are included. Recommended for special collections.

Hanke, Ken. CHARLIE CHAN AT THE MOVIES: HISTORY, FILMOGRAPHY, AND CRITICISM. Jefferson: McFarland, 1989. Illustrated. 288pp.

Pohle, Robert W., and Douglas C. Hart. SHERLOCK HOLMES ON THE SCREEN. Cranbury: A. S. Barnes and Company, 1977. Illustrated. 260pp.

Covering almost three hundred films about the venerable detective and his friend Dr. Watson, this extensive filmography does a yeomanlike job in confronting the controversies surrounding the various productions, historical sources, and screen interpretations. Following a brief introduction, the authors discuss each film in chronological order, with its date and place of release, cast and credits, a short synopsis, critical commentary, selected film reviews, and a collection of well-chosen illustrations. Periodically, individual chapters are set aside for the most noted performers, directors, and technicians: e.g., Basil Rathbone, John Barrymore, Carlyle Blackwell, Francis Ford, William Gillette, Raymond Massey, Peter Cushing, Christopher Lee, and Douglas Wilmer. Serious students will find the analysis intelligent and entertaining. A good bibliography and index complement the well-done study. Recommended for special collections.

Tuska, Jon. THE DETECTIVE IN HOLLYWOOD. Garden City: Doubleday and Company, 1978. Illustrated. 436pp.

A valuable companion to Everson's earlier book on the subject, the analysis is much more extensive in its scope but not more substantive in its content. The author is interested in three different aspects of the genre: "the popular detectives and the authors who created them; how these detectives changed when they were brought to the screen; and the lives and personalities of those who played in the detective films, or adapted for the screen, or directed them." The result is a lively survey of the formula, brief sketches of significant personalities, interviews with surviving contributors, behind-the-scenes anecdotes, lucid plot summaries, and financial revelations about specific films. Edgar Allan Poe's 1841 short story, "The Murders in the Rue Morgue," is credited with inaugurating "detective fiction"; and Biograph's 1900 movie, SHERLOCK HOLMES BAFFLED, with being the first detective film. Before we get to the text's last film, THE LATE SHOW (1977), Tuska suprises us with his

emphasis on the unusual rather than on the mainstream events. For example, the lives of Myrna Loy and William Powell are given more attention than their screen roles as Nick and Nora Charles; an entire chapter is devoted to Raymond Chandler, but not to Samuel Dashiell Hammett; and Philo Vance gets more attention than Sherlock Holmes. Film buffs will enjoy the profuse illustrations and the chatty text, while serious students will find Tuska's observations on the metamorphosis of the screen detective from bedroom sleuth to armed crusader entertaining and stimulating. No bibliography or filmography is provided, but the index is extensive. Recommended for special collections.

THE EPIC FILM

*Elley, Derek. THE EPIC FILM: MYTH AND HISTORY. London: Routledge and Paul Kegan, 1984. Illustrated. 223pp.
 Thoughtfully conceived and effectively designed, this sympathetic analysis of the epic film continues the refreshing research conducted by the British series on film and society. It looks at the epic form as a modern day equivalent of ancient art forms and attempts to discover how modern commentators use their methods of mass entertainment to reflect the hopes, fears, and fantasies of contemporary society. The focus is on film as a historical document and as entertainment. Since the main exponents of the epic film are from Italy and the United States, the book's twelve chapters examine how these filmmakers reinterpret the legacy of the past to reflect present day values and concerns. Elley's training in classics enables him to draw many interesting parallels between the ancient literary works of Tacitus, Pliny, Herodotus, and THE BIBLE; and the film spectacles dealing with periods up to the end of the Dark Ages. Among the diverse group of filmmakers explored are Sergio Leone, Vittorio Cottafavi, Mario Bava, Sergio Corbucci, Pietro Francisi, William Wyler, Anthony Mann, Richard Fleischer, Franklin J. Schaffner, Howard Hawks, Cecil B. DeMille, and Samuel Bronston. The overriding theme found in their epic films, according to Elley, is that of "the message of personal and political freedom, more often than not expressed in the form of Christianity (or Zionism) triumphant--often, one feels, by special prerogative rather than any vote of confidence or popularity." The rare exceptions are to be found in the epic Greek and Roman film treatments, where the "message of liberty [has] been allowed to emerge untrammeled by religious paraphernalia."
 In addition to delightful and numerous illustrations, the book also contains an invaluable filmography, a sketchy bibliography, and a helpful index. Serious students and film buffs will find as much to enjoy in the intelligent text. Recommended for special collections.

Hirsch, Foster. THE HOLLYWOOD EPIC. South Brunswick: A. S. Barnes and Company, 1978. Illustrated. 129pp.
 The thesis of this worthwhile study is that the movie is an ideal medium for the epic form, because of "its broad movements through time and space, and its emphasis on action and external characterization." To prove his point, Hirsch describes how the film epic has been a movie staple from QUO VADIS? (1912) and CABIRIA (1914) to THE THREE MUSKETEERS (1974) and BARRY LYNDON (1975). The oversized book is divided into eight entertaining chapters, beginning with a historical overview before treating the moral, religious, national, international, historical, and other characteristics of the epic film. The most attention is paid to biblical epics like KING OF KINGS (1927), THE TEN COMMANDMENTS (1923 and 1956), THE FALL OF THE ROMAN EMPIRE (1964), and THE GREATEST STORY EVER TOLD (1965). While the individual comments rarely provide much detail about a specific film, the entire history offers a stimulating perspective on the much-maligned genre. Of particular value are

the refreshing number and quality of illustrations. A minimal bibliography and index are provided. Recommended for special collections.

*Munn, Mike. GREAT EPIC FILMS: THE STORIES BEHIND THE SCENES. New York: Frederick Ungar, 1983. Illustrated. 191pp.

Neither analytical nor critical, this lightweight text examines how more than fifty epic films from THE BIRTH OF A NATION (1915) to JESUS OF NAZARETH (1975) survived serious production problems before reaching mass audiences. The writing is crisp, entertaining, and stimulating. Accuracy is another matter. The author makes many assertions about controversial issues and never provides a footnote or bibliographical reference to support his claims. We are told, however, that he interviewed many stars and filmmakers, including Charlton Heston, Jesse Lasky, Jr., Carroll Baker, James Stewart, Tony Curtis, Kirk Douglas, J. Lee Thompson, Jean Simmons, Robert Powell, and Angela Lansbury. Thus when Stewart is quoted as saying director Henry Hathaway "was pretty much responsible for" HOW THE WEST WAS WON (1962), we don't even know if Munn is quoting him accurately. If that isn't a concern, the reader should find the many lovely visuals and fast-paced narrative a rewarding experience. More discerning readers will have difficulty with a book that contains no table of contents, bibliography, filmography, or index. Worth browsing.

Solomon, Jon. THE ANCIENT WORLD IN THE CINEMA. South Brunswick: A. S. Barnes and Company, 1978. Illustrated. 210pp.

Scholarly and entertaining, this important study combines insightful observations on over four hundred films along with significant illustrations to produce the best text yet published on the subject of the ancient epic art forms being translated to the screen. Solomon's academic background in Greek and classical languages and literature qualifies him to examine critically the cinematic adaptations of ancient and biblical texts. His enthusiasm for movies allows his discussion of historical accuracies in the cinematic treatment of ancient civilizations like Greece, Rome, Babylon, and Egypt to be lively, challenging, and enjoyable. No attempt is made to discuss each film in detail. Rather, the author identifies one or two prominent aspects of each film: e.g., the scenery in THE GREATEST STORY EVER TOLD (1965), the special effects in THE TEN COMMANDMENTS (1956), and the scandal that beset CLEOPATRA (1963). Solomon also makes no attempt to be definitive either in his classical analyses or film survey. Thus very few sources are provided for future study, and close to two dozen silent films are ignored. Particularly valuable are the author's chronological charts that appear in most of the book's nine chapters. The charts are divided into three areas: date, historical event, and film. For example, the period from 41-30 B. C., dealing with the relationship between Anthony and Cleopatra, has inspired so far eleven films--ANTHONY AND CLEOPATRA (1913), CLEOPATRA (1899, 1910, 1917, 1928, 1934, 1963), LEGIONS OF THE NILE (1959), MARCANTONIO E CLEOPATRA (1913), SERPENT OF THE NILE, and TWO NIGHTS WITH CLEOPATRA (both in 1953).

In addition to the useful captions and the fascinating bits of information, the book provides a strong argument that studios deserve more recognition than they have received from critics for the historical and archeological components of the films. An index is provided, but no filmographies or bibliography. Recommended for special collections.

THE GANGSTER FILM

Alloway, Lawrence. VIOLENT AMERICA: THE MOVIES 1946-1964. New York: The Museum of Modern Art, 1971. Illustrated. 95pp.

Focusing on more than just gangster films,[438] this general study of movies and popular culture takes a look at the way the medium contributes to society's taste for violence. The book is based on a film series entitled "The American Action Movie: 1946-1964," which was shown at the Museum of Modern Art from April 24 to June 6, 1969. Among the thirty-five films discussed are THE KILLERS (1946 and 1964 versions), THE LADY FROM SHANGHAI (1948), KISS ME DEADLY (1955), and THE MANCHURIAN CANDIDATE (1962). Handsomely designed and well-written, the publication contains useful observations on the theory that violence in the arts may not be cathartic. Well worth browsing.

*Baxter, John, THE GANGSTER FILM. New York: A. S. Barnes and Company, 1970. Illustrated. 160pp.
 In this general and useful index to movies dealing with organized crime, Baxter divides his entries into two categories: (1) personalities and themes, and (2) film titles. He also has some helpful illustrations. Well worth browsing.

*Clarens, Carlos. CRIME MOVIES: FROM GRIFFITH TO "THE GODFATHER" AND BEYOND. New York: W. W. Norton, 1980. Illustrated. 351pp.
 A scholarly approach to the intentions and contributions of filmmakers depicting crime in America, the refreshing narrative goes into considerable detail on how the movies relate to the eras in which they are made. Clarens has an especially good concluding chapter on the techniques of violence. Throughout the historical study the comments are challenging; the stills, useful; and the text, enjoyable. Recommended for special collections.

*Davis, Brian. THE THRILLER: THE SUSPENSE FILM FROM 1946. New York: E. P. Dutton and Company, 1973. Illustrated. 159pp.
 Beautifully illustrated, the book provides an overview of the metamorphosis in the genre since the mid-1940s. Davis credits films like THE HOUSE ON 92ND STREET (1945) and THE NAKED CITY (1948) with starting the transformation that eventually led to gritty thrillers like DIRTY HARRY and THE FRENCH CONNECTION (both in 1971). In addition to an emphasis on chase and robbery films, Davis demonstrates an intelligent awareness of how filmmakers use the genre to examine social and political problems in works like CROSSFIRE (1947), THE MANCHURIAN CANDIDATE (1962), and Z (1969). Don't be fooled by the pictorial format. Well worth browsing.

[438] For a study of the gangster genre, see *Robert Warshow, "The Gangster as a Tragic Hero," THE IMMEDIATE EXPERIENCE (New York: Doubleday and Company, 1964), pp. 83-8; Robert Siodmak, "Hoodlums: The Myth," FILMS AND FILMING 5:10 (June 1959):10, 35; Richard Whitehall, "Crime: Part I," FILMS AND FILMING 10:4 (January 1964):7-12; ___, Part II," ibid.,10:5 (February 1964):17-22; and ___, Part III," ibid., 10:6 (March 1964):39-44; John Howard Reid, "The Best Second Fiddle," ibid., 9:2 (November 1962):14-8; Alan Warner, "Yesterday's Hollywood: Gangster Heroes," ibid., 18:2 (November 1971):16-25; Charles T. Gregory, "The Pod Society Versus the Rugged Individualists," THE JOURNAL OF POPULAR FILM 1:1 (Winter 1972):3-14; R. G. Powers, "J. Edgar Hoover and the Detective Hero," THE JOURNAL OF POPULAR CULTURE 9:2 (Fall 1975):257-78; Carlos Clarens, "The Hollywood G-Man, 1934-1945," FILM COMMENT 13:3 (May-June 1977):10-6; Maria-Teresa Ravage, "The Mafia on Film: Part One," FILM SOCIETY REVIEW 7:2 (October 1971):33-9; ___, "Part Two," ibid., 7:3 (November 1971):32-6; "Part Three," ___, ibid., 7:4 (December 1971):37-40; "Part Four," ___, ibid., 7:5 (January 1972):41-4; and Stuart M. Kaminsky, "LITTLE CAESAR and its Role in the Gangster Film Genre," ibid., 1:3 (Summer 1972):208-27.

Edelson, Edward. TOUGH GUYS AND GALS OF THE MOVIES. Garden City: Doubleday and Company, 1978. Illustrated. 133pp.

Geared primarily for the elementary schools, the simplistic text gives a superficial but pleasant introduction to famous screen personalities like James Cagney, Edward G. Robinson, Humphrey Bogart, Charles Bronson, Bela Lugosi, and Bette Davis. Edelson emphasizes how one screen performance led to a series of imitations from one generation to another. The stills are well presented, and an index is provided. Worth browsing.

*Everson, William K. THE BAD GUYS: A PICTORIAL HISTORY OF THE MOVIE VILLAIN. New York: The Citadel Press, 1964. Illustrated. 241pp.

Placing the movie villains into twenty inventive categories, the distinguished film historian chronologically surveys sixty years of noted actors and their screen conventions. Everson is delightful in his attempt to explain why the antics of these bad guys "tell us far more about the changing mores and morals of our times than a similar study of good guys could ever do." Lest the reader be wary of a heavy-handed sociological orientation, let me add the book's major value is as a respectful, nostalgic visit with brutes, monsters, train robbers, gangsters, and all-around heavies. Recommended for special collections.

*Gabree, John. GANGSTERS: FROM LITTLE CAESAR TO THE GODFATHER. New York: Pyramid Publications, 1973. Illustrated. 156pp.

Noting that the term "gangster film" in its purest form refers only to a few early years in the 1930s, the author broadens his study to include "those films about organized criminal activity and those that have been influenced by gangster film iconography." Gabree first gives us a superb breakdown of the gangster conventions, and then moves to a highly provocative history of the genre from the days of Robinson and Cagney to the "blaxploitation" films of the 1970s. As always with the fine Pyramid series, there is an excellent blending of scholarship, visuals, and fast-paced narratives. A filmography and index are provided. Recommended for special collections.

Karpf, Stephen Louis. THE GANGSTER FILM: EMERGENCE, VARIATION AND DECAY 1930-1940. New York: Arno Press, 1973. 299pp.

No attempt is made to rework the dry doctoral prose of this thesis written originally for Northwestern University. Its initial concern is with analyzing archetypal films like LITTLE CAESAR (1930), THE PUBLIC ENEMY (1931), SCARFACE (1932), and THE PETRIFIED FOREST (1936). Afterward, Karpf traces how the genre decayed, shown principally in the fluctuating roles of Robinson, Cagney, Muni, and Bogart. The examples illustrate how the genre makes use of physical characteristics, specific film personalities, and specific plots. Employing an historical-critical methodology, the author focuses on two major qualities of the archetypal films: e.g., episodic, socio-historical narratives; and central characters. Attention is also given to how Hollywood used the medium to comment on actual events as the roots of the gangster genre. Of particular value are the two appendexes on plot synopses of subsidiary films outside the genre and credits and cast lists. Recommended for special collections.

Lee, Raymond, and B. C. Van Hecke, GANGSTERS AND HOODLUMS: THE UNDERWORLD IN THE CINEMA. Foreword Edward G. Robinson. New York: A. S. Barnes and Company, 1971. Illustrated. 261pp.

A very badly prepared introduction goes along with a very good pictorial survey of crime movies. But even the still collection is hampered by pathetic captioning and poor reproduction qualities. Approach with caution.

*McArthur, Colin. UNDERWORLD USA. New York: The Viking Press, 1972. Illustrated. 176pp.

Using an AUTEUR approach, McArthur provides a revisionist history of the gangster/thriller films as seen through the works of nine directors: Fritz Lang, John Huston, Jules Dassin, Robert Siodmak, Elia Kazan, Nicholas Ray, Samuel Fuller, Don Siegel, and Jean-Pierre Melville. He notes the close relationship that the two genres have with each other, especially in the area of iconography; and then establishes a theory explaining why Hollywood and its values have been rejected unjustly by serious critics. In particular, he attacks the followers of F. R. Leavis for underestimating the intellectual worth of American films, and he charges the disciples of Paul Rotha with neglecting stylized film directors in favor of those making overtly "social" films. The author next offers an explanation of the genre's iconography and its historical development from the 1930s on. Each director is then analyzed to show how he contributed to the formula's conventions. Unfortunately, the illustrations are reproduced poorly, and the scholarly references leave much to be desired. The approach, however, is well handled conceptually and makes for challenging reading. Recommended for special collections.

Manchel, Frank. GANGSTERS ON THE SCREEN. New York: Franklin Watts, 1978. Illustrated. 120pp.

"The duality of public attraction to and repulsion by this genre is explored with insight, considering such elements as the use of violence. . . ."[439]

*Parish, James Robert. THE TOUGH GUYS. New York: Arlington House, 1976. Illustrated. 635pp.

The somewhat misleading title fails to explain that the book is a collection of seven biographies of famous Hollywood actors: i.e., James Cagney, Kirk Douglas, Burt Lancaster, Paul Muni, Edward G. Robinson, Robert Mitchum, and Robert Ryan. Each chapter comes complete with a chronological overview, an extensive filmography, and well-chosen stills. Particularly noteworthy is the author's skill in blending behind-the-scenes anecdotes with critical evaluations of both the star and his films. A valuable index adds to the book's film-buff appeal. Worth browsing.

Parish, James Robert and Michael R. Pitts. THE GREAT GANGSTER PICTURES. Metuchen: The Scarecrow Press, 1976. Illustrated. 431pp.

Narrowing its focus mainly to American-produced feature films, this adequate filmography offers cast and technical credits, plot summaries, and film review excerpts. The major attraction for serious students is a listing of gangster-crime-detective-police shows on television. The 150 illustrations offer minimal information, while Edward Connor provides a good introductory essay on the genre's history. Worth browsing.

Rosow, Eugene. BORN TO LOSE: THE GANGSTER FILM IN AMERICA. New York: Oxford University Press, 1978. Illustrated. 411pp.

In this most extensive study to date on the Hollywood gangster film, the author chronologically explores how the genre relates to American culture and why it remains one of the industry's most popular formulas. One reason given is that the genre's conventions represent "a superstructure of values and ideas that make up a self-image of America's advanced capitalistic society." A second reason is the manner in which

[439] Roberta L. Arbit, "Book Review: GANGSTERS ON THE SCREEN," SCHOOL LIBRARY JOURNAL 25:5 (January 1979):62.

the films parallel the rise of organized crime in this country. Unlike lesser books, this one acknowledges the roots of the genre in the early days of silent films and thus offers us both a critical and nostalgic visit with many famous stars, studios, and important movies. Attention is paid to the way in which the genre's iconography was established by movies like THE MUSKETEERS OF PIG ALLEY (1912), UNDERWORLD (1927), LITTLE CAESAR (1930), THE PUBLIC ENEMY (1931), SCARFACE (1932), G-MEN (1935), WHITE HEAT (1949), BONNIE AND CLYDE (1967) and THE GODFATHER (1972). In addition to the high quality reproduction of the illustrations, the text offers a good critical filmography, a useful bibliography, and an adequate index. Recommended for special collections.

Shadoian, Jack. DREAMS AND DEAD ENDS: THE AMERICAN GANGSTER/CRIME FILM. Cambridge: The M.I.T. Press, 1977. Illustrated. 363pp.

More limited in scope than Rosow's narrative, but far more complex, this challenging study is the best examination of how the genre functions as an art form and a cultural myth. To develop a theory on how the gangster film operates as a psychic mirror, Shadoian limits himself to eighteen films strategically discussed in six chapters. For example, the chapter on the classic gangster films includes an analysis of LITTLE CAESAR (1930) and THE PUBLIC ENEMY (1931); another chapter treats FILM NOIR, HIGH SIERRA (1941) and THE KILLERS (1946); and another explores contemporary gangster films, BONNIE AND CLYDE (1967), POINT BLANK (1967), THE GODFATHER (1972), and THE GODFATHER II (1975). A chronological perspective allows the author to demonstrate how the formula responds to socio-historical factors and to changes in the medium itself. Among his many interesting observations is that "Our involvement with the gangster rests on our identification with him as archetypal American dreamer whose actions and behavior involve a living out of the dream common to most everyone who exists in the particular configurations and contradictions of American society, a dream in conflict with society." Regrettably, the bibliography and the illustrations are not impressive, and the index is adequate. Recommended for special collections.

THE HORROR FILM

*Annan, David. CINEMA OF MYSTERY AND FANTASY. New York: Lorrimer Publishing, 1984. Illustrated. 136pp.

A companion volume to THE HOUSE OF HORROR: THE COMPLETE STORY OF HAMMER FILMS, this heavily illustrated work is advertised as "a hallucinatory trip into the depths of the mind that are illuminated in the science fiction and horror movies of the past eighty years." It is actually a sensible, enjoyable, and stimulating overview of many fine films dealing with myths, dreams, machines, and ancient superstitions. The charming stills and the breezy prose make for a quick survey on the history of civilization's fears and anxieties. No bibliography, filmography, or index is provided. Worth browsing.

*Anobile, Richard J., ed. JAMES WHALE'S FRANKENSTEIN. New York: Avon Books, 1974. Illustrated. 256pp.

Despite the editor's problems with the history of the genre,[440] his concept of reconstructing the classic horror film in book form is wonderful. The more than one

[440] Some good articles are Elliot Stein, "Have Horror Films Gone Too Far?" NEW YORK TIMES 2 (June 20, 1982):1, 21; Tania Modleski, "The Terror of Pleasure: The Contemporary Horror Film and Postmodern Theory," STUDIES IN ENTERTAINMENT:

thousand blown-up photographs sequentially arranged and complete with dialogue from the original soundtrack help one considerably in remembering the events and in analyzing many aspects of the 1931 production. Of special note are the author's restoration of the censored scenes depicting the monster's relationship with the peasant child. Recommended for special collections.

*Beck, Calvin Thomas. HEROES OF THE HORRORS. New York: Collier Books, 1975. Illustrated. 353pp.
Concerned more with the famous screen actors and their creepy roles than with the history of horror films, the author packages a rare collection of "horror" photographs with a literate set of biographies on Lon Chaney, Sr., Bela Lugosi, Boris Karloff, Peter Lorre, Lon Chaney, Jr., and Vincent Price. After a brief overview of the genre, individual chapters chronicle the lives of the stars. Beck is good at providing thumbnail plot synopses of the films, quoting memorable statements by significant reviewers, and making brief critical evaluations. Particularly disappointing is the absence of a much needed bibliography and index. Scholars may also find problems with the author's conclusions about who were the best contributors to the evolution of the genre, especially since the Hammer stars who played villainous roles are ignored in the text. The book's rich production qualities almost compensate for the author's narrow perspective. Well worth browsing.

Brosnan, John. THE HORROR PEOPLE. New York: St. Martin's Press, 1976. Illustrated. 304pp.
Associating horror with the bizarre, the author gives us a biographical history of the genre from THE CABINET OF DR. CALIGARI/DAS KABINETT DES DR. CALIGARI (1919) and NOSFERATU (1922) to ROSEMARY'S BABY (1968) and THE EXORCIST (1973). Included among the stars, directors, writers, and producers profiled are Lon Chaney, Sr., Tod Browning, Boris Karloff, Bela Lugosi, Val Lewton, Lon Chaney, Jr., James Whale, Robert Bloch, Terence Fisher, Christopher Lee, Peter Cushing, Vincent Price, William Castle, Samuel Z. Arkoff, Roger Corman, Richard Matheson, and Milton Subotsky. Brosnan incorporates material gleaned from personal interviews and published material to create a useful chronology of influential people who have shaped the conventions of the horror film. Two major flaws are the lack of critical film commentary and an unwillingness to challenge the comments of the people interviewed. The illustrations are adequate, a fine appendix on additional film personalities provides useful biographical sketches, and an extensive index completes the film-buff oriented text. Worth browsing.

CRITICAL APPROACHES TO MASS CULTURE, ed. by Tania Modleski (Bloomington: Indiana University Press, 1986), pp.154-66; Derek Hill, "The Face of Horror," SIGHT AND SOUND 28:1 (Winter 1958-59):6-11; William K. Everson, "A Family Tree of Monsters," FILM CULTURE 1:1 (January 1955):24-30; ___, "Horror Films," FILMS IN REVIEW 5:1 (January 1954):12-23; Edward Connor, "The Return of the Dean," ibid.,15:3 (March 1964):146-60; Robert C. Roman, "Boris Karloff," ibid., 15:7 (August-September 1964):389-412; Vincent Price, "Mean, Moody and Magnificent," FILMS AND FILMING 11:6 (March 1965):5-8; Leslie Halliwell, "The Baron, The Count and Their Ghoul Friends: Part One," ibid.,15:9 (June 1969):12-6; ___, "Part Two," ibid.,15:10 (July 1969):12-6; Michael Armstrong, "Some Like It Chilled: Part I," ibid., 17:5 (February 1971):28-34; ___, "Part II," ibid., 17:6 (March 1971):32-7; ___, "Part III," ibid.,17:7 (April 1971):37-42; ___, "Part IV," ibid.,17:8 (May 1971):76-82; Brian Murphy, "Monster Movies: They Came from Beneath the Fifties," THE JOURNAL OF POPULAR FILM 1:1 (Winter 1972):31-44; Walter Evans, "Monster Movies: A Sexual Theory,' ibid., 2:4 (Fall 1973):353-65; and Dennis L. White, "The Poetic of Horror: More than Meets the Eye," CINEMA JOURNAL 10:2 (Spring 1972):1-18.

Bussing, Sabine. ALIENS IN THE HOME: THE CHILD IN HORROR FICTION. Westport: Greenwood Press, 1987. 205pp.

A unique contribution to the study of the genre, this informative study pioneers an examination of how children are treated by horror book authors. The author defines horror fiction as "'literature of fear,' which subsists both on the terrors it describes and the dread and anxiety it evokes within the reader. . . ." Bussing divides the research into four major sections: "The Child's Outward Appearance," "The Child and Its Environment," "The 'Evil Innocent,'" and "The Monster." An appendix on the child in horror films, a filmography, endnotes, a bibliography, and an index are included. Well worth browsing.

Butler, Ivan. THE HORROR FILM. 3rd ed., rev. New York: A. S. Barnes and Company, 1970. Illustrated. 162pp.

This updated version stresses specific films within the matrix of the period and the conventions of the genre. The author comments upon the roots of the horror films before offering fascinating analyses of major works. For example, separate chapters treat the Dracula/Frankenstein films, the efforts of Val Lewton, Hitchcock's PSYCHO (1960), Roger Corman's screen treatments of Poe, and Roman Polanski's REPULSION (1965). Of particular interest in this new edition are his perceptive interpretations of the "unholy trinity" of horror films from 1967 to 1976: ROSEMARY'S BABY (1968), THE EXORCIST (1973), and THE OMEN (1976). An excellent, annotated filmography and terse index are provided. Recommended for special collections.

*Clarens, Carlos. AN ILLUSTRATED HISTORY OF THE HORROR FILM. New York: Capricorn Books, 1967. Illustrated. 256pp.

One of the best of the books on the subject but needing an updated edition, it is a well-researched record of the major movies, plus an invaluable cast and credit directory at the end. Also worthwhile are the clever and entertaining illustrations, which are thematically grouped. Highly recommended for special collections.

Derry, Charles. DARK DREAMS: A PSYCHOLOGICAL HISTORY OF THE HORROR FILM. New York: A. S. Barnes and Company, 1977. Illustrated. 143pp.

This literate survey concentrates on the effects that the 1960s and 1970s had on the evolution of the genre's themes and iconography. Derry categorizes the results into three broad horror themes: personality (i.e, PSYCHO, STRAIT-JACKET, WHAT EVER HAPPENED TO BABY JANE?), Armegeddon (i.e., THE WAR GAME, THE BIRDS, NIGHT OF THE LIVING DEAD, PLANET OF THE APES), and the demonic (THE EXORCIST, DON'T LOOK NOW, IT'S ALIVE!). The text concludes with thumbnail sketches of the important directors, a filmography, a bibliography, and an index. The illustrations are adequate and the comments provocative. Recommended for special collections.

*Dillard, R. H. W. HORROR FILMS. New York: Monarch Press, 1976. Illustrated. 129pp.

More propaganda for studying the genre than critical of its contents, this slim volume offers surprisingly insightful comments on well-covered territory. Dillard uses four important films--FRANKENSTEIN (1931), THE WOLF MAN (1941), NIGHT OF THE LIVING DEAD (1968), and SATYRICON (1969)--to argue his thesis that "the horror film is a valid and meaningful artistic genre directly related to our direct experience." Unfortunately, only the discussions of the Whale and Romero works are persuasive. The book's many fine comments and excellent bibliography are also marred by the poorly labeled visuals and the absence of an index. Worth browsing.

*Drake, Douglas, HORROR. New York: The Macmillan Company, 1966. Illustrated. 309pp.
 This is a more reflective book than the others on the relationship between history and the fictional tales in literature and on the screen. It is useful for background material on legends and superstitions, but almost worthless for film criticism. Worth browsing.

*Eyles, Allen, et al. THE HOUSE OF HORROR: THE COMPLETE STORY OF HAMMER FILMS. New York: Lorrimer Publishing, 1984. Illustrated. 144pp.
 A lovely illustrated history of the British studio that delivered such late-night winners as PLAGUE OF THE ZOMBIES (1966) and CREATURES THE WORLD FORGOT (1971), this entertaining chronology also points out that Hammer Film Productions produced a 140 films between 1947 and 1984. As the author shows, many of these unusual films served as vehicles for notable performers like Tallulah Bankhead, Peter Cushing, Bette Davis, Christopher Lee, and Raquel Welch. Eyles presents his high-camp history with a minimum of analysis, a lot of anecdotal information, and a wonderful array of pictures. A filmography is included, but no bibliography or index. Well worth browsing.

*Gagne, Paul R. THE ZOMBIES THAT ATE PITTSBURGH: THE FILMS OF GEORGE A. ROMERO. Introduction Tom Allen. New York: Dodd, Mead and Company, 1987. Illustrated. 237pp.
 The first and maybe the last behind-the-scenes examination of the movies' gruesomest Pittsburgh troupe of horror film addicts, this detailed biography focuses on the king of the ghoulish filmmakers, George A. Romero. The squeamish will be repelled by the director's satirical approach in his cult trilogy NIGHT OF THE LIVING DEAD (1968), DAWN OF THE DEAD (1979), and DAY OF THE DEAD (1985). Die-hard horror fans, however, should relish the care and patience that the author takes in discussing and analyzing these signficant films, as well as Romero's "zombie" films like MARTIN (1978) and KNIGHTRIDERS (1981). Writing with gusto and deep affection, Gagne not only describes what it takes to operate outside mainstream quarters but also provides reactions to Romero from his associates and gives a splendid introduction to the concept of "splatter" filmmaking. A filmography, endnotes, and an index are included. Well worth browsing.

*Gifford, Denis, MOVIE MONSTERS. New York: E. P. Dutton and Company, 1969. Illustrated. 159pp.
 The only value of this book is its handsome selection of stills characterizing man-made creations, the living dead, and the host of horror transformations. Approach with caution.

Glut, Donald F. CLASSIC MOVIE MONSTERS. Metuchen: The Scarecrow Press, 1978. Illustrated. 442pp.
 Lacking the breadth of the author's other major reference works but not their depth, this fact-filled volume examines eight significant horror characters: i.e., the Wolf Man, Dr. Jekyll, the Mummy, Quasimodo, the Phantom of the Opera, the Creature from the Black Lagoon, King Kong, and Godzilla.[441] Each monster is given a separate chapter, which includes a chronological history together with relevant information on literary and media treatments, critical evaluations, and visuals. This work is

[441] For a useful discussion of the monster, see Chon Noriega, "Godzilla and the Japanese Nightmare: When Them! is U.S.," CINEMA JOURNAL 27:1 (Fall 1987):63-77.

noteworthy as the only reference book including in detail Hispanic horror productions like PACT WITH THE DEVIL/PACTO DIABOLICO (1968) and THE MUMMY'S REVENGE/LA VENGANZA DE LA MOMIA (1973). A fine index is provided. Highly recommended for special collections.

*Glut, Donald F. THE DRACULA BOOK. Metuchen: The Scarecrow Press, 1975. Illustrated. 410pp.

The first and still the major source of information on the Dracula story in legend, history, and the media, this impressive study indicates why the Count has had such a long and successful career. Thirteen highly informative chapters chronicle the villain's remarkable attraction to audiences throughout the centuries. Not until a third of the book is completed does the author begin to comment on the various worldwide screen versions that began in 1922. As always, Glut incorporates cast and technical credits, plot synopses, visuals, and extensive footnotes with a sparse narrative style to provide his readers with an important reference book. A fine index is included. Recommended for special collections.

Glut, Donald F. THE FRANKENSTEIN CATALOG. Jefferson: McFarland, 1984. Illustrated. 539pp.

Glut, Donald F. THE FRANKENSTEIN LEGEND: A TRIBUTE TO MARY SHELLEY AND BORIS KARLOFF. Metuchen: The Scarecrow Press, 1973. Illustrated. 398pp.

This book provides the most complete account of the Frankenstein monster in history, legend, and the media. Packed with facts and written with a detached but genuine commitment to the genre, the narrative traces the development of the FRANKENSTEIN story from its birth to the present day. The author includes plot synopses, character analyses, critical judgments, and selected visuals in a straightforward manner that results in the text being more valuable as a reference guide than as a nostalgic survey for film-buffs. Recommended for special collections.

*Gow, Gordon. SUSPENSE IN THE CINEMA. New York: A. S. Barnes and Company, 1968. Illustrated. 167pp.

A breezy survey of a much-neglected subject that does a disservice to both its subject and audience, the simplistic narrative is divided into nine thematic categories: i.e., precepts, isolation, irony, phobia, all in the mind, among thieves, by accident, the occult, and fantasy and reality. A smattering of adequately produced visuals is used to illustrate the author's provocative comments. Especially disappointing are the weak bibliography and the absence of an index. A limited filmography is included. Approach with caution.

Halliwell, Leslie. THE DEAD THAT WALK: DRACULA, FRANKENSTEIN, THE MUMMY, AND OTHER FAVORITE MOVIE MONSTERS. New York: Continuum, 1988. Illustrated. 262pp.

A nice mixture of high camp and provocative insights, this very entertaining study covers familiar territory, while offering new assessments of the screen adaptations and the studios that made them. The emphasis is on discovery rather than on plot summaries. Nicely illustrated and written with wit, the book's one glaring failure is the absence of footnotes or a bibliography to document the author's assertions. A filmography and an index are included. Well worth browsing.

*Hoberman, J., and Jonathan Rosenbaum. MIDNIGHT MOVIES. New York: Harper and Row, 1983. Illustrated. 338pp.

An affectionate and fascinating account of movies that fail at the box office and then become cult films, this entertaining text examines the reasons for the ultimate "success" of films like KING OF HEARTS/LE ROI DE COEUR (1966), NIGHT OF THE LIVING DEAD (1968), THE MOLE/EL TOPO (1970), PINK FLAMINGOS, THE HARDER THEY COME (both in 1972), THE ROCKY HORROR PICTURE SHOW (1973), THE TEXAS CHAINSAW MASSACRE (1974), and ERASERHEAD (1977). In addition to a chatty and behind-the-scenes discussion of production difficulties and critical interpretations, the skilled author examines the careers of the controversial filmmakers who made this mixed assortment of midnight movies. Among the most interesting chapters are those treating George Romero, Alexandro Jodorowsky, and John Walters. A strong bibliography and good index are provided. Recommended for special collections.

*Hogan, David J. WHO'S WHO OF THE HORRORS AND OTHER FANTASY FILMS: THE INTERNATIONAL PERSONALITY ENCYCLOPEDIA OF THE FANTASTIC FILM. San Diego: A. S. Barnes and Company, 1981. Illustrated. 279pp.
Here's a case of trying to do too much with too little information and skill. Writers, directors, producers, stars, character actors, set designers, cinematographers, makeup artists, special effects technicians, and composers get brief and sometimes critical annotations in this film-buff publication. Readers will be confused by the chronological filmography-index. Unless one knows the year in which the film was produced, locating the picture will be a problem. The profuse and refreshing illustrations, however, compensate for the book's otherwise pedestrian quality. Worth browsing.

*Huss, Roy, and T. J. Ross, eds. FOCUS ON THE HORROR FILM. Englewood Cliffs: Prentice-Hall, 1972. Illustrated. 186pp.
Noted authors like Ray Bradbury, Ernest Jones, Jack Kerouac, and film critics like Raymond Durgnat, Stephen Farber, and Manny Farber explore the evolutionary process of horror films. The book is divided into four uneven sections: "The Horror Domain," an overview of myths; "Gothic Horror," a general review of the genre from 1895 to the early 1970s; "Monster Terror," speculative essays on the relationship between the films and the times in which they were made; and "Psychological Thriller," critical examinations of specific films such as ROSEMARY'S BABY (1968) and REPULSION (1965). No clear-cut editorial guidance is apparent. Thus the essays are of varying lengths and quality, the omission of significant films in the chronological filmography is never justified or explained, the few illustrations serve little purpose, and the index is too brief to be meaningful. Initially, the annotated bibliography proved helpful, but it is now dated. Approach with caution.

Hutchinson, Tom. HORROR AND FANTASY IN THE CINEMA. London: Studio Vista, 1974. Illustrated. 156pp.
Six excellently illustrated chapters enhance the value of this film-buff story of movies about the irrational, the supernatural, and the inexplicable. The author considers these films as a means of escape for their audiences and as a way of revealing some kind of psychic truth about society and the age in which the films were produced. Readers can ignore the well-meaning but simplistic text in favor of looking at the fascinating stills, lobby cards, and posters that occupy almost the entire book. Recommended for special collections.

*Krogh, Daniel, with John McCarty. THE AMAZING HERSCHELL GORDON LEWIS AND HIS WORLD OF EXPLOITATION FILMS. Foreword Herschell Gordon Lewis. Albany: FantaCo Enterprises, 1983. Illustrated. 167pp.

Following the breakup of the studio system in the fifties, a new breed of movie mogul became popular with exhibitors desperate for product: the exploitation filmmaker. "Working on budgets that amounted to pocket change compared with the huge amounts tossed around by the major studios, and yet competing for the same customer's hard earned buck," goes the strained rationale by McCarty, "the exploitation filmmaker had to be before anything else a shrewd marketer. To be successful, he had to be able to smell a trend well before its aroma reached the rarified air of Hollywood. Then he had to be able to exploit that trend quickly, shooting his films and rushing them into distribution with almost lightning speed." The best of the exploiters was the Chicago-based Herschell Gordon Lewis. He touched almost all the bases: producer, writer, cameraman, director, scorer, publicity hound, and distributor. (One might speculate he did all these things because no one would work with him on his outrageous productions.) For more than a decade, the maverick producer turned out a splatter of gruesome, sleazy films: THE PRIME TIME (1960), NATURE'S PLAYMATES (1962), BLOOD FEAST (1963), A TASTE OF BLOOD (1967), and MISS NYMPHET'S ZAP-IN (1970). Knowing how eager all of us are to read why Lewis's thirty-seven movies did well at the box office, the authors have gone to considerable pains to use posters, still photographs, and other memorabilia to illustrate the mentality and interests of this violent and disturbing filmmaker. The emphasis is on "how-to-do-it" in the gore market. That is, how to survive in the bizarre world of exploitation filmmakers. If your sensibilities aren't offended by the content, you will find the study well written and fast moving. Voyeurs, here is a chance to visit your pioneering hero in the movies. A filmography, listing of rental sources for the folk hero's films, and some of his selected song lyrics conclude the experience. Worth browsing.

*King, Stephen. DANSE MACABRE. New York: Everest House, 1981. Illustrated. 400 pp.

The author takes a hard, absorbing look not only at his own horror output--e.g., CARRIE (1976), SALEM'S LOT (1979), and THE SHINING (1980)--but also at some of his favorite spooky films produced by other people--e.g., ROSEMARY'S BABY (1968) and THE AMITYVILLE HORROR (1979). He explains how he writes, what influences him, and the impression that the genre has made on him over the years. Two particularly good chapters discuss the modern horror film and the horror movie as junk food. A helpful filmography, bibliography, and index add to the book's value as a source of information. Recommended for special collections.

*London, Rose. CINEMA OF MYSTERY. New York: Lorrimer Publications, 1975. Illustrated. 110pp.

The central theme throughout this quick survey of the mystery film is that Edgar Allan Poe was responsible for much of what is found in the history of the genre. London's comments suggest more than they can substantiate, but her excellent visuals make the competent narrative more enjoyable than expected. A considerable amount of scholarship and research has gone into the selection of stills, press book reproductions, posters, and illustrations. Anyone interested in an inexpensive but beautiful pictorial review of suspense from the days of Griffith to the TV series about Batman and Robin should examine this book. Worth browsing.

Manchel, Frank. AN ALBUM OF MODERN HORROR FILMS. New York: Franklin Watts, 1983. Illustrated. 90pp.

"Gory creatures leering from the cover and a chapter discussing voyeurism make this a more sophisticated extension of the milder vampire and werewolf sagas related in Edward Edelson's GREAT MONSTERS OF THE MOVIES . . . and Thomas G. Aylesworth's MOVIE MONSTER . . . Many of the best and worst films of the genre are discussed critically and with attention to the specific elements in each which produce horror in viewers . . . Profusely illustrated with black-and-white stills

from many of the most striking films, this will appeal to even young horror fans, but is most suited to the tastes of horror film addicts and serious film history students who are old enough to view the discussed R-rated features in their uncensored forms."[442]

Manchel, Frank. TERRORS OF THE SCREEN. Englewood Cliffs: Prentice-Hall, 1970. Illustrated. 122pp.
 "The popularity of the topic along with the general excellence of the treatment and production offered here makes this volume a basic for school libraries."[443]

*Mank, Gregory William. IT'S ALIVE! THE CLASSIC CINEMA SAGA OF FRANKENSTEIN. San Diego: A. S. Barnes and Company, 1981. Illustrated. 196pp.
 Comprehensive and entertaining, this book captures the author's admiration for the various screen adaptations by Universal Pictures of Mary Shelley's memorable horror story. Mank includes for each of the eight films from FRANKENSTEIN (1931) to ABBOTT AND COSTELLO MEET FRANKENSTEIN (1948) detailed credits of the cast and crew, a good synopsis of the plot, famous dialogue lines, notes on plot inconsistencies, a production history, and critical reactions. In addition, the author traces the production of other FRANKENSTEIN films that have appeared in the movies and on television and radio. Nostalgia fans will enjoy both the 150 illustrations and Mank's witty commentary on the people responsible for the films' appeal. The book concludes with a biographical appendix for twenty-three of the formula's most celebrated veterans. The one regret is that the author provided no index. Well worth browsing.

Mank, Greg. KARLOFF AND LUGOSI: THE STORY OF A HAUNTING COLLABORATION, WITH A COMPLETE FILMOGRAPHY OF THEIR FILMS TOGETHER. Jefferson: McFarland, 1989. Illustrated. 400pp.

*McCarty, John. PSYCHOS: EIGHTY YEARS OF MAD MOVIES, MANIACS, AND MURDEROUS DEEDS. New York: St. Martin's Press, 1986. Illustrated. 212pp.
 A high camp treatment of the psycho in over 400 films, this film-buff study is an illustrated history of murder, rape, and insanity on the screen. The material is presented tastefully, while the author coolly and intelligently discusses the films and their place in film history. A filmography, a bibliography, and an index are included. Well worth browsing.

*McCarty, John. SPLATTER MOVIES: BREAKING THE LAST TABOO. Albany: FantaCo Enterprises, 1981. Illustrated. 160pp.
 "Splatter movies," the author gleefully explains, "are off-shoots of the horror film genre, [which] aim not to scare their audiences, necessarily, nor to drive them to the edge of their seats in suspense, but to MORTIFY them with scenes of explicit gore." Considering the gory message of these films, McCarty gives an intelligent and interesting rationale for their appeal and quality. He establishes their historical roots in literature and drama, distinguishes between serious and exploitative filmmakers, comments about censorship problems, and philosophizes on the meaning that graphic

[442] Ann G. Brouse, "Book Review: AN ALBUM OF MODERN HORROR FILMS," SCHOOL LIBRARY JOURNAL 30:4 (December 1983):68.

[443] George Rehrauer, CINEMA BOOKLIST (Metuchen: The Scarecrow Press, 1972), p.364.

violence in movies holds for contemporary audiences. Among the more prominent personalities examined are Herschell Gordon Lewis, George Romero, David Cronenberg, and Tom Savini. The profuse visuals tastefully illustrate technique rather than exploit scenes of mutilation. An extensive chronological filmography completes the book's positive aspects. Unfortunately, the material covered still presents enough ghoulish delights to offend conservative readers; and the examination copy I received fell apart from its cheap binding after only one reading. Don't mail order your copy; browse all the way through before you consider purchasing. Approach with caution.

McNally, Raymond T., and Radu Florescu. IN SEARCH OF DRACULA: A TRUE HISTORY OF DRACULA AND OTHER VAMPIRE LEGENDS. Greenwich: New York Graphic Society, 1972. Illustrated. 223pp.

Two serious researchers spent ten years rooting out the legends and facts about Prince Dracula, including visits to his alleged birthplace at Sighisoara in Transylvania and to his isolated grave in the island monastery at Snagov. His ghoulish atrocities and the material--e.g., books, stage plays, films, television programs--that resulted from those fascinated by his personal depravities serve as the focus for this historical narrative. The results are interesting, but hardly convincing or definitive. Most useful for film scholars are the extensive bibliographical references and the rich visual material. No index is included. Worth browsing.

*Moss, Robert F. KARLOFF AND COMPANY: THE HORROR FILM. New York: Pyramid Publications, 1973. Illustrated. 158pp.

Content with presenting a concise survey of the genre, Moss omits several important horror films and excludes excursions into the area of science fiction. His comments are limited "to terrestrial gothic works of the past and the present; the sole unifying element among these works is the presence of horrific elements with the clear intention to scare." The results, while not innovative or startling, are presented in a lucid and intelligent text that is worth reading. Eight well-illustrated chapters review the basic information on ghouls, ghosts, and maniacs. Regrettably, the filmography and bibliography don't measure up to the quality of other books in this notable series. An index is included. Worth browsing.

Murphy, Michael J. THE CELLULOID VAMPIRES: A HISTORY AND FILMOGRAPHY, 1897-1979. Ann Arbor: Pierian Press, 1979. Illustrated. 351pp.

More scholarly in format than in content, the book represents a misguided attempt to survey comprehensively "the vampire film." Part of the problem is that Murphy defines his subject too broadly and thus loses focus from chapter to chapter. Another problem is that the seven chapters contain little new or interesting information, and include a repetition of familiar and trite illustrations. Adding to the problems are Murphy's reluctance to examine critically the films he discusses, errors on dates and in captioning, and a limited bibliography. The only benefits for serious students derive from looking at the filmography and fingering through the index. Worth browsing.

*Naha, Ed. HORRORS FROM SCREEN TO SCREAM: AN ENCYCLOPEDIC GUIDE TO THE GREATEST HORROR AND FANTASY FILMS OF ALL TIME. New York: Avon Books, 1975. Illustrated. 306pp.

Spanning the years from Edison's one-reel version of FRANKENSTEIN (1910) up to the mid-1970s, the film-buff reference book pays homage to hundreds of famous monster movies. The most important films, stars, producers, and directors are arranged in alphabetical order. Particularly enjoyable for fans are Naha's film entries, which include a brief plot synopsis and cast and directorial credits. Most disconcerting are the questionable critical judgments liberally sprinkled throughout

the volume. The profuse illustrations offer something for almost everyone. Worth browsing.

*Newman, Kim. NIGHTMARE MOVIES: WIDE SCREEN HORROR SINCE 1968. New York: Proteus Publishing Company, 1984. Illustrated. 160pp.
 Another high camp approach to horror films from the 1960s to the present, this breezy survey stresses wit more than erudition in offering amusing interpretations of the genre's major films and themes. Putting aside any expectations of serious, critical analyses, one gets a good idea of the show business appeal of the the important filmmakers and their associates. The best parts of the book are the well-produced illustratations. A filmography and an index are included. Worth browsing.

Perry, George. THE COMPLETE PHANTOM OF THE OPERA. New York: Henry Holt and Company, 1987. Illustrated. 169pp.
 A lovely coffee-table presentation of the marvelous theatrical legend, this well-researched study traces the ideas's evolution from the opening of Charles Garnier's great opera house in Paris in 1875 and the 1911 publication of Gaston Leroux's classic novel to the various versions on stage and in film of the memorable horror tale, and climaxing with an elegant visual review of the current musical triumph by Andrew Lloyd Weber. The writing is crisp and lucid, while the illustrations are stunning. In addition, this enchanting book includes the complete libretto of Weber's 1986 London production. Recommended for special collections and gifts for friends.

*Pirie, David. A HERITAGE OF HORROR: THE ENGLISH GOTHIC CINEMA 1946-1972. New York: Avon Books, 1973. Illustrated. 192pp.
 Written from a literary perspective, this original and valuable study makes a significant contribution to our understanding of the essential relationship between literature and film. Pirie shows how the British cinema effectively and effortlessly dominated the international market of horror films from the mid-1950s until the early 1970s, because it chose not to imitate American or European models. Instead, the English filmmakers, led by the Hammer production company, investigated Britain's gothic literature. Among the major personalities that the author credits with strengthening the horror film movement in England are Terence Fisher, John Grilling, Vernon Sewell, Peter Sasdy, Michael Powell, Michael Reeves, and Don Sharp. His perceptive comments lucidly presented in chronological fashion, accompanied by fresh visuals, evaluate not only the roots of the gothic tradition, but also the effect they had on British science fiction films. An extensive but not exhaustive annotated filmography concludes the text. Regrettably, no index is provided. Highly recommended for special collections.

*Pitts, Michael R. HORROR FILM STARS. Jefferson: McFarland and Company, 1981. Illustrated. 324pp.
 Intended as a nostalgic collection of biographies on past and present day horror film performers, the book lacks either the much-needed film-buff format or the scholarly commentary. The first section features fifteen of the genre's most prominent stars, including Lionel Atwill, John Carradine, Peter Lorre, Paul Naschy, Barbara Steele, and George Zucco. The entries run several tedious pages and include names and dates of the stars' important film works. Assertions rather than analyses link one film to another, while a smattering of adequate still reproductions represents the performer's career. Each biography concludes with a filmography, minus cast and technical credits. The second section provides twenty-eight shorter biographies. Among the individuals treated are John Agar, Evelyn Ankers, Dwight Frye, Rondo

Hatton, Edward Van Sloan, and Fay Wray. A bibliography and index are included. Worth browsing.

Prawer, S. S. CALIGARI'S CHILDREN: THE FILM AS TALE OF TERROR. New York: Oxford University Press, 1980. Illustrated. 307pp.
 Well-organized and conceptually intriguing, this literate narrative takes a detailed look at the genre's conventions and continued popularity. Prawer draws important distinctions among horror in literature, drama, and the media, while emphasizing the continuities and links shared by all. In eight thoughtful chapters, he charts the iconography and motifs of horror in representative works like DR. JEKYLL AND MR. HYDE (1932), VAMPYR (1932), INVASION OF THE BODY SNATCHERS (1956), and THE OMEN (1976). Discussions center on acting, direction, techniques, and theories. His concluding chapter on the contrasting themes of normality and monstrosity should be required reading for serious students. The author also provides a strong bibliography and three good indexes. Regrettably, no filmography is included. Recommended for special collections.

*Russo, John. THE COMPLETE "NIGHT OF THE LIVING DEAD" FILMBOOK. Preface George Romero. New York: Harmony Books, 1985. Illustrated. 120pp.
 The story of how a group of Pittsburgh filmmakers made their first feature film and established a new direction in horror films is told, not surprisingly, in thirteen chapters. Anecdotal and intriguing, the chatty prose and the excellent visuals combine to make a very informative history of a significant filmmaking experience. Regrettably, no index is provided. Well worth browsing.

*Schoell, William. STAY OUT OF THE SHOWER: 25 YEARS OF SHOCKER FILMS BEGINNING WITH "PSYCHO." New York: Dembner Books, 1985. Illustrated. 184pp.
 A breezy glance at the horror film from the 1960s to the present, this book is short on detail and big on pictures. The author offers a number of witty observations, but the overall content never goes beyond the film-buff level. An embarrassingly brief set of endnotes and index are included, but no bibliography is provided. Approach with caution.

*Sennett, Ted. MASTERS OF MENACE: GREENSTREET AND LORRE. New York: E. P. Dutton, 1979. Illustrated. 228pp.
 Although the two consummate actors appeared in only nine films together, they are fondly remembered as a sinister team that specialized in exuding danger and decadence. The enormous appeal they had for audiences is explained in this affectionate and intelligent book. Sennett begins by making clear that both men were vastly different off the screen. Sydney Greenstreet was a genial, rather reserved actor who entered the movies at the age of sixty-one after a distinguished theatrical career, mainly as a Shakespearian actor. Although just as much a professional, Peter Lorre was a stage actor who had come to the movies early, looked on his job as amusing and somewhat degrading, and remained throughout his career a tireless prankster. Since the two men worked together for only five years at Warner Bros., the author imaginatively organizes his book into individual sections on what each actor did before they began their collaborations, followed by a discussion of their memorable meeting during THE MALTESE FALCON (1941), then a chapter on their work from 1941 to 1946, and concludes with a chapter on their years apart. Sennett avoids biographical fluff in favor of critical commentary. His lucid narrative, filled with plot synopses and perceptive analyses, blends effectively with the text's many striking visuals. Each actor has his own filmography, in addition to a general bibliography and index. Recommended for special collections.

Silver, Alain, and James Ursini. THE VAMPIRE FILM. South Brunswick: A. S.
Barnes and Company, 1975. Illustrated. 238pp.
 Intended as a "critical survey," the book is similar to Murray's text on horror.
The first section explores the vampire as a central figure in films and literature.
We revisit the historical and legendary sources for the creature's treatment in the
arts before moving on to two interesting chapters on male and female vampires.
Taking care to mention key films, dates, and important film contributions, the authors
end their narrative portion of the text with a routine discussion of emerging vampire
traditions in the Hammer and Mario Bava films. The second section includes a good
annotated filmography and basic bibliography. Unfortunately, the profuse visuals are
not only poorly reproduced, but are also inserted randomly throughout the text.
Why more editorial care wasn't taken to insure maximum value to the reader is curious.
A helpful index includes many cross-listed references to foreign titles. Here's a book
where the authors were short changed by their publishers. Worth browsing.

*Stanley, John. CREATURE FEATURES MOVIE GUIDE: OR AN A TO Z
ENCYCLOPEDIA TO THE CINEMA OF THE FANTASTIC, OR IS THERE A MAD DOCTOR
IN THE HOUSE? Pacifica: Creatures at Large,[444] 1981. Illustrated. 208pp.
 This amusing but superficial resource serves as an excuse for the author to
make witty comments about monster, horror, and science fiction films. Typical of
Stanley's entries are his observations on LOGAN'S RUN (1976): "Incredible is the
only word to describe this version of the William Nolan-George Clayton Johnson novel
. . . incredible in the sense that a major studio, MGM, could have so thoroughly
botched a multimillion dollar science-fiction thriller. Instead of using a decent
screenplay by the original authors, the studio had it rewritten into a bastardization
full of glaring holes and inconsistencies, peopled by uninteresting characters and
often ineptly directed. . . ." The visuals are plentiful, but poor in quality. Worth
browsing.

*Stanley, John, and Mal Whyte. MONSTER MOVIE GAME. San Francisco: Troubador
Press, 1974. Illustrated. 64pp.
 Trivia questions about monsters, vampires, werewolves, split personalities,
phantoms, she-creatures, colossal beasts, half humans, and favorite villains
contribute to this party game book. The visuals add to the fun of remembering what
happens when Dracula walks in front of a mirror, or trying to match up the name
of a Japanese monster with its mutated species like Gyaos. Rather than spend over
forty dollars for the current TRIVIA game, film-buffs might just as easily take
advantage of this inexpensive publication. Worth browsing.

*Stoker, Bram. THE ANNOTATED DRACULA. Introduction, Notes, and Bibliography
Leonard Wolf. Art SATTY. With Maps, Drawings, and Photographs. New York:
Ballantine Books, 1975. Illustrated. 362pp.
 This fact-filled publication should satisfy the appetite of almost any Dracula fan.
Wolf treats the original 1897 DRACULA with respect, going into considerable detail
about its origins, Stoker's research, specific allusions in the text, and crucial
accompanying visuals. The scholarship is good and the illustrations above average.
It's worth examining the publication just to see how many different ways an editor
can create supporting material for a work of fiction. A bibliography, filmography,
and index are included. Recommended for special collections.

[444] The address for Creatures at Large is 1082 Grand Teton Drive, Pacifica,
California 94044.

Turner, George E., and Michael H. Price. FORGOTTEN HORRORS: EARLY TALKIES FROM POVERTY ROW. Cranbury: A. S. Barnes and Company, 1980. Illustrated. 216pp.

A chronology of shoestring cinema from 1929 to 1936, this interesting history book works hard at convincing its readers that poverty row was the breeding ground for inventive filmmakers. The authors resurrect a hundred odd, trite, and forgettable productions like JAWS OF JUSTICE (1933), THE MYSTIC HOUR (1934), and ONE FRIGHTENED NIGHT (1935). Each film is introduced by its cast and technical credits, followed by a plot synopsis, and concluded by a brief set of critical notes. The adequate visuals effectively illustrate the enormous budgetary and acting problems evident in almost any film to come out of "the Hell's Kitchen of Hollywood." Of particular interest are the comments by survivors of the era, plus nostalgic reminders of what happened to once famous stars when they fell out of favor with their fickle audiences. A good index is provided. Recommended for special collections.

*Twitchell, James B. DREADFUL PLEASURES: AN ANTOMY OF MODERN HORROR. New York: Oxford University Press, 1985. Illustrated. 353pp.

A splendid chronological look at the roots of horror from pre-historic days to the modern "splatter" films, this scholarly and entertaining inquiry emphasizes a psychological perspective on the paintings, plays, books, and films that have become part of the modern era. Three legends in particular--Dracula, Frankenstein, and the transformation monster (the Wolf man, Dr. Jekyll and Mr. Hyde--take center stage. The writing is intelligent, stimulating, and perceptive. Endnotes, a bibliography, and an index are included. Recommended for special collections.

*Waller, Gregory A., ed. AMERICAN HORRORS: ESSAYS ON THE MODERN HORROR FILM. Champaign: University of Illinois Press, 1987.

*Wolf, Leonard. A DREAM OF DRACULA: IN SEARCH OF THE LIVING DEAD. New York: Popular Library, 1972. Illustrated. 326pp.

What starts out as a reflective examination of the vampire legends in literature and the arts turns into a meandering treatise on almost any cultural subject that comes to the author's mind. His interview with Christopher Lee, for example, tells us more about the actor's home than it does about his horror roles. The references to vampire films are loaded down with subjective statements valuable only to readers not seriously concerned with the subject. Extensive footnotes and a bibliography are provided, but no index. Approach with caution.

*Wolf, Leonard. MONSTERS: TWENTY TERRIBLE AND WONDERFUL BEASTS FROM THE CLASSIC DRAGON AND COLOSSAL MINOTAUR TO KING KONG AND THE GREAT GODZILLA. San Francisco: Straight Arrow Books, 1974. Illustrated. 127pp.

A once-over-lightly look at popular monsters is done poorly by the author in a book where Don McCartney's design is much more interesting than the narrative. Among the terrifying creatures mistreated by the superficial prose are the Unicorn, the Cockatrice-Basilisk, the Minotaur, the Golem, the Griffin, and the Manticore. No index is provided. Approach with caution.

*Wood, Robin, and Richard Lippe, eds. THE AMERICAN NIGHTMARE: ESSAYS ON THE HORROR FILM. Toronto: Festival of Festivals, 1979. Illustrated. 100pp.

Twelve highly refreshing essays about the relationship between the sexual and social revolutions of the 1960s and the horror film make this slim volume a first-rate publication. Wood's opening observations on the reactionary and repressive role of the family in our society, as well as his discussion of the contextual similarities of horror in all the arts, set the tone for the challenging analyses of films like

NOSFERATU (1922), THE EXORCIST (1973), SISTERS (1973), JAWS (1975), MARTIN (1977), and FULL CIRCLE (1977). Most of the authors take a Marxist/Freudian perspective, arguing persuasively the value of such an approach in analyzing filmmakers such as George Romero, Harry Cohn, and Brian De Palma. Regrettably, the significant content is poorly edited, comes with a flimsy binding, and has no index. Recommended for special collections.

Wright, Gene. HORROR SHOWS: THE A-TO-Z OF HORROR IN FILM, TV, RADIO AND THEATER. New York: Facts on File Publications, 1986. Illustrated. 296pp.
 A handy source book offering minimal cast and technical credits, this thumbnail reference work, broken down into twelve topical chapters, with each entry in the chapters arranged alphabetically, is useful for quick and easy questions about the productions. The topics include "Crazies and Freaks," "Mad Scientists," Cataclysmic Disasters," "Splatter," and "Horror-Makers." Particularly enjoyable are the author's subjective evaluations of the films. A bibliography and index are provided. Well worth browsing.

THE MUSICAL FILM

*Altman, Rick. THE AMERICAN FILM MUSICAL. Bloomington: Indiana University Press, 1987. Illustrated. 388pp.
 A comprehensive and intelligent survey of the genre, this book is the best introduction to the aesthetic, social, and economic development of the Hollywood musical. The author provides a scholarly perspective on the relationship between genre analysis and the style of the American film musical. Nine excellent chapters explore the relationship between society and the conventions of the popular genre and provide in-depth discussions of the various subgenres of the musical. Endnotes and an index are included. Highly recommended for special collections.

Altman, Richard, ed. GENRE: THE MUSICAL. Boston: Routledge and Kegan Paul, 1981. 228pp.
 Part of a series initiated by the British Film Institute to make important publications in small journals more widely accessible to serious students, this collection presents fourteen articles written since 1975 on the musical film.[445] The contributors, who include Robin Wood, Lucy Fischer, and Jane Feuer, examine the

[445] For some more information on musicals, see the following: Harry Geduld, "Film Music: A Survey," QUARTERLY REVIEW OF FILM STUDIES 1:2 (May 1976):183-204; Jane Feuer, "The Self-Reflective Musical and the Myth of Entertainment," ibid., 2:3 (August 1977):313-26; Jennifer Batchelor, "From AIDA to ZAUBERFLOTE: The Opera Film," SCREEN 25:3 (May-June 1984):26-38; Simon Frith, "Mood Music: An Inquiry into Narrative Film Music," ibid., pp.78-87; Douglas Gallez, "Theories of Film Music," CINEMA JOURNAL 9:2 (Spring 1970):40-7; Charles Berg, "Cinema Sings the Blues," ibid., 17:2 (Spring 1978):1-12; Win Sharples, Jr., "A Selected and Annotated Bibliography of Books and Articles on Music in the Cinema," ibid., 17:2 (Spring 197):36-67; William Johnson, "Face the Music," FILM QUARTERLY 22:4 (Summer 1969):3-19; Kathryn Kalinak, "The Fallen Woman and the Virtuous Wife: Musical Stereotypes in THE INFORMER, GONE WITH THE WIND, and LAURA," FILM READER (1982):76-82; David Vaughan, "After the Ball," SIGHT AND SOUND 26:2 (Autumn 1956):89-91, 111; Edward Jablonski, "Filmusicals," FILMS IN REVIEW 6:2 (February 1955):56-69; John Cutts, "Bye Bye Musicals," FILMS AND FILMING 10:2 (November

genre from many different viewpoints, including semiology, AUTEURISM, feminist criticism, and psychoanalysis. Among the more interesting topics are Mark Roth's "Some Warners Musicals and the Spirit of the New Deal," Jim Collins's "Toward Defining a Matrix of the Musical Comedy: The Place of the Spectator within the Textual Mechanisms," and Martin Sutton's "Patterns of Meaning in the Musical." Particularly noteworthy is Feuer's annotated bibliography. An index is provided. Recommended for special collections.

*Applebaum, Stanley. THE HOLLYWOOD MUSICAL: A PICTURE QUIZ BOOK. New York: Dover Publications, 1974. Illustrated. 221pp.

Another in a delightful series of nostalgic visual guessing games, this creative review of the genre's history contains 215 well-chosen, handsomely reproduced stills to jog your memory. Applebaum begins with an emphasis on stars like Al Jolson, Judy Garland, Fred Astaire, and Gene Kelly before moving on to famous bandleaders, vocalists, and dancers. The charming survey ends with famous production numbers, Broadway stars in early musicals, and famous personalities appearing in musicals. An index of performers is provided. Recommended as a good, inexpensive gift for a friend.

Atkins, Irene Kahn. SOURCE MUSIC IN MOTION PICTURES. East Brunswick: Fairleigh Dickinson University Press, 1983. Illustrated. 190pp.

Written by the daughter of songwriter Gus Kahn, this informative work investigates the type of music "that, whether emanating from a source visible on the screen (such as a musical instrument or ensemble, a vocalist, a radio, a record player, or a television receiver) or not, is assumed to be audible to the characters in the film." The author raises important questions about the function of such music in film history since 1927, while contrasting the reasons why visual, narrative, and musical elements underwent periods of abuse and support. Of particular interest are her sensible explanations of the problems encountered by filmmakers who used old songs in nostalgic films and period pieces, concert programs and operatic works written especially for specific films, and non-traditional and non-Western music written or adapted for movies with historical or ethnic backgrounds. The book also contains the best bibliography on the subject. An index is provided. Highly recommended for special collections.

Babington, Bruce, and Peter William Evans. BLUE SKIES AND SILVER LININGS: ASPECTS OF THE HOLLYWOOD MUSICAL. Dover: Manchester University Press, 1985. Illustrated. 258pp.

A polemical analysis of the links between American society and the Hollywood musical, this stimulating commentary on American culture does a nice job of blending scholarly interests with enthusiasm for the genre itself. The chronological focus of the book's four major sections from the thirties to the present is on less than a dozen key films: GOLD DIGGERS OF 1933 (1933), THE MERRY WIDOW (1934), SWING TIME (1936), THE JOLSON STORY (1946), JOLSON SINGS AGAIN (1949), SUMMER HOLIDAY (1948), IT'S ALWAYS FAIR WEATHER (1955), CAROUSEL (1956), ON A CLEAR DAY YOU CAN SEE FOREVER (1970), and HAIR (1979). The writing is informative, critical, and challenging. Endnotes are provided, but no bibliography or index is included. Well worth browsing.

1963):42-5; Lionel Godfrey, "A Heretic's Look at Musicals," ibid., 13:6 (March 1967):4-10; George Sidney, "The Three Ages of the Musical," ibid., 14:7 (April 1968):4-7; and Alan Warner, "Yesterday's Hollywood: Musicals and Comedies," ibid., 8:1 (November 1971):18-33.

Bazelon, Irwin. KNOWING THE MUSIC: NOTES ON FILM MUSIC. New York: Van Nostrand Reinhold, 1975. Illustrated. 352pp.

One of the few books missed in Kahn's extensive bibliography, the idea for the text grew out of a course the author taught for young film students at the School for the Visual Arts in New York City. Bazelon's major objectives are to get viewers to take film music seriously in terms of its "functions, emotional impact, capabilities and limitations, and not to go along with the myth propagated by past Hollywood filmmakers that film music is only good when nobody notices it." Six technical but lucid chapters cover the relationship between film music and the composer, a historical overview, and contemporary examples of how recent filmmakers are using music to enhance or detract from our involvement in their films. Particularly interesting are the author's interviews with Bernard Herrmann, John Barry, and Richard Rodney. Drawing upon his career as a composer, Bazelon offers a critical evaluation of the subtle and intricate ways in which film music operates in important films from ALEXANDER NEVSKY (1938) to THE DISCREET CHARM OF THE BOURGEOISIE (1973). An index is provided. Recommended for special collections.

Berg, Charles Merrell. AN INVESTIGATION OF THE MOVIES FOR AND REALIZATION OF MUSIC TO ACCOMPANY THE AMERICAN SILENT FILM 1896-1927. New York: Arno Press, 1976. 300pp.

Originally a 1973 University of Iowa doctoral thesis, this well-written study investigates how and why music was used by the silent film. Eight detailed chapters consider topics like the use of agreeable musical sounds to neutralize or mask disagreeable sounds in and out of the movie theaters, the use of music to help audiences psychologically and physiologically adjust to the stream of silent images, the use of music to provide film continuity, the use of dramatic music for interpretation, and the use of music for economic gains. Berg's research concludes with a speculative chapter on the influence of silent music on the sound film. A bibliography is provided, but no index. Well worth browsing.

Bruce, Graham. BERNARD HERRMANN: FILM MUSIC AND NARRATIVE. Ann Arbor: UMI Research Press, 1985. 248pp.

Originally written as the author's 1982 NYU doctoral dissertation, this detailed investigation of Herrmann's film career provides the most complete and authoritative source of information on the noted musician. Bruce gives in-depth analyses "of the interaction between Herrmann's music and the filmic texts in which it participates . . . [and examines] how the musical segments relate to the formal articulation of a sequence, how the music contributes to the formal structure of a filmic system, and how an orchestral color appropriate to a particular narrative situation is achieved." The author offers three chapters on Herrmann's evolutionary approach to Hollywood's use of music and three chapters on the composer's relationship with Hitchcock. Bruce's impressive analytical skills result in a better understanding of how the film industry was forced to rethink its musical strategies in light of Herrmann's accomplishments. Several filmographies, endnotes, a bibliography, and an index are included. Recommended for special collections.

*Delamater, Jerome. DANCE IN THE HOLLYWOOD MUSICAL. Ann Arbor: UMI Research Press, 1981. 313pp.

A revision of a 1978 Northwestern University doctoral thesis, the significant study considers three areas in analyzing the use of dance in the history of the Hollywood musical: (1) the actual forms of dance choreographed in the films, (2) the various approaches to filming dance in the genre, and (3) the relationships that exist between dance and the totality of the films. The author's scholarly insights reveal how dance has become more sophisticated in films, due in part to the efforts of artists like Busby Berkeley, Fred Astaire, Ginger Rogers, and Gene Kelly. Of particular

interest to serious students is a series of appended interviews the author conducted with Jack Cole, Betty Garrett, Gene Kelly, Eugene Loring, Preston Ames, Randall Duell, Jack Martin Smith, Vincente Minnelli, and Joseph Ruttenberg. An index and bibliography are provided. Recommended for special collections.

Druxman, Michael B. THE MUSICAL: FROM BROADWAY TO HOLLYWOOD. South Brunswick: A. S. Barnes and Company, 1980. Illustrated. 202pp.
The profusely illustrated book raises a number of important questions about the screen adaptations over the past three decades of twenty-five Broadway musicals--both hits and flops--like ON THE TOWN (1949), GUYS AND DOLLS (1955), THE MUSIC MAN (1962), STOP THE WORLD--I WANT TO GET OFF (1966), OLIVER! (1968), and A LITTLE NIGHT MUSIC (1977). The problem is that we never get good answers to how the producers approach their difficult tasks, the key difficulties they encounter, or the critical value of the finished products. Less discriminating readers will be pleased with the plot summaries, entertaining commentaries, and bountiful stills. A title index is provided. Worth browsing.

*Evans, Mark. SOUNDTRACK: THE MUSIC OF THE MOVIES. New York: Hopkinson and Blake, 1975. Illustrated. 305pp.
A comprehensive history of movie music written affectionately by a sensitive author, this lively narrative offers a good introduction to a much neglected subject. Evans swiftly covers the first forty years of film history, before taking a closer look at the "Golden Age of Film Music" from 1935 to 1950. Rather than bog down in too much detail, he provides nostalgic profiles on the major European and American composers of the 1940s: e.g., Alfred Newman, Bernard Herrmann, Victor Young, Miklos Rozsa, and Dimitri Tiomkin. The comments reflect the author's love of his subject and his anecdotal style of scholarship. A composer and conductor himself, Dr. Evans also provides an insider's look into the film musical trends of the 1950s and 1960s and into how music functions in Hollywood movies. A particularly fascinating chapter is devoted to "Ethics and Aesthetics, Fables and Folklore." An index is provided. Recommended for special collections.

*Feuer, Jane. THE HOLLYWOOD MUSICAL. Bloomington: Indiana University Press, 1982. Illustrated. 130pp.
Starting with a simple but crucial observation that musicals deal not only with singing and dancing, but also that they are about singing and dancing, Feuer uses her considerable skills to analyze the reasons why the musical is such a popular and conservative formula. The idea for a text on the Hollywood musical as a genre that seeks to bridge the gap between producer and spectator grew out of a University of Iowa graduate seminar in 1975, and then developed into a dissertation before being revised for this scholarly publication. As a result, not even the adequate illustrations and attractive design can mask the serious tone of the narrative. In straightforward prose, Feuer dissects how the genre functions as a folk art, hides behind its glossy surface to conceal its own classical features, glorifies its own musical form, and thrives on its star personas. The latter are credited with symbolizing the genre's vision and the loss of that vision. Only serious students will appreciate the depth of the author's challenging theories on the technological, industrial, and commercial nature of the Hollywood musical. A filmography is provided, but no index. Recommended for special collections.

*Fordin, Hugh. THE MOVIES' GREATEST MUSICALS: PRODUCED IN HOLLYWOOD USA BY THE FREED UNIT. New York: Frederick Ungar Publishing Company, 1984. Illustrated. 568pp.

This affectionate tribute to Arthur Freed examines his films from THE WIZARD OF OZ and BABES IN ARMS (both in 1939) to LIGHT IN THE PIAZZA (1961). Filled with facts, financial analyses, stills, and Hollywood gossip, the fast-reading text is invaluable to film buffs and serious film students. Much of the entertaining information is based upon the author's inside knowledge of MGM politics and his five hundred hours of interviews with dozens of celebrities like Fred Astaire, Alan Jay Lerner, Andre Previn, Harold Arlen, and Betty Comden. A fine filmography and a useful catalogue of Freed's songs are provided. Recommended for special collections.

*Fordin, Hugh. THE WORLD OF ENTERTAINMENT: HOLLYWOOD'S GREATEST MUSICALS. Garden City: Doubleday and Company, 1975. Illustrated. 566pp.
 Appealing both to serious students and film-buffs, this highly entertaining account concentrates on Arthur Freed's fabulous thirty-year career as a producer at MGM. The author incorporates material from Freed's personal archives with his own extensive research to provide an invaluable behind-the-scenes look at forty of the most important Hollywood musicals in film history: e.g., THE WIZARD OF OZ (1939), FOR ME AND MY GAL (1942), CABIN IN THE SKY (1943), MEET ME IN ST. LOUIS (1944), GOOD NEWS (1947), ON THE TOWN (1949), AN AMERICAN IN PARIS (1951), SINGIN' IN THE RAIN (1952), THE BAND WAGON (1953), and GIGI (1958). A complete filmography is provided but no index. Recommended for special collections.

*Gorbman, Claudia. UNHEARD MELODIES: NARRATIVE FILM MUSIC. Bloomington: Indiana University Press, 1987. Illustrated. 190pp.
 A theoretical and analytical study of how the realist cinema uses music in its narrative films, this book, relying on semiological, psychoanalytical, and historical perspectives, is aimed at both general students and film scholars "who are curious about the ways of music in film." The focus is on getting us "to start LISTENING to the cinema's use of music in order to read films in a literate way." To demonstrate her points, Gorbman examines three films: UNDER THE ROOFS OF PARIS/SOUS LES TOITS DE PARIS (1930), ZERO FOR CONDUCT/ZERO DE CONDUITE (1933), and HANOVER SQUARE (1944). The writing is informative, stimulating, and lucid. Endnotes, a bibliography, and an index are included. Recommended for special collections.

*Green, Stanley. ENCYCLOPEDIA OF THE MUSICAL FILM. New York: Oxford University Press, 1981. 344pp.
 A sheer delight to read and use, this beautifully produced book has more than sixteen hundred entries on important actors, composers, lyricists, directors, choreographers, producers, films, and music. All are arranged in alphabetical order, with the film annotations providing short synopses, behind-the-scenes anecdotes, comparisons with other films having similar themes, relevant credits, AND all the songs in the films with the names of the vocalists (including songs recorded for the film but cut before the picture was released). In addition are several appendexes listing Oscar winners, title changes, films with biographical subjects, as well as a bibliography and discography. Best of all, the text is reliable. Highly recommended for special collections.

Harris, Thomas J. CHILDREN'S LIVE-ACTION MUSICAL FILMS: A CRITICAL SURVEY AND FILMOGRAPHY. Jefferson: McFarland, 1989. Illustrated. 208pp.

*Hemming, Roy. THE MELODY LINGERS ON: THE GREAT SONGWRITERS AND THEIR MOVIE MUSICALS. New York: Newmarket Press, 1986. Illustrated. 388pp.

A coffee-table collection of biographies on the composers who worked during the heyday of the studio system, this entertaining book celebrates the lives and contributions of ten important songwriters: Harold Arlen, Irving Berlin, George Gershwin, Jerome Kern, Jimmy McHugh, Cole Porter, Ralph Rainger, Richard Rodgers, Harry Warren, and Richard Whiting. The imaginative author divides his individual chapters on these men into a biographical sketch, a discussion of their major films, and a filmography. The writing is chatty, informative, and nostalgic. Particularly enjoyable are the lovely visuals. An appendix listing the Oscar nominations and winners, a bibliography, and an index are included. Well worth browsing.

*Hirschhorn, Clive. THE HOLLYWOOD MUSICAL. New York: Crown Publishing, 1981. Illustrated. 456pp.

Another book omitted from Atkins's bibliography, this lush pictorial history suffers because its text is unreliable. The author is a former film critic and presently drama critic for THE LONDON DAILY EXPRESS who should have taken more care with his comprehensive treatment of 1,344 movies from 1927 to the beginning of the eighties. However, if one skims the text and takes advantage of the marvelous collections of illustrations, the experience evokes many warm and memorable moments in the history of the Hollywood musical. Those who wish to take a risk can also examine the appendexes on fringe musicals, miscellaneous pop musicals, and documentaries. Five indexes are provided on film titles, song and musical titles, performers, composers and lyricists, and other creative personnel. Well worth browsing.

Hofmann, Charles. SOUNDS FOR SILENTS. Foreword Lillian Gish. New York: Drama Book Specialists, 1970. Illustrated. 90pp.

A rare and informative book by the musician who plays the music for silent screen presentations at the Museum of Modern Art, the narrative briefly illustrates how and why music was used in the early days of film history. The comments mix critical observations with affectionate anecdotes to evoke both a nostalgic mood and an intelligent perspective. Considerable attention is paid to reprinting original scores and placing specific music within the context of a particular film. Of special interest is an accompanying record--played, composed, and arranged by the author--which includes music used with such films as THE LONESDALE OPERATOR (1911), THE BIRTH OF A NATION (1915), BROKEN BLOSSOMS (1919), and PETER PAN (1924). Recommended for special collections.

*Jenkinson, Philip, and Alan Warner. CELLULOID ROCK: TWENTY YEARS OF MOVIE ROCK. London: Lorrimer Publishing, 1974. Illustrated. 136pp.

Intended neither as a definitive nor exhaustive study, this film-buff history offers a cursory survey of popular music in American and British films from THE WILD ONE (1954) to WATTSTAX (1973). Seventeen superficial chapters filled with many relevant visuals offer impressions of performers like Elvis Presley, the Beatles, the Rolling Stones, Chuck Berry, and Pat Boone. For those who enjoy the movies featuring rock'n'roll, twist, and beach party music, the fast-reading text acts as a pleasant reminder of the past. Serious students, however, will be frustrated by the limited amount of insights. A filmography and index are provided. Worth browsing.

*Kreuger, Miles. THE MOVIE MUSICAL FROM VITAPHONE TO 42ND STREET: AS REPORTED IN A GREAT FAN MAGAZINE. New York: Dover Publications, 1975. Illustrated. 367pp.

An excellent use of the material published in the monthly issues of PHOTOPLAY magazine at the time the movies made their transition from the silents to the talkies, the remarkable collection is a joy to read and to study. The editor focuses on the

years from 1926 to 1933, excerpting details about every film musical released in the United States up to 42ND STREET (1933). Detailed cast and character information is provided in almost every case, along with full-page ads for the specific movies, essays about sound and dubbing problems, and related biographical articles. Kreuger's intelligent editing offers in chronological order valuable insights into why James R. Quirk's magazine was not only highly respected, but also why it serves as a useful resource for contemporary scholars interested in the styles and attitudes of the era. Adding to the book's scholarly value are an appendix of record reviews and a separate film and personality index. Recommended for special collections.

Landon, John W. BEHOLD THE MIGHTY WURLITZER: THE HISTORY OF THE THEATRE PIPE ORGAN. Westport: Greenwood Press, 1983. Illustrated. 232pp.
 The memorable theater organ developed by Robert Hope-Jones from the church organ is chronicled in detail in this informative and scholarly study. Five well-written chapters cover the evolution of the theater pipe organ from the early 1900s to the present, providing information not only on how it worked and was manufactured but also on the people who used it and the reasons for its demise. Two valuable appendexes deal with biographical notes and theater organ listings. Endnotes, a bibliography, and an index are included. Well worth browsing.

Limbacher, James L., ed. FILM MUSIC AND KEEPING SCORE: FROM VIOLINS TO VIDEO. Metuchen: The Scarecrow Press, 1974. 835pp.
 Prepared by one of the academic community's most distinguished film archivists, this flawed reference work attempts to place in a single reference book the entire field of film music. Limbacher divides his overly ambitious project into two sections. The first includes fifty-two articles by noted composers, reviewers, and critics concerned with the art of the film. What unites the diverse opinions are seven basic topics: the silent era, theoretical considerations, techniques, scoring the dramatic film, spectacle films, classical music on the screen, and music in animated films and comedies. Most of these essays were published originally in FILM MUSIC NOTES, and the editor deserves thanks for assembling the out-of-print material in such an accessible source. The second section consists of three alphabetically arranged filmographies--i.e., film titles and dates, films and their composers, composers and their films--along with a discography of recorded musical scores and an index to section one. Suffering from a rash of errors and stylistic problems, the book will have limited value until the author undertakes a much-needed revision and produces the significant work he has achieved in other areas. Worth browsing.

*McVay, Douglas. THE MUSICAL FILM. New York: A. S. Barnes and Company, 1967. Illustrated. 175pp.
 This thumbnail sketch is a chronological survey of musicals from 1927 to 1966. It has a good bibliography and a much-needed index to specific titles. The comments are useful, provocative, and usually accurate. Its major drawback is the author's preoccupation with subjective rather than scholarly judgments. Worth browsing.

*Mordden, Ethan. THE HOLLYWOOD MUSICAL. New York: St. Martin's Press, 1981. Illustrated. 261pp.
 A mixed bag of controversial judgments and witty prose, the chronological narrative traces the Hollywood musical from the early days of sound to the present. The author concentrates more on the 1930s than the 1940s. His moving more gingerly through the remaining decades serves to remind us of the genre's decline in popularity after World War II. Mordden's best comments are reserved for why and how musicals appealed to artists and audiences in the first decade of the talkies. An adequate discography, bibliography, and index are included. Worth browsing.

Prendergast, Roy M. A NEGLECTED ART: A CRITICAL STUDY OF MUSIC IN FILMS. Foreword William Kraft. New York: New York University Press, 1977. Illustrated. 268pp.

Aimed primarily at readers with strong musical backgrounds, this historical study is written by a talented musicologist interested in analyzing film music as composition and as a central element in cinematic expression. Prendergast's approach permits him to select a limited number of films for use as instructive prototypes for the critical examination of music in film history. He sees few significant differences between the use of music in documentary and in fiction films and thus avoids any meaningful discussion of its use in nonfiction genres. In an attempt to reach a wider audience, the author divides the book into three sections--i.e., history, aesthetics, technique--and almost succeeds in balancing the critical and technical parameters within which he discusses the key concepts and composers. General readers will enjoy his analyses of important film theories set forth by critics Kurt London and Hanns Eisler, while more serious students will relish the stimulating analyses of film music. A bibliography and index are included. Recommended for special collections.

Rapee, Erno. MOTION PICTURE MOODS FOR PIANISTS AND ORGANISTS. New York: Arno Press, 1970. 678pp.

Originally published in 1924, this collection of musical scores was to help pianists and organists playing background music for the movies shown in small theaters. The author created fifty-two divisions and classifications for the music used most often in screen synchronizations. Typical of the system were entries like FUNERAL, Marche Funebre (from Sonata Op. 35), Frederic Chopin; GROTESQUE, Misterioso No. 1, Otto Langey. Worth browsing.

Sennett, Ted. HOLLYWOOD MUSICALS. New York: Harry N. Abrams, 1981. Illustrated. 384pp.

The biggest and most lavish of the coffee-table books on musicals, this nostalgic undertaking offers a loving tribute to the genre from its roots in the late 1920s to the 1980s. The author's chronological approach emphasizes anecdotal information on the studios, stars, and films, while paying homage to the role of the musical both in film history and in American culture. The best part is the collection of more than 400 illustrations (110 of which are in color). A bibliography, filmography, and index are included. Well worth browsing.

*Springer, John. ALL TALKING! ALL SINGING! ALL DANCING! A PICTORIAL HISTORY OF THE MOVIE MUSICAL. New York: The Citadel Press, 1966. Illustrated. 256pp.

This is one the best sources on the outstanding songs, performers, and films of the screen. Springer, in a pleasant, quick, and sensitive survey, provides a valuable reference guide, as well as five hundred illustrations, a name and title index, and valuable annotations for the hundreds of stills. Well worth browsing.

*Stern, Lee Edward. THE MOVIE MUSICAL. New York: Pyramid Publications, 1974. Illustrated. 159pp.

Fast-paced and lovingly told, the slim volume focuses on the genre's classic films. The qualities that these unique musicals have in common are a self-imposed style, an emphasis on movement, and often the help of a special performer (e.g., Fred Astaire, Gene Kelly) or director (e.g., Ernst Lubitsch, Bob Fosse). Stern's perceptive observations make the familiar survey from THE JAZZ SINGER (1927) to MAME (1974) an interesting and entertaining experience. Regrettably, the book provides little more than observations and contains a weak bibliography and filmography. An index is also included. Worth browsing.

*Taylor, John Russell, and Arthur Jackson. THE HOLLYWOOD MUSICAL. New York: McGraw-Hill and Company, 1971. Illustrated. 278pp.

Starting with the definition that a true musical film is one that is totally controlled by the music's overwhelming the drama and its sudden jumps into fantasy through song or dance scenes, rather than lyrical dramas (THE UMBRELLAS OF CHERBOURG/LES PARAPLUIES DU CHERBOURG), Taylor, the LONDON TIMES film critic, offers an exhaustive and extremely useful study of Hollywood's popular genre. The second part of the book belongs to music critic Jackson who also offers an exhaustive listing of more than fourteen hundred musicals, plus a detailed filmography of the 275 most popular and a complete index of over 2,750 songs. This is a very good book to have around. Recommended for special collections.

Thomas, Tony. MUSIC FOR THE MOVIES. South Brunswick: A. S. Barnes and Company, 1973. Illustrated. 270pp.

An informative look at background music in Hollywood films, the book examines how scoring for the movies developed from the early 1930s to the late 1960s. The major information is gleaned from the the author's interviews with composers like Franz Waxman, Miklos Rozsa, George Antheil, and Henry Mancini. While Thomas records their reactions to the films they scored, he avoids technical explanations. Thus readers lacking a musical background will have no trouble in understanding why Hugo Friedhofer's most charming score, for example, was THE BISHOP'S WIFE (1948); or his greatest technical difficulties came with THE SUN ALSO RISES (1957). The author's well-intentioned chapter on recordings of film scores runs into the standard problems of reconciling European and American labeling systems. A list of each composer's films and an index are included. Recommended for special collections.

Thomas, Tony. FILM SCORE: THE VIEW FROM THE PODIUM. South Brunswick: A. S. Barnes and Company, 1980. Illustrated. 266pp.

Another crusading book for the importance of film scoring, this one contains the opinions of twenty experts on the craft of writing music for the movies. Thomas handily summarizes in individual chapters the contributions to film history of famous composers like Aaron Copland, Miklos Rozsa, David Raskin, Franz Waxman, Hugo Friedhofer, Max Steiner, Erich Wolfgang Korngold, Dimitri Tiomkin, Hans J. Salter, Bronislau Kaper, Alfred Newman, Bernard Herrmann, Elmer Bernstein, Henry Mancini, Fred Steiner, William Alwyn, John Addison, Jerry Fielding, Jerry Goldsmith, and Leonard Rosenman. The commentaries contain historical, critical, and personal evaluations. A discography and bibliography are included, but regrettably not an index. Recommended for special collections.

*Vallance, Tom. THE AMERICAN MUSICAL. New York: A. S. Barnes and Company, 1970. Illustrated. 192pp.

This book offers a comprehensive and valuable guide to American artists connected with film musicals up to the late 1960s, including some critical comments, credits, and biographical information. Well worth browsing.

THE NEWSPAPER FILM

Barris, Alex. STOP THE PRESSES! THE NEWSPAPERMAN IN AMERICAN FILMS. Cranbury: A. S. Barnes and Company, 1976. Illustrated. 211pp.

A clever idea gets no more than adequate treatment in this superficial work. What's disappointing is that the author obviously knows a great deal about the trivial history of the genre from the first version of THE FRONT PAGE (1928) to its third in 1974. Throughout the breezy text, Barris captures the various conventions of Hollywood-styled reporters, columnists, editors, and publishers. He understands the

ways in which the studios altered their roles, forcing stars like Clark Gable, James Cagney, and Jack Lemmon to play crimebusters, crusaders, and cynics, while famous actresses like Joan Crawford, Bette Davis, and Katharine Hepburn were relegated to "sob sister" parts. What Barris doesn't care about are the more scholarly issues of genre roots in the silent era or film sources in literature and drama. Not even three hundred refreshing visuals can compensate for a book that offers a historical treatment without offering a filmography or bibliography. An index is included. Worth browsing.

THE ROAD FILM

*Williams, Mark. ROAD MOVIES. New York: Proteus Books, 1982. Illustrated. 127pp.
 The dictionary format divides the genre into two main types of films: "Those that simply pander to car chauvinism, and those that exploit the nation's belief in the freedom that lies across a state line or two, with a car being the means to that end." The first type is illustrated by films like GRAND PRIX (1966), WINNING (1969), and THE LAST AMERICAN HERO (1973); the second, VANISHING POINT (1971), THE GETAWAY (1972), and THE SUGARLAND EXPRESS (1974). For Williams, either version offers a wonderful opportunity to comment on male camaraderie and its misogynist tendencies. His annotations of more than one hundred films indicate minimal production credits and synopses, but offer fascinating technical critiques along with rare visuals. Worth browsing.

THE SCIENCE FICTION FILM

*Annan, David. MOVIE FANTASTIC: BEYOND THE DREAM MACHINE. New York: Bounty Books, 1975. Illustrated. 132pp.
 Novel and provocative in style and treatment, this fast-paced history traces the roots of the horror, fantasy, and science fiction film[446] from the days of the caveman through ancient civilizations up to the present. Annan cleverly divides his

[446] Some useful information on that subject can be found in the following: Francis Arnold, "Out of This World," FILMS AND FILMING 9:9 (June 1963):14-8; Margaret Tarratt, "Monsters from the Id--an Examination of the Science Fiction Film Genre, Part I," ibid., 17:3 (December 1970):38-42; ___, "Part II," ibid.,17:4 (January 1971):40-2; Gordon Gow, "Cinema of Illusion: Part I," ibid., 18:6 (March 1972):18, 22; ___, "Part II," ibid., 18:7 (April 1972):40-4; ___, "Part III," ibid., 18:8 (May 1972):40-44; ___, "The Non Humans," ibid., 20:12 (September 1974):59-62; Richard Hodgens, "A Brief, Tragical History of the Science-Fiction Film," FILM QUARTERLY 13:2 (Winter 1959):30-9; Lee Atwell, "Two Studies in Space-Time," ibid., 26:2 (Winter 1972):2-9; J. P. Telotte, "Human Artifice and the Science Fiction Film," ibid., 36:3 (Spring 1983):44-51; Fred Glass, "Sign of the Times: The Computer as Character in TRON, WAR GAMES, and SUPERMAN III," ibid., 38:2 (Winter 1984-85):16-27; Penelope Houston, "Glimpses of the Moon: Science Fiction," SIGHT AND SOUND 22:4 (April-June 1953):185-8; Garrett Stewart, "Close Encounters of the Fourth Kind," ibid., 47:3 (Summer 1978):167-74; Philip Strick, "The Age of the Replicant," ibid., 51:3 (Summer 1982):168-72; Carlos Clarens, "SciFi Hits the Big Time," FILM COMMENT 14:2 (March-April 1978):49-53; Robin Wood, "The Return of the Repressed," ibid., 14:4 (July-August 1978):24-32; Harlan Kennedy, "21st Century Nervous Breakdown," ibid., 18:4 (July-August 1982):64-8; Marc Mancini, "Thunder & Lightning," ibid., 19:4 (July-August

film-related themes into four major sections: Myths--e.g., CAT PEOPLE (1942), THE WITCHFINDER GENERAL (1968), THE DEVILS (1971); Machines--e.g., TWENTY THOUSAND LEAGUES UNDER THE SEA (1954), FIRST MEN ON THE MOON (1964), FANTASTIC VOYAGE (1966), BULLITT (1968); Visions--e.g., NOSFERATU (1922), METROPOLIS (1926), THINGS TO COME (1936); and Nightmares--RASHOMON (1950), THE INCREDIBLE SHRINKING MAN (1957), KWAIDAN (1964). Three hundred stills, line drawings, and poster reproductions add considerably to the enjoyable but superficial survey. An index is provided. Well worth browsing.

*Atkins, Thomas R., ed. SCIENCE FICTION FILMS. New York: Monarch Press, 1976. Illustrated. 101pp.

An overly ambitious anthology, this collection of seven uneven essays seeks a "basic reevaluation" of science fiction movies from A TRIP TO THE MOON/LE VOYAGE DANS LA LUNE (1902) to SOLARIS (1972). Fifty illustrations nicely reproduced, intelligent analyses by Vivian Sobchack on science fiction films in the fifties, and Stuart M. Kaminsky on INVASION OF THE BODY SNATCHERS (1956) make the effort of obtaining this book worthwhile. A limited bibliography is provided, but no index. Worth browsing.

*Baxter, John. SCIENCE FICTION IN THE CINEMA. New York: A. S. Barnes and Company, 1970. Illustrated. 240pp.

One of the few good comprehensive books available on this subject up to the end of the 1960s, the text offers a wealth of information about films, key personalities, and credits. Regrettably, the visuals are few and of limited value. Well worth browsing.

1983):52-5; ___, "The Future Isn't What It Used to Be," ibid., 21:3 (May-June 1985):11-5; Constance Markey, "Birth and Rebirth in Current Fantasy Films," FILM CRITICISM 6:1 (Fall 1982):14-25; J. P. Telotte, "The Doubles of Fantasy and the Space of Desire," ibid., pp.56-68; Tony Williams, "Close Encounters of the Authoritarian Kind," WIDE ANGLE 5:4 (1983):22-9; Denis Wood, "Growing Up Among the Stars," LITERATURE/FILM QUARTERLY 7:4 (Fall 1978):327-41; Conrad Kottack, "Social-Science Fiction," PSYCHOLOGY TODAY (February 1978):12-8; Barry K. Grant, "From Film Genre to Film Experience," PAUNCH 42-43 (December 1975):123-37; James M. Martin, "The Best of All Possible Worlds," AMERICAN FILM 1:5 (March 1976):28-32, 49; Bart Mills, "The Brave New Worlds of Production Design," ibid., 7:4 (January-February 1983):40-6; H. Bruce Franklin, "Future Imperfect," ibid., 8:5 (March 1983):47-9; Hal Hinson, "Dreamscapes," ibid., 10:3 (December 1984):44-50; Kenneth Jurkiewicz, "Technology in the Void: Politics and Science in Four Contemporary Space Movies," NEW ORLEANS REVIEW 9:1 (1982):16-20; Harry M. Geduld, "Return to Melies: Reflections on the Science Fiction Film," THE HUMANIST 27:6 (November-December 1968):23-4, 28; Larry N. Landrum, "A Checklist of Materials about Science Fiction Films of the 1950s," THE JOURNAL OF POPULAR FILM 1:1 (Winter 1972):61-3; ___, "Science Fiction Film Criticism in the Seventies: A Selected Bibliography," ibid., 6:3 (Summer 1978):287-9; Frank D. McConnell, "Song of Innocence: THE CREATURE FROM THE BLACK LAGOON," ibid., 2:1 (Winter 1973):15-28; Joan F. Dean, "Between 2001 and STAR WARS," ibid., 7:1 (Winter 1978):32-41; Marina Heung, "Why E. T. Must Go Home: The New Family in American Cinema," ibid., 11:2 (Summer 1983):79-85; Daniel Dervin, "Primal Conditions and Conventions: The Genres of Comedy and Science Fiction," FILM/PSYCHOLOGY REVIEW 4:1 (Winter-Spring 1980):115-47; and Robert F. Moss, "To Sci-Fi Writers Hollywood Is Mostly Alien," NEW YORK TIMES H (June 4, 1989):13, 18.

Brosnan, John. FUTURE TENSE: THE CINEMA OF SCIENCE FICTION. New York: St. Martin's Press, 1978. Illustrated. 320pp.
A nice blending of cinematic and literary perspectives characterizes this useful chronology of the science fiction film. The author comments on almost four hundred films from A TRIP TO THE MOON/LE VOYAGE DANS LA LUNE (1902) to STAR WARS (1977), although he spends most of his energy in evaluating the years from 1960 on. Suitable attention is given to plot synopses, technical developments, important contributions, and significant filmmakers. Brosnan's skill in discussing special effects adds a special dimension to his highly readable survey, which contains many rare visuals satisfactorily reproduced. A useful appendix on television science fiction films and two indexes on titles and personalities are included. Recommended for special collections.

*Finch, Christopher. THE MAKING OF "THE DARK CRYSTAL": CREATING A UNIQUE FILM. New York: Holt, Rinehart and Winston, 1983. Illustrated. 96pp.
The achievements of Muppet genius Jim Henson are discussed in this study of the five-year undertaking that produced the technical wizardry of the puppet film. Finch not only explains how the movie evolved but also tells us about the contributions of Henson's associates as well as the sources of the imaginative film. The illustrations are stunning. Well worth browsing.

*Hardy, Phil, ed. SCIENCE FICTION. New York: William Morrow and Company, 1984. Illustrated. 400pp.
This delightful dictionary, chronologically arranged, covers the history of the genre from its cinematic roots to 1983. Entries include titles (foreign titles where appropriate), studio names, color or b/w, running time, cast and technical credits, and evaluative comments. Generally, a still accompanies the thumbnail annotations. The information is valuable, entertaining, and provocative. Appendices are provided on the best box-office films, critics' "Top Ten" lists, and Oscar nominations and winners. A bibliography and index are included. Recommended for special collections.

*Harryhausen, Ray. FILM FANTASY SCRAPBOOK. 2nd ed., rev. South Brunswick: A. S. Barnes and Company, 1972. Illustrated. 142pp.
One of the giants in film special effects, the distinguished author discusses in a modest chronological survey of fantasy films from KING KONG (1933) to THE GOLDEN VOYAGE OF SINBAD (1974) his remarkable insights into three-dimensional animated films. In particular, Harryhausen draws on his early Hollywood days from 1946 with Willis O'Brien while making MIGHTY JOE YOUNG (1949) to give us behind-the-scenes accounts of the techniques that led to O'Brien's Oscar for special effects. He reveals how his long association with producer Charles H. Schneer on films like IT CAME FROM BENEATH THE SEA (1955) and TWENTY MILLION MILES FROM EARTH (1957) led to important breakthroughs in cinematic techniques culminating in the Dynamation process in THE SEVENTH VOYAGE OF SINBAD (1958). The marvelous and profuse visuals illustrate what the author's modest prose states only matter-of-factly. The book's major flaw is that it avoids detail in favor of observations. Thus serious students will be frustrated by the lack of specific information, dates, cast and technical credits, bibliographies, and an index. Recommended for special collections.

Hickman, Gail Morgan. THE FILMS OF GEORGE PAL. Cranbury: A. S. Barnes and Company, 1978. Illustrated. 177pp.
The most detailed study yet of the famous producer/director who made such renowned films as DESTINATION MOON (1950), THE WAR OF THE WORLDS (1953), and THE TIME MACHINE (1960), the insightful discussion offers a wealth of information on why Pal received countless awards, including six Oscars. Hickman

critically examines the puppet filmmaker's childhood in Hungary, through the difficult pre-World War II years, to his rise to prominence in Hollywood and the fourteen films that he produced or directed. The author also provides useful information on the development of Pal's three-dimensional color cartoons known as the "Puppetoons." Helped considerably by a lucid writing style and an extensive collection of visuals, the film-rather-than-biographical emphasis appeals to all audiences. An index is included. Recommended for special collections.

*Johnson, William, ed. FOCUS ON SCIENCE-FICTION FILM. Englewood Cliffs: Prentice-Hall, 1972. Illustrated. 182pp.
 For those interested in a useful casebook on the history and theoretical aspects of science-fiction movies, this one is a must. Among the films covered are THE WOMAN IN THE MOON/DIE FRAU IM MOND (1929), THINGS TO COME (1936), DR. CYCLOPS (1940), DESTINATION MOON (1950), INVASION OF THE BODY SNATCHERS (1956), THE TIME MACHINE (1960), FAHRENHEIT 451 (1966), and 2001: A SPACE ODYSSEY (1968). Adding to the book's value are excerpts from filmmakers' diaries and scripts, a filmography, bibliography, and index. Recommended for special collections.

Larson, Randall D. MUSIQUE FANTASTIQUE: A SURVEY OF FILM MUSIC IN THE FANTASTIC CINEMA. Metuchen: The Scarecrow Press, 1985. Illustrated. 592pp.
 Describing how music complements the visual action and helps set the mood in science fiction, horror, and fanstasy films, this valuable resource book provides a historical and analytical guide to the often ignored genres. Larson relies heavily on three sources in compiling his material: (1) his subjective judgments on the music discussed, (2) published accounts found in books and periodicals, and (3) interviews with nearly two dozen composers. Sixteen fact-filled chapters, nicely documented, offers the most comprehensive perspective on the subject. Appendices dealing with landmark works and a selected chronology add to the book's value. A filmography, discography, and an index are included. Recommended for special collections.

*Lee, Walter. REFERENCE GUIDE TO FANTASTIC FILMS: SCIENCE FICTION, FANTASY AND HORROR. Volume 1, A-F. Volume 2, G-O. Volume 3, P-Z. Los Angeles: Chelsea Lee Books, 1972, 1973, 1974. 189 pp. 406pp. 613pp.
 This worthwhile study offers a much-needed index of the material connected with the history of fantastic films. It provides information on such things as titles of films, articles, different versions of the same story, dates for the completed film, countries involved in the productions, and credits. Lee's important work ought to stimulate similar studies in other genres. Recommended for special collections.

Lentz, Harris M., III. SCIENCE FICTION, HORROR & FANTASY FILM AND TELEVISION CREDITS. Two Vols. Foreword Forrest J. Ackerman. Jefferson: McFarland, 1983. 1400pp.

Lentz, Harris M., III. SCIENCE FICTION, HORROR & FANTASY FILM AND TELEVISION CREDITS SUPPLEMENT: THROUGH 1987. Jefferson: McFarland, 1988. 936pp.

*Lucanio, Patrick. THEM OR US: ARCHETYPAL INTERPRETATIONS OF FIFTIES ALIEN INVASION FILMS. Bloomington: Indiana University Press, 1987. Illustrated. 195pp.

Taking the position of a crusader defending a badly maligned genre, the author sets out two objectives: (1) to prove that "there exists a specific body of films, separate from the horror film, that is best described as the alien invasion film and best understood as a distinct part of the science fiction genre," and (2) to demonstrate that "Jungian psychology . . . [is] a practical and meaningful methodology for the study of films which, like the alien invasion film, have too often been excluded from critical assessment for vague and arbitrary reasons, foremost of which is their ostentatious rejection because the titles alone imply some kind of irresponsible, tasteless, and inconsequential formula." Lucanio's head-on attack on genre criticism and his stimulating assertions about the films' being projections of our repressed unconsciousness result in a lively, challenging, and highly entertaining study. Endnotes, a filmography, a bibliography, and an index add to the scholarly discussions throughout the text. Recommended for special collections.

*Manchel, Frank. AN ALBUM OF GREAT SCIENCE FICTION FILMS. Rev. ed. New York: Franklin Watts, 1982. Illustrated. 88pp.

"Outstanding movies, television series, and important eras in the history of science fiction film production are treated in this book. Approximately 111 black-and-white stills illustrate the text, which is organized in chapters in rough chronological order from the 1902 French movie, A TRIP TO THE MOON, through the 1982 release, E. T.: THE EXTRA TERRESTRIAL. The introduction distinguishes between science fiction films and the overlapping (excluded) genres of horror and fantasy. The chapters provide a leisurely discussion of the approximately 130 selected titles, not only covering routine matters such as plot, characters, actors, writers, producers, and directors, but also placing each film in perspective according to period or country of production, special effects, themes, historical impact, and sense of social responsibility (the latter a hallmark of many sf films). A brief bibliography and index of names and titles conclude the volume.

The ALBUM, now in its second edition, is a pleasure to browse through, both for its illustrations and for the insights it provides. Its careful definition of science fiction, and its contrast of films with published works should be quite useful to teachers as well as to students and other fans."[447]

Menville, Douglas. A HISTORICAL AND CRITICAL SURVEY OF THE SCIENCE-FICTION FILM. New York: Arno Press, 1975. 185pp.

Initially a 1959 master's thesis at the University of Southern California, the minimally revised study indicates how far the subject has developed over a twenty-year period. The first version provided the only serious examination of a genre held in very low esteem. The second version has made no changes in the main body of the text, adding only a brief introduction and an index. Thus the omissions and limited historical and critical information associated with Menville's original chronological narrative are more pronounced when compared with other existing material, including his newer 1977 publication. Serious students will appreciate the author's pioneering efforts and gain a good perspective on how film scholarship has evolved. Worth browsing.

*Menville, Douglas, and R. Reginald. THINGS TO COME: AN ILLUSTRATED HISTORY OF THE SCIENCE FICTION FILM. Introduction Ray Bradbury. New York: Times Books, 1977. Illustrated. 212pp.

[447] Mary Jo Walker, "Book Review: AN ALBUM OF GREAT SCIENCE FICTION FILMS, Rev. ed.," AMERICAN REFERENCE BOOK ANNUAL 1984, pp.475-6.

Menville's most recent effort at surveying the history of the genre benefits from a superior collection of illustrations and a more casual writing style. Together with Reginald, he revisits the familiar path from the first moon maidens of the silent era to the climactic days of early 1977, when STAR WARS was revolutionizing the science fiction formula. Brief synopses and critical comments link one film to another in a survey that moves rapidly through eighty years of visual and technical wonders. The one serious flaw is that not enough credit has been given to the special effects personnel and their major contributions to the genre. A case in point is the several page review of STAR WARS, which relies almost exclusively on a retelling of the plot. A bibliography and index complete the book. Worth browsing.

*Meyers, Richard. S-F 2: A PICTORIAL HISTORY OF SCIENCE FICTION FILMS FROM "ROLLERBALL" TO "RETURN OF THE JEDI." Secaucus: The Citadel Press, 1984. Illustrated. 256pp.
A companion volume to A PICTORIAL HISTORY OF SCIENCE FICTION FILMS, this pleasant coffee-table book regales us with chatty information about dozens of science fiction movies from 1975 to the mid-1980s. Nine chronologically arranged chapters, filled with lovely illustrations, provide plot summaries, production information, and anecdotes about the filmmakers and the stars. No documentation is presented for the many assertions made. Neither is there a filmography or an index. Worth browsing.

Meyers, Richard. THE WORLD OF FANTASY FILMS. South Brunswick: A. S. Barnes and Company, 1980. Illustrated. 195pp.
A refreshing look primarily at the years from 1975 to 1979, this affectionate and detailed chronology is conceived as an extension of Jeff Rovin's THE FABULOUS FANTASY FILMS. Meyers explores the contributions to the fantasy film formula made by movies like JAWS (1975), KING KONG (1977), and SUPERMAN (1978), while taking a longer backward look at the impact of television and animation on the genre. His book is divided into five enjoyable sections: the Occult--e.g., THE SENTINEL (1976), CARRIE (1976), AUDREY ROSE (1977); Beasts--e.g., THE WHITE BUFFALO (1977), THE SWARM (1978), IT LIVES AGAIN (1978); Fantastic Science--e.g., AT THE EARTH'S CORE (1976), THE SPY WHO LOVED ME (1977), STARSHIP INVASIONS (1978); Television--e.g., BEWITCHED (1964-82), THE PRISONER (1968-69), KOLCHAK: THE NIGHT STALKER (1974); and Cartoons--e.g., GERTIE THE DINOSAUR (1909), PORKY'S DUCK HUNT (1937), THE RESCUERS (1977). Over 160 well-produced visuals illustrate the author's brief plot summaries, critical comments, and historical insights. An extensive index is provided. Recommended for special collections.

*Nicholls, Peter. THE WORLD OF FANTASTIC FILMS: AN ILLUSTRATED SURVEY. New York: Dodd, Mead and Company, 1984. Illustrated. 224pp.
A beautifully illustrated resource book that chronicles the evolution of the genre, this guide also provides a detailed look at parallel developments in special effects technology. The author, while giving the impression that he is mainly aiming his information at film buffs, does a nice job of analyzing and evaluating over 300 films. Seven factual chapters, filled with stunning illustrations, provide the basic details; while an extensive filmography adds more information on a total of 700 films. An index and bibliography are included. Recommended for special collections.

Parish, James Robert, and Michael R. Pitts. THE GREAT SCIENCE FICTION PICTURES. Metuchen: The Scarecrow Press, 1977. Illustrated. 390pp.

This valuable reference book presents over 350 genre titles from the silent era to the present in alphabetical order, complete with cast and production credits, synopses, excerpts from reviews, general background information, and editorial comment. A limited selection of visuals adds to the book's appeal for general readers, while Vincent Terrace's useful listing of science fiction programs on radio and television provides an a bonus. The one surprising aspect in such an extensive resource book is the limited bibliography. Recommended for special collections.

*Peary, Danny, ed. OMNI'S SCREEN FLIGHTS/SCREEN FANTASIES: THE FUTURE ACCORDING TO SCIENCE FICTION CINEMA. Introduction Harlan Ellison. Garden City: Doubleday and Company, 1984. Illustrated. 310pp.
 This welcome anthology contains more than forty original essays by gifted commentators on "futuristic films." These movies that tell us about what the earth will be like five, fifty, five hundred, or one thousand years from now have several common concerns: e.g., an antinuclear bias, a distrust of artifical life, an anxiety over technology, a suspicion of scientists and other intellectuals, and an uncertainty about the future. To present alternative perspectives, Peary divides his book into four sections. Harlan Ellison has the Introduction all to himself, as he gives an entertaining overview of the science fiction genre. The next two sections give the viewpoints of film critics (e.g., Joan Mellen, Philip Strick, David Thomson, Michael Goodwin, Allen Eyles, Richard Schickel, and Gerald Peary), famous science fiction writers (e.g., Isaac Asimov, Frederick Pohl, Robert Scheckley, Robert Silverberg, Robert Bloch, Harlan Ellison, and Harry Harrison), and noted filmmakers (e.g., Nicholas Meyer, Stanley Kramer, Cornel Wilde, Dan O'Bannon, Paul Bartel, John Badham, and John Sayles). Also included are exclusive interviews with stars and filmmakers like Buster Crabbe, Sigourney Weaver, Leonard Nimoy, Roger Corman, Ridley Scott, Michael Crichton, and George Miller. The final section provides a brief filmography of futuristic films.
 The lovely blending of color and black-and-white illustrations with an all-star lineup of celebrities and thoughtful prose makes this publication a pleasure to read. An index is included. Recommended for special collections.

Pickard, Roy. SCIENCE FICTION IN THE MOVIES: AN A-Z. London: Frederick Muller, 1978. Illustrated. 160pp.
 How interested are you in finding out the answers to questions like "How many intergalactic languages can See Threepio translate in STAR WARS"? Do you have a need to know the name of the spacecraft that traveled to Jupiter in 2001: A SPACE ODYSSEY? The answers to these and other delightful bits of trivia are available in this compact dictionary. The author's short but witty general annotations make for very pleasant reading. The film comments come complete with dates, synopses, cast and technical credits, and running times. Recommended as a good gift for science fiction fans.

Rovin, Jeff. THE FABULOUS FANTASY FILMS. South Brunswick: A. S. Barnes and Company, 1977. Illustrated. 271pp.
 Dedicated to films that showcase the supernatural, mythology, or incredible creatures, this nostalgic analysis pays an affectionate tribute to a world where irrationality reigns supreme and common sense sulks in the cellar. Rovin argues that fantasy films are different from horror and science fiction films, because the latter depend a lot on technology and fear rather than on a sense of wonder. To illustrate his enormous fascination with the subject, the author presents us with seventeen enthusiastic chapters on such topics as ghosts, fairy tales, devils, vampires, werewolves, monsters, reincarnations, giant monsters, witchcraft, and magic. The subjective treatment of more than six hundred movies is enhanced by nearly four hundred well-chosen visuals, many of them rare and stimulating. A filmography of five hundred fantasy films, thumbnail interviews with film personalities--e.g., George

Pal, Tony Randall, Robert Wise, Ray Harryhausen, William Castle, Ricou Browning--, and an index complete the informative book. Recommended for special collections.

*Rovin, Jeff. A PICTORIAL HISTORY OF SCIENCE FICTION FILMS. Secaucus: Citadel Press, 1975. Illustrated. 240pp.

Using 450 illustrations to chart the history of science fiction films, Rovin does an above average job of reworking well-traveled territory. His photographic collection captures the range of interests that has preoccupied filmmakers and fans for eight decades, but his film-buff text fails to give very many new insights. Here's a case of affection interfering with critical judgments. A filmography is included, but no index. Worth browsing.

*Rovin, Jeff. THE SCIENCE FICTION COLLECTOR'S CATALOG. San Diego: A. S. Barnes and Company, 1982. Illustrated. 182pp.

A high-camp approach to memorabilia fans, this resourceful book is out to please everyone. Not only are there detailed listings of where to go to get you know what, but there is also an overview of the genre. Sixteen chapters offer expert information on pulp magazines, comic books, comic strips, film stills, movies, record albums, and toys. If you want it, Rovin tells you the best sources to satisfy your needs. In the process, he does a nice job of surveying the field and of illustrating the options. Well worth browsing.

Slusser, George E., and Eric S. Rabkin, eds. SHADOWS OF THE MAGIC LAMP: FANTASY AND SCIENCE FICTION IN FILM. Carbondale: Southern Illinois University Press, 1985. Illustrated. 259pp.

A collection of essays presented at the fourth Eaton Conference, this anthology is a welcome addition to scholarly material on the genres. Fourteen knowledgeable authors pool their ideas on the importance of science fiction and fantasy films to society from the rise of the cinema to the present. The topics include "Genre and the Resurrection of the Past" (Leo Braudy), "Children of the Light" (Bruce Kawin), "Subversive Play: Fantasy in Robbe-Grillet's Films" (Ben Stolzfus), "The Virginity of Astronauts: Sex and the Science" (Vivian Sobchack), "Pods, Blobs, and Ideology in American Films of the Fifties" (Peter Biskind), "Don't Look Where We're Going: Visions of the Future in Science Fiction Films, 1970-1982" (H. Bruce Franklin), "Nostalgia Isn't What It Used To Be: The Middle Ages in Literature and Film" (E. Jane Burns), "The Problem of Realizing Medieval Romance in Film: John Boorman's EXCALIBUR" (Cyndia Clegg), "Achieving the Fantastic in the Animated Film" (Fred Burns), "Musical Fantasy: THE LITTLE PRINCE" (James W. Arnold), "Traditions of Trickery: The Role of Special Effects in the Science Fiction Film" (Albert LaValley), "The 'Videology' of Science Fiction" (Garrett Stewart), "Fantasy, Science Fiction, Mystery, Horror" (George Slusser), and "Born in Fire: The Ontology of the Monster" (Frank McConnell). The writing is uniformly interesting and informative. Endnotes and an index are included.

Sobchack, Vivian Carol. THE LIMITS OF INFINITY: THE AMERICAN SCIENCE FICTION FILM 1950-1975. South Brunswick: A. S. Barnes and Company, 1980. Illustrated. 246pp.

The most satisfying reevaluation of the genre to date, this thoughtful, academic study breaks new ground in the theoretical consideration of science fiction films. Sobchack begins with an extensive analysis of the genre's limitations in terms of definitions and themes. Her discussion of previous scholarship in the areas of horror and science fiction leads her to the conclusion that "The SF film is a film genre which emphasizes actual, extrapolative, or speculative science and the empirical method, interacting in a social context with the lesser emphasized, but still present,

transcendentalism of magic and religion, in an attempt to reconcile man with the unknown." The author then follows up with an imaginative argument for analyzing science fiction films not by their surface imagery, but by the way the iconography functions within the film. She concludes her challenging theory with an argument for rethinking the pedestrian sound effects and dialogue of science fiction films. Her arguments are stimulating, intelligent, and controversial. Worthy of special notice are the innovative ways she uses more than forty visuals to illustrate her theories and not just evoke memories of the films. Film-buffs will be turned off by the dry narrative and the tendency to avoid synopses, analyses of special effects, and original sources. The latter suggest this book as a companion piece to Brosnan's FUTURE TENSE. Serious students may bristle at Sobchack's reluctance to set aesthetic standards for discriminating good from bad science fiction films. The impression she leaves is that every film has something worth discussing. A strong bibliography and index complete the book. Well worth browsing.

*Sobchack, Vivian. SCREENING SPACE: THE AMERICAN SCIENCE FICTION FILM. Second, enlarged edition. New York: Ungar Publishing Company, 1987. Illustrated. 345pp.
 Don't be fooled by the fact that the author has only added one chapter and updated her bibliography for this edition. The new chapter, entitled "Postfuturism," does more than discuss science fiction films since 1977. It also incorporates aspects of contemporary film theory that explore creatively the current thinking on ideology and the film. Sobchack relies heavily on Fredric Jameson's writings[448] to argue that "Today, one need not 'be a Marxist' to realize that aesthetics, politics, economics, technology, and social relations are interdependent cultural phenomena." Regrettably, her extensive bibliography is not always reliable. Well worth browsing.

Steinbrunner, Chris, and Burt Goldblatt. CINEMA OF THE FANTASTIC. New York: Saturday Review Press, 1972. Illustrated. 282pp.
 Fifteen uneven, extended film reviews spotlight classic movies in this disappointing publication. What was intended as a nostalgic overview of the genre turns into a curiously weak picture-and-text history of A TRIP TO THE MOON/LE VOYAGE DANS LA LUNE (1902), METROPOLIS (1927), FREAKS (1932), KING KONG (1933), THE BLACK CAT (1934), THE BRIDE OF FRANKENSTEIN (1935), MAD LOVE (1935), THINGS TO COME (1936), FLASH GORDON (1936), THE THIEF OF BAGDAD (1940), BEAUTY AND THE BEAST/LA BELLE ET BETE (1946), THE THING (1951), 20,000 LEAGUES UNDER THE SEA (1954), INVASION OF THE BODY SNATCHERS (1956), and FORBIDDEN PLANET (1956). The chapters begin with cast and credit information before giving a lengthy synopsis and a few meagre critical observations. Adding to the reader's frustration is the absence of either a bibliography or index. Approach with caution.

Strickland, A. W., and Forrest J. Ackerman. A REFERENCE GUIDE TO AMERICAN SCIENCE FICTION FILMS. Vol. 1. Bloomington: T. I. S. Publications, 1981. Illustrated. 397pp.
 This oversized and important reference book provides researchers with the most detailed information on science fiction films from 1897 to 1929. The material is divided into three decades, each section beginning with an overview of the era and ending with a classification of the films and their releasing companies. The body of the

[448] See Fredric Jameson, THE POLITICAL CONSCIOUSNESS: NARRATIVE AS A SOCIALLY SYMBOLIC ACT (Ithica: Cornell University Press, 1981); and ___, "Postmodernism, or the Cultural Logic of Late Capitalism," NEW LEFT REVIEW 146 (July-August 1984):53-92.

sections is broken down into year-by-year categories, with specific films listed alphabetically. Each entry includes credit and cast data, references, synopses, and critical commentary. Excerpts from reviews of the day and illustrations accompany many of the films after 1900. The commendable enterprise concludes with a filmography, summary lists of film classifications and releasing companies, references, a bibliography, and an index. Recommended for special collections.

*Vale, V., and Andrea Juno. RE/SEARCH #10: INCREDIBLY STRANGE FILMS. San Francisco: Re/Search Publications, 1986. Illustrated. 224pp.

An intriguing guide to neglected films and directors, this cleverly designed resource book offers rare illustrations and provocative biographical portraits of Herschell Gordon Lewis, Russ Meyer, Larry Cohen, Ray Dennis Steckler, and Ted V. Mikels. Claiming that its "functional" approach provides an alternative to the types of traditional criticism directed against films that "test the limits of contemporary (middle-class) cultural acceptability," the editors argue that their perspectives show why films like INSECTS AS CARRIERS OF DISEASE (1945), BLOOD FEAST (1963), THE INCREDIBLY STRANGE CREATURES WHO STOPPED LIVING AND BECAME MIXED-UP ZOMBIES (1964), and MANSON MASSACRE (1977) are "sources of PURE ENJOYMENT AND DELIGHT. . . ." Here is the opportunity to finally satisfy your curiosity about such memorable genres as psychedelic movies, bikers films, women-in-prison films, and juvenile delinquency films. Hard-core voyeurs will be shocked to find that the interviews are shallow and brief; and the pictures, modest and circumspect. Nonetheless, for readers interested in the lower depths of fantastic films, this is a good place to begin. A filmography and index are included. Worth browsing.

Von Gunden, Kenneth, and Stuart H. Stock. TWENTY ALL-TIME GREAT SCIENCE FICTION FILMS. New York: Arlington House, 1982. Illustrated. 250pp.

Don't be deceived by the picture-text appearance of this oversized book. The authors go beyond the standard data-gathering techniques and provide a literate and perceptive analysis of THINGS TO COME (1936), DESTINATION MOON (1950), THE THING (1951), THE DAY THE EARTH STOOD STILL (1951), THE MAN IN THE WHITE SUIT (1951), DONOVAN'S BRAIN (1953), THE MAGNETIC MONSTER (1953), INVADER FROM MARS (1953), THE WAR OF THE WORLDS (1953), THEM (1954), THIS ISLAND EARTH (1955), FORBIDDEN PLANET (1956), INVASION OF THE BODY SNATCHERS (1956), VILLAGE OF THE DAMNED (1960), DR. STRANGELOVE OR: HOW I LEARNED TO STOP WORRYING AND LOVE THE BOMB (1963), ROBINSON CRUSOE ON MARS (1964), 2001: A SPACE ODYSSEY (1968), THE MIND OF MR. SOAMES (1969), COLOSSUS--THE FORBIN PROJECT (1970), and A CLOCKWORK ORANGE (1971). The lucid text gets an able assist from 150 visuals and an intriguing appendix that includes a filmography of the major personalities associated with each film. For example, the entry for THINGS TO COME contains a filmography for Raymond Massey, Ralph Richardson, and Alexander Korda. An index and bibliography are also included. Recommended for special collections.

Warren, Bill. KEEP WATCHING THE SKIES! AMERICAN SCIENCE FICTION MOVIES OF THE FIFTIES. Vol. 1. 1950-1957. Jefferson: McFarland, 1982. Illustrated. 467pp.

The most satisfying and refreshing reference book on the science fiction films of the fifties, it combines a wealth of information, subjective judgments, and critical comments. Warren divides the basic material into eight chapters from 1950 to 1957, although thematically he treats the decade as if it fell into two major sections: 1950-1957 and 1958-1962. He argues persuasively that the era didn't end when the fifties ended, but gradually lost the period flavor in 1962. The chapters list the individual films alphabetically, with the author emphasizing what made the movie good or bad from a technical and innovative perspective rather than just an aesthetic point

of view. As might be expected, more space is devoted to the decade's most important films like FORBIDDEN PLANET (1956) and THE INCREDIBLE SHRINKING MAN (1957), but Warren frequently surprises his readers by championing films like THE MONOLITH MONSTERS and ATTACK OF THE CRAB MONSTERS (both in 1957). A highlight of this unique volume is its many cross-listing features, which include appendexes on cast and credits, films in order of release, announced (but not produced) films, science fiction serials of the 1950s, and an index. Highly recommended for special collections.

*Weldon, Michael, et al. THE PSYCHOTRONIC ENCYCLOPEDIA OF FILM. New York: Ballantine Books, 1983. Illustrated. 815pp.

An acknowledged "celebration" of more than three thousand exploitation movies, the zealous author explains that "PSYCHOTRONIC films range from social commentary to degrading trash." He should know. The former editor of a weekly New York publication, PSYCHOTRONIC, Weldon enjoyed giving TV viewers up-to-the-minute information on which local station was showing the worst movies. Many of these "junk" films are now seen by Weldon as "classics or cult films despite unfavorable critical response or initial box office failure." Among these priceless "gems" are THE LITTLE SHOP OF HORRORS and SEX KITTENS GO TO COLLEGE (both in 1960), PANIC IN YEAR ZERO (1962), HOT RODS TO HELL (1967), and SLAVE OF THE CANNIBAL GOD (1977). The last entry is a good example of what qualifies a film for inclusion in this arbitrary source book. Stacy Keach and Ursula Andress are the film's stars. We're given not only a brief plot synopsis, date and origin of release (Italy), but also the name of the film's director (Sergio Martino) and the original title (IL MONTAGNA DI DIO CANNIBALE). In addition, Weldon points out that the stripping and painting scene in the Bo Derek movie TARZAN, THE APE MAN (1981) is indebted to the similar preparation scene in this film.

In fairness to the book, not all of the alphabetically arranged annotations concentrate on violent themes, sexual imagery, and/or drug-related experiences. Among the science-fiction, horror, and teenage film entries (Weldon's three major categories), there are many features between the 1930s and the early 1980s which are capsulized because they relate to the stars of PSYCHOTRONIC movies: e.g. NINOTCHKA (Bela Lugosi) and THE KEYS OF THE KINGDOM (Vincent Price). The fascinating stills and the interesting information liberally sprinkled throughout the amusing text should appeal to serious students who see in such films important information about the society in which we live. Worth browsing.

Willis, Donald C. HORROR AND SCIENCE FICTION FILMS. Metuchen: The Scarecrow Press, 1972. 612pp.

An impressive listing of close to forty-four hundred titles is presented in this comprehensive and pioneering bibliography, along with production data, full credits, short bibliographical references, and brief critical comments. The information is reliable and concise, and serious students will find the book's organization logical and helpful. An appendix offers a listing of titles announced for 1971-72 release; a listing of shorts (1930-1971) and animated and puppet films; an "out" list of excerpts from horror and science fiction films; and a bibliography. If updated, the text would benefit from a more extensive set of annotations. Recommended for special collections.

*Willis, Donald C., ed. VARIETY'S COMPLETE SCIENCE FICTION REVIEWS. New York: Garland Publishing Company, 1985. 479pp.

Celebrating ninety years of science fiction movies, this valuable collection offers an intriguing overview of the mainstream reactions to the genre from November 23, 1907, to December 26, 1984. Over a 1,000 reviews, chronologically arranged, present not only cast and production credits, but also plot synopses and evaluative comments. In addition to the editor's brief overview of the science fiction film, there is a

much-needed film title index to help in locating a specific review. Well worth
browsing.

Wright, Gene. THE SCIENCE FICTION IMAGE: THE ILLUSTRATED ENCYCLOPEDIA
OF SCIENCE FICTION IN FILM, TELEVISION, RADIO AND THE THEATER. New York:
Facts on File Publications, 1983. Illustrated. 336pp.
 More than a thousand entries alphabetically arranged and sporting over two
hundred photographs compose this notable attempt at a comprehensive historical
survey. The author does a nice job of blending plot summaries, cast and technical
credits, and brief critiques with references to the development of the genre. Anyone
wanting thumbnail information on seminal SF authors and filmmakers, performers,
special effects artists, and easy-to-follow explanations of technical breakthroughs in
special effects will find this text pleasant and entertaining reading. SF purists,
however, will be dismayed at Wright's unwillingness to differentiate among horror,
fantasy, and science fiction films and stories. Well worth browsing.

THE SERIES FILM

Limbacher, James L., ed. HAVEN'T I SEEN YOU SOMEWHERE BEFORE?: REMAKES,
SEQUELS, AND SERIES IN MOTION PICTURES AND TELEVISION 1896-1978. Ann
Arbor: Pierian, 1979. 279pp.
 One of the best and most informative studies on the recycling of movies, this
impressive chronology uses dates, titles, and characters to chart the film industry's
strategies in capturing an audience's interest. The three alphabetically arranged
sections and the several indexes make research easy and fun. Recommended for
special collections.

Nowlan, Robert A., and Gwendolyn Wright Nowlan. CINEMA SEQUELS AND REMAKES,
1903-1987. Jefferson: McFarland, 1988. Illustrated. 966pp.

Parish, James Robert, ed. THE GREAT MOVIES SERIES. South Brunswick: A. S.
Barnes and Company, 1971. Illustrated. 333pp.
 Ambitiously conceived and fun to read, this nostalgic text begins by drawing a
significant distinction among the terms "film series," "serials," and "sequels." Film
series were "built on a basic set of characters, governed by a particular backlog of
events, which control, but do not hinder, the future tide of their happenings."
Serials, on the other hand, were "action chapter plays which conclude each 13- to
20-minute episode with a hopefully rousing anti-climax. . . ." Sequels were "a
self-contained film that spawns continuation follow-up films, dealing with an
established set of characters in a carry-over progression of events. . . ." The
ground rules established, Parish includes in each of his twenty-four chapters a
history of the specific series (including radio and television versions), helpful
biographies of the leading players, complete filmographies for the various episodes
in the film series, and numerous visual illustrations. The series covered include ANDY
HARDY, BLONDIE, BOMBA, BOSTON BLACKIE, BOWERY BOYS, CHARLIE CHAN,
CRIME DOCTOR, DR. CHRISTIAN, DR. KILDARE, ELLERY QUEEN, THE FALCON,
HOPALONG CASSIDY, JAMES BOND, JUNGLE JIM, MATT HELM, MR. MOTO, PHILO
VANCE, THE SAINT, SHERLOCK HOLMES, TARZAN, and THE THIN MAN. More
demanding readers will fault the book's sloppy editing, which permits typographical
errors as well as specious plot synopses. But since this chronology aims mainly at
the film-buff market, it should appeal to the reader's curiosity about struggling

contract players and old-time matinee movies. Regrettably, no index is provided. Well worth browsing.

Zinman, David. SATURDAY AFTERNOON AT THE BIJOU. New Rochelle: Arlington House, 1973. Illustrated. 511pp.

"From Hollywood's standpoint," explains the enthusiastic historian, "series films were an integral part of movie economics. In that period of 'block-booking,' theatres were required to take a series in order to get major productions. And so the series movies were either made by the big studios as a necessary part of the twin-feature setup, or by the shoestring boys who couldn't afford a star. But they were a vast proving ground for some key talents." The filmmakers also knew how to turn a quick profit on standing sets, contract players, and presold popular fictional characters. The book's thirty chapters focus primarily on the series movies in the 1930s and 1940s: e.g., TARZAN, THE WOLF MAN, FRANKENSTEIN'S MONSTER, THE INVISIBLE MAN, THE CISCO KID, SHERLOCK HOLMES, THE SAINT, THE THIN MAN, CHARLIE CHAN, MR. MOTO, FU MANCHU, BLONDIE, and ANDY HARDY. Occasionally, Zinman tosses in a series to illustrate how formula films progressed in later decades (e.g. James Bond and THE PLANET OF THE APE films in the 1960s), or to point out how Americans differed from the British in their depictions of doctors (e.g., THE DOCTOR IN THE HOUSE English series versus the DR. KILDARE and DR. CHRISTIAN American series). Each chapter is filled with pictures, details, and gossip; and all end with a thin filmography. Although not very penetrating, the effort evokes many pleasant memories. A good index is included. Well worth browsing.

THE SPORTS FILM

*Bergan, Ronald. SPORTS IN THE MOVIES. London: Proteus Books, 1982. Illustrated. 160pp.

Enjoyable both as a nostalgic exercise and as a reference book, this highly entertaining text offers the most thorough survey of the genre. Bergan organizes his subject into nine thematic categories: Boxing--e.g., THE HARDER THEY FALL (1965), ROCKY (1976), THE MAIN EVENT (1979); Football--e.g., THE FRESHMAN (1925), HORSE FEATHERS (1932), KNUTE ROCKNE, ALL AMERICAN (1940); Baseball--e.g., THE PRIDE OF THE YANKEES (1942), THE WINNING TEAM (1952), FEAR STRIKES OUT (1957); Horse Racing--e.g., SPORTING BLOOD (1931), A DAY AT THE RACES (1937), THE MISFITS (1961); Motor Racing--e.g., WINNING (1969), THE LAST AMERICAN HERO (1973); the Olympics--e.g., JIM THORPE, ALL AMERICAN (1951), THE JERICHO MILE (1979), CHARIOTS OF FIRE (1981); Tennis, Golf, Rugby, Soccer, and Cricket--e.g., HARD, FAST AND BEAUTIFUL (1951), PAT AND MIKE (1952), THE SPORTING LIFE (1963); Hunting, Shooting, and Fishing--e.g., THE MACOMBER AFFAIR (1947), THE MOUNTAIN (1956), DELIVERANCE (1972); and Basketball, Bullfighting, and Wrestling--e.g., HIGH SCHOOL HERO (1927), THE HARLEM GLOBETROTTERS (1951), THE ONE AND ONLY (1978). The commentary is straightforward, with a concern for demonstrating how sports films provide both escapist entertainment and social statement. Each chapter ends with a short filmography. An index is provided but no bibliography. Recommended for special collections.

Manchel, Frank. GREAT SPORTS MOVIES. New York: Franklin Watts, 1980. Illustrated. 116pp.

"In his usual competent fashion, Manchel provides much content and coverage in his survey . . . Once again . . . making film study attractive to young

readers by intelligent selection, arrangement, and presentation."[449]

Zucker, Harvey Marc, and Lawrence J. Babich. SPORTS FILMS: A COMPLETE REFERENCE. Jefferson: McFarland, 1987. Illustrated. 622p.

THE SPY FILM

*Bennett, Tony, and Janet Woollacott. BOND AND BEYOND: THE POLITICAL CAREER OF A POPULAR HERO. New York: Methuen, 1987. 315pp.

The popular hero who first emerged in Ian Fleming's novels during the 1950s and in films during the 1960s is given a thorough and scholarly review in this highly informative and entertaining book. The authors make clear that their interest in the character goes beyond the film buff level, pointing out that they are also concerned "with the diverse and changing forms in which it has been produced and circulated, and in the varying cultural business that has been conducted around, by means of and through his character during the now considerable slice of post-war history in which it has been culturally active." The in-depth discussions carried out in nine stimulating chapters illuminate important debates about the relationship between film and ideology that have surfaced in the past three decades. Endnotes and an index are included, but no bibliography or filmography. Recommended for special collections.

Brosnan, John. JAMES BOND IN THE CINEMA. 2nd ed. San Diego: A. S. Barnes and Company, 1981. Illustrated. 309pp.

A highly entertaining analysis of Ian Fleming's 007, the comprehensive history covers eleven James Bond thrillers: DR. NO (1962), FROM RUSSIA WITH LOVE (1963), GOLDFINGER (1964), THUNDERBALL (1965), YOU ONLY LIVE TWICE (1967), ON HER MAJESTY'S SECRET SERVICE (1969), DIAMONDS ARE FOREVER (1971), LIVE AND LET DIE (1973), THE MAN WITH THE GOLDEN GUN (1974), THE SPY WHO LOVED ME (1977), and MOONRAKER (1979). Brosnan begins with a good history of how the character was created, the first attempts to adapt Bond for CBS television in 1955, and the steps leading up to the first Harry Saltzman-Albert R. Broccoli film DR. NO. The rest of the book is devoted mainly to discussing the eleven films in chronological order with individual chapters giving production data and behind-the-scenes anecdotes. A concluding section provides information on the movie spinoffs of the Bond series, featuring heroes like Matt Helm and Derek Flint. In the process, the author sketches the reasons for the formula's phenomenal success over two decades: e.g., the unique style, the "we" versus "them" theme, the stress on fantasy, a tongue-in-cheek approach to sex and violence, and the appeal of both Sean Connery and Roger Moore. Brosnan's leisurely writing style buttressed by a good selection of visuals makes this book a delight for Bond fans. Other readers may find a bit much a narrative of this length on a subject the author argues should not be taken seriously. A complete filmography is provided, but no index. Worth browsing.[450]

[449] THE MACMILLAN FILM BIBLIOGRAPHY, p.392.

[450] For additional information, see Drew Minot, "James Bond and America in the Sixties: An Investigation of the Formula Film in Popular Culture," JOURNAL OF THE UNIVERSITY FILM ASSOCIATION 28:3 (Summer 1976):25-33.

Hibbin, Sally. THE OFFICIAL JAMES BOND MOVIE BOOK. Foreword Albert Broccoli. New York: Crown Publishers, 1987. Illustrated. 128pp.

Commemorating the twenty-fifth anniversary of the Bond films, this warm-hearted coffee-table book deserves attention primarily for the more than 110 beautifully produced illustrations. The narrative consists mainly of chatty comments, plot synopses, and cast and technical credits. An index is provided. Well worth browsing.

Parish, James Robert, and Michael R. Pitts. THE GREAT SPY PICTURES. Metuchen: The Scarecrow Press, 1974. Illustrated. 585pp.

An intelligent and extensive reference guide to the genre, the book presents a comprehensive listing of 463 spy movies from the early days of film up to 1972. The entries identify the best European and American productions, indicating full cast and credit data, a synopsis, review, and editorial comment. An attractive feature of the annotations is that the character's name is included with that of the performers. Serious fans will enjoy quibbling with the authors' subjective judgments, while scholars will appreciate the painstaking work done on compiling appendexes dealing with spy-adventure shows on television and on radio, plus a selected bibliography of spy novels. This is clearly the book with which to begin the study of spy films. Recommended for special collections.

*Rubin, Steven Jay. THE JAMES BOND FILMS: A BEHIND THE SCENES HISTORY. Westport: Arlington House, 1981. Illustrated. 183pp.

Covering the same territory surveyed by Brosnan but with a lot less skill and information, this book depends heavily on its excellent and extensive visuals for reader appeal. Film buffs may even prefer Rubin's clever tongue-in-cheek writing style with its fascination for trivia to Brosnan's more in-depth presentation. Production data for each of the eleven films is provided, but no complete filmography or index. Serious students should consult Brosnan first. Well worth browsing.

THE SWASHBUCKLER FILM

*Parish, James Robert, and Don E. Stanke. THE SWASHBUCKLERS. New Rochelle: Arlington House, 1976. Illustrated. 672pp.

More a series of biographical essays than a history of the genre, this devoted study focuses on the stars who portrayed daring men "Knighted by their king, embraced by their one true love, [and] acclaimed by adoring peasants." The eight performers dominating these roles are chronicled here: Tyrone Power, Errol Flynn, Douglas Fairbanks, Sr., Ronald Colman, Stewart Granger, Victor Mature, Cornel Wilde, and Tony Curtis. More than three hundred visuals coupled with extensive filmographies round out the above average separate chapters on the stars, with the primary emphasis on movies rather than on personal history. The history of swashbuckling films is treated in a general introduction by Edward Connor. Throughout the fact-filled volume hard questions are avoided in favor of tactful information. Serious students will need to study more critical accounts, but film buffs should find the material satisfying. An index is provided. Worth browsing.

*Richards, Jeffrey. SWORDSMEN OF THE SCREEN: FROM DOUGLAS FAIRBANKS TO MICHAEL YORK. London: Routledge and Kegan Paul, 1977. Illustrated. 296pp.

The first of a superb series of books about film and society, this perceptive analysis adds a new dimension to our understanding of the neglected genre. Richards traces the chronological development of the swashbuckling film, examining its role as a reflection of the eras that produced it and as an operative force on those eras.

Attention is given not only to the stars, set designers, and directors, but also to changing fashions in heroes, stylized plots and choreography, dialogue, and values. Twelve highly informative chapters examine the genre's appeal, what contributions it made to film history, and how it relates to the long tradition of popular folkloric entertainment. In addition to 175 well-produced visuals and good bibliography, the in-depth look at American and British movie swordsmen is fun reading for both scholars and film buffs alike. A general and a film index are provided. Recommended for special collections.

THE WESTERN FILM

Adams, Les, and Buck Rainey. THE COMPLETE REFERENCE GUIDE TO WESTERNS OF THE SOUND ERA: SHOOT-EM-UPS. New Rochelle: Arlington House, 1978. Ilustrated. 633pp.

Comprehensive and reliable, this major reference book contains entries for almost every American western,[451] regardless of length or producing company, made from 1928 to 1977. Except for the opening chapter on the silent years, the authors divide their material into nostalgic and devoted four- to five-year periods: e.g., The Transition Years, 1928-1932 ("The Perilous Plunge into the Chasm of Fear"); The Boom Years ("Come on, Rebel, We'll Head 'Em Off at the Pass"). Each section begins with a brief essay on the period, followed by an annual filmography. The complete text contains more than three thousand film listings, arranged in chronological order, offering information on production and distribution companies, release dates, running times, director, story and screenplay authors, producer, and casts. Each listing is

[451] The following is a selected list of articles: Peter John Dyer, "A Man's World," FILMS AND FILMING 5:8 (May 1959):13-5, 32-3; George N. Fenin, "The Western--Old and New," FILM CULTURE 2 (1956):7-10; George N. Fenin and William K. Everson, "The European Western: A Chapter from the History of the Western Film," ibid., 20 (1959):59-71; Sidney Field, "Outrage: A Print Documentary on Westerns," FILM QUARTERLY 18:3 (Spring 1965):13-39; "The Six-Gun Galahad," TIME (March 30, 1959):52-4, 57-60; Robert Warshow, "Movie Chronicle: The Westerner," THE IMMEDIATE EXPERIENCE (New York: Doubleday, 1964), pp. 89-106; Frederick Woods, "Hot Guns and Cold Women," FILMS AND FILMING 5:6 (March 1959):11, 30; Frank Manchel, "The Archetypal American," MEDIA AND METHODS 4:8 (April 1968):36-8, 39, 48; William K. Everson, "Europe Produces Westerns Too," FILMS IN REVIEW 4:2 (February 1953):74-9; William K. Everson, "Stunt Men: They Should Be As Well Known As the Stars for Whom They Often Double," ibid., 6:7 (August-September 1955):394-402; George Mitchell and William K. Everson, "Tom Mix," ibid., 8:8 (October 1957):387-97; Anthony Thomas, "Tim McCoy," ibid., 19:4 (April 1968):218-30; John Ford and Burt Kennedy, "Ford and Kennedy on the Western," ibid., 20:1 (January 1969):19-33; Richard Whitehall, "The Heroes Are Tired," FILM QUARTERLY 20:2 (Winter 1966-67): 12-24; Lionel Godfrey, "A Heretic's View of Westerns," FILMS AND FILMING 13:8 (May 1967):14-20; David Austen, "Gunplay and Horses: Howard Hawks Talks about His Way with Westerns," ibid., 15:1 (October 1968):25-7; Jim Kitses, "The Rise and Fall of the American West: Borden Chase Interviewed," FILM COMMENT 6:3 (Winter 1970-71):14-21; Alan Warner, "Yesterday's Hollywood: Western Heroes," FILMS AND FILMING 18:5 (February 1972):34-40; Lewis Beale, "The American Way West," ibid., 18:7 (April 1972):24-30; David Austen, "Continental Westerns," ibid.,17:10 (July 1972):36-42; Ralph Willett, "The American Western: Myth and Anti-Myth," JOURNAL OF POPULAR CULTURE 4:2 (Fall 1970):455-62; and Ralph C. Croizier, "Beyond East and West: The American Western and Rise of The Chinese Swordplay Movie," ibid., 1:3 (Summer 1972):229-43.

also assigned a sequential number, which allows researchers using the alphabetical film title index to locate the film quickly in the text. The profusely illustrated book, its twelve critical essays, and the extensive listings earn the book a place in every serious library on the western. Recommended for special collections.

*Bataille, Gretchen M., and Charles L. P. Silet, eds. THE PRETEND INDIANS: IMAGES OF NATIVE AMERICANS IN MOVIES. Ames: The Iowa State University Press, 1980. Illustrated. 202pp.

Justifiably upset by the confused and fictional images of Native Americans, the editors of this consciousness-raising anthology present a valuable collection of essays describing and criticizing the manner in which "the image of the Indians has radically shifted from any reference to living people to a field of urban fantasy in which wish fulfillment replaces reality." In essence, the Native American is depicted as either a dangerous villain or a doomed and tragic hero. The twenty-five stimulating academic and popular commentaries reprinted from previous publications are arranged in four sections: myth and media stereotyping of Native Americans, early views of Indians in films, later perspectives, and a photographic essay on Hollywood's visual depiction of the Indian. Highly respected contributors like Richard Slotkin, Leslie A. Fiedler, Ralph E. Friar, Nastasha A. Friar, Philip French, John G. Cawelti, Richard Schickel, and Pauline Kael offer provocative observations on the devastating results that the negative indoctrination imposed on all Americans. Among the many films critiqued are A MAN CALLED HORSE (1970), SOLDIER BLUE, LITTLE BIG MAN (both in 1970), ULZANA'S RAID (1972), and BUFFALO BILL AND THE INDIANS (1975). Only the brevity of the selections and the absence of a much-needed filmography detract from the educational value of the text. An annotated bibliography and helpful index complete the volume. Recommended for general readers.

*Brauer, Ralph, with Donna Brauer. THE HORSE, THE GUN AND THE PIECE OF PROPERTY: CHANGING IMAGES OF THE TV WESTERN. Bowling Green: Bowling Green University Popular Press, 1975. Illustrated. 246pp.

The authors say this book sprang from their feeling of schizophrenia resulting from using popular culture to escape from the insane world of the Vietnam War, political assassinations, and events like Kent State and the 1968 Chicago presidential conventions. Thus the narrative is concerned with more than just the evolution of the TV western. It works diligently at demonstrating that the video growth of the genre did not occur in a vacuum. In this context, presidential speeches, television, the westerns, popular singers, consequences of the Vietnam War, and the deaths of the Kennedy brothers, Malcolm X, and Dr. Martin Luther King become part of the complicated story. The Brauers divide their challenging study into three parts: a historical overview of the TV western, an examination of its iconography, and an extended essay on Nixon's Manson speech as it relates to Bob Dylan's 1968 record album JOHN WESLEY HARDING and TV westerns. The narrative never bogs down in pedantic arguments, although the conclusions reached are far from definitive. What's surprising is that the book was initially Ralph Brauer's doctoral dissertation at the University of Minnesota, yet the bibliography and reference material are weak. The book also needs an index. Worth browsing.

*Calder, Jenni. THERE MUST BE A LONE RANGER: THE AMERICAN WEST IN FILM AND IN REALITY. New York: Taplinger Publishing Company, 1975. Illustrated. 241pp.

Written both as social history and film criticism, this absorbing book illustrates how a knowledge of the American West--e.g., its cowboys, Native Americans, cattlemen, sheepherders, lonely heroes, homesteaders--and the myths that surround the West reveal a considerable amount about how we idealize both our past and ourselves. Fourteen lucid chapters subtly and chronologically describe the complex relationship between fictional works, feature films, and the real West. Considerable

space is given to analyzing law enforcement, violence, the role of women, the gold
rush, the coming of the railroad, and the treatment of the Indians. The author never
allows her concern for the truth to detract from her love for the legendary qualities
that appear in the work of film directors like John Ford, Sam Peckinpah, and Howard
Hawks or the writings of authors like Zane Grey, Max Brand, and Luke Short. Her
scholarly but very readable text includes a bibliography, filmography, and index.
Recommended both for general readers and specialists.

Cary, Diana Sierra. THE HOLLYWOOD POSSE: THE STORY OF A GALLANT BAND
OF HORSEMEN WHO MADE MOVIE HISTORY. Boston: Houghton Mifflin Company, 1975.
Illustrated. 268pp.
 Definitely not the definitive story about the stunt men, doubles, and extras that
gave westerns their real action, this anecdotal narrative gives an insider's view of
the genre's history. The author's father rode and performed with these cowboys,
while she worked in the silent era as a child star under the name of "Baby Peggy."
Thus Cary had a unique opportunity to know the band of cowboys she affectionately
describes in her informal study. The men appear as a tightly knit, independent, and
heroic group, never exceeding two hundred over a fifty-year period, who fought as
many battles off screen as on. Film buffs should enjoy her affectionate recollections
about famous personalities like Cecil B. DeMille, Tom Mix, and John Wayne, as well
as the humorous observations about life in Gower Gulch. But serious students will
be disappointed by the absence of any scholarly sources and a much needed index.
Worth browsing.

*Cocchi, John. THE WESTERNS: A PICTURE BOOK QUIZ. New York: Dover
Publications, 1976. Illustrated. 123pp.
 In addition to getting us to guess who were the soldiers of fortune in THE
PROFESSIONALS (1966), or what western Frank Sinatra used for his retirement from
movies, this delightful quiz book offers 238 excellent visuals. They are superbly
grouped into sections on the silent period, the thirties to the seventies, Academy
Awards, the great directors, John Wayne, serials, musicals, comedies, remakes, the
"B" stars, and the big stars. A title and film index are included for the insecure
and the impatient. Recommended as a good gift.

Corneau, Ernest N. THE HALL OF FAME OF WESTERN FILM STARS. North Quincy,
Mass.: The Christopher Publishing House, 1969. Illustrated. 307pp.
 This is a helpful thematic directory of stars and directors connected with cowboy
films, but it's poorly organized for locating information quickly. Lots of good shots
of famous personalities are sprinkled throughout the text. Worth browsing.

*Everson, William K. A PICTORIAL HISTORY OF THE WESTERN FILM. New York:
Citadel Press, 1969. Illustrated. 246pp.
 This is a very much condensed version of Everson's original work with Fenin
in 1962, but a delight to read and look at. It should be read after the longer and
revised 1973 edition. Recommended for special collections.

*Eyles, Allen. THE WESTERN: AN ILLUSTRATED GUIDE. New York: A. S. Barnes
and Company, 1967. Illustrated. 207pp.
 This is a less-expensive directory than Corneau's, but not as accurate or useful.
Over 350 stars, supporting players, directors, screenwriters, composers, cameramen,
and authors are arranged alphabetically and given brief acknowledgments for their
contributions to the genre. A second section provides a film title index, indicating
the year of release and cross listed references to section one. Worth browsing.

Fenin, George N., and William K. Everson. THE WESTERN: FROM SILENTS TO THE SEVENTIES. A NEW AND EXPANDED EDITION. New York: Grossman Publishers, 1973. Illustrated. 396pp.

This is the standard work in English and should be the starting point for American students. It has superb sections on themes, conventions, and directors. In addition, the many well-selected and well-produced visuals add considerably to a very entertaining and intelligent interpretive history. Two major criticisms are the authors' failure to list the sources of their research and the overemphasis on "B" westerns and their minor cowboy actors. An index is provided. Highly recommended for special collections.

Frantz, Joe B., and Julian Ernest Choate, Jr. THE AMERICAN COWBOY: THE MYTH AND THE REALITY. Norman: University of Oklahoma Press, 1955. Illustrated. 232pp.

A serious and respectful examination of the cowboy, it differs from other attempts because the authors place him within a more panoramic view of the real West. Twelve critical chapters explore his environment, the start of the great trail drives, life on the range, myths that have grown up about his lawless behavior, the famous range wars, and the literature that describes his history. The scholarly approach, put into lucid prose and amply documented, serves as a good resource for students examining the relationship between fact and legends. A bibliography and index are included. Recommended for special collections.

*Frayling, Christopher. SPAGHETTI WESTERNS: COWBOYS AND EUROPEANS FROM KARL MAY TO SERGIO LEONE. London: Routledge and Kegan Paul, 1981. Illustrated. 284pp.

If any book can restore films like A FISTFUL OF DOLLARS/PER UN PUGNO DI DOLLARI (1964), FOR A FEW DOLLARS MORE/PER QUALCHE DOLLARO IN PIU (1965), and ONCE UPON A TIME IN THE WEST/C'ERA UNA VOLTA IL WEST (1968) to a place of prominence in the genre, this first-rate study is the one. It is another welcome addition to the excellent Cinema and Society series that expertly appeals to film buffs and scholars alike. Frayling presents a critical/appreciative survey of the best of four hundred Italian westerns produced between 1964 and 1970. He not only analyzes their unauthentic and vulgar characteristics, but also how the better ones deserve the cult status they are accorded by aficionados of the genre. Serious students will applaud the chapters on context and cultural roots, as well as appreciate the inclusion of appendexes on sequences cut from Sergio Leone's westerns, the impact of the Italian movies on American westerns, and a critical filmography. Many wonderful visuals, a strong bibliography, and a name and film title index are included. Recommended for special collections.

Friar, Ralph and Natasha. THE ONLY GOOD INDIAN . . . THE HOLLYWOOD GOSPEL. New York: Drama Book Specialists, 1972. Illustrated. 332pp.

The best book to date asking us to reevaluate the role of Native Americans in the movies, the text contains a detailed history of the cinema's irresponsible contribution to race hatred and misunderstanding of the Indian. The authors trace the problem back to the original explorers to the New World and then show in twenty-two stirring chapters how movies from the silent era to the seventies practiced cultural genocide. What's valuable about the book's perspective is its willingness to identify unusual depictions as well as condemn the preponderance of racist interpretations. For example, John Ford gets applauded for his impartial treatment of the Indian in films like FORT APACHE (1948) and SHE WORE A YELLOW RIBBON (1949) before the Friars criticize him for shifting to an increasingly negative iconography of Native Americans in WAGON MASTER (1950), RIO GRANDE (1950), THE SEARCHERS (1956), and SERGEANT RUTLEDGE (1960). The issues raised are not always persuasively argued, particularly over Ford's treatment of blacks versus Indians in westerns. Nevertheless, film courses that take seriously the need to

discuss stereotyping and the artist-film-audience relationship should have this book on every required reading list. Excellent indexes and eighty visuals add to the book's scholarly value. Highly recommended for special collections.

*Garfield, Brian. WESTERN FILMS: A COMPLETE GUIDE. New York: Rawson Associates, 1982. Illustrated. 386pp.

This ambitious book attempts to cover in one comprehensive volume the most important American westerns since 1927. Taking an arbitrary approach to the definition of the genre, Garfield includes "eastern" films like FORT TI (1953) and SEMINOLE (1953) along with nontraditional westerns like THE GRAPES OF WRATH (1940) and THE MISFITS (1961). They are related by theme or setting to the more traditional westerns from THE GREAT TRAIN ROBBERY (1903) to THE LONG RIDERS (1980). On the other hand, he puts "B" westerns and twelve- and sixteen-chapter serials outside the scope of his encyclopedic text. Throughout, the author takes his subject very seriously, making clear in the book's twelve sections the difference between "the professionalism that entertains and the art that inspires." An iconoclastic tone found in many of the more than two thousand entries may annoy some readers. For example, Garfield makes clear at the outset that he has little patience with anyone who "holds that LITTLE BIG MAN . . . [is] anything more than a pretentious arty work of distasteful parody." The film annotations are arranged alphabetically from ABILENE TOWN (1945) to ZANDY'S BRIDE (1974), and include production data, synopses, and commentary. Over one hundred visuals plus several appendexes and a selective bibliography complete this useful, but highly subjective reference work. Recommended for special collections.

*Graham, Don. COWBOYS AND CADILLACS: HOW HOLLYWOOD LOOKS AT TEXAS. Austin: Texas Monthly Press, 1983. Illustrated. 145pp.

An entertaining mixture of memoir and movie history, this easygoing narrative explores why "Texans have two pasts, one made in Texas, one made in Hollywood." Graham left his native state in the early 1960s to teach English at the University of Pennsylvania. But it was his film course on the western in 1973 that gave him the "privileged chance to take a close look at the popular culture roots of my raising." His research included examination of Hollywood westerns from 1909 to 1982, as well as the TV versions of the state as "a desert inhabited by lusty citizens quintessentially Western in manners and dress." Illustrations from over forty significant films plus amusing anecdotes and down-to-earth observations make the book pleasurable reading. A good survey of the films discussed, a list of sources, and an index add to the book's value. Well worth browsing.

Hamilton, John R., and John Calvin Batchelor. THUNDER IN THE DUST: CLASSIC IMAGES OF WESTERN MOVIES. New York: Stewart, Tabori and Chang, 1987. Illustrated. 160pp.

Relying heavily on photographer Hamilton's thirty-year association with westerns, this superbly illustrated coffee-table book captures the visual elegance of the frontier films. Batchelor's breezy narrative serves mainly as an excuse to show the magnificent shots of film sets, action scenes, and film heroes at work. No filmography or index is included. Recommended for a gift to a good friend who loves westerns.

Hitt, Jim. THE AMERICAN WEST FROM FICTION (1823-1976) INTO FILM (1909-1986). Jefferson: McFarland, 1989. Illustrated. 368pp.

Holland, Ted. WESTERN ACTORS ENCYCLOPEDIA: FACTS, PHOTOS, AND FILMOGRAPHIES FOR MORE THAN 250 FAMILIAR FACES. Jefferson: McFarland, 1988. Illustrated. 512pp.

Horner, William R. BAD AT THE BIJOU. Jefferson: McFarland and Company, 1982. Illustrated. 165pp.
 A wordy and pretentious look at important screen villains and supporting actors, this disappointing book was intended as a tribute to ten character actors who generally play the heavies in westerns: Luke Askew, Neville Brand, Robert Donner, Jack Elam, Bo Hopkins, L. Q. Jones, Strother Martin, Bill McKinney, Andrew Robinson, and Lee Van Cleef. The uneven set of essays is based on telephone interviews the author held with the actors between early 1976 and late 1979. The visuals do little more than identify the actors, while the individual filmographies list only the name of the producing company and date of release. An index completes this marginal effort. Approach with caution.

Horowitz, James. THEY WENT THATAWAY: A FRONT ROW KID'S SEARCH FOR HIS BOYHOOD HEROES--THE OLD-TIME HOLLYWOOD COWBOYS. New York: E. P. Dutton and Company, 1976. Illustrated. 281pp.
 A slight and nostalgic biography of an old-time western fan who, when he turned thirty, set out to meet his favorite screen cowboys. The comments about trail blazers like Gene Autry, Tim McCoy, Joel McCrea, and Sunset Carson strike tender notes, but never provide much in-depth information. Pleasant enough for nondiscriminating readers. Serious students will be dismayed at the lack of footnotes, reference material, filmography, and index. Approach with caution.

*Kitses, Jim. HORIZONS WEST: ANTHONY MANN, BUD BOETTICHER, SAM PECKINPAH--STUDIES OF AUTHORSHIP WITHIN THE WESTERN. New York: Doubleday and Company, 1969. Illustrated. 176pp.
 This AUTEUR approach to western films centers on three directors popular in the 1950s and the 1960s: Anthony Mann, Budd Boetticher, and Sam Peckinpah. Even if most of the narrative is provocative speculation, Kitses discusses the western with more sensitivity than most other writers on the subject. Each director gets his own filmography, but regrettably no general index is provided. Recommended for special collections.

Lahue, Kalton C. WINNERS OF THE WEST: THE SAGEBRUSH HEROES OF THE SILENT SCREEN. New York: A. S. Barnes and Company, 1970. Illustrated. 353pp.
 Devoted exclusively to the western star, this book presents a helpful guide to biographical information about thirty-eight of the silent screen's most popular heroes. Among those profiled are Bronco Billy Anderson,[452] Yakima Canutt, Harry Carey, Hoot Gibson, William S. Hart, Buck Jones, Tom Mix, and Bob Steele. Poor still reproductions affect the book's overall appearance, but not enough to void its usefulness for general information. Approach with caution.

*Lenihan, John H. SHOWDOWN: CONFRONTING MODERN AMERICA IN THE WESTERN FILM. Urbana: University of Illinois Press, 1980. Illustrated. 214pp.

[452] For more information, see Lane Roth and Tom W. Hoffner, "G. M. 'Bronco Billy' Anderson: The Screen Cowboy Hero Who Meant Business," JOURNAL OF THE UNIVERSITY FILM ASSOCIATION 30:1 (Winter 1978):5-13.

This challenging study examines how the western functions as a reflection of the nation's policies from 1945 to the end of the seventies. Over five hundred films are used to explain the effect that McCarthyism, the Cold War, racism, the Korean War, individualism, social conformity, and the Vietnam War had on the shape and content of the significant genre. The author's stimulating content analyses, along with scholarly references to important modern commentators (e.g., David Reisman, Eric Fromm, Herbert Marcuse, John Cawelti), provide fascinating conjectures about the political and social relationships between Hollywood and Washington. The major drawback is that too many of Lenihan's well-intentioned premises require more proof than is provided. Less serious but disconcerting is the author's inability to differentiate between major and minor films. It may be true that taken as a totality, the postwar westerns embraced specific themes. How much these films reflected society, however, is related to the commercial reception that reinforced or negated the filmmaker's success with the public. A good listing of the films covered, an excellent bibliography, and an index are included. Recommended for special collections.

Manchel, Frank. CAMERAS WEST. Englewood Cliffs: Prentice-Hall, 1971. Illustrated. 150pp.
 "Illustrated with stills from outstanding Westerns, CAMERAS WEST is a lively, informative, and detailed movie history which defines the mystique of Westerns."[453]

*Maynard, Richard A., ed. THE AMERICAN WEST ON FILM: MYTH AND REALITY. Rochelle Park: Hayden Book Company, 1974. Illustrated. 130pp.
 The purpose of this competent anthology is to provide suitable resources for the serious study of the western and its implications for society. Most of the excerpts, essays, and commentaries stress the roots of the western myth and reflect the thinking of noted scholars like Philip Durham, Henry Nash Smith, Everett L. Jones, George Fenin, and William K. Everson. Adequate space, however, is provided for film critics like Vincent Canby, Pauline Kael, and Robert Warshow to provide perspectives on the treatment of the real west in the movies. A filmography and distributor roster end the slim volume. Regrettably, no bibliography or index is provided. Worth browsing.

McClure, Arthur F., and Ken D. Jones. HEROES, HEAVIES AND SAGEBRUSH: A PICTORIAL HISTORY OF THE "B" WESTERN PLAYERS. South Brunswick: A. S. Barnes and Company, 1972. Illustrated. 351pp.
 This is the best book to date on the important character actors of the programme westerns made in the 1930s and 1940s. Five perceptive chapters thematically grouped according to topics like heroes, sidekicks, and heavies compare and contrast in alphabetically arranged annotations the life styles and personal fortunes of men like Gabby Hayes, Walter Brennan, and Andy Devine, who worked with big stars like John Wayne, Tom Mix, and Gene Autry. Stills, biographical sketches, anecdotes, and critical commentary blend nicely in this nostalgic reference book. Recommended for special collections.

*McDonald, Archie P., ed. SHOOTING STARS: HEROES AND HEROINES OF WESTERN FILM. Bloomington: Indiana University Press, 1987. Illustrated. 267pp.

[453] Andrea M. Skivington, "Book Review: CAMERAS WEST," LIBRARY JOURNAL 97:8 (April 15, 1972):1619.

Twelve essays on famous stars who rode the range make up this informative and perceptive anthology. The focus is on showing how players like William S. Hart, Ken Maynard, Randolph Scott, Gary Cooper, Gene Autry, John Wayne, Audie Murphy, Ronald Reagan, Burt Lancaster, and Clint Eastwood affected American values and behavior over a ninety-year period. My favorite essay is Sandra Kay Schackel's "Women in Western Films: The Civilizer, the Saloon Singer, and Their Modern Sister." Well worth browsing.

Meyer, William R. THE MAKING OF THE GREAT WESTERNS. New Rochelle: Arlington House, 1979. Illustrated. 464pp.
Aimed more at film buffs than scholars, this superficial book takes a quick look at thirty important westerns, from the time they first took shape to the critical reactions following their release. The sources for the assertions about the problems and issues related to films from TUMBLEWEEDS (1925) to MCCABE AND MRS. MILLER (1971) are never documented, nor does it appear as if the author did any more research than grabbing the most readily accessible film history book off his reference shelf. About the only value to this botched genre attempt are the profuse visuals adequately reproduced. A very limited bibliography and extensive index are included. Approach with caution.

*Miller, Don. HOLLYWOOD CORRAL. New York: Popular Library, 1976. Illustrated. 255pp.
This pleasant and entertaining study of "B" westerns covers the years from 1929 to 1955. A cross between nostalgia and critical appreciation, the narrative touches on the major trends, the key personalities, and the innocent programs that charmed several generations of children at thousands of Saturday matinees. Miller fondly recalls the likes of Hoot Gibson, Ken Maynard, Tom Mix, Buck Jones, Tim McCoy, Bob Steele, Tom Tyler, George O'Brien, Tom Keene, Gene Autry, Roy Rogers, Charles Starrett, Fuzzy Q. Jones, Gabby Hayes, and Warner Baxter. The shopworn conventions of heroes who shot first and asked questions later are discussed, especially their unswerving commitment to a code of honor long since vanished with the changing motion picture code of the 1960s. It's a shame that a little more effort didn't go into producing a bibliography, filmography, and index. Well worth browsing.

*Nachbar, John G., ed. FOCUS ON THE WESTERN. Englewood Cliffs: Prentice-Hall, 1974. Illustrated. 150pp.
Another strong addition to a fine film series, this valuable anthology demonstrates several central themes of the western: e.g., the importance of a three-hundred-year-long confrontation between Europeans and Americans and the North American frontier, a preoccupation in most western films with the period from 1860 to 1890, and the perpetuation of a myth linking the wilderness and a confident belief in America's national identity. In his own essays and those of his contributors, Nachbar exhibits a rare talent for making profound ideas both accessible and stimulating for most audiences. Writers represented in this text include Jon Tuska, Robert Warshow, John G. Cawelti, Jim Kitses, Frederick Elkin, Michael T. Marsden, and Ralph Brauer. The book concludes with a good chronology of the western, an annotated bibliography, and an index. Highly recommended for special collections.

Nachbar, John G. WESTERN FILMS: AN ANNOTATED CRITICAL BIBLIOGRAPHY. New York: Garland Publishing, 1975. 98pp.
The best annotated reference to date on books and articles dealing with the genre. Intelligently organized and demonstrating a detailed understanding of the subject matter, the resource guide is divided into ten sections: selected reference works, western film criticism, pre-1950, specific western films, western film

performers, makers of western films, western film history, theories of western films, the western audience, comparative studies, and westerns in the classroom. The book concludes with a list of periodicals and an author and subject index. Anyone seriously interested in examining westerns should begin with this book. It should serve as a model for other genre studies. Highly recommended for special collections.

*Parish, James Robert. GREAT WESTERN STARS. New York: Ace Books, 1976. Illustrated. 256pp.

A breezy, small-scale review of twenty-five cowboy stars from Gene Autry to John Wayne, this superficial book should satisfy only the most indiscriminate audiences. Each entry identifies the star's date of birth, marital status, and, where appropriate, date of death. This information is followed by a weak biographical commentary illustrated by a single visual and concludes with a chronological film listing. No index or bibliography is provided. Far below the standards of this prolific author. Approach with caution.

Parish, James Robert, and Michael R. Pitts. THE GREAT WESTERN PICTURES. Metuchen: The Scarecrow Press, 1976. Illustrated. 477pp.

Similar in format to the authors' reference works on gangster and spy films, this text lacks the uniqueness of other books. The main reason is not the quality of the more than three hundred film annotations, but the fact that there are more books on the subject available. The detailed casts-characters-credits data, synopses, and critical comments continue the high standards established by the series and are supplemented by Vincent Terrace's listing of radio and television programs and Edward Connor's bibliography of western novels. More than 135 captioned visuals complete this respectable undertaking. Recommended for special collections.

Parish, James Robert, and Michael R. Pitts. THE GREAT WESTERN PICTURES II. Metuchen: The Scarecrow Press, 1988. Illustrated. 428pp.

This updated edition includes not only westerns made after 1976 (the publication date of Volume I), but also titles omitted from the first edition. Special efforts are made to incorporate more "B" westerns than in the past. Comprehensive and informative, it is a welcome addition to current information on westerns. Recommended for special collections.

*Parks, Rita. THE WESTERN HERO IN FILM AND TELEVISION: MASS MEDIA MYTHOLOGY. Ann Arbor: UMI Research Press, 1982. 190pp.

Originally a 1974 Northwestern University Ph.D. thesis, the book examines the creation and development of the western hero concept from its inception in print in the 1830s to its present mass media image. The primary emphasis concerns the generic constraints and artistic variables in the two media's depiction of the hero, and what occurs as that persona moves back and forth from film to television. Four perceptive chapters make a commendable attempt to interpret questions about the roles of history and myth in shaping the American experience, to identify the primary mythmakers and the changes they made in transforming fact to fiction, to explain why both the western and its hero have had such an enduring popularity, and to interpret the impact of these conventions and messages on a mass audience. The author's historical-critical methodology brings a much-needed objectivity to a rather complex undertaking. While the results are not startling, the trail she follows opens up many new interpretations of the genre's role in responding to the needs and dreams of a society. A listing of American television westerns from 1948 to 1972, footnotes, a bibliography, and an index add to the book's scholarly value. Recommended for special collections.

*Pilkington, William T., and Don Graham, eds. WESTERN MOVIES. Albuquerque: University of New Mexico Press, 1979. Illustrated. 157pp.

A switch from nostalgic or pretentious examinations of the genre, this competent anthology takes a look at westerns by commenting on fourteen classic films. The essays, many of which are reprints, explore the range of critical perspectives from structuralism and AUTEURISM to historical and mythological critiques. Generalists more than scholars will enjoy the discussions of THE VIRGINIAN (1929 and 1946), STAGECOACH (1939), FORT APACHE (1948), HIGH NOON (1952), SHANE (1953), RIO BRAVO (1959), HUD (1963), THE WILD BUNCH (1969), LITTLE BIG MAN (1970), A MAN CALLED HORSE (1970), THE GREAT NORTHFIELD MINNESOTA RAID (1972), ULZANA'S RAID (1972), and THE MISSOURI BREAKS (1976). A bonus is the author's witty and intelligent overview of the current status of the western. A bibliography is provided, but not an index. Recommended for special collections

Pitts, Michael R. WESTERN MOVIES: A TV AND VIDEO GUIDE TO 4200 GENRE FILMS. Jefferson: McFarland, 1986. 635pp.

Rothel, David. THE SINGING COWBOYS. South Brunswick: A. S. Barnes and Company, 1978. Illustrated. 272pp.

A nostalgic look at the "B" musical westerns of the 1930s, this pleasant text offers film-buff profiles of saddle crooners like Gene Autry, Tex Ritter, Roy Rogers, Eddie Dean, Jimmy Wakely, Monte Hale, and Rex Allen. Each actor gets a full chapter treatment, complete with a filmography and a discography when possible. For popular but more minor personalities like Dick Foran, Fred Scott, George Houston, Smith Ballew, Jack Randall, Tex Fletcher, Dusty King, James Newell, and Bob Baker, one chapter suffices for all. Much of the appreciative narrative is based upon personal interviews that the author conducted with many of the stars, directors, and related personalities who rode the dusty paths created by the chiefs of Gower Gulch. Don't expect anything extraordinary and the book will be serviceable. Lots of good illustrations, a bibliography, and an index are provided. Approach with caution.

Rothel, David. WHO WAS THAT MASKED MAN? THE STORY OF THE LONE RANGER. Cranbury: A. S. Barnes and Company, 1976. Illustrated. 256pp.

Until something better comes along, this nostalgic study of the birth, development, and status of the Lone Ranger will appeal to film buffs. It provides a good discussion of the popular radio show in the 1930s; a reasonable explanation of how the character was promoted into a cult figure through movie serials, comic strips, and novels; and a helpful analysis of what made it possible for the masked man and his faithful Indian friend to become successful movie and television stars in the late 1940s and 1950s. More than 160 visuals help us "return to those thrilling days of yesteryear," and recreate the conventions of a formula that has worked for two generations. An index is included. Worth browsing.

Sarf, Wayne Michael. GOD BLESS YOU, BUFFALO BILL: A LAYMAN'S GUIDE TO HISTORY AND THE WESTERN FILM. Rutherford: Fairleigh Dickinson University Press, 1983. Illustrated. 279pp.

Intended neither as a history of the genre nor a comprehensive study of the western as an art form or social document, this informal work explores how movies and television have blurred the difference between fact and legend in their treatment of the Old West. Eight entertaining chapters review the film industry's creation of a mythical past where heroes defend the downtrodden, lawmen violently civilize the wilderness, and the Noble Savage is mistreated. Sarf's thematically arranged discussions emphasize the specifics of error and misrepresentation on television and in the movies, yet he concludes that while the resemblance between reality and fiction

was superficial, the degree of similarity between the two was amazing. A bibliography and index are provided. Worth browsing.

*Silver, Charles. THE WESTERN FILM. New York: Pyramid Publications, 1976. Illustrated. 158pp.

Far more sentimental than other genre studies in this commendable series, this book packs the history of the western into fifteen brief chapters. Silver's observations alternate between general comments on conventions to unabashed adoration for directors like John Ford, Raoul Walsh, Howard Hawks, and Anthony Mann. Interestingly, William S. Hart and Tom Mix get special attention denied to the most enduring star of them all, John Wayne. The fast-paced narrative gets considerable help from the many fine visuals. A bibliography, filmography, and index are included. Worth browsing.

*Stedman, Raymond William. SHADOWS OF THE INDIAN: STEREOTYPES IN AMERICAN CULTURE. Foreword Rennard Strickland. Norman: University of Oklahoma Press, 1982. Illustrated. 282pp.

Important and fascinating, this historical examination of the white man's mistreatment in the media of Native Americans is a valuable supplement to the film research done by the Friars. Stedman's treatment takes a broader and more scholarly look at the roots of the negative iconography, beginning with the first reports of the American settlers and the ensuing myths created by the Puritans depicting Native Americans as "a Satanic" presence in the woods. Fourteen detailed chapters, making excellent use in a scholarly manner of literary and popular culture resources, examine the evolution of stereotypes portraying Native Americans as benevolent primitives, savage beasts, or noble elders. The lucid book concludes with a literary and historical chronology, a bibliography, and a general index. Recommended for special collections.

Tuska, Jon. BILLY THE KID: A BIO-BIBLIOGRAPHY. Westport: Greenwood Press, 1983. Illustrated. 235pp.

Everything you need to know about the notorious outlaw is contained in this well-written, highly informative study. In addition to an in-depth biography, the resourceful author traces the gunman's treatment in literature and film, providing many new insights into the Kid's place in American culture. Bibliographies, footnotes, appendexes, filmographies, and an index are included. Recommended for special collections.

Tuska, Jon. THE FILMING OF THE WEST. Garden City: Doubleday and Company, 1976. Illustrated. 618pp.

Concentrating on one hundred westerns from THE GREAT TRAIN ROBBERY (1903) to THE COWBOYS (1972), the author examines chronologically how the genre evolved, who made the important films, who were the principal performers, and what it was like working and living in the eras in which these films represent. Tuska's detailed plot discussions and critical comments along with over two hundred visuals effectively illustrate important trends, the significant studios, and the major genre conventions. Unlike other reference books where an overemphasis on data for the sake of data dominates a dry narrative, this stimulating text neatly blends information with provocative opinions. Regrettably, the author neglects to share his scholarly sources with the reader. He does provide, however, a listing of film rental distributors and an index. Recommended for special collections.

Chapter 3: Stereotyping in Film

The cinema, in many ways the dominant art of our time, has become--because of its nature--a mirror of the community in which it is produced, and it would seem that the relation between the film and society may well become a central problem for critical analysis.

J. A. Wilson, THE CINEMA, 1962

The issue of what movies represent remains one of the most challenging topics discussed by our society-at-large. Are they an art or a product? Do they negatively or positively affect our culture or merely react to the ideological system that produced them? Do they change our behavior or reinforce our dreams? Are they part of a continuum or separate works? More important, did movies develop and grow as an isolated phenomenon or are they part of a mass entertainment system that stretches beyond national boundaries? If it is true that for over seventy years the film industry has operated as an oligopoly, who controls the film industry, for what purpose, and through what means? The central theme of this chapter is an examination of those types of questions.

Five assumptions underline this focus. First, movies are both a business and an art, and the structure of the film industry historically developed with that duality in mind. The importance of that duality is reflected in the controversies over who should control the production of films and their content and what implications that control has for society. Second, movies are not a unique phenomenon. Rather, they are part of an evolving network of mass entertainment satisfying widespread and multi faceted audience needs. The fact that those needs are more perceived than actual does not diminish their importance or relevance. Third, the mass media reveal, through the use of stock situations and social types, significant data about us and our nation. Moreover, this data is based on a dynamic and complex communication process that functions from production to reception. On the one hand, it corresponds to an impersonal relationship between the public and the industry that limits and controls access to the process of production and distribution. On the other hand, it places the film industry in a highly dependent relationship in order to reap maximum profits by catering to the inscrutable preferences of mass audiences. Fourth, theatrical films place their primary emphasis on how and why characters behave as they do. The unstated purpose is to allow audiences to identify with specific emotions and attitudes in order to insure widespread acceptance of the film's entertainment and box-office values. Consequently, another principal concern in this chapter is the manner in which audiences identify with characters and human conflicts in films. Fifth, the film continuum does not operate in a vacuum. Whatever the goals or strategies of the filmmakers themselves, the production, distribution, exhibition, and reception of movies are linked tightly to prevailing political and economic events both at home and abroad. Rarely if ever does the success or failure of a film rely exclusively on the imagination of the filmmaker(s) alone.

Before discussing these issues, I need to reiterate several operational strategies. First, historical and social comments will take precedence over stylistic analyses. That is not to downplay the importance of motivation, camera techniques, acting, screenwriting, or production. But since the purpose of this book is to provide resource information, I want to concentrate on objective data as much as possible. Having said that, I immediately want to acknowledge that pure objectivity is not possible. Not only am I influenced by my personal experiences and values, but individual differences among the vast movie audiences around the world and through time also make any generalizations about reception highly questionable. Thus the tentative observations that follow only outline the patterns and problems that more knowledgeable film scholars will pursue in greater detail. Second, it is helpful at the outset to distinguish between my use of the terms "cinema" and "movies." The former relates specifically to the medium as art. It denotes an artistic form of communication equal to the status afforded the traditional arts. The term "movies" or "films,"

however, relates to the medium as a popular form of entertainment and mass communication. My purpose here is to call attention to its use as a mass medium and to its role in society. There is no intention to denigrate either the medium's quality or importance as an art form. Third, it is also important to make a distinction between "audience" and "spectator." The former refers to a social group, while the latter relates to an individual viewer interacting with a specific text (the form and content of film). Elsewhere in this book, I argue for the recognition of film as art. My interest here is with illustrating how stock situations and social types in theatrical films operate as a social force in society and the problems they encounter.

No one doubts that stereotypes play a crucial role in the mass media. Confusion occurs in understanding what is meant by "stereotypes," and how the concept is perceived and received. According to Ellen Seiter, "reevaluating and clarifying the term . . . [improves] the way we study the media, particularly television, in the academy, in our research, and in our teaching."[1] To that end, she compares and contrasts the different ways researchers in social psychology, mass communications, the humanities, and popular culture use the term. For example, Seiter finds social psychologists explaining stereotypes by referring to cognitive skills, "as one form of mental category among many that allow us to organize information."[2] This often results in a misunderstanding over the ideological role that stereotypes assume. On the other hand, mass communication scholars, who frequently stress the ideological nature of stereotypes, focus on representational issues that distort reality. In such instances, what frequently gets overlooked is how stereotypes originate, what their relationship is to the social structure, and how those concepts evolved. "If we fail to examine the evaluative as well as the descriptive components of stereotypes," explains Seiter, "there is a danger of mistaking the PRESENCE of white, bourgeois values for the ABSENCE of stereotypes and, therefore, for mere truth and realistic respresentations."[3] For their part, humanists employ the term as a form of condemnation to distinguish one-dimensional, flat, and false characterizations from "well-rounded, individual ones."[4] Such a position assumes that art and stereotypes are incompatible. In fact they are not. Great novelists like Charles Dickens often use stereotypes in their characterizations. Popular culturalists, meanwhile, reject such elitist notions and argue instead that stereotyping is part of ALL forms of fiction. The humanist perspective, Seiter points out, oversimplifies "the relationship between culture and society by treating it as direct and unmediated."[5] The drawback in such an approach is the tendency to minimize the relationship between the works produced and the society that produced them. Having compared the various approaches to stereotyping, Seiter concludes that the most sensible approach is to examine stereotypes historically and in comparison to each other. In her words, "We must distinguish between their descriptive and their evaluative aspects, analyzing their history and their content as well as their frequency."[6]

Central to our purpose is the distinction that Orrin E. Klapp makes between stereotypes and social types. If by the former one means immutable, distorted popular images used indiscriminately for specific personalities without accurate references to

[1] Ellen Seiter, "Stereotypes and the Media: A Re-evaluation," JOURNAL OF COMMUNICATION 36:2 (Spring 1986):14.

[2] Seiter, pp.15-6.

[3] Seiter, p.20.

[4] Seiter, p.21.

[5] Seiter, p.22.

[6] Seiter, p.25.

their true characteristics, then clearly "stereotyping" is a negative term. It bases judgments on "perceptual and cognitive deficiencies" while ignoring valuable truths and important social functions. Conversely, the term "social types" accents positive qualities. Unlike stereotypes, social types unite a society by stressing commonsense judgments. The focus is on the familiar rather than the unknown, on firsthand observations rather than prejudice.[7]

Given the increasing tendency of opinion makers to rely on celebrities as important symbols for complex ideas, we need to distinguish between personalities presented as stereotypes, and those presented as social types. A recent negative example in a 1985 press conference was President Ronald Reagan's flip remark, "Make my day" (taken from Clint Eastwood's 1983 film, SUDDEN IMPACT). Forget for the moment that Eastwood's film character is the notorious "Dirty Harry" Callahan, a relentless San Francisco policeman who shows no interest in legal subtleties. Forget that many viewers applaud Callahan's penchant for executing felons rather than for bringing them to trial. Consider instead that the president of the United States thinks it's funny to deal with world problems by referring to Callahan's hard-boiled and gory sense of justice. Consider as well that in an April 1985 Roper poll, Eastwood was "listed as the No. 1 hero of 18- to 25-year-old Americans. Mother Teresa and the Pope were lower on the list."[8]

Perhaps it is also necessary to state that the meaning of words always depends

[7] *Orrin E. Klapp, HEROES, VILLAINS, AND FOOLS: REFLECTIONS ON THE AMERICAN CHARACTER (Englewood Cliffs: Prentice-Hall, 1962, San Diego: Aegis Publishing Company, 1972), p.15. All quotations cited in this chapter are from the later edition.

[8] Aljean Harmetz, "Eastwood Top Event at Cannes," NEW YORK TIMES C (May 13, 1985):16. Interestingly, President Reagan turned to the movies again for a symbol of how to deal with an eighteen-day hostage crisis in June and July of 1985. During one prebroadcast session, he reportedly said, "Boy, I saw 'RAMBO' last night. I know what to do the next time this happens." Cited in Francis X. Clines, "Prayer of Thanks, Dreams of Vengeance," NEW YORK TIMES E (July 7, 1985):1. The sociologist Amitai Etziom noted that many people reacted negatively to the president's allusion, but the George Washington University professor pointed out that people really want "nothing" done: "Rambo allows you to feel tough without getting off your movie seat. Reagan allows you to feel tough without doing the hard work of reacting to terrorism." Cited in Don Wycliff, "Where Have All the Heroes Gone?", NEW YORK TIMES C (July 31, 1985):12. A more commercial reaction to the Rambo issue was the announcement by Coleco Industries, the organization that made Cabbage Patch children a national phenomenon, that it was mass producing a Rambo-doll and accessory line. Cf. Todd S. Purdum, "Coleco to Add RAMBO Line," NEW YORK TIMES D (August 1, 1985):1, 19. The selection of Rambo war toys produced for the 1985 Christmas season by toy manufacturers so revolted the film critics Gene Siskel and Roger Ebert, that they did a special TV show--"Is Hollywood Selling War to Kids?"--on November 23, 1985. The upshot of the half hour program was that both Hollywood and the toy dealers should be ashamed of their crass behavior. The negative reaction to the RAMBO toys is also described in "Groups Protest Toys with War Theme," NEW YORK TIMES C (December 4, 1985):12. For another perspective on President Reagan's use of movie dialogue, see Martin Tolchin, "How Reagan Always Gets the Best Lines," NEW YORK TIMES B (September 9, 1985):8. For insights on what David Morrell, the author of FIRST BLOOD (the thriller that introduced Rambo to mass audiences), feels about his creation, see Scott Heller, "English Professor Who Created Rambo Says Colleagues Don't Scoff at His Work," THE JOURNAL OF HIGHER EDUCATION 31:10 (November 6, 1985):3. For a Soviet reaction, see Elisa Tinsley, "Soviets Assail RAMBO Film Cult," BURLINGTON FREE PRESS A (January 4, 1986):1, 14.

upon the context. Any definition, concept, or word can be distorted.[9] Consider the term "honor," and the way in which it is used in Shakespeare's JULIUS CAESAR by Brutus, Cassius, and Mark Anthony. In the context of this book, "stereotypes" has a dual meaning. When used wisely, the judgments accurately capture what mass audiences feel at a specific time in our history. In that respect, the concept is synonymous with Klapp's social types. However, when stereotypes are used foolishly, the judgments rendered are pedestrian, distorted, and inflexible. They do a disservice both to the issues and to the people who use them. Improperly employed in a motion picture, stereotypes corrupt not only the film's entertainment value, but also its social value to the audience.

The assumption that the mass media can play an important role in shaping or retarding changes in our society is a perspective held by many individuals and groups throughout the past century. For example, in Chapter 2, considerable time was spent discussing how propagandists used the media to support the positions of their governments before, during, and after times of great upheavals throughout the world. In this chapter I will try to provide a historical perspective on the effects of movies on society. Although it is not possible to give a complete accounting of the problems or personalities involved in film history, the intent is to focus on social and economic issues as they evolved in American films over the past century. In doing so, I will delve into many disciplines in which I lack adequate training and insights. But not to explore the contributions of psychology, economics, sociology, and linguistics to the study of film is to ignore the fact that film analysis is a synthetic art. Whenever possible, I have called upon the talents of my colleagues in those fields to offer advice on the intricate relationships between their disciplines and mine. If this effort produces positive results, it is to their credit. Where it fails, the fault is mine.

One underlying and underdeveloped thread in my approach is the notion that mass communication models exist that offer some insights into the process of originating, sending, and receiving a mass media message. Denis McQuail and Sven Windahl offer an excellent summary of the types of graphic descriptions available for discussing and analyzing a variety of communication relationships. For example, they define a model as "a consciously simplified description in graphic form of a piece of reality . . . [that] seeks to show the main elements of any structure or process and the relationships between these elements."[10] These sundry models--e.g., balance, stimulus-response, two-step flow, audience-centered, and free market--help explain how various events and concepts interact with each other and shed light on a range of experiences that most people involved in the mass media continuum do not fully understand or appreciate. The simpler descriptions look only at the structure of a phenomenon. The more complicated ones reveal the important links between our behavior and our culture.

Certain research models are more useful to our purposes than others. For example, Dennis Howitt reports that mass communications scholars have a "Cultural Ratification Model" (CRM) designed to evaluate how "the media, along with many other social institutions, act as agencies of the political control of society."[11] Not

[9] For a good introduction to the verbal taboos in our society and their relationship to film censorship, see Marilyn Hurlbut, "Verbal Taboo in SHAMPOO," JOURNAL OF THE UNIVERSITY FILM ASSOCIATION 28:3 (Summer 1976):35-8.

[10] *Denis McQuail and Sven Windahl, COMMUNICATION MODELS FOR THE STUDY OF MASS COMMUNICATIONS (London: Longman, 1981), p.2.

[11] *Dennis Howitt, THE MASS MEDIA AND SOCIAL PROBLEMS (Oxford: Pergamon Press, 1982), p.16. For an interesting essay on how the film, ALL THE PRESIDENT'S MEN (1976) influenced attitudes toward the press, see William R. Elliott and William J. Schenck-Hamlin, "Film, Politics and the Press: The Influence of ALL THE PRESIDENT'S MEN," JOURNALISM QUARTERLY 56:3 (Autumn 1979):546-53. For another

surprisingly, those people who make the most use of the CRM are Marxists and left-wing political thinkers. On the one hand, they recognize that almost no empirical evidence exists to substantiate how the power structure through the media effectively manipulates the public to accept unpopular points of view or governments. On the other hand, they argue that without oppositional perspectives, the media can and does slow down changes occurring within the culture.

Another useful strategy for examining how people use the mass media is known as "the Uses and Gratification Model" (UGM). In essence, investigators examine the multitude of reasons why the mass media serve as a form of education and as an emotional release for millions of people. The problem is that the research often tells us more about how the public uses the media than about what the media does to the public. In Howitt's words, "The actual research emerging from this approach tends to be banal, stifled by the limitations of method."[12] If we are to avoid the UGM's major drawbacks--e.g., ambiguous terms, serious oversimplifications, and unrealistic expectations--then we need to understand the complexity of the mass communication process and recognize that within each medium there are subtle distinctions that must be accounted for in arriving at conclusions about how people use the mass media for gratification: e.g., not all messages have the same effect, the mass media cannot be examined in isolation for their social context, not everyone reacts to a message in the same way, and some members of the audience (i.e., children and criminals) are more susceptible to media influences than others.[13]

For our purposes, the UGM is linked to the theory that members of the audience experience the need to relate or to empathize with specific film characters and situations. How that theory functions in reality has been investigated by numerous scholars.[14] For example, Mary C. Gentile makes it clear that filmmakers know that audiences who empathize with the feelings and experiences of specific film characters often lose track of reality. In fact, most mainstream filmmakers pride themselves on their ability to involve an audience emotionally. The two most obvious ways in which the process occurs involve getting the audience to suspend disbelief about the characters and action and to rely heavily conventions and popular stars.[15] According to Garth Jowett's extensive research, the key factors in maximizing audience empathy with the characters and action relate to similarities and wishful identification.[16]

The issue here is whether the identification process is beneficial to viewers. Clearly it is, if the audience becomes conscious of tensions and contradictions in society that need rectifying. But too often that is not the case. Audiences unwittingly manipulated by patriarchal film strategies, Gentile claims, find it difficult "to develop a critical subjectivity." Even worse, many of the manipulative experiences in mainstream films are antithetical to the spectator's welfare: "Instead of perceiving

perspective, see Joan Mellen, "Hollywood's 'Political' Cinema," CINEASTE 2:2 (Spring 1972):26-31.

[12] Howitt, p.12.

[13] Howitt, pp.14, 18-26.

[14] For more information, see *Garth Jowett and James M. Linton, MOVIES AS MASS COMMUNICATION (Beverly Hills: Sage Publications, 1980), pp.92-3.

[15] Interestingly, the 1987 Congressional report titled EDUCATIONAL ACHIEVEMENTS: EXPLANATIONS AND IMPLICATIONS OF RECENT TRENDS discounted the impact of TV on Standard Achievement Tests (SATs). According to Edward B. Fiske, the study found that "The television viewing habits of American students have remained relatively constant for two decades and thus cannot be associated with either the decline or subsequent rise in test scores." See Edward B. Fiske, "Report Warns School Reforms May Fall Short," NEW YORK TIMES A (August 24, 1987):13.

[16] Jowett and Linton, p.92.

and recognizing contradiction, the viewer is encouraged to remain within a specific perspective, that of the character with whom the viewer identifies."[17]

One way that mass communications scholars approach these problems is through the concept of "Functionalism." Robert C. Allen explains this theoretical perspective as an "examination of the mass communication media as social and economic systems, each composed of interacting sub-systems."[18] The researchers focus on a variety of arrangements including audiences, production and distribution units, financial sources, and formal and informal regulatory groups. Attention is also paid to the links between the various media. In particular, investigators want to understand the role of the audience in the mass media continuum. Implicit in such research, explains Allen, "is an acknowledgement that a medium may serve multiple purposes, that it may simultaneously satisfy different requirements within individual audience members or speak to the needs of various sub-groups within an audience."[19]

Working on that assumption, it behooves us as serious students to study not only how popular culture allegedly manipulates our emotional needs through myths and symbols, but also what the actual consequences are.[20] At the same time, we need to examine how the variety of social meanings generated by stock situations and social types directly relates to the values and attitudes of a society at a particular time and place.[21] For example, Edward D. C. Campbell, Jr., argues that films "reflect the way we are." From his perspective, what attracts many people to certain historical films is the fact that "they reveal so much about the society which so avidly supported them." He goes on to say that the importance of films, as cultural history, resides in the realization that "each production was concerned--often intentionally--with lessons for the present viewed through a contemporary interpretation of the past." Thus an examination of film history and the subtle variations in specific film stereotypes from the mid-1890s to the present reveals, in Campbell's judgment, significant insights on "how Americans perceived themselves and their racial and economic problems. . . ."[22]

Campbell is not alone in his concerns over how films reflect society. As discussed in Chapter 1, Siegfried Kracauer's extraordinary study, FROM CALIGARI TO HITLER (1947) claims that a psychological pattern of how a nation thinks is discernible in that nation's film content. He points out that

[17] *Mary C. Gentile, FILM FEMINISMS: THEORY AND PRACTICE (Westport: Greenwood Press, 1985), p.74.

[18] Robert C. Allen, VAUDEVILLE AND FILM 1895-1915: A STUDY IN MEDIA INTERACTION (New York: Arno Press, 1980), p.13.

[19] Allen, p.15.

[20] For a recent example of how students claim their ethical values are molded by TV, see Herbert London, "What TV Drama Is Teaching Our Children," NEW YORK TIMES 2 (August 23, 1987):23, 30.

[21] Filmmakers and television producers often use stereotypes when they depict foreign countries and people. The trouble, according to one recent study, is that "The stereotypes influence our national consciousness as well as our personal encounters with foreigners." See "Ethnic Images: What We See Isn't Always Who We Are," NEW YORK TIMES B (April 28, 1986):4. For an example of how different nations trade filmic insults, see Aljean Harmetz, "U. S. and Soviet Film Makers Debate Stereotypes," NEW YORK TIMES C (March 25, 1987):19.

[22] Edward D. C. Campbell, Jr., THE CELLULOID SOUTH: HOLLYWOOD AND THE SOUTHERN MYTH (Knoxville: The University of Tennessee Press, 1981), pp.4-5.

The films of a nation reflect its mentality in a more direct way than any other artistic media for two reasons:

First, films are never the product of an individual

Second, films address themselves, and appeal, to the anonymous multitude. Popular films--or, to be more precise, popular screen motifs--can therefore be supposed to satisfy existing mass desires To be sure, American audiences receive what Hollywood wants them to want; but in the long run public desires determine the nature of Hollywood films.[23]

From Kracauer's perspective, the more certain film conventions remain popular with the public, the more they reveal a nation's collective mentality.

Paul Monaco, in his attempt to analyze the most popular French and German films in the 1920s, takes a different approach to how films reflect society. Instead of arguing that films influence behavior and convey significant information (claims he feels are greatly exaggerated), Monaco stresses the skill of filmmakers in catering to public taste. The problem for scholars is how to relate collective appeal to "a method for analyzing film as a reflection of the group process in society."[24] While crediting Kracauer with "an intriguing account of Weimar cinema that read too much of the films through hindsight," Monaco favors an analysis of the "relationship of collective thoughts as expressed in cultural symbols to actual political events" and focuses on the similarities between dreams and films. "The dreamlike function of the popular cinema," he writes, "reflects concerns about events of the recent past and their aftermath."[25]

Andrew Bergman's book, WE'RE IN THE MONEY: DEPRESSION AMERICA AND ITS FILMS (1971), is yet another example of the concern that authors have about how films reflect society. Starting with the assumption that Americans during the Depression "needed their movies," he set out to prove that films represented considerably more than pure escapism. "People do not escape," he claims, "into something they can not relate to." He went on to say that "As films are not viewed in a void, neither are they created in a void. Every movie is a cultural artifact . . . and as such reflects the values, fears, myths, and assumptions of the culture that produces it."[26] Bergman also points out his disagreements with Kracauer's assertions about the "films of a nation" reflecting its collective consciousness more directly than other artistic media. For example, he agrees that films may be made by a collective process but insists on the overriding importance of the director and screenwriter. As for movies satisfying mass desires, Bergman, unlike Kracauer, finds it impossible to draw a straight linear connection between films and "popular thought."[27]

How to verify the assertions of Bergman, Campbell, Kracauer, and Monaco is a serious problem. The debate over the value of making claims that cannot be empirically demonstrated will be examined throughout this chapter, particularly in reference to the use of a methodology called "content analysis."

[23] *Siegfried Kracauer, FROM CALIGARI TO HITLER: A PSYCHOLOGICAL HISTORY OF THE GERMAN FILM (Princeton: Princeton University Press, 1947), pp.5-6.

[24] Paul Monaco, CINEMA AND SOCIETY: FRANCE AND GERMANY DURING THE TWENTIES (New York: Elsevier, 1976), pp.4-5.

[25] Monaco, p.160.

[26] *Andrew Bergman, WE'RE IN THE MONEY: DEPRESSION AMERICA AND ITS FILMS (New York: Harper & Row, 1971), p.xii.

[27] Bergman, pp.xiii-xiv.

This chapter begins, therefore, with a discussion of the general issues related to film as a form of mass communication. It surveys the basic concerns film critics and historians have about aesthetics, economics, politics, film audiences, and social values in relation to the medium of film and popular culture.[28] The intention is to demonstrate that a study of film stereotypes (both stock conventions and social types) is not merely a matter of looking at film content alone. Rather, it involves an examination of the economic and social history of the film industry in order to understand how production, distribution, exhibition, and external forces realistically determine what role the repetition of stock images and social types plays in our lives and in our culture.

One intriguing approach to examining the interactive process between film and society is proposed by Andrea S. Walsh. Beginning with the premise that popular culture arises out of conflicting social relations as well as consensus, she stresses the need to view its themes as "both historically specific and humanly universal."[29] Furthermore, Walsh insists that we cannot rely solely on traditional methods in analyzing the artifacts and rituals of popular culture. For example, using realism as a criterion is a mistake, because it does not address the underpinnings of public consciousness.[30] And since emotions are a primary factor in the public's attraction to the movies, an effective critical tool is the notion of collective perceptions and the decoding of symbols and myths.[31] This approach allows the scholar to examine the way in which filmmakers play on, and profit from, the emotional needs of the audience. Particularly significant is the concept of "cultural hegemony"--a complex process involving a series of relationships that collectively reflect a nation's social values. Any analysis of cultural hegemony will reveal that it is a multi-dimensional rather than a monolithic process.

The concept, as developed by theorists like Antonio Gramsci and Raymond Williams, operates in three ways. The "dominant" strand reflects the social values of those groups in power. Consider the American mass media's treatment of the Vietnam War from the 1950s to the mid-1980s.[32] Except for low-budget movies like A YANK IN INDOCHINA (1952) and THE QUIET AMERICAN (1958), Hollywood ignored developments in Vietnam. Furthermore, as Jill S. Beerman points out, prior to the

[28]	For purposes of this chapter, "popular culture" relates to the interaction between society and the mass media in which the entertainment produced reflects the experiences and social values of the society-at-large.

[29]	*Andrea S. Walsh, WOMEN'S FILM AND FEMALE EXPERIENCE 1940-1950 (New York: Praeger Publishers, 1984), p.6.

[30]	For a discussion of the relationship between film and reality, see Chapters 1 and 2.

[31]	For a good introduction to the complicated issue of perception in the cinema and in the world at large, see *Dudley Andrew, CONCEPTS IN FILM THEORY (New York: Oxford University Press, 1984), pp.19-36.

[32]	Some recent studies on the relationship between the movies and the Vietnam War are Susan Jeffords, "The New Vietnam Films: Is the Movie Over?", JOURNAL OF POPULAR FILM AND TELEVISION 13:4 (Winter 1986):186-94; ___, "Friendly Citizens: Images of Women and the Feminization of the Audience in Vietnam Films," WIDE ANGLE 7:4 (1985):13-22; Michael Clark, "Vietnam: Representations of the Self and War," ibid., pp.4-11; Steve Fore, "Kuntzel's Law and UNCOMMON VALOR, Or Reshaping the National Consciousness in Six Minutes Flat," ibid., pp.23-32; Judy Lee Kinney, "The Mythical Method: Fictionalizing the Vietnam War," ibid., 35-40; and David James, "Presence of Discourse/Discourse of Presence: Representing Vietnam," ibid., 41-51. For more information, see Chapter 2.

Tet offensive in 1968, "television espoused values which encouraged an uncritical acceptance of Vietnam." Her research demonstrates that the TV networks in the 1950s emphasized the notion that "Communism is evil" and that it was necessary to "sanitize" the violence in war.[33] For this dominant cultural perspective to prevail into the late 1960s, however, Walsh and others argue that it constantly had to battle the social values of both "residual" and "emergent" cultures. That is, the social values of the cold war era--values based on past experiences (residual)--not only had to be carried over into the sixties, but also had to challenge the prevailing social values on the conduct of the Vietnam War. Those residual values about communism, heroics in war, and the domino theory were the basis for many of the authoritarian, militaristic, and nationalistic attitudes articulated by the dominant strand of cultural hegemony.

Moreover, Beerman's research indirectly reminds us how the residual and dominant strands coexisted during the sixties. Noting that two of the ten most popular TV shows (MISSION IMPOSSIBLE and I SPY, ranked fifth and eighth, respectively) focused on military and espionage themes, she indicates how the settings of these shows were located either "in the World War II years or in a timeless cold-war era."[34] The shows themselves illustrate how the dominant strand constantly reworked, adjusted, and reacted to the residual values in terms of the action series. But in the 1960s, new ideas and new relationships pertaining to Vietnam were being explored by a counterculture seeking to challenge both the dominant and residual social values of American society. This anti-war movement, as Howard Elterman describes it, espoused themes that declared the Vietnam War immoral. What's more, "They were anti-authoritarian, anti-militaristic, anti-nationalistic. And they offered a radical critique of the war."[35]

In Walsh's notion of cultural hegemony, the counterculture represented the "emergent cultures," representative of new meanings and positions that were challenging both dominant and residual cultures. Thus, by the mid-1970s, the interaction among the three strands of cultural hegemony had resulted in a series of documentaries, theatrical films, and TV shows exploring the Vietnam War from multiple perspectives. That is not to say that the dominant social values now were those of the emergent cultures, nor is it to argue that the emergent cultures were co-opted by the establishment and thus neutralized. It is to say that to survive, our patriarchal system was forced by social, economic, and political realities to incorporate into our society many of the oppositional elements in "emerging" cultures. The inclusion of "counterhegemony" in our patriarchy, as Walsh explains, represents the dynamics of the process. For Gramsci, it represents "common sense." In essence, everyday citizens, regardless of their political or social power, exert a significant influence on the context in which popular culture is produced and received. It is this interactive process that requires our attention.[36]

[33] Karen J. Winkler, "Television and Film Ignored Vietnam Until the Late 1960's, Scholars Argue," THE CHRONICLE OF HIGHER EDUCATION 31:12 (November 20, 1985):5.

[34] Winkler, p.5.

[35] Winkler, p.9.

[36] Walsh, pp.8-11. Worth noting is the fact that politics and film are neither a new topic nor the special province of film feminists. Jean Furstenberg, the director of the American Film Institute, cites the role of the movie THE RIGHT STUFF (1983) in the 1984 presidential campaign, as well as the influence of Reagan's movie career in his accession to the presidency. See Jean Furstenberg, "Politics and Film: Strange Bedfellows?", AMERICAN FILM 9:3 (December 1983):96. For examples of the fears that people have about movies attacking the dominant strand, see Walter Goodman, "The False Art of the Propaganda Film," NEW YORK TIMES 2 (March 23, 1975):1, 15; Vincent Canby, "When Movies Are Political

A second intriguing approach to studying the role of film as a social force has been described by Julia Lesage. In attempting to establish theoretical parameters, she suggests that we examine film "as a total process from its inception to its reception by an audience."[37] To account for the different reactions to a specific film during different periods of film history, she divides her schemata into six areas. First, the critic studies "the pre-filmic milieu," taking into account everything from past film history to the present, in order to highlight the economic and ideological conditions that predetermine the creation and reception of the film yet to be made. Or, as the French sociologist Pierre Sorlin states the theory, " . . . because it is an item of goods, designed to be sold at a profit, every film puts into operation the rules of its own commercialization."[38] Second, the critic focuses on the "collaborative filmmaker." Here the emphasis is on demonstrating that no single person determines a film's direction and outcome. Third, the critic analyzes the film itself, but not independent of the milieu in which it was created. In this way, the critic reminds us that forces exist that affect the message and the form the finished film takes. Fourth, the investigator examines the audience collectively and individually. Lesage always wants us to view filmmaking as a continuum in which viewers have as much to do with constructing a film's meaning as do the filmmakers or the critics. Fifth, the investigator analyzes the milieu of the audience, thus pointing out that spectators bring to their perception of the film a perspective that is "historically/temporally/spatially/socially different from the maker's milieu. . . ." Finally, each stage in the analysis reflects the fact that production and distribution considerations affect each of the five subsections of the schema. That is, the economic base (e.g., capitalistic and socialistic) determines not only who produces, distributes, and exhibits a specific film, but also how the attitudes of specific audiences influence their reception of films, filmmakers, and milieu.[39] Lesage's plan is to demonstrate how films derive their form, content, and meaning from past associations, present experiences, and current audience reactions.

Usually, assumptions about how the mass communication process operates have some drawbacks. A word of caution is therefore in order. Howitt, in talking about "the Effects Model" of mass communication research (of which more later), points out flaws in that theory and the Cultural Ramification model that are applicable in many ways to the Walsh and Lesage schemata. First, it is false to assume that there is a simple and direct relationship in the mass media between the communicator and the receiver. In fact, just the opposite is true. Moreover, attempts to conduct experimental research that equate events in real life with psychological laboratory tests often lead to the misunderstanding that the two are the same. They are not. Second, while it is important to understand how effects are related to content and how that content is determined, no one, as Howitt states, "has yet discovered a way of investigating the totality of human experience in one fell swoop. . . ." Third, there is no way of accurately measuring how the total effects produced by the media balance

Harbingers," ibid., 2 (December 14, 1980):21-3; and Robert Sklar, "Politics in Film: How Moviemakers Handle Hot Issues," ibid., 2 (July 18, 1982):1, 5.

[37] Julia Lesage, "Feminist Film Criticism: Theory and Practice," JUMP CUT 5/6 (1974):13; *SEXUAL STRATAGEMS: THE WORLD OF WOMEN IN FILM, ed. Patricia Erens (New York: Horizon Press, 1979), pp.144-55. All quotations cited in this chapter are from the former publication, JUMP CUT.

[38] Cited in Keith Reader, CULTURES ON CELLULOID (London: Quartet Books, 1981), p.5.

[39] Lesage, pp.13-5. Brian Henderson advocates a similar point of view, stating "that no text is isolated, discrete, unique, and that none is self-originating. Every text is a combination of other texts and discourses, which it 'knots' in a certain way and from a certain ideological position." See Brian Henderson, A CRITIQUE OF FILM THEORY (New York: E. P. Dutton, 1980), p.217.

out in terms of positive and negative influences. That is, certain programs may indeed induce negative and anti-social behavior. Rarely, however, is there any study of the positive effects produced by anti-crime and non-violent programs. Finally, no one yet has proven that the types of effects produced by the media justify, in Howitt's terms, the need for "pressing concern."[40]

As will become evident later, the fact that no evidence exists to justify the assumptions made by scholars like Walsh and Lesage in no way dismisses the possibility that the scholars may be right. Walsh and Lesage may recognize the existence of a serious problem for which no reliable research tools have yet been created. My purpose here is only to indicate the possible drawbacks in their approaches and to emphasize the tentativeness of their schemata. Even further, it is important to stress at the outset that there is a significant difference between a filmmaker's intentions and the way in which the public receives the released film. No one in the film continuum can ever be certain of what meaning the public will attach to characters, plots, or themes. Nor, for that matter, is there any assurance that values will remain constant from generation to generation.

The work of M. H. Abrams offers a third approach for a simple and manageable yet flexible frame of reference for a study of the art of the film in relation to social issues. As noted throughout this book, the similarities between film and the traditional arts make extrapolation of traditional critical analyses applicable under certain conditions to the study of film. In synthesizing the dozens of historical-theoretical patterns relating to literary criticism, Abrams suggests four basic components that we can transpose meaningfully for our purposes. First, there is the work itself, in this case the FILM. And since it is fashioned by human beings, the second component is the FILMMAKER. Third, the film has a subject, consciously presented or deviously implied, which like the traditional arts, "is derived from existing things--to be about, or signify, or reflect something, which either is, or bears some relation to, an objective state of affairs." This third component, whether intended as a visual picture of human beings and actions, thoughts, and emotions, or of divine essences, is aptly termed THE UNIVERSE. Finally, there is the AUDIENCE: the viewers for whom the work is intended or to whose attention it has come.[41]

These three types of theoretical constructs afford countless opportunities for discussing and analyzing the perplexing alternatives that mass art poses both for society in general and film students in particular. For example, Janet Staiger makes an impressive argument for contemporary scholars examining how film historians, theorists, filmmakers, and critics approach the canonization of films.[42] Concerned more with exposing how the process works than with making a case for relativity, she indirectly employs many of the techniques suggested by the Walsh, Lesage, and Abrams's perspectives. In explaining how the early days of film history acted as the stimulus for the medium's defenders, Staiger points out that the "politics of admission" operated on one basic assumption: "Some moving pictures ought to be included in the group of objects that the cultural elite terms aesthetic."[43] No attempt is made to reexamine the films in light of new ideas, techniques, or content. The process simply is one of admission for a select group.[44]

[40] Howitt, pp.8-9.

[41] *M. H. Abrams, THE MIRROR AND THE LAMP: ROMANTIC THEORY AND THE CRITICAL TRADITION (New York: W. W. Norton and Company, 1958), pp.6-7.

[42] Janet Staiger, "The Politics of Film Canons," CINEMA JOURNAL 24:3 (Spring 1985):4-23.

[43] Staiger, p.5.

[44] The debate over traditional standards of artistic quality is not limited to film

At the heart of Staiger's argument are an attack on the notion of pluralism and a concern with the relationship among the spectator, film, and reality. She sees pluralism as representing a "neutral" or "wait and see" attitude that has unacceptable political consequences. For example, people who wish to use films to advance fascistic or homophobic values, take advantage of pluralists who tolerate extreme views in order to preserve the right of freedom of expression.[45] Staiger thus rejects the pluralist on the grounds that "The study of film is not an experience isolated from our moral and political lives. . . ."[46]

The issue of spectator/film/reality is a complicated matter. Film theorists, as discussed in Chapter 1, have been wrestling with the problem of who and what controls a film's meaning: the creator or the viewer? We will discuss this issue later in the chapter. For now, we need to understand that Staiger refuses to accept either the "text-activated" or the "reader-activated" position. Instead, she insists that film analysis mandates that we focus on "differences (cognitive, cultural, political, psychoanalytical, sexual, etc.), while also considering that groups of readers are constituted by hegemonic and 'sub'-hegemonic systems."[47] That is, we need to examine how films affect us and how we understand and use those experiences in our lives.

At the same time, Staiger indicates how social and economic contexts relate to aesthetic considerations in dealing with the politics of admission. For example, she argues that not only did the status of the popular art form affect the fledgling film industry's profits, but also it became prudent to distinguish between those films that exhibited the "essence of art," and those that did not. One group perceived art as an object that had unique qualities, while another group insisted that a film deserved inclusion in the film canon if it exemplified film maturity. Thus, by the 1920s, critics were debating among themselves the most efficient way to sort out the chaotic state of film production and to select those films that contained "the essence of art." But Staiger finds much of the selection process flawed and misleading. Worst of all, she argues, the evaluative process is self-serving to those who are in positions of power in academic and commercial circles. Her premise is that film canons are not for the good of the majority, but rather for maintaining uniformity and suppressing dissent.

Staiger's position has not gone unchallenged. For example, Dudley Andrew takes exception to the notion that culture represents a single, rather than a competitive, thing. And since the competitors battle with each other to maintain power, he views canons as not only inevitable, but also important. Andrew is most concerned,

circles. Joseph Berger reports that literary scholars are also debating whether cultural and political values are not as significant as cultural values in determining literary quality. Explaining that the concept of "canon" dates back to biblical categories that determine acceptable works, Berger quotes one professor who insists that 'What is being questioned . . . is whether power, beauty, greatness as experienced by one group of people is locked into the work so that those who don't experience that are pathological, or alternatively whether the two different experiences reflect differences about these groups, differences in the historical and social situations." See Joseph Berger, "U. S. Literature: Canon Under Siege," NEW YORK TIMES B (January 6, 1988):6. See also Richard Bernstein, "In Dispute on Bias, Stanford Is Likely to Alter Western Culture Program," NEW YORK TIMES A (January 19, 1988):12.

[45] For an example of how blatant political messages can be in action films, see J. Hoberman, "The Fascist Guns in the West," AMERICAN FILM 11:5 (March 1986):42-6,48.

[46] Janet Staiger, "Janet Staiger Replies to Dudley Andrew and Gerald Mast," CINEMA JOURNAL 25:1 (Fall 1985):61-2.

[47] "Janet Staiger Replies," p.63.

however, that canons not be equated with art, which involves championing one set of values over another, and that is not the function of art, which he views as operating "intimately" and "momentarily." Put another way, knowledge becomes the goal of canons; experience, the goal of art.[48]

Gerald Mast quarrels with Staiger's unstated assumptions about the spectator who reads films. He feels that ideological critics like Staiger generally assume that passive and naive spectators are ingesting mainstream conservative messages. He finds such a position unacceptable for many reasons, including those dealing with matters of evidence, prejudice, and history. "A consistent error of Staiger's ideological critics," Mast argues, "is to take 'realism' at its word without realizing that a 'realistic fiction' or a 'realistic illusion' is either a paradox or an oxymoron, which both filmmakers and film spectators may well understand from the beginning as an ironic rule of the game."[49] Furthermore, he is not willing to trust ideological critics, given the world's experiences with an intellectual tradition that falsely claims a greater insight than other intellectual traditions in matters of wisdom and heresy.

It is not vital to our interests here to argue the strengths and weaknesses of Staiger's neo-Marxist approach. What is important is our understanding that film analyses benefit from examining a film's antecedents, its relationship with other industrial and mass entertainment systems, the underlying assumptions of the collaborative filmmakers, and the variety of meanings that result from the past associations and present experiences of the people who view a film. Furthermore, Staiger deserves recognition for getting us to think anew about the spectator/film/reality issue. By reawakening the debate about the differences between art and reality, she asks us to examine closely the links between how we teach and what we believe. Even further, she stresses the need to be aware of the fact that our lives and teaching strategies are affected by our attitudes about art and the way in which we incorporate aesthetic experiences into our being.

In the pages that follow, we will encounter again and again the arguments that elitist and conservative critics present as indictments of film and television. That is, mass media art desensitizes our emotions, corrupts our taste, and makes us ill-equipped to appreciate beauty. Neo-Marxist film critics go further, arguing that not only are movies profit-oriented, but also that they exist mainly as means of maintaining the STATUS QUO. Almost all of the medium's detractors single out stereotypes as a leading danger to our culture. They become the scapegoat for society's inability to distinguish the boundaries between fiction and reality. They are condemned for causing the breakdown in interpersonal communication and for the debasement of artists and their art.

This chapter, however, offers a different perspective. It suggests that viewers use stereotypes as images and ideas of what commercial artists and mass audiences collectively believe and feel at a particular time and place. Knowing what is being used to represent our values and symbolize our status in society affords us the opportunity not only to reject the ideas we find oppressive and dangerous, but also to take action against false values and distorted images. Thus I am operating on the assumption that film spectators are neither naive nor passive. I also assume that films are not the sum of, or the only experience in, the viewer's worldview. That is, those who watch movies are individuals with familial, religious, social, economic, and political responsibilities. Their judgments therefore are not made in isolation. For the most part, they recognize the difference between fiction and the "real world."[50] What they may not understand or appreciate is the cumulative impact of repetitive images,

[48] Dudley Andrew, "Of Canons and Quietism: Dudley Andrew Responds to Janet Staiger's 'The Politics of Film Canons,'" CINEMA JOURNAL 25:1 (Fall 1985):55-7.

[49] Gerald Mast, "Gerald Mast Replies to Janet Staiger's 'The Politics of Film Canons,'" CINEMA JOURNAL 25:1 (Fall 1985):60.

[50] For a useful discussion of the distinction between fiction and the "real world"

Chapter 3: STEREOTYPING IN FILM

ideas, and stock situations on their behavior and attitudes.[51] Many uncritical viewers may also not realize the value in considering film as more than mere entertainment.

This chapter argues that films have a significant relationship to our past and to our hopes for the future. That is, the filmmakers, intentionally or not, create experiences that trigger childhood fantasies and revive dormant desires and memories. Those events affect our behavior. Furthermore, the range of experiences provided by films and television gives the public more opportunities to enjoy, understand, and appreciate high-quality entertainment than ever before in history. That is not to say that high-quality entertainment is restricted to products representing high culture. It is to say that high-quality entertainment is related to the pluralistic tastes of the public.

This chapter thus reinforces the notion that the communication between the mass media and society is quite complex. Walsh's perspective insists that we view the process as dynamic rather than as static. Lesage's schema provides a framework for debating the notion that conspirators are at work unilaterally propagating an oppressive ideology on a passive audience. Abrams's plan serves as a reminder that meanings and images are a collaborative affair that, properly understood, brings a clearer understanding not only of mass media art, but also of mass media art as a social force in society. And as Staiger's polemic essay on film canons makes clear, there is no consensus on what the essence of film art is, let alone on what a specific film means or represents.[52]

The traditional approach to analyzing films as a social force is to begin with the general recognition that Hollywood movies are perceived as a mass-produced, formula product. Although formula filmmaking was discussed in Chapter 2, it makes sense to review what many film critics and historians have taken for granted in their discussions about American movies. The core qualities of what is commonly referred to as the "Formula" have been summarized by Peter Roffman and Jim Purdy. The ingredients were all in place by 1930 and did not break down until the mid-fifties, when television replaced the movies as the most popular form of mass entertainment. After that shift, American filmmakers reevaluated both their techniques and their formulas. Up to that time, however, the patterns were rather rigid. First, the major studios made certain that their assembly-line products dovetailed with what were perceived as audience expectations and fantasies. Narratives had to be linear, centered around an identifiable hero (or heroine), and depicting a dramatic conflict between a polarized case of good and evil. "Conflict and emotion," point out Roffman and Purdy, "were generally expressed in terms of violent action . . . [and the good-evil battle] called for a clear-cut, gratifying plot resolution--the Happy Ending, in which evil was destroyed and good rewarded."[53] At the same time, each studio made certain to differentiate its product in order to maintain its competitive edge.

made by spectators, see Wolfgang Iser, THE ART OF READING (Baltimore: Johns Hopkins University Press, 1978), p.61.

[51] Roy Huss points out that "Since a daydream or fantasy is usually the release, by a present event, of a storehouse of images created by wishes rooted in the experience of the past, Freud speculates that a work of art may also have its well-springs hidden in aspirations dating back to a far-removed past." See Roy Huss, THE MINDSCAPES OF ART: DIMENSIONS OF THE PSYCHE IN FICTION, DRAMA, AND FILM (Rutherford: Fairleigh Dickinson University Press, 1986), p.27.

[52] For an interesting discussion on how different cultures view the same film, see Stephen Crofts, "BREAKER MORANT: Quibbling Over Imperialism," JUMP CUT 27 (July 1982):13-4.

[53] *Peter Roffman and Jim Purdy, THE HOLLYWOOD SOCIAL PROBLEM FILM: MADNESS, DESPAIR, AND POLITICS FROM THE DEPRESSION TO THE FIFTIES (Bloomington: Indiana University Press, 1981), pp.3-5.

How the major studios varied their formula products is discussed in more detail in Chapter 6. Why the process was necessary and how it evolved are covered later in this chapter. What is worth pointing out here is that by 1934, the Formula had been crystalized into an ideological casing called "The Production Code." While the filmmakers claimed publicly that messages should be sent in telegrams, not in movies, they recognized privately that the effect of the Code was to "spell out in pontifical tones the moral and value system behind the Hollywood Formula. . . ."[54]

Clearly, as Roffman and Purdy discuss, there were exceptions to the Formula process. Anyone in the vast creative pool--e.g., producer, star, director, screenwriter--could influence a film's image or meaning. How often that was done is the stuff that doctoral theses are made of. Even a shift in public taste could alter a film's intended meaning and result in an unintended reception. Furthermore, the fact that a film made money at the box office does not tell us anything more than that many people went to see it. "Box-office revenue," Roffman and Purdy observe, "did not measure audience response to a film, did not record whether the spectator enjoyed or agreed with what he saw."[55] The difficulties in analyzing audience tastes and reactions will be covered later in this chapter. Suffice it to say here that far too many people have operated on the false assumptions not only that the Formula and the self-contained system that produced it represent a defined and predictable explanation of what took place in American film history, but also that the Formula still prevails in American films, without any real awareness on our part of what effects it has on American society.

To better understand how films function as a social force, we need to go beyond such standard interpretations of film history and investigate radical but disciplined approaches to formal questions about the themes and perspectives found in movies. As Alan Lovell points out, the general framework in such structured discussions of form in film is "designed to help more precisely uncover the subject matter of the film--though what the film is 'about' may now be described in less traditional critical terms such as ideology or world view."[56] What must not happen, however, is that we let our interest in formal questions obscure our recognition of the filmmaker's responsibility for providing entertainment for mass audiences. That is yet another issue that we will discuss later. A major concern of this chapter will be to champion the necessity of taking into account historical, cultural, sexual, and social differences when discussing the entertainment film as a social force in our culture, and to disprove the notion that entertainment films contain only trivial meanings and messages.

In the pages that follow, we will find many examples of how film scholars try to explain the multiple approaches that films use to produce significant meanings and messages. Mary Beth Haralovich, in her helpful survey of social film history, identifies

> the vexing problematics which the social history of film shares with other aspects of film study: adequate theorization, methodological assumptions, relations between texts and social subjects, the tentative nature of empirical data and social facts, the care needed in drawing causal and even conjuntional relationships.[57]

[54] Roffman and Purdy, p.6.

[55] Roffman and Purdy, p.9.

[56] Alan Lovell, "THE SEARCHERS and the Pleasure Principle," SCREEN EDUCATION 17 (Winter 1975-1976):53.

[57] Mary Beth Haralovich, "The Social History of Film: Heterogeneity and Meditation," WIDE ANGLE 8:2 (1986):5.

What she suggests is that a fruitful social history should concentrate on two basic and related objectives. First, it should seek to explain how the public shares in the creation of its own social consciousness. Second, it should explain how a study of the past relates to an understanding of the present. Like many authors already cited, Haralovich stresses the need for social film historians to make us aware of all aspects of the film continuum and not limit our attention to films being produced in a vacuum. "If the goal of a social history of film is to show how film participates in the construction and distribution of social knowledge," she writes, "theories and methodologies which can position the processes of film within larger social processes must be talked over."[58]

To appreciate how films communicate ideas and why this type of communication creates problems for individuals as well as governments, we need to establish how studying the movies as popular culture differs from analyzing the aesthetic qualities of the cinema. To repeat what was said earlier, popular terms like "movies" and "films" relate to the way the public perceives and uses the popular form of entertainment for personal and group needs such as escape, identification, information, and enjoyment.

The easiest way to examine such assertions, obviously, is to study books and articles that have analyzed film stereotypes. This approach, which is analogous to reading translations, is not as effective as seeing the actual images in the film. However, in dealing with movies, the films are not always available. In other cases, some distributors' rental prices are prohibitive.

Whatever method is employed, the study of stereotypes should illustrate how stock situations and social types could conceivably affect a work of art and communicate multiple values to mass audiences. In Chapters 2 and 5, I demonstrate the ways in which stereotypes can contribute positively to film experiences. There is also value in studying how they (1) prevent viewers from thinking for themselves, (2) present a distorted viewpoint that is artistically and psychologically misleading, and (3) become a vicious weapon for propaganda purposes by manipulating an audience. By combining elements of the theoretical guidelines suggested by Walsh, Lesage, and Abrams--e.g. cultural hegemony, common sense, milieu, movie, filmmaker, universe, audience, economic structure--I wish to consider the role of film stereotypes as they relate to the function of films in our society and in our lives.[59] There are two basic reasons for doing so: to understand how stereotypes satisfy our needs and to appreciate the ramifications of that relationship.

First, stereotypes are symbols of the world in which we live. Film educators realize (as do other sophisticated people) that human beings need to symbolize their world, that they need to put their disordered perceptions into some order. Susanne K. Langer, for example, feels that the arts are based upon humanity's need and ability to symbolize. Hence, symbolization becomes a basis for all creative, conceptual thinking.[60] Symbols, as well as myths and archetypes, are attempts to help explain ourselves and our society. But in the process of symbolizing, we rely on a level of abstraction that favors hegemony. For example, many feminist film critics believe (not

[58] Haralovich, p.13.

[59] Another viable approach to examining the structure and nature of the film industry can be found in MOVIES AND SOCIETY, where Ian Jarvie poses four basic questions: (1) "Who makes films, and why?" (2) "Who sees films, how and why?" (3) "What is seen, how and why?" and (4) "How do films get evaluated, by whom and why?" For more information, see Ian Jarvie, MOVIES AND SOCIETY (New York: Basic Books, 1970), p.14.

[60] *Susanne K. Langer, PHILOSOPHY IN A NEW KEY: A STUDY IN THE SYMBOLISM OF REASON, RITE AND ART (Cambridge: Harvard University Press, 1942), Chapters 1 and 4.

without good reasons) that the myths and archetypes so valued in our patriarchal society accent male dominance and female dependency.[61] In Jan Rosenberg's words:

From infancy to adulthood, the feminists argue, parents, teachers, and the "media" bombard girls and women with powerful normative signals which embody and perpetuate female subordination and inferiority. Having internalized these media-transmitted messages, most women then "choose" roles on which the age-old structure of female subordination squarely rests. Although the two main (initial) branches of feminism, "women's rights" and "women's liberation," concurred in their diagnoses of the media, they prescribed different remedies. The "rights" branch emphasized reforming the dominant culture, while the "liberationists" put their energies into creating alternative cultural forms, e.g., feminist magazines, newspapers, and "independent" films.[62]

As a result, feminists find themselves in a historical dilemma. On the one hand, they argue that human beings should think critically, and, on the other hand, they claim that we are conditioned to think by the cultural values of the society in which we live. Put another way, symbols are for many people pre-existing codes inextricably linked to a culture's dominant ideology. For example, Claire Johnston argues that

All films or works of art are products: products of an existing system of economic relations, in the final analysis. This applies equally to experimental films, political films and commercial entertainment cinema. The idea that art is universal and thus potentially androgynous is basically an idealist notion: art can only be defined as a discourse within a particular conjecture--for the purpose of women's cinema, the bourgeois, sexist ideology of male dominated capitalism. It is important to point out that the workings of ideology do not involve a process of deception/intentionality. For Marx, ideology is a reality, it is not a lie . . . Clearly, if we accept that cinema involves the production of signs, the idea of non-intervention is pure mystification. The sign is always a product.[63]

In many respects, Langer and Johnston raise issues that indirectly relate to the Effects Model, the Uses and Gratification Model, and the Cultural Ratification Model.
 Neither Langer nor Johnston uses such models, nor do they make claims that art or symbols are universal. But as Robert Bone points out, how a society conceptually symbolizes its values represents a national iconography.[64] In other words, he feels that image-makers bear a responsibility for the images they create.

[61] For the purposes of this chapter, "feminist film criticism" refers to a specific political and analytical perspective in which methodologies from sociology, psychology, film studies, semiotics, and related areas are used to analyze motion pictures in which the relationship between women on the screen and women in society is depicted. The intention is not to suggest that one feminist perspective is more valid than another. It is to suggest that seeing films from the perspective of an "outsider" or "subordinate" position provides an alternative point of view to the standard interpretations of film history, theory, and criticism.

[62] Jan Rosenberg, WOMEN'S REFLECTIONS: THE FEMINIST FILM MOVEMENT (Ann Arbor: UMI Research Press, 1983), p.1.

[63] Claire Johnston, "Women's Cinema as Counter-Cinema," NOTES ON WOMEN'S CINEMA, pp.28-9; SEXUAL STRATAGEMS, pp.139-40. All quotations cited in this chapter are from the publication SEXUAL STRATAGEMS.

[64] For purposes of this chapter, film iconography refers to the ways in which

The artist, or image-maker, is guardian of the national iconography. And since the power of images for good or evil is immense, he bears an awesome responsibility. If his images are false, if there is no bridge between portrayal and event, no correspondence between the shadow and the act, then the emotional life of the nation is to that extent distorted, and its daily conduct is rendered ineffectual or even pathological.[65]

Whether one agrees or disagrees with Bone depends on a perception of how art should function in society.

Obviously, those who believe in the notion of art for the sake of art examine stereotypes differently from those who are worried about the educational and political ideology certain stereotypes represent. What is important for our purposes is that we study films in terms of images and recurring themes and not as single, trivial entities. "It is an approach," Lawrence Alloway forcefully explains, "that accepts obsolescence and in which judgments derive from the sympathetic consumption of a great many films."[66]

There is, however, a difference in quality between a myth and a stereotype.[67] The former, when properly used, serves as a vehicle for primordial images embodying truths about humanity that have recurred throughout the ages. Or, in Freud's terms, myths are "distorted vestiges of the wish phantasies of whole nations--the age-long dreams of young humanity."[68] By using such images, the filmmaker takes advantage of a common denominator in human experience to evoke profound emotional responses and thereby maximize the film's appeal. In critiquing the work of these types of filmmakers, we become concerned with the manner in which the material has been shaped to exploit or to examine "the age-long dreams of young humanity." Stereotypes, on the other hand, are stock conventions or social types that are repeated so often as to become cliches. As indicated in Chapter 2, stereotypes play a significant role in film genres. But far too often the unimaginative filmmaker resorts to stereotypes to give ready-made answers to complex situations. In those instances, the result is an emphasis on prejudice as well as a reinforcement of a limited point of view. One goal of this chapter is to sensitize readers to the different ways in which stereotypes are created and perceived.

filmmakers through the language of film--e.g., editing, camera angles, lighting, composition, acting, music, dialogue, and sound effects--construct a film's meaning and its ideology.

[65] Robert Bone, "Ralph Ellison and the Uses of the Imagination," ANGER AND BEYOND, ed. Herbert Hill (New York: Harper & Row, 1966), pp.100-1.

[66] Lawrence Alloway, VIOLENT AMERICA: THE MOVIES 1946-1964 (New York: The Museum of Modern Art, 1971), p.19.

[67] An example of an alternative point of view is presented by Vivian Sobchack, who argues that "primitive" myths of older civilizations function basically as American genre films in the twentieth century. That is, the genre film "follows codified narrative patterns, uses stereotypical characters, and clusters of action and imagery." Where we part company is in her assertion (false, in my opinion) that genre films derive their appeal "not through novelty but through imaginative repetition of known stories." My position, as argued in Chapter 2, is that both conventions AND novelty are vital to a genre's appeal. For Sobchack's position, see Vivian Sobchack, "Genre Film: Myth, Ritual, and Sociodrama," *FILM/CULTURE: EXPLORATIONS OF CINEMA IN ITS SOCIAL CONTEXT, ed. Sari Thomas (Metuchen: The Scarecrow Press, 1982), pp. 147-65.

[68] Sigmund Freud, "The Relation of the Poet to Daydreaming" (1908), *CHARACTER AND CULTURE, ed. Philip Rieff (New York: Collier Books, 1963), p.42.

A second reason for knowing about film stereotypes is to help us understand their misuse. We are able, simultaneously, to view a record of society's prejudices, to learn how distortions have prevented us from developing our imaginations, and to discover how we have been led astray. Furthermore, a rational understanding of the norms that the images present to the public and of the public's shared responsibility for those images will help us develop better self-images and, hopefully, to become more responsible citizens.[69] This issue is discussed more fully in Chapter 4. Here it is worth restating that films cannot avoid suggesting norms. As Frederick Elkin points out,

> In any society, the norms--the ideas of what are proper and improper, right and wrong, good and bad--are in part implicitly formulated and in part explicitly suggested . . . Every film . . . expresses some norms intentionally or unintentionally. By virtue of the fact that a movie occurs in given settings, has characters and tells a story, it suggests that, depending upon the occasion, one type of behavior and feeling is appropriate and another type is inappropriate; that some goals are worthy and others are unworthy; that certain types of men [and women] are heroic and others are villainous; that some actions merit praise and others merit censure; that certain ideas are serious and others are comic; that certain relationships are pleasant and others are unpleasant.[70]

The difficulty in applying Elkin's theory to film audiences becomes apparent once we recognize the complexity of audience behavior. Here again, it is important to remember that there is no simple and direct relationship among the sender, the message, and the audience.

Both pessimists and optimists have made claims, since the birth of film, that stereotyping of the world in which we live generally and of American life in particular has had, and continues to have, a considerable impact on audiences everywhere. "Although on an individual, case-specific level there may be a grain of truth at the root of the stereotype," Eugene Franklin Wong explains, "the application, the blanketing of the belief, of the case-specific origin to the majority of the target people carries with it serious, even dangerous, implications when a minority group is the object."[71] Wong perceptively points out that the existence of a racial stereotype is not tantamount to labeling the film industry as a racist organization. From his theoretical perspective, time plays a crucial role in determing whether institutional racism exists.[72] That is, change from one stereotype to another is less significant

[69] Huss (p.37) provides a useful summary of Freud's belief that all of us--artists as well as audiences--"share the same fantasies, but no one is able to communicate them DIRECTLY to another because of their shameful, taboolike--often even repressed and therefore unconscious--nature." Thus, the artist disguises the disagreeable elements with "beauty" in a work of art. What Freud advocated, explains Huss, is that we see within works of art opportunities for catharsis. That is, the work offers us a therapeutic chance to release our repressed desires and tensions. For more information, see Sigmund Freud, "Psychopathic Characters on Stage" (1905-1906), STANDARD EDITION, Volume 7, ed. and trans. James Strachey (London: The Hogarth Press, 1953).

[70] Frederick Elkin, "The Value Implications of Popular Films," SOCIOLOGY AND SOCIAL RESEARCH 38:5 (May-June 1954):320.

[71] Eugene Franklin Wong, ON VISUAL RACISM: ASIANS IN THE AMERICAN MOTION PICTURES (New York: Arno Press, 1978), pp.19-20.

[72] Charges of racist characterizations are not limited to American filmmakers. Worth examining is the character of La India Maria, a Mexican movie image depicting a

than the manner and degree to which the industry uses stereotypes to depict a group in society.[73] Another commentator on film myths and symbols, John Clellon Holmes, puts it this way,

It has been said that if you would understand the mind of my generation you must start with World War II, on the theory that a widespread attitude is shaped by a common experience . . . It was the experience of moviegoing in the 1930s and early 1940s, and it gave us a fantasy life in common, from which we are still dragging up the images that obsess us.[74]

Holmes's argument illustrates how people study the media not only from the perspective of what it does to us, but also from the perspective of how we react to the media.

Many commentators stress the value of studying what the media do to us.[75] For our purposes here, one example will suffice. Leslie Gelb, a national security correspondent for THE NEW YORK TIMES, believes that movies like THE CHINA SYNDROME (1979), MISSING (1982), UNDER FIRE, BLUE THUNDER, and SILKWOOD (all in 1983) indicate and reinforce an underlying feeling that our government has become too authoritarian and sinister. Gelb argues that

The overriding themes of these films in recent years cannot be dismissed as "mere entertainment." Many of the liberal-nightmare movies did well at the box office. They also coincided with the emergence of foreign policy as a major point of contention in the coming [1984] Presidential election, worries about a Government increasingly collusive with big business and the nuclear freeze movement . . . The filmmakers sensed the trends and reinforced them.[76]

Clearly, if audiences are affected by such messages and dramatizations, it behooves us to be aware of what the public wants and desires and of the needs and interests of the filmmaker.[77]

poor and illiterate woman who tries to deal with the problems of her society. For more information, see Larry Rother, ""Film Version of Everyman Wins Mexico," NEW YORK TIMES A (November 6, 1988):6.

[73] Wong, pp.20-1.

[74] John Clellon Holmes, "15 Cents Before 6:00 P.M.: The Wonderful Movies of the 'Thirties," HARPER'S MAGAZINE 221 (December 1965):51.

[75] For more information, see *Jack G. Shaheen, THE TV ARAB (Bowling Green: Bowling Green State University Press, 1984); Mark Winokur, "Improbable Ethnic Hero: William Powell and the Transformation of Ethnic Hollywood," CINEMA JOURNAL 27:1 (Fall 1987):5-22; Roger B. Dooley, "The Irish on the Screen: 1," FILMS IN REVIEW 8:5 (May 1957):211-17; Roger B. Dooley, "The Irish on the Screen: II," ibid., 8:6 (June 1957):259-70; Jack Spears, "The Indian on the Screen," ibid., 10:1 (January 1959):18-35; Maryann Oshana, "Native American Women in Westerns: Reality and Myth," FILM READER 5 (1982):125-31; Robert Larkin, "Hollywood and the Indian," FOCUS ON FILM 2 (March-April 1970):44-53; and CELLULOID EGGHEAD: THE PORTRAYAL OF THE INTELLECTUAL IN THE AMERICAN FILM, 1930-1976 (Unpublished Ph.D. dissertation: University of Southern California, 1977).

[76] Leslie Gelb, "Do Movies Predict the Public Mood?", NEW YORK TIMES H (April 8, 1984):36. For another perspective, see Walter Goodman, "Hollywood's Spotty Record on Foreign Affairs," ibid., H (August 31, 1986):11, 20.

[77] An interesting offshoot of this phenomenon is the reaction of Jeremy Larner, the

Whichever perspective one accepts on the Uses and Gratification approach to film, it is important to remember that images can be used to maintain the STATUS QUO. It is also important to remember that in determining how the STATUS QUO is maintained, we need to consider what the intentions of the filmmaker were. Because the film continuum has created numerous stereotypes, let us examine what they are and what presumed influences they have had on society, as well as the extent and the range of the process.

We first start with a discussion of the relationship between ideology and entertainment, followed by a general overview of what stereotyping is and how it is perceived by alarmed social critics. Next we consider how film critics and therapists analyze the film-audience relationship. From there, the chapter reviews how the growth and the development of the film industry led to the present domination of producers-distributors over exhibitors, and how this affects the multiple roles movies perform in our society. The nature and composition of the film audience is considered in the next section, followed by a sampling of the types of stereotypes produced by the film industry. The chapter concludes with a discussion of how pressure groups have attempted to control film content in order to prevent a restructuring of American society away from traditional values and mores.

IDEOLOGY VERSUS ENTERTAINMENT

At the outset, we need to understand that many people throughout the ages have been hostile to entertainment in general. In his historical analysis of why social critics perennially attack entertainment, Harold Mendelsohn comments:

In short, entertainment is relegated to those rubrics that are ordinarily reserved for the "evils of society" such as prostitution, alcoholism, drug addiction, sexual promiscuity, criminality and the like. Further indication that entertainment is generally equated with evil in our society among the responsible sectors of our culture is the occasional distinction that is accorded to "wholesome" or "family" entertainment as contrasted with just "entertainment" which, when the noun is not accompanied by a positive modifier, is presumed to be "unwholesome" or unfit for the normal family. [78]

It is not uncommon, therefore, to find the same attacks made consistently about the content of television programs and movies. That is, screen images are accused of pandering to our prurient interests and of inciting anti-social behavior. [79] Validity often has no relation to facts. For example, Mendelsohn argues that the theory of

screenwriter of THE CANDIDATE (1972), who feels that politicians and the public misunderstood the ironic nature of the film. See Jeremy Larner, "Politics Catches Up to THE CANDIDATE," NEW YORK TIMES E (October 23, 1988):23.

[78] *Harold Mendelsohn, MASS ENTERTAINMENT (New Haven: College and University Press, 1966), p.18.

[79] For more information on the debate relating to mass culture, entertainment, and films, see Robert Albert, "The Role of the Mass Media and the Effect of Aggressive Film Content Upon Children's Aggressive Responses and Identification Choices," GENETIC PSYCHOLOGY MONOGRAPH 55 (1957):223-85; D. W. Brogan, "The Problem of High Culture and Mass Culture," DIOGENES 3 (1954):1-17, Rpt. in MASS CULTURE: THE POPULAR ARTS IN AMERICA, pp.59-73; Jay Haley, "The Appeal of the Moving Picture," QUARTERLY OF FILM, RADIO AND TELEVISION 6:4 (Summer 1952):361-74; Dwight Macdonald, "A Theory of Mass Culture," DIOGENES 5 (1954):1-13; and Martin Quigley, "The Importance of the Entertainment Film," ANNALS OF THE AMERICAN ACADEMY OF POLITICAL AND SOCIAL SCIENCE 254 (November 1947):65-9.

people using entertainment as a form of "escape" is not a valid sociological proposition. His data demonstrate that both extremes of the social register in America use the mass media in much the same way and at the same rate. Clearly, both groups do not have the same reasons or needs for escape. As a result, Mendelsohn concludes that people learn from the movies because they either like the characters or aspire to be like them. Known as the "Reference Group theory," it suggests that movies cater to the emotional needs of the audience.[80] In much the same way, movies also function as "social lubricants" that facilitate new social relationships as well as solidifying old ones. Frequently, it is mass entertainment that provides opportunities for young people to develop feelings of mutual rapport.[81] In essence, the mass media can be seen as strengthening rather than weakening an individual's self-image and confidence.

Confronted with a constant barrage of negative reactions to film and television, it helps to put these complaints against the media into a historical perspective. In that way, one can see more clearly how the problems of acceptance faced by the media are not limited to film or television. For example, the emergence of the telegraph in the mid-1800s radically transformed American newspapers from personal and political publications to news-gathering organizations. The attacks on this revolutionary switch brought forth the by-now standard charges that technological changes in communication were harming the American character by emphasizing trivia, adding to the strain of everyday life, and undermining democracy by weakening the intellectual power of the public to make rational decisions. Since then, these same charges have been leveled against radio, movies, and television. The best modern example is the current furor over the docu-drama and its blurring of fact and fiction. In fact, as Robert Edward Davis discovered,

> From 1906 through 1955, whenever writers wished to dramatize the spectacular dangers of innovation, whenever proponents sought to support the need for new regulation of the media, whenever defenders felt it necessary to justify existing systems of censorship, they turned to arguments of morality. Never was the line of argument discarded, nor was it changed substantially through the years . . . In each new attack, and for each new generation of readers, arguers made certain that the audience was aware that in dealing with the mass media they were involved in a moral controversy.[82]

What makes this historical litany of charges against the media relevant to our academic concerns is its theoretical underpinnings. The presumption is that the media, by virtue of their content and context, can influence the public. But no one understands fully just how the process works. Do the media in fact alter behavior, socialize the audience, and affect our values? If the answer is affirmative, then how is the influence manifested and with what consequences? What proof is there that the impact is positive or negative? Even further, by whose standards are these judgments measured? These issues cannot be resolved in this book. They require more space and more expertise than I possess. Let it suffice to say that an examination of the development of the technological revolution in communication since the mid-1800s will give us a better grasp of the issues of why and how the media have altered our culture, even if it will not provide a definitive answer to these questions.

Thomas Kando takes a similar tack in his attempt to provide a conceptual

[80] Mendelsohn, pp.53-4.

[81] Mendelsohn, p.76.

[82] Robert Edward Davis, RESPONSE TO INNOVATION: A STUDY OF POPULAR ARGUMENT ABOUT NEW MASS MEDIA (New York: Arno Press, 1976), pp.229-30.

framework for discussing both the heuristic and pragmatic values of popular culture.[83] His analysis begins by making it clear that the ideological debate over the value of popular culture essentially is between two warring groups--those who are repulsed by mass culture (e.g., elitists, conservatives, and idealists)[84] and those who defend it (e.g., liberals, optimists, realists).[85] Complicating matters is the fact that each group uses fuzzy definitions of what it means by culture, popular culture, high culture, mass culture, mass media, mass leisure, and mass consumption.

There is no confusion, however, about why the two groups view mass culture as good or bad. The idealists insist that catering to the masses impedes cultural progress. Where once the best a society had to offer in terms of taste and values was handed down by an educated class to one less educated, it now is commonplace for the masses to indulge their base tastes without the benefit of traditional standards. Popularity rather than quality, commercial benefits rather than aesthetic values, and irresponsible image-makers rather than responsible experts, explain why our cultural life is diluted by the mass media. Instead of delivering a more meaningful way of life, the producers of popular culture assume that the "common person" cannot appreciate quality in recreation or the arts. In short, the working class is synonymous with vulgarity and tastelessness. Since it cannot appreciate quality, you give it "bread and circuses."[86] Realists, on the other hand, argue that more is better than less. Whatever presumed limitations uneducated and unsophisticated people may have in terms of appreciating art, modern popular culture has provided them with more artistic experiences than those available to their forebears. Furthermore, the public is given what it wants rather than what a more socially stratified society felt the public should have. Popular culture also operates as an important means of social reform. That is, the public can choose an unlimited number of recreational and leisure time activities, while at the same time being exposed to revolutionary ideas.

In an effort to be fair to both the idealists and the realists, Kando redefines terms like "culture," "popular culture," "mass media," and "leisure." Central to his position is the notion of what was and was not "typical" in American society and how that made us unique among the world's popular cultures. For example, he defines "culture" as "the typical ways in which a society, or type of society, spends its time when not working."[87] "Popular culture" he defines as "the typical cultural and recreational activities of typical segments of a society."[88] Each refinement of the definitions led Kando to the conclusion that

> modern technology and affluence promised the leisure society but instead produced the consumer society; we seemed to have transformed means into ends; that is, material consumption, instead of remaining a means toward a more leisurely life, has become our guiding principle; our greed seems insatiable,

[83] Thomas Kando, LEISURE AND POPULAR CULTURE IN TRANSITION (St. Louis: C. V. Mosby Company, 1975), pp.39-62.

[84] Included in the "Idealist" category are people like Clive Bell, Daniel Boorstin, Sebastian de Grazia, Ernest van den Haag, Oscar Handlin, Randall Jarrell, C. Wright Mills, Herbert Read, and Bernard Rosenberg.

[85] Included in the "Realist" category are people like George H. Lewis, Leo Lowenthal, Marshall McLuhan, De Montaigne, Leo Rosten, Edward Shils, Arthur Schlesinger, Frank Stanton, Gregory P. Stone, Alvin Toffler, Marcello Truzzi, and David Manning White.

[86] Kando, p.49.

[87] Kando, p.40.

[88] Kando, p.41.

and the Protestant work ethic, far from becoming obsolete, dictates continued hard work, overtime, moonlighting; in the face of plenty, we adhere to the principle of scarcity.[89]

What this consumer approach to leisure did, Kando argues, was to obliterate many of the old divisions among high culture, mass culture, subcultures,[90] and countercultures. In the end, the author points out, the most sensible way to approach the debate about the value of the mass media to contemporary society is to acknowledge the overlapping and ambiguous nature of popular culture. It is not the province of any one segment of society. Its products are not trivial pastimes. In fact, the more leisure time we gain, the more we need to understand how that leisure time is linked to our social system "and that to describe these processes implies neither their necessary endorsement nor their rejection."[91]

Daniel J. Czitrom is another mass media scholar who recognizes that an overlap exists between the categories of culture and communication. "Modern media," he argues, "have become integral to both the conception and reality of culture, especially popular culture. I argue that the term POPULAR CULTURE, in its current sense, dates back to the rise of the movies."[92] That is, the creation of movies, synthesizing science, commercial entertainment, art, and spectacle, posed both a threat to the traditional American establishment, and the promise of a national culture long dreamed of by the nation's cultural elite.[93] Typical of the problems, to be discussed in Chapter 5, was the reaction, in the early 1900s, of a theater critic like Walter P. Eaton. At first optimistic about the potential of movies to raise audience taste for theatrical works, the "purist" drama critic eventually abandoned his positive outlook and advocated that true drama "fight motion pictures, not accommodate them."[94]

This rejection of the movies as an art form, along with the blind acceptance of the values espoused by cultural traditionalists, illustrates a vital concern for advocates of the media: how to diffuse culture to all elements of society without cheapening it. In this respect, Ralph Waldo Emerson's thesis that personal experience is far more important than venerating the great works of the past is a good starting point for measuring how the media provide worthwhile experiences for the public. If, on the one hand, it can be demonstrated that through media programming the public learns taste, discrimination, and how to interact with the unknown, then it can be argued that the media serve a key cultural role in society. If, on the other hand,

[89] Kando, pp.42-3.

[90] Sociologists have been debating for decades just what constitutes a "subculture." Current usage, as Gina Marchetti points out, defines "any identifiable and cohesive group which is outside the dominant culture and its ideological norms because of differences of race, age, gender, sexual orientation, lifestyle or outlook" as a subculture. The advantages to film study of using this approach include an awareness that a viewer's reception of a film is linked to the person's relationship (or lack there of) to a specific subculture. Gina Marchetti, "Subcultural Studies and the Film Audience: Rethinking the Film Viewing Context," CURRENT RESEARCH IN FILM: AUDIENCES, ECONOMICS, AND LAW, Volume 2, ed. Bruce A. Austin (Norwood: Ablex Publishing Corporation, 1986), pp.64-5.

[91] Marchetti, p.58.

[92] *Daniel J. Czitrom, MEDIA AND THE AMERICAN MIND: FROM MORSE TO McLUHAN (Chapel Hill: University of North Carolina, 1982), p.xii.

[93] Czitrom, p.31. For another useful perspective, see Walsh, pp.17-8.

[94] Cited in Czitrom, p.56.

it can be proved that the media acting on a wish-fulfillment basis develop a pattern of sequels, reruns, and imitations that result in society's being desensitized to its individual and collective responsibilities, then the charge of the media being a negative force in our lives must not only be faced, but also resolved positively. What links the studies of the past to the present, as one source explains, is the realization that "Entertainment forms show remarkable continuity over the ages despite the fact that the original media through which they were presented have frequently been replaced by a relatively new (mass) media."[95]

At the same time, however, feminist media critics make a compelling argument for viewers' challenging the sexist and oppressive images in media entertainment. The charges are well documented and are part of our cultural heritage.[96] For example, Gaye Tuchman offers a summary of how television in the 1970s threatened women's self-perceptions about themselves and their status in society.[97] Two key ideas serve as the basis for her analysis of the image of sex roles in our culture: "the reflection hypothesis" and "symbolic annihilation." The former refers to the media's use of dominant social values. Here the assumption is that the corporate character of "commercial television" causes program planners and station managers to design programs that appeal to the largest audiences. To attract these audiences (whose time and attention are sold to commercial sponsors), the television industry offers programs consonant with American values.[98]

What Tuchman argues is that the planners often assumed America's values to be as much a part of our culture as "the air we breathe." To prove her point, she cites George Gerbner's 1972 study of "the links between TV dramas and violence."[99] Gerbner demonstrates that in the 1950s, the typical television family--mother, father, and two children living in an upper middle-class one-family, suburban home--symbolized the ideal and not the actual American family. In short,

[95] "Introduction," ENTERTAINMENT: A CROSS-CULTURAL EXAMINATION, eds. Heinz-Dietrich Fischer and Stefan Reinhard Melnik (New York: Hastings House, 1979), p.xv.

[96] Worth examining in this connection is an essay by Raymond A. Bauer and Alice H. Bauer concerning the relationship between society and its system of communication. While the Bauers admitted they did not know what the long-term effects were for American society, they did address the confusing issue of the mass media's present-day role and concluded (p.66) that they were "not even convinced with certainty that the theorists of mass media are wrong in their over-all [negative] conclusions--merely that there is evidence contrary to specific propositions, and that there are other ways of looking at American society that other scholars have found profitable." Cf. Raymond A. Bauer and Alice H. Bauer, "America, 'Mass Society' and Mass Media," JOURNAL OF SOCIAL ISSUES 16:3 (1960):3-66. Two other valuable essays related to this subject are Herbert J. Gans, "Popular Culture in America: Social Problem in a Mass Society or Social Asset in a Pluralist Society?", SOCIAL PROBLEMS: A MODERN APPROACH, ed. Howard Becker (New York: John Wiley and Sons, 1966), pp.549-620; and Harold Wilensky, "Mass Society and Mass Culture," AMERICAN SOCIOLOGICAL REVIEW 29:2 (April 1964):173-97.

[97] Gaye Tuchman, "Introduction: The Symbolic Annihilation of Women by the Mass Media," *HEARTH AND HOME: IMAGES OF WOMEN IN THE MASS MEDIA, eds. Gaye Tuchman et al. (New York: Oxford University Press, 1978), pp.3-38.

[98] Tuchman, p.7.

[99] George Gerbner, "Violence in Television Drama: Trends and Symbolic Functions," MEDIA CONTENT AND CONTROL: TELEVISION AND SOCIAL BEHAVIOR, Volume 1, eds. G. A. Comstock and E. A. Rubinstein (Washington, D.C.: U. S. Government Printing Office, 1972), pp.28-187.

television presented to its vast audiences the notion "that this kind of family (or social characteristic) is valued and approved."[100] On the other hand, "symbolic annihilation" represents what television condemned or trivialized. For example, Tuchman points out that despite the fact that women accounted for fifty-one percent of the population and for more than forty percent of the work force in the 1970s, relatively few women appeared on commercial television. Furthermore, the image of those women who were visible on commercial television programs was "symbolized as child-like adornments who need to be protected or they are dismissed to the protective confines of the home."[101] In other words, women were subjected to "symbolic annihilation." Tuchman then goes on to show that the reflection hypothesis carried over into images of women both in noncommercial television and in television commercials. Her conclusion is that profit was not the sole criterion for "symbolic annhilation." What television was telling women about themselves in the 1970s represented what society felt about the status of women.

The reflection hypothesis, symbolic annihilation, the Reference Group theory, and the frequent allusions to escapist entertainment suggest that individuals and groups are discontented with their lives. For Richard Dyer, the manner in which entertainment performs these functions explains "the cultural and historical specificity of entertainment."[102] Allowing for the differences that exist among performers, audiences, and intentions over the passage of time and in different societies, Dyer defines entertainment as "a type of performance produced for profit, performed before a generalized audience (the 'public'), by a trained, paid group who do nothing else but produce performances which have the sole (conscious) aim of providing pleasure."[103] More to the point, the professional entertainer determines what function and form entertainment takes. This is not to say that the process is only one-sided or matter-of-fact. As will be discussed in detail later, the economic structure of the film industry illustrates the complex interaction that occurs in the production, distribution, and exhibition of films. It is to say that professional entertainers, as discussed earlier in connection with cultural hegemony, consciously balance their dependent status between the power structure in the industry, and the need to offer utopian pleasure to mass audiences seeking in movies a form of escape or wish-fulfillment.

The utopianism Dyer identifies in his definition of entertainment is located in emotional personifications rather than in the utopian models of society created by thinkers like Sir Thomas More and his followers down through the centuries.[104] The codes used by the professional entertainers go beyond just a star system.[105] They also involve "non-representational signs" and stock values: e.g., energy, abundance, intensity, transparency, and community. To demonstrate his point, Dyer offers a useful chart of definitions and categories. For example, in speculating on why

[100] Cited in Tuchman, p.8.

[101] Tuchman, p.8.

[102] Richard Dyer, "Entertainment and Utopia," MOVIE 24 (Spring 1977):2-13. Rpt. in IN GENRE: THE MUSICAL: A READER, ed. Richard Altman (London: Routledge and Kegan Paul, 1981), p.176. All quotations cited in this chapter are from IN GENRE.

[103] Dyer, p.176.

[104] The obvious exceptions are films like THINGS TO COME (1936) and LOST HORIZON (1937).

[105] For more information on the star system, see Chapters 5 and 6.

entertainment "WORKS," he cites musicals like GOLD DIGGERS OF 1933 (1933)[106] and FUNNY FACE (1957) as illustrations of how professional entertainers use aspects of reality as a springboard for resolving the differences between what we are conditioned to want and what we realistically are able to get and/or to achieve.[107] What particularly disturbs Dyer is that the paradox of entertainment is both satisfying our desires and limiting our options.

In relation to the notion of discontented audiences and their interaction with entertainment, it is worth remembering what Walsh has to say about the dynamics of cultural hegemony. She attaches considerable significance to the struggle between "emergent" and "dominant" cultures. She rejects the standard interpretation that the dominant social groups often co-opt oppositional values and thus neutralize them. Drawing from the work done by Gramsci and Williams, she insists that just the reverse may be true. That is, the emergent culture is too significant to ignore and too powerful to co-opt. Thus the presence of alternative values in the dominant culture signals its social force and widespread appeal. In Walsh's words, "The dominant culture is FORCED to embody within itself oppositional elements, thus changing its character and compelling it to express (at the same time it tries to contain) the sentiments of its own transformation, a potential counterhegemony."[108] If she is right, then we need to rethink prevailing notions about the American film industry. What we need to consider is not what Hollywood is alleged to impose on our psyches, but rather what forces are battling each other behind and in front of the camera. The schemata for dealing with such an approach, as already discussed, are provided by scholars like Walsh, Lesage, Abrams, and Staiger.

In pursuing the interaction between society and entertainment, Mendelsohn also discusses why individuals and groups routinely are viewed as discontented with society and are constantly in search of diversions anywhere they can be found. In fact, many of the reasons why normative behavior (the activities of society-at-large) is often perceived as deviant behavior ("a social problem") can be traced historically and socially to "the influences of Greco-Roman morality, Hebraic-Christian concepts of sin, Catholic and Protestant asceticism, Puritan dogma, secular royalism, liberalism and reformism, and ideological Marxism. . . ."[109] Add to this list the influence of the mass media, and one better understands why Mendelsohn believes that our basic fears and anxieties are reinforced by a world-weary value structure. The test, therefore, for distinguishing between inferior works and works of art, in Mendelsohn's model of community-media interaction, is whether the work adds to our well-being rather than detracts from it. In analyzing "passivity-fantasy-escape" attacks on the mass media, he finds the empirical evidence to be almost groundless. While some people may under certain conditions exhibit negative behavior possibly caused by the mass media, he concludes that there is no rational evidence to support the accusation that the mass media are harming society generally.

Julia Bannerman and Jerry M. Lewis concur. In their summary of the claims and counterclaims, they indicate that those who feel that popular culture is a destructive force focus on the ways in which the media limit audience options, debase tastes, and distort values.[110] On the other hand, those who defend popular culture insist that

[106] For another perspective, see Paula Rabinowitz, "Commodity Fetishism: Women in GOLD DIGGERS OF 1933," FILM READER 5 (1982):141-9.

[107] For an interesting variation on this theme, see Kathryn Kalinak, "The Fallen Woman and the Virtuous Wife: Musical Stereotypes in THE INFORMER, GONE WITH THE WIND, and LAURA," FILM READER 5 (1982):76-82.

[108] Walsh, p.10.

[109] Mendelsohn, p.31.

[110] A useful perspective is provided by Jules J. Wanderer, who reviews the "myths

it satisfies audience needs and "that the producers provide what the public wants."[111] Neither side, they claim, has employed credible empirical and objective methods of investigation. Consequently, their arguments can neither be accepted nor rejected. "In fact," the researchers conclude, "it is possibly the very lack of data which has spawned and sustained the controversy over popular culture."[112]

To be fair to the alarmists' position, however, defenders of popular culture need to acknowledge the subversive nature of mass media products and that they regularly incorporate residual and emerging social values that directly challenge the dominant culture. It would be absurd to state, on the one hand, that popular culture involves two-way communication; and, on the other hand, that the process exists only on the level of reinforcing dominant values. Michael Selig puts the case differently, stating that "After only a few years of looking at media products in this manner, it seems like common sense to me that the repetition of a limited world-view reaffirms the oppressive (ruling) ideology as being racist and sexist."[113] Gerbner argues in a similar vein, albeit from a different perspective, pointing out that often the function of images is to resist change by discrediting, isolating, or undercutting oppositional social values.[114] And C. Wright Mills makes the valid point that "Manipulations by professional-image makers are effective because their audiences do not or cannot know personally all the people they want to talk about or be like, and because they have an unconscious need to believe in certain types."[115]

To assess how movies function and react to their environment, we need to recognize how they operate as a mass medium. Even this position is controversial. Mass media scholars for a variety of reasons--e.g., artistic status, terminology, and structure--dismiss film from the generally accepted notions of what constitutes a mass medium. With due respect to communications scholars who take this position, they underestimate and misunderstand the film medium. Movies, both in form and process, do qualify as a model of mass communication worthy of serious study. They have their roots in the popular culture of their societies and transmit ideas and images that are both familiar and unique to mass audiences.

Like other forms of popular culture, the mass media embody the principles in the simple but classic definition of communication by Harold Lasswell: "WHO says WHAT, to WHOM, through WHAT MEDIUM, with WHAT EFFECT." The "filmmakers" refer to the WHO; the "content," the WHAT; the "audience," the WHOM; the "process of film," the MEDIUM; and the "social force," the EFFECT. Any serious study of film

surrounding popular taste" as they relate to the "conjectures and condemnations of professional critics of popular culture." In essence, Wanderer rejects the notion that critics are snobs. His data (5,644 film reviews published over a twenty-two year period) offers a secondary analysis comparing and contrasting popular taste with those of the professional critic. See Jules J. Wanderer, "In Defense of Popular Taste: Film Ratings Among Professionals and Lay Audiences," AMERICAN JOURNAL OF SOCIOLOGY 76:2 (September 1970):262-72.

[111] Julia Bannerman and Jerry M. Lewis, "College Students' Attitudes Toward Movies," JOURNAL OF POPULAR FILM 6:2 (1977):126. The essay is based upon on Bannerman's 1976 Kent State M.A. thesis, A METHODOLOGICAL EVALUATION OF THURSTONE'S MOVIE ATTITUDE SCALE. Lewis was the thesis director.

[112] Bannerman and Lewis, p.127.

[113] Michael A. Selig, letter to author, November 15, 1985.

[114] George Gerbner, "The Dynamics of Cultural Resistance," HEARTH AND HOME: IMAGES OF WOMEN IN THE MASS MEDIA, p.47.

[115] *C. Wright Mills, WHITE COLLAR: AMERICAN MIDDLE CLASSES (New York: Oxford University Press, 1956), p.xiii.

as a mass medium clearly demonstrates how examining the institution of film--producing, distributing, marketing, and exhibiting--involves a need to examine how audiences relate and react to movies and how critics and the public evaluate moving pictures.

Furthermore, Linton has summarized the intricate ways in which movies interact with television, the record industry, publishing houses, the theater, radio, and comic books. He has also explained how specific films and film cycles[116] generate spin offs, sequels, remakes, reissues, TV shows, and imitations. The reason, therefore, that we need to examine the film process, Linton aptly states, is that "only by tracing movies from their inception right through to their diffusion into the social/cultural/political milieu, and by linking these stages to each other, [will we] come to understand the way the movies function in our lives and the extent to which they influence us individually and as a society."[117] I would add to Linton's perceptive argument the need to examine as well the economic development of the film industry as one more example of how society uses institutions and cultural hegemony to reinforce the STATUS QUO.[118]

Worth mentioning in this regard is William Stephenson's theory that "at its best, mass communication allows people to become absorbed in SUBJECTIVE PLAY."[119] That is, the mass media permit us to enjoy ourselves in a complex but voluntary manner, while at the same time providing "social control" and "convergent selectivity." The manner in which society through its institutions and peer pressures socializes its members to internalize the culture's beliefs and values is what Stephenson means by "social control." On the other hand, "convergent selectivity" relates to individual choices. In simplified terms, viewers individually select those elements that satisfy and amuse them from a number of possible choices. The selection process provides the individual's linkage with other members of society who have made similar choices. The manner in which the producers of the mass media understand how viewers respond to specific stimuli in making choices indicates how the selection process affects the types of messages and values communicated through radio, television, and film at different times in our history. Thus watching movies can positively or negatively affect our personal beliefs and values by either interfering with or by reinforcing societal needs.[120]

Stephenson's "play theory" bears a resemblance not only to Walsh's arguments about cultural hegemony, but also to John G. Cawelti's theories about formula films. Film conventions and inventions, as discussed in the last chapter, also have specific cultural functions. The former symbolize society's shared values; the latter, new perceptions. In short, the play theory reinforces the perspective shared by a range of film critics who argue that the state's ideological apparatus manipulates the way in which members of society view themselves and objective reality.[121]

[116] For a recent look at how movies about babies, body swapping, and reincarnation are mushrooming, see Aljean Harmetz, "The Hollywood Cluster Syndrome," NEW YORK TIMES C (March 30, 1988):17.

[117] Jowett and Linton, pp.23-4.

[118] For an interesting perspective on this theme, see Judith Hess, "Genre Films and the Status Quo," JUMP CUT 1 (May-June 1974):1, 16, 18.

[119] *William Stephenson, THE PLAY THEORY OF MASS COMMUNICATION (Chicago: The University of Chicago Press, 1967), p.1.

[120] For more insights into Stephenson's ideas on the immediate effects of films on spectators, see William Stephenson, "Applications of Communication Theory: IV, Immediate Experience of Movies," OPERANT CONDITIONING 1:4 (July 1978):96-116.

[121] Modleski speculates (p.97) that much of the pleasure audiences derive from

What troubles many contemporary film theorists is the manner in which modern technology "masks" images in order to project undetected ideological positions. Bill Nichols, for example, argues that "Ideology uses the fabrication of images and the processes of representation to persuade us that how things are is how they ought to be and that the place provided for us is the place we ought to have."[122] As we will see throughout this chapter, Nichols's position represents what many film studies accept as a given in the sociology of the film: i.e., Hollywood and its clones around the globe transform "reality" into accessible and understandable images that reinforce the illusion of order in world of chaos, but the audience is never encouraged to be aware of how the process of transformation operates or how they unconsciously contribute to the process. In Nichols's words, "Ideology appears to produce not itself, but the world. It proposes obviousness, a sense of 'the way things are,' within which our sense of place and self emerges as an equally self-evident proposition."[123]

The implication is that ideolgy operates as a society's self-fulfilling image, in that what we see is what we choose to see. James Hay takes Nichols's concept one step further. "While this [Nichols's] view of images and ideology helps explain the necessary and inevitable role of images in stabilizing a social order and its value," he explains, "it tends to ignore (as Nichols admits) the generative and historical qualities of both ideology and modern cultural forms, such as cinema, through which images are produced." Hays's point is that "Ideology cannot be said to 'inform' outside a culture's signifying practices and the availability of techniques that make possible certain modes or conventions of communication and exchange."[124] That is, we must always remember that a transformation is necessary to project an acceptable cinematic image. "To acknowledge that images transform and reconstitute our perceptions," Hays observes, "implies that they do not merely AFFIRM an order or that order is not itself transformed through the production of images (at all points in the chain of signification)."[125] The issue, following Hays's logic, is: How are cinematic images

repetitive situations and types is linked to Freud's theory of "repetitive compulsion." In oversimplified terms, repetition allows the individual to master a frustrating situation. The advantage of formula films with stock situations and social types is that the public can identify with specific characters and problems and by frequent viewings gain the illusion, for a brief period, of being in control of the events and the personalities in the film and, by extension, the real-life association evoked by the film. On this same issue, Robert Warshow commented that "One goes to any individual example of the type with very definite expectations, and originality is to be welcomed only in the degree that it intensifies the expected experience without fundamentally altering it . . . It is only in an ultimate sense that the type appeals to its audiences' experience of reality; much more immediately, it appeals to the previous experience of the type itself; it creates its own field of reference." Cf. *Robert Warshow, THE IMMEDIATE EXPERIENCE: MOVIES, COMICS, THEATRE, AND OTHER ASPECTS OF POPULAR CULTURE (Garden City: Doubleday and Company, 1962), p.128.

[122] *Bill Nichols, IDEOLOGY AND THE IMAGE: SOCIAL REPRESENTATION IN THE CINEMA AND OTHER MEDIA (Bloomington: Indiana University Press, 1981), p.1.

[123] Nichols, p.2.

[124] *James Hay, POPULAR FILM CULTURE IN FASCIST ITALY: THE PASSING OF THE REX (Bloomington: Indiana University Press, 1987), p.20.

[125] Hay, pp.20-1.

codified, assimilated, and used?

THE FEMINIST APPROACH

No area of investigation involving film images is more innovative and intriguing today than that of feminist film criticism. For more than a decade, a growing number of scholars and critics have drawn serious attention to the complex and paradoxical media images of women who are, on the one hand, glamorized and, on the other hand, oppressed.[126] It is the sense of contradiction existing within a film or a society that becomes pivotal for feminists in developing an awareness of alternatives to the dominant ideology in that culture. In other words, the fact that women exist as both subject and victim/object in a patriarchal society is central to feminist film criticism. Hollywood, in particular, symbolizes for feminists the way in which women have been exploited in order to reinforce the false myth that men are by right and by tradition the dominant figures in an industrial society. The merits of that perspective will be discussed later. An underlying assumption of this chapter, however, is that all minorities and outsiders can enhance their self-image and status first by recognizing how they are symbolized paradoxically in mass communications, and then by seeking ways to redefine and to reinterpret the images and ideas presented to them. In addition, it is hoped that filmmakers can be persuaded to change the images, so that a cycle of negative images isn't perpetuated.

While all feminist film critics share a concern over the image of women in film and the relationship of that image to the "real world," a split has developed between American and British feminist film critics. For the most part, the former (e.g., Patricia Erens, Karyn Kay, Molly Haskell, Sumiko Higashi, Julia Lesage, Joan Mellen, B. Ruby Rich, Marjorie Rosen, Andrea S. Walsh, and Janice R. Welsch) concentrate on analyzing the history of female images in mainstream cinema.[127] Their objective is to sensitize the public to the close links between culture and society. Starting with the image of innocent heroines, FEMMES FATALES, and the flappers of the silent era and running through the career women and no-nonsense stars of Hollywood's golden years and continuing to the present, American feminist film critics map out the formulas and stereotypes mainstream cinema has used to portray and to exploit women in and on film. At the same time, they make us conscious of how mainstream theatrical films have ignored and/or distorted the images of the handicapped, lesbians, and other minorities. The images themselves and what they represent are the focus of the research. The initial intent of such studies in the context of a resurgence in the Women's Movement was to stimulate spectator reactions against the negative images of women in popular culture and to bring about social reform.

[126] The first important chronology of feminist film criticism was B. Ruby Rich, "The Crisis of Naming in Feminist Film Criticism," JUMP CUT 19 (December 1978):9-12. It was revised two years later by Rich--i.e., "In the Name of Feminist Film Criticism," HERESIES 9 (Spring 1980):74-81; Rpt. in *JUMP CUT: HOLLYWOOD, POLITICS AND COUNTER-CINEMA, ed. Peter Steven (Toronto: Between the Lines, 1985):209-30--and then used as part of a more up-to-date chronology by Mary Ann Doane et al.--i.e., "Feminist Film Criticism: An Introduction," *RE-VISION: ESSAYS IN FEMINIST FILM CRITICISM, ed. Mary Ann Doane et al. (Los Angeles: The American Film Institute, 1984):3-4.

[127] Mainstream, or dominant cinema, in this chapter refers to the Hollywood theatrical film, primarily during the heyday of the studio system. By using the years from 1930 to 1950 to represent the classic Hollywood cinema, feminist film critics are able to stress the importance of formula filmmaking in the American film system. For more information on film conventions from film to film, see Chapter 2.

Recently, however, theoreticians like Lesage and Rich have moved closer to a more academic analysis of film images.

For their part, British feminist film critics (e.g., Pam Cook, Christine Gledhill, Claire Johnston, E. Ann Kaplan, Annette Kuhn, Laura Mulvey, and Janey Place) show a greater interest in developing theories for analyzing how films "communicate" sexist and racist images. The concern is more with the "cinematic apparatus" (the context in which films are produced, distributed, and exhibited) than with the images. The theoretical thrust is directed more toward the study of film than toward film as a form of activism to reform society. Male directors like Michelangelo Antonioni, Ingmar Bergman, Carl T. Dreyer, Jean-Luc Godard, Susumu Hani, Kenji Mizoguchi, Satyajit Ray, and Jean Renoir are contrasted with female directors like Dorothy Arzner, Alice Guy Blache, Germaine Dulac, Marguerite Duras, Sara Gomez, Jeanne Moreau, Leni Riefenstahl, Esther Schub, Agnes Varda, Margarethe von Trotta, and Lina Wertmuller. Each is discussed in terms of how to define a feminist aesthetic that is useful for understanding film both as art and as a social force in society. The "relevance" strategy is to make clear to viewers how the cinematic apparatus contains within its deceptive "natural" presentation of objective reality an ideology that is at odds not only with the viewer's true-life experiences, but also with the apparatus and the text.[128]

No one has analyzed these two opposing traditions more precisely or pointed out more clearly the oversimplification of the controversy itself than Christine Gledhill.[129] Instead of focusing on their confrontational characteristics, she deftly shows the overlapping nature of both the American and British positions. Her primary interests, and those that unite the various approaches, lie in discovering why women are not adequately represented in the mass media, how this relates to other cinematic representations, what forces female fictional constructions to represent a patriarchal perspective, and how the process of signification operates in terms of a mass audience. Seen in that light, feminist film criticism on both sides of the Atlantic attempts to grapple with the process of producing film messages. In essence, the issue is the nature of feminist film practice. As a result, the research done by feminist film critics on aesthetic techniques, film "realism," oppressive screen images, the nature of film as entertainment/ritual/art, and the ability to use stereotypes politically to challenge rather than reinforce a dominant ideology, converges on the notion that filmmaking involves more than one signifying system.

Each feminist approach--e.g., sociological, psychoanalytical, textual--starts with the premise, conscious or otherwise, that women function as outsiders in the mass media and in society as well. Each feminist study exposes one more instance of how ideology can be perceived to operate in film and on mass audiences. Whether or not a dominant ideology operates monolithically in film is of less importance to Christine Gledhill than the realization that signification is not a simple and indisputable exercise. More significant than issues related to illusion and identity is an awareness of the importance of the difference that exists between them. "The real issue for feminism," explains Gledhill, "is the potential contradiction between woman as characterization in terms of the independent woman stereotype and woman as a sign

[128] The term "consciousness" is used in this chapter as a synonym for how individuals consciously think and feel. Implied, but rarely discussed in detail, is the notion that an individual's feelings are linked to subconscious and unconscious experiences.

[129] Christine Gledhill, "Recent Developments in Feminist Criticism," QUARTERLY REVIEW OF FILM STUDIES 3:4 (1978):457-93; Rpt. in a shortened and revised form, with an "Afterthoughts," in RE-VISION, pp.18-48. All quotations cited in this chapter are from the publication RE-VISION.

in a patriarchal discourse."[130] That is, concerned critics should not assume that images of women reflect a straightforward message or role. In fact, they can be very contradictory, even liberating.

In the pages that follow, we will explore how consciousness-raising studies about film stereotypes can be turned to positive ends. We will examine how stock situations and social types can make us more knowledgeable about the very areas the stereotypes presume to delimit. For our purposes here, it need only be stressed that feminist film criticism collectively is more united than divided in its investigation on the omissions and distortions in film theories, history, aesthetics, and filmmaking.

Because feminist film scholars emphasize the advantages of psychoanalysis, poststructuralism, semiotics, and neo-Marxist criticism, their work has met with less than favorable reactions from cultural traditionalists who strongly resent the difficulty encountered not only in having to learn a complicated and revolutionary method for examining a popular art, but also in having to deal with "oppositional" analyses. As a result, feminist film criticism remains in many film quarters a marginal area of study. I believe that cultural traditionalists have misjudged both the quality and the importance of feminist film criticism. That is not to ignore the fact that feminist film criticism in its formative stages has demonstrated a number of critical flaws. For example, many practitioners often analyze film texts independent of economic and historical contexts and blame the movies for what may actually be only a reflection of the society in which the movies are made. Furthermore, there is a tendency in the feminist film criticism of the 1970s to ignore what appears in the film and substitute instead what should have been done or said by the characters and the filmmakers.

Issues like these have been discussed in many professional meetings and journals. For example, Barbara Klinger, in her articulate report on a feminist film conference in 1980, called attention to a number of related problems: (1) an ambivalence that feminist film critics have toward "theory" as "an unnecessary obfuscation of issues, a practice affiliated with a social elite, and/or a form of reasoning that is a product of a patriarchy"; (2) a sociological approach used in many film analyses that overemphasizes sex-role critiques to the neglect of film form; (3) a lack of interest in "discussing the specificity of cinematic practice"; and (4) a disdain for matters of "textuality and system-theory as unnecessary or circuitous, if not supercilious elaborations of the basic issue of women's oppression."[131] In short, feminist film critics have redefined the crucial characteristics of film. Arguing that an analysis of creator, text, and critic is of secondary import, feminists have concentrated on the concept that the canon (what it is, how it is) is perceived and measured by patriarchal assumptions and insights. That having been said, the consciousness-raising aspects of the movement require that film scholars and students systematically reconsider the historical, social, political, and economic development of the film industry and the manner in which its products are perceived. This chapter cannot present a comprehensive analysis of a feminist perspective on film history or its relationship to current films. But to completely ignore the valuable insights provided by feminist film scholarship is unthinkable.

My plan, therefore, in studying film stereotypes is to incorporate as fully as possible the schema suggested by Walsh, Lesage, and Abrams along with the basic issues addressed in feminist film criticism. This chapter will concentrate on matters related to the Hollywood cinema from the 1890s to the present. My reasons for taking this approach are fivefold. First, the women's movement places great emphasis on the works of Freud and Marx; attention is drawn frequently, as Teresa De Lauretis notes, to "the twin birth of cinema and psychoanalysis around the year 1900 . . . as well as their inheritance of the novel, or better the novelistic, with its built-in

[130] Gledhill, p.40.

[131] Barbara Klinger, "Conference Report: Conference on Feminist Film Criticism," CAMERA OBSCURA: A JOURNAL OF FEMINISM AND FILM THEORY 7 (1981):137-43.

standard of truth, its 'verite romanesque.'"[132] That twin birth is reflected throughout film history in the way that filmmakers use their narrative skills in creating a complete and unified visual space that captures a spectator's attention and imagination. This visual pleasure, Freud's SCHAULUST (scopophilia), relates directly to our satisfaction with the images represented in visual narrative.[133] The neo-Marxist critics, sensing the film's ability to orchestrate and organize meanings through carefully constructed media representations, insist that ideology plays a dominant role in the way members of a society communicate with each other.[134] The key problem for feminists, however, is that they see no widely accepted process to offset the patriarchal values of our society. Using this perspective, the film critic determines whether the artist (spectator) is able, let alone willing, to express (perceive) an independent point of view, or is manipulated by forces, conscious or unconscious, over which he or she has no control. Clearly, the issues addressed by feminist film theorists influence, challenge, and expose substantive areas of study not covered in more traditional film analyses.

Second, feminist film criticism, understandably, focuses on the importance of "cultural politics." One position argues that each society maintains its own set of images, representations,[135] ideologies, and meanings that automatically get passed on through the signification process to its preconditioned spectators. Another position argues that the process of meanings is ongoing and always in flux. Whichever position on cultural politics is assumed through textual analysis, the critic examines theories of perception, and studies of reception about how images, representations, ideologies, and meanings are constructed to reinforce (or to rebel against) a particular society's

[132] *Teresa De Lauretis, ALICE DOESN'T: FEMINISM, SEMIOTICS, CINEMA (Bloomington: Indiana University Press, 1982), p.67.

[133] De Lauretis, p.67.

[134] For purposes of this chapter, ideology refers to the images and symbols used by a specific society to define its view of the "real world" and to perpetuate itself. The emphasis is on mythology rather than on immediately held values. The assumption is that within each society's dominant ideology (e.g., capitalism and socialism), there are complex and contradictory systems that constantly battle each other for supremacy: i.e., a Republican president and a Democratic Congress, federal and state laws, and a separation between church and state. Who is in control at any precise moment is more conjecture than fact. What appears nondebatable is that every group is concerned with justifying its right to be the dominant group.

[135] For purposes of this chapter, "representations" refers to the illusions created by filmmakers to approximate what they feel reality to be. It definitely does not relate to accurate or realistic images.

[136] The term "text" here refers to the organic unity of a film and the manner in which its various elements contribute to the communication of ideas about the characters, setting, theme, etc. "Reading a text" involves a viewer's paying close attention to the way in which the various elements--e.g., lighting, dialogue, performers, editing, sound effects, etc.--communicate ideas that contribute to the overall reception of the film [text]. The more alert the reader is to the process of signification--how meanings are constructed--the more the reader will appreciate the importance of various elements as signifiers (message carriers) and as signified (reference points for the signifiers). For example, a close up shot signifies specific information about a character's emotions. In comedies, close ups add to the humor of a scene; in dramas, they heighten the psychological tension. The close up is the signifier; the character, the

values and needs.[136] For example, Susan Morrison offers valuable insights on how few Hollywood films are relevant to "female concerns and/or female points of view." To prove her point, she contrasts REBECCA (1940) with DESPERATELY SEEKING SUSAN (1985). The earlier film centralizes "the importance and dominance of the male protagonist's position within the Hollywood cinema." The later film, on the other hand, demonstrates "that rare instance of a contemporary film which takes as its subject the relationship, indeed obsession, of one woman with another--a relationship couched not in the conventional negative terms (i.e., jealousy) but in absolute positive ones (i.e., admiration)."[137]

Of particular value to film neophytes is the manner in which feminist film critics like Morrison sensitize readers to image distortions or omissions often ignored in standard accounts of film history.[138] What concerns us in this chapter is whether or not the emphasis on distortions and omissions is counter-productive to redefining what film is and how it operates as a social force in society.

Third, the ideological issues related to feminist film criticism enhance our general understanding of how filmmakers and mass audiences create and react to film images in our society. They expose the simplicity of analyses ignoring the complex issues surrounding realistic representations and the skill filmmakers employ in convincing their audiences that film images are lifelike.[139] Feminist film critics make clear that

signified. Feminist film critics like Adrienne Rich see the "re-reading" process as essential to a woman's survival in a patriarchy. Modleski believes that the constant use of close ups in soap operas provides a distinction between popular art forms primarily interested in satisfying male fantasies, and those aimed at women. For more information, see Adrienne Rich, "When We Dead Awaken: Writing as Re-Vision," *ON LIES, SECRETS, AND SILENCE: SELECTED PROSE 1966-1978 (New York: W. W. Norton and Company, 1979), pp.33-49; and Modleski, pp.99-100.

[137] Susan Morrison, "Girls on Film: Fantasy, Desire and Desperation," CINEACTION: A MAGAZINE OF RADICAL FILM CRITICISM & THEORY 2 (Fall 1985):2.

[138] In reviewing the influences of eighteenth- and nineteenth-century narratives on contemporary life and letters, Tania Modleski notes that Daphne Du Maurier's 1938 novel, REBECCA, revived society's interest in Gothic novels: "Significantly, this second 'Gothic revival' took place at the same time that 'hard-boiled' detective novels were attracting an unprecedented number of male readers In the forties, a new movie genre ['gaslight' films] derived from gothic novels appeared around the time that hard-boiled detective fiction was being transformed by the medium into what movie critics currently call 'film noir.'" The "gaslight" films were then ignored by comparison to the FILM NOIR genre. Feminist film critics are now pointing out, however, that the gaslight genre reflects the fears that women had about being forced back into the home and taking a subordinate role in society. See *Tania Modleski, LOVING WITH A VENGEANCE: MASS-PRODUCED FANTASIES FOR WOMEN (Hamden: Archon Books, 1982), p.21. For another related book on the relationship between demeaning myths and romantic fiction, see *Janice A. Radway, READING THE ROMANCE: WOMEN, PATRIARCHY, AND POPULAR FICTION (Chapel Hill: University of North Carolina Press, 1986).

[139] Christine Gledhill stresses the fact that many film feminists make a distinction between notions of realism and genre. Feminists, especially those emerging from the Women's Movement, associate realism with "real life," "truth," or "credibility." On the other hand, they associate genre production with "illusion," "myth," "conventionality," and "stereotypes." In Gledhill's words, "The Hollywood genres represent the fictional elaboration of a patriarchal culture which produces macho heroes and a subordinate, demeaning and objectified place for women." Cf. Christine Gledhill, "KLUTE 1: A Contemporary Film Noir and Feminist Criticism," *WOMEN IN FILM NOIR, ed. E. Ann Kaplan (London: British Film Institute, 1980), p.7.

there is no guarantee that the conscious efforts of filmmakers to impart or to dictate a preferred meaning in a film text or stereotype are accepted by viewers. In fact, the opposite effect may result. That is, an audience may reject the film's preferred meaning either because of personal motives or because of the context in which it is presented. At the same time, the types of questions addressed by feminist film critics incorporate many of the issues raised by traditional scholars interested in mass communications research, notions of realism, and psychoanalytic criticism. That is not to suggest that every issue is the same and thus to downplay the uniqueness of problems related to women, children, and minorities in society; rather, it is to say that pursuing these issues allows us to reflect on and to review important stages of film history and ideological analyses.

Fourth, the arguments presented by feminist film critics require not only that traditional aesthetic and technical assumptions be reexamined, but also that standard interpretations of events and film content be reevaluated. For example, Mary C. Gentile summarizes what many feminists believe to be axiomatic: it is important and necessary that there be a "passionate proclamation of 'difference' . . . [in any] feminist critique of any aspect of society." She goes on to write that "it is only from the consciousness of our positioning as the 'second sex,' as 'Other'--that is, from an awareness of our oppositional position--that an analysis of ideological practice and the constriction of a female subjectivity can develop."[140]

Nevertheless, Gentile perceives feminist film criticism as being more than an oppositional approach to gender-related subjects. In her valuable study, she makes clear how feminist film criticism has broadened our understanding of class struggles, ageism, racial inequality, children's rights, and the problems of the handicapped. For that reason, she stresses the need for multiple perspectives, critical subjectivity, and a dual consciousness of contradictions and commonalities in film texts. I would add that feminists have increased our understanding of how stereotypes serve as a means to change a system one finds intolerable.[141]

Finally, feminist film criticism makes abundantly clear that films are more than escapist entertainment. In fact, as will be discussed later, it is the misunderstanding over how films communicate specific ideas to mass audiences and with what effects that brought feminist film criticism to the forefront of the profession today.[142] In

[140] Gentile, pp.4-5.

[141] For a recent example of how movies manipulate the image of women, see Mona Harrington, "WORKING GIRL in Reagan Country," NEW YORK TIMES E (January 15, 1989):27.

[142] My broad overview of feminist film criticism has been shaped and influenced by Professor Patricia Erens. In addition to the work already done by De Lauretis, Doane, Erens, Gentile, Gledhill, Staiger, and Walsh, the basic bibliographical material used for the ideas relating to feminist film criticism in this chapter are the following: Jean-Louis Baudry, "Ideological Effects of the Basic Cinematographic Apparatus," trans. Alan Williams, FILM QUARTERLY 28:2 (Winter 1974-75):39-47, Rpt. *NARRATIVE, APPARATUS, AND IDEOLOGY, ed. Philip Rosen (New York: Columbia University Press, 1986), pp.286-98; Susan Lurie, "The Construction of the Castrated Woman in Psychoanalysis and Cinema," DISCOURSE 4 (Winter 1981):52-74; Gaylyn Studlar, "Masochism and the Perverse Pleasure of the Cinema," *MOVIES AND METHODS: AN ANTHOLOGY, Volume 2, ed. Bill Nichols (Berkeley: University of California Press, 1985), pp.602-21; Kaja Silverman, "Fragments of a Fashionable Discourse," STUDIES IN ENTERTAINMENT: CRITICAL APPROACHES TO MASS CULTURE, ed. Tania Modleski (Bloomington: Indiana University Press, 1986), pp.139-52; ___, "Masochism and Subjectivity," FRAMEWORK 12 (1980):2-9; Michelle Citron, et al., "Women and Film: A Discussion of Feminine Aesthetics," NEW GERMAN CRITIQUE 13 (Winter 1978):83-108; Teresa De Lauretis,

short, studying film texts from a feminist point of view is an important way of reminding audiences that viewers, like filmmakers, are subject to the same determination of a world-view, and that there is more to the image than "meets the eye."

It is evident, however, that most people in and out of the film industry consider movies primarily entertainment. For their part, the mainstream filmmakers worry most about the profits that pictures can produce. Audiences, on their part, are preoccupied with relaxation rather than reflection. Yet theatrical films, like traditional literature, are an art that uses humanity as their subject.[143] Familiar screen images,

"Aesthetic and Feminist Theory: Rethinking Women's Cinema," ibid., 34 (1985):154-75; Helene Cixous, "Castration or Decapitation," trans. Annette Kuhn, SIGNS 7:1 (Autumn 1981):41-55; Miriam Hansen, "Pleasure, Ambivalence, Identification: Valentino and Female Spectatorship," CINEMA JOURNAL 25:4 (Summer 1986):6-32; Jean-Louis Comolli and Paul Narboni, "Cinema/Ideology/Criticism," trans. Susan Bennett, SCREEN 12:1 (1971):27-35, Rpt. in SCREEN READER 1, (1977):2-11 (all quotations cited are from SCREEN); Jacqueline Rose, "Paranoia and the Film System," ibid., 17:4 (Winter 1976-77):85-104; Pam Cook, "Approaching the Work of Dorothy Arzner," NOTES ON WOMEN'S CINEMA, ed. Claire Johnston (London: Society for Education in Film and Television, 1973):9-18, Rpt. in SEXUAL STRATAGEMS: THE WORLD OF WOMEN IN FILMS, pp. 224-35; ___, "Duplicity in MILDRED PIERCE," WOMEN IN FILM NOIR, ed. E. Ann Kaplan (London: British Film Institute, 1978):68-82; Elizabeth Dalton, "Women at Work: Warners in the Thirties," VELVET LIGHT TRAP 6 (1972):15-20; *Molly Haskell, FROM REVERENCE TO RAPE: THE TREATMENT OF WOMEN IN THE MOVIES (New York: Holt, Rinehart, and Winston, 1973); Claire Johnston, "Introduction," NOTES ON WOMEN'S CINEMA, pp.2-4; ___, Feminist Politics and Film History," SCREEN 16:3 (1975):115-24; E. Ann Kaplan, "Aspects of British Feminist Film Theory," JUMP CUT 12/13 (1976):52-5; ___, "Interview With British Cine-feminists," WOMEN AND THE CINEMA: A CRITICAL ANTHOLOGY, eds. Karyn Kay and Gerald Peary (New York: Dutton, 1977); ___, "Integrating Marxist and Psychoanalytical Approaches in Feminist Film Criticism," MILLENNIUM: FILM JOURNAL 6 (Spring 1980):8-17; ___, *WOMEN AND FILM: BOTH SIDES OF THE CAMERA (New York: Methuen, 1983); Karyn Kay and Gerald Peary, WOMEN AND THE CINEMA: A CRITICAL ANTHOLOGY; Annette Kuhn, "Women's Cinema and Feminist Film Criticism," SCREEN 16:3 (1975):107-12; *___, *WOMEN'S PICTURES: FEMINISM AND CINEMA (London: Routledge and Kegan Paul, 1982); Frank Manchel, WOMEN ON THE HOLLYWOOD SCREEN (New York: Franklin Watts, 1977); *Joan Mellen, WOMEN AND THEIR SEXUALITY IN THE NEW FILM (New York: Dell, 1974); Laura Mulvey, "Visual Pleasure and Narrative Cinema," SCREEN 16:3 (1975):6-18, Rpt. *WOMEN AND THE CINEMA, pp.412-28 and *NARRATIVE, APPARATUS, AND IDEOLOGY, pp. 198-209; Steve Neale, "New Hollywood Cinema," SCREEN 17:2 (1976):117-22; ___, "Oppositional Exhibition: Notes and Problems," SCREEN 21:3 (1980):45-56; Constance Penley, "The Avant-Garde and Its Imaginary," CAMERA OBSCURA: A JOURNAL OF FEMINISM AND FILM THEORY 2 (1977):3-33; Janet Bergstrom, "Alternation, Segmentation, Hypnosis: Interview with Raymond Bellour," ibid., 3-4 (1979):71-104; ___, "Enunciation and Sexual Difference," ibid., pp.33-70; ___, "Sexuality at a Loss: The Films of F. W. Murnau," POETICS TODAY 6:1-2 (1985):185-203; Janey Place and Julianne Burton, "Feminist Film Criticism," MOVIE 22 (1976):53-62; *Marjorie Rosen, POPCORN VENUS: WOMEN, MOVIES AND THE AMERICAN DREAM (New York: Coward, McCann and Geoghegan, 1973); Maureen Turim, "Gentlemen Consume Blondes," WIDE ANGLE 1:1 (1979):52-9; Julia Kristeva, "Ellipsis on Dread and the Specular Seduction," ibid., 3:3 (1979):42-7; David Rodowick, "The Difficulty of Difference," ibid., 5:1 (1982):4-15; Judith Mayne, "The Limits of Spectacle," ibid., 6:3 (1984):5-14; and Kaja Silverman, "Lost Objects and Mistaken Subjects: Film Theory's Structuring Lack," ibid., 7:1-2 (1985):14-29.

[143] Ian C. Jarvie makes the point that it is not necessary to concede anything about the status of film to "'old-fashioned' intellectuals." All that need be said

aimed at satisfying the widest possible audience in order to generate the greatest possible profits, routinely appear in film narratives depicting popular life-styles and personal struggles.[144] Historically, mainstream films like THE BIRTH OF A NATION (1915), FOOLISH WIVES (1921), SUNRISE (1927), THE PUBLIC ENEMY (1931), THE GRAPES OF WRATH (1940), THE BEST YEARS OF OUR LIVES (1946), HIGH NOON (1952), THE GRADUATE (1967), THE FRENCH CONNECTION (1971), THE TURNING POINT (1977), THE KILLING FIELDS (1984), and MOONSTRUCK (1987) allow individuals and groups the opportunity to create popular myths and to share common fantasies. Thus, film also becomes a social document, in which may be found perspectives on such problems as war, injustice, personal responsibilities, heroism, cowardice, prejudice, mental illness, and poverty. In watching these films, viewers are given patterns of behavior, alternative choices, and a range of solutions to the issues and dilemmas that engulf many of us.[145] For example, journalists often rely on film metaphors like "Westway as a Frank Capra fable," and "The Rambo Doctrine" to simplify political approaches to complex issues.[146]

Claire Johnston argues that it is this type of solution to our everyday existence that has led feminists to focus on the role of the media in society:

about film is that it "is an art; the function of art is to enrich our experience through entertainment; [and] it no more needs an apologia in sociological terms, than poetry does." See Jarvie, MOVIES AND SOCIETY, p.10. Much as I sympathize with Jarvie's idealistic assertion, I do not find it a realistic approach to getting contemporary educators in many of today's public schools and institutions of higher learning to examine film as a mass medium. My suggestion for studying film stereotyping as a means to understanding one aspect of the structure and nature of film may not be the best way to bridge the gap between the traditional scholar and the modern social scientist. But in no way should it be seen as either a denial of film's artistic qualities or a retreat into insipid moralizing about movies.

[144] For purposes of this chapter, film narrative refers to the causal relationships that constitute the actions and the messages contained in a specific film text. The story elements--e.g., characters, setting, plot--represent the accepted meanings connected with actual events (the diegesis). Each element has its own set of rules or conventions that semiologists call "codes." These various film codes--e.g., the sign systems of language, dress, and sexual habits--represent insinuations and value judgments about society (the discourse). Film codes also influence the film's point of view and how spectators are addressed. For an interesting perspective on this theme, see Julia Lesage, "S/Z and RULES OF THE GAME," JUMP CUT 12-13 (Winter 1976-77):45-51.

[145] Not everyone feels that the choices offered by mainstream cinema provide the range of alternatives suggested by my statement. For example, Lesage makes a strong case for hegemony doing just the opposite. "The concept of hegemony," she argues, "is most useful if seen as operating on two interrelated and mutually reinforcing levels: the institutional and the psychological. The dominant class has the power to write history and impose norms because it controls and directs economic, state, cultural, scientific, religious, educational, etc. institutions." Lesage then goes on to say that "Most of the narrative arts of our era--novels, plays, films, television programs--are devoted to working out the conflicts and contradictions of the bourgeoisie in terms understandable and acceptable to its male members." See Julia Lesage, "The Hegemonic Female: Fantasy in AN UNMARRIED WOMAN and CRAIG'S WIFE," FILM READER 5 (1982):83.

[146] Russell Baker, "Big One Gets Away," NEW YORK TIMES A (October 9, 1985):23; and Anthony Lewis, "The Rambo Doctrine," ibid., A (October 10, 1985):31.

In the media, woman have experienced the profoundest contradictions in their situation, because it is in the media that the grossest imbalance between production and consumption operates. In the ghettos of the family and "women's work" women have become the major agents of consumption for the products of capitalism: this fact articulates their cultural oppression and underpins their ideological manipulation: women are appealed to AND manipulated by the communications industry, and it is this basic contradiction which underlies the intervention women have sought to make in the media as a whole, and in film in particular.[147]

Whether one accepts Johnston's Marxist-feminist perspective is not the issue here. What is nondebatable is the position taken by feminist film critics and traditional scholars that the more celebrated the movie, the more it becomes a valuable reservoir of instructions (and misperceptions) about the world in which we live.

Feminists, semiologists, psychoanalysts, sociologists, and neo-Marxist film critics point out that every film is influenced not only by economic factors, but also by ideological considerations. For example, Laura Mulvey states that "cinematic codes create a gaze, a world, and an object, thereby producing an illusion cut to the measure of desire."[148] This illusion of desire is presented in a "natural" or "invisible" manner by a classic Hollywood style that obscures the way in which the illusion is constructed. For years it was mistakenly assumed that the "seamless narratives" without interference inflicted ideological positions on unsuspecting audiences. But by the fifties, mass communication scholars began calling attention to the limitations of this monolithic theory. We finally began to realize that audiences are not passive nor is film production a one-way process. In addition, Walsh's arguments about cultural hegemony astutely revealed that dominant social values are in a constant state of flux. Nonetheless, Mulvey's discussion of cinematic codes calls attention to the conflict that exists between dominant and subordinate groups, between acts of commission and acts of omission, as well as between simple-minded interpretations of a film's meaning and complex multi-layered reactions to a film's content. Staiger's perspective on ideological considerations is that

many of our most famous (and equally canonized) writers have been implicitly or explicitly interested in the social and historical effects of films on spectators. Siegfried Kracauer, Walter Benjamin, Dziga Vertov, Sergei Eisenstein, and Andre Bazin chose, analyzed, and discussed the implications of film form, style, and subject matter as it related to specific historical and social conditions. Each judged films in terms of whether or not they led to progressive or regressive social or political effects.[149]

Here again it is important to draw attention to the limitations of monolithic theories of communication and stress instead the nature of the reception process. For example, spectators may refuse to accept either the filmmaker's preferred meanings or the climax suggested by a film's resolution. Furthermore, film resolutions may explain more about what constraints the filmmaker encountered during the production of a particular narrative than about the story itself. For example, a "happy ending" may tell us more about censorship problems than about a logical resolution to a character's particular problems. Even further, how a film is received, as Keith Reader observes, may, in part, depend on how knowledgeable a society is about its own history and culture:

[147] Johnston, "Introduction," p.2.

[148] Mulvey, pp.17-8

[149] Staiger, p.14.

The manner in which [Jean] Renoir reconstructs the Revolution of 1789 in LA MARSEILLAISE, or John Wayne the time of Davy Crockett in THE ALAMO, tells us a great deal more about the time of the films' making than about that in which they were set . . . But the history of (or in) a film does not come to a stop when the shooting finishes. The long history of censorship, and its constant proof that what is acceptable in one period may turn out to be "pernicious" or subversive" in another, is proof of that. Films undergo a multiplicity of readings, rereadings, and reevaluations from one period to the next.[150]

In short, a film is influenced not only by economic considerations, but also by ideological positions.

Mulvey, Staiger, and Reader are not unique in their views. Many observers comment on the relationship between form and content in the cinematic apparatus and its ability to reinforce or to counteract the dominant ideology of the society in which the film continuum operates. In Chapter 2, I identified a number of critics who are interested in examining how formula films in America responded throughout most of the twentieth century to the tensions within and without our nation's borders. The point here is that the notion of ideological analysis has its roots firmly planted in studies done prior to the emergence of the political movements of the 1960s.

While this approach existed in various forms throughout film history, the notion of ideological analyses gained renewed prominence after the explosive political and social events of May, 1968, in France.[151] Responding to those events, the highly influential CAHIERS DU CINEMA changed its previous apolitical policies and advocated ideological analyses of films. In their October-November 1969 issue, the new editorial board announced their neo-Marxist position (heavily influences by Brecht's theories on theater) that not only were audiences misled into thinking that films mirrored reality, but also that films were not independent of the ideological systems that produced them. What was important for audiences to understand was that each filmmaker played a different role in creating the illusion of reality. Therefore, they wrote, "It is the job of criticism to see where they differ, and slowly, patiently, not expecting any magical transformations to take place at the wave of a slogan, to help change the ideology which conditions them."[152] The points that needed emphasis in the revised CAHIERS DU CINEMA approach were (1) the "political" nature of film (i.e., films cannot escape the values of the system that produce them); and (2) the false assumption that each film presents some concrete reality of the world.

The CAHIERS DU CINEMA writers argued just the opposite: "reality" in film was nothing more than an "expression of the prevailing ideology." Filmmakers do not deal with a true relationship to the way in which they live. Instead, they "react to their conditions of existence." What the camera records "is the vague, unformulated,

[150] Reader, pp.3-4.

[151] For a good summary of the events of May, 1968, see Sanche de Gramont, "A Bas--Everything!", NEW YORK TIMES MAGAZINE (June 2, 1968):23-5, 84-9.

[152] Reprinted in part in Comolli and Narboni, p.30. For useful introductions to the evolution of the magazine's 1969 position, see *Jim Hillier, ed., CAHIERS DU CINEMA: THE 1950s--NEO-REALISM, HOLLYWOOD, NEW WAVE (Cambridge: Harvard University Press, 1985); ___, CAHIERS DU CINEMA: 1960-1968--NEW WAVE, NEW CINEMA, REEVALUATING HOLLYWOOD (Cambridge: Harvard University Press, 1986); T. L. French, ed., CAHIERS DU CINEMA (New York: The Thousand Eyes, 1977); Sylvia Harvey, MAY '68 AND FILM CULTURE (London: British Film Institute, 1978); and George Lellis, BERTOLT BRECHT: "CAHIERS DU CINEMA" AND CONTEMPORARY FILM THEORY (Ann Arbor: UMI Research Press, 1982).

untheorized, unthought-out world of the dominant ideology."[153] The "depiction of reality" resulting from a film's economic roots thus became for the CAHIERS DU CINEMA revisionists the vital distinction upon which ideological analyses operated.

The issue itself was worth raising. If movies did reflect reality, then arguments raised by gender-influenced critics are simplistic. The standard defense is that "We're just showing things as they are." But if the movie images are distortions, masking a host of important omissions about society and its outsiders, then it is incumbent on responsible critics to identify the distortions/omissions, how the process operates, and the conceivable damage done to unsuspecting audiences. To that end, the CAHIERS DU CINEMA writers listed seven film classifications useful for ideological analyses: e.g., theatrical films completely consumed by the ideology that produced them, theatrical films that attacked the dominant ideology, theatrical films not explicitly political but that became so as a result of critical attention, theatrical films explicitly political, theatrical films ambiguous toward the dominant ideology, mainstream documentaries, and alternative documentaries.

In essence, the critic using this Marxist, materialist approach investigates both film content and style and how the film as a commodity represents political realities. The question, as Stephen Heath explains, "is not 'where is reality?' but 'how does this [e.g., prop, character, situation] function?', 'where is the reality IN THAT?'"[154] Heath goes on to explain that relationships in film (i.e., imaginary--"the mode of illusion, the inverted image") are just as real as those found in the social order. By examining a film's assumptions, the critic recognizes that the notion of ideology refers to the "UNITY of the real relations and the imaginary relations between men and women and the real conditions of their existence."[155]

In other words, ideology operates at every stage in the film process: from the nature of the institution that creates the film to the audience that receives it. Meaning is produced at each point of contact between individuals. By using the methodologies developed by neo-Marxists, feminists, psychoanalysts, semiologists, sociologists, and poststructuralists, a resourceful investigator "deconstructs"[156] the fabric of a film

[153] Comolli and Narboni, p.30.

[154] *Stephen Heath, QUESTIONS OF CINEMA (Bloomington: Indiana University Press, 1981), p.5.

[155] Heath, p.5.

[156] Deconstruction requires the investigator theoretically to reduce the structure of a film to its individual parts. These parts are then analyzed one by one. For example, the CAHIERS DU CINEMA writers after 1969 advocated breaking up the narrative structure of a film and then critiquing the separate parts in chronological order. Feminist film critics like Pam Cook and Claire Johnston, on the other hand, advocated "deconstructing" only those portions of the film that indicated ideologically internal conflicts. These "pregnant moments" became the focus of the initial textual analyses found in the studies on the work of Dorothy Arzner. Kuhn finds the distinction between ideology that creates tensions in film and ideology that doesn't to be insignificant, however, since film texts are read differently in different places and times, and thus critics have no need to search for film "ruptures." Furthermore, those who are looking for a more positive and subversive voice in films point out that "reading against the grain" ignores the textual system in which the "pregnant moments occur." Gentile, however, feels (p.9) that feminists benefit from having multiple interpretations, perspectives, and readings. For more information, see Cook, "Approaching the Work of Dorothy Arzner"; Claire Johnston, ed., THE WORK OF DOROTHY ARZNER: TOWARDS A FEMINIST CINEMA (London: The British Film Institute, 1975); Klinger, pp.137-43; *Kuhn, WOMEN'S PICTURES: FEMINISM AND CINEMA,

and determines where and how a particular film text contains the social and political values of the society and the historical period in which the film text was constructed.

Stereotypes, in this type of analysis, function as a visible contradiction between what is presented and what exists in real life, thereby serving as a stimulus for reform. For example, modern audiences are far too cynical to accept the notion that "Crime doesn't pay" or "Good guys always finish last." Watching gangster films from the classic Hollywood era often reveals how the Production Code forced filmmakers to preach unrealistic messages. By deconstructing films like G-MEN (1935) and THE ROARING TWENTIES (1939), the viewer demonstrates the difference between reality and illusion. On the other hand, audiences not aware of how ideology operates in films use stereotypes as a means of reinforcing values that critics representing residual and emerging cultures are challenging.

On the surface, the approach appears straightforward. The assumption is that individuals are guided, consciously or unconsciously, by ideological perspectives when producing a film. For their part, sensitive viewers recognize that meanings are imbedded or "stitched" into the various elements in the construction of films. They come to understand the considerable gap between "the real-world" and "screen reality." What was once accepted as a realistic image of the world is now perceived as a constricted image based on unseen assumptions that are ideologically motivated. Consequently, they see how crucial the moment of reception is in mediating between the film's preferred meaning and the reader's interpretation of the film text. The critic's responsibility is to make us aware of how the stitching process operates, what the potential consequences of the process are, and what alternatives there are to what we see in film texts.

We know, however, that neither the reader nor the film text itself is perfected enough to reduce meanings to exact terms. We know as well that demystifying one approach can mislead people into the false premise that another approach is more definitive. Linguists, film scholars, and semiologists acknowledge that ideologies, codes, signs, languages, images, messages, and readers are complex concepts requiring not only precise definitions and applications, but also that they are susceptible to multiple interpretations and uses. Therefore, to assume that there is one meaning or one use to which an ideological approach and its stock conventions and social types can be applied is naive. Bill Nichols, who scorns any film analyses modeled on the "langue of spoken languages," is also critical of the CAHIERS DU CINEMA approach. While not dismissing the entirety of their argument, he does attack

> their inability to deal with logical typing in communication--with how the context is defined and controlled and how this relates to patterns of social control, and the inability to apply mediation theory as an instrument of historical placement for cultural processes The concepts of logical typing, context, system, structure, and history need to be used to ask questions such as who exploits whom, what parts of a message circuit control (or mediate between other parts), how do frames generate paradox and who profits/suffers from it.[157]

Constance Penley points out that Heath's deconstruction approach "'is clearly the impass of the formal device' and that a socio-historically more urgent practice would be a work not on 'codes' but on the operations of narrativization which for him [Heath] means 'the constrictions and relations of meaning and subject in a specific signifying practice.'"[158] That being said, however, the attempt to deconstruct a mainstream film's ideological meaning and become sensitive to its stereotypes does

pp.84-108; and Judith Mayne, "Visibility and Feminist Film Criticism," FILM READER 5 (1982):120-4.

[157] Nichols, p.621.

[158] Penley, p.25.

introduce a valuable perspective on the way in which commercial theatrical films operate as a social force in society.

The editors of CAHIERS DU CINEMA successfully launched their Marxist, materialist approach with their analysis of John Ford's YOUNG MR. LINCOLN (1939) in 1970.[159] Their plan involved rescanning certain "classic" Hollywood films with the purpose of making

them say what they have to say WITHIN what they leave unsaid, to reveal their constituent lacks; these are neither faults in the work (since these films, as Jean-Pierre Oudart has clearly demonstrated . . are the works of extremely skilled film makers) nor a deception on the part of the author (for why should he practice deception?): they are STRUCTURING ABSENCES, always displaced--an overdetermination which is the only possible basis from which these discourses could be realized, the unsaid included in the said and necessary to its constitution.[160]

The notion that films could be "re-written" by critics and spectators was a basic assumption readily accepted by the editors. In their words, " . . . we do not hesitate to force the text, even to rewrite it, insofar as the film only constitutes itself as a text by integration of the reader's knowledge. . . ."[161]

To illustrate their thesis, they noted both that Hollywood and America in 1938-39 were still reacting to the Great Depression and that films made at the end of the decade took pains to reaffirm the film industry's support of the American capitalistic system. YOUNG MR. LINCOLN became the means of demonstrating for the CAHIERS DU CINEMA writers how 20th Century-Fox, its production head Darryl F. Zanuck, and its director John Ford incorporated into the context of the film an ideology reacting to federal centralism, isolationism, the economic reorganization of both America and Hollywood, the growing polarization of the Democratic and Republican parties, the dangers posed from international and domestic crises, and the economic and political battles being waged in Hollywood during the late 1930s.[162] As Brian

[159] Editors of CAHIERS DU CINEMA, "John Ford's YOUNG MR. LINCOLN," CAHIERS DU CINEMA 223 (1970):5-44. This important article has since been translated by Helen Lackner and Diana Matias and reprinted in SCREEN 13:3 (Autumn 1972):5-44; SCREEN READER 1 (1977):113-52; *MOVIES AND METHODS: AN ANTHOLOGY, ed. Bill Nichols (Berkeley: University of California Press, 1976), pp.493-529; and NARRATIVE, APPARATUS, AND IDEOLOGY, pp.444-82. All quotations cited in this chapter are from SCREEN READER. In addition, interested students will find helpful the following critical commentaries: Peter Wollen "Afterword," SCREEN 13:3, pp.152-55; Ben Brewster, "Notes on the Text, John Ford's YOUNG MR. LINCOLN," ibid., pp.156-70; Nick Browne, "The Spectator of American Symbolic Forms: Re-Reading John Ford's YOUNG MR. LINCOLN," FILM READER 5 (1979):180-88; ___, "Cahiers du Cinema's Rereading of Hollywood Cinema: An Analysis of Method," QUARTERLY REVIEW OF FILM STUDIES 3:3 (Summer 1978):405-16; Brian Henderson, "Critique of Cine-Structuralism (Part II)," FILM QUARTERLY 27:2 (Winter 1973-74):37-46; Bill Nichols, "Style, Grammar, and the Movies," ibid., 28:3 (Spring 1975):33-49, Rpt. MOVIES AND METHODS, pp.607-28. All quotations cited in this chapter are from MOVIES AND METHODS; Richard Abel, "Paradigmatic Structures in YOUNG MR. LINCOLN," WIDE ANGLE 2:4 (1978):20-6; Lellis, pp.114-6; J. A. Place, "YOUNG MR. LINCOLN, 1939," ibid., pp.28-35; and Jeff Sconce, Program Notes: YOUNG MR. LINCOLN," CINEMATEXAS PROGRAM NOTES 26:2 (March 6, 1984):46-52.

[160] Editors of CAHIERS DU CINEMA, p.116.

[161] Editors of CAHIERS DU CINEMA, p.145.

[162] For another ideological perspective, see Marsha Kinder, "The Image of Patriarchal

Henderson summed up CAHIERS DU CINEMA's political and economic reasons, "They concluded that the Republican Zanuck wanted to make a film about the Republican Lincoln in order to promote a Republican victory in the Presidential election of 1940."[163] The ideological construction consisted of reformulating "the historical figure of Lincoln on the level of the myth and the eternal."[164]

A case in point was the omission in the film of any meaningful discussion of Lincoln's attitude toward slavery. This is seen by the neo-Marxist editors as an example of "POLITICAL SIGNIFICANCE," because the filmmakers want to make the Lincoln image synonymous with the Republican party's positive image in the late 1930s. To show the historical Lincoln as favoring an evolving emancipation of blacks or to intimate that the Republican party in the post-Civil War period pursued a racist and sexist policy would hardly accomplish the alleged purposes of the filmmakers. In Henderson's view, the CAHIERS DU CINEMA writers argue that

> the truth of the film does not consist in the discourses which it speaks, but in the ways in which it presents, absents, hides, delays, transforms, and combines the discourses which speak it. Of course this operation is ideologically determined and is only revealed by an ideological analysis.[165]

Peter Wollen, however, disagrees with the conclusions that the editors of CAHIERS DU CINEMA reach about the depiction of slavery in YOUNG MR. LINCOLN. The issue is not simply one of chronology (the movie ends before the Civil War develops as a national crisis). For Wollen, the issues surrounding the Civil War are presented implicitly rather than explicitly.[166] Lovell also objects to the CAHIERS DU CINEMA perspective, not because the Marxist, materialist analysis of the film content distorts the ideas intended by the filmmakers, but because the French critics ignore the cultural context in which the film was shown. That is, people go to the movies in search of entertainment. "What happens to the film's ideological operation," Lovell asks, "if people are bored by the film? Does it then have no ideologial effect? Does the disruption that the analysis discerns at work in the film make it more entertaining for the audience or less by unsettling it?"[167]

The ongoing debate over the significance of the CAHIERS DU CINEMA piece is covered in articles already cited. It is not my intention here to analyze the merits of each side in the ideological controversy. Suffice it to say that the essay raised two key issues. First, it situated the operations of film texts within their historical, social, economic, and political contexts. Second, it raised the issue of acts of omission and pointed out that films can be reconstructed to reveal a latent meaning (one implied but never stated). Reconstruction is justified, as the CAHIERS DU CINEMA writers established, because a close reading of specific film texts often reveals internal inconsistencies between what is being shown at different times in a scene and from scene to scene. That is, "The ideology . . . becomes subordinate to the text.

Power in YOUNG MR. LINCOLN (1939) and IVAN THE TERRIBLE, PART I (1944)," FILM QUARTERLY 39:2 (Winter 1985-86):29-49.

[163] Henderson, p.38.

[164] Editors of CAHIERS DU CINEMA, p.121.

[165] Henderson, 43.

[166] Wollen, p.152.

[167] Lovell, p.53.

It no longer has an independent existence: it is PRESENTED by the film. . . ."[168] When that occurs, as in the case of the CAHIERS DU CINEMA critique of YOUNG MR. LINCOLN, perceptive readers find ideological analysis easier to achieve, because the film has made clear that ideological problems already exist within the film text and are hindering the continuous flow of the narrative. One could apply the same approach to deconstructing the stereotypes of Lincoln throughout film history.

CAHIERS DU CINEMA was not the only French film periodical reacting to the socio-political events of May, 1968. That same year CINETHIQUE began publication, also with the aim of developing a more critical perspective on the ideological relationship between film and society.[169] In a 1970 edition of the magazine, Jean-Louis Baudry set out to answer the question of whether the "technical nature of optical instruments, directly attached to scientific practice, serve[s] to conceal not only their use in ideological products but also the ideological effects which they may provoke themselves?"[170] His thesis was that the social and economic factors in the nineteenth century had motivated and shaped the invention of the basic cinematic apparatus. Baudry realized the need to define the criteria on which his conclusions would be based and offered tentative guidelines for making future judgments.

First, there was the need to recognize that a product ("a WORK") interposed itself between "'objective reality' and the camera, site of the inscription, and between the inscription and projection. . . ."[171] As a result, viewers aren't able to see or to participate in the transformation that occurs as the film is constructed shot by shot and edited into a finished product.

Second, it is important to understand what occurs in the process of transformation. Drawing upon the work of Louis Althusser,[172] Baudry stressed that film consumers (the audience) don't appreciate the fact that what they are viewing carries with it a hidden "ideological" message. That is, the transformation process related to filmmaking involves an obfuscation of knowledge rather than a scientific accounting of reality. What we see, therefore, is determined by the ideological system that ties together in continuous fashion the discontinuous elements that produce the images of the film. Our vision of reality is manipulated rather than determined by our independent judgment.[173]

Third, the ideology in films made in Western cultures relies on a perspective derived from the Renaissance. Just as the Renaissance painters gave their viewers a central and integrated perspective dependent on the artist's point of view and the importance of the human eye, so the contemporary filmmaker uses the center of the

[168] Editors of CAHIERS DU CINEMA 216-217 (October-November 1969). Cited in Comolli and Narboni, p.33.

[169] For more information, see Thomas Elsaesser, "French Culture and Critical Theory: CINETHIQUE," MONOGRAM 2 (Summer 1971):31-7.

[170] Baudry, p.40. See also Jean-Louis Comolli, "Technique and Ideology: Camera Prespective, Depth of Field," trans. Diana Matias FILM READER 2 (1977):128-40; Peter Lehman, "Style, Function, and Ideology: A Problem in Film History," FILM READER 4 (1979):72-80; and James Spellerberg, "Technology and Ideology in the Cinema," QUARTERLY REVIEW OF FILM STUDIES 2:3 (August 1979):288-301.

[171] Baudry, p.40.

[172] Two basic books are Louis Althusser, FOR MARX, trans. Ben Brewster (New York: Vintage, 1969); and ___, *LENIN AND PHILOSOPHY AND OTHER ESSAYS, trans. Ben Brewster (New York: Monthly Review Press, 1972).

[173] For another view of Althusser's treatment of ideology, see Simon Clarke et al., ONE-DIMENSIONAL MARXISM: ALTHUSSER AND THE POLITICS OF CULTURE (London: Allison and Busby, 1980).

space framed in the film to emphasize a continuous ideological perspective directly related to the film's subject. That is, the film determines for us what our point of view will be. The film subject (the "I" as the nucleus of the universe) functions as the "vehicle and place of intersection of ideological implications. . . ."[174] Substituting for the viewer's ego, the subject acts as the representative of a complete vision of what occurs in the viewer's range of experiences. This "world-view" leads the unsuspecting viewer to assume that what is being shown is an accurate image of objective reality. Thus Baudry believes that we must deal with the way in which filmmakers transform objective reality into an ideology that then appears to us in the finished product as if it were objective reality. Rather than allowing the filmmakers to make us forget how editing and montage are doctoring the images we see, he wants us to be conscious of the differences between what we see on screen and what exists in reality.

Fourth, Baudry points out that the Renaissance linear perspective in film creates a new meaning for the image created. It no longer is the object recorded, but an image defined by its new context. In short, the screen image is an "impression of reality."[175] Film critics must therefore reject the deceptive naturalness of the medium and investigate what new meanings are inherent in screen images, what the relationship is between the subject and the meanings associated with it.

Fifth, we need to deal with what "the reworked 'objective reality'" wants us to believe or to accept as ideological assertions about the characters, events, and themes in the film. Here Baudry relies on the "Mirror Phase theory" developed by Jacques Lacan.[176] The famous post-Freudian psychoanalyst will be discussed in more detail later. For our purposes here, it is important to point out that Baudry draws on Lacan's blending of semiotics and psychoanalysis to draw an analogy between the experiences of an infant in the first six to eighteen months of childhood, and the experiences of a viewer in a darkened movie house where the viewer is immobile and dependent on visual communication.[177] In simplified terms, both individuals in those circumstances rely on a self-image derived from an imaginary world. Objective reality in that time frame assumes a secondary importance. In particular, the film viewer uses film reality as the basis for what he or she accepts or rejects. In Baudry's words, "The spectator identifies less with what is represented, the spectacle itself, than with what stages the spectacle makes it seem, obliging him to see what he sees. . . ."[178] By having his spectator identify both with the film's characters and with the camera's perspective, the critic makes the false assumption that the spectator is

[174] Baudry, p.46.

[175] Baudry, p.43.

[176] See Jacques Lacan, THE LANGUAGE OF THE SELF, trans. Anthony Wilden (Baltimore: John Hopkins University Press, 1968); ___, "The Mirror Phase as Formative of the Function of the "I," NEW LEFT REVIEW 51 (1968)71-7; ___, "The Insistence of the Letter in the Unconscious," STRUCTURALISM, ed., J. Erhmann (New York: Anchor Books, 1970); and ___, *ECRITS: A SELECTION, trans. Alan Sheridan (New York: W. W. Norton, 1977).

[177] Worth noting is that Christian Metz also places great significance on the dreamlike state that takes place in a darkened auditorium where the spectator remains relatively motionless for the duration of the dramatic viewing. Unfortunately, this attitude carries with it the mistaken notion that audiences passively accept whatever messages are contained in the film. Cf. Christian Metz, *THE IMAGINARY SIGNIFIER: PSYCHOANALYSIS AND THE CINEMA, trans. Celia Britton et al. (Bloomington: Indiana University Press, 1977), p.117; and Penley, pp.9-14.

[178] Baudry, p.45.

not only passive, but also there is a direct line of communication between the artist and the spectator.

Baudry's ahistorical approach is tied to the problems generally associated with psychoanalytical and semiological studies, where the concern with the nature of film language ignores how a time and place affect the meaning of an image created by an artist, whether in Renaissance Italy or in modern Hollywood. It poses serious problems for feminist film critics who, on the one hand, argue that a sense of contradiction is the means whereby an individual gains critical understanding, and on the other hand insist that our subjectivity is controlled by the cinematic apparatus.[179] Baudry's essay also avoids the kinds of meanings "reworked objective reality" produces. That is, we do not get a sense of how class or gender interacts with the film process, of the actual relationships between the filmmakers and the material being transformed, and of the differences between the object being reproduced and the reproduction. The emphasis is almost exclusively on the construction of the illusions. More to the point, as De Lauretis argues, commentators like Baudry make a false analogy when comparing a mature film spectator with an infant during the Mirror Phase. The latter can be perceived as not yet aware of gender; the former cannot.[180] Consequently, mature film spectators bring to movies encrusted notions about issues, images, and interpretations. Furthermore, no attention is paid to the use of stock conventions and social types as basic ingredients in the film continuum. Each of these problems will be addressed later. For now, it is important to note that they exist as flaws not only in Baudry's essay, but also in the theories advanced by Lacan and Althusser.

The continent was not the only place that was reacting to political and social forces in the late 1960s. In America, for example, a group of feminist film critics began publishing WOMEN AND FILM in 1972. Focusing on the American film industry and the content of its movies, the magazine's initial editorial proclaimed that "The U. S. cinema, joining hands with local capitalists of other countries, has deformed peoples everywhere forcing them to be passive consumers of an alienating ideology but not creators of their own ideology."[181] The editors then went on to offer a quasi-sociological overview of how Hollywood exploited its employees in terms of race, gender, and education.[182] The emphasis was on pointing out how capitalist filmmakers not only contributed to and reinforced our neuroses, but also set false standards that the mass audience accepted and followed. Hollywood allegedly did this through its screen distortions of sex roles. The use of stereotypes came under severe attack because of its presumed debilitating effects on film audiences. WOMEN AND FILM offered itself as an alternative to the "schizophrenia, superficiality, perverted egocentricity, violence, and other neuroses" supplied by the American film industry by first identifying six immediate problems:

(1) A closed and sexist industry whose survival is precisely based on discrimination, . . . (2) The persistently false image of women on the screen no matter how "liberal" looking Ali McGraw is in LOVE STORY. (3) The persistence and consistency of the publicity department's packaging of women as sex objects, victims of chain or cycle gangs, or vampires of horror stories. (4) The auteur theory which has evolved into a male and masculine theory on all levels . . . (5) The process of System Cinema filmmaking itself, which is inhuman, involving an elitist hierarchy, destructive competition, and vicious internal politics. (6) The prejudice on the part of film departments in

[179] For an interesting perspective on Baudry, see Penley, pp.14-21.

[180] De Lauretis, p.145.

[181] "Overview," WOMEN AND FILM 1:1 (1972):3.

[182] The editors of RE-VISION correctly point out (p.16) that many of the magazine writers also used semiological arguments in attacking sexist film images.

universities and film institutes in accepting women in the faculty or as production students.[183]

WOMEN AND FILM's solution to these problems was to change the process by which a "sexist-elitist hierarchy" functioned and produce instead a "People's Cinema." The collective concept functioned in terms of WOMEN AND FILM where editorial decisions were arrived at by consensus.

Like most of the early feminist film criticism, the oppositional articles found in WOMEN AND FILM reminded us of the double standard by which a patriarchy discriminated against women publicly and privately. WOMEN AND FILM not only challenged the underlying assumptions of distorted images of gender-related issues, but also contributed to the growing demand that traditional interpretations of film history and theory be reexamined. What the magazine did not do, however, was give us much insight into the conditions that led to the distressing situation or make clear how a misunderstanding over the difference between perception and reality was causing massive confusion about gender-related issues in society.

Not surprisingly, the magazine's sociological and political position generated considerable controversy. In fact, the editors stated in their second volume that some of their critics took issue with their "'rhetoric,' calling it 'shrill.'"[184] Others suggested that the editors sounded "hysterical" and "irrational." Even more damaging to the magazine's aspirations, a number of contributors angrily disagreed with its theoretical approach. Committed to the strategies developed by semiologists, poststructuralists, and psychoanalytic critics, the outspoken opponents waged a losing battle to change the magazine's approach to feminist film criticism.

As a result, this dissatisfied group abandoned WOMEN AND FILM (which ended publication in 1975) and working through the University of California at Berkeley, began publishing CAMERA OBSCURA: A JOURNAL OF FEMINISM AND FILM THEORY in 1976. Also committed to a socialist and oppositional perspective, its editors advocated an analysis of film texts that revealed how meanings were influenced and formed in the process of signification. Owing much to the work done by linguists like Ferdinand de Saussure[185] and Christian Metz, the editors pointed out the importance of the relationships between different signs within a sign system (LANGUE). The key idea in such a textual approach was to examine how the signs operated as a form of communication (PAROLE). Metz, in particular, emphasized the value of knowing who was doing the communicating (the subject "I") and who was being targeted as the audience (the object "You").

The editors of CAMERA OBSCURA, well aware of studies done by Roland Barthes on literary codes,[186] incorporated the notion of LANGUE, PAROLE, "I," "You," and codes into their politically oriented film analyses. The analyses, however, went beyond textual explications. "Crucial to the feminist struggle," the opening editorial proclaimed, "is an awareness that any theory of how to change consciousness requires

[183] Editors of RE-VISION, pp.5-6.

[184] "A Note From the Editors, . . . " p.3.

[185] For a good introduction to his work, see Ferdinand de Saussure, *A COURSE IN GENERAL LINGUISTICS, trans. Wade Baskin (New York: The Philosophical Library, 1959).

[186] For useful information, see Roland Barthes, *ELEMENTS OF SEMIOLOGY (London: Jonathan Cape, 1967); ___, MYTHOLOGIES, trans. Richard Miller (London: Jonathan Cape, 1972); ___, S/Z, trans. Richard Miller (New York: Hill and Wang, 1974); ___, *THE PLEASURE OF THE TEXT, trans. Richard Miller (New York: Hill and Wang, 1975).

a notion of how consciousness is formed, of what change is and how it occurs."[187] It also requires that texts be seen as open, since open texts operate "as a social space through which various languages (social, cultural, political, and aesthetic) circulate and interact."[188]

Especially important to the CAMERA OBSCURA writers was the role played by culture in determining not only the way a film's meaning was constructed, but also the way in which it was received. Like their counterparts in France, the American theorists valued Lacan's psychoanalytic models. The four women who produced CAMERA OBSCURA (Janet Bergstrom, Sandy Flitterman, Elizabeth Hart Lyon, and Constance Penley) emphasized the significance of "A space in which the mechanisms of the unconscious and the construction of the human subject can be seen . . . [as the result of] the breaks, dislocations and deformations in the conscious text--the remembered dream, the film."[189] They explained that the magazine's metaphoric title was indicative of how ideology and representation can converge to constitute meaning in a product. For example, a capitalist society used the notion of ideology and representation converging to construct a piece of equipment. Marx and Freud, on the other hand, used the idea of the fifteenth-century camera obscura as a metaphor for describing the union of ideology with the unconscious.

The CAMERA OBSCURA writers incorporated these views into the title of their magazine, pointing out that feminist film theory should examine "the ideological effects of the cinematic apparatus on the spectator/subject, understanding the spectator as a social subject, a locus of ideological determinations."[190] This approach foreshadowed the growing recognition that contradictions can serve as a springboard for reform, rather than remain as a nonproductive source for critical disdain.

Journalistic attempts to widen alternatives to analyzing popular films continued into the 1980s. Starting in the spring of 1985, a short-lived Canadian film periodical, CINEACTION: A MAGAZINE OF RADICAL FILM CRITICISM,[191] appeared and reemphasized the importance of debating the "relationship between aesthetics and ideology."[192] Nowhere was the magazine's radical/social position more apparent than in Robin Wood's introductory essay on the dominant tendencies of Hollywood movies in the Reagan era.[193] From his neo-Marxist perspective, Wood perceived a common thread running through the period's commercially successful science fiction films, mad slasher movies, and family melodramas. Not only were many movies in these genres popular at the box office, but they also provided "the easy satisfactions of reassurance and the restoration of the 'good old values' of patriarchal capitalism."[194]

[187] Editors of CAMERA OBSCURA, "Feminism and Film: Critical Approaches," CAMERA OBSCURA: A JOURNAL OF FEMINISM AND FILM THEORY 1:1 (Fall 1976):3.

[188] Editors of CAMERA OBSCURA, p.5.

[189] Editors of CAMERA OBSCURA, p.6.

[190] Editors of CAMERA OBSCURA, p.10.

[191] The periodical changed its name after the first issue to CINEACTION: A MAGAZINE OF RADICAL FILM CRITICISM AND FILM THEORY. After only seven issues, it discontinued publication.

[192] The CineAction Collective, "Editorial," CINEACTION: A MAGAZINE OF RADICAL FILM CRITICISM 1:1 (Spring 1985):1.

[193] For another interesting perspective, see Vincent Canby, "Is Action or Politics the Real Attraction?", NEW YORK TIMES H (September 29, 1985):24, 38.

[194] Robin Wood, "80s Hollywood: Dominant Tendencies," CINEACTION: A MAGAZINE OF RADICAL FILM CRITICISM 1:1 (Spring 1985):2.

He saw American filmmakers performing their traditional role, discussed in greater detail in Chapter 5, of linking the tenets of the American Dream with popular entertainment. In other words, the psychological damage done to the American psyche by the Vietnam War and Watergate was being healed by movies that restored our confidence in patriarchal values. Thus films like KRAMER VS. KRAMER (1979) and ORDINARY PEOPLE (1980) restored "the law of the Father" to its pre-1960s standing. TRIBUTE and THE GREAT SANTINI (both in 1980) reiterated the necessity for the male child to be reconciled with his father. AUTHOR! AUTHOR! (1982) and RETURN OF THE JEDI (1983) pointed out that in a patriarchal society women functioned best as mothers and wives. RAIDERS OF THE LOST ARK (1981) and GHOSTBUSTERS (1984) reassured us that no problem was unsolvable in our nuclear age. E. T.: THE EXTRA-TERRESTRIAL (1982) and AN OFFICER AND A GENTLEMAN (1983) reminded us that we have to accept our society's shortcomings in order to take advantage of its considerable benefits. And HALLOWEEN (1978) and PORKY'S (1981) played with our hedonistic fantasies and winked at our adolescent desires, suggesting anew that we remain dependent on father figures for our protection.[195] Within a few pages of analysis, Wood synthesized the basic arguments that neo-Marxists, feminists, and gay liberationists make against the mass media and its "mindless" and "tasteless" audiences.

In the next issue of the radical magazine, Scott Forsyth examined the justification for Wood's elitist and extremist arguments about a monolithic ideology functioning in contemporary Hollywood movies. His respectful but adamant rejection of Wood's theory was linked first to

classic counter-assertions . . . that art does not strictly "reflect" the social (or psychic) order; that ideology does not produce art, but that the ideological text is one level of a complex interaction in any art (including media) amongst production, form, reception, social moment--a process not simply homogeneous and monolithic; that the issues of form and pleasure can't be read as "simply" ideological even if ideologically inflected or implicated; that the political ranking of art may be a drastic simplification of politics, if not an erroneously truncated evaluation of art; that political criticism must mesh, in some way, with aesthetic criticism.[196]

In short, Forsyth found Wood's "ideological critique outmoded in important ways." (1) It offered far too narrow a theory on both dominant ideology and social reality. (2) It assumed erroneously that written ideology is synonymous with history. (3) It ignored the relationship between ideological and institutional flexibility. (4) It mistakenly encapsulated political, social, and psychological factors under the concept of an authoritarian personality. (5) It overemphasized the power of the patriarchal family in a bourgeois society.

Forsyth went on to point out how the political movements of the 1960s and 1970s were as much in step with "bourgeois liberalism" as they were with "a generation of radicals."[197] That is, these political movements lacked permanence, challenge, or potency. In fact, Forsyth insists that it was their disorganization and sporadic characteristics that fostered the reemergence of the Right as a force in the 1980s. Thus he saw Wood making a major miscalculation in believing that the efforts by

[195] Wood, pp.2-5. Wood's article is a terse summary of his book HOLLYWOOD FROM VIETNAM TO REAGAN (New York: Columbia University Press, 1985).

[196] Scott Forsyth, "Fathers, Feminism and Domination: Marxist Theory on Ideology in Popular Film," CINEACTION: A MAGAZINE OF RADICAL FILM CRITICISM AND FILM THEORY 1:2 (Fall 1985):29.

[197] Forsyth, p.31.

African-Americans, feminists, environmentalists, gay liberationists, and antinuclear activists were going to serve as the basis for reforming society. Furthermore, Wood, in reducing his arguments to a single major influence, totally overlooked the important relationship between mass audiences and the mass media. One need only understand the use that Hollywood makes of genres and their stereotypes to play on the desires audiences have for innovation and tradition to recognize that a one-dimensional interpretation of film production is unjustified.

Forsyth, for his part, sees neo-Marxist ideology as a more effective methodology:

the [patriarchal] model tends to efface class, or makes it appear as an addendum. In fact, only as specific oppression is understood as operating through class structure, and political differentiation and class consciousness develops within the "movements," can there be some hope for a comprehensive radicalism.[198]

The remainder of Forsyth's argument consists of showing how the past ten years of Hollywood filmmaking are nothing more than a rehashing of traditional class struggles and old-fashioned anti-Communist rhetoric.[199] He is particularly effective in showing how mainstream cinemas have co-opted radical feminist values into conventional Hollywood women's roles in movies from JULIA (1977) and NORMA RAE (1979) to the recent flurry of films about courageous farmers' wives--PLACES IN THE HEART, THE RIVER, and COUNTRY (all in 1984). Whether one accepts Forsyth's neo-Marxist premises or downplays the flaws in Wood's ahistorical reductionist theory is not central to the issue here. What is relevant is that radical theory about ideology as art should be seen as neither homogeneous nor univocal.

The dilemma created by the flaws in radical film theory is how to salvage the valuable arguments about ideology in film made by authors like those in CAHIERS DU CINEMA, CINETHIQUE, WOMEN AND FILM, CAMERA OBSCURA, and CINEACTION and, at the same time, acknowledge the importance of anchoring film analyses in historical and institutional contexts. One way to solve the dilemma, suggests Robert Arnold, is to perceive a historical analysis of the "subject" as "necessarily a question of RECEPTION."[200]

[198] Forsyth, p.32.

[199] For more of Forsyth's ideological analyses, see Scott Forsyth, "Capital at Play: Form in Popular Film," CINEACTION: A MAGAZINE OF RADICAL FILM CRITICISM AND FILM THEORY 1:3/4 (Winter 1986):91-7.

[200] Robert Arnold, "The Architecture of Reception," JOURNAL OF FILM AND VIDEO 37:1 (Winter 1985):37. Much of reception theory emanates from current literary studies. For more information, see Chapter 1 and the following books: *Stanley Fish, IS THERE A TEXT IN THIS CLASS?: THE AUTHORITY OF INTERPRETIVE COMMUNITIES (Cambridge: Harvard University Press, 1980); ___, *SELF-CONSUMING ARTIFACTS: THE EXPERIENCE OF SEVENTEENTH CENTURY LITERATURE (Berkeley: University of California Press, 1972); ___, *SURPRISED BY SIN: THE READER IN PARADISE LOST (Berkeley: University of California Press, 1967); Norman Holland, THE DYNAMICS OF LITERARY RESPONSE (New York: Norton, 1975); ___, FIVE READERS READING (New Haven: Yale University Press, 1975); *Jane P. Tompkins, ed. READER-RESPONSE CRITICISM: FROM FORMALISM TO POST-STRUCTURALISM (Baltimore: John Hopkins University Press, 1980); and Wolfgang Iser, "The Reading Process: A Phenomenological Approach," ibid., pp.50-69; Rpt. from *Wolfgang Iser, THE IMPLIED READER: PATTERNS IN COMMUNICATION IN PROSE FICTION FROM BUNYAN TO BECKETT (Baltimore: John Hopkins University Press, 1974), pp.274-94. See also Harald Stadler, "The Spectacle of Theory: An Historical Speculation," WIDE ANGLE 8:1 (1986):4-9; Patrice Petro, "Reception Theory and the Avant-Garde," ibid.,

That is, the investigator begins with the assumption that the work being studied constantly produces different reactions from its audiences, depending on the social, political, and economic contexts in which it is presented. As Tony Bennett points out, "It is . . . a call to displace the existing object of literary analysis--the text--in the sense that . . . the text itself, as something that is independent of the varying contexts which define the real history of its productive consumption, is an inconceivable and non-existent object."[201] For example, Arnold's problem with Baudry's analogy comparing Renaissance paintings with modern filmmaking is that "textual" similarities overshadow "contextual" differences.

One remedy to that problem is to define "context" in two specific senses: historical and institutional. The former emphasizes the evolutionary characteristics of a changing ideology, while the latter relates to the medium in which the artist creates. For example, the historical context forces us to examine what effect penny arcades had on the way films evolved over time as a means of communication and as a business.[202] The institutional context asks that we consider what effect seeing a film in an art theater, a picture palace, or at a drive-in has on our reading of the film.[203] The point is that we recognize that differences exist between the two contexts and that we not blur those differences by making them appear to be one and the same. In fact, Arnold insists that it is the differences between the "ideology of perspective images" found in historical and institutional contexts that is the important aspect of analysis. Compare, for example, the stage and social perspectives of the Baroque theater with the nature of film. The former emphasized both humanistic values and the social demands of an absolutist class system. The latter, on the other hand, reflects a "democratic" orientation both to humanism and to a classless society.

Considerations precisely like these lead Arnold to outline "the necessity for both SYNCHRONIC and DIACHRONIC modes of historical vision, to account not only for the historical specificity of particular signifying institutions, but also for the important historical changes that occur between them."[204] He illustrates his hypothesis by theorizing that movies appeared only after the stage had begun to incorporate into its production and exhibition policies those practices that favored more "democratic" conditions than were found in Renaissance and Baroque stage traditions governed by absolutist doctrines of social class. He also notes the importance of the historical shift in society from a pre-industrial environment in which spectators exerted considerable influence on stage performances, to a complex division of labor in which mass audiences are too fragmented and too removed from the product to influence immediately its nature and content. Although Arnold's neo-Marxist comparison of the Baroque theater and the modern movie house only skims the surface of the complex audience-stage/film relationship, it nonetheless raises our consciousness about the complicated bonds that exist between films and mass audiences, the ideological advantages that film may have over the stage, and the possible role film can perform as a social force in society.

pp.11-7; and Janet Staiger, "'The Handmaiden of Villainy,": Methods and Problems in Studying the Historical Reception of a Film," ibid., 29-38.

[201] Tony Bennett, "Text and Social Process: The Case of James Bond," SCREEN EDUCATION 41 (Winter/Spring 1982):3-14. Cited in Arnold, p.46.

[202] For a discussion on how business people are currently be stereotyped on TV, see Barbara Basler, "'Bad Guys' Wear Pin Stripes," NEW YORK TIMES D (January 29, 1987):1-2.

[203] For an example, see Neal Gabler, "For 25 Cents, Every Moviegoer was Royalty," NEW YORK TIMES A (January 24, 1989):21.

[204] Arnold, p.38.

Arnold's approach also relates well to the strategies of feminist film critics who advocate psychoanalysis as a critical tool. Because the feminist film critics claim that only after an industrial society came into being was it possible to create mechanical art forms like cinema, radio, and television, many of them view psychoanalysis as the best means for illuminating how an industrial society through its mechanical art forms, influences and controls mass audiences. It is at the moment of reception that psychoanalytic critics examine how the process works.

Clearly, popular movies produce more than opinions on social, political, and economic issues. They are also significant advertisements for products other than the movies themselves.[205] For instance, most film histories report how stars like Rudolph Valentino, Gloria Swanson, and Clara Bow set fashion trends by the clothes and cosmetics they wore in their 1920s films.[206] A decade later, Walt Disney turned product spin-offs--e.g., Mickey Mouse watches, Donald Duck comic books--into the beginning of a multimillion dollar empire.[207] Fan magazines of the 1930s helped the starstruck public imitate the beauty secrets of their screen favorites and helped recreate them in their homes, the interior decorations of homes owned by their movie idols.[208] Ever since, entrepreneurs have recognized that their brand products often benefit considerably by being "tied-in"[209] with a major motion picture.[210] In fact,

[205] For one example, see "Commercials at Movies: The Filmgoers' Burden," NEW YORK TIMES (October 7, 1974):21.

[206] Helpful for understanding how clothing and other fashion trends function as signifiers or as representations of cultural values are Barthes's studies conducted on "codes." To oversimplify a complex concept, Barthes argues that films transform the meanings of everyday representations into mythological representations that are then used repeatedly from film text to film text. For example, a glass of champagne (a signifier) loses on screen its realistic meaning and becomes instead a cultural symbol for romance (a signified). That transformation of meaning from denotative to connotative is the basis for analyzing a film text's ideology. For specific examples of how Barthes develops the concept of film codes, see his MYTHOLOGIES. For specific examples of how clothes used in film codes are much more than cosmetic props, see *Rebecca Bell-Metereau, HOLLYWOOD ANDROGYNY (New York: Columbia University Press, 1985).

[207] In 1939, Walt Disney Enterprises claimed that over 145 different individuals or companies had permission to manufacture close to 2,200 different spin-offs modeled after characters and props in SNOW WHITE AND THE SEVEN DWARFS. Cited in Margaret Farrand Thorp, AMERICA AT THE MOVIES (New Haven: Yale University Press, 1939), p.118.

[208] For examples of how the film-audience relationship operates in this regard, see *Richard Dyer, STARS (London: British Film Institute, 1979); and Maureen Turim, "Gentlemen Prefer Blondes," WIDE ANGLE 1:1 (1976):52-9.

[209] It is important to distinguish between "tie-ups" and "tie-ins." The former refers to efforts by the film industry to relate a particular film to a local activity. For example, an exhibitor contacts public schools when a film based upon a famous book is being shown. For more information see Margaret Thorp, AMERICA AT THE MOVIES (New Haven: Yale University Press, 1939) pp.58-60. "Tie-ins" refers to the selling of products associated with a particular film.

[210] For examples of how the tie-in process operates, see Frank Barron, "Movie-Themed Films Aimed at Large Record-Buying Audience," HOLLYWOOD REPORTER (March 22, 1978):1, 16; _____, "Worldwide Merchandising Yields Heavily For Factors," ibid., (April 12, 1978):9; Don Safran, "'Fever' Yields Merchandising Gold; Promoter Gives Input," ibid., (July 12, 1978):3; Arlene Hershman, "The New Money in

film tie-ins had become so commonplace by the early 1980s that Janet Maslin took for granted the paraphernalia that arrived in the stores simultaneously with the premiere of the film E. T.: THE EXTRA-TERRESTRIAL (1982): e.g., E. T. dolls, clothes, bedsheets, key chains, pins, calendars, notepads, erasers, and ice cream.[211] Aljean Harmetz reported that "Kamar International, the California toy company that designed and is manufacturing five or six versions of the stuffed toy, expects to do $40 million in business by selling six million toys ranging in price from $5 to $20."[212] Except for the occasional promotional miscalculations tied in with films like ANNIE (1982) and GREMLINS (1984), "filmmakers have become so impressed with the benefits accruing from ancillary rights [e.g., free film promotion, reduced production costs, enormous side-profits]," explains Don Safran, that "merchandizing representatives are now reading advanced film treatments to suggest script inserts of ideas to help sell film-related items."[213] Even further, as will be discussed later in this chapter, the intricate interrelationships among banking interests, multi-national corporations, and the film industry extend to other sectors of the social, political, and economic areas of the world.[214]

Not all of the interaction that occurs between the filmmaker and the public, however, is intentional. For example, Warner Bros., in the 1930s, ran into trouble with American parents when its production of THE ADVENTURES OF ROBIN HOOD (1938) stimulated some youngsters to practice their archery by shooting "chickens, cats, and each other."[215] Walt Disney found himself at odds with J. Edgar Hoover over the filmmaker's treatment of the Federal Bureau of Investigation in movies like MOON PILOT (1962) and THAT DARN CAT (1964).[216] The producers of GUESS WHO'S COMING TO DINNER? (1968) had no way of knowing that their references to Dr. Martin Luther King would necessitate re-editing problems when he was murdered during the film's initial run. Surely, Columbia Pictures never expected that their 1983 TV mini-series SADAT would result in Egypt's banning all films produced or distributed by the company.[217]

Movies," DUN'S REVIEW (February 1971):33-6; Edwin McDowell, "Dinesen a Big Seller Again With Film Tie-In," NEW YORK TIMES C (December 30, 1985):13; Aljean Harmetz, "Movie Merchandise: The Rush Is On," ibid., C (June 14, 1989):19, 26; David A. Daly, A COMPARISON OF EXHIBITION AND DISTRIBUTION PATTERNS IN THREE RECENT FEATURE MOTION PICTURES (New York: Arno Press, 1980); and *Garth Jowett and James M. Linton, MOVIES AS MASS COMMUNICATION (Beverly Hills: Sage Publications, 1980), pp.60-2, 128. For another perspective on tie-ins, see Charles Eckert, "The Carole Lombard in Macy's Window," QUARTERLY REVIEW OF FILM STUDIES 3:1 (Winter 1978):1-21.

[211] Janet Maslin, "The Store Promotions Are Trivializing E. T.," NEW YORK TIMES C (December 9, 1982):21.

[212] Aljean Harmetz, "Thousands of E. T.'s Are Heading for Stores," NEW YORK TIMES C (July 16, 1982):8.

[213] Safran, p.3.

[214] For one recent example, see Aljean Harmetz, "Movies Look Abroad for Profit," NEW YORK TIMES A (December 17, 1988):13.

[215] Cited in Thorp, p.33.

[216] "Files of F.B.I. Tell of Contacts Between Hoover and Disney," NEW YORK TIMES A (October 15, 1985):25.

[217] Judith Miller, "Upset by SADAT, Egypt Bars Columbia Films," NEW YORK TIMES A (February 2, 1984):1, C17. For another interesting story about Soviet pressure

Nor for that matter did many of the Hollywood contract directors perceive themselves as AUTEURS. In their minds they were doing a commercial job that not only paid well, but also was glamorous. Charles Boultenhouse sums up the opinion of many movie veterans:

The Hollywood director is usually surprised to discover that his 'art' has been taken seriously; this is because he has never been serious about 'art' as such. His first concern has been to make his film as exciting as possible in order to keep the customers coming to see it, so that the investment would be protected--yield a profit. A Hollywood director, plainly speaking, is a craftsman using all his skills to protect an investment by making as much profit as possible. If his skills and devices are repeated and developed to the point where they can be identified, this does not make him into an artist . . . When it comes to the total work of these efficient imaginative craftsmen, one must simply face the facts. Their films cannot be studied as a developing revelation of artistic intention, not because their skills did not develop, but because they never had a single artistic intention, and it is pointless to pretend that they did. The truth is that the commercial director should have the proper and honest reward of being credited with a job well done rather than wear the dubious appellation of artist.[218]

Nonetheless, generations of critics have found a multitude of messages that communicated significant and disturbing ideas about our society in the films of directors like Dorothy Arzner, Frank Capra, George Cukor, John Ford, Samuel Fuller, Howard Hawks, Alfred Hitchcock, Val Lewton, Ida Lupino, Douglas Sirk, and George Stevens. As Michael Selig summarizes the theory, "Sirk and his peers 'create' films that have two levels embedded--manifest (conventional) content and latent, ironic subtext (often Brechtian)."[219] At the same time, Keith Reader points out that the revisionist status of low-budget directors like Sirk and Fuller can obscure "the circumstances of a film's making" and distort how a film is interpreted in a way different from its first release.[220]

Both Selig and Reader, however, are concerned with how audiences receive film messages. The claims made by such critics are rooted in the fact that filmed dramas depict identifiable events either in our imagination or in our experience. They act as interpretations of "the real world." That is, millions of people around the globe go to the movies for credible impressions of our physical environment, down-to-earth

relating to a media event, see Peter J. Boyer, "ABC Delays AMERIKA, Discloses Soviet Warning," ibid., C (January 6, 1986):22; "ABC Criticized for Move After Soviet Threat," ibid., A (January 12, 1986):4; Bernard Weinraub, "ABC Admits an Error in Airing Russian's Views," ibid., A (February 28, 1986):4; "The Amerikan Way on TV," ibid., E (February 15, 1987):20; John E. Mack, "'Amerika'--an Irresponsible TV Series," ibid., p.21; and John J. O'Connor, "'Amerika'--Slogging Through a Muddle," ibid., pp.B1, 29. For still another example, there is the reaction of the American Museum of Natural History to the violence in China in June 1989. See Herbert Mitgang, "Museum Cancels China Film," NEW YORK TIMES C (June 16, 1989):13.

[218] *Charles Boultenhouse, "The Camera as a God," THE NEW AMERICAN CINEMA: A CRITICAL ANTHOLOGY, ed. Gregory Battcock (New York: E. P. Dutton and Company, 1967), pp.107-9.

[219] Michael A. Selig, letter to author, November 15, 1985.

[220] Reader, p.4.

reactions to emotional traumas, and pragmatic evaluations of the possible solutions to contemporary problems.[221]

How people "learn" from the movies relates to the manner in which they view films. It isn't just a matter of knowing what information impacts on a spectator. It is also important to understand why a particular "message" is received. A tentative theory identifying the significant variables and the relationship among them is offered by James M. Linton. He begins by arguing that the film-viewing experience consists as a composite of "the physical characteristics of the activity, and the psychological or personality characterizations of the viewer."[222] At the heart of the relationship between those factors is "identification," the process that transports viewers from their world to the reel world. Linton then draws upon the work of researchers like Peter Dart, Gordon Noble, Cecilia V. Feilitzen, Olga Linne, Denis McQuail, and Andrew Tudor to identify various ways whereby identification occurs. Particularly beneficial is his summary of Tudor's four types of identification: "emotional affinity, self-identification, imitation (of physical and simple behavioral characteristics), and projection."[223] Each of these forms of identification, Linton suggests, remains bound to the physical, social, and psychological nature of the viewing experience. The manner in which they interact determines a film's reception and interpretation by the viewer. Linton also stresses that because North Americans perceive films primarily as "light, somewhat frivolous, value-neutral and socially innocent experiences," the viewers become especially "susceptible to new attitudes and opinions, beliefs and values dealing with unessential or unfamiliar matters. . . ."[224]

The nature of the interaction between filmmakers and their audiences, and how it functions, remains among the most hotly debated issues in the twentieth century. Few intellectuals today deny that the communications revolution that started in the 1830s with inexpensive daily newspapers and continued with the telegraph, telephone, moving pictures, radio, and television has contributed significantly to reshaping and molding our civilization. What intellectuals do argue about is whether the changes are for the better. Much, but not all, of the problem relates directly to the fact that the new mass media are linked closely to popular culture.

BOOKS

*Artel, Linda, and Susan Wengraf. POSITIVE IMAGES: A GUIDE TO NON-SEXIST FILMS FOR YOUNG PEOPLE. San Francisco: Booklegger Press, 1976. Illustrated. 168pp.

Concerned primarily with evaluating media materials from a feminist perspective, Artel and Wengraf selected materials that met at least one of the following characteristics: "Presents girls and women, boys and men with non-stereotyped behavior and attitudes, i.e., independent, intelligent women; adventurous, resourceful girls; men who are nurturing; boys who are not afraid to show their vulnerability. Presents both sexes in non-traditional work or leisure activities, i.e., men doing housework, women flying planes. Questions values and behavior of

[221] For an example of the problem, see Caryn James, "Lately, Seeing Isn't Believing," NEW YORK TIMES H (November 20, 1988):13, 18.

[222] James M. Linton, "The Nature of the Viewing Experience: The Missing Variable in the Effects Equation," FILM/CULTURE, p.186.

[223] Linton, p.188.

[224] Linton, p.192.

traditional male/female role division. Deals with a specific women's problem such as pregnancy, abortion, rape in a non-sexist way." Not surprisingly, few media materials were found that met these ideal standards. As a result, the authors note the reservations they have about the sexist elements in the materials listed in the book's four major divisions: films, video, filmstrips and slide shows, and photographs. Alphabetically arranged, each section contains information about renting, purchasing, or obtaining the material, along with recommendations about suitability, running time, date of release, and whether the material is in color or black and white. Anyone planning a classroom unit on sexism should appreciate the book's organization, the more than 400 annotations, and the three concluding sections on distributors' addresses, selected resources for non-sexist education, and a subject index. Well worth browsing.

*Bell-Metereau, Rebecca. HOLLYWOOD ANDROGYNY. New York: Columbia University Press, 1985. Illustrated. 260pp.

A study of over 250 movies dealing with some type of role exchange or transvestism in a key scene or as a plot device, this book takes an eclectic approach in order to be as comprehensive as possible. "With some films," Bell-Metereau writes, "I have gone into detail on the cultural background and critical reception of the film to highlight how it reflects contemporaneous social concerns. In other cases, I have examined the influential work of a director, actor, or actress who, despite commercial pressures, has managed to put his or her personal stamp on the image of androgyny." Of the book's five entertaining chapters, only the first two treat female impersonation before 1960. The lively narrative stresses the major breakthroughs, the important films, and the controversial images. Endnotes and an index are included. Well worth browsing.

*Betancourt, Jeanne. WOMEN IN FOCUS. Dayton: Pflaum Publishing, 1974. Illustrated. 186pp.

A first-rate pioneering filmography annotating more than ninety "non-sexist" films by women filmmakers, this handy book alphabetically lists movies (primarily short subject and documentaries) by filmmaker, distributor, type, theme, chronology, and nationality. Included in the citations are information about date of release, descriptions of the film, critical reactions, targeted audiences, and useful discussion topics. A valuable annotated bibliography suggests helpful background material for discussing sensitive films related to issues like abortion, childbirth, homosexuality, women on welfare, prostitution, rape, and pregnancy. Even though much of the text may be out-dated by current standards and scholarship, the information contributes to a better understanding of women's issues in the seventies and the present. Librarians and public school teachers probably will benefit most from having this book available for their selection of suitable films for young people. Well worth browsing.

*Blonski, Annette, et al., eds. DON'T SHOOT, DARLING! WOMEN'S INDEPENDENT FILMMAKING IN AUSTRALIA. Richmond, Australia: Greenhouse Publications, 1987. Illustrated. 400pp.

*Brunsdon, Charlotte, ed. FILMS FOR WOMEN. London: British Film Institute, 1986. Illustrated. 236pp.

"This book," Brunsdon writes, "brings together a range of articles made in Europe and North America since the emergence of the 'new feminism.'" Limiting her anthology to essays dealing with "women as an audience," rather than as producers of films. Brunsdon's contributors "focus on the representations of women that women have made, and which the film industry has offered us, rather than on the role of women as film-makers, in whatever capacity." Instead of examining intentions, the authors offer a series of "readings" of films like GIRLFRIENDS (1978), A QUESTION

OF SILENCE/DE STILTE ROND CHRISTINE M (1982), and PERSONAL BEST (1983). The book itself is divided into four major sections: documentary, fiction, Hollywood, and distribution and exhibition. Each section begins with a useful overview, discussing the relevance of the material to the current debates about realism and AVANT-GARDE cinema, positive images of women, the politics related to the representation of the female body, attitudes toward the commercial film industry, and the nature of the audience. An appendix listing three statements about British feminist exhibition and distribution, endnotes, a filmography, and an index are included. Recommended for special collections.

*Cristall, Ferne and Barbara Emanuel. IMAGES IN ACTION: A GUIDE TO USING WOMEN'S FILM AND VIDEO. Toronto: Between the Lines, 1986. Illustrated. 120pp.
 A handy guide on how to run a feminist screening, this resource book attempts to provide basic information on setting up film series, festivals, and consciousness-raising programs. Four brief chapters suggest organizational strategies and comment on feminist filmmaking outside mainstream channels. Appendices provide thumbnail accounts of important women in film history, how to locate a specific film, "cineographies," and a bibliography. No index is provided. Well worth browsing.

*Dawson, Bonnie. WOMEN'S FILMS IN PRINT: AN ANNOTATED GUIDE TO 800 16mm FILMS BY WOMEN. San Francisco: Booklegger Press, 1975. 165pp.
 Not as detailed as Betancourt's reference book, this well-organized resource work nonetheless is a welcome addition for teachers and librarians searching for suitable films to include in thoughtful programs on women in and on film. Dawson identifies the efforts of 370 women filmmakers who more often than not were excluded from the traditional distribution outlets and whose work was inaccessible to students and teachers up until 1975. The films themselves range from documentaries and theatrical releases, to short subjects and animated cartoons. No attempt is made to analyze their quality. Instead, the author only wants to indicate what the film is about and to provide relevant information about date of release, running time, and rental cost. The major portion of the book is alphabetically arranged by the name of the filmmaker. Other sections include distributors' addresses, a bibliography, a title index, and a subject index to the films. Well worth browsing.

*De Lauretis, Teresa. ALICE DOESN'T: FEMINISM, SEMIOTICS, CINEMA. Bloomington: Indiana University Press, 1982. 220pp.
 Thoughtful and challenging, this complex book nevertheless presents problems for novices not trained or sympathetic to militant film theory. Right from the start, De Lauretis states, "For me it is important to acknowledge, in this title, the unqualified opposition of feminism to existing social relations, its refusal of given definitions and cultural values. . . ." Her strategy is to extend the "arguments" against mainstream culture evident in feminist circles; and then through six excessively theoretical essays confront the hegemonic discourses that have masterminded the dominant screen representations of "woman." The concept of "woman" is distinguished from that of "women." The former refers to a "fictional construct"; the latter, "real historical beings." In short, she uses "writing AND reading . . . [as strategies for] cultural resistance." Those writers most frequently cited in dealing with the representations of woman are Sigmund Freud, Jacques Lacan, Claude Levi-Strauss, Italo Calvino, Alfred Hitchcock, Michael Snow, Nicolas Roeg, Michel Foucault, Umberto Eco, and Jurij M. Lotman.
 In Chapter 1--"Through the Looking Glass"--De Lauretis demonstrates her methodology by reexamining the recent film theories from semiotics and psychoanalysis. "Whether we think of cinema as the sum of one's experiences as spectator in the socially determined situations of viewing," she writes, "or as a series of relations linking the economics of film production to ideological and institutional

reproduction, the dominant cinema specifies woman in a particular social and natural order, sets her up in certain positions of meaning, fixes her in a certain identification." In essence, woman becomes "a ground of representation, the looking-glass held up to man." The formula presents "woman as sign or woman as the phallus equals woman as object or woman as the real, as Truth. . . ." De Lauretis then proceeds to explain the similarities between semiotic and psychoanalytic discourses on movies. Crucial to her argument is the notion that the novel, television, and cinema should not be lumped together. Their content and the manner in which they are significant involve different modes of production, are targeted for different audiences, and involve different modalities of enunciation. Thus, she insists that we shift attention away from examining movies as a social technology, and concentrate instead on alternative reception theories.

Chapter 2--"Imaging"--begins with an exploration of how woman is represented as a spectacle, an object to be observed, and as an image of beauty. The intent is to demonstrate how spectators see and what meanings they attribute to mainstream film images. Her discussion of recent developments in perception theories and the role of subjectivity in the reception process leads to an intriguing overview of the shift away from the study of language to the study of discourse. Afterward, the focus is on reformulating the issues related to the notion of film imaging to account for "context, pertinence, and purposefulness (of the codes)." Particular attention is paid to analyzing the theories of cinematic language postulated by Pier Paolo Pasolini and the notion of illusion discussed by E. H. Gombrich. De Lauretis's conclusion is that "narrative and visual pleasure need not and should not be thought of as the exclusive property of dominant codes, serving solely the purposes of 'oppression.'" Instead, feminists should use cinematic meanings and images to expose the "contradictions of women as social subjects."

Chapters 3 and 4 provide examples of filmmakers who have used narrative and imagistic strategies to call attention to the contradictory nature of women spectators. For example, Michael Snow's film PRESENTS (1981) illustrates how image and narrative play on tensions and affect the spectator's subjectivity. Nicolas Roeg's BAD TIMING--A SENSUAL OBSESSION (1980) represents a unique category of mainstream films and seems to have offended almost everyone who has seen it. But despite its controversial blending of sex and politics, the film illustrates, for De Lauretis, an example of how "unpleasure" can undercut "a spectator's pleasure by preventing both visual and narrative identification. . . ."

Chapter 5--"Desire in Narrative"--analyzes both the relation of narrative to genres, and the relation of narrative and desire to textual practice. The stimulating exercise involves a feminist re-reading of highly prized film texts, with a particular concern for the gender assumptions underlying mythical subjects in folktales and the Oedipus story. Her theory is that such an examination reveals how narratives take over the role of mythical subjects and concentrate on producing a legitimation of differences. These images of differences, in turn, operate ideologically to legitimate the status of men and position women as "Non-men" or "Other." Over a period of time, this patriarchal sense of the world is equated with pleasure, and audiences feel uncomfortable when it is omitted or attacked in mainstream or alternative films. Mainstream filmmakers concentrate on satisfying their audiences' desires; thus the problem with mainstream cinema and critical viewing. Women spectators, therefore, must deal with the complexity of the cinematic identification process.

The last chapter--"Semiotics and Experience"--focuses on the importance of understanding how subjectivity (e.g., "the construction of sexual difference") is achieved--that is, how the dynamic nature of personal interaction with "practices, discourses, and institutions" produces our perspective on human and abstract relationships. Among the topics covered are the feminist critique of ideology, relating experience to subjectivity, and the role of semiotics in linking the external world to the internal one. In effect, De Lauretis points out how events and experiences intersect in a patriarchy to construct a female subjectivity. The challenge for feminists, therefore, is how to fashion a coherent theory that analyzes, understands, and articulates how the female subjectivity is constructed and with what effects.

De Lauretis's book suggests both the strengths and weaknesses of feminist film theories. On the one hand, the questions raised about pleasure, desire, narratives, codes, and psychoanalytic issues direct our attention to important topics. Even the author's academic prose and numerous digressions do not diminish the value of the subject matter to general readers interested in thinking about the role of current film theory in interpreting cinematic experiences and film history. Not only is the material challenging, but also relevant and original. Furthermore, it does not minimize the problems that feminists face in developing meaningful film strategies to counteract the effects of mainstream films. Where De Lauretis runs into trouble is in offering practical and reliable answers to the problems she poses. For example, no attention is paid to how non-conforming filmmakers can operate successfully in the current film continuum. Nor is it enough to extol only films that have minimal exposure or critical success.

On balance, however, the book provides knowledgeable students of feminist film theory with a noteworthy summary of the important ideas currently associated with radical film theory. Whatever reservations one might have about De Lauretis's excessively theoretical analyses, her intellectual discussions deserve attention and applause. Helpful endnotes and a name index complete the book. Recommended for specialized audiences.

*De Lauretis, Teresa. TECHNOLOGIES OF GENDER: ESSAYS ON THEORY, FILM, AND FICTION. Bloomington: Indiana University Press, 1987. 151pp.

Deming, Barbara. RUNNING AWAY FROM MYSELF: A DREAM PORTRAIT OF AMERICA DRAWN FROM THE FILMS OF THE FORTIES. New York: Grossman Publishers, 1969. Illustrated. 210pp.

Originally written in 1950 as A LONG WAY FROM HOME: SOME FILM NIGHTMARES OF THE FORTIES, Deming waited almost two decades before she decided to publish her psychological reactions to the movies of her youth and how this "imagined world . . . projected upon our movie screens . . . a nightmare realm . . . where visions tantalize but deceive, what seems substantial may prove insubstantial, what promises life may bring death." Her basic premise is that the movies represent an important aspect of our national consciousness. They are dreams that reveal our fears and anxieties. In this regard, Deming offers a striking contrast to Carol Traynor Williams's more positive analysis of the same era. Both feminists deal with audiences' desires and needs, but Deming refuses to credit the movies with anything other than providing us with false hopes. Furthermore, she insists that neither the audience nor the filmmakers understood what the escapist entertainment meant other than providing wish-fulfilling dramatizations of contemporary predicaments and amassing considerable profits at the box office.

Deming's strength comes from focusing on consistent themes and screen stereotypes rather than on analyzing individual films. Although she spends considerably more time than does Williams on critiquing specific movies--e.g., THE MALTESE FALCON (1941), CASABLANCA (1942), MURDER, MY SWEET and PASSAGE TO MARSEILLES (both in 1944), THE POSTMAN ALWAYS RINGS TWICE, DOUBLE INDEMNITY, THE BIG SLEEP (all in 1946), and MONSIEUR VERDOUX (1947)--the emphasis remains on identifying specific images of war heroes, casualties, villains, private detectives, comic types, drifters, tough guys, and nihilists. Her reminder rings true that the forties reflected our preoccupation with successful and macho heroes whose film plots often preached, albeit unconsciously, disillusionment and the seeds for a feminist revolution in a patriarchal society.

Where the book's ten intriguing chapters fall short is in failing to account for how films are made, the influences of creative personalities and financial considerations on the films themselves, the attitude the filmmakers had to their original sources, and the power of the Motion Picture Production Code. She also can be faulted for ignoring many films that directly contradict her pessimistic perspective.

As Richard Schickel points out in his perceptive critique of the book, Deming does not do justice to the films of the forties: the decade "represented the height of the era of social consciousness in Hollywood. In its war films, in its first fumbling attempts to deal with such issues as racial prejudice, in its often inept dredgings of history, it was both overtly and covertly attempting to give voice to our best, most liberal, most idealistic impulses."[225]

Taken as one indication of how movies reflect public attitudes in a given period, the book offers entertaining and provocative assertions. The plot summaries, while dull, do serve as a useful summary of the conventions and stereotypes in dozens of World War II movies. It is not, however, a thorough or impressive academic study. A filmography is included, but no index. Worth browsing.

*Doane, Mary Ann. THE DESIRE TO DESIRE: THE WOMAN'S FILM OF THE 1940s. Bloomington: Indiana University Press, 1987. Illustrated. 211pp.

*Doane, Mary Ann, Patricia Mellencamp, and Linda Williams, eds. RE-VISION: ESSAYS IN FEMINIST FILM CRITICISM. Los Angeles: The American Film Institute, 1984. 169pp.

An important and thoughtful collection of feminist film criticism, this book is the third part of the monograph series undertaken by The American Film Institute in collaboration with the Center for the Humanities at the University of Southern California (USC) and the Center for Twentieth Century Studies at the University of Wisconsin-Milwaukee. Four of the seven papers included in this edition--Mary Ann Doane's "The Woman's Film: Possession and Address," Linda Williams's "When the Woman Looks," Kaja Silverman's "Dis-Embodying the Female Voice," and Teresa De Lauretis' "Now and Nowhere: Roeg's BAD TIMING"--were presented at the May 1981 conference held at USC entitled "Cinema Histories, Cinema Practices I." Three other essays--Cristine Gledhill's "Developments in Feminist Film Criticism," Judith Mayne's "The Woman at the Keyhole: Women's Cinema and Feminist Criticism," and B. Ruby Rich's "From Repressive Tolerance to Erotic Liberation: MAEDCHEN IN UNIFORM"--are former publications that dovetailed with the purposes of the book.

The rationale for this collection is described in a skillful introduction by the editors. Beginning with a succinct overview of the history of feminist film criticism, they identify several major categories: the role of women's film festivals and initial feminist documentaries, the rise of a scholarly concern with the image of women in a patriarchal cinema, the recognition of women's role throughout film history, the contributions of semiology and psychoanalysis to feminist film criticism, and the acceptance of feminist film criticism in academic circles. They pay particular attention to the problems that limit analyses of women's images in film. For example, the editors point out that mainstream films have provided few opportunities for women to be portrayed as anything other than objects. They also attack Hollywood's classic style, explaining that "In film even the most blatant stereotype is naturalized by a medium that presents a convincing illusion of a flesh and blood woman." Factors such as these lead the editors to insist on shifting attention away from discussing "images" to examining the "axis of vision itself--to the modes of organizing vision and hearing which result in the production of that 'image.'" The insightful introduction also points out the relationship between feminists' concerns and the contemporary theories of the text associated with authors like Roland Barthes and Adrienne Rich. Two strategies in particular are noted: (1) "multiplicity of meaning in texts . . . as a way of denying the rigid constraints of sexual duality" and (2) "entering old texts from new critical directions." Brief discussions followed by a look at the information gleaned from new developments in psychology and semiology outline the stages that resulted

[225] Richard Schickel, "RUNNING AWAY FROM MYSELF," THE NEW YORK TIMES BOOK REVIEW (October 26, 1969), p.16.

in feminists on both sides of the Atlantic exploring revolutionary methods for explaining the status of women in film, raising consciousness, and formulating a feminist "counterculture." A passing nod is given to the split between American and British feminist positions, but clearly the editors favor textual analyses over studies dealing with the accuracy of woman's image on screen. In fact, the debate over demystification and remystification is evident in the choice of the book's essays. Almost all the authors, as the editors freely admit, emphasize "an almost aggressive use of the possessive, delineated as specifically female, laced with more hesitant refusals of a static definition." At the same time, we are told of the limitations associated with their concern with the possessive in terms of a patriarchal society committed to issues of ownership, individualism, and capitalism. In the end, the editors argue for the importance of discourse theory and the contributions made by the theories of Michel Foucault.

What is best about the essays that follow is a sense of balance and a range of views. For example, Gledhill's essay follows on the heels of the introduction and indirectly challenges many of the editors' assumptions. Doane's analysis of "the Woman's film" as a genre makes a strong case for examining the convention of "medical discourse" in the formula, while Williams provides an intriguing notion of how horror films can be re-examined from a feminist perspective. On the other hand, the essays by Mayne and Silverman focus on the contributions of independent and mainstream women filmmakers, thereby calling attention to the feminist strategies surveyed in the book's introduction.

The book's relatively few problems relate to editing, selection, and an almost exclusive reliance on textual analyses. The editing problems are the ones most easily corrected. No continuity exists from essay to essay in footnoting, no overall bibliography is provided, and a much-needed index is omitted. Although the selection of essays is generally very good, the inclusion of De Lauretis's essay serves mainly to demonstrate how far she has progressed in her full-scale treatment of feminism in her book ALICE DOESN'T: FEMINISM, SEMIOTICS, CINEMA. Finally, it is disconcerting for the American Film Institute, an organization that has a much wider base than just that of semiologists, to publish a book on feminist film criticism that limits its critical perspectives so narrowly.

Overall, the book is a valuable piece of scholarship that adds to the growing collection of textual feminist film criticism. Considering the price and the accessibility in one place of key essays, the volume should be bought quickly before it goes out of print. Recommended for special collections.

Dolan, Jill. THE FEMINIST SPECTATOR AS A CRITIC. Ann Arbor: UMI Research Press, 1988. Illustrated. 154pp.

*Erens, Patricia, ed. SEXUAL STRATAGEMS: THE WORLD OF WOMEN IN FILM. New York: Horizon Press, 1979. Illustrated. 336pp.

One of the first and best early attempts to publish an anthology representing the critical and controversial views of men and women on both sides of the Atlantic, this pioneering text explores from a historical perspective "the variety of images of women as they have appeared on the screen and the contribution of women as filmmakers." Erens's imaginative overview succeeds in establishing the need for a complete review of criteria needed for film criticism in the seventies. Even when some of the feminist essays appear strained and simplistic, they challenge the reader to present thoughtful and rigorous reactions.

In the first of the book's two major divisions--"The Male-Directed Cinema"--the editor provides a general indictment of how a patriarchal film industry has limited and distorted the image of women. For Erens, screen stereotypes of women fluctuate from "idolatry to ignominy." The problem is that given the topic, the treatment is too brief to be useful and too general to be insightful. The material in this section is subdivided into "Images and Distortions" and "Films Directed by Men." The former

contains a terse summary by Majorie Rosen of her book POPCORN VENUS and a
stimulating essay by Gerard Lenne on sexism in horror films. While Rosen's ideas now
seem routine (thanks in large part to her ground-breaking study), Lenne's views
on eroticism and sexuality relating to the historical development of the literature of
the fantastic retain their original appeal. The subsection on male-directed films
contains stimulating articles by Lucy Fischer ("The Image of Woman as Image: The
Optical Politics of DAMES"), Molly Haskell ("MADAME DE: A Musical Passage"), Chuck
Kleinhans ("TWO OR THREE THINGS I KNOW ABOUT HER: Godard's Analysis of
Women in Capitalist Society"), Anna Marie Taylor ("LUCIA"), Birgitta Steene
("Bergman's Portrait of Women: Sexism or Suggestive Metaphor?"), and Daniel
Serceau ("Mizoguchi's Oppressed Women").[226] Each article adds to the spectrum of
female images Erens sets out to establish as a basis for discussing what can be done
about the historical paradox of having women portrayed as both object and victim.
For example, Fischer's perceptive comments on Busby Berkeley's MISE EN SCENE link
together female film imagery, the relationship between those images and the filmmaker,
and the attitudes of the commercial film industry toward its depiction of women in film.
Haskell's astute analysis of Max Ophuls's film demonstrates how a director can portray
woman with honor and love and still neither destroy nor sanctify the female image.
Steene's evenhanded discussion of Bergman's films proves that great filmmakers can
be discussed without the critic's being intimidated by contemporary standards or awed
by an artist's preeminent reputation. The major drawback in these otherwise
commendable essays, as one book reviewer has already pointed out, is that "the notion
of 'images of women' is already complex and contradictory because an image never
exists in itself, but is always understood in a socially and psychologically mediated
way--its PROCESS of production must be examined before any conclusions can be
drawn about its effects."[227]

Part 2--"The Woman's Cinema"--allows the reader to get a more useful insight
into Erens's thinking on feminist film criticism in the 1970s. In her lengthy
introduction to why film criticism must be responsive to new developments and ample
opportunities made available for alternative approaches to filmmaking, she skillfully
summarizes the major thinking of the decade. That is, films cannot avoid including
the ideology of their creators. Steps must be taken to reevaluate ignored works and
demythologize traditional screen values, and the goal in each instance must be a
changing consciousness about the film continuum. With her characteristic sense of
balance and good judgment, she divides this section into three parts: "A Feminist
Perspective," "Women Directors," and "Films Directed By Women." The first includes
Claire Johnston's seminal essay, "Women's Cinema as Counter-Cinema," Julia Lesage's
important commentary, "Feminist Film Criticism: Theory and Practice," and Erens's
thoughtful but neglected essay, "Towards a Feminist Aesthetic:
Reflection-Revolution-Ritual." The latter is particularly valuable in reminding readers
how aesthetics relates to experimental, documentary, and narrative films throughout
film history. The next two sections highlight the historical contributions of women
filmmakers like Alice Guy Blache, Esther Schub, Maya Deren, Germaine Dulac, Leni
Riefenstahl, Mai Zetterling, Leontine Sagan, Dorothy Arzner, Nelly Kaplan, Lina
Wertmuller, Chantal Akerman, and Shirley Clarke. Although the writers again can
be faulted for oversimplifying complex issues, the essays in their day pointed the
way for future and more in-depth analyses.

The fact that more recent anthologies advance the ideas summarized by Erens's
earlier collection should not deter readers from browsing through this fascinating
book. The well-captioned illustrations and useful filmography of women directors offer
a perspective on what the 1970s meant to daring film students determined to change
our perspective on stereotyping and film criticism. The lengthy bibliography also

[226] The Serceau essay is translated by Leah Maneaty.

[227] "Book Review: SEXUAL STRATAGEMS: THE WORLD OF WOMEN IN FILM," FILM QUARTERLY 33:4
(Summer 1980):30.

includes a number of important references omitted in later bibliographies and books. My one major disappointment is the editor's failure to provide an index. Recommended for specialized collections.

Everson, William K. LOVE IN THE FILM. Secaucus: Citadel Press, 1979. Illustrated. 251pp.

*Feret, Bill. LURE OF THE TROPIX: A PICTORIAL HISTORY OF THE JUNGLE HEROINE, JUNGLE QUEENS, WHITE GODDESSES, HAREM GIRLS, AND HUNTRESSES. Introduction Kay Aldridge. New York: Proteus Books, 1984. Illustrated. 160pp.

A glossy, entertaining survey of mainstream movies about tropical sirens, this twenty-one chapter book is filled with many nostalgic stills and tidbits about low-budget melodramas, serials, and exploitative jungle movies. Among the topics covered are the relationship between literary and silent screen exotic jungle women, the TARZAN movies, the comic tropical films, the video amazons and jungle series, the prehistoric feature films, and the tropical musicals. Special sections are devoted to film favorites like Dorothy Lamour, Kay Aldridge, Ann Corio, Frances Gifford, Patricia Morison, Yvonne De Carlo, Debra Paget, Ursula Andress, Betty Grable, and Esther Williams. Feret clearly loves the material and has done a great deal of research on the history of this exploitative genre. Nowhere is this more evident than in the exceptional collection of pictures superbly selected and handsomely reproduced. Given the fact that the book is intended as a tribute to a subject generally dismissed by film historians, Feret deserves recognition for the manner in which he highlights the importance of these generally "B" films as a training ground for performers and technicians. His fast-paced chapters evoke many mixed emotions about these fantastic and crude movies. Whatever reservations one may have about the mistreatment of women depicted in the distorted scenarios, the author makes a good case for reexamining a class of cheap films that "enraptured a large, loyal audience." An index is provided. Worth browsing.

*French, Brandon. ON THE VERGE OF REVOLT: WOMEN IN AMERICAN FILMS OF THE FIFTIES. New York: Frederick Ungar Publishing Company, 1978. Illustrated. 165pp.

Fast-moving and wonderfully combatant, this reexamination of the 1950s from a feminist perspective is fun reading even if it isn't always on target. "The Western myth of world order," French tells us in the book's first line, "is based upon a hierarchy of male dominance descending from God the Father." Everything that follows relates in some way to French's efforts to foster rebellion against the patriarchal culture that has forced women to replace "reality with an idealized image (such as 'the happy housewife') . . . [that] is schizoid. . . ." On the surface, films of the fifties, in French's view, tried to reassure women that the image was a valuable defense against their realistic horror of submission in a male-dominated society. But the movies' denial of reality was only partially successful. Many of the sexual and emotional traumas women were undergoing in the transition from the post-World War II period to a reactionary era crept into the Hollywood movies of the 1950s. To prove her point, she selected thirteen films that could shed light on issues related to "romance, courtship, work, marriage, sex, motherhood, divorce, loneliness, adultery, alcoholism, widowhood, heroism, madness, and ambition." Twelve controversial but absorbing chapters arranged in historical order recount how at three different stages--1950-1952, 1953-1956, and 1957-1959--conflict and contradiction faced off against change and growth in the battle by the transitional woman for an understanding of herself and her status in society. Each chapter relies heavily on plot summaries and character analyses to make the author's arguments convincing, along with a representational still and a sprinkling of relevant quotations from experts in a related field.

More often than not, the feminist author offers a refreshing point of view about fifties' films like SUNSET BOULEVARD (1950), THE COUNTRY GIRL (1954), THE TENDER TRAP and MARTY (both in 1955), ALL THAT HEAVEN ALLOWS and PICNIC (both in 1956), HEAVEN KNOWS, MR. ALLISON (1957), THE NUN'S STORY (1958), and SOME LIKE IT HOT (1959). For example, French offers an insightful perspective on Norma Desmond in SUNSET BOULEVARD, rejecting the notion that age loses out to youth in the Hollywood patriarchy. "What renders Norma less desirable," the author explains, "is her neurosis, not her age." French also provides a succinct but powerful assessment that THE COUNTRY GIRL represents the ultimate fifties' film about "the identity abyss between male reverence and damnation above which the transitional American woman was suspended." In analyzing THE TENDER TRAP, she points out how the film's scheming ingenue is related to a popular fifties' convention evident in films like THREE COINS IN THE FOUNTAIN (1954), TO CATCH A THIEF (1955), and ASK ANY GIRL (1959). MARTY offers an excellent opportunity to illustrate how clever scripts played against film conventions by having the heroine think more of career women than she does of happy homemakers. In her analysis of these nine movies, French makes a creditable argument that the seeds for female revolt were evident in film plots, characterizations, and specific situations.

Her arguments about the book's other major films--THE QUIET MAN and THE MARRYING KIND (both in 1952), SHANE and FROM HERE TO ETERNITY (both in 1953)--have just the opposite effect. Often overstated and jarring, they represent a reductionist perspective that fails to account for the filmmaking process or for the fact that movies are a business. For example, THE QUIET MAN represents for French an antiquated attempt by the director, John Ford, to manipulate "a marriage of conservative and progressive elements." The character of Sean Thornton (John Wayne) is perceived as symbolizing the forties' warrior who fought for profits rather than for purpose, and in the fifties recognizes his guilt and returns home to find his true values. French's parochial notions carry over into her other discussions. In THE MARRYING KIND, the only serious commercial and critical failure discussed in the book, the author makes no distinction between its significance compared to the other films she analyzed. She not only describes SHANE as a western "and a domestic comedy," but she also refers to the Starrett family by the name of "Start." Moreover, Marion (Jean Arthur) gets more discussion proportionately in the analysis than she does in the film. Furthermore, none of the analyses, except those dealing with Jones's FROM HERE TO ETERNITY, make any serious references to their original sources or screenplays unless the writer is a woman. Even more discouraging is the absence of any recognition that MISE EN SCENE can highlight the contradictions between what is being said and what is being shown. Surely, in a book that is based on the assumption that the films of the fifties operate as "double texts," consideration should have been given to original sources and visuals.

On balance, French deserves credit for summarizing many pertinent feminist perspectives on the image of women in the fifties' films. Her acute observations and skillful writing style compensate for her lack of cinematic insights. A limited bibliography, some rental information, and a brief index are provided. Well worth browsing.

*Gentile, Mary C. FILM FEMINISMS: THEORY AND PRACTICE. Westport: Greenwood Press, 1985. 182pp.

This intriguing book begins by acknowledging the importance of earlier feminist film studies based on non-conformist ideology. Such works placed more emphasis on what was seen than on how it was seen. However, Gentile finds such arguments "limited in the questions they may ask and the perspectives they may reflect." She wants to open up feminist analysis with an alternative use of "difference," one that emphasizes process more than ideology. This more self-conscious feminism incorporates "opposition into itself." It uses the process of opposition as "a unifying force, a thread of commonality." Her plan is to align ideology and subjectivity in order to discover how the concept of the "Other" is constructed and how it affects each of us. Gentile is not asking that we ignore the uniqueness of specific victimizations in

favor of universal victimization. Instead, she wants to call attention to differences in order to locate their commonality. In this way, every spectator who feels outside the mainstream discovers how dominant political, psychological, cultural, and social forces function. Central to her thesis is the notion of "multiple perspectives," an emphasis that focuses on what determines what we see. In Gentile's reading model the spectator remains active in constructing the meaning of a text and also demonstrates a willingness to allow alternative perspectives.

In the first of the book's two major sections, the author builds her case for an "engaged" film theory that is process-oriented. Chapter 1--"Critical Subjectivity"--explores the variety of dynamic roles film theory performs and how they relate to feminism. This gives Gentile the opportunity to deal generally with the assumptions established film theorists are making, why they feel the way they do, and why it is valuable to present these theorists with an alternative world view. Characteristic of her alternative perspective is the recognition that the filmmaker, the film spectator, and the film theorist are each integral components of the film continuum. Together, they share in the construction of the product, experience, and meaning of a film text. What has been a key problem for feminist film critics in the past, however, is the assumption that the spectator has the ability to maintain an individual consciousness. That assumption has been challenged by the works of Althusser and Lacan. The former argues that ideology shapes our subjectivity; the latter, preexistent language. Rather than accept the paradox of having to critique a system that denies such a critique, Gentile insists that it is the contradiction and not the critique that is important. In other words, the fact that women exist outside the system makes it possible for them to have a "critical subjectivity." What this critical subjectivity permits is a "dual consciousness." That is, the engaged spectator, able to appreciate and to experience multiple perspectives, stands apart from the text and its contradictions and recognizes the adjustments required of an intelligent person.

Chapters 2 and 3 analyze the theories of Eisenstein and Bazin to illustrate Gentile's premise that male classicists struggle with the same contradictions as feminists do. With mixed results, she tries to reconstruct the thought processes that led the famous theorists to the conclusions they reached on film means and film ends and explains why their work remains appealing to feminist film critics. At the same time, she points out why the classical theories contain "potentially dangerous assumptions." For example, Eisenstein's goal of forging a unifying film theory based on socialist ideology runs into conflict with his insistence that content is more important than process. That is, the spectator cannot participate in the film continuum if the spectator's role is reduced to accepting the vision of the filmmaker's social ideology. In Gentile's words, "Although Eisenstein is aware that each individual spectator will pull her associations from a different bank of memories and experiences, he expects that each spectator will nevertheless arrive at the same final concepts." The key point is that revolutionary action requires multiple rather than homogeneous perspectives. Her critique of Bazin stresses his misperceptions on how we see. Not only does she find his concepts of reality "fuzzy and even self-contradictory," but she also faults him for his unclear acceptance of ambiguity in a text. The latter point often misleads feminist film theorists, particularly because it emphasizes the spectator's role in the construction of a film's meaning. The problem, for Gentile, is whether the text creates the contradictions or whether the spectator merely asserts that the contradictions exist. No attention is paid to the notion that appearances may be variable rather than constant. Or, as she argues, "Bazin recognizes the way films and images work but he is unable to disengage himself sufficiently so that he might question the underlying assumptions."

Chapter 4 summarizes what a good feminist film theory will account for during the filmmaking process as well as the types of ideological barriers that filmmakers and film theorists encounter in constructing feminist projects and positions. Most of the section's concluding chapter, however, deals with developing feminist film strategies for filmmaking and film viewing. She organizes her admittedly tentative suggestions around two pairs of extremes: "conflict and gap, particularity and

commonality." This method allows Gentile to take pot shots at movies like KRAMER VS. KRAMER (1979), GLORIA, NINE TO FIVE and MY BRILLIANT CAREER (all in 1980), and TERMS OF ENDEARMENT (1983). Such films not only fail to "make visible" the conflicts and gaps that women face, but also disguise the problems by providing substitute issues that repress the viewer's recognition of the omissions. In addition, she feels that form is just as important as content in making viewers aware of how women are oppressed. That is, women must have meaningful choices in the film texts, not the best of no-win situations. Films that Gentile recommends as significant alternatives are JEANNE DIELMAN, 23 QUAI DU COMMERCE, 1080 BRUXELLES (1975), THE ALL-AROUND REDUCED PERSONALITY (1977), and SIGMUND FREUD'S DORA: A CASE OF MISTAKEN IDENTITY (1979). In short, the best films are those that encourage viewers to recognize differences and distinctions and to apply those insights both to their lives and to their social contexts.

Section 2--"Theory in Practice"--illustrates how the concepts of critical subjectivity and dual consciousness have been appropriated by discussing four films: Marta Meszaros's WOMEN (1977), Helke Sander's THE ALL-AROUND REDUCED PERSONALITY (1977), Yvonne Rainer's FILM ABOUT A WOMAN WHO . . . , and Marleen Gorris's A QUESTION OF SILENCE/DE STILTE ROND CHRISTINE M (1982). Not only are they made by women and released recently, but also their subject matter and their formal strategies exemplify Gentile's suggested strategies. The focus is on showing how screen narratives can produce more engaged audiences. Particularly important is the distinction between feminist filmmaking and a feminist experience. Since the author equates how we see with a feminist perspective, she shows little interest in discussing what makes a feminist film. That is not to say that she neglects the importance of having people consciously make alternative films. But since audiences can reject a filmmaker's preferred meaning, she finds it more useful to discuss how to make filmgoing a feminist experience.

In short, the author's intelligent discussion of multiple narrative readings, audience identification with characters, and critical subjectivity turns this tightly written book into an invaluable resource for classroom use. A good bibliography, a useful index, and a relevant filmography add to the book's value. Recommended for special collections.

*Haskell, Molly. FROM REVERENCE TO RAPE: THE TREATMENT OF WOMEN IN THE MOVIES. New York: Holt, Rinehart and Winston, 1974. Illustrated. 388pp.

The author begins her controversial and pioneering study with the observation that "If it weren't for selective memory, the consolation of the loser, our consciousnesses might have risen a long time ago. Like recollections of old love affairs, the images of the stars that stay with us are the triumphs rather than the disappointments." Haskell then proceeds to recollect and to examine her experiences with film history, with the purpose of raising our consciousness about sexism in our lives. Chapter 1--"The Big Lie"--sets the book's revisionist tone by hammering away at the image perpetuated in Western society that women are inferior beings: e.g., the image of a husband replacing his older wife with a younger woman; the stereotype of a woman's chastity being relative to a man's honor. What particularly infuriates Haskell is not only that the movies are the "propaganda arm of the American Dream machine," but also that the film industry is "dedicated for the most part to reinforcing the lie." Even more infuriating is the fact that the male-dominated industry bases its success and power on the exploitation of women. Rather than condemn the stars who make the stereotypes possible and appealing, the tough-minded author argues that film actresses are caught in a dialectic between the past and the present. They represent both a barometer of the values in their era and a guidebook for revolution and reform from traditional values. To illustrate the point, her impressionistic study surveys the treatment of women through a "progressive" decade like the twenties, to the independent years in the thirties, through the paranoid period of the forties, to the repressive era of the fifties, and finally to the "liberated" decades of the sixties and early seventies. How the movies both reinforced and deviated from the distorted romantic fantasies and degraded images of women is the major theme of the

book. To Haskell's credit, she takes pains not to graft modern values onto historical events or to misrepresent the media as operating independent of historical baggage. First a film critic and then a feminist, she is more interested in art than in sociology. Nonetheless, the striking portrait of female stereotypes presented in the eight stimulating chapters sheds more light on the film industry's social values than on its artistic skills.

One of Haskell's writing strengths is her ability to blend film criticism with social commentary. For example, in discussing the power struggle between the "new women" (e.g., Clara Bow, Gloria Swanson, and Joan Crawford) and the "old-fashioned women" (e.g., Lillian Gish, Mary Pickford, and Janet Gaynor) in movies of the twenties, the author reminds us that the decade may be closer to the modern period than the intervening decades. That is, the twenties' assault on conventional morality anticipated the feminist movement of the sixties and seventies. But Haskell describes in detail why the "new morality" of the 1920s is still rooted in the virgin-heroine "in the romantic spirit of mutual reverence." She also notes trends that start early and retain their appeal throughout film history. A case in point is the image of women as "entrappers and civilizers." A second example relates to the contrast between male and female comedians. The former, points out Haskell, are always more heretical in their attitudes toward society than their accommodating female counterparts.

Another joy in reading Haskell's prose is the scope of her analyses. Not content with critiquing female performers, directors, and screenwriters, she also calls attention to the inner-workings of the film industry. For example, in the chapter on the thirties, Haskell examines the sexist impact that the production code had on female stereotypes. She deftly shows the changes in the types of stars before 1934 (e.g., Greta Garbo, Marlene Dietrich, Mae West, and Jean Harlow) and those after 1934 (e.g., Katharine Hepburn, Jean Arthur, and Rosalind Russell). In the chapter on the forties, she adroitly contrasts the sexual aggressiveness of stars like Barbara Stanwyck, Ida Lupino, Jennifer Jones, and Linda Darnell with the boy-meets-girl heroines of the thirties like Jean Arthur, Loretta Young, and Ginger Rogers. As Haskell wisely observes, what matters most to the former is satisfying their personal needs rather than pursuing some noble goal. In the chapter on the fifties she does a first-rate job of explaining why the downfall of the studios was a mixed blessing for women. On the one hand, they gained greater freedom in their choice of roles. On the other hand, the stars not only lost the brilliant technical and public relations staff that solidified their hold on the public, but they also made fewer films and thus had less economic leverage. In the chapter on the sixties and seventies, the author deserves praise for her perceptive comments on how Hollywood provided a commercial backlash to the increased demands and power women achieved during the civil rights era. In addition to listing the range of films and personalities that bucked the tide, she also exhibits considerable wit in explaining what types of directors female stars faced: e.g., the major filmmakers are either "neurotic and talented AUTEURS . . . , whose sexual anxieties spilled over in their treatment of women [or], relatively neutral directors, . . . whose prestige projects . . . and star vehicles . . . all seemed overstuffed with self-importance or 'production values' and undernourished." Particularly impressive is Haskell's analysis of the European system. Unlike many of her peers, she does not assert that foreign is synonymous with better. In fact, the idea that women are the weaker sex is more pronounced in European films mainly because European traditions go back much further in time than ours do.

Where Haskell runs into problems is in her failure to explore more sensitively why female audiences supported many of the film industry's negative efforts. For example, in the chapter, "The Woman's Film," she explains how the changing times gave rise to a new genre. She then patronizes the formula as one that, at its lowest point, gets women to be moved, "not by pity and fear but by self-pity and tears, to accept rather than reject, their lot." We're told about the centrality of middle-class values in the genre, but are not given any satisfying explanation of why the problems and moral codes of these middle-class characters proved so pleasing to millions of women of all classes. In fairness to Haskell's position, she does acknowledge that "there are as many kinds of women's films as there are kinds of

women." The difficulty, however, is that despite the variety, she finds almost all of them aimed at getting women to remain subservient and docile. It may be true that one effect of these kinds of movies was to get certain types of individuals to identify vicariously with the stars' sexual freedom. But it is also true that many viewers found these images persuasive arguments for rebelling against a patriarchy. Another difficulty is Haskell's willingness to accept the woman's film as "the closest thing to an expression of the collective drives, conscious and unconscious, of American woman. . . ." However, Haskell makes no reference to any systematic studies, nor offers any data on audience research.

Given the recent studies on women in film, this impressionistic study appears to overemphasize sex-role critiques to the exclusion of film form and the way the communication process operates. What makes it an invaluable contribution to film scholarship, however, is the author's considerable historical knowledge buttressed by impeccable taste. An extensive index is included. Recommended for special collections.

Higashi, Sumiko. VIRGINS, VAMPS, AND FLAPPERS: THE AMERICAN SILENT MOVIE HEROINE. Montreal: Eden Press Women's Publication, 1978. Illustrated. 226pp.

Working on the premise "that a society's feminine ideal is related in complex ways to its moral climate and values," this well-intentioned but shaky study based on a screening of 165 silent films attempts to prove that the screen image of women during the jazz age is a valuable source of evidence about the nation's social and cultural development. Higashi's approach to the topic is similar to that of film historians who view movies as a literal reflection of reality. The trouble in such instances is that too much attention is paid to content analysis and too little to economics, aesthetics, and the collaborative nature of the medium. Such is the case here.

In using film as social history, the author justifies her thesis by pointing out that nearly 100 million people went to the movies every week and that the teens and twenties witnessed a revolution in manners and mores that was symbolized by "the flapper as a new woman." Movies, emerging as the most popular art form in America, represented a tremendous financial problem to their backers who demanded a minimum of risk taking. Thus, the conservative nature of the medium linked to its need to attract mass audiences resulted in movies' becoming the repository of the nation's collective perceptions. In theory, this is an assumption made by many respected social critics. The difficulty has always been in proving it.

Higashi divides her "scissors and paste" analysis into two sections. The initial four chapters explore the image of screen heroines as virgin and vampire: e.g., Mary Pickford, Lillian Gish, Theda Bara, Nita Naldi, and Greta Garbo. The emphasis is on comparing and contrasting sentimental heroines with "bad women" who achieve redemption through love. The second half of the study analyzes how the screen image of women changed during the twenties away from virgins and vamps and toward a more contemporary woman: e.g., working women, socialities, and flappers. In these four chapters, Higashi spends considerable time speculating on the reasons why society altered its attitudes toward women portrayed by Clara Bow, Gloria Swanson, Olive Thomas, and Corrine Griffith. The book ends with some examples of silent screen heroines who broke with the industry stereotypes and fashioned new role models for women.

In Higashi's favor, her feminist perspective provides an interesting insight into silent film heroines. She intelligently explores the notions of Victorian sexuality and its relationship to the Lillian Gish, Mary Pickford, and Theda Bara roles from the early teens to the mid-twenties. She explains the nuances in neutralizing the treatment of fallen women, and how the pre-World War I vamps resurfaced in the twenties as "disreputable glamour girls, prostitutes, mistresses or kept women, and adulterous wives." Higashi does an especially fine job in discussing the gap between the actual working woman and her "Cinderella" counterpart in the movies. The writing is clear, the data persuasive, and the content intriguing.

What distracts the reader almost from the first page, however, is the author's unwillingness to deal carefully with anything other than her feminist issues. For example, she carelessly repeats the discredited notion that Hollywood ranked fourth among American industries by the late twenties, tries to pass off Mary Pickford as a loving foster parent (she disinherited her two adopted children), and insists that Vincent Canby was accurate in characterizing Clara Bow as the AUTEUR of the film IT. Furthermore, many of her observations on screen heroines are predictable and superficial. Instead of interpreting the many fine quotations extracted from significant studies, she prefers to let the work of others speak for her. Worst of all, the author demonstrates little understanding of how movies are made, let alone how images are created and marketed.

For those unwilling to dig more deeply into the intricate ties between the screen and the audience, and who want more than a thumbnail overview of the issues, this dry account of silent screen heroines is adequate. It is written with conviction and wit a good set of assumptions. Useful endnotes, a bibliography, a filmography, and an index are provided. Worth browsing.

*Kaplan, E. Ann. WOMEN AND FILM: BOTH SIDES OF THE CAMERA. New York: Methuen, 1983. Illustrated. 259pp.

Aimed at undergraduates and nonspecialists, this book attempts to make palatable the obscure language used in feminist film criticism during its formative decade in the 1970s. Space, however, has forced Kaplan to confine her analysis of the "theories in action" to the issue of the male gaze and to restrict significantly any film analyses to historical and institutional contexts. Thus, representative films, rather than the major films of each decade, are used to illustrate how the male gaze functions throughout specific periods in film history. For example, three films from the thirties and forties--BLONDE VENUS (1932), CAMILLE (1936), and THE LADY FROM SHANGHAI (1946)--are discussed, but none from the fifties. Her reasoning is that the earlier films reveal how sexual and ideological values controlled film texts, while the latter period reflects not only the end of a long process, but also an anomaly. LOOKING FOR MR. GOODBAR (1977) is used as representative of the contemporary cinema. Her emphasis is on showing how the structuring of the narrative and women's placement within that narrative "transcend the historical and institutional specificities." In short, sociopolitical contexts overshadow historical dimensions. To her credit, Kaplan realizes from the beginning that she is leaving herself open to the familiar charge that textual analyses are ahistorical. In her defense, she points out that in areas like marriage, sexuality, and the family, the problems of women go beyond historical contexts and relate more to the issues of absence, silence, and marginality. As a result, she points out that histories written by white male authors have very little to do with the realities of women in society. Kaplan also points to Michel Foucault's distinction between "total" and "general" history as an example of how feminists are reexamining history. "Total" history refers to a specific center as the focus for a complete world view. "General" history, on the other hand, concentrates on segments, limits, and various relationships. Obviously, feminists find "general" history more valuable than "total" history. Kaplan denies that she is espousing a theory that advocates "an ESSENCE that is uniquely feminine. . . ." Her argument is meant only to draw attention to the acts of omission in dominant art forms and in traditional historical modes of discourse. Kaplan further acknowledges the methodological tension created by her ahistorical approach. Still, she persists in seeing the sociological and psychoanalytical strategies as parallel rather than mutually exclusive realms of criticism. The former she finds relevant when discussing sex roles like Virgin and Vamp; the latter, when analyzing the construction of those roles in the classic Hollywood cinema. To demonstrate her thesis, Kaplan divides her book into two main parts.

Part 1I--"The Classical and Contemporary Hollywood Cinema"--begins by charting how semiologists, psychoanalytic critics, and structuralists developed the concept of the male gaze. Using the aforementioned films, Kaplan identifies certain

basic and recurring patterns that follow the analyses outlined by Molly Haskell's FROM REVERENCE TO RAPE: THE TREATMENT OF WOMEN IN THE MOVIES. For example, CAMILLE (1936) demonstrates for Kaplan that women (portrayed as victims) depend upon CERTAIN men to protect them from OTHER men. BLONDE VENUS (1932) shows how men try to dismiss "Woman qua WOMAN" by fetishizing the female form. THE LADY FROM SHANGHAI (1948) proves that men have as much to fear as to desire from sexually seductive women, thereby justifying the murder of FEMMES FATALES. And LOOKING FOR MR. GOODBAR illustrates how the contemporary film has improved on FILM NOIR and its depiction of female sexuality.[228] The result is a greater display of phallic symbols in contemporary films to rationalize male domination of women. Kaplan concludes, therefore, that in Hollywood movies "women are ultimately refused a voice, a discourse, and their desire is subjected to male desire." To appreciate how the system operates, she turns to psychoanalytic theories as a means of explaining feminine "socialization in society." Her method is to apply psychoanalysis as a tool for deconstructing Hollywood movies in order to expose how psychoanalytic discourse places women in an abject position. The primary theme is that the screen image of motherhood provides the best opportunity for spectators to identify the patriarchal treatment of women in the movies. That is, women are sex objects prior to marriage and maternity. Afterward, they're forced to repress their sexuality. When successful, the technique enables us to better understand the difficulties women face in being subjective and the contradictions they often encounter in their lives.

Part 2--"The Independent Feminist Film"--discusses how women filmmakers outside of dominant cinema try either to find a voice for their feminist perspectives or to make explicit what is meant by femininity. Kaplan begins by identifying three important types of independent feminist filmmakers: experimentalists, documentary directors, and AVANT-GARDE filmmakers. While credit is given to specific male directors like Pare Lorentz, Willard Van Dyke, and Stan Brakhage, Kaplan hones in on the reasons why women filmmakers have been sensitive to following traditional film patterns of form, style, and conventions. Most noteworthy in alternative film history are filmmakers like Maya Deren and Germaine Dulac. They demonstrate for Kaplan how experimental filmmaking became an escape from the oppressive nature of dominant cinema. Particular attention is paid to the criticism of American lesbian women "who see theorizing as perpetuating male domination." They prefer that feminists give more attention to "women-identified women" and "female bonding" as alternatives to the screen images presented in the dominant cinema. Kaplan then draws a distinction between European and American women directors. The former--e.g., Marguerite Duras and Margarethe von Trotta--are typical of European feminists working in France who specialize in theatrical films. For example, Duras's NATHALIE GRANGER (1972), with its stress on the politics of resistance, represents the influence of the NOUVELLE VAGUE on European women directors. Von Trotta's MARIANNE AND JULIANE (1981), with its focus on how to survive in a male-dominated society, reveals a desire to relate theme to form and not a concern with how the process of cinema operates. A director like Yvonne Rainer, on the other hand, illustrates how American feminists concentrate more on documentary films. Her movies--LIVES OF PERFORMERS (1972), FILM ABOUT A WOMAN WHO . . . (1974)--appeal to feminists who value antinarrative film styles that require open-ended interpretations. Having drawn the distinction between European and American independent feminist filmmakers, Kaplan proceeds to discuss the ongoing debate about realist documentary films--e.g. GROWING UP FEMALE (1969), THE WOMAN'S FILM (1970), JOYCE AT 34 (1971), JANIE'S JANIE (1972), and UNION MAIDS (1976)--and their relevance to feminist film strategies. Kaplan is especially critical of those filmmakers who mistakenly assume that the best way to reform society is to adapt the eighteenth-century elitist position that art imitating life brings about a change in undesirable behavior. Clearly, such a tack relates only

[228] For an interesting discussion on this subject, see Robert G. Porfiro, "Whatever Happened to the Film Noir?: THE POSTMAN ALWAYS RINGS TWICE (1946-1981)," LITERATURE/FILM QUARTERLY 13:2 (1985):102-11.

to those aspects of society being replicated and not to individuals or events omitted or ignored. In short, this form of "film realism" is too limited in scope. At the same time, she explores the response by AVANT-GARDE films--e.g., SIGMUND FREUD'S DORA: A CASE OF MISTAKEN IDENTITY and THRILLER (both in 1979), AMY! (1980)--to the British-initiated realist film theories. In each instance, she makes a formidable case against both binary and monolithic strategies. Less of a dogmatic approach, more varied perspectives, and a concern for audience responses are her reactions to a theory of realism that is both "unnecessarily rigid" and "inadequate when applied to practice in the sense of bringing about concrete change in the daily lives of women." To emphasize her point, the author focuses attention on RIDDLES OF THE SPHINX (1976) and DAUGHTER RITE (1978) as two worthwhile examples of a constructive approach to the much-ignored problem of mother-daughter relationships. Kaplan follows her discussion on how independent women directors try to find a feminine voice by looking at the Third World and at Sara Gomez's ONE WAY OR ANOTHER (1974). In contrasting the screen images of women in a socialist patriarchal system with those from a capitalist patriarchal system, the author explores the implications for feminists and feminist cinema everywhere. The book's two final chapters follow through on this theme with a look at the production-distribution-exhibition problems facing independent women directors and the difficulties encountered in creating an alternative film system to the dominant cinema.

With all its many pluses, Kaplan's psychoanalytic approach to film criticism presents a number of problems. The most obvious is that it is far too optimistic about consciousness-raising as a means for combatting mainstream cinematic traditions. She places too heavy an emphasis on how spectators can more effectively interpret family melodramas, but almost never acknowledges the minor status of that genre in the pantheon of Hollywood formulas. Kathryn Kalinak makes a similar observation in her review, adding that the author doesn't provide much discussion of other important issues related to "masquerade, family romance, resistance, suture, hegemony."[229] Far more serious is the problem of organization, analysis, and objectivity. Zeavlin and Harris, for example, chide Kaplan for her inability to reconcile Lacanian psychoanalysis and feminist film criticism. They astutely point out that Lacan's theories go beyond merely substituting a woman for a male as a film director or using a female gaze to revive women and thus heal their objectification.[230] The most devastating attack on Kaplan's work is summed up by B. Ruby Rich's review. Not only does she enumerate a significant number of historical and critical omissions in Kaplan's discussion of feminist issues, but Rich also skillfully points out how Kaplan's "inflexible" methodology can limit discussion on the very issues important to feminist film critics.[231]

Giving the book's critics their due, I found Kaplan's work very useful as an example of the strengths and weaknesses of the psychoanalytic approach. Kaplan's efforts exemplify the pitfalls in branching out into shark-infested waters and not only surviving but also being strenghtened by the experience. In short, the book is a valuable teaching tool. The intriguing study concludes with an ample supply of endnotes, a very helpful filmography with synopses, an appendix for teachers, a bibliography, and name and subject indexes. Well worth browsing.

[229] Kathryn Kalinak, "Book Review: WOMEN AND FILM: BOTH SIDES OF THE CAMERA," FILM QUARTERLY 27:4 (Summer 1984):40.

[230] Zeavin and Harris, p.57. For another attack on the same point, see Chris Straayer, "Book Review: WOMEN AND FILM: BOTH SIDES OF THE CAMERA," JOURNAL OF FILM AND VIDEO 36:1 (Winter 1984):67-71.

[231] B. Ruby Rich, "Cinefeminism and Its Discontents," AMERICAN FILM 9:3 (December 1983):68-75.

*Kaplan, E. Ann, ed. WOMEN IN FILM NOIR. London: British Film Institute, 1980. Illustrated. 132pp.

Growing out of a session at the British Film Institute Summer School in 1975, this book examines the complex relationship between the patriarchal Hollywood FILM NOIR formula and female sexuality. All but one of the insightful authors--e.g., Christine Gledhill, Sylvia Harvey, Pam Cook, E. Ann Kaplan, Richard Dyer, and Claire Johnston--view the 1940s thrillers and their counterparts today as examples of a distinct and separate genre. Or, as the editor states, " . . . in terms of thematic concern, narrative structure, iconography etc., a number of recognizable conventions run through them." For example, Harvey finds the genre's dominant characteristics those that stress an "abnormal and dissonant" product, a "sense of disorientation and unease," and "strained compositions and angles." Such stylistic techniques are more than rhetorical devices. She argues that such "visual dissonances . . . are the mark of those ideological contradictions that form the historical context out of which the films are produced." The one dissenting voice in this highly enjoyable collection belongs to Janey Place, who insists that the cinematic style and narrative concerns of FILM NOIR limit the formula exclusively to the World War II years and the postwar decade that followed. She therefore considers the films involving dark ladies, spider women, and evil seductresses to be representative of a movement rather than a genre. That is, FILM NOIR, with its emphasis from the 1940s and early 1950s on portraying male fantasies of women terrified, reflects the dominant feelings of the age in which the films were made rather than a genre that exists independent of time.

Kaplan deserves credit for the manner in which she has organized the anthology. The interest in narrative structure and thematic concerns operates as one unifying force and adds an extra dimension to the book's emphasis on a feminist film perspective. For example, Gledhill's skillful two-part essay on KLUTE (1971) describes how ideological analyses can be used to compare and contrast two apparently divergent movie traditions: e.g., the humanist realist European conventions of the art film versus the narrative and stylistic conventions of FILM NOIR. Another unifying element is the tacit agreement among the seven authors about what constitutes a "classic text" in relation to Hollywood movies. In Kaplan's words, "The 'classic text' (applicable to genre and non-genre films) describes a DOMINANT MODE OF PRODUCTION, which masks its own operation--either in terms of covering over ideological tension and contradiction, thereby giving dominance to a metadiscourse . . . which represents the Truth VIS-A-VIS the film's content and meaning; or in terms of giving the impression that it gives access to the 'real world'." A third unifying element is the notion of reception theory. Although no consensus emerges from the eight essays, the authors raise a number of key issues about meaning, DISCORS, stereotypes, and residual effects. For example, in her analysis of MILDRED PIERCE (1945), Cook draws attention to the difference between what we see and hear in the movie, and what symbols are used to represent the legal and patriarchal positions on law and order. Kaplan's examination of THE BLUE GARDENIA (1953) highlights the role of conflicting DISCORS in lieu of the standard, monolithic patriarchal point of view. Dyer's critique of GILDA (1946) provides a valuable discussion of the interplay between the star system, genre conventions, and audience expectations.

This highly readable and consistently informative collection has a number of bonuses. One is price. A second is a good picture collection. A third is quality research and intelligent discussion. Regrettably, there is neither a bibliography nor an index. Recommended for special collections.

*Kay, Karyn, and Gerald Peary, eds. WOMEN AND THE CINEMA: A CRITICAL ANTHOLOGY. New York: E. P. Dutton, 1977. Illustrated. 464pp.

Along with Patricia Erens's SEXUAL STRATAGEMS: THE WORLD OF WOMEN IN FILM, this pioneering anthology represents the first important collection of essays dealing with feminist film criticism past and present. Many of the forty-five articles, divided into seven categories, are culled from the pages of SIGHT AND SOUND,

FOCUS, and THE VELVET LIGHT TRAP. Although they represent more than a decade of diverse critical and personal observations, each piece has been selected by the enterprising editors for the contribution the material makes to consciousness-raising. The book's sociological bent is sounded in the spirited preface, where we're told that "The more women really delve into the vast vaults of filmmaking, the more awesome the findings: new heroines to champion, new artists and artisans to admire, new women (real and fictional) to claim as 'sisters,' an assortment of works (traditional and experimental, feature length and shorts, narrative and documentary) that offer discovery and dialogue to womankind."

Part 1--"Feminist Perspectives"--provides a delightful range of autobiographical and historical-critical opinions and experiences. For example, Colette comments on her work as a screenwriter for the 1916 silent screen adaptation of her novel LA VAGABONDE; the editors reprint their breakthrough essay on Dorothy Arzner's DANCE, GIRL, DANCE (1940); Diane Giddis gives an imaginative defense of Jane Fonda's controversial Bree Daniels in KLUTE (1971); Janet Maslin explores the reasons why ALICE DOESN'T LIVE HERE ANYMORE and A WOMAN UNDER THE INFLUENCE (both in 1974) are less than satisfactory as feminist films; and Jeanine Basinger discusses ten Hollywood films that have provided positive images of women. Almost all of the essays open with a brief comment on the author, and the section ends with a useful bibliography. This approach is followed in the other six sections.

Part 2--"Actresses"--includes a mixture of performers and critics assessing what life in the movies meant and represented for women. Among the highlights are Louise Brooks's iconoclastic remarks on the production of G. W. Pabst's PANDORA'S BOX (1928); Greta Garbo's defense of her privacy; Alexander Walker's assessment of Marlene Dietrich; Janice Welsch's critique of four female screen archetypes--Doris Day, Marilyn Monroe, Elizabeth Taylor, and Audrey Hepburn--in the 1950s; Simone de Beauvoir's militant analysis of Brigitte Bardot; and Molly Haskell's insightful evaluation of Liv Ullmann. The ease with which these authors articulate their feelings about film acting makes for thoughtful and enjoyable reading.

The next three sections focus on various aspects of production and the problems women face in the film industry at home and abroad. The material on American women includes Gerald Peary's tribute to Alice Guy Blache; Richard Koszarski's paean to Lois Weber; the editors' "authorized interview" with Dorothy Arzner; Debra Weiner's informative interview with Ida Lupino; Dennis Peary's helpful overview of director Stephanie Rothman's films; Leigh Brackett's personal account of what it was like to work with Howard Hawks; and Patrick McGilligan's analysis of film editor Dede Allen. The essays on the independent and experimental filmmakers deal with Germaine Dulac, Maya Deren, Storm De Hirsch, Shirley Clarke, Yoko Ono, and Joyce Wieland. The last set of articles in this section looks at women and political filmmaking. For example, [Susan] Elizabeth Dalton examines how the screen image of women in Warner Bros. films reflected the studio's patriarchal biases. Ruth McCormick's essay then surveys the growing importance of women filmmakers in the independent field during the early to mid-seventies. Other articles involve an interview with Jane Fonda on progressive filmmaking, a Marxist evaluation of radical French films, an autobiographical commentary by Sarah Maladoror (real name: Sarah Ducados) on her revolutionary theatrical film SAMBIZANGA (1974), a comparison of screwball comedies with the form of the medieval NOH plays, and an interview with Lina Wertmuller.

The final two sections of the anthology provide a summary of the issues and theories of the early feminist film critics. Authors like Alice Guy Blache, Barbara Bernstein, Barbara Halpern Martineau, Susan Sontag, Ellen Willis, and Andrew Sarris debate questions of status, the existence of a patriarchal film system, and the controversial films of Leni Riefenstahl and Lina Wertmuller. Best of all, the final essays include some of the most noteworthy commentaries on the era by E. Ann Kaplan, Claire Johnston, Laura Mulvey, and Molly Haskell.

While there is much to recommend this collection as a historical record, serious students might object to the generally uncritical and simplistic array of opinions that dominate the book. Another drawback to the many republished articles is the fact that some of the essays, here abridged, are less than satisfactory. If the purpose is to

provide a historical perspective, then it would be more helpful to print the articles as they originally appeared. The book concludes with a minimal filmography and bibliography and a helpful index. Well worth browsing.

Kowalski, Rosemary Ribich. WOMEN AND FILM: A BIBLIOGRAPHY. Metuchen: The Scarecrow Press, 1976. 278pp.
 An uneven annotated bibliography distinguishing the contributions of women from those of men, this project grew out of a school assignment for the author's course in "Library Research Methods." The stilted writing and matter-of-fact comments obscure the hard work that obviously went into the book's four major sections on women as performers, filmmakers, screen images, and gossip columnists and critics. For example, each of the first three sections attempts to facilitate the work of the reader by separating the material into reference tools or historical surveys followed by lists or catalogues of films. The section then concludes with an extensive listing of specific works. The materials are alphabetically arranged and add up to more than 2300 entries. A subject and name index add to the book's value for dedicated researchers. Less conscientious film sleuths will probably be content to use other reference works that contain much of the material that is up dated and more usefully annotated. Worth browsing.

*Kuhn, Annette. CINEMA, CENSORSHIP AND SEXUALITY, 1909-1925. London: Routledge, 1988. Illustrated. 160pp.

*Kuhn, Annette. THE POWER OF THE IMAGE: ESSAYS ON REPRESENTATION AND SEXUALITY. London: Routledge and Kegan Paul, 1985. Illustrated. 146pp.

*Kuhn, Annette. WOMEN'S PICTURES: FEMINISM AND CINEMA. London: Routledge and Kegan Paul, 1982. 226pp.
 The author's primary objective is to demonstrate the explicit (political) and implicit (philosophical) underpinnings between feminist film theory and feminist film production by tracing the development of the theory and providing an overview of current work related to the subject. She justifies using "feminism" as a methodology for analyzing film because it is related not only to an existing body of knowledge, but also to vital questions concerning "relationships between films, film makers and audiences, the kinds of pleasures women may derive from watching films, and the nature and implications of representations of women constructed in different types of cinema." Overall, Kuhn does an admirable job of avoiding many of the problems readers often encounter with feminist film criticism.
 The first of the book's four major sections--"Passionate Detachment"--begins with Kuhn's defining very broadly what she means by "cinema" (all institutions traditionally associated with film production, distribution, and exhibition) and "feminism" ("a set of political practices founded in analyses of the social/historical position of women as subordinated, oppressed or exploited either with dominant modes of production . . . and/or by the social relations of patriarchy or male domination"). The focus of the book, however, is much narrower in that it examines only what are perceived by the author as the actual and ideal relationships between feminism and cinema. The basic assumption is that cultural politics "is a legitimate and important area of analysis and intervention for feminists." Interestingly, she subordinates economic influences to ideological ones as the central element in the organization of social structures and formations. Her reason is that those who wish to change the STATUS QUO can do so independently of economic influences. Kuhn boldly claims that her book suggests how such interventions could occur. The first step is by acclimating oneself to how the media construct an ideal female, and why such an objective image is not only unattainable, but also oppressive. Kuhn never oversimplifies the problem by assuming that more women operating in place of men

in the dominant cinema would result in more feminist films. Explaining that the issue goes beyond an individual's sex, she describes how the "meaning" of a "text" is endowed with a perspective endemic to the relationship between film and feminism, as well as to the reception and "reading" of the film by the audience. Her thesis dismisses the assumptions about authorial intentions underlying the AUTEUR theory. Since no one can control the meaning of text, being a feminist is in itself no guarantee of a film's becoming a feminist text. Interpreting signification and representation are also problems, since their meanings, too, are determined at the moment of reception. As an alternative to the AUTEUR theory, Kuhn draws upon authors who have theorized about feminine language and feminine writings (e.g., Luce Irigaray, Roland Barthes, Christian Metz, Julia Kristeva, Stephen Heath, and Helene Cixious) as well as making a distinction between a "feminist" and a "feminine" text. For example, a feminist text cannot be defined, she argues, "either A PRIORI or universalistically," because meaning is determined at the point of reception by the spectator. On the other hand, a feminine text is evident by the manner in which it challenges at the moment of reception the singleminded, fixed meanings of the dominant cinema. That is, feminine films offer many possible interpretations of what is possible; their meaning is always "shifting and constantly in process." To her credit, Kuhn senses the reservations narrative critics have with a theory that makes meaning crucially dependent on the moment of reception. Not only is there a question of "preferred meanings," but also there is the complicated issue of knowing when it is reasonable to transfer meaning from the author to the audience. Simply put, when does the feminist reading go astray and the author's stated intentions ("tendency") get ignored or misunderstood? Although Kuhn acknowledges that her theory is paradoxical--on the one hand, the viewing process is characterized "as nothing more than the site of struggle for the production of meanings" and, on the other hand, there are texts that have "preferred readings"--she does not provide a useful set of criteria for making helpful distinctions. The best she can do is to admit that there is no answer applicable to all situations. Openness rather than closure remains the basic test in determining whether a text is masculine or feminine.

Part 2--"Dominant Cinema"--examines the characteristics of the classic Hollywood cinema and reviews why feminist film criticism has developed as a response to the practices of the American film industry. First, Kuhn critiques Hollywood as a social and economic institution. Although many feminists concentrate on the decades of the thirties and forties as symbolic of the ideal type of dominant cinema, Kuhn aptly focuses on Hollywood after 1950 as a means for analyzing "the historically specific relationship between the economic and the ideological--in the 'cinematic apparatus'. . . ." She sees the dominant cinema's institutions as having general characteristics: e.g., films are physically reels of celluloid and ideologically bearers of meaning; films are big business in which most people are employees; and ownership is not vested in the majority of those who produce the films. However, the startling changes in production, distribution, and exhibition (especially the advent of videocasssete recorders, videodiscs, and videotapes) are seen as having enormous implications for women filmmakers working within or on the fringes of the dominant cinema: e.g., the success of a low-budget film like GIRLFRIENDS (1977), film viewing occurring in the privacy of one's home. Running throughout her cursory analysis, however, is a naivete about Hollywood. For example, a division of labor is neither unique nor alarming either for major industries or commercial filmmakers. Alternatives to dominant cinema still require specialization. Furthermore, the existence of more independent companies does not by itself insure access to mass markets. In short, her criticism oversimplifies the complexity of the film industry. Next, she examines Hollywood's textual features in relation to their social and economic bases. Here, too, she identifies some general characteristics "organized around both a narrative structure, and a specific discourse or set of signifiers, which become the vehicle of the narrative, the means by which the story is told." This allows her to distinguish between story and plot and the ordering of events within the narrative. In pursuing this approach, Kuhn discusses the Formalist tradition adopted by literary critics like Roland Barthes and Vladimir Propp. She draws special attention to the latter's concept

of the "retardation device," whereby pleasure results from the reader's expectation of the narrative's resolution. Her primary example in film is MILDRED PIERCE (1945), perceptively analyzed by critics like Pam Cook and Joyce Nelson. Kuhn's persuasive argument is that feminists prefer inductive rather than deductive analysis. That is, the emphasis is on the changes over time instead of a hermetic perspective focusing on internal structures. While structuralists analyze a screen image, the feminist critics Kuhn favors examine the "real life" person represented on the screen who is driving the story and the plot. Using this approach, the critic searches for recurring patterns that relate directly to the woman's fate in the narrative. As a result, the ideal films for feminists analyzing the classic Hollywood cinema are those in which the narrative is "disrupted" and the resolution left ambiguous (e.g., the FILM NOIR of the 1940s). Kuhn also examines how the "naturalness" of film disguises how films produce meanings. By referring to four types of cinematic codes--the photographic image, MISE EN SCENE, mobile framing, and editing--the discussion leads to the value of semiotics and psychoanalysis to feminist film criticism: e.g., the concept of the "subject" and its unconscious relationships within the narrative, the positioning of the spectator vis-a-vis the rhetoric of film, the function of "suture," the unconscious viewing process itself, and the manner in which movies evoke "scopophilia." She concludes by reminding us that the codes unobtrusively used to create meaning in the cinema do not exist independently of the institutions that govern the production of film texts. What is crucial, therefore, is a recognition of the conditions in which the spectator and the text interact. Equally important is an awareness of women's place in society and how other modes of subjectivity might be brought into play.

Part 3--"Rereading Dominant Cinema: Feminism and Film Theory"--looks at the relationship of feminism to film criticism and film theory as it developed between 1972 and the early 1980s. One constant theme is that feminist film criticism must focus on "making the invisible visible"; on making audiences conscious of the cinema's many acts of omission as well as those of commission. In essence, the models she advocates aim at discussing both context and text and the relationship between the two. As an introduction to feminist film history and its major premises, this analysis does a first-rate job of listing a number of important concepts related to feminist film theory: e.g., the meaning-production process, deconstruction, and the relevance of ideological readings of texts to feminist film criticism. Where Kuhn gets into trouble is in committing serious acts of omission in her overview of the feminist film movement, especially in dealing with the battles between the editors of WOMEN AND FILM and CAMERA OBSCURA.[232] Kuhn's brief account of the premises, methods, and applications of ideological analysis takes issue with the concept of "rupture," since all films contain ideology and are therefore open to ideological analysis. She champions recent feminist film criticism that illustrates how sexist ideology operates and textual analyses that demonstrate how new meanings can replace preferred ones. Kuhn does make a distinction between structural and poststructural textual analyses. The former relies too heavily on a Formalist approach, while the latter pays more attention to the process of reception. To show the value of the poststructuralist approach, she provides an extensive summary of Raymond Bellour's work on Hitchcock and shows how Bellour's psychoanalytical textual analyses explicate a film text's concrete details. The great value she finds in his work is the stress on "repressive" elements or what is left unsaid in the film text. At the same time, she points out the need for textual critics to place their investigations in institutional, social, and historical contexts. To demonstrate how that approach works, Kuhn cites the studies done on the star system by Mary Beth Haralovich, Richard Dyer, and Maureen Turim. Special attention, however, is devoted to an anlysis of pornography, mainly because it demonstrates the ties among films, other media, and specific institutional apparatus. Pointing out the influences that social and historical contexts have on the shifting definitions given to the concept of pornography, Kuhn stresses its representational function and a privileged reader-text relationship. That is, for feminists like Kuhn,

[232] For specifics, see Rich, pp.70-1.

pornography relates to the manner in which male spectators relate to, and depict, the female body: i.e., women encoded as a sex object and the sexual acts represented. More important than a single example in a particular film text is a historical pattern in which the example cited is but one more illustration. That pattern is linked to a social structure influenced by economic and political ideology. Her prime example is Brian de Palma's DRESSED TO KILL (1980).

The book's concluding Section 4--"Real Women"--shifts attention away from mainstream cinema and toward issues feminist film criticism poses for both conventional theatrical films and their alternative forms. Kuhn explores first the existing ideological conflicts apparent in specific theatrical films as identifed by feminist critics like Molly Haskel and Marjorie Rosen. For example, she asserts that the writings of these authors have resulted in a "new Hollywood" image of women found in mainstream films like ALICE DOESN'T LIVE HERE ANYMORE (1975), AN UNMARRIED WOMAN, GIRLFRIENDS, and JULIA (all in 1977), and STARTING OVER (1979). While not representative of every female code in dominant cinema, such films illustrate how filmmakers are now aiming their work for a specific audience. What is never fully explored is the possibility that women are still being exploited by American filmmakers to conform with the current social climate. One need only examine the treatment of women in the "blacksexploitation" films of the late 1960s-early 1970s. In fairness to Kuhn, however, she does insist that "Whatever positive identifications . . . [the new Hollywood cinema] offers to those who choose to make them, new women's cinema cannot in the final instance deal in any direct way with the questions that feminism poses for cinematic representation." A case in point is provided by contrasting two "working class films": SALT OF THE EARTH (1954) and NORMA RAE (1979). Kuhn also offers some observations on the contributions of feminist documentary cinema in films like JANIE'S JANIE (1971), WOMEN OF THE RHONDDA (1973), and UNION MAIDS (1976). From here, she turns to the "countercinemas" and their various textual strategies. The countercinema is seen as an attack on "illusionism"--an ideological process that passes off screen images as an accurate reflection of the "real world." For Kuhn the best strategy involves film texts that deconstruct the "voyeuristic-scopophilic look." That is, spectators are turned into alert and questioning viewers of film texts. The texts themselves consciously oppose the conventions and images of the dominant cinema. Examples cited are LIVES OF PERFORMERS (1972), ONE WAY OR ANOTHER (1974), THRILLER (1975), WHOSE CHOICE? (1976), DAUGHTER RITE (1978), and JEANNE DIELMAN, 23 QUAI DU COMMERCE, 1080 BRUXELLES (1979). In each instance, the films illustrate how their countercinema status results from their relationship to dominant cinema. Particular signifying processes that enable countercinema to operate are changes in the way "looks" are exchanged, the structure of the "narrative and narrative discourse, subjectivity and autobiography, fiction as against non-fiction, and openness as against closure." Kuhn concludes with a discussion of institutions and their relationships to textual practices. She stresses that feminist countercinema is more than a set of films in opposition to the dominant cinema. It also involves the way in which meanings are produced and received. Particularly helpful is her discussion on getting alternative films made, distributed, and exhibited.

Whatever the book's theoretical problems, its straightforward and lucid position makes it valuable as an introduction to feminist approaches to film in England during the late 1970s. Adding to the book's value are a sensible glossary, a brief filmography with rental sources, a selected bibliography, and a helpful index. Recommended for special collections.

*Library Staff of Women's History Research Center. FILMS BY AND/OR ABOUT WOMEN. Berkeley: Women's History Research Center, 1972. 72pp.

This useful and valuable pioneering directory lists names of filmmakers, films, and distributors on the international scene. The brief annotations are taken from three sources: films by women on any subject, films by men or organizations that illustrate something a women's group has wanted to communicate about women, and

films by men about a particular woman or women's event. The topical listings, alphabetically arranged, contain descriptions presented by the filmmakers themselves. In addition, there is an index of films by female filmmakers, an index of films by distributors, and a section devoted to work-in-progress and last-minute additions. Worth browsing.

Manchel, Frank. WOMEN ON THE HOLLYWOOD SCREEN. New York: Franklin Watts, 1977. Illustrated. 122pp.
 "The reader of this volume will not only be richly entertained, but will also be rewarded by a superb exposition of modern social drama."[233]

Martin, Linda, and Kerry Segrave. WOMEN IN COMEDY. Secaucus: The Citadel Press, 1986. Illustrated. 449pp.

McCreadie, Marsha. WOMEN ON FILM: THE CRITICAL EYE. New York: Praeger Publishers, 1983. 157pp.
 A well-intentioned but "unabashedly partisan" survey of thirty-two American and European women who have analyzed films, this controversial undertaking is divided into nine terse chapters. The major premise is that women not only have a unique perspective socially and psychologically, but also reveal their gender in their work. McCreadie's overreliance on experimental psychology for claims that women possess these unique critical talents will offend some scholars.[234] Another controversial premise is that the low status of the movies as a medium of mass entertainment made it possible for women to make notable contributions to film criticism and theory. After all, who cared about what was said and done in a popular and trivial pastime? McCreadie tries to set the record straight. In addition to analyzing the strengths and weaknesses of major women critics throughout film history, she also explains what led them into the film world. Even if McCreadie doesn't wind up with a totally convincing case that all of her female critics possess unique intuition, perception, and sensitivity, the author does provide an introductory summary of the major contributions by women critics and intellectuals to film criticism and theory.
 Chapter 1 illustrates the author's strengths and problems as she analyzes the writings of such contemporary critics as Pauline Kael and Penelope Gilliatt. In discussing Kael, McCreadie manages to lose any sense of objectivity. Following a perfunctory listing of THE NEW YORKER critic's acknowledged stylistic qualities (e.g., "charm, wit, enthusiasm"), the author proceeds to find fault with almost everything Kael has done. We're reminded of charges of "repetitiveness, favoritism, and lack of consistent theory . . . lack of visual sensibility, and an over reliance on literary references." She concludes that Kael has been on a "gradual downslide" since the early 1970s and "an unthrilling predictability has taken over" her writings. This excessively harsh and ungenerous evaluation includes only one element of information that offers new insights into Kael's roller coaster career: the details concerning Kael's work on RAISING KANE: THE CITIZEN KANE BOOK. In this instance, McCreadie does not go far enough in castigating Kael for her reprehensible treatment of Howard Suber and his important and uncredited research on Orson Welles. This author also remembers, however, the brilliant assault that Kael led against psuedo-intellects and stuffy academicians in the sixties and early seventies and thus feels that Kael deserves better than the assessment that she is nothing

[233] George Rehrauer, THE MACMILLAN FILM BIBLIOGRAPHY, Volume 1: Reviews (New York: Macmillan Publishing Company, 1982), p.951.

[234] For one example, see Ernest Callenbach, "Book Review: WOMEN ON FILM: THE CRITICAL EYE," FILM QUARTERLY 36:4 (Summer 1983):33.

better than a "glorifed film buff." By contrast, McCreadie is all sweetness and light in comparing Kael with her one-time colleague at the NEW YORKER. Not only is there a great deal of sympathy for Gilliatt's emotional troubles, but criticisms about her film writings are also quickly followed by enthusiastic defenses. For example, McCreadie writes that "if Gilliatt's free associations were 'uncritical,' they were also splendidly descriptive and evocative of the particular film or individual."

Other sections in the book are not much more successful in dealing objectively with the past or the present. A case in point is Chapter 2, which serves as a reminder that, except for British-born Iris Barry, American female film critics have never been identified with aesthetic movements in film. European women critics like C. A. (Caroline) Lejune, Bryher (Winifred Ellerman), Lotte Eisner, Penelope Houston, and Jan Dawson are used to illustrate the dramatic differences between the American reviewers and their foreign counterparts. Of particular value is the refresher course on British novelist and critic Bryher's contributions as co-editor of CLOSE UP. On the other hand, the author is so intent on praising these noteworthy journalists that she often abandons critical analysis in favor of stressing the importance of each "first" and "extraordinary" position taken by the female European journalists in advancing the art of the film. Symptomatic of the loss of objectivity is her exaggerated assertion that "No film critic or historian, American or European, brings as many and as wide art historical references to bear on film as Eisner."

Chapter 3 illustrates another problem as the author attempts to discuss four important film feminists: Molly Haskell, Marjorie Rosen, Joan Mellen, and Laura Mulvey. Noting that these women share many of the characteristics long identified with female film critics--e.g., personalizing film experiences, pointing out the collective works of a performer rather than highlighting one role, and stressing the impact of film on society--the author goes out of her way to fault each of the American feminists for doing little more than "grafting . . . [a] 'new sensibility' onto film." In addition to patronizing the significant contributions of early film feminist historians like Rosen and Haskell, the author goes on to demonstrate a lack of understanding of what each of these women critics was trying to do. Whatever critical weaknesses exist in Rosen's pop-culture approach (and there are many), she still deserves enormous credit for reaching a vast audience of readers intellectually unable or unwilling to consider the negative effects of a patriarchal film history. And she did it before a good many others who today pat themselves on the back for the ground she broke. As for Haskell's perceptive and original research (also with methodological problems), its sophisticated analysis of women in film not only went beyond the intellectual pretensions of Rosen's book, but also became the first book that academicians could not dismiss as hysterical or shrill. It represented a major challenge to traditional approaches and forced many of us to reevaluate not only how we saw women on the screen but also how we taught film history. Regrettably, McCreadie fails to discuss this in her uncharitable assessment of the two pioneering authors and concludes, "If Haskell's approach is darkly, demoniacally psychoanalytic, Marjorie Rosen's work seems too frequently single-mindedly sociological, or else tritely, patly feminist." Although Mellen gets a condescending compliment, McCreadie saves most of her praise for the British critic and filmmaker Mulvey. Even though the author displays her biases toward semiological analyses, she finds Mulvey's "feminist conclusions about sexuality and repression . . . [not] too hard to swallow."

The next five chapters continue McCreadie's uneven assessment of film reviewers and intellectuals like Judith Crist, Dilys Powell, Renata Adler, Janet Maslin, Susan Sontag, Annette Michelson, Maya Deren, Hortense Powdermaker, Claude-Edmonde Magny, Diana Trilling, Simone de Beauvoir, Joan Didion, Nora Sayre, Colette, Louise Bogan, Virginia Woolf, Dorothy Richardson, Marianne Moore, H. D. (Hilda Doolittle), and Anais Nin. The basic problem remains the author's inability to delve meaningfully into the economic, social, and political intricacies of the film continuum. In the words of Lauren Rabinowitz, McCreadie "equates all types of writing, treating the texts

under discussion as a series of organically formed, objective objects."[235] Why one woman writer is juxtaposed with another is never made clear, nor is a clear distinction made between the ideologies of various writers and intellectuals.

The problems are compounded in the author's final chapter. Her conclusion that most of the collected writings of the thirty-two women amount to a theory emphasizing the importance of the star and the general blurring between the star's roles and her "real-life" adds very little to film scholarship. Nor is McCreadie breaking new ground with the assertion that good critics pay attention to details. What is not proved is that gender makes the difference in "emphatic understanding" and "a yearning for power." Carrie Rickey may sum up the feelings of many readers when she writes, "In reneging on her promise of identifying a feminine aesthetic, McCreadie invents what Cynthia Ozick might term "The Ovarian Theory of Film Criticism, observing a passivity, subordination, and powerlessness of women writing about film while it is instead their active theories of aesthetics, social criticism, and observations on high-versus-mass culture that have enabled such women to dominate the field."[236]

For those looking for a general collection on what women writers and intellectuals contributed to the history of international cinema, this is a flawed but useful introduction. The journalistic writing style, coupled with the author's partisan opinions, makes for fast and entertaining reading. For those concerned with intellectual rigor, this is not the place to find it. A selected annotated bibliography and index are included. Approach with care.

*McCreadie, Marsha, ed. THE AMERICAN MOVIE GODDESS. New York: John Wiley and Sons, 1973. Illustrated. 92pp.

Part of the "Perception in Communication Series" of topical readers designed to stimulate expository writing in freshman college courses, this slim book offers an interesting selection of "photographs, essays, song lyrics, illustrations, and other material from three decades of recent cultural history: the thirties, the forties, and the fifties." McCreadie's thesis is that the mass media foisted on an unsuspecting and manipulated public specific images of women that revealed the nation's desires and popular beliefs. The three movie stars most representative of this ideological process were Greta Garbo, Rita Hayworth, and Marilyn Monroe. For example, Garbo symbolizes for McCreadie the "streamlined austerity and the glamorized no" of the 1930s. This reflection of a nervous, discontented era was replaced in the forties by a marriage of sex and technology symbolized by Hayworth. This FEMME FATALE was, in turn, replaced by the spontaneous and innocent generation of the fifties, personified by Monroe. While some readers may find the book's assumption stimulating and entertaining, the simplistic approach to both the issues and the mass media process is disconcerting. The vast amount of information about perception, film reality, and feminist film theory that is currently available and valuable makes this pioneering venture outdated and misleading. As a curiosity piece, the book is very enjoyable. As a college reader, its time has passed. Approach with care.

*Mellen, Joan. WOMEN AND THEIR SEXUALITY IN THE NEW FILM. New York: Horizon Press, 1973. Illustrated. 255pp.

In a prefatory author's note to this insightful feminist study, Mellen acknowledges that the book was written in collaboration with her husband, Ralph Schoenman. Why he wasn't given credit on the title page is never explained. What is clear from the outset is Mellen's intense personal dissatisfaction with the image of women in modern films. Twelve chapters, aggressively written but lacking a clear-cut

[235] Rabinowitz, p.62.

[236] Carrie Rickey, "Book Review: WOMEN ON FILM: THE CRITICAL EYE," FILM COMMENT 19:3 (July 1983):23.

methodology, explore how female sexuality, lesbianism, and sexual politics distract and pervert the efforts of contemporary filmmakers.

Chapter 1 begins with Mellen's subjective lament that there are no new perceptions of women in contemporary movies either in America or abroad. "The world cinema today [1973] is unable," she argues, "to provide an image of women who achieve THROUGH their drives instead of by an unnatural distortion of them." Her broadsides at socialist cinemas, with their basically subservient depictions of women, finally break out of the anti-American rut typical of reductionist film criticism in the sixties and seventies. Mellen does draw attention, however, to the theory that "The governing ideas of both so-called socialist and capitalist nations are bourgeois." That is, the primary social unit is the family, and women are relegated to a subordinate position in a nuclear family lorded over by a domineering patriarch. She then goes on to identify movies that challenge not only the helplessness of women but also the decadence of bourgeois societies. Among the films cited are LOVING (1970), BORN TO WIN and THE PANIC IN NEEDLE PARK (both in 1971), and THE DISCREET CHARM OF THE BOURGEOISIE/LE CHARME DISCRET DE LA BOURGEOISIE 1972). What's bad about these films, according to Mellen, is that shrillness and unseemly behavior have replaced coquettishness. Thus the artistic freedom so long desired by filmmakers has resulted not in humane alternatives to bourgeois values but in films of panic and fear. In addition, the reemergence of women screenwriters and directors in mainstream movies has not helped in the process of providing alternative images to the traditional stereotypes of women. Citing works by screenwriters like Adrien Joyce (Carole Eastman), Eleanor Perry, and Penelope Houston, Mellen attacks the images of dependent and pathetic female characters in movies like FIVE EASY PIECES and DIARY OF A MAD HOUSEWIFE (both in 1970) and SUNDAY, BLOODY SUNDAY (1971). Women directors who have failed to break the mold, according to Mellen, include Agnes Varda (LION'S LOVE), Karen Sperling (MAKE A FACE), Kate Millett (THREE LIVES), and Susan Sontag (DUET FOR CANNIBALS). In short, the reason why women continue to be stereotyped as passive and anxious victims is that "The tension, self-suppression and restriction demanded by . . . [social] institutions register themselves in our bodies and their inner processes."

The book's remaining eleven chapters spell out how the process operates and how women have been demeaned. For example, the chapter on female sexuality explores how male filmmakers like Alan J. Pakula, Frank Perry, Ingmar Bergman, Luis Bunuel, Mike Nichols, and John Schlesinger portray women as infantile and dependent in movies like KLUTE (1971), DIARY OF A MAD HOUSEWIFE, THE TOUCH (both in 1970), BELLE DE JOUR (1968), CARNAL KNOWLEDGE and SUNDAY, BLOODY SUNDAY (both in 1971). The chapter on lesbianism in films discusses how most filmmakers portray lesbians as "either compulsively sadistic or masochistic, always possessive, jealous, hateful, and indeed, 'sick.'" The major exceptions, according to Mellen, are foreign directors like Ingmar Bergman, Claude Chabrol, and Bernardo Bertolucci. But even these well-intentioned males get lambasted for their patronizing efforts. In addition to chapters devoted to the works of directors: e.g., Bergman, Chabrol, and Bertolucci, the author provides studies of Eric Rohmer, Luis Bunuel, Luchino Visconti, Dusan Makavejev, Mark Rydell, Mae West, and Irvin Kershner. In essence, Mellen argues that liberated images of women can only be produced by individuals who appreciate how specific social forms condition us to enslave women.

What is most refreshing about this provocative study is the skillful way in which Mellen has organized and presented her controversial opinions. The accessible prose on very complicated issues reflects what can be accomplished without excessively theoretical arguments. In addition, Mellen deserves high marks for being among the first academic critics to challenge the then-entrenched notion that Bergman could do no wrong. Having said that, I must point out that Mellen's subjective judgments assert more than they prove. They also illustrate how some feminist film critics substituted what they wanted to appear in contemporary movies for what actually appeared. Other slight regrets deal with the author's failure to provide a bibliography, a filmography, and an index. Recommended for special collections.

Miller, Lynn Fieldman. THE HAND THAT HOLDS THE CAMERA: INTERVIEWS WITH WOMEN FILM AND VIDEO DIRECTORS. New York: Garland Publishing, 1988. Illustrated. 271pp.

*Modleski, Tania. LOVING WITH A VENGEANCE: MASS-PRODUCED FANTASIES FOR WOMEN. Hamden: Archon Books, 1982. 140pp.

Offering a serious and intriguing analysis of Harlequin Romances, female Gothics, and soap operas, the author makes a good case for rejecting the traditional theory that mass art forces us to have "false needs" and produces "false anxieties." Modleski, a professor of film and literature at the University of Wisconsin-Milwaukee, believes that the reverse may be true. That is, mass art operates as a complex means of satisfying our real-life dilemmas and desires. Furthermore, the intricate relationships between today's popular arts produced for women have their antecedents in the popular feminine narratives of the eighteenth and nineteen centuries, with their emphasis on unusual heroines. Modleski divides her study into four major sections, beginning first with a detailed overview of mass-produced fantasies for women. After explaining the limitations imposed on female protagonists and female popular fiction, she explores the argument that fictional male counterparts enjoy a more favorable status. Modleski makes it clear that over the years women as well as men have "generally adapted one of three attitudes [toward feminine narratives]: dismissive, hostility; . . . or, most frequently, a flippant kind of mockery." Such attitudes are also related to the critical hostility toward melodrama. In such instances, both plot and protagonists routinely are attacked for their hyperbolic actions and exaggerated conventions. Modleski's theory draws heavily on the work of Marxist, psychoanalytic, and feminist film critics in order to prove that much of the popularity of mass art is based on the manner in which the popular genres targeted at women satisfy female desires arising out of real-life situations. For example, Section 2--"The Disappearing Act: Harlequin Romances"--relates to women's desire for revenge against all-powerful males. At the same time, the analysis reassures female readers that the appearance that men do not value women is only an illusion. Each narrative reaffirms the fact that women are intensely loved by men. Section 3--"The Female Uncanny: Gothic Novels for Women"--points out the striking differences between Harlequin and Gothic narratives. The latter confirm the paranoid fears positively dismissed in the Harlequin romances. Yet Modleski finds each type of feminine narrative related to two basic anxieties women have: guilt and fear. Section 4--"The Search for Tomorrow in Today's Soap Operas"--illustrates the crucial differences between masculine and feminine narrative films. Unlike the former, the feminine text opts for complicated situations that not only intensify the problems in the plot, but also defy resolution.

Reactions to this explanation of what actually occurs between popular art and its mass audiences depend on one's willingness to accept Modleski's controversial premises. If one takes the position espoused by CHOICE, then you may find the work "tedious" and the thesis "self-contradictory: today's Harlequin romances, Gothic novels, and soap operas provide their female audiences with the escape they require because of women's traditional, restricted roles; however, while reinforcing those roles, these media products also challenge them."[237] On the other hand, as Ellen Seiter persuasively argues, "In explaining the appeal of these mass-produced fantasies, Modleski challenges us to begin imagining and producing healthier fantasies for women."[238] Adding to the book's appeal are useful endnotes, a lengthy bibliography, and a helpful index. Recommended for special collections.

[237] "Book Review: LOVING WITH A VENGEANCE: MASS-PRODUCED FANTASIES FOR WOMEN," CHOICE 20:6 (February 1983):861.

[238] Ellen Seiter, "Theory: LOVING WITH A VENGEANCE: MASS-PRODUCED FANTASIES FOR WOMEN," FILM QUARTERLY 37:1 (Fall 1983):48.

*Penley, Constance, ed. FEMINISM AND FILM THEORY. New York: Routledge, 1988. Illustrated. 271pp.

*Rosen, Marjorie. POPCORN VENUS: WOMEN, MOVIES AND THE AMERICAN DREAM. New York: Coward, McCann & Geoghegan, 1973. Illustrated. 416pp.
 "How profoundly Hollywood's values have influenced a gullible public--like myself," Rosen writes in her preface. She then adds, "But why did the public--and especially its females--so passively embrace the industry's interpretations of life? After all, an image--even one created by so rare an animal as a movie mogul--is molded from prevailing audience attitudes; indeed, the public determines the life or death of a movie." These issues--the public's desires, the industry's needs, the role of women in the process, and the process itself--become the major topics in this popular and stimulating study of the treatment of women in Hollywood film history. Each of the book's six chatty sections is subdivided into a series of chapters on specific themes exploring the relationship between movies and society. Although none of the major topics receives in-depth analysis, every one is explored consistently. Rosen's witty and perceptive writing style does an impressive job of masking her many undocumented assertions about motives, psychological effects, and industry practices.
 Section One--"Emerging From Victorianism"--sets the tone by first establishing the fact that the limitation of women's sexual and social roles was not invented by the film industry. Except for the few optimists among the suffragettes from the 1890s on, the everyday female at the turn of the century found herself dependent on men for her safety and security. According to Rosen, the birth of the movies dramatically changed how most women perceived themselves and their options. Although she provides minimal documentation for her claims, the author insists that women and children accounted for three-quarters of the audience attending New York City's 550 nickelodeons by 1908. Using this figure, she then mistakenly confuses the number of people who attended the movies with what they presumably liked, valued, and learned from the movies they saw. Furthermore, Rosen enjoys flaunting her feminist perspective by asserting that "in the name of moral outrage women and children were always lumped together; rarely was the 'community' wary of the influence of movies on men." Such oversimplifications inevitably lead to the predictable attacks on film stars like Mary Pickford and the "Griffith's Girls." Unlike Haskell, who worked hard at not using current values to judge historical events, Rosen grafts her modern sensibility onto her evaluations of the past. For example, she dismisses Pickford's screen image as an insult, but praises the star's contributions to turning the small movie business into a major art and into an international industry. Almost no consideration is given to understanding Pickford's extraordinary popularity or her ingenious characterizations. The section concludes with a chapter attacking alternative images to those of the virgin-heroines. In the process, Rosen omits a surprising number of facts. For example, in her explanation of how sex was starting to permeate American culture, Sennett's Bathing Beauties are ignored and there is no mention of the influence of George White's Scandals, Florenz Ziegfeld's Follies, and the world of Burlesque.
 Once one becomes acclimated to her breezy style, the erratic social history serves as a step above the routine nostalgic experience for film buffs. The section on the twenties highlights how movies introduced the chorus genre, glorified the poor-but-honest working woman, and kept marriage and children as the ultimate goal of almost every screen heroine. The underlying thread through the blending of statistics and film criticism is that "Movies . . . contributed concretely to developing false values in life and overemphasizing the worth of secondary ones." The section on the thirties reviews the new criteria for sexual and social behavior. "Talkies" and the Depression made characters more realistic, dialogue more brittle, and actresses more dependent on their wits rather than on their charms. Rosen is very skillful in recreating the mood and values portrayed by stars like Garbo, Dietrich, West, and Crawford. She also offers a fascinating theory on why various studio moguls opted for a "Depression landscape" that featured social fantasies about

profligate socialites. The chapter on the forties recounts how World War II revamped society and movies toward a female-orientation. Not only did the woman's film gain considerable prominence, but also stories about what women should do without men became the rage. Although the author avoids in-depth analyses, she demonstrates a knack for knowing how and why women felt and did what they did during the war years. Rosen also makes an alluring case for why actresses became second-class screen personalities in the immediate postwar period. The chapters on the fifties and sixties focus on how the now powerless stars became screen "buffoons." While one set of actresses codified myths about naive and unpretentious women, "Perpetual Virgins," or "loved-starved pariahs," another group of stars "standardized and distorted" the images of teenagers or exploited the new-found sexual freedom of the sixties. So long as Rosen sticks to her entertaining generalizations about the past, she remains an absorbing journalist. But when she moves into the early seventies and responds to what her contemporaries are about, she becomes not only a weak reporter, but also a poor analyst. For example, Rosen overestimates the multi-dimensional personalities of European celebrities, is overly optimistic about the future of women's roles, and fails badly in understanding the relationship between the film and television industries.

In short, this book illustrates the strengths and weaknesses of the first serious attempt to reassess film history from a feminist perspective. On the positive side, it establishes the basic parameters on which future film historians have begun in-depth evaluations. It summarizes the fundamental complaints that socially conscious critics would make in a more scholarly way in the decade to follow. And it popularizes a subject that would become less and less accessible to general readers. On the negative side, the author makes almost no attempt to anchor her opinions in any industrial or objective context. A series of minimal endnotes, a good bibliography, and a useful index are provided. Well worth browsing.

*Rose, Jacqueline. SEXUALITY IN THE FIELD OF VISION. London: Verso, 1986. illustrated. 256pp.

Rosenberg, Jan. WOMEN'S REFLECTIONS: THE FEMINIST FILM MOVEMENT. Ann Arbor: UMI Research Press, 1979. 143pp.

*Russ, Joanna. MAGIC MOMMIES, TREMBLING SISTERS, PURITANS & PERVERTS: FEMINIST ESSAYS. Trumansburg: The Crossing Press, 1985. 120pp.

*Silverman, Kaja. THE ACOUSTIC MIRROR: THE FEMALE VOICE IN PSYCHOANALYSIS AND CINEMA. Bloomington: Indiana University Press, 1988. 257pp.

Slide, Anthony. EARLY WOMEN DIRECTORS. South Brunswick: A. S. Barnes and Company, 1977. Illustrated. 119pp.

In his usual dry and straightforward manner, Slide attempts to put misperceptions about the silent era in proper perspective. This time he's annoyed with feminist claims about the image of women in film. "The careers of several women directors," Slide points out, "have been the subject of much analysis and discussion, most of it regrettably far too biased to be worthwhile." In fact, there were more than thirty women directors active in Hollywood by 1920. Six of them--Alice Guy Blache, Lois Weber, Margery Wilson, Mrs. Wallace Reid, Frances Marion, and Dorothy Arzner--are discussed in succinct chapters, while the book's remaining two chapters survey the other prominent filmmakers. Before beginning his objective and colorless reports, Slide takes a few potshots at the women's movement. Noting that feminist film treatises generally have ignored the early years of film history, he chides those

activists who find it "far easier to protest about discrimination against women than to accept that there were more women directors at work in the American film industry prior to 1920 than during any period of its history." In quick fashion, he lists the number of influential stars, the important screenwriters, the powerful gossip writers, and the many editors, all women, and all vital to the health of the American film industry.

If facts are what the reader is after, then Slide's pedantic style won't prove bothersome. He is not only reliable, but also enterprising. What commentator on early film history has done as well as Slide in unearthing information on star-directors like Cleo Madison or Ruth Stonehouse? Even better than the limited information provided are 100 rare (and often amusingly annotated) stills of women directors who left the mark of their style and ideas on the industry. Like the prose, the picture reproduction quality is adequate rather than sparkling. Nevertheless, I found the book to be an invaluable aid in doing serious film study. A limited bibliography but no index is provided. Recommended for special collections.

*Smith, Sharon. WOMEN WHO MAKE MOVIES. New York: Hopkinson and Blake, 1975. Illustrated. 307pp.

"The purpose of this book," writes Smith, "is two-fold: (1) to present a history of women filmmakers, and (2) to identify the new women filmmakers. If, in the telling, the charge of discrimination recurs it is because discrimination has been, and to an unfortunate extent still is, intrinsic to the story of women who make films." Over a four-year period during which Smith worked on her master's degree at the University of Southern California, she corresponded with hundreds of women filmmakers, interviewed a number of prominent artists, and viewed many of the films she discusses in her useful narrative. The book itself is divided into three parts: a historical overview, an annotated listing of modern women filmmakers, and a directory of women filmmakers living in the United States. Part 1 pays primary attention to the silent film director Alice Guy Blache, who began her film directing career with Leon Gaumont's camera manufacturing plant in France in 1896, and then emigrated to America eleven years later and established a famous film studio in Fort Lee, New Jersey. Part 1 also provides a thumbnail survey of significant directors, editors, and screenwriters both in America and abroad. Once Smith gets to the modern era, she occasionally includes direct quotes from interviews she held with women filmmakers like Shirley Clarke, Faith Hubley, Barbara Loden, and Elaine May. Part 2 alphabetically lists biographical information about key women filmmakers, but offers minimal details about their professional careers or aesthetic principles. Part 3, on the other hand, was, and to a large degree remains, a valuable source of information about where to locate specific women filmmakers who are producing documentary, industrial, and experimental films. The material on their more noted films, including the running times, is interesting but hardly sufficent to the needs of programmers. The book concludes with a list of useful women's organizations, a directory of distributors, a bibliography, and an index. Worth browsing.

For its time, the pioneering text provided an invaluable service for teachers, librarians, and researchers breaking new ground in feminist film criticism. Although recent publications provide more detailed reference material, the overall scope and focus of the book still justify its place in specialized collections.

Sullivan, Kaye. FILMS FOR, BY AND ABOUT WOMEN, Series II. Metuchen: The Scarecrow Press, 1985. 780pp.

A companion to the 1980 publication, this edition contains approximately 3,200 film titles of current productions (made by both men and women) noted for their content, and technical and artistic quality. Unlike the first book, the subject index now includes women's names, thereby expediting searches for film(s) about a specific person. In addition, there are new listings for topics like Child Custody, Children's Rights, and Adoption. The author has also increased the information provided in her

synopses. For example, we are told about (1) film credits, including director, producer, choreographer, consultant, screenwriter, and editor; (2) screen adaptions when appropriate, including the relationship between the film and its source; (3) materials that accompany the film, such as study guides or script; and (4) sexual material when appropriate, including the nature of the presentation and whether it is "explicit sex." The main section of the book is arranged alphabetically by film titles. Directly after the title is information about running time in minutes, color, production date, release date, whether it is a silent film, whether it is an edited version, and copyright date. Occasionally, we're told if the film is in cinemascope. Particularly useful is the videocassette information indicating whether the film is available in Beta or VHS. The book concludes with a directory of film sources and an index of women filmmakers. Recommended for special collections.

*Walsh, Andrea S. WOMEN'S FILM AND FEMALE EXPERIENCE 1940-1950. New York: Praeger Publishers, 1984. Illustrated. 259pp.

Originally written as a doctoral dissertation at SUNY-Binghamton, this refreshing study sets out to discover how American women and their traditional work and family roles were altered by World War II. The central cultural artifact is the movies of the 1940s and the genre of women's films. Walsh defines the genre as a form of popular culture not only produced for the public, but also reflective of the public's everyday lives. The films themselves are viewed by her as encompassing widely held emotions and values of women dating as far back as the transformation of America from an agrarian to an industrialized society. The themes of the women's film--e.g., birth, love, death, and sexual and social conflicts--are interpreted as "both historically specific and humanely universal." Walsh's theoretical framework permits her to place these potential mediators of public consciousness in the context of research done by writers and scholars like Marx, the Frankfurt school, Antonio Gramsci, Raymond Williams, Stuart Hall, Annette Kuhn, Tania Modleski, Paul Lazarsfeld, and Herbert Gans. One underlying assumption is "that popular culture reflects, through the mediation of myth and symbol, significant themes within popular consciousness." That is, how films are made and received represents an interactive process illuminating cultural hegemony. Popular culture--in this case the women's film--operates as the vehicle for analyzing "the maincurrents and undercurrents within American female consciousness of the 1940s." The analysis, Walsh sensibly points out, does not rely on how realistically the films depicted these various currents: "The challenge of cultural analysis is to decode that symbolic structure, and analyze why audiences and readers in specific societies and subcultures prefer particular patterns of fantasy over others." In her five fact-filled chapters, she questions and re-evaluates the female stereotypes of subordination and subservience institutionalized by the Depression era. The focus is on analyzing the dominant narrative patterns in over forty top grossing "women's films" of the forties: e.g., HIS GIRL FRIDAY (1940), SUSPICION (1941), MRS. MINIVER, NOW, VOYAGER, WOMAN OF THE YEAR (all in 1942), WATCH ON THE RHINE (1943), SINCE YOU WENT AWAY, GASLIGHT, LADY IN THE DARK (all in 1944), A TREE GROWS IN BROOKLYN and MILDRED PIERCE (both in 1945), TO EACH HIS OWN (1946), POSSESSED (1947), I REMEMBER MAMA, SLEEP MY LOVE (both in 1948), A LETTER TO THREE WIVES, LITTLE WOMEN, and ADAM'S RIB (all in 1949). The most common narrative patterns in this representative group are identified as the maternal melodrama, the career woman comedy, and the paranoid women's film (the sub-genre based on suspicion and distrust). Throughout her study, she makes an intriguing case for the recognition of mass-mediated culture as popular culture. At the same time, her impressive introduction challenges prevailing theories about women being held captive by a patriarchal film industry.

Chapter 1--"The Women's Film"--chronicles the birth and development of a mode of film whose psychological feminine motifs distinguish it from movies made for men. The problem for Walsh is how to define the women's film. She rejects the genre classification because the cinematic tone is evident in too many narrative modes, visual styles, and plot structures. On the other hand, it does have a specific set of conventions that can be identified and analyzed. For example, women's films

concentrate on women living in a patriarchal society. The themes emphasize emotionality, human attachments, and the fear of separation from one's loved ones. Unlike "male films"--e.g., westerns, war films, and gangster movies--where the filmmakers rely on individualism, action-packed drama, sparse dialogue, and wide open spaces, the women's film opts for family relationships, non-violent confrontations, frequent discussions, and interior settings. And despite the fact that both gender-related categories stress the importance of making moral choices, the woman's film makes the choices more concretely than does the male-oriented film. In each step of her analysis, Walsh cogently explains how melodramatic excess pervades this unique mode of film, but she offers no useful definition to substitute for calling it a genre. For example, she willingly talks about categories (or what I would label "sub-genres"): maternal dramas, "working girl" movies, paranoid dramas, and "a woman in suffering" type. She skillfully points out the differences between female characters in the woman's film and women in the male-oriented movies (e.g., a different sense of narrative pleasure), while making a good argument for there being no predominantly visual style for the woman's film. Even here she wavers, admitting that most women's films draw heavily on the FILM NOIR traditions and on the classic Hollywood realist style. Walsh is very good, however, at tracing the roots of the woman's film from the origins of Gothic literature to the contemporary soap operas. She also provides a useful summary of how creative women struggled within the confines of a patriarchal film industry to fashion a feminine narrative. Best of all, Walsh offers a strong argument for the woman's film evolving as a result of both a sizable female audience and the personal involvement of many talented women directors, screenwriters, stars, editors, and set designers.

Chapter 2--"Divided and United: American Womanhood on the Homefront"--reviews the social history of American women in the 1940s and concludes that World War II multiplied and intensified the contradictions that women faced in a patriarchal society. The changes were not immediately apparent, however. At first, Walsh explains, America's involvement in the world conflict left the dominant ideologies toward femininity in place. That is, feminists symbolized for many Americans "images of humorless, aging spinsters battling militantly for rights won and forgotten about long ago." But by mid-1942, as large numbers of women began entering the work force, government and industrial leaders made a complete about-face. The problem now was in getting society-at-large to rethink its male chauvinistic attitudes. In an impressive blending of well-chosen quotations and statistical data, Walsh demonstrates how sexual equality ran afoul of "a misogynist work culture" and the discrimination that followed. Information is provided on the controversies surrounding childcare and community services, the transformations occurring in both professional and personal lives, the separation of families and sexes during wartime, and the trauma of demobilization. For example, reading about the fears women had about male infidelity and desertion, coupled with the explanations of why men equated casual sex with the experience of violence, serves as an excellent introduction for the fifties films about "men in grey flannel suits." In short, Walsh does a first-class job of showing how the climate of World War II created not only a patriotic fervor, but also significant domestic problems for the population and the government.

Chapters 3 through 5 detail the dominant narrative patterns within popular women's films of the 1940s. Uppermost in the hearts of wartime women was the maternal melodrama, which epitomized the tension between traditionalism and change. The principal convention stressed how women used their power and influence to benefit "the family, community, and others." Where Walsh runs into difficulty is in trying to balance feminist criticism with film scholarship. For example, in making a good case for Steinbeck's Ma Joad as the ultimate wartime image of a self-sacrificing mother, the author overlooks the contributions to that image made by the screenwriter, Nunnally Johnson. In discussing Greer Garson's role in MRS. MINIVER (1942), Walsh again omits the screenwriters' contributions (in this instance, James Hilton, George Froeschel, Claudine West, and Arthur Wimperis), and fails to note the difference between American movies dealing with domestic problems, and those movies dealing with the wartime domestic problems of our allies. Clearly there was a

difference between bombed-out communities and the American home front. In analyzing the feminist values in WATCH ON THE RHINE (1943), Walsh departs from her auteuristic praise of directors to praise the screenwriter (Lillian Hellman). Except for these types of reductionist slips, she provides an excellent summary of why the maternal melodrama appealed to women: e.g., its ability to mirror women's lot in wartime, the intriguing settings, and the crucial role that female bonding had in the stories. Also worth examining are her analyses of the films that represented significant variations on the sub-genre's themes: e.g., NOW, VOYAGER (1942), MILDRED PIERCE (1945), and TO EACH HIS OWN (1946). The chapter on career women comedies reviews how the twenties' heroines of the affluent flapper movies were replaced during the Depression with images of sacrificial mothers and downtrodden working women. Both such stereotypes were transformed into the "superwomen" of the forties. Among the films discussed are HIS GIRL FRIDAY (1940), WOMAN OF THE YEAR (1942), LADY IN THE DARK (1944), and ADAM'S RIB (1949). Walsh's conclusion is that although heterosexual monogamy remained the dominant value in mainstream movies, alternative models of marriage did emerge, and within the comic mode women were willing to experiment with non-traditional relationships. In the chapter dealing with madness, suspicion, and distrust in popular Hollywood movies of the forties, the author provides a fascinating analysis of the relationship between FILM NOIR traditions and the women's film. For example, she illustrates why "Don't trust your husband" movies like SUSPICION (1941), GASLIGHT (1944), and SLEEP MY LOVE (1948) appealed to women. In addition to providing a good summary of the classic plot, Walsh also offers a persuasive explanation of why 1940s audiences were intrigued with endless stories about victimized wives and potentially murderous husbands. What she fails to provide, however, is any useful discussion of how the studio system operated and who deserved credit for these productions of paranoid films. Taken together, these three chapters contain pertinent information on cultural hegemony and how it relates to feminist film criticism.

The final chapter skillfully summarizes the effects that the 1940s women's films had on American women in that era, as well as on main-currents and undercurrents in female consciousness. Walsh finds that in each of the three main subgenres the filmmakers were willing to tolerate female bonding and power as long as domesticity remained in the forefront of the film. Furthermore, she argues that Hollywood's women's films of the era fitted neatly into the context of American society during the decade. That is, polls taken during the 1940s reinforced the movies' dominant values relating to masculine and feminine attitudes of dominance and subordination. The book makes its greatest contribution in demonstrating that the 1940s were years in which feminine consciousness did experience a notable change in values. Adding to the book's value are three appendexes (charts on the marquee values of women film stars, the 1930 Production Code, and selected popular women's films of the 1940s), a brief filmography, a good bibliography, and a helpful index. Recommended for special collections.

Welsch, Janice R. FILM ARCHETYPES: SISTERS, MISTRESSES, MOTHERS AND DAUGHTERS. New York: Arno Press, 1978. 371pp.

Originally submitted as a Northwestern University doctoral dissertation in 1975, this interesting study examines the on-screen images of seven successful but diverse movie actresses in the post-World War II era: Doris Day, Debbie Reynolds, Marilyn Monroe, Kim Novak, Elizabeth Taylor, Audrey Hepburn, and Grace Kelly. Each in her own way symbolizes the film myths of women as sisters, virgins, mistresses, earth-mothers, vamps, and goddesses. What makes the actresses unique, for Welsch, is the manner in which they broke the Hollywood stereotypes of those mythical images. For example, Day's virginal image is traceable to the Mary Pickford tradition. While Reynolds shared many of Day's screen qualities, her good-natured athletic behavior differentiated her from the roles played by Day. Monroe epitomized the more sexually stimulating childlike heroine, who, in turn, created the demand for shapely blonde competitors like Novak. Taylor, on the other hand, shared the qualities of all the great movie heroines because her brilliant career spanned three decades and provided

many opportunities for her to change her screen persona. Only Hepburn and Kelly, however, symbolized the qualities of the "well-bred lady." But the author is more interested in exploring what the roles represented for the star system and the fifties than she is in identifying the stars' dominant traits. What intrigues her about the fifties is the opportunity to dissect the changes taking place in the star system as a result of the chaotic industry conditions. Not only did agents become more important than studio heads, but the phenomenal salaries they obtained for their clients created problems of incorporation, taxation, and appropriate film assignments. Welsch wisely limits her investigation to stars initially nurtured by the movie moguls during the heydays of the studios. She then examines what made it possible for these remarkable women to surmount the industry's traumatic problems and become independent superstars. "While the study," the author explains, "does not purport to be a justification or confirmation of feminist views, it does attempt to clarify the position of several women in the postwar society who achieved international recognition and extremely high financial rewards."

The book is divided into three very informative sections. We're told about numerous movies, provided with details about cast and characters, offered intriguing comparisons about film archetypes, and provoked by assertions that the stars benefited little from their studio and professional associations. Unfortunately, the least satisfying section is the first one, in which Welsch explains her methodology for analyzing star images. Searching for a systematic and empirical means for examining "the mythological and social impact of particular stars," she relies heavily on content analysis and AUTEURISM to decode the substructure and characteristics of the actresses' screen roles. It is one thing to identify career and role patterns in a specific film and then quantitatively to compare the data with the star's other roles and those of her peers. It is quite another to draw conclusions about psychological and social effects, when no substantive analysis is done of audience identification, collaborative creative efforts, studio politics, and economic and social constraints. Welsch's rationale that the work of Dorothy B. Jones establishes the precedent for using "the chronological and sociological age of the characters and their economic, social and marital status as well as their nationality, occupation and familial relationships" to arrive at perceptive film insights underscores her basic misunderstanding about content analysis. It is not a reliable technique for interpreting the complex relationship between film and society. It does not tell us anything important about how "messages" are sent or received by filmmakers or audiences. Furthermore, what makes one actress more memorable than another has less to do with quantitative analyses and more to do with the performer's personality, the input of her collaborators, the match between star and role, and her quality as an artist. Illustrative of Welsch's misuse of content analysis is her simplistic explanation of how audiences interact with studios. She points out that "refined audiences" played the key role in getting performers and film executives to reevaluate their attitudes about name players. That certainly was true in the teens, but it is questionable in the thirties and the forties. Without the studio publicity departments, many stars were overnight hasbeens. What's more, the author is analyzing a period in which stars were losing their "bankability" because they were independent entities.

Welsch is at her best when quantifying the relationships between the stars and their screen personae. In section two, dealing with "archetype as structure," she points out that the screen images of the seven stars are linked closely to male co-stars and romantic plot conventions. The result is a set of classifications matching the roles the women specialized in: e.g., sisters (Day and Reynolds); mistresses (Monroe and Novak), mothers (Taylor), and daughters (Kelly and Hepburn). These classifications also make clear how limited and distorting such classifications are for interpreting the appeal of an actress, let alone the range of her acting abilities. In section three, where the individual stars are given extensive evaluations, the author bombards the reader with many bits of information, ranging from the trivial to the perceptive. For example, Day's husband-manager, Martin Melcher, is credited with having the greatest influence on her career (one that has a much more unifying and discernible pattern than does Reynolds's). Although Monroe never reached the star status of

Day, Taylor, Reynolds, and Novak, she held fast to the notion that the public deserved the credit for making her a star. What made Novak distinct among this selection of stars is a propensity for playing women who are unhappy and die early. Taylor comes off as "more earthy than Monroe and Novak, more exotic and volatile than Day and Reynolds." Obviously, these judgments are the stuff that cocktail conversations and academic debates are made of. What makes Welsch's study highly readable is the organized and matter-of-fact way in which she presents her findings. Even her extensive plot summaries (often very boring) serve a useful, albeit unintentional, purpose in reminding us how important it is to analyze film as film and not as short story.

Overall, my reaction to this well-intentioned study is mixed. Having grown up in the era analyzed, I find the material both nostalgic and fascinating. While many of the generalizations seem obvious or insignificant, the study itself is fun to read. An appendix explaining the content analysis approach and a bibliography conclude the book. Worth browsing.

Wheeler, Helen. WOMANHOOD MEDIA: CURRENT RESOURCES ABOUT WOMEN. Metuchen: The Scarecrow Press, 1972. 335pp.

A practical reference book about feminism and the media, this annotated resource on print and non-print media materials offers a positive but limited accounting for educators interested in dealing with the women's movement in the early 1970s. Wheeler divides her work into six parts: a women's liberation awareness inventory, documentation for human equality, a basic book collection, non-book resources, a directory of resources, and five appendexes. The pioneering tone of the book is apparent in the opening awareness inventory. Using a simple question-and-answer format, Wheeler sets out to dramatize the need for feminist study in the schools. The purpose, she claims, is "to evaluate attitude and openmindedness." The follow up to the interesting exercise is a valuable discussion of more than 300 books useful for dealing with sexism in society. While time may have made some of the material out-dated and unavailable, the nature of the enterprise and the strong feelings expressed make the source material and information useful for anyone valuing a historical perspective on the initial approaches feminists used to begin examining the problem in the public schools. Well worth browsing.

Williams, Carol Traynor. THE DREAM BESIDE ME: THE MOVIES AND THE CHILDREN OF THE FORTIES. Rutherford: Fairleigh Dickinson University Press, 1980. 304pp.

Focusing primarily on the generation of Americans who grew up in the forties, the author makes a stimulating argument that a child's romantic myths and ideals gleaned from going to the movies not only remain with the person into adulthood, but also act as the basis for many contemporary problems and anxieties related to modern sexual relations. "More than movies before or after," Williams insists, "those of the war years seem now to have been more memorable and more influential, because they were a communal rite." To her, films represent "a social and not an aesthetic event." Four uneven and provocative chapters review the role of women in forties' films, the stars and movies that most affected an impressionable young woman's ideas and understanding of romance, the actresses who women modeled themselves after, and the important differences between the World War II and the postwar movie themes and images. Williams candidly recalls her psychological reactions to male stars and how she translated her film-going experiences into day-to-day relationships. But she does not rely exclusively on her memories. Instead, she makes extensive use of memoirs, psychoanalytic studies, film criticism, and sociological reports to bolster her assertions that the generation she was part of also had similar reactions to love, sex, and lust in films from GONE WITH THE WIND (1939) to PINKY (1949). Each chapter stresses catalog descriptions of characters, types, and themes that appeared in countless movies. While the author deserves credit for her details and research, she can be faulted for the dry and unsophisticated explanations of how films are conceived and produced. It's a case in which the subject overshadows objective and

critical discussion. She does offer useful endnotes, and the book concludes with an appendix listing the numerous stars that figure prominently in her discussions, as well as a valuable bibliography and index. Well worth browsing.

FILMS

A QUESTION OF SILENCE/DE STILTE ROND CHRISTINE M (Netherlands--VHS: 1982, 96 mins., b/w, sound, S-NEL)[239]

Directed and written by Marleen Gorris, this intriguing film looks at the emotional problems of three women: a middle-aged divorcee (Nelly Frijda), a housewife and mother (Edda Barends), and an unmarried secretary (Henriette Tol). The story of how they meet in a boutique, where the housewife, caught shoplifting, is suddenly aided by the other women and together kill the manager is secondary to the film's feminist argument that the problems of women result in their need for asserting themselves and for becoming more independent. In particular, the trial itself serves as an opportunity to demonstrate how men are incapable of understanding how women feel or behave. As Sheila Johnston observes, Gorris's cinematic technique is to make us remove our sympathies from the murdered man and toward that of the women: "Stylized through a deliberate, almost ritual execution, and a camera calmly intent on the slayers, not the slain, the killing is for Gorris a 'metaphorical act,' as consistent with the fictional logic of her film as (and, from a feminist perspective, rather more justifiable than) the punishment of a woman for her sexuality in the conventional male thriller."[240]

GIRLFRIENDS (Warner Bros--16mm: 1978, 88 mins., color, sound, R-SWA)

Claudia Weill, making her feature film directorial debut, explores the emotions of a newly graduated single female (Melanie Mayron) who works as a photographer for a New York rabbi. Together with her roommate (Weill), she tries to blend her artistic ambitions with her personal ups and downs. The screenplay by Vicki Polan (based on a story by Weill and Polan) dwells on the un-Hollywood characteristics of the two women--e.g., size 14s, with poor teeth and ugly glasses--and how irrelevant their physical attributes are to their good-natured humor, abiding friendship, and productive lives. As Christine Geraghty points out, the film stresses Mayron's "individuality, her quirkiness, her unconventionality, in order to make us feel that she is more 'real' than the heroines we are given."[241]

LUCIA (Cuba--16mm: 1972, 160 mins., b/w, sound with English subtitles, R-NYF, UNI; S-UNI)

[239] The film can be purchased in VHS format from Nelson Entertainment, 335 North Maple Drive, Suite 350, Beverly Hill, California 90210.

[240] Sheila Johnston, "DE STILTE ROND CHRISTINE M (A QUESTION OF SILENCE)," MONTHLY FILM BULLETIN 50:589 (February 1983):48.

[241] Christine Geraghty, "Three Women's Films," FILMS FOR WOMEN, ed. Charlotte Brunsdon (London: British Film Institute, 1986), p.140.

Directed by Humberto Solas, the intriguing story explores three Cuban women during different periods of their nation's turbulent history. One of the most unusual characteristics is the attention paid to the role of women during a social revolution. The cast includes strong performances by Raquel Revuelta and Eslinda Nunez.[242]

THE PLEASURE FACTOR

Establishing film as a form of popular culture operating in the mass media raises the issue of why individuals and groups prefer the films they do and what the variations are from person to person. Very little is known about this important but neglected area. For example, what role does "pleasure" perform in influencing audience tastes and reactions. Many people, as we have discussed earlier, assume that movies satisfy the public's need for wish-fulfilling fantasies.[243] But Constance Penley argues that "rather than fulfilling a role of giving cinematic PLEASURE or SATISFACTION . . . [the fantasmatization of the subject] represents an extreme form of cinema's possibilities for serving a DEFENSIVE function for the spectator/subject."[244] On the other hand, Laura Mulvey believes that the classic Hollywood production technique is a structuring of texts based upon our unconscious "ways of seeing and pleasure in looking."[245]

Given the importance of Mulvey's assertion in contemporary film study, we need to review her basic position. She emphasizes in her widely read essay that Hollywood traditionally relies on the stereotyped image of women in a patriarchy as a means of giving "order and meaning to the world."[246] She supports her thesis by pointing out how several of Freud's writings--e.g., THREE ESSAYS ON SEXUALITY (1905) and INSTINCTS AND THEIR VICISSITUDES (1915)--underscore the importance of "scopophilia" in our lives. Freud focused his attention on the pleasure children receive in looking at other people and in pregenital autoeroticism. What Hollywood did through film, Mulvey theorizes, is to assimilate Freud's theories of the fetish and to give the spectator the illusion of seeing into a private world.[247] In addition, the incorporation of Freud's theory also made woman a paradoxical symbol of a patriarchal society. On the one hand, she symbolized "the castrated male," thus reminding men of their vulnerability. On the other hand, her subordinate position in the film world confirmed her secondary status in society. In other words, the physical environment in which films are projected and viewed by mass audiences approximates a scopophiliac-like state in which film images represent reality rather than illusions. In producing movies, therefore, the emphasis is placed on getting the spectator to identify with similarities between himself or herself and the performer and on making the viewer's perspective identical to the camera's point of view. Unwittingly, the

[242] See *Joan Mellen, WOMEN AND THEIR SEXUALITY IN THE NEW FILM (New York: Horizon Press, 1973), pp.19-22.

[243] For a recent example of the pleasure factor in contemporary films, see Walter Goodman,"The Casino as a Movie Setting and Metaphor," NEW YORK TIMES C (January 16, 1989):13-4.

[244] Penley, p.16.

[245] Mulvey, p.414.

[246] Mulvey, p.412.

[247] Mulvey, pp.415-6.

spectator is drawn invisibly into the "seamless" film narrative, and he or she unconsciously assumes that what is seen is true to life.[248]

The challenge for spectators, therefore, is to break free of Hollywood's traditional voyeuristic narrative traditions.[249] But those traditions go beyond the birth of the cinema itself. As Mayne points out,

> It is through the conventions of the traditional cinema that most of us, critics and filmmakers included, have learned how to "watch" the movies. The conventions of the traditional cinema: These are, first and foremost, narrative conventions, the descendents, in some sense, of the narrative conventions of the novel. Or put another way, cinema combines narrative and spectacle, story-telling and display. Some of the particular problems and issues of women's cinema are worth considering against that background of a narrative tradition which for two centuries before the development of moving pictures was dominated by the novel.[250]

Her point is that any meaningful discussion about how film narratives shape subjectivity must take into account historical and literary precedents.

It is not enough to know, however, that feminist dissatisfaction with narrative conventions and their "preferred meanings" predate the birth of the moving picture. We still need to clarify, as Modleski argues, the false assumption that there is only one type of narrative pleasure and that it is essentially masculine. She correctly points out that women not only find pleasure in already existing narratives (e.g., soap operas and family melodramas), but also that they enjoy films in which "the illusion of unity and totality" is disrupted.[251] Gertrud Koch makes the argument that women often go to the movies "to indulge in the voyeurism that is otherwise denied to them."[252] But, as Koch explains, wanting something is not the same thing as achieving it. That is, women who use the darkened movie theater for their voyeuristic pleasure are still dependent primarily on mainstream films employing patriarchal perspectives related to traditional male-female roles. In addition, there is no guarantee, as discussed earlier, that a direct link exists between a film's preferred meaning and its reception by the spectator.

Lovell approaches the issue of pleasure in film from a different perspective. Rather than concerning himself with general questions about form, he explores the pleasure that a specific film, THE SEARCHERS (1956), offers an audience. This allows him the opportunity to anchor his general notions about the pleasure principle in concrete examples related to film genres and the star system. At the same time, he is able to examine matters related to narrative, narrative structure, character,

[248] For a more esoteric discussion, see Christian Metz, "The Imaginary Signifier," SCREEN 16:2 (Summer 1975):14-76.

[249] Many modern commentators point out that the medium of film is inextricably tied to pornography. For example, Stanley Cavell speculates that "the ontological conditions of the motion picture reveal it as inherently pornographic." Cf. *Stanley Cavell, THE WORLD VIEWED: REFLECTIONS ON THE ONTOLOGY OF FILM, Enlarged edition (Cambridge: Harvard University Press, 1979), p.45.

[250] Judith Mayne, "The Woman at the Keyhole: Women's Cinema and Feminist Criticism," NEW GERMAN CRITIQUE 23 (Spring-Summer 1981):29; Rpt. in RE-VISION, pp.49-66. All quotations cited in this chapter are from NEW GERMAN CRITIQUE.

[251] Modleski, pp.103-9.

[252] Gertrud Koch, "Why Women Go to the Movies," trans. Marc Silberman, JUMP CUT 27 (July 1982):51-3.

violence, eroticism, racism, community, costume, locations, and composition. In each instance, Lovell stresses that a discussion of formal questions related to film cannot be divorced from the film's entertainment value.[253] Gentile also points out that identification must not be tied to a specific gender. That is, if the filmmaker can force spectators to identify "across gender lines," then each of us can develop multiple perspectives and empathize with the myriad of problems facing a pluralistic society.[254]

Most film histories and biographies acknowledge the importance of pleasure as it relates to a film's commercial and artistic success. These books are filled with anecdotes and analyses of the ways in which stars are photographed to exploit audience expectations; the significance of the image (especially the female image) to the commercial success of the film narrative and the growth of Hollywood, and the importance of the viewer's ego and desires in merchandising film themes and in star-audience relationships. In Mulvey's words, "The conventions of mainstream film focus attention on the human form. Scale, space, stories are all anthropomorphic."[255] Although each commentary also reinforces our awareness of how different people react differently to the same film, theme, and characters, all the commentaries underscore the importance that mainstream filmmakers and audiences attach to narcissistic pleasure.

Particularly significant for feminists is the observation that a spectator can see the paradox in the classic Hollywood image of women as both pleasing and threatening. Stars like Greta Garbo, Marlene Dietrich, Bette Davis, Jean Harlow, Mae West, and Carole Lombard are singled out as examples of actresses who perfected the image of women who appeal to men's fantasies of romance and glamor but who are difficult to control, subordinate, or possess. Whether to satisfy the need for escapism or for enjoyment, Hollywood's "seamless narratives" emphasized not only the physical attributes of these screen goddesses, but also their passion and desires. Though each characterization might involve subtle differences--e.g., the aloofness of Garbo compared to the cunningness of Dietrich--the consistent emphasis was on the stars' mystical beauty. What the critical spectator can do, many feminist film critics insist, is re-view or re-read film texts like BLONDE VENUS (1932)[256] or CAMILLE (1936) in order to focus on the omissions or conflicts between what we're asked to admire and what we're asked to reject.

Analyses of how women function in films as objects and victims are not limited just to one historical period or one genre. Gerard Lenne, for example, offers an intriguing summary of how female characterizations throughout the history of horror films exploit the genre's emphasis on eroticism and sexuality.[257] Brandon French, Molly Haskell, Sumiko Higashi, E. Ann Kaplan, Marjorie Rosen, and other feminist film historians also chronicle the types of roles that indicate the duality of images contained within a specific film stereotype repeated endlessly in various film genres.

In applying the arguments used by Abrams, LeSage, and Walsh to our study of the relationship between pleasure and film, we need to consider at least two issues. On the one hand, we need to understand the underlying assumptions of stock film conventions and social types, as well as why erotic pleasure is derived from

[253] Lovell, pp.53-8.

[254] Gentile, p.79.

[255] Mulvey, p.416.

[256] For an example of how self-censorship worked at the studios and why re-viewing films is sensible, see Lea Jacobs, "The Censorship of BLONDE VENUS: Textual Analysis and Historical Method," CINEMA JOURNAL 27:3 (Spring 1988):21-31.

[257] Gerard Lenne, "Monster and Victim: Women in the Horror Film," SEXUAL STRATAGEMS: THE WORLD OF WOMEN IN FILM, pp.31-40.

narcissistic experiences. On the other hand, we need to recognize the way in which the "ideal female image" is oppressive. That is, why is it necessary for screen heroines to subordinate their independence and femininity to male desires and domination in order to be happy, to find security, and to be respected members of decent society? However, the danger in such sex-role analyses, particularly for feminist film criticism, is that they may define themselves only "as a study of the endless circulation of variable stereotypes of women in cinema and address . . . the issue of feminine difference as self-evident."[258]

Another danger is the false assumption that feminist film criticism relates only to older films. Contrary to what many periodicals proclaim as the new women's image in contemporary films, the classic Hollywood image of women as both object and victim remains alive and well. For example, Meryl Streep's portrayal of a tormented mother in KRAMER VS. KRAMER (1979) exemplifies the contemporary approach to the predictable Hollywood image of women. Rather than remain an ignored and frustrated wife, Streep abandons her family to seek her own identity. "Everyone profits from her action," Gentile points out, "except the wife herself, who sacrifices her son to her husband's new role as responsible father."[259]

What feminist film critics are urging spectators to do is not to give A PRIORI a right or wrong response to film conventions and social types. Rather, their strategy is to insist on our recognizing not only the limitations and consequences of a character's behavior and actions in relation to the alternatives that do exist in the "real world," but also on our remaining alert to the fact that often film endings are tacked on to satisfy motives external to the film. The point is to make viewers critical of the assumptions that the film makes about people, their roles in society, and the opportunities available to those viewers willing and able to challenge traditional values. At the very least, the strategy of multiple readings requires us to consider the possible effect of accepting the non-traditional aspects of female roles.

In this regard, feminist film critics like Marsha McCreadie claim that women who write about film are unique in the manner in which they use autobiographical allusions in analyzing the role and effect of movies in society. That some women do personalize in their film criticism is undeniable. Consider the case of the screenwriter, Joan Didion. In discussing Hollywood as a "mechanical monster," for example, she lapses into personal recollections of what she has seen on network television and the filmmakers she has met.[260] Didion also relates her own personal experiences when reviewing the characters in Woody Allen's ANNIE HALL (1977), INTERIORS (1978), and MANHATTAN (1979). For example, Tracy (played by Mariel Hemingway in MANHATTAN) reminds the critic of a movie executive who advised her, "by way of pointing out the absence of adult characters in AIP beach movies, . . . nobody ever paid $3.00 to see a parent."[261]

[258] Klinger, p.139.

[259] Gentile, p.65.

[260] Joan Didion, "I Can't Get That Monster Out of My Mind," THE AMERICAN SCHOLAR 33 (Autumn 1964):629-34. For more information on the writer, see Leslie Garis, "Didion & Dunne: The Rewards of a Literary Marriage," NEW YORK TIMES MAGAZINE (February 8, 1987), pp.18-24, 26, 52, 55, 58, 65.

[261] Joan Didion, "Letter From MANHATTAN," NEW YORK REVIEW OF BOOKS (August 16, 1979):18. This perspective reminds us that a producer's interests can subvert the integrity of a film narrative, render certain elements in the film irrelevant, and thus unwittingly add a further dimension to the film as a social document.

Obviously Didion is not the only example of how women personalize their reactions to films. What should be equally obvious is that many male critics do the same. For those who wish to pursue the matter further, Lauren Rabinowitz suggests reading the writings of James Agee, Robert Warshow, Stanley Cavell, Andrew Sarris, and Jonas Mekas.[262]

A unique paradox of the relationship between the notion of pleasure and the stereotyped ideal female image in film is that both are indispensable to the flow of the narrative and yet disruptive of plot development. This is because the female's visual presence[263] plays a central role in the story, while at the same time forcing us to reflect erotically on her beauty and glamor. Freezing the action to contemplate the image thus disrupts the narrative flow. There is, of course, no way to prove or to disprove this assumption, which depends on individual reactions to visual images. What is evident, however, is that it is unwise to assume that the average spectator is passive and naive and that a single point of view is predictable.

The issue over how women are positioned in films and the effect that positioning has on reception continues to play a central role in feminist film criticism. Mulvey's work in this area provides a good illustration. In reflecting on her celebrated article on visual pleasure, she reinforces the importance of Freud's Oedipus complex for film criticism and female positioning. Noting that her original essay had ignored both the issue of women in the audience and the nature of melodrama, the forthright critic points out that "the female spectator may find herself so out of key . . . [with the masculine point of view presented on screen], that the spell of fascination is broken."[264] But from her new vantage point, Mulvey has become interested more in what would occur if that spell were not broken and the female spectator enjoyed the "masculine" imagery.

In that case, she sees Freud's attitudes toward femininity and daydreaming as extremely relevant.[265] Anchored in the crucial stage of parallel sexual development, his terms describing femininity fail to provide girls with a separate identity. This obviously creates problems of language as well as limits to useful discussions about his interpretations of actions by young women. However, Freud's failure to

[262] Lauren Rabinowitz, "Book Review: WOMEN ON FILM: THE CRITICAL EYE," JOURNAL OF FILM AND VIDEO 36:1 (Winter 1984):63.

[263] Berger makes a strong argument (pp.45-6) that in our culture, a woman's social presence is perceived differently from that of a man. For example, the latter's stature is seen as directly proportional to the significance of a "promised power" in areas related to morality, bodily pursuits, temperament, economics, social relations, and sexuality. In each instance, a man's presence is judged by objects external to his person. On the other hand, a woman's presence is linked not only to her own self-esteem, but to "what can and cannot be done to her." She is perceived in terms intrinsic to her individuality: e.g., clothes, mannerisms, and taste.

[264] Laura Mulvey, "Afterthoughts on 'Visual Pleasure and Narrative Cinema' Inspired by DUEL IN THE SUN (King Vidor, 1946)," FRAMEWORK 15 (Summer 1981):12.

[265] For more information on Freud's theories, see Sigmund Freud, *THE INTERPRETATION OF DREAMS, trans. Dr. A. A. Brill (New York: The Modern Library, 1950). For a useful discussion of Freud and Lacan's theories on daydreaming and on their relationship to feminist film criticism, see Penley, pp.16-26. Also worth reading is Marc Vernet, "Freud: Effets Speciaux; Mise En Scene: U.S.A.," COMMUNICATIONS 23 (1975):223-34.

discriminate permits Mulvey to make valuable comparisons between the status of girls in Freud's terminology and the submissive role of women in society.[266]

More to the point, she insists that Hollywood narrative films, most notably westerns, produce patterns and character functions that tie in "closely with Freud's remarks on daydreaming."[267] That is, Freud speculates (some argue falsely) that the dreams of young women focus on erotic pleasures. That assumption is then translated into critical theories explaining the female interest in romance. Furthermore, Mulvey sees the popular cinema relying on "inherited traditions of story telling that are common to other forms of folk and mass culture, with attendant fascinations other than those of the 'look.'"[268]

To Mulvey, Vladimir Propp's study of character functions in primitive societies is also linked to popular films and to Freud's theories on daydreaming.[269] A prime example is the role of marriage in narrative closures evident both in primitive tales and in movie westerns. In such instances, the stereotyped image of the ideal woman is not only indispensable to the flow of the narrative, but also disruptive of plot development, because assertive (phallic) sexuality is identified with males and submissive (vaginal) sexuality with women. The result is that a "female spectator's phantasy of masculation . . . [is] always to some extent at cross purposes with itself, restless in transvestite clothes."[270] Whether one agrees with Mulvey's perspective on female positioning is not the central issue for our purposes. What is important here is that we remain open-minded about the multi-layered meanings possible in film narratives.

E. Ann Kaplan offers further evidence of the need for multiple interpretations in discussing the relationship between identification and pleasure in films, arguing that women particularly are drawn to film melodramas because they identify strongly with the objectification of women: "Our positioning as 'to-be-looked-at,' as object of the (male) gaze, has come to be sexually pleasurable." When male stars, for example, perceive women as sex objects, the preconditioned and uncritical female audience quite often identifies with the male star's fantasies and desires, as well as with what the object represents. Kaplan insists that it is commonplace to find spectators deriving pleasure from female characters who initially rebel against male dominance (e.g., CAMILLE, MILDRED PIERCE, and THE REVOLT OF MAMIE STOVER). The same spectators also feel no apparent discomfort with story resolutions that place the actress once more in a subordinate position dependent on a man's charity or strength. What Kaplan suggests as a remedy for pleasures clouding one's judgment vis-a-vis oppressive images is to investigate how psychoanalytic methodology can help us understand the socialization of women in patriarchy.[271]

The notion of scopophilia and male fantasies also continues to have a central role in contemporary film criticism. Mulvey points out that with the change in Hollywood's structure following the end of the 1950s, spectators no longer had to accept the distorted images of the mainstream cinema. Instead of giving in to our conditioned

[266] For another valuable perspective, see Shoshana Felman, "Rereading Femininity," YALE FRENCH STUDIES 62 (1981):19-44.

[267] "Afterthoughts," p.14.

[268] "Afterthoughts," p.13.

[269] For another useful perspective, see De Lauretis, pp.113-6, 118-21.

[270] "Afterthoughts," pp.14-5. For purposes of this chapter, the term "penis" denotes a part of the anatomy; the term "phallus," an aggregate psychic observation of the signifying object.

[271] WOMEN AND FILM, p.34.

curiosity and narcissistic impulses, we could now find alternative as well as more intelligent images in "feminist" films located outside the mainstream exhibition outlets (i.e., libraries, schools, conventions, and feminist distribution sources). Gentile argues that if "multiple gazing" could occur across genders, then the traditional scopophilic pleasure found in mainstream films "will be thrown into question."[272] The process is linked to a residual distrust in the world views created by film narratives. Once this premise is accepted, spectators can use the stock situations and social types as a means of deconstructing not one film, but the range of film experiences they have shared individually and collectively. In addition, Forsyth argues that much of radical criticism is concerned with illustrating various disruptions and inconsistencies in film narratives where the quasi-political values are in opposition to the resolution dictated by traditional narrative strategies.[273]

Those who attack films for the demeaning pleasure they provide mass audiences rely on the assertion that movies in general and Hollywood in particular are conditioned by the values of a patriarchal society. That is, the basic unit is the nuclear family presided over by a dictatorial patriarch. The woman's role is subordinate in that unit, and every representation of her role is designed to reinforce the benefits of being subservient. No matter what freedoms she loses in that relationship, the patriarchal filmmakers tell us, she nonetheless has enormous benefits. The role of film stereotypes is to depict those benefits and the dangers that derive from either accepting a subordinate role or challenging it. In particular, the concept of a male gaze is consciously or unconsciously adapted to place the spectator in the role of the enforcer of those patriarchal values. Almost every social institution conditions both men and women to feel at home with such perspectives. As feminist film critics have pointed out, it is extremely difficult to convince women that such a conditioning occurs. Despite evidence to the contrary, many female spectators see nothing upsetting in film formulas that define them on the object-victim level. The best that can be hoped for such feminine masochists is that their consciousness will be raised and that they will learn to "re-read" the films they once accepted as pleasurable. Whether one accepts or rejects the theory that pleasure, identification, and patriarchal values are crucial to understanding the role of movies as a social force in society depends upon one's values and attitudes.[274] What is nondebatable is that for many contemporary critics that theory is a valid and important means to evaluating film history and criticism.

In the pages that follow we shall discuss how the psychoanalytic theory of the "castrated woman" functions in film analysis. Suffice it to say that the male-dominated American film industry in the decades between the 1920s and the 1950s discovered (often intuitively) how scopophilia appealed to mass audiences and thus encoded the industry's patriarchal perspectives on female images in a stereotyped manner designed to maximize audience pleasure and to insure greater film profits. By investigating how cultural hegemony (the complex set of relationships that collectively reflect a nation's world view) operates in a particular time and place, we take advantage of an important means of discussing how popular culture operates as a social force in society.[275]

[272] Gentile, pp.79-80.

[273] Forsyth, p.33.

[274] For another point of view, see Lucie Arbuthnot and Gail Seneca, "Pre-Text and Text in GENTLEMEN PREFER BLONDES," FILM READER 5 (1982):13-23.

[275] For other theories of how movies play on audience desires, see Philip Anast, "Personality Determinants of Mass Media Preferences," JOURNALISM QUARTERLY 43:4 (Winter 1966):729-32; ___, "Differential Movie Appeals as Correlates of Attendance," ibid., 44:1 (Spring 1967):86-90; Patricia Baggett, "Structurally Equivalent Stories in Movie and Text and the Effect of the Medium on Recall,"

The relationship among Hollywood films, psychoanalytic theories, and mass audiences will be discussed in more detail later in this chapter. For now, it is valuable to point out two important aspects of the pleasure factor. First, the fact that the spectator can reinterpret in a significant way actions not originally intended in film narratives makes it clear that those who create films do not have the only or the final say in what the film and its stock situations and social types mean. Secondly, feminists believe that many women cannot help themselves when it comes to watching oppressive images, because the emotional aspects of pleasure are so strong. Thus, the alternative strategies proposed by feminists--e.g., intellectualizing pleasure, as well as watching AVANT-GARDE films and feminist documentaries--often don't appeal to large audiences, primarily because the dominant pleasure factor is not only missing, but also under attack. Except for already committed viewers, many spectators find feminist films boring and "shrill." Furthermore, if meaning is tied to the moment of reception, it becomes almost impossible to label a film "feminist" until after it has been viewed. Certainly, it cannot be determined A PRIORI by either knowing the filmmaker's gender or intentions. The challenge for feminists and other radical film critics, therefore, is to find a way in which their films both entertain and teach. It is also necessary, as Gentile explains, for feminist film critics to construct a strategy that does not rely on binary oppositions. Multiple possibilities, perspectives, and readings offer far more advantages for subordinate groups than do essentialist and reductionist theories.[276]

THE MULTIPLE ROLE OF MOVIES

One approach in assessing the multiple roles movies play in our society is to examine the historical context in which filmmakers have tried to satisfy audience tastes. The concerns involve more than stereotyped female images. For example, movie moguls throughout the first fifty years of film history claimed as one of their major talents the ability to know instinctively what mass audiences would and would not like.[277] The most oft-quoted example of this vain boast was Harry Cohn's notorious statement concerning his "foolproof device" for determining a film's box-office potential. "If my fanny squirms," said the head of Columbia Pictures in the golden years, "it's bad. If my fanny doesn't squirm, it's good. It's as simple as that."[278]

Fortunately for film scholars, we no longer have to compare our judgments with Harry's posterior acuity. Investigations into the nature of the public's film preferences continue to suggest that the mind and the heart more than the buttocks play the crucial role in film selection. For example, Boris W. Becker and his research team present "the notion that film preference is related to and based on a most

JOURNAL OF VERBAL LEARNING AND VERBAL BEHAVIOR 18:3 (June 1979):333-56; Fred Elkin, "The Psychological Appeal of the Hollywood Western," EDUCATIONAL SOCIOLOGY 24:1 (September 1950):72-87; Norman L. Friedman, "Some Sociological Notes on the Boom in Film Interest," YOUTH AND SOCIETY 2:3 (March 1971):323-32; and Edward Shils, "Daydreams and Nightmares: Reflections on the Criticism of Mass Culture," SEWANEE REVIEW 65:4 (1957):587-608.

[276] Gentile, p.19.

[277] For an interesting comparison between Hollywood moguls and film commissars, see Carol Flake, "Stranger in a Strange Land," AMERICAN FILM 11:3 (December 1985):40-6.

[278] Cited in *Bob Thomas, KING COHN: THE LIFE AND TIMES OF HARRY COHN (New York: G. P. Putnam's Sons, 1967), p.142.

fundamental determinant of a person's attitudes and behaviors--personal values."[279] Immediately relevant to our concerns are the distinctions that the Becker team makes between "values," "attitude," and "behavior." That is, "values may be conceived as global beliefs (about desirable modes of behavior and end-states) that underlie attitudinal and behavioral processes. Attitudes are cognitive and affective orientations toward specific objects and situations. Behavior, finally, is a manifestation of one's fundamental values and consequent attitudes."[280] If the Becker team theory is right, the theoretical and practical impact on producers and publicists should be considerable. Knowing what the dominant values in society are should directly affect what types of films are made and how they are marketed.

But neither the Becker team nor highly successful filmmakers really know what the audience prefers in advance of a film's release.[281] If they did, then modern heads of production would last longer at their jobs than they do. For every quasi-success story like that of Yoram Globus and Menaham Golan,[282] there are many more tales like those concerning Raphael Etkes and Steven Bach, who gambled big and lost.[283] "Frankly," explained Daniel Melnick (then studio boss at Columbia Pictures), "I think

[279] Boris W. Becker et al., "The Influence of Personal Values on Movie Preferences," CURRENT RESEARCH IN FILM: AUDIENCES, ECONOMICS, AND LAW, Volume 1, ed. Bruce A. Austin (Norwood: Ablex Publishing Corporation, 1985), p.37.

[280] Becker, p.38.

[281] Many Hollywood observers credit American filmmakers with considerable acuity in predicting box-office results. Raymond Durgnat speaks for many of them when he states, "American directors can calculate audience sympathies to the Nth decimal place, with a finesse which, given the cultural diversity of their audience, is far from inconsiderable classicism." See *Raymond Durgnat, DURGNAT ON FILM (London: Faber and Faber, 1976), p.28.

[282] Globus and Golan are Israeli cousins who in 1979 took over a "poverty-row" operation and turned it into an influential film company. The problem with such stories, however, is that they don't always have happy endings. For more information, see Sandra Salmans, "Cannon's Box-Office Respect," NEW YORK TIMES D (April 26, 1983):1, 5; Nicholas D. Kristof, "Cannon Seeks Respectability: Grudge Seen in Hollywood," ibid., D (January 21, 1986):1, 8.; "Warner's Financial Aid Helps Rescue Cannon," ibid., D (December 24, 1986):1, 12; Geraldine Fabrikant, "Cannon Loses Some Luster," ibid., D (January 26, 1987):1, 4; Therese L. Wells, "Cannon Faces New Copyright Charges," HOLLYWOOD REPORTER (August 7, 1987):1, 33; and William K. Knoedelseder, Jr., "Cannon Group Loses $9.9 Million in Quarter," LOS ANGELES TIMES (August 7, 1987):2. In addition, interested students might want to study the recent success of Vistar Films. For more information, see Geraldine Fabrikant, "Market Place: Dramatic Rise of Vistar Films," NEW YORK TIMES D (April 28, 1986):8.

[283] Bach was the senior vice president responsible for the worldwide production of HEAVEN'S GATE. When the film failed terribly at the box office, United Artists fired him. Bach was then replaced by Etkes, who months earlier had been fired from his job at Filmways Pictures. For more information, see Aljean Harmetz, "United Artists Executive Ousted After 'Heaven's Gate' Fiasco," NEW YORK TIMES C (May 1, 1981):26. For more details see Steven Bach, *FINAL CUT: DREAMS AND DISASTER IN THE MAKING OF "HEAVEN'S GATE" (New York: William Morrow, 1985). For those who mistakenly think that Hollywood learned its lesson on films going drastically overbudget, see Aljean Harmetz, "ISHTAR: A $51 Million Film Project in Trouble," NEW YORK TIMES C (May 19, 1987):17. For other examples of executive downfalls, see Aljean Harmetz, "Universal Pictures Aide Resigns Under Pressure," NEW YORK TIMES C (September 17, 1986):20; "Only In Hollywood," FORBES (November

most of the heads of production live in a constant state of panic."[284] Consider how
Alan Ladd, Jr., must have felt when he was production head at 20th Century-Fox.
His decision in 1977 to produce AT LONG LAST LOVE and LUCKY LADY proved
disastrous to the company's finances.[285] Then his gamble on STAR WARS paid off
and he allegedly received a million dollar bonus. Shortly thereafter, Ladd discovered
that he had made another financial mistake with DAMNATION ALLEY.[286]

Consider as well the case of Marvin Adelson and Lee Rich, chairman and
president, respectively, of Lorimar Productions.[287] Both men had made it big in
television with hit shows like DALLAS and THE WALTONS. They decided in 1977 to
try the movie business. During the next six years, Lorimar made over twenty films,
including BEING THERE (1979), THE POSTMAN ALWAYS RINGS TWICE and S. O.
B. (both in 1981), before the firm revised its policies. The reason was that spiraling
production costs and higher interest rates had Lorimar owing approximately 115 million
dollars. "Had Lorimar's movies been blockbusters," explained Sandra Salmans, "its
financing costs would have been acceptable. But few of the movies performed even
respectably at the box office. . . ."[288] Neither Ladd nor Lorimar Productions
disappeared from the film industry. They did, however, become more cautious.
Greater attention was paid to the way in which movies were packaged and promoted.
Lorimar, for example, focused more attention on low-budget pictures, ancillary
outlets, and television revenues in addition to box-office receipts.[289]

A second dimension to assessing the multiple roles movies play in our society
is that the people who become the executive stars of the film industry appear
compelled to gamble on almost anything except a radical change in film genres in order
to succeed. In their desperation to maintain their six-figure incomes and their
luxurious life-styles,[290] some industry leaders like Joseph M. Schenck and David

1, 1977):77; and *Hortense Powdermaker, HOLLYWOOD: THE DREAM FACTORY (Boston:
Little, Brown and Company, 1950), pp. 100-30.

[284] Leo Janos, "The Hollywood Game Grows Rich--and Desperate," NEW YORK TIMES 2
(February 12, 1978):15.

[285] AT LONG LAST LOVE also proved disastrous for the film's producer-director Francis
Ford Coppola, who pinned the survival of his Zoetrope Studios on the movie's
success. Cf. Ray Loynd, "'Heart' Survives Crisis: Zoetrope Delivers Paychecks,"
HOLLYWOOD REPORTER (February 11, 1981):1, 3; ___, "Zoetrope Up For Sale," ibid.,
(April 16, 1982):1, 4; and Aljean Harmetz, "Coppola, Heavily in Debt, Decides
to Sell Studio," NEW YORK TIMES C (April 16, 1982):11.

[286] Janos, p.1. See also Aljean Harmetz, "The Summer of Fox's Discontent," NEW YORK
TIMES 4 (August 3, 1979):3; and Andrew Neff, "Laddies' Fox Exit Won't Be
Prolonged," VARIETY (July 4, 1979):3.

[287] Lee Rich is today chairman of the board of United Artists.

[288] Sandra Salmans, "Lorimar's Retreat from Films," NEW YORK TIMES D (May 2, 1983):4.

[289] Salmans, p.4.

[290] Typical of the staggering salaries paid to top film executives was the 1981, 10
million dollar contract given to Columbia Pictures's chairperson Frank Price,
which guaranteed him, even if his judgment over a four-year period proved
completely wrong, "a minimum of 6 million dollars, plus 100,000 shares of
Columbia stock." 20th Century-Fox studio head Alan Ladd, Jr., earned close to 2
million dollars in 1978, thanks to a 1.5 percent profit-sharing clause in his
contract. Cf. Aljean Harmetz, "For Film Moguls, Salaries in Megabucks," NEW YORK
TIMES C (December 14, 1981):15. Another striking example is the earnings of

Begelman break the law.[291] They find themselves making illegal deals with gangsters or embezzling company funds.[292] On the other hand, there are major executives who have no qualms about producing films that offend traditional values in an attempt to gain immediate popularity and profits. A familiar example is the movie advertisement exploiting society's fascination with sex and violence.[293] But most filmmakers take countless precautions to reinforce dominant and residual values. That is not because they are good Samaritans. It just makes good sense to give the public tried and tested products rather than to risk millions of dollars on emerging values. To paraphrase Shakespeare, the staggering salary doth make cowards of them all. However, mass media alarmists attack the entire film industry and its annual outpouring of unique products as "unwholesome" and as a "threat to society."

This outpouring of abuse on the mass media reflects a change between the view of alarmists toward the popular arts in this century, and the view of alarmists in centuries past. Not until modern times have social critics considered the debate in absolute terms. Now, however, those who produce popular culture are perceived as being controlled absolutely by economic constraints. Critics, therefore, feel compelled to educate audiences to the alleged dangers of a mass art presumed to be intentionally preoccupied with preserving the STATUS QUO.

In her insightful study, Modleski summarizes the current debate over the nature of popular art. On the one hand, those who follow the asocial arguments against the popular arts (first initiated by members of the Frankfurt School) stress that "contempt for mass art [is] a politically progressive attitude." On the other hand, scholars like Fredric Jameson defend popular art by pointing out that (1) "high art . . . has not remained apart from the processes of the 'commodification of art'" and that (2) "mass culture performs a 'transformational work on (real) social and political anxieties and fantasies which must then have some effective presence in the mass cultural text in order subsequently to be "managed" or repressed.'"[294] Modleski takes the position that the popular arts function both as a stimulus and as a salve to our social anxieties, but she is unwilling to claim that the producers of mass art

Michael Eisner, the chairperson of the Walt Disney Company. In 1988, his salary, mostly made up of profits from his stock options, was 40.2 million dollars. See "$40.2 Million to Disney Chief," NEW YORK TIMES D (January 12, 1988):11. Powdermaker points out (p.35) that "The unusually high salaries are as important a control as the big profits. It is extremely difficult for the writer, the actor, the director, to do other than the bidding of the studio heads." For a helpful introduction to the brief reign of David Puttnam as studio head of Columbia Pictures, see Colin MacCabe, "Puttnam's New Mission," AMERICAN FILM 12:1 (October 1986):39-41, 43-5. Still further, one can get a sense of the studio head's professional quarters by reading Aljean Harmetz, "Star Role for Hollywood Offices," NEW YORK TIMES C (November 4, 1987):21.

[291] For more information, see Clifford G. Christians and Kim B. Rotzoll, "Ethical Issues in the Film Industry," CURRENT RESEARCH IN FILM: AUDIENCES, ECONOMICS, AND LAW, Volume 2, pp.225-37. For an analogous discussion on documentary filmmaking, see Calvin Pryluck, "Ultimately We Are All Outsiders: The Ethics of Documentary Filming," JOURNAL OF THE UNIVERSITY FILM ASSOCIATION 28:1 (Winter 1976):21-9.

[292] For information on Joseph Schenck, see Chapters 5 and 6. The Begelman case is covered in detail in David McClintick, *INDECENT EXPOSURE: A TRUE STORY OF HOLLYWOOD AND WALL STREET (New York: William Morrow and Company, 1982).

[293] Vincent Canby, "Reveling in Unembarrassed Trash," NEW YORK TIMES 2 (December 9, 1979):21, 24.

[294] Modleski, pp.26-7; Frederic Jameson, "Reedification and Utopia in Mass Culture," SOCIAL TEXT 1 (1979):130-48.

have any significant understanding of what they are producing or what effect their products will have on audiences. It is for this reason that she values the psychoanalytic approach in determining how ideology is produced in mass art.[295]

How we see the past and who controls our understanding of it are, as John Berger argues, no trivial matters. The debate clearly needs to take into account the multiple roles that the visual arts play in our society. At the very least, what we see is far more comprehensive than what we can explain. Historically, images became the means by which our ancestors could symbolize what was absent in their lives. Of particular importance, Berger explains, was the fact that

> Gradually it became evident that an image could outlast what it represented; it then showed how something or somebody had once looked--and thus by implication how the subject had once been seen by other people. Later still the specific vision of the image-maker was also recognized as part of the record.[296]

Up to the time of the Renaissance, how individuals interpreted what they saw remained largely an individual choice. But once art became commodified by experts, Berger claims it became "mystified" and an elite group of specialists began using art to justify "the role of the ruling classes." Those who would free art from such purposes, according to Berger, have a responsibility not only to demystify the process of viewing images, but also to sensitize the public to the uses that have been made of art by hegemonic social institutions. In Berger's words,

> The art of the past no longer exists as it once did. Its authority is lost. In its place there is a language of images. What matters now is who uses that language for what purpose, . . . A people or a class which is cut off from its own past is far less free to choose or act as a people or class than one that has been able to situate itself in history.[297]

One doesn't have to agree with all of Berger's premises to appreciate his argument that controlling how and what we see influences our values and behavior. In effect, it is just one more argument for emphasizing that popular culture is more than escapist entertainment and that remaining innocent about images is tantamount to being ignorant about how ideas are incorporated into our thought processes.

Another way to approach the multiple roles that movies play in our society and the issue of reception is through the theory that interpretation requires learned skills. That is, we need to acquire special skills before we are competent to decipher what films "mean." Here we are talking about the most rudimentary stages of interpretation--what a film represents--and not the more complex matters of messages, metaphors, or aesthetics. According to the research summarized by Paul Messaris, a number of tentative conclusions are possible. First, the evidence suggests that we can interpret "the content of most single shots." That is, most viewers, since the dawn of film, comment consistently about the "true-to-life" images on the screen.[298] Second, a number of studies indicate "that there is a continuum in the degree to which editing devices present an obstacle to interpretation and that the place of a particular

[295] Modleski, pp.28-31.

[296] *John Berger, WAYS OF SEEING: BASED ON THE BBC TELEVISION SERIES (London: British Broadcasting Corporation, 1972), p.10.

[297] Berger, p.33.

[298] Paul Messaris, "To What Extent Does One Have to Learn to Interpret Movies?" FILM/CULTURE, pp.171-2.

device on this continuum depends on the degree to which it combines images in a way similar to the possibilities of real-life visual experience."[299] Stated somewhat differently, the extent of one's viewing experience in regard to interpreting a film is related directly to the complexity of the editing device in the editing continuum. That is, a very experienced viewer will still have difficulty interpreting a film like LAST YEAR AT MARIENBAD/L'ANNEE DERNIERE A MARIENBAD (1961) because the editing techniques occur near the complex end of the editing continuum. On the other hand, an inexperienced viewer will have little difficulty interpreting GONE WITH THE WIND (1939), because the editing process is closer to the straightforward end of the editing continuum. In essence, Messaris argues that the key problems are related to breaks in space and time. The more the filmmaker violates "the inexperienced viewer's reality-based expectations of image flow," the more likely the viewer needs to acquire new skills for interpreting the film. Furthermore, visual perception does not depend upon the filmmaker's being absolutely accurate or detailed in the images presented to the audience.[300]

A third dimension to assessing the multiple roles movies play in our society is the question of evaluation. Filmmakers never fail to remember that "they are only as good as their last film." With no sure way of determining what makes a film a hit or flop, most producers, distributors, and exhibitors use the profit margin as the basis for judging a "good" or "bad" film. That is, PORKY'S (1981), BEVERLY HILLS COP (1984), and POLICE ACADEMY (1985) are "socko flicks." On the other hand, THE KILLING FIELDS, A PASSAGE TO INDIA, and AMADEUS (all in 1984) are "art" films with "poor legs."[301] Critics and social historians often take just the opposite point of view. Popularity and box-office receipts don't count much to them in evaluating a picture's worth to society.

In studying the medium as a social force, we should be careful about the criteria used in judging whether a film is "good" or "bad" according to sociological values. B. Ruby Rich's essay on Leni Riefenstahl illustrates the problem.[302] After first identifying the major dilemmas that film critics and historians have with TRIUMPH OF THE WILL/TRIUMPH DES WILLENS (1935)--e.g., (1) determining if the film is propaganda or documentary, and (2) deciding whether it is possible or accurate to separate art and politics--the author insists that the film remains true to the spirit and mythic stature of German Romanticism. No serious attempt is made to discuss the film's fascistic ideology or even to acknowledge the differences between Nazi filmmaking and alleged parallels in film history. In fact, Rich simplistically argues that "The sins of Riefenstahl in the realm of aesthetics are equally the sins of Hollywood, Moscow, China, India, Egypt, Europe, of everywhere in the world where the notion of representing reality is the basis for cinema and the aim of controlling audience response its foundation of ideology."[303] What Rich does not present, however, is any evidence to support her claim that Riefenstahl did record faithfully

[299] Messaris, p.175.

[300] Messaris, pp.180-1.

[301] According to the long-time successful Vermont film exhibitor Merrill Jarvis, the general rule for determining whether a film has "legs" (i.e., will have a long run), is as follows: if a film makes a hundred percent of its first week grosses the second week, it will be a "monster" (e.g., STAR WARS); if it makes seventy-five percent the second week, it will have "legs"; and if it makes only fifty-five percent of its grosses, it will not last very long in its initial run. Interview with Merrill Jarvis, May 30, 1985.

[302] B. Ruby Rich, "Leni Riefenstahl: The Deceptive Myth," SEXUAL STRATEGEMS: THE WORLD OF WOMEN IN FILM, pp.202-9.

[303] Rich, p.207.

the legends, myths, and beauty of German Romanticism. Other sources with far greater documentation, discussed in Chapter 2, offer contrary claims that Riefenstahl did indeed distort not only German myths, but also the spirit of the event. Furthermore, Rich offers no evidence either on the legitimacy of her superficial parallels drawn to film history or on how successfully TRIUMPH OF THE WILL/TRIUMPH DES WILLENS "controlled audience response." It becomes difficult, therefore, to accept Rich's sociological assertions. She might have been on firmer ground if she had applied the same stipulation to film that Northrop Frye makes about literature, namely, the responsibility for art's correct images depends upon the audience:

> There's no such thing as a morally bad novel: its moral effect depends entirely on the moral quality of the reader [viewer], and nobody can predict what that will be. And if literature isn't morally bad, it isn't morally good either.[304]

But we need to remember that while morality is within the audience, who need to be educated to the role they play in constructing meanings, there is a legitimate concern about the stereotyped images presented by the artists.

It is also not enough to say that literature is art and therefore not morally good or bad. "I certainly can't imagine art for art's sake," James Baldwin explained, ". . . that's a European approach which never made any sense to me."[305] Herbert Hill argues,

> For the serious writer [filmmaker] there must be a fundamental connection between artistic means, that is technique and discipline, with social and moral conviction, and a recognition of the significant relationship between individual freedom and social necessity, between form and content.[306]

Furthermore, as discussed earlier, we need a better understanding of the relationship between the public and its perceptions of reality if we are to better understand the multiple roles that movies play in society. E. H. Gombrich, for example, insists that we should never apply terms like "true" and "false" to works of art. In his words, films "are no more . . . true or false than a statement can be blue or green. Much confusion has been caused in aesthetics by disregarding this simple fact."[307] In other words, in deciding whether or not the film is a work of art or a successful commercial product, we should be clear about what we are evaluating: e.g., content, effect, aesthetic qualities, relationships with reality, or a film's role in film history.

We began this chapter, therefore, with an indication of the general role that American commercial feature films play in human communication. (Elsewhere, other scholars have identified how the films of other nations function in their societies.)[308] The initial emphasis was on showing that the relationship between filmmakers and their

[304] *Northrop Frye, THE EDUCATED IMAGINATION (Bloomington: Indiana University Press, 1964), p.80.

[305] Cited in Mel Watkins, "James Baldwin: Writing and Talking," NEW YORK TIMES BOOK REVIEW (September 23, 1979):36.

[306] Herbert Hill, "Introduction," ANGER AND BEYOND, Herbert Hill, ed. (New York: Harper & Row, 1966), p.xiv.

[307] E. H. Gombrich, ART AND ILLUSION (New York: Pantheon Books, 1960), pp.67-8.

[308] A good starting point is a group of British film studies. Ernest Betts, THE FILM BUSINESS: A HISTORY OF BRITISH CINEMA, 1896-1972 (New York: Pitman Publishing, 1973); *James Park, LEARNING TO DREAM: THE NEW BRITISH CINEMA (London: Faber and

audiences is complex. It is not simply a matter of profits, escapism, identification, or entertainment. As indicated earlier, commercial films provide an important commentary (or misperception) on how we live and the many possibilities open to us as individuals and as groups. At the same time, feminist, Marxist, and psychoanalytical film criticism are making clear the ways in which the social, political, and economic history of the film industry has resulted in a series of intolerable sexist and racist screen myths.

Our examination so far indicates that the more one investigates the film-viewing process, the clearer it becomes that multiple meanings are possible at the point of reception. In an attempt to expand our horizons, film scholars are drawing attention not only to acts of commission, but also to acts of omission. Both acts are linked to the role of ideology found in, and emanating from, film. Today's scholars want to know how past and present screen images relate to a text's internal contradictions. At the same time, they want to understand how these misperceptions evolved, how we formed the self-images we have, and how the mass media profited (and profits) by our need for an imaginary world to communicate our feelings and desires. Their second concern is with suggesting materials and strategies that should further film study in the area of visual literacy. To that end, this chapter now surveys the variety of research done on a number of related topics--e.g., the nature of stereotyping; the celebrity problem; the economic structure of the film industry; the makeup of film audiences; the screen images of women, blacks, and Jews; and the nature of film violence and censorship. The major concern, however, is with exploring film's frequent use of stereotypes and their multiple effects on the audience.

THE NATURE OF STEREOTYPING

Inquiry into the role of images in shaping values and policy is not new. Social critics--e.g., Plato, Aristotle, Augustine, Bacon, Emerson, Goethe, Montaigne, Darwin, Samuel Johnson, Kant, Kepler, Nietzsche, Pascal, Pope, De Tocqueville, Schopenhauer, Shakespeare, Shaw, Marx, Freud--have been concerned for centuries about the positive and negative effects of the arts on the public.

In the early 1900s, Walter Lippmann led the way in getting intellectuals to rethink their attitudes toward fiction and symbols in society's conduct of public affairs. The hub of Lippmann's analysis is that neither the framers of American democracy nor the English Guild socialists of the 1900s who criticized them ever confronted adequately the conflict between perceptions and reality. His basic premise was that as individuals we act "not on direct and certain knowledge, but on pictures made by . . . [ourselves] or given to . . . [us] ."[309] Those "pictures" of the world in which are determined our reactions to specific events are rarely based on truth or reality, yet we react just as forcefully to these pseudo-environments as to the real environments. In doing so, we make "fictions" just as important as reality. Lippmann defined "fictions," not as a pack of lies, but as the "representation of the environment which is in lesser or greater degree made by man himself."[310]

Faber, 1984); Jeffrey Richards, THE AGE OF THE DREAM PALACE: CINEMA AND SOCIETY 1930-1939 (London: Routledge & Kegan Paul, 1954); and Jeffrey Richards and Anthony Aldgate, BRITISH CINEMA AND SOCIETY, 1930-1970 (Ottawa: Barnes and Noble Books, 1983). For a helpful European overview, see MOVIES AND SOCIETY, pp.56-61.

[309] *Walter Lippmann, PUBLIC OPINION (New York: Macmillan Company, 1921; New York: Macmillan Company, 1957; *New York: Macmillan Company, 1965), p.24. For other examples of how Lippmann's ideas apply to film criticism and history, see the discussion on propaganda in Chapter 2 and the sections on silent German films and Italian Facist films in Chapter 7.

[310] Lippmann, p.13.

While it is true that fictions in and of themselves are not dangerous as long as the public understands the degree of fidelity the fictions possess (a point argued brilliantly by Lippmann's film disciple John Grierson), the perceptive intellectual realized that the world and the responsibilities we face as citizens had by 1919 become too complex, too large, and too ephemeral to be manageable by traditional, self-contained methods of decision-making. Society no longer possessed the ability to understand and grasp events outside its direct experience. "The only feeling that anyone can have about an event he does not experience," explained Lippmann, "is the feeling aroused by his mental image of the event."[311] In large part, "mental pictures" formed in the early 1900s were supplied by mass circulation newspapers, periodicals, and motion pictures. The result was that in the twentieth century the public, inundated with the rush of news and the necessity for quick decisions, had become in many cases incompetent to deal with the world in which it operated. Making matters more troublesome was the fact that given certain conditions--e.g., the imperfect nature of mass communication, our private fears and prejudices, ignorance, turmoil, boredom, and indifference--and given the complexity of the issues and the effort by special interest groups to deceive us, the public helps "create the very fictions to which they respond."[312] The remedy for this intolerable situation, reasoned Lippmann, was to have the public understand the relationship between the event itself, the mental image of that event, "and the human response to that picture working itself out upon the scene of action."[313]

In his seminal work on the manipulation of public opinion, Lippmann explores why our mental images often mislead us in our dealings with the external world. He discusses how difficult it is for us to get the facts about events because of basic factors like censorship, fragmented social contact, the pressure of day-to-day events keeping us from becoming seriously involved in public issues, the abridged manner in which news is reported, the limitations of language in conveying the complexities of the information communicated, and the reluctance many of us have in dealing with issues contrary to our self-interests. His next step was to focus attention on the manner in which our prejudices and mental images interpret and react to the messages we do receive. The result, as Lippmann describes it, is to form "a pattern of stereotypes" that conforms to our special desires and interests.

Of special interest to serious students of visual literacy is his section on "Stereotyping."[314] Noting that "The facts we see depend on where we are placed, and the habits of our eyes. . . ." Lippmann points out that "For the most part we do not first see, and then define, we define first and then see."[315] That is, our culture creates our stereotypes--preconceived perceptions that determine the character of what we transmit through the senses to our intellect--thus making it difficult to understand the behavior of other nationalities until we first understand the refracted process by which we gain our information about other people. This process has special significance for films as Lippmann explains,

> Photographs have the kind of authority over imagination to-day [sic], which the printed word had yesterday, and the spoken word before that. They come, we imagine, directly to us without meddling, and they are the most effortless

[311] Lippmann, p.13

[312] Lippmann, p.14.

[313] Lippmann, p.17.

[314] For a summary of the research that disagrees with Lippmann's notion that stereotypes are factually incorrect, see Thomas, pp.200-1.

[315] Lippmann, pp.80-1.

food for the mind conceivable. Any description in words, or even any inert picture, requires an effort of memory before a picture exists in the mind. But on the screen the whole process of observing, describing, reporting, and then imagining has been accomplished for you. Without more trouble than is needed to stay awake the result which your imagination is always aiming at is reeled off on the screen.[316]

If this is true, our viewing habits are based upon selective exposure.[317] That is, we generally choose what we wish to see. On the other hand, what we do not want to see, we consciously avoid; this is what is meant by cognitive dissonance.[318]

Obviously, this oversimplified explanation only skims the surface of the selective perception phenomenon. For example, communication scholars in the seventies discovered that one of the assumptions about selective exposure--that it reinforces previously held views--is not true in all cases. According to David L. Paletz and his colleagues, selective exposure can have a "boomerang effect." That is, an individual's expectations, when violated by the content screened, can weaken his or her position rather than strengthen it.[319] On the other hand, Walsh points out that popular culture can create a "sleeper effect." In this instance, the effect of a popular culture experience can only be seen months or years after the event occurred.[320]

In this connection, it is important to stress again that stereotypes are not neutral. They are highly charged, emotional operatives that provide us with a sense of security and with attitudes directly related to our behavior. In essence, the pattern of stereotypes unconsciously assimilated by individuals and cultures operates as their main line of defense (or helplessness) in dealing with interpersonal relationships and public issues. Furthermore, there is no way of determining what the long-term effects of constant exposure to a stock situation and/or social type will have on individuals or groups.

It is clear that politically motivated media merchants can use stereotypes to attack opposed values.[321] Thanks to Gerbner's analysis of media tactics of resistance to change, we can identify three specific ideological methods. The first is the technique of "discrediting" a conflicting social and political movement by highlighting

[316] Lippmann, p.92.

[317] Charles R. Wright, *MASS COMMUNICATIONS (New York: Random House, 1959), pp.73-4. In brief, selective exposure relates to the process by which the mind organizes, structures, and provides meaning to our everyday experiences. By actively selecting what we see, the mind predetermines and filters our perceptions of the world. Thus selective exposure argues against the theory of the passive viewer helplessly being assaulted by the messages of the media. It argues, instead, for an image of alert individuals choosing and interpreting what they will and will not accept as credible. It also explains how individual prejudices screen out conflicting points of view.

[318] For a more detailed discussion, see Jack W. Brehm and Arthur Cohen, EXPLORATIONS IN COGNITIVE DISSONANCE (New York: John Wiley and Sons, 1962); *Leon Festinger, A THEORY OF COGNITIVE DISSONANCE (Evanston: Row, Peterson and Company, 1957); and Gary Schulman, THE TWO-STEP FLOW HYPOTHESIS OF MASS COMMUNICATION: A REFORMULATION USING COGNITIVE DISSONANCE THEORY (Unpublished Ph.D. dissertation, Stanford University, 1965).

[319] David L. Paletz et al., "Selective Exposure: The Potential Boomerang Effect," JOURNAL OF COMMUNICATION 22:1 (March 1972):48-53.

[320] Walsh, p.14.

[321] Gerbner, p.48.

its more bizarre characteristics. For example, in a November, 1985, episode of the CBS series CAGNEY AND LACEY, the liberal-minded producers attacked the motives of an anti-abortion group by focusing on the psychotic behavior of one of the group's members. Not only was she portrayed as a fanatic, but her anti-social behavior resulted in the death of an innocent party.

The second technique of politically motivated media merchants is "isolating" a positive aspect of the opposing group and giving it special status. For example, in the aforementioned CAGNEY AND LACEY episode, the anti-abortion leader aids the police in their investigation. She is depicted as favorably disposed to law and order. She believes her views against abortion are in the American tradition of free speech. This approach permits the media merchants to pass themselves off as fair-minded and even-handed in dealing with sensitive issues. But the third tactic of this ideological strategy is "undercutting." By demonstrating that the "isolated" positive trait can lead unintentionally to violence and murder, the producers of CAGNEY AND LACEY terrorize their mass audience into believing that anti-abortion groups can pose a danger to everyone's welfare. Whether one is for or against abortion is not the issue here. What is relevant is how politically motivated media experts can exploit contemporary issues for profit and ideological benefits.

Another dimension of the stereotype problem is offered by Donald Horton and R. Richard Wohl. In their view, the stage is set for misinterpretations when audiences and performers give each other the false impression that they have a meaningful relationship, a "para-social relationship." As Horton and Wohl explain,

> One of the striking characteristics of the new mass media--radio, television, and the movies--is that they give the illusion of face-to-face relationships with the performer. The conditions of response to the performer are analogous to those in the primary group. The most remote and illustrious men are met as IF they were in the circle of one's peers; the same is true of a character in a story who comes to life in these media in an especially vivid and arresting way.[322]

Emphasizing TV talk show personalities as their model, the University of Chicago scholars explain how audiences frequently are lulled into believing that they are interacting with prominent people.[323] The TV talk show host, aided by clever camera work and studio sets, fine-tunes his/her performance to the assumed reactions of the viewing audience as well as to the responses of spectators who are physically present in the television studio. The illusion, created in a subtle, matter-of-fact, and relaxed manner, minimizes the fact that the "para-social interaction" taking place "is

[322] Donald Horton and R. Richard Wohl, "Mass Communication and Para-Social Interaction: Observations on Intimacy at a Distance," PSYCHIATRY 19 (1956):215.

[323] Phil Donahue is one talk show host who illustrates the process. By virtue of his continuing success, explains Frank P. Tomasulo, Donahue presents "a persona which represents him as a rational, though sympathetic, father figure." But the DONAHUE show is neither neutral nor participatory; the "spectators remain passive receivers of disguised rhetoric who, in contradistinction to Donahue's stable personality as the father, end up weak, powerless, and decentered." See Frank P. Tomasulo, "Donahue: Spectator Positioning in the Talk Show Genre," A Paper Presented at the 1983 Conference at the Society for Cinema Studies, University of Pittsburgh, May 4, 1983. For another example of how TV shows produce audience identification with TV personalities, see Patricia Leigh Brown, "Where America Feels at Home: The Sitcom Living Room," NEW YORK TIMES C (January 29, 1987):1, 6.

one-sided, non-dialectical, controlled by the performer, and not susceptible of mutual development."[324] Although there are options open to the viewers--e.g., turning their TV sets to another channel--those who continue to watch the program participate in para-social interaction. The effect, however brief in duration, creates a confusion between reality and fiction. At the same time, these TV talk shows provide a platform for celebrities to discuss matters outside their range of expertise. What most alarms cultural critics is the presumption that the viewing audiences, failing to see the blurring of boundaries between fiction and reality, develop more respect for the opinions of the personalities than for those of recognized authorities.

Relating para-social interaction to film images becomes easy once we recognize that the film industry is interested in selling a product. Therefore, it tries to blur the distinction between reality and fiction by anticipating what audiences will want to see and what they will avoid. Such determinations are based not only on sex, race, religion, age, and social status, but also on the mood of the audience at a particular time in history. In essence, the product depends heavily on box-office approval. When the industry discovers a successful stereotype, it continues to use that image as long as the public accepts it. Besides affecting the types of films produced, as well as their content, this repetitive method conditions many members of the audience to accept stereotypes as reality. For example, Gerbner insists that stereotypes operate as "projective devices" that make it easier for mass audiences to deal with other members of society. He sees stereotypes being used especially for new and deviant groups, thereby providing "the social function of coping with threats, for it justifies both dismissing and brutalizing these groups."[325] The threat to our society is apparent once we grasp how much of what we do not know first-hand is transmitted to us by the mass media in general and films in particular. One need only recall that every year published statistics tell us that the "average American household" watches seven hours of television a day.[326] Much of this viewing is related to films first popularized by film exhibitors.[327] And there is no doubt that a large number of Americans often go to the movie theaters and frequently rent videocassettes.

Interpreted by some social critics as an unhealthy reliance on the melodramatic and the sensational for our cultural nutrition, the viewing habits of the public result in a frustrating situation where prejudice and distortion may take the place of

[324] Horton and Wohl, p.215.

[325] Gerbner, p.49.

[326] According to the Television Bureau of Advertising, "Average daily television reached an all-time high in 1985 of 7 hours, ten minutes per household. . . ." For more information, see "Small Rise in TV Viewing Reported," NEW YORK TIMES C (February 4, 1986):16. In addition, Gerbner and a number of other communication scholars point out that the emergence of videocassette recorders and an increase in TV viewing opportunities have resulted in a significant change in how viewers react to the medium. For example, there is an increase in viewing hours, more switching from channel to channel, and an increase in action-oriented programs. For more information, see Sally Bedell Smith, "New TV Technologies Alter Viewing Habits," NEW YORK TIMES C (October 9, 1985):22. Cassettes are also having an impact on the profits normally associated with winning an Oscar. For more information, see Aljean Harmetz, "Cassettes Imperil Post-Oscar Profits," NEW YORK TIMES C (January 28, 1986):13. See also Aljean Harmetz, "The Expensive Manipulations Behind the Oscar Nominations," NEW YORK TIMES C (March 30, 1989):17.

[327] Ryland A. Taylor presents a useful explanation on the viewer demand for movies on television and how it impacts on TV programming. See Ryland A. Taylor, "The Repeat Audience for Movies on TV," JOURNAL OF BROADCASTING 17:1 (Winter 1972-1973):95-100.

accuracy and reality in forming the attitudes and values that stimulate our actions and behavior.[328] Few people will debate the issue that the mass media have an impact on viewers. In fact, Robert Warshaw insists that "every production of mass culture is a public act and must conform with accepted notions of the public good. Nobody seriously questions the principle that it is the function of mass culture to maintain public morale, and certainly nobody in the mass audience objects to having his morale maintained."[329] The reliability of the different positions in that debate centers on quantifiable data that prove why, how, and to what degree such assumptions about positive or negative effects are verifiable.

It is not pertinent to our concerns here to debate whether Lippmann's solution to this dilemma--i.e., the creation of an "independent expert organization" to select, organize, and present unseen facts to decision makers--is reasonable or possible.[330] Much has changed in the media--e.g., the emergence of sound films, radio, television, computers, and videocassette recorders--since PUBLIC OPINION was first published in 1921. In addition, considerable research has been conducted on the nature and influence of propaganda in our society, as well as on developing a better understanding of stereotyping and its effects. Among more recent discoveries, as discussed earlier, is the fact that viewers do not react passively to what they see. Nevertheless, Lippmann's shrewd examination of a simpler age still offers us a foundation for understanding the basics of our cultural stereotypes and for the problems they present to responsible citizens.

Another influential modern utopian thinker on this topic is Daniel J. Boorstin. In his best-selling book THE IMAGE, OR, WHAT HAPPENED TO THE AMERICAN DREAM?, Boorstin asserts that people continually substitute images of reality for almost every feature of American life. They do so consciously and with the help and encouragement of well-meaning but misguided citizens. Unlike the propagandists discussed in our last chapter, the contemporary image-makers dealing with artificial substitutes, according to Boorstin, produce the exact opposite of propaganda. That

[328] For examples of studies relating to this issue, see Stanley J. Baran, "How TV and Film Portrayals Affect Sexual Satisfaction in College Students," JOURNALISM QUARTERLY 53:3 (Autumn 1976):468-73; William A. Fisher and Donn Byrne, "Individual Differences in Affective, Evaluative, and Behavorial Responses to an Erotic Film," JOURNAL OF APPLIED SOCIAL PSYCHOLOGY 8:4 (1978):355-65; Ralph Gundlach, "The Movies: Stereotypes or Realities?", JOURNAL OF SOCIAL ISSUES 3:3 (1947):26-32; Gerald H. Heisler, "The Effects of Vicariously Experiencing Supernatural-Violent Events: A Case Study of THE EXORCIST's Impact," JOURNAL OF INDIVIDUAL PSYCHOLOGY 31:2 (November 1975):158-70; Russell Middleton, "Ethnic Prejudice and Susceptibility to Persuasion," AMERICAN SOCIOLOGICAL REVIEW 25:5 (October 1960):679-86; Patricia Schiller, "Effects of Mass Media on the Sexual Behavior of Adolescent Females," TECHNICAL REPORTS OF THE US COMMISSION ON OBSCENITY AND PORNOGRAPHY I (Washington, D.C.: US Government Printing Office, 1970), pp.191-95; John E. Teahan and Edward C. Podany, "Some Effects of Films of Successful Blacks on Racial Self-Concept," INTERNATIONAL JOURNAL OF SOCIAL PSYCHIATRY 20 (Autumn/Winter 1974):274-80; Joe Vincenzo et al., "The Relationship Between Religious Beliefs and Attending the Fear-Provoking Religiously Oriented Movie--THE EXORCIST," OMEGA 7:2 (1976):137-43; and Stephen Worchel, "The Effects of Films on the Importance of Behavioral Freedom," JOURNAL OF PERSONALITY 40:3 (September 1972):417-33.

[329] Warshaw, pp.83-4.

[330] John Dewey, for example, disliked the notion that a corpus of experts should solve problems for the public. "The enlightenment of public opinion still seems to me," he wrote (p.288) in a review of PUBLIC OPINION for the NEW REPUBLIC (May 3, 1922), "to have priority over the enlightenment of officials and directors."

is, they produce "an ambiguous truth," unlike propagandists who offer "an appealing falsehood." The image-makers' "pseudo-events"--i.e., "synthetic novelties"--are patriotic in nature, "thrive on our honest desire to be informed, to have 'all the facts,' and even to have more facts than there really are." Put another way, "Propaganda oversimplifies experience, pseudo-events overcomplicate it."[331]

Interestingly, Boorstin singles out the movies as the most important worldwide influence not only on how Americans are perceived by other nations, but also on how we see the world.[332] For example, he believes that Americans in the 1950s mainly pictured Rome as the setting of the hit movie ROMAN HOLIDAY (1953). They visited the eternal city primarily as an excuse to see the settings where popular films like BEN HUR (1959) and SPARTACUS (1960) were shot.[333] At the core of the film industry's negative influence, according to Boorstin, is its ability to transform ordinary people into famous personalities. Where once greatness required admirable qualities, the modern equivalent is being well-known. Thus movie personalities frequently take on a greater significance than the personalities they portray on the screen. In contemporary terms, that would mean that George C. Scott overshadows Patton, Ben Kingsley overshadows Gandhi, Thomas Hulce overshadows Mozart, and Vanessa Redgrave overshadows Fania Fenelon. In short, the noted historian believes that ". . . we have filled our world with artificial fame."[334]

No one who lived through the marriage of Grace Kelly to Prince Rainier doubts that such an influence existed in the 1950s. Bernard Rosenberg and David Manning White observed that more correspondents covered that event than reported the Normandy invasion of June 6, 1944.[335] Rosenberg and White go on to say that "It is probably true that the 'average' American's knowledge about the lives, loves and neuroses of the demi-gods and goddesses who live in the Olympian heights of Beverly Hills far surpasses his knowledge of current affairs (local, state and national combined.)"[336]

However, Boorstin's thesis has many flaws, not the least of which is the lack of historical justification for many of his exaggerated claims. Nor for that matter should one assume that only Americans suffer from the celebrity syndrome. As Alistair Cooke once noted, "The survival of the British Empire depended more upon Sir C. Aubrey Smith than upon Neville Chamberlain or Winston Churchill."[337] This is not the place to dispute Boorstin's understanding of film or society.[338] For our present purposes, we need to understand that his perceptions are shared by many advocates

[331] *Daniel J. Boorstin, THE IMAGE: A GUIDE TO PSEUDO-EVENTS IN AMERICA (New York: Atheneum, 1978), pp.34-5. Originally published in 1961 as THE IMAGE, OR, WHAT HAPPENED TO THE AMERICAN DREAM?

[332] Boorstin, p.241.

[333] Boorstin, p.107.

[334] Boorstin, p.47.

[335] Rosenberg and White, p.254.

[336] Rosenberg and White, p.254.

[337] Cited in Andrew Sarris, "The Myth of Old Movies: An Interpretation of Dreams," HARPER'S 251:1504 (September 1975):39.

[338] For critiques of Boorstin's book, see "Utopia 'Tis of Thee," TIMES LITERARY SUPPLEMENT (April 20, 1962):257-8; Martin Mayer, "Wanted: More Events, More Heroes," NEW YORK TIMES BOOK REVIEW (April 8, 1962):4; Morse Peckham, "Book Review: THE IMAGE, OR WHAT HAPPENED TO THE AMERICAN DREAM," THE ANNALS OF THE AMERICAN ACADEMY OF POLITICAL AND SOCIAL SCIENCE 344 (November 1962):183; and

of high culture. Just as elitists should not dismiss popular culture, we should not ignore the arguments put forth by prominent social historians and critics.[339]

The problem is exemplified by the February 10, 1985, edition of the Sunday NEW YORK TIMES. On the front page of the Arts and Leisure section was the headline, "India Is on Our Minds, But Whose India?" The article, by the TIMES's former correspondent to India, William Borders, concerned our understanding of India as derived from David Lean's 1984 screen adaptation of E. M. Forster's novel, A PASSAGE TO INDIA, Richard Attenborough's 1982 Oscar-winning film GANDHI,[340] the Ismail Merchant-James Ivory 1983 film version of Ruth Prawer Jhabvala's novel, HEAT AND DUST, Satyajit Ray's 1985 film treatment of Rabindranath Tagore's novel, THE HOME AND THE WORLD, Home Box Office's sumptuous 1984 TV version of the novelist, M. M. Kaye's THE FAR PAVILIONS, and the heralded 1984 Granada TV adaptation of Paul Scott's RAJ QUARTET, THE JEWEL IN THE CROWN. In particular, Borders questioned what we really knew about the "complex love-hate relationship that existed--and still exists--between the English and the Indians."[341] He worried about the sharp contrast between what Americans see on their screens and what they read in the headlines concerning the October, 1984, assassination of Indira Gandhi and the shocking news concerning the horrendous January, 1985, Bhopal disaster in which 2,000 Indians were gassed to death.

Clearly, the image projected on TV and in the movies was far from complete. On the positive side was the long overdue recognition that the British Empire did not symbolize nobility and greatness. On the negative side was the false impression that the long, bitter years of British imperialism in India ended on an uplifting old boys' agreement of good fellowship. Borders quotes K. Shankar Bajpai, India's ambassador to Washington, as commenting on the Lean film and on the Granada series as reflecting "an understandable nostalgia for Britain's lost glories, but they do not have much to do with India."[342] Borders's point is that these fictional works are trying to romanticize the declining fortunes of England in the modern-day world. Like Boorstin, the author notes how America's love for "dazzling spectacles," "pageantry," and sexual intrigue permits image-makers to substitute artificiality for reality.

On the same front page is John Corry's disturbing article on the February, 1985, CBS mini-series dealing with the Wayne Williams murder case.[343] Convicted in 1982 of killing two black adults, Williams was also presumed guilty of murdering a total of twenty-three people. As a result, the Atlanta police closed their files on these other cases. The CBS docu-drama dangerously skirts the line between fact and fiction in reconstructing the events that led up to the trial as well as the courtroom drama

D. W. Brogan, "THE IMAGE, OR, WHAT HAPPENED TO THE AMERICAN DREAM?" SATURDAY REVIEW 45:10 (March 10, 1962):37.

[339] For a sample of the debate, see D. W. Brogan, "The Problem of High Culture and Mass Culture," DIOGENES 5 (1954):1-13; and Bernard Rosenberg, "Mass Culture Revisited," MASS CULTURE REVISITED, ed. Bernard Rosenberg and David Manning White (Cincinnati: Van Nostrand Reinhold Company, 1971), pp.6-8.

[340] For a general article on the director's career, see Louise Tanner, "Sir Richard Attenborough," FILMS IN REVIEW 37:1 (January 1986):25-9.

[341] William Borders, "India Is on Our Minds, But Whose India?" NEW YORK TIMES 2 (February 10, 1985):1. For a contrasting perspective, see John Corry, "Pageantry Colors a Historical Perspective," ibid., 2 (January 26, 1986):29, 38.

[342] Borders, p.27.

[343] John Corry, "'The Atlanta Child Murders': A Trial by TV," ibid., pp.1, 29.

itself. "We are meant," the noted TV critic tells us, "to weigh evidence and then pass judgment, not minding that television has passed judgment for us."[344]

Again, like Boorstin, the author implies that film celebrities overshadow real-life personalities. That is, Jason Robards, Jr., overshadows the defense attorney, Alvin Binder; Rip Torn overshadows prosecuting attorney, Lewis Slaton, Ruby Dee overshadows Williams's mother, and Calvin Levels overshadows Williams. Corry justly praises the performers, but points out that "Fact has run a battle with fancy, and fancy seems to have won."[345] In an attempt at fairness, the TIMES ran another story on the series in its Television section, where Robert Lindsey interviewed the mini-series producer, David Wolper.[346] In the end, however, the TIMES felt compelled to print an editorial in the News section in which it blasted the program by stating, "Does no one in charge of television care enough about either news or fiction to halt this corruption?"[347]

In judging the relationship between film and its audience, the evaluations should depend not on how well the movies satisfy the goals of cultural traditionalists, but rather on how effectively the film industry--e.g., producers, distributors, and exhibitors--combines intellectual curiosity, emotional appeal, and sense gratification in the service of a popular culture directly influencing and defining individual and collective social values. The most valuable tests for the media could be accuracy and fairness.

Complicating the solutions to the problems of how to communicate intelligence through technology is the role of the celebrity alluded to by Lippman and Boorstin. In more recent days, the film critic, Richard Schickel, has taken up the issue of the celebrity problem and the danger that it poses to us individually and collectively. His basic thrust is that in the latter half of the twentieth century, stardom has become the dominant force in our lives. The result of the communications revolution in technology has been that "we live now in an age rife with . . . falsities."[348] This is caused in part by the media's having almost destroyed the traditional barriers between the "well-known and the unknown." Or, as John Ellis states, "The star is at once ordinary and extraordinary, available for desire and unattainable."[349] Thus film and TV producers can use stars as a means of mediating between illusion and reality. Reinforced by the alarming number of interviews and profiles appearing in the print and electronic media, the concept of celebrity has become synonymous with prosperity and achievement in the public's mind. The cult of celebrity also keeps alive the perverted image of the American Dream developed in the Gilded Age, discussed

[344] Corry, p.1.

[345] Corry, p.29.

[346] Robert Lindsey, "A Mini-Series Mogul Dips Into History Again," ibid., p.29.

[347] "Docudrama Strikes Again," ibid., E p.20. See also Sally Bedell Smith, "TV Docudrama: Question of Ethics," ibid., C (February 14, 1985):30. Three other comments on docudramas worth reading for contrast are "Amerikan Broadcasting," ibid., A (January 14, 1986):24; Ross K. Baker, "Moscow K.O.'s ABC in the First Round," ibid., p.25; Peter J. Boyer, "ABC Will Proceed with AMERIKA," ibid., C (January 23, 1986):5; and Mary McGrory, "Hats Off to ABC For Not Applying Rambo Mentality," BURLINGTON FREE PRESS A (January 17, 1986):12. For a related perspective, see Stephen Farber, "TV Subjects Share Lives With Mixed Feelings," NEW YORK TIMES C (November 10, 1986):22.

[348] *Richard Schickel, INTIMATE STRANGERS: THE CULT OF CELEBRITY (New York: Garden City, Doubleday and Company, 1985), p.7.

[349] *John Ellis, VISIBLE FICTIONS: CINEMA, TELEVISION, VIDEO (London: Routledge & Kegan Paul, 1982), p.91.

more fully in Chapter 5. While intellectuals have long since pointed out the dangers of American industrial capitalism in stressing individual imperiousness and social mobility (e.g., the demise of the extended family, and the decline of a sense of neighborhood), the media border on social irresponsibility in falsifying the success of the modern celebrity. Thus, in Schickel's words, "We look to the mass media for glimpses of the good life, for models of public display, on the off chance that our prosperity might correlate somehow with at least local fame."[350]

Print and video gossip about celebrities adds to the illusion of a false intimacy between celebrated people and the rest of us. Where once these journalistic establishments acted as safeguards against misperceptions and corruptions, they now have the opposite effect. Instead of helping us deal with abstract and inexplicable issues, the media distract us and divert our attention toward personalities and trivial answers to complex problems.

Schickel's solution is to rethink our definitions of language in order to understand that the traditional ways of communicating have been corrupted by the mass media. We must, he argues, stretch the concept of language "to include visual as well as verbal symbolizations of thought."[351] This step would at least make clear the processes by which modern media operate. Even so, he has no faith that anything will work by this late date. The "forces of corruption" cannot be turned back. All Schickel can suggest is that we resist as best we can the celebrity in our culture. His well-worn arguments not only follow the routes taken by Lippmann and Boorstin, but also by social observers like Richard Sennett, Walter Benjamin, C. Wright Mills, Jacques Ellul, Norman Mailer, Murray Kempton, George W. S. Trow, Joe McGinnis, Marshall Berman, Tom Wolfe, and Garry Wills.

At this point, it is sensible to reiterate why "stereotyping" has a negative connotation for many academicians. As Jarvie reminds us, critics frequently use it as a synonym for "conventions." The former he considers "bad"; the latter, "neutral." What Jarvie finds particularly repellent is the stereotyping of races, because it often appears unintentionally in the popular arts. That is, some filmmakers and audiences, in their desire to understand a specific problem, resort to unintentional slurs and effects for purposes of clarity.[352] Excellent examples are films dealing with the Vietnam War: e.g., COMING HOME (1973), THE DEER HUNTER (1978), and APOCALYPSE NOW (1979). In these cases, not only is clarity subverted, but racism is also reinforced.

The problem of determining when and where stereotypes aid or hinder our social and political understanding holds particular interest for Steve Neale. He worries about analysts' employing the term as a means of examining racism and sexism in works of art.[353] His primary concern "is that certain uses of the concept (above all the tendency to think of 'stereotypes' as empirical entities) can actually block the productive analysis of the bodily differences central to categories of race and gender."[354] Neale sees the critical concept "stereotypes" as being applicable almost exclusively to analyzing characters and characterizations. That is, it deals with a set of conventions that manifest themselves in a myriad of texts, specific character

[350] Schickel, p.16.

[351] Schickel, p.298.

[352] Jarvie, p.166.

[353] Powdermaker speculates (p.79) that filmmakers may be concerned with making their characters and plot motivations credible as well as moral. In rare instances, she finds examples of films that are entertaining, moral, and profitable.

[354] Steve Neale, "The Same Old Story: Stereotypes and Difference," SCREEN EDUCATION 32:33 (Autumn/Winter 1979-1980):33.

constructions within those specific texts, and the need to remain constant from text to text. What happens, therefore, is that a complex and heterogeneous process becomes merely a limited, repetitive search. The danger is even greater, Neale argues, when the critical concept is used for ideological analyses. Not only do we learn little about race and gender, but we also ignore other valuable features of the work of art.

This disservice occurs in two ways. One involves a misguided attempt to compare stereotypes with a preconception of "the Real." In our day, for example, we are concerned with the accuracy of the images of women, African-Americans, and homosexuals in films like THE RETURN OF THE SOLDIER (1983), A SOLDIER'S STORY (1984), and MASK (1985). What bothers Neale about such a position "is its inherent empiricism."[355] Instead of the stated comparison, researchers often measure stereotypes against "reality." The second disservice involves a comparison of "ideals" instead of perceptions of reality. Here the attempt is made by some analysts to show an ideologically and politically progressive process by which negative images are replaced by positive ones. Thus we might judge the image of black women better in SOUNDER (1972) than in IMITATION OF LIFE (1934); the image of homosexuals better in MAKING LOVE (1983) than in DOG DAY AFTERNOON (1975). Neale rejects such an approach. He feels that "identification as an artistic practice can never be progressive since it fails to produce knowledge or to allow the inscription of the potentiality of transformation both of which are dependent upon the inscription of difference and distance."[356] The solution for Neale is to concentrate on difference rather than repetition. In other words, shift interest away from set explanations--e.g., Marilyn Monroe's standard "dumb blonde" film image--to distinctions--e.g., what makes each of her roles and films different. Furthermore, terms like "sexist" and "racist" are related not to the texts being analyzed, but rather to the discourse through which they are read. In short, the film scholar's emphasis should be concerned with how texts construct their meanings and imagery.

The problem of comparing stereotypes to reality, however, is much more complicated. Klapp has pointed out that "When persons have inadequate relationships because of different type systems you have what is properly called stereotyping."[357] But the typing process is not simply pigeonholing. It is principally a two-fold collective operation. One phase is the "dramatic-personal, namely, how people are cast in public roles as defined by audiences, and the consequences of this casting upon them and the audience."[358] For example, much of what the public thinks about personalities like Richard M. Nixon, Martin Luther King, and Jane Fonda may be directly related to the roles they played in specific events that held society's attention. A second phase of a complex typing system is known as "collaborative-structural." More enduring and complicated than the dramatic-personal process, it contains "definitions of particular persons . . . [that] are part of a stock of type images which society maintains."[359] This stable system of images periodically experiences changes in relation to specific personalities, groups, and human relations. For example, the way many people perceive Jane Fonda changed dramatically from the sixties to the eighties. Characterized by conservatives and middle-Americans during the Vietnam War as a troublemaker and rebel, her left-wing views in the seventies made her a heroine type in the minds of many of her former antagonists. In films like JULIA (1977), COMING HOME (1978), and THE CHINA

[355] Neale, p.34.

[356] Neale, p.35.

[357] Klapp, p.4.

[358] Klapp, p.7.

[359] Klapp, p.7.

SYNDROME (1979), her acting now was perceived by mass audiences as being in the best traditions of American values: smart, good as a lover, heroic, and a defender of the oppressed. In essence, the former social outcast became a socially desirable figure for the times.[360] Klapp makes clear that collaborative-structural classifications are non-scientific. Their roots are in our everyday experiences and represent practical responses to real-life situations. But he does not consider them distortions. He sees them as truthful images, fulfilling "the functional needs of a group . . . [symbolizing] an idealized concept of how people are expected to be or to act."[361]

Jarvie suggests another approach to the problems created by stereotypes, celebrities, and anticipatory feedback: examine the work of social psychologists. He sees their studies bearing directly on film study in

> the initiation of both children and adults into the rules, obligations and privileges of social groups (SOCIALIZATION); the effects of social groups on the development of the individual (PERSONALITY FORMATION); and the unique characteristics taken on by people in groups (COLLECTIVE BEHAVIOR).[362]

In fact, Jarvie advocates that we go beyond these three broad psychological categories in examining the role of movies in our society. This can first be done by realizing that there is more to the social whole than its individual members. Second, causal relations don't always emanate from individuals to the society as a whole. At times, the process operates in reverse.[363]

But a social critic like Bernard Rosenberg doesn't care how the process works. For him, the end result is that the mass media are an anti-intellectual "phenomenon which continues to revolt some of us as much as it pleases others." He sees popular culture as aesthetically and intellectually trivial, "the Nielsen Ratings . . . [as] not so much a justification but an indictment," and the mass media effect on the audience as one of "depersonalization, concentration, and deracination."[364]

Jarvie's reaction to such arguments, however, is that we should minimize the rhetoric and concentrate instead on proving how film as a social force influences our positive and negative values, causes psychological harm, and elicits undesirable group behavior.[365] Once we understand that we can benefit both as a society and as individuals by following the guidelines set out by scholars like Jarvie, it becomes evident that for too long we have been remiss in learning what options films offer and how these options function in our culture.

[360] Scott Forsyth argues (p.34) that Fonda is a classic example of how mainstream filmmakers subsume and revive radical ideas and images. For an example of Fonda's transformation and the reactions to it, see Nick Ravo, "Jane Fonda Finds Peace in Her Time," NEW YORK TIMES B (August 4, 1988):1, 5. The Associated Press, however, reports the Veterans of Foreign Wars were more than skeptical of the actress's 1988 apology for her trip to Hanoi in the late 1960s, worrying that it might be "a means of bolstering her sagging career and personal fortunes." See "Fonda is Rebuffed by V.F.W.," NEW YORK TIMES A (August 27, 1988):8.

[361] Klapp, pp.10-1.

[362] Ian C. Jarvie, MOVIES AS SOCIAL CRITICISM: ASPECTS OF THEIR SOCIAL PSYCHOLOGY (Metuchen: The Scarecrow Press, 1978), pp.x-xi.

[363] Jarvie, p.xii.

[364] "Mass Culture Revisited," pp.3, 7, 11.

[365] Jarvie, p.4.

Cultural traditionalists and film critics aren't the only people who react negatively to the way in which the media as a whole supply specious social types as models through whom we can better identify our goals and self-images. Even members of the moviegoing public feel guilty about relating positively to what generally is regarded as escapist entertainment. Robert D. Marcus speaks for many guilt-ridden film addicts when he asks, "Yet, given these very controversial observations, why do so many of us feel that the movies have somehow been our touchstone of reality, our way of discovering America, of keeping in touch with our culture, of overcoming the sense of isolation and privatism that Tocqueville so long ago saw was the fate to which we in America were born?"[366]

These anxieties persist despite distinguished scholars' insistence that constant feedback is occurring between filmmakers and their audiences. Herbert J. Gans, for example, in his invaluable sociological studies on mass media relationships highlights the importance of residual feedback in the moviemaking process. While not ignoring the fact that mass audiences have many identities, Gans explains how filmmakers incorporate into their productions a variety of themes that have proved popular in past films. The "anticipatory feedback" process begins with a filmmaker imagining his or her target audience. The image is based upon tried and tested assumptions that are often racist and sexist--e.g., males prefer mystery and action; women, romance and fashions--relating to prior box-office results. This "audience image thus functions to bring the moviemaker in contact with one of his major reference groups."[367] The decision-making process then involves the "creator's" balancing his or her commercial and artistic obligations between peer groups and reputable critics and the assumed predilections of the target audience. For each new film, the filmmaker initiates a new "audience image" to test against past hits and flops.[368] Adding to everyone's anxiety is the division of labor which goes into a film production. With decisions being made by producers, writers, directors, stars, financiers, distributors, agents, and a host of assorted members of the technical crew, each of whom has his or her own "audience image," it sometimes seems a miracle a film is finished, let alone released and exhibited. "Consequently," as Gans speculates, "decisions may be made on the basis of irrelevant, but enforceable criteria."[369] Another way of saying this is that no one in the film business ever knows what will or will not succeed.[370]

[366] Robert D. Marcus, "Moviegoing and American Culture," JOURNAL OF POPULAR CULTURE 3:4 (Spring 1970):755.

[367] Herbert J. Gans, "The Creator-Audience Relationship in the Mass Media: An Analysis of Movie Making," MASS CULTURE: THE POPULAR ARTS IN AMERICA, p.317.

[368] Rebecca Bell-Metereau (p.9) offers a similar perspective when discussing how our culture relates a variety of traits to gender: e.g., biological traits (relationship of shoulders to hip size) and cultural traits (aggressiveness in language and gestures). She then points out that in filmmaking, "it is not society's actual beliefs and values surrounding gender that are at issue, but movie-makers' conceptions of these beliefs." In Bell-Metereau's judgment, the emphasis is on equating popularity with profits.

[369] Bell-Metereau, p.322.

[370] To understand how filmmakers try to satisfy their "audience image," see the following books: *Jerome Agel, ed., THE MAKING OF KUBRICK'S "2001" (New York: Signet, 1970); Steven Bach, FINAL CUT: DREAMS AND DISASTER IN THE MAKING OF "HEAVEN'S GATE," (New York: Morrow, 1985); *Bruce Bahrenburg, FILMING "THE GREAT GATSBY" (New York: Berkley Medallion Books, 1974); Daniel Berrigan, S. J., THE MISSION: A FILM JOURNAL (New York: Harper and Row, 1986); *Edith Blake, THE MAKING OF THE MOVIE "JAWS" (New York: Ballantine Books, 1975); *William Peter

One of the issues we will keep coming back to in this chapter relates to the alleged effects stereotypes and their values have on film and television viewers. Studies exist that purport to identify the reasons why the mass media produce such dire effects and what presumably can be done to rectify the dangerous situation. But as the social sciences have taught us, there is more to society than the members themselves. In making judgments, we need to be conscious of economic, historical, and political factors that impact on the film industry. At the same time, we must understand how cultural hegemony (the intricate process of relationships that collectively reflect a nation's world view) operates. What should become obvious by the end of this chapter is that individual and group perceptions are not the only factors that determine the commercial and social fate of a film. As a result of film advertising and marketing, in addition to the constant repetition of screen conventions and stereotypes, individuals and groups in our society develop preconceptions of what a film is about. These preconceptions, as discussed in Chapter 2, result in film formulas that impact significantly on all aspects of film--production, distribution, and exhibition. But often these prejudgments may, in fact, be unfounded in the case of particular films. For example, many members of the film public who dislike science fiction films and normally avoid seeing them were attracted nonetheless to STAR WARS (1977) and E. T.: THE EXTRA-TERRESTRIAL (1982). Even more dramatic is the positive reception given by a conservative American patriarchal society to an alternative lifestyle in LA CAGE AUX FOLLES (1979). It is also apparent that more often than is generally assumed viewers reject a film's preferred meaning and substitute an interpretation more in keeping with their critical subjectivity.

BOOKS

*Bergman, Andrew. WE'RE IN THE MONEY: DEPRESSION AMERICA AND ITS FILMS. New York: Harper & Row, 1971. Illustrated. 200pp.
 Originally written as a doctoral thesis at the State University of New York at Stony Brook, this slim book appeals both to film buffs and serious students. Bergman's introduction establishes how movies of the 1930s offer valuable documentation on the Depression. One of his basic assumptions is that films had an

Blatty, WILLIAM PETER BLATTY ON "THE EXORCIST": FROM NOVEL TO FILM (New York: Bantam Books, 1974); *Susan Dworkin, MAKING "TOOTSIE": A FILM STUDY WITH DUSTIN HOFFMAN AND SYDNEY POLLACK (New York: Newmarket Press, 1983); Theodore Gershuny, SOON TO BE A MAJOR MOTION PICTURE: THE ANATOMY OF AN ALL-STAR, BIG-BUDGET, MULTIMILLION-DOLLAR DISASTER (New York: Holt, Rinehart and Winston, 1980); *William Goldman, WILLIAM GOLDMAN'S STORY OF "A BRIDGE TOO FAR" (New York: Dell Publishing Company, 1977); *Carl Gottlieb, THE "JAWS" LOG (New York: Dell Publishing Company, 1975); *Peter Guber and Barbara Witus, INSIDE "THE DEEP" (New York: Bantam Books, 1977); *Aljean Harmetz, THE MAKING OF "THE WIZARD OF OZ" (New York: Alfred Knopf, 1977); *C. Kirk McClellan and Doran William Cannon, ON MAKING A MOVIE: "BREWSTER MCCLOUD" (New York: Signet, 1971); *David Michael, THE MAKING OF "SUPERMAN" (New York: Warner, 1978); *Lillian Ross, PICTURE (London: Penguin Books, 1952); *Alexander Solzhenitsyn and Ronald Harwood, THE MAKING OF "ONE DAY IN THE LIFE OF IVAN DENISOVICH (New York: Ballantine Books, 1971); *Susan Sackett and Gene Roddenberry, THE MAKING OF "STAR TREK: THE MOTION PICTURE" (New York: Pocket Books, 1980); *Derek Taylor, THE MAKING OF "RAIDERS OF THE LOST ARK" (New York: Ballantine Books, 1981); Peter Travers and Stephanie Reiff, THE STORY BEHIND "THE EXORCIST" (New York: Crown Publishers, 1974); *James Goode, THE MAKING OF "THE MISFITS" (New York: Limelight Editions, 1986); *John Sayles, THINKING IN PICTURES: THE MAKING OF MATEWAN (Boston: Houghton Mifflin Company, 1987); and Katharine Hepburn, THE MAKING OF "THE AFRICAN QUEEN" OR HOW I WENT TO AFRICA WITH BOGART, BACALL AND HUSTON AND ALMOST LOST MY MIND (New York: Alfred A. Knopf, 1987).

enormous grip on the national imagination, evident in the fact that many unemployed people became frequent moviegoers. "Americans needed their movies," Bergman asserts. "Moving pictures had come to play too important a role in their lives to be considered just another luxury item." He makes clear, however, the scholarly risks in analyzing films as a frame of reference for society's fears, anxieties, and dreams. Citing Kracauer's FROM CALIGARI TO HITLER as an example of how researchers can overstate the links between filmmakers and "popular thought," the author nevertheless feels that the very existence of mass audiences guarantees that a study of the intellectual history of films will reveal the various tensions and assumptions of the age in which the films were made. The key, for Bergman, is in specific film cycles and genres: e.g., gangster films, "fallen women" cycles, "shyster" movies, and "backstage" cycles. "The existence of these cycles," he writes, "fostered and withered by public interest and disinterest, helps us understand the problem of intent and causality." Bergman theorizes that movies in the early 1930s functioned as repositories of traditional American values, while movies at the end of the decade rationalized that the system was good, but that individuals were causing social evils.

In the first of the book's two major sections, the author examines the years from 1930 to 1933. Bergman leads off with a chapter on gangster films, pointing out that LITTLE CAESAR (1930) spawned no less than fifty clones within a twelve month period. After describing the reactions of civic pressure groups to such an unprecedented rash of film violence, Bergman draws parallels between Caesar Enrico Bandello and Andrew Carnegie's formula for success, making the point that the gangster's values were deeply rooted in American traditions. What was harmful was not an emphasis on success, but on the manner in which the law was treated. Other films critiqued are THE PUBLIC ENEMY, CITY STREETS, CORSAIR (all in 1931), and THE SILENT SIX (1932). Chapter 2, "The Shyster and the City," focuses on the behavior of lawyers, politicians, and journalists. "Understand the shysters and their city," Bergman asserts, "and one has a key to much of Hollywood's relation to the Depression." In movies like THE FRONT PAGE (1931), THE MOUTHPIECE, LAWYER MAN, THE DARK HORSE, and STATE'S ATTORNEY (all in 1932), a mythical New York becomes the archetype of big cities, attracting and repelling ambivalent Americans. Newspapers function as the cynical source of data on big city corruption. Crooked politicians exist because the public is gullible, fickle, and untrustworthy. Chapter 3, "Some Anarcho-Nihilist Laff Riots," reminds us that some of the best film comedians of the early 1930s dealt with the nation's bitterness and despair: the Marx Brothers and W. C. Fields. Among the films discussed are MILLION DOLLAR LEGS (1932), DUCK SOUP, and THE FATAL GLASS OF BEER (both in 1933). In Bergman's view, these zany clowns "entertained a bleak and heartsick civilization that expected the worst from everyone." Chapter 4, "Sex and Personal Relations: Women of the Streets, Women of the World," examines the world of film prostitution in the early 1930s. Noting that the "fallen woman" route was the flip side of gangsterism, the social historian describes how stars like Marlene Dietrich, Tallulah Bankhead, and Greta Garbo portrayed females enslaved by a patriarchy. The films cited to illustrate "women of the street" themes are SAFE IN HELL, SUSAN LENNOX: HER FALL AND RISE (both in 1931), BLONDE VENUS, and FAITHLESS (both in 1932). On the other hand, Bergman does point out a number of instances--e.g., Mae West's SHE DONE HIM WRONG and I'M NO ANGEL (both in 1933), Ernst Lubitsch's ONE HOUR WITH YOU, TROUBLE IN PARADISE (both in 1932), and DESIGN FOR LIVING (1933)--where Hollywood mocked conventional sexual mores. The conclusion the author reaches is that these latter films, plus the works of the nihilistic clowns, signaled "that old verities, limits, and definitions were cracking apart." Once the Production Code gripped Hollywood, filmmakers began cranking out movies that obfuscated American problems and possible solutions. Chapter 5, "A Musical Interlude," concludes Part One with a matter-of-fact observation that backstage musicals like GOLD DIGGERS OF 1933, 42nd STREET, and FOOTLIGHT PARADE (all in 1933) were fact-of-life films, unlike their lifeless spin-offs and sequels during the remainder of the decade.

Part Two, the years from 1933 to 1939, argues that fantasy rather than reality characterized the Hollywood product from the darkest days of the Depression to the advent of World War II. Chapter 6, "Back to the Earth: King Kong and King Vidor,"

returns to the theme of ambivalent audiences romanticizing a "back to the earth" philosophy. That is, the more desperate out-of-work Americans got, the more they imagined that living off the land was the answer to their problems. To prove his thesis, Bergman points to films like KING KONG, THE LIFE OF JIMMY DOLAN (both in 1933), and OUR DAILY BREAD (1934). Chapter 7, "The G-Man and the Cowboy," argues that law and order made a comeback by 1935. No longer populated by inept cops and glamorized crooks, films like G-MEN (1935), BULLETS OR BALLOTS, PUBLIC ENEMY'S WIFE, THE PLAINSMAN, and THE TEXAS RANGERS (all in 1936) portrayed federal agents and western heroes as credible figures making society a "fit place to raise a family." Chapter 8, "Warner Brothers Presents Social Consciousness," describes how the topical studio dealt with political and social issues shunned by the other major film corporations. The emphasis was always on a gritty social realism. Nonetheless, films like I AM A FUGITIVE FROM A CHAIN GANG (1932), HEROES FOR SALE, and WILD BOYS OF THE ROAD (both in 1933) epitomized how the Warner brothers never felt compelled to explain why the nation was in such upheaval. Bergman then indicates how movies like MASSACRE (1934), BLACK FURY (1935), and BLACK LEGION (1936) suddenly began examining why society was going sour and concluded that the shysters were back in action. Chapter 9, "The Mob and the Search for Authority, 1933-1937," considers a cycle of films that clamored for a benevolent dictator, one that would have the ends justify the means. THIS DAY AND AGE, GABRIEL OVER THE WHITE HOUSE (both in 1933), and THE PRESIDENT VANISHES (1934) are seen by Bergman as right-wing movies pandering to America's need to be told what to do. By the mid-1930s, films like FURY (1936) and THEY WON'T FORGET (1937) were hammering home the idea that the masses couldn't be trusted and that what protected us from mob rule was a benevolent federal government. Chapter 10, "Frank Capra and the Screwball Comedy, 1931-1941," discusses how the brilliant film director of Columbia Pictures set about "reconciling the irreconcilable." Taking issue with Lewis Jacobs's claim that Capracorn was in the tradition of alienation and Arthur Knight's interpretation that the Capra films were socially aware documents, Bergman asserts that movies like IT HAPPENED ONE NIGHT (1934), MR. DEEDS GOES TO TOWN (1936), and YOU CAN'T TAKE IT WITH YOU (1938) were comedies that "became a means of unifying what had been splintered and divided." Capra himself is pictured as a combination hustler and idealist. By the late 1930s, he begins subverting comedy in favor of populist messages warning us of the threat to traditional American values: e.g., MR. SMITH GOES TO WASHINGTON (1939) and MEET JOHN DOE (1941). Chapter 11, "A Solution to Environment: The Juvenile Delinquent," takes a look at how Hollywood explained neighborhood crime. Films like DEAD END (1937) and ANGELS WITH DIRTY FACES (1938) insisted that young hoodlums had hearts of gold. It was the slum conditions, and not what caused them, that turned good boys into gangsters. Bergman is especially critical of what these films implied--"stay off the streets, stay out of trouble, and don't emulate gangsters who are sapped of their heroic strength"--and what they refused to confront--the need for "minimum wages, social security, medical and unemployment insurance, aid to education and housing. . . ." Bergman's conclusions, summarized in Chapter 12, emphasize the fantasy aspect of the 1930s films. The institutions are venerated, the opportunties for success glorified, and the federal government idealized. Scapegoats are everywhere.

Whatever reservations exist about Bergman's ability to link specific films to the tensions and assumptions of the 1930s, the story he tells is imaginatively conceived and delightfully delivered. Valuable endnotes, a good bibliography, and a helpful index are provided. Recommended for special collections.

*Boorstin, Daniel J. THE IMAGE: A GUIDE TO PSEUDO-EVENTS IN AMERICA. New York: Atheneum, 1978. 316pp. Originally published in 1961 as THE IMAGE, OR, WHAT HAPPENED TO THE AMERICAN DREAM?

A good idea overstated, this provocative book "is about our arts of self-deception, how we hide reality from ourselves." Boorstin, a former-professor of

history at the University of Chicago,[371] provides a wide-ranging list of alleged illusions that nearly all Americans share and that prevent us from facing needed and valuable experiences. What is meant by "reality" is never explained; what is deemed worthwhile is never proven. Nevertheless, he argues that the cause of our national self-hypnosis rests in the misuse of our considerable wealth, literacy, and technology. It is linked to unrealistic and extravagant expectations about what is possible in the world and the power we possess to shape nature to our desires. "By harboring, nourishing, and ever enlarging our extravagant expectations," he explains, "we create the demand for the illusions with which we deceive ourselves." Interestingly, Boorstin claims that the business of deception is seen by honorable and sincere people as a respectable occupation. His job is to disillusion us; to make us understand that at the heart of our problems are illusions, not vices or weaknesses. That is, we mistake images for reality. Where once America was "a land of dreams"--a place where one's aspirations could be compared to reality, it has become a prosaic place where there is nothing to reach for, nothing to aspire to, nothing to be exhilarated by.

Boorstin is at his best in enumerating the types of "ghosts" that populate our thoughts and cloud our vision. In six challenging chapters, he explores our extravagant expectations about the amount of novelty in the world, the power to make human beings famous, the changing attitudes toward travel, the reshaping and disembodying of works of art, the quest for self-fulfilling prophecies, and the misconceptions concerning prestige. Each of these unreasonable expectations creates the need for "pseudo-events" that "make up for the world's deficiency." Pseudo-events possess a common set of characteristics: they are planned rather than spontaneous, created for the convenience of the media, designed to render reality ambiguous, and intended as self-fulfilling prophecies. Unlike the spontaneous events they overshadow, pseudo-events are more dramatic, easier to disseminate, repeatable at will, expensive to produce, reassuring, convenient to observe, have status in the general community, and spawn other pseudo-events. Public relations is a prime example. Politicians continually use the news-reporting media as a means for satisfying both the public's thirst for news, and for enhancing the politician's image. Political events often become secondary to the dramatic and intriguing events that surround the events. Style replaces substance. Although Boorstin neglects to cite the activities of the House Un-American Activities Committee, it is an excellent illustration of how Americans can be manipulated by pseudo-events. An example he does use is the difference between travel and tourism. The former involves a romantic and stirring experience with the unfamiliar; the latter represents a commodity that has "diluted, contrived, prefabricated" the once-exotic experience.

At first glance, Boorstin's arguments sound uplifting and right on the mark. He is arguing for quality rather than quantity, for originality rather than artificiality. But as one examines many of his examples more closely, one finds him not only snobbish, but also unfair to the cultural life of the twentieth century. For example, in blaming the movies for debasing the form of the novel, he neglects the fact, documented by theater historians like A. Nicholas Vardac and Allardyce Nicoll, which the sweeping landscapes and violent action found in novels were being translated to the stage in the nineteenth century. What's more, these same theater historians claim that the growth of stage realism helped pave the way for the birth of the film. A more thorough understanding of literary history would have made Boorstin aware that the form of the novel has constantly been changing from the days of Daniel Defoe to the times of Herman Melville and Leo Tolstoy to the writings of William Faulkner, Henry Miller, and James Joyce. Art is not a closed concept. It grows in response to the visions of artists in relation to the challenges of their age. Thus, to accuse the new medium of debasing the art of the novel is both false and shrill. So too is his attack on screen adaptations of books and plays. Even by 1961, a distinguished scholar like Boorstin should have understood that print and film are different art forms. To compare them without acknowledging their separate virtues is imprudent.

[371] Boorstin is currently the librarian of Congress.

Rather, they are different aesthetic experiences that have their own standards for determining artistic merit. Intelligent people understand that movies cannot give us the "nub of the novel," just as the novel cannot give us the "nub of historical events" or "the nub of famous personalities." A more thorough understanding of film history would have taught the author that Mary Pickford's hard-earned fame was not based on her flouting of morality, or that moviemaking after World War II had more to do with changing conditions in the industry than with the cost of owning a studio. Furthermore, his purist position against the new media of radio, film, and television completely ignores the benefits derived from the best use of those media. Throughout this stimulating text, the author often glosses over the problems of the past to paint an unrealistic image of the Good Old Days. His much needed indictment of widespread illiteracy and shallow values would have been on safer grounds if he had chosen to focus instead on the misuse of popular culture, rather than on a total rejection of it.

My disappointment aside, this elegantly written narrative deserves a hearing if only because of the challenges it poses to the real problems of values in the twentieth century. A good bibliography and index are included. Well worth browsing.

*Cagin, Seth, and Philip Dray. HOLLYWOOD FILMS OF THE SEVENTIES: SEX, DRUGS, VIOLENCE, ROCK 'N' ROLL & POLITICS. New York: Harper & Row, 1984. Illustrated. 290pp.

"The subject of this book," Cagin and Dray write, "is Hollywood's third--and most fleeting--golden age, Political Hollywood, which emerged from the postwar bust and ground to a small halt in the early eighties, as symbolized, perhaps, by the $44 million HEAVEN'S GATE debacle in 1980, and Francis Ford Coppola's plagued $32 million ONE FROM THE HEART (1982." Casting the crisis in the seventies as "something more than a technological and economic reorganization," they see the problems arising out of the success of cable television and "the fragmentation of American society in the eighties." Thus the era is characterized as one in which Hollywood struggles to survive rather than to regain its supremecy in the world of popular culture. The film capital wins the fight, according to Cagin and Dary, because of its newfound links to America's youth culture. "The primary aim of this book," Davies and Neve insist, "is to relate this salient history of dramatic changes in American society, as attitudes toward sex, drugs, violence, art and politics were stood on their head, with repercussions we have yet to assimilate." The authors have no interest in surveying the best (commercial or aesthetic) films of the late sixties to the eighties. Instead, they focus on films that they consider "seminal, transitional, and exemplary." Five intriguing and entertaining chapters explore "The Quest for Autonomy" (e.g., PATHS OF GLORY, LOLITA, FAIL-SAFE, RIDE THE HIGH COUNTRY, and THE GRADUATE); "Subversive Currents" (e.g., REBEL WITHOUT A CAUSE, THE WILD ANGELS, THE TRIP, and EASY RIDER), "The Whole World Was Watching" (e.g., FIVE EASY PIECES, ALICE'S RESTAURANT, LOVE STORY, CARNAL KNOWLEDGE, BLOW-UP, MEDIUM COOL, WOODSTOCK, PUTNEY SWOPE, and HEARTS AND MINDS), "Epic Visions" (e.g., M*A*S*H, LITTLE BIG MAN, SLAUGHTERHOUSE FIVE, CABARET, THE WILD BUNCH, STRAW DOGS, and THE GODFATHER), "Disillusionment" (e.g., AMERICAN GRAFFITI, THE EXORCIST, KLUTE, JOE, DIRTY HARRY, DEATH WISH, JAWS, and TAXI DRIVER). In the book's epilogue, Cagin and Dray use films like ANNIE HALL, THE TURNING POINT, COMING HOME, THE DEER HUNTER, APOCALYPSE NOW, and REDS as examples of a Hollywood that gave the authors "a political and moral education" and made "a bid to change the world." While the assertions are stirring and the writing is passionate, the effect of the discussion is more nostalgic than critical. A filmography, a bibliographical essay, and an index are included. Well worth browsing.

Christensen, Terry. REEL POLITICS: AMERICAN POLITICAL MOVIES FROM "BIRTH OF A NATION" TO "PLATOON." New York: Basil Blackwell, 1987. Illustrated. 244pp.

Davies, Philip, and Brian Neve, eds. CINEMA, POLITICS AND SOCIETY IN AMERICA. New York: St. Martin's Press, 1981. 266pp.

"The papers in this book," the editors explain, "draw in particular on a number of recent developments in the study of American film and the American film industry: a revived interest in the social significance of the recurring themes and images of American film, and a growing body of work on the political and economic history of the American film industry." Eleven stimulating essays try to persuade the reader that feature films can provide valuable perspectives on the political and social climate of the era in which the films were made. P. H. Melling's "The Mind of the Mob: Hollywood and Popular Culture in the 1930s" challenges Bergman's theories on the Great Depression. Ralph Maltby offers two provocative analyses on the evolution of the American film industry. In "The Political Economy of Hollywood: The Studio System," he discusses the origins of cartel practices in the pre-WWI era. In "Made for Each Other: The Melodrama of Hollywood and the House Committee on Un-American Activities, 1947," he describes the film industry's naive assumptions following World War II and the paranoia that ensued, particularly in the FILM NOIR movies of the period. Ralph Willett's "The Nation in Crisis: Hollywood's Response to the 1940s" discusses the ties between the film capital and government agencies during World War II. Christopher Frayling's "The American Western and American Society" offers a broad sociological perspective on a neglected film genre and examines the shifts in its conventions over a prolonged period of time. Brian Neve's "The 1950s: The Case of Elia Kazan and ON THE WATERFRONT" delves beneath the film's popular appeal to its underlying political messages. Philip Davies's "A Growing Independence" reviews the rise of the independent film movement from the post-WWI period to the present. Leonard Quart and Albert Auster's "The Working Class Goes to War" links the ideology in ON THE WATERFRONT (1954) to current populist films like WHITE LINE FEVER (1975) and why Hollywood has become so interested in the working classes. Mary Ellison's "Blacks in American Films" explores the reasons why Hollywood abandoned its negative stereotypes in the late 1940s and began attacking racism in America. Robert Reiner's "Keystone to Kojack: The Hollywood Cop," explores the "vigilante" traits in Depression gangster films and how they evolved into the contemporary police films made by Clint Eastwood. And Eric Mottram's "Blood on the Nash Ambassador: Cars in American Films" exposes a number of neglected motifs and themes in Hollywood movies. Good bibliographies, insightful observations, and well-made arguments characterize the collected writings. An index is provided. Recommended for special collections.

Downing, John D. H., ed. FILM AND POLITICS IN THE THIRD WORLD. New York: Praeger Publishers, 1987. 320pp.

A pioneering collection of articles on important filmmakers and national cinemas in the Third World, this English-language anthology offers interviews, analyses, and examples of political manifestos not found anywhere else in current publications. Twenty-three useful and provocative chapters open up fresh perspectives on the role of politics in the media. Scholarly references are provided, but no index or filmographies. Recommended for special collections.

*Ellis, John. VISIBLE FICTIONS: CINEMA, TELEVISION, VIDEO. London: Routledge and Kegan Paul, 1982. Illustrated. 295pp.

A valuable look at the relationship between film and video, this pioneering study explores the theoretical and historical links between the media and the new social roles that both play in the contemporary world. A bibliographical essay is provided, but no index is included. Well worth browsing.

*Glassman, Marc, and W. W. Baker, eds. THE JOURNAL OF FORBIDDEN FILMS. Toronto: Toronto Arts Group for Human Rights, 1984. Illustrated. 88pp.

A collection of useful articles on filmmaking around the globe, this anthology explores the relationship between movies and censorship in the area of human rights. The fourteen essays are brief but to the point and shed new light on the methods that censors use in preventing alternative views not only from getting distributed, but even from reaching the screen. Particularly useful is the annotated list of films not readily found anywhere else. No index is provided. Well worth browsing.

Harris, Thomas J. COURTROOM'S FINEST HOUR IN AMERICAN CINEMA. Methuen: The Scarecrow Press, 1987. Illustrated. 177pp.

A general introduction to courtroom films, this superficial overview tries to fill the scholarly vaccum surrounding the history of the genre in American films. The author sounds like a cheerleader in his eight chapters on the films he feels represents the best of the legal dramas dealing with judges and juries: 12 ANGRY MEN (1957), WITNESS FOR THE PROSECUTION(1958), I WANT TO LIVE! (1958), COMPULSION (1959), ANATOMY OF MURDER (1959), INHERIT THE WIND (1960), JUDGMENT AT NUREMBERG (1961), and THE VERDICT (1982). The shallow endnotes, the lame analyses, and the padded plot summaries will disappoint the reader. A film title index and a name index are included. Approach with caution.

*Jowett, Garth S. FILM: THE DEMOCRATIC ART. Boston: Little, Brown and Company, 1976. 518pp.

One of the most useful books yet written on the social history of film, this scholarly volume surveys and analyzes many of the ways in which the movies influenced American society, as well as those factors, both good and bad, which fashioned the movies we saw. The emphasis is on demonstrating how movies function as a socializing agency, particularly in the first half of this century. Jowett's perspective is more than a revisionist look at film history or an academic shift away from biographical and aesthetic questions and toward psychological and sociological issues. It is also a major bibliographic resource on traditional film sources and on heretofore relatively ignored research in the social sciences.

The thought-provoking introduction offers a first-rate explanation of Jowett's concerns with major questions about the social, political, cultural, and economic adjustments necessitated by the growth and development of film: e.g., what institutional changes did this new force inaugurate? What effect did they have on the general public? Unlike many of his predecessors, the erudite author anchors his conclusions in the larger context of changes revolutionizing America at the turn of the century: urbanization, industrialization, and the communications revolution. The latter in particular interests Jowett because of the deep and rapid changes it made in society's symbolic representations of its collective consciousness. How this occurred and what the problems were in the accommodation process are central to the book's social history. Thus the fourteen fact-filled chapters pay almost as much attention to the types of adjustments movies forced on society, as to the behind-the-scene activities of the American film industry itself.

At the outset, let me say categorically that except for Sklar's pioneering study, MOVIE-MADE AMERICA: A SOCIAL HISTORY OF AMERICAN MOVIES, there are few books in recent memory that provide as much information succinctly and effectively as this praiseworthy effort.[372] The work is comprehensive and detailed, and, on those grounds, almost unparalleled in film scholarship up to 1976. The author also demonstrates unusual skill in tying together a wide range of facts, interpretations,

[372] For a comparison of the two books, see Frank Manchel, "Book Reviews," THE JOURNAL OF AESTHETIC EDUCATION 12:3 (July 1978):117-20.

and events. On the other hand, Jowett's ambitious undertaking needs to be read with caution, since many of his conclusions rely too heavily on uncorrected errors of the past.

The opening chapters demonstrate a number of pluses and minuses in the chronologically arranged social film history. For example, Chapter One explores "The Recreation Revolution" with almost no mention of the moving image. Chapter Two introduces the subject and then divides its topic into a host of sub-themes: e.g., "The Search for Pictorial Realism," "The Origins of an Industry," "The First Motion Picture Audiences," "The Content of Early Motion Pictures," and "Special Studies and Statistics." As long as Jowett deals with the interpretations of sociologists, he is on firm ground. But when he begins applying their work to his perspective, he periodically falters. For example, he too easily accepts the now-discredited "chaser" theory and seriously undervalues the role of vaudeville houses in the economic history of movies. By the time we get to Chapter Three and the development of the film industry between 1909 and 1918, Jowett's pattern of letting summaries of his extensive research carry the burden of his argument is clear. What is also clear is Jowett's basically conservative approach to film history. That is, he is reluctant to challenge many of the traditional theories about the Trust, the star system, and the rise of feature films. Rather than break new ground, he is content to amplify what is already known. He makes the false assertion that film producers rarely created and distributed "deliberately contrived propaganda" films prior to World War I, and he oversimplifies Wall Street's early involvement in the expansion of the film industry.

None of these criticisms, however, is meant to detract from the enormity of Jowett's overall contribution to film scholarship. Neither Sklar nor his predecessors matches Jowett's ability to amass in one volume a more intriguing collection of data on the influence of film in transforming society. For example, Chapter Four contains a superb discussion on the role of the Progressive movement on film content and reception. The treatment of the criticisms leveled at film before 1918 and the shift away from an examination of the film's educational possibilities to its new status as an art form is both informative and stimulating. The same could be said for the chapters on film censorship, film influence from 1918 to 1930, social science and the movies, and what Hollywood meant to the general public during and immediately after World War II. In each instance, Jowett not only adds to our understanding of film history, but also opens new doors for future investigators. Of particular note are his suggestions about why the new medium faced such opposition during the first half of this century. For example, he gives the distinct impression that if the power moguls in film had not been almost exclusively European-Jewish immigrants, then America's reformers, politicians, and self-appointed do-gooders would not have been as energetic in their attacks on the new medium. Another major reason why traditional power groups in America feared the movies, Jowett persuasively argues, is that they deeply resented the flow of information reaching social classes through the movies. In the past, many of these groups remained uninformed about a number of issues now being dramatized and popularized in American films. And third, cultural leaders realized early on, that the movies, with their emphasis on the lurid and the sensational aspects of society, posed a serious threat to established and more sedate forms of entertainment.

In short, Jowett's informed perspective and his almost-encyclopedic account of the social history of film remain an admirable attempt to focus attention on many ignored aspects of film study. Twenty-one useful appendexes, an extensive bibliography, and a fine index add to the book's value as an important resource. Recommended for general collections.

Kagan, Norman. GREENHORNS: FOREIGN FILMMAKERS INTERPRET AMERICA. Ann Arbor, Pierian Press, 1982. Illustrated. 172pp.

Beginning with the silly choice of "GREENHORNS" as a title for a discussion of noted foreign directors, the author provides a minimal introduction to the question of how other filmmakers interpret our behavior and use our film genres. The seven directors and their films selected for study are Michelangelo Antonioni, ZABRISKIE

POINT (1969); John Boorman, POINT BLANK (1967); Jacques Demy, THE MODEL SHOP (1968); Milos Forman, TAKING OFF (1971); Jean-Luc Godard, MADE IN U. S. A. (1967); John Schlesinger, MIDNIGHT COWBOY (1969); and Agnes Varda, LION'S LOVE (1970). Each of the seven chapters contains a production history, an extensive synopsis with appropriate dialogue included, some terse critical observations, and a brief comment on the director. Individually, the chapters have little to recommend them, but taken collectively, they suggest an intriguing area for in-depth research on how the Vietnam War affected foreign filmmakers who either wanted to work in American films or to comment on American society. Kagan knows better than most the limitations of his theme and includes in the slight book a valuable filmography on foreign filmmakers in America. While admittedly tentative and incomplete, it indicates the range of options open to further investigation: e.g., foreign expatriates working in America, foreign versions of American film genres, alienated U.S. ethnics. A helpful set of endnotes is included, but regrettably no index. Approach with caution.

*Klapp, Orrin E. HEROES, VILLAINS, AND FOOLS: REFLECTIONS ON THE AMERICAN CHARACTER. San Diego: Aegis Publishing Company, 1972. 176pp. Originally published by Prentice-Hall in 1962.

A survey of the major social types in American society, this provocative book provides an enterprising examination of the role that heroes, villains, and fools play in the structure of our culture. Klapp's informative but subjective approach relies heavily on the revelations to be found in studying the names and epithets used in American history to the present. The two key functions are in defining the national character and ethos and in status and identity negotiations. Klapp makes it clear that while changes in types do occur, there has been considerable continuity and oscillation in America's self-portrait over the past 200 years. He focuses on the most durable examples and their important abstract roles, "encoded in popular language and used in symbolic action," in maintaining control, status modification, and self image. The scholarly overview frequently reminds us that in choosing a role and self image, we often experience personal "conflict, alienation and identity problems. . . ."

In the first of the study's three stimulating sections, the author introduces a number of important distinctions. For example, members of a democratic society cannot prevent from being stereotyped. Our only option, Klapp argues, is in choosing the type commensurate with our social status and ambitions. But in this molding process of "finding oneself," we also stereotype others. Each symbolic act furthers our construct of ourselves. That is, human relationships in a mobile society require identifying abstract roles and types that define the desirable and undesirable elements of our national character. Such categories rely on insight rather than reason, on experience rather than logic. As collective norms of role behavior, they are both the group's product and property. What are paramount in the collaborative-structural phase of the collective stereotyping process are questions about how types form, build a social structure, and function within and as a system for controlling human behavior. In particular, the categories of heroes, villains, and fools illustrate how a society passes judgment on itself. Klapp pinpoints this operation as the key to our national character. Almost as valuable as the insightful discussion are the book's profuse footnotes and erudite asides. Distinctions are made between social types and social roles; social types, models, and norms; and subclassifications of social types within professional subcultures.

Section Two--"Popular American Social Types"--does a first-rate job of describing the major motifs of our national character. The chapter on heroes offers five categories on the themes of value and achievement that we admire as a society: winners, splendid performers, heroes of social acceptibility, independent spirits, and group servants. The chapter on villains demonstrates how the best villains symbolize the exact opposite values of the hero and menace the group the hero satisfies. Thus, "good Joes" are offset by "strangers," "conformers" by "outlaws," "martyrs" by "traitors," and "strong men" by "cowards." The chapter on fools points out how

sarcasm and wit punctuate our social pretensions. The major areas of folly are put into five categories: incompetents, people who claim more than they have, nonconforming types, overconformers, and types acting as outlets for aggressive tensions. Typical of the last group are comic butts and clever fools like Mark Twain, Groucho Marx, and Woody Allen.

In Section Three--"Impressions of American Heroes"--Klapp shifts his emphasis from description to interpretation. It's here that the linguistic analysis encounters its greatest problems. In comparing, for example, the multitude of American hero types with the much smaller number found in European societies, the author draws the unsupported conclusion that the variety characteristic of America implies there is "little consensus about 'highest' or absolute ethical standards. . . ." The result is a cafeteria-style assortment of personalities that then results in many people assuming roles totally unsuited to what they are or what they truly want to be. Klapp further believes that the absence of a value consensus also produces a secularized society, which values mainly the superficial and the physical. That is, America is a society at play, and celebrities are preferred to saints and heroes. One searches in vain for a measuring rod to test these dubious hypotheses. How can one gauge the accuracy of Klapp's assertion that the "central theme of the American ethos" is found in the cluster of social types that include the good Joes, squares, sissies, and eggheads; that we have an excessive admiration for specialists; and that Americans are fascinated by audience-directed personalities who exist to "wow" large crowds? Even more difficult to fathom is the statement that the good Joe, smart operator, and playboy "sum up, as far as these three types could, the aspirations and character of one hundred and seventy million people--what the new American character is coming to be." While it makes sense to speculate about the decline of the American hero in the sixties, it seems reasonable to ask for specific evidence when Klapp lists four reasons--anomic types, the cult of celebrities, corruption of the hero, and mockery of heroes--why heroes have deteriorated in our society. His impressionistic assessments in the section's four chapters offer challenging possibilities for future scholars, but become disconcerting as the distinctions between fact and opinion become neglected.

The entertaining ideas in this straightforward work overshadow the author's tenuous conclusions. Read for the insights it provides on examining the national character through linguistic analysis, the delightful text does a first-rate job of stimulating the reader's imagination. Regrettably, no index is provided. Well worth browsing.

Maltby, Richard. HARMLESS ENTERTAINMENT: HOLLYWOOD AND THE IDEOLOGY OF CONSENSUS. Metuchen: The Scarecrow Press, 1983. 417pp.

"The central proposition in this book," Maltby writes, "is straightforward: that the American cinema should be understood for what it is: primarily a commercial institution, engaged in manufacturing and selling a specific product in a capitalist market-place, and only incidentally a species of art, a political statement, a sociological document, a cultural product or an object of theoretical speculation. I do not dispute that the American cinema is all of these things, but I want to suggest that, before it can be treated as cultural history or sign system [sic] it must be comprehended as a commercial commodity. Only by acknowledging the explicit primary purpose of every act of cinematic production within Hollywood--to make money--can we properly place the subsidiary intentions or incidental consequences of any particular film. In setting the stage for his scholarly arguments, the author challenges recent film theories based on the work of Marxist semiotics and Lacanian psychoanalysis. The two major weakesses he identifies as originating from the idea of a theoretical systemic model are related to a misunderstanding over shared forms and private experiences and a misplaced emphasis on analyzing film as language rather than film as an experience. In developing his arguments for a new look at the context in which films are made, distributed, and exhibited, Maltby provides four major sections, packed with insighful observations, and the ideological study of Hollywood.

The one glaring problem with the author's extensive bibliography is that the articles cited list no page numbers or dates. An index is provided. Well worth browsing.

*Marsden, Michael T. et al. MOVIES AS ARTIFACTS: CULTURAL CRITICISM OF POPULAR FILM. Chicago: Nelson-Hall, 1982. Illustrated. 274pp.

Arguing that America has never developed a "school" of cultural film criticism, this stimulating text suggests a coherent, viable approach to film study: "present material which treats films because of their popularity, not in spite of it." The book's more than twenty essays originally appeared in THE JOURNAL OF POPULAR FILM, founded in 1971 and renamed THE JOURNAL OF POPULAR FILM AND TELEVISION in 1980. Marsden, along with his co-editors, John G. Nachbar and Sam L. Grogg, Jr., were the JOURNAL's founding fathers. They maintain their conviction that film is a commercial venture that can withstand critical examination and still be responsive to audience tastes. To demonstrate the point, the book is divided into five sections. Each begins with a terse introduction, followed by a variety of opinions on how audiences interact with filmmakers.

Section One--"Movies and Their Audiences"--offers a historical perspective on the links between movie audiences and film development. Using sociological data for evidence, Garth S. Jowett stresses the importance at the turn of the century of increasing leisure time and the incorporation of melodramatic traditions in the first movies as vital to the establishment of film as a major form of mass entertainment. Ralph Bauer gives his impressions on what watching movies during the Depression meant to millions of Americans. "The films of the '30s," the noted fiction writer states, "provide an insight into the collective mind of the popular New Deal the same way that government documents are an insight into the collective mind of the governmental New Deal." Taking note of the radical changes in the film industry following the Second World War, Calvin Pryluck discusses how institutional constraints affected film content from 1945 to 1969. Brian Rose concludes the fascinating section with an examination of how the 1970s produced in filmmakers a "blockbuster" mentality that left everyone uncertain about the direction in which movies were headed.

Taken collectively, the four essays indicate valuable areas for further study. At the same time, they highlight the problems that scholars and editors have in such anthologies. For example, Bauer's essay not only repeats the impressionistic flaws attacked by the editors in their introduction, but also oversimplifies the institutional problems filmmakers faced in the 1930s. No mention is made of how the industry was controlled by a few individuals or the impact that internal and external politics had on the types of films that were made or censored. Pryluck's helpful charts need reorganizing so that chronologies appear more logical, while Rose's essay (at variance with Pryluck's assertions about production strategies in the 1960s) has endnotes with no page references. In fact, there seems to be no editorial guidance throughout the book in handling citations.

Section Two--"Movie Stars"--effectively illustrates how performers mirror the age in which they star. James Damico's speculative essay on why Ingrid Bergman's notorious romance with Roberto Rossellini in the late 1940s generated such a heated public reaction is a good starting point for understanding the appeal of film stars in American society. Julian Smith's meandering reflections on the importance of Audie Murphy as a screen image introduce some novel ideas about the moods and feelings film personalities encourage in their fans. By far the best essay is Gene D. Phillips's insightful analysis of why Paul Newman's anti-hero film persona remained such a splendid image of alienation in America from the late 1950s to the end of the 1970s. Also impressive is the author's description of how James Wong Howe lit Newman in HUD (1963) and won the distinguished cinematographer an Oscar.

Section Three--"Movie Genres"--focuses on the cultural significance of film types "which, because of their consistent and frequent repetition, seem to fulfill our continuing cultural needs and desires." Michael T. Marsden's praiseworthy observations on the religious undertones in American westerns reinforce the major contributions to popular culture of scholars like John Cawelti and Albert F. McLean,

Jr. Timothy E. Scheurer constructs a good case for analyzing the musical as an INTERPRETATION of life rather than as a reflection of it. Walter Evans's provocative but forced arguments about the relationship between movie monsters and the sexually confused adolescent are delightful reading. Stuart M. Kaminsky makes a valiant but not compelling case for seeing the Chinese Kung Fu or martial arts films both as violent myths and as almost musical displays. His comments on the links between these intense films and minority audiences, however, are very significant and deserve further study. The book's least satisfying essay is Joseph W. Slade's overview of the pornography market in the 1970s. Nowhere near as informative as the excellent comments in PLAYBOY by Arthur Knight and Hollis Alpert, the narrative plods along with poorly reproduced stills underscoring the timidity of the author in dealing candidly with a much neglected subject.[373]

Section Four--"Movies and Their Times"--contains the book's most enjoyable material on how films fit into the evolution of mainstream American culture. Thomas H. Pauley's commendable essay on GONE WITH THE WIND (1939) and THE GRAPES OF WRATH (1940) presents invaluable comments on the realistic elements in these two films and why they epitomize the fears and frustrations moviegoers felt during the Depression era. Although Brian Murphy's article on the symbolic value of 1950s monster movies lacks scholarly consistency, his vivid impressions merit consideration. For example, Murphy's now discredited claim that Hollywood in the 1950s was noted only for its technical experiments is balanced with astute observations on viewing science fiction films as illustrations of what human beings were made of. Vivian C. Sobchack's impressions on the cathartic nature of violent films suggest another dimension to the film-audience relationship. Closing out this section is John Yates's perceptive discussion of THE GODFATHER films as "a brilliant revelation of the family, how it worked through the generations, and how it now falls apart." A minor but annoying matter is the poor reproduction of the stills, plus the omission of Michael and Kay in the wedding portrait in THE GODFATHER (1972).

Section Five--"Movies and the Continuing Human Condition"--sums up how movies reflect human desires and needs. Frank McConnell's charming essay on Jack Arnold's 1954 CREATURE FROM THE BLACK LAGOON is a fine combination of affection and scholarship. The efforts by Alice Sodowsky and her colleagues to dissect the myths found in AMERICAN GRAFFITI (1973) offer an enlightened analysis on how filmmakers use their work to restructure the past. Charles S. Rutherford's approach to SOUNDER (1972) convincingly shows the influence of Homer on both the author William H. Armstrong and the film that was adapted from his novella. Finally, Maurice Yacowar's treatment of ZABRISKIE POINT (1970) and BILLY JACK (1971) demonstrates one more aspect of American protest in the 1970s.

If nothing else, this entertaining collection deserves praise for its warm appreciation of American films. Rarely does one find in scholarly circles critical acuity coupled with genuine affection for the movie and the audience. Furthermore, Larry N. Landrum's excellent bibliography puts to shame many similar efforts by bibliographers less thorough or knowledgeable. I would have said as much even if the astute bibliographer had not praised FILM STUDY: A RESOURCE GUIDE. An index is provided. Recommended for general collections.

McClure, Arthur F., ed. THE MOVIES: AN AMERICAN IDIOM; READINGS IN THE SOCIAL HISTORY OF THE AMERICAN MOTION PICTURE. Rutherford: Fairleigh Dickinson University Press, 1971. 435pp.

An uneven attempt at describing the historical relationship between American movies and the society that produced them, this intriguing anthology, arranged in quasi-chronological order and in three major sections, includes commentaries by

[373] In this connection, worth reading is Pauline B. Bart and Margaret Jozsa, "Dirty Books, Dirty Films, and Dirty Data," *TAKE BACK THE NIGHT: WOMEN ON PORNOGRAPHY, ed. Laura Lederer (New York: William Morrow and Company, 1980), pp. 204-17.

reporters, critics, historians, sociologists, humorists, novelists, and devotees of the film. Part 1 explores the rise of the film from 1900 to 1949. Among the more noted commentators are Terry Ramsaye, Richard Schickel, Lewis Jacobs, and Siegfried Kracauer. Part 2, covering the policies of retrenchment and renewal from 1950 to 1969, includes worthwhile observations by John Howard Lawson, Thomas R. Cripps, and Stephen Farber. Part III, the future of Hollywood from the early 1970s and on, offers an excellent opportunity to see the problems of predicting how the film industry will behave. Among the more impressive essays are those written by Ben Hecht, John Cassavetes, Charles Champlin, and Arthur Knight. Regrettably, no index is provided. Worth browsing.

Michalczyk, John J. COSTA-GAVRAS: THE POLITICAL FICTION FILM. Philadelphia: Art Alliance Press, 1984. Illustrated. 296pp.
 While acknowledging that the political film existed long before Z (1969), this book asserts that it was Costa-Gavras's work that gave the genre its major stimulus as a commercial and ideological product. The purpose of the book, therefore, is "to document the progressive stages of Costa-Gavras's political filming in a now commercialized genre, concomitantly to raise pertinent questions about contemporary directors' perception of social cinema for the masses, by comparing them with Costa-Gavras, the re-creator and popularizer of political fiction." In the first of eight chapters, Michalczyk defines what he means by a "political film" and how much the director's ideology counts in labeling the film "political"? Costa-Gavras's films exemplify what the author concludes are political films: "They deal with such ideological topics as totalitarianism, imperialism, collaboration. They manifest unquestionably the leftist and anti-Establishment view of the director. Despite their apparent authenticity, they are not documentary, for Costa-Gavras's purpose is to DRAMATIZE the historical situation." In the chapters that follow, Michalczyk examines the director's films from THE SLEEPING CAR MURDERS/COMPARTIMENTS TUEURS (1965) to MISSING (1982). Although the study meanders somewhat, the ideas are stimulating and information useful. A filmography, bibliography, and index are included. Well worth browsing.

*Monaco, James, ed. CELEBRITY: THE MEDIA AS IMAGE MAKERS. New York: Dell Publishing Company, 1978. Illustrated. 258pp.
 Working on the premise that celebrities are exerting too much control over our lives, Monaco offers "a cooperative attempt to redress the balance between life and fiction--to regain some control--by investigating some of the basic factors that make up the phenomenon we call 'celebrity.'" Monaco divides thirty-four essays by authors like Joan Didion, Morley Safer, Richard Schickel, Roland Barthes, Norman Mailer, and Nora Ephron into eight major sections: e.g., the state of the art, the role of the media celebrity in everyday living, the people who are victimized by celebrity status, how the system works, how celebrities approach their roles, the public's fascination with the "do-it-yourself persona," and the function of gossip in the celebrity game. What's appealing about the anthology is the editor's willingness to mix print perspectives with visual ones. What's disappointing is the unevenness of the selections and Monaco's failure to provide more focus to the subject. An index is included. Worth browsing.

Reader, Keith. CULTURES ON CELLULOID. London: Quartet Books, 1981. Illustrated. 216pp.
 A well-intentioned study of how "different national cultures depict THEMSELVES in and through their cinematic industries," Reader tends to overstate his conclusions that "all film cultures we shall look at in different ways, acted as propaganda for and endorsement of its country's 'way of life' within the country in question and abroad." The four countries examined in a rapid and unconvincing pace are the United

States, England, France, and Japan. A question that immediately arises is why Reader, who is senior lecturer in French at Kingston Polytechnic, did not include at least one of the Soviet bloc nations as a basis for contrast in dealing with profit-minded film industries and propaganda. In discussing how certain attitudes, activities, and geographical regions were excluded in films made by his primary countries, the author could have been more effective in showing how this differed from state-controlled industries. Reader's rationale is that his book is intended for British audiences and that he has placed utmost importance on the films under discussion being readily available in Britain. Furthermore, the relevance of the other three nations selected is based on their cultural and ideological influence worldwide (all the more reason to include the Russian film industry). Even here a distinction is drawn. For example, the American film industry is surveyed from the time of the silent era up through the Vietnam War, with an emphasis on "the ideology (or ideologies) of market political and economic freedom." The study of French film history ends with the New Wave, with Reader stressing "that nation's perception of itself as the first and archetypal modern nation-state." England and Japan, on the other hand, are given far less attention. The former is analyzed in regard to its "peculiarly perverse attitude towards sexuality"; the latter, through an examination of four major filmmakers: Yasujiro Ozu, Akira Kurosawa, Kenji Mizoguchi, and Nagisa Oshima.

Whatever reservations one might have about the uneven methodologies and the lack of adequate representation of market and non-market driven film industries, the book does offer some stimulating moments. Reader's basic instincts about the importance of populism in American films, the intrigue in the French film industry prior to World War II, and the theory that the value of films often lies in their acts of omission rather than those in commission are right on target. Even if his analyses fail to make persuasive cases, they do raise many important and stimulating issues. Also included are a minimal set of endnotes, a weak bibliography, a poor glossary, a slight filmography, and an adequate index. Approach with caution.

*Roffman, Peter, and Jim Purdy. THE HOLLYWOOD SOCIAL PROBLEM FILM: MADNESS, DESPAIR, AND POLITICS FROM THE DEPRESSION TO THE FIFTIES. Bloomington: Indiana University Press, 1981. Illustrated. 364pp.

A flawed but intriguing study, the purpose of this provocative book is "to provide a comprehensive overview of the cycles and patterns of the [social problem film] genre, examining the relationship between political issues and movie conventions, between what happened in American society and what appeared on its screen." In simpler terms, the plan is to show how moviemakers directly attempted to influence American life. Roffman and Purdy's theory is that Hollywood transformed social content into marketable social drama by combining social analysis and dramatic conflict within a unified narrative structure. Roffman and Purdy define their special genre as one committed to "statements" and recognizable by "a self-conscious approach to theme and topic." The conventions include dramatic plots focusing on the interaction between the protagonists and social institutions (e.g., governments, political causes, and industry), and glib themes that are more interested in skimming the surface of a society's perceived social values than in offering a more penetrating study of the social values found in the family, organized religion, and human sexuality. Interestingly, Roffman and Purdy feel that this type of didactic genre inhibits rather than hastens social change. That is, by concentrating on surface problems, the filmmakers downplay the magnitude of the problem and thus reinforce the STATUS QUO.

The major focus is on the period from 1930 to the mid-fifties, when socially conscious filmmaking and studio formulas combined to create the social problem film. The authors do an excellent job of reminding us how a self-contained corpus of films retained a consistent political viewpoint and provided a considerable cultural force in society. The useful introduction summarizes the essence of the Hollywood movie in the thirties and forties and its important relationship to production policies. Among the strong points made are that the industry considered the quantity of movies more significant than their quality of pictures, that the Formula (e.g., a standard mode

of expression relying on a series of basic conventions) had little relationship to a film's quality, and that the filmmakers based their fortunes on stars, genres, and the need to equate entertainment with wish fulfillment.

The book itself is divided into four main sections. Part 1--"The System Breaks Down: The Individual as Victim, 1930-1933"--examines the relationship between the Depression and the way in which Hollywood responded to the desperation of American society. Succinct but utilitarian plot summaries of films like HELL'S HIGHWAY, STATE'S ATTORNEY, THE DARK HORSE, WASHINGTON MERRY-GO-ROUND, and I AM A FUGITIVE FROM A CHAIN GANG (all in 1932) indicate the social types and stock situations that populated the rise of the social problem film: gangsters, fallen women, shysters, happy hoboes and sentimental heroines yearning for an idealized past, greedy business magnates, and corrupt politicians. The point stressed throughout is that the studios remained committed to a capitalist society and discouraged any revolutionary alternatives to the system. Part 2--"The System Upheld: The Individual Redeemed, 1933-1941"--discusses how the public often mistook Hollywood's optimistic movies as endorsements of New Deal policies. Thus progressive films about unemployment, militant unionism, rural problems, juvenile delinquents, and ex-cons retained a basic conservatism while giving the appearance of being socially progressive. Even when Hollywood touched on problems not related to the Depression--e.g., a doctor's role in society, the mistreatment of racial minorities--the message accented America's inherent ability to overcome its weaknesses. According to social problem films like WILD BOYS OF THE ROAD (1933), GENTLEMEN ARE BORN (1934), and MY MAN GODFREY (1936), what we needed was faith in ourselves and not a change in the system. Furthermore, American filmmakers rarely wanted to take sides in controversial matters and thus often made a variety of movies that pandered to both political extremes just to be safe. Part III--"Fascism and War"--chronicles how Hollywood perceived domestic and foreign fascism replacing economic dislocation as the primary danger to national security. This, in turn, required the filmmakers to reevaluate their stands on controversial issues. For example, when fear of the American right dissipated in the mid-thirties, the ever-cautious filmmakers began repudiating an earlier cycle of pro-Fascist films like THE SECRET SIX and BEAST OF THE CITY (both in 1932), GABRIEL OVER THE WHITE HOUSE (1933), and THE PRESIDENT VANISHES (1934). Lynching and the fascist organizations it fostered were attacked in movies like LEGION OF TERROR and FURY (both in 1936), THEY WON'T FORGET and BLACK LEGION (both in 1937), THE TALK OF THE TOWN (1942), and THE OX-BOW INCIDENT (1943). Roffman and Purdy devote one chapter to Frank Capra's social parables and anti-fascist films like MR. DEEDS GOES TO TOWN (1936), YOU CAN'T TAKE IT WITH YOU (1938), MR. SMITH GOES TO WASHINGTON (1939), and MEET JOHN DOE (1941). Another chapter reviews movies about native fascist movements: e.g., CITIZEN KANE (1941), KEEPER OF THE FLAME (1942), PILOT NUMBER FIVE (1943), and ALL THE KING'S MEN (1949). A third chapter deals with international fascism and traces Hollywood's path from pacifist movies like ALL QUIET ON THE WESTERN FRONT, JOURNEY'S END, THE CASE OF SERGEANT GRISCHA, and BROKEN LULLABY (all in 1930), to anti-isolationist films like THE LAST TRAIN FROM MADRID (1936) and BLOCKADE (1937), and then to attacks on Nazi Germany in films like THREE COMRADES (1938), CONFESSIONS OF A NAZI SPY (1939), THE GREAT DICTATOR and THE MORTAL STORM (both in 1940), and SERGEANT YORK (1941). A disappointing epilogue summarizes the purposes of wartime film propaganda, with a post-mortem on films like WILSON (1944) and THE SEARCHING WIND (1946). Part IV--"The Postwar World"--argues that Hollywood resumed its traditional role of reassuring the public that a capitalistic America was capable of solving its problems of race riots, labor unrest, radical violence, domestic terrorism, and government interference without having to revolutionize the system. If anyone seriously objected to the American way, Rothman and Purdy point out, it was Hollywood's job to convince the individual that the "conflict . . . must lie in his own inability to adapt, that is, in his own personal neurosis." How the filmmakers calmed the public's jitters is reviewed in movies about readjustment--e.g., PRIDE OF THE MARINES (1945), THE BEST YEARS OF OUR LIVES (1946), anti-Semitism--e.g., CROSSFIRE and

GENTLEMAN'S AGREEMENT (both in 1947), the African-American problem--e.g., HOME OF THE BRAVE, PINKY, LOST BOUNDARIES, and INTRUDER IN THE DUST (all in 1949), other minorities--e.g., BROKEN ARROW (1950), THE LAWLESS and BAD DAY AT BLACK ROCK (both in 1954), alcoholism and insanity--e.g., THE LOST WEEKEND (1945), THE SNAKE PIT (1948), postwar labor problem--e.g., THE WHISTLE AT EATON FALLS and ON THE WATERFRONT (both in 1954), and the crisis between the individual and society--e.g., IT'S A WONDERFUL LIFE (1946), BODY AND SOUL (1947). On rare occasions, the authors deal with an American movie made outside of Hollywood and use it to contrast content and technique: e.g., SALT OF THE EARTH (1954). The section concludes with the observation that "The genre . . . accurately reflects the liberal concerns of its time; its limitations were very much the limitations of its audience and era."

Where Roffman and Purdy go astray is in never examining the effect that technique, style, or performer had on the message presented in the genre. Too much time is spent on plot summaries and on drawing links between the movies and political and social events. Another problem is oversimplification. Very complicated issues like the treatment of minorities or fascism are addressed in brief paragraphs, and then comes a list of films quickly identified as dealing with the problem. No serious attempt is made at discussing either aesthetics or content. Furthermore, discussions of Hollywood history tend to blur rather than clarify events. For example, the authors' comments on the House Un-American Activities Committee (HUAC) ignore the committee's rise in the thirties, fail to make the connection between MISSION TO MOSCOW (1943) and MY FOUR YEARS IN GERMANY (1918), and omit David Culbert's important research on MISSION TO MOSCOW.

How important details are to the reader will determine the book's value. Those who appreciate an enjoyable writing style coupled with a stimulating premise and an impressive listing of films will want to examine this study. On the other hand, serious students in search of thought-provoking ideas will be disappointed both in the authors' methodology and conclusions. Endnotes, a bibliography, a filmography, and an index complete the work. Well worth browsing.

Ryan, Michael, and Douglas Kellner. CAMERA POLITICA: THE POLITICS AND IDEOLOGY OF CONTEMPORARY HOLLYWOOD FILM. Bloomington: Indiana University Press, 1988. Illustrated. 329pp.

"Our study," Ryan and Kellner explain, "focuses on the relationship between Hollywood film and American society from 1967 to the mid-eighties, a period characterized by a major swing in dominant social movements from left to right." Stressing how the modern films mobilize audiences to conservative ideology "from the family to the military to economic policy," Ryan and Kellner point out the dangers in what seem to them to be "frequently neofascist ideals and images. . . ." At the same time, they argue that opposing forces are alive and well and doing an effective job in attacking the right wing films. In fact, after eight years in researching the topic, the authors are convinced that "it is the very nature of conservative reaction to be indicative of the power of the forces which threaten conservative values and instituitions." Ten highly stimulating and perceptive chapters reveal the authors' Marxist positions and do a fine job of illustrating the value of deconstructionism to contemporary film scholarship. Endnotes, a bibliography, and an index are included. Highly recommended for special collections.

*Schickel, Richard. INTIMATE STRANGERS: THE CULT OF CELEBRITY. Garden City: Doubleday and Company, 1985. 299pp.

Throughout his journalistic career, Schickel has been absorbed with the complex relationship between celebrities and society. In books like THE STARS, THE DISNEY VERSION, HIS PICTURE IN THE PAPER, CARY GRANT: A CELEBRATION, HAROLD LLOYD: THE SHAPE OF HIS LAUGHTER, and D. W. GRIFFITH: AN AMERICAN LIFE, the perceptive film critic and cultural observer speculated on the manner in which celebrities manipulated their images to capture the public's attention and the

consequences. In this lively but uneven text, he turns away from examining the lives of the celebrities and focuses instead on celebrity "as the principal source of motive power in putting across ideas of every kind--social, political, aesthetic, moral." The major assumption is that symbolization makes people famous. Either individuals personify a particular value and thus gain prominence ("Steinem=feminism, Nader=consumerism"), or famous individuals symbolize society's values ("Lincoln=democracy, Hitler=fascism"). The conclusion Schickel reaches is that the act of reducing complex ideas to emblems corrupts our lives and our culture. That is, celebrities "are turned into representations for . . . inchoate longings; they are used to simplify complex matters of the mind and spirit; they are used to subvert rationalism in politics, in every realm of public life; and most important, they are both deliberately and accidentally employed to enhance in the individual audience member a confusion of the realms (between those matters of the mind that are best approached objectively and those that are best approached subjectively), matters that are already confused enough by the inherent tendencies of modern communications technology." It is a conclusion neither unique to the author nor completely persuasive to more objective critics. What is worth considering, however, are the steps that lead Schickel to his dour outlook.

He performs an impressive service by collating in one source a range of celebrity types in our culture. From the way in which the media are linked to psychotic behavior in society (e.g., the Jodie Foster-TAXI DRIVER-John William Hinkley, Jr. fantasy connection, the Norman Mailer-Gary Gilmore-Jack Henry Abbott literary controversies) to challenging the presumed role of television in influencing our day-to-day lives (e.g., it has only a marginal effect on political contests, it does not encourage emulative behavior), Schickel insists that what makes the media so dangerous is its ability to create an "illusion of intimacy" with strangers and to elevate these individuals who live in an "electric limbo" to center stage in our fantasies. His wrath is not limited to television alone. He also views film, theater, literature, art, the press, pop music, and politics as subverting our consciousness. From his agitated perspective, they have taken on new functions not only in style but also in substance. They now emphasize personalities "at the expense of ideas." Throughout eight alarming chapters, Schickel argues that this "cult of personality" has substituted "for a sense of organization, purpose, and stability in our society."

This disastrous transformation, explains the disconcerted critic, began with the nineteenth century revolution in communications technology. What was perceived at first as a boon to the flow of information--e.g., the telegraph, mass circulation newspapers, and photography--has resulted in a corruption of ideas. First, the speed and amount of information flow (particularly with the advent, in the twentieth century, of film, radio, and television) required a means of simplification. Ever since the late 1800s, the public has needed more and more symbols to assimilate and respond to the "rush of news" and the rush of its existence to behave "as reflective political creatures." Second, the new forms of communication irresponsibly mislead audiences into assuming that they have an intimate relationship with celebrities. The guiding principle in modern communications is that "names make news"; the emphasis is on emotion rather than on reason. The journalistic community that once deplored William Randolph Hearst's practices--e.g., using distortions and outright inventions to merchandise crime, disasters, human tragedies, and news as a form of entertainment--now uses them matter-of-factly both in the print and electronic press. As a result, the coverage given to politicians, performers, and tastemakers encourages the public in its misperceptions about celebrities. The problem is compounded when the false perception replaces reason as society's basis for making decisions from the trivial to the profound. At the silliest level, the worth of an athlete is measured more by salary than by talent; of a performer, more by box-office draw than by artistry. At a much more significant level, presidents are chosen more for their ability to communicate than for their ability to lead. Overworked and ill-informed politicians, entrusted with the responsibility for acting in the public's behalf, chose indecision rather than action as the best means for retaining power and for obfuscating the problems related to reform.

Schickel's subjective insights are noteworthy in the area of film and theater. For example, in analyzing the myths about F. Scott Fitzgerald and Frances Farmer, he not only speculates effectively that their careers might have ended just the same if they had never gone to Hollywood, but also argues sensibly that the "self-romanticizing myth of Hollywood as an anti-Eden . . . was too precious to the literary community, to the middlebrow world in general, to let reality even partially contradict it." His theory that film production took hold more readily in America than in England because the former had no deeply rooted theatrical tradition rings true. Arguments about what the movies have done to living theater notwithstanding, the fact is we had little to defend in American theater in the early part of the twentieth century. Thus the switch in audience interest from living theater to the visual arts can as easily be seen as a rejection of the stage as an acceptance of commercial films' standards. Schickel also deserves high marks for his stimulating interpretations of what Marlon Brando and Marilyn Monroe symbolize about our national values from the 1950s to the 1980s. The former symbolized "the new sort of cultural hero"; the latter, "the dumb blonde gone wrong." Monroe, in particular, becomes for the despairing critic the epitome of confused values--hers and society's. In his characteristically ungenerous style, Schickel links Monroe, Judy Garland, Elvis Presley, "trashed rock singers, Joplin, Morrison, and Hendrix . . . [along with] all the other prematurely dead pop artists . . . And John Lennon" to the status of permanent icons "kept alive in memory by the messy untimeliness of their departures." It is the critic's hypothesis that the ability of these stars, either living or dead, to transcend their mortal bounds and produce a "profound emotional impact" on society continues to capture the reader's interest. A principal argument found throughout the book is that traditional safeguards against the corruption of reason no longer perform their old mediating roles.

However earnestly felt or provocatively described, the author's subjective insights appear strained and shrill. Consider Schickel's argument that celebrities are a recent twentieth-century phenomenon. Linguistically that may be true. It is also fair to argue that the relationship between the public and the personality was more complex in the past. What is not persuasive is that only recently have strong personalities had the power "to cloud men's minds and to change our traditional modes of apprehending the world and responding to the world." Sheer numbers alone do not a fact make. To paraphrase Eugene Debbs, just as the public was always willing to follow a leader into Egypt, so have they been willing to follow one out. Sheep remain sheep whatever name we call them. One can also take exception to Schickel's unkind estimates of artists like F. Scott Fitzgerald ("a distinctly minor writer [who] did not achieve exemplary status hunched over his typewriter in splendid isolation") and Andy Warhol ("the dumb blonde of Hollywood lore, displaced but distinctly reincarnated"). In his eagerness to condemn, Schickel ignores or refuses to concede the value these artists had in encapsulating the mood and spirit of their times. The oversimplification may be more the fault of the audience than of the artist. Neither Fitzgerald nor Warhol repressed thought. If anything, their efforts exposed the limitations of pseudo-intellectualism in high society and the arts.

In essence, Schickel plays the very game he attacks others for playing. The more successful the individual, the easier it is to decry the celebrity's presumed influence. Instead of apprehending how celebrity as the principal source of motive power can function effectively as well as negatively, Schickel remains content only to identify the negative aspects of the celebrity system. Aside from raising the specter of envy and resentment, he too easily reworks material more originally developed by authors like Lippmann and Boorstin. Even critics favorably disposed to Schickel's text observe that "His glib pessimism prompts one to grope for the bright side of the communications revolution. After all, television is still in its infancy."[374] For carrying the torch of concern into the eighties, the critic deserves our thanks.

[374] Christopher Lehmann-Haupt, "Books of the Times," NEW YORK TIMES C (February 21, 1985):21.

But in failing to enlarge our vision, his gloomy text merely leaves us wanting more substance than rhetoric. No bibliography, footnotes, or index is provided. Worth browsing.

*Sklar, Robert. MOVIE-MADE AMERICA: A SOCIAL HISTORY OF AMERICAN MOVIES. New York: Random House, 1975. Illustrated. 341pp.

One of the most enjoyable and intelligent books ever written on the links between society and movies, this extraordinary analysis reflects the author's concern with people and their lives rather than with artists and their creations. His social history, therefore, examines the role of movies in American culture as a perceived threat to the existing order and institutions. How that challenge was met and the reactions it produced are Sklar's primary concerns in the book's four scholarly sections.

Part 1--"The Rise of Movie Culture" details the birth of the movies, the popularity of the nickleodeons, the rise and fall of the Trust, and the contributions of D. W. Griffith to the art of the film. Working on the premise that the new medium was in the right place at the right time, Sklar describes how the revolutionary changes taking place in the social structure of American life encouraged the fledgling film industry at the turn of the century. Over two decades (1890-1910), as Sklar explains, the industry matured and the nation became an industrial society.

Part 2--"The Movies in the Age of Mass Culture"--offers an impressive analysis of the birth of Hollywood, life-styles in the film capital, the genius of the silent filmmakers, the attacks on film morality, and the driving force of Adolph Zukor in shaping the movies into an oligopoly. The fast-paced, lucid prose skillfully illuminates how the thirst for respectability affected the filmmakers and their products. Particularly effective is Sklar's analysis of the strengths and weaknesses of the Payne Fund studies.

Part 3--"Mass Culture in the Age of Movies"--analyzes the effects of the Depression on the film industry, the creation of the Breen Office, the rise of a new breed of Hollywood filmmakers, the significance of directors like Frank Capra and Walt Disney, the impact of movies overseas, and the turmoil in the film capital prior to WWII. The focus is on showing why Hollywood suddenly assumed the mantle of guarding America's most cherished myths and traditions. Especially interesting are Sklar's analyses of the gangster film, screwball comedies, the changes brought about by David O. Selznick and Darryl F. Zanuck, the structure of the European film market, and the "boom-town" mentality that characterized Hollywood throughout the 1930s.

Part 4--"The Decline of the Movie Culture"--captures succinctly the reasons why WWII dramatically affected the structure of the film capital, how the movies lost their hold on American audiences, the effect of the PARAMOUNT decree on the studio system, and the steps filmmakers took to survive. The most controversial aspects of the book are the reasons that Sklar provides for the cracks that ruptured Hollywood's domination of American culture. Among the most debatable are his handling of the HUAC hearings and the tactics of the "Hollywood Ten," the role of television in hastening the fall of the studio system, the quality of the post-WWII movies, and the nature of the new independent filmmakers.

This scholarly, well-written study has a number of weaknesses common to a single-volume cultural history. First, it covers ground familiar to experts but unfamiliar to neophytes. And because Sklar's rich imagination offers exciting new avenues of research, his limited space works against the suggestions he makes about the history of American films being primarily a class struggle. Second, topics like censorship, blacklisting, and audience studies require more data and depth than this sweeping study can provide. Third, the years from 1950 to 1973 seem slighted in comparison with the first fifty years of film history.

With all its space problems, this remains the best introductory book on the cultural history of the movies. The author is not only a gifted storyteller, but also a solid researcher. His well-chosen illustrations, useful bibliography, and adequate index enhance the book's value. Recommended for general collections.

*Thomas, Sari, ed. FILM/CULTURE: EXPLORATIONS OF CINEMA IN ITS SOCIAL CONTEXT. Metuchen: The Scarecrow Press, 1982. 275pp.

Pointing out that too often film commentaries stress aesthetics over sociological perspectives, the editor focuses his attention on film as a social construct rather than as a work to be critically evaluated. "This book," Thomas writes, "will argue that social analysis enhances rather than inhibits film appreciation . . . Since cinema is inextricably entwined with social institutions (regulating production and policy), social codes (conventions of form and content), and social roles for behavior (producer, exhibitor, viewer), the elimination of this cultural context in the name of 'Art' serves only to block a richer appreciation of film. Information, in other words, should not be equated with sterility." Dividing the anthology into three major sections, Thomas provides a variety of descriptive, socially oriented analyses of the medium. Part 1, "The Industry," offers five essays dealing with the writing of film history (Daniel Manny Lund), film financing and banking (Janet Wasko), film and the non-profit media institutions (J. Ronald Green), film and labor (Robert Gustafson), and the economics of film (Douglas Gomery). Part 2, "Form and Content," examines the conventions and codes of film, with essays by Sol Worth, John Carey, Richard Chalfen, Warren Bass, and Vivian Sobchack. Part 3, "The Audience," concentrates on the social effects of movies. The contributors discuss how viewers may not need to learn cinematic codes in order to understand a film's preferred meaning (Paul Messaris), explore the behavorial implications of continuous film conventions (James Linton, Gorham Kindem, and Charles Teddlie), review the history of film's alleged effects on sexual behavior (Garth S. Jowett), comment on the public's attitudes toward filmgoing (Bruce Austin), discuss the use of film in everyday conversations (George Custen), and analyze the changing social role of film in society (Ian Jarvie).

Despite the brevity of the individual essays, their collective descriptive scholarship serves as a good introduction to the types of issues that sociological research explores. An index is provided. Well worth browsing.

*Steven, Peter. JUMP CUT: HOLLYWOOD, POLITICS AND COUNTER-CINEMA. Toronto: Between the Lines, 1985. Illustrated. 400pp.

A collection of the most provocative articles from the first decade of the polemical periodical's life, this anthology demonstrates why since 1974 JUMP CUT has been in the vanguard of American film journals in confronting the conservative values of the academic community and of the American film industry. The magazine's socialist-feminist orientation stresses political film criticism and has resulted in a limited but extremely devoted readership. This book, as Stevens tells us, has as one of its three goals expanding the audience for JUMP CUT. The other two goals relate to demonstrating the viability of political film criticism and to encouraging closer examinations of specific films and film movements. Divided into five major sections, the areas covered are "Hollywood: the Dominant Cinema," "Independent Filmmaking in North America," "Women's Counter-Cinema," "Gay and Lesbian Cinema," and "Radical Third World Cinema." An appendix on the most widely used films on Central America, a reader's guide to film and politics, and an index are included. Well worth browsing.

Tunstall, Jeremy, and David Walker. MEDIA MADE IN CALIFORNIA: HOLLYWOOD, POLITICS, AND THE NEWS. New York: Oxford University Press, 1981. 204pp.

Concerned with the role that California plays in the nation's media-induced fantasies, two British commentators provide a competent summary of what makes the paradoxical state both unique and typical of American society. Their examination concentrates on "the circumstances of California history and the location of the entertainment-producing industries." One emphasis is on showing why the state's media--its newspapers and broadcasting, with their diverse audiences and objectives--illustrate the average and special cases of American problems. Another emphasis is on comparing the multiple differences between the East and West coasts.

The former remains identified with high culture (news programming); the latter, low-culture (entertainment).

In nine uneven chapters, Tunstall (a sociology professor at the City University of London) and Walker (a London-based correspondent of THE ECONOMIST) pick away at the long-standing image of California as an un-American enclave of film degenerates and wild-eyed pinkos corrupting the political scenes. Chapters Two through Four focus on what is unique about California, especially Beverly Hills. For example, the narrative cites Ben Stein's book THE VIEW FROM SUNSET BOULEVARD as symptomatic of the conspiracy theories historically linked to Hollywood: "that living in California's sun and affluence somehow breeds up anti-American humors." Stein's work is then attacked as being too dependent on a small selection of situation comedy shows and too much influenced by "New Right ideas about the subversion of the American business culture." This opens the door for an attack on the New Right author Daniel Bell. Not only do the authors disagree with his assertions about the "normlessness" of central California life, but they also insist that the Beverly Hills image dominating the media stresses the esteem the residents have for the good life and the importance of conspicuous consumption in their lives. At the same time, attention is drawn to the film community's stinginess toward academicians. Knowing how much is to be gained by courting production people, major schools allegedly have compromised their academic programs to underplay critical studies in favor of technical competence. Here the authors demonstrate a basic weakness in their scholarship. No evidence is presented to support academic irresponsibility, nor is much thought given to the industry-related problems of production and distribution. Instead of insights into the complex relationship between industry and education, superficial judgments are passed off as accurate observations. Glibness dominates the text. Casual connections are asserted, evasive theories substitute for thoughtful analyses, and the complex relationship between the media and society is never fully engaged. One exception is the brief but perceptive comment that Hollywood never operated by the seat of its pants. Overdue recognition is given finally to the crude but valuable use of numerical indicators like fan mail, fan clubs, and sneak preview questionnaires.[375]

Chapters Five through Seven describe the alleged reasons why California is typical of the trends and tendencies in the national media. High on the list is the struggle to remove racism from the media and in the major cities and suburbs, the excessive visibility of the San Francisco and Los Angles police departments, and the constant omission from the media's spotlight of important segments of West Coast living--e.g., its agriculture, its ethnic relations, and its own media industries. Particularly interesting are the accounts relating to the failure of television and the press to adequately cover statewide politics. Tunstall and Walker effectively highlight the importance of professional campaign workers in California politics. Starting with the role played by Clem Whitaker (Sacramento journalist turned lobbyist) and Leon Baxter (Chamber of Commerce agent) to defeat Upton Sinclair in the 1934 gubernatorial campaign, the authors speculate on why media manipulation has become standard operating procedure in state politics. The final two chapters examine in more detail the impact of the Hispanic population and the implications for American society in general. "Of this mixture of the typical and the exceptional," argue the English observers, "are California dreams made."

Except for a few editing problems and occasional pedestrian analyses, this provocative book outlines what intricate relations exist among news, media, and politics. Readers familiar with the issues will appreciate the encapsulated comments. Neophytes should be careful not to take the material too literally. A good bibliography is provided but no index. Worth browsing.

[375] For another perspective, see Aljean Harmetz, "Is That Old Hollywood Tradition--the Sneak Preview--Fading Out?", NEW YORK TIMES C (February 1, 1982):11.

Wood, Michael. AMERICA IN THE MOVIES: OR "SANTA MARIA, IT HAD SLIPPED MY MIND." New York: Basic Books, 1975. Illustrated. 206pp.

Working on the hypothesis that American films affect how we think and behave, this meandering but intriguing book provides stimulating observations on the influences of Hollywood films of the forties and fifties. The two decades are loosely characterized as an era of big stars, major studios, and gigantic audiences, even though most of those trademarks began to dissipate midway through the period chronicled. Like many books penned by transplanted English critics residing in America (Wood was born in England and now teaches English and Comparative Literature at Columbia University), it provides a useful but predictable perspective on the relationship between American society and its movies. The standard theories about the films' echoing our subconscious needs, satisfying our fantasies, compensating for our disappointments, and reinforcing our dreams are treated respectfully. Hollywood's responsibility, according to Wood, is to provide us with momentary relief from our daily problems. American filmmakers achieve this questionable catharsis by manipulating modern dilemmas and by permitting us the opportunity to face our problems and then overcome them in the safety of darkened movie houses. Admittedly, the experience does a disservice to reality. What's more, the audience knows it's being deceived, but because we need a movie "fix" to survive, we consciously consume the untruths without hesitation. Wood points out that this "pack of lies" may be good for large segments of the population. Like myths of old, the myths created by the movies afford the public the opportunity to put its problems in some manageable perspective. The difficulty in analyzing contemporary films and their impact is that we are too close to the films and the times to be objective. It's only in hindsight that we begin to appreciate the complex relationship. By going back in time, however, the relationship becomes clearer. The purpose of the book, therefore, is to examine how Hollywood works its "magic." Wood insists that collectively the movies of the forties and the fifties "were a system of assumptions and beliefs and preoccupations, a fund of often interchangeable plots, characters, patches of dialogue, and sets." What is never adequately discussed is whether these conventions grew out of the studio system or suddenly emerged at the end of the thirties. He views Hollywood's repetitive nature as a means for reworking reality to create new myths for us to live by. That is, the filmmakers offer alternatives to the difficulties of living in an industrialized society and maintaining pre-industrial values of friendship, family, and togetherness. Starting with the Great Depression, he sees Hollywood as assuming the responsibility for helping us deal with a reexamination of what it means to be successful, how one determines a proper life-style, the best way to develop meaningful relationships, and what our collective responsibilities are as a moral nation in a period of global conflict. Interestingly, Wood is more concerned with "the cluster of worries" American society possesses, than with the myths themselves.

Each of the book's nine speculative chapters deals with a recurring theme and the stars that symbolize it in American movies. That is, Hollywood focuses on loneliness (Humphrey Bogart), the dangerous attraction of a FEMME FATALE (Rita Hayworth), fluctuating self-confidence (Gene Kelly), an inability to recognize evil (Alfred Hitchcock), the worry that nice guys finish last (Paul Newman), the price of success (Anne Baxter), what it means to be number one (Glenn Ford), the nature of innocence (Marilyn Monroe), and the idealized woman (Greer Garson and June Allyson). Not surprisingly, the films Wood cites as having the most influence on the public include GONE WITH THE WIND (1939), THE OX-BOW INCIDENT (1943), MILDRED PIERCE (1945), GILDA (1946), CROSSFIRE (1947), SINGIN' IN THE RAIN (1952), and THE HUSTLER (1961).

Unfortunately, Wood doesn't pay much attention to justifying his intriguing assertions, a point made by many reviewers of the book. For example, David Bromwich attacks him for misreading what the films actually state. Where Wood argues that movies like THE OX-BOW INCIDENT and CROSSFIRE typify Hollywood's penchant for presenting "a political feeling generally on the side of the mob," Bromwich insists that Jane Darwell's "war whoop" in the lynching scene in THE OX-BOW INCIDENT

shows that just the opposite is true.[376] Paul J. Vanderwood, while sympathetic to Wood's speculations, nonetheless faults him for failing "to give other than school boyish historical explanations for the foundation of American myths and the succeeding impact of a developing America on those myths. . . ."[377] Gerald Weales, admitting to "an uneasy mix of admiration and misgiving, of acceptance and dismissal, of praise and blame," finds Wood's book "derivative and too often platitudinous." I am particularly sympathetic to his conclusion that "Wood's generalizations tend toward the obvious (the Fifties were less placid than they looked), and the movie discussions are usually too brief, allusive, and familiar."[378] Even Arthur Schlesinger, Jr., who begins his review with the comment that "This book is an astute and absorbing meditation on the American movies," attacks Wood for "subjective and impressionistic" scholarship and concludes with the caveat that "meditation is an art form that should be reserved to the attentive and scrupulous observers."[379]

In short, this controversial study is filled with provocative ideas and vexing comments that reinforce the assumptions made by authors like Stanley Cavell, Barbara Deming, Siegfried Kracauer, Nathan Leites, Marjorie Rosen, Robert Sklar, Parker Tyler, and Martha Wolfenstein. And despite its aforementioned weaknesses, it offers an entertaining, albeit disappointing, source of interest. An index is provided. Worth browsing.

FILMS

DIRTY HARRY (Warner Bros.--16mm: 1971, 103 mins., color, sound, R-FES, FNC, SWA, TWY, WIL; anamorphic version, TWY)

Directed by Don Siegel, the screenplay by Harry Julian Fink and Rita M. Fink deals with a rogue cop (Clint Eastwood) who ruthlessly pursues criminals and who rejects their constitutional rights. He is given every dirty assignment that San Francisco law enforcement agencies are unable to deal with through legitimate means and yet is despised by the authorities as a man unfit to mingle with decent people. To a large degree, the film equates physical action with real justice and ridicules those who claim that the end does not justify the means. Filled with continuous violence, expertly crafted, and forcefully acted by Eastwood, the film is one in a series of "Dirty Harry" movies extolling vigilantism in police work. Seth Cagin and Philip Dray point out that this modern cop film is a prototype of the notion that "'One man's sense of right,' an American theme and a counter-culture theme, has . . . been reappropriated by a conservative standard bearer, mutated from a radical into a reactionary precept."[380]

YOUNG MR. LINCOLN (Fox--16mm: 1938, 100 mins., b/w, sound, R-FNC, IVY, TWY)

[376] David Bromwich, "Not What They Seem," NEW YORK TIMES BOOK REVIEW (August 3, 1975):5.

[377] Paul J. Vanderwood, "Book Review: AMERICA IN THE MOVIES," JOURNAL OF POPULAR FILM 5:1 (1976):80.

[378] Gerald Weales, "Books," FILM COMMENT 12:4 (July-August 1976):62-3.

[379] Arthur Schlesinger, Jr., "Hollywood and the Collective Myth," AMERICAN FILM 1:1 (October 1975):75-6.

[380] *Seth Cagin and Philip Dray, HOLLYWOOD FILMS OF THE SEVENTIES: SEX, DRUGS, VIOLENCE, ROCK 'N' ROLL & POLITICS (New York: Harper & Row, 1984), p.219.

Directed by John Ford, the Lamar Trotti screenplay depicts the early career of Lincoln (Henry Fonda) in Springfield, Illinois, where the future president makes a name for himself as a skilled trial lawyer. Two brothers are accused of murder, but neither one is guilty. The manner in which Lincoln arrives at the truth underscores his compassion and wisdom, as well as demonstrates the lawyer's fitness to lead the nation in years to come. The film itself has become a fixture in political film criticism as an example of how filmmakers not only reconstruct history to interpret contemporary issues, but also how critics can deconstruct a film to locate crucial paradoxes in film ideology.

Z (France--16mm: 1969, 128 mins., color, sound, English subtitles, R-CIV)
Based upon Vassili Vassilokos's novel, this masterful political thriller focuses on the moral dilemma of a conscientious government investigator who discovers that the state has murdered an important pacifist leader of the opposition party. Yves Montand and Jean-Louis Trintignant are superb as the pacifist and government official, respectively.[381] Nominated for four Oscars, including Best Picture, Best Director, and Best Screenplay Based on Material from Another Medium (Jorge Semprun and Costa-Gavras), it won for Best Film Editing (Francoise Bonnot).

PSYCHOANALYSIS AND FILM

In this section we continue to explore the question of how films affect our culture. Do they change our behavior or reinforce our dreams? Are they part of a continuum or separate works? A major assumption is that the mass media in general and film in particular reveal, through the use of stock situations and social types, significant data about us and our culture. The hypothesis is that while artists may use the media to symbolize covert and forbidden material, audiences may see, in the finished product, images of their repressed fantasies. In the end, both the creator and the receiver are able to use the symbolic forms as a means of satisfying certain basic desires and needs. The process, therefore, is one more indication of the general role that movies play in human communication. It further illustrates the complex relationship between filmmakers and their audiences. It also underscores the limitations of reductionist theories that limit film analyses to profits, escapism, identification, or entertainment.

No one seriously doubts that people view films differently. What is not often understood is how film and psychological analyses interrelate. To appreciate how the process operates, Jowett identifies a number of critical areas to examine: the psychology of movie viewing, movie viewing as a collective experience, the use of psychological techniques in movie marketing, the nature of film analysis, and the role of movies in society.[382] The underlying assumption uniting each of the categories is that movies affect us both individually and as members of a social community. How that works has been discussed in part earlier and will be taken up in more detail later in this chapter. We need only remember at this juncture that responsible members of society since the birth of mass communications have been worried about the political, moral, and social consequences of the mass media on our lives. "Research activity began," McQuail and Windahl explain, "with practical concerns and was fed by developments in psychology and sociology and by general advances in methodology, especially the use of experiments, social surveys and statistics."[383] Film critics and

[381] In addition to COSTA-GAVRAS: THE POLITICAL FICTION FILM, see Joan Mellen, "Fascism in the Contemporary Cinema," FILM QUARTERLY 24:4 (Summer 1971):2-19.

[382] Jowett and Linton, pp.87-101.

[383] McQuail and Windahl, p.5.

historians in the silent film era put their faith in the "hypodermic" effects theory, making the assumption that the industry's film values and ideas impacted directly on passive and naive audiences. As we shall see, by the forties advances were made in mass communication research that shifted attention away from the "direct" effects approach and toward more sophisticated models that took into account a range of variables: e.g., the mediating influence of personal contacts, the nature of the information being disseminated, and the unintentional consequences of messages read "against the grain."[384]

In the meantime, depth psychologists, as Roy Huss points out, have developed a number of important theories to explain how the representational arts relate to individual feelings and emotions. For example, Alfred Adler's ideas on the relationship between the family and society and the manner in which they shape individual power drives and complexes force us to consider more than just one variable in examining social behavior.[385] The representational arts thus become an object lesson in how the family, society, and the state operate to shape and to manipulate human beings. Through an artist's imagination and talent, archetypal characters and events are created. These, in turn, become clinical case studies that can be analyzed by researchers to illustrate how body movements, physical distances, and specific actions reveal the psychological process of personalities. In such interpretations, the primary emphasis is on character analysis.

Another major concern of film scholars in this area is the complex relationship among psychiatry, film, and dreaming. For example, Marsha Kinder explored the findings of many researchers who perceived dreaming as a possible "evolutionary mechanism that mediates between genetic programming and cultural imprinting. . . ."[386] Her efforts convinced her that dreams are determined in part by the "reservoir of memories" that the forebrain draws upon to generate the self-images an individual uses. These images, molded by the society in which the dreamer resides, are being shaped by high technology almost to the same degree as it is transforming our everyday lives. In Kinder's view,

> The fact that visual images are directly recorded by our brain, and reprocessed in our dreams, means that they readily become part of us. we have an extraordinary capacity to become what we see. Literature cannot influence our dreams as strongly as film and television because it is not a visual medium Reading is essentially a private act . . . We have much less control over visual media, where the rhythms are set by the editing and where the images represent the external world more directly and concretely than words, thus giving them another meaning besides those established by the particular context in which they appear.[387]

What intrigues Kinder is the interplay between dreams and films. That is, dreams not only are adapted to a multitude of film types, but the various art forms are also incorporated into an individual's dreams. J. Allen Hobson shares a number of Kinder's assumptions about the relationship between dreams and film. First, he too believes that there is a basic similarity among film technique and film images, dreaming sleep, and the dream. Second, he feels that dreams and film produce similar psychological effects. These isomorphisms, or affinity of forms, explain his respect

[384] McQuail and Windahl, p.7.

[385] Huss, pp.52, 55-7.

[386] Marsha Kinder, "The Adaptation of Cinematic Dreams," DREAMWORKS 1:1 (Spring 1980):54.

[387] Kinder, p.54.

for "Fellini's proposition that film is a dream, and its corollary that film is a model of the dream experience."[388] In addition, Nick Browne and Bruce McPherson skillfully argue that filmmakers since the birth of the cinema have reinforced the theory that a complex relationship exists between dream and film. Furthermore, that analogy--"not just the observations of a line of distinguished German, French, and American critics, whose work constitutes something of an 'approach'--has served as a formal and practical model" for films like THE CABINET OF DR. CALIGARI/DAS KABINETT DES DR. CALIGARI (1919), ORPHEUS/ORPHEE (1949), and LAST YEAR AT MARIENBAD/L'ANNEE DERNIERE A MARIENBAD (1961).[389]

One word of caution is worth raising about a too facile assumption that film occupies a unique relationship to human unconsciousness. As Paul Sandro reminds us, the notion does not generally acknowledge the fact that much of the cinema's treatment of the unconscious derives from nineteenth-century literary conventions. Moreover, he points out that "These narrative conventions are supported by a more general desire for continuity that recent theoretical studies in psychoanalysis and cinema trace to the splitting of the psyche in the human subject's development of an ego."[390] In simpler terms, the way we approach the unconscious is determined in part by cultural codes and by past perceptial practices.

Given the current interest in the relationship not only between psychiatry and film but also between the film and the spectator, it makes sense to examine both the theories about dreams (normal, though puzzling) and about insanity (abnormal and puzzling).[391] Helpful in that purpose is Michael Fleming's summary of the history of the perception and treatment of insanity through the ages. He points out that two opposing traditions reflected society's attitudes toward madness up to the middle of the nineteenth century. The oldest was the "psychodynamic orientation." It explained mental illness as the result of forces in the unconscious being continously in flux. The more contemporary approach was the "organic orientation." It explained abnormal behavior in terms of physical disorders. From these two basic perspectives emerged a series of models of how to deal with insanity. One was the "medical model." It asserted that a physician was the expert in analyzing the treatment and prognosis of mental illness. A second approach was the "impaired model." Although it too relied on the physician as the expert in treating mental illness, the theory assumed that insanity was an incurable disease and that doctors were more supervisors than healers. A third approach was the "moral model." It presumed that mental illness was dysfunctional behavior. What was required, therefore, was to educate the patient to what was socially acceptable behavior. A fourth approach was the "psychoanalytic model." Here the assumption was that people behave abnormally as a result of not repressing traumatic experiences or repressing them too much. Fleming then went on to add three additional models that have emerged since the 1960s. For example, the "social model" theorized that madness was linked to the social order. The more unstable the culture, the more aberrant the behavior of its members. The "psychedelic model" portrayed mental illness as another type of human experience. In such mental states, insanity was only a stepping stone to another world. Finally, the

[388] J. Allan Hobson, "Film and the Physiology of Dreaming Sleep: The Brain as a Camera-Projector," DREAMWORKS 1:1 (Spring 1980):9.

[389] Nick Browne and Bruce McPherson, "Dream and Photography in a Psychoanalytic Film: SECRETS OF A SOUL," DREAMWORKS 1:1 (Spring 1980):35.

[390] *Paul Sandro, DIVERSIONS OF PLEASURE: LUIS BUNUEL AND THE CRISES OF DESIRE (Columbus: Ohio State University Press, 1987), p.14.

[391] For an interesting perspective on psychoanalysis as a cultural theory, see Sandy Flitterman-Lewis, "Psychoanalysis, Film, and Television," CHANNELS OF DISCOURSE: TELEVISION AND CONTEMPORARY CRITICISM, ed. Robert C. Allen (Chapel Hill: The University of North Carolina, 1987), pp.172-210.

"conspiratorial model" viewed mental illness not as a reality but as a prognosis made by powerful people to keep their opponents oppressed.[392] The value of these admittedly tentative classifications becomes readily apparent once they are applied intelligently rather than indiscriminately to specific films related to dreams and dream theory. For example, the conspiratorial model is applicable to films like THE DEER HUNTER (1978) and APOCALYPSE NOW (1979), the impaired model WHITE HEAT (1949) and IN COLD BLOOD (1968).

Because the history of film is replete with examples of psychologists and mass communication scholars drawing links between the medium and real-life situations, it is not surprising that film critics often comment on how ideas borrowed from the discipline of psychology are used in movies to influence society. According to Michael Wood,

> The business of films is the business of dreams, as Nathanael West said, but then dreams are scrambled messages from waking life, and there is truth in lies, too, as Lamar Trotti wrote in the screenplay of THE OX-BOW INCIDENT (1943), if you get enough of them . . . Much of our experience of popular films--and of popular culture generally: jokes, plays, novels, songs, night-club acts, television shows and series--resides in the place we usually call the back of the mind, the place where we keep all those worries that won't come out into the open and won't go away either, that nag at us from the edges of consciousness.[393]

The Hollywood movie becomes for Paul Weitz a modern folk art. "For better or worse," he explains, "they [American films taken altogether] are a real reflection, as are foreign films presented in the United States, which tend to represent the best of a given society."[394] The "worse" undoubtedly refers to the filmmakers' reliance on stock situations to describe complex relationships. J. P. Mayer emphasizes the strong emotional appeal movie stars have for the public. "It is quite common," he points out, "for the dreamer, male or female, to imagine himself or herself in the place of the hero or heroine of the particular film."[395] This point relates directly to Klapp's observations about a spectator's inadequate relationships resulting in the creation of stereotypes, which, in turn, symbolize how the spectator should behave or act. Raymond Durgnat claims that "For the masses, the cinema is dreams and nightmares, or it is nothing. It is an alternative life, experience freed from the tyranny of that 'old devil consequences,' from the limitation of having only one life to lead." He then goes on to add, "WE are the immortal Gods watching the screen characters live their anguished lifetime-in-90-minute lives . . . Art doesn't really make the artist immortal, but it makes the audience FEEL immortal."[396] Durgnat is making a point similar to that suggested earlier by Walsh, namely, that popular culture's power resides in its metaphors and symbolic modes and not in how closely the media product represents reality. Sam L. Grogg, Jr., and John C. Nachbar assert that "To view

[392] Michael Fleming and Roger Manvell, IMAGES OF MADNESS: THE PORTRAYAL OF INSANITY IN THE FEATURE FILM (Rutherford: Fairleigh Dickinson University Press, 1985) pp.21-7. For another interesting approach, see Rudolf Arnheim, "The Artistry of Psychotics," AMERICAN SCIENTIST 74:1 (January-February 1986):48-54.

[393] Michael Wood, AMERICA IN THE MOVIES: OR "SANTA MARIA, IT HAD SLIPPED MY MIND" (New York: Basic Books, 1975), p.16.

[394] Paul Weitz, NEW YORK FILM FESTIVAL, September 8, 1965.

[395] J. P. Mayer, SOCIOLOGY OF FILM (London: Faber and Faber, 1946), p.153.

[396] Raymond Durgnat, FILMS AND FEELINGS (Cambridge: The M.I.T. Press, 1967), p.135.

an American film is to witness the dreams, values, and fears of the American people, to feel the pulse of the American culture."[397] Here again the emphasis is on popular culture as a two-way process in which the audience contributes a significant portion of the media product's meaning and reception.

Martha Wolfenstein and Nathan Leites postulate what has now become a cliche: that "daydreams" serve as the touchstone of literary and dramatic works. Through the talents of poets, dramatists, novelists, and screenwriters, the subconscious, forbidden desires and fantasies of a society sharing a common culture take on a collective image identifiable to mass audiences. "These ready-made daydreams," explain the researchers, "come to occupy a larger place in the conscious experience of most individuals than their most fugitive, private, home-made daydreams." Viewers can first experience these common "daydreams" and later reject them. In the end, everyone rationalizes that what occurred in the screenings was merely escapist entertainment with no ties to reality.[398] Put another way, popular culture through its use of myths and symbols provides excellent insights into a nation's collective perceptions.

Also employing the "daydream" theory and the image of American film studios as "dream-factories," Parker Tyler hypothesizes that

Hollywood is but the industrialization of the mechanical worker's daylight dream . . . extended ritualistically into those hours reserved by custom for relaxation and amusement. The compulsiveness of the movie habit is neither simple nor limited; it has power even over those who escape from intimate concern with the wheels of the material world. For after all, such an escape is in great part an illusion--as though we could escape from the dark. The best we can do is to isolate ritually the dark from the light.[399]

Tyler, like many of his associates, is stressing the fact that entertainers do not impose their products of pleasure unilaterally on a passive audience. In fact, the reason why residual, dominant, and emerging social values intersect to form a cultural hegemony is because a major portion of the popular culture audience is "addicted" to having their emotional needs satisfied in the mass media-audience relationship. Furthermore, addiction to film viewing is not limited to a particular age group, specific background, educational level, or type of illness.

What is common to movie addicts is the pleasure they derive from being in a well-defined, secure environment where they can empathize with the make-believe exploits of screen personalities. Harvey R. Greenberg, a psychologist who is also a self-proclaimed movie addict, argues that

Cinema is a supremely valid source of free associations, a powerful touchstone into the unconscious. The movies, like waking dreams, interpret every aspect of our lives--the unquiet past, the troubled present, our anxious premonitions

[397] Sam L. Grogg, Jr., and John C. Nachbar, "Movies and Audiences: A Reasonable Approach to American Film Criticism," *MOVIES AS ARTIFACTS: CULTURAL CRITICISM OF POPULAR FILM, ed. Michael T. Marsden et al. (Chicago: Nelson-Hall, 1982), p.5.

[398] Martha Wolfenstein and Nathan Leites, THE MOVIES: A PSYCHOLOGICAL STUDY (Glencoe: The Free Press, 1950), pp.12-3.

[399] *Parker Tyler, THE HOLLYWOOD HALLUCINATION. Introduction Richard Schickel (New York: Simon and Schuster, 1944; New York: Simon and Schuster, 1970), p.237.

of the future, our neurotic conflicts and our inspired gropings toward the light.[400]

In effect, what Greenberg is suggesting is that popular culture not only acts as an escape mechanism, but also as a means of experiencing the unconscionable in a responsible way. That is, through vicarious relationships we can participate in acts that a conservative ideology defines as forbidden in our day-to-day lives. The importance of these psychological and impressionistic studies for film students is that they allow us to speculate about how audiences organize their experiences by projecting onto the film their personal and everyday visions. In Greenberg's terms, "We let the movies take up where we have left off: they seem to think like us and therefore it is amazingly easy to let them think--and live--FOR us."[401]

The complex relationship between dreaming and film has also been examined from the perspective of how filmmakers use their skills to create the oneiric aspect of movies. The first significant study, as discussed in Chapter 1, was done by the Harvard psychologist Hugo Munsterberg. In his ground-breaking investigations of the primitive photoplay, the noted scholar discovered that the filmmaker's use of close-ups and flashbacks made it possible to manipulate significantly the viewer's attention and emotions:

> The photoplay can show in intertwined scenes everything which our mind embraces . . . THE PHOTOPLAY TELLS US THE HUMAN STORY BY OVERWHELMING THE FORMS OF THE OUTER WORLD--NAMELY, SPACE, TIME, AND CAUSALITY, AND BY ADJUSTING THE EVENTS TO THE FORMS OF THE INNER WORLD, NAMELY, ATTENTION, MEMORY, IMAGINATION, AND EMOTION.[402]

Central to Munsterberg's theory was the notion that movies work best when they appeal to our imagination rather than to our intellect.

In the decades that followed, scholars and film critics on both sides of the Atlantic continued the investigation of how movies could represent various psychological states of mind and how films approximated dreams. Among the more prominent investigators, as Vlada Petric points out, were Robert Desnos, Rene Clair, Jean Epstein, Andre Malraux, Serge Lebovici, Ado Kyrou, George Linden, F. E. Sparshott, Charles Tart, Sergei M. Eisenstein, Lotte Eisner, P. Adams Sitney, David Curtis, Jean Cocteau, and Ingmar Bergman.[403] Most of these investigations focused on the movies' surrealistic qualities rather than on what made film so similar to dreams.

Susanne Langer was one notable exception. In FEELING AND FORM: A THEORY OF ART DEVELOPED FROM "PHILOSOPHY IN A NEW KEY," she explores the similarities and differences between movies and dreams. At the outset, Langer makes

[400] *Harvey R. Greenberg, THE MOVIES ON YOUR MIND (New York: Saturday Review Press 1975), p.3.

[401] Greenberg, p.6.

[402] *Hugo Munsterberg, THE PHOTOPLAY: A PSYCHOLOGICAL STUDY (New York: D. Appleton and Company, 1916; New York: Dover Publications, 1970), p.74. All quotations in this chapter are from the 1970 edition.

[403] *Vlada Petric, "A Theoretical-Historical Survey: Films and Dreams," FILMS AND DREAMS: AN APPROACH TO BERGMAN, ed. Vlada Petric (South Salem: Redgrave Publishing Company, 1981), pp.1-48. The British periodical SCREEN also has number of articles published between 1973 and 1982 that examine the psychological relationship between image and viewer.

it clear "(1) that the structure of a motion picture is not that of a drama, and indeed lies closer to narrative than to drama; and (2) that its artistic potentialities became evident only when the moving camera was introduced."[404] What is unique about film, Langer insists, is that "it makes the primary illusion--virtual history--in . . . THE DREAM MODE."[405] That is, movies create the impression that what is being shown is actually happening now. This is quite different from art forms that try to represent what the past was like or to induce feelings of remembrance. Put another way, the narrative form of the cinema suggests that it is like the drama or the novel in telling a story, but the mode of film presentation "creates a virtual present, an order of direct apparition."[406] Of particular importance in the process, Langer explains, is that the movies are identical to dreams in that both modes place the dreamer-percipient at the center of the presentation. No matter what events, actions, or other people are employed in the narrative, the film is perceived from one individual's perspective: that of the viewer. Finally, Langer makes it clear that her theory is related to ideas developed not only by Eisenstein, but also by critics like R. E. Jones and Ernest Lindgren.[407]

Petric's invaluable scholarship surveys what was done up to the late 1970s to answer essential questions on how filmmakers achieve their dreamlike imagery and how viewers are affected on both the psychological and physiological levels. For our purposes, what is most useful is his summary of how the narrative cinema treats dreams in four specific ways:

Thematic: the emphasis on dream content within the narrative framework of the film

Psychoanalytical: the associative-symbolic interpretation of dream content in relation to the function of the characters and conflicts between them

Psychological: the mental activity and emotional states evoked in the viewer during and after watching a film

Physiological: sensory-motor and vestibular activation incurred by the act of viewing a film, including the possibility of modifying the interpretation of dream content by the increased physiological responses in the viewer's neural centers.[408]

Adding to Petric's useful essay is his list of filmmakers who have used elements of dream structure from the start of the cinema to the mid-1970s: e.g., Georges Melies, D. W. Griffith, Fritz Lang, Sergei M. Eisenstein, Charles Chaplin, Peter Weir, Jean-Luc Godard, Bernardo Bertolucci, Ken Russell, Federico Fellini, Kenji Mizoguchi, and Ingmar Bergman.

One striking omission in Petric's study, however, is the absence of any meaningful discussion of the work of Christian Metz. His important views, as discussed in Chapter 1, represent the most significant contemporary focus on Freudian psychoanalysis and its relationship to the nature of cinematic spectatorship,

[404] *Susanne K. Langer, FEELING AND FORM: A THEORY OF ART DEVELOPED FROM "PHILOSOPHY IN A NEW KEY" (New York: Charles Scribner's Sons, 1953), p.411.

[405] Langer, p.412.

[406] Langer, p.412.

[407] For more information, see Sergei M. Eisenstein, *THE FILM SENSE, trans. and ed. Jay Leyda (New York: Harcourt Brace & Company, 1942), pp.4, 8, 17, 31, 33; *R. E. Jones, THE DRAMATIC IMAGINATION: REFLECTIONS AND SPECULATIONS ON THE ART OF THE THEATRE (New York: Duell, Sloan & Pearce, 1941), pp.17-8; and Ernest Lindgren, THE ART OF THE FILM (London: Allen & Unwin, 1948), p.92.

[408] Petric, p.24.

as well as on the links between film and voyeurism, fetishism, perception, fantasy, and secondary identification.[409] But Metz's theories, as Gaylyn Studlar notes, are not the only models currently being studied: "Interesting models have been adapted from the neurophysiological dream research that has directly challenged Freud's conclusions and replaced his disguise-censorship theory of dream with an activation-synthesis model."[410]

The most recent book-length scholarly hypothesis on the complex relationship between dreaming and film is presented by Robert T. Eberwein.[411] Taking the position that watching movies thrusts us "back in time to infancy," Eberwein draws heavily on Bertram Lewin's theory of a "dream screen" consisting of two key elements: "the mother's breast, or a surrogate for it, and our own sense of self, the ego."[412] The elements combine to shape a dream screen that presents dreams to the sleeper. That is, the sense of oneness experienced by us in infancy remains with us as we mature. When we "dream," we not only regain that contact with the oneiric universe of our childhood, but also suspend disbelief in terms of the unrealistic and illogical elements that appear to us in our dreams. Eberwein argues that films trigger that sense of oneness. In his words, "the filmic and oneiric worlds are extensions of ourselves and we seem to inhabit the same space."[413] To prove his point, the imaginative author offers a taxonomy of dreams generally associated with specific characters: e.g., dreams that reveal what it is like to be drugged or drunk--Emil Jannings in THE LAST LAUGH/DER LETZE MANN (1924); Mia Farrow, ROSEMARY'S BABY (1968); dreams depicting traumatic events--Isabelle Adjani in THE STORY OF ADELE H./L'HISTOIRE D'ADELE H. (1975), Timothy Hutton, ORDINARY PEOPLE (1980), and dreams depicting anxieties--Werner Krauss in SECRETS OF A SOUL (1926), Paul Newman, BUFFALO BILL AND THE INDIANS, OR SITTING BULL'S HISTORY LESSON (1976). The pleasure we derive from watching such films, according to Eberwein, is that the dreamlike quality of the movie propels us back to infancy, where ego fused with the mother's breast and we identified "with those characters who are 'not-me.'"[414] In many respects, the author is making a point about the spectator-subject's unity that is quite similar to a Lacanian-style analysis of movies.

[409] *Christian Metz, THE IMAGINARY SIGNIFIER: PSYCHOANALYSIS AND THE CINEMA (Bloomington: Indiana University Press, 1982), pp.99-147.

[410] Gaylyn Studlar, "Book Review: FILM AND THE DREAM SCREEN: A SLEEP AND A FORGETTING," FILM QUARTERLY 39:1 (Fall 1985):54.

[411] For a listing of sources relating to film and television studies on the oneiric effect of dreams on the moving image, see Marsha Kinder, "Music Video and the Spectator: Television, Ideology and Dream," FILM QUARTERLY 38:1 (Fall 1984):2-15.

[412] Robert T. Eberwein, FILM AND THE DREAM SCREEN: A SLEEP AND A FORGETTING (Princeton: Princeton University Press, 1984), pp.3-4. For another perspective on Lewin's theories and their relationship to film, see Jean-Louis Baudry, "The Apparatus: An Introduction," CAMERA OBSCURA: A JOURNAL OF FEMINISM AND FILM THEORY 1 (Fall 1976):99-126.

[413] Eberwein, p.5.

[414] Eberwein, p.41. Professor Richard E. Musty, a member of the Psychology Department at the University of Vermont, considers this position "idle nonsense." He writes, "One can call it hypothesis, but I doubt if we showed people these films that we would produce any evidence of an 'infancy' response in viewers." Musty, a note to author, September 10, 1986.

Given the current popularity of psychoanalytic theories, it is predictable that modern-day film scholars stress the importance of exploring how film technique exploits the spectator's willingness to suspend disbelief and accept what is projected on screen as a facsimile of reality. For example, Kaplan points out that an excellent reason for studying psychoanalytic discourse is because it may have contributed to the oppression of women. Working on that premise, she argues that "we need to know exactly HOW psychoanalysis has functioned to repress what we can potentially become. . . ."[415] Koch goes further, arguing that "The psychoanalytic approach aims at the psychic appropriation and conversion of what is seen."[416] That is, psychoanalytic discourse makes clear the emotional relationship between the film and the spectator. In addition, it draws attention to how the filmmaker evokes that reception in the viewer. "Films, therefore, are not so much reflections of external or social nature," asserts Koch, "as they are reflection and product of the inner nature of the subjects: their wishes, needs, erotic images, drives, etc."[417]

The issues of pleasure, escapism, marketing, identification, stereotyping, celebrity influences, and the need to distinguish between reality and fantasy have already been reviewed. These issues will reappear as we discuss the nature of film audiences; the difficulties presented by stereotypes of women, African-Americans, and Jews; and the steps taken by social organizations seeking to control the content of film. Here we turn our attention to the hypothesis that films operate as forms of compensatory gratification for filmmakers and audiences. In particular, we look at the issue of psychoanalysis, psychotherapy, and the possibilities these disciplines have for film studies and for our interest in film stereotyping.

Of more than passing interest to screen educators is the work of film critics and therapists exploring the thin line between normality and neuroticism and the psychological reactions that members of society have to film images.[418] Obviously, not everyone approaches the problem in the same way. Some scholars turn to psychoanalytic theories as a means of determining how people develop their self-perceptions and their personal motivations. Others examine how representations of our social institutions have evolved and what their links are to social and economic conditions. Because these theoretical constructs appear repeatedly throughout current film literature, I need to review in more detail first what the value of psychoanalytic analysis is to film studies, and second, what its limitations are.

At the outset, we need to understand, as Lynne Zeavin and Adrienne Harris succinctly point out, that psychoanalysis can operate as an ideology as well as a clinical theory. As an ideology, psychoanalysis views clinical practice as a radical means of revealing an individual's unconscious wishes and fantasies. The analysis focuses on the close ties between culture and society. In emphasizing therapy, however, the clinical theory takes on a more conservative character. Instead of examining the culture's influence on an individual's disorder, the therapist frequently strives to make the individual accept his or her environment. Accommodation and positivism rather than criticism and cynicism dominate.[419] Whether Europeans favor

[415] Kaplan, WOMEN AND FILM, p.24.

[416] Koch, p.52.

[417] Koch, p.52.

[418] For some useful essays, see Raymond Bellour, "Psychosis, Neurosis, Perversion," CAMERA OBSCURA: A JOURNAL OF FEMINISM AND FILM THEORY 3/4 (1979):105-32; Stephen Heath, "Film and System: Terms of Analysis, Part I," SCREEN 16:1 (1975):7-77; ___, "Part II," ibid., 16:2 (1975):91-113; and Penley, pp.3-33.

[419] Lynne Zeavin and Adrienne Harris, "Book Reviews of WOMEN'S PICTURES and WOMEN IN FILM," CINEASTE 14:1 (1985):56.

a more radical approach than Americans to psychoanalysis, as Zeavin and Harris claim, is a matter of debate.

Also highly debatable is the value of approaching a work of art from a psychoanalytic perspective. Huss identified four standard objections to psychoanalytic interpreters and four counterarguments. For example, critics argue that "A fictional character is not a person with a past or a future beyond the text, and therefore cannot be subjected to an analysis of his presexual development, childhood traumas, etc."[420] Huss's counterargument is that people concerned with the representational arts focus on characters possessing easily recognizable human qualities. Even further, traditional literary critics emphasize the importance of human emotions in analyzing a work in terms of motivation, denouement, climax, and catharsis. Thus, the best criticism, in Huss's view, sheds light on the unity of a work, rather than on its isolated parts. A second objection to psychoanalytic criticism is its reductive nature. But the counterargument is that psychoanalytic interpreters who concentrate on "uncovering the dynamics of relationships" offer a "holistic rather than a reductive" criticism.[421] A third objection is that psychoanalytic interpreters fail to distinguish good from bad works. Here Huss argues that no school of criticism can go beyond its own frame of reference. "The best that can be said of psychoanalytic interpretation," he states, ". . . is that it can reveal . . . whether there is real connectedness among apparently disparate parts."[422] The fourth objection identified is that pyschoanalytic criticism insists that art arises out of the artist's pathological state or era. Huss points out that while this may have been true in the past, recent psychological critics like Gilbert Rose and Normand Holland "draw upon the concept of an integrative and synthesizing force in the ego and in the self . . . rather than counting on merely defensive maneuvers at work."[423] In short, approaching a work of art from a psychoanalytic perspective has drawbacks as well as virtues.

One controversial approach involving psychoanalytic analysis and film is the use of a film star as an illustration of how an abnormality could be treated. Consider the case of Marilyn Monroe and Heinz L. Ansbacher's application of Adlerian theories to Monroe's various suicide attempts.[424] Although he never met his famous "patient," the bold clinician used two specific media reports on the unfortunate actress as the basic data for his novel interpretation of what might have been done for the "immature" star who "remained unprepared to meet the tasks of life as a human being."[425]

[420] Huss, p. 11.

[421] Huss, p. 12.

[422] Huss, pp. 12-3.

[423] Huss, p. 14.

[424] Heinz L. Ansbacher, "Goal-Oriented Individual Psychology--Alfred Adler's Theory," OPERATIONAL THEORIES OF PERSONALITY, ed. Arthur Burton (New York: Brunel-Mazel Publisher, 1974), pp. 123-42. For another application, see Heinz L. Ansbacher et. al., "Lee Harvey Oswald: An Adlerian Interpretation," PSYCHOANALYTIC REVIEW 53:3 (1966):55-66.

[425] Ansbacher, p. 125. The articles related to Monroe are Richard Meryman, "Interview with Marilyn Monroe," LIFE 53:5 (August 3, 1962):31-4, 36, 38; and TIME (August 10, 1962):45. The noted psychologist also commented on the Monroe case in Heinz L. Ansbacher, "Alfred Adler, Individual Psychology, and Marilyn Monroe," PSYCHOLOGY TODAY 3:10 (February 1970):42-4, 46.

Ansbacher deduced that there was little correlation between the fact that Monroe's film success was based on her sexual attraction and the assumption that she was uninterested in sex and unable to deal with her feminine role in real life. Before beginning to answer questions like why the actress couldn't succeed emotionally and why she felt inferior, the psychological investigator explained that the purpose of his therapy would be "to attempt to modify [the patient's] goal, which would also involve opinion of the self and the world, in order to attain more self-transcending, contributive, and satisfactory behavior."[426] Each instance of difficulty he detected in Monroe's (reported) behavior--e.g., obsession with nudity, lack of social interest, and refusal to take responsibility for her actions--provided Ansbacher with an opportunity to describe how behavior modification might occur. For example, he pointed out that Monroe's pampered childhood gave her the basis for always blaming other people for the problems she herself created. This error in her life-style could then be corrected "by getting her to see what she is really doing, namely behaving as if she were not subject to the common human order of living."[427]

Whether one agrees or disagrees with this Adlerian theoretical examination, let alone with the conclusions that Ansbacher draws about Monroe's life-style, is less important than recognizing that some knowledgeable people see celebrities as prime illustrations of personality disorders in our society. They believe that a discussion of a particular star's problems can provide a valuable service in improving a society's mental health and in helping students to understand the nature of mental disorder.

Clearly, Ansbacher's approach is but one psychoanalytic technique used in film studies. Many feminist film theorists (e.g., Pam Cook, Claire Johnston, Gertrud Koch, Julia Lesage, Christine Gledhill, E. Ann Kaplan, Annette Kuhn, Mary C. Gentile, and Laura Mulvey) rely on psychoanalytic theory not as a major tool for film analysis, but as an extremely important technique for sensitizing viewers to the manner in which meaning is related to the perspective of an individual seeing a film. "With its emphasis on the role of the unconscious and fantasy," Kaplan points out, "psychoanalysis revealed that watching films or T.V. is far from a simple, one-way process and that a complex, dialectical relationship in fact exists between media productions and the people who watch them."[428]

In her assessment of what is being done by scholars to clarify the precise nature of the film-viewing relationship, Kaplan refers to the influence of Althusser and Barthes. The former is credited with perceiving "ideology as a series of representations and images . . . linked to the unconscious . . . [and not] to the ideological component in all bourgeois institutions and modes of production. . . ."[429] Those who follow Althusser's lead feel that audiences need to confront the images and illusions created by the media in order to understand how ideology operates in our lives. The contributions of Barthes to psychoanalytic film criticism stem from his studies on the sign systems that operate in the cultural world. Feminists build on his theories of everyday behavior and dress, sexual relationships, and language to demonstrate how our values are shaped unconsciously by our environment. Feminist film critics also rely on the work done by Althusser and Barthes to illustrate why movies like ALICE DOESN'T LIVE HERE ANYMORE (1974) and TOOTSIE (1982) don't offer perceptive analyses about oppressed women trying to survive in a competitive society with complex male-female relationships. What these

[426] Ansbacher, p.128.

[427] Ansbacher, p.135.

[428] E. Ann Kaplan, "Integrating Marxist and Psychoanalytical Approaches in Feminist Film Criticism," MILLENIUM FILM JOURNAL 6 (Spring 1980):8-17.

[429] Kaplan, p.9. See also Stuart Hall, "Signification, Representation, Ideology: Althusser and the Post-Structualist Debates," CRITICAL STUDIES IN MASS COMMUNICATION 2:2 (June 1985):pp.91-114.

films reveal instead is what filmmakers and many viewers imagine to be the kinds of relationships and experiences that persist in our society.

At the same time, Koch wisely points out that the oppression of women does not originate in false images. This misunderstanding has resulted in a number of misinterpretations springing from a confusion between cause and effect. "Not until we have clarified which needs Hollywood's phallocentric films produce," argues Koch, "and which they appear to satisfy can we understand why women too idolize stars."[430] Adding to the confusion is why the number of women viewers has decreased over the past decade. Koch theorizes that it may, in part, relate to an increased inability of women to identify with characters and situations in contemporary movies.

What is clear is that the conservatism of French psychotherapists in the era following World War II led the post-Freudian practitioner Lacan to develop a radical approach to analysis that later became a cornerstone of feminist film criticism in the 1970s.[431] Simply stated, Lacan argues that what an individual is results from his or her interaction with society and the way in which language conceives that subject.[432] How we feel, what exists in our unconscious, and how we interpret the world are determined by our acquisition of language and the subject's relationship to parental authority. Central to the process of language "creation" is the manner in which the "subject's Unconscious" is formed at the same time as the human subject. During the process, as Kuhn explains, "the subject undergoes formative stages in the course of which a series of repressions which become the content of the Unconscious is produced."[433]

Two examples of repression are the Oedipus complex and the Mirror Phase. The former relates to the prelinguistic male infant who, reaching the phallic stage, discovers that his mother lacks a penis and is drawn to and repulsed by her as the source for learning how to distinguish between himself and others through the symbolic use of language. At the moment the infant shifts from an imaginary to a linguistic orientation, the phallus comes to represent paradoxically both gratification and desire as well as frustration and castration. Language and the father, meanwhile, become the means for discriminating between the haves and the have-nots. Notably missing in this psychoanalytic theory is any positive role for female children. The male infant assumes that everyone is born with a penis. Those whom he sees without one are assumed to be castrated and unable to satisfy their desires. Since the English language has a male-orientation, it becomes (consciously or not) a means for distorting and confusing what is or is not possible in a male-dominated world. In such instances, the infant fears for his own penis and distances himself from the mother. Some post-Freudians have incorporated into this concept the idea that female infants are jealous of males and blame the mother for the female's missing penis. Film scholars who accept these premises insist that the stock situations and social types evident in film genres represent the distortions and perversions of a patriarchy unwilling and ill-equipped to understand and to deal fairly with women.

The Mirror Phase refers to the time when an infant recognizes his or her own identity (as "other"). The infant "misrecognizes" the image by taking it as him or herself. The mirror is the object that makes the awareness concrete. After the Mirror Phase, the infant begins using language to distinguish between himself and other

[430] Koch, p.53.

[431] For another valuable perspective, see Colin McCabe, "Theory and Film: Principles of Realism and Pleasure," SCREEN 17 (Autumn 1976):7-27, Rpt. *NARRATIVE, APPARATUS, AND IDEOLOGY, pp.179-97.

[432] The term "subject" refers to the perceiving and ordering self, as in the term "subjective," and not to the topic of discourse.

[433] Kuhn, WOMEN'S PICTURES, p.46.

people. This is called the "symbolic." Again, language becomes the source for organizing how the world operates and how people behave. It functions along with the individual's narcissistic, exhibitionist, and voyeuristic feelings. Ironically, even though the infant has now adopted a linguistic orientation for symbolizing the world, he forever searches for some way to return to the imaginary and unified world of earlier days. For our purposes, it is important to remember that films reconstruct those imaginary worlds. Nowhere is this more evident than in the more than 200 movies showing with cross-dressing. "We are allowed," Bell-Metereau sensibly explains, "forbidden glimpses of what was once a very real confusion over sexual identity--visions that call back a long-buried fascination with adult costumes of gender."[434]

Understandably, feminist film critics see a need to offset the negative implications of the Oedipus complex and the Mirror Phase theory for women. Mary Ann Doane, for example, points out that the trouble with Freud's work on femininity and the way in which filmmakers use it relates to "the impossibility of a generalized iconic representation" and the unique place of woman in "cinematic representation while denying her access to that system."[435] Whether one examines the voyeuristic emphases of the silent era or the modern day prohibitions of popular culture in depicting the human body, contemporary theorists recognize the importance of male desires in spectatorial pleasure. What to do with male fantasies in a number of horror and action-packed genres does not seem to be a matter of concern for many critics, other than to say that "the boys in the back row" need help and that the gruesome films should be banned.

In the meantime, a major emphasis of contemporary feminist film theory relates to offsetting the proclivities of female spectators to be taken in by voyeurism or fetishism. The current consensus is for a performer to reverse the relationship and appropriate "the gaze for her pleasure."[436] That is, actresses can subvert the Freudian dilemma in two specific ways: transvestism and masquerade.[437] Each, in turn, is affected by the framing of the image on screen and on the spectator's viewing position. For example, by donning male clothes, stars playing female transvestites not only are able to impersonate men in films like VICTOR, VICTORIA (1983), but also are able to alter the focus and meaning of the male gaze as in films like HUMORESQUE (1946) and ALIEN (1979).[438] These performances are sometimes

[434] Bell-Metereau, p.17.

[435] Mary Ann Doane, "Film and the Masquerade: Theorizing the Female Spectator," SCREEN 23:3-4 (September-October 1982):76.

[436] Doane, p.77.

[437] Rebecca Bell-Metereau in discussing androgyny makes a distinction (p.239) among "cross-dressing," "transvestism," and "dressing in 'drag.'" Cross-dressing relates to any situation in which a woman puts on male clothing or vice versa, for whatever reasons. Transvestism applies "to heterosexual, fetishistic use of clothing of the opposite sex." Dressing-in-drag is a slang expression usually denoting homosexual donning of clothes of the opposite sex; homosexuals, however, explain "being-in-drag" as the use of "a uniform that suggests self-conscious role-playing."

[438] Bell-Metereau offers a series of intriguing comparisons of men dressed as women and vice versa. For example, in the years prior to 1960, she contrasts the styles in two key male cross-dressing films--I WAS A MALE WAR BRIDE (1949) and SOME LIKE IT HOT (1959)--with a host of female cross-dressing films--e.g., A SONG TO REMEMBER (1945), JOAN OF ARC (1948), CALAMITY JANE (1953), JOHNNY GUITAR (1954), and SILK STOCKINGS (1957). For more information on the history of film cross-dressing, see HOLLYWOOD ANDROGYNY.

troubling to women in the audience who feel that transvestism brings them too close to the recognition of their own "castration." On the other hand, by "disguising their bodies," female protagonists can don masquerades that either manipulate the manner in which they are perceived, as in films like NOW, VOYAGER (1942) and LEAVE HER TO HEAVEN (1945), or obscure their masculine behavior in films like THE MALTESE FALCON (1941) and BODY HEAT (1982).[439] Unlike fetishism, masquerade distances the female spectator from her subordinate status and emphasizes instead the need for women to conceal their real identities from threatening men. Doane credits both film approaches with giving female spectators the ability to appropriate male pleasures for their own satisfaction.

Another slant on the male gaze and voyeurism is provided by THE NEW YORKER staff writer Veronica Geng in her review of PERSONAL BEST (1983). Leaping to the defense of producer-writer-director Robert Towne, who came under heavy attack for his "sexist" story of two female athletes competing for berths on the 1980 U. S. Olympic team, Geng applauded the film's ability to establish meaningful and non-self-conscious attitudes about the female body. She begins by pointing out that "The women's excellence, competitiveness, sexuality, and concern for each other are issues, or gifts that the screenwriter lets them earn after a hundred pages; they are given."[440] The review then goes on to discuss how personal relationships are also a given, with the film concentrating more on how "human bodies in expressive motion . . . test and explore a proposition about how to live."[441] Geng extols Towne's ability not to "prowl" the bodies of the female athletes, making a contrast with the works of pornographic filmmakers who single out a woman's anatomy as an excuse to debase her into "generalized body parts." PERSONAL BEST, Geng insists, excels in relating emotions to physical characteristics, the performers appear natural not stylized, the dialogue builds on "sensitive misunderstandings," and the characterizations are honest examples of independent women. At the same time, the author dutifully notes that some male critics--e.g., Vincent Canby, Carlos Clarens, and Joel Siegel--perceived the film as "undisguised voyeurism," "personal voyeuristic fantasy," and "peeping Tom fantasies."[442]

The difficulty in the approaches of these male critics, as Forsyth points out, is that "Oedipal emphases in film criticism frequently overemphasize the importance of a psychological 'moment' to the exclusion of others."[443] Gentile points out that the theories of people like Althusser and Lacan undermine our abilities to be subjective.[444] If we cannot make independent judgments and must rely instead on a communication system that predetermines who is and is not dominant in society, then how can minorities or subordinate groups function independently and critically?[445] Kaplan also is extremely antagonistic to Lacanian systems, because of "their

[439] Bell-Metereau, pp.81-5.

[440] Veronica Geng, "Good at Games," NEW YORK REVIEW OF BOOKS 29:4 (March 18, 1982):45. For other useful perspectives, see Elizabeth Ellsworth, "Illicit Peasures: Feminist Spectators and PERSONAL BEST," WIDE ANGLE 8:2 (1986):45-56; and Linda Williams, "PERSONAL BEST: Women in Love," JUMP CUT 27 (July 1982):1, 11-12.

[441] Geng, p.45.

[442] Geng, p.45.

[443] Forsyth, p.33.

[444] For another perspective, see Penley, pp.21-6.

[445] Gentile, p.22.

determinism, ahistoricity, and anti-humanism, and because they seemed to lock us inevitably into a framework that degraded women."[446] This is not the place to debate the merits of these intricate concepts. Suffice it to say that investigators like Gentile and Kaplan are not naive about the film-viewing process. They do not assume that audiences passively accept as true what they see on screen. But what troubles these feminist film critics and their colleagues is that the dominant film myths and images "intervene between lived experience and its expression in film."[447]

Once again, it is important to stress that direct cause and effect theories runs counter to communications research. For example, we now know that audiences are neither passive nor single-minded in the way they receive information and ideas. We know as well that the messages contained in popular culture are neither monolithic nor fixed in meaning. In almost every instance, the moment of reception directly affects how a spectator in a given situation interprets a mass media product. Therefore, to assume, as some radical theorists do, that position, pre-determination, and a patriarchal language preclude multiple meanings does not correlate with mass communications research. Those who would challenge the dominant social values must account for the residual and emergent cultural tensions that exist in various stages and periods of popular culture. The challenge for feminists, as Gentile argues persuasively, is how to use what is basic in the existing society and still maintain an independent point of view. That is, ideology and language must not be seen solely as threats to critical subjectivity, but as the source of contradictions that provide the basis for developing a critical subjectivity.[448]

In movies the psychological problems, as discussed earlier, are compounded because the classic Hollywood cinema signifies on an impersonal level. Referred to as "suture," the concept describes how characters perform, events occur, and actions take place, but the audience remains ignorant of who is relaying the story or why.[449] In other words, we are being "positioned" in relation to the screen. We are drawn into the world of the story through camera techniques and editing. What is extremely important is the way in which characters look at each other, the manner in which we are led by filmmakers to view the characters and the events, and the link between the gaze of the characters and ourselves. This "DISCOURS" is the presumed source of our pleasure. The impression generated by many feminist film critics is that what is shown is perceived as reality. That is, if screen women are shown rebelling against men in the patriarchal plot, then the story must "recuperate" (place) the women in a subordinate role by the film's resolution in order to preserve the sanctity of the patriarchy.

Anyone familiar with film history can readily understand why Molly Haskell feels that certain star images are remembered "not for the humiliations and compromises they endured in conforming to stereotypes, but for the incandescent moments in which their uniqueness made mockery of the stereotypes."[450] Some feminists react particularly to films made during Hollywood's golden years. Stars like Greta Garbo, Jean Harlow, Joan Crawford, Marlene Dietrich, and Bette Davis personified the image of the unique celluloid woman constructed by a patriarchal cinema. More often than

[446] WOMEN AND FILM: BOTH SIDES OF THE CAMERA, p.152.

[447] "Integrating Marxist," p.10.

[448] Gentile, pp.20-2.

[449] For more information about "suture," see Stephen Heath, "Cinema and Suture," SCREEN 18:4 (Winter 1977-78): 35-47; ___, "Notes on Suture," ibid., 48-76; Daniel Dayan, "The Tutor-Code of Classical Cinema," FILM QUARTERLY 28:1 (Fall 1974):22-31; and William Rothman, "Against the System of Suture," FILM QUARTERLY 29:1 (Fall 1975):45-50.

[450] Haskell, p.v.

not, these actresses illustrated an ideal female image turned into a spectacle for the "male gaze."[451] The glamor, attractiveness, and female form were accented to the exclusion of a woman's intelligence and independence. On those occasions when the actress assumed an aggressive role and dominated her own life, the film narrative insured that she was either punished or reformed. Each film--e.g., FLESH AND THE DEVIL (1927), HELL'S ANGELS (1930), RAIN (1932), THE DEVIL IS A WOMAN (1935), JEZEBEL (1938)--revealed how the sexually active woman, doing no more than what had been traditional behavior for the male, was restrained either through sexual submission and marriage or removed from decent society through banishment or death.[452] Given this perspective, it is not surprising that Haskell concludes, in her pioneering feminist film history of Hollywood, that American filmmakers were "the propaganda arm of the American Dream Machine," dedicated to reinforcing "through the myths of subjection and sacrifice . . . the lie of women's inferiority."[453]

This simplified account of how film functions psychologically as a means of reinforcing a society's dominant ideology represents for many modern film scholars a useful approach to socio-political analysis. It does, however, have several important drawbacks beyond those already noted. For example, Heath points out that the major error of analyses based on the process of production linked to psychoanalytic theories is the single-mindedness of the analyses. "Primary identification, voyeurism, and so on, have entered the argument," he explains, "as static and absolute determinants, without history. . . ."[454] That is, sometimes the psychoanalytic critic assumes that there are no historical reasons why spectators derive erotic pleasure from viewing someone without the spectator's being detected (voyeurism). It is a concept worth exploring in Hitchcock's PSYCHO (1960), with its presentation of a male protagonist who specializes in relating voyeurism and fetishism to his unconscious needs. The same theoretical flaws associated with objectification are evident in critics who fail to put into historical context why exhibitionists take erotic pleasure in displaying their bodies to other people, either as a form of public performance or as a sense of personal gratification.

Another problem with psychoanalytic film criticism relates to the analogy between clinical interaction with a patient, and a critic analyzing a film. Where the analyst in the clinic maintains a constant dialogue with the patient, the film critic relies almost exclusively on speculations and has no feedback from the film. Another difference is that a patient submits to a curative treatment, while film spectators (rightly or wrongly) feel themselves, within broad limits, to be "normal." Even more troublesome, as Kaplan points out,

[451] For purposes of this chapter, the concept of the "male gaze" refers to the way in which Hollywood filmmakers use viewing as a means to provide sexual pleasure and to reinforce a patriarchal point of view. The three types of "looks" involve the way women within the film are seen as sexual objects, the way the audience assumes the view of the males within the film, and the way in which the filmmaker constructs the film's patriarchal point of view. The crucial distinction between men and women who are involved with "gazing" in films is that the former invariably maintain the authority and the psychological imperative of making women subordinate.

[452] Modleski points out (pp.22-4) that "domestic novels," which constituted the most popular literary form for nineteenth-century women, served as the basis for the "so-called woman's film of the 1930s and 40s. . . ." Its stock figures--e.g., "strong and brave heroines, the weak, often dissolute men--abound in the woman's film."

[453] Haskell, pp.1-2.

[454] Heath, QUESTIONS OF CINEMA, p.243.

The [Lacanian psychoanalytic] model does explain women's subordinate place in a patriarchal society, but this symbolic order is taken out of history, located as an abstract, fixed entity not subject to process or historical change Common sense and Marxist concepts show, on the other hand, that change can and does take place, that things are in dialectical progression . . . Second, in seeing art only in terms of inner, unconscious processes, art is, although in a different way from art-for-art's sake believers, once again made into an autonomous realm. The model seems tied to the social formation in focusing on the patriarchal system, but in fact this system is rendered so abstract and isolated from actual social and economic changes that it becomes a realm of its own.[455]

Kaplan's way out of the problem is to focus more attention on how social conditions, rather than our imaginary world, create our symbolic representations of society. She sees feminist critics and responsible filmmakers as directly assaulting the false images instituted and perpetuated by the mainstream cinema. In performing that role, they need not ignore sociological criticism or rely too heavily on psychoanalytic theory. Fantasy and psychological interaction are, after all, related to the way in which social conditions shape our everyday needs and desires.[456]

A major concern in dealing with screen images, therefore, is how to establish effective criteria for disabusing impressionable people of the notion that neither celebrities nor film images are synonymous with reality. At the same time, we need to be reminded frequently that there is a significant gap between what a filmmaker intends to project in a film, and what meaning a spectator receives from the film. Here we have discussed how our values have been determined by our unconscious and by the way we communicate with society. The next step is to examine the complex relationships among stereotyping, economic structure, the nature of the film industry, and the uncertainties found in market conditions. In particular, the focus will be on the key economic, legal, and cultural events triggered by price discrimination, the Depression, antitrust actions, world wars, technological breakthroughs, and constantly shifting audience tastes and values. We then will review the history of film audience research and a variety of approaches to determining who (and for what

[455] "Integrating Marxist," pp.11-2.

[456] For other articles of interest, see Charles Altman, "Psychoanalysis and Cinema: The Imaginary Discourse," QUARTERLY REVIEW OF FILM STUDIES 2:3 (August 1977):257-72; Albert Benderson, "An Archetypal Reading of JULIET OF THE SPIRITS," ibid., 4:2 (Spring 1979):193-206; Browne and McPherson, pp.35-45; Noel Carroll, "Nightmare and the Horror Film: The Symbolic Biology of Fantastic Beings," FILM QUARTERLY 34:3 (Spring 1981):16-25; Robert Curry, "Films and Dreams," JOURNAL OF AESTHETICS AND ART CRITICISM 33:1 (Fall 1974):83-9; Daniel Dervin, "Filmgoing and Bertam Lewin's Three Worlds of Experience," PSYCHOCULTURAL REVIEW 1:1 (Winter 1977):247-9; Robert T. Eberwein, "The Filmic Dream and Point of View," LITERATURE/FILM QUARTERLY 8:3 (1980):197-203; ___, "Reflections on the Breast," WIDE ANGLE 4:3 (1978):4-9; Hobson, pp.9-25; Kinder, "The Adaptation of Cinematic Dreams," pp.54-68; ___, "The Art of Dreaming in THREE WOMEN and PROVIDENCE: Structures of the Self," FILM QUARTERLY 31:1 (Fall 1977):10-8; Bruce F. Kawin, "Creative Remembering and Other Perils of Film Study," ibid., 32:1 (Fall 1978):62-5; ___, "Right-Hemisphere Processing in Dreams and Films," DREAMWORKS 2:1 (Fall 1981):13-7; Marie Jean Lederman, "Dreams and Visions in Fellini's CITY OF WOMEN," JOURNAL OF POPULAR FILM AND TELEVISION 9:3 (Fall 1981):114-22; John Michals, "Film and Dream," JOURNAL OF THE UNIVERSITY FILM ASSOCIATION 32 (1980):85-7; Vlada Petric, "Bergman and Dream," FILM COMMENT 17:2 (March-April 1981):57-9; F. E. Sparshott, "Retractions and Reiterations on Films and Dreams," JOURNAL OF AESTHETICS AND ART CRITICISM 33:1 (Fall 1974):91-3; and ___, "Vision and Dream in the Cinema," PHILOSOPHIC EXCHANGE 1 (Summer 1971):111-21.

reasons) constitutes the typical filmviewer. Finally, we will review the methods used by the industry and its critics to try to control the content of film. The research should make it clear that a multiplicity of perspectives rather than a monolithic ideology dictates the film continuum of industry, audience, and critic.

BOOKS

Charney, Maurice, and Joseph Reppen, eds. PSYCHOANALYTIC APPROACHES TO LITERATURE AND FILM. Rutherford: Fairleigh Dickinson University Press, 1987. 306pp.
 The seventeen essays in this anthology use various psychoanalytic concepts and methods to analyze literary texts and films; avoided are the more traditional psychoanalytic approach of focusing on biographical examinations of the author and his or her characterizations. Instead, the authors, some of whom are practicing pyschiatrists or psychotherapists, emphasize textual analysis and concentrate on themes, imagery, and symbolic structure. Charney and Reppen divide the material into four major sections: "Psychoanalytic Approaches to Authorship," "Shakespeare," "Film and Theater," and "Psychoanalytic Theory." Endnotes are provided, but no bibliography or index is included. Well worth browsing.

Eberwein, Robert T. FILM AND THE DREAM SCREEN: A SLEEP AND A FORGETTING. Princeton: Princeton University Press, 1984. Illustrated. 247pp.
 In a stimulating and informative manner, Eberwein builds on Bertram Lewin's theory of a "dream screen" to offer a complex study of the relationship between dreams and film. Eberwein argues that no matter how old and rational we become, we still sense the "reality" of our dreams in much the same manner as in infancy. What ties the filmic experience to the dream screen is that (1) they both provide a feeling of oneness, and (2) the worlds they create not only are extensions of ourselves but also appear to inhabit the same space. The study itself is divided into two parts: theoretical considerations and applications.
 In Part One, Eberwein offers a succinct overview of major dream theories from a psychoanalytic and physiological perspective. He begins appropriately by critiquing Freud's theory that "a dream is ultimately an infantile wish that emerges during sleep." The reason for the wishful dream is linked to our inhibitions and to the fact that certain acts and emotions are objectionable in everyday life. We thus are able to mask these objectionable thoughts and rethink them through dreams. While noting several features of a dream (e.g., incorporation of "the day's residue," erotic material, and preserver of sleep), the author reminds us that Freud referred to two types of dreams that contradicted his notion of dreams satisfying infantile wishes: examination and traumatic dreams. Eberwein then proceeds to identify alternative theories to those of Freud proposed by researchers like Carl G. Jung,[457] Alfred Adler, G. Trumbull Ladd, Hans Berger, William C. Dement, Howard P. Roffwarg, Robert W. McCarley, and J. Allen Hobson. This eclectic approach reinforces Eberwein's belief "that our considerations of dreams and their appearance in films can be enriched by cautious application of . . . psychoanalytic theory . . . [as well as the incorporation of] the findings and suggestions of researchers and theorists in other disciplines such as linguistics and child development." To that end,

[457] Worth consulting is the following series of articles: Don Fredrickson, "Jung/Sign/Symbol/Film, Part One," QUARTERLY REVIEW OF FILM STUDIES 4:2 (Spring 1979):167-92; ___, "Jung/Sign/Symbol/Film, Part Two," ibid., 5:4 (Fall 1980):459-79; and ___, "Two Aspects of Jungian Perspective Upon Film: Jung and Freud," JOURNAL OF THE UNIVERSITY FILM ASSOCIATION 32:1-2 (Winter-Spring 1980):49-57.

he offers a valuable description of the oral world of the infant. For example, clinical observers like Jean Piaget, Julia Kristeva, and D. W. Winnicott concluded that (1) oral activities are vital to an infant's survival; (2) oral activities physically link the infant to the world around him; and (3) sleep can revive sensations associated with a person's earliest oral activities. Equally important in Eberwein's dream screen theory is the infant's relationship with the mother. For the author, the cinematic screen acts as "the ultimate prosthesis in the history of human invention." It functions as a surrogate, emanating from infancy, "for the physiological and psychic union we enjoyed with the mother: the screen is both breast and infant, the mother and self." The "dream screen" contains a blank background (surrogate for the mother's breast) and represents the dreamer's wish to sleep. What the individual dreams is the "dream picture." Put another way, "We are what we dream, not only in a psychoanalytic sense, but in a perceptual sense as well." Where Eberwein parts company with Lewin's theory is in the area of the ego. Lewin stresses the importance of the screen-breast-surrogate; Eberwein, the role that ego plays in fusing the subject and the object, the infant and the breast. As for movies, they represent "the dreams we never had, the dreams we yet await." In fact, the author sees films as dissolving the ego, forcing us back into a state of infancy, of childish perceptions of the world around us. Thus both the oneiric and movie dream screens are extensions of ourselves, stimulating us not only to recollect, but also to imagine. This act of remembering is not only creative, but also disorienting.

In Part Two, Eberwein demonstrates his dream screen hypothesis and how it functions in particular films. The premise is that no matter how dreams are induced (either by sleep or by the cinematic screen), we identify with the dreaming character. One example relates to films that actually portray the dream screens of the filmic characters. The degree of our involvement in these cinematic dreams depends primarily on the narrative situation and on the filmmaker's technical skill, but Eberwein makes it clear that our involvement is not automatic. When it does occur, however, the major link is with the character's thoughts rather than actions. Furthermore, our involvement is "part of a collective dream experience." To illustrate how this unique phenomenological relationship operates, he lists six categories identified with particular film characters and describes how filmmakers sensitize us to dreams. Two categories involve dreams related to a physiological stimulus: mind-body isomorphism. One set of films depicts the reactions of a person either drugged or drunk: e.g., DREAMS OF A RAREBIT FIEND (1906) and THE LAST LAUGH/DER LETZE MANN (1924). A second set of films depicts the character experiencing a more traumatic stimulus: e.g., a patient fantasizes that a tree is being cut down rather than that his leg is being amputated in THIRTY SECONDS OVER TOKYO (1944), and a woman imagines that the rape she is experiencing is only a dream in ROSEMARY'S BABY (1968). A third category of dreams relates to a character's fears and anxieties. Among the more prominent films dealing with these types of uncertainties are WILD STRAWBERRIES/SMULTRONSTALLET (1957) and BUFFALO BILL AND THE INDIANS, OR SITTING BULL'S HISTORY LESSON (1976). The former points out how dreamers identify with themselves in dreams; the latter, how dreamers try to cope with their own sense of inadequacies. Fourth, there are the dreams representing our desires. The multitude of wants is evident in films like THE GOLD RUSH (1925), AN AMERICAN IN PARIS (1951), and THE ELEPHANT MAN (1980). Fifth, certain filmmakers focus on creating dreamlike conditions rather than on a particular character's dream. Two notable examples are THE ANDALUSIAN DOG/UN CHIEN ANDALOU (1928) and DOG-STAR MAN (1961-1964). The sixth and last category contains films that use dreams as a foreshadowing device. For example, the screen version of GONE WITH THE WIND (1939) has a recurring dream in which Scarlett appears lost in a fog. Near the end of the film, the dream becomes real as the heroine actually searches through a fog-shrouded street for her husband.

Part Two also provides a detailed discussion of four films that detail a character's dream screen on film: SHERLOCK, JR. (1924), SPELLBOUND (1945), THE TEMPTATIONS OF DR. ANTONIO (1961), and PERSONA (1966). Each analysis contains an extended plot summary, with the express purpose of showing how the screen dreamer uses the cinematic screen as an extension of his or her personality.

In Eberwein's words, "The union with the dream screen of infancy affords the dreamer a sense of oneness with the external world." This psychic two-way mirror creates a bonding between the screen dreamer and ourselves and allows us to become introspective.

Another type of presentational mode analyzed in Part Two relates to "the retroactive mode." That is, only in retrospect do we realize the images we have been watching are part of a dream. Such films come in two varieties. First, there are movies like DELIVERANCE (1974) and THE LAST WAVE (1979) that provide only slight hints that what we are watching is in part a dream. Second, there are films like BELLE DE JOUR (1966) and THE DISCREET CHARM OF THE BOURGEOISIE/LE CHARME DISCRET DE LA BOURGEOISIE (1972) that are entirely dreams. To a large degree, both types of films manipulate our emotions without our knowing exactly what is happening. Unlike Eberwein's earlier taxonomy of dreams, where the filmmakers gave us clues to the manifest cinematic dreams, this latter group of films lulls us into a situation where we are unsure of whom we are identifying with. In Eberwein's words, "We watch the characters' dream screens in a way that does not maintain the psychical and physical distance between us and the characters; instead we are plunged unknowingly into another's consciousness." Once we realize what has occurred, we are forced to reevaluate our attitudes both to the characters and to their values. The chief advantage of being "on the other side of the screen" is that satiric and ironic comments can be made by the filmmaker about the characters and ourselves.

The weaknesses in Eberwein's discussion involve acts of omission as well as acts of commission. For example, he neglects, as Gaylyn Studlar notes, issues related to subject formation, particularly in the areas of polarizations: e.g., "active/passive, sadistic voyeurism/ masochistic exhibitionism, male/female, symbolic/imaginary."[458] Put another way, Eberwein ignores many current discussions about the importance of phallic influences in creating our reactions to the cinematic screen. Although there are passing references to Metz's work on the film-dream relationship and Lacan's observations on the mirror phase, the focus of Eberwein's research remains almost exclusively on the pre-Oedipal stage. Another problem, pointed out by Virginia Gilcrease, is Eberwein's approach to the issue of regression. He does not examine critically the question: "Is regression to infancy the only route to an experience of an egoless state of unity, or are there other routes possible, which retain adult capabilities? If there are, can films inspire a 'progressive' unity as well as a regressive unity?"[459] As for his film analyses, they remain for the most part more exercises than in-depth discussions. That is, they assert more than they persuade. Studlar puts the case well, stating that Eberwein "does not reveal how his theory or readings might be viewed within the context of current theoretical discourse on dream, visual pleasure, and film."[460]

Overall, Eberwein provides a useful introduction to the complex relationship between our film experiences and the experiences of our infancy. Whether or not one accepts the notion that the cinematic screen acts as a surrogate for our dream screen, the book offers a good summary of dream theories and the way pre-Oedipal research can increase our understanding of how and why we relate to movies. A valuable set of endnotes, a strong bibliography, and a invaluable index add to the book's value as an introductory study of the subject. Well worth browsing.

[458] Studlar, p.55.

[459] Virginia Gilcrease, "Book Review: FILM AND THE DREAM SCREEN: A SLEEP AND A FORGETTING," JOURNAL OF FILM AND VIDEO 38:1 (Winter 1986):107.

[460] Gilcrease, p.56.

Fleming, Michael, and Roger Manvell. IMAGES OF MADNESS: THE PORTRAYAL OF INSANITY IN THE FEATURE FILM. Cranbury: Fairleigh Dickinson University Press, 1985. Illustrated. 365pp.

The result of the authors' collaboration in teaching courses in film and psychology at Boston University, this book examines theatrical movies depicting madness in a variety of forms over a fifty-year period. It is neither a definitive nor a pedantic approach. Rather, the work, divided into two informative sections, offers the first full-scale overview of American and European films to deal with the complex and subtle relationship between psychiatric and cinematic portrayals of insanity.

The engaging introduction identifies a number of important issues about the book's purpose and methodology. For example, madness is defined as being in opposition to sanity and reason and thereby raises profound implications not only about who and what we are, but also about the nature of the world around us. Fleming and Manvell therefore conclude that an interdisciplinary perspective--e.g., a clinician's view of the irrational coupled to an artist's portrayal of madness--is the most enlightened way to begin investigating the subject. Their discoveries to date are more predictable than surprising. For example, they found that perceptions about madness are linked closely to the historical development of civilization; and that such perceptions often blur distinctions between the ancient and the modern, the popular and the scientific. Another discovery was that since the dawn of the movies the medium has demonstrated an affinity for, and a fascination with, depicting the image of insanity. To demonstrate the significance of their findings, the authors argue that a study of madness in film from the 1920s to the present yields three academic benefits: (1) a chronology of notable films depicting madness; (2) an analysis of how artistically and clinically timely and accurate the depiction of madness is in specific films; and (3) a comparison of the differences between one era and another in portraying, analyzing, and treating madness. The authors acknowledge at the outset that their overview is controversial since there are many theories and approaches to the study of madness both in clinical and artistic circles. Consequently, their thematic summaries opt for consensus rather than precision. What is evident, however, is that the psychiatric profession, intentionally or not, has had an effect on the cinematic depiction of madness. That is, psychiatrists have acted as consultants, appeared in screen roles, or had their findings adapted by screenwriters. To determine the degree of influence that the profession has had on a specific film, the authors focus on the relationship between the film's basic ingredients (e.g., plot, characterization, and cinematography) and how the film generally reflects the prevailing psychiatric literature of the period. The authors also concern themselves with the impact film has had on the psychiatric profession. For example, they explore how films like THE LOST WEEKEND (1945) and THE EXORCIST (1973) reflected their intended audiences' attitudes toward possession and how therapists treated possession at the time of the films' release. Throughout the ambitious study, the work occasionally explores in a general manner the impact that sociocultural issues had on the relationship between psychiatry and film. A case in point is the analysis of ONE FLEW OVER THE CUCKOO'S NEST (1976). We are reminded that not only did the film differ from both the book and the stage version, but also that the Zeitgeist-depicted inmates are more sane than heads of state. Finally, the authors offer a useful review of the major trends in the understanding of insanity throughout recorded history. Beginning with prehistoric notions about madness resulting from an invasion of the human body by supernatural or magical forces, the straightforward and lucid analysis provides an important set of explanations about how and why madness has been treated and analyzed. In addition, the stimulating introduction includes a useful classification of theoretical models--e.g., social, psychedelic, conspiratorial, family, and medical--applicable for analyzing the relationship between psychiatry and film.

Fleming clearly makes the most significant scholarly contribution to the subject. His Part 1--"Themes of Madness"--separates the subject into ten common themes: society and madness, possession as madness, eros and madness, murder and madness, war and madness, drugs and madness, paranoia and madness, sanity as madness, madness as sanity, and madness and the psychiatrist. Each of the ten intriguing

chapters relies primarily on a brief but valuable discussion of the specific psychiatric and sociopolitical forces impinging on the films' depiction of insanity. Two films, generally thirty years apart, are then contrasted as an illustration of how attitudes about a specific form of madness have evolved and changed over a prolonged period of time. For example, in discussing the importance of the family as the principal caretaker of mentally ill people, Fleming contrasts NOW, VOYAGER (1942) with A WOMAN UNDER THE INFLUENCE (1974). The former points out how mothers can be responsible for their children's aberrant behavior; the latter looks at the mental problems created for a mother by an extended family. Each of the films reveals the psychiatric views of the era in which the film was made. The one major objection to the analyses is the superficial way in which other aspects of the films are treated. Almost all attention is focused on identifying a psychiatric attitude and its relationship to the prevailing theory. While the method is informative, it borders on being reductionist.

Manvell's contribution consists of plot synopses, terse critical comments, and abbreviated cast and technical credits for 150 films dealing with the ten categories discussed by Fleming. As always, he demonstrates a keen awareness of the field, coupled with a knack for cramming a wealth of information into a tight format. Among the section's highlights are his comments on films like AGUIRRE, THE WRATH OF GOD/AGUIRRE, DER ZOEN GOTTES (1972), BELLE DE JOUR (1966), LET THERE BE LIGHT (1945), and PERSONA (1966). The comments are lucid, stimulating, and original. Regrettably, the same cannot be said for a number of entries limited to a single paragraph: e.g., THE BLUE ANGEL/DER BLAUE ENGEL (1929), THE CAINE MUTINY (1954), COMPULSION (1959), and MAGIC (1978). In short, Manvell's filmography at best is a mixed bag. Again, the problem is more one of brevity than of quality.

Overall, the authors demonstrate the relationship between psychiatry and film and how that link is tied both to the past and the present. The crisp writing plus an intelligent organization adds to the book's value as an important introduction to the topic. A good bibliography and a useful index complete the work. Recommended for special collections.

*Fowler, Douglas, ed. THE KINGDOM OF DREAMS: SELECTED PAPERS FROM THE TENTH ANNUAL FLORIDA STATE UNIVERSITY CONFERENCE ON LITERATURE AND FILM. Tallahassee: Florida State University Press, 1986. 148pp.

The subject of this stimulating conference that generated the twelve essays in this useful publication, Fowler tells us, is "the dream-within-art as myth, vision, revelation, ideal, terror, lost paradise." Entertaining and informative, the papers cover such topics as "The Nightmare World of Hitchcock's Women" (Diane Carson), "Dreaming and Thinking: S. O. B. and Its relationship to Blake Edwards' Genre Films" (Peter Lehman and William Luhr), "FLASHDANCE: Eroticism and the American Dream" (Jeanne Lebow), "'ROSEBUD' and the Illusions of Childhood Innocence in CITIZEN KANE" (Marshall Deutelbaum), "KOYAANISQATSI: Godfrey Reggio's Filmic definition of the Hopi Concept of 'Life out of Balance'" (Cynthia Ramsey), "Pascal's Wagner and the Feminist Dilemma in Eric Rohmer's MY NIGHT AT MAUD'S" (Frank R. Cunningham), "From Dictatorship to Democracy: Carlos Saura's CARMEN" (Deborah J. Hill), "Dream as Reality: Bunuel/Dali's UN CHIEN ANDALOU" (Erdmute Wenzel White), and "Androgynous Scribes, Duplicitous Inscriptions: Isaac Bashevis Singer's Cinematic Dreamscapes" (Eillen T. Bender). An index is included. Well worth browsing.

*Greenberg, Harvey R. THE MOVIES ON YOUR MIND. New York: Saturday Review Press, 1975. 273pp.

Being both a practicing psychologist and a film aficionado, Greenberg applies considerable skills to his imaginative Freudian interpretations of more than a hundred movies produced since the 1930s, which represent for him the dreams and fantasies

of our society. The highly selective focus is almost exclusively on Hollywood films--e.g., THE WIZARD OF OZ (1939), THE MALTESE FALCON (1941), CASABLANCA (1942), THE TREASURE OF THE SIERRA MADRE (1948), PSYCHO (1960)--with specific references to only two foreign movies--WILD STRAWBERRIES/SMULTRONSTALLET (1957) and 8 1/2/OTTO E MEZZO (1962). Almost no time is spent on the filmmakers or the industry. "Movies," he sees as "complex phantasmagorias, manufactured and merchandised by an ulcer-ridden conglomerate of dedicated artists, workaday technicians and shrewd hucksters who probably consume more psychoanalytic time and keep more therapists in Jaguars and golf shoes than any labor force in the nation." What is important for Greenberg is the subliminal link between the industry and the public. Each, he suggests, is manipulating the other in an unstated attempt to satisfy "half-formed yearnings" and "obscure cultural imperatives." Thus he sets out to unravel the various motivations and defense mechanisms found in popular Hollywood film genres like science fiction and horror films. His contention is that psychologists, unlike other analysts, are able "to perceive the exquisite meshing of individual and collective fantasy, as the timeless myths of personal and cultural history are reinvented on the silver screen." Although Greenberg admits that movies and their stars are not patients, that the conclusions he reaches are based on extremely inferential evidence, and that film criticism using psychoanalytic techniques in the past has vastly oversimplified complex issues, he nevertheless feels confident that his interpretations will not reduce the central concerns to a "few dreary rubrics--penis envy, anal eroticism, breast fixation. . . ."

In many respects, the narrative supports the author's intentions. One reason is that its entertaining prose frequently masks its dubious conclusions. For example, Greenberg claims that in THE MALTESE FALCON Gutman "wants to SCREW Spade literally and figuratively, and if the detective dies as a result, why, that will give an added cinematic pleasure!" One can only guess how Dashiell Hammett would have reacted to this intriguing interpretation. Better still, imagine Hitchcock reading that in PSYCHO he was showing how "The past preys upon the present; the present preys upon its helpless child. (Mothers most of all, the basis, I suspect, for Hitchcock's lady-killing!) and God, who wears Hitchcock's inscrutable features, shits us into the world to shit us out again." Surely, this is not a dreary rehash of anal eroticism. Another reason why the narrative holds the reader's interest is the successful and succinct way in which it summarizes Freudian theories. In discussing THE WIZARD OF OZ, for example, Greenberg reminds us how Dorothy's "trip" acts as an effective metaphor for the archetypal rites of psychological passage taken by all adolescents. His splendid plot summary serves as an excuse to deal with the emotional conflicts of childhood, the effect that puberty has on the manner in which children view their parents, and the subtle psychic shifts that teenagers experience as they readjust to their surroundings. Despite the author's annoying, unconvincing speculations about Dorothy's deceased father (never discussed in either the L. Frank Baum novel or the film), the text provides an impressive argument for re-evaluating in the movie the role of women as a single image of a Good-Bad Mother. Greenberg's fertile imagination offers stimulating perspectives in all of the book's eleven chapters. In discussing THE TREASURE OF THE SIERRA MADRE, he talks about Freud's description of "individuals 'wrecked by success'--whose neurosis broke out directly AFTER some long sought goal had been achieved"; Fred C. Dobbs becomes an addition to the examples of Lady Macbeth and Rebecca West used by the great psychologist. In analyzing CASABLANCA, Greenberg offers an engaging image of Bergman as the "Madonna-Whore" syndrome, whereby Bogart refuses to allow one woman "to satisfy both his sexual and non-sexual needs because of anxiety over unconscious incestuous feelings toward his mother." Even if Bogie would blush at such a horrendous suggestion, the author makes such an appealing case for the supposition that readers need to see the film afresh and with an open mind to reject the suggestion. In fact, after reading Greenberg's often hilarious speculations about DRACULA and FRANKENSTEIN (both in 1931), KING KONG (1933), and THE BRIDE OF FRANKENSTEIN (1935), a raconteur could keep audiences entertained for hours with new perspectives on classic films.

In the end, however, Greenberg's analyses are in the orthodox Freudian mold and remain as unconvincing as those of his predecessors. One reason is that they rely too heavily on literary issues. That is, images are secondary to dialogue and sound effects. Nowhere is this more evident than in his discussions of 8 1/2 /OTTO E MEZZO and WILD STRAWBERRIES/SMULTRONSTALLET. Another problem the narrative encounters is the too-obvious interpretations of presumed, overworked phallic symbols. Picture if you will, Judy Garland following the Yellow Brick Road and interpreting broomsticks and red slippers as explanations for "her sense of incompleteness upon an imaginary lost penis." Let your mind savor the possibility that the reason why Fred C. Dobbs doesn't want Curtin (Tim Holt) to leave first is that he's afraid the American has homosexual leanings and will attack Dobbs from the rear! Play with the thought that the real reason why Sam Spade turns in Brigid (Mary Astor) is that having warded off "a series of hostile father surrogates," he is not about to place himself in the clutches of a "Witch-mother." What undercuts many of these radical speculations is the author's refusal to acknowledge the existence of external and internal censorship forces operating on the filmmakers. Without an awareness of the production constraints, unsophisticated viewers get the impression that scripts and cinematic techniques are left to the whims of the industry and not dictated by the "moral" constraints of self-appointed guardians of society. For example, it doesn't seem fair to blame Ilsa for her dilemma with Rick and Laszlo when the production code decreed that a woman could not be unfaithful to her spouse and be treated sympathetically. Finally, there is a frivolous tone that creeps into the narrative that belies the author's contention that the issues be taken seriously. A case in point is the cynical dismissal of Cecil B. DeMille's film spectacles as giving the audience, for a single ticket, "both sermons AND tits!"

For all the book's problems, it remains a highly entertaining approach to film criticism. Greenberg's obvious love both for his subject and his discipline are apparent throughout. The complex material is presented in a straightforward manner, with an emphasis on clarity and intellectual stimulation. Besides, anyone who remembers fondly his screenings at the Midwood Theater in Brooklyn can't be all wrong. A useful index is provided, but no worthwhile bibliography or filmographies. Well worth browsing.

Huss, Roy. THE MINDSCAPES OF ART: DIMENSIONS OF THE PSYCHE IN FICTION, DRAMA, AND FILM. Rutherford: Fairleigh Dickinson University Press, 1986. 225pp.
The standard approach by psychoanalytic critics to the representational arts is to see them and their characters as symptoms, as signs of defense, or as sublimations of the author's neuroses. Because such theories tend to be reductive, psychoanalytic interpretations are under constant attack. In Huss's study, however, the plan is to demonstrate how flexible and rich psychological interpretations of the arts can be by showing how depth psychology theories cut across national boundaries, periods, and genres. Particular attention is given to the "individidual psychology" theory of Alfred Adler; the post-Freudian "object-relations" theory and ego-psychology techniques as developed by Erik Erikson, Jean Piaget, Margaret Mahler, and D. W. Winnicott; the anthropologically oriented science of proxemics (the study of body distances) and kinesics (the study of body language); and the formulations about borderline psychotic and narcissistic personalities by Otto Kernberg and Heinz Kohut. Among the notable omissions relating to recent psychological theory and practice are references to behaviorism, semiotics, structuralism, and psycholinguistics. Not only does Huss object to their antihumanistic stance, but he also feels that they appear "incapable of enriching the interpretation of a humanistically based text." Not surprisingly, Huss's psychoanalytic treatment of aesthetic issues relies almost exclusively on characterization as the key point of reference. Thus his discussions of camera techniques stress the relationship between the image and the character, how editing reinforces a character's emotional state, and why new theatrical devices grow out of a need for the stage to be more innovative in expressing identity diffusion. In addition, the book's nine academic chapters, loosely set in a historical

review of psychological theory and clinical practice, are designed to highlight contrasts and developments within specific genres and theories.

In many respects the study demonstrates a variety of intriguing approaches to psychological interpretations of the representational arts. A useful introduction lists the standard objections to such interpretations and redirects our attention to the importance of psychoanalysis in analyzing characters in fiction, drama, and film. Chapter One offers a helpful reevaluation of Freud's views on character and form in art and then proceeds to a discussion of how his work has been applied and criticized. Particularly interesting is a comparison of Freud and Aristotle in terms of how they view art as an imitation of reality and its cathartic and therapeutic effects.

Having established that both Freudians and Aristotelians agree on the importance of character in motivating action in the representational arts, Huss pursues his basic argument about art being, in Freud's terms, "the precipitate of an older content." What becomes apparent early in the book is that specific works of fiction, drama, and film have been chosen as much for their contrasts as for their commonalities. Thus Chapter Two discusses Grimms's tale, "The Table, the Ass, and the Stick," as an example of the fairy tale as psychosexual conflict, while Chapter Three provides an Adlerian perspective on Sophocles's Oedipus plays. The Grimms story gives Huss the opportunity to describe why fairy tales are most in touch with our primordial nature and to suggest a number of psychological viewpoints (e.g., Jungian and Adlerian). OEDIPUS TYRANNUS and OEDIPUS AT COLONUS serve as excuses for negating either ontogenetic or phylogenetic interpretations. That is, Huss believes the focus should not be either on a clinical examination of Oedipus's symptoms as related to his sexual feelings or on interpreting his actions as "a mythic composite of almost forgotten ancient rituals or systems of social adaptation." Instead, the author argues for an Adlerian psychosocial perspective that takes into account the influences the extended family, society, and state can have on individual strivings. In developing his psychological interpretations, Huss effectively demonstrates how the Grimms tale and the Oedipus plays stress the narcissistic scars inflicted on a son by a father. Even more important, because the works in question relate to the primitive rituals of pre-history and folklore, Huss uses both chapters as a foundation for the application of depth psychology.

The next three chapters examine the problems of adolescents in a variety of representational works--e.g., Henry James's short story, "The Pupil," Larry Peerce's screen adaptation of A SEPARATE PEACE (1972), Michal Bat-Adam's film EACH OTHER (1979), Frank and Eleanor Perry's movie version of DAVID AND LISA (1962), and Zenzo Matsuyama's film THE HAPPINESS OF US ALONE (1961). Each chapter continues to shift attention away from Freud's notions on instinctual drives and toward Adler's emphasis on a social matrix of behavior. The strategy is to explain how adolescence represents a significant transitional period in human development between childhood and adulthood. Huss then proceeds to contrast the works being analyzed. For example, in analyzing James's concern with the way family dynamics form character, Huss summarizes the work of early childhood specialists like Winnicott, Mahler, and Piaget in the controversial areas of the pre-Oedipal dyadic relationship of mother and child. Here the focus is on demonstrating that the emotions and attitudes experienced in childhood and adolescence shape the "characterological armour of the 'mature' adult." In examining Peerce's screen treatment of characters' outward defenses for their complex, volatile emotions, Huss points out the importance of visual and aural symbols. In fact, he uses the director-screenwriter's representational camera work as an illustration of how psychoanalytic interpretations can be used to determine aesthetic excellence. The analyses of the Perry and Matsuyama films suggest how kinesics and proxemics can enrich our understanding of the arts. At the same time, Huss makes the point that much of contemporary art deals with the modern universal predicament of how to communicate effectively in a fragmented world that encourages both emotional outpourings and narcissistic self-preoccupations.

Chapters Six and Seven contrast John Osborne's popular play LOOK BACK IN ANGER with two of Anton Chekhov's short stories, "Misery" and "Rothchild's Fiddle." Starting with the premise that Osborne's social protest play works better as rhetoric than as drama, Huss demonstrates how psychological interpretations can reveal the

gap between what characters say and the dynamic substructure of the play. He also makes a good case for Osborne's failure as a major dramatist. Huss then goes on to explain why a writer like Chekhov, whose style and dramatic emphasis were diametrically opposite to Osborne's, was able to explore successfully hidden psychic elements found in repressed feelings. The reason why Chekhov surpasses Osborne in probing psychological movements, according to this study, is that Chekhov's characters have an underlying pattern to their primary process thinking, while Osborne's do not. The question Huss pursues in these two chapters is: "To what extent is a hidden element in a work of art shown by psychology to be a truly dynamic enhancement of the work's aesthetic effect, and to what extent might it be shown to be an impurity or a disruptive part?"

The final chapter explores seven treatments of the Prodigal Son parable that have appeared in the representational arts from biblical times through Franco Zeffirelli's film, BROTHER SUN, SISTER MOON (1973). At the heart of Huss's argument is the thesis that youthful rebellion cannot be explained simply as "Oedipal" hostility to paternal authority. Rather, the erosion of paternal authority and the emergence of the "PRODIGALITY" relate to "a pre-Oedipal, narcissistic disturbance bordering on identity diffusion and psychopathy." When children fail to get meaningful parental guidance, they not only reject their parents' values, but also disrupt the structure of the nuclear and extended family. Huss argues that the sensitive artist throughout the ages has made it clear the different forms and meanings father-son relations can take as a result of identity diffusion and the loss of parental authority.

Overall, Huss provides a stimulating collection of essays with several models useful for psychological critics investigating the representational arts. However, the analyses rely heavily on a familarity with depth psychology and may be too abstract for the average reader. Two appendexes on "Images of the Mind in Theater and Film" and "The 'Complexes' of Art" discuss in more general terms the problems artists face in trying to communicate emotional issues and the important legacy that mythology has bequeathed to psychoanalysis. A set of endnotes, a bibliography, and an index are also included. Well worth browsing.

Wolfenstein, Martha, and Nathan Leites. THE MOVIES: A PSYCHOLOGICAL STUDY. Glencoe: The Free Press, 1950. Illustrated. 316pp.

In one of the best studies on film stereotyping, the pioneering authors examine the content of 166 American "A" movies released in New York after September 1, 1945, and then compare them with French and British films they decided were typical products of the respective countries. They point out that "Day-dreams contain clues to deeper-lying, less articulate aspirations, fears and wishes." They believe that the protagonist in fiction is the symbolization of a common daydream, and that the daydream is an image that the audience can relate to. When people share a common culture, it is not unlikely that they also share common daydreams. To demonstrate their thesis, the authors present an analysis of films made in the 1940s to see how the industry treated the recurrent "daydreams which enter into the consciousness of millions of moviegoers." Some of their conclusions are that (1) the problem in American films concerning love was how to make it interesting while at the same time get it past the censors; (2) there was a tendency to depict protagonists in American films as free agents not restricted by family ties; (3) violence was shown as a threat from the outside, rather than from within one's emotions and instability; (4) there was a preoccupation with showing a conflict between what appeared to be bad and what was "really" bad, between the reality and the illusion of a person's actions and appearance. In this last category, the reader will find available in MASS CULTURE: THE POPULAR ARTS IN AMERICA an analysis of what Wolfenstein and Leites call the

"Good-Bad girl"[461]--that is, the device of having Hollywood's heroines appear "bad" at the beginning of the film, but showing them to be "good" by the end.

Three major weaknesses in their approach are, first, their failure to recognize the importance of the motion picture code in determining the stereotypes described; second, confusion of the subject matter with its effect on the audience; and third, the failure to differentiate between significant and trivial films.

Anyone seriously examining the history of film research and movie content should put this book on a must-read list. An index is included. Recommended for special collections.

*Wood, Robin. HOLLYWOOD FROM VIETNAM TO REAGAN. New York: Columbia University Press, 1986. Illustrated. 328pp.

Conceived from a radical political viewpoint, this extraordinary book analyzes the shift in American movies from the 1970s--when Americans aggressively challenged many of their most sacrosanct institutions--to the reactionary and recuperative movies of the present. Wood's central theme "is the attempt to grasp, in all its complexity, a decisive 'moment,' an ideological shift, in Hollywood cinema and (by implication) in American culture." At the same time, Wood explores many of the era's most controversial films, distinguishing between what the public and the author find significant. For example, filmmakers often insist that they give the public only what the public wants, thus rationalizing the value of conformist films and dismissing the non-commercial value of radical movies. From Wood's perspective, the conforming commercial ventures result in our becoming "cynical, disillusioned, apathetic or negatively anti-social." That is, we are denied the means to imagine radical ways to reform and revitalize our culture. Consequently, for him, what distinguishes a film as great is its relationship to its time, the relationship "being frequently (today, necessarily) one of opposition." The crucial relationships appear in the form of "cracks, disruptions, countercurrents." By examining and exploring those opposing perspectives to the classical Hollywood narrative, Wood sensitizes us to "how individual films dramatize . . . the conflicts that characterize our culture: conflicts centered on class/wealth, gender, race, sexual orientation."

The book is not, however, a standard survey of genres, important filmmakers, and key sociological events. Although arranged chronologically, the individual chapters represent independent essays on directors Wood likes and dislikes, critical trends, Hollywood's response to the feminist movement, and the film industry's treatment of bisexuality. What concerns the author is the "interconnectedness of these phenomena." In applying feminist, Marxist, and psychoanalytical theories, he not only moves away from his prior emphasis on AUTEURIST criticism but also provides an engaging opportunity for reviewing how contemporary film theory can be used in a revisionist approach to the study of film history. It should be noted that much of the material is a reworking of articles Wood had published earlier in film periodicals like MOVIE, FILM COMMENT, AMERICAN FILM, MOSAIC, CANADIAN FORUM, and BODY POLITIC. The various essays also reveal Wood's considerable debt to the influence of Richard Lippe, Andrew Britton, and Varda Burstyn.

Each of the book's thirteen chapters include many insightful and exasperating observations. For example, Chapter 2, dealing with an analysis of Arthur Penn's THE CHASE (1966) and relying heavily on E. H. Gombrich's ART AND ILLUSION, allows Wood to debate the merits of the AUTEUR theory, particular assumptions about "realism" and the "realistic," and to contrast the major differences between the classical and modern Hollywood film. In the process, he perceptively shows the importance of genres and their conventions in getting the public to deal with the unknown. Chapter 3, concerning the centrality of Arthur Penn's work to the development of American films, is an intriguing essay on the themes of disintegration

[461] Martha Wolfenstein and Nathan Leites, "The Good-Bad Girl," MASS CULTURE: THE POPULAR ARTS IN AMERICA, pp.294-307.

and breakdown as depicted in Hollywood movies since the early 1960s. Chapter 4, focusing on coherence-incoherence in film narratives of the 1970s, remains one of the book's most difficult chapters. Relying heavily on Freud's theory of repression, Wood stresses the appearance of "contradictions," "gaps," "strains," and "dislocations" in contemporary films. The two keys to understanding what has caused Hollywood's change from the past are the Vietnam War and the horror film. It's at this point in the book that the arguments try one's patience. For example, Wood's discussion of the impact of Vietnam on societal values fails to be convincing because of his strained analyses of LOOKING FOR MR. GOODBAR (1977) and CRUISING (1980). On the other hand, Chapter 5, describing the seventies as the golden age of the horror film, contains an excellent argument for the distinction between basic and surplus repression. Indebted to the writings of Herbert Marcuse and Gad Horowitz, Wood draws an important link between repression and oppression, and then proceeds to identify central features of the evolution of American horror films. Chapter 6, comparing the horror films of Larry Cohen to those of George Romero, illustrates Wood's theories on the relationship between monsters and normality. Chapter 7, analyzing the works of Brian De Palma, contains a dogmatic discussion of Freud's theories on time castration anxiety. Chapter 8, exploring the phenomenal success of George Lucas and Steven Spielberg, attacks the filmmakers' reliance on reassuring motifs that pander to the public's adolescent desires and fears. It also illustrates the author's close-mindedness in analyzing films that reassure patriarchal values and his acid wit in attacking critics who disagree with his Marxist-Freudian values. For example, Wood lambasts E. T.: THE EXTRA-TERRESTRIAL (1982) and then adds that "apart from Pauline Kael (whose feminist consciousness is so undeveloped one could barely describe it as embryonic), I know of no women who responded to the film the way so many men did (though not without embarrassment), as, in Kael's term, a 'bliss-out.'" Chapter 9, critiquing the horror films of the 1980s, distinguishes between the apocalyptic horror films of the previous decade (e.g., filled with despair and negativity) and the reactionary movies of the present (e.g., monsters appear nonhuman and simplistically evil). Chapter 10, examining Hollywood feminism, insists that American mainstream filmmakers dismiss the existence of a "woman's movement" and concentrate instead on showing specific women personally oppressed. To Wood's credit, he does point to four films that are exceptions to his hard-hitting attack on Hollywood: Claudia Weill's GIRLFRIENDS (1978), Lee Grant's TELL ME A RIDDLE (1980), Joan Micklin Silver's CHILLY SCENES OF WINTER (1982), and Amy Heckerling's FAST TIMES AT RIDGEMONT HIGH (1985). Chapter 11, tracing examples of repressed bisexuality in films from the 1970s to the middle 1980s, presents the most exasperating analyses in the book. Films like SCARECROW (1973), CALIFORNIA SPLIT, THUNDERBOLT AND LIGHTFOOT (both in 1974), DOG DAY AFTERNOON (1975), MAKING LOVE, and VICTOR, VICTORIA (both in 1982) are given star treatment by virtue of their interpreted sexual politics. The final two chapters, dealing with the directors Martin Scorsese and Michael Cimino, conclude the book on an outstanding note. In fact, Wood's brilliant analyses of RAGING BULL (1980), THE DEER HUNTER (1979), and HEAVEN'S GATE (1981) should be required reading. Not only are the interpretations fresh and exciting, but the discussions are also a model of creative thinking.

Despite its many admirable qualities, there is still something intellectually disappointing about the book. Part of the problem is that a third of the way through one senses knee-jerk reactions to classical Hollywood narratives. As Jeanne Anderegg notes, "While Wood intends his politics to be inclusive, his primary focus is anti-patriarchal and pro-bisexual. Films are rewarded for suggesting bisexuality and devalued if insufficiently opposed to traditional family patterns."[462] In short, Wood is very heavy-handed in his analyses. Another problem is that many of the author's

[462] Jeanne Anderegg, "Book Review: HOLLYWOOD FROM VIETNAM TO REAGAN," WILSON LIBRARY BULLETIN 60:8 (April 1986):70.

theoretical positions are superficially explained. Albert LaValley makes a similar criticism, pointing out that "Wood wants to be accepted as a Freudian and a Marxist critic, yet he seems largely unaware of the strands of both traditions that have changed the face of recent film criticism. Similarly, Wood considers himself a feminist, but apart from a few mentions of Laura Mulvey, there is no awareness of recent refinements in feminist theory."[463]

Given these reservations, the book's appeal is somewhat limited. Its title suggests a much more popular orientation than is contained in its often irritating pages. But for those who have the patience to read it from cover to cover the rewards are considerable and the experience lively. A weak bibliography and less-than-adequate index conclude the work. Well worth browsing.

FILMS

AMERICAN GRAFFITI (Universal--16mm: 1973, 109 mins., color, sound, R-SWA; V-SWA)

Directed and co-scripted by George Lucas, this entertaining comedy about growing up in smalltown America during the early 1960s is a prime example of what can be done with Lacanian analysis. Colin McCabe uses the dilemma of graduating high school seniors as evidence of how Lucas and his co-authors, Willard Huyck and Gloria Katz, manipulate an audience's emotions to oscillate between the symbolic and the imaginary. Particular attention is paid to the Richard Dreyfuss character and his search for a father figure, as well as the way mainstream films resolve apparent contradictions in a capitalist society.[464] Nominated for five Oscars, including Best Picture, Best Supporting Actress (Candy Clark), Best Director, Best Story and Screenplay--Based on Factual Material, and Best Film Editing (Verna Fields and Marcia Lucas), it came up empty at the awards ceremony.

IN COLD BLOOD (Columbia--16mm: 1967, 134 mins., b/w, sound, R-BUD, FNC, IMA, KIT, MOD, SWA, TWY, WEL, WHO, WIL)

Written and directed by Richard Brooks, the story based on a "non-fiction novel" by Truman Capote deals with two ex-cons, Perry Smith (Robert Blake) and Dick Hickock (Scott Wilson), who murder a Kansas farmer and his family because the men want to cover-up a bungled robbery of the farmer's house. In the end, the killers are captured and executed. The film itself is a fine example of the debate over docu-dramas in general and voyeurism in particular. That is, does the film appeal to audiences because of the abnormal behavior of the two killers and their disturbed past, and is it responsible filmmaking to recreate clinically scenes of violence and murder? As Manvell explains the controversy, ". . . the film raises the issue that it may well have created too much curiosity or even sympathy for such unusual personalities, leaving the victims, who are duller people, to stew in their own blood."[465] Nominated for four Oscars, including Best Director, Best Screenplay, Best Cinematography (Conrad Hall), and Best Original Music Score (Quincey Jones), it came up empty at the awards ceremony.

PERSONA (Sweden--16mm: 1966, 84 mins., b/w, English subtitles, sound, R-BUD, FES, FNC, EMG, IMA, IVY, MGM; S-REE, TIF)

[463] Albert J. LaValley, "Nuclear Family War," AMERICAN FILM 11:2 (November 1985):70.

[464] McCabe, pp.7-27.

[465] IMAGES OF MADNESS, p.249.

Produced, scripted, and directed by Ingmar Bergman, this seminal film recounts what happens to a famous actress (Liv Ullmann) when during a performance of ELECTRA she suddenly stops speaking and refuses to utter a sound. Taken to a psychiatric clinic, she confounds her doctors who can find nothing physically wrong with her. While there, however, the actress and her nurse (Bibi Andersson) develop a strong attachment to each other. Thinking that the relationship may produce a cure, the physician in charge of the case (Margaretha Krook) sends the two women to her isolated cottage near the seashore. As the days pass, the nurse imagines that she is becoming more and more like her star patient. Then one day she discovers through an unsealed letter that the actress is only amused by the relationship. Hurt and angry, the nurse turns on the actress. Soon, they both return to the clinic, where the nurse suffers a mental breakdown and become totally incoherent. In many respects, Bergman's film not only comments on the nature of duality and transference, but also on the illusions of the motion picture. It is also, as Eberwein points out, a unique opportunity to examine the relationships among a filmmaker, the characters in a film, and the audience: "Bergman addresses us as being implicated in HIS dream, the film, and hence breaks down the ultimate physical and psychic barrier between us and his narrative; the work now becomes partly OUR dream as well."[466]

SPELLBOUND (Selznick--16mm: 1945, 111 mins., color, sound, R-FES)
 Directed by Alfred Hitchcock, the script by Ben Hecht presents one of the classic film stories about amnesia. A new doctor (Gregory Peck) assumes the directorship of a private mental institution, but his colleague (Ingrid Bergman) realizes almost immediately that the incoming psychiatrist is deeply disturbed over a recurring nightmare. Because she has fallen in love with him, Bergman pursues her investigations and discovers not only is the man an imposter who assumed the real director's identity, but also he is suffering from amnesia and thinks that he has murdered the man he is impersonating. More important than the denouement is the treatment of psychiatry in the film and the way in which it reflects Hollywood's primary approach to the profession during the 1940s and 1950s. Nominated for six Oscars, including Best Film, Best Supporting Actor (Mikhail Chekhov), Best Director, Best Cinematography (George Barnes), and Best Special Effects (no credits listed), it won for Best Scoring of a Dramatic or Comedy Film (Miklos Rozsa).

THE FILM INDUSTRY

Thus far we have been discussing the general issues related to film as a form of mass communication. The emphasis has been on the theoretical concerns that critics and historians have about the movies affecting our culture and on their reflecting an ideological system that produced them. The plan has been to show that film is part of an evolving network of mass entertainment satisfying widespread and multifaceted audience needs. The tentative conclusion reached is that while those needs may be more perceived than actual, the importance of those preceived needs is clear both to the industry and to the audience. Discussions about ideology, entertainment, and stereotypes reveal that the movies offers significant data about us and our nation. Moreover, this data is based on a dynamic and complex communication process that functions from production to reception. Implicit in that complex film continuum is the fact that mainstream theatrical films rely heavily on audience identification with screen conventions to insure widespread acceptance of the film's entertainment and box-office values. It should be evident by now that films do not operate in a vacuum. Whatever the goals or stategies of the filmmakers themselves, the production, distribution, exhibition, and reception of films are linked to prevailing political and economic events

[466] Eberwain, p.120. For more information on the film, see Chapter 7.

at home and abroad. Rarely, if ever does the success or failure of a film rely exclusively on the imagination of the filmmaker(s) alone.

What we need to do now is begin to fill in the ahistoricism of the "sociological" and "psychological" criticism previously discussed. A useful way to start to understand the nature of the film experience is by reiterating what has been said about the movies' being primarily a business. [467] The assumption is that the economic

[467] My broad overview of the economic history of the film industry is based upon the following publications: Jeanne Thomas Allen, "The Decay of the Motion Picture Patents Company," THE AMERICAN FILM INDUSTRY, pp. 119-34; ___, "Afterword," THE AMERICAN MOVIE INDUSTRY, pp. 68-75; Robert Anderson, "The Motion Picture Patents Company: A Reevaluation," THE AMERICAN FILM INDUSTRY, Rev. ed.; *Tino Balio, ed., THE AMERICAN FILM INDUSTRY, Rev. ed. (Madison: The University of Wisconsin, 1985); *Daniel Bertrand et al., THE MOTION PICTURE INDUSTRY--A PATTERN OF CONTROL (Washington, D. C.: U. S. Government Printing Office, 1941; New York: Arno Press, 1978); A. William Bluem and Jason E. Squire, eds., THE MOVIE BUSINESS: AMERICAN FILM INDUSTRY PRACTICE (New York: Hastings House, 1972); Robert A. Brady, "The Problem of Monopoly," THE ANNALS OF THE AMERICAN ACADEMY OF POLITICAL AND SOCIAL SCIENCE 254 (November 1947):125-36; Benjamin M. Campaine et al., eds., WHO OWNS THE MEDIA?: CONCENTRATION OF OWNERSHIP IN THE MASS COMMUNICATIONS INDUSTRY (White Plains: Knowledge Industry Publications, 1979); Ralph Cassady, Jr., "Some Economic Aspects of Motion Picture Production and Marketing," THE JOURNAL OF BUSINESS OF THE UNIVERSITY OF CHICAGO 6:2 (April 1933):113-31; ___, "Monopoly in Motion Picture Production and Distribution: 1908-1915," SOUTHERN CALIFORNIA LAW REVIEW 32:4 (Summer 1959):325-90; Rpt. and badly abridged in Kindem, pp. 25-68 (see below); Michael Conant, ANTITRUST IN THE MOTION PICTURE INDUSTRY: ECONOMIC AND LEGAL ANALYSIS (Berkeley: University of California Press, 1960); Anthony H. Dawson, "Motion Picture Economics," HOLLYWOOD QUARTERLY 3:3 (Spring 1948):217-40; ___, "British and American Motion Picture Wage Rates Compared," ibid., pp. 241-47; ___, Patterns of Production and Employment in Hollywood," ibid., 4:4 (Summer 1950):338-53; David Gordon, "Why the Movie Majors Are Major," SIGHT AND SOUND 42:4 (Autumn 1973):194-196; Rpt. in THE AMERICAN FILM INDUSTRY, pp. 458-67; ___, "Ten Points About the Crisis in the British Film Industry," ibid., 43:2 (Spring 1974):66-72; *Douglas Gomery, THE HOLLYWOOD STUDIO SYSTEM (New York: St. Martin's Press, 1986); Thomas H. Guback, THE INTERNATIONAL FILM INDUSTRY: WESTERN EUROPE AND AMERICA SINCE 1945 (Bloomington: Indiana University Press, 1969); Benjamin B. Hampton, A HISTORY OF THE MOVIES (New York: Covici-Friede, 1931; Rpt. A HISTORY OF THE AMERICAN FILM INDUSTRY FROM ITS BEGINNINGS TO 1931, (New York: Dover Publications, 1970); Mae D. Huettig, ECONOMIC CONTROL OF THE MOTION PICTURE INDUSTRY: A STUDY IN INDUSTRIAL ORGANIZATION (Philadelphia: University of Philadelphia, 1944), New York: Jerome S. Ozer, 1971; Gertrude Jobes, MOTION PICTURE EMPIRE (Hamden: Connecticut, 1966); *Garth S. Jowett, FILM: THE DEMOCRATIC ART (Boston: Little, Brown and Company, 1976); *Gorham Kindem, ed., THE AMERICAN MOVIE INDUSTRY: THE BUSINESS OF MOTION PICTURES (Carbondale: Southern Illinois University Press, 1982); *Howard Thompson Lewis, THE MOTION PICTURE INDUSTRY (New York: D. Van Nostrand Company, 1933); *Michael F. Mayer, THE FILM INDUSTRIES: PRACTICAL BUSINESS/LEGAL PROBLEMS IN PRODUCTION, DISTRIBUTION AND EXHIBITION, THE, 2nd ed. (New York: Hastings House, 1978); Donald LeRoy Perry, AN ANALYSIS OF THE FINANCIAL PLANS OF THE MOTION PICTURE INDUSTRY FOR THE PERIOD 1929 to 1962 (Unpublished Ph.D. dissertation, University of Illinois, 1966); *Robert Sklar, MOVIE-MADE AMERICA: A SOCIAL HISTORY OF AMERICAN MOVIES (New York: Vintage Books, 1976); John Spraos, THE DECLINE OF THE CINEMA: AN ECONOMIST'S REPORT (London: George Allen and Unwin Ltd., 1962); *Jason E. Squire, ed., THE MOVIE BUSINESS BOOK (Englewood Cliffs: Prentice-Hall, 1983); Janet Staiger, "Combination and Litigation: Structures of U. S. Film Distribution, 1896-1917," CINEMA JOURNAL 23:2 (Winter 1983):41-72; *Corbett Steinberg, REEL FACTS: THE MOVIE BOOK OF RECORDS (New York: Vintage

structure of film significantly affects its content and messages.[468] For example,
Joseph R. Dominick asserts that the two factors, oligopoly and demand uncertainty,
strongly influence film content. In his words,

> Classic economic theory predicts that firms in an oligopoly converge on product
> features . . . This convergence phenomenon is referred to as a trend toward
> excessive sameness . . . Moreover, the existence of demand uncertainty
> and the complexities that go with it usually result in decision makers allaying
> anxieties by engaging in routinized action. In Hollywood, this entails, among
> other things, imitating well-tried formulas with known audience appeal and
> copying trends and ideas that have worked in the past.[469]

Mary Beth Haralovich makes a similar assertion in her examination of why key film
conventions remain characteristic of major genres and why changes in those
conventions reveal a great deal about a genre's historical context as well as the
audiences that support them. She writes,

> Analyzing genre characteristics in terms of the constraints exerted by the
> process of production is predicated on the contention [Stephen] Heath makes
> that the creative alternatives of filmmaking are contained by conventions of
> genre which are useful to the industry. The repetition of significant features
> minimizes production costs. In addition, genre films sell themselves to audiences
> not only on the basis of their meaning as particular films but because they meet
> audience expectations generated by their genre conventions.[470]

What we will examine in this section is the way in which film as both a business and
an art affects film content and messages.
 While the movies are a service industry involving production (manufacturing),
distribution (wholesaling), and exhibition (retailing), they are not a typical economic
institution. On the one hand, the similarities are striking. As Hortense Powdermaker

Books, 1978); Glen Stewart, AN ANALYSIS OF MOTION PICTURE FINANCING (Masters
thesis, University of New Orleans, 1975); J. C. Strick, "The Economics of the
Motion Picture Industry: A Survey," PHILOSOPHY OF THE SOCIAL SCIENCES 8:4
(1978):406-17; Richard C. Vincent, FINANCIAL CHARACTERISTICS OF SELECTED "B"
FILM PRODUCTIONS OF ALBERT J. COHEN, 1951-1957 (New York: Arno Press, 1980);
*Janet Wasko, MOVIES AND MONEY: FINANCING THE AMERICAN FILM INDUSTRY (Norwood:
Ablex Publishing Corporation, 1982); *John Izod, HOLLYWOOD AND THE BOX OFFICE,
1895-1986 (New York: Columbia University Press, 1988); and *Suzanne Mary Donahue,
AMERICAN FILM DISTRIBUTION: THE CHANGING MARKETPLACE (Ann Arbor: UMI Research
Press, 1987).

[468] It is important, as J. Douglas Gomery wisely explains, to make a distinction
between "business" and "economics." The former relates to "management, finance,
accounting, and marketing." The latter investigates "the processes that
households, firms, and government institutions employ to produce and allocate
goods and services." In oversimplified terms, "business" deals with practical
matters; "economics," with theoretical constructs. For more information, see
Douglas Gomery, "The Economics of Film: What Is the Method?" FILM/CULTURE:
EXPLORATIONS OF CINEMA IN ITS SOCIAL CONTEXT, pp.80-94.

[469] Joseph R. Dominick, "Film Economics and Film Content: 1946-1983," CURRENT
RESEARCH IN FILM: AUDIENCES, ECONOMICS, AND LAW, Volume 3, ed. Bruce A. Austin
(Norwood: Ablex Publishing Corporation, 1987), p.138.

[470] Mary Beth Haralovich, "Sherlock Holmes: Genre and Industrial Practice," JOURNAL
OF UNIVERSITY FILM 31:2 (Spring 1979):53.

points out, "Certainly its financing, its relationships with banks, boards of directors and stockholders, its distribution and advertising, its problems of markets, domestic and foreign, and its labor relations are all the well-recognized parts of any big business."[471] Its three branches require dramatically distinct skills, each skill contributing to the public's ability to view motion pictures regularly.[472] Furthermore, the dynamic creative personalities involved with the film industry--e.g., producers, directors, performers, screenwriters, cinematographers, editors, musicians, costume designers, set decorators. . . .--also insure that the product is constantly being differentiated.[473] In noting the similarities between the film industry and other economic institutions, particular attention needs to be paid to the concept of differentiation. Given the competing outlets for screen entertainment--e.g., network television, pay TV, cable systems, videodiscs, videotapes, laserdiscs, and theater exhibition--it is the novelty of a new film that proves the magnet at the box office and in the television ratings. That emphasis on novelty is what assures the existence of cultural hegemony (a complex process involving a series of relationships that collectively represent what a large segment of society values or rejects at a specific time in history and under particular conditions). Producers eager to maximize their profits respond to social, political, and economic realities and incorporate into the dominant value structure of their products the residual and emerging values of

[471] Hortense Powdermaker, HOLLYWOOD: THE DREAM FACTORY (Boston: Little, Brown and Company, 1950), p.25.

[472] For more information on what the titles and names at the end of each movie mean, see Robert Gustafson, "Film and Labor: What the Credits Mean," FILM/CULTURE: EXPLORATIONS OF CINEMA IN ITS SOCIAL CONTEXT, pp.60-80.

[473] For more information on how members of the film industry are perceived and feel about the business, see Ralph J. Batschelet, THE FLICK AND I (Smithtown: Exposition Press, 1981); David Chase, FILMMAKING: THE COLLABORATIVE ART (Boston: Little, Brown and Company, 1975); Judith Crist and Shirley Sealy, eds., TAKE 22: MOVIEMAKERS ON MOVIEMAKING (New York: Viking, 1984); Digby Diehl, SUPERTALK (Garden City: Doubleday and Company, 1974); *Alan Ebert, INTIMACIES: STARS SHARE THEIR CONFIDENCES AND FEELINGS (New York: Dell Publishing Company, 1980); Ross Firestone, THE SUCCESS TRIP: HOW THEY MADE IT, HOW THEY FEEL ABOUT IT (Chicago: Playboy Press, 1976); *G. Barry Golson, ed., THE PLAYBOY INTERVIEW (Chicago: Wideview, 1981); Harry M. Geduld, ed., FILM MAKERS ON FILM MAKING (Bloomington: Indiana University Press, 1967); *Joseph Gelmis, THE FILM DIRECTOR AS SUPERSTAR (Garden City: Doubleday & Company, 1970); *Dan Georgakas and Lenny Rubenstein, eds., THE CINEASTE INTERVIEWS ON THE ART AND POLITICS OF THE CINEMA, Foreword Roger Ebert (Chicago: Lakeview Press, 1983); Dorothy Herrmann, WITH MALICE TOWARD ALL (New York: G. P. Putnam's Sons, 1982); Charles Higham, CELEBRITY CIRCUS (New York: Delacorte Press, 1979); Charles Higham and Joel Greenberg, THE CELLULOID MUSE: HOLLYWOOD DIRECTORS SPEAK (London: Angus & Robertson, 1969); Wende Hyland and Roberta Hayes, HOW TO MAKE IT IN HOLLYWOOD (Chicago: Nelson-Hall, 1975); Bernard R. Kantor et al., eds., DIRECTORS AT WORK: INTERVIEWS WITH AMERICAN FILM-MAKERS (New York: Funk & Wagnalls, 1970); *Joseph McBride, ed., FILMMAKERS ON FILMMAKING: THE AMERICAN FILM INSTITUTE SEMINARS ON MOTION PICTURES AND TELEVISION (Los Angeles: J. P. Tarcher, 1983); Edwin Miller, ed., SEVENTEEN INTERVIEWS: FILM STARS AND SUPERSTARS (New York: Macmillan Company, 1970); Leonard Probst, OFF CAMERA: LEVELING ABOUT THEMSELVES (New York: Stein and Day, 1975); Bernard Rosenberg and Harry Silverstein, THE REAL TINSEL (New York: Macmillan Company, 1970); Andrew Sarris, ed., INTERVIEWS WITH FILM DIRECTORS (Indianapolis: Bobbs-Merrill Company, 1967); Eric Sherman and Martin Rubin, THE DIRECTOR'S EVENT: INTERVIEWS WITH FIVE AMERICAN FILM-MAKERS (New York: Atheneum, 1970); and *Bob Thomas, ed., DIRECTORS IN ACTION: SELECTIONS FROM ACTION, Introduction Frank Capra (Indianapolis: Bobbs Merrill Company, 1973).

influential groups. In this way, the film industry resembles many other economic
institutions. On the other hand, market conditions over the past ninety years have
forced the separate branches of the movie business to integrate into controversial
combinations. Basic to the film industry's uniqueness is its concern with profits, art,
and purpose. It is those concerns that directly affect what stock situations and social
types are used in formula films, as well as the conditions surrounding the reception
of films by mass audiences.

Not surprisingly, the relationship between filmmakers and their audiences is
predicated on profits, predictions, and predilections. The film industry, aptly
described by Joseph E. Levine as "composed of an indescribable collection of dreamers
and schemers, geniuses and phonies, sharpshooters and lunatics," thrives on
attracting mass audiences to the box office.[474] The box-office receipts not only are
subject to seasonal and cyclical fluctuations (e.g., Easter, summer, and
Christmas),[475] but also to the ways that the various production patterns of the majors
and the independents impact on the problems of employees.[476] In addition, producers,
distributors, and exhibitors recognize the wide range of personalities and occupations
that characterize domestic and international audiences. The difficulty in determining
the nature and composition of the film audience will be discussed later in this chapter.
Suffice it to say that filmmakers understand how poor casting, offensive
characterizations, and anachronistic values siphon off potential ticket holders,
buyers, and investors. To minimize the risks created by an uncertain, highly
speculative market, experienced filmmakers spend considerable sums of money
(sometimes more than double the cost of the film negative itself) in merchandizing
and promoting their products.[477] They consciously incorporate tried and tested
elements into every theatrical film produced. Thus the latest commercial movie has
not only the expected conventions, but also the appropriate fashions in clothes,[478]

[474] Joseph E. Levine, "Ars Longa, Vita Brevis," NEW YORK TIMES 1 (October 10,
 1974):41. For an entertaining look at modern Hollywood deals, see Arthur
 Wellesley, "Behind TV's Angelgate Mess: How Dirty Deals Work and Why Hollywood
 Loves Them," PANORAMA: TELEVISION TODAY AND YESTERDAY 1:9 (October 1980):34-9,
 93.

[475] For an example of the types of competition that occur during a specific season,
 see Geraldine Fabrikant, "Marketing Movies for Children," NEW YORK TIMES D
 (November 28, 1988):15.

[476] "Patterns of Production," p.338.

[477] John Larmett et al., ANALYSIS AND CONCLUSIONS OF THE WASHINGTON TASK FORCE ON
 THE MOTION PICTURE INDUSTRY (Washington, D.C.: U. S. Government, 1978):8.

[478] For a good historical model, see Robert Gustafson, "The Power of the Screen; The
 Influence of Edith Head's Film Designs on the Retail Fashion Market," THE VELVET
 LIGHT TRAP 19 (1982):8-15.

language, special effects, music,[479] and romance.[480] These same considerations go into the making of every film.

Nonetheless, filmmakers know first-hand the limitations of their marketing schemes and the uncertainty of the marketplace. Put in industry terms, a basic concern, reports Thomas M. Pryor, "is that if a truly fine picture finds an impressive audience (one which would make it profitable on an investment of $1,500,000 to $3,000,000) but doesn't draw a high percentage of repeat goers it would go down the drain with a nut of $7-10,000,000 to work off, not unusual these days."[481] The crucial area for the practical business person is to find the common denominator in the film that will appeal to the public. As Don Yakir comments,

> Establishing a movie's identity--the mark of such classic campaigns as "Jaws," "Alien," and "Close Encounters of the Third Kind"--also involves recognition of its relative strengths and weaknesses; this determines how and when the picture will be released (exclusive, first-run or multiple-theater opening), who its presumed audience is (age groups, gender), and which media (television, radio, newspapers) would be the most appropriate for reaching it. These considerations help to assess the movie's box-office potential, which, in turn, dictates the budget allocated to the advertising campaign.[482]

Depending on which accounts one accepts, history has shown that as many as seventy-five percent of the films made in a given year [1967] can fail to make back their initial investments during their theatrical run.[483]

[479] Michael Arciaga, a major representative of film musicians, claims that "In many cases, there is more money to be made from the music than from the film. That is why so many movie producers are going into musicals today." Cited in Barron, "Movie-Themed Films," p.16. In movies like AMERICAN GRAFFITI (1973), SATURDAY NIGHT FEVER (1977), and FM (1978), reports John Rockwell, we saw a new trend in dramatic films where the soundtrack was released as a hit record album. In addition, he points out that "these albums will make so much money that they've become almost as important in putting deals together as the movies themselves." Cf. John Rockwell, "When the Soundtrack Makes the Film," NEW YORK TIMES 2 (May 21, 1978):14.

[480] Harry Geissler, president of Factors Etc. Inc., claims that his highly successful packaging and merchandizing company for movies and TV is able to "pick out stars in advance . . . We know what is, and what is not, acceptable to the public. We know who is coming up, and we spot trends in TV, movies, and the music field. We get their images out to the masses, and we know within 48 hours if they are acceptable." Cited in Barron, "Worldwide Merchandizing," p.9. The concept of "packaging" involves getting creative personnel, a script, and a budget together for a specific deal.

[481] Thomas M. Pryor, "Fabulous Decade Ending in Risky Multi-Million-$ Films; Diller on 'Cycles,'" VARIETY (January 3, 1979):16; and "Is It Worth Making Blockbuster Films?" BUSINESS WEEK (July 11, 1977):36.

[482] Dan Yakir, "Marketing a Movie Is More Than Selling Jell-o," NEW YORK TIMES 2 (January 6, 1980):16. For another example on how films are promoted, see Geraldine Fabrikant, "Campaign Propels LA BAMBA," NEW YORK TIMES D (August 13, 1987):19.

[483] Industry spokespeople at the 1985 SHOWEST convention in Las Vegas claimed that six out of ten films failed to make back their costs in 1984; Janos (p.15) stated that in 1978 only twenty percent showed a profit and thirty-three percent a loss. For other sources, see Jowett and Linton, p.28.

As we will see, the economic history of the movies reveals a series of transitional stages in which market conditions resulted in moves by one or more organizations to gain control of production, distribution, and exhibition.[484] The point that must be stressed is that one phase of the industry dominated all other phases of film during each central period in film history.[485] At first, there was a state of "pure competition," where many buyers and sellers, each aware of the market conditions, determined the market price of their products based almost exclusively on supply and demand. Despite the claims of a few major patent holders (e.g., Thomas Edison, the Latham family, C. Francis Jenkins, Thomas Armat, and the Lumiere brothers), suppliers and buyers moved in and out of the market with relative ease. Then in 1908, one company acting as a patent pool attempted to "monopolize" the film industry. That is, a trust tried for a brief time to become the exclusive seller of film equipment and services. Although other sellers and buyers existed, the imperfect monopoly controlled the flow of goods and the means of production, distribution, and exhibition. But even here, buyers' demands influenced the prices set by the monopoly. A series of complex events soon destroyed the monopolistic corporation, and the independents established an "oligopoly." Known as "the majors," these large firms supplied the entire American market with differentiated products, but with strikingly similar methods of production, distribution, and exhibition.[486] Price competition was kept to an absolute minimum in favor of product differentiation, price leadership, and collusion.[487] Exclusive territories ("zones") were staked out by the majors for the express purpose of suppressing competition and maximizing profits.[488] The irony,

[484] The definitions of "pure competition," "monopoly," "oligopoly," and "cartel" are derived from *Gerson Antell, ECONOMICS: INSTITUTIONS AND ANALYSIS (New York: Amsco School Publications, 1974), pp.97-105, 110. See also *Robert C. Allen and Douglas Gomery, FILM HISTORY: THEORY AND PRACTICE (New York: Alfred A. Knopf, 1985), pp.143-50.

[485] For another interesting perspective on studying economic film history, see J. Douglas Gomery "Film Industry Studies: The Search for a Theory," QUARTERLY REVIEW OF FILM STUDIES 1:1 (Winter 1976):95-100.

[486] The term "independents" creates occasional problems in discussing the economic history of the film industry. During the first stages of film history, the term referred to any small company involved in production, distribution, or exhibition. Later on, it became associated with organizations too small to have a vertical corporation. Today, it relates to any organization other than the top conglomerates or theater circuits. In the context of this section, "independents" refers to small organizations that depend upon other sources for their funding and distribution, or are not part of a large theater circuit.

[487] For a capsule discussion of how price discrimination (the process by which sellers generate more revenue) operated, see Gomery, THE HOLLYWOOD STUDIO SYSTEM, pp.15-8.

[488] For more information about zones, clearances, first-run agreements, and play dates, see Chapter 6. Let the following suffice for now: "Zones" refer to special arrangements among the major film corporations to give preferential treatment in specific geographical areas to each other's films and to exclude independents from having their films usurp the first-run play dates of the Class "A" productions released by the majors. "Clearances" relate to the length a film ran in a particular zone, as well as how much time was required to elapse between first-runs and subsequent runs. Prior to the late 1940s, play dates included not only the time a film was shown to the public, but also the admission price exhibitors were required to charge.

as Douglas Gomery points out, was that at the time Hollywood moved toward vertical integration (dominating production, distribution, and exhibition), local businessmen like Chicago's Barney Balaban and Sam Katz moved toward horizontal integration (turning individual theaters into major movie chains).[489] Internationally, the majors formed "cartels" that divided foreign markets, fixed prices, and controlled American exhibition and distribution overseas.[490] Even further, as Daniel Manny Lund noted, "After nearly five decades of filmmaking it had become clear that exhibition was the most problematic sector, given the heavy capitalization required and the volatility of the market." Thus he pointed out, "Distribution was generally acknowledged as the fulcrum point, both for generating capital for production and for maximizing the return on investment in production."[491]

The oligopolistic practices of the film industry suffered a setback in the late 1940s because of government antitrust actions, the influx of foreign films, a change in American behavior regarding leisure time activities, and the rise of nationalistic policies by foreign governments to protect their film industries. However, the years between 1950 and 1970 provided most of the major corporations with opportunities to regain their position of dominance in the film industry. Whether as a reaction to the emergence in the mid-1950s of television as the dominant commercial amusement in America or as a means to stave off control by financial groups outside the industry, the majors reorganized their production and distribution strategies by decreasing their annual output of films, by depending upon television as a crucial source of revenue, and by becoming members of conglomerates or by diversifying their activities. At the same time, the majors turned their attention to gaining a greater share of the international market. In essence, present market conditions strongly reinforce the oligopolistic practices of the large firms.[492]

In fact, Linton argues convincingly that film's unique qualities and "demand uncertainty" prod major film producers-distributors into market strategies that invariably result in an "oligopolistic" structure. That is, filmmakers spend more time in promoting their product and outsmarting their competitors than they do in fighting over the price of admission to see films. In Linton's educated judgment, the history of economic practices in the movies should be viewed "as a struggle for dominance among the various segments of the industry (production/distribution/exhibition)."[493]

To appreciate why the film industry operates today as it does, and why a multiplicity of perspectives is required to understand the film continuum, it makes sense to review in more detail how movies originated, developed, and matured as a business. What were the marketing conditions that led filmmakers first to consolidate and then to diversify? What obstacles did they encounter? What were the crucial periods in the economic history of film? Of special importance to this chapter is an understanding of how the industry's economic history relates to film stereotypes. We need to describe the conditions under which the film industry's need to minimize financial risk forces filmmakers to respond to market conditions, which, in turn, make profit rather than purpose the crucial factor in the images presented to the public.

One point that needs stressing at the outset is that this author does not accept the conventional myth of the film industry as a polarized one-dimensional battleground between artists and entrepreneurs. For me, it is not a case of D. W. Griffith, Erich

[489] Allen and Gomery, p.198.

[490] For more information, see Campaine, pp.186-90.

[491] Daniel Manny Lund, "Writing Film History: The Struggle for Synthesis," FILM/CULTURE, p.24.

[492] For a brief summary of these issues, see Thomas C. Cochran, "Media as Business: A Brief History," JOURNAL OF COMMUNICATION 25:4 (Autumn 1975):155-65.

[493] Jowett and Linton, p.36.

von Stroheim, Carl Foreman, and Francis Ford Coppola on the one side as "creators," and Louis B. Mayer, Adolph Zukor, Harry Cohn, and Alan Ladd, Jr., on the other side as "capitalistic Philistines." Surely there are as many power struggles among creative people (e.g., directors, performers, and screenwriters) about the quality of a film as there are confrontations between producers and their talented subordinates. For that matter, it is well-documented that the administrators constantly struggle among themselves about the elements that make for a commercially successful movie. In fact, the conflict between business and art transcends the film industry.[494] Knowing about the battles involved in the film continuum permits us to learn at the same time how powerful filmmakers have used their economic advantages to influence social, political, and economic attitudes and values that reinforce the STATUS QUO. And that awareness, in turn, demonstrates the importance of cultural hegemony in the film continuum. David Gordon puts the case well:

> One does not have to be a particularly hidebound Marxist to realize that a capitalist world, with profit-motivated corporations, is not going to turn out films which often challenge the basis of that world. But it is dangerous nonsense to see the movie companies as the natural enemies of film's creative talent.[495]

This general historical review of the American film industry, therefore, summarizes why an anti-business, monolithic mythology has misled both the public and many film historians into underestimating the multiple economic factors that determine production policies and their impact on film content. To illustrate the links between an economic history of the film industry and cultural hegemony, this section also periodically summarizes the evolution and development of female stereotypes and the "women's film" as a reflection of how filmmakers incorporated conflicting social values in formula films as a means of maximizing profits.[496]

[494] According to the anthropologist Powdermaker (p.29), it "is a reflection of the conflict within our culture, but it is more sharply focused . . . [in Hollywood] than elsewhere. It is . . . a point of view culturally determined and exaggerated there." Raymond Williams makes a similar point, only from a different perspective. He believes that the cultural elite, starting with the advent of the printing press, conceived of the word "masses" as a new term for "mob, and the traditional characteristics of the mob were retained in its significance: gullibility, fickleness, herd-prejudice, lowness of taste and habit. The masses, on this evidence, formed the perpetual threat to culture." The way in which the cultural elite reacted to the danger posed by the masses or working class was to preserve an exclusive control over the techniques and distribution of mass communication. The plan was, and presumably remains in effect, to have the dominant hegemony implanted in the minds of those in subordinate positions. As Williams explains, "Culture is the product of the old leisured classes who seek now to defend it against new and destructive forces." See Raymond Williams, CULTURE AND SOCIETY, 1780-1950 (New York: Columbia University Press, 1958), pp.298, 319.

[495] Gordon, p.194.

[496] For purposes of this chapter, the term "women's film" is meant to represent a film genre dealing with narrative patterns specifically concerned with themes and production qualities appealing primarily to female audiences. Admittedly, this definition contains many ambiguities, not the least of which is the inability to determine how women perceive film plots and production qualities. For a good summary of the recognizable traits of the women's film, see Walsh, pp.23-48. Where Walsh and I part company is in her refusal to view the women's

The initial steps from pure competition to imperfect monopoly to oligopoly appear clear-cut in reviewing the early years of American film history. From the 1890s to 1908, the pioneering film industry operated under difficult and unstable conditions. It started with little more than an idea that moving pictures could be commercially profitable to inventors, speculative investors, and a handful of bankers as well as highly entertaining to lower and middle class audiences. But someone had to invent and manufacture the cameras, the raw film stock, and the projectors.[497] These new inventions then had to be marketed. Thus the chief concern of the bantam-size, decentralized industry during its embryonic stages was in manufacturing and selling film equipment.

At the outset, the short, quickly made, and inexpensive movies were little more than a product that was sold by its length (approximately fifty feet) and then used until the films virtually deteriorated. By the early 1900's, every film program was essentially the same regardless of theater location, quality, size, or type of theater. That is, penny arcades, peep shows, shooting galleries, storefront theaters, vaudeville programs, and itinerant shows[498] ran the standard one-reelers (a thousand-foot film) showing movement for the sake of movement.[499] The differences, of course, came in whether the films were viewed in a machine or projected on a screen; whether there was one film seen or a dozen shown in succession; whether the experience occurred in an open field or in a comfortable vaudeville theater; whether there was music provided or whether the films were seen silently; and

film as a genre. She finds the patterns (p.24) to be too diverse, while I find the recognizable conventions to be the overriding consideration. Since there are many authors who object to the term, it is important to identify the genre's two primary uses. One approach is to label any film made by a female director a woman's film. I do not subscribe to this approach. A second approach, and the one I favor, is to identify any Hollywood theatrical film appealing to female audiences as a woman's film. Both of these approaches have limitations and often result in misunderstandings among critics and the general public. For example, Mary Ann Doane finds it problematic that women "possess" specific types of film and that "their terms of address are dictated by the anticipated presence of the female spectator." What is much more interesting to her is the relationship between the "illusory female spectator" and persecution in films like REBECCA (1940) and CAUGHT (1949). For more information, see Mary Ann Doane, "CAUGHT and REBECCA: The Inscription of Femininity as Absence," ENCLITIC 516 (Fall 1981):75-89; Jeanine Basinger, "Why Women Wept," AMERICAN FILM 2:10 (September 1977):52-7; and Mayne, pp.27-43.

[497] Kenneth MacGowan, "The Coming of the Camera and the Projection," QUARTERLY OF FILM, RADIO, TELEVISION 9:1 (Fall 1954):1-14. For more information, see Chapter 7.

[498] Calvin Pryluck, "The Itinerant Movie Show and the Development of the Film Industry," Paper presented at the University Film and Video Conference, Denton, Texas, August 1983. For a discussion of what early film programs were like in vaudeville theatres, see Charles Musser, "American Vitagraph: 1897-1901," CINEMA JOURNAL 22:3 (Spring 1983):19-21.

[499] For a helpful review of how the programs worked, see Robert C. Allen, "Vitascope/Cinematographe: Initial Patterns of American Film Industrial Practice," JOURNAL OF THE UNIVERSITY FILM ASSOCIATION 31:2 (Spring 1979): 13-8; Rpt. in THE AMERICAN MOVIE INDUSTRY, pp.3-11; and Edward Lowry, "Edwin J. Hadley: Travelling Film Exhibitor," *FILMS BEFORE GRIFFITH, ed. John L. Fell (Berkeley: University of California Press, 1983), pp.131-43. For a discussion of what the early films were like, see Richard Arlo Sanderson, A HISTORICAL STUDY OF THE DEVELOPMENT OF AMERICAN MOTION PICTURE CONTENT AND TECHNIQUE PRIOR TO 1904 (Unpublished Ph.D. dissertation, University of Southern California, 1961).

whether the film was a documentary or a melodrama. At first, turn-of-the-century audiences, as we will see later, went by the thousands to gaze at the new mass amusement, regardless of the film content. But very soon, the complex market conditions produced a demand for longer, narrative movies (e.g., two-reel story films, and serials), and exhibitors responded in a uniform manner. Most exhibitors made certain to do exactly what their competitors did. Cost, not quality, was the issue. Supply and demand overshadowed ethics.

Getting into the film industry was relatively simple. With minimal funds, as discussed in Chapter 6, dozens of entrepreneurs like William Fox, Samuel Katz, Nicholas and Joseph M. Schenck, Adolph Zukor, Marcus Loew, Louis B. Mayer, Jesse Lasky, Carl Laemmle, Pat Powers, Lewis J. Selznick, Samuel Goldfish [later Goldwyn], and the Warner brothers could get into the production, distribution, and exhibition business. As also discussed in Chapter 6, the literature about these aggressive personalities demonstrates that chance and ingenuity as much as talent and vision brought these businessmen to the forefront of the industry within a very short period of time.

Meanwhile, the big money-makers were the producers and inventors who controlled the camera and projection patents. The principal patents crucial to film production, points out Janet Staiger, were "the camera patent, . . . Edison's film stock patent reissue, a projector patent, the Latham loop patent, and the Pross patent on projector shutters."[500] The inventors did not concern themselves with long-term plans or external funding. They financed their film operations mainly out of retained earnings. Not much attention was paid to stabilizing the industry or establishing bank credit. These fast-moving, aggressive entrepreneurs were interested primarily in maximizing their profits and not in incurring long-term debts. What made such plans possible were the unique features of the infant film industry. Given the fact that vaudeville houses provided the major mass market for films, almost no money went into establishing complex distribution channels or in building expensive theaters exclusively for movies. Vaudeville had its own well-established distribution network that more than made possible the mass circulation of movies.[501] The haphazard schedule of film releases made it nearly impossible for exhibitors outside the vaudeville circuit to maintain a steady change of program that would make owning a movie theater a sensible business undertaking. It made much more sense for fly-by-night business people to rent facilities or to convert readily accessible buildings into "movie theaters" when an appropriate number of films became

[500] Staiger, p.45.

[501] John Izod argues that the Keith Theatre Circuit played a major role not only in establishing the suitability of the early films for vaudeville, but also in establishing the intense competition between the producers of film equipment. See Izod, pp.3-4. Kristin Thompson claims that the economic stranglehold held by vaudeville on the nascent film industry played a key role in determining film content. See David Bordwell, Janet Staiger, and Kristin Thompson, THE CLASSICAL HOLLYWOOD CINEMA: FILM STYLE & MODE OF PRODUCTION TO 1960 (New York: Columbia University, 1985), pp.159-61.

[502] It is important to reiterate that sweeping generalizations about moviegoing patterns and exhibition practices are very suspect, primarily because not much research has been done on local film history. Even accounts of what occurred in major cities like New York, Boston, and Chicago leave serious scholars uneasy about the conclusions reported in popular film history books. Clearly, there were exceptions to the "store-front theater" accounts and the notion that the early theaters catered mainly to immigrants. Space does not permit a detailed discussion of those exceptions. Suffice it to say that the reader should not only

available.[502] In short, the major investment in the fledgling film industry was almost exclusively in production.

But by 1905, noticeable changes were taking place in the market. For example, as the Harvard economist Howard T. Lewis points out, "When successful projection made screen exhibition possible, the problem of distribution became much more serious."[503] Projection not only decreased the demand for a film because so many people could now see it at one viewing, but also constant changes in programs resulted in far too many prints of the same film being made for individual theater owners. Starting in 1902, film exchanges, operated mostly by showmen intent on insuring an inexpensive, steady flow of films for their movie houses, appeared as intermediaries between the producers and the thousands of small, unorganized exhibitors. The roughly 140 "distributors" who appeared on the scene in the next three years initiated a policy of buying movies from the producers and leasing them on a "state's rights" basis to the exhibitors.[504] The new distributors also started releasing films at specific times rather than immediately after a film was made. In this way, higher rental rates could be charged for more prestigious films. These attempts to reduce financial risks entailed more money than was generated by film rentals. Thus the film exchanges began making overtures to wealthy industrialists and investment corporations. The same was also true for exhibitors, who, in 1905, began converting their small, storefront theaters and failing vaudeville houses into "nickelodeons" (over 3,000 in 1907; nearly twice as many a year later).[505] For the most part, however, the conservative industrialists and investors stayed clear of the unpredictable film world where the leaders were characterized as "spend-thrift,

be sensitive to the tentative nature of my narrative, but also to the need to check my sources carefully for information on contrasting interpretations.

[503] Lewis, p.3.

[504] Douglas Gomery claims that, in the early days of film, there might well have been thousands of distributors flourishing in and around America's major cities. Cf. *Douglas Gomery, THE HOLLYWOOD STUDIO SYSTEM (New York: St. Martin's Press, 1986), p.3.

[505] According to Kevin Brownlow and John Kobal, "The Nickelodeon craze was regarded as easy money for entrepreneurs--another Klondike--and so it was, but because of the high rental offered to secure the site and wages for manager, doorman and operator, they were not cheap to run. To seat more than 200 required a theatrical licence [sic], which cost $500 a year. Most Nickelodeons, therefore, seated 199, and paid amusement licences at $25. A Nickelodeon had to have a weekly minimum of 4,000 visitors to cover the $200 running costs. Since by 1907, more than two million people were visiting Nickelodeons every day of the year, most of the little theatres were doing well." See Kevin Brownlow and John Kobal, HOLLYWOOD: THE PIONEERS (New York: Alfred A. Knopf, 1979), p.46. For information on how the nickelodeons were designed, see Charlotte Herzog, "The Archeology of Cinema Architecture: The Origins of the Movie Theater," QUARTERLY REVIEW OF FILM STUDIES 9:1 (Winter 1984):11-32. Information about the rise, location, and impact of "the nickelodeon era" remains limited and controversial. Pitted against the reports of social workers and historical anecdotes of the period are the recent observations of film historians like Robert C. Allen, J. Douglas Gomery, Charlotte Herzog, Garth S. Jowett, Russell Merritt, and David O. Thomas. The former talk about the influence of the dark and dingy movie theaters operating in working-class neighborhoods and the manner in which they educated immigrants to the mores and values in American culture. The latter insist that not only were the theaters not restricted to ghetto neighborhoods, but also that film exhibitors quickly improved the quality of their theaters and that the educational value of the films was far less than assumed.

ego-centric, unbusinesslike, and unprofessional . . . 'lunatics'. . . ."[506] The changes only underscored the industry's need to reform its volatile financial state.

Of particular importance was that from about 1896 on, the Edison Manufacturing Company, the major holder of equipment patents, found itself in a head-to-head struggle not only with the American Mutoscope Company (eventually the American Mutoscope and Biograph Company), but also with European competitors like the Lumiere Company.[507] In fact, up to World War I, the Europeans, most notably the French and the Italians, dominated the domestic and the world market in both products and profits.[508] Edison, ironically, was responsible for many of his own problems. Having failed to copyright his patents overseas, Edison appeared helpless as a number of European manufacturers used his patents to produce equipment eagerly purchased by Americans determined to enter the film business.

Competition was fierce and ruthless. Prior to 1908, rivals not only robbed and cheated their competitors, but also hired thugs and saboteurs to wreck theaters and laboratories as well as to disrupt distribution channels and assault the employees of competing firms. Unscrupulous as well as incompetent distributors encouraged price wars, duping, bicycling of prints,[509] and inferior film programs. Up to 1905, exhibitors, for their part, generally ignored the comfort and health of their patrons. Movies were shown under intolerable seating and viewing conditions, often at great risk to the customers due to the highly inflammablity of nitrogen prints[510] and due to the unsanitary surroundings. Vaudeville houses were the major exception. There, in ornate surroundings, middle-class audiences could enjoy the moving picture in a non-threatening environment. Except for investment firms like Kuhn, Loeb & Company, financiers continued to shy away from the highly volatile film world.[511]

[506] Wasko, p.201.

[507] Also worth consulting on early industrial matters are the following: Charles Musser, "The Early Cinema of Edwin Porter," CINEMA JOURNAL 19:1 (Fall 1979):1-38; and ___, "American Vitagraph: 1897-1901," ibid., 22:3 (Spring 1983):4-46.

[508] Kristin Thompson claims that prior to the formation of the Trust, Pathe sold the most films to American distributors and exhibitors. See *Kristin Thompson, EXPORTING ENTERTAINMENT: AMERICA IN THE WORLD FILM MARKET 1907-34 (London: The British Film Institute, 1985), pp.2-12. Robert C. Allen presents a fascinating description of why the market strategies of the Lumiere Company in America not only weakened the economic strength of Edison's firm, but also foreshadowed the film industry's future distribution patterns. For a valuable introduction to the way in which economic relations affected the exchange of films, talent, technology, and resources among nation-states, see Janet Staiger and Douglas Gomery, "The History of World Cinema: Models for Economic Analysis," FILM READER 4 (1979):35-44. A more recent example of the impact of this essay on current research is Michael Selig, "(Not) Developing An Indigenous Film Industry: The Case of the New German Cinema," Paper presented at the March, 1984, Society for Cinema Studies conference.

[509] Exhibitors would "switch" prints rather than rent or purchase a new one. Working in pairs in the local area, exhibitors tried to maximize the availability of a print and show it on whatever screens generated the most money.

[510] For a useful overview of the nitrogen problem, see Allen and Gomery, pp.28-30.

[511] For one useful account of a banker's perspective, see Attilio H. Giannini, "Financing the Production and Distribution of Motion Pictures," ANNALS OF AMERICAN ACADEMY OF POLITICAL AND SOCIAL SCIENCE 128 (November 1926):46-9.

Not only did the absence of any tangible collatoral worry them, but they also doubted the value of the product itself. Joseph P. Kennedy put matters well:

> When you make a steel rail you make something that is so long and so heavy and of such a quality. But when you make a foot of film, it is subject to the judgment of millions of people, each with his own standard of measurement.[512]

In short, the film industry was held in very low esteem by most respectable people.

Industry leaders, however, by 1907 were beginning to understand the need to stabilize the film business if the soaring profits were to be maintained.[513] The "Patents War" had resulted in costly legal battles. Exhibitors suffered from the senseless price wars and conflicting patents claims. Distributors recognized the disadvantages of selling or renting films on a state-by-state basis. From the vantage point of history, a 1941 Senate Committee pointed out that early in the evolution of the film industry, sharp business leaders discovered that price competition was not the way to solve industrial problems. The emphasis shifted quickly to the notion of "cooperation." That is, filmmakers saw cooperation as extending

> to the preservation of the status-quo--the system under which the consumer, no longer protected by constant competition in the matter of prices, can be made to pay for all this industrial good will . . . Less openly, cooperation frequently takes forms which are designed to prevent the intrusion of new competitors into the business or industrial field.[514]

The film historian Robert Anderson effectively summarized the situation by declaring that "By 1908, the American film industry appeared to be at the crossroads between reform or collapse."[515]

The period from 1909 to 1920 escalated the shift from pure competition to imperfect monopoly and restrictive trade practices. In September, 1908, a trust called the Motion Picture Patents Company (MPPC) was formed by the producers of cameras, projectors, and other equipment for the express purpose of concentrating control in the hands of a single corporation. For a time (1908-1912), it looked as if the MPPC's monopolistic ambitions in production, distribution, and exhibition might work. Traditional accounts, discussed in Chapter 6 and based mainly on the research done by Terry Ramsaye, Mae D. Huettig, Benjamin B. Hampton, Lewis Jacobs, Ralph Cassady, Jr., and Michael Conant, argue that the Department of Justice and a hardy band of independents ended the monopolistic ambitions of the MPPC.[516] What's more,

[512] Joseph P. Kennedy, ed., THE STORY OF THE FILMS (New York: A. W. Shaw Company, 1928), pp.78-9.

[513] Robert Anderson points out that "The dynamic expansion of the nickelodeons coupled with the relative dearth of domestically manufactured films from 1905-1907 led to the mass importation of foreign motion pictures and the creation of illegal duplicating or duping plants in Chicago, Philadelphia and San Francisco." See Robert Anderson, "The Role of the Western Film Genre in Industry Competition, 1907-1911," JOURNAL OF THE UNIVERSITY FILM ASSOCIATION 31:2 (Spring 1979):20.

[514] Bertrand, p.xii.

[515] Anderson, p.137. This essay is adapted from Anderson's 1983 University of Wisconsin unpublished Ph.D. dissertation, THE MOTION PICTURE PATENTS COMPANY.

[516] A decision against the MPPC was handed down by a federal court in 1915. By January, 1916, the MPPC was told to disband, but the monopoly appealed the decision. The appeal was dismissed in 1918, and the organization ceased to exist.

the scholars insist that although the MPPC was treated harshly, it was treated fairly. On the other hand, contemporary scholars like Robert Anderson, Jeanne Thomas Allen, and Janet Staiger disagree with the standard interpretations and offer instead a fascinating case for reevaluating the role of the MPPC in the history of the film industry. They argue that the MPPC must be seen in the context of its time, a period in which many firms pooled their patents and integrated their resources to control the marketplace. Making money and stabilizing the industry were then and are now the paramount concerns.

In essence, the years from 1909 to 1920 set in motion not only changes in the production, distribution, and exhibition of films, but also sweeping changes in film content, aesthetics, and censorship. Each of these factors is dicussed in Chapter 6. Here we need only indicate what they were. For example, the period saw the rise of feature films, the star system, a run-zone-clearance system, the creation of national regulatory systems for the exhibition of films, revolutionary narrative techniques, the rise of film criticism, the emergence of screenwriters and the creation of scenario departments (discussed in Chapter 5), the birth of national distribution systems, the emergence of "block booking" and "blind buying," the beginnings of a war to acquire theaters, and the move to make the film industry into a vertical operation whereby the people who produced and distributed films also exhibited them.

The period from 1909 to 1920 also reveals that women played a much larger role in the artistic side of the American film industry than is generally understood. One reason may have been the lack of rigidity within the film business. Almost any woman who knew how to put pen to paper, edit two pieces of celluloid, or direct performers and had the gumption to make herself known to her bosses had a chance to influence the direction of American films. Thanks to Anthony Slide's tireless research on silent film history, we can identify over thirty women directors who were active in film production by the start of the twenties. Among the most famous were Alice Guy Blache, Frances Marion, and Lois Weber. From Slide's perspective, "Women might be said to have virtually controlled the film industry." That is, "The stars were all women--the number of male actors who achieved any real prominence may be counted on the fingers of one hand--and many such stars had their own independent producing companies."[517]

In addition to the number of women directors and performers, Slide points to the many important publicists, editors, and screenwriters who populated the American film scene. What happened to the crucial role of women in the industry after Hollywood became the center of the filmmaking process is all too obvious to most film historians. As movies moved away from free competition and toward an imperfect monopoly, more restrictions were placed on who could do what. It was clear to the sons of immigrants and second-generation Americans that a woman's place required that she be subordinate to men not only in the home but also in business relations. Slowly but systematically, women found themselves stripped of their authority and responsibility in the film continuum.

The irony of women's losing status and power in the evolving film industry at the very moment they were being recognized as crucial and prosperous consumers has been perceptively pointed out by Jeanne Thomas Allen. Noting that the business community in the post-World War I period capitalized on the buying power of women, Allen explains that

In the 1920's advertising targeted women as the prosperous and expanding domestic market. Four out of five sales were decided by women who also made 82% of department store purchases, 81% of grocery store purchases, bought 75% of the pianos and men's socks in the United States, 90% of the jewelry, 81% of

[517] Anthony Slide, EARLY WOMEN DIRECTORS (South Brunswick: A. S. Barnes and Company, 1977), p.9.

electrical supplies and more than 40% of the automobiles. Women spent more money on clothes than any other member of the family.[518]

This enormous buying power destabilized the status of women in society. On the one hand, the patriarchal society still argued that a woman's place was in the home. On the other hand, the Roaring Twenties encouraged women to be sexually liberated, economically independent, and single. What Hollywood did in this paradoxical situation, states Allen, was to unite glamor and film technique to match consumer values, "particularly around the image of woman as the ultimate constructed product for consumption."

The American film industry by the mid-1920s had also learned some other crucial business lessons.[519] Industrial leaders like Loew, Mayer, Fox, Laemmle, and Zukor knew first-hand the effects that political wars and economic recessions could have on business.[520] They learned the hard way about the limitations associated with a state-by-state distribution system and an external censoring body. These former merchants thoroughly understood the inefficiency of marketing products through individual retail outlets (theaters) operated independently of each other. Thus the film leaders set in motion a series of oligopolistic practices, modeled in large measure on the strategies developed by vaudeville circuits and chain store retailers,[521] that were designed not only to make the film industry immune to economic and political fluctuations, but also to provide key producers, distributors, and exhibitors with methods for maximizing profits, fully utilizing resources, solidifying control, and increasing growth. In 1927, for example, fewer than ten percent of all American movie theaters (17,836) were designated first-run houses, and no more than eighteen percent of the entire number were located in the downtown areas. Nonetheless, the

[518] Jeanne Thomas Allen, "Gender and Genre." A paper delivered at the August 1985 Meeting of the University Film and Video Association at the University of Southern California. See also Jeanne Thomas Allen, "The Film Viewer as Consumer," QUARTERLY REVIEW OF FILM STUDIES 5:4 (Fall 1980):481-99. See also Leslie Fishbein, "The Demise of the Cult of True Womanhood in Early American Film, 1900-1930: Two Modes of Subversion," JOURNAL OF POPULAR FILM AND TELEVISION 12:2 (Summer 1984):66-72.

[519] For other interesting studies of the film industry, see Rita Ecke Altomara, HOLLYWOOD ON THE PALISADES: A FILMOGRAPHY OF SILENT FILMS MADE IN FORT LEE, NEW JERSEY, 1903-1927 (New York: Garland Publishing, 1983); Gary R. Edgerton, AMERICAN FILM EXHIBITION AND AN ANALYSIS OF THE MOTION PICTURE INDUSTRY'S MARKET STRUCTURE, 1963-1980 (New York: Garland Publishing, 1983); William Franklin Grisham, MODES, MOVIES, AND MAGNATES: EARLY FILMMAKING IN CHICAGO (Unpublished Ph.D. dissertation, Northwestern University, 1982); and Richard Alan Nelson, FLORIDA AND THE AMERICAN MOTION PICTURE INDUSTRY, 1898-1980, Two volumes (New York: Garland Publishing, 1983). A good bibliography is also provided in Richard Alan Nelson, "Before Laurel: Oliver Hardy and the Vim Comedy Company, a Studio Biography," CURRENT RESEARCH IN FILM: AUDIENCES, ECONOMICS, AND LAW, Volume 2, pp.147-50.

[520] Gomery correctly points out (p.4) that Zukor and Famous Players-Lasky (later Paramount) led the way in transforming the structure of the American film industry. For two valuable articles on the corporate structure and behavior of Paramount, see "Paramount Pictures," FORTUNE 15:3 (March 1937):87-96; and "Paramount: Oscar for Profits," ibid., 35:6 (June 1947):90-4.

[521] For more information, see "The Movies in Vaudeville," p.81; Douglas Gomery, "U. S. Film Exhibition: The Formation of Big Business," THE AMERICAN FILM INDUSTRY, Rev. ed., pp.218-28; and ___, THE HOLLYWOOD STUDIO SYSTEM, pp.18-22, 28-31.

ten percent showcase theaters accounted for more than a quarter of all box-office receipts.[522]
 In implementing their plans, the industrial leaders first analyzed the three types of theater outlets for their products: the affiliates (theaters owned by the majors), the large independent circuits, and the Mom-and-Pop movie houses. Although the last group was the largest in number, it was the most insignificant in box-office receipts. Clearly the movie moguls couldn't own every significant theater circuit, nor was there any reason to do so. Careful study revealed that the key to maximum profits was the large first-run downtown theaters. These "picture palaces" not only produced valuable grosses (because of higher ticket admission prices and greater seating capacities), but also influenced what subsequent exhibitors and audiences would rent and see.[523] The plans of self-made men like Loew, Zukor, the Schenck brothers, Laemmle, the Warner brothers, and Fox involved purchasing important first-run exhibition sites strategically located throughout the nation as "insurance policies" for their expensive film productions.[524] These thirty-two key locations (the distributing centers of the majors)[525] would orchestrate the first-run options of the new films through a system of price discrimination, zones, clearances, and play dates.[526] That

[522] Dora H. Stecker, "Some Desirable Goals for Motion Pictures," The National Conference of Social Work, PROCEEDINGS, 1927, pp.360-70.

[523] Margaret Farrand Thorp (pp.9-10) estimated that in 1939 there was one seat for every twelve people in America; one seat for every twenty-one people in the east south central states. Ticket prices ranged from over $2.20 in urban centers, to ten cents in rural areas. The average price in American movie theaters was about thirty cents. Worth noting is that picture palaces did more than increase profits. For more information on how film exhibitors combined film and live entertainment in the 1920s, see Charlotte Herzog, "Movie Palaces and Exhibition," FILM READER 2 (January 1977):185-97. For a perspective on how film exhibition operated in the thirties and forties, see Gomery, THE HOLLYWOOD STUDIO SYSTEM, pp.20-2.

[524] Hampton (pp.252-80) describes in detail the battle by the key film corporations to take over large exhibiting organizations like the Stanley Company of Philadelphia, the Saenger Amusement Company of New Orleans, and Black's New England Theaters, Inc. Zukor took the lead, and by 1921 he owned more than 300 theaters. Within two years, the basic takeovers of exhibition by integrated companies like Loew's, Fox, and First National had taken place. Warner Bros. and RKO would enter the battle a few years later. For useful information on the corporate structure of Warner Bros., see "Warner Brothers," FORTUNE 16:6 (December 1937):110-3. For information on RKO, see "RKO: It's Only Money," FORTUNE 47:5 (May 1953):122-7; Ron Haver, "The Mighty Money Machine," AMERICAN FILM 3:2 (November 1977):55-61; ___, ""RKO Years, Part II," ibid., 3:3 (December-January, 1978):28-34; and "RKO Radio: An Overview," THE VELVET LIGHT TRAP 10 (Fall 1973). For a recent analysis of the "battle for theaters" and the difficulties that ensued from indiscrimate purchases of movie houses, see Donahue, pp.18-21.

[525] Thorp (p.154) reported that thirty key distributing centers existed in the United States in 1939. Each distributor's "territory" included about 500 theaters, which involved the distributor in precise scheduling arrangements (pickups, deliveries, setting show dates, and establishing ticket prices).

[526] The most influential regional monopoly during the twenties was the Chicago theater chain of Balaban & Katz. By the mid-twenties, it merged with Zukor's Famous Players-Lasky (Paramount) and remained in total control of the clearance

is, movie houses would be labeled from first-run to fifth-run, and then assigned films on a priority basis. The assignments would be based more on ties to the major film corporations than on the merit of the films. The preferential status also entitled the exhibitor to charge higher admission prices and thus make more money. The significance of being a preferred first-run theater was that during this period in film history movies made their profits during the initial six months of release. After that, the vast majority of films disappeared from view. Only the "classic" film profited from being re-released at some later date. Thus the large film corporations were interested in agreements among themselves, that reduced the danger that a Class "A" film would be "lost" in a rash of new releases during the important seasons of the year when young people from ages eight to thirty were on vacation.[527] Of particular importance was the need to keep the theaters filled. The emphasis was on satisfying audience expectations based on past experiences.[528] Each motion picture corporation maintained statistical data on box-office revenues, which, in turn, guided New York-based executives in their decisions to allocate specific sums of money to the number of "A" and "B" productions made in the west-coast studios.[529]

A second crucial lesson related to distribution, which now replaced patent control as the number one agenda item in corporate meetings. The fact that each large corporation now distributed its own films insured not only that their films got preferential treatment in rental costs and marketing, but also that the producers kept their expenses down. In addition, the scheme guaranteed a large source of income to the production arms of the corporation, thus making it possible to put the most creative people in the industry under long-term contracts.[530] While the major firms might battle each other over suitable "properties," creative personnel, and technological advantages, there was no reason to believe that any specific problem could not be settled quietly and amicably among "equals." For example, if a particular corporation needed help in producing or casting a film, a "deal" could be worked out that was commercially and artistically beneficial to both parties.[531]

and zoning of Chicago film releases until the end of World War II. For more information, see Douglas Gomery, "The Growth of Movie Monopolies: The Case of Balaban & Katz," WIDE ANGLE 3:1 (1979):54-63.

[527] Typical agreements involved "formula deals" and "master agreements." The former refers to price fixing for the entire run of a specific film; the latter relates to an exhibitor's payments to the distributor being based on a percentage of the gross revenues of a circuit rather than on those of an individual theater. For more information, see Conant, p.74. For a good summary of the legal problems resulting from the studios' contracts with exhibitors, see Donahue, pp.21-6.

[528] For a useful perspective on how moviegoing functioned as an urban phenomenon, see Douglas Gomery, "Movie Audiences, Urban Geography, and the History of the American Film," THE VELVET LIGHT TRAP 19 (1982):23-9.

[529] For a good overview on how the process worked, see Gomery, THE HOLLYWOOD STUDIO SYSTEM, pp.17-20.

[530] The most controversial aspect of the studio contract was the option clause. The contract generally covered seven years, with the studio determining whether or not to invoke the option of rehiring the employee--e.g., director, writer, performer, and producer--at six month or yearly intervals. Under no conditions could the employee take the initiative and unilaterally abrogate the contract before the seven-year period ended. On those occasions when an employee rebelled against an assignment, the studio suspended the recalcitrant employee for an indefinite period. Among the more famous court battles between stars and the studios were those involving James Cagney, Bette Davis, and Olivia De Havilland.

[531] Among Hollywood's famous "loan-outs" were those involving Clark Gable (IT

 If a "major" needed a first-run theater in a competitor's territory, deals were always possible. In fact, the system of zoning included pooling arrangements among the major noncompetitive theater chains. That is, the majors regularly exhibited each other's product in their first-run houses.[532] In that way, nationwide distribution was available for each of the forty to fifty films produced annually by the big film corporations. Those companies not party to the agreement faced serious economic problems. Upton Sinclair put the case well when justifying William Fox's need to own large exhibition circuits:

> There had been formed what was practically a motion picture trust, through the alliance of the Loew family with that of Zukor, president of Paramount. These two big concerns had an understanding between them. They would run each other's pictures in their chains of theatres, but they would not run the pictures of any outsiders. It made no difference how good the Fox pictures might be, the exhibitors decided that they were not worthy of exhibition. If they used Fox pictures at all, they would use them in third or fourth grade houses, and then only when the joint products of Loew and Paramount were insufficient in number to fill these houses. So of course it became necessary for Fox to get his own theatres . . . then and then only was he able to make a satisfactory deal with Loew and Paramount.[533]

Ironically, as discussed in Chapter 6, Fox's greed for more and more theaters led to his eventual downfall.

 A third lesson the majors learned by the mid-1920s was the need for a "gentleman's agreement" among themselves. The willingness of large corporations to act "reasonably" with each other destroyed any serious threat that smaller companies had posed in the past.[534] Independents now were required to use the distribution and exhibition sources of the major corporations. Actually, as Daniel Bertrand reports,

> By the early twenties, most of the important independent corporations and individuals were eliminated or submerged. The industry had already passed from one of many small independent companies to one controlled by a few relatively powerful organizations.[535]

HAPPENED ONE NIGHT and GONE WITH THE WIND), Bette Davis (OF HUMAN BONDAGE), and Ingrid Bergman (CASABLANCA and FOR WHOM THE BELL TOLLS).

[532] Sometimes this system worked to the disadvantage of a major corporation. For example, Paramount had the largest theater holdings (over 1000 movie houses), and often it benefited by having hit MGM films playing in exclusive first-run Paramount theaters. Nevertheless, the majors had to show each other's films since no one corporation produced enough films to satisfy the frequent changes in program demanded by audiences during the thirties and forties.

[533] Upton Sinclair, UPTON SINCLAIR PRESENTS WILLIAM FOX (Los Angeles: Upton Sinclair, 1933), pp.80-1.

[534] According to Huettig (p.44), the only company that didn't get regular preferential treatment in the theaters owned by the majors was Warner Bros. After 1927, however, when Warner Bros. owned exclusive rights to Vitaphone, the upstart company was in a much better position not only to negotiate screen time in rival theaters, but also to "pay back" the other studios for their slights during the twenties.

[535] Bertrand, p.6.

In essence, the independents who survived needed the majors both for obtaining financing and for distributing their products.[536] This industrial stranglehold allowed the large corporations to limit the number of films independents could produce. After all, there was little profit to be made in making films that couldn't be distributed for mass audiences to view.

A fourth lesson that the studio heads grasped in the post-WWII era was the necessity of maintaining good public relations both with the authorities and with social reformers. The early attempts at keeping outsiders from meddling with filmmaking activities--e.g., the 1909 New York Board of Motion Picture Censorship, later changed to the National Board Board of Review-- had fallen into disfavor by the early 1920s. In 1922, as protection against outsiders' upsetting their financial bonanza, the movie moguls established a self-censorship organization--The Motion Picture Producers and Distributors of America (MPPDA)--which had as its primary goals staving off local, state, and national censorship, as well as controlling film content. That is, the MPPDA maintained tight control over script approval and made it nearly impossible for any controversial subject matter to reach the production stage, let alone gain access to the thousands of American movie theaters. How the MPPDA operated will be discussed later in this chapter. Here we need only note that the MPPDA also served to limit entry into the burgeoning film industry and to retain power centrally.

A fifth lesson learned by the industrial leaders after years of intense competition was the value of having overseas markets to underwrite domestic film costs. With European film industries in disarray after World War I, American film corporations, as Thomas H. Guback points out, gained greater economic power in foreign countries.[537] By the mid-twenties, American exports to Europe amounted to "about sixty-five percent of overseas revenue."[538] Foreign markets, on the other hand, accounted for thirty percent of the revenues of the American film industry.[539] Put another way,

In the decade up to 1923, the volume of America's film exportation quadrupled and by 1925 it stood at 235 million feet. During these dozen years [1913-1925], film exports to Europe increased five times and exports to the rest of the world 10 times, as the industry staked out markets in the Far East, Latin America, and elsewhere. It was possible for American films to achieve this dominance because, in part, investments in them were recouped in the home market, which

[536] The two most powerful independents during the thirties and forties were Monogram and Republic. To make a profit, however, they depended heavily on the national and international distribution networks of the eight majors.

[537] The references throughout this chapter to international filmmaking relate almost exclusively to Western Europe. My research has failed to locate sufficient scholarly material on international financing and co-productions in Latin America, Africa, and Asia. The few sources are noted mainly in Chapter 7, where the film histories of these continents are discussed. Hopefully, future editions of FILM STUDY: A ANALYTICAL BIBLIOGRAPHY will remedy this significant omission.

[538] Thomas H. Guback, "Hollywood's International Market," THE AMERICAN FILM INDUSTRY, Rev. ed., p.466.

[539] FILM: THE DEMOCRATIC ART, p.203. Gomery claims that overseas revenues accounted for nearly half of the money made on theatrical films. Cf. Gomery, THE HOLLYWOOD STUDIO SYSTEM, p.12. For other estimates, see C. J. North, "Our Foreign Trade in Motion Pictures," ANNALS OF THE AMERICAN ACADEMY OF POLITICAL AND SOCIAL SCIENCES 128 (November 1926):100-8; and William V. Strauss, "Foreign Distribution of American Foreign Motion Pictures," HARVARD BUSINESS REVIEW 8:3 (April 1930):307-15.

had about half the world's theatres, and thus films could be rented abroad at rates often undercutting those of foreign competitors.[540]

Obviously, Hollywood valued international markets and constructed appropriate strategies to offset the quota policies devised by countries like Germany and France in the late 1920s.[541] The U. S. government even sent a note in April, 1929, to a number of European governments, pointing out that while these countries felt certain measures were necessary to "protect through censorship the national traditions of public morals," America had always maintained a free market.[542] In effect, this policy of exporting mass media productions set the stage for what later would be labeled America's "media imperialism."[543]

The nature and structure of the American film industry thus had changed dramatically since the pre-World War I era. The once short, quickly made movies had grown into expensive multi-reel productions. The former dingy, unsanitary movie houses had been transformed into spacious, clean, middle-class theaters. Hollywood had replaced New York and New Jersey as the production capital of the American movie industry. Investments had shifted away from equipment and into theater acquisitions and expensive studio lots. Distribution took place on a national and international level more than on a state-by-state basis.[544] Each integrated film corporation differentiated its product by a well-publicized star system and "protected" its products through a system of price discrimination, clearances, zones, play dates, pooling agreements, and first-run theaters. The production of film had moved from a small undertaking into large, mass-produced industries with complex techniques and formidable budgets. The more standardized the film industry became in its oligopolistic evolution, the more difficult it became for independents to exist.[545] Particularly relevant to our concerns, the decisions of who made movies, what those movies offered in terms of images and ideas, who distributed films, and what films were shown to mass audiences were concentrated in the hands of a small number of film moguls.

For those who might not appreciate the magnitude of the changes that had taken place since 1900, when there were only fifty movie houses in the country, the sums involved in film exhibition in a single community in 1919, the figures from Toledo, Ohio, are instructive (see Tables 1 and 2).[546] Additional insights are provided by the trade publication THE FILM DAILY, which reported in January, 1923, that there were more than 15,000 movie theaters in America, attracting 50 million people a week

[540] Campaine, p.181.

[541] For an example of the animosity generated by American film imports, see David Straus, "The Rise of Anti-Americanism in France: French Intellectuals and the American Film Indsutry, 1927-1932," JOURNAL OF POPULAR CULTURE 10:4 (Spring 1977):754-9.

[542] Lewis, p.406.

[543] For more information and a useful bibliography, see Campaine, pp.182, 235.

[544] The importance of the states-rights groups up to the 1920s was evident in two such organizations joining the ranks of the major motion picture corporations in that decade: Warner Bros. and Columbia Pictures.

[545] To get a good overview of regional filmmaking in the early days of film, see Diane Waldman, "'What Do Those Birds in Hollywood Have that I Don't?': Early Filmmaking in Colorado," THE VELVET LIGHT TRAP 22 (1986):3-15.

[546] Rev. J. J. Phelan, MOTION PICTURES AS A PHASE OF COMMERCIALIZED AMUSEMENT IN TOLEDO, OHIO. (Toledo, Little Book Press, 1919), pp.41-2.

and bringing in receipts of 52 million dollars on a weekly basis.[547] Another way of picturing the film industry in the mid-twenties is to look at the state-by-state theater distribution. In 1925, WORLD ALMANAC provided such information (see Table 3),[548] along with caveats such as the fact that only thirty-five American theaters had more than 3,000 seats and fewer than 471 of 1,142 theater chains combined vaudeville with motion picture exhibition. For an illustration of how difficult entry into the film industry had become by the 1920s, it is also instructive, as will be discussed later, to examine the short-lived history of Yiddish films as well as the fortunes of African-American entrepreneurs like George and Noble Johnson.

TABLE 1

APPROXIMATE INVESTMENT IN MOTION PICTURE INDUSTRY OF TOLEDO, OHIO
(1919)

1. Land and Buildings	$6,200,000
2. Pianos and Organs	140,000
3. Seats and Chairs	56,132
4. Moving Picture Machines	33,000
5. Picture Screens and Curtains	6,000
Total	$6,435,132

By the beginning of World War I, Wall Street financiers, venture capitalists, and insurance companies, along with California bankers and investors, began reexamining their negative attitudes toward the film industry.[549] In the past, with few exceptions, the film pioneers had relied on their personal resources, the generosity of their friends, and day-to-day business receipts for the cash flow necessary to underwrite production, distribution, and exhibition. The self-made men who once brooked no outside interference into their affairs now realized that they needed more capital than they had available personally in order to increase their real estate holdings and production expenditures. Financiers, for their part, recognized that movies were not a transitory and trivial amusement and that stability would make the rapidly expanding film industry less of a risky business investment. Although the few daring bankers who lent their resources to film corporations like World Film and Triangle soon regretted their actions, the tide had shifted.[550] By 1919, as mentioned earlier, the structure and reputation of the film industry had changed significantly. Moreover, the expansionist plans of Zukor, Loew, Mayer, Fox, and the twenty-six founders of

[547] William Marston Seabury, THE PUBLIC AND THE MOTION PICTURE INDUSTRY (New York: The Macmillan Company, 1926; Rpt. New York: Jerome S. Ozer, 1971), pp.278-9.

[548] Cited in Seabury, p.285.

[549] When Wall Street actually began to rethink its position is debatable. For more information, see "Before Laurel," p.139.

[550] MOVIES AND MONEY, p.11. For information on specific deals between eastern financiers and film companies, see Maurice Bardeche and Robert Brasillach, THE HISTORY OF MOTION PICTURES (New York: W. W. Norton and Company, 1933), p.199.

TABLE 2

APPROXIMATE OPERATING EXPENSES FOR THE YEAR (1919) IN MOTION PICTURE
INDUSTRY OF TOLEDO, OHIO

1. Cost of Film Service	$ 416,000
2. Wages of Employees	396,240
3. Cost of Rental Fees (building)	239,000
4. Cost of Advertising	100,000
5. Taxes on Real Estate	97,960
6. Wages of Orchestra	51,480
7. Wages of Motion Picture Operators	45,500
8. Cost of Heating	45,000.00
9. Federal and County Taxes for Privilege of Exhibition	45,000
10. Wages of Piano Players	30,000.00
11. Wages of Film Exchange Employees and Office Rental	23,000
12. Cost of Admission Tickets (18 Rolls of 2,500 each)	15,169
13. Cost of Electricity	7,020
14. Cost of Taxes on Personal Property	3,817
Total	$1,515,186

The First National Exhibitors Circuit made them more dependent than ever on external funding.[551]

Whether Wall Street investors rather than California bankers led the way is a matter of controversy. Hampton, for example, believes that the young industry's roots on the East Coast gave Wall Street the advantage:

Although Los Angeles had become the capital of motion picture production, financing for the studios was almost all coming from New York. Los Angeles banks occasionally made loans on individual pictures and to studios and producers, but by and large the movie game was too queer for deposit-bankers to understand, and their cautious, prudent participations in its kaleidoscopic changes had permitted New York investment bankers and other financiers to absorb nearly all investments and loans in the industry.[552]

Wasko, on the other hand, feels that the California banking establishment bought into the film industry sooner. She argues that (1) Hollywood encouraged the local economy and bank services; (2) California banks took a more personal interest in the productions themselves, which were located on the West Coast; and (3) Hollywood's unconventional style did not lend itself to Wall Street's corporation-minded business practices.[553] The major reservation I have about Wasko's theory concerns banks' financing specific films during this period. It does not seem plausible that commercial

[551] For more information on the first successful large-scale issuance of film securities on Wall Street, see Perry, pp.24-5.

[552] Hampton, p.380.

[553] Wasko, p.121.

TABLE 3

MOTION PICTURE EXHIBITION IN THE UNITED STATES IN 1925

There were 17,836 motion picture theatres in the United States in 1919, divided as follows:

Maine	191	Kentucky	300
New Hampshire	109	Minnesota	566
Vermont	94	North Dakota	218
Massachusetts	438	Iowa	729
Rhode Island	66	Missouri	618
Connecticut	185	North Carolina	234
Virginia	238	South Carolina	120
Ohio	1040	Florida	167
Illinois	1307	Mississippi	116
Michigan	614	Louisiana	237
Wisconsin	543	Arkansas	220
South Dakota	203	New Mexico	72
Nebraska	414	Wyoming	80
Kansas	494	Arizona	79
Tennessee	186	Nevada	35
Georgia	192	California	775
Alabama	150	Washington	306
New York	1458	Oklahoma	482
New Jersey	422	Texas	709
Pennsylvania	1397	Colorado	233
Delaware	38	Montana	159
Dist. of Columbia	58	Utah	141
Maryland	194	Idaho	157
West Virginia	280	Oregon	209
Indiana	565		

banks would lend non-trivial sums of money to anyone lacking significant collateral. And a film by itself in the early 1920s was not adequate collateral.

Whatever the truth, from 1919 to 1925 the large film corporations began constructing lavish and expensive first-run theaters. Picture palaces, modeled after the famous vaudeville houses, became the rage; and every major city by the end of the decade boasted of a showcase theater with auditoriums seating over 1,500 people.[554] It was during this building boom that bank loans gradually increased both in dollars and frequency.[555] But after 1925, due to the rapid rise in theater and real estate holdings (which provided excellent collateral for bank loans), going to the banks to underwrite the film industry became standard operating procedure.

[554] For an overview of what is happening in the modern era to some of these picture palaces, see David W. Dunlap, "Broadway's Grand Cinemas Are Fading Away," NEW YORK TIMES E (July 26, 1987):28; and ___, "Fadeout for Movie Palace in Brooklyn," ibid., B (March 30, 1988):1-2.

[555] At one time in 1922, relations between the financial community and Hollywood deteriorated to the point where VARIETY reported that bank loans were at the zero level. Cf. Raymond Moley, THE HAYS OFFICE (New York: Bobbs-Merrill Company, 1945), p.41.

For example, Wasko located two studies that illustrate the size of the investments. A Halsey, Stuart, and Company report "stated that between 1925 and 1927 over a million in securities were issued for film companies by Wall Street and LaSalle Street investment houses."[556] THE ARCHITECTURAL FORUM "claimed $1.5 billion was invested in the entire industry, with new theater construction totalling over $199 million."[557] The involvement of bankers in what had up to then been personal business ventures had major repercussions for the free-wheeling filmmakers, who enjoyed taking great risks and operating on their intuition. Not only did the financiers insist on cost accountability, but also on efficient management. Furthermore, the need for stabilizing the industry, reducing operating risks, and maximizing profits resulted in a situation in which meaningful competition from independents virtually disappeared between 1920 and the late thirties.

Research on the important links between the banking community and the film industry during this transitional period makes it clear that finance capital was important but not necessarily that power was shifting from the producers to the financiers. What had started in the 1920s as consolidation for the film industry turned first to a period of profits, growth, and overextension; and then, following the effects of the Depression on the major film corporations, to an era of bankruptcies, receiverships, massive reorganizations, and mergers. Only Loew's Inc. (MGM) and Warner Bros. avoided drastic restructuring during the 1930s.[558] Thanks to the invaluable research done by investigators like Upton Sinclair, Francis D. Klingender and Stuart Legg,[559] Howard Thompson Lewis, J. Douglas Gomery,[560] Michael Conant, Mae D. Huettig, Donald L. Perry, Tino Balio, and Janet Wasko, it is clear that financial dynasties like the Morgans (AT&T) and the Rockefellers (RCA) exerted enormous power over the destiny of the film industry.[561] Each of the various studies offers evidence of how profits and borrowing increased financial representation on

[556] The report is available in THE AMERICAN FILM INDUSTRY, Rev. ed., pp.195-217.

[557] Wasko, pp.30, 32.

[558] For useful information on the corporate structure of MGM, see "Metro-Goldwyn-Mayer," FORTUNE 6:6 (December 1932):51-8; and "Loew's Inc.," ibid., 18:2 (August 1938):69-72. Both articles are reprinted in THE AMERICAN FILM INDUSTRY, Rev. ed.. See also John Emmett Hughes, "M-G-M: War Among the Lion Tamers," FORTUNE 56:2 (August 1957):98-103, 206, 208, 210, 212, 214, 216; "Loew's Inc.," ibid., 20:2 (August 1939):25-31, 104-6, 114; and Robert Sheehan, "The Cliff-Hanger at M. G. M.," ibid., 56:4 (October 1957):134-5, 278, 280, 283.

[559] Francis D. Klingender and Stuart Legg, MONEY BEHIND THE SCREEN (London: Lawrence and Wishart, 1937).

[560] J. Douglas Gomery, THE COMING OF SOUND TO THE AMERICAN CINEMA: A HISTORY OF THE TRANSFORMATION OF AN INDUSTRY (Unpublished Ph.D. dissertation, University of Wisconsin-Madison, 1975).

[561] In Richard Maltby's judgment, "The emergence of the new technology of sound [and the presence of AT&T and RCA] added to both the expansionist impulse and the pressure to cartel action." See Richard Maltby, "The Political Economy of Hollywood: The Studio System," CINEMA, POLITICS AND SOCIETY IN AMERICA, eds. Philip Davies and Brian Neve (New York: St. Martin's Press, 1981), pp.46-7. For an interesting aside, see Diane Waldman, "'Toward a Harmony of Interests'? Rockefeller, the YMCA and the Company Movie Theater in Colorado," WIDE ANGLE 8:1 (1986):41-51.

the various film corporate boards.[562] Each board member, by virtue of his ability
to control capital as well as to influence corporate policy, impacted on the creative
practices of the film industry. Eventually, mythmakers and dissidents simplistically
portrayed the era as one in which creativity was taken over by know-nothing
bankers. In fact, one of the most persistent illusions about the film industry is that
at no time were there ever more than a handful of executives or producers who
understood either the true collaborative nature of the business or the artistic value
of the medium.

One thing that was clear to the American film industry during the silent era,
as Sumiko Higashi points out, was the importance of three female screen types:
virgins, vamps, and flappers. Each, in turn, exemplified how cultural hegemony
incorporated the residual values of the Victorian age with those of the teens and
twenties, while at the same time accommodating the emerging values of the
contemporary woman. For example, Lillian Gish and Mary Pickford, discussed in
detail in Chapter 6, epitomized the ideal Victorian female personified in terms of a
"sentimental heroine as both victim and redeemer" or "in the guise of the manipulative
little girl in a fatherless world."[563] Equally important was the presence of the female
star. Both actresses, through their screen popularity at the box office and the
formula films they starred in, contributed significantly to the profits earned by their
respective companies as well as to the growing financial stability of the fledgling film
industry. For example, many exhibitors willingly paid more for a "Gish" or a
"Pickford" film than for those featuring unknown players.

Producers, less willingly, agreed to improve their production facilities,
standardize their distribution patterns, and enlarge their first-run theater holdings.
They assumed that the presence of stars like Gish and Pickford gave their film
products an edge over those products with less distinguished and popular performers.
The subtle changes from film to film in the Gish and Pickford screen conventions
reflected important shifts in the nation's social, economic, and political values.
Filmmakers also discovered by the teens that audiences enjoyed alternatives to the
dominant screen images of the ideal Victorian "virgins." At first, the "vampire" image
of Theda Bara provided a commercially successful bifurcated film screen protagonist.
But over a period of time, Higashi argues, Bara's persona "proved too threatening
to the male ego," and she was replaced by screen types like Nita Naldi, Carmel
Meyers, Pola Negri, and Greta Garbo, who were "more susceptible to love."[564]

Since cultural hegemony is a dynamic rather than a static process, the screen
images of virgins and vamps, reflecting both dominant and residual values, faced a
serious challenge in the twenties. The contemporary woman, popularized by F. Scott
Fitzgerald, Elinor Glyn, and Anita Loos, reflected the illusion of a radical new female
in both high society and the working classes. I say illusion, because it is clear from
any serious study of the twenties that many white middle- and upper-class women
did not share in the life of the "IT Girls," many minority women didn't relate even
remotely to Zelda Fitzgerald's life-style, and many women in rural America held fast
to Victorian values.

In fact, the movies more than almost any other social document of the silent era
exemplify how flapper screen heroines like Clara Bow, Joan Crawford, and Gloria
Swanson failed to satisfy the presumed needs and desires of the "new woman." On

[562] Janet Wasko offers a useful summary of the two most important forms of film
 financing: "debt" and "equity" financing. The former "covers bank loans, involves
 commercial banks extending credit, or a specific sum of money lent for a specific
 time of interest." The latter covers "the issuing of corporate stock, or
 shareholdings, and involves investment-banking firms." For more information, see
 Janet Wasko, "Film Financing and Banking," FILM/CULTURE, pp.27-36.

[563] VIRGINS, VAMPS, AND FLAPPERS: THE AMERICAN SILENT MOVIE HEROINE, p.v.

[564] Higashi, p.5.

the surface, the movie flappers appeared to be assimilating the emerging values of a sexual revolution, but by the end of their films residual values of husband, home, and children remained dominant. Thus by the arrival of the talkies, the American film industry had discovered that insuring the degree of predictability necessitated, as Higashi notes, "an organization with a conservative front office that would discourage artistic experimentation." She then goes on to say that "As a result, the industry settled upon formulated plots, such as the triangle love story with hero, heroine, and villain, which gave the viewers recurrent deja vu."[565]

Film historians are quick to point out how sound did not appear suddenly in 1926; that THE JAZZ SINGER (1927) was in reality a silent film with a few lines of dialogue and a handful of songs; and that the film corporations took their time in making the transition.[566] What is not generally understood are the reasons why the switch to sound occurred when it did, the motivation for Warner Bros. and Fox taking the leadership role, and the reasons for the majors doing what they did between 1926 and 1928.[567]

No scholar in recent years has done more to clarify the issues than J. Douglas Gomery. In his neoclassical economic assessment of how and why the large film corporations switched to sound in the late 1920s, he provides a new perspective on the reasons that motivated Warner Bros. and the Fox Film Corporation to initiate the transitions.[568] Warner Bros., bankrolled by Waddill Catchings of the influential Wall Street firm, Goldman Sachs, converted its operation to sound as a means of improving its theater chain status; and not, as traditionally reported, because Warner Bros. was on the verge of bankruptcy. At the same time, the resourceful scholar points out how the key film corporations--e.g., Loew's Inc., Universal, First National, Paramount, and Producer's Distributing Corporation (owned at the time by the Keith-Albee vaudeville circuit)--agreed in early 1927 not to make a move to sound conversion until it became clear which sound system proved most compatible with the existing industry structure. Known as the "Big Five Agreement," it made certain that the industry, not an external company, would control the production, distribution, and exhibition of the "talkies." The Fox Film Company, according to Gomery's invaluable research, followed the neoclassical economic theory of

[565] Higashi, p.iv.

[566] For more information, see Chapter 7.

[567] For a useful overview of the effect that the sound transition had on American film interests abroad, see Douglas Gomery, "Economic Struggle and Hollywood Imperialism: Europe Converts to Sound," YALE FRENCH STUDIES 60 (1980):80-93.

[568] J. Douglas Gomery, "The Coming of Sound: Technological Change in the American Film Industry," THE AMERICAN FILM INDUSTRY, Rev. ed., pp.229-51; ___, "Tri-Ergon, Tobias-Klangfilm, and the Coming of Sound," CINEMA JOURNAL 16:1 (Fall 1976):51-61; and ___, "Re-Thinking U. S. Film History: The Depression Decade and Monopoly Control," FILM AND HISTORY 10:2 (May 1980):32-8. For more extensive material on the sound revolution, see *Evan W Cameron, ed., SOUND AND THE CINEMA: THE COMING OF SOUND TO AMERICAN FILM (Pleasantville: Redgrave, 1979); Allen and Gomery, pp.115-24; and Claudia Gorbman, "Bibliography on Sound in Film," YALE FRENCH STUDIES 60 (Spring 1980):269-86.

Worth noting are the problems that scholars like Edward Buscombe raise in connection with Gomery's economic approach to film history. Among other things, Buscombe finds Gomery's economic theories of limited use and simplistic. For more details, see Edward Buscombe, "Sound and Color," JUMP CUT 17 (April 1978):23-5.

technological change (invention, innovation, and diffusion).[569] That is, Fox employed a new product (or production process) as a means of increasing profits. The three stages of technological change also corresponded to William Fox's plans to use the inventor Theodore W. Case's sound technology to enlarge the profits of Fox's film company by introducing a new sound system called Movietone.[570] But the decision in 1928 by corporations like Loew's Inc. and Paramount to go with the Western Electric process developed by AT&T made what had been the novelty of sound a standard industry product by 1930.[571] The inevitable squabble over patents between AT&T and its major rival, RCA, was settled by the mid-thirties.[572] In the interim (1926-1935), not only had Warner Bros. become a major film corporation, but the Radio-Keith-Orpheum Corporation (RKO) had been born and admitted to the ranks of the powerful film organizations. William Fox, in the meantime, had been attacked by the Justice Department for antitrust violations and bankrupted by the Depression. His partners forced him to sell his shares in the corporation in 1930. Two years later the corporation itself went into receivership.

The major controversy today is whether or not finance capital became the dominant force in the film industry after 1930.[573] Wasko, for example, insists that the poor management practices, the effects of the Depression, and the large sums of capital needed to convert the silent film industry to sound put bankers in control. Lewis Jacobs observes that

The entire motion picture industry . . . through patent ownership is indirectly under a monopoly control far beyond the early aspirations of the Motion Picture Patents Corporation. That control is "never for one moment basically deflected by the unceasing obbligato of government anti-trust actions that enlivens its progress." The peak figures in American finance, Morgan and Rockefeller, either indirectly through sound-equipment control or directly by financial control or backing, now own the motion picture industry.[574]

[569] In the Kinder edition of Gomery's essay on "The Warner-Vitaphone Peril," the author indicates (p.133) that one limitation of his original thesis was that in using the neoclassical model as a means of reevaluating film history, he "assumed away many other crucial issues." Another limitation was too heavy a reliance on the narrative elements of structure.

[570] See J. Douglas Gomery, "Problems in Film History: How Fox Innovated Sound," QUARTERLY REVIEW OF FILM STUDIES 1:3 (August 1976):315-30.

[571] Warner's Western Electric Vitaphone system employed a sixteen-inch, single-sided, long-playing phonograph recording which corresponded in real time to one reel of film. For more information, see "The Vitaphone--Pro and Con," THE LITERARY DIGEST 90:13 (September 25, 1926):28-29.

[572] The RCA Photophone system, sound-on-film, is the one that is currently used in films today.

[573] Professor Raymond Fielding takes the position that neither bankers nor industry leaders really determine broad historical changes in the movie business. Rather it is the technological changes--e.g., lighting, color, sound, and screen sizes--that constantly require reorganization and restructuring of the film industry. (Prof. Fielding, discussion with author, August 5, 1985, at the 39th Annual University Film and Video Association Conference.)

[574] Jacobs, p.421.

But other scholars like J. Douglas Gomery, Paul M. Sweezy,[575] and David Kotz[576] insist that the focus should be on how the major corporations prevented bankers from taking power away from the industry's leaders. Gomery summarizes the position of his colleagues:

> Important implications follow from Sweezy and Kotz's work. They argue that for the thirties we should move our analysis away from banks to that of giant corporations, principally focusing on intercorporate conflict. A new type of competition emerged. Giant corporations often stood together rather than attempt [sic] to eliminate each other. They preferred to struggle for a share of an agreed upon profit pie.[577]

Because of the sketchy details surrounding the operations of the banking and film industries, it is difficult at this stage to know definitely which side is right concerning the direct or indirect takeovers that occurred in the thirties.[578] What is clear is that by the mid-thirties, the movies ranked forty-fifth among the nation's top industries.[579] This was true despite the fact that the general economic depression had resulted in 30 million fewer people going to the movies by 1933 than had gone in 1930.[580] That same year, the Depression also put 5,000 movie theaters out of business.[581] Not surprisingly, the overextended film companies found themselves in a series of financial crises.[582] Disastrous box-office receipts made it impossible to meet payments on bank mortgages and loans as well as to meet the contractual obligations to their stable of stars, producers, directors, technicians, and staff. The effects of the move to the vertical integration system and its relationship to the rise of organized labor in the film industry are discussed in Chapter 5. Here we need only mention the fact that the industry's financial plight only accelerated labor problems during the transition to sound movies. In the words of Rupert Hughes, the years between 1930 and 1933 put the film industry in "a state of almost utter bankruptcy with threats of complete paralysis . . . [It was] torn by dissensions within and shaken by earthquakes without."[583] Nonetheless, within a

[575] *Paul M. Sweezy, THEORY OF CAPITALIST DEVELOPMENT (New York: Monthly Review Press, 1953).

[576] *David Kotz, BANK CONTROL OF LARGE CORPORATIONS IN THE UNITED STATES (Berkeley: University of California Press, 1978).

[577] Douglas Gomery, "Review of MOVIES AND MONEY: FINANCING THE AMERICAN FILM INDUSTRY," FILM QUARTERLY 38:1 (Fall 1984):57.

[578] For more information on how the advent of the talkies resulted in a further concentration of capital in the movie industry, see Perry, pp.27-8.

[579] Huettig, pp.56-7.

[580] For more information, see J. Douglas Gomery, "The Popularity of Filmgoing in the US, 1930-1950," HIGH THEORY/LOW CULTURE, ed. Colin McCabe (London: Manchester University Press, 1986), pp.71-9.

[581] Conant, p.32.

[582] According to Gomery, the only major motion picture corporation not to go in the red was Loew's, Inc. Cf. Gomery, THE HOLLYWOOD STUDIO SYSTEM, p.57.

[583] Rupert Hughes, "Calamity, With Sound Effects," NEW OUTLOOK 162:3 (September 1933):23.

decade, according to Dawson's calculations, the film industry was thirty-fifth among the nation's top industries.[584]

During that period, eight corporations--five "majors" (Warner Bros., Paramount, Loew's Inc., 20th Century-Fox, and RKO); three "minors" (Universal, Columbia Pictures, and United Artists)--dominated the industry.[585] The largest total investments of the "Big Five" were in theater holdings (over ninety-three percent), followed by production (close to six percent), and distribution (less than one percent).[586] The "Little Three" had no theater holdings. To be even more precise, Robert A. Brady points out that the eight reigning film companies

> produced 70 percent of all features. In distribution the eight large companies have released between 90 and 95 percent of high quality features, and a somewhat smaller, though still predominating percentage of most of all (except the poorer grade) of "quickies" and certain lines of special subject film. The same group received about 95 percent of all film rentals in the United States. In exhibition they held in that same year control over 2,800 theaters (including 200 jointly owned by two of the majors), or about 16 percent of the 17,000 theaters in the United States. These percentages are roughly typical of the industry today [1947].[587]

Brady also points out how each of the majors had established theater domination in separate parts of the country by 1939. That is, Paramount had fifty percent of its theaters in the South; 20th Century-Fox concentrated its holdings on the "Pacific Coast and Mountain states; Warners with a similar number . . . [500 were] concentrated heavily in the Middle Atlantic states. More than half of RKO's theaters . . . [were] located in New York and New Jersey. More than half of Loew's theaters . . . [were] located in New York City."[588] Gomery puts the case even more strongly, claiming that Paramount reigned supreme in the South, New England, and the Upper Midwest; Fox dominated the Far West; RKO and Loew's Inc. shared control of the New York, New Jersey, and Ohio areas; and Warner Bros. laid claim to the mid-Atlantic states.[589] According to Huettig's accounts, based upon data published in the August 10, 1940 issue of VARIETY, the five majors owned or controlled more than seventy-seven percent of the first-run theaters in the nation's twenty-five largest cities. At the time, fewer than forty first-run theaters were independently

[584] "Motion Picture Economics," p.217.

[585] In comparative terms, as Balio points out, Warner Bros. had the most subsidiaries; MGM, through its affiliation with Loew's, Inc., had the wealthiest theater organization; Paramount had the most complex operation; RKO and 20th Century-Fox were about equal; and United Artists was the smallest of the "Little Three" organizations. See THE AMERICAN FILM INDUSTRY, Rev. ed., p.253. For useful information on the corporate structure of Paramount Pictures, see "Paramount," FORTUNE 15:3 (March 1937):86-96, 194-212; John Russell Taylor, "Paramount," FILMS AND FILMING 35:7 (June 1984):7-10; and ___, "Paramount, Part II," ibid., 35:8 (July 1984):7-10. For information on the corporate structure of 20th Century-Fox, see "20th Century-Fox," FORTUNE 12:6 (December 1935):85-93. For more information about the corporate structure of United Artists, see "United Artists: Final Shooting Script," FORTUNE 22:6 (December 1940):95-102.

[586] "United Artists," p.225.

[587] Brady, p.126.

[588] Brady, p.129.

[589] Gomery, THE HOLLYWOOD STUDIO SYSTEM, p.13.

owned or operated (see Table 4).[590] Noticeably absent from Table 4 are the minors, which owned no theaters. In fact, while Columbia and Universal both produced and distributed films, United Artists acted primarily as the key distributor for independent producers.

Not surprisingly, many film historians believe that collusion was standard operating procedure for the majors. That is, the pool, the community of interest, and the market cartel that limited competition allowed a small coterie of vertically integrated, horizontally coordinated, and monopolistically inclined corporations through the use of complicated and questionable arrangements to control and to dominate the film industry.

TABLE 4

FIRST-RUN THEATERS OWNED BY FIVE MAJOR CORPORATIONS IN 1940

COMPANY	NUMBER OF CONTROLLED FIRST-RUN THEATERS
Paramount	29
Warner Bros.	28
20th Century-Fox	26
Loew's	24
R.K.O.	19
Non-affiliated	37
Total	163

Thus, contrary to the popular perception that production was the most significant feature of the film industry, "the crux of the motion picture industry . . . [was] the theatre," as Huettig perceptively points out in the mid-1940s.[591] That is, theater ownership in itself was the principal source of revenue for the majors.[592] Theater ownership also acted as a buffer against overall market risks by guaranteeing a minimal rental return and a major showcase for future distribution policies. Put another way, the basic advantage to a filmmaker in being tied to a major producer was in making certain that first-run theaters exhibited important films on a preferential basis.

Of primary importance to our concerns in this chapter is the recognition of the crucial role that exhibition and banking interests played (and play today) in determining the multiple types, messages, and content of film. Not only did the conclusions reached by single-minded executives, distributors, and exhibitors restrict the actions of producers, but also their collective judgments affecting the content of commercial films came to approximate a repository of what mass audiences valued or discounted at specific periods of American history. A case in point was the Production Code Adminstration (PCA), discussed in more detail later in the chapter. Suffice it

[590] Huettig, p.77.

[591] Huettig, p.54.

[592] For more information about the limitations of first-run policies, see J. Douglas Gomery, "The Picture Palace: Economic Sense or Hollywood Nonsense," QUARTERLY REVIEW OF FILM STUDIES 3:1 (Winter 1978):29-32; and _____, "U. S. Film Exhibition," pp.218-28.

to say here that the PCA made certain that characters, themes, and values alien to the oligopoly had difficulty in getting approved, distributed, or exhibited in most American movie houses. That is not to say that bankers told producers what specific movies to make or that residual and emerging social values did not appear in Hollywood films. Nor is it to suggest that audiences interpreted films uniformly or as the filmmakers intended. It is a fact, however, that financiers, interested in maximizing their profits, demanded that filmmakers conceive of projects with the widest possible appeal. Furthermore, the fact that exhibition was perceived as the key to profits and that exhibitors argued strenuously for popular and proven stars and genre films made it almost impossible for controversial and oppositional ideas and messages to reach millions of moviegoers during the twenty years that the Hollywood studio system reigned in America. These pressures resulted in the formula filmmaking discussed in Chapter 2.

Another case in point was the star system. Cathy Klaprat, for example, effectively summarizes how the major film corporations relied on their extensive publicity programs and creative departments to "manufacture" screen personalities who operated both as symbols for differentiating products and as catalysts around whom specific films were made.[593] What made the star system so valuable to the motion picture corporations was the fact that performers, directors, producers, and writers were put on long-term contracts beneficial primarily to the studios. Not only was it difficult for a studio's "stars" to negotiate meaningful salary increases and better working conditions, but also they couldn't take their talents elsewhere and work. This economic servitude flourished from the mid-twenties until the start of World War II. During those years, the majors remained secure in the knowledge that they would produce and distribute a financially effective product for their vast theater chains. This mode of production was altered, however, when the creative personnel, as discussed in Chapter 5, began unionizing into different guilds (e.g., the Screen Writers Guild, the Actors Guild, and the Directors Guild). As long as the system worked, producers could depend upon the support of the financial community. Wasko states the banker-producer relationship effectively: "The Hollywood box-office mentality was not necessarily INITIATED by bankers; yet this attitude was certainly REINFORCED and INTENSIFIED by the banks' constant efforts to maintain the film industry as a profitable, stable, and continually expanding business."[594]

This chapter will argue that given the oligopolistic American film industry, the majors adroitly used film stereotypes to maximize profits, to minimize business risks, and to centralize control. Although there were periodic attempts by government decrees (to be discussed later in this chapter) and powerful organizations (e.g., The Legion of Decency) to influence film content, the majors exercised caution in choosing specific film formulas and prudence in altering their conventions to reflect the periods in which the films were made. Put another way, from the continuity script[595] to the neighborhood screen, film content relied heavily on stereotypes to insure the favored economic status of the majors. Furthermore, the significant battles that occurred in the process of cultural hegemony were won more on economic grounds than on social issues.

A classic example of how Hollywood used formula films and the star system to minimize financial risks and maximize profits is the evolution of the "women's film" during the 1930s. Aimed primarily at female audiences, it boasted, as Andrea S. Walsh

[593] Cathy Klaprat, "The Star as Market Strategy: Bette Davis in Another Light," THE AMERICAN FILM INDUSTRY, Rev. ed., pp.351-76. For a more general but relevant discussion, See Berger, pp.129-54.

[594] Wasko, p.94.

[595] Janet Staiger, "Blueprints for Feature Films: Hollywood's Continuity Scripts," THE AMERICAN FILM INDUSTRY, Rev. ed., pp.173-92.

observed, a number of unique characteristics.[596] First, most of the women's films made women the center of the screen universe. For example, films like ANNA CHRISTIE (1930), SUSAN LENNOX: HER FALL AND RISE (1931), THE PAST OF MARY HOLMES (1932), QUEEN CHRISTINA (1933), SADIE MCKEE (1934), CAMILLE (1936), and JEZEBEL (1938) not only accented the importance of the main female character, but also reinforced the star's screen persona. At other times, the inclusion of a feminine theme was made clear by the film's title: e.g., BLONDE VENUS (1932), THE SCARLET EMPRESS (1934), FRONT PAGE WOMAN (1935), MORE THAN A SECRETARY (1936), MARKED WOMAN (1937), and THE OLD MAID (1939).

Formula filmmaking and the star system were just two of many hotly debated means of safeguarding the financiers' investments in the film industry. Another controversial trade practice of the period was known as "block booking."[597] The principal argument against this restrictive policy was that it approximated "full-line forcing." That is, exhibitors found themselves coerced into showing a block of a studio's films (short subjects and "B" films included) in order to guarantee that they would get the studio's Class "A" pictures for their theaters. What made the matter more intolerable was the fact that exhibitors paid inflated prices for leasing large numbers of short subjects.[598] As Cassady describes the practice, "The price of the product . . . [was] predicated upon a basis almost totally foreign to the value of the short subjects; . . . [was] indeed based more upon the value of a few important features."[599] On the other hand, distributors defended their actions by arguing that it was a standard wholesaling practice used in all the major industries. Even Cassady felt in the 1930s that the "'evil' effects of block-booking . . . [had] been overemphasized, considering the fact that independent exhibitors, at present, account for, at most, only 20 percent of the buying power of the industry."[600] In analyzing the advantages and disadvantages of the various "protection" trade practices like block booking, Huettig finds the arguments circuitous:

> The circularity of the process is indisputably clear: Large theatre chains, both affiliated and unaffiliated, receive preferential terms from the major distributors because of their buying power; as a result of the favored treatment they achieve a dominant position in the theatre market, attracting trade with the better choice of pictures, earlier runs, etc.; once this was achieved, they were in an excellent position to demand a continuation of the favored treatment because of their hold over an important share of the volume of business.[601]

[596] Walsh, pp.23-48.

[597] Block-booking refers to a trade practice in which two types of films ("A" and "B" productions) are "sold" simultaneously in a large number at a fixed group price. Another variation is blind buying, which requires films to be "bought" even before they are produced. For more information, see Chapter 6.

[598] It's important to differentiate between block booking for the major film corporations and large independent film circuits, and arrangements for small theater owners. The majors and their "friends" could pick and choose the films they needed to provide weekly program changes. The smaller firms had only the option of canceling 10 percent of a full-line forcing arrangement.

[599] "Some Economic Aspects," p.121.

[600] "Some Economic Aspects," p.121.

[601] Huettig, p.124.

It would be only a matter of time, however, before the Supreme Court in the PARAMOUNT case (1948) would rule in favor of the small exhibitors and validate their claims that block booking was both discriminatory and compulsory.

Still another major debate surrounding the vertical integration and horizontal combinations of the film industry during the 1920s and 1930s was whether the public benefited from the creation of an oligopoly. Was it true, for example, that the system produced excellent entertainment at minimum cost for the maximum number of viewers? Or, as the independents claimed, did the practices maximize profits while minimizing artistic efforts and reduce film content to the lowest common denominator?[602] In an impressive survey of the various claims and counterclaims, J. C. Strick points out that

it has been contended that the oligopolistic control of the movie industry did not serve the public interest as it stifled individuality and creativity . . . Producers in the majors were too prone to follow the leader in the cycle system--one successful gangster film was immediately followed by dozens of similar type (Cassady). That innovations were few and far between was attributed to the lack of competition. The new features introduced between the mid-1920's to the mid-1950's included sound (1926), colour (1932), and wide screen (Cinerama and Cinemascope [sic] in the 1950s). Some of the innovations, however, were pioneered by independents or minor firms before being used or adapted by the established majors (Hellmuth). For example, . . . the wide screen process was first employed by two independent producers when they presented Cinerama, which was then followed by 20th Century-Fox's popular cinemascope. This lack of innovation is a well-known characteristic of an oligopolistic industry where an individual firm is reluctant to disturb the STATUS QUO because of uncertainty and for fear of retaliation by competitors. The majors began to experiment with various wide screens and sound effects primarily to make motion pictures more attractive in comparison to television (Bernstein).[603]

The debate continues to this day over how beneficial the studio system was to the public and the industry. The debate about its legality, however, was settled by the end of the 1940s.

Ever since the early days of sound, independents and government agencies had challenged the antitrust violations of the eight leading film corporations.[604] The one notable exception occurred between June 16, 1933, and May 27, 1935, with the establishment of the National Industrial Recovery Act (NIRA). Although the NIRA is discussed in more detail in Chapter 5, here we should note that the National Recovery Administration (NRA) reinforced the oligopolistic practices of the film industry by setting up "codes of fair competition" that protected the majors from federal prosecution under the tenets of the Sherman Anti-Trust Act of 1890.[605] That

[602] Among the major independent producers during the 1930s were Charles Chaplin, Miriam Cooper, Walt Disney, Samuel Goldwyn, David O. Selznick, and Walter Wanger.

[603] Strick, pp.411-2.

[604] For a good discussion of the effect of small antitrust cases on the PARAMOUNT case, see Cathy Schwichtenberg, "A Case Study of Film Antitrust Legislation: R. D. Goldberg v. Tri-State Theatre Corporation," CURRENT RESEARCH IN FILM: AUDIENCES, ECONOMICS, AND LAW, Volume 2, pp.238-48.

[605] The "codes of fair competition" affected more than 600 American industries. Those relating to the film industry provided for sixty-two boards composed of industry representatives (almost all from the majors) who had the responsibility for

meant that small exhibitors who tried to compete with the major theater circuits by lowering prices, offering "double bills" (two pictures instead of one for the same price),[606] and designating specific week nights as "novelty" evenings (e.g., lotteries, giveaways, and talent nights) were prevented from taking such actions. The first important breakthrough occurred in 1935 when the NIRA was declared illegal by the Supreme Court and the small exhibitors were able to resume their tactics against the major theater circuits.[607] Moreover, Jowett believes that with the termination of the NRA code, the film industry fell into "absolute chaos" as self-regulation disappeared, antitrust actions mounted, and no one of the majors was able to control "recalcitrant exhibitors and distributors. . . ."[608] Sklar, on the other hand, insists that the NRA had strengthened the position of the small exhibitors, and it was this group that suffered most from the 1935 Supreme Court decision.[609] Gomery disagrees with both social historians. In his revisionist perspective, small-time exhibitors lost ground during the NRA days, and the eight corporations were "near the acme of their power in the period after 1935."[610]

The next significant breakthrough occurred on July 20, 1938, when the Department of Justice filed its antitrust suit, "UNITED STATES V. PARAMOUNT, INC., et al." The crux of the twenty-eight complaints in the suit was that a vertical system of production, distribution, and exhibition was illegal.[611] Although five years' work had gone into constructing the government's case, the 1940 trial in the Southern District Court of New York lasted only three days. Rather than have the case settled by judges, the majors (Loew's, Inc., Paramount, Warner Bros., 20th Century-Fox, and RKO) agreed on November 20, 1940, to a consent decree that, in effect, planted the seeds to suspend block booking, blind selling, and full-line forcing. In what

settling internal business matters in thirty-one designated zones in the nation. For more information, see Douglas Gomery, "U. S. Film Exhibition: The Formation of Big Business," THE AMERICAN FILM INDUSTRY, pp.226-8; and FILM: THE DEMOCRATIC ART, pp.244-64.

[606] The major impact of the short-lived two-feature movie program was to create a need for more films quickly made and cheaply rented. The demand resulted in the creation of Poverty Row filmmakers like Republic Pictures and Monogram Pictures. For more information on the fortunes of Monogram, see Tom Onosko, "Monogram: Its Rise and Fall in the 1940s," THE VELVET LIGHT TRAP 5 (1972):5-9. For examples of negative reactions to the "double bills" policy, see Samuel Goldwyn, "Hollywood is Sick," SATURDAY EVENING POST 213 (July 13, 1940):18-9, 44, 48-9; and "Screen Fans Organize to Bite Hand that Feeds Double Features," NEWSWEEK 10:14 (October 4, 1937):25-6. For a fresh perspective on the issue, see Mary Beth Haralovich, "Sherlock Holmes: Genre and Industrial Practice," JOURNAL OF THE UNIVERSITY FILM ASSOCIATION 31:2 (Spring 1979):53-8.

[607] For a good summary of the "novelty" wars, see Donahue, pp.24-5.

[608] FILM: THE DEMOCRATIC ART, p.246.

[609] Sklar, pp.167-71.

[610] Douglas Gomery, "Hollywood, the National Recovery Administration, and the Question of Monopoly Power," THE AMERICAN MOVIE INDUSTRY, p.206. The article was originally published in JOURNAL OF THE UNIVERSITY FILM ASSOCIATION 31:2 (Spring 1979):47-52. See also Douglas Gomery, "Rethinking American Film History: The Depression Decade and Monopoly Control," FILM AND HISTORY 10:2 (May 1980):32-8.

[611] For a good summary of the amended petition filed on November 14, 1940, see Donahue, pp.26-7.

turned out to be a futile effort to settle industry disputes, an arbitration process patterned after the practices established by the NRA was created.[612]

The scheme was to provide small, independent exhibitors with an exclusive forum for settling issues related to contracts and status. Of the 450 cases presented to thirty-one tribunals between 1941 and 1946, the majority concerned status (first-run, second-run, etc.).[613] The minors--Columbia, Universal, and United Artists--did not function as exhibitors, and thus they did not participate in the compromise plan. The majors also agreed to book no more than five films at one time and to freeze their theater holdings (See Table 5).[614] For its part, the government was willing to let the film industry police itself through a process of arbitration and agreed not to pursue the issue of production being separate from exhibition. The consent decree was for a three-year period. After that, the government was to decide on its effectiveness.

TABLE 5

THEATERS OWNED BY FIVE MAJOR CORPORATIONS IN 1940 and 1948

	1940(a)	1948(b)
Paramount	1,273	1,565
20th Century-Fox	538	485
Loew's	122	116
Warners	557	465
RKO	132	104(c)

(a) M. D. Huettig, ECONOMIC CONTROL OF THE MOTION PICTURE INDUSTRY, p.72.

(b) HOLLYWOOD REPORTER, March 4, 1948

(c) Figure received directly from RKO

In the interim, World War II had several significant effects on the economic patterns of the film industry. On the most obvious level, a large part of the foreign market disappeared. The once lucrative German and French outlets, along with those of other European nations, did not become accessible again to Hollywood until the mid-1940s. The same was true for Asian distribution and exhibition. Only the abbreviated British film market remained a valuable source of film revenues for the

[612] "Symposium on Arbitration in the Motion Picture Industry," ARBITRATION JOURNAL (1941):10-61.

[613] Conant, p.96.

[614] "Motion Picture Economics," p.288.

[615] Raymond Moley provides useful information on the effects of The British Cinematograph Act of 1938, which led to limitations on the amount of money that American producers could take out England. It wasn't until 1943 that the Hays Office, ". . . after nearly four years of laborious effort, . . . [was able to get] the burdensome transfer restrictions imposed at the outbreak of the war . . . eliminated." See Raymond Morley, THE HAYS OFFICE (Indianapolis: The Bobbs-Merrill Company, 1945), p.184.

Americans.[615] The one major market expanded for Hollywood films was in Latin America, but it in no way compensated for the international trade lost elsewhere.[616]

A much more significant effect of World War II was to cause Hollywood to focus more intently on its domestic market. Particularly important was the fact that the wartime economy put more money in the public's pocketbooks but gave the public fewer places to enjoy it. As a result, movie attendance soared to all-time highs at the same time war shortages, rationing, and studio enlistments in the military were reducing the number of films released annually by the majors. For example, the majors released 363 films in 1940. Four years later, the number was 270.[617] Adding to the studios' problems were their relationships, as discussed in Chapter 2, with the Office of War Information (OWI). In essence, a battle raged over what types of films would best help the nation's morale and cause.[618] For our purposes here, it is worth pointing out that the issue became moot midway through the war when Congress did away with the OWI's funds and the War Activities Committee became the dominant coordinating government agency in 1944.

Another significant outcome of the production decline was an increase in the number of independent films shown in American theaters. One reason was that a new crop of independent producers like Lester Cowan, David Loew, and Hunt Stromberg successfully supplemented the product of the majors, thus increasing film revenues for the big corporations. A second reason for the independent spurt was that during the war thousands of movie theaters needed more films than the majors could supply. A third reason related to the changing attitudes of the Internal Revenue Service. As Balio explains,

> . . . the wartime income tax rates had badly eroded the take-home pay of high-priced talent. By operating his own independent production company, a producer, director, or actor in the top income bracket could reduce his effective tax rate from 80 to 60 percent. Moreover, under certain conditions, an interest in a completed picture could be sold as a capital asset, making the profit from such a sale subject to only a 25 percent capital gains tax.[619]

[616] For the best information on American films in South America, see Gaizka S. de Usabel, THE HIGH NOON OF AMERICAN FILMS IN LATIN AMERICA (Ann Arbor: UMI Research Press, 1982), pp.145-92.

[617] William Fadiman puts the numbers somewhat differently. He compares the total number of annual productions in America and abroad by major American companies: 763 films released in America in 1936 compared to 425 in 1946. See William Fadiman, HOLLYWOOD NOW, Foreword Irving Wallace (New York: Liveright, 1972), p.8. Balio claims that the reason fewer pictures were produced was in large part the result of the studios' believing that by decreasing production they could increase profits. See THE AMERICAN FILM INDUSTRY, Rev. ed., p. 282.

[618] The image of women in films made during World War II is covered later in this chapter. Here it is useful only to quote Izod's observation (p.114) that "during the war women's pictures changed to reflect the altered circumstances of the audience and showed women coping with a new independence in both their private and working lives . . . And for the first time exhibitors were faced with the problem of marketing devices to attract the single woman--distributors encouraged them to display glamour pictures of males stars outside theaters." See also Sylvia Harvey, "Women's Place: The Absent Family," WOMEN IN FILM NOIR, ed. E. Ann Kaplan (London: The British Film Institute, 1980), pp.22-34.

[619] THE AMERICAN FILM INDUSTRY, Rev. ed., p.413. According to Frank E. Rosenfelt, a new member of MGM's legal department in 1950s and later the president of the company, income taxes were a major factor in bringing independent filmmaking into

Gomery makes the point that the eight major corporations were all handling independent films by the end of World War II.[620] Throughout this book, and particularly in Chapters 5 and 6, examples of creative personalities who took the independent production route (especially in the late forties and early fifties) are discussed.[621] The moves toward independent production during and immediately following World War II contributed significantly to the trends and changes that were taking place in the structure and nature of the film industry.[622]

Ironically, the fact that independents were in a better position six years after the PARAMOUNT antitrust action was first filed did not prevent the Department of Justice from reopening its antitrust case against the majors in August, 1944.[623] According to Suzanne Mary Donahue,

By 1945, 3,137 of 18,076 motion picture theaters in the United States were either solely or jointly owned by the majors. They, however, comprised 70 percent of the first-run theaters in the ninety-two largest cities and 60 percent of the first-run theaters in smaller cities. In 1947, 107 distribution companies were in business in the United States. However, the eight majors dominated

the studios. To avoid paying increasingly higher taxes, he claims, stars and directors were advised by their accountants to incorporate. When they did this, the studio system took one giant step toward collapse. Cited in Aljean Harmetz, ROLLING BREAKS AND OTHER MOVIE BUSINESS (New York: Alfred A. Knopf, 1983), p.175.

[620] Gomery, THE HOLLYWOOD STUDIO SYSTEM, p.11.

[621] Two actors who went into independent production were Burt Lancaster and Gregory Peck. A useful bibliography on Lancaster is Jerry Vermilye, BURT LANCASTER: A PICTORIAL TREASURY OF HIS FILMS (New York: Crescent Books, 1970); *Tony Thomas, BURT LANCASTER (New York: Pyramid Publications, 1975); and *Robert Windler, BURT LANCASTER (New York: St. Martin's Press, 1984). A useful bibliography on Peck is Michael Freedland, GREGORY PECK: THE MAN BEHIND THE LEGEND (New York: William Morrow and Company, 1980); and *Tony Thomas, GREGORY PECK (New York: Pyramid Publications, 1977). Doris Day is an example of an actress who went into independent production. A useful bibliography is A. E. Hotchner, DORIS DAY: HER OWN STORY (New York: William Morrow and Company, 1976); *George Morris, DORIS DAY (New York: Pyramid Publications, 1976); and *Tedd Thomey, DORIS DAY (Derby: Monarch Books, 1962). Otto Preminger is an example of a director who went into independent production. A useful bibliography is Willi Frischauer, BEHIND THE SCENES OF OTTO PREMINGER: AN UNAUTHORIZED BIOGRAPHY (New York: William Morrow and Company, 1974); Theodore Gershuny, SOON TO BE A MAJOR MOTION PICTURE: THE ANATOMY OF AN ALL-STAR, BIG-BUDGET, MULTIMILLION-DOLLAR DISASTER (New York: Holt, Rinehart and Winston, 1980), *Gerald Pratley, THE CINEMA OF OTTO PREMINGER (New York: A. S. Barnes and Company, 1971); and Otto Preminger, PREMINGER: AN AUTOBIOGRAPHY (Garden City: Doubleday and Company, 1977). See also Kevin Hagopian, "Declarations of Independence: A History of Cagney Productions," THE VELVET LIGHT TRAP 22 (1986):16-32; Matthew Bernstein, "Fritz Lang, Incorporated," ibid., pp.33-52; Tino Balio, "When Is an Independent Producer Independent?: The Case of United Artists after 1948," ibid., 53-64; and Edward Lowry, "Dimension Pictures: Portrait of a 70's Independent," ibid., pp.65-74.

[622] Izod reports (p.126) that "By 1945, there were about 40 independent producers, 70 the following year, 90 in 1947, and about 165 a decade later."

[623] For a useful perspective on this issue, see Donald Nelson, "The Independent Producer," THE AMERICAN ACADEMY OF POLITICAL AND SOCIAL SCIENCE 254 (November 1947):49-57.

eleven of these companies, which were the only ones to distribute nationally. [624]

In essence, the limited curtailment of trade restrictions had not broken the majors' oligopolistic control of the film industry. Thus in the summer of 1945, the government once more went to trial against the eight defendants in the Federal District Court in the Southern District of New York. In June, 1946, the District Court in Foley Square rendered a decision that satisfied almost no one. [625] Because the information is readily available in most books on the subject, the decision need only be summarized here. In effect, the three-judge panel dismissed all charges against the eight defendants as PRODUCERS. This had the effect of undermining the purpose of the suit, which was to break up the oligopolistic nature of the film industry.

In the area of distribution, the defendants were enjoined in nine areas, including special arrangements for minimum price fixing, formula deals, clearances, block booking, and pooling agreements. Now, distributors had to display their finished products before exhibitors entered into a competitive bidding process, and film licenses had to be granted film by film and theater by theater solely on a merit basis.

In the area of exhibition, the defendants were enjoined in seven specific ways, including leasing theaters for a share of the profits. Furthermore, the defendants had to free themselves of franchise agreements and pools. [626] The intention of the ruling was to establish a more competitive market in both distribution and exhibition. On December 31, 1946, the District Court issued its decree incorporating the opinions put forth in June.

At first glance, the decree presented a major gain for independent and foreign filmmakers. The defendants began producing fewer pictures and participating more in productions by independents. Furthermore, the majors began renting their lots and equipment as well as financing independent films.

For example, before 1948, fewer than five percent of Class "A" features were made by independents; by 1957, over fifty percent of American films were independent productions, most of them Class A features.

But it didn't take long for the eight defendants, the Department of Justice, and the independents to see the flaws in the plan. With the vertically integrated system left in place, there was not much hope for substantial reforms in the film industry. The fact was that the majors controlled nearly three-quarters of the first-run theaters in the limited states, and that control gave them the power to determine which films would or would not be successful. Consequently, everyone agreed to pursue the case up to the Supreme Court. In UNITED STATES V. PARAMOUNT PICTURES, 334 U. S. 131 (1948), one of the most important decisions in film history was rendered. The specific details of the PARAMOUNT antitrust decision are summarized admirably by Conant, and every important book on the film industry provides useful and relevant analyses. Let it suffice to say that the Supreme Court unanimously decreed that the lower court had not gone far enough in altering the structure of the film industry to prevent the eight corporations from monopolizing the industry. Except for the issue

[624] Donahue, pp. 27-8.

[625] United States District Court, Southern District of New York in U. S. v. Paramount Pictures, Inc.; Paramount Distributing Corporation; Loew's Incorporated; Radio-Keith-Orpheum Corporation; RKO Radio Pictures, Inc.; Keith-Albee-Orpheum Corporation; RKO Midwest Corporation; Warner Bros. Pictures, Inc.; Vitagraph, Inc.; Warner Bros. Circuit Management Corporation; 20th Century-Fox Corporation; Screen Gems Inc.; Universal Corporation; Universal Pictures Company, Inc.; Universal Film Exchanges, Inc.; Big U Film Exchanges, Inc.; and United Artists Corporation, entered into December 31, 1946.

[626] Brady, pp. 133-5.

of competitive bidding, which the court found unrealistic, the justices not only reaffirmed the changes dictated by the 1946 District Court decision, but also ordered that steps be taken by the eight defendants to eliminate vertical integration and horizontal collaboration. That is, the majors could not own large theater chains. By July, 1949, the district court had complied with the Supreme Court request.

In essence, the majors had to divest themselves of specific movie houses as well as massive numbers of theaters. The result was that five new exhibition operations were established by the late 1950s: RKO Theatres Corporation (from RKO Pictures Incorporated), United Paramount Theatres Corporation (from Paramount Pictures Corporation), National Theatres Company (from 20th Century-Fox), Stanley Warners Corporation (from Warner Bros. Pictures), and Loew's Theatres, Inc. (from Metro-Goldwyn-Mayer Corporation). The top theater circuit was United Paramount Theatres, which was taken over by the American Broadcasting Company in 1953. Renamed the American Broadcasting Companies, Inc. three years later, the powerful giant owned close to 600 movie houses. Its nearest competitor was National Theatres, which operated almost 400 movie theaters. What was fascinating about the divestiture decrees was that the new theater circuits could purchase production companies, and the "new" production-distribution companies (the PARAMOUNT defendants) could still operate theaters. The crucial conditions in each case were tied to the maintenance of a free and open market.

Not surprisingly, the film industry and the scholarly community have been arguing ever since about who won and lost as a result of the PARAMOUNT antitrust decision. On the one hand, many theater owners benefited from having a "free market" where first-runs were determined not only on a picture-by-picture basis, but also by not having preferential treatment given to the majors and their "friends." Independent filmmakers also enjoyed the "freedom" of having their films selected by merit rather than by having to be subservient to the large corporations. On the other hand, the banks still funneled their funds through the majors, who alone had the resources necessary to distribute films on a national and international basis. A declining film market had resulted in large numbers of independents defaulting on loans.[627] As always, the need to reduce risks and maximize profits made independents too shakey an investment unless the bank had certain guarantees that only a major could provide.[628]

In the area of block booking, a number of commentators found that the old system had worked to the advantage of small exhibitors who had neither the resources nor the time to review individually each film booked into their neighborhood theaters. Furthermore, it was sensible for the majors to dispatch sales personnel to all areas when negotiating for a full-line booking contract. It made no sense to continue this practice once films could be sold only in blocks of five. Small exhibitors, therefore, now ran into trouble getting a steady supply of films, and many went out of business in the 1950s. They also discovered, as will be discussed later, that the powerful producer-distributors found ways to bring back blind bidding and preferential contract adjustments. Ironically, the only clear winners, as Conant explains, were the minors (Universal, Columbia, and United Artists), which never should have been defendants in the PARAMOUNT case since they operated no theaters.[629]

[627] For critical reactions to the independent film boom, see Richard Dyer MacCann, "Independence With a Vengeance," FILM QUARTERLY 15:4 (Summer 1962):14-21; and Terry B. Sanders, "The Financing on Independent Feature Films," QUARTERLY OF FILM, RADIO AND TELEVISION 9 (1954-55):380-9.

[628] For a good summary of bank financing--e.g., "first money," "second money," "completion money," "distribution gross," and "net producer's cost"--see Wasko, pp.103-47. See also Patrick McGilligan, "Bank Shots: Interviews with Two Film Financiers," FILM COMMENT 12:5 (September-October 1976):20-5.

[629] For an example of how antitrust action in the broadcasting industry is related

Of particular importance to our concerns is the effect that the PARAMOUNT decision had on formula filmmaking. Throughout the twenty-year reign of the Hollywood studio system, the determination of what films would be made remained closely tied to the financial interests of corporation heads housed not on the West Coast, but in New York. Their decisions were determined in large measure by the needs of their theater chains. As long as the exhibitors insisted upon having commercially popular movies, creative personnel in Hollywood were restricted to the types of film formulas that had proven box-office success. Experimentation was kept to a minimum. The PARAMOUNT decision disrupted the standard operating procedures. Profits were still uppermost in the minds of the business community, but now the opportunity for more experimental and non-traditional projects expanded. Independent American filmmakers as well as foreign filmmakers had the chance to prove that their ideas and techniques could work. In the years that followed, not only did the age-old taboos on controversial subject matter fall, but also the stereotypes of society underwent significant changes. That is not to say that the art of the film progressed to a higher plane. Nor is it to say that what we saw was more enlightened or more realistic. It is to say that more opportunities existed for a wider variety of voices and images to reach the screen.

In general, the problems besetting the film industry starting in 1947 are well known and documented in every major film history book. Here we need only note that declining audiences; the reemergence of national cinemas, overseas tariffs and quotas; government anti-Communist investigations; antitrust litigation; increasing production costs and shrinking profits; the changing nature of film content; and the impact of television, all contributed to a restructuring of the American film industry.[630] Much of that restructuring was straightforward and, to date, has not involved significant historical reinterpretation.[631] A case in point is retrenchment in the major film corporations. Divestiture of theaters from the production and distribution arms of the industry put an end to the long-term contracts used to control directors, producers, performers, and technicians.[632] The loss of protection for production also sharply reduced the number of pictures produced by the majors. For example, the PARAMOUNT defendants collectively had released 651 movies in the 1942-1945 period; a decade later, the number had dropped to 533.[633] By the 1960s, the entire American

to the PARAMOUNT case, see Gary Edgerton and Cathy Pratt, "The Influence of the Paramount Decision on Network Television in America," QUARTERLY REVIEW OF FILM STUDIES 8:3 (Summer 1983):8-23.

[630] In evaluating the various factors affecting the financial health of the American film industry, Perry (pp.96-7) identifies three categories: economic risks (e.g., inflation, taxation, and economic growth), business risks (e.g., government actions, consumer preferences, and alternative forms of recreation), and financial risks (e.g., amount of equity capital available).

[631] For some interesting reactions to the changes taking place, see Robert Ardsley, "Hollywood: The Toll of the Frenzied Forties," THE REPORTER 16 (March 21, 1957):29-33; Dorothy Jones, "Tomorrow the Movies: Is Hollywood Growing Up?", THE NATION 160:5 (February 3, 1945):123-5; and "Trouble in Paradise," TIME 45:5 (January 29, 1945):82-6.

[632] In March, 1980, Federal Court Judge Edmund L. Palmieri ruled that Loew's, Inc. could once more produce and distribute films. The justification was that only a small handful of films could dominate the market in the 1980s and therefore the addition of a new company would add to the quality of the film industry. The repercussions from this decision are still being felt at the end of the decade, as more and more studios are going back into the exhibition business.

[633] FILM: THE DEMOCRATIC ART, p. 430.

film industry was releasing on the average about 450 movies a year. "Admissions to theatres fell," points out another study, "from about $1.7 billion in 1946 to only $.9 billion in 1962, and this paralleled a decline in the number of theatres from about 18,600 in 1948 to fewer than 12,700 in 1962."[634]

Another clear-cut development was the change in attitude of the American film industry toward its overseas markets, the importation of foreign films, and the production of movies abroad.[635] This turnabout has been analyzed most effectively by Thomas H. Guback in his highly regarded study, THE INTERNATIONAL FILM INDUSTRY. He details how American filmmakers surmounted initial problems--e.g., postwar quotas, tariff restrictions created by foreign governments to protect national film industries, and boycotts--and with the help of our government not only established a major role in the production of foreign films in specific countries--e.g., Italy, France, Germany, and England--but also transformed the nature and structure of American film corporations into international organizations producing, distributing, and exhibiting movies worldwide. In Guback's words, "With a market of more than eighty countries, the American film [in the late 1960s] occupies more than 50 percent of world screen time and accounts for about half of global film trade."[636]

Other commentators on the overseas market call attention to the importance it played in putting American films into the black. For example, Andrew Dowdy points out that "Before the war four out of five pictures returned their costs in U. S. bookings alone. By 1950 the number was one in ten."[637] On the other hand, as Izod reports, "The foreign earnings of the American industry had amounted to some 40 per cent of all theatrical revenue in the 1950s, and increased to about 53 per cent in the early 1960s. Europe returned about 80 per cent of these overseas rentals."[638]

Two events, however, require a reexamination of standard assumptions: the impact of television from 1947 to 1955 on the American film industry and the demise of the "B" film in the 1950s. The standard interpretation of what happened at the box office starting in the late 1940s is that television was a major reason why the film industry ran into serious economic trouble. Almost everywhere one turns in the literature, investigators assert that filmmakers were trying frantically to cope with the challenge from the infant television industry. John Spraos makes the same claims for the restructuring of the British film industry.[639]

The most persuasive assertion that television by 1948 had dramatically and adversely affected the movie market is presented by Frederic Stuart's enterprising

[634] Campaine, p.184.

[635] For another perspective, see Aljean Harmetz, "Hollywood Thinks Small in a Big Way," NEW YORK TIMES 2 (March 13, 1983):1, 41.

[636] Thomas H. Guback, "Film as International Business: The Role of American Multinationals," THE AMERICAN MOVIE INDUSTRY, p.338. For a discussion of how the MPAA assists American filmmakers abroad, see Clyde H. Farnsworth, "Jack Valenti's State Department," NEW YORK TIMES B (December 18, 1985):11.

[637] Andrew Dowdy, "MOVIES ARE BETTER THAN EVER": WIDE-SCREEN MEMORIES OF THE FIFTIES (New York: William Morrow and Company, 1974), p.173.

[638] Izod, p.159.

[639] John Spraos, THE DECLINE OF THE CINEMA: AN ECONOMIST'S REPORT (London: George Allen and Unwin, 1962), pp.19-31. For additional information, see Anthony H. Dawson, "British and American Motion Picture Wage Rates Compared," HOLLYWOOD QUARTERLY 3:3 (Spring 1948):241-7; Thomas Guback, "Shaping the Film Business in Postwar Germany," THE HOLLYWOOD FILM INDUSTRY: A READER, ed. Paul Kerr (London: Routledge and Kegan Paul, 1986), pp.245-75; and Izod, pp.117-20.

but flawed empirical examination of American industry statistics.[640] Scholars since then, like Jowett and Kinder, rely heavily on Stuart's 1960 Columbia University doctoral dissertation as the basis for their conclusions that within a few years after World War II, "the introduction of the new medium was the PRINCIPAL reason for the decline in movie audiences in the period 1948-1956."[641]

A close reading of Stuart's data, however, reveals a serious problem: the major audience decline OCCURS BEFORE television becomes a significant factor.[642] For example, Stuart acknowledges that Hollywood began its severe decline in 1947, losing nearly fifty percent of its customers by the mid-1950s (see Table 6). He rightly points out that the biggest drop in box-office receipts occurred in the years from 1948 to 1952. But Stuart insists that television was the major cause of the decline in theater attendance, not related events like the removal of wartime shortages, the population

[640] Frederic Stuart, "The Effects of Television on the Motion Picture Industry: 1948-1960," THE AMERICAN MOVIE INDUSTRY, p. 257. Stuart's entire doctoral dissertation was published by Arno Press in 1975 under the title, THE EFFECTS OF TELEVISION ON THE MOTION PICTURES AND RADIO INDUSTRIES. See also Stanley Ray Rinehart, FACTORS AFFECTING THE DECLINE OF THE MOTION PICTURE AUDIENCE IN THE UNITED STATES SINCE WORLD WAR II (Masters thesis: Ohio State University, 1959); Henry Williams, ECONOMIC CHANGES IN THE MOTION PICTURE INDUSTRY AS AFFECTED BY TELEVISION AND OTHER FACTORS (Unpublished Ph.D. dissertation, Indiana University, 1968); Milton MacKaye, "The Big Brawl: Hollywood vs. Television--Part I," SATURDAY EVENING POST, 224:29 (January 19, 1952):17-9, 70-2; ___, "Part II," ibid. 224:30, (January 26, 1952):30, 119-22; ___, "Part III," ibid. 224:31, (February 2, 1952):30, 100-02; Harvey J. Levin, "Competition Among Mass Media and the Public Interest," PUBLIC OPINION QUARTERLY 18:1 (Spring 1954):62-79; Rodney Luther, "Television and the Future of Motion Picture Exhibition," HOLLYWOOD QUARTERLY 5:2 (Winter 1950):164-77; Lawrence L. Murray, "Complacency, Competition and Cooperation: The Film Industry Responds to the Challenge of Television," JOURNAL OF POPULAR FILM 6:1 (1977):47-74; and Perry, pp.102-5. For a perspective on the relationship between TV and film, see Duncan Crow, "From Screen To Screen: Cinema Films on Television," SIGHT AND SOUND 27:2 (Autumn 1957):61-4, 106; Andre Bazin, "Cinema and Television: Jean Renoir and Roberto Rossellini," ibid., 28:2 (Winter 1958-59): 26-30; Jean R. Debrix, "TV's Effect on Film Esthetics," trans. David A. Mage, FILMS IN REVIEW 3:10 (December 1952):504-6; and Barry R. Litman, "Decision-Making in the Film Industry: The Influence of the TV Market,"

[641] FILM: THE DEMOCRATIC ART, p. 350. In fairness to Kinder, he does suggest (p.xxiv) that Stuart failed "to explore fully factors related to social change "

[642] I wish to thank Dean John G. Jewett of the University of Vermont for his help in analyzing this issue.

shift to the suburbs, the rise of drive-ins,[643] increasing traffic congestion in downtown areas, and the alleged deterioration of film content in the late 1940s.[644]

How he arrives at his conclusions is revealing. For instance, Stuart admits that a boom in postwar consumer expenditures offers a reasonable explanation for the drop in box-office figures for the last two years of the 1940s, but not for the 1950s. Yet he fails to understand that 1948 and 1949 are the period when the sharpest decline occurs: a drop of twenty-two percent in numbers of people at the box office! Put another way, theater admissions income declined only eighteen percent from 1950 to 1957. How is it possible, therefore, to credit television with being the major cause for the decade-long decline?

Another reason for doubting Stuart's theory is his analysis of the population shift to the suburbs. He argues reasonably that only a small fraction of the population made the move, a fraction too insignificant "to account for much of the forty-nine percent drop in motion picture attendance. . . ."[645] Yet Stuart cites television, up to 1951, when little more than twenty-three percent of American households owned TV sets, as the cause of a drop in movie attendance between 1947 and 1951 amounting to forty percent of the 1947 box-office figures.

There is no question, however, that television penetration affected motion picture attendance. Stuart is very helpful in showing the relationship in specific states between homes that owned TV sets and the drop in movie theater attendance. For example, his figures relating to television density from 1955 to 1958[646] indicate the impact of the new medium on film receipts, but offer absolutely no evidence for Jowett's assertion about a "video tidal wave" that rolled across America after 1947.[647] Nor for that matter does Stuart make a convincing argument that the drop in operating movie theaters (from 18,631 to 18,491 between 1948 and 1954) was "attributable to television competition."[648] TV may have been a contributing factor,

[643] Interestingly, Donahue also insists that TV was the major factor in the decline of film profits between 1947 and 1953. Yet she points out (p.29) that "By 1953, only 32.4 percent of all theaters were making a profit on admission income. Another 38.4 percent were losing money at the box office but making a profit through concession sales . . . The remaining 29.2 percent were losing money . . . In the decade from 1946 to 1956, more than four thousand theaters closed. THEIR LOSS WAS, HOWEVER, BALANCED BY THE CONSTRUCTION OF NEW DRIVE-INS" [Italics mine). For more information on drive-ins, see Bruce A. Austin, "The Development and Decline of the Drive-In Movie Theater," CURRENT RESEARCH IN FILM: AUDIENCES, ECONOMICS, AND LAW, Volume 1, pp.59-91; Harris M. Plotkin, "Protolite Screen: Drive-In Breakthrough," BOXOFFICE (March 1983):64-5; "Drive-Ins," TIME 38:2 (July 14, 1941):66; William Geist, "Drive-In Movies: An Innovation Hits 50 and Passes Its Prime," NEW YORK TIMES B (June 7, 1983):1, 5; Barbara Slavin, "It's Technology to the Rescue of Drive-In Movie Theaters," ibid., A (August 8, 1978):12; Alice Hoffman, "The Drive-In at Twilight," ibid., H (September 4, 1988):18; Toby Thompson, "The Twilight of the Drive-In," AMERICAN FILM 8:9 (July-August 1983):44-9; Douglas Kneeland, "Drive-In Time," NEW YORK TIMES MAGAZINE (June 25, 1978):16-7; and Frank Taylor, "Big Boom in Outdoor Movies," SATURDAY EVENING POST 229:11 (September 15, 1956):31, 100-2.

[644] Stuart, p.262.

[645] Stuart, p.263.

[646] Stuart, p.266.

[647] FILM: THE DEMOCRATIC ART, p.281.

[648] Stuart, p.275. Stuart also claims that on a per-capita basis, "the number of operating theaters dropped by 10 percent."

but not necessarily any more than other factors mentioned earlier, including weather conditions and seasonal fluctuations in entertainment preferences.[649] Even here Stuart's data prove more speculative than factual. For example, he argues that TV is less damaging to theater attendance in the summer months than during the winter[650] yet people have more recreational options during the summer. Thus TV may have little or nothing to do with summer box-office receipts. It is mainly when television networks program a major summer event--e.g., the 1984 Summer Olympics--that a clear causal relationship is established. Furthermore, people may stay home more on winter evenings because of the cold weather, hazardous road conditions, and shorter daylight hours than because they prefer television to movies.

The problem of the impact of television on the American film industry is too significant and complex an issue to be successfully challenged as superficially as I have done here. When scholars of the stature of Jowett and Kinder claim that the transition began in the late 1940s, and not, as I suspect, in 1953, it behooves one to be hesitant about conclusions. Nevertheless, I do suggest that the issue needs reexamination, if only to clarify the discrepancy between theater attendance and television density in American households.[651]

[649] For a useful listing of reactions to why people went to the movies in the fifties, see Jowett and Linton, pp.84-5.

[650] Stuart, p.288.

[651] Professor Nick Danigelis of the Department of Sociology at the University of Vermont was kind enough to read Stuart's article and give me his reactions to both Stuart's interpretation and my interpretation of television's effect on the film industry. (Nick Danigelis's letter to author, September 11, 1985.)

"After reading both the Stuart article, 'The Effects on the Motion Picture Industry: 1948-1960,' and pages 684 to 689 of your Chapter 3, 'Stereotyping in Film,' I have come to agree with your basic contention that television in the late 1940s to very early 1950s is hardly likely to have had a serious impact on movie attendance during that period.

"One reason is the one you forward: the extremely small numbers of families owning television sets (even allowing for family and friends to 'share' sets by watching in groups) are likely to have had only a small effect on movie attendance.

"Two other reasons stem from my reading of Stuart's own treatment of his data and the questionable inferences drawn from the data. The problem which occurs in several places in his article is that data from a single point or series of points in time are used to predict data for a prior point or series of points in time. For example, Figure 13.2 and Table 13.6 show the correlation between television density, as measured by percent change in per-capita motion picture receipts between 1948 and 1954. Stuart hypothesizes the former causes the latter. The above data, regardless of the strengths of the correlation between the two variables, cannot logically provide support for the hypothesis for two reasons. First and quite obviously, the television data are from a time period following the movie data. It is patently absurd to argue that what happened in 1955 had any effect on changes between 1948 and 1954. A second problem with the data is that he is trying to show the cause of change in movie attendance to be a static quality about television set ownership at one point in time. Ideally, one should use television set ownership for a series of points in time to predict movie attendance for a series of points in time for each unit of analysis, whether it be state, city or whatever. I don't know how complete the information on television set ownership is for the period immediately after World War II. Finally, even if one has data for each year between 1945 and 1955 on both movie attendance and television set ownership by state, there remains the problem of

Standard accounts dealing with the 1950s also claim that the "B" film was a major casualty of the PARAMOUNT decision and the TV incursion into movie markets. But research initiated by Richard C. Vincent is forcing scholars to reevaluate the demise of the low-budget film. No one disputes that the inexpensive movie (i.e., movies budgeted roughly between $100,000 and $150,000 as compared to prestige movies with a film budget of $250,000 and over in the 1930s) began to flourish during the early days of the talkies as part of a scheme to attract more people to the box office. The "B" picture played as the second feature on the neighborhood theater's double bill.[652] At one point in the mid-thirties, "B" films constituted eighty-five percent of the double bill programs in American movie houses.[653] Right after World War II, however, moviegoing habits changed.

The argument concerns whether the film industry abandoned the "B" film starting in the 1950s in favor of spectaculars and blockbuster movies. Vincent contends that not only did studios continue making the low-budget film through the 1950s, but also that theaters demanded "B" films "in order to fill the void" left by the reduced number of "A" films released by the film industry.[654] Other reasons for the continued importance of the low-budget film were the high studio overheads and the need for training new talent for the film industry. Television had not yet developed as a major source of revenue to keep the sluggish studios active on a regular basis; nor had the filmmakers themselves perceived the fledgling industry as a valuable format for developing technicians, performers, directors, producers, screenwriters, or editors.[655] To support Vincent's position, one can examine the early careers of stars like Grace Kelly, Marlon Brando, Marilyn Monroe, Jeff Chandler, Tony Curtis, and Rock Hudson, who worked in low-budget productions during the 1950s.[656] In addition, readers can examine the influence and popularity of science fiction films in the 1950s to understand how active "B" films were in movie houses around the world.[657]

inferring individual level behavior from aggregate level data--the ecological fallacy. It does not necessarily follow that showing an inverse correlation between percent of households with televisions and motion picture receipts demonstrates that the people with television sets are the ones who are not going to the movies. To make that inferential leap requires either data about individuals or complex data analytic techniques like ecological regression.

"In summary, I find your arguments on the decline in motion picture receipts reasonable; and, at the same time, neither the arguments nor data which Stuart forwards are persuasive."

[652] For more information see *Don Muller, "B" MOVIES (New York: Curtis Books, 1973); and *Todd McCarthy and Charles Flynn, eds., KING OF THE Bs: WORKING WITHIN THE HOLLYWOOD SYSTEM (New York: E. P. Dutton, 1975).

[653] Charles Flynn and Todd McCarthy, "The Economic Imperative: Why Was the B-Movie Necessary?" KING OF THE Bs, p.15. See also Don Miller, "The American B Film: A Fond Appreciation," FOCUS ON FILM 31 (November 1970):31-48.

[654] Vincent, p.11.

[655] Vincent, pp.11-3.

[656] Thomas M. Pryor, "Hollywood's Search For Stars," NEW YORK TIMES MAGAZINE (June 12, 1955):14-5, 26-8. See also Freeman Lincoln, "The Comeback of the Movies," FORTUNE 5 (February 1955):127-31+; Rpt. THE AMERICAN FILM INDUSTRY, pp.371-85.

[657] According to Charles Flynn and Todd McCarthy, Monogram Pictures became Allied Artists on November 11, 1953, and pointed the film industry not only toward the "exploitation film" but also toward the newly emerging youth market. See Charles

Chapter 3: STEREOTYPING IN FILM

TABLE 6

TELEVISION, POPULATION AND ATTENDANCE 1945 to 1965

Year	Theater Attendance		TV & Color TV Households			Total Population
	People Millions per week	Percent of population	TV households millions	Percent of US homes	Percent of Color TVs	Millions
1945	85	61				140.5
1946	90	64	00.01	00.02		141.0
1947	90	64	00.01	00.04		144.7
1948	90	61	00.17	00.40		147.2
1949	70	47	00.94	02.30		149.3
1950	60	39	03.88	09.00		152.3
1951	54	35	10.32	23.50		154.9
1952	51	32	15.30	34.20		157.6
1953	46	29	20.40	44.70		160.2
1954	49	30	26.00	55.70		163.0
1955	46	28	30.70	64.50	0.02	165.9
1956	47	28	34.90	71.80		168.9
1957	45	26	38.90	78.60		172.0
1958	40	23	41.92	83.20		174.9
1959	42	24	43.95	85.90		177.8
1960	40	22	45.75	87.10		180.7
1961	42	23	47.20	88.80		183.7
1962	43	23	48.86	90.00		186.9
1963	42	22	50.30	91.30		189.2
1964	44	23	51.60	92.30	3.10*	191.90
1965	44	23	52.70	92.60	5.30	194.30

*From TV FACTS

a) Total Population from: STATISTICAL ABSTRACT OF THE UNITED STATES 1985, 105th edition, (U. S. Dept. of Commerce, U. S. Dept. of Census, USGPO, 1984), p.6.
b) "TV and Color TV Households," from:
 Cobbett Steinberg, TV Households and % of U. S. Homes, TV FACTS (New York: Facts on File, 1980) p.142.
 "% of U. S. Homes with Color," LES BROWN'S ENCYCLOPEDIA OF TELEVISION, (New York: Zoetrope 1982) p.492.
c) Theater Attendance from: HISTORICAL STATISTICS OF THE U. S. COLONIAL TIMES TO 1970, Part 2, (U. S. Department of Commerce, Bureau of the Census, USGPO, 1975) p.400.

Obviously, the American film industry did not stand idly by as its box-office receipts and audiences dropped precipitously. One strategy for recovery involved a

Flynn and Todd McCarthy, "The Economic Imperative: Why was the B-Movie Necessary?" KING OF THE Bs, pp.34-5.

reevaluation of television as a new market for producing, advertising, and exhibiting films.[658] Some companies like Monogram and Republic (both in 1951) and RKO (in 1954) sold their pre-1948 film inventories to TV outlets.[659] Other companies eventually followed, with Paramount holding out until 1958. Although the outright sale of films to television gave film corporations unexpected windfalls, it also presented certain problems to the film industry, both in terms of labor groups who demanded and eventually received compensation for their share in the production of films, and the eventual realization by the film corporations that more money could be made by leasing rather than selling films to TV networks and stations.[660]

A second strategy, initiated by film companies like Columbia Pictures (Screen Gems), Monogram (Interstate Television), and Universal (United World Films), was to begin making low-budget films and programs for television.[661] ("A" productions targeted exclusively for TV started in the sixties.) By the mid-fifties, most studios had their own TV formats: e.g., WALT DISNEY'S WONDERFUL WORLD OF COLOR, WARNER BROTHERS PRESENTS, M-G-M PARADE, and TWENTIETH CENTURY-FOX HOUR. The most active company, however, was the Music Corporation of America

[658] William Boddy points out that "It is difficult to find a period in television history when the major Hollywood studios did not take an active interest in the industry." His prime example is Paramount Pictures and its TV holdings that dated back to 1944. For more information, see William Boddy, "The Studios Move into Prime Time: Hollywood and the Television Industry in the 1950s," CINEMA JOURNAL 24:4 (Summer 1985):24; and William Lafferty, "'No Attempt at Artiness, Profundity, or Significance': FIRESIDE THEATER and the Rise of Filmed Television Programming," ibid., 27:1 (Fall 1987):23-46. See also John Izod, "Walt Disney Innovates the Television Showcase," The AMES JOURNAL 2 (1985):38-41; Geraldine Fabrikant, "Warner, HBO Deal Reported: Rights to Films Set to be Sold," NEW YORK TIMES D (June 3, 1986):4; Tony Schwartz, "Hollywood Debates HBO Role in Film Financing," ibid., D (July 7, 1982):19; Robert Lindsey, "Home Box Office Moves in on Hollywood," NEW YORK TIMES MAGAZINE (June 12, 1983):30-6, 38, 66-7, 70-1; Thomas H. Guback and Dennis J. Dombkowski, "Television and Hollywood: Economic Relations in the 1970s," JOURNAL OF BROADCASTING 20:4 (Fall 1976):511-27; Sonny Kleinfield, "TIME Inc. Is Everything," ROLLING STONE 407 (October 27, 1983):48-56; Tom Nicholson et al., "HBO Versus the Studios," NEWSWEEK 100:20 (November 15, 1982):83; Howard Polskin, "Paramount Deal with Showtime Shakes Pay-TV," TV GUIDE (December 31, 1983):A1; Tom Allen, "The Semi-Precious Age of TV Movies," FILM COMMENT 15:4 (July-August 1979):21-3, 47; Daniel Menaker, Television Apposite Reactions, " ibid., 16:4 (July-August 1980):76-7; Charles Champlin, "TV: The End of the Beginning," AMERICAN FILM 5:5 (March 1980):60-3; and Patrick McGilligan, "Movies Are Better than Ever--On Television," ibid., pp.50-4.

[659] For a typical example of the response to such moves see S. Snieder, "Wider Scope: Hollywood Is Expanding Its Business Horizons," BARRON'S 41:39 (September 25, 1961):11.

[660] For a good overview, see THE AMERICAN FILM INDUSTRY, Rev. ed., pp.433-8. Ellis points out (p.273) that initially the unloading of old films on TV was an attempt by the film companies to hurt the networks: "The leasing and outright sale of the hundreds of old feature films was directed toward the independent stations, either directly or through packaging agencies, so as to constitute maximum competition to network programming."

[661] Boddy, p.26. See also *Christopher Wicking and Tise Vahimagi, THE AMERICAN VEIN: DIRECTORS AND DIRECTIONS IN TELEVISION (New York: E. P. Dutton, 1979; and William Paul, "Hollywood Harakiri: On the Decline of an Industry and an Art," FILM COMMENT 13:2 (March-April 1977):40-3, 56-62.

(MCA) which began TV production in 1949, grew wealthy on its TV revenues in the early 1950s, and by the end of the decade dropped its interests in talent representation.

The third notable strategy was technological innovation. Working on the assumption that TV was draining the theaters, filmmakers gambled on two significant alternatives to television: color productions and widescreen techniques. Both innovations were closely linked to the first stages of film history. The attempts to bring "natural color" to the screen started in the mid-1890s, as Robert Allen Nowotny points out, with experiments with hand tinting and toning. These hand-colored films led to processes like Kinemacolor, Chronochrome, Brewster Color, and Kodachrome.[662] "Each of these systems," Nowotny explains, "contributed to the technological advancement of the motion picture, culminating in the successful development and eventual acceptance of the now-famous three-strip method developed by Technicolor."[663] Although the latter had virtually monopolized the film market since the mid-thirties, it did very little to increase its production capabilities until the post-World War II period. But following the government's successful antitrust action--U. S. v. TECHNICOLOR, INC., TECHNICOLOR MOTION PICTURE CORP., AND EASTMAN KODAK CO., (S.D. Cal. 1947)--Technicolor, along with its film supplier Eastman Kodak, began licensing a number of its color patents.[664]

Dudley Andrew has provided an invaluable summary of the contradictory economic impulses that inhibited the immediate use of the long-awaited patent releases. By 1953, however, the film industry had started to take full advantage of using color movies to offset the appeal of black-and-white TV programs. Thereafter, the battle between the two media in this area would fluctuate for a decade before settling into the present relationship. "Taking the entire leisure-time context into consideration," explains Andrew, "we might say that color played a crucial role early in American

[662] For a good concise description of the history and nature of these various color processes, see Anthony Slide: THE AMERICAN FILM INDUSTRY: A HISTORICAL DICTIONARY (Westport: Greenwood Press, 1986).

[663] Robert A. Nowotny, THE WAY OF ALL FLESH TONES: A HISTORY OF COLOR MOTION PICTURE PROCESSES 1895-1929 (New York: Garland Publishing, 1983), p.4. See also *Raymond Fielding, A TECHNOLOGICAL HISTORY OF MOTION PICTURES AND TELEVISON (Los Angeles: University of California Press, 1967); James Limbacher, FOUR ASPECTS OF THE FILM (New York: Russell and Russell, 1968); Roderick T. Ryan, A STUDY OF THE TECHNOLOGY OF COLOR MOTION PICTURE PROCESSES DEVELOPED IN THE UNITED STATES (Unpublished Ph.D. dissertation, University of Southern California, 1967); ___, A HISTORY OF MOTION PICTURE COLOR TECHNOLOGY (New York: Focal Press, 1978); Fred E. Basten GLORIOUS TECHNICOLOR (San Diego: A. S. Barnes and Company, 1980); Edward Branigan, "Color and Cinema: Problems in the Writing of History," FILM READER 4, ed. Blaine Allan et al. (1979):16-34; ___, "The Articulation of Color in a Filmic System: Two or Three Things I Know About Her," WIDE ANGLE 1:3 (1976):20-31; Gorham A Kindem, "Hollywood's Conversion to Color: The Technological, Economic, and Aesthetic Factors," JOURNAL OF THE UNIVERSITY FILM ASSOCIATION 31:2 (Spring 1979):29-36; Bill O'Connell, Fade Out," FILM COMMENT 15:5 (September-October 1979):11-8; and Paul C. Spehr, "Fading, Fading, Faded: The Color Film Crisis," AMERICAN FILM 5:2 (November 1979):56-61.

[664] For more details, see George E. Frost and S. Chesterfield Oppenheim, "A Study of the Professional Color Motion Picture Antitrust Decrees and Their Effects," PATENT, TRADEMARK AND COPYRIGHT JOURNAL OF RESEARCH AND EDUCATION (Spring 1960):1-39; ___, ibid., (Summer 1960):108-48; and Dudley Andrew, "The Postwar Struggle for Color," CINEMA JOURNAL 18:2 (Spring 1979):41-52.

films because of factors like television and the competition fostered by the 1948 Paramount decision."[665]

The film industry also gambled successfully that widescreen films could be competitive with TV viewing. Just as it had done during the transition to sound, the American film industry dug deeply into its past to discover what wide screen techniques had been tried and discarded. Two alternatives--both unveiled at the turn of the century--were three-dimensional films (stereoscopic projection, or 3-D)[666] and a shift away from the traditional screen ratio of 1:1.33 (e.g., three units high, by four wide) to a CinemaScope screen ratio of 1:2.35 (e.g., a seventy-to-fifty-three foot screen projection).[667] Starting in 1952 with CINERAMA, American filmmakers unveiled a stream of novel screen exhibition techniques: e.g., 3-D, 2-D, Super Panavision, Super Technirama, Todd-AO, and VistaVision. Every important text on the period discusses the pros and the cons of these widescreen and optical experiments.[668] Suffice it to say that the most successful was 20th Century-Fox's CinemaScope. Together with epic and spectacular movies designed to magnify the widescreen format, to exploit hi-fidelity sound, and to create a greater illusion of depth, the film industry managed not only to stop its decline but also to stage a minor recovery between 1953 and 1956 (see Table 6).

Another significant change occurring in the film industry was a a greater emphasis on the blockbuster film. By the mid-1950s, with fewer films being released, the majors, as Izod reminds us, became more dependent than ever on a handful of movies making it big. That is, the studios' enormous "shareholding and long-term corporate debts had to be serviced by profits correspondingly large."[669] The result was not only a greater concern in acquiring best-sellers and hit plays for screen adapatations, but also in making films that appealed to a cross-section of the mass

[665] Andrew, p.51.

[666] For a good, concise description of the various screen processes, consult THE AMERICAN FILM INDUSTRY: A HISTORICAL DICTIONARY. For more detailed information, see Brian Coe, THE HISTORY OF MOVIE PHOTOGRAPHY (New York: Zoetrope, 1982); Martin Quigley, NEW SCREEN TECHNIQUES (New York: Quigley, 1953); *Hal Morgan and Dan Symmes, AMAZING 3-D (Boston: Little, Brown and Company, 1982); Charles Barr, "Cinemascope: Before and After," FILM QUARTERLY 16:4 (Summer 1963):4-24, FILM THEORY AND CRITICISM, 2nd ed., pp.140-68; Michael Kerbel, "3-D or Not 3-D," FILM COMMENT 16:6 (November-December 1980):11-20; Michael Stern, "Widescreen," BRIGHT LIGHTS 2:1 (Fall 1976):26-31; Derek J. Southall, "Twentieth Century-Fox Presents a Cinemascope Picture," FOCUS ON FILM 31 (1978):8-26, 47; Kemp Niver, "Motion Picture Film Widths," JOURNAL OF THE SOCIETY OF MOTION PICTURE AND TELEVISION ENGINEERS 77:8 (August 1968):814-8; Kenneth MacGowan, "The Screen's New Look--Wider and Deeper," QUARTERLY OF FILM, RADIO, AND TELEVISION 11:1 (Fall 1956):109-30; Wilton R. Holm, "Holographic Motion Pictures for Theater and Television," AMERICAN CINEMATOGRAPHER 55:4 (April 1974):455, 458-64; Petro Vlahos, "The Role of 3-D in Motion Pictures," ibid.,pp. 490-2; Daniel L. Symmes, "3-D: Cinema's Slowest Revolution," ibid., pp.406-9, 434, 456-7, 478-85; H. Mark Gosser, SELECTED ATTEMPTS AT STEREOSCOPIC MOVING PICTURES AND THEIR RELATIONSHIP TO THE DEVELOPMENT OF MOTION PICTURE TECHNOLOGY, 1852-1903 (New York: Arno Press, 1977); and THE VELVET LIGHT TRAP 21 (Summer 1985), which devotes its entire issue to the study of American widescreen theory and history.

[667] See Limbacher, pp.85-9.

[668] For a useful discussion on how the new screens affected movie theaters, see Will Szabo, "Some Comments on the Design of Large-Screen Motion-Picture Theaters," SMPTE 85:3 (March 1976):159-63; Ellis, pp.274-8; and Cook, pp.414-22.

[669] Izod, p.158.

audience. In practical terms, that meant casting films that paired stars of the past (e.g., Bing Crosby, John Wayne, Betty Grable, Jane Wyman, Dick Powell, Humphrey Bogart, Gregory Peck, Gary Cooper, Henry Fonda, and James Cagney) with upcoming stars and popular entertainers of the day (Audrey Hepburn, Grace Kelly, Debbie Reynolds, Jack Lemmon, Ricky Nelson, and Doris Day). The practice is still going strong in the late 1980s with films co-starring the youthful Tom Cruise and oldtimers like Paul Newman--THE COLOR ON MONEY (1986)--and Dustin Hoffman--RAIN MAN (1988).

It became clear in the mid-1950s, however, that blockbuster films, color movies, widescreen devices, and the sale of pre-1948 film inventories would not be enough to offset the fact that TV had now displaced the movies as the central commercial amusement in the second half of the twentieth century.[670] For example, Boddy reports that "In 1954 it was estimated that only 32 percent of the theaters were breaking even on box-office receipts alone."[671] In comparing the Hollywood of the fifties with its forebears in the thirties, Leo Rosten proclaimed that "The men who run the movie studios today operate business enterprises, not personal empires . . . On the social front . . . moderation has replaced extravagance. . . ."[672] The film industry thus did the one sensible thing possible at the time; it moved toward coexistence with the new medium rather than remaining its primary competitor. In the years that followed, American film production increasingly became unalterably intertwined with television in terms of employment, film content, and studio space allocation.[673]

[670] For more specific information, see Stuart, pp.291-307; Barry R. Litman, "The Economics of the Television Market for Theatrical Movies," THE AMERICAN MOVIE INDUSTRY pp.308-21; and Spraos, pp.13-31. For a discussion of how color is being used to recycle old films, see Leslie Bennetts, "'Colorizing' Film Classics: A Boon or Bane?", NEW YORK TIMES A (August 5, 1986):1, C14; Andrew L. Yarrow, "Action But No Consensus On Film Coloring," ibid., C (July 11, 1988):13, 16; and Eric Allen, "'Classics' Fans Oppose Colorizing," HOLLYWOOD REPORTER (June 29, 1988): 6.

[671] Boddy, p.26. The source of Boddy's assertion is Lawrence L. Murray, "Complacency, Competition and Cooperation: The Film Industry Responds to the Challenge of Television," JOURNAL OF POPULAR FILM 6:1 (Winter 1977-78):51. For additional perspectives on wide-screens and spectaculars, see the following: Editors, "The Big Screens," SIGHT AND SOUND 24:4 (Spring 1955):209-12; Derek Prouse, "Dynamic Frame," ibid., 25:3 (Winter 1955-56):159-60; Gavin Lambert, "Report on New Dimensions," ibid., 20:4 (April-June 1953):157-60; Richard Kohler and Walter Lassally, "The Big Screens," ibid., 24:3 (January-March 1955):120-6; Penelope Houston and John Gillett, "The Theory and Practice of Blockbusters," ibid., 32:2 (Spring 1963):68-74; Barry Day, "Beyond The Frame," ibid., 37:2 (Spring 1968):80-5; Henry Hart, "Cinerama," FILMS IN REVIEW 3:9 (November 1952):433-5; Edward Connor, "3-D on the Screen," ibid., 17:3 (March 1966):159-74; David Robinson, "Spectacle," SIGHT AND SOUND 25:1 (Summer 1955):22-7, 55-6; William K. Everson, "Film Spectacles," FILMS IN REVIEW 5:9 (November 1954):459-71; Stephen Farber, "The Spectacle Film: 1967," FILM QUARTERLY 20:4 (Summer 1967):11-22; and Raymond Durgnat, "Epic," FILMS AND FILMING 10:3 (December 1963):9-12.

[672] Leo C. Rosten, "Hollywood Revisited," LOOK 20:1 (January 10, 1956):19.

[673] For two useful studies on the subject, see Robert McLaughlin, BROADWAY AND HOLLYWOOD: A HISTORY OF ECONOMIC INTERACTION (New York: Arno Press, 1974); and Amy Schnapper, THE DISTRIBUTION OF THEATRICAL FEATURE FILMS TO TELEVISION (Unpublished Ph.D. dissertation, The University of Wisconsin, 1975).

The screen image of women and the women's film in the 1950s revealed not only the effects of the postwar period, but also foreshadowed the beginnings of the revival of the women's movement in the late 1960s. The stereotype inherited from the previous era, as Brandon French points out, "was the product of certain sociologists, psychologists, anthropologists, educators, authors, and physicians, as well as the organs of mass media, which preached the dangers of women's lost femininity and the bounties which awaited women within the boundaries of the traditional family role."[674] Neither the subversive nature of the traditional image of the happy homeowner nor its hidden meaning to sensitive spectators, however, was evident at the time. "On the surface," as French argues, "fifties films promoted women's domesticity and inequality and sought easy, optimistic conclusions to any problems their fictions treated. But a significant number of movies simultaneously reflected, unconsciously or otherwise, the malaise of domesticity and the untenably narrow boundaries of the female role."[675] Using the concept of a "double text"--two conflicting perspectives unintentionally found in a single movie--French offers intriguing new analyses of films like SUNSET BOULEVARD and THE AFRICAN QUEEN (both in 1950), THE BIG HEAT, THE QUIET MAN, and THE MARRYING KIND (all in 1952), SHANE and FROM HERE TO ETERNITY (both in 1953), ALL THAT HEAVEN ALLOWS, THE COUNTRY GIRL (both in (1954), THE SHRIKE, THE TENDER TRAP, and MARTY (all in 1955), PICNIC (1956), THE SEVEN YEAR ITCH and HEAVEN KNOWS, MR. ALLISON (both in 1957), THE NUN'S STORY (1958), THE MISFITS, AUNTIE MAME, and SOME LIKE IT HOT (all in 1959). In her analysis, French divides the decade into three periods. The films of the early fifties (1950-1952) establish the fact that women considered themselves equal to the men they loved, but did not seriously challenge their traditional roles as wives, sweethearts, or mothers. The films of the middle years (1953-1956) accented women's sexual frustrations and loneliness, while exonerating the patriarchy of any responsibility for a woman's unhappiness. Nevertheless, as French demonstrates, "The films reveal how sex and love were often misused to obscure or resolve deeper sources of female (and male) dissatisfaction."[676]

The films of the final period (1957-1959) contained the most revolutionary, albeit heavily camouflaged, messages. The emphasis was on reasserting female independence, arguing that a good marriage depended on both mates having equal rights and responsibilities, and on a blurring of sexual roles. French's analyses can be used as examples of how cultural hegemony operates in American society. They also demonstrate how the transition in the film industry affected the content and style of Hollywood movies. That is, screen conventions dealing with marriage, careers, and lovemaking underwent significant changes. They were replaced with new ideas not only on sex roles and responsibilities, but also on how these new conventions should be presented to the public. The films cited by French illustrate how different kinds of films--blockbusters and low-budget movies, color and black-and-white feature films, melodramas and farces, star-vehicles and plot-centered films--explored formulas and formats that would compete successfully with both art house movies and television programming. Here again, the conflicts and contradictions of the industry and society are evident in the products of the period.

Understandably, the uncertainty of the 1950s coupled with the new role of television and foreign markets forced the American film industry to restructure its organizational patterns.[677] For example, as discussed in Chapters 5 and 7, filmmakers now relied more heavily on pre-sold sources (e.g., best sellers and hit Broadway

[674] French, pp.xvii-iii.

[675] French, p.xxi.

[676] French, p.xxii.

[677] For information on the labor problems in Hollywood during this period, see

plays) rather than on original screenplays. The competition for such material became intense. It even got to the point where studios were putting up thousands of dollars for ideas for books and plays, hoping that being in on the ground floor would ease the cost of purchasing the material once it was in print. In addition, as Andrew Dowdy points out, a public relations expert named Ted Loeff founded the Literary Projects Company and "arranged multiple tie-ins among producers and publishers to guarantee mutually profitable exploitation of novels sold to movies prior to publication."[678] According to Izod, this emphasis on pre-sold sources began "a major process of restructuring in Hollywood that was to have large consequences for the ways narrative fictions were constructed and marketed in the Western world."[679]

Another restructuring of the American industry involved the filmmakers returning to their roots and shifting production from studios to location shooting. The emphasis was on "realistic settings." Beginning in the 1950s, as Gary Edgerton observes, "Hollywood has outgrown its geographic boundaries and now goes on location more and more across the United States.[680] As a result, state governments and major metropolitan centers established special agencies designed to attract the lucrative film projects.

By the start of the sixties, the American film industry had a new look. The most evident change in the sixties was that independents had the largest say in the creative end of filmmaking.[681] With the majors concentrating on the "big hit" mentality, they were making fewer films. The theater owners, now divorced from the majors and able to choose any films they wanted for exhibition, needed a steady supply of pictures that the majors couldn't provide. Consequently, the independents found their products much in demand. This new position not only gave them a greater percentage of the profits but also provided them with a greater visibility in movie theaters. According to Donahue, the decreased number of films being distributed by the majors resulted in the independents securing "a larger share of the domestic box office, rising from 5 percent to 15 percent."[682] Working with independent filmmakers in the sixties made good business sense for the majors. Not only were they the most productive group in the industry, but they also served as models for the major studios to reshape their production policies along the independent method of filmmaking. In fact, the skill in which the majors adjusted their

Chapter 5; and Irving Bernstein, HOLLYWOOD AT THE CROSSROADS (Hollywood: Hollywood AFL Film Council, 1957).

[678] Dowdy, p.209.

[679] Izod, p.155.

[680] Gary Edgerton, "The Film Bureau Phenomenon in America: State and Municipal Advocacy of Contemporary Motion Picture and Television Production," CURRENT RESEARCH IN FILM: AUDIENCES, ECONOMICS, AND LAW, Volume 2, p.204. For more information, see David Tuller, "Moviemakers Come to Main Street," NEW YORK TIMES 3 (April 27, 1986):4; Judith Cummings, "Plea From Los Angeles: Big Films, Come Home," ibid., (August 17, 1986):24; Wilborn Hampton, "An Unlikely Movie Mecca," ibid., C (December 29, 1987):13; "California Leads States in Money From Filming," ibid., C (January 5, 1988):17; Paul Goldberger, "New York as Film Setting and as Star," ibid., C (July 11, 1989):13; and Laura Landro, "New Hollywood: De Laurentiis's Moves Point Up the Changes in Economics of Films," WALL STREET JOURNAL 208:96 (November 13, 1986):1, 24.

[681] For a useful perspective on the transition, see Janet Staiger, "Individualism Versus Collectivism: The Shift to Independent Production in the US Film Industry," SCREEN 24:4-5 (July-October 1983):68-79.

[682] Donahue, p.30. For more information on independents, see Chapter 7.

production-distribution policies to accommodate independent filmmakers enabled the majors to retain control of the industry.

For those who doubt that the major producer-distributors (which by the early 1970s included Buena Vista Productions) still were in control, David Gordon offers some helpful observations. While acknowledging that the secretive nature of the majors' commercial transactions makes it difficult to document corporate power, he insists that statistical information frequently published in VARIETY demonstrates that the major distributors were tightening their grip on the American market (see Table 7).[683] He lists three factors to support his position. First, distributors understood the film market very well, a fact most evident when it came to getting financiers and bankers to fund productions.[684] Second, the enormous monetary risks associated with distribution made distributors especially conservative in what they selected for marketing. And third, the hefty distribution fees paid by producers and exhibitors to the distributors underwrote both the marketing risks and rewards for the gambles taken during the process. The bottom line, according to Gordon, is that "For good economic reasons, the bulk of the films that get to the screen are financed by the distributors."[685]

TABLE 7

THE DOMINANT MAJORS
Share of US and Canadian Distributors' Grosses

	1972%	1971%	1970%
Paramount	21.6	17.0	11.8
Warner Brothers	17.6	9.3	5.3
United Artists	15.0	7.4	8.7
Columbia	9.1	10.2	14.1
20th Century-Fox	9.1	11.5	19.4
MGM	6.0	9.3	3.4
Universal	5.0	5.2	13.1
Walt Disney	5.0	8.0	9.1
National General/Cinema Center	3.2	8.0	7.0
ABC/Cinerama	2.7	3.6	3.0
Others	5.7	10.5	5.1
	100.0	100.0	100.0

Source: VARIETY

[683] Gordon, p.195. In addition, there is a useful summary of practices designed to use movies as a direct personal and corporate investment: see Steven J. Ross, "Reports: The Symposium on Movie Business and Finance," JOURNAL OF THE UNIVERSITY FILM ASSOCIATION 28:1 (Winter 1976):36-43.

[684] To support Gordon's position on bank attitudes during the sixties and early seventies, see A. H. Howe, "A Banker Looks at the Picture Business," THE JOURNAL OF THE SCREEN PRODUCER'S GUILD 7:4 (December 1965):9-1, JOURNAL OF THE SCREEN PRODUCER'S GUILD 11:1 (March 1969):15-22; ___, "Hollywood at the Crossroads," ibid., 12:1 (March 1970):13-4; and ___, " "A Banker Looks at the Picture Business--1971," ibid., 13:2 (June 1971):3-10.

[685] Gordon, p.196.

Douglas Gomery also argues persuasively that few changes were made in the economic structure and power of the film industry. Not only does he view the film industry as a "stable oligopoly," but he also believes that it has remained such since the 1920s. Based upon the most famous producer-distributors, he notes that "throughout the Seventies, seven firms [e.g., 20th Century-Fox, United Artists, Warner Bros., Universal, Columbia, Paramount, and Disney] continued to dominate the production and distribution by all measures."[686] The secret, according to Gomery, was twofold. First, the majors placed a greater emphasis on manipulating financial resources than on producing films. And second, the marketplace functioned as a "bilateral oligopoly." In Gomery's words, bargaining took place in which "there were eight major movie companies on one side, and five or so exhibition chains on the other." He then explains that "there existed a two-sided market (bilateral) in which both sellers and buyers were part of close-knit oligopolies."[687] A 1978 report by the Washington Task Force on the Motion Picture Industry put the case somewhat differently, stating that the "majors are effectively limiting competition by maintaining tight control over the distribution of films, both by their failure to produce more films and by their failure to distribute more films produced by others."[688]

The independents discovered very quickly that their ability to produce, distribute, and exhibit films still relied heavily on the cooperation of the majors who "controlled" access to the financial markets that bankrolled filmmaking. For this reason, it became more and more important in the sixties to arrange "package deals" with stars, writers, directors, and distributors. The key point, as Izod observes, is that "the agent-originated package, like all independent projects, was not inherently different from the studios' own productions: where the studio took a share of the action they usually made sure the film would conform to their idea of what was likely to attract an audience--and their inherent conservatism in these matters was not magically dissipated with divorcement."[689] Here again we sense how stereotyping maintained its economic base in mainstream and independent filmmaking.[690] As Staiger observes, "In the conflict between individualism and

[686] Douglas Gomery, "The American Film Industry of the 1970's: Stasis in the 'New Hollywood,'" WIDE ANGLE 5:4 (1983):53. For a good overall picture, see *Pat Billings and Allen Eyles, HOLLYWOOD TODAY (New York: (A. S. Barnes, 1971); and *Les Keyser, HOLLYWOOD IN THE SEVENTIES (San Diego: A. S. Barnes and Company, . 1981).

[687] Gomery, p.54. See also J. Douglas Gomery, "Corporate Ownership and Control of the US Film Industry," SCREEN 25:4-5 (July-October 1984):60-9.

[688] Cited in Campaine, p.186.

[689] Izod, p.153.

[690] Handel makes the point (p.22) that the PARAMOUNT decision drastically affected the number of original screenplays that reached the screen. In the past, nearly seventy percent of the films made by the studio system originated at the studios. After the breakup of the studios, the majors put very little faith in unknown projects. It was much easier to sell financiers on a package deal using a best-seller or a popular play. Nevertheless, I believe that the plots of the books and dramas still relied on conservative values embodying traditional stereotypes.

collectivism, individualism may seem to have won out, but it is an individualism which retains a great number of the characteristics of its predecessor."[691]

The sixties also saw Hollywood paying much more attention to overseas filmmaking, distributing, and exhibiting. In fact, by the end of the decade, the American film industry's biggest investment in theatrical features was in international productions. Known as "runaway films" (because they were expensive and because they were made overseas to escape the cost of American labor requirements), these productions accounted for fifty-three percent (123 out of 232) of all American-sponsored films made in 1968. A year later, fifty-two percent (118 out of 226) of such productions were made abroad. Although the percentage dropped to less than forty-two percent (almost 100 out of 270) in 1970, William Fadiman points out that "Seven out of every ten films shown in the United States [in 1972] are in this 'runaway' category, whereas in the late 1950s, only 5 percent of the feature films produced by American-owned or American-financed companies were initiated and completed outside our borders."[692] Put another way, Eric Johnston, president of the MPAA from 1945 to 1963, said as early as 1953, "It is a little known fact that 9 out of 10 United States films cannot pay their way in the domestic market alone. It is only because of revenue from abroad that Hollywood is able to turn out pictures of high artistry and technical excellence."[693]

Worth noting at this point is the effect that the changing economic patterns had on cultural pluralism. Thomas H. Guback, for example, writes about the need to study the "social and industrial mechanisms" behind the films and how they "reflect certain beliefs and assumptions we have about the best way to organize ourselves to meet our needs."[694] He is particularly concerned about the effect that American film interests have in shaping the film content of Western Europe. After reviewing the economic control that Hollywood gained overseas since the post-WWII period, he concluded in the early 1970s that

> a basic problem confronting European film industries is their acceptance of foreign involvement with the illusion of fiscal solvency and consequently their rejection of economic independence and the opportunity for cultural autonomy. It is apparent that there is a growing centralization of control in the industry and that this is the trend of economic organization in our time. But such concentration in any medium of communication is undesirable, especially one operating on an international level.[695]

Guback's pleas could extend as well to the major networks and the crisis that the mass media faces in the late 1980s as control more and more resides in the hands of a few key individuals and conglomerates.

Indicative of the dilemma in Hollyood's transitional years were the shifts in the organizational structure of the film industry.[696] Robert H. Stanley correctly points out that in the 1960s conglomerates became interested in taking over the major film

[691] "Individualism Versus Collectivism," p.79.

[692] Fadiman, p.9.

[693] Cited in Guback, pp.3-4.

[694] Thomas H. Guback, "Film and Cultural Pluralism," CINEASTE 5:1 (Winter 1971-72):1.

[695] "Film and Cultural Pluralism," p.7.

[696] For a good overview, see *John Baxter, HOLLYWOOD IN THE SIXTIES (New York: A. S. Barnes and Company, 1972); *Charles Champlin, THE MOVIES GROW UP 1940-1980, Rev. ed. (Athens: Swallow Press Books, 1981); Robert W. Crandall, "The Postwar Performance of the Motion Picture Industry," ANTITRUST BULLETIN 20 (Spring

corporations because of the "potential profits in ownership of film libraries, real estate assets, and musical and literary copyrights."[697] MCA started the trend in 1962, when it acquired Universal-International Pictures.[698] The various changes affecting the other major film corporations are detailed in Chapter 6. Here we need mention only that Paramount was taken over by Gulf & Western in 1966;[699] United Artists first became part of Transamerica in 1967 and then was sold to MGM in 1980;[700] MGM acquired conglomerate status in 1969 when purchased by the hotel and casino tycoon Kirk Kerkorian, who sold it to the entrepreneur Ted Turner in 1986;[701] Warner Bros.

1975):49-88; Douglas Gomery, "The Film Industry Today," SCREEN 21 (Spring 1980):15-7; *Gordon Gow, HOLLYWOOD IN THE FIFTIES (New York: A. S. Barnes and Company, 1971); Axel Madsen, THE NEW HOLLYWOOD: AMERICAN MOVIES IN THE 70's (New York: Thomas Y. Crowell Company, 1975); *James Monaco, AMERICAN FILM NOW: THE PEOPLE, THE POWER, THE MONEY, THE MOVIES (New York: Oxford University Press, 1979); and Michael Pye and Linda Myles, THE MOVIE BRATS (New York: Holt, Rinehart and Winston, 1979).

[697] *Robert H. Stanley, THE CELLULOID EMPIRE: A HISTORY OF THE AMERICAN MOTION PICTURE INDUSTRY (New York: Hastings House, 1978), p.232.

[698] For more information on the transformation of Universal Pictures to Universal-International Pictures (in 1946), to the corporation's becoming a subsidary of MCA (in 1962), and to its current status in the 1980s, see Michael Pye, MOGULS: INSIDE THE BUSINESS OF SHOW BUSINESS (New York: Holt, Rinehart and Winston, 1980), pp.15-74; Gomery, THE HOLLYWOOD STUDIO SYSTEM, pp.147-60; and Wasko, pp.175-9. For a more recent look at MCA, see Geraldine Fabrikant, "MCA Turns Hand to Acquisitions," NEW YORK TIMES D (February 9, 1987):1, 3.

[699] In June, 1989, Paramount Communications, Inc. became the new name for Gulf & Western, Inc. For more information on Paramount's role in film history from the sixties to the present, see Wasko, pp.184-6; and Gomery, THE HOLLYWOOD STUDIO SYSTEM, pp.48-50.

[700] For more information, see Peter Schuyten, "United Artists' Script Calls for Divorce," FORTUNE 97:1 (January 16, 1978):130-3, 136-7; N. R. Kleinfield, "What Is Transamerica?" NEW YORK TIMES 3 (March 1, 1981):1, 22; and Robert Metz, "U. A. Theatre and Cable Deal," ibid. 4, (March 6, 1981), p.6.

[701] Two-and-a-half months after Turner bought the MGM/UA Entertainment Company, he agreed to sell MGM Entertainment to Lorimar-Telepictures Corporation. United Artists had been sold earlier to Kerkorian. All that Turner retained from the March, 1986, deal was the MGM library of more than 2,200 films. For information on MGM's chaotic corporate life from the late sixties , through the seventies (it ceased distribution in 1973, but resumed it by the end of the decade), and into the eighties when the corporation acquired United Artists, was purchased and then sold by Turner to become the MGM/UA Communications Company, see Thomas C. Hayes, "MGM, Its Image Bruised, Is Straining to Find Hits," NEW YORK TIMES F (January 30, 1983):1, 25; ___, "MGM/UA May Sell Unit Assets," ibid., D (July 17, 1985):2; Robert Lindsey, "The Film Giant With No Studio," ibid. 3, (March 27, 1977):1, 15; Geraldine Fabrikant, "Ted Turner's Screen Test," ibid., 3 (March 30, 1986):1, 8; Aljean Harmetz, "Lee Rich's Stubborn Optimism," ibid., C (November 30, 1987):13; Geraldine Fabrikant, "Plan to Split MGM/UA Is Reported," ibid., D (July 11, 1988):1, 4; Richard W. Stevenson, "MGM/UA's Plan to Spin Off a Studio Collapses," ibid., D (July 29, 1988):4; Wolf Schneider, "Viacom Most Likely Turner Partner for MGM/UA Buy," HOLLYWOOD REPORTER 190:36 (February 10, 1986):1, 13; Bill Desowitz, "UA Unveils Future Film Plans," ibid., 191:22 (August

became part of Kinney National Service in 1969 (thereafter known as Warner Communications Inc.);[702] and Columbia was absorbed by the Coca Cola Company in 1982.[703] Of the eight defendants in the PARAMOUNT antitrust case, only one had left the film industry (RKO in 1957)[704] and only one (20th Century-Fox) had retained its independence.[705] Put another way, six of the eight defendants, despite their new corporate structure, still exercise an oligopolistic role in the film industry.[706]

Still another shift in the American film industry during the 1960s was a desire to make films and television not only compatible but also mutually beneficial. Particularly interesting are the steps taken by Walt Disney to upgrade the status of his company to the ranks of the majors, to revolutionize distribution policies in the United States, and to create major diversification options for his company. These plans had important ramifications for both the film and the television industries.[707] Equally important were the immediate effects of the growing symbiotic relationship between film and television. For example, the increasing number of theatrical films being shown on television created economic problems for movie theaters, who claimed that people didn't want to pay for what they could see free at home. Thus filmmakers explored two new approaches to filmmaking. One option, already discussed, was to make the types of films that didn't appear on TV: e.g., blockbusters, widescreen features, and color productions. The second option, to produce films that could then be rented to TV for huge rental sums, became of paramount importance following the

22, 1986):1, 65; Ray Loynd, "Ted Turner in the Lion's Den," DAILY VARIETY 208:45 (August 8, 1985):1, 15; and Wasko, pp.176-8, 182-4.

[702] For more information on the studio's success story from the seventies to the mid-1980s, see Geraldine Fabrikant, "Warner's Scenario for Hits," NEW YORK TIMES D (March 21, 1986):1, 4; ___, "How Warner Got Back Its Glitter," ibid., 3 (December 14, 1986):1, 32; ___, "Warner in Deal to Acquire Lorimar," ibid., D (May 11, 1988):1, 3; "Lorimar and Warner Case," ibid., D (October 17, 1988):3; and Wasko, pp.180-2.

[703] For more information on the reasons leading up to Columbia's becoming a subsidiary of Coca Cola, see Wasko, pp.186-91.

[704] For more information on RKO's troubles and the steps leading to its temporary exit from films in 1957, see Gomery, pp.124-46; and Wasko, pp.77-90. For more recent developments, see "Gencorp to Sell RKO Pictures," NEW YORK TIMES D (March 11, 1987):5. Also worth seeing is the effective 1987 BBC documentary, HOLLYWOOD: THE GOLDEN YEARS, covering the history of RKO up to 1957.

[705] Donahue points out (p.30) that 20th Century-Fox was purchased by Marvin Davis and Marc Rich and converted from a privately held corporation to a privately owned company in 1981. For more information on how 20th Century-Fox has fared under the control of the oil magnate Marvin Davis and the communications mogul Rupert Murdoch, see Wasko, pp.178-80; and Cliff Rothman, "Murdoch Officially Closes Fox Deal to be Sole Studio Owner," HOLLYWOOD REPORTER 289:41 (December 5, 1985):1, 4. See also Douglas Gomery, "Vertical Integration, Horizontal Regulation: The Growth of Rupert Murdoch's US Media Empire," SCREEN 27:3-4 (May-August 1986):78-86; Aljean Harmetz, "Producer Will Head Fox Studio," NEW YORK TIMES D (November 17, 1986):1-2.

[706] For the most recent analysis of the effects of the PARAMOUNT decision, see Michael Conant, "The Paramount Decrees Reconsidered," THE AMERICAN FILM INDUSTRY, Rev. ed., pp.537-73.

[707] For a good summary of the Disney contributions, see Izod, pp.161-4.

successful screening of THE BRIDGE ON THE RIVER KWAI in 1965.[708] Eventually, option two proved more advantageous to the filmmakers than option one. Of course, the more popular the film was in the movie houses, the more money the producers could demand from the networks. But in the end, just as the majors began putting their faith in pre-sold properties for screen adapatations, they also began gearing their productions for screenings on television.[709]

The sixties also witnessed a discernible shift in the images of women on the screen. Most feminist film histories describe in detail the way in which confused Hollywood filmmakers were unable or unwilling to deal with female characterizations. Initial attempts to measure the impact of the sexual rebellion on box-office receipts resulted in a rash of films exploring the world of prostitution: e.g., BUTTERFIELD 8, ELMER GANTRY, and THE WORLD OF SUZIE WONG (all in 1960). Encouraged by audience reaction, the filmmakers then challenged the movie code further in films like BREAKFAST AT TIFFANY'S, THE HUSTLER, and SPLENDOR IN THE GRASS (all in 1961). But by the mid-sixties, the decline of the studios had damaged a star's marketability. No longer able to star in several films a year and thus gain a recognizable image, actresses had to succeed in fewer film roles. Even established stars like Elizabeth Taylor found themselves a hit in a film one year (BUTTERFIELD 8) and a disaster in another year (CLEOPATRA).[710]

As discussed earlier, the breakup of the studios made the performers dependent on agents instead of on a powerful film corporation. Package deals rather than studio assignments became the order of the day. At the same time, the emphasis on foreign films, art houses, and runaway productions brought American actresses in direct competition with their European counterparts.[711] In addition to the new film images were new social values from abroad. By the end of the decade, nudity and violence were having an effect on which stars were proving popular with mass audiences as well as on the relevance of the film subject to specialized audiences. The more discriminating filmgoer considered a film's theme more important than its performers. To make matters worse, mainstream filmmakers became frightened of the counterculture's reaction to almost any image of women on the screen and thus focused their cameras on "Buddy films" in which men were the main characters: THE PROFESSIONALS (1966), THE DIRTY DOZEN and COOL HAND LUKE (both in 1967),

[708] For more information, see Izod, pp.167-9; and THE AMERICAN FILM INDUSTRY, Rev. ed., p.435.

[709] For a good summary of the wheeling and dealing that took place in terms of film rentals to television, see THE AMERICAN FILM INDUSTRY, Rev. ed., pp.433-8; Charles Champlin, "Can TV Save the Films?" THE MOVIES: AN AMERICAN IDIOM; READINGS IN THE SOCIAL HISTORY OF THE AMERICAN MOTION PICTURE, ed. Arthur F. McClure (Rutherford: Fairleigh Dickinson University Press, 1971), pp.370-4; and Izod, pp.166-70.

[710] Important to remember is that the emphasis on blockbuster films in the sixties put the studios themselves in great jeopardy. It was one thing to have a series of flop films with a top actresss (e.g., Katharine Hepburn in SYLVIA SCARLET and BRINGING UP BABY were box-office disasters and Hepburn became known as "box-office poison") in the 1930s and quite another thing for a box-office failure like CLEOPATRA in the sixties. RKO easily survived the Hepburn problem; 20th Century-Fox almost went under because of the Taylor fiasco.

[711] For a useful discussion of American influence on European markets in the sixties and early seventies, see Thomas Guback, "Cultural Identity and the European Economic Community," CINEMA JOURNAL 14:1 (Fall 1974):2-17; Eitel Monaco, "The Financing of Film Production in Europe," ibid., pp.18-25; and Neville Hunnings, "Film and European Competition Law," ibid., pp.26-31.

EASY RIDER, BUTCH CASSIDY AND THE SUNDANCE KID, and MIDNIGHT COWBOY (all in 1969).

The seventies began with the American film industry in serious trouble. According to Donahue, the large sums of money spent on blockbuster films during the late-1960s had created a depression within the industry.[712] From Madsen's perspective, "A combination of bad gambling and audience defection to upstart 'little' films caught Hollywood with capital investments of $100 million; and understandably, the conglomerates' ardor cooled."[713] Studio lots were auctioned off, production schedules were hastily revised. "The studios," Stuart Byron observes, "carried huge inventories of properties and developing projects that would never be made. Stars seemed questionable guarantors of a film's success. During the 1969-1972 period, the seven major studios posted losses aggregating $500 million."[714] William Paul, arguing that the "new Hollywood" was more financially unstable than in the past, singled out the industry's blockbuster obssession as a major reason for Hollywood's problems. In the past, he explains, the studios diversified their output, but in the seventies the filmmakers turn out the "big-budget multi-character action film to the exclusion of much else."[715]

Not only didn't the industry offer its standard variety of film formulas, but it also had cut down on the number of films being released. As pointed out earlier, the result was a continuing "shortage" of worthy films for exhibition. In their quest for megabucks, the majors had jeopardized the economic welfare of the film industry. It wasn't that there weren't enough pictures to screen during the key seasons (e.g., Easter, the summer, and Christmas). Exhibitors had to pay high prices for a presumed blockbuster at the box office, but the films were available. The problem was that these seasonal releases had to be booked for extended runs. Thus a bad choice by an exhibitor could put a small theater owner out of business. For example, a Vermont exhibitor put up a $50,000 guarantee and agreed to an extended run in order to book LAST TANGO IN PARIS (1973). When the film bombed in Burlington, Vermont, the exhibitor never recovered and went out of business shortly thereafter. Of course, if a theater owner got lucky, he or she might make big bucks on a major film like LOVE STORY, AIRPORT (both in 1970), THE FRENCH CONNECTION, DIRTY HARRY (both in 1971), THE GODFATHER, and THE POSEIDON ADVENTURE (both in 1972). The question was how much could you afford to lose if you wanted to survive. It was obvious by the mid-1970s, that only a small percentage of the films being released were making big money. For example, Paul calculates that in 1975, " . . . of the top seventy-nine films . . . a mere fifteen accounted for fifty-seven per cent of the total income."[716] Clearly a number of changes were needed if the industry was to survive.

Nevertheless, by 1975, Hollywood was in the throes of a three-year prosperity period. What caused the turnabout and how it affected the future of the industry is a matter of debate. Byron, for example, claims that the reason why Hollywood survived the decade with its "glitz and hype" intact is that (1) the industry set up a system of "guarantees," whereby producers, TV networks, and exhibitors shared in the risks connected with theatrical films costing more than $10 million; (2) the majors agreed to share with independent financiers the cost of underwriting a big production rather than going it alone as had been the case in the sixties; (3) the majors revised their old-fashioned key theater distribution policies and opted for

[712] Donahue, p.31.

[713] Axel Madsen, "The Changing of the Guard," SIGHT AND SOUND 39:2 (Spring 1970):63.

[714] Stuart Byron, "The Industry," FILM COMMENT 16:1 (January-February 1980):38.

[715] Paul, p.41.

[716] Paul, p.57.

large-scale openings of big films in hundreds of theaters across the country;[717] and (4) the newly introduced ratings system of the late 1960s gave the majors the opportunity to make films dramatically different from those seen on television.[718]

Richard Corliss claims that the seventies put an end to the film capital's "reliance on plays and novels as fodder for its movies."[719] Indicative of the change are the sources for Oscar-winning films in the 1970s. As Corliss points out,

> In the years from 1939-49, eight of the eleven winners of the Best Film Oscar were based on popular novels; in the seventies, only three were (the two GODFATHERS and ONE FLEW OVER THE CUCKOO'S NEST). In the Sixties, five top-Oscar-winning films were from hit plays; in the Seventies, none. In the forty years from 1939 to 1969, only eight Best Films were from original screenplays; in the Seventies, five have been (and, unless KRAMER VS. KRAMER cops the big one this year [it did!] 1979 will make six).[720]

The significance, Corliss believes, is not so much in the number of original scripts, but in the fact that the important creative decisions were being made by writer-directors rather than by studio heads or producers. In other words, the major creative decisions, as will be discussed in Chapter 7, were being made by writer-directors like Woody Allen, Robert Altman, Francis Ford Coppola, George Lucas, and Paul Mazursky.

J. Hoberman, while lamenting what happened to AVANT-GARDE filmmakers in the seventies, argues that "Perhaps the key structural event of the decade was the absorption of the New American Cinema into the universities."[721] The significance of underground filmmakers' moving into academia, explains Hoberman, is that they not only trained a new generation of AVANT-GARDE filmmakers and helped re-orient film study in the classroom but also helped produce "a serious, educated audience."[722]

Another particularly significant change was the sources of the new industry leaders. For example, studio heads no longer came from within the ranks. The most prominent group were former agents: David Begelman (Columbia), Mike Medavoy (Orion), Alan Ladd, Jr. (20th Century-Fox), Ned Tanen (Universal), Martin Elfand (Warner Bros.), and Richard Shepard (MGM). An equally important group consisted of executives who had training in mass market programming in television: Daniel Melnick (Columbia), Michael Eisner (Paramount), Barry Diller (Paramount), and Frank

[717] A key factor in the revised distribution policies was the marketing of BILLY JACK (1971) and THE TRIAL OF BILLY JACK (1974). For more information, see Ted Siminoski, "The 'BILLY JACK' Phenomenon," VELVET LIGHT TRAP 13 (Fall 1974):36-9; Wayne Kabak, "The Industry: Four-Walling," FILM COMMENT 11:6 (November-December 1975):30-1; and Lee Beaupre, "Industry," ibid., 14:5 (September-October 1978):68, 70, 72, 77.

[718] Byron, pp.38-9.

[719] Richard Corliss, "We Lost it at the Movies: The Generation that Grew Up on THE GRADUATE Took Over Hollywood--and Went into Plastics," FILM COMMENT 16:1 (January-February 1980):38.

[720] Corliss, p.38. Interestingly, a new cycle of theatrical films appeared in the late 1980s. For more information, see Mel Gussow, "Encore! From Stage to Screen," NEW YORK TIMES C (February 1, 1989):17, 21.

[721] J. Hoberman, "Indpendents," FILM COMMENT 16:1 (January-February 1980):43.

[722] Hoberman, p.43.

Price (Columbia).[723] Of equal importance was the fact that many of the filmakers were graduates of the major film programs at UCLA and USC. For example, the UCLA "academics" included Francis Ford Coppola, Colin Higgins, Gloria Katz, and Paul Schrader; the USC "academics" included Dan O'Bannon, Hal Barwood, John Carpenter, Bob Gale, William Huyck, Gary Kurtz, George Lucas, John Milius, Matthew Robbins, and Robert Zemeckis. East Coast academic programs could boast of graduates like Brian De Palma (Columbia University) and Martin Scorsese (NYU).[724]

Thus by the mid-1970s, the American film industry found itself in an unsual position. On the one hand, it was making more money than ever. Independents, according to Dale Pollock, were turning out nearly 300 films a year at a cost of almost $100 million of production time.[725] Tv had become a lucrative outlet for theatrical releases, and a major like Universal was making most of its money on TV productions rather than on theatrical releases.[726] In addition, as Gordon points out, the market strength of the majors by 1977 was such that "in 1977 they accounted for 93 per cent of American distributors' gross in the United States and Canada . . . [while the] smaller film distributors--the hundreds of them that operate nationally or in the states--shared the other meagre 7 per cent."[727] Donahue puts the fortunes of the distributors even more dramatically. Aided by a theater-building boom and the shortage of product, they increased their dominance in the film industry and took more than a third of box-office profits for themselves. By the end of the decade, the figure reached forty percent of theater receipts.[728] Even exhibitors, who were paying enormous percentages (e.g., ninety percent of the box-office grosses) to distributors just for the privilege of screening a film for an extended run, were doing well as a result of the "candy" sales that often exceeded the profits from the film run.[729]

On the other hand, not everyone was enjoying the "good" times. For example, the public appeared to be short-changed by the industry. Film releases had dropped

[723] For more information, see Geraldine Fabrikant, "Columbia Studio Chief Faces Industry Doubts," NEW YORK TIMES C (July 5, 1986):33-4; *Lester D. Friedman, HOLLYWOOD'S IMAGE OF THE JEW (New York: Frederick Ungar Publishing Company, 1982) pp.225-6; and *James Monaco, AMERICAN FILM NOW: THE PEOPLE, THE POWER, THE MONEY, THE MOVIES (New York: Oxford University Press, 1979), pp.1-49.

[724] Cited in Corliss, p.35.

[725] Dale Pollock, "From Depths to Heights," DAILY VARIETY (October 1979):30. Cited in Donahue, p.31.

[726] Donahue, p.31.

[727] David Gordon, "The Movie Majors," SIGHT AND SOUND 48:3 (Summer 1979):151.

[728] Donahue, p.32.

[729] According to Gomery, the idea of exhibitors' making money on treats came into vogue during the 1930s. Prior to the Great Depression, film audiences bought their "sweets" in stores close to the theater. But the sharp drop in attendance during the early days of the 1930s forced theater owners to seek additional revenues. The massive firings of ushers gave customers greater mobility inside the theater, while the convenient packaging of treats soon led to the creation of concession stands in the theater lobby. After that, it was simply a matter of conditioning the audience to buy treats before and during the show. For more information, see Douglas Gomery, "The Popularity of Filmgoing in the US, 1930-1950," HIGH THEORY/LOW CULTURE: ANALYZING POPULAR TELEVISION AND FILM, ed. Colin MacCabe (New York: St. Martin's Press, 1986), pp.76-7.

by a third (from 180 to 120) between 1969 and 1975.[730] "With few exceptions," Gordon points out, "only those [films] distributed by the majors have a chance of success."[731] Moreover, the strength of the majors was tied not only to the domestic market, but also to the television industry. That is, the TV networks paid top dollar only for the hit films and the hit films almost always came from the majors who controlled distribution channels. The majors' preoccupation with blockbuster films naturally resulted in escalating the expense of making such films. As the "package deals" cost more to put together, discussed earlier, the amount of money required for a film to "break even" increased. That, in turn, meant that fewer films succeeded at the box office. Consequently, financiers demanded, and often got, film projects that appealed more and more to mass audiences rather than to select audiences. More specifically, films were made that appealed to those between the ages of twelve and thirty. As will be discussed later, the film industry in the seventies seemed to write off people over thirty years of age. In doing so, the emphasis in film content was on special effects, action-packed subjects, and sentimentality.

As the decade drew to a close, filmmakers began responding to the product shortage and increased the annual output of films, the conflicts between distributors and exhibitors intensified, and the cost of filmnmaking continued to skyrocket. Nowhere were the dangers of the blockbuster mentality more apparent than in the horrendous failures of films like Steven Spielberg's 1941 (1979) and Michael Cimino's HEAVEN'S GATE (1980). According to Lee Beaupre, the failure of these two films

only supports the designation of the Seventies as Hollywood's marketing decade. Because Spielberg's two previous movies [JAWS and CLOSE ENCOUNTERS OF THE THIRD KIND] had placed among the top ten all-time boxoffice champions, and because Cimino had just converted the "uncommercial" Vietnam War into an Oscar-winning moneymaker [THE DEER HUNTER], both filmmakers were given exhorbitant production funds and the right to shield their sets from the media and the studios' own marketing staffs.[732]

Beaupre goes on to describe how the hit-flop mentality resulted in few interesting films being produced and how difficult it had become to gauge audience interests. "Until recently," he comments, "it was possible to draw certain conclusions about the changing national temper from the films Americans chose to attend en masse, but increasingly the public appears more susceptible to marketing strategies than to emotionally resonant myths."[733]

Throughout the seventies, images of women continued to fluctuate between movies stressing women's themes--e.g. ALICE DOESN'T LIVE HERE ANYMORE and A WOMAN UNDER THE INFLUENCE (both in 1974)--and patriarchal stories in which women find trouble by seeking independence--e.g. ANNIE HALL and LOOKING FOR MR. GOODBAR (both in 1977). There was also a negative trend depicting the brutalization of women. Joan Mellen is particularly incensed about violent films like STRAW DOGS and THE FRENCH CONNECTION (both in 1971), DIRTY HARRY and

[730] Cited in Izod, p.174.

[731] "The Movie Majors," p.151.

[732] Lee Beaupre, "Industry--Grosses Gloss: Breaking Away at the Box-Office," FILM COMMENT 16:2 (March-April 1980):69. Izod makes (pp.183-5) the observation that key films in setting the new marketing priorities in the 1970s were THE GODFATHER (1972), THE DEEP, and STAR WARS (both in 1977). For a recent example of successful marketing, see Alajean Harmetz, "Marketing Magic, With Rabbit, for Disney Films," NEW

[733] "Industry-Grosses Gloss," p.73.

FRENZY (both in 1972). Not only does she criticize the emphasis on eroticism, but she also argues that the message skirts close to telling women what might happen to them if they try to escape from their subordinate role in a nuclear family dominated by a strong patriarch. In a sense, society "enslaves those it protects and it rapes and mutilates those who escape its inhibiting norms, even when, as with whores, it is at society's own behest."[734] In each instance, the determination of stories, performers, and treatments is related to the economic power of the major distributors. Of particular interest, however, is Mellen's assertion that "the old stereotype of women as passive anxious victim[s] . . . [does not] substantially differ in American as distinct from European films."[735]

As the eighties began, filmmaking entered a new era of production-distribution.[736] In fact, as Myron Meisel reported, more than half of the top film companies had executive shakeups in 1980-1981: 20th Century-Fox was taken over by Marvin Davis, United Artists got swallowed by MGM, "Norman Lear's T. A. T. Communications absorbed Avco-Embassy; and Coca-Cola announced plans to acquire Columbia Pictures."[737] Another important observation by Meisel was that only three genres (comedy, action-comedy, and fanstasy-adventures) were represented in the top twenty box-office films of 1981. If this pattern persisted, he commented, "The occasional moviegoer will be ignored; the size and scope of the market will shrink; and the glut of comedies and fanstasy-adventures will devour themselves in competing for the dollars that remain."[738] Two months later, Harlan Jacobson reported that Hollywood's reaction to fears about a shrinking market resulted in the majors' making more films costing $12 million instead of blockbusters costing $30 and $40 million. The significant change, however, was that the importance of the producer in filmmaking resurfaced. "Some are packagers," Jacobson observes, "some are executives, many have something of Thalberg in them. But the industry is fundamentally different."[739] The repositioning of the film industry and its big-budget gambling in the eighties produced mixed results midway through the decade. For example, Mike Bygrave points out that by 1985, Hollywood was breaking box-office records, evening out its release patterns rather than concentrating just on the major seasons, increasing the number of film productions, giving exhibitors better deals, and turning out critically acclaimed films. At the same time, the studios continued shuffling executives, movies were becoming more violent, comedies and adventure-fantasies still dominated the production schedule, and the filmgoing audience showed no change in size since the fifties.[740]

[734] Mellen, pp.26-7.

[735] Mellen, p.48.

[736] For a good overview of the problems, see Alan Stanbrook, "Hollywood's Crashing Epics," SIGHT AND SOUND 50:2 (Spring 1981):84-5; L. M. Kit Carson, "The Hard Part, I: Getting it Made--Breathless Diary," FILM COMMENT 19:3 (May-June 1983):34-8; Stephen Farber, "The Hard Part, II: Getting it Shown--Shelf Life," ibid., pp.39-43; and David Ehrenstein, "The Hard Part, III: Getting it Right--The Aesthetics of Failure," ibid., pp.44-7.

[737] Myron Meisel, "Industry: Seventh Annual Grosses Gloss," FILM COMMENT 18:2 (March-April 1982):60.

[738] Meisel, p.61.

[739] Harlan Jacobson, "Hollywood Lays an Egg," FILM COMMENT 18:3 (May-June 1982):49.

[740] Mike Bygrave, "Hollywood 1985," SIGHT AND SOUND 54:2 (Spring 1985):84-8.

Once again, the pundits who predicted the demise of Hollywood had misread the signs. The American film industry was bigger than ever. Budd Schulberg describes the new Hollywood perceptively, stating that the studios were "ready to call themselves majors again." Their confidence resided in technological innovations "that will revolutionize the very nature of entertainment in America."[741] While few people doubt that the majors still retain their oligopolistic powers, scholars are debating whether or not the financial risks remain as great as ever in filmmaking. Gregg Kilday reports that "The average film that costs $12 millon and requires another $8-10 million in prints and advertising before it can be set before the public is hard-pressed to achieve profitability on a return of fewer than $20 million in North American rentals."[742] At the time Gregg made his comments, fewer than half a dozen of nearly 600 released films earned more than twenty to thirty million dollars. Geraldine Fabrikant reports that a 1980 study by the Association of Motion Picture and Television Producers noted that "the average film fell $4 million short of recouping its releasing and negative costs at the domestic box office." She added, "In 1981, that shortfall increased to $5.5 million. By 1985, the shortfall was $9.5 million."[743] Moreover, Harmetz's 1987 report claims that "only a small fraction of new movies--some say just 1 in 20--is now profitable at the box office, with financial success hinging on video cassette and cable television sales later on."[744]

Contributing to the modern film's unpredictability in the marketplace, in addition to audience fickleness and rising costs of negatives, are competitive bidding practices, exhibitors' biases, an over-abundance of product during peak seasons, and flawed marketing strategies. Consider the case of the Coca-Cola Company and Columbia Pictures. Following Coke's takeover of the movie company in 1982, Columbia waged a more aggressive film campaign to garner a larger share of the movie business. But in less than three years, marketing costs forced Columbia to cut back on production (from eighteen to thirteen films a year) and to revise its marketing strategies.[745] Consider as well the effect that runaway costs had on the film industry in the Spring of 1987. "The Union representing Hollywood's extras," reports Harmetz, "has agreed to studio demands for sharp cutbacks in wages and benefits for new members. MCA/Universal has discharged 200 employees and is about to order

[741] Budd Schulberg, "What Makes Hollywood Run Now?," NEW YORK TIMES MAGAZINE (April 27, 1980):52-86.

[742] Gregg Kilday, "Tenth Annual Grosses Gloss," FILM COMMENT 21:2 (April 1985):62.

[743] Geraldine Fabrikant, "Small Studios' Tough Season," NEW YORK TIMES (July 6, 1987):38.

[744] Aljean Harmetz, "Hollywood Battles Killer Budgets," NEW YORK TIMES F (May 31, 1987):1. For an example of the specific costs in making a popular modern film--i.e., PROJECT X (1987)--see "An Average High-Priced Movie: Where All the Money Goes," NEW YORK TIMES F (May 31, 1987):8.

[745] Geraldine Fabrikant, "A Shift at Columbia Pictures," NEW YORK TIMES D (November 12, 1985):1. See also "Columbia Working to Manage Word of Mouth on Pictures," HOLLYWOOD REPORTER 182:30 (May 15, 1978):12; and Aljean Harmetz, "Film Studio's Chief Fails to Establish Brave New World," NEW YORK TIMES C (September 29, 1987):17. For other perspectives on marketing in the eighties, see Dan Yakir, "Industry: Campaigns and Caveat," FILM COMMENT 16:3 (May-June 1980):72-7; and William Severini Kowinski, "The Malling of the Movies," AMERICAN FILM 8:10 (September 1983):52-3,55-6; and Helen Dudar, "All the Right Moves," ibid., 9:5 (March 1984):36-9, 42.

executives traveling to New York to use only those hotels that offer corporate rates."[746]

In addition, the industry is becoming extremely centralized. James Monaco's impressive statistics on twelve of America's (and the world's) biggest and most influential media corporations dramatize how a few companies are striving to gain a virtual stranglehold on our channels of communication.[747] For example, Monaco reports that "In any one year, three out of the top five film distributors receive more than half of total film revenues."[748] Joseph R. Dominick claims that the current film industry is a "'tight' oligopoly." That is, the top four distributors in the film industry "typically account for 60-65 percent of total film rental revenue."[749] Add to these conditions Richard Gold's observations that the character of the American film market for foreign films is undergoing a negative transformation,[750] and you begin to understand why American filmmakers are so reluctant to gamble on controversial and untested movies.[751]

On the other hand, Fabrikant reports that the foreign markets for American films are more significant than ever in determining the commercial success of a movie. Consider CHILDREN OF A LESSER GOD (1986). Although a mediocre success in the United States ($16 million at the box office), the film during its "first three months of release overseas . . . brought in $23 million"[752] Thus by the time it finishes its theatrical run, the film will be both a critical and a commercial success.

[746] "Hollywood Battles Killer Budgets," p.1.

[747] James Monaco, "Who Owns the Media: The Conglomerates Have a Stranglehold on Mass Entertainment," TAKE ONE 6:12 (November 1978):24, 26-8, 58-9. The major media conglomerates listed are American Broadcasting Companies, Inc.; CBS, Inc.; Columbia Pictures Industries, Inc., Gulf-Western Industries, Inc.; MCA Inc.; New York Times Company; RCA Corp.; Time Incorporated; Times-Mirror Company; Transamerica Corporation; 20th Century-Fox Film Corporation; and Warners Communications Inc.

[748] Monaco, p.24.

[749] Dominick, p.137.

[750] Richard Gold, "U. S. Market Needs Specialty Pix," VARIETY 319:1 (May 1, 1985):1.

[751] The uncertain fate of small films in the late 1980s is highlighted by the fact that a number of risky and unusual projects initiated by David Puttnam, the former head of Columbia Pictures, remained in limbo eighteen months after he exited the studio in September 1987. For more information, see Aljean Harmetz, "In Re: Columbia Pictures and Puttnam's Orphans," NEW YORK TIMES C (February 2, 1989):17, 21. On the other hand, the success of films like THE BEER DRINKER'S GUIDE TO FITNESS AND FILMMAKING (1988) prove that independent filmmakers with little and unknown movies can make money. The film played opposite RAMBO III in Burlington, Vermont, during the 1988 summer season and outgrossed the more heavily advertised film. For more information, see Sue Halpern, "Adirondack Film Maker Seeks Big-City Success," NEW YORK TIMES B (August 18, 1988):5. For other perspectives on independent filmmaking in the eighties, see Mitch Tuchman, "Declaration of Independence," FILM COMMENT 16:3 (May-June 1980):20-2; Austin Lamont, "Independent's Day," ibid., 17:6 (November-December 1981):15-20, 69-74, 76; Aljean Harmetz, "At Independent Film Festival, Hail and Farewell," NEW YORK TIMES C (February 1, 1989):17, 24; and ___, "Redford Broadens Pet Project," ibid., A (February 4, 1989):11.

[752] Geraldine Fabrikant, "Box Office Abroad Now More Valuable," NEW YORK TIMES D (September 28, 1987):1.

Moreover, scholars like Wasko point out that ancillary rights, tie-ins, the videocassette revolution, pay cable, and TV networks have opened new sources of revenues and outlets for filmmakers.[753] While it may be more difficult to recoup costs in initial exhibition runs, the chances of a film's making money in subsequent markets are very high.[754] For example, the once supreme power of the three major netoworks (ABC, CBS, and NBC) ended in the late 1970s. As Robert E. Mulholland states, "Technology, with government's approval, added strange new words to the TV dictionary: satellite, transponder, cable, pay cable, superstation. And unfamiliar combinations of letters blossomed: HBO, ESPN, CNN, C-SPAN, MTV."[755] The "video revolution" changed not only the way movies were conceived, produced, and exhibited, but also films were deemed financially successful. Harmetz reported in the summer of 1985 that the videocassette industry, non-existent eight years ago, "is attracting almost as much money as movie box offices."[756] By 1987, however, experts were taking a more cautious attitude on the videocassette and pay television outlets. While it is true that film hits still do very well in such markets, less popular films are not being bought and shown in large numbers. In addition, rising production and marketing costs, as well as the decision by the three major networks to limit severely the purchase of commercial films has had a drastic effect on small studios.[757] By the end of 1988, Harmetz was reporting that Hollywood was once more in the doldrums. Except for the Walt Disney Company's increased film production schedule, filmmaking is on the decline. Among the companies no longer making films or on the verge of bankruptcy are the De Laurentiis Entertainment Group, the Lorimar Telepictures Corporation, the Cannon Group, MGM, and United Artists. Moreover, the majors, rocked by stormy managerial changes, are doing poorly at the box office. Among those corporations having a particularly bad year are Warner Bros. and Universal Pictures.[758]

[753] For a useful example of the new sources, see Stephen Farber, "Australia Stands In as a Television Hollywood," NEW YORK TIMES D (May 16, 1988):10. For recent examples of the majors moving into TV, see Geraldine Fabrikant, "Paramount to Acquire Right to 5 TV Stations," NEW YORK TIMES D (January 18, 1989):1, 16; Andrea Adelson, "When Disney Buys a TV Station," ibid., D (January 23, 1989):9; and Richard W. Stevenson, "Lear Back in TV Production in a Venture with Columbia," ibid., D (February 2, 1989):1, 19.

[754] Wasko, "Film Financing and Banking," p.29.

[755] Robert E. Mulholland, "Behind the Strike at NBC," NEW YORK TIMES (September 26, 1987):27.

[756] Aljean Harmetz, "Big Gains for Video Cassettes: Revenues Nearing Box-Office Income," NEW YORK TIMES A (August 21, 1985):1, C13. See also "Hollywood Worried by Growing Cassette Rentals," ibid., C (November 18, 1985):18; Aljean Harmetz, "Studios Woo Cassette Mass Market," ibid., C (January 27, 1986):24; *James Lardner, FAST FORWARD: HOLLYWOOD, THE JAPANESE, AND THE ONSLAUGHT OF THE VCR (New York: W. W. Norton and Company, 1987); Peter Guber, "The New Ballgame: The Cartridge Revolution," CINEMA 6:2 (1970):21-31; Richard Kahlenberg and Aaron Chloe, "The Cartridges Are Coming," CINEMA JOURNAL 9:2 (Spring 1970):2-12; and Henry Hart "Cassettes," FILMS IN REVIEW 21:9 (November 1970):521-4.

[757] "Small Studios' Tough Season," p.38.

[758] Aljean Harmetz, "Disney Expansion Set+ Film Output to Double," NEW YORK TIMES D (December 2, 1988):1, 3.
 Film Output to Double

Consequently, conservatism rather than an adventurous spirit dominates the film business.[759] The content of movies remains tied to tested formulas that have worked at the box office.[760] For example, Dominick argues that between 1964 and 1983 the number of sequels has increased steadily, "reaching its peak in the last five years . . . The number of reissues per year generally follows the same trend . . . [and that the data highlights] the increasing tendency for the studios to minimize their risk taking in the past few years.[761] Thomas Simonet also cautions against sweeping generalizations about the nature of the "New Hollywood." He rejects the commonly held notion that since the 1970s conglomerate ownership has resulted in an increased number of films based upon recycled scripts--e.g., film remakes, sequels, and series. His data covering 3,490 movies released between 1940 and 1979 indicates that "far more recycled-script films appeared before the conglomerates takeovers. . . ."[762] Moreover, Simonet points out that "it would appear that originality suffers more in periods of high volume of production than in an era of conglomerate control."[763] Whether one accepts Dominick or Simonet's arguments, it is clear that the stock situations and social types found in the majority of American films are determined by a relatively few powerful corporations. The distribution power of those organizations translates into who makes the movies that get maximum national and international distribution and worldwide exhibition.

The problems that such a system presents to independent and radical filmmakers who seek to change society through the visual arts are formidable and filled with contradictions and paradoxes. For example, those unconventional filmmakers interested in reaching mass audiences need to use the very delivery channels they are seeking to undercut. Furthermore, these same filmmakers face an uphill battle in producing commercially acceptable images that contradict the dominant social values audiences have been conditioned to enjoy. And even if the networks of production and distribution were available and the residual or emerging social values were commercially feasible, independent and radical filmmakers still must contend with the attitudes and values of tradition-minded exhibitors and audiences.

Technologically, the film industry continues its experimentation in screen sizes and sound innovations.[764] For example, work progresses on Douglas Trumbull's

[759] For an example of how the fortunes of a film company (New World Entertainment Ltd.) are tied to the thinking of the investment community, see Richard W. Stevenson, "New World's New Order," NEW YORK TIMES F (May 15, 1988):6-7; ___, "New World Accepts Offer by Pathe," ibid., A (February 25, 1989):35, 47; and Geraldine Fabrikant, "New Lease on Life for New World," ibid., D (September 29, 1988):2.

[760] In defense of contemporary filmmakers who frequently recycle their ideas, George Lucas argues that "Art is the retelling of certain themes in a new light, making them accessible to the public of the moment." Quoted by Aljean Harmetz, "A Pained Lucas Ponders Attack on WILLOW," NEW YORK TIMES C (June 9, 1988):23.

[761] Dominick, p.146.

[762] Thomas Simonet, "Conglomerates and Content: Remakes, Sequels, and Series in the New Hollywood," CURRENT RESEARCH IN FILM, Volume 3, pp.156-7.

[763] Simonet, p.161.

[764] For more information, see Pat Dowell and Ray Heinrich, "Bigger Than Life," AMERICAN FILM 9:7 (May 1984):49-53; Karen Stabiner, "The Shape of Theaters to Come," ibid., 7:10 (September 1982):51-6; and Allan Stegman, "The Large-Screen Film: A Viable Entertainment Alternative to High Definition Television," JOURNAL OF FILM AND VIDEO 36:2 (Spring 1982):21-30, 72.

Showscan, a 70mm projection system operating at 60 frames per second.[765] The towering 70mm Imax system, with its ability to maximimize audience involvement with film action through theater design and screen size, continues to attract limited interest.[766] Nonetheless, most film theaters use 35mm projection, with the bigger ones employing 70mm. In sound, filmmakers are exploring at least two dozen different approaches to high technology high-fidelity music and special effects: e.g., stereo, quadrophonic, Dolby, Lucas "THX" sound, Sensurround, Sound 360, and Acoustic Sound Recording.[767]

Scholars studying the economics of the film industry remain handicapped, because of limited financial information, to the annual reports of companies in the industry,[768] as well as the bits and pieces that appear in such trade publications as VARIETY, HOLLYWOOD REPORTER, and newspapers or magazines. In addition, their access is limited to whatever information can be obtained directly from production, distribution, and exhibition firms and from personal interviews with people associated with the industry.[769] Adding to the problem is that ever since the mid-sixties, the industry has become increasingly complex and diversified and less definable in economic terms. Compounding the problem is the paucity of reliable and meaningful information and data on the various economic facets of the industry, such as organizational structure, interrelationships with television, the distribution of costs, the profitability of films, sources of finance, producer-distributor and

[765] For more information, see George E. Turner, "Showscan: Doug Trumbull's New 70MM Format,". AMERICAN CINEMATOGRAPHER 65:8 (August/September 1984):113-4,116-9; Bill Desowitz, "Showscan Moving With Theatres, Films," HOLLYWOOD REPORTER 287:11 (May 29, 1985):1,16; Karen Jaehne, "Trumbull's Progress," SIGHT AND SOUND 54:2 (Spring 1985):102-5; Alan Karp, "Showscan: Coming Soon to a Theatre Near You," BOXOFFICE 121:6 (June 1985):20-3; Bill Krohn and Harley Lond, "Showscan: A New Type of Exhibition for a Revolutionary Film Process," ibid., 119:11 (November 1983):10-11; and Richard W. Stevenson, "Bringing the Movies to Life," NEW YORK TIMES D (November 4, 1987):10.

[766] Herb A. Lightman, "Film at Expo '74," AMERICAN CINEMATOGRAPHER 55:10 (October 1974):1161-2, 1196-7; and Vincent Canby, "'Big Screen' Takes on New Meaning," NEW YORK TIMES H (April 19, 1987):18-9.

[767] Jowett and Linton, p.121.

[768] In advising me on this section of the manuscript, Charles H. Harpole voiced some reservations. Rather than try to paraphrase his comments they are included: "Although it is most generally true that the Hollywood industry has kept its paper documents out of the reach of scholars, several studios have donated company papers to archives (such as USC, UCLA, and the Wisconsin Center). Usually, these papers are 'safely' aged--very seldom is free access granted to contemporary documents. Documents from companies that have gone out of business are more likely to appear in archives. Researchers should be, of course, wary of the likelihood that any deposit of company records may have been sifted by the business's legal staff or others who may have, often without saying so, removed, selectively, some documents. However, the researcher is well advised to seek out studio documents in unlikely places. For example, many studio memos and the like, which expose company business policies and attitudes, can be found in the attached documentation stored in the script collections of USC. Thus, one should not assume, in this example, that only scripts are to be found in this part of the USC archive." Charles H. Harpole, letter to author, April 17, 1986.

[769] For more information on the secretive nature of film data, see Jowett and Linton, pp.28-9.

distributor-exhibitor arrangements, data on marketing patterns, information on marketing and pricing practices and on expanding markets through the potential of new technologies (e.g., pay television).[770] James Monaco notes that just six film companies completely control film distribution. Yet when economic film historians investigate the revenue statements and analyze how this is done, they find that in each of the twelve cases he cites, "the media operations, despite being a percentage of the whole, compare absolutely in size with other companies' media activities."[771] Axel Madsen also places great emphasis on the evolution of the entertainment industry "into a 'congeneracy,' i.e., a communications service providing books, records, movies, radio, television, and other sources of electronic information not yet invented or just on the drawing boards."[772]

Determining how each of these interests affects the economic and artistic future of the film industry becomes very difficult. Furthermore, as Madsen points out, the improvisational aspects of the congeneracy world may well be to turn movies into "a parody of themselves: self-indulgent playbacks of each consumer's own fantasies rather than someone else's experience absorbed for entertainment and enlightenment."[773] Understandably, the attitudes and actions of the prominent producer-distributors will establish the important trends in production, distribution, and exhibition.

On the positive side, Gomery offers a useful introduction to three methodological approaches to studying the film industry: business studies, industrial-organization economics, and classic Marxist economics.[774] The approach chosen directly influences the shape and breadth of the analysis undertaken. For example, Gomery cites Michael F. Mayer's THE FILM INDUSTRIES: PRACTICAL BUSINESS/LEGAL PROBLEMS IN PRODUCTION, DISTRIBUTION AND EXHIBITION, Rev. ed. (1978) as an illustration of the business studies approach. That is, Mayer directs his information primarily to independent filmmakers who do not have the benefit of business management experts found in great numbers at the major studios. As noted elsewhere, Mayer's manual functions as a blend of theory and practice on the movies as a business.

On the other hand, Gomery finds Michael Conant's ANTITRUST IN THE MOTION PICTURE INDUSTRY indicative of the industrial-organization approach to analyzing the film industry. Here the material focuses mainly on the concern for the types and quantities of goods and services a society should produce and on the best way the end-products should be distributed to members of society. What scholars like Conant investigate, explains Gomery, is "how profit-maximizing business concerns interact with the market forces of supply and demand."[775] Three elements determine the results of the industrial-organization economist's work: structure, conduct, and performance. Thus Conant's classic study, detailed elsewhere, describes how the method works. In simplified terms, he first identifies the existence of an oligopolistic structure in the film industry prior to 1938. Next, he outlines how the majors through specific marketing, legal tactics, and pricing behavior conducted themselves in a way

[770] For an example of new technology in the film industry, see Marjorie Costello, "The Big Video Picture From Japan," VIDEOGRAPHY 10:6 (June 1985):27-31; and Hans Fantel, "New Technology Moving into Films," NEW YORK TIMES C (March 12, 1985):18.

[771] Monaco, p.24.

[772] Axel Madsen, THE NEW HOLLYWOOD: AMERICAN MOVIES IN THE 70'S (New York: Thomas Y. Crowell Company, 1975), p.151.

[773] Madsen, p.152.

[774] Gomery, "The Economics of Film," pp.81-94.

[775] Gomery, p.85.

contrary to American law. He concludes that the film industry's performance resulted
in the U. S. Department of Justice's demand for an end to vertical integration.

Different from either the business studies or the industrial-organizations'
approach, according to Gomery, is that of the classic Marxist economics. It alone is
preoccupied with examining the structural flaws of a capitalist economic system. To
illustrate his point, Gomery reviews Thomas H. Guback's important Marxist study,
THE INTERNATIONAL FILM INDUSTRY: WESTERN EUROPE AND AMERICA SINCE
1945 (1969), and points out how Guback goes beyond "the effects of economic
structure-conduct-performance . . . [to Hollywood's exploitation of European
markets and] the major economic effects on the behavior of film industries on both
sides of the Atlantic."[776] Each of these three methods, Gomery rightly argues, can
provide valuable insights into film history. Most important is the film students'
recognition that there is no simple, unified approach to analyzing the film industry.

Whichever approach the investigator may take, of special interest is the ongoing
battle between the powerful producer-distributors and exhibitors. From Michael F.
Mayer's perspective, "the 'standard' exhibition contract . . . has become little
more than a snare and a delusion."[777] To the unsophisticated onlooker, both sides
in the picture deal appear to have made a reasonable arrangement. The contract
contains a host of agreements--e.g., advertising responsibilities,
percentage-of-gross, taxes, clearances, and cash guarantees--that seem to protect
everyone's interest.[778] Furthermore, the deal is made after negotiations and, when
appropriate, competitive bidding. What is not generally recognized is the way in which
the powerful producer-distributors have merchandised the exhibitors. That is, some
producer-distributors attempt to insist upon unwritten block booking arrangements
to secure a premiere film. Others take advantage of the U. S. Department of Justice's
ruling that three films per distributor can be distributed blind each year.[779] Linton

[776] Gomery, p.92.

[777] Michael F. Mayer, "The Exhibition Contract--A Scrap of Paper," THE MOVIE
BUSINESS: AMERICAN FILM INDUSTRY PRACTICE, eds. A. William Bluem and Jason E.
Squire (New York: Hastings House, 1972), p.210.

[778] In addition to the books by Balio, Bluem and Squire, Jowett and Linton, Kindem,
and Mayer, for more information on how financial arrangements are determined,
see Lee Beaupre, "How to Distribute a Film," FILM COMMENT 13:4 (July-August
1977):44-50; Michael F. Mayer, "New Trends in Exhibition," TAKE ONE 4:5
(September 1974):48, 50; ___, "New Trends in Exhibition Deals," ibid., 5:4
(October 1976):31-3; ___, "The Exhibition License--Part II," ibid., 5:6 (January
1977):29-30; and "Hollywood Battles Killer Budgets," p.8.

[779] The procedure involves a distributor's informing all the film exhibitors in a
designated area that a movie is open for "bids." The only information available
on the film is its title, cast, availability dates, and, frequently, a terse
summary of the plot. For example, in the fall of 1978, films that were blind bid
included ESCAPE FROM ALCATRAZ, PROPHECY, ALIEN, ROCKY II, MOONRAKER, and THE MAIN
EVENT (all in 1979). Before agreeing to definite terms related to cash guarantees
and weeks of playing time, the exhibitor had to decide how sensible it was to
book that type of film or featured players at his or her movie house. Harmetz
reported that the terms for blind bidding on STAR TREK: THE MOTION PICTURE (1979)
"required the exhibitor to guarantee [Paramount Pictures, the
producer-distributor] to show the movie . . . sixteen weeks on the same standard
90 percent-10 percent split." For more information, see Aljean Harmetz, "15th
State Outlaws Blind Bidding on Films," NEW YORK TIMES C (June 19, 1979):7. Other
articles that add to the issue of blind-bidding are Janet Maslin, "Splitting Jaws
with the Happy Booker: A Talk with a Circuit Buyer," FILM COMMENT 11:4

describes an innovative practice known as the "five o'clock look." Simply put, special customers are given the chance to screen a competitor's bid in order to provide the preferred customer with an opportunity to resubmit a higher bid and thus win the film.[780] Mayer points out that preferred customers also get a second special "look" or "adjustment." This arrangement calls for a "second view by the exhibitor after the engagement is concluded to determine whether in his view, the film rental payable under the contract is reasonable and appropriate."[781]

Of course, the exhibitors have their own way of retaliating against unfavorable forms of blind bidding, block booking, and contract adjustments.[782] The obvious way is to take the producer-distributor to court when illegal methods are used to force an exhibitor to take unwanted films. Although such cases are costly, trade papers regularly report instances where producer-distributors have not only been sued but beaten. Exhibitors, on the other hand, are not above bending the law. For example, a number of exhibitors "siphon" or "skim" the daily gross receipts reported to the distributor. One way this is done is by having two sets of tickets, one for the actual count and one unreported. Another way is to take the customer's cash and not issue a ticket. Even better, the exhibitor issues a ticket, takes it back, and then doesn't tear it, thereby making it possible to reuse the tickets at another time. A third way is to run special shows and not report the receipts at all. Exhibitors also demand, and frequently get, arbitrary percentage reductions when an expected film hit turns out to be a box-office failure. "Although the percentage formula," explains Mayer, "is the best way of sharing the disappointment between the parties, . . . the rental may be excessive where an exhibitor suffers a serious loss."[783] It is not uncommon in such cases for an exhibitor to refuse to pay the agreed upon percentage. And it is not uncommon for the distributor to back off, fearing that legal action is not good for either the distributor's reputation or for future business dealings. Equally disturbing to the producer-distributor, as Linton observes, is "product splitting." This practice involves an illegal arrangement among the exhibitors in a specific area to decide secretly among themselves which films they will and will not bid on. In this way, the cost of renting each film is reduced and the producer-distributor is deprived of considerable revenue.[784]

The prominence of the major producer-distributors (which in the 1980s includes Orion Pictures Corporation and Tri-Star Pictures)[785] offers a focal point for the economic study and analysis of the motion picture industry in the modern era, as

(July-August 1975):57-62; Roger Cels, "Antiblind-Bidding Contributed to Downbeat B. O.: Mancuso," HOLLYWOOD REPORTER 263:1 (August 13, 1980):1, 4; ___, "Blind-Bidding Factions Nearing Final Deal; Blocks Still Remain," ibid., 265:25 (February 10, 1981):1, 3; ___, "Montana Becomes 21st State to Outlaw Blind-Bid Practice," ibid., 266:11 (April 2, 1981):1, 21; and Izod, pp.192-4.

[780] Jowett and Linton, p.42.

[781] Mayer, "A Scrap of Paper," p.211.

[782] For another innovative option, see Dale Pollock, "Exhibs As Pards in Pic Sell Plan," VARIETY 296:13 (October 31, 1979):1, 113.

[783] Mayer, "A Piece of Scrap," p.213.

[784] Jowett and Linton, p.42. Linton also describes two other splitting practices: "vertical" and "horizontal." The former involves limiting an exhibitor's bids to one company; the latter, limiting bids to movies one at a time. For an example of the problem, see Teri Ritzer, "Motion to Reinstate Ban on Splits Denied Distrib'rs by Calif. Court," HOLLYWOOD REPORTER (April 29, 1983):1, 4.

[785] Tri-Star Pictures was formed from Coca-Cola's Columbia Pictures Industries (CPI), Home Box Office (HBO), CBS, Inc. in 1983. When the company went public,

did the major production studios in the era prior to 1948.[786] The fact that ten majors still dominate the American film industry reinforces the basic assumptions that underlie this general economic history of the movie business. That is, tried and tested approaches to film production, distribution, and exhibition strive to maximize profits, minimize risk, and centralize control. The results, as Campaine summarizes them, are staggering (see Table 8).[787] No consistent policies either by foreign governments

CBS sold all its shares and HBO sold 50 percent of its shares, leaving CPI as the major stockholder. In 1987, Coke merged its film and TV holdings with Tri-Star. For more information, see Gregg Kilday, "How Dare They," ESQUIRE 103:2 (February 1985):121-5; Sandra Salmans, "Tri-Star's Bid for Movie Stardom," NEW YORK TIMES F (May 13, 1984):1, 12-3; Geraldine Fabrikant, "Coke Unit, Tri-Star to Join Operations," ibid., D (September 2, 1987):1-2; ___, "Hollywood's Newest Heavyweight: Victor A. Kaufman--Taking Tri-Star Into the Big Time," ibid., (September 6, 1987):4; and Aljean Harmetz, "Tri-Star to Become Part of Columbia Pictures," ibid., C (March 7, 1989):20.

[786] For a useful perspective on the tie-in between film and television, see Edward Buscombe, "Thinking it Differently: Television and the Film Industry," QUARTERLY REVIEW OF FILM STUDIES 9:3 (Summer 1984):196-203; Douglas Gomery, "Failed Opportunities: The Integration of the Motion Picture and TV Industries," ibid., pp.219-28; Robert Vianello, "The Rise of the Telefilm and the Networks' Hegemony Over the Motion Picture Industry," ibid., pp.204-18; Douglas Gomery, "Television, Hollywood, and the Development of Movies Made-for-Television," *REGARDING TELEVISION, ed. E. Ann Kaplan (Frederick: University Publications of America, 1983), pp.120-9; ___, "The Coming of Television and the 'Lost Motion Picture Audience,'" JOURNAL OF FILM AND VIDEO 38:3 (Summer 1985):5-11; William Boddy, "The Studios Move into Prime Time: Hollywood and the Television Industry in the 1950s," CINEMA JOURNAL 24:4 (Summer 1985):23-37; Peter J. Boyer, "Tartikoff Escorts NBC Into the Movie Business," NEW YORK TIMES C (August 19, 1986):16; Vincent Canby, "Small Screens Breed Small Movies," ibid., H (December 15, 1985):1, 25; Geraldine Fabrikant, "Mixed Reviews for Wyman," ibid., D (October 25, 1985):1, 5; ___, "ABC Discontinues Movie Operations," ibid., D (October 29, 1985):4; Phil Dougherty, "Diener Builds Ties to Movies," ibid., D (October 29, 1985):25; Aljean Harmetz, "Murdoch to Unite Fox," ibid., D (October 10, 1985):1-2; ___, "Fox Plans a TV Program Service," ibid., C (May 7, 1986):30; ___, "Fox's Barry Diller Gambles on a Fourth TV Network," ibid., H (October 5, 1986):1, 26; Richard Stevenson," A Quiet, Influential Investor: Laurence A. Tisch," ibid., D (October 18, 1985):1, 4; Stephen Farber, "Series Stars Moonlight in TV Films," ibid., C (October 20, 1986):22; Thomas Morgan, "Networks Raise ratings by Showing More Films," ibid., C (October 23, 1986)26; "Loews Theatres Sold in $160 Million Deal," HOLLYWOOD REPORTER 287:41 (July 11, 1985):1, 28; "HBO Nears Fox, Paramount Accord," ibid., 293:22 (August 22, 1986):1, 66; Louis Chunovic, "Turner Wants His MGM TV," ibid., pp.1, 66; Chuck Ross and Cliff Rothman, "MGM/UA, HBO in Film Deal," ibid., 293:23 (August 25, 1986):1, 8; Richard W. Stevenson, "A Financial Battle to Make TV Series," ibid., D (April 27, 1987):1, 7; Dennis J. Dombkowski, FILM AND TELEVISION: AN ANALYTICAL HISTORY OF ECONOMIC AND CREATIVE INTEGRATION (Unpublished Ph.D. dissertation, University of Illinois, 1982); David Alan Larson, INTEGRATION AND ATTEMPTED INTEGRATION BETWEEN THE MOTION PICTURE AND TELEVISION INDUSTRIES THROUGH 1956 (Unpublished Ph.D. dissertation, Ohio University, 1979); Barbara Ann Moore, SYNDICATION OF FIRST-RUN TELEVISION PROGRAMMING: ITS DEVELOPMENT AND CURRENT STATUS (Unpublished Ph.D. dissertation, Ohio University, 1979); and Amy Schnapper, THE DISTRIBUTION OF THEATRICAL FEATURE FILMS TO TELEVISION (Unpublished Ph.D. dissertation, University of Wisconsin, 1975).

[787] Campaine, p.205.

or the American judicial system have caused the major film corporations to limit their influence on film content. Furthermore, nothing in the literature on the film industry refutes two observations by Jarvie on the American film business: (1) "No society is affluent enough to allow ANYONE with the urge to create in the cinema the resources to do so";[788] and (2) filmmakers are not at a disadvantage, because they "work within a complex production organization; . . . [in which] the advantages outweigh the disadvantages, which anyway tend to be made up of artistic idealizing, and naive juxtapositions of art and commerce."[789]

TABLE 8

INDICATORS OF SIZE OF THE MOTION PICTURE INDUSTRY, 1963-1976
(dollars in millions)

	1963	1967	1972	1976
Motion picture distribution and allied services				
Number of establishments	3,729	4,565	8,555	N.A.
Receipts	$ 1,520	$ 2,183	$ 2,920	N.A.
Establishments with payroll	2,829	3,375	4,704	4,346
Receipts	$ 1,510	$ 2,169	$ 2,857	N.A.
Payroll	$ 479	$ 699	$ 795	N.A.
Paid Employees	48,806	64,581	64,660	N.A.
Motion picture theatres				
Number of establishments	12,652	12,187	12,699	N.A.
Receipts	$ 1,063	$ 1,293	$ 1,833	N.A.
Establishments with payroll	12,040	11,478	11,670	10,289
Receipts	$ 1,057	$ 1,283	$ 1,816	N.A.
Payroll	$ 250	$ 281	$ 381	N.A.
Paid Employees	112,521	112,109	127,435	N.A.
Total				
Number of establishments	16,381	16,762	21,254	N.A.
Receipts	$ 2,583	$ 3,476	$ 4,753	N.A.
Establishments with payroll	14,869	14,863	16,374	14,748
Receipts	$ 2,567	$ 3,452	$ 4,673	$ 6,100
Payroll	$ 729	$ 980	$ 1,176	$ 1,549
Paid employees	161,327	176,690	192,095	184,607

N.A. Not available
Source: U. S. Department of Commerce, Bureau of the Census: 1963, 1967, 1972: CENSUS OF SELECTED SERVICE INDUSTRIES, MOTION PICTURES. 1976: COUNTY BUSINESS PATTERNS, and U. S. SERVICE INDUSTRIES IN WORLD MARKETS (December 1976).

[788] MOVIES AND SOCIETY, p.42.

[789] MOVIES AND SOCIETY, p.37.

As for the image of women in American films up to the mid-1980s, the problems of the past persist. "The reemergence of the strong heroine in the 1970s was not, as is sometimes assumed," explains Elayne Rapping, "a great leap forward, although the terms upon which the 'new woman' was presented differed in ways which clearly reflected the influence of the newly visible women's movement, and the changes in family brought about by feminism, as well as major changes in the economy and women's place within it."[790] On the surface, the new film images in movies like ALICE DOESN'T LIVE HERE ANYMORE (1974) and AN UNMARRIED WOMAN (1977) exposed the problems married women faced in repressive homes. But closer analysis revealed that the future of these screen heroines appeared brighter than it actually was. By limiting the options open to widows and divorced women, the films focused on what Rapping called "the feminization of poverty."

The most significant change to date in the women's film, Rapping observes, is to shift attention away from the problems of women to the problems of men. That is, "In most 'family breakdown movies' of . . . [the late 1970s and early 1980s], it is the father and husband who suddenly becomes the 'heroine,' the good guy who is seen to change and grow into a responsible, nurturing provider/parent, while the estranged wife is the heavy."[791] Typical examples that Rapping finds of that shift are in films like KRAMER VS. KRAMER (1979) and ORDINARY PEOPLE (1980). In her informative survey of a more recent crop of American movies featuring strong independent women, the author argues that the American film industry continues to undercut emerging values while, at the same time, suggesting that the industry is responsive to the demand for a change in women's status in a patriarchy. The films reviewed were all released in the fall of 1985: SWEET DREAMS, JAGGED EDGE, MARIE, AGNES OF GOD, and PLENTY. Among her intriguing observations are that the filmmakers accepted matter-of-factly that women now occupied important roles in American public life and that domestic bliss was not a prerequisite for satisfying lifestyles for women. Nevertheless, Rapping concludes with the caveat that "There is very little in any of these films that would make a young woman envy these heroines."[792]

The image problem for women is compounded once we recognize that what is seen on screen is affected by the people writing the scripts and directing the films. A good insight into the status of women in modern films is revealed in the gender structure of the Academy of Motion Picture Arts and Sciences (AMPAS). Except for the performing wing of the AMPAS, which has equal representation, every other wing, Emanuel Levy explains, is male-dominated: "In the Director's Branch, for example, only two of 224 members in 1984 were women: Elaine May and Claudia Weill. And there is only one woman, Brianne Murphy, among the 108 Academy cinematographers. In some branches, there are no women at all."[793] On the other hand, the producer Gale

[790] Elayne Rapping, "Hollywood's New 'Feminist' Heroines," CINEASTE 14:4 (1986):4-9. See also Judy Klemesrud, "Where Are All the Women Who Fell for 007?" NEW YORK TIMES 2 (June 21, 1981):1, 17.

[791] Rapping, p.5.

[792] Rapping, p.9.

[793] Emanuel Levy, AND THE WINNER IS . . . THE HISTORY AND POLITICS OF THE OSCAR AWARDS (New York: Ungar Publishing Company, 1987), p.7.

Anne Hurd says that "women directors are no longer considered to be anomolies, despite the fact that 93% of the guild are men."[794]

In this filmic patriarchy, a starting point for contemporary scholars studying the economic structure of the American film industry is an awareness that as of 1984, the majors in order of importance are Paramount Pictures, Warner Bros., Universal Pictures, Orion Pictures Corporation, 20th Century-Fox Corporation, Columbia Pictures, Tri-Star Pictures, MGM/United Artists,[795] Walt Disney Productions,[796] and Embassy. Nine of these corporations,[797] out of eighty-eight active companies producing and distributing films in the United States, released 166 films (including reissues) in 1984 or thirty-two percent of the movies produced in America (i.e., 520 films were released by the MPAA and independents). The gross ticket sale income of the eighty-eight active film companies from their combined released films that year was $4,030,600,000; the average ticket price was $3.36, based on total ticket sales amounting to $1,199,100,000. Moreover, in 1984, there were 20,200 movie screens operating.[798] Among the more successful independent producers in the mid- to late 1980s are The Samuel Goldwyn Company, Manson International, and New Line Cinema Corporation. Their influence, however, depends mainly on a picture-by-picture basis. Their access to mass audiences is limited by their relationship to the majors and by the sources of distribution permitted them.[799] Thus the greatest power of the modern majors, largely due to the PARAMOUNT Decree, is in the area of distribution.

Not only do the majors exert an enormous influence on the entire industry at the present time, but they will continue to reign supreme for the foreseeable future.[800] As Wasko rightly concludes, the major producer-distributors have a fourfold "insurance policy": (1) control of the domestic market guarantees an acceptable risk on every film handled by the majors, (2) control of foreign film imports minimizes the threat from external filmmakers, (3) massive international distribution systems allow for considerable profits and influence worldwide, and (4) diversification allows the majors to retain flexibility and strength.[801]

[794] Cited in Claudia Eller, "AFI Celebrates Directing Workshop," HOLLYWOOD REPORTER (August 7, 1987):12.

[795] Starting in 1973, MGM distributed its films through United Artists.

[796] For a current overview of Disney, see Geraldine Fabrikant, "Bonanza at the Top of Disney," NEW YORK TIMES (August 29, 1987):35, 37.

[797] Tri-Star is not a member of the MPAA, which supplied the statistics to the author on August 1, 1985.

[798] For another set of interesting statistics dealing with costs of feature films, box-office grosses, and average weekly attendance figures, see Donahue, p.33.

[799] For an insight into independent filmmaking today, see Leslie Bennetts, "Desperately Seeking Hollywood," NEW YORK TIMES C (February 8, 1988):16.

[800] The acquisition of movies theaters by major studios begun in 1985 with Columbia Pictures taking over the Walter Reade organization continues to bother America's leading theater chains. For more information, see Aljean Harmetz, "Film Studios Buying Up Theaters in Major Cities," NEW YORK TIMES C (October 23, 1986):20.

[801] Janet Wasko, "Hollywood, New Technology and International Banking: A Formula for Success," CURRENT RESEARCH IN FILM: AUDIENCES, ECONOMICS, AND LAW, Volume 1, pp.102-4. For an example of one nation's problems in entering the American market, see Manjunath Pendakur, "Canadian Feature Films in the Chicago Theatrical Market, 1978-1981: Economic Relations and Some Public Policy Questions," ibid., Volume 2, pp.186-203.

Only in the exhibition area, where independent theater owners and chains select a film on an individual basis, do the majors face a serious challenge. Interestingly, it is an area undergoing considerable flux from the mid- to late 1980s. For example, in January, 1985, of the twenty-eight major theater chains in the United States, the largest were General Cinema Theatres, United Artists Theatre Circuit Inc.,[802] American Multi-Cinema, Plitt Theatres, Famous Players, Cineplex Odeon Theatres,[803] Martin, Commonwealth Theaters Inc.,[804] Mann Theaters Corporation of California, Inc., Redstone Theaters, Tom Moyer Theaters, and Synfy Enterprises.[805] By December of 1988, however, the lineup had changed significantly. Now the ten giant theater circuits in order of importance are United Artists Theatre Circuit, Inc. (total screens: 2,735),[806], American Multi-Cinema, Inc. (total screens: 1,502), General Cinema Theatres (total screens: 1,415), Cineplex Odeon Theatres (total screens: 1,200), Loews Theatre Management Corporation (total screens: approx. 801), Carmike Cinemas, Inc. (total screens: 705), Mann Theatres Corporation of California, Inc. (total screens: approx. 470), National Amusements, Inc. (total screens: 467), Hoyts Cinemas Corporations (total screens: 420), and Cinemark Theatres (401 screens). To further dramatize the changes between 1985 and 1988, one needs to look at the jump a number of the big ten theater circuits made between 1987 and 1988. For example, in one year Loews moved from twelfth to fifth place, Carmite dropped from fifth to sixth place, Mann dropped from sixth to seventh place, Hoyt from sixteenth to ninth place, and Cinemark dropped from ninth to tenth place.

Where then does the American film industry stand at the end of the eighties? SHO WEST '89 addressed that question by seeking to find out where the movies had been and where they were heading. Delivering the Valentine Day news at the opening session were NATO's newly elected president, William F. Kartozian and Jack Valenti, president of the MPAA. Kartozian began by drawing parallels between the industry in 1968 and 1988. That is, the American film industry at the end of the sixties supported 13,000 screens, at the end of the eighties 24,000 screen, an eighty-five percent increase.[807] In 1968, 900 million people went to the movies annually, in 1988, 1.1 billion went to the movies, a twenty percent increase. In 1968, the box-office

[802] Tri-Star acquired the United Artists theaters in July, 1986. For the details, see Cliff Rothman, "UA Communications Sold to TCI; Tri-Star Buying Screens," HOLLYWOOD REPORTER 292:44 (July 15, 1986):1, 4; ___, "Tri-Star Sets Exhib Example," ibid., 292:45 (July 16, 1986):1, 21; and Martin Grove, "Tri-Star's Screen Buy Moves Studio to Industry Forefront," ibid., 292:49 (July 22, 1986):1, 38. For information of Tri-Star's intentions to expand its theater acquisitions, see "Tri-Star Planning Loews Expansion," NEW YORK TIMES D (May 29, 1987):4.

[803] Universal bought a sizable share of stock of the Cineplex-Odeon stock in 1986. For more information, see Andrew L. Yarrow, "Chains Seek Film House Domination," NEW YORK TIMES C (December 17, 1987):7.

[804] Commonwealth Theaters Inc., America's sixth largest theater chain, was bought by Cannon Group, Inc. in May, 1986. For more information, see Geraldine Fabrikant, "Cannon to Buy Chain of Theaters," NEW YORK TIMES D (May 8, 1986):4.

[805] For a more complete listing, see Jim Robbins, "U. S. & Canada Theater Circuits Ranked By Size," VARIETY 317:12 (January 16, 1985):38, 76. For another view, see Campaine, p.226.

[806] Information on the top ten theater circuits is obtained from BOXOFFICE 124:12 (December 1988):18-27.

[807] For another perspective, see Shawn G. Kennedy, "Real Estate: A Movie House Boom In Manhattan," NEW YORK TIMES D (July 5, 1989):9.

gross in American theaters was 1.2 billion dollars, twenty years later, it is 4.4 billion dollars, a 270 percent increase.[808] Kartozian noted, however, that not everything was rosy for the exhibitors in the industry. He pointed to the growing concern over the reemergence of aligned circuits and the growing consolidation within exhibition and distribution circles, the very type of behavior that produced the PARAMOUNT decision in 1948. In concluding his keynote address, the optimistic NATO president reminded his audience that the "average American" is attending film theaters more than four times a year and that small independent exhibitors should take heart in the fact that the law prescribes that distributors place films picture-by-picture, theater-by-theater.

Valenti quickly echoed Kartozian's hopes and fears.[809] On the positive side, the master statistician pointed out that box-office receipts were at an all-time high in 1988 ($4.4 billion), that for only the third time in recorded film history (1984, 1987, and 1988) admissions had gone over the one-billion mark (1.085 billion), and that for the first time since the industry began keeping records, the box office took in at least $1 billion in each of the four quarters of the 1988 season. Valenti also pointed to other good news for the American film industry. Particularly important was the fact that the 4.4 billion box-office figure represented a per capita American theater attendance that translated into "every man, woman, and child in this country in 1988" going to the movies more than four times a year. The impressive statistic is even more dramatic if compared with the same per capita figures for Great Britain (1.4 per capita), Canada (2.8 per capita), Italy (1.6 per capita), West Germany (1.9 per capita), and France (1.9 per capita). Equally positive for the American film industry was the fact that at long last negative print costs were beginning to decline. According to Valenti's accounting, the average negative cost of the movies handled by members of the MPAA in 1988 dropped for the first time since such records were kept (from $20.1 in 1987 to $18.1 in 1988), a ten percent decline. Finally, the MPAA head boasted that the ratings system that he inaugurated twenty years ago had been evaluated by the Opinion Research Corporation of Princeton, New Jersey, in the summer of 1988 and the results were overwhelmingly positive. That is, in a nationwide poll involving 2,600 randomly selected people, nearly three-quarters of American parents of children under thirteen years of age believed that the ratings system "was very useful to fairly useful" in helping the parents determine what films their children should see. Only twenty-two percent found the system not helpful in making such decisions.

On the negative side, Valenti explained, were the five percent increase in print and advertising costs and the financial woes of domestic distribution. The distributor problem particularly worried him. Using a new index, the MPAA discovered that domestic distributors had a $1.5 billion-deficit in 1988. The calculation was based on the number of films distributed by the members of the MPAA in 1988 and the application of the average negative cost to that number, coupled with the rental receipts that accrued in 1988 to distributors and producers. The upshot was that the $1.5-billion deficit required that these MPAA members now seek alternative markets domestically and abroad to cover their investment costs and to find potential profits for their films. (It wasn't clear why the same people hadn't been seeking alternative markets all along to maximize costs and profits.)

On balance, Valenti, as is his admirable style, found the American film industry in very good health. True, admissions had held constant around the billion mark for the past thirteen years. But the theater business, he claimed, was more than holding its own in the "watching war" going on in the entertainment industry. After all, he told the exhibitors, one needs only look at the incredible set of viewing statistics that characterize the American public: 49 million cable subscriber, 37 million paid-cable subscriptions (19 million of those subscriptions include pay-for-view TV), 56 million VCR housholds (in which one out of every five contains-more than one VCR), and

[808] A speech delivered at SHOWEST '89 at Los Vegas, Nevada, on February 14, 1989.

[809] A speech delivered at SHOWEST '89 at Los Vegas, Nevada, on February 14, 1989.

90 million TV households (in which the "average" family watches TV forty-nine hours a week). Thus for the film industry to keep a consistent attendance record through a thirteen-year period in the face of their entertainment revolution is not only impressive, but also indicative of the nation's "appetite for movies."

This general overview of the economic history of American films only touches on the cyclical nature of the American film industry. It does, however, underscore the fact that the movie business is affected not only by political and economic forces, but also by what audiences feel and do about the movies they see as well as by the artistic achievements, technological breakthroughs, and financial organization of the film industry. While it is true that to survive, the movies must no longer occupy center stage in popular culture, they still depend upon satisfying audience expectations and needs. "Seen in this light," as Seth Cagin and Philip Dray point out, "as a battle not for supremacy--which has long since been lost to television and the recording industry--but rather for survival, the current specter of a $3.5 billion industry locked in an identity crisis becomes comprehensible."[810]

Examining the economics of the American film industry, therefore, provides only a partial explanation of how cultural hegemony operates and why stereotypes function as they do in American movies. Another ingredient in the process is the presumed audience for whom films are made. Who are the people who frequent the movie houses? What can the filmmakers do to please their customers to the point that not only will they buy a ticket and junk food at the concession counter, but also encourage others to see the movie, watch for it on network television, and rent or buy it on videocassette or videodisc? Has the makeup of audiences been consistent in terms of sex, education, income, and age over the past ninety years? If not, when, why, and how has the audience changed? Also of interest is the impact of the new technologies (e.g., cable, pay TV, and videocassettes) on the film continuum. Once these questions are addressed, we can review the literature on what types of screen images have been presented in American film history, how they have been received, with what "effects," and how society has reacted to film as a social force in our culture.

BOOKS

*Balio, Tino, ed. THE AMERICAN FILM INDUSTRY. Rev. ed. Madison: The University of Wisconsin Press, 1985. Illustrated. 664pp.

Originally published in 1976, this impressive expanded and revised anthology includes an updated introductory essay and ten new chapters. It remains the best book available for introducing students to a general overview of the economic history of American films. Balio's ambitious goal "is to present a systematic survey of the history of the industry, allowing the individual materials to suggest to the reader ways in which the realities of economics, changing legal restraints, technological advances, studio organization and procedures, financing, distribution trade practices, and exhibitor preferences have influenced the form and content of the movies." In keeping with that goal, he skillfully organizes his subject matter into four broad areas, each of which begins with a detailed summary essay about the period discussed and the relevance of the articles included in the particular section.

Part 1 (1894-1908) explores the rise of the film novelty and its transformation into a major industry. Balio is especially effective in providing the historical overview. For example, he makes terse but useful comparisons between the Edison and the Lumiere projectors, offers thumbnail reminders about the initial problems in film exhibition, describes how film exchanges were organized, and points out that narratives did not emerge as a significant force in movies until after the nickelodeon boom. A. R. Fulton's essay on the prehistory of the movie industry concentrates on

[810] *Seth Cagin and Philip Dray, HOLLYWOOD FILMS OF THE SEVENTIES: SEX, DRUGS, VIOLENCE, ROCK 'N' ROLL & POLITICS (New York: Harper & Row, 1984), p.xii.

film as a machine, not as an art form. Gordon Hendricks's excellent summary of the history of the Kinetoscope is a model of scholarly clarity. Equally satisfying is Robert C. Allen's perceptive analysis of the crucial role that vaudeville played in early film exhibition, particularly his point that film technology grew out of, rather than remained outside of, history. Allen also deserves recognition for his handling of the "chaser" issue, making it clear that films were much more popular and diverse than they were generally given credit for. Russell Merritt's outstanding research on the Boston nickelodeons provides a much-needed perspective on how film exhibitors appealed to middle-class patrons and what the steps were that led these same exhibitors to turn their backs on their original supporters, the working class. At the same time, he drops little bits of information that explode long-standing myths. For example, he states that Giovanni Pastrone's CABIRIA was the first film shown in the White House (June 1914), not THE BIRTH OF A NATION (February 1915). My one major reservation about Merritt's research is his argument that only "a few movies" actually provided "entertaining guides to the values and customs of the new world." Not only does the thesis run counter to widely reported opinions, but Merritt also offers no substantive evidence to support his position.

Part 2 (1908-1930) investigates the struggle for control of the burgeoning national film industry. The introduction starts with a review of the controversies over the role of the Motion Picture Patents Company (MPPC) in improving the state of the industry, goes through the battle for theaters in the twenties, and concludes with the first stages of the transition to sound. In the process, Balio corrects a number of misperceptions: e.g., Hollywood grew to prominence as a safe haven from the Trust (actually, Trust filmmakers arrived first); Adolph Zukor inaugurated feature films in America (more than twenty had been shown before the 1912 New York screening of QUEEN ELIZABETH). Robert Anderson's opening essay challenges and repudiates the generally negative image of the MPPA. Not only does Anderson insist that the MPPA "radically altered, upgraded, and codified American film production," but he also argues that its most significant contribution was "transforming the fledgling American motion picture business into an internationally competitive industry." Balio condenses three chapters from his important study on United Artists to provide a useful essay on how Mary Pickford's popularity changed trade practices in the film industry. Janet Staiger's erudite essay analyzes the shift from dramatic to continuity scripts and shows how that transformation established set styles in Hollywood feature films. In order to make readers aware of the importance of investment houses, banks, and lawyers to the art of the film, this useful section contains a copy of the May 27, 1927, Halsey, Stuart and Company prospectus on why the movies made for an excellent investment. Best of all, Douglas Gomery contributes two valuable essays on exhibition strategies and the way sound revolutionized the movies. The former explores how the film moguls relied on vast theater chains as a means for consolidating and strengthening their positions in the film industry. The key, according to Gomery, was making movies operate much the same as other mass-retailing business firms in the American economy. His essay on technological changes is based on a series of articles he wrote between 1976 and 1980.

Part 3 (1930-1948) chronicles the film industry as a mature oligopoly. In the least effective of the book's introductions, Balio gives a hurried look at the structure of the industry during the 1930s, the effects of the Depression, the nature of the Production Code Administration, and the impact of World War II on Hollywood. One reason for my dissatisfaction with the overview is the author's failure to deal candidly with Hollywood labor relations. Not only does Balio characterize industrial relations as "harmonious" up to the time of the NRA, but he also tiptoes around the creation and function of the Screen Playwrights in the mid-1930s. Another problem with the introduction is the superficial treatment given to film censorship. To say that filmmakers abided by the Production Code up to 1932-33 is to ignore a salty portion of film history between 1929 and 1931. Regrettably, the severe editing of Mae D. Huettig's scholarship on the economic structure of the film industry omits too much of her important research. Two invaluable FORTUNE magazine articles on MGM and Loew's Incorporated are printed in full, although one wishes Balio had made some editorial comments on factual errors. For example, Mayer did not help his father with

a New England ship-salvaging firm; and First National did not start the vertical integration of the film industry. Cathy Klaprat provides the section's best essay, updating the development of the star system by describing how Bette Davis was merchandised as a key market ingredient for Warner Bros. The section ends with a poorly abridged version of Ruth Inglis's significant comments on the Production Code. Overall, the problem with Part 3 is that it gives the misleading impression that Hollywood "enjoyed unbridled prosperity until 1948."

Part 4 (1948 to the present) describes the repercussions of the PARAMOUNT case on the film industry and how filmmakers adjusted to the Supreme Court's decision on divestiture. Balio's flawed introduction focuses on the problems of retrenchment, reappraisal, and reorganization. He is most effective in summarizing the importance of foreign markets, the rise of independent producers, and Hollywood's response to television. Problems surface, however, when he tries to put too rosy a glow on controversial events. For example, he insists that the divorced theater circuits did better than independent exhibitors in the years following 1950, and misleads readers into thinking that the 1947 and 1951 House Committee on Un-American Activities hearings remained almost exclusively concerned with screenwriters. Ernest Borneman's opening essay provides an intelligent summary of the U. S. Department of Justice's tactics in forcing the "Big Five" of Hollywood to divest their theater holdings, although his conclusions appear more as assertions than as facts. Thomas H. Guback's original essay on foreign markets draws attention to how American filmmakers not only exploit the international market, but also act as conveyers of American myths and values. Editing problems become an issue with the abridged version of John Cogley's informative comments on HUAC. The topic requires more information and discussion than is provided. On the other hand, Richard S. Randall's review of censorship from THE MIRACLE (1948) to DEEP THROAT (1972) does a good job of explaining how the movies gained greater freedom of expression beginning with the May 26, 1952, Supreme Court decision in the case of BURSTYN v. WILSON. Michael Conant's condensation of his important 1981 article on reassessing the PARAMOUNT decrees is also a skillful summary of how the three branches of the film industry responded to the past thirty years. The material is divided into three main areas: e.g., production (how it was affected by economic factors, aggressive strategies by independents, industrial self-censorship, and the rise of movies-made-for and -by television networks); distribution (how the industry developed new market strategies, the emergence of conglomerates, the demise of small distributors, and block booking); and exhibition (how the market changed the strategies of the divorced circuits, the new pricing policies, and the collusion of exhibitors). What is particularly interesting in light of Balio's introduction to Part 4 is Conant's conclusion that "The five theater circuits of the major PARAMOUNT defendants have been especially impaired by the decrees." Robert Gustafson's original essay on Warner Bros. as an example of a modern film company operating within a conglomerate helps in outlining recent trends in the film industry. It makes very clear the differences between past and present business practices and relationships. In addition, Balio wisely includes a supplement on Warner Communications' internal operations. The handy anthology concludes with a condensation of two reports written by the financial analyst for Wortheim and Company, David J. Londoner, on the changing economic patterns in the entertainment world. The major conclusion from his extensive research is that the one person most likely to benefit from all the internecine warfare is the copyright holder.

It is clear that Balio has put together a much-needed chronological overview of economic film history and that future editions will only enhance the book's considerable value. Hopefully, the surprisingly skimpy bibliography will be expanded. An index is included. Recommended for special collections.

Balio, Tino. UNITED ARTISTS: THE COMPANY THAT CHANGED THE FILM INDUSTRY. Madison: The University of Wisconsin Press, 1987. Illustrated. 447pp.

Bertrand, Daniel, W. Duane Evans, and E. L. Blanchard. THE MOTION PICTURE INDUSTRY--A PATTERN OF CONTROL. Washington, D.C.: U. S. Government Printing Office, 1941. New York: Arno Press, 1978. 92pp.

This compact and valuable U. S. Senate monograph was submitted to the Temporary National Economic Committee on January 15, 1941. Its authors included the senior economist in the Department of Labor (Evans), an administrative assistant to the committee's executive secretary (Bertrand), and a committee staff member (Blanchard). Both Evans and Bertrand had been closely connected to the government's activities in regard to movies by virtue of their having served on the various NRA committees to regulate fair trade among the filmmakers. The report capsulizes how the film industry evolved to its oligopolistic state, and provides extensive information on how the major corporations concentrated their stranglehold on the film industry. In many ways, it serves as a justification for the Department of Justice's decision to enter into a Consent Decree with the large film companies.

In straightforward language and with a minimum of jargon, the authors share the data they have collected on the number of theatrical movies produced in the U. S. from 1930-1931 to 1938-1939, the number of theaters operated by the majors in 1940, the number of first-run metropolitan theaters operated by each of the major companies in thirty-five key cities in 1940, the control of exhibition exercised by the majors in cities of 100,000 or more, and the number of loans made by the large film companies since 1933. The book itself is divided into three main chapters and three appendexes. Chapter 1 describes succinctly the film industry's pattern of control, how it developed, and how it crystalized in the late 1930s. Chapter 2 examines the issues surrounding that pattern of control: e.g., block-booking, forcing of short subjects, blind-selling, designated play dates, overbuying, selective contracts, clearance and zoning, and unfairly specified admission prices. Chapter 3 offers the authors' observations, including a number of interesting conclusions. For example, Betrand and his colleagues found that the eight major film companies in many respects were not unique in their approach to big business in the United States. The reasons why they required special attention were twofold. First, their size did not provide benefits to the consumer, much as other concentrations of power did. Second, the movie industry was far more significant as a social and cultural force in society than it was as a profit-making industry. "Its importance," state the authors, "must then be measured in terms other than the conventional ones of dollars and cents." The three appendexes provide information on the eight major film companies, the Motion Picture Producers and Distributors of America, Inc., and the November 20, 1940 Consent Decree.

Despite the price of this slim reprint, the factual description of the film industry and the condensation of data make the book must reading for any serious study of the history of film economics. An index is included. Recommended for special collections.

Bluem, A. William and Jason E. Squire, eds. THE MOVIE BUSINESS: AMERICAN FILM INDUSTRY PRACTICE. New York: Hastings House, 1972. 368pp.

Conant, Michael. ANTITRUST IN THE MOTION PICTURE INDUSTRY: ECONOMIC AND LEGAL ANALYSIS. Berkeley: University of California Press, 1960. 240pp.

The two primary goals of this stimulating study are (1) "to analyze and evaluate the impact of antitrust actions on the structure, behavior, and performance of an industry"; and (2) "to examine the development of antitrust law within an industry and the effect of government prosecutions as an impetus to private treble-damage actions." It is an ambitious project, which, for the most part, is commendably pursued and impressively reported. Conant's legal background and skillful observations provide an in-depth analysis of data found in professional journals, congressional reports, court records, and industry publications. He takes the position that the constantly changing nature of the film product necessitated a pattern of price discrimination that produced government reactions that eventually altered the

structure and nature of the film industry. The key to film monopoly was in exhibition, not production, in horizontal collaborations, not vertical integration; and a good portion of the text shows why that is true and how industry domination eventually occurred. The book's nine statistically-packed chapters explain the fluctuating market conditions, the industry changeover from a decentralized industry to one vertically integrated, and the struggle among the various branches for industry domination.

In light of the subsequent research done on the economics of the film industry, Chapters 1 and 2 offer little more than a chance to review film's unique qualities. The by-now familiar characteristics of a product's being distinctly different on a weekly basis, its earning life being limited mainly to the first four to six weeks of exhibition, and the difficulty in determining the absolute size of the audience, are noted. At the same time, the author discusses the interdependence among screenplays, types of films, screen personalities, and advertising in relation to reducing market uncertainties. Where Chapter 1 falters is in evaluating consumer spending and television's impact on film audiences. The former alludes to the amount of money the public spent on such things as radio, television, records, and movies without making clear how the cost of each form of recreation affected the reported percentages. As for television's "being the chief cause for the decline in motion picture attendance," since 1950, the figures cited don't explain how they relate to film attendance or what percentage of the population had stopped going to the movies before television began to have an impact in the mid-1950s. Not only is 1950 too early a date for making the causal relationship, but there is also no evidence to support the assertion that the sale of 5 million television sets in the 1950-1951 period resulted in an estimated seventy percent drop in film attendance. Chapter 2 chronicles the development of the movie business from the 1880s to the late 1930s, with an emphasis on the antitrust conditions operating to encourage or to deter new firms from entering the film industry. The narrative touches on the central issues relating to the active market control of the Patents Company (1909-1914), the reactions of exhibitors to distributor monopoly power (1917-1918), the involvement of Eastern bankers in the development of the film industry, the real estate and building boom of the 1920s, and the effects of the general economic depression on the film industry beginning in 1931. Of special importance is Conant's discussion of the 1921 antitrust action of the Federal Trade Commission against Famous Players-Lasky regarding the latter's intention of "building, buying, and otherwise controlling first-run theaters . . . for the purpose of intimidating and coercing all theaters to license Famous Players-Lasky films." Equally significant is Conant's conclusion that there was no evidence to support the charge that banking interests influenced the oligopoly that eventually developed among the major film corporations.

It's in Chapters 3 and 4 that Conant begins the first of his crucial analyses. He starts by examining what restrictive trade practices led to the famous PARAMOUNT antitrust decision. In regard to the charge that the eight largest distributors of films monopolized production, the narrative explains why the government failed to prove its case. Not only were there more independent producers around, but many of them were formally under exclusive contract to the defendants. The author effectively demonstrates that what bothered the courts most were the difficulties independents faced in marketing their films. Besides the barriers erected by the Production Code Administration and its required seal of approval for exhibition in the theater circuits controlled by the majors, it was clear that independents did not have access to enough first-run theaters to make a reasonable profit on their films. For example, of the 458 film exchanges in 1946, 242 belonged to the PARAMOUNT defendants. By citing key sections and stipulations from the actual court records and exhibits, Conant analyzes the specific problems the Supreme Court detected in the bilateral oligopoly. He takes particular interest in explaining how the defendants exercised price discrimination: e.g., uniform systems of runs, clearances, and zoning in regard to local distribution patterns. He concludes this invaluable section by labeling the film industry "an incomplete cartel."

In Chapter 5, the author takes a step backward and examines the litigation against circuit buying power (1928-1948) that precipitated the demise of this restrictive trade practice. For example, three cases--UNITED STATES V. CRESCENT AMUSEMENT CO., 323 U. S. 173 (1944); UNITED STATES V. GRIFFITH, 334 U. S. 100 (1948); and SCHINE CHAIN THEATRES V. UNITED STATES, 334 U. S. 110 (1948)--were filed against the top three independent theater circuits in 1939. Each case focused on the abusive practices associated with circuit buying power. In reviewing the legal process, Conant shows why the Supreme Court felt that intent was not the key issue. What mattered most was "that a restraint of trade resulted as a consequence of defendant's conduct or business arrangements." Special attention is also given to the 1940 consent decree in the PARAMOUNT antitrust case and the establishment of "independent arbitration tribunals," as well as to the substance of the 1948 Supreme Court decision and why Conant believes that the minors were unfairly treated by the judicial system.

The question of how the PARAMOUNT antitrust decision affected the film industry and the public is covered in Chapters 6 and 7. Conant first describes the different approaches taken by the eight defendants to conform with the decisions rendered. For example, RKO and Paramount moved quickly to comply with the divestiture requirements, while the other firms stalled for as long as they could. In fact, Loew's Inc. held out until the mid-1950s. Conant next turns his attention to the reactions of the PCA and then to the defendants themselves. In his judgment, the only serious problems created for the majors were those produced by the advent of television and not by the divestiture decrees. Furthermore, he does not credit the 1948 litigation with the demise of thousands of small movie theaters in the 1950s; rather, television and drive-ins are shown to be the culprits. In Chapter 7, Conant illustrates his thesis with an examination of the JACKSON PARK CASE. This antitrust complaint by an exhibitor on Chicago's South Side initiated against the majors in 1942 and resolved by 1947 is used to demonstrate the impact of federal litigation on local market control, marketing patterns, prices, and revenues of distributors and exhibitors. In effect, Conant believes that by the late forties, despite the intentions of federal litigation, the result of the consent decrees was to place monopoly power in the hands of the distributors by leaving the film copyrights with them.

Chapter 8 reveals the dramatic transformation that took place in litigation against the major distributors and dominant theater circuits after 1940. Up to that point, the plaintiffs rarely were able to substantiate their claims to the satisfaction of the judicial system. But after the 1940 consent decree associated with the PARAMOUNT antitrust case, the concept of "conscious parallelism" became the operative force in the courts. That is, what was required was proof of "an inference of conspiracy." Not only did the treble-damage cases increase by the hundreds against the PARAMOUNT defendants, but the plaintiffs also won many more cases than they lost. Of particular significance is Conant's analysis of why the THEATRE ENTERPRISE case of 1955 caused the courts to establish a four-year statute of limitations concerning private antitrust suits and to downgrade the importance of the conscious parallelism doctrine.

In Chapter 9, Conant summarizes his feelings about the PARAMOUNT antitrust case and subsequent legal actions. He sees the decrees of divorcement and divestiture as effectively ending the bilateral oligopoly of the majors. He believes that the federal litigation justifiably stopped a number of oppressive trade restrictions like block-booking. Thus independents not only had greater access to first-run theaters, but also the new industrywide freedom improved the quality of film products. However, the author faults the courts for not going far enough in their attempt to end the monopoly control by the eight PARAMOUNT defendants. Distributors with their copyrights and large theater circuits with their optimum buying power still controlled the film industry as they had done since the mid-1920s.

Where Conant's detailed presentation is vulnerable is in the picture he paints of a marketplace that requires restrictive trade practices in order to maintain the existence of a wide variety of producers, distributors, and exhibitors. How to balance pure competition as a principle with an imperfect monopoly that is required by the uniqueness of the film industry is never resolved. On a smaller scale, it is disappointing to see such a shrewd commentator accepting the false myth of art being

incompatible with business. His brief comments about film formulas "being destructive of creativeness in writers" are typical of Conant's anti-Hollywood attitude.

The still fresh and insightful observations on federal litigation and industrial economics more than overshadow the narrative's inability to resolve the intellectual dilemma over freedom and survival. Conant's clear explanations of complex issues and extensive data provide factually inclined readers with an excellent introduction into the peculiarities of the film industry and its battles with antitrust laws. A strong bibliography and valuable index are included. Recommended for special collections.

David, Saul. THE INDUSTRY: LIFE IN THE HOLLYWOOD FAST LANE. New York: Times Books, 1981. 278pp.

An insider's account of how films were made during the 1960s in Hollywood, this book is a breezy and amusing memoir by the man who produced VON RYAN'S EXPRESS (1965), OUR MAN FLINT, and FANTASTIC VOYAGE (both in 1966). Thirty-four uneven chapters reveal the author to be a man of considerable wit who has an intense dislike of Hollywood but prefers to mask his cynicism with jokes rather than with objective analysis. For example, in discussing Hollywood screenwriters and their strident attitudes, David observes that "Drenched in liberal-Democratic politics, sponsoring every minority crusade and passing flaming Jacobin resolutions for the press, these talented creators in their fierce tug-o'-war with the moguls have perfected a major contribution to culture--the blockbuster social drama, the lucrative rubber sword of safe controversy." The author's comments on David and Richard Zanuck, Frank Sinatra, and what it means to "grovel" in the presence of powerful personalities make for entertaining anecdotes. An index is provided. Approach with caution.

*Donahue, Suzanne Mary. AMERICAN FILM DISTRIBUTION: THE CHANGING MARKETPLACE. Ann Arbor: UMI Research Press, 1987. 385pp.

A first-rate overview of the film business, this in-depth study is filled with perceptive comments and important analyses of how distributors seek to maximize profits. The book's twelve fact-filled chapters examine historical trends, the influence of censorship on distribution, methods of securing finance, the importance of critics and film festivals in the film business, the role of marketing in creating a box-office hit, the relationship between distributors and exhibitors, foreign and ancillary markets, the distribution agreement, the major distributors, and independent films and distributors. Although originally written as Donahue's 1984 USC doctoral thesis, the revised version has none of the standard academic tediousness found in such projects. Two minor reservations relate to editing problems and to a certain naivete about film history (e.g., Donahue still accepts the defunct "chaser" theory and places too great an emphasis on the impact of TV on film in the late 1940s). On the other hand, she presents a superb appendix on box-office champs, including information on the film's domestic distribution company, year of release, and total rentals up to the mid-1980s. She also provides details on how independently produced films succeeded between 1970 and 1983, a breakdown by genre of independently distributed films, and a list of "successful" independent distribution companies between 1979 and the mid-1980s. Extensive endnotes, a flawed bibliography (e.g., some citations don't exist), and an index are included. Well worth browsing.

Edgerton, Gary R. AMERICAN FILM EXHIBITION AND AN ANALYSIS OF THE MOTION PICTURE INDUSTRY'S MARKET STRUCTURE, 1963-1980. New York: Garland Publishing, 1983. 235pp.

Fadiman, William. HOLLYWOOD NOW. Foreword Irving Wallace. New York: Liveright, 1972. 174pp.

An uneven mixture of colorful observations and self-serving pronouncements, this insider's account of the movie business offers a useful commentary on the transition from the Hollywood of the independent studios to the Hollywood of the conglomerates. The author is well-suited for the task. During his thirty years in the business, Fadiman not only worked as a story editor, producer, and vice president at a number of major studios but also was an executive assistant to Dore Schary. The author's one glaring problem is that he allows his biases to overshadow his judgment. For example, he goes out of his way to show contempt for actors, directors, and writers throughout the book's seven informative and sometimes irritating chapters on agents, directors, stars, and writers.

Fadiman's most useful contributions are his revelations on the panic and thought processes of businessmen during the post-World War II era. We learn about studio executives' fear about the competition from art houses, the advent of TV, and the conglomerate takeovers. For example, Fadiman accuses the large corporations of being greedier than the once all-powerful film moguls, asserts that corporate hegemony makes for more repressive working conditions than in the days of the independent studio system, and explains that "Hollywood is not against art on principle; it is only against art if there is too small a market for it." Not surprisingly, Fadiman offers an excellent rationalization of why writers find working in films so difficult. He knows first-hand what compromises have to be made and why writers rebel against the loss of their autonomy. Best of all, Fadiman makes good use of humor. A case in point is his discussion of formula filmmaking. Noting that the story department at Warner Bros. was notorious for recycling plots, he quips that it was known as "the echo chamber." In recalling why Eddie Mannix, one-time MGM vice president, refused to have screenwriters present during a story conference, he remembers that Mannix felt that "Writers clutter up a story conference." In giving a definition for a producer, he refers to Martin Ragaway's explanation that a producer was "a clever man whose brain starts working when he gets up in the morning and doesn't stop until he gets to the studio."

At other times, however, Fadiman proves exasperating. Consider his analysis of film and television relationships. He cites 1957 as "a significant date . . . because it was before the advent of television," claims it was "bizarre" for the movie studios to make films for TV, argues that TV will only provide moderate revenues for the film companies, and bemoans the fact that the film producers have nothing to offer TV except film libraries. In addition, he often ignores the difference between short-term and long-term conditions. That is, he fails to see that Hollywood had little to fear from the popularity of foreign films, that the immediate effects of the November 1968 code revisions would benefit the industry, and that film companies would not abandon expensive productions in favor of more moderately priced films.

In short, Fadiman offers a contrast between the scholar who is able to sit back and analyze events, and the practical businessperson who struggles each day to survive. Those who like to second-guess authors will find this book delectable--the author is wrong more times than he is right. On the other hand, those who appreciate the problems with forecasting and admire candor and wit should find Fadiman an interesting and amusing commentator. A slight bibliography and adequate index are provided. Worth browsing.

Farber, Stephen, and Marc Green. OUTRAGEOUS CONDUCT: ART, EGO, AND THE "TWILIGHT ZONE" CASE. New York: Arbor House, 1988. Illustrated. 394pp.

*Gomery, Douglas. THE HOLLYWOOD STUDIO SYSTEM. New York: St. Martin's Press, 1986. Illustrated. 213pp.

One of the best and most informative books on the corporate structure that dominated the world film industry, this compact study examines the structure, conduct, and effectiveness of the eight major motion picture corporations between 1930 and 1949. The writing is brisk, the comments insightful, and the information eye-opening. Following a fact-filled survey of how the Hollywood studio system

functioned, the author analyzes the corporate behavior and the economic forces that require a rethinking of how American films have been assessed by the academic community.

One of Gomery's basic themes is that far too much attention has been paid to the production end of the film industry and not nearly enough to its financial base operating in New York. For example, relatively few film educators stress the importance of exhibition in determining the types of films produced by the studios on the West Coast, while most film books stress the important contributions of the production bosses and their popular film records. Yet Gomery effectively points out that as far back as 1921, Adolph Zukor had set in motion a three-pronged strategy for controlling the American film industry: product differentiation, global rather than local distribution, and first-run theater domination. By 1930, the plan had put the future of American (and eventually world) film in the hands of five major motion picture corporations (Paramount, Loew's Inc., Fox, Warner Bros., and RKO) and three small film corporations (Universal, Columbia, and United Artists). Less than six percent of the money invested in the movies related to either production or distribution. Even so, there are still film instructors who refuse to discuss with their students the economic base of the movie industry, the impact of unionization on filmmaking, and the role of exhibition in the areas of film content and censorship. Gomery, on the other hand, offers extensive data to show how the Big Five used their vast theatrical holdings to protect each other, exclude their competitors, and insure large profits. Of particular importance is his description of the production process, which originated on the east, not the west, coast. Only after the home office had determined the sums to be spent on "A" and "B" productions did the more visible Hollywood executives get in gear. In Gomery's words, "Once these decisions were made--always by the corporate president and his staff in the New York office--the Hollywood staff was relatively free to decide how to produce the most popular products." But even after this initial decision, negotiations and conferences continued in matters of release dates, wages, and budgets.

The major portion of the book's ten chapters is devoted to the individual motion picture corporations. Having made his case about the importance of distribution and exhibition and the fact that there was little differentiation from corporation to corporation, Gomery turns his attention to a three-part analysis. First, he describes the historical evolution of each corporation and its place in the industrial hierarchy. Second, he analyzes the corporate structure, concentrating on ownership, finance, and composition of assets. Finally, he assesses corporate behavior, focusing on how changes in management affected production schedules and products. The chapters proceed in order of the corporations' wealth and power: Paramount, Loew's Inc., 20th Century-Fox, Warner Bros., Radio-Keith-Orpheum, Universal, Columbia, and the specialized studios (e.g., United Artists, Monogram, and Republic).

The comprehensive reviews draw not only on Gomery's personal scholarship, but also on data found in archives and in specialized articles. Most of the material presented is reliable and stimulating. For example, the section on Paramount perceptively points out that the strength of the Paramount studio lay in its reliance on talent drawn from vaudeville, radio, and the stage. Noting that MGM was the "Tiffany of movie corporations to Wall Street analysts," the author explains why Loew's never went in the red under the management team chaired by Nicholas Schenck. At the same time, Gomery discusses why MGM's conservative policies eventually worked against the corporation. The material on 20th Century-Fox offers a refreshing reappraisal of the Betty Grable Technicolor spectacles during the 1940s and the contributions of Winfield Sheehan to film production policies. Particularly interesting is the data on Warner Bros. showing that the films that made money for the studio were in the late 1940s and early 1950s rather than in the widely acclaimed films of the 1930s. Gomery also makes an excellent case for Warner Bros.'s being the most interesting of the Big Five Hollywood studios, while pointing out that none of the studio's top stars ever was number one in the annual box-office poll and that the corporation dragged its feet on Technicolor productions.

The book's few disappointments result as much from stylistic problems as from inaccuracies. That is, the author provides no footnotes for any of the data included in the narrative. The question is whether such an approach is appropriate in a book written for serious students. In no way does the limited bibliography fulfill the need for specific documentation in instances where Gomery is asking scholars to reorient their approach to the history of the Hollywood studio system. Elsewhere, he makes the discredited claim that President Franklin Roosevelt directly requested the filming of MISSION TO MOSCOW (1943) at Warner Bros. (Jack Warner denied this claim at the 1947 HUAC hearings.) There are also some very surprising omissions. In addition to a shocking slight of Thalberg's role at MGM, Gomery omits from his bibliography any mention of Raymond Fielding's impeccable research on newsreels and the MARCH OF TIME. At the same time, the author provides considerable detail on the importance of newsreels and shorts in the corporate life of the eight primary film corporations.

These points aside, Gomery has demonstrated again his remarkable ability to ferret out information vital to our understanding of the economic history of the Hollywood studio system. His detached analysis represents the most accessible introduction yet written to the eight important film corporations. A bibliography and index are provided. Recommended for specialized collections.

Guback, Thomas H. THE INTERNATIONAL FILM INDUSTRY: WESTERN EUROPE AND AMERICA SINCE 1945. Bloomington: Indiana University Press, 1969. 244pp.

Based predominantly on interviews with key personalities in business, academia, government, labor groups, official international circles, and other professional areas related to film, this highly regarded study represents a seven-year examination of the shifting and complex effects of America's penetration into European film industries. At the outset, Guback makes it clear that the changes brought about by film exporting have occurred on both sides of the Atlantic, that film is both a business and a mode of communication, and that economic imperatives influence film content both in America and Europe. To develop his arguments, the author divides his investigation into three broad areas: a review of the interaction between film industries in the United States and Europe, an analysis of the structures and policies that have been created to control that interaction, and a look at how the film continuum is tied to economic imperatives.

Chapter One establishes why businesspeople consider film to be such an easy, inexpensive, and highly desirable export product. This fact was recognized early in the silent era and was used by most filmmakers worldwide. But after World War I and a need for more film product in the devastated European community, Americans were the only ones able to capitalize on producing a substantial number of prints for foreign consumption. Within a period of six years, the Americans had cornered ninety-five percent of the English market, seventy percent of the French market, and sixty-eight percent of the Italian market. Guback then goes on to demonstrate why our film industry became so dependent on European markets as a major source of revenue. What is impressive about this important book is the author's ability to produce evidence to support his claims. The vast collection of data is a testimony to his scholarship and resourcefulness.

The next two chapters go into greater detail on how the exporting of films developed after World War II. Beginning with an explanation of how the Americans operated and the large number of films they exported, Guback briefly traces the primary restrictions--e.g., limiting imports and blocking earnings--set up by foreign governments to safeguard their national film industries. He focuses on four European countries: England, France, Italy, and West Germany, with some attention paid to a number of smaller nations like Finland, Sweden, Norway, Denmark, Belgium, and Spain. Each protective measure (e.g., quotas, and tariffs) is discussed and reasons are provided for its strengths and weaknesses.

In Chapter Four, the author switches his focus and looks at foreign films operating in the American market. Guback wisely stresses the problems foreign film companies have in getting their products distributed and exhibited in America, thereby reminding readers that self-interest remains at the heart of all restrictive

policies. Nevertheless, foreign films made significant inroads into the American market after World War II; and we are given a host of reasons why, especially those dealing with the problems related to Hollywood's blocked foreign revenues. Guback also makes a distinction between "pure foreign films" and foreign films bought by American companies. The latter relates to movies made abroad rather than in Hollywood studios and movies using American capital: "The point is that there is an American investment in these films, whether they are American films shot on location abroad or true foreign films made in their native countries--although the distinction is increasingly difficult to draw."

The next three chapters concentrate on American film policies that defended and expanded its exporting programs. Attention is first drawn to the Motion Picture Association of America (MPAA) and its Motion Picture Export Association (MPEA). The latter, established as a legal cartel and registered in 1946 under the rules of the Webb-Pomerene Export Trade Act of 1918, is described as "the Little State Department" because of the way in which it functions. The author outlines how the MPEA fought, and continues to fight, for unlimited access to European film markets. We are also shown how a number of American government agencies assist the American film industry in its search for representation in overseas trade groups and increased foreign revenues. Guback is especially helpful in explaining how overseas representation provides foreign film industries with an opportunity to neutralize or to affect American foreign film policies. Thus politics and profits work to the benefit and liability of all the major parties.

Chapters Eight through Ten examine the extent and nature of the financial assistance provided by different European governments to their film industries and the effort made by Americans toward coproductions. Guback's convincing thesis is that European film production requires subsidization in order to survive, that European governments feel an obligation to preserve and encourage art, and that international filmmaking is both sensible and profitable. Knowing about the various types of subsidies not only provides a better understanding of how and why European films are financed, but also offers a valuable perspective on whether similar policies should be tried in America. The author also explains why American film companies continue to invest heavily in the European film industry: e.g., the size of the market, labor costs, the quality of production facilities, and blocked earnings. The coproductions that result permit many artistic, technical, and financial benefits, each of which is discussed with the aid of financial data.

The book concludes with a helpful summary of the reasons why film industries in America and Europe have become internationalized. Given the complexity of the topic, Guback does a good job of presenting the dry data in an interesting and accessible format. Several appendexes, a limited bibliography, helpful endnotes, and a valuable index add to the book's importance to the study of film economic history. Recommended for specialized collections.

Hayes, R. M. 3-D MOVIES: A HISTORY AND FILMOGRAPHY OF STEREOSCOPIC CINEMA. Jefferson: McFarland, 1989. Illustrated. 400pp.

Huettig, Mae D. ECONOMIC CONTROL OF THE MOTION PICTURE INDUSTRY: A STUDY IN INDUSTRIAL ORGANIZATION. London: Oxford University Press, 1944. New York: Jerome S. Ozer, 1971. Illustrated. 163pp.

This practical and invaluable pioneering text delineates the factors that enabled five theater-owning companies (Paramount, Loew's, Warner Bros., 20th Century-Fox, and RKO) and three other significant producers (Columbia Pictures, Universal Corporation, and United Artists) to dominate the film industry. Funded by Carnegie and Rockefeller grants, it began as a two-year study (1939-1941) analyzing film production, but became instead an examination of the industry as an entirety, encompassing distribution and exhibition as well. Huettig divides her rich collection of rare data into five sections: the development of the film industry, its status in

the early 1940s, the profitabilty of movies as a business, how films are marketed, and a set of conclusions. Her numerous financial analyses highlight the considerable difficulty researchers have in interpreting the industry's economic structure. For example, in compiling data on motion picture exhibition, she lists several limitations: (1) determining how many corporations operated theaters (many exhibitors were not corporations and thus were not required to publish their financial reports); (2) determining how many film producers were actually in the entertainment market; and (3) determining what was accurate in the Motion Picture BULLETIN published by the U. S. Department of Commerce (the agency often cited statistics from trade organizations and industry leaders without checking on the accuracy of the information). In short, the book illustrates both the author's intelligence and her resourcefulness.

Beginning with a fact-filled Introduction, Huettig sets out to show what made the eight majors so powerful. Typical of her approach is to explain how many motion picture corporations existed (3,700) and what percent of the gross income in the integrated industry (936 million dollars) was garnered by the eight majors (fifty-three percent). Care is also taken to establish the relative strength of independent exhibitors (394 companies responsible "for 4,130 theaters, or 24 percent of the total number of theaters in the country"). Put another way, of the 15,000 theaters nationwide, close to sixteen percent (2,600) were operated by Paramount, Warner Bros., RKO, Paramount, and 20th Century-Fox.

The first section subdivides the history of the industry into the crucial stages of development from 1889 to 1929. Her by-now standard interpretations of the patents war, the moves toward vertical integration, and the effects of sound on the film community, not only highlight important statistics, but also stress why various film branches possessed certain advantages at specific stages of the industry's evolution from pure competition to an oligopoly. Special attention is given to Zukor's aggressive policies and the way he ordered his priorities. For example, he initially sought to minimize risk by controlling the top industry talent. When the First National Exhibitors Circuit took the opposite tack (moving from exhibition into distribution), Zukor reassessed his position. Attention is also paid to the meaningful similarities between the American Telephone and Telegraph Company (AT&T) and the MPPC's pattern of operations. Once sound took over the film industry, AT&T attempted to establish restrictive trade practices that would make Ma Bell a formidable force in the movies. And third, this useful analysis reviews the alleged switch from private resources to bank control of the film industry.

The second section on the state of the movies in the early 1940s is notable for its sensible analysis of economic issues and policy decisions. Not only does Huettig take the standard routes of industry analysis (e.g., volume of business, capital investments, and the number of employees), but she also explores how industrial leaders determined the types of films they made. Helpful footnotes indicate the value for future scholars of using the U. S. Treasury's STATISTICS OF INCOME and the SOURCE BOOK, census reports, U. S. Federal Trade Commission DECISIONS, and the records of the Securities and Exchange Commission. Many invaluable and often-cited tables demonstrate that the majors were involved in numerous activities far beyond production. Worth noting, the leaders of the industry came more from the ranks of finance and real estate, than from those of production. No one who reads Huettig's voluminous statistics will doubt that exhibitors were the chief beneficiaries of the move toward integration that began in the early 1900s.

Section three on the profitability of the movies illustrates how vertical integration proved to be more profitable to large corporations than a combination of the industry's three branches. By operating on borrowed funds, the majors could pay meager profits to stockholders, while at the same time allowing specific groups within the corporations (e.g., film executives, talented performers, and technicians) to receive large salaries, big bonuses, and plush expense accounts. Interestingly, Huettig takes pains to show that the majors developed different internal financial structures. These were caused as much by a corporation's origins as by its managerial style.

Section four offers an invaluable summary on why the principal trade practices involving the sale of films by distributors to exhibitors and exhibition policies significantly influenced marketing strategies. In discussing the former, Huettig provides a detailed explanation of the strengths and weaknesses associated with block-booking, blind-buying, and designated play dates. In analyzing exhibition practices, she explains the advantages and disadvantages of clearance, zoning, and over-buying. Throughout this portion of the text, the author underscores the interdependency of the majors and their reluctance to deviate from standard trade procedures. She also provides a good overview of the November 20, 1940, consent decree reached by the Department of Justice and the five major companies. Particularly ironic is Huettig's aside that "recent developments indicate that the antitrust division has no immediate interest of continuing the action."

In the book's concluding section, Huettig neatly ties together her intriguing research. She reiterates that the majors, through their first-run theaters, affected not only their own status, but also the types and volume of productions by other producers in the industry. As buyers and sellers, the majors created an interdependent arrangement whereby large, vertically integrated organizations made the film industry unique for its time. Competition did exist in the movies, she claims, but it was a special competition limited in production to getting new talent, top executives, and story material; in distribution, to the fact that the sellers were also the buyers; and in exhibition, to rivalry between theaters for box-office receipts rather than for a choice of product.

Whether or not one agrees with Huettig's assessment of the film industry as a combination of competition and monopoly, her work remains the source which any serious examiner of the economic history of the movies must consult as a primary reference. A solid bibliography and a good index complete the book's considerable value to students. Recommended for special collections.

*Izod, John. HOLLYWOOD AND THE BOX OFFICE, 1895-1986. New York: Columbia University Press, 1988. 240pp.

An important and highly readable commentary on the business of film, this informative study examines the economics of the American film industry from the early days of patent competition up to the present-day conglomerate control of filmmaking. Izod quickly establishes himself as a valuable observer of the changes that have taken place in the American film industry over the past one hundred years. Among the reasons he cites for his "general approach" to the changes in movies brought about by commercial considerations are that (1) business matters are but one factor in the making a film, (2) financial reports in the film business are very unreliable, (3) his survey history is concerned more with an overview rather than with examining primary evidence. The book's ten chapters effectively and succinctly cover the major period in American film history, offering not only some fresh perspectives but also providing useful syntheses of past accounts. Occasionaly, Izod demonstrates a lack of interest in revisionist theories about filmmakers (e.g., Edwin S. Porter is dismissed as a "mechanical" filmmaker after THE GREAT TRAIN ROBBERY) and the contributions of various periods to the development of film as a business and as an art (e.g., the influence of exhibitors on the industry during the nickelodeon period). Endnotes, a bibliography, and an index are included. Recommended for special collections.

*Kerr, Paul, ed. THE HOLLYWOOD FILM INDUSTRY: A READER. London: Routledge and Kegan Paul, 1986. 290pp.

*Kindem, Gorham, ed. THE AMERICAN MOVIE INDUSTRY: THE BUSINESS OF MOTION PICTURES. Carbondale: Southern Illinois University Press, 1982. 448pp.

A collection of eighteen essays surveying the economic history of American films, this book illustrates the strengths and weaknesses of anthologies that promise more than they can deliver. In a single volume, Kindem wants to deal significantly, in a discontinuous fashion, with the growth of the movie business from a state of pure competition to an oligopoly, the shift to sound that completed the vertical integration of the film industry, the legal battles that destroyed the power of the film moguls, and the transition to conglomerates and international coproductions from the sixties to the present. The editor inaccurately claims that "Each chapter has been thoroughly researched" and each essayist "has carefully examined relevant business records, legal proceedings, government and industry statistics, and trade papers in an attempt to evidence their theses about important historical developments with primary as well as secondary source materials." Kindem separates his topical and chronological collection into six sections: the initial patterns of production, distribution, and exhibition; the evolution of business strategies; technological changes (e.g., sound and color); regulations and censorship problems; the interaction between film and television; and America's role in international filmmaking. He then makes the immodest assertion that we are about to read "many . . . case studies . . . [that] are seminal works."

A careful reading of the book, however, reveals that only a handful of the essays are in-depth studies, nearly fifty percent of the chapters represent the work of just three scholars (the editor, Douglas Gomery, and Robert C. Allen), and the documentation throughout the collection periodically suffers from distortions, a much too narrow focus, and unnecessary acts of omission. In fact, Dan Greenberg, in his stinging review of the anthology, states that "The volume is marred beyond rehabilitation by unacknowledged abridgements, biased presentation, questionable standards of documentation, and such limited coverage as to make one wonder about the rationale for the volume in the first place."[811] What particularly infuriates Greenberg is the deplorable editing of Ralph Cassady's important study of monopolistic practices between 1908 and 1915; the lack of any serious consideration of Latin America, Asia, and Africa in the section on international filmmaking; and the refusal of the editor to acknowledge the extent to which previously published essays and case studies have been abridged. I would add to the charges the uncritical reissue and condensation of Frederic Stuart's seriously flawed study on the effects of television on the motion picture industry from the post-WWII era to 1960, and the failure to indicate a number of factual errors in Simon N. Whitney's "Antitrust Policies and the Motion Picture Industry."

Without minimizing Greenberg's justifiable criticism, some useful aspects of Kindem's anthology are worth noting. Not the least is its provision of easy access to three valuable essays by Gomery ("The Movies Become Big Business: Public Theatres and the Chain-Store Strategy," "The Warner-Vitaphone Peril: The American Film Industry Reacts to the Innovation of Sound," and "Hollywood, the National Recovery Administration, and the Question of Monopoly Power"); the Douglas Ayer-Roy E. Bates-Peter J. Herman comprehensive essay, "Self-Censorship in the Movie Industry: A Historical Perspective on Law and Social Change"; Janet Staiger's stimulating analysis of early film business strategies, "Dividing Labor for Production Control: Thomas Ince and the Rise of the Studio System"; and Kindem's provocative review of changing Hollywood technologies in the twenties and thirties, "Hollywood's Conversion to Color: The Technological, Economic, and Aesthetic Factors." While it is true, as Greenberg claims, that these and ten other anthology articles are available in publications like CINEMA JOURNAL and the JOURNAL OF THE UNIVERSITY FILM ASSOCIATION, the fact is that most of the film programs in this country do not have adequate reference libraries and depend heavily on interlibrary services. Having the opportunity to review the material in one source and understanding the length to

[811] Dan Greenberg, "Book Review: THE AMERICAN MOVIE INDUSTRY," FILM QUARTERLY 38:1 (Fall 1984):42.

which editing occurred, it helps to have at hand one scholarly group's perspective on crucial issues in film history.

Taken as a primer rather than as a primary document on the evolution of film history and scholarship, the anthology serves as an expedient document suggesting not only where to go for more information, but also how good intentions can go awry. A series of endnotes, a selected bibliography, and an index complete the book. Approach with extreme caution.

LaBrecque, Ron. SPECIAL EFFECTS: DISASTER AT "TWILIGHT ZONE"--THE TRAGEDY AND THE TRIAL. New York: Charles Scribner's Sons, 1988. Illustrated. 304pp.

*Lees, David, and Stan Berkowitz. THE MOVIE BUSINESS. New York: Vintage Books, 1981. 196pp.

The idea for this anecdotal and informative look at the ins and outs of the film industry originated in a series of articles written for LOS ANGELES magazine, BOX OFFICE, and the Los Angeles TIMES. The subject of movies and money so intrigued the two reporters that they expanded their original material into a full-length manuscript based upon numerous interviews with producers, directors, supervisors, assistant directors, actors' agents, and grips. "This book," Lees and Berkowitz state at the outset, "will provide you with a clear picture of the way Hollywood works. Not only will we look at how movie deals are initiated and how movies are distributed and exhibited, but we'll see what part personalities play in this highly idiosyncratic business." The emphasis is on film economics, with observations on where investment money comes from, what channels it goes through, and what profits filmmakers amass. The journalistic writing, geared for the general reader, reflects a competent, succinct analysis of the tricky film continuum. Sixteen entertaining chapters cover topics like credits, the problems of independent producers, people behind the scenes, budgeting, tax shelters, domestic and foreign distribution, blind bidding, marketing, merchandising, and the value of Oscars. By the time the book completes its survey of what it takes to get a film honored, let alone made, you wonder how anyone can study film aesthetics independent of the financial underpinnings of the industry. An index is included. Well worth browsing.

*Litwak, Mark. REEL POWER: THE STRUGGLE FOR INFLUENCE AND SUCCESS IN THE NEW HOLLYWOOD. New York: William Morrow and Company, 1986. Illustrated. 336pp.

*Mayer, Michael F. THE FILM INDUSTRIES: PRACTICAL BUSINESS/LEGAL PROBLEMS IN PRODUCTION, DISTRIBUTION AND EXHIBITION. 2nd ed., revised and enlarged. New York: Hastings House, 1978. 230pp.

A practical guide to the day-to-day affairs of the movie business, this straightforward and comprehensive book is authored by a theatrical attorney who prides himself on clarity and organization rather than on complex ideas and stimulating prose. The contents are intended for film producers, their agents, and attorneys, as well as for anyone daring enough to want to invest in filmmaking. To help sort out the traps, Mayer divides his book into four sections: production, problems in distribution-exhibition, problems of content, and concluding thoughts. The section on production is matter-of-fact, with general information on option contracts, how to locate talent, the difficulties in getting a film financed, different types of subsidies, and breezy comments about film popularity. Section two, however, provides authoritative details about print piracy, non-theatrical markets, and film publicity. Section three offers the most entertaining chapters on classification problems, defamation and invasion of privacy, protection of titles, and the use of music. The

final section on what filmmakers can expect in the future might better have been omitted, since it states the obvious and does so poorly. If Mayer can be faulted for not making better use of his considerable business experience, it is for not providing more details about the controversy surrounding the role of conglomerates in the film industry. He rarely deals with nuances and tends to reduce complex questions regarding finance and power to oversimplified statements. An index is provided. Worth browsing.

*Morgan, Hal, and Dan Symmes. AMAZING 3-D. Boston: Little, Brown and Company, 1982. Illustrated. 176pp.

Ottoson, Robert. AMERICAN INTERNATIONAL PICTURES: A FILMOGRAPHY. New York: Garland Publishing, 1985. Illustrated. 425pp.
 A useful guide to the prolific exploitation company whose films from the mid-1950s to 1980 provided thrills for teenagers and career opportunities for many important actors and directors, this reference book contains an annotated, chronological listing of AIP's works and cast credits. A brief introduction describes the events leading up to the company's formation in 1954 and how it evolved over the next three decades. The major sections of the book are devoted to the fifties, the sixties, and the seventies. Each chapter provides credit information, a synopsis, and terse critical comments. A bibliography, a title index, and a name index are included. Well worth browsing.

Schatz, Thomas. THE GENIUS OF THE SYSTEM: HOLLYWOOD FILMMAKING IN THE STUDIO ERA. New York: Pantheon Books, 1988. Illustrated. 514pp.

Schnitman, Jorge A. FILM INDUSTRIES IN LATIN AMERICA: DEPENDENCY AND DEVELOPMENT. Norwood: Ablex Publishing Corporation, 1984. 134pp.

Slide, Anthony. THE AMERICAN FILM INDUSTRY: A HISTORICAL DICTIONARY. Westport: Greenwood Press, 1986. 431pp.

Spraos, John. THE DECLINE OF THE CINEMA: AN ECONOMIST'S REPORT. London: George Allen and Unwin, 1962. 168pp.
 Responding to the rigidity of the English film industry and its inability to adapt to "the cataclysmic decline in its fortunes" from the end of World War II to the late 1950s, the author sets out to analyze the reasons why the industry behaved as it did. Spraos divides his valuable report into three sections. Part 1 examines why the previous decade resulted in movie attendance dropping by nearly two-thirds and almost a third of the movie houses that were operating in 1955 closing by 1960. Part 2 explores the steps taken by the industry to offset this trend and the effectiveness of those measures. Part 3 raises a number of policy issues that the English government and the film industry were asked to consider: e.g., do away with inexpensive theaters, reduce competing cinemas that show similar films in the same area, improve the quality and comfort of the remaining film theaters, emphasize long rather than short runs, and make moviegoing an event rather than a habit. Although the material often makes for tedious reading matter, it is worth the time. The ten individual chapters are filled with factual, scholarly, and statistical information. An index is provided. Recommended for special collections.

*Squire, Jason E., ed. THE MOVIE BUSINESS BOOK. Englewood Cliffs: Prentice-Hall, 1983. 414pp.

One of the most authoritative textbooks on the business end of the movies, this competent anthology is the successor to the highly regarded pioneering work, THE MOVIE BUSINESS: AMERICAN FILM INDUSTRY PRACTICE, co-edited by William Bluem and Jason E. Squire. This updated version is organized around the life of a film. That is, the ten stimulating sections deal successively with the creators (e.g., producers, directors, and writer-directors), the property (e.g., screenwriters, literary agents, and story editors), the money (e.g., elements of feature financing, bankers and feature financing, foreign tax incentives and government subsidies, and financing and foreign distribution), the management (e.g., film company management, film companies as financier-distributors, and studio operations), the deal (e.g., the entertainment lawyer, business affairs and the production/financing/distributing agreement, over-budget protection and completion guarantees, and the talent agent), the shooting (e.g., line producers and shooting preparation and paperwork for THE CHINA SYNDROME), the selling (e.g., an overview of distribution and exhibition and motion picture marketing), the distributors (e.g., the studio as distributor and independent distribution), the exhibitors (e.g., sample exhibition contracts, theater chains, independent exhibitors, exhibition licenses, and refreshment sales), the audience (e.g., industry economic review and audience profile, the movie rating system, National Screen Service, and merchandising), and the future (e.g., emerging technologies in movies). Adding to the scope and substance of the undertaking is the fact that most of the forty-three essays contracted for the book are written by some of the most knowledgeable people in the business. For example, the opening section contains articles by Robert Evans, Sydney Pollack, Mel Brooks, Joan Micklin Silver, and Russ Meyer. Other well-known personalities adding their ideas to the issue of money and movies are William Goldman, David V. Picker, A. D. Murphy, James Bridges, Michael F. Mayer, and Jack Valenti. An index is provided. Recommended for special collections.

*Stanley, Robert H. THE CELLULOID EMPIRE: A HISTORY OF THE AMERICAN MOVIE INDUSTRY. New York: Hastings House, 1978. Illustrated. 328pp.

Intended as "an informational frame of reference that . . . [would] permit the formation of sound critical judgments concerning America's movie industry," this book fares poorly in the areas of accuracy, scholarship, and insightful comments. Acknowledging the fact that he used "literally thousands of bits of information," he nonetheless decided not to insert any footnotes. For the curious reader who wants to know Stanley's sources for his many assertions about corporate relationships and how the oligarchical structure of the industry evolved, he states that "most" of his sources are listed in the book's selected bibliography. Adding to this academic frustration is the fact that almost no attention is paid to revisionist theories on the birth and development of the industry during the silent era. Even well-known information is mishandled. For example, Stanley claims that THE BIRTH OF A NATION (1915) was based on Thomas Dixon's novel, THE CLANSMAN, but fails to mention the second novel, THE LEOPARD'S SPOTS, or the stage play based upon the two books; and he mistakenly credits Harry Cohn with perfecting the idea of shooting schedules (it was Thomas H. Ince). His analysis of the thirties and forties prove equally troublesome. He glosses over the reasons why the Motion Picture Academy of Arts and Sciences entered into labor negotiations, fails to understand Edgar Wallace's contributions to KING KONG (1933), ignores the effect that the National Industrial Recovery Act had on the showing of "double bills," and misrepresents how some of our wartime allies felt about American war movies downplaying the contributions of allied countries to the war effort (e.g., England's reaction to OBJECTIVE BURMA!).

Fortunately, the book does have some good moments. For instance, Stanley is one of the few recent film historians to recognize that theater acquisitions, and not financial chaos, were the basic reason for the transition from silent to sound movies. His comments on how industry leaders acted illegally to determine which was the best sound system to adopt (e.g., AT&T vs. RCA) and why this collusion resulted in Vitagraph's being forced into new negotiations with Electrical Research Proucts Inc.

(ERPI) may not be suitably documented, but they do raise interesting issues about the events of the period. Stanley also deserves recognition for his extensive captions for the many reproduced illustrations. They are not only well-chosen, but also nicely incorporated into the material discussed.

Overall, this analysis takes few intellectual risks and often restates familiar and, at times, outdated concepts about the history of American films. Two appendexes on censorship and advertising, a selected bibliography, and an index are included. Approach with caution.

Tarbox, Charles H. THE FIVE AGES OF THE CINEMA. Smithtown: Exposition Press, 1980. Illustrated. 90pp.

A curious and glib review of the economic history of American films, this book illustrates how an author's practical experience in movies does not necessarily lead to any insightful conclusions about the activities of the film industry. Tarbox is a veteran film distributor and exhibitor who wanted to provide a perspective on the evolving, shifting, and confusing patterns of production, distribution, and exhibition in American movies. To satisfy his objective, he divides the history of moviemaking into five separate and intellectually unsatisfying periods: 1895-1903, 1903-1911, 1911-1927, 1927-1948, and 1948-1980. Not only is too much information rapidly jammed into uneven historical periods, but also dubious assertions about events and personalities lack suitable documentation. For example, the author shows no interest in the subtleties of business dealings, while blurring the transitional stages from the days of the nickelodeon to the picture palaces. At times, he also provides misinformation. The one worthwhile aspect of this disappointing project is the collection of unusual illustrations of early film businessmen and the 1915 Motion Picture Board of Trade. Two indexes on film titles and names are provided. Approach with caution.

Thompson, Kristin. EXPORTING ENTERTAINMENT: AMERICA IN THE WORLD FILM MARKET 1907-34. London: British Film Institute, 1985. 238pp.

Usabel, Gaizka S. De. THE HIGH NOON OF AMERICAN FILMS IN LATIN AMERICA. Ann Arbor: UMI Research Press, 1982. 317pp.

Vincent, Richard C. FINANCIAL CHARACTERISTICS OF SELECTED "B" FILM PRODUCTIONS OF ALBERT J. COHEN, 1951-1957. New York: Arno Press, 1980. 231pp.

Originally submitted as a master's thesis at Temple University in 1977, this intriguing study provides many useful insights on a popular form of production about which very little is known. Vincent begins by establishing how "B" films were defined in the heyday of the studio system either by their function (the lower half of a double feature bill) or by their cost (usually less than $300,000 and shot within two weeks). He then goes on to describe their characteristics, the problems associated with determining their general costs, shooting ratios, and other reasons why their status was affected by the events of the post-World War II era. Albert J. Cohen, an ex-literary agent who in 1932 began an on-again, off-again association with Universal Pictures that lasted until the mid-1960s, is selected as the focus for determining what "B" films cost to produce in the 1950s and whether those costs can tell us anything about changing film financing patterns in this transitional decade. The budgets and final cost reports of ten out of the twenty films produced by Cohen for Universal Pictures in the years from 1952 to 1956 are examined in detail: HORIZONS WEST and BECAUSE OF YOU (both in 1952), EAST OF SUMATRA, THE GREAT SIOUX UPRISING, GIRLS IN THE NIGHT, THE GLASS WEB, and THE VEILS OF BAGDAD (all in 1953), BORDER RIVER and PLAYGIRL (both in 1954), and OUTSIDE THE LAW (1956). Serious film students who are interested in how the film industry adapted to

the problems generated in this crucial period will find Vincent's data helpful in interpreting conflicting accounts of the alleged demise of "B" films. Filmmakers also will benefit from the author's sensitivity to production budgets, above-the-line costs (i.e., costs fixed before shooting begins), below-the-line costs (i.e., costs accumulated during the shooting and the completion process), and shooting schedules. In fact, almost seventy percent of the book contains top sheets and production budgets to illustrate the conclusions reached by Vincent that "B" film production was tightly controlled and that changes did occur in the cost and shooting schedules of "B" films in the 1950s. A selected bibliography, but no index is provided. Well worth browsing.

*Wasko, Janet. MOVIES AND MONEY: FINANCING THE AMERICAN FILM INDUSTRY. Norwood: Ablex Publishing, 1982. 247pp.
 In a resourceful and provocative examination of the intimate ties between American films and money, Wasko focuses on the role of monopoly capitalism in the history of American films. The study itself was done initially as Wasko's 1977 doctoral dissertation at the University of Illinois and updated for this publication. Its most commendable feature is the impressive way in which the access problems normally associated with basic research involving bank finances and film economics have been resolved. Nonetheless, geographical and practical constraints result in the author's understandable emphasis on film production and distribution, with only modest attention paid to film exhibition. Her wealth of primary data, interesting statistics, facts--and her candor--contribute to a thesis that is often asserted but never proved: the economic structure of the movies constitutes an intricate pattern of personal and corporate arrangements that determine why the majors remain powerful and why many films are what they are. "Unquestionably," Wasko argues, ". . . the American movie has evolved not purely as art or communication, but as a commodity which is produced, distributed, and exhibited under market conditions that inevitably influence the kind of films made, who makes them, and how they are distributed to the public." In examining the chronological history of profit maximization in the film industry, she overdramatizes the relationship of film economics to the political, social, and economic structure of American society. The author's inflexibility over the issue of how dominant monopoly capitalism operated in the ninety years of film history undercuts what otherwise is a very challenging overview about monopolies, mergers, conglomerates, and market conditions. In other words, her assertions about movies' reinforcing "IDEOLOGICAL as well as ECONOMIC components of the capitalist system" make for fascinating reading but offer few concrete examples to support such a theory in a book this size.
 The problems become apparent in Chapter One, where Wasko recounts how the business side of film history affected the artistic, technological, and cultural aspects of the movies from their inception in the 1880s to World War I. Before delving into the specifics, she offers a primer on how banks supply business credit and capital for corporations--e.g., "debt" and "equity" financing and "production" and "corporate" loans--as well as other important types of interactions between bankers and industries--e.g., underwriting corporate stocks and bond issues and director interlocks. At the same time, the author makes clear her Marxist emphasis on bank capital's being "a dominant economic force in the development of monopoly capitalism." She wants us to see how capital creates power, which, in turn, affects the political, social, and economic structure not only of industries, but also of nations. Despite a willingness to acknowledge the problems with seeing "finance capital as the DOMINANT FORCE in monopoly capitalism," as described in the economic theories of Karl Marx, V. I. Lenin, and Rudolph Hilferding, Wasko refuses to abandon the concept. So long as the argument is confined to the first forty years of film history, the theory remains credible. She is able to show how in the pioneering period bankers and investors like Erastus A. Benson, Thomas R. Lombard, Norman C. Raff, and Frank R. Gammon were atypical financiers who supplied business credit and capital for the budding young American films. In emphasizing the disdain that more traditional financiers had

for the vulgar fad, Wasko stresses the need for the infant industry to establish stable and respectable practices in order to obtain the necessary capital for growth and prosperity. Rather than merely repeating the by-now standard stabilizing influences on movies during their first twenty years, she also points out the few tentative ways in which bankers began their involvement with film financing: e.g., corporate and production loans and underwriting a handful of stocks and bonds.

Chapter Two covers the decade from 1918 to 1928, when the once-cautious financiers reversed their long-standing policies toward the film world. Starting with the important investment links between Famous Players-Lasky Corporation and Kuhn, Loeb & Co. in 1919, she chronicles the reasons why film was now perceived as a "legitimate industry." Equally important to increasing profits, a stable distributing policy, and large real estate holdings in terms of theaters and studios was the fact that the "friendly" bankers--e.g., Felix E. Kahn and A. H. Giannini--shared a common background with the immigrant leaders of the film industry. To illustrate how the bankers involved themselves in the era of film financing, Wasko cites the case of D. W. Griffith and his relationship with nearly thirty-five banks over two decades.

Wasko runs into serious problems with her thesis in Chapter Three, where she picks up her theme of banks' and bankers' gaining financial control of the film industry between 1929 and 1939. For example, she insists that the switch from silent to sound films resulted in two crucial moves by the financial community. First, banks linked to major electrical companies became interested in the movies. Second, the interest of one segment of the banking community produced an interest on the part of other investors in getting "in on the action." Regrettably, no attention is paid to the way in which the majors organized their corporations and consolidated their efforts to prevent the bankers from gaining too much power in the film industry. Instead, Wasko first documents the various machinations that gave the sound systems owned by AT&T and the Radio Corporation of America dominance in the field; and then she argues that financial control of the film industry demanded "more attention to the concept of corporate control itself and the role of finance capital in monopoly capitalism. . . ." Particular attention is given to specific examples of how this control was managed overtly and covertly. Among the case studies offered as proof are those involving the Fox Companies and the Radio-Keith-Orpheum Corporation. The problem is that the author's theory, as Douglas Gomery points out in his excellent review of Wasko's research, is contrary to "some of the very social and economic thinkers Wasko cites [who] have argued that dominance by US [sic] bankers ended in 1930, replaced by a corporate hegemony."[812]

From this point on, therefore, the study proceeds on shaky ground. Chapter Four investigates the transitional decades (1940s and 1950s), when major changes occurred in the film industry and in its financial structure. Wasko's analysis takes into account the problems the movies faced after World War II, including declining box-office receipts and the restrictions in foreign film markets. She notes the large numbers of filmmakers defaulting on their bank loans and the banks that were forced to institute numerous foreclosures. She explains that the staggering losses required a tightening of credit and set in motion an era of retrenchment and reorganization. To appreciate the problems this created both for bankers and the rising number of independents, the author also examines the loan application procedures and the specific criteria employed by the bankers when considering loan requests. Of particular value is her conclusion that it was almost impossible "for an unknown producer or director to garner funds to produce a film independent from the major studios." In addition, the recognition in the 1950s that independent production was preferable economically to studio productions and that studios had the best credit lines led to the majors' rethinking their basic organizational patterns. Instead of increasing production, the studios decided to utilize the efforts of others in maximizing profits. It's at this point that the chapter again has difficulties with its thesis. Instead of viewing the financiers as secondary influences, Wasko claims that

[812] Short Take, p.57.

the banks encouraged the majors to act as their surrogates. They needed more security for the loans they were willing to make essentially only to the majors. Thus studio production decreased, studio facilities were leased rather than kept private, and distribution became the key to financial success in the film industry. Mergers and submersion into existing conglomerates became commonplace, closer ties to television were established, and internationalization of the film industry occurred quickly. Each development, Wasko asserts but never proves, resulted from the intricate role of the banks. In tracing the growth of independent film financing, she stresses the historical role played by the Bank of America and A. H. Giannini.

Chapter Five, with its emphasis on debt financing, chronicles how the transitional decades required the majors to develop new strategies in order to maintain their dominance in the film industry. The chapter effectively illustrates how the shift from vertical organizations into conglomerates bankrolling independent films and making fewer studio productions followed a trend in other industries. The emphasis was on umbrella organizations, with production and distribution being only one part of the corporate enterprise. To demonstrate her thesis, Wasko briefly examines each of the major film corporations and their ties to banking interests in order to provide a much-needed perspective on the present structure of the film industry. Diversification, conglomeration, and internationalization thus became the replacements for production and exhibition in continuing the oligopolistic nature of the film industry. For example, the majors' interest in television series, their role in the technological development and implementation of new cable systems, and their joint ventures with videocassette producers all testify to the manner in which the film industry leaders are using diversified ventures to strengthen their hold on the film industry. Wasko also makes it very clear that the majority of independendent productions require one form of support or another from the majors in order to obtain bank funds. She never makes it clear, however, whether the present conditions result from the internal strength of the majors or from the dominant role of the bankers.

In her succinct and perceptive concluding chapter, the author summarizes the stages from pure competition to imperfect monopoly to oligopoly that characterize the film industry. She stresses that film as "commodity" rather than as art or communication has always been the attraction for bankers; it was film properties (i.e., studios, theaters, and real estate) and the film market rather than film as a social force that had the economic draw for investors. Only in insisting on finance capital as the dominant force in film history and in trying to tie in the banking community with an alleged attempt to use film as a means of "reinforcing dominant ideology . . . or selling a specific way of life" does Wasko lose her credibility. Nowhere in this otherwise informative and stimulating text does she present any meaningful evidence that the financial appeal of the movies is anything other than a banker's interest in profits or glamor.

These reservations aside, this detailed treatment of the intricate role between the financial community and the movies demonstrates that studying corporate strategies can be almost as enjoyable as reading about the film personalities themselves. While graduate students will find the contents most rewarding, undergraduates should take the time to examine the author's thesis. An impressive bibliography and a helpful index add to the book's value. Well worth browsing.

Yule, Andrew. FAST FADE: DAVID PUTTNAM, COLUMBIA PICTURES, AND THE BATTLE FOR HOLLYWOOD. New York: Delacorte Press, 1989. Illustrated. 376pp.

THE FILM AUDIENCE

Surprising as it may seem, the people who pay to see movies are the ones least knowledgable about the history of film. While a great deal of time and print have gone into analyzing the content of the movies, the way in which films are made, and the conditions under which the film industry operates, film scholars and mass

communication experts rarely found it valuable or necessary to examine why the public throughout the twentieth century consumed films so voraciously. No one has done more in recent years to alter these circumstances than Bruce A. Austin. In 1983, he summarized the reasons why this scholarly omission needed our attention. First, a systematic study "of the early film audience would, today, be useful insofar as it would provide baseline data upon which a multitude of future comparisons might have been made. . . ." Second, "The popularity of movies, . . . as measured by recreational expenditures, warrants research attention." Third, there is a need to explain what factors have contributed to the decline of the average weekly attendance. As Austin explains, "In 1970 the total U. S. population had grown by 65 percent to 203 million while the average weekly film attendance had dropped by 83 percent (since 1930) to 15 million." Fourth, there is a need to understand why "box office records continue to be broken annually by a few films," despite the aforementioned sharp decline in attendance since 1930. In Austin's view, "Perhaps a final comment to the question 'Why study the film audience?' is: to provide an accurate accounting, grounded in theory, of film-goers' motives for attendance, the gratifications they derive from the movie experience, and the effects of movies on the audience."[813]

Clearly, to understand how the movies operate both as business and as an art, we need to appreciate the importance of the audience in the film continuum. While Austin makes a good case for studying film audiences, he tends to oversimplify the problems involved. For example, defining the composition and nature of the film audience is a complicated task. First, audiences are considered by sociologists to be "unstructured groups." That is, an audience "exists as a group only intermittently and for a short while; . . . it shifts and reforms itself constantly with different membership."[814] Or, as Ian Jarvie puts it,

> Technically speaking a film audience is a quasi-group; that is, a body of persons physically present to one another and united by one purpose only, lacking other ties, structures, or traditions through time. Television audiences, by contrast, being predominantly familial, are primary groups proper, and quasi-groups only in bars, public lounges, etc.[815]

An audience, therefore, has nothing that binds it together other than the fact that it behaves in a specific way at a specific time in relation to a specific event. It differs from organized groups like professional associations that are structured, follow definite procedures and rituals, lobby for particular purposes, have designated leaders, and maintain a certain status in society. In short, audience analysis involves more speculation than substance.

[813] Bruce A. Austin, THE FILM AUDIENCE: AN INTERNATIONAL BIBLIOGRAPHY OF RESEARCH, WITH ANNOTATIONS AND AN ESSAY (Metuchen: The Scarecrow Press, 1983), pp.xix-xx. See also Bruce A. Austin, "Film Audience Research, 1960-1980: An Annotated Bibliography," JOURNAL OF POPULAR FILM AND TELEVISION 8:2 (Spring 1980):53-80; ___, "Film Audience Research, 1960-1980: An Update," ibid., 8:4 (Winter 1980-1981):57-9; ___, "Research on the Film Audience: An Annotated Bibliography, 1982-1985," JOURNAL OF POPULAR FILM AND TELEVISION 14:1 (Spring 1986):33-9; and Douglas Gomery, "Movie Audiences, Urban Geography, and the History of the American Film," THE VELVET LIGHT TRAP 19 (1982):23-9.

[814] MOVIES AND SOCIETY, p.89.

[815] Ian Jarvie, "Suppressing Controversial Films: From OBJECTIVE BURMA! to MONTY PYTHON'S LIFE OF BRIAN," CURRENT RESEARCH IN FILM: AUDIENCES, ECONOMICS, AND LAW, Volume 1, p.183. For additional information, see Eliot Freidson, "Communication Research and the Concept of Mass," AMERICAN SOCIOLOGICAL REVIEW 18:3 (June 1953):313-7.

Second, film audiences are not the same as audiences for the traditional arts. As Gans points out, the latter place a higher status on "the creators" rather than on the performers, who "are viewed not as stars but as tools of the director and dramatist unless they can demonstrate that they have taken part in directing their own performance."[816] Audiences for the movies, however, rarely make clear what it is they value. More meaningful to these sociological abstractions, according to Gans, is "reassurance that . . . [society] continues to abide by the moral values important in the lower-middle-class generally."[817] Yet with the fragmentation that exists in modern society, many filmmakers worry about what social values to use in their films. How, for example, should one depict the institution of marriage, politicians, pre-marital sex, or intellectuals? What should be the image of men and women in family situations or in combat? Should police officers be shown enforcing the law aggressively or concerned with protecting the rights of criminals? Consider the contrast between audiences in the 1940s and today. Audiences in the 1940s, Susan Morrison argues, felt that "Sexuality outside of marriage, whose aim . . . [was] illicit pleasure rather than procreation, was rightfully punishable by death. To an '80s audience, however, the ideological necessity of punishing the sexually independent woman seems oppressive and unnecessarily cruel."[818]

Third, we need to understand that filmmakers themselves are not clear on what variables are important in determining the nature and composition of their abstract audiences. For example, Lee C. Garrison explains that

The potential United States audience for motion pictures includes all persons who are physically and economically able to attend. Of the present [1972] United States population of about 206 million, only about 144 are potential moviegoers. This is based on the same proportion of the total population estimated by industry sources to be potential moviegoers in the late 1940s.[819]

Up to the 1950s, as Leo A. Handel observed, there was no distinction made by filmmakers among "(1) the potential audience; (2) the actual audience; (3) the average weekly motion picture attendance; (4) the maximum number of admissions or potential audience for a motion picture; and (5) the average number of admissions for a motion picture."[820] Despite such problems, as John Izod points out, the American film industry, in the early 1950s, concluded that nearly three-quarters of its audience is under thirty years of age, "with the greater part coming from the age range 14-25, a pattern which [Hollywood maintains has not altered] . . . during the next thirty-five years."[821]

In addition to types of audiences, explains Paul F. Lazarsfeld, age, education, sex, and income also play a crucial role in defining the composition and nature of the

[816] *Herbert J. Gans, POPULAR CULTURE AND HIGH CULTURE (New York: Basic Books, 1974), p.78.

[817] POPULAR CULTURE, p.86.

[818] Morrison, p.5.

[819] Lee C. Garrison, "The Needs of Motion Picture Audiences," CALIFORNIA MANAGEMENT REVIEW 15:2 (Winter 1972):147.

[820] Leo A. Handel, HOLLYWOOD LOOKS AT ITS AUDIENCE: A REPORT OF FILM AUDIENCE RESEARCH (Urbana: University of Illinois Press, 1950), p.94. New York: Arno Press, 1970.

[821] Izod, p.181.

film audience. At the same time, these four factors present additional problems of interpretation.[822] For example, America's push toward universal education starting at the turn of the century never reached many of the people who came here as immigrants or who were forced during the early 1900s to find jobs and quit school. On the other hand, children born during the 1930s on the average are better educated than were their parents. "Therefore," Lazarsfeld argues, "if we want to study the role of age, we must investigate it separately for respondents on different educational levels."[823]

Nevertheless researchers, relying on these basic audience characteristics, believed that by the mid-1940s women were the major force in making a film commercially successful. For example, in one large urban city, Lazarsfeld found that more than ninety percent of the women interviewed went to the movies with members of their family seventy percent of the time. Of this group, more than thirty-three percent did so on a regular basis and on a particular day. Of special interest were the reasons why almost a third of those sampled maintained irregular film attendance: e.g., objections to film themes or content, medical reasons, and economic constraints.[824] What strikes a modern scholar in reviewing the results is the apparent willingness of people to believe that mass numbers of patrons would be deterred from buying a ticket because they objected to the film's content. Not only couldn't the content be judged, but viewers in the pre-television era were also hardly that selective in their moviegoing habits. That is, people went to the movies, not to a movie.[825]

This early form of communications research also did not provide much psychological information on film audience tastes and moviegoing habits. Were movies, for example, used for escape, identification, information, or entertainment? What in the movie particularly appealed to the individual or attracted that person to the box office? Robert C. Allen points out, for example, that in the 1920s people often distinguished between "going to the movies" and "seeing a movie." The former "included the architecture and furnishings of the building itself, an elaborate stage show, the newsreel, a program of shorts, AND the feature film."[826] It is quite conceivable in that decade that many customers paid little attention to the film itself. While opinionmakers clearly played a role in the selection of a specific film for many filmgoers, how much of a role and in what ways were not easily understood.

If, as Allen, Austin, Gans, Handel, Jarvie, Jowett, Lazarsfeld, and Linton agree, film audiences in general shift from film to film and defy precise descriptions, how then can filmmakers feel confident about incorporating the appropriate elements into a movie for mass appeal? The obvious answer is that they can't. Yet the American film industry continues to rely on abstract audience perceptions and film formulas that have proven successful in the past. This paradoxical situation poses difficulties for sociologists and critics who claim that an audience has rejected, accepted, or been affected by a film's content. Reasonable people wonder just what audience is being discussed and where the evidence is for such assertions.

[822] Robert C. Allen suggests that moviegoing habits are also influenced by region, social class, and ethnicity. See Allen and Gomery, pp.202-7.

[823] Paul F. Lazarsfeld, "Audience Research in the Movie Field," ANNALS OF THE AMERICAN ACADEMY OF POLITICAL AND SOCIAL SCIENCES 254 (November 1947):162.

[824] Lazarsfeld, pp.164-5.

[825] In fairness, it is widely accepted theory in contemporary film circles that nearly twenty-five percent of the modern audience will stay away from a film based mainly on hearsay evidence about a film's subject matter or because of a poorly conceived title.

[826] Allen and Gomery, p.157.

Market research is hindered as well by theoretical considerations about how movies allegedly "affect" their audiences. As discussed earlier, there are those who view audiences as "passive" receptacles unconsciously manipulated by the media. Other researchers take the position that audiences intentionally select the messages they receive. Still further, there are the investigators who not only insist that media messages reach us only after being filtered through a set of variables closely identified with group dynamics, but also that the films themselves produce multiple rather than monolithic reactions from their heterogeneous audiences. Each theory and counter-theory has its share of advocates.

One fact, however, seems nondebatable: the elements that dictate the shape and direction of the film also influence the social comment of the artist and the multiple meanings audiences give to film texts. That is, filmmakers intentionally relate their works to what they perceive as an audience's needs and desires. However, there is no evidence that audiences have these "targeted" desires or that they accept the filmmakers' preferred meanings. Put another way, American movies, described in more detail in Chapter 2, operate primarily as formula films. Conventions are established that function as a means for sharing alleged group values. But as we discovered in Chapter 2, the formula method constantly needs revision and innovation in order to result in box-office success.

The difficulty in using audience research to shed light on the realtionship between film and society, therefore, is what approach to use. At one time, the most popular method for studying the social history of film was the "empirical" approach. In simplified terms, it relied on the obvious for its conclusions. That is, the historian collected "facts" to prove the validity of a specific interpretation of a historical event. For example, Edwin S. Porter did direct THE GREAT TRAIN ROBBERY in 1903, Louis B. Mayer was the head of MGM during the time Irving Thalberg worked on A NIGHT AT THE OPERA in 1934, and the coming of the talkies did result in an influx of Eastern screenwriters to Hollywood. Each of these facts can be verified independent of a particular historian's perspective.

The problem with the empirical approach, however, is that it tends to be as simplistic as it sounds. Not only is history more than a collection of random facts, but it also requires a historian to exercise judgment in selecting and interpreting relevant facts. In Chapters 6 and 7, I discuss in more detail the various problems with past film historiography. Here we need only note that empiricism implies an objectivity that does not exist. Film historians are part of the film continuum and thus subject to the same influences--e.g., intellectual, social, political, and economic--that influence the phenomenon of film. An empirical analysis of film formulas and their conventions, therefore, often fails to account for significant factors that lie beneath the observable "facts."

One long-standing empiricist approach to identifying film conventions is through content analysis. The film conventions become one means of determining what society "felt" at a particular time in history. Because the controversial approach has been used repeatedly throughout the history of film audience reasearch, we need to consider its purpose and value to our concern with film stereotyping. The seminal book on content analysis--the WHAT in the Lasswell formula--is Bernard Berelson's CONTENT ANALYSIS IN COMMUNICATIONS RESEARCH, in which the author defines content analysis as "a research technique for the objective, systematic and quantitative description of the manifest content of communication."[827] The three major assumptions of the technique are (1) that inferences based on the relationship between intent and content, or between content and effect, have validity; (2) that by studying manifest content, a reliable meaning can be found; and (3) that there is a valid meaning to the quantitative description of communication.

[827] Bernard Berelson, CONTENT ANALYSIS IN COMMUNICATIONS RESEARCH (Chicago: University of Chicago Press, 1952), p.18.

In essence, the empirical social scientist explains an objective reality by quantifying observable data and then by comparing it with other factors. The purpose, in fact, is to relate the sensory data to the "actual world." For instance, the investigator of psychological films might "count" in a given era how many murderers are men, what jobs they have, and what motivates them to commit acts of violence. The data could then be compared to actual statistics about murders in our society. In such cases, the content analyst dismisses or ignores aesthetic or technical considerations. The investigator is concerned exclusively with identifying events, individuals, or "facts" with which objective comparisons between the fictive and the "actual world" can be made on a regular basis.

A major assumption that many content analysts make is that film messages in capitalistic countries are directly linked to film production and box-office profits. As Allen explains,

> The audience votes, in effect, for various types of films with their box-office dollars. Storylines, characters, settings, themes, actors that prove popular are recycled into subsequent films; failures disappear from the screen. According to this logic, popular entertainment films are not so much the result of personal artistic expression or manipulation by producers as they are the medium through which society communicates with itself.[828]

Once the investigator determines how he or she thinks films reflect society--either through total production or box-office hits--a set of quantifiable data based upon manifest content is examined. Each film is analyzed "objectively" and "systematically." The reliability of content analysis as a research method is an issue we will return to shortly. For now we need only recognize that it represents a significant stage in the analysis of film content from the late 1920s to the present.

The conventions identified in content analyses rely heavily on stereotypes about heroes and villains that relate the past to the present. Such stereotypes are not randomly selected. Social historians like Thomas Cripps, Patricia Erens, and Molly Haskell remind us how certain images of African-Americans, Jews, and women appear with distasteful regularity, while other preferable film images remain dormant on the silver screen. The issues, as discussed throughout this chapter, are related to what movies represent and with what effects. In particular, the emphasis is on why certain stereotypes occur to the exclusion of others, how they originate, what their survival rate is, and what factors generate changes, if any.

Knowing more about the social, political, and economic influences that shape these preconceived images allows us to better understand the relationship between film and society. They help us to appreciate the assertions that movies operate as an ideological tool of the society that produces them. Moreover, knowing the links between the stock situations and social types that exist in our cultural products and the values and habits we possess both as individuals and as members of a community helps us appreciate the role of movies in our lives.

Let us be clear on this point: studying film stereotypes does not provide a justifiable substitute for evaluating the artistic quality of a film. To analyze films on aesthetic principles requires taste and judgment, not statistics and sensory data. This is a point I will come back to again and again, in part because countless books and articles allude to the impact of films ("realistic" and "unrealistic") on society. Many of these treatises equate ideology with art and do so from an uninformed elitist or oppositional standpoint, displaying neither imagination nor respect for the medium. Genre studies in particular thrive on making aesthetic and social judgments independent of a specific film's box-office or critical success. As factual information, the description of such films with their conventions and inventions has value in explaining various aspects of our society. But to ignore completely the commercial or artistic merit, irrelevant as that may be to some reviewers, is to misunderstand

[828] Allen and Gomery, p.165.

the importance of cultural hegemony and art in describing the complicated process of human communication as it relates to the mass media. Even further, as Robert C. Allen states, "One need only note the current state of the mass entertainment complex in the United States, with the predominance of media conglomerates, the hybridization of television and film production techniques, and cross-media marketing strategies, to realize that inter-media relationships are central to a number of aesthetic, social, and economic issues in cinema studies."[829]

Clearly, this chapter cannot adequately explore the complex set of interrelationships between film and other forms of entertainment, nor can it do justice to parallel patterns evident in the development and growth of the mass media. What is provided is at best an introduction to the range of questions serious students will pursue in greater detail about the nature and influence of film as a social force in society. Studying about stereotypes does, however, make us aware of how the process of perception and the moment of reception affect our judgments and behavior. It also sensitizes us to the ways in which filmmakers cater to our desires and rely on alleged audience identification to maximize film profits. Given the concern that social observers have with the impact of stereotypes and celebrities on twentieth century audiences, it seems sensible to examine just how the perception-reception process evolved and why. A basic assumption in this section is that those who go to the movies not only influence the content and meaning of films, but also reveal socially significant information about a major segment of the nation's character and values.

Trying to determine the nature of the film audience is itself nearly a century-old dilemma. "The exact composition and nature of the first motion picture audiences," writes Garth S. Jowett, "has always been something of a mystery."[830] Jowett's research hypothesizes that the pioneering film audiences included at least three groups: members of the middle class who broke loose from prior religious inhibitions and went to commercial amusements for the first time, members of the middle and upper working classes who especially adored melodramas, and the large urban working

[829] Allen, p.1.

[830] Garth S. Jowett, "The First Movie Audiences," JOURNAL OF POPULAR FILM 3 (Winter 1974):39-54, MOVIES AS ARTIFACTS, p.14. In addition to Allen's important study on vaudeville, other useful sources on the early film audiences are "Boy Meets Facts," TIME (July 21, 1941):73-4; Bosley Crowther, "It's the Fans Who Make the Films," NEW YORK TIMES MAGAZINE (June 24, 1945):14, 29-30; Harold Ellis Jones and Herbert S. Conrad, "Rural Preferences in Motion Pictures," JOURNAL OF SOCIAL PSYCHOLOGY 1 (1930):419-23; Garth S. Jowett, MEDIA POWER AND SOCIAL CONTROL: THE MOTION PICTURE IN AMERICA, 1896-1936 (Unpublished Ph.D. Thesis: University of Pennsylvania, 1972); _____, "Giving Them What They Want: Movie Audience Research Before 1950," CURRENT RESEARCH IN FILM, Volume 1, pp.19-35; *Benjamin Hampton, A HISTORY OF THE MOVIES (New York: Covici-Friede Publishers, 1931, New York: Arno Press, 1970); *Lewis Jacobs, THE RISE OF THE AMERICAN FILM: A CRITICAL HISTORY WITH AN ESSAY "Experimental Cinema in America 1921-1947" (New York: Harcourt, Brace and Company, 1939, New York: Teachers College Press, 1968); Russell Merritt, "Nickelodeon Theaters, 1905-1914: Building an Audience for the Movies," AFI REPORT 4:2 (May 1973):4-8, Rpt. and expanded in THE AMERICAN FILM INDUSTRY, Rev. ed., pp.83-102; Alice Miller Mitchell, CHILDREN AND MOVIES (Chicago: University of Chicago Press, 1929); Rev. J. J. Phelan, MOTION PICTURES IN A TYPICAL CITY (Toledo: Little Book Press, 1919); Calvin Pryluck, "The Itinerant Movie Show and the Development of the Film Industry," THE JOURNAL OF THE UNIVERSITY FILM AND VIDEO ASSOCIATION 35:4 (Fall 1983):11-22; and Ray Leroy Short, "A Social History of the Motion Picture," (Master's thesis: Iowa State University, 1961).

class who found in movies their prime source of entertainment and information about customs and manners.[831]

The basic reason why these three groups appeared in such large numbers so quickly had to do with the increased amount of leisure time and recreational emphasis at the dawn of the twentieth century.[832] This, in turn, precipitated the rise of a variety of entertainment forms. Among them was the motion picture. By 1894, the penny arcades were filled with viewing machines. Two years later, the flickering images were projected onto screens. The more people saw, the more excited they became about the moving pictures. In effect, the film caused a revolution in mass entertainment. It became the first mechanical amusement to gain worldwide distribution. At the same time, the emerging film industry established a direct link between its product and its mass audiences. The presumed influence of this powerful interaction made society panic about traditional socializing agencies like the public schools, religious organizations, and the family.[833] What these groups feared most was the ability of the movies to bypass standard social controls. Even further, audiences appeared to be addicted to movies.[834] People of all ages went by the thousands on a regular basis to see the latest films. What they saw, the moralizers argued, was not only trite but also disruptive. These fears have never disappeared. As a result, movies made over the last ninety years have found themselves being examined for a multitude of possible dangers both to the individual and to society.

In the first decade of the twentieth century, film content shifted from actualities to narrative films. The new emphasis (discussed more fully in Chapters 1, 2, 5, and 7), and its ties to the other popular entertainment forms, played a key role in expanding film audiences. Its major appeal was rooted in the story-telling traditions of the past. Along with historians like A. Nicholas Vardac and Allardyce Nicoll, John L. Fell described the important relationship between these early films and nineteenth-century melodrama. "The process," he points out, "seems almost pat evidence for Marshall McLuhan's proposition that a new medium devours as content the medium it seeks to replace."[835]

Because of its relevance to our discussion, we first need to review briefly the nature of, and reactions to, melodrama. Simply put, melodrama permeates almost every theatrical film in motion picture history. "Moreover," as Russell Merritt laments, "melodrama has joined the long list of words hopelessly blurred and debased by

[831] Jowett, pp.17-21.

[832] For a useful discussion of the historical context for the current film industry, see Calvin Pryluck, "Industrialization of Entertainment in the United States," CURRENT RESEARCH IN FILM: AUDIENCES, ECONOMICS, AND LAW, Volume 1, pp.117-35.

[833] For a good summary and models of the movies as social communication, see Jowett and Linton, pp.71-6.

[834] Lary May offers another intriguing side effect of the early popularity of film. He believes that Edison's failure to convince the financial community of the ongoing value of his new "toy" was linked directly to their Victorian work ethic. That is, you do not tempt the working class with novelties like cars, telephones, and moving pictures. In addition, you actively discourage workers from frivolous and immoral behavior. For more information, see *Lary May, SCREENING OUT THE PAST: THE BIRTH OF MASS CULTURE AND THE MOTION PICTURE INDUSTRY (New York: Oxford University Press, 1980), p.26.

[835] John L. Fell, "Dissolves by Gaslight: Antecedents to the Motion Picture in Nineteenth-Century Melodrama," FILM QUARTERLY 23:3 (Spring 1970):22.

popular misuse."[836] In his provocative analysis of the problem, he outlines a number of reasons why the term is both misused and misunderstood. On the one hand, traditional scholars offer three different meanings for melodrama: (1) a negative synonym for theatrical overstatement, (2) a world view noted for its extreme moral positions and absolute rigidity regarding winning and losing, and (3) a form of drama tracing its roots from the eighteenth century to the present mass media.[837] On the other hand, scholars interested in popular culture refer to melodrama as "a specific kind of contemporary story found in movies, television, and best-selling novels, marked by a diffuse structure, a rather complicated plot, and a large cast of characters."[838]

Indicative of the confusion Merritt rails against are the comments of several well-known critics. For example, Thomas Elsaesser's celebrated essay on family melodramas traces the alleged evolution of melodramatic imagination throughout European history. Wherever he looked--in the English Gothic tradition, in the costume dramas and historical novels of France, in the Italian operas, or in the barrel-organ songs and music-hall dramas of Germany--Elsaesser discovered two currents. The one leading from the late Middle Ages included "emotional shock-tactics," "the blatant playing on the audience's emotions," close links between music and narratives, and "the non-psychological conception of the DRAMATIS PERSONAE." The importance of these characteristic features, according to Elsaesser, is their mythmaking function. That is, the emphasis in the melodrama is on structure and circulation of action and not on "psychologically motivated correspondence with individual experience."[839] The second current, and the one most influencing the sophisticated film melodramas of the 1940s and 1950s, grew out of the eighteenth-century romantic novels and the romantic dramas following the French Revolution. Emphasizing "codes of morality and conscience," tied to "periods of intense social and ideological" crises, "the melodramatic elements are clearly visible in the plots, which revolve around family relationships, star-crossed lovers and forced marriages."[840] These two currents, plus the subversive and escapist nature of the formula, allowed filmmakers to appeal to mass audiences. More conservative audiences could be lured with conventions that reinforced traditional values, while more liberal audiences could find pleasure in film inventions that commented on current attitudes and values.

[836] Russell Merritt, "Melodrama: Postmortem for a Phantom Genre," WIDE ANGLE 5:3 (1983):25-31.

[837] Major essays and works dealing with melodrama cited by Merritt are Eric Bentley, "Melodrama," THE LIFE OF DRAMA (New York: Atheneum, 1967); James L. Rosenberg, "Melodrama," THE CONTEXT AND CRAFT OF DRAMA, eds. R. W. Corrigan and J. L. Rosenberg (San Francisco: Chandler Press, 1964); Michael Booth, ENGLISH MELODRAMA (London: H. Jenkins, 1965); *Peter Brooke, THE MELODRAMATIC IMAGINATION: BALZAC, HENRY JAMES, MELODRAMA, AND THE MODE OF EXCESS (New Haven: Yale University Press 1976); *David Grimstead, MELODRAMA UNVEILED (Chicago: University of Chicago Press, 1968); Robert Heilman, TRAGEDY AND MELODRAMA: VERSIONS OF EXPERIENCE (Seattle: University of Washington Press, 1968); Frank Rahill, THE WORLD OF MELODRAMA (Pennsylvania State University Press, 1967); and James L. Smith, MELODRAMA (New York: Harper & Row, 1973).

[838] Merritt, p.25. Among the popular culture authors cited by Merritt are John Cawelti, Thomas Elsaesser, Jean Follain, Laura Mulvey, Bill Nichols, and Stanley Solomon.

[839] Thomas Elsaesser, "Tales of Sound and Fury: Observations on the Family Melodrama," MONOGRAM 4 (1972):2.

[840] Elsaesser, p.3.

Merritt's reaction is to dismiss Elsaesser's definition of melodrama as one without any "essential core, only a proliferation of blurry and occasionally self-contradictory characteristics."[841] In fact, he finds Elsaesser's "level of abstraction" so misleading that the survey might as easily have begun four centuries before 1700.

Although Merritt does not deal with Michael Walker's notions about melodrama, they reveal the manner in which Elsaesser's theory has affected certain film critics. For example, in referring to Elsaesser's "seminal essay," Walker claims that

> Melodrama is arguably the most important generic root of the American cinema. But until it has been located more theoretically as both a dramatic structure and a historical form, our grasp of its relevance will remain restricted and confused.[842]

The approach Walker favors is based on Robert Heilman's theoretical ideas. In his oversimplified terms, Heilman contrasts melodrama with tragedy. What separates the two is the nature of their dramatic conflicts. For example, an individual's "conflicting values and desires" are the hallmark of tragedy, while a divided world (e.g., "good and evil, weak and strong, oppressed and oppressors") is the basic convention of melodrama. The former deals with internal issues; the latter, with external problems. Tragedy deals with the complex choices one makes; melodrama, with the dangers faced by innocent people who need the world ordered for them. What Walker finds especially attractive about Heilman's model is that it provides structure for the concept of melodrama while also making useful distinctions between it and tragedy. In addition, Walker finds the contrast very useful for film analyses.[843]

But as Walker acknowledges throughout his extended essay, the Heilman model also has a number of limitations. One drawback is its failure to deal with ideological discourses and a character's awareness of his or her choices of action. That is, does the protagonist consciously deal with internal conflicts (tragedy); or is the protagonist passively swept up by external events over which he/she has no control (melodrama)? The model also does not differentiate among the sources for characters in melodrama: e.g., "historical, ideological, mythical, psychoanalytical."[844] A second limitation of the model relates to the point of view of the filmmaker, independent of the perspectives presented by the protagonists. That is, one film can polarize its characters, thus limiting our point of view, while another film can provide more complex characters requiring us to understand more than one point of view.[845] In essence, Walker believes that "the melodramatic tradition in Hollywood movies is articulated by the ideology and VICE VERSA."[846]

Another well-known participant in the ongoing debate about melodrama is Geoffrey Nowell-Smith, whose ideas about melodrama and bourgeois values Walker dismisses as "assertions." Nowell-Smith argues that

> Melodrama originally meant, literally, drama + melos (music) and this eighteenth century sense survives in the Italian MELODRAMA--grand opera. In its early form melodrama was akin to pastoral, and differentiated from tragedy in that

[841] Merritt, p.27.

[842] Michael Walker, "Melodrama and the American Cinema," MOVIE 29/30 (Summer 1982):2-38.

[843] Walker, pp.2-3.

[844] Walker, p.5.

[845] Walker, p.24.

[846] Walker, p.28.

the story usually had a happy ending. Not much of the original meaning has survived into later--Victorian and modern--usages of the term, but the differentiation from tragedy has become, if anything, more marked. The principal differences are two . . . The first of these concerns the modes of address and the second the representation of the hero(ine). At the same time, it should be noted that in many other respects the melodrama is the inheritor of many tragic concerns, albeit transposed to a new situation.[847]

Nowell-Smith goes on to describe how the arrival of the novel in the eighteenth century created a more egalitarian relationship among the author, subject matter, and audience than was evident in drama and the literary arts. Just as Robert Arnold noted the changes brought about through shifts in historical and institutional contexts, Nowell-Smith summarized the shift from art works about royalty to popular narratives about and for the bourgeois. Again like Arnold, Nowell-Smith stressed the importance of the changing social relationships between authors and audiences and the impact that change had on popular culture. Replacing the notion of divine laws was a secular emphasis that located the "locus of power . . . [in] the family and individual private property. . . ."[848] Thus the aesthetic issues that interested professional entertainers and mass audiences from the eighteenth century on related to legitimacy and law as they applied to every member of society and not just to aristocrats and monarchs. Particularly controversial was the Victorian and modern emphasis on morality and sexual identity in the family melodramas. In many respects, the genre's reliance on emotions to motivate the actions of its characters reminded Nowell-Smith of Freud's views on "conversion hysteria." That is, "the energy attached to an idea that has been repressed returns converted into a bodily symptom."[849] In terms of melodrama, "conversion hysteria" relates to the excessive emotions that remain unsatisfied by the story but are expressed dynamically through music and MISE EN SCENE.

While Nowell-Smith believes that a melodrama's hysterical moments offer the best examples of the ideology's break down in the text, other commentators express revulsion at the excess of emotion in melodramas.[850] Starting with nineteenth-century French novelists and dramatists who are credited with perfecting the melodrama's popular appeal for mass audiences, the concept, as Peter Brooke points out, is associated with

the indulgence of strong emotionalism; moral polarization and schematization; extreme states of being, situations, actions; overt villainy, persecution of the good, and final reward of virtue; inflated and extravagant expression; dark plottings, suspense, breathtaking peripety.[851]

[847] Geoffrey Nowell-Smith, "Minelli and Melodrama," SCREEN 18:2 (1977):114.

[848] Nowell-Smith, p.115.

[849] Nowell-Smith, p.117.

[850] Doane identifies one generic sub-category of the women's film as the "'paranoid' women's film." A major convention is to contrast a "good and heroic" male with an "evil or psychotic" one. The female lead, "as in Levi-Strauss' fable of the constitution of society, is exchanged from one to the other." A film that typifies the sub-genre is REBECCA (1940). See "CAUGHT and REBECCA," p.89.

[851] *Peter Brooke, THE MELODRAMATIC IMAGINATION: BALZAC, HENRY JAMES, MELODRAMA, AND THE MODE OF EXCESS (New Haven: Yale University Press, 1976) pp.11-2.

Stated differently, many works employing melodramatic conventions dwell on extravagant representations and intense moral codes that motivate the conscious actions of the characters in hyperbolic plots. The characters operate at the crossroads where the primal forces intersect with each other, thereby assigning the characters' actions more moral force than would otherwise be found in traditional tales. Furthermore, Brooke feels it is foolish to ignore the arguments that in melodramas the issues of right and wrong, "salvation and damnation," are polarized within the apparent normalcy of reality and everyday life.[852] In short, melodrama from the start has been for him a democratic and popular entertainment that is aesthetically self-conscious.

Brooke's arguments only add to Merritt's frustration with the current use of the term. Calling him an "essentialist" with "grandiose" claims about melodrama's "reinvesting ordinary life with a sense of transcendental moral significance," Merritt dismisses Brooke's "'excess'-inflated rhetoric" as being little more than "unargued assertion and generalization."[853] Merritt also lambastes popular culture authors whom he perceives as equating melodrama with "secondary," romantic film genres generally associated with women's themes and characterizations. From his perspective, the concept of melodrama never contained a coherent dramatic structure. Its major reason for being, Merritt insists, is "to impose critical order over a vast miscellany of narrative texts found in at least six different countries spanning nearly two centuries."[854] Being neither naive nor foolish, he recognizes that he can't resolve the current confusion surrounding the term "melodrama." But he does suggest that we be clear on what conventions we associate with the concept as a genre. That is, what characters, themes, settings, and conflicts are omitted or included in our discussion of the genre's historical antecedents or contemporary use.

In fairness to those who disagree with Merritt's purist position, they see melodrama as having a unique role in modern society. As Brooke explains, "Melodrama represents both the urge toward resocialization and the impossibility of conceiving socialization other than in personal terms."[855] That is, the genre grew out of society's abandonment of a system of behavior and governance dependent on sacred values.[856] Beginning in the nineteenth century, secularism produced in modern life a sense of guilt and anxiety resulting from the absence of clear-cut values of right and wrong based on religious precepts. What melodrama offered the public, therefore, was a "fully externalized, personalized, and enacted conflict" that purged, purified, and recognized "sacred and cosmic values in a world where they no longer have any certain ontology or epistemology."[857]

John G. Cawelti takes a similar tack. After defining the hallmark of melodrama as being "the drama of intensified effects . . . added to the play to increase its emotional power and intensify its hold on the audience," he goes on to point out that the genre contains

[852] Brooke, p.ix.

[853] Merritt, p.27.

[854] Merritt, p.28.

[855] Merritt, p.16.

[856] Gerbner argues (p.47) in the same vein about television being the "new religion." That is, "It is religion in the sense of pre-industrial pre-Reformation religion, in the sense of one's having no choice--a cosmic force or a symbolic environment that one was born into, and whose assumptions one accepted without much questioning."

[857] Gerbner, pp.200, 204-5.

at its center the moral fantasy of showing forth the essential "rightness" of
the world order . . . Because of this, melodramas are usually rather
complicated in plot and character; instead of identifying with a single
protagonist through his line of action, the melodrama typically makes us
intersect imaginatively with many lives. Sub-plots multiply, and the point of
view continually shifts in order to involve us in a complex of destinies. Through
this complex of characters and plots we see not so much the working of
individual fates but the underlying moral process of the world . . . [Thus
m]elodramatic suffering and violence are [a] means of testing and ultimately
demonstrating the "rightness" of the world order.[858]

In effect, what melodrama provides for our modern age is a facsimile of the real world
in which the options available to us as human beings are discussed.

For those fortunate enough to share in the benefits of a dominant culture, the
mass media melodramas operate not only as role models, but also as a form of security
for the dominant culture's collective perceptions. On the other hand, minorities and
outsiders find in popular melodramas oppressive images and ideas that intentionally
or unintentionally exploit prejudice and fear. They find the predominant ideas and
images not only threatening to residual and emerging social values, but also
counterproductive to the health and welfare of society. As for the movies, Roffman
and Purdy argue that "Victorian melodrama developed into the Hollywood Formula and
contemporary events continued to be interpreted within the bounds of a reactionary
value system."[859]

Particularly relevant to our study of the social history of film is the link between
melodrama and psychoanalysis. The genre's reliance on repressive acts and mentally
disturbed characters suggests to Brooke that melodrama and psychoanalysis share a
number of common concerns: (1) an interest in conflict, (2) the dynamics of
repression, (3) the relation of symbol to symbolized, and (4) the importance of
articulation in producing a resolution/cure.[860] Far from making a frivolous analogy,
Brooke insists that by recognizing melodrama as a form of psychology externalized,
we can study the genre as a symbolic process for analyzing and understanding our
cultural history at a particular time and place. Walker advocates a psychoanalytical
approach to analyzing melodrama, because much of the "inherent power" with which
melodramas treat events lies in the way they "dramatise, however unconsciously, key
psychoanalytical processes, such as the Oedipus complex or 'the return of the
repressed.'" He goes on to add that melodrama not only has a strong connection with
dreams and wish-fulfillment, but also with "a POPULAR culture form, with myths and
folk-tales. . . ."[861]

Equally important for understanding the nature of film audiences at the turn of
the century are the links between the cultural values of the past and the advent of
the motion picture. Thanks to the imaginative summary provided by Lary May, we
can sense the enormous power that Victorian morality exerted on political, economic,
and social values as well as on the world of entertainment. At the heart of Victorianism
was the unquestioning faith that the nineteenth century placed in its conviction that
progress and personal values were inextricably tied together. The middle class, in
particular, wove a set of myths and traditions around the Victorian code: e.g., work
was more a calling than an occupation, popular culture worked best when it reinforced

[858] *John G. Cawelti, ADVENTURE, MYSTERY, AND ROMANCE (Chicago: University of Chicago
Press, 1976), pp.45-6.

[859] Roffman, and Purdy, p.11.

[860] Brooke, pp.202-3.

[861] Walker, pp.10-11.

the values of a strong conscience and social responsibility, and an egalitarian society emphasizing a free economy was better than an aristocratic society with rigid trade restrictions.[862]

Especially relevant to our interests is May's analysis of the role women played in the transition from Victorian society to the modern era. Unlike men who not only were free to compete in the business world but also to enjoy sexual and social freedoms outside the home, genteel women of the Victorian era symbolized the epitome of self-control and refinement. Their function was to teach members of their family and the general community the proper way to behave in society. They were strongly supported in this role by the Protestant church, eager to retain its religious hegemony in America. One of the most potent threats to the middle-class Victorian was popular entertainment. Where leisure time had previously been spent in highly respectable lecture halls and opera houses, the new forms of entertainment--e.g., vaudeville, burlesque, music halls, penny arcades, minstrel shows, and saloons--broke down class barriers and traditional social values. Thus respectable women never went to such disreputable places, unless properly escorted or on a moral crusade.

By the turn of the century, however, the mass immigration begun in the 1880s had made these places major urban attractions. What's more, the "outsiders" rejected many of the Victorian values of restraint, temperance, and dependability. To preserve the values of the Victorian code, its advocates argued for free public education. Here again, women played a crucial role; they made up almost three-quarters of all public school teachers.[863] Their job, according to May, was to instruct the immigrants and other members of the working class about what America valued in its citizens. The emphasis was clearly on assimilating Victorian morality. The problem was that many women who now found themselves in this significant position did not agree with many of the constraints that the code placed on them. Instead of being pleased with their "lofty" place in a Victorian world, many of the women now dreamed of a new role in the industrial society that championed egalitarianism.

Thus, as we approached the widespread acceptance of the moving picture as a new form of entertainment, several important seeds were planted in American society. First, there was the increasing popularity of melodrama as a form of entertainment and instruction. Whatever the problems with giving the formula a precise description, mass audiences had no difficulty in applauding its "realism" as compared to the more traditional cultural forms. Second, a battle royal had developed between cultural traditionalists and the exponents of the new popular culture. The former insisted on holding fast to pre-industrial values of social responsibility and rigid codes of conduct, while the new urban dwellers demanded a democratic society embracing pluralistic values. The fact that the men who eventually gained control of the film industry, as we shall see, were mainly East European Jews who had recently emigrated to America had a great deal to do with both their success and their problems in American society. More than most Americans, they found the melting pot climate in the early 1900s very profitable for business and pleasure. And third, the motion picture itself proved to be an ideal medium to tie together the popularity of melodrama, the need to educate millions of people to what it meant to become an American, and faith in the nation's ongoing destiny.

An excellent illustration of how melodrama and the new American ethic interfaced with the first films is the case history of UNCLE TOM'S CABIN from book to play to film. In discussing one of the world's longest theatrical run, William L. Slout notes, "It was understandable that the new film industry early in our century, sensitive to its theatrical heritage, would adapt UNCLE TOM'S CABIN for presentation to a new

[862] *Lary May, SCREENING OUT THE PAST: THE BIRTH OF MASS CULTURE AND THE MOTION PICTURE INDUSTRY, pp.4-6.

[863] May, pp.8-15.

generation of audience."[864] What made a popular melodrama like UNCLE TOM'S CABIN
so valuable, as Jowett points out, was its respectability, since religious people who
hitherto had been reluctant to go to public amusements, now attended movie
houses.[865]

Another equally significant form of nineteenth-century entertainment cannibalized
by the early films was vaudeville. It was here that the film pioneers first tested and
perfected their commercial projectors. It was here that vaudeville's modular program
structure provided an invaluable exhibition outlet for the first decade of film
products. But vaudeville did more than serve as the most important source for film
distribution and exhibition during the fledgling years of movie history. It was also
crucial to the artistic development of the new medium. "The relationship between
vaudeville and film," observes Robert C. Allen, "does not end with the rise of
small-time vaudeville; the two industries remained closely tied into the 1930s."[866]

Central to our concern is the theory, developed by Albert F. McLean, Jr., that
vaudeville not only was a long-standing "social institution, but also a mythic
reenactment--through ritual--of the underlying aspirations of the American
people."[867] That is, its function was to act "as a means of assimilation and
crystallization of very important and historically significant value judgments upon life
in an expanding industrial democracy."[868] The patterns eventually adapted by the
American film industry in its movie formulas incorporated the dramatic techniques and
social functions perfected in melodramas and vaudeville. Thanks to the splendid
efforts of scholars like Allen, Jowett, McLean, Merritt, and Slout, a foundation has
been laid for the role of early films as one approach by American society, albeit a
patriarchy, moving through a transitional stage in its history, to place in perspective,
its shared experiences. To vaudeville managers, films may have been an invaluable
commercial asset in the ongoing competitive wars, but to turn-of-the-century
audiences films were not mere entertainment or an inexpensive way to escape from
reality. On the contrary, films became a major art form that allowed the public to
interact with its culture. "Judging from the accounts of film historians," Judith
Mayne observes, ". . . films seemed to play three major roles in the lives of
immigrants: they were a form of socialization and apprenticeship into American life;
they were makeshift 'schools' for the learning of English; and they were an escape
from the realities of work and tenement life."[869]

[864] William L. Slout, "UNCLE TOM'S CABIN in American Film History," JOURNAL OF
 POPULAR FILM 2:2 (Spring 1973):143. Interestingly, Modleski reviews studies of
 popular eighteenth and nineteenth century feminine literary work and their
 influence on contemporary life and letters. UNCLE TOM'S CABIN, Little Eva, and
 Harriet Beecher Stowe are considered by some modern feminists responsible "for
 many of the evils of mass culture." See LOVING WITH A VENGEANCE, p.15. May, on
 the other hand, credits (p.16) Stowe with setting the standards that ensured
 Victorian values in theaters as well as in the home and church.

[865] Jowett, p.17.

[866] Robert C. Allen, "The Movies in Vaudeville: Historical Context of the Movies as
 Popular Entertainment," THE AMERICAN FILM INDUSTRY, Rev. ed., p.80.

[867] Albert F. McLean, Jr., AMERICAN VAUDEVILLE AS RITUAL (Lexington: University of
 Kentucky Press, 1965), p.2.

[868] McLean, p.ix.

[869] Judith Mayne, "Immigrants and Spectators," WIDE ANGLE 5:2 (1982):33. For the
 relationship between women and the Hollywood studio system, see Elizabeth Ewen,

Despite the absence of empirical evidence, one can speculate that almost from the birth of projected films moviegoing was mainly a group experience. That is, people viewed movies in the presence of other people. And, as Austin points out,

> Regardless of whether the individual elects to attend alone or in the company of others, the physical ambience of the theater, the form of exhibition, and a host of other factors may play important roles in determining not only attendance decisions but also the film experience itself.[870]

What has never been fully explored in the years that followed was what effect the varying contexts (e.g., vaudeville houses, nickelodeons, picture palaces, second-run theaters, and drive-ins) have had on filmgoers' experiences.

But from the early 1900s on, the film industry strove to become the people's art.[871] The three groups of urban moviegoers identified by Jowett had by 1908 ceased to satisfy the get-rich schemes of the early filmmakers. Exhibitors pictured the ideal audience, according to Russell Merritt, as those who frequened vaudeville houses. Why that was true is not clear. It was assumed, however, that attracting the middle class would also attract increased profits. "The question," observed Merritt, "was how to lure that affluent family trade--so near and yet so far away. The answer most commonly arrived at was through the New American Woman and her children."[872] In the past, European films constituted more than half of the films show on American screens. Not only did the content of these German, French, and Italian productions run counter to Victorian values, but their generally risque overtones also proved offensive to genteel women.[873]

The decision to go after the bourgeoise audience signaled a shift away from foreign films and toward a more "American" product. An appeal to the interests of white, middle-class women, coupled with film content emphasizing a strict Victorian code of morality, produced the desired results.[874] Not only were the movies able to

"City Lights: Immigrant Women and the Movies," SIGNS: A JOURNAL OF WOMEN IN CULTURE AND SOCIETY 5:3 (Spring 1980):45-65.

[870] Austin, THE FILM AUDIENCE, p.xxix.

[871] For examples of what early exhibition patterns were like, see Robert C. Allen, "Motion Picture Exhibition in Manhattan, 1906-1912: Beyond the Nickelodeon," CINEMA JOURNAL 18:2 (Spring 1979):2-15; David O. Thomas, "From Page to Screen in Smalltown America: Early Motion Picture Exhibition in Winona, Minnesota," JOURNAL OF THE UNIVERSITY FILM ASSOCIATION 33:3 (Summer 1981):3-13; Burnes St. Patrick Hollyman, "The First Picture Shows: Austin, Texas (1894-1913)," ibid., 29:3 (Summer 1977):3-8; and Richard Alan Nelson, "Florida: The Forgotten Film Capital," ibid.,pp. 9-21.

[872] Merritt, p.6.

[873] May, SCREENING OUT THE PAST: THE BIRTH OF MASS CULTURE AND THE MOTION PICTURE INDUSTRY, p.37.

[874] Allen and Gomery suggest that many basic assumptions about the so-called "Nickelodean Era" need revision. For example, their research points out the importance of public transportation in determining where movie houses were built, the attractive quality of many of these theaters, the different attitudes immigrant groups like Italians and Jews had toward movies, and the need to consider the years from 1910 to 1915 as more significant in the development of picture palaces than as an era of dingy movie houses. See Allen and Gomery, pp.202-6. In addition, Peter Baxter offers an intriguing commentary on how the exhibitors used electricity to increase profits. See Peter Baxter, "On the History and Ideology of Film Lighting," SCREEN 16:3 (Autumn 1975):83-106A Still

sustain the loyalty of their initial supporters, but, as Merritt reports, by 1912 better-educated patrons and white-collar workers expanded the audience base.[875] I would add that the appeals made to feminine interests represented more what a patriarchy felt white women should value, rather than what women themselves desired. The truth about how women in our culture responded to the stock situations and social types depicting them as both object and victim is yet to be determined. For that matter, we also need to learn a great deal more about the appeal of the new movie houses, and why they were able to draw so many patrons away from big-time vaudeville. In sum, what was the relationship among the audience, the exhibition hall, and the novelty of film?

The period from 1908 to the end of World War I brought about a number of important changes not only to the structure and nature of the American film industry, but also to the relationship between society and film. Many of these changes have been discussed earlier (e.g., the recognition and fear that the medium was undermining social and political traditions of behavior and the growth and development of an oligopolistic industry) or will be discussed in Chapter 6 (the rise of the star system, the construction of picture palaces, and the advent of feature films). What is worth noting here is the manner in which different segments of society from 1908 to 1920 typecast film audiences and the film itself.

In each instance, like those characters who interpreted Hamlet's "antic disposition" to fit their purposes, government officials, educators, social reformers, religious leaders, and critical reviewers perceived the filmgoing public and the medium itself in a manner that fit the observer's specific agenda. For example, I have discussed in Chapter 2 how, in 1917-1918, the Division of Film operating in the Committee on Public Information (CPI) sought to manipulate the values and attitudes of World War I audiences. Films, as far as the CPI was concerned, functioned as a direct stimulus to the impressions and beliefs of a passive and naive mass audience. Known either as "the stimulus-response theory" or as the "hypodermic effect," the fear was that mass audiences responded relatively uniformly to a carefully controlled and calculated stimulus. This virtually unchallenged assumption led government officials and reformers, from 1917 on, to insist on some form of social control over the types of propaganda that could be depicted in theatrical films. Jowett, in much of his published research dealing with the era from 1908 to 1922, describes how progressives feared the influence of movies on manners, health, education, religious values, and child development. In reading Jowett's reactions to the positions taken by Jane Addams, John Dewey, John Collier, William Healy, and Vachel Lindsay, we can see the crucial link between the film's alleged negative influence on childhood development and social conditioning and its presumed threat to society-at-large. In fact, Jowett concludes that despite geographical or educational differences, the concern nationwide was that movies by 1918 contributed to a number of society's problems, including juvenile delinquency, sexual misconduct, anti-social behavior, and difficulties in interpersonal relationships.[876]

There is no doubt that these often reported assertions and long-standing explanations of what films do or do not do, or how they "affect" our society, need reevaluation. If current research on the public's attitude toward movies is accurate, then hostility toward the medium is on the upswing.[877] One particular area especially needing reassessment is mass communications research and its reliance on empirical

further, Isod argues that the new theaters served not only to reinforce popular ideas about equality in the industrial age, but also to provide a common set of values among disparate groups in urban and rural settings. See Izod, pp.9-13.

[875]	May, pp.7-8.

[876]	See, for example, FILM: THE DEMOCRATIC ART, pp. 77-94.

[877]	Austin, p.xxxi.

methodology. Because Robert C. Allen has attempted such a reassessment in his intriguing book SPEAKING OF SOAP OPERAS, his approach merits mention here as an introduction to the general survey of film audience research that follows.

Allen's serious attempt to justify soap operas as a valuable and complex "mode of discourse" taking place in an industrial setting is predicated on an anti-empiricist methodology. He attacks not only exclusively quantitative analyses, but also the lack of objectivity by empirical investigators and the inadequate emphasis they place on research models related to the natural sciences for the examination of cultural phenomena. His justification for devoting the initial part of his stimulating book to a discussion of the "philosophical underpinnings of American empiricist mass media research" is that American scholars still retain a strong commitment to the discredited methodology. Whether or not one agrees with his premise that anti-empiricists now "occupy the field,"[878] the issues he raises about how media study has evolved in this country have relevance to our examination of film and society.

For example, Allen argues that before we can examine what people say about soap operas [or films] there needs to be an examination of what the people who are speaking assume and omit from the discourse. Put another way, and more in the context of this discussion, the turn-of-the-century theater critics who derided film maintained fixed attitudes about what constituted art, who were artists, and what art accomplished.[879] Until such time as those traditional precepts were challenged or reassessed, film remained outside the realm of the accepted arts, the audiences that went to see movies were relegated to a second-class status, and the "things" that movies "did" to people were highly suspect and controversial. In other words, the new media and their genres found themselves involved in the perennial battle between highbrow art and popular culture. It is an issue that we keep coming back to throughout this book. For our purposes here, we need only note that the traditional aestheticians characterized those who substituted "gratification" for "art" as individuals who not only put profit over purpose, but also who subverted the social order. In essence, these traditionalists are reminiscent of those social critics discussed earlier who worried aloud about the negative effects of "celebrities" in our society.

Allen's useful contribution to the study of film audiences is to summarize the problems related to empirical research methods in American mass communications research.[880] Starting with Lazarsfeld's enormous influence in getting American scholars to provide commercial broadcasters with "administrative research" studies, Allen highlights what was wrong with tying academic research to commercial interests. In effect, the industry determined the areas of interest. The assumption, mentioned earlier, was that the media channeled messages much as a "hypodermic" needle injected a serum into a person's arm. The passive individual remained helpless to resist the serum (the message).[881] Since the industrial community was interested in determining how best to create a "hypodermic effect" in a "media audience . . .

[878] *Robert C. Allen, SPEAKING OF SOAP OPERAS (Chapel Hill: University of North Carolina Press, 1985), p.5.

[879] Allen, p.12.

[880] Allen, pp.30-44.

[881] A more balanced interpretation of what researchers meant by "the stimulus-response theory" or "the hypodermic effect" is provided by Melvin DeFleur, who insists that scholars always assumed that human nature and society mediated the effects of media messages. Cf. *Melvin DeFleur, THEORIES OF MASS COMMUNICATION (New York: David McKay Company, 1970), pp.112-117. Also useful is *Denis McQuail, TOWARDS A SOCIOLOGY OF MASS COMMUNICATIONS (London: Collier-Macmillan, 1969), p.52.

atomized, passive, and incapable of mediating the effects of these messages,"[882] Lazarsfeld and his colleagues provided a more reliable interpretation of what actually occurred between the sender of the message and the intended receiver. That is, media effects reach individuals indirectly because they are mediated both by the needs of the individual and the context in which the message is received. This alternative research paradigm appeared more objective and quantitative and consequently appealed to the industrial community. Thus Lazarsfeld's "personal influence" model kept scholars funded while at the same time satisfying broadcasting's economic imperatives. So long as empirical research reinforced the broadcaster's belief that the public could be persuaded to buy a specific product or concept, empirical research flourished.

In the meantime, media observers developed an "encrusted image" of a lower-to middle-class audience incapable of appreciating art, alienated from meaningful experiences, and susceptible to frequent manipulation by media messages. In other words, what social critics and reformers today attack in the media--e.g., sexual promiscuity and gratuitous violence--dates back to what has been assumed about mass media audiences from the start.[883] Allen's intention is not to deny that working-class people watch the media or "learn" from their products. Rather, his point is to sensitize us to the fact that a term like "soap opera . . . [or movie audiences] carries with it a set of deeply embedded attitudes toward it, that it has come to 'mean' because of its position within and across discourses--a position relative to notions of art, mass media, social status, gender, and culture."[884] What scholars like Allen and Jowett have shown is that the film industry consciously directed its procedures and policies toward creating audience desires. The strategy was always to produce a product labeled "escapism," "entertainment," or "realistic drama," and to convince the public that this is what it wanted and enjoyed.

Long before mass media research became a reality, filmmakers made going to the movies a national habit. For example, Merritt conservatively estimates that by 1910, nickelodeons were attracting on a weekly basis almost twenty percent of the American population (26 million people). That same year, he estimates gross receipts for the film industry totaled $91 million.[885] The film industry attracted such impressive numbers by manufacturing massive advertising programs that used the studio's "stars" to differentiate among their products and those of their competitors. Furthermore, Hollywood began by targeting its production policies away from the presumed desires of the working classes and toward a middle-class audience.[886]

[882] SPEAKING OF SOAP OPERAS, pp.22-3.

[883] Susan McNamara reports that current research indicates that major causes of violence in modern children are a result of "divorce, single-parent families, day-care situations, economic problems. . . ." See Susan McNamara, "When Kids Get Mad," BURLINGTON FREE PRESS D (February 1, 1989):1.

[884] SPEAKING OF SOAP OPERAS, P.29.

[885] Merritt, p.86.

[886] Worth examining is an argument by Gans that as late as the 1960s it was Hollywood's working-class emphasis that made American films popular with foreign audiences. He contends that "Hollywood films portray people with working class traits who are seeking . . . [middle-class life styles.]" In addition, Gans points out that the American film industry's formula production policies were conceived during a period when its filmmakers and audiences were "themselves the descendants of European peasants and shopkeepers." Cf. Herbert J. Gans, "Hollywood Films on the British Screens: An Analysis of the Functions of American Popular Culture Abroad," SOCIAL PROBLEMS 9:4 (Spring 1962):324-8.

The strategy worked wonders at the box office. Mass media statisticians claimed that many individuals frequented movie houses on the average of three days a week. W. P. Lawson was more exact:

It is estimated that there are today [1915] between seventeen and eighteen thousand motion picture theatres in the United States, to which more than ten million people go daily. A commission appointed by the Mayor of Cleveland in 1913 reported that one sixth of the population of that city went to movie shows at least once a day. During the summer months of 1914 the National Board of Censorship estimated that in New York City between 850,000 and 900,000--one seventh of the total population--attended the motion picture theatres daily. Admission receipts totaled in 1914 [to December 1] approximately $319,000,000 for the movie theatres of the country.[887]

Czitrom added a graphic summary of the data in his accounting of urban movie audiences from 1911 to 1918 (see Table 9). Such figures demonstrate the massive popularity of the movies in major cities.[888] Whatever one's justifiable skepticism about the interpretations of such claims, it is clear that by 1918 movies had become big business. Audiences demanded and received more optimum viewing conditions, longer and better films, and frequent novelty. To meet the demand, the film industry, as discussed earlier, revolutionized its production, distribution, and exhibition techniques.

TABLE 9

URBAN MOVIE ATTENDANCE, 1911-1918

CITY	POPULATION (1910)	YEAR	WEEKLY ATTENDANCE	NUMBER THEATERS
New York	4,766,883	1911	1,500,000	400
Cleveland	560,663	1913	890,000	131
Detroit	465,766	1912	400,000	n.a.
San Francisco	416,912	1913	327,500	n.a.
Milwaukee	373,857	1911	210,630	50
Kansas City	248,381	1912	449,064	81
Indianapolis	233,650	1914	320,000	70
Toledo	187,840	1918	316,000	58

At the same time, a number of fascinating but unsophisticated and unscientific surveys about the relationship between movies and their audiences began appearing. The Reverend J. J. Phelan, issued the results of his 1918-1919 social survey of movies and their status, in Toledo, Ohio.[889] On the one hand, he found that the popular amusement "possessed of infinite social and economic power and . . . capable of

[887] W. P. Lawson, "The Miracle of the Movie," HARPER'S WEEKLY 60 (January 2, 1915):8.

[888] Czitrom, p.42.

[889] Phelan was a graduate student at the University of Toledo at the time he did the study.

unlimited moral and educational worth. Hundreds of thousands each day secure their chief impressions of life, ethics, religion and morality thru the 'movies.'"[890] On the other hand, the moderate writer noted that "Statistics reveal that there are many who feed their nature upon the abnormal, distorted, suggestive and far too often, vicious things of life."[891] His personal investigation of Toledo's fifty-eight movie houses, which included not only on-site visits but also interviews with a range of concerned citizens (e.g., city officials, educational authorities, juvenile court officials and religious leaders), produced a number of interesting observations. In matters of attendance, approximately 45,000 people went to the movies each day; 316,000 each week; and 16,380,000 each year. Of the 80,000 young people under eighteen years of age, twenty-five percent attended movies on the weekends.[892] Phelan also included in his report the results of other school surveys taken in recent years. For example, data collected on 2,464 grammar schoolchildren in Providence, Rhode Island, revealed that fewer than 160 children never went to the movies; Cleveland reported that seventy-eight percent of its male elementary schoolchildren went to the movies, eighty-four percent of its female students did the same; and Portland, Oregon, had nearly ninety-two percent of its 2,647 children under fourteen years of age attending movies, more than twenty-eight percent twice a week or more.[893]

Phelan's conclusions stressed the fact that analyzing the effects of the movies on society is a complex task. Nonetheless, he believed that the psychological impact from screen stories and images posed a threat to community life and values. One suggestion, therefore, was to sensitize parents to their responsibilities in permitting children to attend movies indiscriminately. He also advocated censorship departments at the municipal level that would coordinate censorship activities with state and national groups.[894] Given the times and the circumstances, Phelan's survey (the first comprehensive study of movies as an urban amusement) sounded a balanced, if somewhat predictable, note.

That was not the case in 1921 when the Columbia psychologist A. T. Poffenberger argued that "an inquiry into the accusations that have been made against the motion picture seems justified at this time when attention is being centered upon the means of crime prevention."[895] Although acknowledging that under the best circumstances movies operated as a powerful educational force at home and abroad, the applied psychologist worried about the potential harm to children and mentally deficient adults who might erroneously use films as "a training school for anti-Americanism, immorality, and disregard for the law. . . ."[896] What distinguishes these two groups from other members of the film audience, he argued, is their gullibility, an inability to act responsibly at all times, the lack of self-restraint, and a frequent misunderstanding of reality. Therefore, the Columbia psychologist felt that movies, with their emphasis on violent crimes, mislead the young and the mentally deficient. While normal adults can see and understand that in the last reel crime

[890] J. J. Phelan, MOTION PICTURES AS A PHASE OF COMMERCIALIZED AMUSEMENT IN TOLEDO, OHIO (Toledo: Little Book Press, 1919), p.9.

[891] Phelan, p.9.

[892] Phelan, pp.37-8.

[893] Phelan, pp.51-3.

[894] Phelan, pp.120-2.

[895] A. T. Poffenberger, "Motion Pictures and Crime," SCIENTIFIC MONTHLY 12:19 (April 1921):336.

[896] Poffenberger, pp.336-7.

doesn't pay, children and mentally deficient adults cannot understand the distinction between right and wrong. Furthermore, he rejected the idea that movies are merely giving the public what it wants. He argued that it was the job of films to teach the public what is worthwhile and then to reinforce it by a series of valuable illustrations. Thus Poffenberger, like Phelan, accepted the then-standard assumptions that the public innocently attended films whose direct and powerful film messages were taken by the passive audience at face value. The two social critics also reinforced the prevailing notion that movies fueled the nation's crime rate and that America's children needed protection from the evil influences of film.

Contributing to the position taken by Phelan and Poffenberger was a noticeable transformation in the way alarmists interpreted the relationship between entertainment and crime in society. Before 1915, for example, Robert Davis discovered that attacks on the media were based upon specific crimes that could be traced to a particular film incident. Social critics then argued from inferences about causal effects. After 1915, however, alarmists relied on less tenuous assertions. Now reformers recorded and reported the opinions of people incarcerated in penal institutions. The general secretary of the big brother movement held personal interviews with boys in reformatories, asking them what influence movies had on leading them into a life of crime. Later studies, as discussed below, came to rely heavily on this type of information gathering.[897]

By the early 1920s, most people were aware that films were a commercial industry trying to sell its product to the public based on the idea that movies were a form of entertainment, nothing more. At the same time, social critics recognized the effect that the illusion of objective reality had on uncritical audiences. As the industry perfected its formula films and increased its popular appeal, social critics debated not just to what extent films should be suppressed, but also what positive uses the film industry could provide.

In 1923, the critic Tamar Lane collected material that was included in articles written for THE MOTION PICTURE MAGAZINE and THE SCREEN in order to demonstrate the great possibilities of films. The problems raised by the medium's detractors, Lamar insisted, resulted from the people who produce films and not from film itself:

> There are no artists of the photoplay. They are all business men and women. All so wrapped up in the chase after the mighty dollar that the only time they have to think of their art is when the interviewer from the Motion Picture Magazine [sic] arrives to have tea with them. They are then artists, exclusively.[898]

The incensed author took particular aim at the "white headed boys of the screen, the pampered pets of the fearless critics, the so-called geniuses of the Photoplay. . . ."[899] Thus, D. W. Griffith, Cecil B. DeMille, and their colleagues were accused of selling out in much the same manner that later generations of social critics would attack each WUNDERKIND of the seventies: Steven Spielberg, George Lucas, and Francis Ford Coppola. In twenty free-wheeling chapters, Lane took potshots at the entire film industry but concluded that the movies would remain a marvelous art form in spite of the current crop of producers, directors, performers, exhibitors, writers, and critics.

How successful Lane and other optimists were in influencing the values of researchers was evident three years later when Harold Ellis Jones and Herbert S.

[897] Davis, pp. 262-3. See also Jowett, "From Entertainment to Social Force," pp. 11-20.

[898] Tamar Lane, WHAT'S WRONG WITH THE MOVIES? (Los Angeles: The Waverly Company, 1923, New York: Jerome S. Ozer, 1971), p. 14.

[899] Lane, p. 15.

Conrad published their investigation into the rural film preferences of New Englanders.[900] Based upon 200 responses from four Vermont and New Hampshire test sites, the investigators concluded as follows:

1. In the use of pictures for motivation purposes in a social survey, the choice of the picture is an important factor. Care is needed in adapting the program to sectional interests.

2. In the rural groups studied, a strong Puritanical tradition is still flourishing, and is no doubt one of the reasons for the adverse criticism of "The Last Laugh" and of Charlie Chaplin. Evil must be painted in murky colors, and the consequences of misdeeds must be clearly exposed. Sympathy with human weaknesses (as with drunkenness in "The Last Laugh") tends to be regarded as a shocking example of moral laxity.

3. The groups showed a dislike for pictures of farm life and of rural settings, unless these were explicitly "Westerns."

4. City and society pictures were unpopular.

5. Films of objective action, with plots at the dime novel level, but with wholesome and happy endings, were uniformly successful. Some of the parents objected that these were "too exciting," but the general tolerance for this type of excitement seemed to be somewhat elastic.[901]

The Jones-Conrad report reflected both the changes that had taken place in American society as a result of the movies' becoming a major industry, and the obstinacy of the medium's critics toward its perceived social role. For example, small towns still maintained a greater hold on their citizenry than urban areas. As a result, it was much easier there to reinforce Victorian values and traditional family life-styles. On the other hand, the filmmakers played to the audiences' curiosity about the transitions taking place in urban areas across the nation. As the films of the twenties "legitimized" the radical changes in sexual roles, family relationships, work habits, and economic values, it became more difficult, as one songwriter aptly wrote, "to keep them down on the farm." And because reformers and researchers still viewed audiences as passive receivers of these subversive messages, social critics understandably feared the negative influence of films on mass audiences. Not surprisingly, the filmmakers remained uneasy about ways to match their profit objectives with the educational and aesthetic demands of society.[902] As for film audience research, it still neglected to determine how audiences made their film

[900] Modern-day researchers are still trying to determine what the public likes and doesn't like in order to insure the success of a commercial venture. For example, a major TV-network has been market-testing its prime-time shows ever since the end of the fifties on the assumption that the testing process works. "The fact is," CBS president Bud Grant states, "70 perecent of all shows fail. If testing were more accurate, all three networks would have nothing but hits." Cf. Sandra Salmans, "At CBS-TV, They're Testing 1, 2, 3, . . ." NEW YORK TIMES D (May 2, 1986):3.

[901] Harold Ellis Jones and Herbert S. Conrad, "Rural Preferences in Motion Pictures," JOURNAL OF SOCIAL PSYCHOLOGY 1:3 (August 1930):423.

[902] Another period study worth reading is *Phyllis Blanchard, CHILD AND SOCIETY (New York: Longmans, Green and Company, 1928).

choices, for what reasons, and what relationship existed between a film's impact and the place in which the film was seen.

A final illustration of the early studies and their concern with the effect that movies were having on the next generation was the investigation undertaken by Alice Miller Mitchell. Conducted in Chicago in 1929, the single most extensive research project since Phelan's Toledo analysis attempted to assess one aspect of the social role of movies in a major city. How important movies were as a social institution in Chicago was evident by the author's hyperbolic report that 384,449 people could go at one time to the city's 382 movie theaters. Even further, if one multiplied the four performances per day per theater, one could estimate that fifty percent of the city could conceivably go to the movies every day.

It was obvious to Mitchell that a large proportion of those who did go to the movies were children. What concerned her was what the movies might be doing to the next generation.[903] To find out, she selected 10,052 children and then divided them into three groups: one from the public schools, one from detention homes for juvenile delinquents, and one from Boy Scouts and Girl Scouts. Her purpose was to compare the film experience of these three control groups. Rather than gathering the data mainly through personal interviews and group discussions, she relied primarily on two written questionnaires administered during the regular school year and under the supervision of a classroom instructor. Clearly, there were drawbacks to this potentially unreliable method of investigation. But in 1929, it represented a major step forward in research methodology.

The results of Mitchell's surveying techniques confirmed a number of widely held views. For example, she reported that "practically all children of all classes go the movies . . . [and that] they all go as a matter of course." In fact, of the 10,052 children tested, she concluded that less than two percent never went to the movies at all. Over ninety percent attended movies from once a month to seven times a week. While juvenile offenders on the average went to the movies frequently, the majority of children averaged one or two visits a week. Of that combined group, boys and girls, on the average, frequented the movie theater about twice a week. A more careful look at the figures revealed that "the number of boys who attend from three to seven times a week is double that of the girls."[904] As for the movie theater, it proved to be not only a more enjoyable and interesting playground than traditional play areas, but also more appealing to young people, "for when he returns from the movie to his own 'back yard' he has new ideas of what to play and how to play it."[905] The types of movies boys most preferred were westerns, adventures, comedies, and mysteries; girls opted for romances, comedies, westerns, and tragedies.[906] Mitchell also discovered that delinquent offenders not only saw more films than the other two groups, but they also had a greater range of choices in what they went to see and when they could go to the movies.[907] In the end, she concluded that exposure to adult themes during a child's formative years was potentially harmful and might even rob children "of some of their preciousness of childhood."[908]

[903] Alice Miller Mitchell, CHILDREN AND MOVIES (Chicago: University of Chicago Press, 1929, New York: Jerome S. Ozer, 1971), p.66.

[904] Mitchell, pp.18-21.

[905] Mitchell, p.76.

[906] Mitchell, p.104.

[907] Mitchell, p.133.

[908] Mitchell, p.148.

Such studies led eventually, as discussed earlier, into a new specialty in the social sciences: mass communications research. Over the next twenty years, as Lazarsfeld observed, the new specialty branched off into four specific sections: the problems of social control, content analysis, the composition of the audience, and the effects of the media on individuals and groups.[909] Film research in these new areas got off to a sluggish start, due in large measure to the attitudes of the filmmakers themselves. Not only did the Hollywood moguls distrust intellectuals and their presumed "scientific" methods, but they also feared that audience research might disrupt studio autonomy and ingenuity. Consequently, they didn't support the research. After all, men like Zukor, Mayer, Thalberg, Fox, Laemmle, the Warner brothers, and Cohn felt that they knew what the public wanted. The soaring box-office profits confirmed their contempt for "researchers" and reinforced their faith that they knew best how to give the public "the movies the public wanted to see."

Despite the discouragement, social historians of the 1910s and 1920s remained intrigued with the relationship between Hollywood's themes and its mass audiences. At first they presumed falsely, that the film capital was synonymous with a standardized product aimed at satisfying the public's most unsophisticated tastes. But thanks to modern scholars like Jarvie, Jowett, Sklar, and Walsh, the "homogeneous film theory" is now in the process of being discredited. A careful reading of the existing research as well as an understanding of cultural hegemony is demonstrating that diversity rather than conformity was more characteristic of West Coast filmmaking in its embryonic stages. For example, in matters of crime, sexual mores, and social injustice, filmmakers exhibited considerable freedom. Indeed, Richard Moley lists more than a score of early 1920s provocative film titles--e.g., A SHOCKING NIGHT, THEIR MUTUAL CHILD, THE WAY WOMEN LOVE--which "blazed on the marquees of thousands of theatres in big cities and small towns all over a country which still preferred to believe, although its eyes and ears told it otherwise, that sons and daughters succumbed to the temptations of neither sex, alcohol nor tobacco."[910] The point is that no one formula prevailed at the box office, nor did dominant social values prevent residual or emerging perspectives from being presented. There is no doubt, however, that Progressives, led by the Protestant establishment, waged a strenuous campaign to force the film industry to turn away from its "disruptive" and "unseemly" value system and move toward a more responsible and uplifting role in society.

Following a series of devastating film scandals in the post-World War I era (discussed in Chapter 6), the film industry suffered serious problems with the public and with the financial community. Thus, the movie moguls found it necessary not only to bring in a film czar, but also to establish (as we shall see later) more rigid controls over film content. The transformation took almost a decade to put in place. The result was to change the relationship between Hollywood's themes and its mass audiences by creating an insulated film industry that significantly limited the scope of its film content from the mid-1930s until the 1950s.

While the nature and impact of that film content remain a central issue in contemporary film studies, we need to reiterate that a major assumption running through the hundreds of mass media studies up to the 1950s was that audiences remained relatively passive in the face of media messages. The behavior stimulated by these media messages was thought, in many cases, to be harmful not only to individuals, but also to groups. Society, therefore, felt required to defend itself against the mass media. As a result, "scientific" studies were often commissioned in

[909] Lazarsfeld, p.160.

[910] Raymond Moley, THE HAYS OFFICE (Indianapolis: The Bobbs-Merrill Company, 1945), p.26.

the hopes of providing a justification for setting up censoring bodies (or anti-propaganda groups), all in the name of social control.

The first major empirical studies on the social content of film and its effects upon the audience were those of the Motion Picture Research Council.[911] Preoccupied with the alleged criminal-inducing effects that movies were having on children, William Short, the man who conceived the project, set out, in Sklar's words, "to get the goods on the movies, to nail them to the wall."[912] Backed by a major grant from the Payne Study and Experiment Fund, Short put together a team of nineteen investigators--psychologists, sociologists, and educators--who were concerned with questions like the following:

> Do the pictures really influence children in any direction: Are their conduct, ideals and attitudes affected by the movies? Are the scenes which are objectionable to adults understood by children, or at least by very young children? Do children eventually become sophisticated and grow superior to pictures? Are the emotions of children harmfully excited?

The difficulty in determining the answers to these questions was compounded by the fact that the investigators modeled their research techniques after a paradigm used in the natural sciences. That is, content analysts presumed that human beings behaved similarly in and out of a "lab" environment.

Initiated in 1928, the Payne Fund studies to determine what to do about the widespread influence of film did not start until 1929. The investigators quickly set their sights on discovering how the movies affected young people in particular. Eleven separate studies, each attempting to measure how content, attendance, and film messages interacted to produce specific results, were synthesized in a single report, W. W. Charters's MOTION PICTURES AND YOUTH: A SUMMARY.[913] The research methods used by Charters not only summarized the techniques employed by the other Payne Fund study investigators, but also illustrated the strengths and weaknesses of "objective" data collection. For example, measuring the nature and type of reaction that film audiences had to specific scenes or incidents required clear definitions of

[911] The series, entitled "Motion Pictures and Youth" and published in New York by the Macmillan Company in 1933, consists of Herbert Blumer, MOVIES AND CONDUCT; Herbert Blumer and Philip M. Hauser, MOVIES, DELINQUENCY AND CRIME; W. W. Charters, MOTION PICTURES AND YOUTH: A SUMMARY, combined with P. W. Holaday and George D. Stoddard, GETTING IDEAS FROM THE MOVIES; Paul G. Cressey and Frederick M. Thrasher, BOYS, MOVIES AND CITY STREETS; Edgar Dale, THE CONTENT OF MOTION PICTURES, combined with Edgar Dale, CHILDREN'S ATTENDANCE AT MOTION PICTURES; ___, HOW TO APPRECIATE MOTION PICTURES; W. S. Dysinger and Christian A. Ruckmick, THE EMOTIONAL RESPONSES OF CHILDREN TO THE MOTION PICTURE SITUATION, combined with Charles C. Peters, MOTION PICTURES AND STANDARDS OF MORALITY; Ruth C. Peterson and L. I. Thurstone, MOTION PICTURES AND THE SOCIAL ATTITUDES OF CHILDREN, combined with Frank K. Shuttleworth and Mark A. May, THE SOCIAL CONDUCT AND ATTITUDES OF MOVIE FANS; and Samuel Renshaw, Vernon L. Miller, and Dorothy Marquis, CHILDREN'S SLEEP. These have all been reissued by Arno Press, under the general editorship of Professor Martin Dworkin. The original twelve studies, published in these volumes, were supervised by Professor W. W. Charters, the Director of Ohio State University's Bureau of Educational Research.

[912] Sklar, p.134.

[913] Actually, there were twelve studies planned. As Sklar notes (p.135), the total project lasted four years (1929-1932): "Nine of the research reports were published in 1933, two came out two years later, another for unknown reasons never appeared in print, and separate scholarly and popular summaries interpreted the significance of the total body of work."

what type of movie--e.g., genre, commercial versus educational movie, and feature or short subject--was being evaluated and in what context--e.g., classroom, movie theater, and experimental center--the evaluation was being done. Equally important was the need to define precisely what presumed effect the movie was having and how the causal relationship was measured and proven reliable. Clearly, the definitions established and the conclusions reached reflected more than a modicum of biases ranging from individual investigator expectations to the group's special interest in providing objectifiable data on the extent of motion picture influence.

To the credit of most of the investigators, they did not claim that their data resulted in absolute knowledge. Instead, they predicated their conclusions on the fact that the tests and measurements resulted in hypotheses rather than in precise, predictable data. Except for Herbert Blumer's controversial book, MOVIES AND CONDUCT, the investigators tried to restrict their theories on how movies affected children to empirical data. For example, Ruth C. Peterson and L. I. Thurstone demonstrated that young people reacted to movies about war and prejudice with a specific set of attitudes that changed over a period of days, weeks, and months following the screening of the films. In the best traditions of content analysis, the researchers based their conclusions only on the empirical evidence they collected, and not on speculations suggested but not confirmed by the data.

An important example of the methods used in gathering empirical information on the comparative social content of films is provided by Edgar Dale's THE CONTENT OF MOTION PICTURES. Focusing on methodologies and classifications, his comprehensive study is divided into three areas. First, he covers the complete film production (1500 films) of major Hollywood studios in the years 1920, 1925, and 1930. Dale then categorized the ten most important themes of the motion pictures according to their frequency in the films. In order of importance, he found love, crime, comedy, sex, mystery, war, travel, history, children, and social propaganda. After this he analyzed 115 films selected from the period 1929-1931. Here his moralistic bias is evident in the treatment given various aspects of our society. His six major categories are the nature of American life and culture, the motivation of characters, crime, delinquency and violence, relations of the sexes, and depiction of underprivileged people. These are again divided into subheadings. For example, under the first category are topics like (a) home, (b) education, (c) religion, (d) economics, (e) agriculture, (f) industry and commerce. There are sixteen subheadings in all, which themselves are divided into additional subheadings. Dale then intensively studied selected films (forty of the previous 115), obtaining film scripts as well as taking copious notes during screenings. Each analysis summarizes the important material connected with setting, characterization, plot development, sex, marriage, romantic love, crime, recreation, drinking, smoking, vulgarity, and the goals of major characters.

By looking at some films from 1929 to 1932--e.g., ALL QUIET ON THE WESTERN FRONT, HALLELUJAH!, SHANGHAI EXPRESS, SCARFACE--and using Dale's subjective value judgments, we have a basis for discussing not only the validity of certain aspects of American mass media research, but also the nature of specific social content and stereotyping in films. In Table 10, Dale gives a balance sheet for motion picture content, which offers a good starting point for analysis.

TABLE 10

BALANCE SHEET FOR MOTION-PICTURE CONTENT

The following aspects or problems have received attention, sometimes excessive, in the motion pictures	The following aspects of problems have received scant attention in the motion pictures

Life of the upper economic strata	Life of the middle and lower economic strata

| Metropolitan localities | Small town and rural areas |
| Problems of the unmarried and the young | Problems of the married, middle aged and old |

| Problems of love, sex, and crime | Other problems of everyday life |
| Motif of escape and entertainment | Motif of education and social enlightenment |

| Interest appeal to young adults | Interest appeal to children and older adults |

| Professional and commercial world | Industrial and agricultural world |
| Personal problems in a limited field problems | Occupational and governmental |

| Comedy foreigner such as dumb Swede | Representative foreigners such as the worker, business man |

Diverse and passive recreations	Active and inexpensive recreations
Individual and personal goals	Social goals
Variety of crimes and crime techniques	Causes and cures of crime
Emphasis on the romance and the unusual in friendships	Emphasis on the undramatic and enduring in friendship
Physical beauty	Beauty of character
Emphasis on physical action and portrayal of character	Increased skill in analysis of motives

| Sports and trivial matters frequently shown in newsreels | World news of an intellectual and perhaps of an undramatic type, results of scientific findings, pictures of real conditions in different parts of the world |

No doubt, the reader has already noticed the many "unscientific" lapses in Dale's research: e.g., the lack of objectivity, the many subjective definitions, the untested assumptions that "reality" and "fiction" are blurred in the eyes of the audience, and the presumption that mass audiences respond relatively uniformly to movie stimuli. For example, noting the lack of reality in the film stories, Dale concluded that motion pictures tended to stereotype society by over-emphasizing sensational aspects of sex, violence, and romantic love.[914] No mention is made of visual or auditory techniques, nor is there any concern for aesthetic differences in the films screened by the audience. Thus, Dale's study exemplifies how, on the one hand, content analysis provided some valuable insights into our culture, and, on the other hand, presumed a "scientific" respectability it neither possessed nor ever developed.

[914] Dale, p.229.

While other Payne Fund studies demonstrated similar problems, they also offered interesting observations. For example, Peterson and Thurstone, using an attitude scale of a paired comparison schedule, studied the effect of motion pictures on the social attitudes of children. One of their major concerns was with measuring the effect that a motion picture could have on attitudes relating to nationality, race, crime, war, capital punishment, and the punishment of criminals. They concluded that "motion pictures have definite lasting effects on the social attitudes of children and that a number of pictures pertaining to the same issue may have a cumulative effect on 'attitude.'"[915] Shuttleworth and May, in working with two groups of school children in Grades 5-9, attempted to measure the responses on examinations by children who went to the movies two or three times a week in contrast to those who went once a month. Recognizing the influence of interacting experiences on the child, they postulated the theory of "specific influence." In effect, this theory holds that when the movies continually present consistent patterns of conduct and personality, there is a carry-over to an individual child's behavior. They concluded that movies do exert an influence, but that the influence is specific for a given child and a given movie.[916] While it was shown that movie children (those who went to the movies more often) made a poorer showing on the educational tests, one wonders whether the tests themselves were valid.

The Payne Fund studies might have made a noncontroversial contribution to the evolution of mass communications research if not for the regrettable exploitation of their findings by a reporter named Henry James Forman. His 1933 sensationalized account of the eleven studies, OUR MOVIE MADE CHILDREN, accented almost every negative conclusion tentatively reached by the investigators. For example, he argued that children who frequented movies most often developed bad sleeping habits, exhibited negative behavior in school, and developed disturbing psychological and mental attitudes. As a result of Forman's opportunistic publication, the film community witnessed a battle of books debating the pros and cons of the Payne Fund conclusions. For example, Mortimer J. Adler took issue with the techniques and assertions by social scientists in evaluating the ethical or political impact of movies in society. In his academically oriented text ART AND PRUDENCE, the scholar virtually decimated the entire mass communications research field.[917] Raymond Moley's concise book ARE WE MOVIE MADE? cleverly tied Forman's merchandising skills to Adler's ideas and presented a more palatable defense of the film industry to a by-now apathetic public.[918] In later years, however, investigators like Margaret F. Thorp, Martha Wolfenstein, and Nathan Leites would return to the issues and methods initiated by the pioneering studies. In almost every instance, the issues discussed throughout this chapter were central in society's fears about the influence of film stereotypes in our society. Each new study rekindled the debate over what kinds of images and ideas were being transmitted to an unsuspecting audience.

As a result of the Great Depression, the early 1930s saw the first major decline in the absolute numbers of people attending films. At the start of the decade, both the public and most film scholars believed the industry's claim that nearly eighty

[915] Peterson and Thurstone, p.66.

[916] Shuttleworth and May, pp.92-3.

[917] Mortimer J. Adler, ART AND PRUDENCE: A STUDY IN PRACTICAL PHILOSOPHY (New York: Longman's, Green and Company, 1937). For a good review of Adler's book, see P. Cressy, "A Study in Practical Philosophy," JOURNAL OF HIGHER EDUCATION 9 (1938):319-28.

[918] Raymond Moley, ARE WE MOVIE MADE? (New York: Macy-Masius, 1938). For a useful summary of the studies' strengths and weaknesses, see FILM: THE DEMOCRATIC ART, pp.220-9; and Thorp, pp.121-3.

million movie tickets[919] were sold each week, and that within three years ticket sales sharply declined. Working on the assumption that the inflated attendance figures for the period were accurate, Ralph A. Bauer found it startling that "If one figures the total population in the early '30s was around 122 million, then the 60 million per week moviegoers represented, on a pure numbers basis, about one-half the population."[920] Whatever discrepancies existed between reported and actual data, by the mid-1930s Hollywood had adjusted to its economic and political problems and attendance was on the rise. FORTUNE magazine, in its April 1936 issue, reported that 70 million people were going to the movies each week. Three years later, according to Kando, "an estimated 85 million Americans once again saw one movie per week."[921] What remained constant in the minds of those who scrutinized the movie industry was the notion that given the right stimulus audiences could be and were influenced by film content.

In examining the reasons for the massive fluctuations in the box office in the mid-1930s, the American film industry focused its attention on stratification.[922] Did it make more sense, the movie moguls asked themselves, to target their films for specific audiences rather than for the general public? "In the past," observed Professor Lewis of Harvard's Graduate School of Business, "the producers had said that pictures cannot be produced for particular classes of people. It has been their contention that these classes are too limited in number and that no picture created for a specific class would have sufficient drawing power to make a financial success."[923] A few experiments were tried, however, and though they produced lackluster results, Hollywood had begun to reconsider one of its most basic approaches to box-office success. That reconsideration led eventually to a reformulation of the industry's stock conventions and social types, and that readjustment in images then affected the ideas marketed in the worldwide distribution and exhibition of American movies.

Uppermost in the minds of many filmmakers of the day was the continuing importance of the gender of the presumed audience. The Payne Fund studies had indicated that women fantasized more than did men in projecting themselves into a film's love story. Furthermore, women allegedly identified more strongly with their screen counterparts than did men. So long as Hollywood believed that women were the dominant force in determining ticket sales, the filmmakers geared their production policies to satisfying the assumed "needs" and "fantasies" of women. For example,

[919] Jowett argues strongly that the film box office was closer to fifty-five million rather than the mythical eighty million traditionally claimed by most film historians prior to the 1980s. He cites as evidence the work of Dr. George Gallup and his Audience Research Institute (ARI). For more information, see Jowett, "Giving Them What They Want," p.30.

[920] Ralph A. Bauer, "When the Lights Went Out--Hollywood, the Depression and the Thirties," MOVIES AS ARTIFACTS, p.27. Bauer credits the 122 million figure to *Arthur Schlesinger, Jr., THE POLITICS OF UPHEAVAL (Boston: Houghton-Mifflin, 1966), p.1; but stresses throughout his perceptive essay that the best figures and statistics are to be found in a 1936 FORTUNE survey that is cited in FILM: THE DEMOCRATIC ART, p.285.

[921] Kando, p.190.

[922] Noel Burch makes the intriguing observation that talkies fundamentally altered the composition of Western film audiences. For example, he claims that seventy-five percent of the French population rarely went to silent films. When sound came in, the population went EN MASSE. See *Noel Burch, TO THE DISTANT OBSERVER: FORM AND MEANING IN THE JAPANESE CINEMA, Rev. ed., Annette Michelson (Berkeley: University of California Press, 1979), pp.144-5.

[923] Lewis, p.83.

Wolfenstein and Leites in their content analysis of American films prior to 1950 conclude that solutions to love problems in American films tended "to be phrased mainly in terms of female types and functions."[924] Not only did Hollywood's heroines seem "in part conjured up in response to otherwise incompletely satisfied wishes,"[925] but also their relationships with their fathers "are almost, without exception, positive"[926] and "the presumable wish of young girls to get their mothers out of the way and to have their fathers to themselves is gratified in . . . films."[927] How movies present women's relationship to men is an issue that feminist film critics continue to debate.

Contributing significantly to Hollywood's attitudes about its mass audiences was Margaret F. Thorp's important study, AMERICA AT THE MOVIES. The noted sociologist pointed out in 1939 that for over a decade the American film audience of 85 million people a week came from approximately twenty-five percent of the population.[928] Put another way, of the 17,000 movie houses found in more than 9,000 towns, there was one seat for every twelve people. The major exception, which will be discussed in more detail later, was the African-American population, whose 12 million people were discriminated against both in film content and in access to movie houses.[929] Thorp's research pointed out that socio-economic factors mattered more to filmmakers than did age, and that industry assumptions about the rigid tastes of small towns and rural patrons were a major factor that helped producers decide what types of films to make.[930]

With so much money and prestige at stake, the film industry finally decided it was in its best interests to know if there was a verifiable pattern to American film tastes. Thus in 1938, Dr. George Gallup (who had been investigating this field since 1935) agreed to establish Audience Research Incorporated (ARI) for the purposes of helping the film industry reduce its business risks. A spinoff from the sampling activities of the American Institute of Public Opinion, the fledgling organization experimented with different techniques for measuring the preferences of mass audiences.[931] Was it true, for example, that stars were the key to box-office success? Once the moviegoing habit is formed, is it indestructible?

[924] Wolfenstein and Leites, p.21.

[925] Wolfenstein and Leites, p.22.

[926] Wolfenstein and Leites, p.713.

[927] Wolfenstein and Leites, p.115.

[928] Margaret Farrand Thorp, AMERICA AT THE MOVIES (New Haven: Yale University Press, 1939), p.3.

[929] Thorp, p.9.

[930] Thorp, pp.10,15.

[931] The ARI, along with Leo A. Handel's Motion Picture Research Bureau (MPRB), provided Hollywood with its basic research information through World War II. During WWII, as Garrison points out (p.145), the most significant information on audiences was gathered by the Research Branch of the War Department. Powdermaker, on the other hand, argues (p.43) that preference polls were not a very effective business practice or a useful guide for producing films. Unlike those preference polls for determining the types of cars consumers want, movie polls operate on a different set of principles. In essence, filmgoers really don't know if they like a film until after they see it.

The first major polling of the public took place in 1940, at the behest of RKO president George J. Schaefer. An ARI team headed by David Ogilvy produced more than 190 surveys that resulted in the demise of many Hollywood box-office myths. For example, the ARI discredited the notion that nearly 80,000,000 people went to the movies each week, that a billion-dollar-a-year box-office gross existed, that women made up seventy-five percent of the audience (the ARI's figure was fifty-one percent), and that people did not grow out of the habit of going to the movies. Of special interest was the fact that nineteen-year-olds went to the movies most frequently, followed by those over thirty. The typical filmgoer was twenty-seven years old. What worried Schaefer and his colleagues most was that a more discriminating film audience was emerging.[932]

Of particular note was the approach taken by the ARI in analyzing "personality values" in the film industry. Known as the "Audit of Marquee Values," it was considered unique for the following reasons: (1) the research was based on a cross-section of the total mass audience going to the movies; (2) the results were obtained through personal interviews, not mailed questionnaires; (3) the questions asked of the theater-going public were more extensively tested than those used in the past; (4) film personalities were chosen by actual ticket-buyers and not by the general public; (5) the actual ratings were determined through a gender analysis of the respondents; and (6) the research was repeated on a regular basis.[933] For example, moviegoers between March 25 and May 5, 1940, were asked which names of stars on the marquee would most get them to buy a ticket. The five leading vote getters that month were Spencer Tracy, Mickey Rooney, Clark Gable, Bette Davis, and James Stewart.[934] In the third audit that same year, Davis had moved into the third spot, Gable had fallen to fourth, and Myrna Loy had tied Stewart for fifth place. The ARI then proceeded to interpret the results, pointing out, for example, that Tracy not only had increased his hold on first place, but also that he was now a bigger box-office draw than Gable. In addition, the analysis provided information on how the size of the community (e.g., under 10,000 and over 500,000) and region of the country (e.g., East or Central) related to the ranking of the various personalities. By the fourth audit in November, 1940, the ARI was charting a performer's progress up and down the popularity poll. The benefit of this trend information, according to the ARI, was to give the studios "a factual basis" for measuring a performer's future popularity and to devise means for influencing the outcome.

While Gallup's Continuing Audit of Marquee Values had considerable respectability for a number of years (it was discontinued in 1952), the technique has recently come under attack as a weak indicator of box-office appeal. Both Thomas Simonet[935] and Gorham Kindem,[936] for example, point out that Gallup's success lies more in measuring the popularity of a star's previous hits, rather than in indicating how successful a star's new film will be with the current audience.

[932] "Boy Meets Facts," p.73.

[933] "Audit of Marquee Values: April 1940," GALLUP LOOKS AT THE MOVIES: AUDIENCE RESEARCH REPORTS 1940-1950 (Wilmington: American Institute of Public Opinion and Scholarly Resources Inc., 1979), pp.1-2.

[934] "Audit," p.3.

[935] Thomas S. Simonet, REGRESSIVE ANALYSIS OF PRIOR EXPERIENCE OF KEY PRODUCTION PERSONNEL AS PREDICTORS OF REVENUES FROM HIGH GROSSING MOTION PICTURES IN AMERICAN RELEASE (New York: Arno Press, 1980).

[936] Gorham Kindem, "Hollywood's Movie Star System: A Historical Overview," THE AMERICAN MOVIE INDUSTRY, pp.86-7.

Of special importance to our understanding of what the film audience looked like by 1940 is Leo C. Rosten's HOLLYWOOD: THE MOVIE COLONY, THE MOVIE MAKERS. Discussed in greater detail in Chapter 5, this seminal work on the American theatrical film industry prior to World War II also dispelled many of the false myths already under attack by Gallup's research team. For our purpose, we need note that Rosten's research confirmed the power of films to influence mass audiences, especially since the images presented on screen were a microcosm of American society that bore a striking similarity in many instances (e.g., marriage and divorce statistics) to actual events.

America's entry into World War II solidified Hollywood's hold on the American public. Dependent almost exclusively on the domestic market, the major studios saw their film rentals skyrocket "from $193 million dollars in 1939 to $332 million in 1946 . . . Weekly attendance by the end of the war reached ninety million, the highest ever."[937] Not surprisingly, the war produced a change in film content, production techniques, and audience attitudes. Most of these changes have been discussed elsewhere, particularly in Chapter 2. Let it suffice to say that the strong bonds between the movies and the American public would never again be as evident as they were from 1941 to 1945.

The major shift in the number of admissions and in box-office figures began after World War II. For example, in the sixteen years prior to 1945, as Calvin Pryluck explains, film ticket buying had accounted for more than twenty percent of America's recreational expenditures; home entertainment, less than thirteen percent. These figures support the statistical conclusions (see Table 11) reached by Dawson in his analysis of consumer expenditures between 1929 and 1945.[938] By the end of the forties, however, "home entertainment and motion picture admissions had reversed their relative standings; home entertainment expenditures accounted for 24.3 percent of recreation expenditures, while motion picture admissions accounted for only 12.1 percent."[939] In his analysis of film audiences, Garrison puts the case differently. By contrasting those patrons physically and financially able to attend movies in the United States in 1946 (seventy percent) with their counterparts in 1972 (forty-five percent), he concludes that motion picture management faced two serious choices in the post studio years: focus attention on increasing "the number of actual moviegoers" or concentrate on increasing the "frequency of attendance of actual moviegoers."[940] Lazarsfeld added to Garrison's arguments by pointing out in 1947 that a review of the available data on movie audiences showed that a filmgoer's age was "the most important personal factor by which the movie audience is characterized"; and that the older people get, the less likely they are to go to the movies.[941]

What was clear by the start of the post-WWII period was that filmgoers had become more discriminating.[942] What was not clear was what made a film more appealing than its competitors. In a few years, the nature of film exhibition and its

[937] Balio, p.281.

[938] Motion Picture Economics, p.221.

[939] Calvin Pryluck, "Front Office, Box Office, and Artistic Freedom: An Aspect of the Film Industry 1945-1969," MOVIES AS ARTIFACTS, p.45. Pryluck's source is HISTORICAL STATISTICS OF THE UNITED STATES (Washington: Bureau of the Census, 1958), p.224.

[940] Garrison, p.147. He defines 'habitual moviegoers" as those who go to the movies at least once a month.

[941] Lazarsfeld, pp.162-3.

[942] For an interesting perspective, see Mildred J. Wiese and Stewart G. Cole, "A

relationship to a film's success would again become an issue as many people began moving to the suburbs and drive-in theaters became available. During the transition, the public began to reassess its attitude toward movies as other forms of recreation (e.g., bowling alleys, miniature golf courses, and television) grew in popularity.

TABLE 11

CONSUMER EXPENDITURE IN MOTION PICTURE THEATERS AS A PROPORTION OF VARIOUS OTHER PERSONAL CONSUMPTION EXPENDITURES, 1929-1945

Year	Consumer expenditure in U. S. theaters as a percentage of 1929	As a proportion of expenditure on		
		Spectator Amusement	Recreation	All consumer goods
	percent	percent	percent	percent
1929	100 (base)	78.86	16.64	0.91
1930	101.67	82.06	18.36	1.03
1931	99.86	84.19	21.80	1.18
1932	73.19	83.52	21.61	1.07
1933	66.94	84.12	21.92	1.04
1934	71.94	82.88	21.26	1.00
1935	77.22	82.74	21.18	0.99
1936	86.94	82.48	20.77	1.00
1937	93.89	82.64	20.04	1.01
1938	92.08	81.25	20.49	1.03
1939	91.53	80.94	18.96	0.98
1940	98.47	80.94	18.96	0.98
1941	105.00	80.68	17.89	0.92
1942	128.33	83.85	20.13	1.02
1943	137.08	84.07	21.62	0.97
1944	142.36	81.61	19.98	0.93
1945	156.25	80.76	19.45	0.92

Source: National Income Supplement to SURVEY OF CURRENT BUSINESS, July, 1947, Table 30. "Consumer Expenditure in U. S. Theaters" from item ix, 1a; "Spectator amusement" from item ix, 1; "Recreation" from item ix; "All consumer goods" from totals at the end of the table.

The ARI, in the meantime, reported more disturbing news to the film industry. Genres and stars appeared to be losing their box-office appeal for filmgoers. As had been expected in the pre-WWII days, the audience itself had become more stratified. A 1945 survey indicated that

Women over 30 in the upper-income group have a disposition toward pictures generally different from that of teen-age boys in small towns. And young men who don't make much money have different tastes from older men who do. Knowledge of this stratification along economic, population and sex lines makes

Study of Children's Attitudes and the Influence of a Commercial Motion Picture," JOURNAL OF PSYCHOLOGY 21 (1946):151-71.

it possible to determine the general areas of a picture's appeal, since experience has proved [sic] that there is a remarkable consistency within these areas.[943]

What this meant in practical production terms, Bosley Crowther pointed out, is that filmmakers were now applying the ARI findings to specific areas of a film's plot, theme, title, and characterizations. Two specific examples are MURDER, MY SWEET (1944) and A SONG TO REMEMBER (1945). The title of the former was changed from that of Raymond Chandler's novel, FAREWELL, MY LOVELY, to one more romantic and less confusing to the tastes of a mass audience. In the case of A SONG TO REMEMBER, the producers again opted for a title that appealed to romantics and that was suitably ambiguous.[944] Crowther correctly concludes that in order to be commercially successful, filmmakers focused on satisfying the public's need for gratification. The profitable way to do that was "to sell a picture on the basis of those elements which have 'sampled' high in its 'want to see.'"[945] Other studies reinforced these by-now standard reports.[946] For example, Handel's examination of film star preferences confirmed the Payne Fund studies' conclusions that nearly two-thirds of people questioned identified most with stars of their own sex. Only now it was men more than women (percent to percent respectively) who accounted for the observation.[947] Thus by the 1940s, the industry should have begun developing specific strategies to mass market its images and ideas, strategies that related to the shift away from a family audience and toward a youth-oriented audience. The fact that the industry failed to do so was to have serious consequences in the decade that followed.

World War II also sensitized the film community to the value of doing mass communications research. For example, America's Research Branch of the War Department had explored the relationship between orientation films and mass groups of troops needing instruction. The parallels between this type of research and that done for filmmakers and audiences was not lost on Hollywood. Only months after Eric A. Johnston replaced Will Hays as head of the Motion Picture Producers and Distributors of America (MPPDA) in 1945, he changed the organization's name to the Motion Picture Association of America (MPAA), and also established a research department, appointing Robert W. Chambers as its director.[948] As far as Chambers

[943] Lazarsfeld, p.14.

[944] "It's the Fans," p.29. For a recent example of title changes and preview testing, see Aljean Harmetz, "Film SEXUAL PERVERSITY Is Getting a New Name," NEW YORK TIMES C (April 16, 1986):19; and Caryn James, "Test Screenings of New Movies Put Demographics Over Creativity," ibid., C (March 9, 1988):17.

[945] "It's the Fans," p.30.

[946] The problem with film titles and their audience appeal continues into the 1980s. For example, in 1980, three films--RESURRECTION, CARNEY, and THE GREAT SANTINI--received significant critical acclaim but did badly at the box office. In each instance, industry research indicated that the films' titles affected audience expectations. For more information, see Aljean Harmetz, "Do Movie Titles Affect Box Offices?", NEW YORK TIMES C (March 11, 1981):19.

[947] Leo A. Handel, "A Study to Determine the Drawing Power of Male and Female Stars Upon Movie-Goers of Their Own Sex," INTERNATIONAL JOURNAL OF OPINION AND ATTITUDE RESEARCH 2:2 (Summer 1948): 215-20.

[948] For an example of the director's views, see Robert W. Chambers, "Need for Statistical Research," ANNALS OF THE AMERICAN ACADEMY OF POLITICAL AND SOCIAL SCIENCE 254 (November 1947):169-72.

was concerned, the film industry knew "less about its audience than any other major industry in the United States."[949] The new department's primary objectives followed the principles initially laid down by the Academy of Motion Picture Arts and Sciences in the late 1920s. That is, Chambers and his colleagues wanted to dispel negative ideas that the public had about industry statistics, to produce more reliable information for the film industry itself, and to demonstrate the cultural significance of the motion picture. Regrettably, the immediate results did not impress key members of the MPAA, and within a short time the research department went out of business.[950]

How the industry worked to meet the research objectives established by Chambers's investigators is summed up memorably by Handel. In his HOLLYWOOD LOOKS AT ITS AUDIENCE: A REPORT OF FILM AUDIENCE RESEARCH, Handel examines the statistical efforts made by Hollywood producers to pretest the stories and images that presumably appealed to the public. He takes particular note of the problems connected with audience research. Because most of the polling was carried out with great speed, many respondents did not quite understand questions asked them in interviews and questionnaires. He also concluded that it was difficult to isolate the effects of previous movies in discussing recent films and to assess the validity of these tests, and furthermore, that not all moviegoers were in a position to decide for themselves what films they actually saw.[951] Of value to our concerns here is Handel's analysis of the types of people who go to the movies:

> Male and female patrons attend at about equal rates. Younger people attend more frequently than older people. Persons in higher socio-economic brackets attend more frequently than those in lower levels. The more years a person has spent in school, the more frequently he sees motion pictures.[952]

In essence, his research indicates the reasons why Hollywood eventually shifted away from producing films for a homogeneous population to a strategy of targeting productions for specific audiences. Why it took almost a decade to move toward a youth-oriented market is suggested by Tom Doherty: (1) Hollywood wasn't like other major industries in the way it sold its products; and (2) the creative personnel were more interested in adult values than in adolescent escapism.[953] When the film industry finally made the switch, the transformation was dramatic. We need only quote Bob Hope's 1960 satirical comment about movies to see how far Hollywood had come from the 1920s to the end of the 1950s: "Our big pictures this year have had some intriguing themes--sex perversion, adultery, and cannibalism. We'll get those kids away from their TV sets yet."[954]

Dorothy B. Jones is another critic interested in the social content in films. Following Dale's work but not his moralistic emphases, she concerned herself with how well film reflected reality. Having examined 100 selected films, she found that

[949] Chambers, p.169.

[950] For more information, see Leo A. Handel, "Hollywood Market Research," THE QUARTERLY REVIEW OF FILM, RADIO AND TELEVISION 7:3 (Spring 1953):304-10.

[951] Handel, pp.12-3, 15.

[952] Handel, p.199.

[953] Thomas Doherty, "Teenagers and Teenpics, 1955-1957: A Study of Exploitation Filmmaking," CURRENT RESEARCH IN FILM: AUDIENCES, ECONOMICS, AND LAW, Volume 2, p.50.

[954] Bob Hope. Quoted by Ezra Goodman, THE FIFTY-YEAR DECLINE AND FALL OF HOLLYWOOD (New York: Simon and Schuster, 1961), p.425.

there were 188 major characters. An analysis of these characters revealed that
two-thirds of them were men, half of whom were affluent, and of these only 20 percent
were married. In addition, only 20 percent of the male characters were foreigners.
A further distortion in the films reviewed was the frequency of happy endings. As
Ellis observes,

> In terms of Dorothy Jones's hypothesis it is possible to say that film characters
> do not mirror the demographic features of the American population, and we can
> speculate as to whether the type of wants and the degree of attainment reflect
> reality.[955]

Ellis fails to mention, however, that Jones's subjective judgments appear as
speculative as Dale's studies. Not only are her research techniques questionable, but
the definitions of her key elements are also unsatisfactory. In short, as Handel
concludes, methods for evaluating the content of motion pictures remained in the
embryonic stage by the start of the fifties. Much work was yet to be done on
analyzing film techniques and terminologies.[956]
 Some verification of Dale's conclusions, however, can be found in the statistical
summary provided by Marie L. Hamilton.[957] She reports that films tended to avoid
the serious in favor of escapist fare as exemplified by the feature films produced in
the United States during 1950. Hamilton classifies the movies by genre and by
frequency of production: drama (53), comedies (57), musicals (27), adventure (26),
melodrama (74), Westerns (88), documentaries (7) and long cartoons (2). Her
division of film subjects into categories such as theme (e.g., medical, ethnic, and
minority problems), milieu (e.g., show business and horse racing), and treatment
(e.g., farce, burlesque, and fantasy) is one more indication of the film industry's
tendency toward stereotyping. One additional value of this study by Hamilton, as
Ellis suggests, is that it provides a model for students to follow in analyzing films
shown at local theaters for a particular semester. All that need be done is to
categorize the films by using the plot summaries printed in such publications as
MOTION PICTURE HERALD, FILM DAILY, and the like.[958]
 Probably the most extensive content analysis of the stereotyping of men and
women in films was done by Martha Wolfenstein and Nathan Leites in their book,
MOVIES: A PSYCHOLOGICAL STUDY. Their analysis identified what were the most
frequent film themes between 1945 and 1947, and how these recurrent topics were
related to "the psychological processes of movie makers and audiences . . . [thus
accounting] for the emotional significance of recurrent themes."[959] For example, in
films like THE BLUE DAHLIA (1946), HIGH WALL, and DARK PASSAGE (both in
1947), the hero finds himself accused of a murder he did not commit. He therefore
goes into hiding and seeks to prove his innocence to a pursuing and skeptical law
enforcement agency. The world the hero finds himself in is "alien, hostile, accusing."
This world mirrors what the authors believe to be a valuable reflection of American
insecurity in situations where we find ourselves "uneasily alone." That is, audiences
in such situations feel unloved and guilty of some deed that makes them unworthy

[955] Ellis, p.273, n.29.

[956] Handel, p.172.

[957] Marie L. Hamilton, "1950's Production," FILMS IN REVIEW 2:1 (January 1951), 8-9.

[958] Jack C. Ellis, APPROACHES TO FILM AS AN ART FORM: A HANDBOOK FOR COLLEGE
 TEACHERS, (Unpublished Ed.D. dissertation, Teachers College, Columbia
 University, 1955), p.272, n.26.

[959] Wolfenstein and Leites, p.304.

and outcast. According to the authors, perceptive filmmakers, recognizing our delusions of persecution and projections of personal self-accusations, use movie heroes to provide us with "relief from guilt about forbidden impulses." Even though the plots may be fictitious, the mechanism of having us identify with the emotional traumas of the hero functions as a form of wish-fulfillment and catharsis. Wolfenstein and Leites make no claims for movies being the sole variable in determining the emotional appeal such recurrent themes have for mass audiences. Rather, the authors surmise that the "ready-made day-dreams" provided by American movies are an interaction with "real life" experiences. Whether as actual projections or reversals of those emotions of hope and fear in each of us, the recurrent themes do symbolize "the larger pattern of the culture [of] which they form a part."[960]

It may help at this point to pause and reflect on how the evidence presented so far relates to our interest in the multiple roles that movies play as a social force in society. We began first with an overview of the basic concerns film critics and historians have about aesthetics, economics, and social values in relation to the medium of film and popular culture. It immediately became apparent that a number of misunderstandings about how films are produced and received preoccupied many members of society in and outside the film industry. In response, feminist film critics, neo-Marxists, sociologists, poststructuralists, and psychoanalysts worried about the relationship between the process of filmmaking and the moment of reception. Social critics like Lippmann, Boorstein, and Schickel were troubled by the role that celebrities and stars have in producing and shaping society's values and attitudes. To understand more completely how the industry operates and thus respond to such ideological concerns, we turned our attention next to the economic pressures that dictate the manufacturing, distribution, and exhibition of films. It soon became clear that profits played a crucial role in determining which genres and formulas mainstream filmmakers presented to mass audiences. It was also apparent that a consistency existed in the stock situations and social types distributed worldwide to millions of filmgoers. Furthermore, it was evident that no monolithic conspiracy for these ideas and images existed in film circles. As a result, multiplicity rather than essentialism remained the best way to analyze the medium and its message. Identifying who made up the film audience, however, remained a century-old dilemma. By examining fifty years of mass communications research, we demonstrated that filmmakers routinely concerned themselves with techniques for gratifying what they presumed to be audience desires. These desires, in varying degrees, related to factors like gender, class, education, income, age, and marital status. Initially, most observers of mass communication assumed that the media merely produced a product containing an "invisible" message that automatically was accepted by an uncritical audience. Self-appointed guardians of social morality then took it upon themselves to battle for national, state, local, and industrial "safeguards" against a medium that was undermining elitist and sacred standards of taste and morality.

But in examining the various studies concerned with identifying the size, composition, and preferences of a mass audience, it became apparent that significant changes had occurred from the early peep show days to the mid-fifties when television replaced film as the major source of popular culture. The new data stressed the importance of age as the key element in box office success. In fact, teenagers became not only the major source of income for filmmakers, but also the opinion leaders in getting their peers to see a film. As a result, the filmmakers began shifting their production strategies from those designed for general audiences to targeting films for specialized and youthful audiences. Where once a greater proportion of the total population had attended movies on a regular basis (at least once a month), the number was rapidly declining by the end of the forties. Furthermore, a careful reading of the audience research revealed major weaknesses in the research methodology and raised serious questions about the reported conclusions. Throughout the material discussed so far, we have also reviewed the ideological warfare among various

[960] Wolfenstein and Leites, pp.181, 184, 305-7.

political, social, and economic forces in society over the nature and role of movies in our lives. The ongoing battle showed us what was at stake in cultural, political, and economic terms. It proved that movies are far from being a trivial medium of entertainment. It demonstrated how stereotypes existed not merely as cliches or one-dimensional representations, but as reflections through cultural hegemony of what society believed and valued at a particular time and place. In the material that follows, we continue to see how movies are both a business and an art form that need to be understood since they play a major role in our lives and our culture.

It was clear that by the 1950s the nature and composition of the American film audience was changing. For example, in his important study on antitrust actions Conant indicated that average weekly attendance reached a peak of "79.4 million admissions a week in 1946 and dropped to 37.7 million in 1957."[961] For him, a central characteristic was age distribution. That is, older people attended movies less frequently than did young people. No more than twenty-eight percent of the total film audience was over thirty years of age. Even more interesting, almost two-thirds of the filmgoing audience on a weekly basis was made up of no more than fifteen percent of the population that goes to the movies at least once a week. Garrison, using the research reported by Gallup and his peers, stressed the fact that once a person left the teens, he or she began tos harply curtail moviegoing. Based upon the findings of several notable studies, it was reasonable to argue that people in their mid-thirties and over rarely were regular filmgoers.[962] Put another way, of the 45 million people going to the movies weekly in 1957, age rather than education, sex differences, or income, was the major factor. This discovery required Hollywood to reassess its stock situations and social types and their use in film formulas.[963]

Nowhere was the changing nature and composition of the American filmgoing audience more succinctly summarized during this period than in Hortense Powdermaker's HOLLYWOOD: THE DREAM FACTORY. An anthropologist, she stresses the fact that with less money to spend on entertainment, film audiences had become more discriminating in their choice of which film to watch. In addition, homogeneity in film audiences had been replaced by a variety of tastes and backgrounds similar to the variety found in the general population. Pointing out that Hollywood had not quickly grasped the change in audience composition, Powdermaker indicates the increasing willingness of filmgoers to visit art houses, see foreign films, and experience more serious movie themes.[964]

Confirming much of what Powdermaker, Handel, Thorp, and other researchers had discovered was an important 1957 MPAA survey on film audiences and their preferences.[965] In a period of little more than a month, investigators queried over 5,000 people (fifteen years of age and older) about a host of Hollywood concerns. The results, as Jowett summarizes them, were reassuring to audience trend watchers; e.g., slightly more than one-quarter of those who went to the movies were over thirty years of age; men, rather than women, constituted fifty-one percent of the moviegoing population; and married people made up less than half the audience, although they

[961] ANTITRUST IN THE MOTION PICTURE INDUSTRY, p.5.

[962] Garrison, p.148.

[963] For an example of what one company did to evaluate systematically its thematic approach to film production, see Dorothy B. Jones, "Quantitative Analysis of Motion Picture Content," PUBLIC OPINION 14 (1950):554-8.

[964] Powdermaker, pp.297-8.

[965] Opinion Research Corporation, "The Public Appraises Movies," A SURVEY FOR THE MPAA (Princeton: December, 1957).

accounted for seventy-three percent of the population.[966] American filmmakers, however, were at a loss in the 1950s as to what to do about the radical changes in audience tastes and alternative forms of entertainment. Contributing to the filmmakers' dilemma were problems of social control over film content, federal litigation, the rising importance of television, and the threat by anti-Communists to make Hollywood an example of how "networks of Reds" could be eliminated. Each of these problems is discussed elsewhere in this book. For now, we should note that the effect of each problem was to challenge the artistic, political, and economic independence of the film industry. The reaction was predictable, given the enormous financial investments involved.[967] The American film industry became even more conservative and produced films that avoided controversy. The results were far from satisfying. Attendance continued its sharp decline, thousands of theaters closed, and television replaced movies as the principal American pastime.

The realization that the future of the film industry rested on new marketing and production strategies resulted in the rise of "exploitation filmmaking." Starting in the mid-1950s, as Doherty observes, the American film industry began making films especially designed to attract teenagers.[968] A key factor in the new equation was the appeal of the drive-in to the youth market. As Izod observes,

> The drive-in made an even more attractive escape from home than the four-wall theatre: courting couples could be fairly private, other youngsters could make all the noise they wanted without bothering the neighbours. In film, as in the clothing and popular music industries this audience was, with the new affluence of young people, becoming an attractive, identifiable market.[969]

Not surprisingly, the companies that took the first steps were the "B" producers rather than the majors. As always in the movie business, the one with the smallest overhead and the most freedom is the one to take the most daring steps.

Entrepreneurs like Sam Katzman, taking their cue from box-office hits like THE BLACKBOARD JUNGLE and REBEL WITHOUT A CAUSE (both in 1955), made a number of "quickie" pictures focusing on the teenage rock and roll craze. Among the more popular titles were ROCK AROUND THE CLOCK (1956), ROCK, PRETTY BABY and DON'T KNOCK THE ROCK (both in 1957). These "teenpics" reflected the growing importance that the industry would eventually place on American youngsters who now were more numerous, more affluent, and more conscious of their unique status in society than ever before. The essential ingredients in the exploitation film were a catchy title, a story directly related to current fads, and streamlined production techniques that made a particular film first to exhibit the new trend. As Doherty neatly summarizes the approach, "The success of . . . quickie productions underscored a truism of exploitation filmmaking: quickness counts for more than quality."[970]

[966] FILM: THE DEMOCRATIC ART, pp.375-6.

[967] For more information, see Thomas C. Hayes, "Accounting Rule Masking Future Profits," NEW YORK TIMES D (January 20, 1982):1, 4; Sandra Salmans, "Movie Investments, Not Always Stars," ibid. 3, (January 23, 1983):16; and ___, "Bankers Star Behind the Scenes," ibid. 2, (February 14, 1982):1, 19.

[968] Doherty, pp.47-61.

[969] Izod, p.144.

[970] Doherty, p.52. For more information, see Richard Staehling, "From Rock Around the Clock to The Trip: The Truth About Teen Movies," THE KING OF THE "B's," pp.220-36; Paul Kerr, "My Name is Joseph H. Lewis," SCREEN 24:4-5 (July-October 1983):48-66; and Izod, pp.144-6.

The most significant company to capitalize on the youth market was American International Pictures (AIP). Founded in 1954 by Samuel Z. Arkoff, a lawyer, and James H. Nicholson, a sales manager for Realart Pictures, the company, first named American Releasing Corporation, started out as a distributor of "B" productions like THE FAST AND THE FURIOUS (1954), APACHE WOMAN, THE BEAST WITH A 1,000,000 EYES, and FIVE GUNS WEST (all in 1955). By 1956, the renamed American International Pictures began producing its own low-budget horror films, westerns, and hot-rod movies, all designed to make a quick profit and to exploit the growing generation gap in the fifties. AIP's top producer was Roger Corman (to be discussed in Chapter 7), who specialized in exciting and shocking imagery instead of carefully crafted stories.

The emergence of the youth market did not completely eclipse the necessity for satisfying the needs of mature filmgoers. In fact, as Izod points out, Hollywood also discovered the appeal of foreign films for the suburban and rural markets.[971] Consequently, the "art house" movement that originated in the late 1940s with the British, French, and Italian films, and increasing with the Japanese imports of the early 1950s (discussed in Chapter 7) took hold in America by the mid-1950s. Moreover, the innovative and candid way in which these films treated sex, violence, and spiritual topics revolutionized the way in which American filmmakers approached heretofore "taboo" subjects in domestic films. As we will see, the result of this new audience and the shift in filmmakers' attitudes toward controversial subjects dealt a death blow not only to the Motion Picture Production Code, but also to a variety of types of film censorship that had been in place since the early 1900s.

Because Hollywood in the late 1950s still attracted seventy million domestic customers--"one out of every 2.5" Americans--on a weekly basis, researchers continued to take a special interest in what people spend over 3.5 billion dollars a year at the box office.[972] For example, in 1960, Marvin E. Olsen reported his conclusions on what previous scholars had produced in trying to explain the public's attraction to films. Except for information on why certain types of people go more frequently to the movies than do others, Olsen did not find previous efforts especially valuable. He then went on to theorize that the appeal of films was, to a large extent, that they offered "a personal form of recreation" not available anywhere else. "In other words," Olsen states, "movies act as a substitute form of recreation for people who lack close friends."[973] The fewer the friends (social isolation), the more films the isolated individual attends. Olsen then tested his theory with a study involving 167 of 172 Standard Metropolitan areas in the United States in 1958. The focus was on community rather than on individual motives for going to the movies. His justification was that "the concept of 'social isolation' is used . . . as a SOCIAL characteristic of a total community rather than as an individual characteristic of any of the people in the community."[974] At first, Olsen felt that the study's results tentatively substantiated his hypothesis. But in a later report, he acknowledged that a "serious methodological error had been made" in computing community disruption.

[971] Izod, p.147.

[972] Jay Haley, "The Appeal of the Moving Picture," THE QUARTERLY OF FILM, RADIO, AND TELEVISION 4:6 (Summer 1952):361-74.

[973] Marvin E. Olsen, "Motion Picture Attendance and Social Isolation," SOCIOLOGICAL QUARTERLY 1:2 (April 1960):108. For a useful report of film audience research in England, see Robert Silvey and Judy Kenyon, "Why You Go to the Pictures Or Stay Away: The BBC Gives the Industry the Facts, . . ." FILMS AND FILMING 11:9 (June 1965):4-5, 36.

[974] Olsen, p.109.

The result was to negate the major empirical evidence, but not necessarily the underlying hypothesis.[975] In effect, Hollywood still didn't understand the relationship between its films and its audiences.[976] Broad generalizations rather than specific answers remained the only recourse for the confused filmmakers.[977]

Olsen's work reflected the significant shift that had taken place in mass communication research since the fifties. To better understand the changes in emphasis and technique taking place, we need to review briefly what academic

[975] Marvin E. Olsen, "Correction: Motion Picture Attendance and Social Isolation," SOCIOLOGICAL QUARTERLY 6:2 (Spring 1965):179.

[976] For an understanding of the types of research being done on the links between films and their audiences in the fifties and the sixties, see P. Anast, "Differential Movie Appeals as Correlates of Attendance," JOURNALISM QUARTERLY 44:1 (Spring 1967):86-90; Lotte Bailyn, "Mass Media and Children: A Study of Exposure Habits and Cognitive Effects," PSYCHOLOGICAL MONOGRAPHS 73:1 (1959):1-48; Albert Bandura et al., "Imitation of Film-Mediated Aggressive Models," JOURNAL OF ABNORMAL AND SOCIAL PSYCHOLOGY 66:1 (1963):3-11; R. Bauer, "The Obstinate Audience," AMERICAN PSYCHOLOGIST 19:5 (May 1964):319-28; Leonard Berkowitz and E. Rawlings, "Effect of Film Violence on Inhibition Against Subsequent Aggression," JOURNAL OF ABNORMAL AND SOCIAL PSYCHOLOGY 66:5 (May 1963):405-12; ___, "The Effects of Observing Violence," SCIENTIFIC AMERICAN 210:2 (February 1964):35-41; Martin Brouwer, "Mass Communication and the Social Sciences: Some Neglected Areas," INTERNATIONAL SOCIAL SCIENCE JOURNAL 14 (1962):303-19; W. R. Catton, "Changing Cognitive Structure as a Basis for the Sleeper Effect," SOCIAL FORCES 38:4 (May 1960):348-54; Erik Eckholm, "2 Studies Link Teen-Age Suicides to TV Programs," NEW YORK TIMES A (September 11, 1986):19; Fred Elkin, "Popular Hero Symbols and Audience Gratifications," JOURNAL OF EDUCATIONAL SOCIOLOGY 29:3 (November 1955):97-107; F. E. Emery, "Psychological Effects of the Western Film," HUMAN RELATIONS 12 (1959):195-232; J. W. C. Johnstone, "Social Context and Mass Media Reception," STUDIES IN PUBLIC COMMUNICATION 2 (November 1959):25-30; E. Katz, "Communication Research and the Image of Society: Convergence of Two Traditions," AMERICAN JOURNAL OF SOCIOLOGY 65:5 (March 1960):435-40; ___ and D. Foulkes, "On The Use of The Mass Media as Escape: Clarification of a Concept," PUBLIC OPINION QUARTERLY 26:3 (Fall 1962):377-88; Joseph T. Klapper, "Mass Communications Research: An Old Road Resurveyed," PUBLIC OPINION QUARTERLY 27:4 (Winter 1963):515-27; Eleanor Maccoby et al., "Differential Movie-Viewing Behaviour of Male and Female," JOURNAL OF PERSONALITY 26 (1958):259-67; Rolf B. Meyersohn, "What Do We Know About Audiences?", JOURNAL OF BROADCASTING 1:3 (Summer 1957):220-31; and Dallas W. Smythe et al., "Portrait of a First-Run Audience," QUARTERLY OF FILM, RADIO, AND TELEVISION 9:4 (Summer 1955):390-409.

[977] Readers interested in other examples of this type of study might find Jan Falewicz's report on a 1964 poll conducted by the Public Opinion Research Centre of Polish Radio and Television interesting. In an attempt to obtain information on the film tastes of Polish audiences, what factors influence these choices, and what motivates the viewers in their evaluations of films, the research agency issued a nation-wide questionnaire to "1,832 adult urban inhabitants chosen proportionately according to sex, age, occupation and place of residence." Among the conclusions reached by the poll were that (1) the opinions of film viewers and film critics converge in relation to the former's "educational and cultural level, and vice versa"; (2) the respondents were influenced by film critics, but film popularity remains independent of film criticism; and (3) film criticism may have its greatest effect through its influence on opinion makers. For more information, see Jan Falewicz, "Effect of Criticism on Urban Film Tastes," THE POLISH SOCIOLOGICAL BULLETIN 19:1 (1964):90-5.

revisionism had occurred. Ever since the birth of the movies, researchers had been trying to measure the effects of the mass media on society at home and abroad. One dominant theme centered on the power of the mass media to shape society's values. There were commentators like Phelan and Lane who viewed the movies as having the potential for making society better. Other observers like Poffenberger and Forman worried about the medium's role in promoting crime, violence, and anti-social behavior. Another dominant theme, as Dennis Howitt points out, was "the political involvement in financing and initiating mass communication research."[978] Whether it was the Payne Fund studies of the thirties or the army research of the forties, it was clear that the research was expensive and that the cost influenced both the type and the direction of mass communication research. The most important research approach up to the 1940s was the "hypodermic effects" model. The basic assumption was that the mass media directly influenced a passive and naive public. While this method of studying stimulus-response accurately reflected the public's worries about the mass media, it eventually was rejected by scholars. The overriding reasons, explains Howitt, were that "the model gives a rather incomplete conceptualization of the role of the mass media in society . . . [and] it tends to demand the highest level of empirical proof which cannot be fully met."[979] By the end of the Second World War, as McQuail and Windahl report, mass communication researchers had become more interested in model-building activities. It no longer was fashionable to talk about the "effects of the media" in simplistic terms. The new students of interpersonal communication and mass communication wanted to know more about "the occurrence of feedback," "the recognition of the non-linearity of communication processes," and "the intersubjectivity of communication."[980] In short, the emphasis was on audience-centered studies.

In 1950, Charles Hoban and Edward Van Ormer published their comprehensive summary of that film research. In regard to the general attitudes of the motion picture audience, they concluded:

> If the conclusions regarding the impact of films on the learning of information could be generalized to attitudes (and there is no evidence to support such generalization), it might be postulated that the force of motion pictures on general attitudes may be greater than that of verbal media alone, when the influence is measured in long-term effects, and when conditions required in the development of general attitudes are satisfied. This postulate is somewhat feasible when reminiscent effect is taken into consideration, and when a relationship between specific and general attitude is assumed. However, research is needed on the long-term attitudinal effects of films to substantiate this postulate.[981]

Over the next decade, mass communication scholars continued to move away from the hypodermic assumptions of the past, to the issues of mediating forces that affect the reception of mass media ideas and messages.

In one of the most impressive studies on the effects of mass communication, Joseph T. Klapper examined and collated over 1000 writings dealing with the field, and concluded that there were some indicative findings that would serve as valid

[978] Howitt, p.4.

[979] Howitt, p.9.

[980] McQuail and Windahl, pp.5-6.

[981] Charles Hoban and Edward Van Ormer, INSTRUCTIONAL FILM RESEARCH 1918-1950, Technical Report SDC 269-7-19 (Long Island, New York: Special Devices Center, 1950), pp.5, 18, New York: Arno Press, 1972.

perspectives from which to view the disorganized and generally inconclusive research. Klapper listed five generalizations, but noted that he was in no way committed to them and speculated that future research would "modify and perhaps annihilate the schema."[982] His generalizations were as follows:

1. Mass communication ordinarily does not serve as a necessary and sufficient cause of audience effects, but rather functions among and through a nexus of mediating factors and influences. 2. These mediating factors are such that they typically render mass communication a contributory agent, but not the sole cause, in a process of reinforcing the existing conditions. (Regardless of the condition in question--be it the vote intentions of audience members, their tendency toward or away from delinquent behavior, or their general orientation toward life and its problems--and regardless whether the effects in question be social or individual, the media are more likely to reinforce than to change.) 3. On such occasions as mass communication does function in the service of change one of two conditions is likely to exist. Either: a. the mediating factors will be found to be inoperative and the effect of the media will be found to be direct; or b. the mediating factors, which normally favor reinforcement, will be found to be themselves impelling toward change. 4. There are certain residual situations in which mass communication seems to produce direct effects, or directly and of itself to serve certain psycho-physical functions. 5. The efficacy of mass communication, either as a contributory agent or as an agent of direct effect, is affected by various aspects of the media and communications themselves or of the communication situation (including, for example, aspects of textual organization, the nature of the source and medium, the existing climate of public opinion, and the like).[983]

Klapper's study set the stage for complex discussions about social variables like the influences on the individual of the family, friends, personal experiences, environment, and the communication process.[984]

The sixties did not do much to resolve Hollywood's anxieties on its declining profits. The research had demonstrated, as Izod explains, that "male and female patronage was about equal, but younger, single people made up a very large part of the audience; and the better educated and paid went to the movies more often than others, paying more for their tickets."[985] The problem was what to do with that information. Television, now firmly established, forced the American film industry, starting in 1966, to switch from primarily black-and-white films (fifty percent) to ninety-four percent color productions.[986] As discussed earlier, attempts to win back

[982] Joseph T. Klapper, THE EFFECTS OF MASS COMMUNICATION (Glencoe: The Free Press, 1960), p.98.

[983] Klapper, p.8.

[984] For more information, see *Robert Atwan, Barry Orton, and William Vesterman, eds. AMERICAN MASS MEDIA: INDUSTRIES AND ISSUES (New York: Random House, 1978); *John R. Bittner, MASS COMMUNICATION: AN INTRODUCTION, 2nd ed. (Englewood Cliffs: Prentice-Hall, 1980); *Melvin L. De Fleur and Sandra Ball-Rokeach, THEORIES OF MASS COMMUNICATION, 4th ed. (New York: Longman, 1982); and *Sandra Lowery and Melvin L. DeFleur, MILESTONES IN MASS COMMUNICATION RESEARCH: MEDIA EFFECTS (New York: Longman, 1983).

[985] Izod., p.149.

[986] Kindem argues that the conversion to color was a forty-year struggle tied to three factors: (1) technological breakthroughs, (2) profit incentives, and (3) audience acceptance. For more details, see Gorham Kindem, "Hollywood's

mass audiences with blockbuster films met with mixed results.[987] For every hit like THE SOUND OF MUSIC (1966) and FUNNY GIRL (1968), there were horrendous failures like CLEOPATRA (1963), DR. DOLITTLE (1967), and STAR! (1968). A few low-budget films like THE GRADUATE and BONNIE AND CLYDE (both in 1967), and EASY RIDER (1969) suggested a direction away from roadshow productions,[988] but here too the overall results proved discouraging. The problem was as old as the film industry itself. That is, no one had yet figured out how audiences choose films or why cyclical trends characterize the industry. Domestically, the American film industry appeared confused and indecisive. Unemployment among both craft and artistic personnel reached panic proportions.[989] Only the majors' backlog of films and valuable real estate could explain their move to conglomerate status, discussed earlier, which began in the early 1960s.

Understandably, the 1960s gave rise to a new marketing strategy to offset the shift from movies made for family audiences to movies produced for targeted groups. The new methodology focused on motivation and personality factors. "Variously called lifestyle, activity and attitude, or psychographic research," explain Steven Knapp and Barry L. Sherman, "this new approach quickly sparked the imagination of many who saw it as a more comprehensive method of understanding consumer behavior."[990] No longer did the interests of individuals get lost in the size of the groups being surveyed. The ability of psychographic research to go from the general to the specific in terms of individual audience reactions and values was particularly helpful in explaining what heretofore had been written off as aberrant. Even with a number of reliability problems (e.g., possible faulty measuring methods and the question of validity), in the years to follow, psychographics proved to be a useful tool for marketing and for film scholarship.

Overseas audiences, in the meantime, continued to enjoy American films. The U. S. Information Agency (USIA) in several different surveys reported the reactions of South American, Western European, and Japanese moviegoers to the imported images. For example, our neighbors to the south "admired the high living standards, harmonious family relationships, and efficiency of law enforcement in the U.S; . . . " while the Japanese liked the film images of "high living standards and consumption levels, individual freedom and equal opportunity, harmonious family life and a spirit of optimism."[991] The latter did not appreciate, however, the emphasis in our films

Conversion to Color: The Technological, Economic, and Aesthetic Factors," THE AMERICAN MOVIE INDUSTRY, pp.146-58.

[987] For another approach, see Stanley Penn, "Focusing on Youth: A New Breed of Movie Attracts the Young, Shakes Up Hollywood," WALL STREET JOURNAL 174:88 (November 11, 1969):1, 22. Also useful is Harry C. Carlson, "Movies and the Teenager," JOURNAL OF THE SCREEN PRODUCERS GUILD (March 1963):23-6.

[988] Roadshows, or blockbuster films, consisted of expensive productions, most often made in 70mm film, requiring special distribution and exhibition arrangements, and shown to the public on a reserved-seat basis. For more specific information, see Joseph D. Phillips, "Film Conglomerate 'Blockbusters,'" JOURNAL OF COMMUNICATION 25:2 (Spring 1975):171-82; Rpt. THE AMERICAN MOVIE INDUSTRY, pp.325-35.

[989] Campaine, p.186.

[990] Steven Knapp and Barry L. Sherman, "Motion Picture Attendance: A Market Segmentation Approach," CURRENT RESEARCH IN FILM: AUDIENCES, ECONOMICS, AND LAW, Volume 2, p.35.

[991] "American Films and Foreign Audiences," FILM COMMENT 3:3 (Summer 1965):50. Worth knowing is that the surveys were done by independent agencies in each country.

on excessive violence, sex, and materialistic values. The Western Europeans shared similar views. On balance, in its survey of seventeen nations around the globe, the USIA concluded that American films created a positive picture for the United States.[992]

In addition to mass communications research on social variables dealing with influences on the individual of the family, friends, personal experiences, environment, and the communication process, mass media scholars in the 1960s focused on the effects of stereotyped patterns of violence and the effects movies can have on stimulating aggressive behavior or acting as a cathartic release from fantasy drives. Seymour Feshback postulated that symbolic expressions of aggression or involvement in vicariously oriented aggressive activity could weaken a student's future aggressive behavior if the conditions were appropriate.[993] Leonard Berkowitz questioned Feshback's catharsis hypothesis on the grounds that conditions that would be appropriate for such fantasy reduction are extremely slight for most of the population.[994] Milton Dickens and Frederick Williams, summarizing the research conducted between 1960 and 1963 on aggression and violence in the mass media, reported that

The greatest restriction in attempting to generalize any degree of the above findings to the possible deleterious effects of violence in the mass media lies in the fact that aggressive behavior in the experiments involved not other adults or children, but toys or dolls--themselves fantasy figures . . . These studies, however, demonstrate two important points: (a) films or cartoons depicting violence can stimulate behavioral patterns which might be defined as aggressive, and (b) children do seem willing and able not only to learn but also to imitate particular patterns of behavior as presented by a mass medium.[995]

Mass media research in the 1960s is also exemplified by Otto Larsen's book VIOLENCE AND THE MASS MEDIA, a collection of essays by social scientists who touched "only incidentally" on such elements as "the breakdown of social institutions, or sexual frustration, or growing moral laxity, or economic deprivation, or population pressure."[996] Although as an editor, Larsen began by admitting that neither his authors nor anyone else can prove that the era was more violent than any previous period in history, the essay writers insisted on making the mass media the whipping boy for society's troubles. In each of the anthology's eight sections, the "experts"

Other useful studies include Roy E. Carter and Orlando Sepulveda, "Some Patterns of Mass Media Use in Santiago de Chile," JOURNALISM QUARTERLY 41:1 (Spring 1964):216-24; and Ilse Dronberger, "Student Attitudes Toward the Foreign Film," JOURNAL OF THE UNIVERSITY FILM PRODUCERS ASSOCIATION 17:1 (1965):6-9, 19-22.

[992] For a useful overview on how domestic audiences view foreign films, see Martin F. Norden and Kim Wolfson, "Cultural Influences on Film Interpretation Among Chinese and American Students," CURRENT RESEARCH IN FILM: AUDIENCES, ECONOMICS, AND LAW, Volume 2, pp.21-34.

[993] Seymour Feshback, "The Drive Reducing Function of Fantasy Behavior," JOURNAL OF ABNORMAL AND SOCIAL PSYCHOLOGY 50:1 (January 1955):3-11.

[994] Leonard Berkowitz, AGGRESSION: A SOCIAL PSYCHOLOGICAL ANALYSIS (New York: McGraw-Hill, 1962).

[995] Milton Dickens and Frederick Williams, "Mass Communications," REVIEW OF EDUCATIONAL RESEARCH 34:2 (April 1964):218.

[996] Otto N. Larsen, ed., VIOLENCE AND THE MASS MEDIA (New York: Harper & Row, 1968), p.3.

deplore the violence in the world without treating its basic roots in life itself. Little concern was given to who ran the mass-media establishments, how they were operated, or what the connection was between the various branches of business and the social codes of the country. Just as interesting was the absence of any sensible comment about children's attitudes toward violence on the screen. For many youngsters, film violence was an amusing and distracting pastime that could easily be dismissed in time for the next activity in a busy schedule. When this was not the case and some negative psychological reaction resulted, the authors should have provided reliable information on what to do, how to help. Such was not the case.[997]

In connection with violence in movies, two interesting monographs reacted against simplistic attitudes on condemning mass media. One of them, "Companion to Violence and Sadism in the Cinema," expresses the philosophy that the audience wants violence and that the suspense connected with physical violence in films is related to pity and terror. For those who object to certain screen representations the editors point out that

If you wish to diminish the public demand for screen violence, first banish it from the history books (Cannae, Agincourt, The Thirty Years War, Waterloo, the Somme, Arnheim). Banish it from the headlines. Not a word please about megadeaths and overkill; we don't wish to know that. Eradicate crimes of violence and notions of punishment as retaliatory. Remove at their root children's temper tantrums, bowdlerize their dreams, eradicate egoism. Remove the masses' feeling of helplessness in the hands of the law, the state, the politicians. And then when you have done all that, do let us know.[998]

Topics covered in the monograph include criminals, famous monsters, sadistic females, the ELAN VITAL of the Japanese cinema, and the psychology of aggression.

The second monograph, "Puritans Anonymous," explores varied aspects of puritanism in films. The editors define and discuss puritanism as

First, the British version of orthodox Calvinism; second, the Protestant-bourgeois-capitalistic nexus established by Max Weber and R. H. Tawney; and third, that mixture of religion and rationalism which became Christian orthodoxy once theologians had married the thought of Plato to that of St. Paul, and which Matthew Arnold evolved into its agnostic form. Behind these looms a broader sense--applying to all those philosophies that aspire, not like Aristotle's to a judicious balance of selfishness and altruism, but, like Plato's to an actual eradication of "unworthy" impulses, however deeply they plunge into the soul. In that sense, every moral code has its own puritanism. Puritanism may be pessimistic ("we are all born corrupted, our wills must be broken for our own good"), or optimistic ("we are all born innocent and kind really"); there are puritanisms of reason (Aldous Huxley), of power, of success, of sensuality (D. H. Lawrence).

"High culture" is traditionally associated with Christian-rationalist "purification"--the academic world even thinks of itself as the "saving remnant," "the salt of the earth." But "low culture," from folk art to the best

[997]	Also useful is Michael Armstrong, "On Violence, . . ." FILMS AND FILMING 15:6 (March 1969):20-31.

[998]	Ian Johnson and Raymond Durgnat, eds., "Companion to Violence and Sadism in the Cinema," MOTION 6 (Autumn 1963):63.

in the mass media, has a lower moral polarity, an Aristotelian, even a Rabelaisian, relaxation.[999]

The authors then explain how the new fields of sociology, anthropology and depth psychology have forced a reexamination of all cultural values, including artistic ones. And Johnson and Durgnat conclude that puritanism, in any moral code, may well be the consequence of the censor's deep-rooted anxiety, distrust, and hatred. They ask,

Is "moral striving" itself a trap; the devil-a-monk-would-be quoting scripture for his own purposes, happy to hate sin as long as he is allowed to hate something? or are puritan ideals essential to every morality?[1000]

Some of the films discussed included THE NIGHT OF THE HUNTER (1955), a textbook illustration of a religious psychopath; WILD STRAWBERRIES/SMULTRONSTALLET (1957), its theme a retired scholar's humiliation; and Robert Bresson's THE DIARY OF A COUNTRY PRIEST/LE JOURNAL D'UN CURE DE CAMPAGNE (1951), a film that correlates the outside world with men's inner conflicts.

Back home, the seventies started out on a low note.[1001] Since 1966, the number of admissions had dipped below 1 billion people per year. In 1970, the number was "920.6 million; 1971, 820.3 million; 1972, 934.1 million; and 1973, 864.6 million."[1002] And then, suddenly, matters began to change. In 1974, admissions rose to 1.7 billion. "After years of decline," proclaimed US NEWS AND WORLD REPORT, "attendance in 1974 shot up to more than 1 billion, the highest since 1966. Box-office receipts rose to an all-time record of 1.9 billion dollars."[1003] As discussed earlier, credit for the boom went to a new crop of creative talents, the era's depressed economic conditions, and the positive influence of television and universities as training grounds for future filmmakers. Special attention was directed toward the emergence of a new audience largely composed of college-educated students:

According to recent studies, 65 percent of Americans with at least a year of college education go to the movies frequently or occasionally.
Only 50 percent of those with a high school education and 25 percent of people lacking a high-school diploma attend the movies regularly. 63 percent of those without a high-school degree never go to the movies.[1004]

[999] Ian Johnson and Raymond Durgnat, eds., "Puritans Anonymous," MOTION 6 (Autumn 1963):3.

[1000] Johnson and Durgnat, pp.10-8.

[1001] For a discussion of the problems faced by the British film industry, see David Gordon, "Ten Points About the Crisis in the British Film Industry," SIGHT AND SOUND 43:2 (Spring 1974):66-72.

[1002] See Appendix IX.

[1003] "New 'Great Era' For Movies: What's Behind the Comeback," US NEWS AND WORLD REPORT 78:11 (March 17, 1975):52.

[1004] "New 'Great Era,'" p.53. For related studies, see Bruce A. Austin, "Film Attendance: Why College Students Chose to See Their Most Recent Film," JOURNAL OF POPULAR FILM AND TELEVISION 9:1 (Spring 1981):43-9; and ___, "People's Attitudes Toward Motion Pictures," FILM/CULTURE: EXPLORATIONS OF CINEMA IN ITS SOCIAL CONTEXT, ed. Sari Thomas (Metuchen: The Scarecrow Press, 1982), pp.222-36.

Lee C. Garrison, meanwhile, had published his investigation of what audiences presumably wanted. Noting the many changes that had occurred since the days of the nickelodeons and the advent of the talkies, he argued that the current trend (1972) "appears to be in the direction of greater choice and increased audience selectivity and sophistication in moviegoing."[1005] While people living in urban areas still went to the movies more often than suburbanites, film going remained a social outing involving two or more people. At the same time, Garrison reiterated what most observers from the peep show days and after believed: "Movies . . . satisfy psychological needs--people project themselves into the film environment, identifying themselves with the leading characters. In essence, the audience of a motion picture is made up of a variety of publics, each with particular needs and interests."[1006] Understandably, the major motion picture corporations now directed their efforts away from the working and middle-class focus of the past and concentrated instead on the college market. The film emphasis was on sophistication and creativity. This was also the age in which theater expansion reminded old-timers of the building boom of the 1920s. In place of the picture palaces of yesterday came hordes of multi-screen theater complexes.[1007]

By 1976, the ever buoyant Jack Valenti, elected president of the MPPA in 1966, was announcing the results of a poll indicating "that 109 million Americans over the age of 12 went to at least one movie . . . [in 1976], a figure, by implication, that indicates that roughly half of Americans never go to the movies."[1008] Trying to give a positive perspective to a trend that revealed a nine to ten percent drop-off from the previous year, he went on to say, "that American movie theaters took in $1,974 billion at the box office . . . [in 1976], the second highest total in history, lagging only behind an estimated $2.1 billion in 1975."[1009] Marvin Goldman, president

[1005] Garrison, p.146.

[1006] Garrison, p.151.

[1007] For more information, see Frank Barron, "Big Movie Houses Going Way of Dinosaurs; Minis Reign," HOLLYWOOD REPORTER 251:3 (April 6, 1978):15; Jowett and Linton, pp.44-5; Douglas Martin, "Jazzing Up the Old Movie House," NEW YORK TIMES F (August 31, 1986):4; Nan Robertson, "Multiplexes Add 2,300 Movie Screens in 5 Years," ibid., C (November 7, 1983):13; and Izod, pp.196-8.

[1008] Cited in Robert Lindsey, "Hollywood's Gamble on Big Hits--Fewer Movies and Emptier Theaters," NEW YORK TIMES 1 (January 27, 1977):42. See also Frank Segers, "MPAA Figures For 1976, Contrasts VARIETY Index," VARIETY 285:11 (January 19, 1977):20.

[1009] Lindsey, pp.37, 42. Interestingly, VARIETY regularly has conflicts with the MPAA's box-office figures. The VARIETY BOXOFFICE INDEX (VBI), set in 1970 at 100.00, was described in the February 4, 1976, issue of VARIETY and a chart was provided showing monthly fluctuations back to 1971. A. D. Murphy, the highly regarded industry statistician, explained that the discrepancies between his VARIETY reports and those of the MPAA in the domestic box-office area result in his being five to six percent higher. He added, however, that "The disparity is synchronous and is also within anybody's statistical tolerance." Cf. A. D. Murphy, "U. S. Ticket Sales $1,750,000,000," VARIETY (January 19, 1977):3, 20. Also important to remember is that box-office receipts do not represent the only, or the most important, source of revenue for filmmakers. Inflation, distribution fees, television sales, foreign markets, reissues, and videocassette releases also play a prominent role in determining a specific film's commercial success. In fact, initial box-office returns function best as predictors of how the film appeals to audiences at the time of its release. This,

of the National Association of Theater Owners (NATO), voiced a more accurate concern. The head of the organization representing nearly 15,000 movie houses attacked filmmakers for producing films geared basically "to people in the 18-32 age group."[1010] In evaluating the various claims, Brian Rose was quick to point out that the drop in attendance between the post-World War II period and the mid-1970s was alarming: approximately seventy-five percent of the population went to the movies in 1946; fifty percent in 1976.[1011]

Pauline Kael, among a host of other critics, added her voice to the argument that the filmmakers' interest in profit had led them to put too much emphasis on "immediate gratification" and to forget about producing public daydreams.[1012] Even the immediate gratification idea was growing wearisome by the end of the decade. For example, the cycle of "disaster movies" that had begun in 1972 with THE POSEIDON ADVENTURE had, by 1979, run its course; and recent films like THE SWARM and BEYOND THE POSEIDON ADVENTURE were not even covering their costs of production and advertising.[1013]

Other claims relating to the composition and nature of the film audience were also attracting the attention of the film industry. For example, Charles Hoag, the resourceful entertainment and advertising director for the MINNEAPOLIS TRIBUNE and STAR, conducted a survey to prove why his twin newspapers were having record advertising gains at a time when film box-office receipts were declining sharply in the Minneapolis area. The reported results stated that ninety-two percent of those polled used newspapers for the major source of information about films.[1014] On a more down-beat note, the critic Gene Siskel and a number of his Chicago-based associates took a secret survey on whether or not local theater owners were enforcing the R-rated section of the MPAA system, which stipulated that young people under seventeen could not be admitted to an R-film without an adult. Eighteen of twenty-four movie houses were found to be in violation of the rating system. This prompted Siskel to declare that the MPAA code was "'a sham' and that parents, more than ever before, may have to assume full responsibility for what their children see in theatres."[1015] The good news for exhibitors across the country, however, was that college students were solid movie fans. Based upon a survey of 3,916 college

in turn, affects the way in which the film will then be distributed for future markets and mass distribution. For more information, see Daly's A COMPARISON OF EXHIBITION AND DISTRIBUTION PATTERNS IN THREE RECENT FEATURE MOTION PICTURES.

[1010] Lindsey, p.42.

[1011] Brian Rose, "From the Outdoors to Outer Space: The Motion Picture Industry in the 1970s," MOVIES AS ARTIFACTS, p.53.

[1012] Pauline Kael, "On the Future of the Movies," NEW YORKER 50:24 (August 5, 1974):43-58. Also worth reading in this connection is Pauline Kael, "Movies on Television," KISS KISS BANG BANG (Boston: Atlantic-Little, Brown, 1968), pp.217-26.

[1013] Aljean Harmetz, "Disaster Strikes Disaster Films," NEW YORK TIMES 3 (December 26, 1979):21.

[1014] "Trib-Star Checks Out Film Fans, And Where They Get Info (Not TV)," VARIETY December 15, 1976):34.

[1015] "WBBM in Live-Lens Survey; 75% of Kids Testing Chicago Theatres Admitted to 'R' Pics," VARIETY 295:1 (May 9, 1979):31. For another perspective on the relationship between the ratings and the films being shown, see Bruce A. Austin et al., "M. P. A. A. Ratings and the Box Office: Some Tantalizing Statistics," FILM QUARTERLY 35:2 (Winter 1981-82):28-0.

campuses, AMPERSAND magazine concluded that male students saw 7.6 percent films in a ninety-day period; women, 6.9 percent during the same time.[1016]

Mass communications research in the 1980s continued to reinforce the film industry's revised production strategies of targeting their products for a more educated audience.[1017] For example, the Opinion Research Corporation (ORC) of Princeton discovered in its summer 1981 survey of the American film audience that eighty-five percent of movie ticket holders were between the ages of twelve and thirty-nine, eighty-four percent of the box-office receipts came from twelve year olds and up who went to the movies at least once a month, sixty-eight percent of the film audience were in the twelve to twenty-nine year old category, and forty percent of the film audience were between twelve and twenty years of age. Particularly interesting was the fact that the latter group constituted less than twenty percent of the American population.[1018] In reviewing the important data provided by the research department of the MPAA, Jason E. Squire found further evidence to support the notion that education increases, rather than decreases, one's film attendance. (Cf. Table 12).[1019]

Other useful information confirmed the results of previous studies that showed that single people went to movies more frequently than did married people and that fewer women went to the movies than did men.

The big change, however, was that market research now had a bright future in the film industry. As Thomas Simonet points out, "Acceptance has been spurred by increasing advertising and production budgets, by the lessons of four-walling, and sometimes by the simple quest of the blockbuster."[1020] What is most notable about the new marketing strategies is not that all of the major studios are conducting interviews, wiring their screening rooms, and setting up controlled test markets, but that they are doing so on such a massive scale.

[1016] "Campus Denizens Go-For-Pix, Disks, Radio, But Not TV," VARIETY 298:2 (February 13, 1980):210. For examples of other types of research being conducted in the seventies, see James H. Bryan and Tanis Schwartz, "Effects of Film Material Upon Children's Behavior," PSYCHOLOGICAL BULLETIN 75:1 (1971)50-9; H. S. Eswara and Nadig Krishnamurthy, " How School Achievement Relates to Mass Media Use," JOURNALISM QUARTERLY 55:4 (Winter 1979):785-88; Daniel J. Klenow and Jeffrey L. Crane, "Selected Characteristics of the X-Rated Movie Audience: Toward a National Profile of the Recidivist," SOCIOLOGICAL SYMPOSIUM 20 (Fall 1977):73-83; Deanna Campbell Robinson, "Television/Film Attitudes of Upper-Middle Class Professionals," JOURNAL OF BROADCASTING 19:2 (Spring 1975):195-209; and Robert Roessler and Forrest Collins, "Personality Correlates of Physiological Responses to Motion Pictures," PSYCHOPHYSIOLOGY 6:6 (May 1970):732-9.

[1017] Interestingly, Thomas Simonet claimed that audience research hadn't progressed much since the late 1920s when Albert Sindlinger, an exhibitor with theaters in Ohio, Pennsylvania, and Wisconsin, "bugged" the restrooms in his theaters to determine what the customers wanted in films. See Thomas Simonet, "Industry," FILM COMMENT 14:1 (January-February 1978):72-3.

[1018] Jason E. Squire, "Industry Economic Review and Audience Profile," THE MOVIE BUSINESS BOOK, ed. Jason E. Squire (Englewood Cliffs: Prentice Hall, 1983), pp.357-8.

[1019] Squire, p.361.

[1020] Thomas Simonet, "Market Research: Beyond the Fanny of Cohn," FILM COMMENT 16:1 (January-February 1980):66.

TABLE 12

EDUCATION

	Less Than High School			High School Completed			College		
	1981	1980	1979	1981	1980	1979	1981	1980	1979
Frequent	12%	13%	10%	19%	21%	20%	34%	29%	27%
Occasional	22	13	16	32	26	28	32	36	37
Infrequent	11	12	11	11	16	17	8	14	12
Never	55	61	63	38	37	35	26	21	23

At the February, 1985, SHO WEST film convention, the irrepressible Valenti "announced that the amount of money Americans paid at movie box offices exceeded $4 billion for the first time in 1984, rising more than 7 percent over 1983. The number of movie screens in the United States also increased, by 6.9 percent, to 20,200."[1021] Joseph Alterman, executive vice president of the National Association of Theater Owners, sounded a similar note of optimism months later, when he prophesied that the number of movie theaters would increase by 6.5 (from 20,000 to 21,500) by the end of 1985.[1022]

A major reason why both Valenti and Alterman were optimistic was the increase in film production brought about by the increase in film markets. Ironically, the fact that producers can sell their products to a number of television systems and to the videocassette industry, as well as to the traditional markets had a positive effect on the number of movies available to film exhibitors. That is, exhibitors gained an advantage over producers in the rental area because there were more movies to show. Fewer films, as one report explained, force exhibitors "to bid more aggressively for the right to play them." On the other hand, the expanded supply reduces the number of large guarantees that distributors demand in advance from the exhibitors in order to get permission to show those films deemed the best for the upcoming season.[1023]

Nevertheless, there were ominous signs indicating that the film business was less well off than its defenders claimed. For example, exhibitors moved cautiously in raising ticket prices because of the soaring sales of videocassette recorders and pay-TV systems. In fact, the dramatic rise in home entertainment options was perceived by many observers as evidence of a change in the way in which films would be produced, distributed, and exhibited in the future. For those who doubted that the threat was real, Wenmouth Williams, Jr., and Mitchell E. Shapiro identified the four specific variables that they used to demonstrate the negative impact of in-home technology on film attendance: "(a) demographic, (b) media use, (c) technology, and (d) innovativeness variables." Each of these in turn was subdivided. For example,

[1021] Lindsey, p.24. Valenti admitted, however, that the increased revenue resulted from increased admission prices. He further stated that yearly ticket sales had remained constant at 1.2 billion for the third consecutive year. For information on film attendance in England during the 1980s, see David Docherty et al., "Who Goes to the Cinema?" SIGHT AND SOUND 55:2 (Spring 1986):81-5.

[1022] Geraldine Fabrikant, "Movie Theater Owners are Bullish on Future," NEW YORK TIMES D (July 22, 1985):1.

[1023] Fabrikant, p.8.

demographic variables were classified according to age, income, education, and the number of children in the household.[1024]

The fact that Williams and Shapiro established a link between the decline in film attendance and the rise in in-home entertainment alternatives only added to the worries of the film industry, which in the summer of 1985 suffered its lowest gross in ticket sales ($1.42 billion) in three years.[1025] Overall, according to A. D. Murphy, the film business's receipts were off for the year by seven percent compared to 1984 (from $4.03 billion dollars to $3.7 billion). In addition, movie admissions dropped by twelve percent from the previous year (1.06 billion).[1026] Interestingly, the upsurge in Christmas ticket sales rekindled the debate about the impact of VCRs on the film industry.[1027] While the decline in receipts was seen as an example of how home entertainment was luring people away from the box office, other industry figures claimed that not only were the VCRs providing additional film revenues to filmmakers, but also "bad movies" were the real villain in the box-office decline.

In December of 1985, the ORC released its latest survey on the "Incidence of Motion Picture Attendance" for the MPAA. It confirmed the trends begun at the start of the decade. For example, the report stated (cf. Table 13) that "The bulk of motion picture admissions continues to be generated by those moviegoers under age 40, accounting for 85% of total yearly admissions."[1028] The breakdown by age groups (cf. Table 14) revealed that eighty-five percent of the box-office receipts came from people thirty-nine and younger.[1029] This figure, which has fluctuated between eighty-one and eighty-six percent during the first half of the 1980s, continued to reinforce the decisions by the majors to focus their production policies around the emotional

[1024] Wenmouth Williams, Jr. and Mitchell E. Shapiro, "A Study of the Effects In-Home Entertainment Alternatives Have on Film Attendance," CURRENT RESEARCH IN FILM, p.95. See also Mark R. Levy, "Home Video Recorders: A User Survey," JOURNAL OF COMMUNICATION 30:4 (Fall 1980):23-7.

[1025] Lynn Elber, "Hollywood's Mean Season Ends," BURLINGTON FREE PRESS D (September 5, 1985):6. See also Vincent Canby, "Even Wands Can't Create Magic at the Box Office," NEW YORK TIMES 2 (September 8, 1985):29, 37.

[1026] Aljean Harmetz, "Christmas Film Sales Set Record," NEW YORK TIMES C (January 15, 1986):20.

[1027] For a good overview and an excellent bibliography on the impact of the new technologies on film, see Bruce A. Austin, "The Film Industry, Its Audience, and New Communications Technologies," CURRENT RESEARCH IN FILM: AUDIENCES, ECONOMICS, AND LAW, Volume 2, pp.80-116.

[1028] A Study Conducted for the Motion Picture Association of America, Inc. by Opinion Research Corporation, Princeton, New Jersey, August 1984. 4pp.

[1029] Joseph Infontino, former assistant director of research, approaches the ORC figures from another perspective. For example, rather than accepting the category of "Percent of Resident Civilian Population" in Table 13, he prefers to indicate it as the "Five and Over Population," with a new entry for 1984, 5-11, reading "25.0%." At the same time, Infontino adds an additional entry to the "Admission by Age Group" category: for 1984, people under twelve, 18.5. As a result, the perspective on who is and is not going to the movies changes dramatically. In Infontino's calculations, the bulk of 1984 admissions generated by moviegoers twenty-four and under, amounts to 63.7 of the "5 and Over Population." Put another way, of the "5 and Over Resident Population" who went to the movies (138.4 million out of a total population of 219.7 million people) 98.1 million people were twenty-four years or younger.

interests of young people and to ignore for the most part movies of interest to the forty-and-over generation, even though the frequent moviegoers represented only twenty-four percent of the public twelve years of age and over (cf. Table 15). Interestingly, the total number of filmgoers had moderately increased by four percent (115.0 million in 1984, to 119.2 million in 1985). Also worth noting is that the ORC survey reinforced the fact that moviegoing was more popular with college-educated adults than with those with more limited educations (cf. Table 16), and that males frequented movie theaters more than females (cf. Table 17). Whether cost and education were the reasons for the current configuration of the movie business was debatable. But clearly the figures indicated that those who go to the movies regularly are a group apart from the more general audience that frequently watches television.

TABLE 13

ADMISSIONS BY AGE GROUPS

| | | Percent Total Yearly Admissions | | | Percent of Resident Civilian Population as of 1/85 |
	1985	1984	1983	1982	
AGE:					
12-15	14	13	13	12	8
16-20	21	23	25	25	10
21-24	18	18	15	14	9
25-29	14	13	15	13	11
30-39	18	18	17	16	18
40-49	7	8	7	8	13
50-59	4	4	4	4	12
60 and over	4	3	4	6	20
	100	100	100	100	100
12-17	20	21	25	22	11
18 and over	80	79	75	78	89

TABLE 14

YEARLY ADMISSIONS AND POPULATION PROPORTIONS

	Percent of Total Yearly Admissions				1984 Percent of Population
	1985	1984	1983	1982	
AGE GROUP:					
12-29 yrs.	67	67	68	64	37
12-39	85	85	86	81	56
16-39	72	72	73	68	48
40 and over	15	15	13	19	44

TABLE 15

FREQUENCY OF ATTENDANCE

	Total Public Age 12 & Over			Adult Public Age 18 & Over			Teenagers Age 12 to 17		
	1985	1984	1983	1985	1984	1983	1985	1984	1983
Frequency of Attendance									
Frequent (at least once a month)	22	23	23	21	21	20	48	51	54
Occasional (once in 2 to 6 months)	29	28	32	28	28	32	38	34	30
Infrequent (less than once in 6 months)	9	8	9	9	9	10	3	6	4
Never	39	39	36	41	41	38	9	5	12
Not reported	1	2	*	1	1	*	2	4	-0-

*Less than 1/2%

Frequent moviegoers constitute only 23% of the public age 12 and over, but continue to account for 82% of admissions.

TABLE 16

EDUCATIONAL LEVELS

	Less Than High School			High School Complete			At Least Some College		
	1985	1984	1983	1985	1984	1983	1985	1984	1983
Frequent	6	9	10	21	23	21	34	33	29
Occasional	20	19	22	30	29	32	33	32	40
Infrequent	7	10	7	11	8	12	9	8	9
Never	66	61	61	37	39	35	24	25	22

Moviegoing continues to increase with higher educational levels among adults.

TABLE 17

SEX

	Age 12 and Over						Age 18 and Over						
	Male			Female			Male			Female			
	1985	1984	1983	1985	1984	1983	1985	1984	1983	1985	1984	1983	
Frequent	25	7	27	21	20	18	23	25	25	19	19	17	
Occasional	30	29	32	27	26	30	29	29	33	27	26	20	
Infrequent		9	7	8	9	10	11	10	8	8	9	10	11
Never	35	35	33	43	42	41	37	36	34	45	44	42	

As in previous years, more males than females tend to be frequent moviegoers.

Note: Some of the tables in this chapter may not add to 100 due to rounding of percentages.

How the film industry viewed all these uncertainties was summarized by Valenti in his keynote address to film exhibitors at SHO WEST '86 on Tuesday, February 11, 1986. The man who had headed the MPAA for twenty years minced no words on what the numbers reported. That is, he reiterated the fact that there was a seven percent decline in box-office receipts and a twelve percent drop in ticket sales for 1985. Valenti then added that "only twelve films in 1985 had rentals exceeding twenty million dollars or more out of 200 films that major companies had put into release in 1985." Put differently, that was two fewer than had cleared twenty million dollars or more in 1984, and six fewer than in 1983. To make matters even worse, the cost of the average 1985 MPAA film was 16.8 million dollars, sixteen percent higher than in 1984 and forty-one percent higher than in 1983. Valenti's point was that as a result of the cost of a print and the attendant marketing requirements, the average MPAA producer had a twenty-four million dollar investment to recoup before anyone else could begin to collect a penny.

Added to these dismal notes were the alarming statistics on the VCR revolution and what it was doing to leisure time activity. According to Valenti's research, the number of VCRs in American homes had increased in 1985 by fifty-six percent over

the number of VCRs in American homes in 1980. In other words, nearly twenty-eight percent of American homes had one or more VCRs by the start of 1986.[1030] The effect on in-home entertainment was dramatic. For example, Valenti cited the latest A. C. Nielsen Company ratings as reporting that the average American home is viewing TV 7.5 hours a day; in a basic cable home setup, 7.8 hours a week; and in a paid cable setup, 8.7 hours a week. Those who own VCRs were watching programs about 6.2 hours a week.[1031]

Given these dire numbers, the ever-optimistic Valenti still painted a bright future for film exhibitors. He gave three basic reasons. First, he predicted that the novelty of VCRs would decrease significantly by 1990. At that point, the sixty million VCRs in American homes would no longer maintain viewer interest at the same level of intensity, and a more casual use would become apparent. Second, he pointed out that human beings are social animals and would always seek social evenings outside the home.[1032] Third, and most important, he argued that filmmakers would provide better products in the future. In Valenti's words, "The program is the thing."[1033]

One way to react to Valenti's optimism is to sum up what has been said about the film industry since the mid-forties. Through experience and experimentation American filmmakers thought they had discovered that moviemaking had entered a new era after World War II, and for a while, it seemed they were right. First, the film industry operated on the assumption (changed in the 1980s) that it no longer needed to target its product for a mass audience. Far more lucrative were those specialized films that appealed to young people who enjoyed seeing a film more than once. Second, although it might be difficult to predict what an audience prefers, it

[1030] For more information on videocassettes and videodisks, see Donald E. Agostino, et al., "Home Video Recorders: Rights and Ratings," JOURNAL OF COMMUNICATION 30:4 (Autumn 1980):28-35; C. Gerald Fraser, "A Star Library Attraction: Loaning Video Cassettes," NEW YORK TIMES C (September 17, 1986):21; Mark R. Levy, "Program Playback Preferences in VCR Households," JOURNAL OF BROADCASTING 24:3 (Summer 1980):327-36; Paul Mareth, "The Video Disc: Shining a New Light," CHANNELS 4:1 (March/April 1984):24-30; Lee Margulies, "Will Movie Theaters Survive Video?", HOME VIDEO 3:11 (November 1982):50-3; and Istvan Sebestyen, "The Videodisc Revolution," ELECTRONIC PUBLISHING REVIEW 2:1 (March 1982):41-89.

[1031] A common fallacy among many viewers is that the Nielsen ratings of specific television programs are important only for their aggregate sums. Actually, they become significant when broken down according to target groups. For example, certain advertisers select shows to sponsor according to the appeal the show has for women eighteen to forty-nine and adults twenty-five to fifty-four . A case in point is NBC's AMAZING STORIES (1985-86 season). The series created by Steven Spielberg, according to Harmetz, came in thirty-fifth in the yearly ratings, but thirteenth in the eighteen to forty-nine women's category and seventh in the twenty-five to fifty-four adult's category. The significance of that difference, explained Harmetz, was that "A 30-second commercial languishing in the middle of the . . . Nielsen . . . ratings would ordinarily sell for $100,000. AMAZING STORIES . . . commanded close to $150,000. . . ." See Aljean Harmetz, "AMAZING STORIES Tries New Tactics," NEW YORK TIMES C (June 2, 1986):16.

[1032] James Monaco supports Valenti's premise with the argument that those in the age group from twelve to twenty-five "are the ones who desperately want to leave the house, which is why the theatrical film is really in no danger from the new home-centered media." See James Monaco, "The Silver Screen Under Glass," CHANNELS 1:3 (August/September 1981):53.

[1033] For additional comments by Valenti, see "Valenti Justifies Prediction of Doom from Home VCRs," HOLLYWOOD REPORTER 255:19 (February 12, 1979):1, 13.

was clear that few films could achieve massive profits without extensive and expensive advertising campaigns. Third, the secret to success lay not in producing large numbers of films, but in concentrating on a select few. In fact, more available films only increased the possibility of more box-office failures. Fourth, film companies that hoped to stay in business needed to diversify their holdings. That is, paying attention to musical recordings, pay cable, TV networks, videocassettes, and other aspects of the entertainment industry was just as important as producing and exhibiting films. In short, there is more for exhibitors to worry about than the product, the social activities of human beings, and the increasing popularity of VCRs.

Another way to react to Valenti's optimism is to note how the film product has changed in recent years.[1034] Canby speaks for many people when he points out that

> The essential nature of movies--the way in which they work on audiences--is no different today than it was in 1935, or even in 1925. Though movie theater audiences are supposedly younger, more hip and more skeptical than they used to be, they continue to respond to movies largely through a simple, immediate, emotionally satisfying identification with the people they see on the screen.[1035]

At the same time, as Richard Corliss comments,

> The genres that stormed the Eighties (sci-fi, horror, action-adventure, slapstick comedy) are now depleted . . . [and t]he sequel, that last refuge of a brain-dead mogulocracy, is king; every studio in town is romancing the clone.[1036]

It isn't just the fact that Hollywood is making so many sequels that is troubling. After all, sequels have been an integral part of the film industry since the silent days. "What is new," explains Harmetz, "is the cost and box-office potential of sequels and the intensity with which Hollywood is spewing them out."[1037]

What is surprising is the misperception that the sequel strategy isn't very effective. For example, Anne Thompson reports that the summer of 1985 saw the worst box-office showing in seventeen years. Of the four films that generated the most commercial success--BEVERLY HILLS COP (1984), WITNESS, BACK TO THE FUTURE, and RAMBO: FIRST BLOOD PART II (all in 1985)--only RAMBO was a sequel. Thompson also states that "Of the 91 pictures released between Labor Day and Christmas, only six grossed over $15 million."[1038] Only two of those big moneymakers were sequels: ROCKY IV and THE JEWEL OF THE NILE. At first glance, a study of these films reveals the limited intellectual level and emotional pitch that filmmakers are using to reach their targeted hip and youthful audiences. A closer examination of industry product, however, reveals that such films "inspired" the industry over the past five years to make more and more spin-offs, sequels, and remakes. Put another way, Valenti's declaration that "The Product is the Thing" suggests only a

[1034] For a unique approach to marketing cult films, see Alicia Springer, "Sell It Again, Sam!" AMERICAN FILM 8:5 (March 1983):50-2, 54-5.

[1035] Vincent Canby, "Emotionally Speaking, It's Still the Same Old Story," NEW YORK TIMES 2 (May 5, 1985):27.

[1036] Richard Corliss, "Out of Affluence," FILM COMMENT 22:2 (March-April 1986):7.

[1037] Aljean Harmetz, "The Sequel Becomes the New Bankable Film Star," NEW YORK TIMES C (July 8, 1985):15.

[1038] Anne Thompson, "Industry: Tenth Annual Grosses Gloss," FILM COMMENT 22:2 (March-April 1986):64.

hollow hope for exhibitors if the current mainstream production mania remains pitched at the same shallow and senseless level. For example, of the top six box-office hits of 1988, one was a sequel, CROCODILE DUNDEE II; and one was THREE MEN AND A BABY, a remake of a popular French film.[1039] Moreover, Hollywood is gearing up for a number of sequels and remakes in 1989. Set for release in the summer of this year are BATMAN, GHOSTBUSTERS II, INDIANA JONES AND THE LAST CRUSADE, THE KARATE KID III, LETHAL WEAPON II, and STAR TREK V. Still further, filmmakers are working on BACK TO THE FUTURE II and III at the same time. Once again, the filmmakers seem to know more than their critics.

A third way to react to Valenti's upbeat predictions is to examine the impact of the cable-TV revolution on the film industry.[1040] As Austin suggests, the best way to do this is to concentrate on "demographics, motives for adoption, and effect on movie attendance."[1041] The research clearly suggests that the same people (under thirty years of age) categorized as frequent filmgoers (who see at least one movie a month) are classified as typical pay cable subscribers. "By itself," as Austin concludes, "this does not bode well for the movie industry [sic], movies are competing for the same demographic aggregate as are cable and pay cable services."[1042] Equally unsettling to film exhibitors was research pointing out that movies were the main attraction of subscribing to cable and pay-TV. That is, people's love for movies has not changed. What is new is the "form of exhibition and viewing context."[1043] Only in the area of cable's effect on film attendance is the research mixed. Several studies report changes in film attendance, while at the same time indicating the existence of social groups that continue to be frequent filmgoers. Despite the sparse amount of evidence and the conflicting messages in the reports that do exist, Austin nevertheless concludes "that cable television has had a detrimental effect on the frequency of moviegoing."[1044] Even worse is the effect of videocassette rentals on film exhibition. According to a survey released by Columbia Pictures in May of 1986, people in every age group are renting films at a staggering rate: "For example, 10-20-year-olds, a prime moviegoing audience, rented 58 million films last August and September, up from seven million during those months in 1983."[1045]

[1039] Aljean Harmetz, "Drama Inches Up on Comedy at the Movies," NEW YORK TIMES C (January 17, 1978):15.

[1040] For useful information, see Hans Fantel, "Guide to Video Systems: Disk and Cassette," NEW YORK TIMES C (March 12, 1981):1, 6; Robert Lindsey, "Video Reshaping Film Industry: TV Technology Erodes Control of Distribution," ibid., D (July 18, 1980):1, 6; ___, "Hollywood Moves to Tap Video Market," ibid., C (July 2, 1979):12; ___, "Video Recorders Change Daily Habits," ibid., C (March 29, 1979):1, 3; Janet Maslin, "Editing and Other Foibles of Movies on Cassettes," ibid., C (April 8, 1982):11; Eric Pace, "The New Video Technologies: System Will Permit Shopping at Home," ibid., D (April 14, 1982):1, 11; Andrew Pollack, "Video Sales Expected to Set Records: Industry Offers Its Latest Wares in Chicago Show," ibid., D (June 1, 1981):1, 8; and ___, "A Battle Over Video Cassettes: Millions in Tape Rentals Are at Stake," ibid., D (December 11, 1981):1, 15.

[1041] "The Film Industry," p.92.

[1042] "The Film Industry," p.93.

[1043] "The Film Industry," p.93.

[1044] "The Film Industry," p.94.

[1045] Aljean Harmetz, "Hollywood's Summer Sweepstakes," NEW YORK TIMES C (May 21, 1986):21.

Perhaps the most disturbing development to the small theater owner surfaced in Valenti's appearance at SHO WEST '87. Instead of delivering his standard upbeat report to exhibitors, the MPAA executive fielded questions from the audience. It was anything but the usual meeting. An independent Texas exhibitor Nancy Noret Moore "grilled Valenti . . . regarding what independents feel are unfair distribution practices that limit their access to day-and-date first-run features and subject them to frequently unfair terms."[1046] Her fiery comments inspired other exhibitors to speak out. For example, an independent exhibitor from the Southwest stated, "We're suffering things in our business that regular, normal business never has to suffer. If we have the best screen in a given town, the best theater, the best seats and the best grossing potential; and we sell the films and we still don't get the picture, it just doesn't seem fair."[1047] Distributors were quick to respond to the charges raised by Moore and her peers. For example, James R. Spitz, president of Columbia Pictures's domestic distribution, argued that "We evaluate bids fairly, and we try to maximize our film rentals."[1048]

The problem of distributor-exhibitor relations, however, goes beyond the issue of bidding. A case in point is the buying power of USA Cinemas, currently the tenth largest exhibitor in the United States. Part of the chain is the recently acquired Sack Cinemas, which has been involved in legal battles with small exhibitors in New Hampshire and Vermont. As reported in the NEW HAMPSHIRE TIMES, the independent exhibitor Barry Steelman sued the Boston-based company because of its "predatory and monopolistic practice" that was forcing him out of business. He argued that Sack was deliberately breaking industry regulations by "showing eight first-run films on its six screens." Industry policy is that first-run films require uninterrupted showings on individual screens. Moreover, the New Hampshire exhibitor claimed that the local Sack theater was misleading the public "by falsely advertising seven movies for a certain time slot when only six were available for each showing." The suit hinged on the limited number of first-run films available in a given film market. Distributors limit access to each of those films. "It is conceivable," observed U. S. District Court Judge Martin Loughlin, "that an exhibitor by showing more first run movies than he has screens available for could corner the market to use the vernacular."[1049] The case was settled out of court and Steelman remained solvent.

In Vermont, the independent exhibitor Merrill Jarvis is pursuing a similar suit against Sack, claiming that the large corporation not only is forcing distributors to sell their products to it, but also that the studios themselves are engaging once more in block booking.[1050] According to VARIETY's Jim Robbins, such "Sweetheart Suits" are common in that "the plaintiff claims 'the big distributor and the circuit owners [industry jargon for multi-screen, multi-theater owners] are in bed together.'"[1051] Another independent Vermont exhibitor, Kevin Mullin of Rutland, echoes Jarvis's fears, stating that "The big boys are getting bigger and are closing up the larger

[1046] "Plight of Indies Emerges as Major Issue at Show West," HOLLYWOOD REPORTER (February 13, 1987):52. For a slightly different perspective see, Therese L. Wells, "Tri-Star Ok'd to Play Loews, Though Indie Plight Recognized," ibid., (June 19, 1987):1, 36.

[1047] "Plight of Indies," p.52.

[1048] Teri Ritzer, "Distributors Challenge Indie Exhibitors to Improve Service," HOLLYWOOD REPORTER (February 13, 1987):52.

[1049] Tim Sandler, "Can New Hampshire's Little Guys Survive a Big Sack Attack?" NEW HAMPSHIRE TIMES (February 22, 1986):1.

[1050] Joshua Mamis, "Takeover!" VANGUARD PRESS (June 7-14, 1987):10-1.

[1051] Cited in Mamis, p.10.

markets. It's almost like the small exhibitors are at war with the distribution companies, and they don't get any concessions."[1052] Referring specifically to Jarvis's complaint, he points out that "Burlington is a blatant example; USA Cinemas has bought out the Nickelodeon (theater) and now the competition against Merrill Jarvis is crazy. . . ."[1053] Although Sack theaters were recently purchased by Loew's Inc., the Vermont case is still in process.

The overall reaction, therefore, to Valenti's position on the future of theatrical film exhibition is, at best, mixed. Clearly, independent theater owners are in danger from a massive move by circuit owners to increase their theater holdings. For example, NATO reports that there were 22,745 screens operating in 1986 (545 more than in 1984) and plans for 1,900 more to appear in 1987.[1054] This expansionist policy is apparently being encouraged by the major distributors. In addition, the current research reveals that both audiences for films and box-office admissions are on the increase. Martin Grove reports that current film industry research indicates that "America is getting older." Translated into box-office jargon, movies need to be produced for adults as well as the industry's "core audience, which is defined as 18 to 24 years old."[1055] Of particular importance is the fact that among the people who frequently go to the movies, the impact of the new technologies is noticeable if not significant. But since the number of people who frequently go to the movies is less than twenty-five percent of the population, the concern is more with the effect that pay-TV, cable, and videocassettes will have on those who intermittently or rarely attend films. And there the news is dismal. The new technologies have not only increased the amount of time spent viewing home entertainment, but also have decreased both the interest in, and the leisure time for, watching movies in a theater. Thus, it is questionable whether Valenti is right in his prediction that the novelty of the videocassette and videodisk[1056] will wear off by the early 1990s. However, there is a possibility that more leisure time will become available in the years to come and thus increase the amount of time available for filmgoing. These optimistic signs are much more problematic than the current data that is sending out strong warning signals to the film industry.

What value does this overview of American film audiences during the past ninety years have for our understanding of how stereotypes function in the movies? First, it describes how important pleasing mass audiences is to the American film industry. This need to reach vast numbers of people is not unique to filmmaking. What is

[1052] Cited in Gayle Hanson, "Vt. Theaters Stuggle for Films, Survival," RUTLAND HERALD (May 10, 1987):1.

[1053] Hanson, p.1.

[1054] Tom Green and Jack Curry, "Hot Tickets May Burn Up Record Books," USA TODAY D (June 17, 1987):2.

[1055] Martin Grove, "Adult-Appeal Releases on Rise During Summer B. O. Season," HOLLYWOOD REPORTER (August 7, 1987):31. See also "Drama Inches Up on Comedy at the Movies, pp.1, 15.

[1056] At present, the videodisk is becoming less and less of a threat to the film industry. Among its major drawbacks are cost of hardware and the inability of the machine to record off-the-air programs. For more information, see Hans Fantel, "Videodisks Battle for Consumer Favor," NEW YORK TIMES D (May 10, 1981):23; Watson S. "Jay" James, "The New Electronic Media: An Overview," JOURNAL OF ADVERTISING RESEARCH 23:4 (August/September 1983):33-7; N. R. Kleinfield, "Video Cassettes Get a Big Play: Videodisk Sales Face Problems," NEW YORK TIMES D (December 18, 1980):1, 4; and Andrew Pollack, "Losses Lead RCA to Cancel Videodisk Player Production," ibid., A (April 5, 1984)1, D23.

significant is that its timing coincided, as Mayne pointed out, with dramatic changes in the socio-economic organization of society and the growth of advertising:

> In their study of monopoly capitalism, Paul Baran and Paul Sweezy write that a century ago, "before the wave of concentration and trustification which ushered in the monopolistic phase of capitalism, advertising played very little part in the process of distribution of products and the influencing of consumer attitudes and habits." By the 1890s, however, advertising had become more common, and it became more and more influential with every successive decade of the twentieth century. It is primarily through advertising and its systematized use of images and texts that we can speak of a CONSUMERIST CULTURE in the twentieth century.[1057]

Malcolm Cowley made a similar observation about the aftermath of World War I:

> To keep the factory wheels turning, a new domestic market had to be created. Industry and thrift were no longer adequate. There must be a new ethic that encouraged people to buy, a CONSUMPTION ethic.[1058]

Thus, from the end of World War I to the present, filmmakers have searched for film images and ideas that people would find both attractive and pleasurable. The images and ideas that proved to be commercially successful were incorporated into film conventions and institutionalized in film formulas.

What has not generally been understood is the relationship among the major motion picture corporations, their commercial underpinnings, and the content of the products produced. Those who persist in accusing Hollywood of releasing only films that reflect a patriarchal point of view fail to understand not only how cultural hegemony operates in the media but also the complexities of the film continuum. What many alarmists also fail to notice about the close ties between movies and their audiences is that the film industry built its appeal on the tried-and-tested formulas found in literary and stage traditions. Furthermore, from the beginning of the industry to the present, filmmakers have revealed an extraordinary skill in merchandising the emotional ties that audiences had and continue to have to moving pictures. That impressive talent has withstood the challenge from media like radio and television and provides the basis for much of the film industry's current optimism about its "war" with the video industry. A large part of the film industry's success story is tied to a formula filmmaking approach that relies almost exclusively on stock conventions and social types molded on both past and present literary and stage traditions. Costly publicity programs geared to reinforcing the images of specific stars performing in predictable and recycled stories remain the mainstay of the major film corporations. Financiers who lend their time and resources to filmmakers expect and receive repeated assurances that the industry's products are expressly aimed at reaching the widest audience possible. For example, writer-director James Cameron believes that "the endless 'remulching' of the masculine hero by the 'male dominated industry' is, if nothing else, commercially shortsighted." Consequently, he credits a good portion of the success of his film ALIENS (1986) to his emphasis on elements that appeal to women. In his words, "I've been told that it has been proved demographically that 80% of the time, it's women who decide which film to see."[1059]

[1057] "Immigrants and Spectators," p.34. The Baran quotation is from Paul Baran and Paul Sweezy, *MONOPOLY CAPITAL (New York: Monthly Review Press, 1966; Rpt. London, Penguin Books, 1973), pp.122-3.

[1058] *Malcolm Cowley, THE EXILE'S RETURN (New York: The Viking Press, 1934; Rpt. 1983), p.62.

[1059] Richard Schickel, "Help! They're Back," TIME 128:4 (July 28, 1986):56.

What is dramatically different from past film history, however, is the industry's recent emphasis on manipulating specialized rather than mass audiences. Thus, negative as well as positive stereotypes continue to serve the profit motives of filmmakers. At the same time, it is clear that no one has yet been able to insure that a film's preferred meaning will be the one uniformly accepted by audiences.

As various methods of mass communications research seek to minimize production, distribution, and exhibition risks, the reported composition and nature of the film audience directly influences the titles, casts, stories, and values in American movies. For example, when white middle-class women were presumed to be the key segment of the audience, the male-oriented film industry mass-produced films with stock female themes and social values, and that approach became a crucial element of production. Clearly, women were both glamorized and exploited by these film images. Nevertheless, there were also women who found in the classic Hollywood films a different "reading" of the plot, characters, and themes. When age more than gender became the key factor in determining box-office receipts, the American film industry responded accordingly. At each stage, the stock conventions and social types were fine-tuned to the age, education, income, and gender of the targeted audience. Not to understand that film images and ideas are tied to political, social, and economic values and thus need to be analyzed in both a historical and an institutional setting is to misunderstand the context in which American films are made, marketed, and received.

BOOKS

Allen, Robert C. VAUDEVILLE AND FILM 1895-1915: A STUDY IN MEDIA INTERACTION. New York: Arno Press, 1980. 334pp.
This 1977 University of Iowa doctoral dissertation is a splendidly researched study on the mutual impact of film and vaudeville at the turn of the century. At the time it was written few film histories had given more than a cursory look at the subject, let alone at the importance of economic considerations in the study of film. As a result, Allen's revisionist task was to set the record straight on a number of issues: e.g., the significance of American movies as a form of mass entertainment, how movies satisfied audience needs in the period between 1895 and 1915, the effect that the topical nature of the first films had on both the medium and vaudeville, the significance of movie theater circuits not only to the film industry but also to vaudeville, and the economic factors that led to the displacement of vaudeville as America's pre-eminent popular entertainment. The fact that most previous film histories had not relied on primary documentation led the author to present his contemporaneous sources in a chronological order. In addition to his issue-by-issue search of leading theatrical trade papers between 1895 and 1915, Allen culled the business records of key concerns like the Edison and Vitascope companies, as well as documents from the B. F. Keith vaudeville circuit. The material was then carefully organized into seven fact-filled chapters dealing with the development of vaudeville as an industry and as an art form, the entrance of movies into the vaudeville format, the initial stages (1897-1904) of film as a vaudeville act, the impact of the Nickelodeon phenomenon on film and vaudeville, and the rise of feature films. In an impressive blend of discriminating scholarship and energetic prose, the author makes a persuasive case for reexamining in more detail the intricate economic, technological, and ideological relationships not only between film and vaudeville, but also among film, other mass media, and major American industries.
Allen's conclusions fall into four categories. First, he focuses on the relationship between film and vaudeville during the 1895 to 1915 period. Having confirmed the rapid rise of the "variety" form from an itinerant and disorganized group of performers to a major popular entertainment in several decades, Allen shows why the movies as a new "act" appealed to vaudeville managers at the turn of the century. It was more a spectacular novelty than an isolated phenomenon. Particularly interesting are the author's reasons why Biograph and the Lumieres, not Edison,

Raff, and Gammon, did so well selling their projectors to vaudeville managers. Equally noteworthy is Allen's new perspective on two controversial issues: the "chaser" theory and the White Rats strike of 1901. Where most standard histories have claimed that movies "drove" audiences out of vaudeville between 1897 and 1901, Allen argues from primary evidence that this theory lacks credibility. Where most standard histories tout the early films as scabs in the 1901 strike, Allen finds no evidence for a resurgence in film popularity during this incident. If there was one problem for films during these years, according to the author, it was an overreliance on topical films. His arguments on how audiences vacillated in their interests, and thereby contributed to a shift from topical to comedy films, make for engrossing reading. The material on how the Nickelodeon drastically altered the vaudeville-film relationship and gave rise to live acts appearing in movie houses covers more familiar ground, but lacks none of the clarity and insights of the more controversial portions of the dissertation. One especially interesting section discusses in considerable detail the competitive struggle between small-time vaudeville (Marcus Loew) and big-time vaudeville (B. F. Keith).

Allen's second set of conclusions deals with the impact of American films on the film-vaudeville relationship. After establishing vaudeville's importance to the fledgling film industry as an outlet for equipment, production, distribution, and exhibition, Allen goes on to argue impressively why standard histories are wrong in claiming that vaudeville up to 1905 had a negative impact on the growth and development of film. For example, he concedes that the availability and accessibility of national vaudeville circuits as exhibition sites deterred many filmmakers from going into the exhibition field. On the other hand, he makes a masterly case for the positive influence that vaudeville audiences had in the growth and development of film genres. More to the point, Allen challenges film traditionalists by asking what standards were applied in evaluating the positive and negative relationship between film and vaudeville. For example, he points out that the rapid success of the Nickelodeons clearly established the importance of narrative films. At the same time, he argues that other film genres suffered from the shift in film production.

The third category, and the least imaginative, concerns film's impact on vaudeville. Allen first rehashes why a movie, at least for the vaudeville managers, was the ideal vaudeville performer. He then explains why the early films had to adjust to the standard variety format of twelve- to twenty-minute acts, and why the older entertainment's rigidity eventually was responsible in part for its decline. But Allen is careful not to be definitive about the factors that eliminated big-time vaudeville. In oversimplified terms, he winds up stating that vaudeville just wasn't able to respond to the challenges presented by the movie moguls like Loew.

The fourth and final category persuasively demonstrates the importance of the other mass entertainment media to film. Among the examples he cites are the influence of vaudeville in the distribution and exhibition areas, the rise of the Nickelodeon as a response to the needs of lower-class audiences, and the growth of small-time vaudeville and movie chains.

Overall, Allen's splendid study reminds us not only how valuable the Arno Press series and its counterparts at EMI are to film scholarship, but also how much work yet needs to be done in reexamining film history. A bibliography is provided, but no index. Recommended for special collections.

Austin, Bruce A. THE FILM AUDIENCE: AN INTERNATIONAL BIBLIOGRAPHY OF RESEARCH, WITH ANNOTATIONS AND AN ESSAY. Metuchen: The Scarecrow Press, 1983. 179pp.

A comprehensive annotated listing of more than 1,200 studies on film audiences, this welcome bibliography has two specific functions: "to provide interested scholars with a handy reference tool . . . [and] to act as an impetus for vigorous scholarly inquiry on the subject of film audience research." The wide-ranging topics include information on art films, drive-in movie patrons, the effects of movies on attitude development, film marketing, psychological effects, and research methodology. The emphasis is on empirical research rather than on speculative or advocacy articles.

Studies not directly related to film audiences (e.g., research on anti-social behavior and the relationship between film and education) are omitted.

Adding to the book's obvious values is a thoughtful introductory essay, "The Motion Picture Audience: A Neglected Aspect of Film Research." First, Austin explains why audience research needs to be conducted. Next, he documents why film scholars historically have neglected film audience research. In essence, Austin argues that research has been traditionally neglected since its benefits have not been apparent--or, perhaps more accurately, given a chance to be "revealed." He is particularly critical of the social sciences, calling attention to a number of invalid assumptions--e.g., the research lacks theoretical underpinnings, it doesn't relate to scholarly interests, the evidence is too difficult to locate, and the topics are trite. Having dismissed the "excuses," the author proceeds to outline four important areas where research on film audiences is needed. The first involves conditions antecedent to filmgoing. For example, a commonly held assumption is that potential patrons are influenced most by what the film is about. A second area for future research is the context of the movie experience. Here the concern is with finding out how audiences interact with the physical context in which they view films. The third area involves the public's film preferences. For example, why does a film succeed with an audience, why does the audience's taste suddenly change, and how do film cycles begin and end? The final area deals with society's biases against Hollywood. As Austin notes, "The public's attitude toward movies can be seen as shifting from a highly favorable one . . . in 1933, to a more tepid response . . . [in 1952 and in 1962], and finally, . . . [the 1981] finding of a somewhat unfavorable attitude."

Anyone interested in studying film audiences will find this book an invaluable resource guide. A splendid title and subject index add to the book's considerable worth. Recommended for special collections.

*Austin, Bruce A. IMMEDIATE SEATING: A LOOK AT MOVIE AUDIENCES. Belmont: Wadsworth Publishing Company, 1988. Illustrated. 194pp.

Another important contribution to understanding how viewers react to the movies they watch, this introductory study summarizes current information on research methods for testing and verifying the conclusions on the interpretations of movie images. Austin's ten lucid and concise chapters review the history, evolution, and current status of audience research. Not only does he explain the various approaches to examining movie audiences, but he also synthesizes the existing literature and offers valuable interpretations about the conclusions reached. The book is especially useful in stimulating ideas for future research. Interestingly, he excludes discussions on the presumed effects of media violence and sexually explicit material, explaining that such information is available in other books. Endnotes, an extensive bibliography, and an index are included. Recommended for special collections.

Austin, Bruce A., ed. CURRENT RESEARCH IN FILM: AUDIENCES, ECONOMICS, AND LAW, Volume 1. Norwood: Ablex Publishing Corporation, 1985. 221pp.

Refreshing and absorbing, this highly original scholarly anthology broadens our understanding of three nontraditional areas of film study: the film audience, motion picture economics, and the legal aspects of film as a mass medium. This establishes a much-needed outlet for film investigators examining a host of topics and issues hitherto omitted, overlooked, or consciously discouraged by other film publications and forums. The most unusual aspect of the work is the editor's willingness to allow his essayists complete flexibility in methodology. Consequently, each of the twelve well-written and accessible essays in this collection illustrates how imagination and hard work can produce intriguing results.

Olen J. Earnest's excellent case study of how George Lucas marketed STAR WARS (1977) demonstrates the value of Austin's publishing vision. Earnest is able to describe in considerable detail how Lucas initiated his marketing plans, marketed

and advertised the film, as well as handled the prerelease, release, and postrelease phases of STAR WARS. Not only does the author isolate the major issues in the marketing of motion pictures--e.g., what makes movies a unique luxury product, the various factors in a high risk market, and the limitations film has in comparison with packaged goods--but he also identifies the ingredients that go into a major marketing campaign--e.g., the importance of testing film titles, concepts, print advertising, TV commercials, and trailers.

Garth S. Jowett follows with yet another impressive analysis on audience research before the 1950s. With characteristic wit and depth, he first describes the dearth of audience studies and the primitive manner in which box-office scrutiny and "unobtrusive observations" dominated audience research during the first thirty years of film history. The main thrust of Jowett's essay, however, is to outline to the sociological, behavioral, and commercial studies carried out by and for the American film industry.

Boris W. Becker and his colleagues in their stimulating exploratory study on film preferences seek to identify linkages between basic human characteristics and film choices. Incorporating their tentative conclusions about individual values and film preferences into a more comprehensive examination of values and consumer choice behavior, the authors use as their subjects seniors and graduate students enrolled in business courses at a western state university. Three film categories were selected--romance, science fiction, and violent action--to measure variations among the three classes of students. While readers may have difficulty grasping the definition for the "violent action category," the group's methodology and interesting summaries should prove to be satisfying reading. For example, the differences in values between those who prefer science fiction films and those who prefer romances have significant implications for scholars studying television as well as for advertising.

The fourth and final essay directly related to film audiences, written by Susan Tyler and her colleagues, examines audience expectations related to the film THIEF (1981) during its regional premiere, and analyzes the effects of movie previews on the public and what the film audiences expected to see in terms of content. Tests were then conducted to measure the degree of satisfaction in relation to expectations after viewing the film. One of the group's several intriguing conclusions is that trailers may not generate the kind of response either the filmmakers or the audiences most desire.

The remaining eight essays probe a wide range of film issues. Austin details the development, growth, and modern status of American drive-in theaters. Wenmouth Williams, Jr., and Mitchell E. Shapiro establish a link between alternative home entertainment--e.g., pay TV, video recorders, cable television--and film attendance. Janet Wasko explores Hollywood's essential relationship with major international financial institutions. Thomas Guback examines the vital links between the film industry and governmental agencies. Mary Beth Haralovich offers a substantive explanation of how film advertising through specific strategies (e.g., the 1940s pin-Up) demonstrates the methods by which the movie industry works to accommodate the social forces in our society.[1060] John Fullertin provides useful information on the production interests of the major Swedish silent film company, AB Svenska Biografteatern. Ian Jarvie's splendid case studies on nongovernmental censorship activities related to OBJECTIVE BURMA! (1945) and MONTY PYTHON'S LIFE OF BRIAN (1975) not only effectively show the changes in suppression tactics over two decades, but also reveal a host of subtleties usually overlooked by investigators of censorship. Denise M. Trauth and John L. Huffman conclude this invigorating text with a discussion of public nuisance laws as a new approach to controlling film censorship.

[1060] For another perspective, see Jane Gaines, "In the Service of Ideology: How Betty Grable's Legs Won the War," FILM READER 5 (1982):47-59.

Where Austin's anthology may run into difficulty is in the area of aesthetics and focus. No doubt, traditional film scholars will argue that here is one more example of our being asked to ignore the product in favor of peripheral issues. In part, I agree. Film as film is still what appeals to mass audiences and to the majority of film students. However, if any text can make an impressive case for finding time in an already crowded film curriculum for the study of film audiences, economics, and legal issues, this is the book. An index is provided. Highly recommended for special collections.

Austin, Bruce A., ed. CURRENT RESEARCH IN FILM: AUDIENCES, ECONOMICS, AND LAW, Volume 2. Norwood: Ablex Publishing Corporation, 1986. 261pp.

A first-rate follow-up to volume 1, this very informative book offers thirteen original essays on a wide range of topics from cultural influences to ethical issues in the film industry. The dominant focus is on audience research and economic topics, with only a passing glance at legal problems. Best of all, most of the creative material opens new areas of research for film scholars.

Regrettably, the opening essays get the volume off to a shaky start. Garth Jowett's "From Entertainment to Social Force: The Discovery of the Motion Picture 1918-1945" suggests that it is exploring a novel approach to how a popular communications medium helped changed twentieth-century society and culture. What we get instead is mainly a competent paraphrasing of material discussed in his other essays. Only in rare instances does he provide fresh examples of the fears expressed by traditionalists about film. On the other hand, Martin F. Norden and Kim Wolfson's "Cultural Influences on Film Interpretation among Chinese and American Students" presents accessibility problems for general readers. In trying to interpret how two different cultures interpret Frederick Wiseman's HIGH SCHOOL (1968), the authors' technical discussion relies too heavily on research methodology and not enough on the intriguing responses and conclusions.

Beginning with Steven Knapp and Barry L. Sherman's "Motion Picture Attendance: A Market Segmentation Approach," the book shifts into a high-powered mode not only adding to our understanding of how audiences are classified, but also giving us access to invaluable reference material. For example, the Knapp-Sherman essay provides a balanced and engrossing study of psychographic correlates of film attendance among adult moviegoers. Among their many interesting findings is the important relationship between spectator sports and filmgoing. Equally stimulating is Thomas Doherty's engaging essay, "Teenagers and Teenpics, 1955-1957: A Study of Exploitation Filmmaking." After tracing the economic and demographic factors that forced the film industry to turn to adolescent audiences in the fifties, the author identifies a number of sophisticated marketing strategies that have evolved from that era: e.g., saturation advertising and simultaneous nationwide theatrical screenings. Gina Marchetti's "Subcultural Studies and the Film Audience: Rethinking the Film Viewing Context" maintains the skillful blend of thoughtful discussion and challenging ideas presented by the earlier essays. Focusing on youth subcultural studies, she cautiously explores why and how young people see themselves and are seen by adults as opposed to almost every value and institution in the dominant culture. What emerges from her sensible approach is a better understanding of the interaction between spectators' cultural backgrounds and their reactions and misperceptions of film messages and experiences. None of the work in this praiseworthy book, however, approaches in scope or in detail Austin's excellent contribution, "The Film Industry, Its Audience, and New Communications Technologies." What makes the effort special is the author's courage in trying to sort out conflicting film trends generated by television-related technologies. While events unknown to Austin have already rendered certain conclusions inoperative (e.g., the Burlington dinner-movie theater is now a Chinese restaurant), one admires both his detailed probing and his intelligent speculations.

Although the remaining articles fail to match Austin's imaginative scholarship, they nonetheless merit attention from scholarly circles. For example, Calvin Pryluck presents an insightful overview on the relevance of nineteenth-century entertainment to the current structure of the film industry. Less intellectually satisfying but still intriguing is Richard Alan Nelson's terse case study of the Vim Comedy Company as an illustration of expansionist activities following the decline of the Trust. Steve Lipkin's review of France in the post-World War II era suggests a fresh approach to explaining Truffaut's attack on the film industry, while Manjunath Pendakur raises important questions about the problems Canadian feature films are encountering in the United States. In addition, Gary Edgerton offers a wealth of material on the growth of American film bureaus (currently listed as ninety-one municipal and state agencies), Clifford G. Christians and Kim B. Rotzoll do a nice job of exploring the special system that the film industry has set up to measure conduct and achievement, and Cathy Schwichtenberg concludes the collection of essays with a case study of the suit between R. D. Goldberg and the Tri-State Theatre Corporation.

One can only hope that Austin and his publisher will continue to attract high-quality manuscripts for years to come. If they do, then CRF will remain one of the most refreshing new publications in the mass communications area. Two indexes--author and subject--close out the book. Highly recommended for special collections.

Austin, Bruce A., ed. CURRENT RESEARCH IN FILM: AUDIENCES, ECONOMICS, AND LAW, Volume 3. Norwood: Ablex Publishing Corporation, 1987. 238pp.

Each new edition of this thought-provoking series continues to challenge current thinking about the film industry. The first of the book's thirteen essays, "Emotion-Eliciting Qualities in the Motion Picture Viewing Situation and Audience Evaluations" tackles the perennial question of why viewers choose the films they do. Rather than accept the conventional wisdom that plot and genre are the crucial variables, the authors Mitchell E. Shapiro and Thompson Biggers examine the question from the perspective of human emotions, subdivided into three essential combinations: pleasure-displeasure, degree of arousal, and dominance-submissiveness. Although their research concludes that the standard factors--e.g., arousal, pleasure, and dominance--still explain audience emotional responses, the investigators argue that "the relative importance of each of these dimensions is somewhat different from that found in previous research." The second essay, "Movie Genres: Toward a Conceptualized Model and Standardized Definitions" follows with another study on the important variables--e.g., film plot and genre--in audience film selections. What interests Bruce A. Austin and Thomas F. Gordon are (1) how the public learns about a film's plot or genre prior to their selection of which film to see; and (2) what qualities the public attributes to particular genres and with what impact at the box office. While I place greater importance on word-of-mouth and bandwagon effects than do the authors, I find their classification of twenty movie genres to be statistically interesting and worth pursuing. The next two essays offer interesting perspectives on the effects that one medium has on the audience of another medium: Keyan G. and Ruth Tomaselli's "Before and After Television: The South African Cinema Audience"; and Joseph Dean Straubher and Gayle King's "Effects of Television on Film in Argentina, Brazil, and Mexico." The fifth essay, Kim B. Rotzoll's "The Captive Audience: The Troubled Odyssey of Cinema Advertising" reviews the controversies associated with advertising for national and regional offices in the past decade. The next three essays deal skillfully with monetary matters both at home and abroad: Thomas Guback's "Government Financial Support to the Film Industry in the United States," Paul Swann's, "Hollywood in Britain: The Postwar Embargo on Exporting Feature Films to Britain," and Edward Benson's "Leisure and Monopoly Capital: Concentration and Standardization in Franco-U. S. Trade in Film."

The ninth essay, "Film Economics and Film Content: 1946-1983," may be the book's most provocative analysis. Working on the general hypothesis that "economic variables are related to predictable changes in motion picture content," the author Joseph R. Dominick explores whether "the degree of oligopoly and amount of risk

involved in filmmaking should be related to (1) the concentration (or diversity) in film content; (2) the year-to-year volatility in the content of the films released; and (3) the degree to which pictures released by one studio resemble the pictures released by the other studios." The author carefully lists several different economic variables (e.g., rental income, concentration of rental income, the Blockbuster ratio, and production cost) that are useful in doing a twenty-year analysis of Hollywood films broken down into thirteen categories (e.g., family films, science fiction, horror, and military/war). Although I have strong reservations about his classification of film content (e.g., general drama, ethnic, and miscellaneous), I remain very impressed by Dominick's longitudinal findings for the various economic and content variables.

The tenth essay, "Conglomerates and Content: Remakes, Sequels, and Series in the New Hollywood," may be the collection's most controversial contribution. Following the obvious observation that "All communication involves a mix of the familiar and the original," the author Thomas Simonet sets out to assess "the impact of conglomerate ownership on the familiarity-originality balance in movie content." He takes a statistical look at a forty-year period of American film remakes, sequels, and series (recycled scripts). Whether one equates absolute numbers with industry emphasis is at the core of the problem. If the answer is "yes," then Simonet proves that there are six times fewer sequels today than in the 1940s. If the answer is "no," then sequels are far more important today in terms of status than they were in the heyday of the studio system.

The concluding three essays round out the volume's stimulating insights to film study. Patricia R. Zimmermann's "Entrepreneurs, Engineers, and Hobbyists: The Formation of a Definition of Amateur Film, 1897-1923" examines the nature of dominant media forms as a power relation to emerging forms. Carolyn Anderson's "The TITICUT FOLLIES Audience and the Double Bind of Court-Restricted Exhibition" investigates the unsual arguments the film encountered in getting exhibited, the depth of the struggle, and the manner in which the issue was resolved. John J. Michalczyk's "Costa-Gavras' MISSING: A Legal and Political Battlefield" offers a useful discussion on the legal repercussions that ensued from this First Amendment case.

Overall, Austin has once more collected a fine assortment of essays, thoughtfully presented and well researched. An index is included. Recommended for special collections.

Austin, Bruce A., ed. CURRENT RESEARCH IN FILM: AUDIENCES, ECONOMICS, AND LAW, Volume 4. Norwood: Ablex Publishing Corporation, 1988. 227pp.

*Czitrom, Daniel J. MEDIA AND THE AMERICAN MIND: FROM MORSE TO McLUHAN. Chapel Hill: University of North Carolina, 1982. 254pp.

A useful overview of media development since the early 1800s, this stimulating intellectual history of modern American mass communications provides a good perspective for film students not familiar with the ways in which our culture is measured and interpreted. A basic assumption that Czitrom makes is that the media in toto subtly deny the past. The reasons have to do as much with aesthetics as with intellectual and cultural priorities. What is important, therefore, is "how the media of communication have altered the American environment over the past century and a half. How did the new media affect traditional notions of space and time, the nature of leisure and consumption, the socialization process, and the intellectual clime?" In seeking to discover how the media became so prominent in American everyday life, he interprets intellectual history in very broad terms. That is, the field explores not "merely the formal history of ideas but ultimately . . . the history of symbolic action and meaning, and their relation to human behavior." The central questions relate to how Americans have understood the revolution in communications technology since the mid-1800s and how that understanding fits into the broader realm of American social thought.

Dividing his inquiry into two parts, Czitrom begins with an analysis of the contemporary responses to three new media: the telegraph, the moving picture, and radio. Each chapter probes the ideas and their interaction with "the technological and institutional growth of the media themselves." For example, the telegraph becomes significant because its first success in 1844 initiated the separation between transportation and communication. Claims have been made on its behalf for transforming politics, trade, and social interaction. Czitrom not only questions the accuracy of such claims, but also examines the problems posed by reducing the world to a village. He wants to know what was gained by forcing the public "to think of all things, at the same time, on imperfect information, and with too little interval for reflection. . . ." In discussing the birth of movies as a cultural turning point, he focuses first on the English critical reaction to the term CULTURE, with its strong ties to religion and class structure. Then he shows how this elitist concept of culture, as a product to be disseminated, was undermined by a democratic society hostile to the notion that noble ideas and impulses were the exclusive property of the upper classes. Citing intellectuals like Ralph Waldo Emerson, who argued that the sordid and the trivial were as important as the good and the beautiful in defining what constitutes culture, Czitrom highlights the tension between the two main cultural theories. This debate provides the background for the social and political problems encountered by the film industry in the early stages of its growth. In one of this splendid book's few lapses, Czitrom fails to explain why the wrath of many non-elitists was directed at the film industry. Notably missing is a reasonable account of just what was being objected to in the average of 500 films released annually between 1930 and 1950. An examination of the birth of radio provides the opportunity for reviewing the flagrant and subtle uses of political censorship. These three chapters collectively reveal the author's disappointment in the promise initially suggested by the rise of the media and the actual results today.

Part Two surveys the three principal traditions in American intellectual circles regarding the impact of modern media on the social process. The pioneering theories of progressive thinkers like Charles Horton Cooley, John Dewey, and Robert Park represent the holistic approach to modern communication. Czitrom succinctly explains how the trio perceived the modern media "as an agent for restoring a broad moral and political consensus to America, a consensus they believed to have been threatened by the wrenching disruptions of the nineteenth century: industrialization, urbanization, and immigration." Crucial to their hopes was the theory, developed by Park, of the media's "'referential' function." In simple terms, the media possess the ability to communicate facts and ideas to the public. The problem comes when the media's "expressive" side--"the communication of sentiments and feelings"--interferes with its more informed point of view. The inability to neutralize the media's expressive nature finally convinced the men to withdraw their support from modern communications. In the end, and after an inadequate examination of how the media properly functioned, the media became for them merely another example of the "superficiality and strain of modern life." The more sophisticated research efforts of empiricists like Harold Lasswell, Walter Lippmann, W. W. Charters, and Joseph T. Klapper in examining the behavioral "effects" of the media represent the shift in American communication studies starting in the 1930s away from a philosophical approach to a methodology based upon observation, experimentation, and verifiable hypotheses. The four major areas of concern--propaganda analysis, public opinion analysis, social psychology, and marketing research--suggest how breadth of interest could relate to a common denominator: the need to understand how the media affected the public mind. For example, the Payne Fund studies dealing with the effects of motion pictures on children reflected the social psychological approach in studying the media. Through a misuse of the conclusions, self-appointed guardians of society waged a constant war against the film industry. Anyone genuinely worried about a "nuclear winter" would do well to review this section to see how public opinion can be mobilized by special interest groups in order to develop public policy. Czitrom's eminently evenhanded approach includes stinging critiques of the empirical methodology used by members of the exiled Frankfurt Institute of Social Research--e.g., Max Horkheimer, T. W. Adorno, and Leo Lowenthal. Insisting that

there were larger issues than those of persuasive effects, the Frankfurt group stressed the need to examine "broader problems of consciousness: namely, issues of cultural value." The impact of this group on contemporary cultural critics can be found in the works of David Riesman and Dwight Macdonald. Finally, the controversial theories of Harold Innis and Marshall McLuhan illustrate a radical change in viewing communications technology from the sixties to the present. Returning to many of the ideas first espoused by progressive American thinkers, the two Canadian theorists emphasized the role of technological determinism in communication research. Innis, for example, argued that "Systems of Communication, that is, modes of symbolic representation, were the technological extensions of mind and consciousness. They therefore held the key to grasping a civilization's values, sources of authority, and organization of knowledge." Clearly supportive of Innis's leanings, the author discusses how civilizations rise and fall in direct relation to the way in which the prominent media of communication function. Czitrom is particularly effective in describing how Innis differentiated between oral and written modes of communication in terms of competing monopolies of knowledge based upon spatial and temporal biases. His straightforward comments about McLuhan help remove much of the confusion surrounding the man's flamboyant style and intellectual gifts.

Given the comprehensive nature of this fascinating study, it is not unusual to find areas of disagreement. Among the significant complaints about this otherwise well-written study are the use of sexist language, an oversimplified assessment of censorship issues, and an unwillingness to provide a more current assessment of modern research in communication study. But Czitrom deserves considerable praise for the manner in which his sweeping historical overview makes one aware of the dialectical tension within the American media. Equally commendable, this accessible text does a masterly job of presenting complex ideas in entertaining prose. Extensive endnotes, a strong bibliography, and a good index add to the book's considerable value. Recommended for special collections.

Handel, Leo A. HOLLYWOOD LOOKS AT ITS AUDIENCE: A REPORT OF FILM AUDIENCE RESEARCH. Urbana: The University of Illinois Press, 1950. 240pp.

This seminal work on film audience research is aimed at students interested in communication studies and film executives unfamiliar with public opinion sampling techniques. Handel's unique position in the late 1940s as the only full-time communication researcher working in the film industry gave him access to data denied other investigators. That rare material--e.g., motion picture production studies and general film audience research--was integrated with noncommercial studies. The results are presented in three pragmatic divisions: the industry and research, studies of individual productions, and studies of general problems.

The first section is relatively short. After giving a terse summary of how and why film audience research developed as it did, Handel explains the strengths and weaknesses of Hollywood's then-standard evaluative procedures: box-office returns, sneak previews, fan mail, exhibitor opinions, and theatrical tryouts. We are then given a review of why audience research done for the film industry runs into unique problems. These arise in large measure because of the limited time between the end of production and a film's release commitments. The need for immediacy, therefore, produces fuzzy sampling techniques that neglect suitable comparisons with other films recently seen by the audience and fail to discriminate among audience responses to questions about film trends and stars. In fact, the issue of audience selectivity from urban to rural areas is often misunderstood in the rush to provide speedy answers to impatient filmmakers.

Far more intriguing is the second section on individual problems. Here Handel is concerned with how audience research can aid a filmmaker "in determining what stories or plots are likely to have a wide appeal among his potential audience . . . [and] which of the available actors the moviegoers would most like to see in certain roles." Readers discover how Hollywood by the 1950s tested stories, possible casting combinations, suitable film titles, and the audience appeal of specific scenes. Once

the production was completed but not yet released, filmmakers turned their attention to analytical previews to determine possible areas for reediting and for the advertising budget required. The author's explanations of the drawbacks in these techniques remind readers of the types of pressures filmmakers faced in the days of the powerful studio system.

The book's final section emphasizes that "The most primitive kind of communications research pertains to the extent and nature of the audience." In a masterly summary of why film audiences constantly shift their seasonal and structural characteristics, Handel provides numerous statistics and conclusions about the nature and composition of movie audiences. Interestingly, he reported that college students were tapering off their filmgoing by the end of the 1940s. No satisfying explanation is provided, but it is fascinating to speculate on why the process underwent a significant reversal a decade later. Another intriguing area for further study emerges in Handel's chapter on film preferences. For example, it would be useful to compare the story preferences of men and women reported in 1950 with audience preferences today. Would it be true now that "the majority of people like the improbable occurrences on the screen"? That is, do we today prefer escapist films to realistic dramas? Is it still true that males prefer male stars, while women prefer female performers? Do women still demonstrate a greater emotional affinity than do men? Do twenty-five percent of the moviegoers still buy tickets without knowing anything about the movie except its title? Just as intriguing are the narrative's statements about the effects of movies on their audiences. For example, why do contemporary scholars still ignore the conclusions, reached in the Payne Fund studies done by Herbert Blumer and his associates, that it was nearly impossible to determine whether movies more often prevented than incited audiences to criminal behavior? No one then or now denies that movies have an effect, but the issues remain how much, how long, and what type. The text ends with an important reminder that misunderstanding is often found in audience research.

Don't be fooled by the publication date of this landmark study. It still remains an informative and stimulating resource on audience research. An appendix on audience sampling techniques, along with a valuable bibliography and index, adds to the book's enduring value. Recommended for special collections.

Jarvie, I. C. MOVIES AND SOCIETY. New York: Basic Books, 1970. 394pp.
Interested in the pervasive influence of movies in our lives and the tendency of previously published studies to confuse psychological research with sociological issues, Jarvie presents a "tentative sociological framework" to sort out the essential facts about the film industry ("who makes films, and why?"), the film audience ("who sees films, how and why?"), the nature of the film experience ("what is seen, how and why?"), and film criticism ("how do films get evaluated, by whom and why?"). Although his major focus is on contrasting the British and American film industries, he draws heavily upon the published reports about countries in Europe and Asia. In the process, he demonstrates both a short temper and a love for movies. For example, he freely admits that studying movies as a social phenomenon requires studying "trash," but reminds his readers that aesthetics is not the relevant issue to sociologists. What is important is how the film continuum operates and why. Furthermore, he argues that most people who discuss and see films remain ignorant about the "making, viewing, experiencing and evaluating of films." Even further, he is adamant that highbrow critics should stop using such words of approval as "committed," "concerned," "sincere," and "superficial." Of course, Jarvie does not apply such restrictions to his own comments. In fact, the Canadian scholar vents his anger with just such terms in rebuking analysts who snub their noses at his beloved medium.

Jarvie's introductory essay serves as a delightful attack on the prejudices found in elitist and conservative strongholds. After listing the reasons why film is not respected, he goes on the offensive by attacking "'old-fashioned' intellectuals" for using disingenuous arguments about the popular arts. Jarvie begins by exposing a number of misconceptions about sociology: e.g., confusing social science with social

work and sociology with social psychology. He is especially antagonistic to Kracauer's book, FROM CALIGARI TO HITLER, describing it as "ingenious but misplaced hindsight." Having established the need for good sociological work on film, he reviews the excuses scholars give to avoid studying movies as a social phenomenon: e.g., movies are vulgar and sociology is trite. He also rejects sociological explanations based on functionalism and psychological needs. Instead, he argues for a methodology that focuses on movies as a mass medium involving notions about art, leisure, entertainment, propaganda, and mass culture.

Each of the book's four principal sections summarize much of what was known and understood about film sociology up to the end of the sixties. For example, Part 1, dealing with the film industry, reviews the specialized nature of the movie business, its growth and development as an industry and the then-current structure, and the role of money and propaganda in the production of films. Among the many interesting bits of information and opinion contained in the section's five chapters are the author's attacks on the notion that artists are abused in the complex world of films ("I cannot think of any argument which would warrant either business or the state giving single individuals large sums of money, and allowing them to make what films they want"); and his assertion that there is no link between the way Hollywood is organized and the global success of its films ("The triumph of Hollywood, [sic] IS the triumph of raising the general standard of films by concentrating on improving the quality of the average product"). Some of the problems in Jarvie's analyses relate to his blurring of dates and events. For example, he glibly asserts that from the start, movies were "a high cost industry, heavy both on overhead fixed costs and on variable costs." Yet such was not the case for the first ten years of film history. He also has a problem with facts when he claims that MGM originally belonged to Loew, Goldwyn, and Mayer; and that New York bankers were the principal underwriters of the early film companies.

Part 2, dealing with the sociology of the audience, is a good attempt at answering why films attract the types of audiences they do. Starting with the caveat that "passivity in mass audiences should earn no more disapprobation than passivity in reading a book," Jarvie provides a first-rate examination of what is known about audiences in general and film viewers in particular. He praises scholars like H. J. Gans and Herbert Blumer for clarifying the dilemma of filmmakers, who must not pander to audience tastes yet must pay close attention to their desires. He makes the invaluable point that the film industry rarely took its audience seriously in the heyday of the studio system, because the audience was "easily-pleased" by the products produced. And he stresses the fact that movies are an important form of entertainment, because they enrich our experiences and also encompass them.

Part 3, dealing with the amount and types of information provided by the films, asserts that films are a far more positive influence in our society than is generally understood. Jarvie begins by comparing filmmakers to opinion leaders, emphasizing that any informed person can see the patterns of behavior stimulated by watching films. He makes the by-now obvious observation that such behavior is not the result of a cause-and-effect relationship. In addition, he leads the film students of the time into seeing that the film's influence goes beyond that of "argument, distraction, and catharsis" and into the areas of education and information. Jarvie is also excellent at pointing out that intellectuals have more difficulty distinguishing between reality and conventions than does the general public. The general public, he argues, uses the conventions as a means to satisfying their fantasies. He does rely heavily, however, on Marshall McLuhan's notions of technology changing not only our environment, but also our experience of it. Where Jarvie falters is in his cavalier attitude about film aesthetics and film genres. For example, he incorrectly praises Hollywood for its historical accuracy in movies about the American West and Civil War, unfairly condemns Hollywood for its stiff screen adaptation of classic English novels, and fails to make clear what differentiates stereotypes from conventions. Furthermore, he oversimplifies the appeal of westerns and gangster films by arguing that their popularity rests on "the simplicity, well-understood character and (connected) ritualistic quality of these two types of story." If that were true, then why has the

western died out since the early seventies? And what relationship is there among the studio system, the era, and the genres themselves? Finally, Jarvie has considerable trouble with editing, typographical errors, and dates.

Unfortunately, Part 4, dealing with how learning and evaluation function in relation to film, does a poor job of tying together a number of theories about the sociology of film. After making a sensible argument that "Box-office returns are a general measure of the importance of the social institution of the cinema and not of the value of the films shown," the author offers the theory that a film's importance arises out of the interaction among the star system, publicity departments, and the audience. He then makes the obvious distinction between reviews and critiques, pointing out that the former relate to general advice on whether or not a film is worth seeing, while the latter deal more rigorously with a film's merits or flaws. At that point, the final section turns into a disappointing overview of the evolution of film criticism. For example, Jarvie first states that he doesn't believe that works of art, unlike human beings, can be judged by their humanity and understanding. He then rejects that position, admitting that art "cannot be divorced from its moral and political dimensions." He also attacks modern film criticism as being "romantic, oracular, and literary," but fails to provide any useful suggestions on how film criticism can be made more effective. Even worse, Jarvie adds a badly edited appendix on the values to be found in watching movies. Not only are there factual errors (e.g., the claim that movies in the forties ranked third among America's industries), but also unsophisticated judgments about film production. The major problem appears to lie in the author's uncritical acceptance of McCluhan's ideas about "the medium being the message."

Fortunately for everyone, the book ends with a wonderful, annotated bibliography and three helpful indexes. In short, Jarvie's admittedly tentative plunge into film sociology runs into a number of analytical problems, but emerges as a stimulating and worthwhile introduction to the general issues and theories. Well worth browsing.

Jarvie, I. C. MOVIES AS SOCIAL CRITICISM: ASPECTS OF THEIR SOCIAL PSYCHOLOGY. Metuchen: The Scarecrow Press, 1978. Illustrated. 207pp.

Concerned with explaining how film operates as a social force in our society, this slim but insightful volume presents a provocative discussion of why movies have been misunderstood and mistreated by social critics intent on alarming the public. Jarvie contends that such perspectives, the twofold assumption that moviegoing and film content impact negatively on learning, socialization, personality formation, and group behavior, result in biases against the context and content of film. Furthermore, he refuses to allow films to become the scapegoat for society's problems. In fact, the book's title represents his belief that films since the 1960s have been providing the public with critical ideas that are ahead of their time. After establishing the relationship between his concerns and those of social psychologists, the author then sets out to promote film by indicating its positive contributions. Attention is given to movies as a social phenomenon, the extent to which films accurately symbolize "the social psychology of the societies which they portray and/or the societies from which they come," how effective movies are as propaganda and education vis-a-vis any other media of communication, and the role of the star system in the social process. Throughout, the narrative wants us to view film "as it is, as it has been, as it can be, as it should be, as it will be--a critical force sometimes galvanizing a society to action." In particular, Jarvie dismisses as cyclical the presumed dramatic change--e.g., the transformation of movies from representing the values of the American mainstream to a "countercultural, revolutionary, sometimes nihilistic" medium--that has occurred between film and society since the 1960s. Proving that the social psychological functions of the movies have not changed is the principal concern of the book's five stimulating chapters.

Before arguing how multifarious the film's social functions have always been, in his opening chapter Jarvie surveys the significant theoretical issues related to social psychology. He reminds us that only recently have scholars become skeptical about

quantifying the "effects" of the media and their "adverse" results. Prior to the 1960s, for example, many strong-willed academics were convinced that they knew "right" from "wrong." The debate about negative film effects carried on between Columbia (A. T. Poffenberger) and Harvard (Hugo Munsterberg) typified the early history of film. For every J. J. Phelan, Tamar Lane, and Phyllis Blanchard, who that followed Munsterberg, there were alarmists like Ellis Oberholtzer and H. J. Forman in the Poffenberger tradition. While the initial section takes a well-traveled path, it does summarize neatly both the scope and biases of the then-standard "investigations," which concentrated on three main areas: censorship, violence, and pornography. The terse, straightforward critiques pinpoint specific methodological problems, but do not adequately credit the scholars with making pioneering strides in media analysis. After dividing the researchers into experimentalists (who use empirical evidence) and analysts (who operate from first principles), he identifies and discusses in "political" terms three categories: pessimists, neutralists, and optimists. That is, the Payne Fund Studies are explained as "experimentalist/neutral"; Forman's OUR MOVIE MADE CHILDREN, "experimentalist/pessimist"; and Moley's ARE WE MOVIE MADE?, "analyst/optimist." Jarvie believes that the most dominant group is the pessimists, among whom the most influential are the "Neo-Marxists": e.g., Arnold Hauser, Dwight Macdonald, Richard Hoggart, Raymond Williams, T. W. Adorno, Herta Herzog, and Siegfried Kracauer. His discussion of the ideological problems faced by Marxists who wanted the intelligentsia to embrace the mass media with the same ardor as the bourgeoisie offers a summary of how future critics interpreted Hollywood as a revelation of American consciousness. At the same time, Jarvie indicates that effective counterarguments have been made by non-Marxist social critics like Edward Shils, Bernard Berelson, Raymond Bauer, D. W. Brogan, William Stephenson, and Kracauer himself. Each, in turn, downplays the presumed film influence on personality formation and socialization as being nothing more than an insignificant pastime and diversion. It's a position Jarvie passionately espouses, particularly because he recognizes that television, beginning in the 1950s, replaced film as the mainstream American medium, and no evidence has yet surfaced that justifies pessimistic or alarmist assertions. For example, he points out the ideological confusion that exists between the "hypodermic" theorists (movies as an influence) and the "selective exposure" advocates (the individual as the controlling force). Either the audience is passive or it's involved. If one is true, the other is not. His position--no media message independently really influences an individual--leans heavily on the important research done by Elihu Katz, Paul Lazersfeld, and Herbert J. Gans. Jarvie is quick, however, to indicate the influences--e.g., stimulated behavior, problem solving, and collective perceptions--that he sees movies having on the public. Foremost is the use of entertainment for social control. Citing the theories of William Stephenson and Franklin Fearing, he discusses how society uses film as a vehicle for interpreting the world. The crucial point, for Jarvie, is that no two audiences are the same. The collective experience is defined not only by geography and date, but also by individual circumstances. That is, the poor may use films for inspiration; the middle class, for alternative entertainment. Even here the experiences of groups within each of those categories is "particular, not general." Nonetheless, he forcefully argues that the relationship between filmmakers and their audiences enables the medium to act as a powerful force for social change in society.

Having made his persuasive case that for young people movies are more important as a social institution than for content, he proceeds in Chapter 2 to focus on the role movies have for adults. Here his basic concerns are with the film's treatment of society--e.g., its ability to idealize, reflect, fantasize, and criticize the world around us. He begins by reexamining the issue of film and reality. This is one of his least satisfying discussions. Relying almost exclusively on films depicting sexual manners and marriage, Jarvie critiques both the cyclical nature of film and the way in which it presents socially significant information about American society. Four specific categories--the reluctant bachelor, the reluctant virgin, chasing the wrong guy, and struggling to get free--illustrate his view that the relationship between filmmakers and the public shifts frequently. In the 1930s, for example, he finds Hollywood and

the popular audience in accord on the virtues of marriage. By the 1960s, film, no longer the central mass medium, is challenging American values. Jarvie's generalizations prevail to the exclusion of persuasive argumentation. In later chapters, he argues that, from the 1950s on, adolescents became the dominant market for filmmakers. Yet in this section he never effectively demonstrates the link between the needs of adolescents and the popularity of movies about middle-aged couples and their marriages. On the surface, the chapter's focus might better have been directed toward the twenty- to forty-year-old audience. His lengthy review of Hollywood over this forty-year period examines superficially how films participated in the ongoing debate about marriage in our society, but does not clarify the causal relationship. An underlying theme in Jarvie's case study relates to television viewing replacing the moviegoing habit. He insists that Hollywood changed its production policies once it had lost its economic base. Given the central role that theatrical films and made-for-TV movies have in television programming and in popular culture, Jarvie might have been more tentative in his assertions. The inconclusive chapter ends with the theory that diversification typified the way filmmakers, from the 1960s on, related to a large segment of America's collective consciousness.

Chapters 3 and 4 continue the author's assertions about the variety of functions movies performed for their new, fragmented audiences. He points out the usual reasons--e.g., the PARAMOUNT antitrust case, the influx of foreign films, and America's cultural mood--why Hollywood's presumed parochialism ended. No useful definition is provided for "parochialism," nor is there any meaningful discussion of why Hollywood accounted itself as it did. New markets, he insists, required new policies and practices. That is, "Inexorable forces have changed the audience, widened the kinds of films available to it, and, of most concern to us here, altered the social psychological processes at work on this social phenomenon." Jarvie's argument is that filmmakers now have to be specialists not in genres, but in matters related to the tastes of subcultures. He rejects the notion that films function as escape, fantasy, or identification mechanisms. Not only does he find such theories implausible, but also naive and nonproductive. Only in cases where we view such assumptions as universal needs for compensating us for our daily frustrations and repressed feelings will these traditional interpretations of how movies function in our society be viewed as reasonable. Instead, he ingeniously concentrates on the way audiences learn from film: e.g., reference groups to which viewers aspire and anticipatory socialization that results in behavior modification. Other valuable functions of the movies relate to the reinforcement of values, the legitimization of life-styles, the opportunity to "try out" different ideas, the means to solidify a community, and pleasure gratification. That is, movies provide external support for internal needs. Jarvie next takes on the traditional view of film as an artificial and unrealistic medium. Not so, he states. First, he wants to know who determined that films had to be realistic. As far as Jarvie is concerned, realism makes no unique demands on film. Furthermore, he sees no measuring rod by which to determine "reality" in film. The judgments are all subjective, and this includes those made by documentary filmmakers as well as the neo-realists. Once again, Jarvie insists on the diversity of the movies. They have many aims and many techniques. The one common denominator is entertainment. And that is what bothers the film's detractors. They want movies to elevate the masses or expose the corruption in society. They will not accept as valid its popular functions.

In the final chapter, Jarvie turns to the types of changes--e.g., youthful rather than middle-aged audiences and film as an alternative rather than as the predominant form of entertainment--brought about by filmgoing's becoming an occasional rather than a habitual event. Unfortunately, at this point the narrative bogs down not only with dull assertions about the industry's stability, but also with misleading comments about African-American imagery in film. The former focuses on what effect the electronic media will have on movies, with Jarvie doing little more than restating Pauline Kael's celebrated 1968 comments about films and television. The section on African-Americans presents more serious problems. After having made a challenging case for reconsidering the positive contributions of film to society, Jarvie feels compelled at the eleventh hour to qualify his praise. American filmmakers have not

resolved their racial mistreatment of African-Americans. Movies, he concludes, "are better understood as events experienced in a collectively pre-structured perceptual field, idiosyncratic to social groups rather than to single individuals." By sounding the alarm concerning stereotypes, he wants to alert our collective consciousness to structural defects in the system. The basis for stereotypes rests, he asserts, in their being used as defenses against presumed or actual dangers. In his view films about African-American stereotypes detract from the characters and place the emphasis on race. The best way to offset this negative social and aesthetic problem is by integrating African-American characters into the film and thereby humanizing them. Everything sounds reasonable until Jarvie cites the ABC production of ROOTS (1977). Not only does he fail to understand the objections many African-Americans had to the slanted production,[1061] but he also subverts his critical perspectives. That is, how can one measure the influence of the media on society if one's well-intentioned perspective distorts evaluation? When a commentator as distinguished as Jarvie misperceives the merchandising of African-American images for commercial gains, how can the popular audience be expected to assimilate and react to images too complex for experts?

These objections notwithstanding, Jarvie remains a formidable social critic of film. Because he has few peers in his area of expertise, even flawed texts like this one deliver more than dozens of handsomely designed and thicker books. An excellent bibliography and three very helpful indexes are included. Well worth browsing.

*Jowett, Garth, and James M. Linton. MOVIES AS MASS COMMUNICATION. Beverly Hills: Sage Publications, 1980. 149pp.

This first-rate textbook offers an invaluable summary of mass communication concepts, analyses, and philosophical perspectives as they relate to film study. Building upon Jowett's impressive background in examining the movies as a medium of mass communication, Linton has designed a framework for the current book that draws heavily upon his training in political science. Each author then assumes responsibility for three of the book's six chapters. Linton and Jowett's combined purpose is to demonstrate why theatrical movies that entertain people around the globe deserve to be studied as a mass medium.

Because of his relative unfamiliarity to film scholars, Linton's contributions provide the most stimulating information. Part of the reason is the author's candor. In Chapter 1, for example, he notes how the film profession constantly finds itself in conflict over which methodology is most appropriate for studying movies, particularly in the areas of criticism and aesthetics. "In many ways," he comments, "movies are being studied in a fashion similar to the examination of the elephant by Saxe's six blind men of Indostan--and with similar results!" To put some order into our fragmented perspectives, Linton takes his cue from the works of Andrew Tudor and proposes that we examine how movies[1062] function as "models" that are "aimed principally at scientific comprehension of [how] film [operates as a medium]. . . ." Focusing on movies as a PROCESS of communication is viewed as the best way to understand fully the nature, function, and effects of the medium. A case in point is the by-now commonplace assertion that since the early 1950s, television drastically reduced the role of film as a major social force in society. Linton's succinct but sensible response is to remind such critics not only of the mass appeal movies maintain both in social rituals and among various age groups, but also of the central role movies perform as "both the source for and the anticipated destination of many other

[1061] For a more balanced overview, see "ROOTS: Eight Points of View," TELEVISION: THE CRITICAL VIEW, 2nd ed., ed. Horace Newcomb (New York: Oxford University Press, 1979), pp.204-30.

[1062] Linton makes a distinction between movies (entertainment) and film (art).

forms of mass communication." Here and elsewhere in this lucid text the authors provide numerous tables and diagrams to illustrate their theses. For example, in discussing the communication process, Linton has one diagram for movie by-products and their relationships to other forms of cultures heavily influenced by the mass media, and another for theatrical movies as a process of mass communication.

In Chapter 2, Linton's best contribution, he provides a broad and invaluable overview of the movies as business. Much of his useful analysis focuses on the historical and contemporary struggles among producers, distributors, and exhibitors for control of the film industry. Particular attention is devoted to noting the problems associated with marketing and audience research. Frequent references are made to important seminal studies as well as to current research. Interestingly, the credited scholarship is paraphrased rather than quoted directly. This allows Linton (and Jowett elsewhere) considerable latitude in linking ideas and conclusions. Paragraphs often appear to be a collection of well-constructed excerpts reworded to produce a smooth flowing summary of significant scholarship done by others. For example, Linton offers a superb list of ten "Articles of Faith" that constitute the "conventional wisdom" of filmmakers. Each item concludes with the source for that observation: e.g., "In order to attract people, movies must mirror public tastes and comply with the demands of the public (Fadiman, 1973)." Linton then reacts quickly but effectively to the various assertions, pointing out that collectively they provide a useful background for examining a more detailed history of economic film history. A good summary of the factors influencing the financing of a film--e.g., market potential, production costs, and funding--serves as a source of information about the overlooked and important Canadian communication research by Garth H. Drabinsky, Hugh H. Edmunds, and John C. Strick. A section on the historical struggle for industry dominance offers three valuable reasons for the current importance of distribution: business acumen, sales outlets, and cash resources. A comparison between majors and independents gives Linton the opportunity to talk about inflated film costs. A comparison between producer-distributors and exhibitors emphasizes the three basic reasons why distributors are in control: selective contract adjustments, blind bidding, and block booking. Linton perceives the major fight between the two groups as being directly related to the risk each one is prepared to take. The outstanding summary concludes with a succinct but strong discussion of JAWS (1975) and THE DEEP (1977) as examples of modern marketing approaches.

The book's next three chapters are written by Jowett and reinforce an already high opinion of his resourceful scholarship. Chapter 3 does a skillful job of indicating how movies have influenced modern mass society. Stressing, as always, the importance of examining films in their social and cultural milieus, Jowett reels off one statistic after another. But unlike Linton, Jowett does not always reveal his sources. For example, he claims that by 1923, America had approximately 15,000 movie theaters, a seating capacity exceeding 7.5 million, an average weekly attendance of more than 50 million, box-office revenue upward of $520 million, and a total industry investment of $1,250,000,000. Yet not one footnote explains how these figures were determined. I suspect they come either from William Marston Seabury's book (reprinted during Jowett's excellent editorial stint for Jerome S. Ozer) or from the January, 1923, issue of THE FILM DAILY. Another distinction between the co-authors is that Jowett tends toward oversimplification more than Linton. For example, he talks of WWII and the immediate postwar period as encouraging a more masculine hero (John Wayne) and a more servile heroine (June Allyson). A closer look at the period would indicate that psychological protagonists and FEMMES FATALES were just as much in vogue and were making more interesting films. Those issues aside, Jowett is very effective in conceptualizing how and why movies became such a powerful social force. For example, he makes the point that at the moment movies institutionalized folk culture into popular culture they became able to "shape" as well as to "reflect" the audience's ideas.

Chapter 4 takes a good look at the psychology of moviegoing. After first stressing that film popularity is directly linked to its educational accessibility, Jowett goes on to explain how filmmakers capitalize on satisfying an audience's emotional and sentimental needs. He sees two factors as the key ingredients: the suspension of disbelief and audience identification with stars and genres. Particularly noteworthy

is the observation that movies play a significant role in the process of stereotyping because they objectify what for many viewers is only a vague and unclear concept or image. Jowett next proceeds to explain the collective experience of going to the movies. Not surprisingly, he concludes that how we interpret a film is tied to where we see it and to the film content itself. That is, seeing a science fiction movie in an airplane produces different emotions within us than would seeing the same film in a drive-in theater, on our TV screen, or in the neighborhood movie theater. The section on psychological techniques in movie marketing quickly reviews the roles that advertising agencies and the Emotional Response Index System Company (ERIS) have in helping filmmakers maximize profits. Regrettably, the remainder of the chapter moves so swiftly as to reduce the social science research to almost trivial statements.

Jowett's last chapter, "The Hollywood Version," continues to raise important questions, even if it doesn't always spend adequate time with the analyses. For example, in four short paragraphs he explores the issue of why movies operate as a major entertainment and social force, using only ideas suggested by Marshall McLuhan, Elizabeth Eisenstein, Eric Havelock, and himself. On the other hand, his brief discussion of how movies shape the culture is first-rate. Among other things, he points out the importance of the novelty of sound to the box office during the Depression, and the relative ease with which a film's ideological biases are perceived by foreigners.

The book ends on an upbeat note with Linton speculating on the future of theatrical movies. Factored into the intriguing predictions are the role of technological innovations, demographic shifts both in the general population and in movie audiences, and economic and social trends. Understandably, the section on television explores the pros and cons of the new medium's impact on film. Equally predictable is the discussion on the film industry's concern over how the revolution in electronics and telecommunication--e.g., videocassettes, and pay-TV--is going to affect profits, production, distribution, and exhibition. Linton, however, does a good job of describing how the movie industry is differentiating itself from network TV programming in terms of theater renovations--e.g., large images and quadraphonic sound systems--and adult themes and language. Linton's analysis is both imaginative and informative. For example, he cites the research done by Irene B. Tauber and the Organization for Economic Co-Operation and Development (OECD) to project how demographic changes in the population (e.g., a decline by the year 2000 in the number of people in the 15-24-year-old category; an increase in the 25-54-year-old category) should result in a highly fluctuating population and film audience. He cites a survey that reported movies ranked sixth in a satisfaction rating that included cars, magazines, clothes, popular music, and TV, in just that order. Especially interesting are his conclusions about how TV is affecting moviegoing. Contrary to other recent reports, Linton suggests that the relationship is beneficial to both media.

This highly unconventional text is one of the truly great buys in the film book business. The compact and comprehensive research gives you both quality and cost efficiency at a time when lesser works are providing less and charging more. A good bibliography and adequate index are included. Highly recommended for special collections.

*May, Lary. SCREENING OUT THE PAST: THE BIRTH OF MASS CULTURE AND THE MOTION PICTURE INDUSTRY. New York: Oxford University Press, 1980. Illustrated. 304pp.

In his desire to understand the "revolution in morals" occurring between the turn of the century and the 1920s, May tries to unravel the complex process whereby filmmakers played a crucial role in transforming the values of our society away from a Victorian ethos, and toward the moral nature of a corporate state. The focus is on the relationship among artists, their mass audiences, and urban life. The concern is with tying the larger social crisis to its impact on filmmakers and the way that impact was translated into film content and aesthetics. To May's credit, his ambitious study (first developed for his 1977 UCLA doctoral dissertation) points the way to

many valuable and overlooked resources for film study, in addition to suggesting an ingenious thesis for a more thorough examination. On the negative side, May's study suffers from too many unsubstantiated assertions and from an overreliance on quantitative data.

The best of the book's nine provocative sections are the first three chapters. Beginning with a narrow review of the underpinnings of Victorian culture, May prepares us for the cultural struggle, primarily by the white, Anglo-Saxon Protestant middle class, to prevent its religious and political values from being undermined by the moral experimentation of a more democratic society composed mainly of Catholic and Jewish immigrants from Europe. He places women at the center of the struggle. Prior to the industrial revolution, they are fully integrated into what May describes as the normal household economy. In the nineteenth century, however, the duties of women get redefined when manufacturing destroyed the traditional family system. Now separated from their normal labor with men, women take on new responsiblities. The poor become part of the work force, while the rich administer a household unrelated to the workplace. In the changeover, the home emerges as the essential place for learning Victorian virtues of self-control and hard work. While mothers and housewives operate as the chief agents in transmitting the Victorian code, they nonetheless grow discontent with their stifling domestic responsibilities and limited social roles. Thus, by the middle of the nineteenth century, we see them taking their moralizing outside the home and into the broader community. More to the point, moral reformers became terrified by the massive waves of immigration sweeping across America in the late 1880s. It was essential, May skillfully argues, that "Anglo-Saxon hegemony" be extended over these "aliens." The way to "tame" the immigrants and to show them "their place" was to get them to assimilate Anglo-Saxon values. One noticeable flaw in this otherwise valuable perspective is, as John Fell correctly notes, "May's exclusion of nineteenth-century precedents to movie 'tradition' . . . [such as] Dime novels . . . [that] challenged Victorian notions of 'lady' (e.g., Calamity Jane) . . . [and] pointed the way to subsequent moral self-censure as early as Erastus Beadle's holy injunctions to potential authors."[1063] In concentrating on the fierce battles that occurred between the early film pioneers and moral reformers, the author effectively illustrates how mass culture contributed to, and reflected the stirrings of a "revolution of morals." The importance of the movies in the transition begins with the growing eminence of film exhibitors working in the immigrant ghettoes of the urban Northeast. They, much more than the mainly Protestant film pioneers, grasp the medium's attraction to restive urban populations. The role of movies in contributing to the moral permissiveness of the pre-WWI era gains momentum by 1908, when the Trust decides to direct its product at the middle classes (especially genteel women) rather than just working-class audiences. Here again, May offers insights into why moral reformers feared the urban amusements where all groups (rich and poor, young and old, foreign and American, and men and women) mixed freely. In tapping a variety of iconographic sources, as Thomas Cripps observes, "May's book points historians of movies toward several fruitful goals . . . [a comparison of] the moviemakers' intentions with their accomplishments . . . [and an examination of] the records of studio sales departments--including preview cards, state and municipal censor boards, and, for later years, public opinion surveys--as evidence of how the movies played Peoria."[1064] May also provides useful clues for reinterpreting the writings of major film commentators like Hugo Munsterberg, pointing out that the Harvard psychologist believed that in order for a democratic order to survive, it had to ignore "'forbidden joys' for society." In addition, there are many fascinating comments about why the film producers joined in with the reformers to make the

[1063] John L. Fell, "Film Books: SCREENING OUT THE PAST," FILM QUARTERLY 34:4 (Summer 1981):35.

[1064] Thomas Cripps, "The Social History of Movies," REVIEWS IN AMERICAN HISTORY 9:3 (September 1981):401.

movies more "uplifting" AND profitable experiences. By the conclusion of May's stimulating first three chapters, a vivid picture is drawn of an age-old cultural battle between Anglo-Saxon hegemony and a growing ethnic, urban population. For anyone interested in a good analysis of the early campaigns against the rise of mass culture, these sections deserve serious consideration.

Regrettably, the remainder of this ambitious project does not flow as smoothly. For example, May relies on an analysis of four filmmakers--D. W. Griffith, Mary Pickford, Douglas Fairbanks, Sr., and Cecil B. DeMille--to support his thesis that the film industry, through its use of stars, the creation of Hollywood, and the construction of movie palaces, "infused life with a new instinctual dynamism and provide[d] a major stimulus for generating modern manners, styles, and models of psychological fulfillment." One major problem with May's presentation, however, is his poorly researched biographical data. For example, he presents an inaccurate account of Griffith's family background, does an equally bad job of reviewing the early careers of Pickford and Fairbanks, and relies far too heavily on assertions for linking the Progressive movement to pre-WWI movies. "Even more damaging," as Robert Sklar points out, ". . . are the pervasive factual errors: names are misspelled, dates for films are incorrectly given, films are egregiously misdescribed, footnotes contain inaccuracies. Most seriously, the basic chronology of events in the history of the motion picture industry is altered so that the thesis may be buttressed: this permits the author to claim that traditional social groups held power over the motion picture long after, in fact, Jewish immigrant businessmen had gained control in the industry."[1065]

In summary, May's book is a mixed bag. While his intelligent thesis raises many serious issues and successfully outlines enormously stimulating observations about the complicated role of art in our society, it promises much more than it delivers. It concludes with two appendexes on historiography and seven tables dealing with the members of the Trust, film plots, and key film personnel; intriguing endnotes; and a useful index. Well worth browsing.

Thorp, Margaret Farrand. AMERICA AT THE MOVIES. New Haven: Yale University Press, 1939. 313pp.; New York: Arno Press, 1970.

A valuable but flawed attempt to measure how film censors and eighty-five million filmgoers affect the American film industry, this book explores questions like what do these viewers "ask from their films and how close do they come to getting it? What devices does Hollywood use to persuade them that it is satisfying their desires, to convince them that they are getting what they want? How do the millions affect the movies and how do the movies affect them? How far are their lives altered by the pictures they see? Who, to begin with, are the eighty-five million? Who goes to the movies?" The nine chapters touch superficially on each of these concerns, resulting in a highly subjective discussion that offers mainly assertions without much-needed documentation. For example, Thorp asserts that it is the "average citizen's wife" who has the most effect on what Hollywood films are made, just as she determines which books make the best-seller lists; and that rubes from Vermont or Arkansas are now mentally able to be comfortable any place in the world as a result of their having gone to the movies. If you don't mind these types of distracting generalizations, Thorp's impressions might provide fun reading. Her journalistic writing style and often entertaining anecdotes make the usually dry subject interesting and stimulating. An index is provided. Worth browsing.

[1065] Robert Sklar, "Lary May, SCREENING OUT THE PAST: THE BIRTH OF MASS CULTURE AND THE MOTION PICTURE INDUSTRY," AMERICAN HISTORICAL REVIEW 86:4 (October 1981):945.

Tudor, Andrew. IMAGE AND INFLUENCE: STUDIES IN THE SOCIOLOGY OF FILM. New York: St. Martin's Press, 1974. 260pp.

Beginning with a rejection of most previous works on the sociology of film ("The few outstanding studies are all but submerged in a sea of mediocrity"), Tudor offers us nine chapters on how and why movies affect our lives. Chapters Two through Four describe the process of communication both in society at large, and in the film community in particular. A number of static categories are presented that serve as a basis for understanding the dynamic between films and their audiences. Chapter Five, "Movie Languages," functions as the transition chapter, shifting the book's focus away from the theoretical, to the empirical. In abstract terms, Tudor constructs a paradigm that analyzes a film's ability to transmit meaning: "ASPECT OF MEANING and CHANNEL OF MEANING." The classification allows the author to divide the "'machinery' of communication" into three equal and parallel channels: "Nature of Film World," "Thematic Structure," and "Formal Structure." Each of these transmits cinematic meanings in three ways: "Cognitive," "Aspect Expressive," and "Normative." For example, the nature of the film world (its "human content") cognitively deals with film's factual aspects, while its thematic structure focuses on the thematic development in plot and the formal structure concentrates on factual meanings conveyed by form. Tudor makes it clear that his paradigm is not meant to replace critical judgments. "By using the paradigm as an analytic map," he explains, "we can do two things. First, we can know explicitly where to look and we can do so in some sort of order . . . Second, the paradigm acts to 'balance' our analyses. That is, it ensures that we do not pay too much attention to one focus of analysis at the expense of others. Instead we attempt to cover the whole range." The next three chapters discuss various ways in which movies operate in society: e.g., patterns of culture, film movements like German Expressionism, and popular genres like westerns, gangster films, and horror movies. According to Tudor, such popular genres function like popular religions of the past. In his words, they "find ways to justify the unjustifiable. They underwrite exploitation, self-interest, and hypocrisy." In his last chapter, "Patterns of Change," Tudor stresses the importance of discovering how the commercial demands of the film industry respond to audience needs and with what effects. Although many of the ideas presented in the book are provocative and challenging, the academic prose limits its appeal to all but serious students. A good bibliography and index are included. Well worth browsing.

FILMS

BUFFALO BILL AND THE INDIANS, OR SITTING BULL'S HISTORY LESSON (United Artists--16mm: 1976, 123 mins., color, sound, R-MGM)

Produced, directed, and co-scripted by Robert Altman, this bicentennial adapation of Arthur Kopit's play is an inventive and intriguing debunking of the western myth. Paul Newman stars as the epitome of the dime novel and Wild West version of William F. Cody, only now we see how shallow the character and his show business exploits are. Altman and co-screenwriter Alan Randolph set the action during the presidency of Grover Cleveland and relentlessly examine the way in which writers, politicians, and entertainers exploit America's past for personal gain. In addition to Newman's outstanding performance, there are fine interpretations of noted celebrities provided by Joel Grey, Kevin McCarthy, Harvey Keitel, Geraldine Chaplin, Frank Kaquitts, Will Sampson, Burt Lancaster, Pat McCormick, and Shelly Duval.[1066]

[1066] For more information, see Neil Feineman, PERSISTENCE OF VISION: THE FILMS OF ROBERT ALTMAN (New York: Arno Press, 1978), pp.209-18; Norman Kagan, AMERICAN SKEPTIC: ROBERT ALTMAN'S GENRE-COMMENTARY FILMS (Ann Arbor: The Pierian Press, 1982), pp.165-7; and Alan Karp, THE FILMS OF ROBERT ALTMAN (Metuchen: The Scarecrow Press, 1981), pp.75-83.

PENNIES FROM HEAVEN (MGM--16mm: 1981, 108 min., color, sound, R-MGM)
Based upon the extraordinary BBC TV series scripted by Dennis Potter, this stunning film, directed by Herbert Ross and adapted by Potter, fuses a number of film genres--melodramas, musicals, and comedy--into a vastly entertaining and imaginative screen experience. Steve Martin gives a brilliant performance as the hard-luck, shifty song plugger who has trouble separating reality from illusion in the lyrics he hustles across the Midwest. The memorable musical fantasies performed by Martin and company, including Bernadette Peters, Christopher Walken, and Jessica Harper, turn the neo-Brechtian film into a stylized work accessible mainly to serious film lovers rather than to the general public. Especially noteworthy are the creative production numbers staged by Ken Adam, the film's associate producer and visual consultant.

THE PURPLE ROSE OF CAIRO (Orion--16mm: 1985, 84 mins., color, sound, R-FNC, SWA)
Written and directed by Woody Allen, this innovative and capitivating surrealistic comedy stars Mia Farrow as a Depression waitress who finds happiness only in watching movies. The exploration of whether Americans have difficulty distinguishing between reality and illusion is beautifully captured as one of the characters in a fictional movie, THE YELLOW ROSE OF CAIRO, exits from the screen and enters Farrow's life. The enchanting episode, handsomely photographed by Gordon Willis, and superbly designed by Stuart Wurtzel, illustrates how movies serve us and its great director as models of behavior and cultural values.

ZELIG (Warner Bros.--16mm.: 1983, 84 mins., b/w, sound, R-FNC, SWA; S-TFF)
Written and directed by Woody Allen, this remarkably conceived and executed comedy is an outstanding example of technical genius and artistic imagination. Allen stars as Leonard Zelig, a man with the ability to assume the personality of the people around him. This ability to become "everyman" offers an ideal opportunity for the brilliant satirist to parody American history and culture. In addition to the talented cast, including Mia Farrow, Gordon Willis deserves praise for his superb cinematography.[1067]

THE HEROINE

To reiterate the basic assumptions of this chapter, theatrical films occupy a unique place in our society. Most people assume that the uniqueness of these films is their ability to provide escapist entertainment for mass audiences worldwide. But we have seen that the products of popular culture do more than provide a means of relaxation. They also serve as a form of social control and as a forum for understanding ourselves and the world around us. Moreover, popular culture, like any social institution, does not operate in a social or political vacuum. Its status and success are inexorably linked to the social and political structure and stability of its parent society. What is presented in popular culture, therefore, reflects how the dominant ideology feels about specific issues at specific times. American film narratives in particular accent many of the important issues uppermost in the

[1067] For more information, see Andrew Sarris, "Woody Allen at the Peak of Parody," VILLAGE VOICE 28:29 (July 19, 1983):39; Janet Maslin, "How the Graphic Arts Feats in ZELIG Were Done," NEW YORK TIMES C (August 31, 1983):11; and Vincent Canby, "Woody Allen Continues to Refine His Art," ibid., B (July 17, 1983):1,15.

collective perceptions of the public: e.g., the nature of justice, the search for knowledge, the meaning of happiness, and the price of success.[1068] These issues, portrayed in symbolic stock situations and social types, epitomize the fusion of a nation's dominant ideology with a commercial product. The fusion is most obvious in Hollywood's formula films (e.g., westerns, musicals, gangster films, and screwball comedies). Being both a business and an art, the film industry, in its use of formulas, relies on stereotypes operating as predictable patterns as a means not only of maximizing box-office profits, but also of satisfying audience expectations and desires.

At the same time, frequent and repeated acts of omission and distortion in popular culture products work toward the symbolic annihilation of minority and outsider values (e.g., the role of women in the work force following World War II). The acts of commission, meanwhile, seek to maintain the STATUS QUO and to limit the horizons of impressionable viewers who see in the media appropriate role models. In short, popular culture works toward perpetuating the dominant ideology.

Stereotypes used by film artists, however, reveal important images of heroes, villains, and fools, and capture what large segments of the public feel about those social types at a specific time. One problem with the standard interpretations and reactions to Hollywood narrative films is that they fail to attribute more than one meaning to a film text, more than one explanation for what transpires in the film process, and more than one motive for the actions of filmmakers and audiences. A second problem is that minority viewpoints are often ignored or trivialized. What is not often understood is how acts of omission and distortion can be used to raise public consciousness and to force the dominant culture to incorporate into its artifacts the social values of the counterculture.

Furthermore, it is clear that alarmist reactions to the film industry are not unique to film but relate as well to the negative attitudes that social critics historically present about the notion of entertainment and the intrusion of mass communications into our industrialized society. That is not to deny the problems created in a world that has come more and more to rely on illusions as a means of dealing with reality. It is to say, however, that developing a critical subjectivity about the acts of commission and omission in film texts provides us with a rational, effective means of enlarging our perceptions and enriching our experiences. The challenges for serious film students are how to overcome the rigid attitudes of a dominant cinema and its commercially successful formulas and how to offer alternative points of view to a mass audience conditioned to accept residual sexist and racist images and ideas.

Whatever strategy one uses--e.g., neo-Marxist, feminist, sociological, psychoanalytical, semiological, aesthetic--to investigate the process of stereotyping, it makes sense to examine the historical and institutional contexts of the process from a film text's pre-filmic origins to its reception by a variety of audiences. By concentrating on the differences from text to text and in relation to specific characters and characterizations, we can use stereotypes to help educate us in matters of taste, discrimination, and meaningful interactions with the unknown and in film history.[1069] For example, sociological and psychoanalytical studies can analyze the relationships between screen and real life characterizations of women in movies like KRAMER VS. KRAMER (1979), TERMS OF ENDEARMENT (1983), and AGNES OF GOD (1985) to reveal how film depictions often play on our unconscious desires and needs, while also affecting our self-images and distorting our perceptions of reality. Textual

[1068] For a good example of how Japanese films reflect the periods in which they are made, see Tadao Sato, CURRENTS IN JAPANESE CINEMA, trans. Gregory Barrett (Tokyo: Kodansha International), pp.38-56.

[1069] For a useful study of "progressive" images of an "independent woman" in COMA (1978), see Elizabeth Cowie, "The Popular Film as a Progressive Text--A Discussion of COMA," M/F 3 (1979):58-81; and ___, "Discussion of COMA--Part 2," ibid., 4 (1980):57-69.

and aesthetic analyses can demonstrate how films like LIPSTICK (1959), PRIVATE BENJAMIN (1980), BODY DOUBLE (1984), and FATAL ATTRACTION (1987) create their multiple meanings and representations through the use of cinematic codes and filmic language.[1070] Such analytical strategies will make abundantly clear how stereotypes used by hacks result in pedestrian and distorted judgments. They will demonstrate how the misuse of stereotypes in low-quality sequels, imitations, and reruns desensitizes a large segment of the public to its individual and collective social responsibilities. Many social critics and artists (cited earlier) testify to situations where the very groups being negatively stereotyped have unconsciously accepted inferior images and notions of themselves. On the other hand, feminists and minority groups, especially, have struggled tirelessly but with mixed results to undo the racist and sexist slurs perpetrated by popular culture against them. No one denies that in those instances stereotyping operates as a dangerous and negative cultural force. More to the point, it is because the problem persists that the major defense a society has against the misuse of stereotypes is a critical and mentally alert citizenry.

In studying film heroines, we readily discover not only how the images have

[1070] For a useful discussion on how Japanese heroines reflect certain cultural biases, see Sato, pp.73-99.

changed considerably from their early status in motion pictures,[1071] but also how the process of stereotyping operates.[1072] A. J. Alexander, for example, did a "pre-feminist"[1073] analysis of the heroine as "the nongenue":

> Her distinguishing characteristic is the aspiration to love. In this aspiration she is not only participant and partner, but protagonist. When she assumes tragic grandeur she is a heroine, not according to the restricted definition, "the principal female character in a story," but in the larger sense, "a woman of heroic character, a female hero." In these respects, she is different from all other film conceptions of woman; her distinctions might properly be fixed with the label, "nongenue." And she is different from all other screen conceptions of the hero in that she is thoroughly modern, a brave new woman.[1074]

[1071] Mary Lee Settle makes the point that "The goddesses are long gone. There may be, at most, only empathy for today's television and movie women. We can no longer identify with them. Instead, their function is reversed. They are designed to identify with us." Cf. Mary Lee Settle, "Bidding Adieu to the Feminine Mystique," NEW YORK TIMES 2 (May 3, 1987):1.

[1072] A useful study to consult is a series of articles by Kevin Gough-Yates: "The Heroine--Part One," FILMS AND FILMING 12:8 (May 1966):23-7; "Part Two," ibid., 12:9 (June 1966):27-32; "Part Three," ibid., 12:10 (July 1966):38-43; "Part Four," ibid., 12:11 (August 1966):45-50. See also, M. Joyce Baker, IMAGES OF WOMEN IN FILM: THE WAR YEARS, 1941-1945 (Ann Arbor: UMI Research Press, 1980); Michael Renov, "From Fetish to Subject: The Containment of Sexual Difference in Hollywood's Wartime Cinema," WIDE ANGLE 5:1 (Winter 1982):16-27; Estelle Changas, "Slut, Bitch, Virgin, Mother: The Role of Women in Some Recent Films," CINEMA 6:3 (Spring 1971):43-7; TAKE ONE 3:2 (November-December 1970), devoted to "Women in Film"; Gregg M. Campbell, "Beethoven, Chopin and Tammy Wynette: Heroine and Archetypes in FIVE EASY PIECES," LITERATURE/FILM QUARTERLY 2:3 (Summer 1974):275-83; Gabriel Miller, "The (Sex) Symbol: Marilyn, Prime Time, and the Nielsens," ibid., 12:4 (1984):257-70; Pam Cook, "'Exploitation' Films and Feminism," SCREEN 17:3 (1976):122-7; Robert Patrick and William Haislip, "Thank Heaven for Little Girls," CINEASTE 6:1 (1973):22-5; Elizabeth Cowie, "Women, Representation and the Image," SCREEN EDUCATION 23 (Summer 1977):15-23; Lynne Agress, "Women as Caricature in Films," USA TODAY 108:240 (July 1979):38-40; Caren J. Deming and Billie J. Wahlstrom, "The Hero, the Harlot, and the Glorified Horse as Mythic Americans," INTELLECT 105:238 (June 1977):439-41; Joyce Howe, "No More Suzie Wongs: Chinese Women in the Movies," VILLAGE VOICE 30:35 (August 27, 1985):60-1; Richard M. Levinson, "From Olive Oyl to Sweet Polly Purebread: Sex Role Stereotypes and Televised Cartoons," JOURNAL OF POPULAR CULTURE 9:3 (Winter 1975):561-72; Nora Sayre, "Did Cooper and Stewart Have To Be So Stupid?", NEW YORK TIMES 2 (August 7, 1977):11-2; and Marlaine Glicksman, "Women in Film . . . Just Barely," FILM COMMENT 21:6 (December 1985):20-5.

[1073] For purposes of this chapter, "pre-feminist" refers to an attitude that may or may not support the current feminist notion of a woman's being entitled to, and able to have, both a successful career and a happy homelife. Its value is in pointing out the presence of an awareness that a conflict exists in screen images of women forced to make a choice between independence and submission, between happiness and a career.

[1074] A. J. Alexander, "A Modern Hero: The Nongenue," FILM CULTURE 22-23 (Summer 1961):81-2.

The films that Alexander uses as examples are ROOM AT THE TOP and THE LOVER (both in 1958), LOOK BACK IN ANGER and HIROSHIMA MON AMOUR (both in 1959) PRIVATE PROPERTY and THE FUGITIVE KIND (both in 1960), and THE SAVAGE EY (1961). One of the many helpful techniques in his analysis of stereotypes is th comparison of the stock Hollywood heroines with the new "nongenue." He points ou that the stereotyped heroine performs as if in a Victorian morality play. By forsakin the bad boyfriend, she often gains a respectable and loving husband. Doris Day i the prototype of this old-fashioned virgin. The new stock heroine is quite different In his simplified analysis, Alexander finds the new heroine emancipated. She break with conventions, admits the importance of sex, and is concerned with shaping a ne morality for herself. Her important function is, according to the films reviewed, "nc procreative but creative, not matrix but cynosure-lover."[1075]

Bosley Crowther offers another pre-feminist view of stereotyped female heroines He talks of Hollywood being a "supermarket" where talent is replaced with sensuality Actresses who have won distinction for their performances--e.g., Joanne Woodward Hope Lange, Lee Remick, Maria Schell, and Geraldine Page--are being ignored becaus of the industry's desire to cater to its mass audience of teenagers. The new star are

> Shirley MacLaine? She's a calculated nitwit, doomed to eternal immaturity. Doris Day? The perennial childbride, still acting as though she's likely to suck her thumb. Julie Andrews? A delightful young woman who appears typed in wholesome school-marm roles. Natalie Wood? An aging teenager with all the presence of the girl next door.

> Then there is the whole range of charm girls--Debbie Reynolds, Jane Fonda, Sandra Dee, Carroll Baker, Carol Lynley, Ann-Margret, Suzanne Pleshette, Yvette Mimieux. Not one seems much more adult than the alarmingly precocious Hayley Mills.[1076]

Obviously, Crowther shared none of the concerns contemporary feminist film critic voice about the need to examine issues of femininity, independence, marriage, family and romance; nor was he much of a forecaster when it came to predicting the futur success of stars like MacLaine, Fonda, and Ann-Margret.

A more sympathetic pre-feminist analysis of the role of females in society an its effect upon screen versions was provided by John Howard Lawson. Writing fro a neo-Marxist point of view, he attacked political and economic factors for th subservient position of women in our culture:

> Cultural attitudes toward women reflect the MORES of capitalism. These MORES are not shaped by sentiment, literary artifice, or the arrogance of the "male animal." The frustrations of the middle class woman do not originate within the walls of her home; the petty occupations which paralyze her personal development are her small part of the toll exacted from her working class sisters. The root of the woman question must be sought in the system of production, which holds women in reserve as a potential threat to the wages of men, or employs them at a lower rate in order to reduce the whole level of

[1075] Alexander, pp.81-2.

[1076] Bosley Crowther, "Where Are the Women?" NEW YORK TIMES, 2 (January 23, 1966):11

wages . . . Hollywood treats "glamor" and sex appeal as the sum-total of woman's personality.[1077]

Lawson goes on to say that portraits of women in Hollywood films were of three kinds: the criminal type or the one who starts the trouble; the perennial loser in the battle of the sexes; and the sexual dream wish of lustful males.[1078] Admitting that the types are not mutually exclusive, he cites films such as LEAVE HER TO HEAVEN (1945), THE LADY GAMBLES (1949), WESTWARD THE WOMEN, A STREETCAR NAMED DESIRE (both in 1951), ALL ABOUT EVE (1950),[1079] THE LAS VEGAS STORY, LYDIA BAILEY, MOULIN ROUGE (all in 1952), as some examples of how women were stereotyped in motion pictures. He notes an increasing emphasis on sadism, tending to make criminal conduct attractive and justifiable; a continued use of sexual promiscuity and homosexuality as appeals to the audience's emotions; and a preference for having women assume the responsibility for the ill treatment they receive because of their having aroused the male's baser instincts.

Particularly useful to appreciating the role of stereotypes in films is Emanual Levy's non-feminist analysis of Oscar roles pertaining to screen heroines and heroes. It reveals substantial differences according to age, physical appearance, marital status, and occupation. As Levy explains, female roles occur in "women's movies," while male roles, by contrast, occur in "serious dramatic pictures dealing with important issues, such as crime, racism, and injustice." He then points out that according to the AMPAS awards, "the contribution of women to society has been in marital and familial roles, as wives-mothers, or in service of professions, as entertainers or prostitutes." Levy concludes that men win Oscars in roles he considers "social TYPES"; women, in roles he considers "stereotypes."[1080]

The distinction is an important one both for Levy and for Klapp. That is, "social types" symbolize our common values, easily understood and readily accepted by the dominant forces trying to convey to the population in general what are the preferred modes of behavior. On the other hand, "stereotypes" signify polarities in our value structure. Those who relate to the positive value judgments symbolized in "good" stereotypes are considered desirable citizens; those who are caricatured in the negative value stereotypes are the undesirables. There is no middle ground. There is either a right or a wrong way to act. For that reason, Levy believes that stereotypes not only distort reality, but also they are "harmful, confining people to narrowly defined ranges of norms of behaviors."[1081]

Without question, the most comprehensive studies on the roles of women in film are by feminist film critics like French, Haskell, Higashi, Kaplan, Mellen, Rosen, Walsh, and Welsch. I have discussed their findings in greater detail elsewhere in this and other books.[1082] What should be noted in passing, however, is the current

[1077] John Howard Lawson, FILM IN THE BATTLE OF IDEAS (New York: Masses and Mainstream, 1953), pp.60-1.

[1078] Lawson, p.62.

[1079] For an interesting update on the film, see Nadine Brozan, "The Real 'Eve' Sues to Film the Rest of Her Story," NEW YORK TIMES C (February 7, 1989):13.

[1080] Levy, p.202.

[1081] Levy, p.202.

[1082] Frank Manchel, WOMEN ON THE HOLLYWOOD SCREEN (New York: Franklin Watts, 1977). See also Frank Manchel, GREAT SPORTS MOVIES (New York: Franklin Watts, 1980); and ___, AN ALBUM OF MODERN HORROR FILMS (New York: Franklin Watts, 1983).

interest in demonstrating how family melodramas illuminate the controversial nature of Hollywood's screen images of women.[1083]

One excellent example of how this works is the Hollywood family melodrama. Griselda Pollock argues that it "can be read as an instance of exposed contradictions within bourgeois society."[1084] It is the "exposed contradictions" and the way in which they can be used as a tool to study not just the film continuum, but also the complex relationships between film and society that have drawn the interest of neo-Marxists, semiologists, and feminist film critics.[1085] As Steve Neale summarizes their position, "melodrama (and in particular the Hollywood melodrama of the 1950s) can be seen as the locus of contradiction and of a potential subversion and disruption of the dominant ideologies and their operations, most conspicuously in relation to the family and sexuality."[1086] Because of the genre's interest in sexual identity and domestic problems, few film critics would deny Kaplan's assertion that the family melodrama is "a genre geared specifically to women."[1087] Florence Jacobowitz and Richard Lippe agree. They believe that

> Traditionally, the representation of the female needs, female sexuality and the woman's place in the family has been addressed in the film melodrama, which saw its heyday in the '40s and '50s; the melodramas which have resurfaced in the '80s, like TERMS OF ENDEARMENT, insist with a vengeance upon the woman's subordinated position.[1088]

Barbara Creed provides an additional dimension, pointing out that

> the structure of the woman's melodrama involves a pattern of female role transgression: the entry of an exceptional male: a marked change in the heroine's point of view: suffering and sacrifice: and, finally, her acceptance

[1083] For more information, see Barbara Creed, "The Position of Women in Hollywood Melodramas," AUSTRALIAN JOURNAL OF SCREEN THEORY 4 (June 1978):27-31; Molly Haskell, "The Women's Film," *FILM THEORY AND CRITICISM, 2nd ed. (New York: Oxford University Press, 1979), pp.505-34; Griselda Pollock, "Report on the Weekend School," SCREEN 18 (Summer 1977):105-19; D. N. Rodowick, "Madness, Authority, and Ideology in the Domestic Melodramas of the 1950's," THE VELVET LIGHT TRAP 19 (1982):40-5; Lucy Fischer, "Two-Faced Woman: The 'Double' in Women's Melodrama of the 1940's," CINEMA JOURNAL 23:1 (Fall 1983):24-43; Diane Waldman, "At Last I Can Tell It to Someone! Feminine Point of View and Subjectivity in the Gothic Romance Films of the 1940s," ibid., 23:2 (Winter 1983):29-40; Mary Beth Haralovich, ROMANCE IN THE HOLLYWOOD FILM AND IN POSTER PUBLICITY: STUDIO YEARS (Unpublished Ph.D. dissertation, University of Wisconsin-Madison, 1984); and Ellen Seiter, THE PROMISE OF MELODRAMA: RECENT WOMEN'S FILMS AND SOAP OPERAS (Unpublished Ph.D. dissertation, Northwestern University, 1981).

[1084] Griselda Pollock, "Dossier on Melodrama," SCREEN 18:2 (1977):105.

[1085] For an interesting perspective on this theme, see Chuck Kleinhans, "Notes on the Melodrama and the Family under Capitalism," FILM READER 3 (February 1978):40-7.

[1086] Cited in Pollock, p.107.

[1087] WOMEN AND FILM: BOTH SIDES OF THE CAMERA, p.25.

[1088] Florence Jacobowitz and Richard Lippe, "Obsession in the Melodrama: Amy Jones' LOVE LETTERS," CINEACTION: A MAGAZINE OF RADICAL FILM CRITICISM & FILM THEORY 2 (Fall 1985):15.

of a more socially desirable role. Sometimes, if she cannot come to terms with her situation she seeks death.[1089]

At the heart of Creed's position is the belief that "the woman's film is based on a structure whose conventions have been established with the intention (conscious or unconscious) of keeping women impotent within the patriarchal order."[1090] Jeanine Basinger reinforces the lackluster image of men in women's films. "Over and over again," she writes, "the women's film established the dilemma of the strong woman tied down to a weak man who wrecked her life as he destroyed his own." Basinger then adds the caveat that "The hope for women in these films was seldom liberation, but to meet THE BETTER MAN and find him to be strong, reliable, honest, even fatherly."[1091] In short, the focus of the Hollywood family melodrama is on human relationships dealing with domestic and romantic problems long identified, rightly or not, with female interests. Regrettably, family melodramas are low on the popularity ladder. As a result, feminine perspectives are relegated to peripheral discussions on social values. Feminists, therefore, find the themes of the family melodrama ignored by many spectators and thus it is significant to make these issues more visible.

One example of a downgraded theme, identified by Jacobowitz and Lippe, is that of mother-daughter relationships. The classic Hollywood approach, evident in movies like IMITATION OF LIFE (both the 1934 and 1959 versions), STELLA DALLAS (both the 1925 and 1937 versions), MILDRED PIERCE (1945), and THE RECKLESS MOMENT (1949), was to preserve the "viable family unit." Even if a mental breakdown occurred because of a rebellion against the existing social system, the disturbed screen characters in films like THE SNAKE PIT (1948) and THE THREE FACES OF EVE (1957) invariably not only found the right physician but also emerged cured. Recently, however, Jacobowitz and Lippe note that a growing number of films are patterning themselves after the gloomier results of childhood traumas depicted in MARNIE (1964).[1092] In such cases, the adult remains not only deeply disturbed, but also unable to function effectively as a mature person. For these critics, the most satisfying, albeit flawed, contemporary film is LOVE LETTERS (1984). It synthesizes many of the themes that current female protagonists are projecting about their hatred for their fathers and empathy for their mothers. Just as in pre-World War II movies, the contemporary family melodramas are dealing with unattainable loves, self-destruction, and the negative effects of living in an industrial age. But Jacobowitz and Lippe do note a major difference between the past and the present. The forties' heroines were perceived as victims trapped by an oppressive social system. The eighties' heroines, however, not only share responsibility for their social status, but also appear satisfied with their wife-mother roles.[1093]

Not all feminists accept the concept that a major benefit of Hollywood 1950s family melodramas lies in how they expose ideological contradictions. "This argument," as Laura Mulvey points out, "depends on the premise that the project of this ideology is to conjure up a coherent picture of a world by concealing the incoherence caused

[1089] Creed, p.28.

[1090] Creed, p.31.

[1091] "When Women Wept," p.53.

[1092] For an interesting perspective on this theme, see Rebecca Bailin, "Feminist Readership, Violence, and MARNIE," FILM READER 5 (1982):24-36.

[1093] For another perspective on Hollywood's reworking of classic feminine themes, see "Are 'New' Women's Movies Guilty of Sexism in Reverse?", NEW YORK TIMES H (November 10, 1985):27.

by exploitation and oppression."[1094] Although such a progressive perspective on unity and closure in the family melodrama has produced a number of positive and revealing insights, Mulvey insists that it makes a fundamental mistake: ideological contradictions are at the center of family melodramas and are not flaws to be deciphered by critical sleuths. Put another way, the "function of 'fifties melodrama' . . . is to provide an outlet for its own inconsistencies."[1095] To demonstrate how the process works, Mulvey points to several films directed by Douglas Sirk: ALL THAT HEAVEN ALLOWS (1955), WRITTEN ON THE WIND (1956), and THE TARNISHED ANGELS (1958). She sees each film acting as a "safety valve for ideological contradictions centered on sex and the family" and thus functioning as a significant outlet for "probing pent-up emotion, bitterness and disillusion well known to women. . . ."[1096] Sirk's melodramas can do this in three ways: through the female protagonist's domineering viewpoint, through the tensions between sexes and generations within the family, or through film style. Whichever perspective directors like Sirk use, Mulvey argues that the crucial explication of melodrama lies in highlighting ideological contradictions and trying to reconcile them within an aesthetic framework.[1097] Interestingly, Kaplan analyzes the situation somewhat differently, arguing that the two major functions in the "masochistic scenarios" in Hollywood family melodramas are "to expose the constraints and limitations that the capitalist nuclear family impose on women and . . . to 'educate' women to accept those constraints as 'natural,' 'inevitable.'"[1098]

A good example of how feminist film critics debate reception theory and the role of Hollywood melodramas in society is the recent controversy over the interpretation of King Vidor's 1937 remake of STELLA DALLAS, first filmed by Henry King in 1925. Linda Williams initiated the debate with her analysis of why "the women's film" and "the sub-genre of the maternal melodrama" devalue and debase film images of mothers "while sanctifying the institution of motherhood."[1099] Focusing on feminist film theory

[1094] Laura Mulvey, "Notes on Sirk & Melodrama," MOVIE 25 (Winter 1977-78):53.

[1095] Mulvey, p.53.

[1096] Mulvey, pp.53-4. See also Paul Willemen, "Distantiation and Douglas Sirk," SCREEN 12:2 (Summer 1971):63-7.

[1097] Mulvey, p.56.

[1098] WOMEN AND FILM: BOTH SIDES OF THE CAMERA, pp.25, 104.

[1099] Linda Williams, "'Something Else Besides a Mother': STELLA DALLAS and the Maternal Melodrama," CINEMA JOURNAL 24:1 (Fall 1984):3. For additional discussion on this topic, see Christine Gledhill, "Stella Dallas and Feminist Film Theory," CINEMA JOURNAL 25:4 (Summer 1986):44-8; E. Ann Kaplan, "E. Ann Kaplan Replies," ibid., pp.49-53; and Ron Graham, "Stella, Reborn as an Unmarried Mother," NEW YORK TIMES H (July 16, 1989):15, 17. For more information on the sub-genre of the Maternal Melodrama, see Serafina Kent Bathrick, THE TRUE WOMAN AND THE FAMILY-FILM (Unpublished Ph.D. dissertation, University of Wisconsin-Madison, 1981); Diane Waldman, HORROR AND DOMESTICITY: THE MODERN GOTHIC ROMANCE FILM (Unpublished Ph.D. dissertation, University of Wisconsin-Madison, 1981); Joanne Yeck, THE WOMAN'S FILM AT WARNER BROS., 1935-1950 (Unpublished Ph.D. dissertation, University of Southern California, 1982); E. Ann Kaplan, "The Case of the Missing Mother: Maternal Images in Vidor's STELLA DALLAS," HERESIES 16 (1983):81-5; Christian Viviani's "Who Is Without Sin? The Maternal Melodrama in American Film, 1930-1939," WIDE ANGLE 4:2 (1980):4-17; and B. Ruby Rich, "The Right of Re-Vision: Michelle Citron's DAUGHTER RITE," FILM QUARTERLY 35:1 (Fall 1981):17-22.

and on the theories of motherhood, the author makes the case that not only have some maternal melodramas "historically addressed female audiences about issues of primary concern to women, but these melodramas also have reading positions structured into their texts that demand a female reading competence."[1100] That is, women living in a patriarchal society assume a special identity directly related to female mothering. The women's film then provides the mixed message "of joy in pain, of pleasure in sacrifice. . . ."[1101] What is important, however, is that feminists spend less time attacking the patriarchal ideology and give more attention to building "upon the pleasures of recognition that exist within filmic modes already familiar to women."[1102] One way is to stress the paradoxes that women encounter in a patriarchy. Another approach is to stress why society has conditioned women to interpret film texts differently from men. Williams then goes on to argue that Hollywood's maternal melodramas don't help women to accept or to escape from the "essential female tragedy." Rather, the sub-genre often provides the movie women with a fate that the audience in part questions.

E. Ann Kaplan reacted to Williams's conclusions with both praise and criticism. On the one hand, she agreed that a female spectator could identify partially with the viewpoint of Stella and be moved by the 1937 film's resolution. Where she disagrees is "whether or not Stella, and the female spectator that the film constructs (identifying with her), see this as a 'happy ending.'"[1103] What disturbs Kaplan is the possibility that patriarchy and the film text condition the spectator to accept mother-daughter sacrifices as normative behavior. Not only does she want an explanation why such sacrifices are warranted, but she also wants to understand how the patriarchal value system affects women's concept of motherhood. Kaplan also challenges Williams's assumption that women do in fact question the resolutions women's films present. At the very least, Kaplan insists on differentiating between a 1937 spectator and a contemporary spectator.

Patrice Petro and Carol Flinn side with Williams and against Kaplan. While noting that both critics agree with the theory that women do identify with Stella's plight, the two authors reject Kaplan's theory that 1937 female spectators had little choice but to accept the patriarchal values in STELLA DALLAS. They claim it is not possible to argue that spectators are responsible for a film's reception and that film texts control a film's meaning. "At the very least," point out Petro and Flinn, "it is certainly a mistake to believe that women in 1937 had absolutely no resources to resist at all."[1104] Even more objectionable are Kaplan's assumptions about female spectatorship and structures of identity. As understood by Petro and Flinn, Kaplan differentiates between the woman's film (a genre that appeals directly to female spectators) and "a woman's melodrama within a male Oedipal tradition."[1105] That distinction, however, undermines Kaplan's argument that STELLA DALLAS is a woman's film. In other words, how can the 1937 film be both a patriarchal narrative and a film that appeals directly to women?

[1100] Williams, pp.7-8.

[1101] Williams, p.2.

[1102] Williams, p.7.

[1103] E. Ann Kaplan, "Dialogue: Ann Kaplan Replies to Linda Williams's "'Something Else Besides a Mother: STELLA DALLAS and the Maternal Melodrama,'" CINEMA JOURNAL 24:2 (Winter 1985):40.

[1104] Patrice Petro and Carol Flinn, "Dialogue: Patrice Petro and Carol Flinn on Feminist Film Theory," CINEMA JOURNAL 25:1 (Fall 1985):50-1.

[1105] Petro and Flinn, p.51.

Kaplan quickly responded, insisting that her views had been misinterpreted. In reference to the notion of a monolithic spectator, she wanted to make it clear that two kinds of spectator-positions exist: (1) the position offered by the film, independent of its historical context; and (2) the position taken by the spectator at the moment of reception. "Potentially, the subject in the cinema is both constructed by the cinematic strategies of the film being viewed," explained Kaplan, 'AND by the social practices and institutions through which the subject lives out his or her historical moment.'"[1106] At issue is the relationship between the film's preferred meaning and the reading formations possessed by the spectator. On the one hand, Kaplan acknowledged that there were conditions under which a film's preferred meaning might overcome a female spectator's resistance to patriarchal values. She also admitted that distinguishing between a woman's film and a woman's melodrama needed more discussion than she provided in her brief comments.[1107] On the other hand, she insisted that her critique focused on Stella's being a "resisting figure." The fact that female spectators have available to them multiple identifications in no way mitigates against the fact that women must deal with the patriarchal imperative.

Whether Kaplan is more on the mark than Williams, Petro, and Flinn is less important than the ongoing debate about how minorities, women, and oppositional groups are "heard" and received in and through the film. So far, we have reviewed the arguments about the importance of film as a social force in society. Among the major assumptions underlying this chapter is the notion that movies operate as a form of popular culture using rituals (conventions and stereotypes) to represent what a large segment of society values (or rejects) at a specific time in history and under particular conditions. One reason why educational institutions and elitist social commentators have not dealt more seriously with movies is that many individuals are intellectually biased against entertainment and the mass media. In particular, traditionalists dismiss movies as a trivial amusement, in part because movies rely so heavily on stereotypes. This chapter has made the case that not only are stereotypes important in a commercially based industry dependent on formulas, but also that stereotypes can be useful in developing a more positive image for those very individuals and groups being stereotyped. That is, the conventions used to represent the collective wisdom presumably shared by a specific society at a historical moment can be "re-written" in order to produce a better self-image and to act as a more beneficial role model. Clearly, mainstream films both in the movie theaters and on television screens are not the only source for such positive images. They are, however, the major channel through which women in the media are perceived and symbolized.

Another underlying assumption debated throughout this chapter is that mainstream movies are not monolithic discourses entrapping a helpless and passive populace. Just the reverse may be true. One need only examine the history of the film industry to see how the box office, world conditions, economic factors, and creative talent have negated attempts at censorship and cultural repression. That is not to say that class, gender, and race are treated accurately or fairly in the mass media. It is to say that an analysis of popular culture based on symbolic and cultural myths helps reveal the tensions and cross-currents that exist in a given society and among large segments of the population. Even further, what the discussion of melodrama, women's films, and female spectatorship makes evident is that feminist film criticism offers a constructive approach to addressing the issues of film narratives, reception theory, and the value of examining stereotypes and their role in the film continuum.

[1106] E. Ann Kaplan, "E. Ann Kaplan Replies," CINEMA JOURNAL 25:1 (Fall 1985):52.

[1107] For more details, see Kaplan's "The Case of the Missing Mother: Maternal Images in Vidor's STELLA DALLAS.

BOOKS

*Allen, Jeanne Thomas, ed. NOW, VOYAGER. Madison: University of Wisconsin Press, 1984. Illustrated. 230pp.
 This first-rate treatment of the hit 1942 Warner Bros. film offers stimulating material about a number of important film issues. Not only does the editor maintain the high standards of script presentation established under Tino Balio's impressive Wisconsin/Warner Bros. Screenplay Series, but also in her noteworthy introduction Allen explores matters related to the women's film, psychoanalytical studies, the star system, and the art of screenwriting.
 The author begins by pointing out that Bette Davis's performance in NOW, VOYAGER provides something unique and critical in American entertainment: "the story of a woman's struggle to gain initiation into adulthood and a relative measure of independence." Allen then proceeds to explore how Olive Higgins Prouty's novel of the same title relates both to this contribution to mass culture and to the popular film itself. Attention is drawn to the fact that Hollywood in the forties, much like the nation itself, had patriarchal attitudes that denigrated melodramatic experiences related to women's emotional lives. For example, few Hollywood movies up to that period made the role of nurturing mother central to a film's resolution. To explain why, Allen traces the roots of the women's film from the rise of American mass culture in the 1800s to the present. She describes how Prouty's NOW, VOYAGER drew on society's predominantly dismissive attitude toward women's fiction; and how subsequent commentators, in turn, ignored the novelist's contributions to the film adaptation of her book. Following a brief but useful biographical sketch of the novelist, Allen critiques the novel and shows its links to Prouty's other stories and novels. Particular attention is given to the novelist's other major work, STELLA DALLAS (1922), and its many media adaptations in film, on the stage, and as a weekly radio serial. The well-written and fast-moving introduction then offers information on the screenwriter-director Edmund Goulding's initial treatment of the screenplay and the final script by Casey Robinson. Succinct comments are also made about the role that the Hays Office played in the film, the influence of psychoanalysis in Hollywood films, as well as the contributions of Davis and the director Irving Rapper. Best of all, Allen is one of the few editors in this enjoyable series who makes an effort to offer a balanced section on critical reactions to the movie.
 Anyone interested in seeing how a film once considered trivial has been transformed into a significant cultural artifact should read this book. In addition to the intelligent introduction, there is also the complete screenplay plus very useful notes and credits. Recommended for special collections.

*LaValley, Albert J., ed. MILDRED PIERCE. Madison: University of Wisconsin Press, 1980. Illustrated. 259pp.
 In a splendid introduction to the 1945 film, LaValley highlights the similarities and contrasts between James M. Cain's 1941 novel and the Jerry Wald-Warner Bros. production. We are first given an insight into the book's depiction of a complex female protagonist who rises from poverty, becomes a wealthy restaurateur, and then loses everything because of a "forbidden wish to control the love of her daughter Veda." LaValley then pinpoints how the broad narrative outline of Cain's novel was reshaped to fit into the "high glossy look and its somewhat lurid subject matter [that] were to become a hallmark of Warner films of the late 1940s. . . ." As he analyzes the evolution of the book and its link to the FILM NOIR tradition, the author skillfully weaves into the thoughtful analysis comments about the studio's popular screen actresses, its tough crime dramas, and the relationship between the screen version of MILDRED PIERCE and other heroines of the woman's film genre. Of particular value is the section on Wald's role as producer. Throughout the eight treatments and screenplays, Wald emerges as the guiding force in selecting the cast and crew, in determining how the screen version would inherit the studio's thematic and stylistic traditions, and in his unique involvement with the project. Also noteworthy are LaValley's perceptive comments on how the final screenplay evolved, starting with

the 1944 version by Thames Williamson and concluding with the final 1945 screenplay by Ranald MacDougall.

Less satisfying are the author's fan-like discussions of Joan Crawford, Ann Blyth, and Eve Arden, as well as his disappointing aesthetic analysis of the film. In fact, LaValley explains in a telling footnote that "Certainly the most interesting writing on the film" is in E. Ann Kaplan's WOMEN IN FILM NOIR, yet his patronizing summary of Pam Cook's essay would suggest otherwise.

Despite these minor irritations, LaValley's study belongs with the best work produced by the excellent Wisconsin/Warner Bros. screenplay series. The complete MacDougall screenplay, enjoyable illustrations, useful endnotes, production and cast credits, and an inventory of material available at the Warner Library of the Wisconsin Center for Film and Theater Research add to the book's considerable value. Recommended for special collections.

FILMS

THE BIG SLEEP (Warner Bros.--16mm: 1946, 114 mins., b/w, sound, R-MGM)

One outstanding film that illustrates the Wolfenstein-Leites thesis is the director Howard Hawks's story about a good-bad girl's relationship with a gangster and a murderer. The screenplay by William Faulkner, Leigh Brackett, and Jules Furthman is based upon Raymond Chandler's novel and features Humphrey Bogart as the existential private eye, Philip Marlowe. Lauren Bacall offers a key version of a FILM NOIR heroine: outwardly dangerous and cynical, inwardly decent and romantic.[1108]

DOUBLE INDEMNITY (Paramount--16mm: 1944, 112 min., b/w, sound, R-SWA, WFM)

Directed by Billy Wilder and based on James Cain's novel THREE OF A KIND, the Raymond Chandler-Billy Wilder screenplay is a seminal FILM NOIR story of a woman's manipulation of a man's greed and lust. Fred MacMurray stars as an insurance

[1108] See *George P. Garrett, O. B. Harrison, Jr., and Jane R. Gelfman, eds., "The Big Sleep," FILM SCRIPTS ONE (New York: Appleton-Century-Crofts, 1971), pp.137-329; *Lauren Bacall, BY MYSELF (New York: Alfred A. Knopf, 1979), pp.118-24; Howard Greenberger, BOGEY'S BABY (New York: St. Martin's Press, 1978), pp.66-74; *William Luhr, RAYMOND CHANDLER AND FILM (New York: Frederick Ungar Publishing Company, 1982), pp.121-53; *Gerald Mast, HOWARD HAWKS STORYTELLER (New York: Oxford University Press, 1982), pp.243-95; *Joseph McBride, HAWKS ON HAWKS (Berkeley: University of California Press, 1982), pp.96-106; Frank McConnell, STORYTELLING AND MYTHMAKING: IMAGES FROM FILM AND LITERATURE (New York: Oxford University Press, 1979), pp.144-50; Stephen Pendo, RAYMOND CHANDLER ON SCREEN: HIS NOVELS INTO FILM (Metuchen: The Scarecrow Press, 1976), pp.38-62; Donald C. Willis, THE FILMS OF HOWARD HAWKS (Metuchen: The Scarecrow Press, 1975), pp.119-30; *Robin Wood, HOWARD HAWKS (Garden City: Doubleday and Company, 1968), pp.168-70; Gwen Rowling, "Program Notes: THE BIG SLEEP," CINEMATEXAS 20: (February 16, 1981):67-77; Jimmie L. Reeves, "Program Notes: THE BIG SLEEP," ibid., 21:1 (October 14, 1981):63-72; John Blades, "The Big Sleep," FILM HERITAGE 5:4 (Summer 1970):7-15; Praxton Davis, "Bogart, Hawks, and THE BIG SLEEP Revisited--Frequently," FILM JOURNAL 1:2 (Summer 1971):3-9; Charles Gregory, "Knight Without Meaning?: Marlowe on the Screen," SIGHT AND SOUND 40:3 (Summer 1973):155-9; James Monaco, "Notes on THE BIG SLEEP--Thirty Years After," ibid., 44:1 (Winter 1975):34-8; "Howard Hawks, 81, Story Teller Who Became a Pantheon Figure," VARIETY (December 28, 1977): 26; Molly Haskel, "Howard Hawks--Masculine Feminine," FILM COMMENT 10:2 (March-April 1974):34-9; and Paul Jensen, "The Writer: Raymond Chandler and the World You Live In," ibid., 10:6 (November-December 1974):18-26.

salesman who falls in love with the beautiful wife (Barbara Stanwyck) of a client. Together they scheme to kill the husband and gain his wealth. Thanks to a superb cast and technical crew, Wilder is able to demonstrate just how mistaken a man can be about his power and perceptions. Stanwyck is the epitome of FILM NOIR's "spider women." Edward G. Robinson also deserves acclaim for his outstanding performance as the insurance company detective who figures out the murder plot.[1109] Although nominated for seven Oscars, including Best Film, Best Actress, Best Director, Best Screenplay, Best Cinematography (John Seitz), Best Sound Recording (Loren Ryder), and Best Scoring of a Dramatic or Comedy Picture (Miklos Rozsa), the film received no honors the night of the presentations.

KLUTE (Warner Bros.--16mm: 1971, 114 mins., color, sound, R-AFI, CCC, FDC, FNC, ICS, SWA, TWY, WFM, WMP; V-SWA)
 Produced and directed by Alan J. Pakula, this intriguing story of a New York call girl and sometime fashion model (Jane Fonda), whose life is threatened by a sadistic and unknown murderer (Charles Ciotti), remains one of the best thrillers in recent years. Feminist film critics in particular are fascinated by what the Oscar-nominated screenplay by Andy K. Lewis and Dave Lewis tells audiences about a women's dilemma in a patriarchal society. In addition to Fonda's Oscar-winning performance, the film contains an impressive job by Donald Sutherland as the patient and hard-working private detective who solves the case.[1110]

[1109] See John Gassner and Dudley Nichols, eds., BEST FILM PLAYS, 1945 (New York: Crown Publishers, 1946; Rpt. 1977), pp.115-74; Bernard F. Dick, BILLY WILDER (Boston: Twayne Publishers, 1980), pp.42-50; *Axel Madsen, BILLY WILDER (Bloomington: Indiana University Press, 1969), pp.87-110; *Steve Seidman, THE FILM CAREER OF BILLY WILDER (Pleasantville: Redgrave Publishing Company, 1977), pp.24, 69-71, 151; Tom Wood, THE BRIGHT SIDE OF BILLY WILDER, PRIMARILY (Garden City: Doubleday and Company, 1970), pp.80-5; *Maurice Zolotow, BILLY WILDER IN HOLLYWOOD (New York: G. P. Putnam's Sons, 1977), pp.111-23; Chris Columbus, "Wilder Times," AMERICAN FILM 11:5 (March 1986):22-8; *Al DiOrio, BARBARA STANWYCK: A BIOGRAPHY (New York: Coward-McCann, 1983), pp.135-7; *Ella Smith, STARRING MISS BARBARA STANWYCK (New York: Citadel Press, 1973; Rpt. and updated 1985), pp.169-77; *Jerry Vermilye, BARBARA STANWYCK (New York: Pyramid Books, 1975), pp.82-4; *Foster Hirsch, EDWARD G. ROBINSON (New York: Pyramid Books, 1975), pp.64, 67, 69, 94, 109; James Robert Parish and Alvin H. Marill, THE CINEMA OF EDWARD G. ROBINSON (Cranbury: A. S. Barnes and Company, 1972), pp.150-3; Edward G. Robinson with Leonard Spigelgass, ALL MY YESTERDAYS: AN AUTOBIOGRAPHY (New York: Hawthorn Books, 1973), pp.236, 321; Stephen Farber, "The Films of Billy Wilder," FILM COMMENT 7:4 (Winter 1971-72):8-22; Charles Higham, "Cast a Cold Eye: The Films of Billy Wilder," SIGHT AND SOUND 32:2 (Spring 1963):83-7, 103; Claire Johnston, "DOUBLE INDEMNITY," WOMEN IN FILM NOIR, pp.100-11; Douglas McVay, "The Eye of a Cynic: A Monograph on Billy Wilder," FILMS AND FILMING 6:4 (January 1960):11-2, 34-5; and Gene Ringgold, "Barbara Stanwyck," FILMS IN REVIEW 14:10 (December 1963):577-602;

[1110] See James Brough, THE FABULOUS FONDAS (New York: David McKay Company, 1973), pp.273-5, 278, 280; *George Haddad-Garcia, THE FILMS OF JANE FONDA (New York: Citadel Press, 1981), pp.157-161; *Gary Herman and David Downing, JANE FONDA: ALL AMERICAN ANTI-HEROINE (New York: Quick Fox, 1980), pp.92-6; Thomas Kiernan, JANE: AN INTIMATE BIOGRAPHY OF JANE FONDA (New York: G. P. Putnam's Sons, 1973), pp.299-309; John Culhane, "Pakula's Approach," NEW YORK TIMES MAGAZINE (November 21, 1982):64-7, 114, 122-3, 131, 134; Diane Giddis, "The Divided Woman: Bree Daniels in KLUTE," WOMEN AND FILM 1:3-4 (1973):57-61, Rpt. *MOVIES AND METHODS: AN ANTHOLOGY, Bill Nichols, ed. (Berkeley: University of California Press, 1976), pp.194-201; Christine Gledhill, "KLUTE 1: A Contemporary Film Noir and Feminist

MILDRED PIERCE (Warner Bros.--16mm: 1945, 111 mins., b/w, sound, R-MGM)
 Produced by Jerry Wald and directed by Michael Curtiz, this classic FILM NOIR
recounts the story of an American matriarch (Joan Crawford) who rises from poverty
to become a rich and unhappy woman. The film was particularly well received, with
Oscar nominations going to the film, the screenplay, Eve Arden, and Ann Blyth.
However, the only Oscar went to Crawford. Ranald MacDougall's screen adaption of
the James Cain novel epitomizes how a partriarchal Hollywood formula appealed to
women's emotions but still maintained a dominantly male value structure.[1111]

NOW, VOYAGER (Warner Bros.--16mm: 1942, 117 mins., b/w, sound, R-MGM)
 Bette Davis gives a stunning performance as a repressive Boston Back Bay
spinster who rebels against her domineering mother (Gladys Cooper) to become a
nontraditional woman. The screenwriter Edmund Goulding made the initial changes in
Olive Higgins Prouty's 1941 novel, but the major writing credits belong to Casey
Robinson. Thanks to Jeanne Thomas Allen's excellent research, the importance of
Prouty's dialogue is also receiving long overdue recognition. Both Davis and Cooper
won Oscar nominations, but only the composer Max Steiner won a gold statue. Other
notables deserving praise are the director Irving Rapper, actors Claude Rains and
Paul Heinreid, and the cinematographer Sol Polito. Of particular value to film studies
is the film's illustration of cultural hegemony and the way in which World War II
brought forth new values of feminine independence and sexual freedom.[1112]

THE HERO

 In addition to the many types of stereotyped heroines, we can find a stock

Criticism," WOMEN IN FILM NOIR, pp.6-21; ___, "KLUTE 2: Feminism and KLUTE,"
ibid., pp.112-28; Marie Mahoney, "Program Notes: KLUTE," CINEMATEXAS 23:1
(December 6, 1982):23-8; Ann Rowe Seaman, "Program Notes: KLUTE," ibid., 21:3
(1981):39-45; Tom Milne, "Not a Garbo or a Gilbert in the Bunch: Alan Pakula
Talks With Tom Milne," SIGHT AND SOUND 41:2 (Spring 1972):89-93.

[1111] See *Albert J. LaValley, ed., MILDRED PIERCE (Madison: University of Wisconsin
Press, 1980); *Stephen Harvey, JOAN CRAWFORD (New York: Pyramid Books, 1974),
pp.94-7; *Lawrence J. Quirk, THE FILMS OF JOAN CRAWFORD (New York: Citadel Press,
1970), pp.156-9; *Bob Thomas, JOAN CRAWFORD: A BIOGRAPHY (New York: Bantam Books,
1978), pp.3-5, 139-40; *Kingsley Canham, THE HOLLYWOOD PROFESSIONALS, Volume 1
(Cranbury: A. S. Barnes and Company, 1973), pp.8-80; William R. Meyer, "Michael
Curtiz," WARNER BROTHERS DIRECTORS: THE HARD-BOILED, THE COMIC, AND THE WEEPERS
(New Rochelle: Arlington House, 1978), pp.75-107; Jack Edmund Nolan, "Michael
Curtiz," FILMS IN REVIEW 21 (November 1970):525-37; Pam Cook, "Duplicity in
MILDRED PIERCE," WOMEN IN FILM NOIR, pp.68-82; Stephen Farber, "The Society:
Violence and the Bitch Goddess," FILM COMMENT 10:6 (November-December
1974):8-11; Claudia Gorbman, "The Drama's Melos: Max Steiner and MILDRED PIERCE,"
THE VELVET LIGHT TRAP 19 (1982):35-9; Joyce Nelson, "MILDRED PIERCE
Reconsidered," FILM READER 2 (January 1977):65-70; Janet Walker, "Feminist
Critical Practice: Female Discourse in MILDRED PIERCE," ibid., 5 (1982):164-71;
Walsh, pp.123-31; and Michael Selig, "Program Notes: MILDRED PIERCE,"
CINEMATEXAS 14:4 (April 26, 1979):55-9.

collection of film heroes.[1113] As Klapp discovered in his linguistic analyses of the sixties, American society has maintained a consistent roster of role models that it selectively uses--positively and negatively--to imitate or to avoid specific patterns of conduct.[1114] Those role models frequently get transferred to the screen. Contemporary examples of the modern film hero based upon the traditional images of the conquering hero of primitive times are the film roles by Sylvester Stallone, Clint Eastwood, and Chuck Norris in movies like FIRST BLOOD (1985), SUDDEN IMPACT (1983), and MISSING IN ACTION II (1985). Characteristic of these modern heroes is their indifference to social acceptability. They do what they do because of choice and courage rather than because of the desire to belong or to be accepted. Their feminine counterparts are Sally Field, Meryl Streep, and Barbra Streisand in films like NORMA RAE (1979), SILKWOOD, and YENTL (both in 1983).

Thanks to Klapp's research, we are able to identify over 800 expressions (many of which are still current twenty years later) designating social types that can be adapted for the screen: e.g., good Joe, champ, wheel, beatnik, egghead, and tightwad. The most admirable terms, reserved for heroes, suggest the range of options that filmmakers can present for the public to emulate: "winners," "splendid performers," "socially acceptable" personalities, "independent spirits," and "group servants." For example, "winners" appear "to live in a world in which life is a battle of champs, even dog-eat-dog competition, in which the strong man is king." On the other hand, "independent spirits" stress either "the importance of standing alone,"

[1112] In addition to Allen's invaluable study, see *Charles Higham, BETTE: THE LIFE OF BETTE DAVIS (New York: Macmillan Publishing Company, 1981), pp.xvii, 1, 99, 133, 159-65, 204, 272; *Gene Ringgold, THE FILMS OF BETTE DAVIS (New York: Bonanza Books, 1966), pp.117-20; *Jeffrey Robinson, BETTE DAVIS: HER FILM TO STAGE CAREER (London: Proteus Books, 1982), pp.81-2; *Whitney Stine, MOTHER GODDAM: THE STORY OF THE CAREER OF BETTE DAVIS (New York: Hawthorn Books, 1974), pp.94, 105, 141, 162-8, 185, 215, 237, 353; *Jerry Vermilye, BETTE DAVIS (New York: Pyramid, 1973), pp.83, 85-7, 95; Hal Wallis and Charles Higham, STARMAKER: THE AUTOBIOGRAPHY OF HAL WALLIS (New York: Macmillan Publishing Company, 1980), pp.88-9, 95, 104-8, 213-4; Fleming and Manvell, pp.34-7; Lea Jacobs, "NOW, VOYAGER: Some Problems of Enunciation and Sexual Difference," CAMERA OBSCURA 7 (Spring 1981):89-104; R. Barton Palmer, "The Successful Failure of Therapy in NOW, VOYAGER: The Women's Picture as Unresponsive Symptom," WIDE ANGLE 8:1 (1986):29-38; and Walsh, pp.112-8.

[1113] Also useful in this connection is Fred Elkin, "Popular Hero Symbols and Audience Gratifications," JOURNAL OF EDUCATIONAL SOCIOLOGY 29:3 (November 1955):97-103; Gary J. Svehla, "Ritual and Heroism in the Fantasy Film," MIDNIGHT MARQUEE 26 (September 1977):4-12; Clifford Odets, "The Transient Olympian: The Psychology of the Male Movie Star," SHOW 5:4 (May 1965):106-7, 130-3, Rpt. SIGHT, SOUND AND SOCIETY: MOTION PICTURES AND TELEVISION IN AMERICA, pp.186-200); Robert Armour, "DELIVERANCE: Four Variations of the American Adam," LITERATURE/FILM QUARTERLY 1:3 (July 1973):280-5; Nick Pease, "THE DEER HUNTER and the Demythification of the American Hero," ibid., 7:4 (1979):254-9; Charles T. Gregory, "Good Guys and Bad Guys," FILM HERITAGE 8:3 (Spring 1973)1-8; Pauline Kael, "Notes on Evolving Heroes, Morals, Audiences," NEW YORKER 52 (November 8, 1976):136-45; John Russell Taylor, "Michael Powell: Myths and Supermen," SIGHT AND SOUND 47:4 (Autumn 1978):226-9; Richard Corliss, "Pursuing the Dream: Sexy, Straight-on and Ambitious, Kevin Costner is a Grownup Hero With Brains," TIME (June 26, 1989):76-80, 82; and Jeanine Basinger, "Why Do We Cheer Vigilante Cops?" NEW YORK TIMES A (July 3, 1989):19.

[1114] For a good introduction of Japanese filmmakers stereotype their heroes, see Sato, pp.38-56.

or escaping "from a confining structure."[1115] Contemporary films illustrating Klapp's five major categories are (1)"winners": the ROCKY films and the DIRTY HARRY series; (2) "splendid performers": SATURDAY NIGHT FEVER (1977) and STAYING ALIVE (1983); (3) "socially acceptable" heroes: the STAR WARS series and LOCAL HERO (1983); (4) "independent spirits": ONE FLEW OVER THE CUCKOO'S NEST (1975) and TOOTSIE (1983); and (5) "group servants," THE YEAR OF LIVING DANGEROUSLY (1983) and THE KILLING FIELDS (1984).

Klapp's study also makes it clear that identifying the types of villains in society clarifies for many people what is and is not desirable.[1116] His five categories of evildoers--villains who pose a threat to the social order, "usurpers and abusers," "traitors and sneaks," "villainous outsiders," and "socially undesirable pariahs"--have their counterparts in many contemporary popular films. For example, villains threatening our social order are characters like Darth Vader in the STAR WARS series and Sam in BODY DOUBLE (1984). Usurpers and abusers are evident in characters like Waldo Rheinlander in Milos Forman's film RAGTIME (1981) and Gordon Gekko in WALL STREET (1987). Traitors and sneaks are exemplified by characters like Christopher Boyce in THE FALCON AND THE SNOWMAN and Ed Biddle in MRS. SOFFEL (both in 1985). Villainous outsiders who force themselves on the community are characters like Jason in FRIDAY THE 13TH (1980) and the computerized automaton in THE TERMINATOR (1984). And the final group of villains, the socially undesirable pariahs, are characters like Paco Moreno in BAD BOYS (1983) and Joe Flynn in THE COTTON CLUB (1984). This varied assortment of evildoers suggests what society rejects in its heroes. Combined with the variety of heroes, the symbolization process makes possible simple concepts for mass consumption. Resorting to these stereotypes is one way in which social institutions attain a surface consensus instead of offering penetrating and complex analyses. Just as celebrities and famous people play a role in social control, status modification, and audience identity, the various types of heroes and villains constitute a focus for idolatry and vilification.

Indicative of the way the process works are a number of articles discussing the relationship between films and heroes. For example, George M. Young, Jr., expresses outrage over the revisionist treatment of fifties' personalities in movies like THE FRONT and MARATHON MAN (both in 1976). The former deals directly with the blacklisting of writers in the television industry in 1953. Young objects very strongly to the movie's message that the writers blacklisted were either "the best writers" or "innocent victims." He is even angrier about MARATHON MAN, a complicated story about a graduate student trying to clear his dead father's name and also stop the activities of a hunted Nazi war criminal:

> "Babe" Levy (that's right fans, there's a new "Babe" to cheer for), the hero of MARATHON MAN, is a new ideal for liberal America, a young Messiah who has come to restore our faith in humanity in the midst of vicious, troubled times, a hero that all America can take to heart. He's the lovable underdog just straining his heart out to catch that heartless blond behemoth who laughed when he passed our game little battler on the Central Park jogging track.[1117]

Young then goes on to identify a number of symbols that modern film directors use to play on audience emotions and expectations. What bothers Young most is the filmmakers' "selective revisionism." That is, the political criminals of the 1950s are

[1115] Klapp, p.28.

[1116] For a discussion of Japanese film villains, see Sato, pp.161-77.

[1117] George M. Young, Jr., "Image Revisionism: Unlikely Hero, Guaranteed Villain," NATIONAL REVIEW 29:18 (May 13, 1977):554.

now "regarded as America's greatest heroes," while their adversaries are depicted as "America's greatest enemies and villains."[1118]

Peter Schillaci takes a more moderate approach as he discusses the changes American filmmakers are making in the screen heroes and heroines of the 1970s as compared to the film stereotypes of the past:

> The demythologizing of the American hero began, as did the apotheosis, with actual persons in historical events. The hero is an individual who performs a brave and significant deed which helps restore the balance of good and evil in the universe. But the problems we face in the Global Village are either too massive for an individual to overcome, or of a nature which we consider unsusceptible to heroics.[1119]

The end result, according to Schillaci, is that the heroes we get now are replete with warts and are short-lived; and thus we are becoming more and more cynical about our society and its institutions. Among the screen casualties are war heroes and political idealists. Except for TV, it was rare in the 1970s to see a film about a decent soldier or a heroic cop. Those stereotypes in the past helped orient audiences to the social, economic, and political problems in society. Schillaci argues that during the seventies, in place of these discredited myths, American filmmakers turn to "metaphor, fantasy and the occult." For example, in disaster films like AIRPORT (1970), THE TOWERING INFERNO and EARTHQUAKE (both in 1974), the "heroes" symbolically function as their peers had in the past. They operate as the protectors of the weak and the helpless. But now, Schillaci points out, "the gesture of heroism is symbolic, an escapist ploy to avoid facing the evil within, and largely uprooted in myth."[1120] Other approaches he sees in dealing with the complex problems of our times are evident in the comic book heroes found in the ROCKY and STAR WARS series, and the heroic women portrayed in THE TURNING POINT and JULIA (both in 1977). Schillaci's plea is that educators teach how it is possible "to keep alive the human need for heroics without souring it with cynicism or inflating it by escapist fantasizing."[1121]

A more scholarly approach to the screen heroes of the past is Russell Merritt's analysis of the 1940s' protagonist who possessed two seemingly incongruous traits: invincibility and incompetence. Known as the "bashful hero," and portrayed by actors like Gary Cooper, Bing Crosby, Henry Fonda, and James Stewart, he was, according to Merritt,

> the classic movie stereotype: the easygoing, stalwart young fellow who is suddenly entrusted with great responsibility and armed merely with his idealism, his homespun shrewdness, and his disarming sense of humor, subsequently overcomes formidable adversaries.[1122]

What is intriguing about Merritt's position is his claim that it is the bashful hero, rather than his more notorious violent counterpart, that deserves credit as the role model for American males. Among the stereotype's most appealing qualities to

[1118] Young, p.555.

[1119] Peter Schillaci, "Where Have All the Heroes Gone?" MEDIA AND METHODS 15:4 (December 1978):13-4.

[1120] Schillaci, p.16.

[1121] Schillaci, p.24.

[1122] Russell L. Merritt, "The Bashful Hero in American Film of The Nineteen Forties," QUARTERLY JOURNAL OF SPEECH 61:2 (April 1975):129.

audiences of his era were his likeable personality, his ability to make the public feel relaxed and comfortable, and his reassurance that there was almost no difference between us and him.[1123] Merritt traces each of these egalitarian traits back to the Progressive movement and its belief in the "ineffable wisdom of the common man." He also points out how early filmmakers developed the rough essentials of the sterotype in various silent film genres like the western, the comedy, and the pastoral romance. The difference between those heroes of the silent era and those of the 1940s relates to the authority and responsibilty the bashful heroes have thrust on them. Also unlike his Progressive forebears, the bashful hero (consciously or unconsciously) models himself on the stereotyped image of Abraham Lincoln: e.g., a combination of humor and idealism, a straightforward approach to problems, and a considerable degree of modesty. Although Merritt proceeds to document how the bashful hero appeared in films from the 1930s to the 1960s, the author remains tentative in his conclusions about the stereotype's ultimate importance to American audiences. At the very least, however, Merritt finds the stereotype to have been a "coercive figure of considerable force." Nevertheless, the bashful hero also confused many Americans. After all, Merritt explains, "He must achieve yet remain common; excel and yet pretend not to; be competitive but remain deferential; play by turns the servant and the master."[1124]

John Mariani is still another observer commenting on the disappearance of a traditional screen hero. He admires not only the acting skills of past stars--e.g., Gary Cooper, Henry Fonda, Clark Gable, and James Stewart--but also "the whole style of the heroism . . . [these stars] represented." He goes on to explain that

It was a panache of a peculiar American variety, poignant in its gentleness and disarming in its determination. I suppose what really got me . . . was the realization that America--both in its movies and its politics--just doesn't make heroes like that anymore. Obviously, the fault is not in our stars but in ourselves.[1125]

The remainder of the essay treats the reasons why melodramatic movies from the late sixties to the early seventies are more interested in anti-heroes than in heroes. In place of resilient male stars, Mariani claims, we are given screen images of physically weak males who not only lack intelligence and sex appeal, but also have few admirable qualities: e.g., Warren Beatty in BONNIE AND CLYDE (1967), Peter Fonda and Dennis Hopper in EASY RIDER, Paul Newman and Robert Redford in BUTCH CASSIDY AND THE SUNDANCE KID (both in 1969), Dustin Hoffman in STRAW DOGS, and Gene Hackman in THE FRENCH CONNECTION (both in 1971). If these anti-heroes encounter serious and frequent problems, it is often explained as the result of their personal insecurities and inaction. While readers can readily see the limitations of Mariani's reductionist position, his perspective reinforces the views of many people of his generation who see film history nostalgically, rather than critically. At the same time, his ideas accurately reflect what scores of moviegoers feel about the Hollywood stars of the thirties and forties.

Not everyone, of course, sees Hollywood's heroes (past or present) as positive role models. The most extensive discussion on the subject is Joan Mellen's controversial book, BIG BAD WOLVES: MASCULINITY IN THE AMERICAN FILM. In it, she discusses a number of problems regarding Hollywood's stereotypes. One obvious drawback she finds is that the screen images of many male stars insist too often on violence to attain victories and superior status in society. In such film

[1123] Merritt, pp.130-1.

[1124] Merritt, p.139.

[1125] John Mariani, "The Missing American Hero," NEW YORK 6 (August 13, 1973):34.

heroics, might equates with right. Thus it matters little in the typical roles played by a Clint Eastwood or a John Wayne what their friends or families think about the necessity of using force to achieve their goals. This points to a second drawback in the American movie model of manliness: the heroes consider no price too high to accomplish the task before them. The effect that such single-mindedness has on loved ones, associates, or the community is always discounted. What matters most is success. The third drawback, consequently, is that impressionable audiences leave the film feeling elated that such heroics are possible but knowing how inadequate they, the viewers, are in comparison to the screen heroes themselves.

For many years such negative reactions to Hollywood heroes have taken a backseat to claims about movies being mere entertainment. Mellen, however, offers a provocative argument for reevaluating what American filmmakers historically offer as role models for manhood. She begins by observing that "American films have not only sought to render men powerless by projecting male images of fearsome strength and competence. They have also proposed consistently over the years that the real man is not a rebel but a conformist who supports God and country, right or wrong."[1126] The questions that motivate Mellen's research are why such stereotypes are so pervasive in the mass media, who benefits from them, and what the consequences are for audiences who assimilate these questionable social values.

The answers she provides in her historical treatment of Hollywood movies are both stimulating and disturbing. For example, Mellen sees the dominant male screen image as a hero "unburdened by family life, the plot sometimes compliantly freeing him from domestic commitments through accidental tragedy."[1127] Add to this statement her list of the most prominent male film stars in the past eighty years--Humphrey Bogart, Marlon Brando, Sean Connery, James Dean, Clint Eastwood, Clark Gable, and John Wayne--and it becomes clear why Mellen's position is both stimulating and disturbing. On the one hand, she forces us to reconsider the reasons why Hollywood has been successful with these popular images. On the other hand, she provides us with little more than her sense of outrage over why these images persist in American films. Another point worth noting is her conclusion that screen masculinity is linked almost exclusively both to patriotism and to Christianity.[1128] While acknowledging that exceptions exist throughout film history--e.g., Charlton Heston in BEN HUR (1959) and Paul Newman in EXODUS (1960)--she makes the valid point that screen heroes generally have Christian stars acting as minority heroes. She also cites the unusual cases in which minority actors not only gain star status but also perform in ethnic roles: e.g., Al Jolson, THE JAZZ SINGER (1927); Danny Kaye, ME AND THE COLONEL (1958); Kirk Douglas, CAST A GIANT SHADOW (1966); and Sidney Poitier, IN THE HEAT OF THE NIGHT (1967). What she never explains, however, is why. More to the point, as will be discussed later, why did the Jewish movie moguls who controlled Hollywood for over thirty years (roughly, 1920-1950) permit this form of racial, ethnic, and religious stereotyping? A third point that Mellen raises is that the dominant Hollywood hero invariably fights to maintain the STATUS QUO. That is, stars like Bogart, Brando, Connery, Dean, Eastwood, Gable, and Wayne discourage rebellion and argue through their actions that real men support prevailing social values and current national policy.[1129] At the same time, they discourage viewers from fostering "feminine" qualities: e.g., "intuition, tenderness, affection

[1126] Joan Mellen, BIG BAD WOLVES: MASCULINITY IN THE AMERICAN FILM (New York: Pantheon Books, 1977), p.5.

[1127] Mellen, p.12.

[1128] Mellen, p.4.

[1129] Mellen, p.5.

[1130] Mellen, p.7.

for children."[1130] The danger of such film fabrications, according to Mellen, is that audiences can accept too readily the need for a strong leader who is both paternal and protective. The danger in such assertions, however, is that readers can be misled into thinking that a hypodermic effect exists between filmmakers and their mass audiences and that the film continuum is a simple process.[1131]

The most extensive journal analysis of the stereotyping of the film hero is Kevin Gough-Yates's "The Hero," a series of four articles in FILMS AND FILMING, on the major and minor motion picture heroes. In his initial article, Gough-Yates points out that every culture creates and perpetuates stereotypes. Appropriately, costumes or the selection of the actor will immediately identify for the audience the forces of good and evil. While there are many reasons for individuals becoming heroic in films and thereby creating many types of outstanding characters, all heroes have one thing in common: "They are all developments of or reactions to the Epic hero, although they may have other characteristics in addition." The stereotyped epic hero always defends a way of life, as evidenced in such film epics as THE LONGEST DAY (1962), EL CID (1961), SHANE (1953), and THE LAST TRAIN FROM GUN HILL (1959).[1132]

In the second article, the author begins by identifying the Epic hero as that character in a film who embodies those factors that suggest divine destiny. The standard characterizations of the epic hero are these: he usually has a mysterious past, is in search of an ideal, and is driven by fate toward an inevitable end. Gough-Yates then goes on to compare the epic hero with a second film stereotype: the romantic or Byronic hero. This type, driven by his desires, does not have the assurance of success characteristic of the epic hero. Three other differences are that the Byronic character often has misguided ambitions, the epic one does not; the former can exist in any movie setting, the latter populates mostly historical films; and usually the Byronic hero fails in the end, which is not the case with the epic type. "Because the Epic hero and his variants symbolize the inevitable, the Byronic hero can not succeed. If he does, he must be shown to have only apparent victory."[1133]

In the third article, Gough-Yates concerns himself with heroes who have no desire for glory. They are neither epic nor romantic, but usually want to be left alone to follow their humble pursuits. These people are always confronted with a particular moral decision. "They can choose one line of behavior or another, but whatever they decide makes their moral decision clear." They will then be evaluated by the choice they make and the manner in which it is handled. This hero becomes what Gough-Yates calls the Biedermeier hero, an average person who is forced to assert himself. Usually this hero cannot control the force of destiny and rarely sees himself as performing significant acts, unlike the epic and romantic hero. In the end, all he desires is to return to his former domestic life.[1134]

In the final article, Gough-Yates summarizes his previous work and introduces additional heroic types:

[1131] For other perspectives on male images in film, see Richard Lippe and Florence Jacobowitz, "Masculinity in the Movies: TO LIVE AND DIE IN L. A.," CINEACTION! 6 (August 1986):35-44; and Robin Wood, "The Woman's Nightmare: Masculinity in DAY OF THE DEAD," ibid., pp.45-9.

[1132] Kevin Gough-Yates, "The Hero: Part I," FILMS AND FILMING 12:3 (December 1965):11-6.

[1133] Kevin Gough-Yates, "The Hero, Part II," ibid., 12:4 (January 1966):11-6.

[1134] Kevin Gough-Yates, "The Hero, Part III," ibid., 12:5 (February 1966):25-30.

There are two kinds of hero, however, who cause their own downfall or earn their condemnation by inaction. The first is the Anti-hero who refuses to adopt any kind of heroic attitude. He is the person who is apathetic or a coward. By implication he associates himself with the tyrant or bully. The second is the hero who begins from a virtually identical position to that of the potential Epic hero. Because of his human failing, he vacillates or suffers the consequences of his weakness by falling from a position of some stature.[1135]

These tragic heroes generally die, and the viewer is always made aware of their tragic flaws. The author concludes by suggesting that the climax of films generally tells the viewer what type of hero has been depicted.

What is apparent in much of the literature on heroes is a deep-seated concern with the way in which audiences relate to screen images. Clearly, there is no consensus. For every fan of old-time stars like Bogart, Brando, Cooper, Gable, and Stewart, there are those who object to the distortions of ideal masculinity that the stars' screen roles institutionalized. At the same time, there are many contemporary film personalities and academics who worry about the deterioration of the hero in our society.[1136] Klapp speaks for many observers when he argues that the problem of deteriorating heroes relates directly to the public's fascination with ordinary people (celebrities), which results in "displacing traditional reverence for great men, even encroaching on and draining from religion itself; and because it isn't based on real merit or achievement, has a debasing effect on American values."[1137]

We thus return again to the central themes of this chapter. Movies are both a business and an art, and the heroes we get on the screen represent the perceptions not only of those who produce film images, but also of those who pay to see them. Furthermore, the film heroes of any age are not unique creations. Their characteristics grow out of past political and literary traditions, while their influence on audiences continues to raise important issues about the role of movies in our lives and in our culture. As David Desser points out,

> For America, the creation of hero-images out of movie actors is an index of the American search for a national identity. A land without a history is a land without a national culture. Genres and stars, associated with certain aspects of the culture, create images which reflexively define the culture that produced them.[1138]

The fact that these influences may be more perceived than actual does not lessen their relevance to responsible critics and scholars. Whether or not we like the types of heroes presented to us is less important than our understanding that the more popular the hero, the more we stand to learn about cultural values in our time. Despite the apparently impersonal relationship between filmmakers and their audiences, the filmmakers ultimately remain dependent on responding to our needs and desires. If we can grasp why heroes behave as they do in films, we can better appreciate why we like or dislike certain social types we encounter in our everyday lives. We can also become more sensitive to how our values and emotions are influenced by the mass media. Finally, a study of film heroes reminds us again that stereotypes do not

[1135] Kevin Gough-Yates, "The Hero, Part IV," ibid., 12:6 (March 1966):25.

[1136] For an entertaining summary on a conference related to movie heroes, see William K. Everson, "Unheroic Age? It is a Screaming Theme," VARIETY (July 13, 1977):7, 22.

[1137] Klapp, pp.142-3.

[1138] *David Desser, THE SAMURAI FILMS OF AKIRA KUROSAWA (Ann Arbor: UMI Research Press, 1983), p.19.

originate in a vacuum. They are linked tightly to the prevailing political, cultural, and economic events both at home and abroad. It is to our advantage, therefore, to be aware of how the mass media in general and films in particular operate within an international setting. At the very least, we need to recognize that film heroes are more than escapist images.

BOOKS

Jay, Michael, ed. HEROES OF THE SILVER SCREEN. New York: Galahad Books, 1982. Illustrated. 64pp.

Mellen, Joan. BIG BAD WOLVES: MASCULINITY IN THE AMERICAN FILM. New York: Pantheon Books, 1977. Illustrated. 365pp.
 This unique account of male screen images provides a provocative and reductionist survey of how Hollywood has defined, influenced, and distorted the relationship between film heroes and their naive audiences. Mellen's sense of outrage over movie models of masculinity intent on subordinating women in a patriarchy allows little room for a discussion of reception theory, the multiple roles movies play in society, and the fact that audiences do not automatically accept film messages. Instead, she relentlessly describes how for three quarters of a century the Hollywood dream factory has portrayed an ideal man as a violent, defiant, and assertive individual who consciously expects the weak to follow and admire his actions. The few male exceptions to this vast generalization are to be found in comedy films and musicals. They alone sidestep the stereotype of self-controlled, stoic heroes. Almost every other genre includes among its conventions a primitive ritual designed to nurture values of "suspicion, fear of one another, and the need to rely on authority, as if to exorcise through images of male prowess the sense of helplessness that life in America induces in us." As a result, Mellen argues that from the dawn of films to the present, American filmmakers have been bringing us closer and closer to a fascist mentality. By the seventies, she views the image of men as "glorifying the ideal of elite, unknown leaders who insist that only they are able to solve our social problems." No longer can screen heroes laugh at their human vulnerability, befriend their women, or nurture their children. Where once these towering heroes tolerated some time off from work to attend to sexual encounters and family matters, now work is all-consuming and domestic responsibilities best avoided. Economic survival and financial success translate into a need for aggressive behavior that, in turn, is depicted as sexually appealing. The disillusionment born out of the frustration in the 1960s at a failure to reform society has, in Mellen's well-intentioned but simplistic perspective, increased the demand for a dehumanized male, one who has no faith in his personal or collective power to change the quality of his life. Furthermore, modern audiences not only share the screen hero's disillusionment, but also applaud his actions while, at the same time, conspiring in their own impotence. Mellen sees women in particular depicted negatively as in need of the violent man's protection and his approval. Those who reject his unfeeling masculinity pose a threat to his success and to his manhood.
 Starting at the turn of the century, the book's eight highly stimulating chapters discuss in emotion-packed interpretations how Hollywood's male mystique evolved. For example, in her "balance sheet" for the twenties, Mellen presents characterizations of male images "who were as often frivolous as they were somber." Not only did they feel comfortable with women and often display their emotions, but also these unique heroes blurred the distinctions between so-called "masculine" and "feminine" traits. Regrettably, the author points out, these unusual heroes began disappearing by the end of the decade. The question never fully explored is how the movies found these stereotypes in the first place. Were they the creation of Hollywood, or did the filmmakers merely appropriate the values inherent in contemporary literature and drama? In addition, as one reviewer aptly notes, "Miss Mellen's survey omits a number

of films and actors, and distorts those she does consider. She tells us that in 'twenties films' the women were invariably reduced to stick figures, doll-like objects (such as Gloria Swanson? Pola Negri? the cheerfully adulterous Lubitsch heroines?).
. . ."[1139]

By the time we get to the early thirties, Mellen's thesis becomes even more suspect. For example, she claims that self-appointed guardians of morality were equating sexual license in films with political unrest. Thus free sensuality was repressed on screen and filmmakers created "the stereotype of the competent, self-sufficient, and ever successful man." One searches in vain for evidence to justify this conspiracy theory. Then there is the thesis that the personification of the moguls' ideal male was Gable. Outwardly tough and all-knowing, he was, internally, gentle, romantic, and decidely heterosexual. What made him especially appealing to women, according to Mellen, is that "he was so unattainable." Consequently, his screenplays exchanged the daydream of mutual involvement with Gable for the fantasy of domesticating him. The one positive element was that the 1930s hero did not fear a high-spirited woman. Mellen's classic example is IT HAPPENED ONE NIGHT (1934), which she asserts was a homage to upward mobility and the most important movie of its time. The problems with such assertions are first defining your standards and then proving your assertions. Mellen does neither. Instead, she demands that we accept her facile interpretations of the relevance of the star, the screenplay, and the film to Depression audiences and to to their political values. It isn't that her ideas are silly. They aren't. Often they are very insightful. The problem is that her explanations vastly oversimplify the film process and experience. What's more, as Robert G. Michels points out, there were a number of male stars who did not conform to a single male screen image: e.g., Cary Grant, William Powell, and Fredric March--and others--e.g., James Cagney, Leslie Howard, William Holden--who "did achieve prominence playing figures not necessarily silent or strong or sympathetic."[1140]

Her singleminded approach continues in her discussion of the film hero of the early 1940s, who forgets all about domestic issues and concentrates almost exclusively on winning the war. Enthusiastic, blatantly optimistic, and confident of his goals and himself, the American movie male measures his masculinity by his courage in battle. But once the war ends, the patriotic yardstick disappears. Suddenly the screen hero loses his nerve and confidence. Despair replaces optimism; cynicism substitutes for innocence. Now the screen hero comes face-to-face with social problems his predecessors ignored or denied existed. The screen now offers a new hero to combat a shabby, corrupt, and decadent society: an existential loner, who has "supreme style, savoir-faire, and romantic sophistication." The epitome of this postwar FILM NOIR mystique is Humphrey Bogart. A close second is John Wayne. The genre most indicative of forties' gloom is the western. Moral codes are deemed irrelevant; force and profits legitimize an unjust society. Most important, according to Mellen, the forties set the patterns for future heroes to follow: e.g., be stoic in the face of adversity, never show your weaknesses, have noble thoughts, and scorn empty materialism. What troubles Mellen is that directors like John Ford also insisted in their westerns that true men "accept their orders and act in the name of the flag, whether at Wounded Knee, Fort Apache, or--by implication--My Lai." Among the obvious flaws in such sweeping generalizations is the lack of evidence to support such claims. In fact, one of the most disturbing aspects of this provocative book is the author's failure to footnote her sources or document in more detail the criticisms she makes. Another telling point, as Mark Crispin Miller observes, is that "By ignoring many films and misreading a few Mellen implies that King Kong could have

[1139] R. K., "Books: BIG BAD WOLVES: MASCULINITY IN THE AMERICAN FILM," HARPER'S MAGAZINE 256:533 (February 1978):91.

[1140] Robert G. Michels, "Of Movies and Men," LITERATURE/FILM QUARTERLY 8:4 (1980):267-8.

played nearly every leading role in Hollywood's history, and then some. . . ." In defense of his attack on Mellen's thesis, Miller notes that "Glenn Ford, Burt Lancaster and Henry Fonda, for instance, have often played weak or gentle heroes or, more to the point, characters too complex for vulgar classification."[1141]

An excellent example of how Mellen tends to anchor her criticism in a vacuum is the chapter on the fifties, where she asserts that the screen mirrored the culture at large. Film heroes, in this section, equate manhood with personal success, crass materialism, and narrow Puritan values. The interesting twist is that the movie males suddenly became introspective. Stars like Marlon Brando, Montgomery Clift, James Dean, and Paul Newman agonize over their sexuality and turn themselves into psychopathic personalities. Rarely does a screen hero define his strength, as Dean did in REBEL WITHOUT A CAUSE (1955), as "tolerance of the weakness of others and acceptance of one's own." Except for MARTY (1955), the cultural expectations reinforced in films of the fifties are that conformity results in rebellion, that men with flawed characters are doomed to a pointless existence. Here again the most telling genre is the western: e.g., THE SEARCHERS (1956) and THE LEFT-HANDED GUN (1958). In the end, it comes down to whether one accepts Mellen's analyses as revisionist criticism or as plain misreadings and distortions.

The chapter on the films of the 1960s explains how heroes became "hard, ungenerous, threatened, and alone." Arguing again from a limited perspective, the author superficially claims that Hollywood, behaving as it had in previous periods of national crisis, responds to a start of war (i.e., the Vietnam War) by removing any psychological subtleties in its movie heroes' characters. Domestic success is discarded early in the decade as heroes like Paul Newman (THE HUSTLER) and Steve McQueen (THE CINCINNATI KID) portray life as a game fought by moody and tough men in a jungle-like environment. What matters most is not sheer strength or macho heroics, but personal confidence. No one screen actor personifies the new image more often than Sean Connery as James Bond, a movie male who skillfully deals with a sinister world and still keeps both a sense of humor and sexual dexterity. A close second is Clint Eastwood, whose spaghetti westerns "closely mirrored" macho American politics. Unlike the Wayne persona of the 1940s, the Eastwood hero criticizes Mom, home, and apple pie. His characters distrust everything and everyone. Their only salvation is their own effectiveness. Those movie heroes closer to the ordinary person--e.g., Dennis Hopper (EASY RIDER) and Warren Beatty (BONNIE AND CLYDE)--struggle to maintain their dignity and independence, only to die young and alienated from society. The morality of the emerging counterculture insists on showing dissatisfaction with traditional values and institutions. What Hollywood does, however, is focus on certain aspects of the counterculture--e.g., drug-dealing and college attrition--and exaggerate their negative effects on the young. The films of ridicule--e.g., EASY RIDER (1969), THE PANIC IN NEEDLE PARK (1971)--appeal to audiences wanting a quick fix for their anxieties. "Thus in the sixties and seventies," explains Mellen, "when the young people of the counterculture and the antiwar movement surface on the Hollywood screen, they appear only in order to be degraded." Such unsubstantiated statements detract from many of Mellen's insightful comments not only about significant male stereotypes predicated on violence, but also about the way many sensitive women reacted to Hollywood's distortions about masculine values.

By Chapter Eight, the author is ready to summarize how the 1970s responded to the mood and values of the past. The revolutionary changes in our social and political life advocated by the counterculture are seen as futile and unrealistic. Screen heroes point out that the world is too corrupt to reform, the victims more often than not are the oppressors, and the disadvantaged in our society represent the greatest threat to peace and security. Consequently, Clint Eastwood, in films like DIRTY HARRY (1971), MAGNUM FORCE (1973), THE OUTLAW JOSEY WALES (1976), and THE ENFORCER (1976), must insist on personal violence and massive devastation to

[1141] Mark Crispin Miller, "Tom Mix was a Softie," NATION 226:15 (April 22, 1978):470.

suppress the anarchy initiated by the poor and minority forces in America. No time is spent in showing how the disadvantaged became deranged, or why the Supreme Court chose to "coddle" criminals. The simple fact, according to Mellen, is that the Eastwood hero must take the law into his own hands if society is to survive and remain free. Eastwood's heroics then became the model for future fascist heroes in films like STRAW DOGS (1971), WALKING TALL (1973), DEATH WISH (1974), TAXI DRIVER (1976), and THREE DAYS OF THE CONDOR (1975). The films of the seventies tolerate no gray areas. Heroes are good, villains evil, and violence must be met with violence. The more brutal the hero, the more masculine he appears. Also catching Mellen's eye in the seventies' hero is his negative attitude toward women. They either must accept a subordinate role in sexual and domestic matters, or be avoided at all costs. Thus the era's two most popular film genres, explains Mellen, are the vigilante film and the buddy movies. The only movies she singles out for presenting quality male images are films like DOG DAY AFTERNOON (1975) and BUFFALO BILL AND THE INDIANS, OR SITTING BULL'S HISTORY LESSON (1976). Their success results more from their debunking qualities, than from their economic or artistic excellence. In short, the image of the macho male, with its fantasy emphasis, really operates as a demoralizing factor in society. Adding to the various problems already noted is the author's tendency to equate a performer's screen persona with his or her personal values. Not only does this blur the important distinction between fiction and fact, but it also ignores the intricate relationship between profits and film conventions. Thus Eastwood's movie roles (which are far more varied and complicated than Mellen indicates) reflect more about his business acumen than about his politics.

Mellen's passion in arguing so strongly for an alternative screen image also underscores the book's central weakness: reductionism. Almost no time is given to how the film industry operates through formulas, with their conventions and inventions. A few examples should suffice. First, in attacking the image of masculinity over an eighty-year period, she constantly equates most of the violent characterizations with masculine insecurity over sexuality. Filmmakers are repeatedly accused of being "frightened," "rejected," or are seen as "failures." Most screen heroes who enjoy heterosexual relationships are accused of being incapable of male companionship. In the author's mind this justifies the popularity of the Lone Ranger and Hopalong Cassidy movies. Even more flimsy is her unwillingness to distinguish between film hits and flops. Forgetting for the moment that profits alone do not indicate a film's psychological impact, it is arguable that a popular movie represents widely held values. But Mellen lumps all film images together. She also fails in her AUTEUR analyses to distinguish between a director's hits and flops. Furthermore, she ignores almost completely the way in which genres respond to changing social and political values. For example, we hear a lot about John Wayne westerns, but no mention is made of films like LITTLE BIG MAN and SOLDIER BLUE (both in 1970). Thus, to say that "from its beginning film was conceived both as entertainment AND as a refuge from political reality" is little more than inflated rhetoric. Finally, her singleminded interest in attacking white male screen images forces her to overlook or to pay token attention to the screen treatment of minority males. In particular, her last-minute discussion of black men is both superficial and trivial.

With all its flaws, this book nonetheless makes for a very enjoyable experience. It isn't just the fun of debating her many unsubstantiated and questionable assertions. They keep you active almost from page to page. The real pleasure comes from knowing how a bright, respected individual can interpret films so radically differently from the way you do. Even when you disagree, you are forced to rethink why and for what reasons. In summary, Mellen's research provides a challenging introduction to a topic grossly ignored or dismissed by film historians. Her chronicle suggests the rich possibilities for an in-depth study of the film's role in developing our social consciousness. What is needed now is a more thoughtful understanding of how audiences receive such images and how they influence their production and longevity. An index is provided, but no bibliography. Well worth browsing.

Neibaur, James L. TOUGH GUY: THE AMERICAN MOVIE MACHO. Jefferson: McFarland, 1989. Illustrated. 232pp.

Pettigrew, Terence. RAISING HELL: THE REBEL IN MOVIES. New York: St. Martin's Press, 1986. Illustrated. 192pp.

Turow, Joseph. PLAYING DOCTOR: TELEVISION, STORYTELLING, AND MEDICAL POWER. New York: Oxford University Press, 1989. Illustrated. 315pp.

FILMS

GONE WITH THE WIND (Selznick--16mm: 1939, 220 mins., color, R-MGM)
 Although directed primarily by Victor Fleming and scripted by a host of writers (with Sidney Howard getting the major credit, along with credits to Jo Swerling, Ben Hecht, and John Van Druten), the film really is the creation of David O. Selznick. Moreover, the adaptation of Margaret Mitchell's highly popular novel about the the antebellum South, its defeat in the Civil War, and the aftermath when the incredible Scarlett O'Hara (Vivien Leigh) and her husband Rhett Butler (Clark Gable) seek to rebuild their lives remains the classic screen example of heroes, heroines, villains, and racist stereotypes up to World War II.[1142] Nominated for twelve Oscars, including Best Actor (Gable), Best Sound Recording (Thomas T. Moulton), Best Original Score (Max Steiner), and Best Special Effects (Photography: John R. Cosgrove; Sound: Fred Albin and Arthur Johns), it won for Best Picture, Best Director, Best Actress (Leigh), Best Supporting Actress (Hattie McDaniel), Best Screenplay (Howard), Best Color Cinematography (Ernest Haller and Ray Rennahan), Best Interior Decoration (Lyle R. Wheeler), and Best Film Editing (Hal C. Kern and James E. Newcom).

STAR WARS (Lucasfilm: 16mm--1977, 121 mins., color, S-videocassette)
 Written and directed brilliantly by George Lucas, this synthesis of oldtime Hollywood genres is an updated version of film myths and Greek epics dealing with the adventures of a youthful hero who goes through a series of trials before achieving his destiny. It can serve not only as a case study of modern heroes and villains, but also as the prototype for the specical effects craze that has preoccupied the contemporary cinema.[1143] Nominated for ten Oscars, including Best Film, Best Supporting Actor (Alec Guinness), Best Director, and Best Screenplay Written

[1142] Although this book cites numerous references to the film, some useful articles to consult, in addition, are John Howard Reid, "The Man Who Made GONE WITH THE WIND," FILMS AND FILMING 14:3 (December 1967):12-7; ___, "Victor Fleming, Part Two," ibid., 14:4 (January 1968):38-46; John D. Stevens, "The Black Reaction to GONE WITH THE WIND," JOURNAL OF POPULAR FILM 2:4 (Fall 1973):366-71;and Clyde Kelly Dunagan, "GONE WITH THE WIND," INTERNATIONAL DICTIONARY OF FILMS AND FILMMAKERS: VOLUME I, pp.179-80. In addition, see the Turner Broadcasting Company's excellent 1988 THE MAKING OF A LEGEND: "GONE WITH THE WIND."

[1143] For more information, see Special Issue of AMERICAN CINEMATOGRAPHER 58:6 (July 1977); Arthur Lubow, " A Space ILIAD: THE "STAR WARS" War: I," FILM COMMENT 13:4 (July-August 1977):20-1; Terry Curtis Fox, "Star Drek: The "STAR WARS" War: Part II," ibid., pp.22-3; Denis Wood, "The Stars in Our Hearts--A Critical Commentary on George Lucas' STAR WARS," JOURNAL OF POPULAR FILM 6:3 (1978):262-79; Peter Lehman and Dan Dasco, "Filmmaking: Special Effects in STAR WARS," WIDE ANGLE 1:1 (1979):72-7; and Thomas Snyder, "STAR WARS Trilogy," THE INTERNATIONAL

Directly for the Screen, it won for Best Art Direction-Set Direction (John Barry, Norman Reynolds, Leslie Dilley, and Roger Christian), Best Sound (Don MacDougall, Ray West, Bob Minkler, and Derek Ball), Best Orginal Score (John Williams), Best Film Editing (Paul Hirsch, Marcia Lucas, and Richard Chew), Best Costume Design (John Mollo), and Best Visual Effects (John Stears, John Dykstra, Richard Edlund, Grant McCune, and Robert Blalack). In addition, Benjamin Burtt, Jr., was given a Special Achievements Award for sound effects for his creation of the voices for the alien creatures and robots.

SOCIAL DISTORTIONS

Having reviewed stereotyped images of men and women, we briefly turn our attention to some general stock responses to social attitudes. Among the most popular stereotypes presented to the public are those relating to Big Business, class systems, teenage problems, social institutions, and racial problems.[1144] More often than not, a film's stereotypes represent not only the times in which it is made, but also the film industry's overriding concern with profits rather than with purpose.

Each of the examples that follows serves as a constant reminder that film and television are more than escapist entertainment. Before we begin, however, it helps to recall the political nature of the mass media and their pervasive influence on our society. To that end, Randall M. Miller's insightful "Introduction" to ETHNIC IMAGES IN AMERICAN FILM AND TELEVISION provides a capsule overview. While acknowledging that Americans have always been sensitive to the propagandistic attractions of the movies and TV, Miller also reminds us that many people still lack a genuine understanding of how movies and TV function in society or how they are produced. He begins, therefore, with a warning that "few citizens can escape the reach of the commercial media's influence."[1145] He then stresses why commercial considerations inhibit the production process as it pertains to the treatment of ethnicity in America. That is, producers' need to attract and to maintain large audiences requires that they stereotype ethnic groups by focusing "on the exterior of culture--dress, eating habits, language accents." The result is that "they suggest that the veneer of culture constitutes its substance."[1146] What often gets lost in such stereotyping is a sense of ethnic religions and family relationships. At the heart of the process is a pitch for the melting pot theory. "Popular television programs," Miller insists, "like two generations of American films before them, stress upward mobility, intermarriage between ethnic groups, accommodation with the prevailing American materialistic culture, and the homogenization of values."[1147] This reinforcement of assimilationist ideals runs contrary, Miller argues, "to the proponents of a multi-cultural society and . . . threaten[s] the value systems and mores of ethnic groups in America."[1148] Just as worrisome is the fact that TV stations, and now the videocassette and videodisc industry, profit through the use of reruns. These old

DICTIONARY OF FILMS AND FILMMAKERS: VOLUME I, pp.447-50. See also ABC's valuable 1977 TV documentary "THE MAKING OF 'STAR WARS.'"

[1144] A good example is William Sloan, "Two Sides of the Civil Rights Coin: A Discussion of TROUBLEMAKERS and A TIME FOR BURNING," FILM COMMENT 4:2,3 (Fall-Winter 1967):54-6.

[1145] Randall M. Miller, "Introduction," ETHNIC IMAGES IN AMERICAN FILM AND TELEVISION, ed. Randall M. Miller (Philadelphia: The Balch Institute, 1978), p.xiii.

[1146] Miller, p.xiv.

[1147] Miller, p.xv.

[1148] Miller, p.xv.

programs and movies, using the stereotypes and sometimes outmoded values of the past, continue to provide impressionable viewers with dubious role models for the contemporary age. And since TV and film executives attempt to build, through their entertainment programs, "a national consensus around certain positive, shared values," we need to understand how an emphasis on conformity can lead to a national consensus.[1149] In order to prevent the negative socialization effects of this production process, we need to recognize the monolithic value structure promoted by movies and television. Such recognition calls attention to the commercial media's political commitment to maintaining the STATUS QUO and points out that this commitment does not serve the public good. At the same time, Miller notes, we should remember that the public often gets what it wants. Many stereotypes reflect what members of the public believe, or choose to believe, "of others in order to serve their own cultural and psychological needs."[1150]

No one seems to have an answer to just how to break the commercial and political hold that large corporations, foundations, and the government have on the production process. For example, we have seen the problems accruing from federal attempts to restructure the film industry as a result of the PARAMOUNT case. We have also seen how much the public enjoys novelty and how quickly it loses interest in stars and popular themes. This much is certain: what we see and assimilate is filtered through a number of variables. At the same time, many members of the audience still remain naive about the socializing effect on our society of films and television.

One example of film distortions that represent the period in which they are presented is the stereotyped image of Big Business. As Eric Larrabee and David Riesman hypothesize,

> The Temper of the Times toward business can be read on numerous barometers, but few of them are as legible as the fictional dramatic arts--where popular images are projected twice life-size, and the public attitudes and assumptions are converted into "stories." Business is not always shown here at its best; thus the demands of Allan Nevins, Edward N. Saveth, John Chamberlain, and others for a more favorable treatment of business life in history and in novels. Yet of all the media the most massive and the most revealing are not books but the movies, and recently it is to them that observers who look for a rapprochement between the world of business and the world of the arts and intellect have turned. If the images of business have been changing, it is on the screen that their new shapes will soon appear.[1151]

Using the movie EXECUTIVE SUITE (1954) as an example of the then most obvious and revealing use of a business background, the authors point out the distortions in the depiction of executive warfare in a furniture corporation. The stereotyped hero becomes a neutral engineer, a character who was once shown in films as hard and insensitive but who has now been spoiled and adulterated by power. Innocence and uninvolvement are replaced by shrewdness and aggressiveness in the hero's climb to the Executive Suite. Big business is portrayed as an arena where the forces of good and evil are arrayed against each other in the common events of daily management.

There are also stereotyped myths that interfere with our understanding of various economic classes. As Geoffrey Nowell-Smith theorizes, the general tendency is for us "to see things under a mythical aspect--using the word 'myth' fairly loosely to cover the generalized images or ideas one has of things, ideas which are mythical

[1149] Miller, pp.xi-xii.

[1150] Miller, p.xvi.

[1151] Eric Larrabee and David Riesman, "Company Town Pastoral: The Role of Big Business in EXECUTIVE SUITE." *MASS CULTURE: THE POPULAR ARTS IN AMERICA, p.425.

only insofar as they are a substitute for direct knowledge or experience."[1152] From his perspective, we must either accept or reject myths on a logical and not on a moral basis. For him, myths represent lies that are the enemies of reason and truth. He cites as an example the film SATURDAY NIGHT AND SUNDAY MORNING (1961), the story of a young factory worker who spends his free time in the local bar, where he gets drunk, fights, and plays practical jokes. Middle-class viewers saw this movie, Nowell-Smith claims, as a realistic expression of the working class, while the working class identified in a more limited sense with the type of ideal they desired, but were unable or afraid to achieve because of moral or material reasons.

Another type of stereotyping, discussed in more detail in Chapter 4, deals with teenage problems and is subtly presented to the public by means of "realistic" films, movies that supposedly present life as it really is. Some examples, as analyzed by Robert Brustein, are films like ON THE WATERFRONT (1954), THE GODDESS (1959), A HATFUL OF RAIN (1948), and EDGE OF THE CITY (1957). Brustein points out that these films follow a formula: one that focuses on Zolaesque naturalism, method acting, and an anti-hero. The films have only changed the luxurious settings from the unrealistic pictures of the past to "shanty-town slums in rotting southern or northern towns, the costumes, apparently acquired no longer from Mainbocher but from the surplus stores of the Salvation Army, hang on the actors as dashing as skivvies on a scarecrow."[1153] Brustein feels that this change occurred because Hollywood considers the majority of its audience to be teenagers and panders to adolescents' interest in films depicting their problems and their generation.

The principle has not changed since then, as evidenced by such recent films on student life as THE BREAKFAST CLUB and ST. ELMO'S FIRE (both in 1984), and FERRIS BUELLER'S DAY OFF (1986). The stereotyped images used in these films are no more honestly presented than those previously discussed. Each represents the filmmakers' intentions to maximize profits and minimize financial risks. The innovations presented are incidental to the filmmakers' basic storyline, and, consequently, represent a minimal attempt to explore the complexity of adolescent behavior and social adjustment. Like their predecessors, these recent film images stress entertainment more than insights. The strategy is to pander to the prejudices of youthful audiences and thereby reap large profits. While mass audiences support such pictures at the box office, there is no way of knowing whether the films themselves are treated as anything more than amusing diversions. What is disappointing, however, is the fact that the filmmakers neglect the opportunity to educate at the same time that they entertain. By oversimplifying the problems of adolescence, they deny us the chance to examine through a popular medium areas of importance to parents, teachers, young people, and society-at-large. On the other hand, as discussed throughout this chapter, if we remain alert to the types of characters and themes presented in popular films, and note the subtle changes from their previous depictions, these recent film hits can provide the chance to improve our understanding not only of ourselves, but also of our times.

Consider, for example, the filmic treatments of various professions.[1154] Many of us can cite pictures that have portrayed "mad scientists," "tranquil, pipe-smoking,

[1152] Geoffrey Nowell-Smith, "Movie and Myth," SIGHT AND SOUND 32:2 (Spring 1963):60.

[1153] Robert Brustein. "The New Hollywood: Myth and Anti-Myth," FILM QUARTERLY 13:3 (Spring 1959):23. See also Leslie Halliwell, "America: The Celluloid Myth--Part One," FILMS AND FILMING 14:1 (October 1967):12-6; ___, "America: The Celluloid Myth--Part Two," ibid., 14:2 (November 1967):10-4.

[1154] Other examples are the following: Edward Connor, "Angels on the Screen," FILMS IN REVIEW 9:9 (August-September 1958):375-79; ___, "Demons on the Screen" ibid., 10:2 (February 1959):68-77; Jack Spears, "The Doctor on the Screen," ibid., 6:9 (November 1955):436-44; ___, "Baseball on the Screen," ibid., 19:4 (April 1968):198-217; Martin J. Klein, "Psychiatry Looks at the Appeal of RAIN MAN,"

idealistic, shabbily dressed professors," and "materialistic doctors." One useful analysis of such stereotyping is presented by Daniel Rosenblatt, in which he lists five major film treatments of psychoanalysis and mental illness:

(1) Psychosis as gothic excitement: sex, violence, murder, suicide . . .
(2) The psychiatrist as hero-villain (Negative transference, fear) . . . (3)
The analyst as comic-relief (Negative transference, belittling . . . 4)
Psychoanalytic Romanticism (Positive Transference) and (5) Finally we reach
the current period of MATURITY. Psychoanalysis is a technique which can be
utilized in the treatment of the emotionally disturbed. The analyst is a kindly,
"warm" human being who has solved almost all of his personal problems,
although he has a few, lovable failings. He smokes a pipe, wears glasses, no
longer has a beard and is either a Jew or a Negro. Rod Steiger in THE MARK,
Sidney Poitier in the Linder-Kornfield PRESSURE POINT.[1155]

Some films that can be used to illustrate Rosenblatt's viewpoint are DAVID AND LISA and FREUD (both in 1962).

In addition, there are stereotypes that involve social situations. Penelope Houston cites four examples that are directed against the traditional images of society's sacrosanct institutions. First, there are the courts. In a film like TRIAL (1955), a murder trial becomes the vehicle for showing the ineffectiveness of our legal system and the danger from corrupt policemen who would rather rig a jury than lose an important and highly publicized case. Second, the police come under attack in a film like THE DESPERATE HOURS (1955). Here we see the possible danger in asking for help from law enforcement officials who might willingly turn a dangerous situation into a shooting match so as to gain votes in the next election. Third, the schools are criticized. THE BLACKBOARD JUNGLE (1955) shows how already difficult teaching conditions are increased by the apathy and incompetence of the staff. REBEL WITHOUT A CAUSE (1955) is another instance in which apathy allows juvenile gangsterism to operate in an ordinary secondary school. Finally there is the family itself. Again, REBEL WITHOUT A CAUSE serves as a useful illustration of how an unhappy and sick marriage further helps to complicate the lives of young people and force them into juvenile delinquency.[1156]

NEW YORK TIMES H (April 16, 1989):24; Wilfrid Sheed, "Why Can't the Movies Play Ball?" ibid., H (May 14, 1989):1, 14; and Dr. Paul Bradlow, "Two . . . But Not of A Kind: A Comparison of Two Controversial Documentaries About Mental Illness--WARRENDALE and TITICUT FOLLIES," FILM COMMENT 5:3 (Fall 1969):60-1. See also Joseph Turow, PLAYING DOCTOR: TELEVISION, STORYTELLING, AND MEDICAL POWER. New York: Oxford University Press, 1989.

[1155] Daniel Rosenblatt, "Dreams in the Dream Factory," FILM SOCIETY 1 (1963):33-4. See also John Fletcher, "Freud at the Movies," NFT JULY PROGRAMME (July 1986):4-8; Glen O. Gabbard and Krin Gabbard "From PSYCHO to DRESSED TO KILL: The Decline and Fall of the Psychiatrist in Movies," FILM/PSYCHOLOGY REVIEW 4:2 (Summer-Fall 1980):157-68; Linda Martin, "The Psychiatrist in Today's Movies: He's Everywhere and in Deep Trouble," NEW YORK TIMES 2 (January 25, 1981):1, 27; "Film Mailbag: Debating the Role of Psychiatrists in Life and on Film," ibid. 2, (February 22, 1981):16; Frank Rich, "Even Misfits Can Live Happily Ever After," ibid., 2 (August 14, 1977):11; Gordon Kahn, "One Psychological Moment, Please," ATLANTIC MONTHLY 178:4 (October 1946):135-7; and Irving Schneider, "Images of the Mind: Psychiatry in the Commercial Field," THE AMERICAN JOURNAL OF PSYCHIATRY 134:6 (June 1977):613-20.

[1156] Penelope Houston, "Rebels Without Causes," SIGHT AND SOUND 25:4 (Spring 1956): 179. Other useful articles are Lionel Godfrey, "Because They're Young--Part One," FILMS AND FILMING 14:1 (October 1967): 42-8; ___, "Because They're Young--Part

Stereotyping also figures prominently in the treatment of social problems. Donald Lloyd Fernow, in a content analysis of the way in which society was treated in film from the silent era to 1952, categorizes four major topics: international relations, economic problems, political issues,[1157] and sociological problems.[1158] In his introduction, Fernow explains that the increasing complexities of living in a technological age, the danger of nuclear war, and the communication crisis among people everywhere have only intensified the need for everyone to become free from prejudice and ignorance. Under each of the four topics, he has subheadings: for example, under sociological problems are the following: (a) minority problems, and (b) the ostracized or stigmatized individual. He gives further subdivisions: for example, under minority problems are (1) races and nationalities--(i) Negro, (ii) Oriental, (iii) Indian, (iv) Mexican, (v) Others--and (2) Religious--i) Jewish, ii) Protestant, iii) Catholic. He concludes, in connection with this area, by stating

> One of the characteristics of prejudice has been the categorizing of individuals within a group as a well delineated stereotype. The perpetuation of such stereotypes, in some instances over centuries, has frequently served the purposes of nefarious parties and further enhanced bigotry with its concomitant intolerance.[1159]

In his conclusion, Fernow points to many of the issues raised throughout this chapter:

> Those entertainment films depicting a social problem which have exercised the greatest influence have been those which have been the most popular with the audiences. Good drama with a well-defined story line and genuine characters, presented with deftness and artistry usually, carries a social message to the audience with compelling poignancy and credibility. A social problem implies a social need for reform to allay it. This can best be done by the motion picture, through engendering in the public an awareness of the problem's existence and instilling in them a sense of responsibility to take rational action to correct it. An entertaining story whose characters are real, genuine people, which is told with sincerity and honesty, and which clearly and definitely presents its case is the best vehicle for accomplishing this purpose.[1160]

Put differently, film audiences need to recognize how their perceptions about social problems can be shaped by the films they dismiss as "mere entertainment." At the same time, we must give more credence to the theory that "meaning" in film is derived from the collected and continued use of conventions tried and tested during the evolution of the film from the turn of the century to the present. To reiterate what Walter Lippmann said decades ago, "For the most part we do not first see, and then define, we define first and then see." While it may be argued effectively that the film industry never had education as its mission or concern, it may also be argued

Two," ibid., 14:2 (November 1967):40-45; and Robin Bean and David Austen, "USA: Confidential," ibid., 15:2 (November 1968):16-28.

[1157] Read Raymond Durgnat, "Vote for Britain: A Cinemagoer's Guide to the General Election--Part One," FILMS AND FILMING 10:7 (April 1964):9-14; ___, "Part Two," ibid., 10:8 (May 1964):10-5; and ___, "Part Three," ibid., 10:9 (June 1964):38-43.

[1158] A useful essay is Peter John Dyer, "American Young in Uproar," FILMS AND FILMING 5:12 (September 1959):10-2, 32-7.

[1159] Donald Lloyd Fernow, "The Treatment of Social Problems in the Entertainment Film," (Master's thesis, University of Southern California, 1952), pp.114-5.

[1160] Fernow, p.180.

persuasively that in their quest for profits filmmakers created conventions that, in turn, resulted both in misperceptions and social awareness about many of the nation's social problems at specific times in our history. To that end, we turn now to a set of summary surveys that illustrate how the American film industry with our help CONSCIOUSLY orchestrated film images to influence and to represent the nation's feelings about specific minorities in society: Jews and African-Americans.

THE JEW IN AMERICAN FILM

The relationship among Hollywood, Jews, and popular culture remains a complex and controversial issue. Almost all of the debate centers on the nature of acculturation and how the Eastern European Jewish immigrants, who gained control of the film industry in the early part of the twentieth century, fitted into American society while retaining aspects of their ethnic heritage.[1161] According to David Weinberg, the debate about the "nature of acculturation of immigrant minorities to American society" is not unique to film. In fact, the issue is very popular in academic circles. "For the most part," he explains, "these debates have centered around the attitudes of minority group members themselves, with some studies emphasizing their willingness to forsake much of their cultural past (the Melting Pot theory and its variants) and others pointing to continued identification with ethnic traditions (the Cultural Pluralist school)."[1162] What is often overlooked, as Weinberg discusses in his analysis of the Jew in popular American movies, is the effect that popular attitudes have on molding the behavior and values of immigrant minorities who arrive in this country eager for economic, political, and social freedom. In the case of the Russian Jews, they quickly attained economic and political independence, but social freedom proved more difficult. In effect, it took decades before Eastern European Jewish immigrants felt accepted by the Gentile world.

In the meantime, because Jews were erroneously thought to be visually and behaviorally identifiable, the Gentile world in the early part of the 1900s updated a set of stereotypes, dating back to the sixteenth century, that served to illustrate the clash between traditional Jewish values and the demands of American life. "Celluloid Jews," as Lester D. Friedman points out, appeared over the years in "a variety of shapes and sizes--sinister shysters, pathetic victims, baffled buffoons, sympathetic workers, struggling students, gallant warriors, star-crossed lovers, and

[1161] Simply put, there were three significant waves of Jewish immigration to America prior to 1920. First came the Sephardic Jews from Spain and Portugal during the late 1600s and early 1700s. The second wave of Jewish immigrants, the Ashkenazim or Western European Jews (mainly Germans), arrived between 1825 and the mid-1880s. Both the Sephardim and the Ashkenazim assimilated rapidly into American society and were relatively secure in business and financial situations prior to the arrival of the third wave of Jewish immigrants from Eastern Europe beginning in the 1880s and lasting until the mid-1920s. Of particular importance was that the Eastern European Jews arrived without money or knowledge of the language, and also that they congregated in massive numbers on the East Coast, mainly in New York City. The condition of these poor immigrants, living in crowded ghettos, and tied to Old World values, distressed the earlier Jewish immigrants who tried to distance themselves from this sad-looking group of refugees. The fact that it was the third group of immigrants who distinguished themselves more than the first two groups is worth noting.

[1162] David Weinberg, "The 'Socially Acceptable' Immigrant Minority Group: The Image of the Jew in American Popular Films," NORTH DAKOTA QUARTERLY 40:4 (Autumn 1972):60.

sadistic gangsters being just a few."[1163] Aspects of the negative stereotypes have been covered in Chapter 2, focusing on Nazi propaganda, and will be discussed more fully in Chapter 5, concerning the nature of the image of Hollywood. Here we need only note that distinguished writers like F. Scott Fitzgerald, Norman Mailer, Budd Schulberg, and Nathanael West rely heavily on traditional stereotypes of Jews in dramatizing the Jewish experience in the film industry. Their celebrated novels, to be examined in Chapter 5, make it clear that Jews ruled Hollywood not only at the executive level (seventy-five percent of the major studios were run by Jews), but also that many of the major stars, producers, agents, lawyers, directors, and screenwriters were Jews. In addition, a number of film historians have chronicled how the Jewish-dominated film industry produced, distributed, and reinforced, through popular culture, a set of stereotypes dealing with the American Dream and the Melting Pot theory. Neal Gabler, for example, asserts that "Ultimately, American values came to be DEFINED largely by the movies the Jews made. Ultimately, by creating their idealized America on the screen, the Jews reinvented the country in the image of their fiction."[1164]

To appreciate the novelty of a Jewish-dominated industry that for over forty years insisted on only marginal representation for the Jew on film, we need to be aware of the correlation between ethnic images and ethnic social development. As Stuart Samuels explains,

> Images of ethnic stereotypes in film tend to be related to the actual social position that [a] particular ethnic cultural group adopts in American society. It has been suggested that all ethnic minorities go through similar stages of acceptance: 1) alienation; 2) acculturation; 3) assimilation; and 4) acceptance. The changing image of the Jew in American film follows this pattern.[1165]

What Samuels indirectly develops in his essay on the evolution of the Jewish screen image from alienation to acceptance is a useful summary of the role that economic considerations and audience expectations play in the treatment of social issues and types. In particular, his efforts highlight the enormous influence that Jews offscreen had on film content. That is not to say that other religious groups, most notably Catholics through the Breen Office, did not influence film stereotyping. They did. Nor is it to say that the Jewish film community originated ethnic stereotypes. They did not. It is to say that in many respects the chronology of the characters and themes in Jewish-American studio films (movies focusing on Jewish perspectives) synthesizes many of the basic assumptions of this chapter.[1166]

[1163] Lester D. Friedman, THE JEWISH IMAGE IN AMERICAN FILM (Secaucus: Citadel Press, 1987), p.9.

[1164] Neal Gabler, AN EMPIRE OF THEIR OWN: HOW THE JEWS INVENTED HOLLYWOOD (New York: Crown Publishers, 1988), p.7.

[1165] Stuart Samuels, "The Evolutionary Image of the Jew in American Films," ETHNIC IMAGES IN AMERICAN FILM AND TELEVISION, p.23.

[1166] This section has been shaped in part by the following works: Carlos Clarens, "Mogul--That's a Jewish Word," FILM COMMENT 17:4 (July-August 1981):34-6; *Sarah Blacher Cohen, ed., FROM HESTER STREET TO HOLLYWOOD: THE JEWISH-AMERICAN STAGE AND SCREEN (Bloomington: Indiana University Press, 1983); Thomas Cripps, "The Movie Jew as an Image of Assimilation, 1903-1927," JOURNAL OF POPULAR FILM 4:3 (1975):190-207; Patricia Erens, THE JEW IN AMERICAN CINEMA (Bloomington: Indiana University Press, 1984); ___, "Gangsters, Vampires, and J. A. P.'s: The Jew Surfaces in American Movies," JOURNAL OF POPULAR FILM 4:3 (1975):208-22; *Lester D. Friedman, HOLLYWOOD'S IMAGE OF THE JEW (New York: Frederick Unger Publishing Company, 1982); ___, "The Conversion of the Jews," FILM COMMENT 17:4 (July-August

One of those assumptions is that the movies represent the times in which they are made. Jewish-American films especially serve as a record of immigrant life on New York's Lower East Side, ethnic strides toward economic, social, and political freedom, and the emphasis immigrants placed on assimilation. The latter point is most evident in the influence that the Jewish film executives exerted on film content, especially during the heyday of the studios. After all, the major corporate leaders were primarily Jewish immigrants or second-generation Americans: e.g., Harry Cohn, William Fox, Samuel Goldwyn, Carl Laemmle, Jesse Lasky, Marcus Loew, Louis B. Mayer, B. P. Schulberg, the Schenck brothers, Lewis J. Selznick, the Warner brothers, and Adolph Zukor. As will be discussed more fully in Chapters 5 and 6, they emerged from the chaos of the early film wars as the dominant entrepreneurs who put profits ahead of purpose. Underlying their phenomenal success was a reaffirmation of the American Dream. More to the point, as Ruth Perlmutter observes, "The mainstream mode [of American filmmaking], with its crisis-to-resolution melodramatic structure, its dramatization of personalized problems of believable characters, and its sexual ambience, charmed the masses who were yearning for acculturation."[1167] Thus it is not surprising that film histories and biographies are filled with stories of the immigrant merchants who, by validating White Anglo-Saxon Protestant values through the classical Hollywood narrative, rose to positions of power and wealth in the New World.

Two points generally overlooked in the telling of their stories are that each mogul fiercely prided himself on being an American first and a Jew second, and that each mogul insisted on the need for assimilating rather than for maintaining his ethnic roots. Before we proceed, however, it is worth recalling Carlos Clarens's observation that "The myth of the Jewish movie mogul is a double-edged one." On the negative side, that perceived through many Gentiles' eyes, the Horatio Alger image of the mobile Jew who rose from the ghetto to the Hollywood mansion epitomizes the anti-Semitic stereotype of the crass, crude, and vulgar Jewish immigrant. These negative traits are used frequently in the works of writers like Fitzgerald, Mailer, Schulberg, and West. On the positive side, that advocated primarily by Jewish activists, the Jewish movie mogul emerges as "a shrewd operator with a direct line to the emotional needs of the movie audience."[1168]

1981):39-48; ___, "Celluloid Assimilation: Jews in American Silent Films," JOURNAL OF POPULAR FILM AND TELEVISION 15:3 (Fall 1987):129-36; Norman L. Friedman, "Hollywood, the Jewish Experience, and Popular Culture," JUDAISM 19:4 (Fall 1970):482-7; Aron Hirt-Manheimer, "From Jews to JAWS," DAVKA 5:4 (Fall 1975):32-40; J. Hoberman, "Yiddish Transit," FILM COMMENT 17:4 (July-August 1981):36-8; Dan Isaac, "Some Questions About The Depiction of Jews in New Films," NEW YORK TIMES 2 (September 8, 1974):13-4; Lary L. May and Elaine Tyler May, "Why Jewish Movie Moguls: An Exploration in American Culture," AMERICAN JEWISH HISTORY 122:1 (September 1982):6-25; Randall Miller, ed., ETHNIC IMAGES IN AMERICAN FILM AND TELEVISION (Philadelphia: The Balche Institute, 1978); Marcia Pally, "Kaddish for the Fading Image of Jews in Film," FILM COMMENT 20:1 (February 1984):49-55; Ruth Perlmutter, "The Melting Pot and the Humoring of America: Hollywood and the Jew," FILM READER 5 (1982):274-56; N. L. Rothman, "The Jew on the Screen" THE JEWISH FORUM 11 (1928):527-8; Howard Suber, "Politics and Popular Culture: Hollywood at Bay, 1933-1953," AMERICAN JEWISH HISTORY 67:4 (June 1979):517-33; Tom Tugent, "A History of Hollywood's Jews," DAVKA 5:4 (Fall 1975):4-8; and H. H. Wollenberg, "The Jewish Theme in Contemporary Cinema," PENGUIN FILM REVIEW (London: Penguin Books, 1948), pp.46-50.

[1167] Perlmutter, p.247.

[1168] Clarens, p.34.

Lary L. May and Elaine Tyler May offer a good starting point for discussing the importance of the moguls' ethnic background. Beginning with the observation that Hollywood was shaped by Jews from Eastern Europe, they discuss how these "outsiders" were quite different from the original Gentile American film pioneers, who were primarily inventors, cameramen, or artists.[1169] For the most part, the future Jewish movie moguls were exhibitors who had roots in retailing and in poverty. On the surface, they seemed not much different from other struggling immigrants trying to find their way in the new land. Nevertheless, the Mays argue, three things made the Jews who monopolized the American film institution unique: (1) their success "epitomized certain common trends within modern Jewish experience," (2) they were especially "prepared to tap the movie phenomenon," and (3) their rise to power reflected "part of the meaning of the film industry in American culture."[1170] The "common trend" argument relates to Jewish history and to the fact that centuries of anti-Semitism had forced many Jews into becoming skilled merchants. That is, the only course open to Jews prevented from entering professions and owning property was commercial trade near large urban centers. And it was in urban business transactions with anti-Semites that the vulnerable Jewish merchant learned the value of hard work, thrift, and tough bargaining. Clearly that was the situation with Eastern European Jews. More than many immigrants, the Jews came to this country equipped to work effectively in an urban setting and to make the most of every commercial opportunity. What made them "prepared to tap the movie phenomenon," explain the Mays, was that their age-old status as outsiders had taught them how to satisfy consumer desires, how to benefit from business opportunities other people frowned upon, and how to rely heavily on "family" networks for financial and social support. In fact, it came as no surprise to scholars that many of the studio bankers were Jewish: e.g., Goldman Sachs for Warner Bros.; Kuhn and Loeb for Paramount; and S. W. Strauss for Universal. The film industry was a particularly timely opportunity for these Jewish immigrants because of its financial benefits and social status. Not only could large sums of money be made quickly, but also the social reality was that success in the movies brought cultural and social recognition. What linked the Eastern European Jews with "part of the meaning of the film industry in American culture" was that the era itself (to be explored more fully in Chapter 5) symbolized the American Dream. Suffice it to say here that the image of the movie industry epitomized freedom from past prejudices, unlimited opportunities, and headstrong individualism.

What was also unique about the Jewish corporate executives was their attitude toward Judaism. "Though most of the moguls," notes Norman L. Friedman, "came from observant Jewish homes and learned some Hebrew and/or had been bar-mitzvahed, they tended, as adults, to live and think in a culturally assimilated life-style removed from the cultural content, activities, or practices of the Jewish heritage, or of the affairs of the larger Los Angeles Jewish community."[1171] It wasn't that they rejected their birthright. It was that they passionately believed the theories about the importance of assimilation in American life preached by the Progressive forces at the turn of the century. More to the point, the Jewish moguls became obsessed with becoming ideal Americans. In essence, that meant rejecting ethnic traditions in favor of modern attitudes and tastes. These were not just their personal values privately kept. Just the reverse was true. In fact, during the silent film era the movie moguls insisted that the screen image of Jews reflect the moguls' assimilationist convictions. The scripts they okayed for production, the professional talent they hired to make the films, and the publicity about these films that flooded

[1169] May and May, pp. 6-7.

[1170] May and May, p. 10.

[1171] Friedman, "The Conversion of the Jews," p. 483.

the nation--all were orchestrated to stress and praise the American way in contrast to Old World values and behavior.

Compare, for example, the film image of Jews from the turn of the century to World War I (when the powerful pioneering filmmakers were mainly Gentiles), with the years from 1919 to 1927 (when Jews were firmly in control). The entire period accounted for well over 200 films related to Jewish themes and characters, more silent films than related to any other ethnic group in America.[1172] One comparison is whether the film image of Jews was positive, neutral, or negative. A second comparison is whether the image remained constant during the silent era.

Film historians who insist that a dramatic change in the film image of the Jew occurred between 1896 and 1918 claim that the pre-WWI screen image reflected the status of Jews in both society and literature. Most Jews at the turn of the century earned a living as merchants or blue collar workers, and thus it was not unusual that a majority of films like OLD ISAACS, THE PAWNBROKER (1908) and GHETTO SEAMSTRESS (1910) pictured Jews in familiar roles. "Although the image of the Jew as businessman, moneylender, and tailor is carried over from traditional literary themes," explains Samuels, "the tone of these films is distinctly sympathetic."[1173] That sympathetic image continued into the post-WWI era. But according to Lester D. Friedman, by the early 1920s Hollywood was stressing the Jews' upward mobility in movies like A TAILOR-MADE MAN (1922), featuring a Jewish shipping tycoon, and ABIE'S IMPORTED BRIDE (1925), showing a wealthy mill-owner's son collecting vast sums of money for the starving Jews in Russia.[1174]

Erens's analysis of the primitive years provides a slightly different perspective, identifying a significant number of Jewish stereotypes adapted from fictional works ranging from THE MERCHANT OF VENICE (1596),[1175] to IVANHOE (1819), OLIVER TWIST (1837-1839),[1176] and THE WAY WE LIVE NOW (1875). According to Erens, the most notable stereotypes were those of the stern patriarch, the prodigal son, and the rose of the ghetto. Each of these one-dimensional types became associated with the film image of the typical Jewish family. Because these stereotypes proved non-threatening to the established Jewish community and useful to social reformers in depicting the struggle to "Americanize" immigrants, the family conventions remained active in films through the 1920s. However, as Erens observes, there were other stereotypes developed in the pre-WWI period that did not carry over into the final days of the silent era: e.g., the scheming merchant, the benevolent pawnbroker, the virginal Jewess, and the Yiddish cowboy. Once Jews gained control of the film industry, these negative images either disappeared or underwent major changes.

[1172] Friedman, "The Conversion of the Jews," p.40. Friedman claims elsewhere (THE JEWISH IMAGE IN AMERICAN FILM, p.15) that between 1900 and the start of the Depression, nearly 320 movies "featured clearly discernible Jewish characters. . . ."

[1173] Samuels, p.24.

[1174] Friedman, p.40.

[1175] Shakespeare's controversial play was adapted to film five times between 1908 and 1914, with each version emphasizing Shylock's stereotypical physical attributes and avariciousness. For some contemporary reactions to the portrayal of Shylock on TV, see John J. O'Connor, "TV: Eva Peron's Argentina and Shylock's Venice," NEW YORK TIMES C (February 23, 1981):18; Michiko Kakutani, "Debate Over Shylock Simmers Once Again," ibid., 2 (February 28, 1981):1, 30; and "Should Shylock Be Suppressed?" ibid., 2 (March 8, 1981):6, 16.

[1176] Dickens's popular novel was adapted to the silent screen six times, again with the major emphasis on Fagin's malevolent qualities.

Thus, the scheming merchant became the "less offensive clever businessman . . . the Yiddish cowboy (both cowardly soldier and reticent cowhand) [disappeared] at the end of the teens, but . . . [remained] a running joke in films about Jews."[1177]

Another debatable issue directly related to the silent era's depiction of Jews is an alleged distinction between vaudeville and the fledgling film industry. On the one hand, according to Ralph Willet, for practical business reasons, vaudeville censured material objectionable to its numerous immigrant and ethnic patrons. On the other hand, Willet finds the early filmmakers far "more aggressive, especially during and after World War I" in producing objectionable ethnic film images. He then goes on to add that "The general effect of World War I, . . . (and the Russian Revolution), was to entrench and legitimize the nativist cause, producing significant political and social effects in the 1920s."[1178] In other words, the more Jewish producers gained control of the production process, the more the film industry stressed assimilation in its film content.

Not every film historian sees the primitive years as rife with anti-Semitism, or the film industry as radically different from its counterparts in the world of entertainment. Even Lester D. Friedman, for example, who argues that a radical shift occurred in film content after WWI, questions the general nature of silent film stereotypes: "To a great degree, ALL silent-film characters--heroes as well as villains, WASPS as well as Jews--were stereotypes. The White Virgin was as unfair to American women as Fagin or Shylock to the Jews."[1179] As for films that portrayed Jews as evil or sneaky, he points out that many more depicted them as victims and/or heroes. Here he makes three interesting observations. First, the Jew as victim almost never occurred in films set in America. That is, the pattern was to show European Jews being persecuted in foreign lands (mostly Russia). There they had no hope of justice or revenge. But in films set in America, the plot emphasized that no matter what problems the immigrant Jews faced (e.g., illiteracy, poverty, or overcrowding), they were far better off than in Europe. Second, Friedman rationalizes the unflattering silent screen images of Jews as being reflective of "the insecurity of Gentile businessman [sic] facing strong Jewish competition."[1180] Third, he argues that many of the screen adaptations relating to Jewish themes and characters remained faithful in spirit if not in text, to the original author's intentions, as well as to the prejudices of the era during which the film was produced. In short, silent films appealed to everyone interested in becoming an ideal American. Negative images were used primarily as an inducement to assimilate. "Any residual anxiety over the loss of ethnic identity," Friedman points out, "was lost in laughter at outmoded ways of thinking--or soothed by promises tacitly given by the new order."[1181]

Perlmutter takes a similar tack, arguing that

> The pressures for assimilation and the absorption of differences into the
> dominant culture were felt at all levels of production and distribution.
> Assimilation stories with stereotyped characters and situations resolved by
> marriage as the goal of communal integration, abounded in most popular cultural
> forms: the musical, low comedy, the social melodrama. In the case of films about
> Jews, the Hollywood patriarchs . . . played a significant role in the

[1177] Erens, THE JEW IN AMERICAN CINEMA, p.72.

[1178] Ralph Willett, "Nativism and Assimilation: the Hollywood Aspect," JOURNAL OF AMERICAN STUDIES 7:2 (August 1973):192.

[1179] Friedman, "The Conversion of the Jews," p.42.

[1180] Friedman, "The Conversion of the Jews," p.43.

[1181] "Celluloid Assimilation," p.136.

acceptance of the stereotypes as the truth of the American-Jewish experience. Believed in by Jews and non-Jews alike, these simplified truths further compounded the repression of differences and inhibited the full expression of the realities and variety of the American-Jewish experience . . . They offered seduction while concealing the tensions shared by Americans, American-Jews and other immigrants.[1182]

The thrust of Perlmutter's argument is that coincidence more than anything else made the interests of the Russian Jews dovetail with the nation's need to assimilate large numbers of immigrants into society and with the economy's flexibility in accommodating the oligopolistic interests of the film industry. She goes on to argue that Chaplin's screen persona typifies the "immigrant temperament," while Keaton's resembles "an endemically American sensibility."[1183]

Samuels generally supports Perlmutter's position, pointing out that the early films were targeted for immigrant audiences and were therefore concerned with offering a product that would prove both entertaining and profitable. The key ingredient was humor. As Samuels explains, "Making fun of Jewish mannerisms and customs, done with sympathy and understanding, made this new 'toy' called films, not only an acceptable mode of entertainment, but also a way of giving these often bewildered, alienated ethnic groups a feeling of cultural familiarity."[1184] Thus neither Friedman, Perlmutter, nor Samuels attaches much importance to charges that the early silent film was anti-Semitic in its themes or characterizations.

Thomas Cripps goes further by making a case for silent film's being particularly sympathetic to Jewish characters and for American movies' actually serving "as a preconditioning contributor to the fading of popular anti-Semitic stereotypes."[1185] His two basic points are that (1) the new urban novelty had its roots in vaudeville, and (2) the small band of enterprising Jews that took over the industry in the teens produced a "sentimentalized stereotype of an Americanized immigrant who symbolized the assimilationist experience of the Jewish studio bosses."[1186] In developing his case, Cripps relies on the theory that vaudeville's comic format operated as a safety valve for relieving the tensions in the ghettos. He briefly reviews the transition from the stage traditions of ethnic types, to their use in the early film comedies of Mack Sennett and Charles Chaplin, pointing out that in most instances, the film comics toned down racial slurs and consciously presented a "friendly depiction of immigrants that endowed them with far better prospects than those available to them in actual life."[1187] Silent film melodramas only added to a romanticized image of ghetto life. In fact, Cripps claims that Jews fared much better in screen narratives than they did in the other media. Not only did filmmakers balance their dramatic tales with Jews as both heroes and villains, but also the variety of characters and plots was so large that the combination "precluded the emergence of a film stereotype."[1188] In response to charges that once the enterprising Russian Jews gained control of the silent film industry no memorable image of Jews appeared, Cripps insists that the

[1182] Perlmutter, p.249.

[1183] Perlmutter, p.250.

[1184] Samuels, p.24.

[1185] Cripps, p.190.

[1186] Cripps, p.191.

[1187] Cripps, p.193.

[1188] Cripps, p.196.

critics are overlooking the role that assimilationist movies like HUMORESQUE (1920), ABIE'S IRISH ROSE (1922), POTASH AND PERLMUTTER (1923), THE COHENS AND THE KELLYS (1926), and THE JAZZ SINGER (1927) played in reinforcing the values of the film moguls. In short, Cripps believes that the generally positive treatment of Jews in the silent film provides the basis for American liberalism that flourished during the New Deal and the Second World War.[1189]

A second assumption throughout this chapter and one directly related to the chronology of the characters and themes in Jewish-American studio films is that since the late 1890s social observers have recognized that movies are more than escapist entertainment. In simple terms, audiences not only "escape from" something, but also "escape to" something. The film industry often understands how to capitalize on audience expectations and societal issues. In those instances, films become "agents" for change or for maintaining the STATUS QUO. Although such interaction can take place on a conscious or unconscious level, the film collectively become a valuable historical document on the emotional and social problems not only of a generation, but also of specific groups. An awareness of the interaction between films and audiences is not relegated to hindsight. As discussed earlier, many film commentators cite examples of social workers, educators, religious leaders, and government officials who "feared" the "effects" of movies on the young and the impressionable.

Few scholars, however, have related these fears to the depiction of Jews or to how movies functioned as a negative socializing mechanism. For example, scant attention is given to the activities, beginning in 1916, of the B'nai B'rith Anti-Defamation League and its crusade to draw attention to the negative images of Jews in early films like INTOLERANCE (1916), where Jews were depicted falsely as responsible for the death of Jesus.[1190] Not only did pressure from B'nai B'rith and middle- and upper-class Jews act to eliminate such distortions during the Progressive era, but such actions also reinforced the views of the film hierarchy who actively searched for a suitable film image for Jews.

The story of how that image evolved from the turn of the century to the present has just begun to be understood, thanks mainly to the efforts of authors like Thomas Cripps, Patricia Erens, Stuart Fox, Lester D. Friedman, Neal Gabler, Eric A. Goldman, and Stuart Samuels. Here we need only outline the pattern described, hoping that future scholars will expand many of the tentative ideas presented. Before beginning, however, we should remember that condensing over eighty years of film history into a few pages grossly distorts how the film continuum operates. It is essential, therefore, that readers recall the three theoretical constructs presented at the start of this chapter. First is Walsh's position that we view the film process as dynamic rather than static. Second is Lesage's schema that to examine film adequately we need to study the total process from its pre-filmic origins to its reception by the audience. Third is Abrams's perspective that meanings and images are a collaborative affair that properly understood bring a clearer understanding not only of mass media, but also of mass media art as a social force in society. In addition, for those readers interested in pursuing how mass communication operates as a process, it is useful to recall the types of graphic descriptions available for discussing and analyzing the relationship between filmmakers and their audiences. For example, the "Cultural Ratification Model" is designed to examine how the media participate, along with other social institutions, as agencies of political control. The "Uses and Gratification Model" functions as a means of evaluating how the media educate us as well as serve as a form of catharsis. Furthermore, there is value in approaching the history of Jewish film images through the concept of "Functionalism," in which investigators explore the role of the audience in the mass media continuum. The focus is on social and economic systems that are then reduced into sub-systems such as pressure groups, production and distribution units, and financial sources.

[1189] Cripps, p.203.

[1190] Cripps, p.72.

Each of these perspectives reminds us in various ways of the danger of overinterpreting film content and of oversimplifying the complex relationship among film conventions, filmmakers, and film audiences. What is offered in the following pages, therefore, is intended only as an outline of important issues that require serious debate and detailed investigation.

As discussed earlier, the primitive period of films (1894-1908) saw filmmakers relying heavily on vaudeville traditions as crucial to film content. Consequently, many of the first film images of Jews reflected considerable xenophobia and ridicule. Foreigners often were caricatured, and, along with Italian, Irish, and German immigrants, the Eastern European Jews were ridiculed both for their physical appearance and for their behavior.[1191]

Once the filmmakers realized that a major appeal of the movies was the "information" about assimilation, their immigrant audiences extracted (and that social reformers demanded be emphasized), film content gradually shifted away from mere caricatures to social types trying to fit into the New World. That is, filmmakers continued to make movies extolling ethnic traditions at the same time that the melting pot theory was beginning to take over the film industry. Understandably, the most prevalent subgenre of the emerging Jewish-American film was the melodrama. One major theme centered on immigrants adjusting to life in the New World. For example, films like A CHILD OF THE GHETTO (1910) and THE HEART OF A JEWESS (1913) show Jews exhibiting the same qualities associated with ideal Americans. The former concerns a Jewish orphan girl whose sterling character convinces a policeman that she is innocent of any wrongdoing. The latter involves a hardworking and virtuous woman who finally chooses the right man as her husband. Both films are set in the crowded living conditions of New York's Lower East Side. As Weinberg points out, it was not enough for the Jewish film characters to have "American" ideals. It was also important, in most of these films, that ethnic identity be associated with "anxiety, despair, and physical hardship." The message was clear: "In order to be accepted in American society, they [the immigrant audience] had to discard their traditional baggage and take upon themselves the common ideals of American life."[1192] A second

[1191] For a good overview of film stereotypes dealing with Germans, Native Americans, Italians, Puerto Ricans, African-Americans, and the Irish, see *Randall M. Miller, ed., THE KALEIDOSCOPIC LENS: HOW HOLLYWOOD VIEWS ETHNIC GROUPS (New York: Jerome S. Ozer, 1980); and ___, ETHNIC IMAGES IN AMERICAN FILM AND TELEVISION. For additional information about Hispanics, see *Gary D. Keller, ed., CHICANO CINEMA: RESEARCH, REVIEWS, AND RESOURCES (Binghamton: Bilingual Review/Press, 1985); Blaine P. Lamb, "The Convenient Villain: The Early Cinema Views the Mexican-American," JOURNAL OF THE WEST 14:4 (October 1975):75-81; *Arthur G. Petit, IMAGES OF THE MEXICAN AMERICAN IN FICTION AND FILM, ed. and Afterword Dennis E. Showalter (College Station: Texas A&M University Press, 1980); and A. Woll, "'Latin' in Hollywood Films Often Caricature to Latins," VARIETY (April 4, 1979):35, 42, 44. Other useful articles on ethnic stereotyping are Jack G. Shaheen, "The Hollywood Arab: 1984-1986," JOURNAL OF POPULAR FILM AND TELEVISION 14:4 (Winter 1987):148-57; "The Arab Image in American Film and Television," CINEASTE 17:1 (1989):2-25; Frank Chin, "Confessions of a Number One Son," RAMPARTS 11:9 (March 1973):41-8; Richard Alan Nelson, "Mormons as Silent Cinema Villains: Propaganda and Entertainment," HISTORICAL JOURNAL OF FILM, RADIO & TELEVISION 4:1 (April 1984):2-14; Richard Schickel, "Why Indians Can't Be Villains Any More," NEW YORK TIMES 2 (February 9, 1975):1, 15; David Hwang, "Are Movies Ready for Real Orientals," ibid., 2 (August 11, 1985):1, 21; "Italian-American Demur Gangster Image in Film," BOXOFFICE 109 (August 30, 1976):E3; and "Richard Conte Getting Offers He Can't Refuse as Ideal Mafia Type," VARIETY 270:5 (March 14, 1973):2, 70.

[1192] Weinberg, p.63.

major theme of the melodramas, as Erens notes, was "the depiction of Czarist oppression in Europe."[1193] For example, IN THE CZAR'S NAME (1910) followed the troubles of a Russian Jewish family surviving a massacre, being exiled to Siberia, and finally immigrating to America. Not content with extolling the virtues of the New World, the filmmaker also made certain to include a positive image of intermarriage.

The twenties witnessed the Jewish movie moguls firmly entrenched and in charge of a large cadre of creative talent. Through a complicated process of pre-production, production, and post-production conferences and strategies, the corporate executives maintained a tight grip on the content of their studio films. That was certainly true of the film image of the Jew. Divided between melodramas and comedies, the Jewish-American film of this era dwelled on sentimentality, pathos, and humor.[1194] For example, HUMORESQUE (1920) gave audiences an emotional feast as a struggling Jewish mother strives to help her loving son become a world-class violinist. While most of the nearly 100 Jewish-American films preached assimilation, a handful of films like HIS PEOPLE (1925), APRIL FOOL (1926), and THE YOUNGER GENERATION (1929) championed Old World values. In these movies, the filmmakers stress the price that people pay for denying their cultural heritage. For example, HIS PEOPLE features two sons, Sammy and Morris, who symbolize the struggle between ethnic and assimilationist values. In the end, Sammy's Old World ties prove to be the most worthy. There was, however, one notable change from the past: Sammy marries a SHIKSA, a non-Jewish woman. In fact, intermarriage epitomized the essence of acculturation in the movies. Furthermore, this perspective on intermarriage reflected the film emphasis during the final days of the silent era on upward mobility and becoming integrated into the modern world. The best example of the decade is THE JAZZ SINGER (1927), with its emphasis on the clash between traditional and contemporary values. Particular attention is paid to what Jackie Rabinowitz (Al Jolson) has to do in terms of dress, speech, and customs in order to be accepted in the Gentile show business world.[1195]

Not every silent film presented the screen image of the Jew fashioned by the Hollywood moguls. The most notable exceptions were found in the Yiddish cinema. Like Hollywood movies, the Yiddish cinema had its roots in the theater, only this time it was the Yiddish theater. According to Judith N. Goldberg,

> The Yiddish theater was the major form of popular entertainment available to Eastern European Jews. Its history is brief. Yiddish theater began in Jassy, Rumania, in 1876 and very quickly developed into a mishmash of historical pageantry, family melodramas, musical comedies, and topical references all tossed together on the stage like chop suey.[1196]

During the third major period of Jewish immigration to the United States (1880-1924), many prominent members of the Yiddish theater established acting companies on the east coast. Their founding father in America was Boris Thomashevsky. The major portion of their repertory was hits from the late 1800s like Solomon Z. Anski's THE

[1193] Patricia Erens, "Between Two Worlds: Jewish Images in American Films," THE KALEIDOSCOPIC LENS, pp.118-9.

[1194] "Between Two Worlds," p.120.

[1195] For more information on the film's star, see Michael Freedland, JOLSON (New York: Stein and Day, 1972); *Robert Oberfirst, AL JOLSON: YOU AIN'T HEARD NOTHIN' YET (San Diego: A. S. Barnes and Company, 1982); Pearl Sieben, THE IMMORTAL JOLSON: HIS LIFES AND TIMES (New York: Frederick Fell, 1962); and Herbert G. Goldman, JOLSON: THE LEGEND COMES TO LIFE (New York: Oxford University Press, 1988).

[1196] Judith N. Goldberg, LAUGHTER THROUGH TEARS: THE YIDDISH CINEMA (Rutherford: Fairleigh Dickinson University Press, 1983), p.18.

DYBBUK/DER BIKUK, Peretz Hirshbein's GREEN FIELDS/GRINE FELDER, and Sholom
Aleichem's TEVYE THE MILKMAN/TEVYE DER MILKHIKER. From their Second Avenue
base, the Yiddish theater companies traveled across the country, building not only
an audience for Jewish culture and theater, but also an audience for Yiddish films.

Although this film genre really did not prosper until the coming of sound, it
had its roots in the silent era. What made a Yiddish silent film different from the
standard Hollywood movies depicting Jewish themes and characters, Eric A. Goldman
explains, was that the Yiddish film was "a Jewish cultural expression on film aimed
primarily at Yiddish speaking audiences which works toward strengthening Jewish
identity and survival."[1197] In place of film plots about intermarriage and upward
mobility, Yiddish filmmakers like Sidney M. Goldin and Ivan Abramson made movies
highlighting anti-Semitic injustices in Russia, unusual Jewish heroes, and the tragic
problems of Jewish immigrants. Their best-known work was REMEMBRANCE/YISKER
(1924), which focused on the problems of immigrant Jews living in an American Gentile
society. It should be noted that these thinly veiled morality films never posed a
serious challenge to the Hollywood box office. Not only was there a limited audience
for the low-budget tearjerkers, but also the total number of Yiddish feature films
between 1910 and 1942 amounted to 130.

As the Jewish film moguls tightened their grip on the film industry in the 1930's,
Hollywood's emphasis on assimilation became even more prominent. The reasons were
many: e.g., ethnic stories were no longer popular or profitable, the moguls refused
to draw attention to their religious heritage, the reliance on overseas markets made
it foolish to antagonize fascist nations like Germany and Italy, and filmmakers aimed
at appealing to the widest possible audiences. There were, however, occasional
exceptions. Early films like THE HEART OF NEW YORK and THE SYMPHONY OF
6,000,000 (both in 1932) depicted the difficulties created by the Depression and
magnified the problems of immigrants trying to adjust to New World values. Unlike
the silent films of the past, the early 1930s movies had sound not only to make their
sentimental points, but also to disguise the identity of screen characters. One result,
according to Samuels, was to eradicate any serious image of the Jew as Jew: "The
aim was to erase all traces of the evidence that the Jew existed apart from
others."[1198] Examples of the "de-Semitization" process can be found in the screen
adaptations of books and plays like COUNSELLOR-AT-LAW (1933), TWENTIETH
CENTURY (1934), THE FRONT PAGE, WINTERSET (both in 1936), and GOLDEN BOY
(1938). As Samuels points outs, names were changed, noses altered, couples
intermarried, accents disappeared, and speech patterns followed WASP
intonations.[1199]

The few notable exceptions to this de-Semitized approach were films like
DISRAELI (1929) and THE HOUSE OF ROTHSCHILD (1934). In those instances where
ethnic cultural ties persisted in screen roles, the characters were presented as
good-natured amusing figures. "What seemed to the public as a stubborn refusal by
original immigrants to social acculturation," comments Weinberg, "thus was explained
away as mere physical peculiarities having no effect upon the acceptance of the
American way of life."[1200] This emphasis is most evident in the delightful film
comedies of Alexander Carr, Sammy Cohen, Max Davidson, Vera Gordon, George
Jessel, Gregory Ratoff, Benny Rubin, and George Sidney.

[1197] *Eric A. Goldman, VISIONS, IMAGES, AND DREAMS: YIDDISH FILM PAST AND PRESENT (Ann
Arbor: UMI Research Press, 1983), p.xviii.

[1198] Samuels, pp.27-8.

[1199] Samuels, p.28.

[1200] Weinberg, p.65.

Another example of the rebellion against social acculturation was the Yiddish film of the 1930s. Its preoccupations, as Betty Yetta Forman reminds us, were "Jewish values subjected to the stresses of immigration, Americanization and the threat of ultimate assimilation."[1201] These concerns flourished in Yiddish films, in part because many of the films were screen adaptations of famous Yiddish literature and dramas. 'Grounded in the concept of MENTSHLEKHKAYT (the ethos of the good man), which is at the heart of all Jewish literature," explains Erens, "Yiddish films emphasized man's obligations to his fellow man, faith in the goodness of all human beings, and a belief in ultimate justice."[1202] The leading producer and director of the independently released and distributed shoestring productions was Joseph Seiden. For more than thirty years (1929-1961), he led the way in adapting the Yiddish theater to the Yiddish screen. Among his more popular films were LOVE AND PASSION/LIBE UN LAYDNSHAFT (1936),[1203] I WANT TO BE A MOTHER/IKH VIL ZAYN A MAME (1937), and HER SECOND MOTHER/IR TSYVEYTE MAME (1940). Another prominent director and producer was the distinguished Yiddish actor Maurice Schwartz. Two of his popular productions were UNCLE MOSES (1932) and TEVYE THE MILKMAN/TEVYE DER MILKHIKER (1939). Perhaps the best known of the Yiddish film directors is Edgar G. Ulmer, who made the noted Hollywood horror film, THE BLACK CAT (1934). Among his hits in the Yiddish film were GREEN FIELDS/GRINE FELDER (1937), THE SINGING BLACKSMITH/DER ZINGENDIKER SHMID (1938), THE DOBBIN/DI KLYATSHE (1939),[1204] and AMERICAN MATCHMAKER/AMERICAN SHADCHAN (1940).

Most of the Yiddish cinema was preoccupied with providing a showcase for legendary Yiddish performers like Celia Adler, Jacob Ben-Ami, Leo Fuchs, Berta Gersten, Ida Kaminska, David Opatoshu, Moisher Oysher, Molly Picon, Maurice Schwartz, Menasha Skulnick, and Boris Thomashevsky. The films themselves ran the gamut of human experiences from bittersweet tragedies to popular revues. According to Forman,

The themes are deceit and disintegration--sibling rivalry, disputed wills, lost children who turn up years later as prosperous and ungrateful doctors and lawyers. The long-suffering main characters are just as likely to be male as female, a fact glossed over by those who mistakenly consider Yiddish cinema matriarchal in orientation. In a theatrical world ruled by coincidence, poetic justice is the ultimate arbiter of fates: the bad are redeemed and the good finally get what they deserved all along. The melodramas duplicate the preoccupations of the most serious plays, but with cruder language, simpler plots and pat resolutions which rely on the raw emotive force of the actors.[1205]

While they lasted, these extraordinary films filled a much-needed role in Jewish life and culture.

But by the end of the 1930s not even the famous stars and the classic literary sources could maintain the Yiddish film. The immigration laws of the middle twenties had drastically reduced the potential audience for these "B" productions. In addition,

[1201] Betty Yetta Forman, "From the AMERICAN SHADCHAN to ANNIE HALL: The Life and Legacy of Yiddish Film In America," THE NATIONAL JEWISH MONTHLY 92:3 (November 1977):4.

[1202] Patricia Erens, "Mentshlekhkayt Conquers All: The Yiddish Cinema in America," FILM COMMENT 12:1 (January-February 1976):48.

[1203] Released as LOVE AND PASSION.

[1204] Released as THE LIGHT AHEAD and FISHKE DER KRUMER.

[1205] Forman, p.6.

as Erens notes, "Second generation American Jews had become assimilated; many no longer understood Yiddish at all."[1206] Finally, audiences had become too sophisticated to accept the highly sentimentalized and crude visual techniques of most of the Yiddish film productions.

Along with the Yiddish films, Hollywood's dialect comedians and gritty depictions of ghetto life soon faded from the screen as the danger of fascism increased in Europe. Except for films like PROFESSOR MAMLOCK (1938), where the Nazi threat to Jews was stated openly, Hollywood found it expedient, for reasons explained earlier, to camouflage the film Jew. Henry Popkin expressed the indignation of many Jews when he wrote, "More disturbing than the disappearance of one Jewish character here and another there, is the absence of recognizable Jews in films that REQUIRE their presence."[1207]

The years leading up to World War II highlighted the fears of Jews in Hollywood.[1208] In particular, the corporate executives and their stables of creative talent faced considerable criticism from pressure groups and congressional committees over the film industry's "Communist leanings." Too many know-nothing critics glibly assumed that since many of the industry's most powerful figures and/or their parents were from Russia, it was obvious that the film community was bustling with "pinkos." On the other hand, it was true that Jews figured prominently in the American Communist Party.[1209] Howard Suber neatly summarizes the situation by pointing out that

> During the Thirties and Forties when the Communist party was at its height, few of America's 4,500,000 Jews were Communists. But there was no doubt that of its 50,000 members "a large proportion . . . were of Jewish origin." In Hollywood their numbers were small but notably conspicuous. Of the 30,000 employees in the motion picture industry less than 400 were Communists. Of these a high proportion were in the Hollywood Section of the Communist party and a majority were Jews. In 1947, of the first nineteen people to be subpoenaed for questioning regarding Communist affiliations by the House Un-American Activities Committee, thirteen were Jews. Of the "Hollywood Ten," the first group to be blacklisted, six were Jews.[1210]

The topic of the "Hollywood Reds" will be covered in more detail in Chapter 5. Suffice it to say that because Hollywood faced considerable criticism for its Communist activities, in addition to Jews having been unjustly stereotyped as international conspirators, the film industry, during a period of massive social unrest between the two world wars, was extremely skittish about calling attention to political, radical,

[1206] "Mentshlekhkayt Conquers," p.53.

[1207] Harry Popkin, "The Vanishing Jew of Our Popular Culture: The Little Man Who Is No Longer There," COMMENTARY 14:1 (July 1952):52.

[1208] For an example of the problems that Sergei M. Eisenstein faced in regard to his Jewish heritage when he came to Hollywood in 1930, as well as the problems of Hollywood Jews in general, see *Marie Seton, SERGEI M. EISENSTEIN: A BIOGRAPHY, Rev. ed. (London: Denis Dobson, 1978), p.168.

[1209] For a good discussion of Jews and middle-class groups and the Communist party, see Nathan Glazier, THE SOCIAL BASIS OF AMERICAN COMMUNISM (New York: Harcourt, Brace and World, 1961), pp.130-68; and Lucy S. Dawidowicz, "Book Review: THE SOCIAL BASIS OF AMERICAN COMMUNISM and WRITERS ON THE LEFT," AMERICAN JEWISH QUARTERLY 53:2 (December 1963):192-7.

[1210] Suber, "Politics," p.518.

and subversive ideas or causes in its popular theatrical films. Not only was it bad for business, but also it was politically dangerous. It is not surprising therefore, that such conservative businessmen made it a point to show the dangers of fascism to everyone and not to focus on the problems of European Jews. The fact that Hollywood put profit before purpose in dealing with Nazism is discussed in Chapter 2. For our purposes, we need only remember that few films showed the danger posed to Jews by Hitler and his cronies. In fact, the major pre-WWII film on the subject--THE GREAT DICTATOR (1940)--was not made by a Jew or by one of the major studios. On those rare occasions when Jews were shown standing up to the Nazi war machine, the screen characters almost always "were depicted as complete assimilationists, fighting the Nazis because of identification with the nation in which they reside rather than because of concern with Jews in other countries."[1211]

Once America entered WWII, Hollywood made certain that Jews played a visible, although not major, role in helping beat the Axis powers. As discussed in Chapter 2, war films generally featured a group of brave Americans doing their duty on the land, in the air, and on the seas. In almost every instance, in films like BATAAN, GUADALCANAL DIARY, AIR FORCE (all in 1943), THE PURPLE HEART (1944), and A WALK IN THE SUN (1945), a Jew is a member of the platoon or squadron. Generally portrayed as the intellectual and laid back type, the Jew invariably dies in order to save his buddies. What is especially interesting, as Weinberg notes, is that the stereotype of the Jew in these 1940s war films excludes any significant concern on his part that WWII is about saving the lives of European Jews. The emphasis is almost exclusively on the Jew defending his country. Samuels sees the wartime films as indicative of the third stage in the acceptance of Jews in American society. That is, mainstream America, through its movies, perceived the Jewish community as having basically the same values and characteristics as the majority of Americans. Whatever differences existed between the minority group and the majority were now deemed trivial.[1212]

In addition to a rash of film biographies about Jews--e.g., George Gershwin, RHAPSODY IN BLUE (1945); Jerome Kern, TILL THE CLOUDS ROLL BY (1946); Al Jolson, THE JOLSON STORY (1946) and JOLSON SINGS AGAIN (1949)--the immediate post-WWII period gave rise to a number of "problem films" describing social injustice in America. Among the lot were two dealing with anti-Semitism: GENTLEMAN'S AGREEMENT and CROSSFIRE (both in 1947). Three striking similarities about the films were these: (1) Jews superficially appeared assimilated into American society; (2) the problem of anti-Semitism resulted from the prejudice of non-Jews rather than

[1211] Weinberg, p.65. See also *Henry L. Feingold, THE POLITICS OF RESCUE: THE ROOSEVELT ADMINISTRATION AND THE HOLOCAUST, 1938-1945 (New Brunswick: Tutgers University Press, 1970), pp.295-307.

[1212] Samuels, p.29. Suber makes the valuable observation that the American film industry's treatment of "minorities" during WWII reveals not only Hollywood's racial values, but also the position of various minority groups in society. For example, the term "minority group" referred almost exclusively to racial or national groups (e.g., Jews, Italians, Poles, and Catholics). "Generally missing from the 'melting pot'," Suber points out, "were blacks, Chicanos, American Indians, and Orientals. And the idea that women, gays, and other non-ethnics might constitute another kind of 'minority group' hadn't even occurred to the vast majority of Americans." For more information, see Howard Suber, "Gays, Gals, Goys, and All Those Other Minorities on Media," VARIETY (January 1, 1976):22.

from the premise that Jews behaved and looked different from other Americans;[1213] and (3) the problem was one that concerned all Americans, not just Jews.[1214]
 The horrors of the Holocaust and the creation of the state of Israel in 1948 presented both a striking cohesiveness among Jews and fresh dilemmas to the filmmakers. First, a new pressure group, the Motion Picture Project (representing various Jewish organizations), demanded a more positive image of Jews on screen. The success of its campaign became obvious not only from the post-WWII films already mentioned, but also from biblical films like SAMSON AND DELILAH (1949), DAVID AND BATHSHEBA (1951), THE TEN COMMANDMENTS (1956), BEN HUR (1959), ESTHER AND THE KING, SOLOMON AND SHEBA, and THE STORY OF RUTH (all in 1960). These stories about ancient atrocities against the Jews became the film industry's initial attempt to depict the Holocaust. More direct references would come later in the 1960s. In the meantime, the question of how to portray Israel on screen became a problem for Hollywood's Jews. On the one hand, the Jewish film establishment took considerable pride in the existence of a national homeland and the heroic efforts that were associated not only with its birth but also with its struggle to survive. Typical of this position were films like SWORD IN THE DESERT (1949), THE JUGGLER (1953), EXODUS (1960), and CAST A GIANT SHADOW (1966). As Gabler points out, "The war didn't make Americans of the Hollywood Jews, but the aftermath of the war DID make Jews out of the Hollywood Americans--at least temporarily."[1215] On the other hand, Israel proclaimed that Jews worldwide owed allegiance, in one form or another, to the Jewish state. Consequently, many American Jews, who never denied their loyalty to America, suddenly appeared to outsiders as having divided loyalties. The Hollywood filmmakers feared that any film championing Israel and her separationist policies would ignite a new wave of anti-Semitism in America.
 Compounding the problem, and to be discussed in detail in Chapter 5, was the infamous blacklisting taking place in Hollywood during the late 1940s and the 1950s.[1216] The combination of anti-Semitism and anti-Red resulted in removing almost any visible portrayal of Jewish culture and history for most of the decade.[1217] Only

[1213] Weinberg, p.66. For useful insights on the two films, see Herbert F. Margolis, "The Hollywood Scene: The American Minority Problem," PENGUIN FILM REVIEW 5 (January 1948):82-5; Louis Raths and Frank Trager, "Public Opinion and CROSSFIRE," JOURNAL OF EDUCATIONAL SOCIOLOGY 21:6 (February 1948):345-68; and Irwin C. Rosen, "The Effect of the Motion Picture GENTLEMEN'S AGREEMENT on Attitudes Towards Jews," JOURNAL OF PSYCHOLOGY 26 (October 1948):525-36.

[1214] Anyone doubting that anti-Semitism still existed in the studios should read Lauren Bacall's anecdote about her experiences with Howard Hawks in the mid-1940s. See Laureen Bacall, BY MYSELF (New York: Alfred A. Knopf, 1979), pp.79, 95. See also Garson Kanin's account about the making of BORN YSTERDAY in *Garson Kanin, HOLLYWOOD: STARS AND STARLETS, TYCOONS AND FLESH-PEDDLERS, MOVIEMAKERS AND MONEYMAKERS, FRAUDS AND GENIUSES, HOPEFULS AND HAS-BEENS, GREAT LOVERS AND SEX SYMBOLS (New York: The Viking Press, 1967), p.373.

[1215] Gabler, p.348.

[1216] For a useful overview of the rise of HUAC, see Chapter 5. For valuable insights into the career of Martin Dies and his relationship to Jews, see William Gellermann, MARTIN DIES (New York: The John Day Company, 1944), pp.49-53, 95-115; Martin Dies, THE MARTIN DIES' STORY (New York: Bookmailer, 1963), pp.157-72; and Alvah Bessie, THE UN-AMERICANS (New York: Cameron Associates, 1957), pp.24-9.

[1217] For a useful account of how many Hollywood Jews reacted to the Communist scare early in the postwar period, see Budd Schulberg, "The Celluloid Noose," SCREEN

as the red scare abated did Hollywood once more explore the nature of Jewish problems. Films like HOME BEFORE DARK, ME AND THE COLONEL, I ACCUSE, MARJORIE MORNINGSTAR (all in 1958), THE DIARY OF ANNE FRANK, THE LAST ANGRY MAN, and THE MIDDLE OF THE NIGHT (all in 1959) once again focused attention on the Jewish experience at home and abroad.

A still further dilemma, discussed earlier, was the beginning of the breakup of the studio system that had dominated Hollywood for nearly three decades. The PARAMOUNT decision set in motion not only the end of the Jewish moguls' enormous power, but also the opportunity for the studios to be bought up by conglomerates in the sixties. Once that occurred, the images manufactured by Hollywood would be created almost exclusively by the dictates of the box office, rather than by the prejudices of studio heads. Films would no longer be targeted for general audiences, but aimed at specific groups. Thus the age-old fear that movies about minorities had too limited an appeal to mass audiences dissipated, especially after the success of Jewish comics and performers--e.g., Milton Berle, Sid Caesar, and Gertrude Berg--on television in the fifties.[1218] Moreover, as Gabler explains, the Jews had lost control of the film industry: "In 1927, when Paramount was riding high and Zukor was in control, twelve of the nineteen directors on the company's board were Jewish. In 1953 two of the ten were, and virtually none of the board members were movie men. The financiers and industrialists--the genteel to which the movie Jews had always aspired--had moved in."[1219]

The social upheaval of the 1960s finally forced filmmakers to abandon their conservative attitudes toward depicting the ethnic traits and traditions of "outsiders." Diversity rather than conformity became the measuring rod by which American idealism was judged. Helping move Jews to acceptance, Samuels points out, was a series of reactions directly related to the survivors of the Holocaust, the growing prominence of Jewish-American authors, the creation of the state of Israel, and the victory of the Jewish nation in the Six-Day War.[1220] The result of the Jews' new status was reflected in the images of Jews on screen. In almost every film genre, Jews assumed a significant role. Gangster films like MURDER INC. (1960) featured Peter Falk as the vicious killer Abe Reles; KING OF THE ROARING TWENTIES (1961) starred David Janssen as the infamous mobster Arnold Rothstein.[1221] Comedians like Mel Brooks and Woody Allen emphasized Jewish culture and values in films like THE PRODUCERS (1968) and TAKE THE MONEY AND RUN (1969).[1222] Also noteworthy was the change in the image of Jewish women. Following the introduction of the Jewish-American Princess in MARJORIE MORNINGSTAR, American filmmakers began turning their attention away from bland characterizations of supportive Jewish sweethearts, wives, and mothers toward a diverse assortment of provocative and controversial

WRITER (August 1946). Rpt in HELLO, HOLLYWOOD: THE STORY OF THE MOVIES BY THE PEOPLE WHO MAKE THEM, eds. Allen Rivken and Laura Kerr (Garden City: Doubleday and Company, 1962), pp.435-53.

[1218] For a useful perspective on the differences between TV shows like the 1950s' "The Goldbergs" and the 1980s' "The Cosby Show," see Francine Klagsbrun, "'The Goldbergs'--Stereotypes Loved by Americans," NEW YORK TIMES A (August 8, 1988):17.

[1219] Gabler, p.428.

[1220] Samuels, p.31.

[1221] For a useful perspective on the Jew as a criminal type, see David Singer, "The Jewish Gangster: Crime as 'Unzer Shtik,'" JUDAISM 23:1 (Winter 1974):70-7.

[1222] For more information, see Samuels, pp.32-4; and Frank Manchel, THE BOX-OFFICE CLOWNS: BOB HOPE, JERRY LEWIS, MEL BROOKS, WOODY ALLEN (New York: Franklin Watts, 1979), pp.61-110.

characterizations in films like ENTER LAUGHING (1967), FUNNY GIRL (1968), GOODBYE, COLUMBUS, and HELLO, DOLLY (both in 1969). In sum, the Jew had finally made the big time in the movies.

By the 1970s, it was obvious that the new Hollywood had a new attitude toward depicting race and ethnicity.[1223] While the protests from special interest groups persisted, as Erens explains, Hollywood shifted away from the traditional stereotypes "of successful merchants, kindly physicians, intellectual lawyers or ubiquitous Jewish mothers," and moved toward a "range of interesting characterizations" involving gangsters, monsters, and "Jewish-American Princesses" (JAP's).[1224] The emphasis now was on cultural pluralism. Thus Jews were presented as multifaceted personalities rather than as one-dimensional heroes or villains. Starting in the late 1960s with I LOVE YOU, ALICE B. TOKLAS (1968), Jewish-American movies like THE FIXER, BYE, BYE BRAVERMAN, NO WAY TO TREAT A LADY (all in 1968), TAKE THE MONEY AND RUN (1969), WHERE'S POPPA? (1970), THE STEAGLE and FIDDLER ON THE ROOF (both in 1971), PORTNOY'S COMPLAINT, THE HEARTBREAK KID, MADE FOR EACH OTHER, and MINNIE AND MOSKOWITZ (all in 1972), and THE WAY WE WERE (1973) proved that the melting pot theory was no longer fashionable. Now the emphasis was on being "realistic," on "telling it like it is," and "letting it all hang out." Consequently, most of the new films took pleasure in showing both the good and bad sides of assimilation and the psychological price one pays for giving up one's ethnicity.

Not surprisingly, the new wave of Jewish film images produced some negative reactions. Typical of the backlash was Julius Schatz's observation that

> Films of the last two decades have tended to present the Jew in one dimensional roles. The picture of the Jewish mother has suffered terribly. In earlier works she cared for her family and protected her children but in WHERE'S POPPA she plays a selfish meddlesome mother and in COME BLOW YOUR HORN she is a whiney, complaining type and in ENTER LAUGHING she is a self-pitying manipulating wife and in PORTNOY'S COMPLAINT her major concern is gastronomic. Wealthier Jewish mothers in GOODBYE, COLUMBUS and SUCH GOOD FRIENDS and BLUME IN LOVE fare no better, interested only in status and material success.[1225]

Robert Moss concurs, commenting that "BLUME IN LOVE, SAVE THE TIGER, and THE HEARTBREAK KID show that not only has there been no advance since 1970 in dealing with the Jewish experience in this country, the movement has been distinctly retrograde."[1226] Marcia Pally states the problem succinctly, "What is happening to the base and core of American Judaism? If YENTL is any indication, we have changed--and in the change, lost too much."[1227]

[1223] For a brief but useful analysis of the changing film images of Jews abroad, see Patricia Erens, "The Image of the Jew in Recent European Pics," VARIETY 278:13 (May 7, 1975):77, 116.

[1224] Erens, "Gangsters, Vampires, and J. A. P.'s," pp.208-9.

[1225] Julius Schatz, "The Image of the Jew (In Films)," VARIETY 277:9 (January 8, 1975):74. See also Lester J. Keyser, "Three Faces of Evil," JOURNAL OF POPULAR FILM 4:1 (1975):4-31; and M. R. Friedman, "Exorcising the Past: Jewish Figures in Contemporary Films," JOURNAL OF CONTEMPORARY HISTORY 19:3 (1984):511-27.

[1226] Robert Moss, "BLUME and HEARTBREAK KID--What Kind of Jews Are They?" NEW YORK TIMES 2 (September 9, 1973):15.

[1227] Pally, p.54.

Although Erens acknowledges the negative reactions of some critics who found the new films "vulgar" and "truly anti-Semitic," she takes the position that "a shred of truth clings to each portrayal."[1228] Furthermore, she points to the impressive gains made by women in the film industry as a result of Women's Liberation: e.g., women screenwriters (Renee Taylor and Elaine May) who collectively offer an alternative to the traditional male interpretation of the urban Jewish experience. "What appears most relevant," Erens concludes, "is that in the midst of the film renaissance about Jewish life and side by side with the stereotyped Jewish mothers and their henpecked husbands are genuine efforts to treat the experience of their troubled off-springs."[1229]

One assumption that is still troubling is the notion that comedy acts as a catharsis against bigotry. Almost every film discussion of the film images of the Jew assumes that comedians from Chaplin to Allen take for granted the power of sight gags and jokes to destroy anti-Semitic attitudes. Perlmutter, for example, believes that acceptance of a minority group by the majority group allows the former to share in the laughter, outrage, and caricature of their stereotyped images along with the latter.[1230]

There is a growing number of critics, however, who feel that just the reverse may be true. That is, the more we are presented with racist and sexist stereotypes, the more these pejorative stereotypes are reinforced. Samuel Lewis Gaber, reacting to the controversial stereotypes in films like PORTNOY'S COMPLAINT, SUCH GOOD FRIENDS, MADE FOR EACH OTHER, and FRITZ THE CAT (all in 1972), describes the situation as "the new anti-Semitism which reinforces anti-Semitic stereotypes in some minds and creates them in others."[1231] An excellent introduction to this debate is found in Richard P. Adler's ALL IN THE FAMILY: A CRITICAL APPRAISAL. In addition to providing three scripts from the popular show, which began in 1971 and ran through the 1970s, the author provides a full range of reviews and a "symposium" on the significance of ALL IN THE FAMILY to American culture. Particularly enlightening is Neal Vidmar and Milton Rokeach's thoughtful and extensive analysis, which concludes that "On balance the study seems to support more the critics who have argued that ALL IN THE FAMILY has harmful effects."[1232]

Today, nearly six million Jews living in the United States and Canada are getting new opportunities to study how they have been and are being treated in moving pictures. According to Karyl Weicher, an executive of Jewish Media Services, a major

[1228] Erens, pp.212-3. Also worth noting are the strong reactions to the 1974 Canadian production of THE APPRENTICESHIP OF DUDDY KRAVITZ. Both the novel and the screenplay were written by Mordecai Richler, who, according to Dan Isaac (p.13), wanted the film to offend no one: "The movie seems to be straining to say: 'Make no mistake about it! We do not condone the behavior of Duddy Kravitz. Nor do we submit that he is representative of Jews in general.'" Isaac then goes on to add, "At least that is what the movie says out of one side of its mouth. From the other side, it seems to be making devastating revelations about its central character whom many will regard as generic."

[1229] Erens, pp.216, 221.

[1230] Perlmutter, p.36.

[1231] Samuel Lewis Gerber, "Jews in American Film and Television," ETHNIC IMAGES IN AMERICAN FILM AND TELEVISION, p.45.

[1232] Neil Vidmar and Milton Rokeach, "Archie Bunker's Bigotry: A Study in Selective Perception and Exposure," JOURNAL OF COMMUNICATION 24:1 (Winter 1974):36-47; Rpt. ALL IN THE FAMILY: A CRITICAL APPRAISAL, ed. Richard P. Adler (New York: Praeger, 1979), 123-37. The quotation cited in this chapter is from ALL IN THE FAMILY, p.137.

conduit for Jewish film and TV programs, "Jewish film festivals have been catching on around the country. . . ."[1233] Films like THEY WON'T FORGET (1937), THE WAY WE WERE (1973), THE FRISCO KID (1979), ZELIG, YENTL (both in 1983), and ONCE UPON A TIME IN AMERICA (1985) only begin to suggest how far the film industry has come from the 1908 film OLD ISAACS, THE PAWNBROKER. Clearly, the range of topics is greater than ever before, even if the depth of the film content is still sadly lacking.

As for the existence of anti-Semitism in Hollywood today, James Greenberg argues that "The Overt anti-Semitism of the old-line Bel Air nobility and Howard Hughes crowd may be gone. But then it has been replaced, in some cases, by a corporate style whitewashing of all ethnic traces."[1234] To prove his point, Greenberg interviews a number of Jewish filmmakers to get their reactions to working in Hollywood. For example, the screenwriter and novelist Steve Shagan points out that currently the only "Jewish" company operating in the industry is MCA "and they've certainly never made Jewish pictures."[1235] Other film personalities talk about the difficulty in getting Jewish films made today and the misperception, fostered by the media, that Jews still run the industry. To balance the attacks on contemporary anti-Semitism in the film industry, Greenberg cites the opinions of Richard Dreyfus, who insists that he doesn't see any "toning done" of Jewish roles; and the observations of Budd Schulberg, who believes that "People in the business are less self-conscious about being Jewish."[1236] In short, controversy still surrounds Jews working in Hollywood.

BOOKS

*Cohen, Sarah Blacher, ed. FROM HESTER STREET TO HOLLYWOOD: THE JEWISH-AMERICAN STAGE AND SCREEN. Bloomington: Indiana University Press, 1983. 278pp.

An uneven and repetitious collection of essays surveying the evolution of Jewish-American drama from the late 1890s to contemporary playwrights and filmmakers, this anthology provides a less than adequate introduction to the efforts of artists interpreting the struggles of immigrant Jews trying to assimilate into American life. The editor's opening essay, "Yiddish Origins and Jewish-American Transformations," sets the tone for the rest of the book. "JEWISH-AMERICAN DRAMA," she proclaims at the outset, "IS NOT AN ORPHANED ART FORM OF unknown parentage." Cohen then discusses how the Yiddish theater acted as the source for Jewish ethnicity in American entertainment, pointing not only to its literary role in dramatizing the conflicts between the Old World and the New, but also to its role in developing the traditions of famous stage personalities and playwrights like Molly Picon, Sophie Tucker, Fanny Brice, Elmer Rice, Arthur Miller, Clifford Odets, Lillian Hellman, Paddy Chayefsky, Lenny Bruce, and Isaac Bashevis Singer. Cohen's summary of film history provides little more than a superficial look at trends and events. A case in point is her treatment of the Hollywood red scare. Glossing over two decades of political infighting in Hollywood, she observes that "in the 1950s Hollywood was more responsive to the witch-hunting of the House Un-American Activities Committee than to the demands for truthful depiction of religious and

[1233] Quoted in Richard F. Shepard, "Cinematic Reflections on Jewish Life in 15-Work Festival at 92d Street Y," NEW YORK TIMES A (September 7, 1986):65.

[1234] James Greenberg, "Our Crowd," AMERICAN FILM 13:9 (July/August 1988):41.

[1235] Greenberg, p.41.

[1236] Greenberg, p.42.

political minorities." Instead of being forthright about the problems of the film industry or sensitive to the nature of the film continuum, Cohen obfuscates by stating that "a number of Jewish artists supposedly had Communist affiliations in the thirties" and attacks Hollywood (in her view, synonymous with Jewish moguls) for giving in to the witch-hunters. In addition, she overstates what the remaining second- and third-generation Jewish filmmakers turned out by way of films about the Holocaust and the state of Israel. Cohen also draws a spurious line between conservative film moguls and creative directors. Thus Sidney Lumet (e.g., THE PAWNBROKER) gets credit for being a "superb adapter of Jewish-American fiction," but Ely Landau, one of Lumet's important film producers, is ignored.

Only four of the anthology's eighteen essays bear directly on film. Lawrence L. Langer's "The Americanization of the Holocaust on Stage and Screen" focuses on plays like Frances Goodrich and Albert Hackett's THE DIARY OF ANNE FRANK, Millard Lampell's THE WALL, Arthur Miller's INCIDENT AT VICHY, as well as films like JUDGMENT AT NUREMBERG (1961) and the TV miniseries HOLOCAUST (1978). The author lambastes the Americans for their "moral oversimplifications," which allow them "to bury their tragedies and let them fester in the shadow of forgetfulness." Mark Schechner's "Woody Allen: The Failure of the Therapeutic" and Sanford Pinsker's "Mel Brooks and the Cinema of Exhaustion" cover familiar ground without offering any new insights. In addition, as David Desser points out, "A certain unfortunate stereotype runs throughout the book . . . especially in the choice of cinematic subjects commissioned for the work, namely while there are nine writers represented here, there are only two film directors (both of whom have a writerly background). In addition, both filmmakers are comics, thus emphasizing, or giving the stereotype more life, the Jew-as-clown."[1237]

The one notable contribution to film scholarship (ironically, the anthology's concluding essay) is Alan Spiegel's "The Vanishing Act: A Typology of the Jew in Contemporary Film." It begins with the observation that until the mid-sixties Jewish-American films lacked both artistic distinction and a distinct Jewish style or sensibility. Although some parallels are drawn between the early and middle 1920s and the late 1960s, Spiegel insists that the earlier period appealed almost exclusively to a minority public: "In spite of the assimilationist zeal expressed in many of these stories, the range of character types was still too heavily marked by an odd mingling of prayer shawls and pushcarts, of Eastern European SHTETL life and Hester Street family clannishness; landlords, merchants, and rabbis; skinflints, kindhearts, and greybeards; weeping mothers and gossipy aunts; wayward sons and blooming daughters: figures at once too exotic and too unglamorously gritty to enter the deepest imagination of the large American audience." His discussion of the new "de-Semitizing" that occurred between the 1930s and the end of World War II focuses on the "somewhat promiscuous mixture" of free market values, political idealism, and personal insecurity of the Jewish film moguls. Spiegel is particularly effective in encapsulating how behind-the-screen anxiety resulted in the on-screen appearance of ambiguous idealized movie heroes and stereotypes of "the Nominal Jew." That is, a supporting character in many films of the decade was a person with a Jewish name who neither was acknowledged as a Jew nor evinced any ethnic qualities or attitudes. In the post-WWII period, the author describes how the Nominal Jew is replaced by two new stereotypes: the Jew as Innocent Victim and the Jew as Biblical Exotic. These, in turn, Spiegel argues, lead to a more complex film image of the Jew by the sixties, most notably in films like EXODUS (1961) and THE PAWNBROKER (1965). The essay then discusses how the seventies produced a film fascination "with the personality, manners, anxieties, hungers, ecstasies, and follies of the contemporary American Jew. . . ." Thus the old stereotypes gave way to new ones, such as the Jewish Mama (powerful and overprotective), the Joseph figure (intellectual and self-absorbed), and the Jacobean striver (a social climber with questionable virtues).

[1237] David Desser, "The Return of the Repressed: The Jew on Film," QUARTERLY REVIEW OF FILM STUDIES 9:2 (Spring 1984):128-9.

838 Chapter 3: STEREOTYPING IN FILM

The latter, in particular, stresses the Jew as a conniving, materialistic, and greedy anti-hero in films like BODY AND SOUL (1947), SWEET SMELL OF SUCCESS (1957), SAVE THE TIGER and THE HEARTBREAK KID (both in 1973), THE APPRENTICESHIP OF DUDDY KRAVITZ (1974), and HESTER STREET (1975).

Clearly, Cohen's anthology does not satisfy the demands of a scholarly audience. Not only are the articles too brief and pedestrian, but also the editor's failure to include an index, bibliography, and visual material detracts from the appeal of the collection to readers unfamiliar with the subject. On the other hand, it remains the only general collection of essays on the subject. Approach with caution.

*Erens, Patricia. THE JEW IN AMERICAN CINEMA. Bloomington: Indiana University Press, 1984. Illustrated. 455pp.

Concerned with documenting the treatment of Jews in American movies from 1903 to 1983, this important study (based upon Erens's 1981 Northwestern University doctoral dissertation) offers the major historical discussion of the studio films made, the variety of characters identified as Jewish, and the history of the narrative context in which these types appeared. To that end, the author establishes a typology of characters and genres that charts the rise and fall of specific characters, genres, and themes, the durability of important conventions from one era to the next, and the crucial changes that took place in direct response to sociohistoric and artistic pressures. Along with the descriptive chronicle comes an analysis. Erens is particularly interested in relating the treatment of Jews in film to the American-Jewish community in general. She therefore attempts to point out the relationship between film cycles and Jewish-American trends regarding acculturation and assimilation. If her study has two apparent flaws at the outset, they are the simplistic analysis of Jewish-American affairs and her decision to separate almost completely the Jew in film from the larger context of the American film industry.

The book itself is divided into eleven chapters, beginning with a flawed introduction to the Jews in America, their depiction in fiction, and how the latter influenced the Jewish image in film. Each chapter has separate headings for particular genres (e.g., dramas, comedies, and war films). The subsections vary with different decades. Thus the chapter on the 1920s deals with comedies, dramas, and biographies, while the chapter on the 1950s concerns dramas, Israel and World War II, biblical epics, comedies, and adaptations. Within these specific categories, the author critically examines important films, focusing almost exclusively on two areas: Jewish characters (either overtly or covertly presented) and themes related to Jewish life. For example, the Jewish characters are identified by names or distinguishing features. Although the study mainly concerns American theatrical films, Erens occasionally includes shorter works as well as foreign films if the pictures received notable exposure on American screens. Interestingly, her commitment to analyzing mass entertainment precludes a discussion of the American-made Yiddish films, although clearly these movies represented a direct reaction by members of the Jewish community to Hollywood's assimilation films. Also somewhat disconcerting is the author's decision to divide film history by decades rather than by specific periods. When the time frames coincide with appropriate shifts in the film industry (e.g., the post-WWI period), the chapters make good reading. On the other hand, the chapters that arbitrarily rely on exact dates (e.g., "The Early Sound Years--1930-1940) appear out-of-sync by downplaying the transition from one stage of film development to another. On balance, this comprehensive survey is an important contribution to film study. It provides a splendid synthesis of material on the Hollywood moguls and their low-profile approach to the image of Jews in American films. In that connection, it serves as an invaluable source for contrasting and comparing the problems that other minorities and women have in projecting their screen images.

The book also highlights significant differences in the way scholars like Lester D. Friedman approach the same material. For example, both Erens and Friedman face problems of space in describing the evolution of Jewish film stereotypes. While neither work is definitive, Erens opts for depth in dealing with the major works, while

Friedman attempts to be more comprehensive. Thus her work appears more lively and informative than his study, even though she includes 200 more titles than Friedman does. Neither one, however, presents a satisfactory account of the film continuum or what percentage of Hollywood's total production policies related to Jewish themes and characters. In fact, both works have a tendency to oversimplify crucial issues. "Erens' analysis," as Allen Graubard points out, "lacks intermediate explanation and analysis; it leaps from simple content descriptions of characters and plots to broad generalizations on the meaning of the content for expressing the author's descriptions of Jewish realities, historical and current."[1238] Friedman's analysis, as Erens points out, does not deal "with sufficient works in detail, especially in the silent period, where he tends to lump films together, . . . [and thus he] distorts history by flattening out contradictions and diminishes the complexities of the themes."[1239]

For anyone beginning a study of the Jew in film, Erens's provocative survey is the one to choose. It contains valuable endnotes, a strong bibliography, a helpful filmography, and two good indexes (general and film titles). Recommended for special collections.

Fox, Stuart, ed. JEWISH FILMS IN THE UNITED STATES: A COMPREHENSIVE SURVEY AND DESCRIPTIVE FILMOGRAPHY. Boston: G. K. Hall, 1976. 359pp.

Growing out of a joint collaboration between the Institute of Contemporary Jewry of the Hebrew University of Jerusalem and the Division of Cinema at the University of Southern California, this pioneering reference book is the second filmography funded by the Abraham F. Rad Jewish Film Archives (the Organization and Information Department of the World Zionist Organization). It functions as a companion book to the CATALOGUE OF JEWISH FILMS IN ISRAEL (1972). The two significant differences between the newer work and its predecessor are that in Fox's work (1) the concept of "Jewish films" has a broader base, thus allowing the filmographer to include many more films than were deemed acceptable for the earlier book; and (2) copies of many films cited in Fox's book may not be in existence today. Unlike his colleagues in Israel, Fox's efforts to be all-inclusive force him to rely heavily on information reported in newspapers and magazines as well as in film archives, Jewish organizations, and film and television companies. The earlier work compiled its information from persons within Israel who actually owned the films.

Fox's filmography, containing nearly 4,000 titles (e.g., feature films, short subjects, documentaries, propaganda movies, educational films, cartoons, television series, and television specials), covers the years from 1903 through 1970. Theatrical films up to World War II are arranged by date, with separate listings provided for documentaries, newsreels, Yiddish films, and television programs. Each listing in each section contains information on technical details and plot. This pioneering reference book concludes with an index to film titles and an index to subjects.

Despite the discrepancies between it and more recent works like Erens's THE JEW IN AMERICAN CINEMA, the book remains a worthwhile source of information. Recommended for special collections.

*Friedman, Lester D. HOLLYWOOD'S IMAGE OF THE JEW. New York: Frederick Ungar Publishing Company, 1982. Illustrated. 390pp.

"By examining how Jews were presented in movies," Friedman theorizes in his Preface, "one might learn what some Jews think of themselves, how the image of Jews in the national consciousness changed over the years, and what Jews were willing

[1238] Allen Graubard, "Book Review: THE JEW IN AMERICAN CINEMA," FILM QUARTERLY 39:4 (Summer 1986):57.

[1239] Patricia Erens, "Book Review: HOLLYWOOD'S IMAGE OF THE JEW," JUMP CUT 29 (February 1984):69.

to show of themselves to a largely Gentile audience." He makes no claims that what is seen is factual. Clearly, movies distort reality. But often it is the distortions themselves that are significant, because for Friedman "they testify to the anxieties and strengths of a particular historical period." This pioneering book thus becomes an important introduction to a group of films that collectively define a film genre known as the Jewish-American film ("movies centering on Jewish issues rather than directed or produced by Jews") and identify specific Jewish-American characters ("figures defined as Jewish within the films rather than as roles played by Jewish performers"). The book's eight chronologically arranged chapters survey the history of the genre from the controversial silent comic shorts like LEVI AND COHEN--THE IRISH COMEDIANS (1903), through the heyday of the studios, and up to the start of the eighties and films like PRIVATE BENJAMIN (1980) and RAGTIME (1981). The focus is on the interaction between Jews and American society. That is, Friedman's analyses stress how the movies shape the nation's attitudes and values (including those of Jews themselves), while at the same time revealing how the society affected the content of the movies dealing with the treatment of Jewish-American screen characters. The book's strength lies in its ability to chronicle the evolution and development of the genre and its conventions. The book's weakness lies in its ill-conceived organization of one decade/one chapter that occasionally produces superficial generalities about key events and personalities.

Friedman is at his best in skillfully describing and synthesizing the plots and major shifts in film history. For example, he begins his examination of the silent era by pointing out that in Manhattan, prior to 1908, "there were seven times more movie theaters in Jewish areas than in other largely ethnic settlements." This serves as a significant explanation not only of why Jewish businessmen were attracted to the new medium of communication, but also of why these film entrepreneurs had an incredible insight into what types of stories and characters appealed to mass audiences. More importantly, Friedman contends that the initial relationship between Jews and films explains why the early films led the way in depicting how Jewish life and culture were interpreted to America. This, in turn, explains why the most-often depicted historical Jew in the silent cinema was Benjamin Disraeli. It also explains why the silent films fell into three basic patterns dealing with lovers' problems, family relationships, and interracial resolutions. In particular, the interracial emphasis stresses the close ties between Jews and the Irish, and why those two groups became interrelated throughout film history. Another attractive feature of Friedman's approach is his reactions to the work of earlier commentators. For example, he calls attention to the negative reactions of critics like Ruth Perlmutter and Randall Miller to the Jewish moguls' emphasis on assimilationist themes, and then rebukes them for ignoring the fact that these were not "pseudodocumentaries" and that the films were intended as "conditioning factors" between Jews and the Gentile world. Friedman's thesis does not explain, however, why most silent screen adaptations of literary works failed to "alter any unsympathetic portraits found in their original sources." His argument that the early film pioneers lacked a meaningful social consciousness hardly does justice to the complex process associated with the film continuum.

Friedman's discussions of "The Timid Thirties" and "The Fashionable Forties" are both enlightening and frustrating. His sweeping look at why the earlier decade represented the nadir of Jewish-American films centers on the efforts by the Jewish film moguls to ingratiate themselves with the Gentile community. Several examples are given of films that de-Semitized Jewish visibility--e.g., STREET SCENE (1931) and THE LIFE OF EMILE ZOLA (1937)--but almost no mention is made of the enormous pressure the film industry was facing from within its own ranks, the isolationist movement nationwide, and the fascist threat to market conditions abroad. Also disappointing is the slight attention paid to a rich array of Jewish comic characterizations. In discussing the forties, Friedman oversimplifies the "melting pot mentality" that gripped Hollywood, citing the Jew's place in the screen's "multi-ethnic platoons" but ignoring completely the film industry's refusal to consider the presence of minority groups like Native Americans, Orientals, and homosexuals in such platoons. On the other hand, he is very effective in noting why the post-WWII

"problem films" failed to "delve very deeply into the problems they . . . [sought] to illuminate." By the conclusion of these two chapters, it is clear that accommodation rather than cultural pluralism still dominated Hollywood's consciousness.

The chapter on "The Frightened Fifties" is one of the book's high points. Drawing a useful comparison to the treatment of Jewish-American characters in the thirties, Friedman identifies the types of problems the traditional screen genres faced during the blacklisting period: e.g., "bloated biblical epics, conventional war sagas, sanitary biographies, and syrupy melodramas." To his credit, however, the author goes on to discuss the changes taking place in the various genres. For example, an important revision in the war film conventions was the focus on anti-Semitism in the heretofore serene multi-ethnic camaraderie: e.g., THE NAKED AND THE DEAD and THE YOUNG LIONS (both in 1958). An important revision in the treatment of mixed marriages was that Jewish men, once the aggressor in the marriage game, now were depicted as sensitive loners whose alienated status is what appeals to women. Most important, the fifties introduced a new Jewish stereotype: the Jewish-American Princess in the form of Marjorie Morningstar. While her image would come under severe attack in the decades that followed, she signaled the dramatic change from the traditional image of Jewish women found in movies like STREET SCENE (1931) and COUNSELLOR-AT-LAW (1933).

The chapter on "The Self-Conscious Sixties" focuses on the decade's obsession with ethnicity. Claiming that film producers transcended "moribund racial stereotypes," the author insists that the new films demonstrated a greater understanding and sensitivity to ethnic issues and characters, particularly in films about the Holocaust. On the one hand, films like JUDGMENT AT NUREMBERG (1961), LISA (1962), and THE PAWNBROKER (1965) dealt more candidly with the pain and trauma of the Jewish horror. On the other hand, these same films deserve credit more for their breaking new ground than for their "understanding" and "sensitivity." By far the most interesting material in this section relates to Friedman's analysis of EXODUS (1960) and his theory that the depiction of Palestine operates as a microcosm of America for the film's director, Otto Preminger.

The chapter on "The Self-Centered Seventies" reviews the effects of the shock waves generated by the social and political events of the sixties and seventies. Once the filmmakers had begun their critical reappraisal of American values and institutions, it was inevitable that more and more variety would appear in the Jewish-American film genre. Friedman continues his skillful summary of how the image of Jews in the national consciousness continued to change. For example, he points to musicals as an indication of an increasing Jewish visibility: FIDDLER ON THE ROOF (1971), CABARET (1972), and FUNNY LADY (1975). He reminds us that Jewish themes were also very much a part of the decade's nostalgia craze: e.g., THE WAY WE WERE (1973), HESTER STREET (1974), HEARTS OF THE WEST, LIES MY FATHER TOLD ME (both in 1975), VOYAGE OF THE DAMNED, MARATHON MAN (both in 1976), JULIA (1977), and THE FRISCO KID (1979). Although he missteps by overstating the importance of Paul Mazursky, equating him with Woody Allen and ignoring Mel Brooks, the author manages to underscore two antithetical movements within the Jewish-American community that typify the mood of the decade: Jewishness and Americanism. In addition, he calls attention to the changing Hollywood scene and the continued influence of Jewish producers, directors, screenwriters, and performers. In the process, he criticizes the filmmakers for their uninspired response to the problems of Israel, the depiction of the Holocaust, as well as the nastiness of the films about Jewish family life.

Regrettably, the last chapter on "The Emerging Eighties" is the book's weakest section. Covering only two years, it offers neither breadth nor depth. In fact, much of the material restates ideas covered more effectively in earlier sections. Particularly disappointing is the author's lackluster critique of THE JAZZ SINGER (1981), which closes this otherwise highly informative study.

Friedman's major problems are in his discussions of film aesthetics and in his simplified analyses of film content. For example, he refuses to take a stand on controversial characterizations, arguing that "offensive" humor is more a question of personal taste than of aesthetic standards. That is true in theory, but the reader

has a right to know what the author's standards are for good taste. In addition, there is far too much reliance on AUTEURISM and not enough on the film process itself. Given the widespread influence of feminist film criticism, it's curious that more attention is not paid to the reaction of feminists to the increasingly shrill image of Jewish women in Jewish-American films. Put somewhat differently, Friedman tends to spend too much time justifying superficial screen images because of extenuating circumstances related to prevailing social conditions and limited film skills. In making such judgments, he ignores what was being achieved by other artists dealing with equally controversial subjects during the same period. A case in point is his discussion of THE JAZZ SINGER (1927). While acknowledging the film's "latent racism," he nonetheless praises its "forceful summation of the assimilationist tendencies present throughout the Silent Era, and indeed, that dominate this genre in films such as GENTLEMAN'S AGREEMENT (1947) and MARJORIE MORNINGSTAR (1958) right up until the sixties." Another example is his discussion of THE WAY WE WERE. More time is spent with an extended plot synopsis than with either the important historical background or the manner in which the Streisand character relates to the pernicious image of the Jewish American Princess. On a minor but annoying note, much of the information on Jewish cultural history and on film industry is often cited without source references. One especially surprising omission is the author's discussion of American newsreels without a single reference to Raymond Fielding's extraordinary research.

Considered the first major study of a long neglected subject, this ambitious book deserves widespread recognition. It contains a useful collection of overlooked film titles and outlets for renting important films, and a valuable bibliography are assembled in three worthwhile appendexes, along with ample endnotes and a good index. It belongs in specialized collections as a companion volume to Erens's work.

Friedman, Lester D. THE JEWISH IMAGE IN AMERICAN FILM. Secaucus: Citadel Press, 1987. Illustrated. 260pp.

An updating of the author's HOLLYWOOD IMAGE OF THE JEW, this profusely illustrated study is filled with intriguing observations and provocative assumptions. On the one hand, Friedman is more preachy than he was in his earlier study. For example, he alludes to the ongoing debate about acculturation versus assimilation and states that "The once-cherished notion of the great 'melting-pot' has gone the way of the horse and buggy. It has been replaced by an understanding that, while we are all Americans, we are something more as well. We are hyphenated citizens. The story of America's celluloid Jews, therefore, remains important not only for what it tells us about one of the country's most prominent minorities, but also for what it reveals about the American Dream, and ultimately, about America itself." Moreover, he still generally refuses to cites sources for many of his film statistics or enunciate clearly his critical standards. On the other hand, Friedman frequently summarizes in succinct and intuitive prose what other authors take pages to discuss and rarely conclude satisfactorily. A case in point is his comments on why Eastern European Jews were so successful so quickly in the fledgling film industry. Noting that the particular talents of these Jewish immigrants were related to their being a "cosmopolitan group well accustomed to minority status in a predominantly Gentile population," Friedman notes how "a long tradition of wandering and accomodation" assisted the East European Jews in resettling in a "rapidly urbanizing, democratic society" that encouraged immigrants to make use of the American Dream. At the same time, he explains that there was a "catch 22" in the evolution from ghetto to country club. The irony was that "all the traits that helped make the newcomers successful simultaneously drove them further from traditional Jewish religious beliefs and practices. Economic freedom made commerce an obsession. The need to make America a permanent home motivated a hasty embrace of its values. Educational opportunities created a generation openly critical of traditional Judaism." The story Friedman unfolds in his nostalgic eight chapters tells us a great deal about how Jewish leaders responded to the "seductive and intoxicating receptiveness of America" to the Jewish newcomers in search of the

GOLDENE MEDINE (the golden land). Another noticeable and stimulating aspect of this updated version is the author's feisty reactions to the scholarship of his peers. He seems to take particular delight in citing authors who present alternative intrepetations and then in lambasting their positions. A bibliography and index are included. Well worth browsing.

Gabler, Neal. AN EMPIRE OF THEIR OWN: HOW THE JEWS INVENTED HOLLYWOOD. New York: Crown Publishers, 1988. Illustrated. 502pp.

A highly entertaining and provocative history of the rise and development of Hollywood, this stimulating social study begins with the paradoxical observation that ". . . the American film industry, which Will Hays, . . . called 'the quintessence of what what we mean by "America,"' was founded and for more than thirty years operated by Eastern European Jews who themselves seemed to be anything BUT the quintessence of America." Moreover, Gabler continues, "The much-vaunted 'studio system,' which provided a prodigious supply of films during the movies' heydey, was supervised by a second generation of Jews, many of whom also regarded themselves as marginal men trying to punch into the American mainstream." The thesis itself is not original. Almost every history of the fabled Hollywood moguls deals with the notion of the "outsiders" whose lust for power and respectability affected not only their families and their methods but also the nature of the film empires they created and the values depicted in movies during the first half of the twentieth century. Even the notion of a chatty and personal account of the moguls' lives is a familiar technique in the numerous books on the famous (some say notorious) personalities, as well as the accounts dealing with stars, directors, and screenwriters. What makes Gabler's version valuable and absorbing is his synthesis of existing material and the perspective he provides as a result of fresh material gleaned from the oral histories housed in various scholarly archives. While one may question the idea that a group of immigrant Jews determined not to suffer the fate of their fathers resulted in a dream factory that remade and refurbished the America Dream, it is hard to dismiss, out of hand, the riveting assertions the author makes about the economic strategies and political alliances that shaped film history. The challenge for serious students is to separate Gabler's passionate desire to reduce social history into a basic assertion that everything these moguls did is directly tied to their Jewish self-hatred and desire to assimilate from the more impressive conclusion that bigotry and neuroses played a crucial role in the way movies affected America in the first half of the twentieth century.

In the first of the book's two major sections, "The Men," Gabler devotes five lively and informative chapters to the biographies of Adolph Zukor, Carl Laemmle, Louis B. Mayer, the Warner brothers, and Harry Cohn. Other key figures--e.g., Sam Goldwyn, the Selznick family, Jesse Lasky, Marcus Loew, Samuel "Roxy" Rothapfel, the Balaban brothers, and the Schenck brothers-- are incorporated into the fabric of the anecdotal histories. Targeting his work to a popular rather than to a scholarly audience, the author takes a matter-of-fact approach to dates, controversies, and recollections, emphasizing instead what these men had to say about themselves and relishing apocryphal events that support his assertions about their individual motivations. If a person's birthdate is widely debated (e.g., Zukor), we're given only the place of birth. If information is lacking on a member of the family (e.g., Zukor's youngest brother), the individual is omitted from the narrative. And, as Molly Haskell points out, "The danger with any thesis is that the exceptional and the unusual are neglected in favor of the pleasing pattern of analogy . . . [thus] Darryl Zanuck, a non-Jew is given short shrift, and RKO is barely mentioned."[1240] The impression that finally emerges is that this history of the moguls' influence on the film industry is not only distorted, but also simplistic. One need only compare

[1240] Molly Haskell, "Epic! Heroic! American!" NEW YORK TIMES BOOK REVIEW (October 23, 1988):59.

David Robinson's exhaustive study on Chaplin to see the difference in scholarly research. Thus complex personalities emerge as transparent, single-minded businessmen whose films and studios reflect basic character traits and personal ambitions.

Nevertheless, Gabler's perspective offers invaluable observations on the transition from the days of the film industry's Gentile founders, to the rise of the great Hollywood studios and on the myths that depict the Jewish immigrants as "impoverished young vulgarians whose motives were purely mercenary." Zukor is a case in point. Starting with a reminder of Zukor's wealth by the time he entered film exhibition in 1903, Gabler points out how important it was that Zukor and Loew established a "Jewish 'network'" both in their financial dealings and in the construction of their fabulous empires. In addition, he dwells on the lessons that Zukor learned from his contacts with early film novelties (e.g., Hale's Tours) and the strict moral code he developed in dealing with people. Anyone interested in what diffferentiated one mogul from another in business, personal relations, and management style should study this book carefully. Gabler is a master at speculating on the reasons why Zukor and his peers manipulated the business and political community to suit the ambitions of the Jewish film industrialists. He is also excellent in describing the relations among the Jewish immigrants themselves, telling us not only how they felt about each other, but also about their wives and children. Rarely in the annals of film history has there been a more compassionate and humane discussion of the Jewish immigrants who took over the film industry in the late teens and shaped its destiny for three decades. Where Gabler's sympathetic commentary falters is in its characterizations of significant film pioneers like Edwin S. Porter ("droopy, lugubrious"), in minimizing the contributions of non-Jews (e.g., the members of the Trust) to the evolution of the film industry, and in omitting important sources like the Warner Bros. filmscript of THE JAZZ SINGER (1927).

In Part Two, "The Empire," Gabler offers his most controversial and intriguing observations on life in Hollywood from the start of the Depression to the end of the studio era in the late 1950s. Five lively chapters cover the cinematic styles of the various studios, the effect of local and national politics on the film industry, the battles between Mayer and Thalberg at MGM, the life-styles of the Hollywood moguls, the way in which the moguls united to fight their common enemies outside the film industry, the importance of the Jewish community leaders (e.g., Rabbis Edgar Manin and Max Nussbaum, and Mendel Silberberg) to the film moguls, and the events leading to the demise of the moguls' influence in Hollywood. The writing is crisp, the stories highly amusing, and the observations extremely stimulating. At times, however, Gabler fails to delve very deeply into important anecdotes. A case in point is his reference to Fitzgerald's drunken behavior in Thalberg's presence. Gabler comments that it was used by Fitzgerald in THE LAST TYCOON but fails to mention its use in Fitzgerald's famous short story, "Crazy Sunday." Moreover, he quickly glosses over the ill-will between the producer and the screenwriter.

The most fascinating material concerns the role of the Communist party in Hollywood. Here Gabler exposes both his strengths and weaknesses as a social historian. On the positive side, his review of the events from the mid-1930s (when Upton Sinclair made an unsuccessful run for the governorship of California) to the blacklisting era of the 1950s is filled with first-rate anecdotes and innovative speculations about behind-the-scenes maneuverings. It would be difficult to find a better collection of jokes, stories, and asides than in this superb accounting. Particularly impressive are the author's explanations for the industry's political consciousness, the difficulties the moguls faced with an isolationist Congress in the early 1940s, and the origins of House Committee on Un-American Activities (HUAC).

On the negative side, Gabler merely skims the surface of important events and issues. For example, he notes Sinclair's willingness to help Eisenstein in Mexico but makes no mention of how the two men eventually parted and the deep resentment that ensued. The analysis concerning the relationship between the producers and the screenwriters is vastly oversimplified, particularly in the pre-WWII period. Although Gabler makes use of the major research on the topic, he surprisingly ignores the fact

that many people in Hollywood joined the Communist party not just because it was an act of political and social conscience, but also because it was the chic thing to do and that's where the best social life was to be had. He also ignores the relationship between Dies's attack on the Federal Theatre Project and the pre-WWII investigation in Hollywood. In dealing with the 1947 HUAC hearings, Gabler incredibly downplays the labor strife in the postwar period and the reasons why Disney and Jack Warner were so eager to be friendly witnesses. Interestingly, no mention is made of Ronald Reagan's role during this period, or how significant the East Coast banking interests were to the blacklisting in the studios. A good example of the way the author blurs important distinctions is his comment that after the HUAC hearings ended abruptly, "All the Hollywoodites--the unfriendlies, the members of the Committee for the First Amendment, the executives--returned to the West Coast that week in a state of agitation and uncertainty." The fact is they left at different times, under very different circumstances, and with quite different expectations for the future.

Given the importance of the topic and the skill with which Gabler argues his thesis, this social history deserves careful attention. It not only focuses on many facets of film history, but also introduces many significant questions on how and why film history evolved as it did. My one major reservation is that in overstating the moguls' self-hatred of their Jewishness and the obsession with assimilating, Gabler weakens his credibility on other issues.[1241] General readers should enjoy the sweeping overview, while serious students should have fun identifying acts of omission and reductionism. Endnotes, a bibliography, and an index are included. Recommended for special collections.

Goldberg, Judith N. LAUGHTER THROUGH TEARS: THE YIDDISH CINEMA. Rutherford: Fairleigh Dickinson University Press, 1983. Illustrated. 171pp.

Started as a master's thesis in 1975, this pioneering study provides a general overview of the Yiddish film from 1910 to 1961. The author divides her topic into four distinct periods: (1) the formative years when the genre was developing as an art form, including the pre-WWI era in Russia, Poland, and the United States; (2) the post-WWI period, when production companies in these nations specialized in adapting Yiddish literature to the screen; (3) the impact of sound on Yiddish films, highlighting the reasons why the genre first flourished in the thirties and then declined by the advent of WWII; and (4) the aftermath of WWII, focusing on the last ditch efforts to stimulate new interest in Yiddish films. Throughout the study, one detects both a sense of pride in the ingenuity of filmmakers like Joseph Seiden and Edgar G. Ulmer, and a sense of outrage at the anti-Semitic obstacles the filmmakers and their audiences faced. At the time Goldberg began her work, little was known about the relationship among the SHTETLS of Eastern Europe, Jewish mass immigration to America, the Yiddish theater movement in the large European cities, and the rise of the Yiddish film. To her credit, Goldberg links the various movements and events in a useful thumbnail sketch of YIDDISHKEIT (the culture of the Eastern European Jews who came to America between 1881 and 1924). Although her film analyses prove to be superficial, her sweeping overview provides some worthwhile information.

Following a matter-of-fact introductory chapter, Chapter 2, dealing with 1910 to WWI, points out how the violent and bloody pogroms in Russia (e.g., 1881, 1903, 1905, and 1910) served as the inspiration for many of the best Yiddish films. For example, the notorious anti-Semitic group, "the Black Hundred," and the infamous Mendel Beiles case are featured regularly in many nihilist Yiddish films of the silent era, including RUSSIA, THE LAND OF OPPRESSION (1910) and THE BEILIS CASE/DELO BEILISA (1917). Attention is also given to Sidney M. Goldin (Golden), one of the first independent film directors in America and later a director of Yiddish

[1241] In one recent response to the book, Ring Lardner, Jr., denies a number of statements attributed to him in the book. See Ring Lardner, Jr., "On Jewish Hollywood," NEW YORK TIMES BOOK REVIEW (November 27, 1988):38.

sound films. The titles of his silent films indicate their focus: e.g., THE SORROW OF ISRAEL, NIHILIST VENGEANCE, THE HEART OF A JEWESS, THE BLACK 107 (all in 1913), and ESCAPED FROM SIBERIA (1914).

Chapter 3, "From WWI to the arrival of the Talkies," covers several topics, including the activities of independent European film companies that collectively produced over 350 Yiddish films in Moscow until 1921, as well as the adventures of Goldin in Vienna and his eventual collaboration there with stars of the Yiddish theater like Molly Picon in EAST AND WEST/OST UND WEST (1923) and Maurice Schwartz in REMEMBRANCE/YISKER (1924). Although Goldberg never probes deeply, she does suggest many areas for future research. For example, her discussion of Yiddish culture in America during the twenties raises anew the question of why Hollywood abandoned the Jewish immigrant population in its movies. In Goldberg's words, "Only in the United States were the Jews ignored in the popular culture of film."

Chapter 4, "The Yiddish Talkies from 1929 to 1934," concentrates on how Russian, Polish, and American movies preserved the heritage of the Yiddish theater. Goldberg gives most of the credit to Joseph Seiden. Her resourceful interview with the most prolific of all Yiddish film directors adds to our understanding of how the success of Yiddish newsreels led the innovative entrepreneur into Yiddish feature films. In a breezy prose style, the author describes the formation of Seiden's American-based Judea Pictures Corporation in December, 1929, reviews a number of its noted films like MY YIDDISH MAMA/MINE YIDDISHE MAME (1930), and explains the problems that independent filmmakers had in distributing their products. Other directors profiled include Asher Chasin and Joseph Green (Greenberg).

Chapter 5, "The Yiddish Cinema in America," offers a useful summary of the problems of independent, low-budget American film producers. The focus is once more on Seiden, detailing how his formula filmmaking strategies (e.g., "contemporary melodramas with convoluted plots, singing, religion, and the requisite ending") were widely imitated by other Yiddish film producers. Edgar G. Ulmer's four Yiddish films are then offered as a contrast to the work of his peers. Although they too were low-budget productions, they eschewed the traditions of the Yiddish theater. For example, GREEN FIELDS/GRINE FELDER (1937) was a comedy; THE SINGING BLACKSMITH/DER ZINGENDIKER SHMID (1938), a romantic melodrama in the modern tradition. "What is most striking in Ulmer's films," Goldberg explains, "is their total lack of religiousness." Other directors given a modest profile are Henry Lynn, Maurice Schwartz, and Max Nosseck.

Chapter 6, "The Yiddish Film in Poland," summarizes the problems sound posed for European Yiddish filmmakers and the breakthroughs engineered by the producer Joseph Green. The problems relate not only to government taxes and regulations, but also to the Polish Jews' fears about Yiddish films stirring up anti-Semitic feelings among the Gentile population. Green's return to Poland in 1936 forced a reevaluation of the negative attitude toward the production of Yiddish films. Using his own money, he coordinated efforts between his New York firm (Sphinx Films) and his Polish company (Greenfilm). The result was four Yiddish musical comedies--YIDDLE WITH A FIDDLE/YIDL MITN FIDL (1936), THE JESTER/DER PURIMSPILER (1937), A LITTLE LETTER TO MAMA/A BRIVELE DER MAMEN, and LITTLE MOTHER/MAMELE (both in 1938). Regrettably, the Nazi invasion of Poland put an end to Yiddish film production in Europe. Within two years, European outlets all but disappeared for American independent producers, thus bringing an end to a renaissance for Yiddish films.

In the book's concluding chapter, "Aftermath," Goldberg briefly reports on the attempt in the post-WWII period to resurrect an interest in Yiddish films. We get a glimpse of Seiden struggling in vain in the 1960s with Cinema Service, a rental company for Yiddish films. There are also references to a handful of compilation films, described more as a salvage operation than as a serious undertaking. But the author makes it clear that with the coming of WWII, the genre became more a museum piece than a vibrant work of art.

Several reasons why this flawed book should not be ignored are (1) the interviews with Yiddish film pioneers, (2) the helpful bibliography, (3) the variety of illustrations relating to posters and stills, and (4) the collection of endnotes. A filmography and index are also provided. Worth browsing.

*Goldman, Eric A. VISIONS, IMAGES, AND DREAMS: YIDDISH FILM PAST AND PRESENT. Ann Arbor: UMI Research Press, 1983. Illustrated. 224pp.

The best chronological history available about the birth, evolution, and fate of Yiddish films, this book focuses on the historic ties between the film genre and its theatrical roots in Yiddish drama. Goldman demonstrates little interest in matters of aesthetics or stylistics. Instead, he explores not only the reasons why specific films were made, but also how they relate to an individual filmmaker's total work. The emphasis is on production techniques, motivations, targeted audiences, and performers.

Following a perfunctory introduction explaining what is meant by a Yiddish film and what criteria are used for including films in this study, Goldman's first chapter identifies the precursors to the Yiddish film. A smattering of historical information on Jewish history (e.g., the confinement of Russian Jews in a "Pale of Settlement" starting in 1794, the outbreak of pogroms across the Pale beginning in 1881, regulations prohibiting Jewish mobility that led not only to resettling Jews but also to their mass emigration out of Russia) serves as a backdrop to the initial Russian propaganda films about how well-treated Jews were under the czar. These films, in turn, motivated a Russian emigre named Sidney M. Goldin to produce films in America documenting Soviet oppression to his people. His success with Jewish-oriented films like THE SORROW OF ISRAEL and BLEEDING HEARTS (both in 1913) led him first to make a documentary on the efforts of Jewish agencies to help struggling Jewish immigrants, HOW THE JEWS TAKE CARE OF THEIR POOR (1913), and then to a number of films condemning Russian anti-Semitism, THE TERRORS OF RUSSIA/THE BLACK HUNDREDS (1913) and ESCAPED FROM SIBERIA (1914). Goldin's history soon becomes intertwined with Jewish cultural life in Eastern Europe. Details about Yiddish theater companies like the Kaminsky troupe, which had their stage performances routinely put on film by the Warsaw film organization, Sila, add to the sense of discovery about the roots of the Yiddish cinema. Although names and dates predominate, the fast-moving prose results in a useful overview of how "filmed theater" and Russian anti-Semitism inspired filmmakers to target movies primarily for Yiddish-speaking audiences.

The next two chapters review the history of silent Yiddish films. In dealing with Poland, Austria, and the United States from 1919 to 1928, Chapter 2 traces the steps that filmmakers took in divorcing the Yiddish film from its theatrical roots. For example, Austria provided the production site for Goldin's escapist Yiddish films EAST AND WEST/OST UND WEST (1923) and REMEMBRANCE/YISKER (1924). In Poland, where Yiddish film production had stopped in 1916, the screenwriter Henryk Bojm and the producer Leo Forbert kindled a renewed interest in Yiddish films with THE VOW/TKIES KAF (1924) and IN POLISH WOODS/IN POYLISHE VELDER (1928). To Goldman's credit, his discussions about the European developments highlight the changes in editing and acting in the post-WWI productions. Regrettably, the attention given to the American efforts by Maurice Schwartz's BROKEN HEARTS/TSEBROKHENE HERSTER (1926) is too minimal to be of value. Chapter 3, on the Soviet Union from 1925 to 1933, emphasizes how Yiddish pictures evolved as an important part of the post-Revolution film industry. Goldman first establishes the significance of two drama groups, "Habima" and the "Moscow Yiddish State Art Theater (GOSET)," and then analyzes their roles in adapting writers like Sholom Aleichem to the screen. The author also offers some insights into the problems faced by Jewish screenwriters who ran afoul of Soviet censorship. There was constant "fear of creating something unacceptable within the shifting limits of prevailing ideological policy." Consequently, the Yiddish film in Russia had a brief existence.

Chapter 4 concentrates on the Yiddish-American "B" films from 1929 to 1937, with special attention given to Joseph Seiden. For example, the discussion dealing with Seiden's creation of Judea Pictures Corporation in late 1929 provides information on the company's shorts, feature films, and production policies. The well-chosen stills, skillfully captioned, add considerably to the valuable history of this important independent company. Goldman also reviews the efforts of one-time independent companies like High Arts Pictures Corporation and Sov-Am Productions, the rise of the Yiddish compilation film, and Goldin's last film, THE CANTOR'S SON/DEM KHAZNS ZUNDL (1936).

The next few chapters deal with what Goldman calls "The Golden Age of Yiddish cinema." In Chapter 5, focusing on Poland in the years from 1936 to 1939, Goldman points out that since the advent of sound, European Jewry had imported its Yiddish films from America. Then in 1935, a group calling itself "The Initiative of Jewish Actors and Artists" joined together to form a film cooperative called KINOR. From that beginning came a Polish renaissance in matters related to Jewish culture. Special attention is paid to the efforts of Joseph Green, who throughout the decade spent six months in Poland, his place of birth, and six months in New York each year. In addition to interesting biographical comments, Goldman includes stimulating information on Green's four Yiddish-Polish films: YIDDLE WITH A FIDDLE/YIDL MITN FIDL (1936), THE JESTER/DER PURIMSPILER (1937), A LITTLE LETTER TO MAMA/A BRIVELE DER MAMEN (1938), and LITTLE MOTHER/MAMELE (1938). For anyone interested in the ten entertaining Yiddish films produced in Poland during this period, this book is required reading. Chapter 6, dealing with the Golden Age of Yiddish cinema in America from 1937 to 1940, gives a good overview of the genre's financial and artistic breakthroughs prior to WWII. Although "quality" was still linked to classics of the Yiddish theater, Goldman explains how the legendary stars of the Yiddish stage now gravitated toward films. Much of the success associated with the Yiddish film's "star system" is credited to filmmakers like Roman Rebush, Edgar G. Ulmer, Jacob Ben-Ami, Maurice Schwartz, Max Nosseck, and Joseph Seiden.

The last chapter, examining the period from 1946 to 1950, summarizes the renewed interest in Yiddish films in Poland and America following WWII. One fascinating section deals with Israel Becker, a refugee stranded in Germany, who eventually produced a film about his wartime experiences, DEATH FACTORIES/TOYTMILN (1946). There is also an absorbing account about Shaul Goskind, a Polish Jew who sought refuge in Russia during the war years, and the film work he did once he returned to Poland. Still further, there is a useful discussion of Seiden's work in America and the steps leading up to the decline of Yiddish cinema.

Goldman's epilogue describes his own involvement in Yiddish cinema, while also making an optimistic case for the future of Yiddish pictures, both for spectator and producer. He takes satisfaction in the fact that many films are being restored and that there is a growing interest in viewing and studying Yiddish films. For those desiring more information, he points out the existence of key film archives and what types of material they include.

Given the lack of scholarship on this neglected topic, Goldman's book functions as a solid introduction. His background information sets the stage for a more comprehensive and critical discussion of an alluring subject. In addition to helpful endnotes, the book contains a filmography, bibliography, rental information, and an index. Recommended for specialized collections.

*Kaufman, Deborah, and Janis Plotkin, eds. A GUIDE TO FILMS FEATURED IN THE JEWISH FILM FESTIVAL. Berkeley: Jewish Film Festival, 1986. Illustrated. 64pp.

Shavelson, Melville. HOW TO MAKE A JEWISH MOVIE. Englewood Cliffs: Prentice-Hall, 1971. Illustrated. 244pp.

FILMS

CROSSFIRE (RKO--16mm: 1947, 86 mins., b/w, sound, R-RKO)
 Directed by Edward Dmytryk, the screenplay by John Paxton (based on Richard Brooks's novel THE BRICK FOXHOLE) focuses on the murder of a Jew (Sam Levene) by an anti-Semitic army sergeant (Robert Ryan) and his eventual capture by the police. The film itself is important for several reasons. First, it was the first of the hard-hitting "social-problem" movies in the post-WWII period. Second, it was the last important film made by its director and producer (Adrian Scott) before they were blacklisted in the late 1940s. Interestingly, Dore Schary, the film's producer and the man who encouraged the project, later fired Dmytryk and Scott for being Communists and cited the film as an example of their subversive works. Third, it is a good example of how FILM NOIR worked in the post-WWII period. In relation to the image of Jews on screen, CROSSFIRE effectively demonstrates how filmmakers worked hard to show that Jews were no different from anyone else, and that anti-Semitism is a national not a minority problem. Nominated for four Oscars, including Best Film, Best Supporting Actor (Ryan), Best Director, and Best Screenplay, it came up empty at the awards ceremony, overshadowed by GENTLEMAN'S AGREEMENT, the film it had beaten in the race to be the first major movie about anti-Semitism in the postwar period.

THE DIARY OF ANNE FRANK (Fox--16mm: 1959, 170 mins., b/w, sound, R-FNC; anamorphic b/w: R-FNC)
 The Frances Goodrich-Albert Hackett screenplay was adapted from the authors' stage play based on the book ANNE FRANK: THE DIARY OF A YOUNG GIRL. Directed by George Stevens, the powerful film centers on a small attic in Amsterdam during the early 1940s, when two Jewish families and a dentist (Ed Wynn) hid for two years from the Nazis. Anne (Millie Perkins) was one of the eight people who coped with the complex problems of adults and children crowded together in terrifying circumstances. Among the gifted cast are Joseph Schildkraut (Otto Frank, the father), Lou Jacobi, Shelley Winters (Mr. and Mrs. Van Daan), and Diane Baker (Margot, Anne's sister)..[1242] Nominated for eight Oscars, including Best Picture, Best Supporting Actor (Ed Wynn), Best Director, Best Scoring of a Dramatic or Comedy Film (Alfred Newman), and Best Black-and-White Costume Design (Charles LeMaire and Mary Wills), it won for Best Supporting Actress (Winters), Best Black-and-White Cinematography (William C. Mellor), and Best Art Direction-Set Direction (Lyle R. Wheeler, George W. Davis; Walter M. Scott, and Stuart R. Reiss).

EXODUS (United Artists--16mm: 1960, 207 mins., color, sound, R-MGM)
 Directed by Otto Preminger, the screenplay by Dalton Trumbo (based on Leon Uris's novel) deals with the plight of 30, 000 Jews interned by the British on the island of Cyprus and refused permission to emigrate to Palestine. The plot follows their eventual settlement in Palestine and the birth of the state of Israel. The film itself serves as a good example of how fear and economics played a role in the way Hollywood treated Jews in film during the fifties.[1243] For example, Lester D. Friedman

[1242] See Alpert, pp.145-7; Albert Johnson, "The Diary of Anne Frank," FILM QUARTERLY 12:4 (Summer 1959):41-4; Peter John Dyer, "The Diary of Anne Frank," FILMS AND FILMING 5:10 (July 1959):21-2; Herbert G. Luft, "George Stevens," FILMS IN REVIEW 9:9 (November 1958):486-96; Helen Weldon Kuhn, "The Diary of Anne Frank," ibid., 10:4 (April 1959):232-4; and DIALOGUE WITH THE WORLD (New York: Encyclopaedia Britannica Films, 1964), pp 28-30.

[1243] Preminger describes in his autobiography how he had to overcome the fear of threatened Arab boycotts, controversy over the hiring of the blacklisted

argues that the movie has more to do with the problems of a Gentile widow (Eva Marie Saint) and her love affair with a Jewish hero (Paul Newman) than with the founding of Israel.[00] Erens reports that "Alongside the positive reviews and huge box-office returns, many disparaged the work, referring to EXODUS as a 'Jewish Western' and 'Preminger's 'Matzo Opera.'"[1245] Nominated for three Oscars, including Best Supporting Actor (Sal Mineo) and Best Color Cinematography (Sam Leavitt), it won for Best Scoring of a Dramatic or Comedy Picture (Ernest Gold).

FIDDLER ON THE ROOF (United Artists--16mm: 1971, 179 mins., color, sound, R-MGM)
 Directed by Norman Jewison, the screenplay by Joseph Stein (based on his hit musical play adapted from Sholom Aleichem's play TEVYE AND HIS DAUGHTERS) recounts the fortunes of a Jewish family at the turn of the century in the Ukranian village of Anatevka. Tevye (Topol) is a milkman, who is always on the lookout for hsubands for his five daughters. How the daughters react to their father's traditional values, his relationship to changing times, and the role that local officials play in the everyday affairs of the people serve not only as the motivation for an exquisite musical score, but also as a valuable reminder of Old World values and experiences. Although not a great film, as Joseph Gelmis observed when the film was released, "It is handsome, simplistic, burdened with stereotypes, conventional in film, and it runs a very long three hours."[1246] Nominated for eight Oscars, including Best Film, Best Director, Best Actor (Topol), Best Supporting Actor (Leonard Frey), Best Art Directior-Set Direction (Robert Boyle, Michael Stringer, and Peter Lamont), it won for Best Cinematography (Oswald Morris), Best Sound (Gordon K. McCallum and David Hildyard), and Best Scoring: Adaptation and Original Song Score (John Williams).

HESTER STREET (Midwest: 16mm: 1975, 91 mins., color, sound, R-CIV)
 Written and directed by Joan Micklin Silver, the screenplay (based on Abaraham Cahan's story YEKL) recounts the story of Jake (Steven Keats), a Russian Jew, who immigrates to America without Gitl (Carol Kane), his wife, at the turn of the century. His experiences working in the sweatshops, living in the ghetto, and amusing himself in the evenings at a dance academy capture the reasons why he tries so hard to assimilate himself into New World values. When Gitl finally arrives in America, she finds not only a changed and unfaithful husband, but also serious challenges to her traditional way of life. How Gitl handles the advice of friends and neighbors illustrates brilliantly the plight of immigrants who relied on common sense, hard work, and education to survive in a strange land. As Jill Forbes points out, "Holding firmly to the middle ground, . . . HESTER STREET entirely avoids parody or fetishism: American myths are rarely enacted so subtly or so sympathetically."[1247] Carol Kane is outstanding in her Oscar-nominated role as the bewildered wife who emerges triumphant.

screenwriters Dalton Trumbo and Albert Maltz, and the objections of Israel to unflattering images of the Jewish state. See Otto Preminger, PREMINGER: AN AUTOBIOGRAPHY (Garden City: Doubleday and Company, 1977), pp.165-72.

[1244] Friedman, p.190.

[1245] Erens, THE JEW IN AMERICAN CINEMA, p.219.

[1246] Joseph Gelmis, "FIDDLER ON THE ROOF," NEWSDAY (November 4, 1971). Cited in FILMFACTS 14:16 (1971):390.

[1247] Jill Forbes, "HESTER STREET," MONTHLY FILM BULLETIN 42:503 (December 1975):262.

THE WAY WE WERE (Columbia--16mm: 1973, 118 mins., color, sound, R-BUD, IMA, MOD, TWY, WEL, WHO; R-SWA, Anamorphic color version)

Directed by Sydney Pollack, the screenplay by Arthur Laurents (based on his novel) covers the romance of Katie Morosky (Barbra Streisand), from her college days as president of the Young Communist League when she meets the school's all-around athletic hero, Hubbell Gardiner (Robert Redford), to their friendship during World War II and marriage in the postwar period, to their conflicts in Hollywood during the blacklisting period, and concludes with their divorce and chance meeting in the early 1970s. The thirty-year period offers a number of engaging opportunities to explore inter-racial marriages, conflicting life-styles and values, the effects of the Hollywood witchhunt on friends and families, and the role that politics played in postwar film history. Among the significant achievements of the film, as Erens points out, are the positive image of a modern Jewish woman and a switch in the relationships involved in a mixed marriage. The film also is important because it remains "one of the few Hollywood films to portray Jewish social commitment (the socialist movement of the thirties and the protests during the 1950s."[1248] Nominated for four Oscars, including Best Actress, Best Art Direction-Set Direction (Stephen Grimes and William Kiernan), and Costume Design (Dorothy Jeakins and Moss Mabry), it won for Best Song ("The Way We Were").

AFRICAN-AMERICANS IN HOLLYWOOD FILMS

Although the history of blacks in American films predates that of the Jews, the influence of African-Americans on the evolution and growth of the film industry is much less understood and appreciated, and the distorted portrait of black culture remains among the most pernicious forms of stereotyping in the annals of film.[1249] An examination of how African-Americans fought to change their intolerable status in American films reveals important lessons about the multiple roles of imagery in the entertainment world. For example, American movies in the period from 1910 to 1915, when the nation was celebrating the semicentennial of the Civil War, show how the public altered its attitudes toward the defeated South yet maintained its romanticized notions about slavery. The value in studying the dilemmas faced by black audiences is suggested by Sidney Poitier who, in acknowledging the dramatic increase in African-American performers working in films during the early 1970s, points out how black audiences, seeing the proliferation of new faces, imagined there was an opportunity for them in movies. "That army of hopefuls," he writes, "unaware that they were being victimized by their own fantasies, set out after their dreams with one-way tickets to Hollywood and New York."[1250] What happens to those "hopefuls" and the lessons to be learned from the controversial 1970s add not only to our understanding of film history but also to our understanding of how our nation evolved.

Thus a discussion of why African-American film images changed as they did provides a useful summary of the major topics addressed in this chapter. That is, by examining the stereotypes about African-Americans, we can better understand the relationship between entertainment and ideology, the psychological effects of stereotyping on American character, the problems of minority filmmakers who struggle

[1248] Erens, THE JEW IN AMERICAN CINEMA, p.323.

[1249] For a useful introduction to the subject, see Francis W. Alexander, "Stereotyping as a Method of Exploitation," BLACK SCHOLAR 7 (May 1976):26-9.

[1250] Sidney Poitier, "Walking the Hollywood Color Line," AMERICAN FILM 5:6 (April 1980):28.

to find a niche in the highly conventionalized film industry, and the preliminary steps required to make American films more responsive to the needs and desires of all citizens. This overview, however, is not intended as a denunciation of racist actions by a misguided industry operating as a microcosm of a racist society. That story has already been documented by a host of scholars like Donald Bogle, Thomas R. Cripps, Daniel J. Leab, Lindsay Patterson, Jim Pines, and Harry T. Sampson. Nor is what follows a comprehensive look at the variety of experiences portrayed in documentaries, short subjects, or foreign films. These topics are beyond the scope of this chronological condensation of scholarly efforts. Rather, the purpose here is to review the nature of the problems blacks face in theatrical American films, outline their scope, and highlight alternatives to historical patterns.

We begin with the observation that the literature on African-American film history is replete with comments about the impact of movies on the lives of black audiences. According to James P. Murray, the first black film critic elected to membership in the New York Film Critics Circle,

> movies have become [by the 1970s] the greatest sociological influence on black
> people other than their immediate environment. Not only is the search for
> entertainment a factor in their lives, but movies are also a way for black people
> to see themselves in relation to society as a whole.[1251]

Bogle comments that "for the duration of my childhood in the 1950s and throughout adolescence in the 1960s, I found myself always on the look-out in movies and on television for black faces."[1252] His experiences were not unique. "While motion pictures (of the Hollywood genre) have always been racial or racist, depending upon how one views them," writes Sheila Smith Hobson, "they have undoubtedly held a place in the childhood and adult life of every American--black, white, or brown."[1253] She goes on to say that Hollywood "brought to many of us, black and often poor, rare opportunities to escape the dull throb of our everyday lives. As we sat in our ghetto theaters, Hollywood gave us laughter, beauty and the envied riches of the 'good white life.' Hollywood symbolized the impossible dream made possible for an afternoon."[1254] As they matured, Bogle and Hobson modified their attitudes toward the screen images of blacks. For example, Bogle felt that watching films like GONE WITH THE WIND (1939) not only misled viewers about the acting abilities of black artists, but also "denied black America a certain cultural heritage."[1255] Once Hobson matured, her black consciousness rejected Hollywood's "golden web of enchantment and entrapment." She understood how films distorted real life situations. She saw how Hollywood's values were not only irrelevant to black aspirations, but also that the American film industry "wallowed in the illusions of childhood."[1256] In that respect, Bogle and Hobson are like many adults today. They sense how African-Americans

[1251] James P. Murray, TO FIND AN IMAGE: BLACK FILMS FROM UNCLE TOM TO SUPER FLY (Indianapolis: Bobbs-Merrill, 1973), p.2.

[1252] *Donald Bogle, TOMS, COONS, MULATTOES, MAMMIES, AND BUCKS: AN INTERPRETIVE HISTORY OF BLACKS IN AMERICAN FILMS (New York: The Viking Press, 1973), p.vii.

[1253] Sheila Smith Hobson, "Black Films of Old," THE PEOPLE (December 25, 1971):19.

[1254] Hobson, p.19.

[1255] TOMS, p.ix.

[1256] Hobson, p.19.

were "colonized" by a racist majority,[1257] they appreciate the links between social control and entertainment.

Making African-Americans aware that film in not merely entertainment is a growing concern of many black intellectuals and artists. Lindsay Patterson speaks for many black parents when he writes to his son,

> Make no mistake about it, movies have a psychological and sociological impact on societies that is frightening. They set tones in morality and dress (one has only to walk through the urban centers of America to see how pervasive this influence is) for millions of people throughout the world. And I know for a fact that the existence of racial discrimination in some countries is a result of their populations having continuously viewed the black man as a foot-shuffling idiot in American films.[1258]

Haile Gerima takes a similar position, arguing that

> Black filmmakers . . . can not view film primarily as entertainment. To do so would mean the acceptance of a fully destructive set of cultural assumptions. Cinema, as entertainment, conditions our lives, our relationships and the things we do. It has strong and severe influences on the way we pattern our social activities as well as on our socio-psychological behavior. The way we dress, the things we talk about, the values we hold dear, our conceptions of beauty, and even our approaches to sexuality are subject to the influences of media messages. To summarize, cinema plays a major role in what we know as life through the way it functions to present certain points of views as social norm and to render others as problems, or as being illegitimate.[1259]

The story of how African-Americans came to the realization that movies play such a prominent role in their lives parallels the findings reported in the Payne Fund studies, discussed earlier. Moreover, modern social scientists remind us that "The myth that 'pure entertainment' exists is one that is slowly but surely being dismantled. Entertainment fulfills a variety of social functions and hence cannot avoid being political in the widest sense of the term."[1260]

To sum up previous discussions, the politics of entertainment are evident once we realize that every society maintains its own set of images, representations, ideologies, and meanings and that these sets are routinely transmitted through the signification process to preconditioned spectators. The mainstream filmmaker's goal is to find a common denominator that will represent the dominant values of a society at that time in history and thus have the movie gain wide acceptance at the box office. The fact that commercial films search for a common denominator to appeal to the widest audience results in the distributed product's achieving a celebrity status that often

[1257] Interestingly, Neal Gabler in his history of the film moguls argues that "By making a 'shadow' America, one which idealized every old glorifying bromide about the country, the Hollywood Jews created a powerful cluster of images and ideas--so powerful that, in a sense, they colonized the American imagination." Cf. Gabler, p.7.

[1258] Lindsay Patterson, "Introduction," BLACK FILMS AND FILM MAKERS: A COMPREHENSIVE ANTHOLOGY FROM STEREOTYPE TO SUPERHERO, ed., Lindsay Patterson (New York: Dodd, Mead & Company, 1975), pp.ix-x.

[1259] Haile Gerima, "On Independent Black Cinema," *BLACK CINEMA AESTHETICS: ISSUES IN INDEPENDENT BLACK FILMMAKING, ed. Galdstone L. Yearwood (Athens: Ohio University, 1982), p.108.

[1260] "Introduction," ENTERTAINMENT, p.xix.

overshadows minority values. The result is that reactionary film messages generally are granted more credibility in determining community values than enlightened positions not popularized by the mass media. That is not to say that a mainstream filmmaker's preferred meaning is accepted passively by the audience. In fact, the opposite effect may occur.

But more often than not, the commercial success of a film is linked to reinforcing what the film companies, their executives, and publicity experts consider the prevailing values of a predominantly white, middle-class society. That is because over a period of time, a reciprocal relationship develops between movie audiences and successful filmmakers. For example, the negative values that many pre-WWII Americans had toward blacks were represented in African-Americans' consistently being stereotyped as servants, entertainers, or clowns in popular American films made by directors of the stature of Victor Fleming, John Ford, and King Vidor. (As we shall see, there are many critics today who argue that the current image of blacks in film retains the industry's demeaning values, only in different forms.)

Throughout the pre-WWII period, Hollywood defended its stereotyping patterns by insisting that nearly one-third of the nation's theaters were located in the South. The theory, as crystalized by Cripps, was that filmmakers needed to factor into the filmmaking process the biases of the Southern audience in order to maximize profits. When challenged, the box-office-driven producers argued that ticket sales in the South often made the difference between a film's breaking even or losing money. But as Cripps points out, Hollywood was only rationalizing its deep-seated prejudices. Looking at the world through a biased prism of American values labeled "Southern box office," the filmmakers were allowed "to believe that the tastes and prejudices of the American South were at the core of their own decision-making processes." More to the point, Cripps concludes, "it allowed them the luxury of creating the concommitant myth of their own innocence."[1261]

A second link between the politics of entertainment and African-American stereotypes surfaces when one examines the variety of relationships presented in the mass media and pinpoints the status of dominant, residual, and emerging values in our culture at a particular time and place. For example, Charles Husband studied the function of the mass entertainment media in England in 1977 to better understand how they contributed to maintaining the values of a white-dominated culture. Despite the fact that close to forty-five percent of the population attending films was black and born in Britain, Husband's research reveals that in the context of television, "the portrayal of black people is most disturbing," and "Radio at a national level has shown itself incapable of responding to the ethnic heterogeneity of its audience."[1262]

[1261] Thomas R. Cripps, "The Myth of the Southern Box Office: A Factor in Racial Stereotyping in American Movies, 1920-1940," *THE BLACK EXPERIENCE IN AMERICA: SELECTED ESSAYS, eds. James C. Curtis and Lewis L. Gould (Austin: University of Texas Press, 1970), pp.121, 144. Jarvie considers Cripps's position a NON SEQUITUR, pointing out that "Hollywood may have been afraid of the RACE ISSUE, but much more important to it was the fact with so many profitable films to be made, why risk making any that could cause controversy?" See MOVIES AS SOCIAL CRITICISM, pp.164-5.

[1262] Charles Husband, "Some Aspects of the Interaction of the British Entertainment Media with Contemporary Race Relations," ENTERTAINMENT, pp.201-2. For useful studies on the treatment of African-Americans on American TV, see Cherry A. McGee Banks, "A Content Analysis of the Treatment of Black Americans on Television," SOCIAL EDUCATION 41:4 (April 1977):336-9, 344; Marilyn Diane Fife, "Black Images in American TV: The First Two Decades," BLACK SCHOLAR 6 (November 1974):7-15; Norman Friedman, "Responses of Blacks and Other Minorities to Television Shows of the 1970s About Their Groups," JOURNAL OF POPULAR FILM AND TELEVISION 7:1 (1978):85-102; R. Errol Lam and Kalman S. Szekely, "Blacks in Television: A

According to Bridget Barry, the NAACP feels the same pernicious images exist in America today, mainly because the mass media exploit the image of the Civil Rights movement by dwelling on negative images of African-American criminals and by avoiding postive images of successful blacks.[1263] "The racism that I am concerned about," explains Roy Innis, national chairperson of the National Association for the Advancement of Colored People (NAACP), "comes from the media and the slick politicians and prosecutors who are playing games . . . There is a media agenda of some indecent people."[1264] As we shall see, studies of African-American film stereotypes illustrate how at one point in history (1920-1941) derogatory images reinforced the political, social, and economic aims of a racist society; and, at another point in history (1949-1970), black stereotypes attempted to offset residual racist values in our culture.

There is, of course, considerable debate over the reasons why American film companies and their employees produce and circulate specific racial stereotypes, the rigidity of the signification process, and the pliability of preconditioned spectators with respect to preferred meanings in theatrical films. What is not debatable is that many spectators use movies to reinforce (or to rebel against) a particular society's needs and values. For example, GUESS WHO'S COMING TO DINNER? (1967) convinced a number of viewers that interracial marriages were not a problem. SONG OF THE SOUTH (1946) persuaded others that not all slaves were treated badly. On the other hand, MANDINGO (1975) demonstrated just how much the evils of slavery had been ignored by earlier Hollywood films. BUCK AND THE PREACHER (1972) helped correct the mistaken notion that blacks had no role in the development of the American West. Each of these films was in large measure a response to the manifest desires of a segment of the public to reinforce and/or to reevaluate its attitudes toward African-Americans. A study of this "uses and gratification" concept highlights the emotional impact that movies have on our lives.[1265] When the concept is applied in detail to specific films, it describes how film technique and content can affect a nation's political, social, and economic goals as effectively as can more traditional forms of persuasion.

To be convincing, the investigators studying racial images need to minimize their subjective judgments and/or moral outrage. The scholarly approach, as Pines points out, should be as objective and analytical as possible. He begins by noting that "one of the outstanding characteristics of racial images is their explicit relation not only to race ideology, but also to the dominant (i.e. surface-level) racial attitudes and

Selective, Annotated Bibliography," ibid., 14:4 (Winter 1987):176-83; "Dr. Jackson: Ratings Services Show Minority Discrimination," HOLLYWOOD REPORTER 256:18 (April 23, 1979):1, 4; George Gent, "Exit Darkies, Enter Blacks," NEW YORK TIMES I (July 3, 1968):71; Howard Taylor, "She Wants to Change TV's Image of Blacks," ibid., B (April 22, 1979):35; C. Gerald Fraser, "Few Offers to Actors in ROOTS," ibid., A (March 18, 1979):46; and Roscoe C. Brown, Jr., "Let's Uproot TV's Image of Blacks," ibid., B (February 18, 1979):35. For a good discussion of the ties between academia and television news, see *Richard Weaver, IDEAS HAVE CONSEQUENCES (Chicago: University of Chicago, 1948).

[1263] Bridget Barry, "Innis Points a Finger at the Media," BURLINGTON FREE PRESS B (February 14, 1989):1.

[1264] Cited by Barry.

[1265] For a useful discussion of the pros and cons of the "Uses and Gratification" approach, see Sinclair Goodlad, "Mass Entertainment in Perspective: The Need for a Theory of the Middle Range," ENTERTAINMENT, pp.120-8; and Stefan R. Melnik, "The 'Uses and Gratifications' Approach in the Study of 'Entertainment' and Leisure Use," ibid., pp.144-52.

expectations held within the society."[1266] In studying stereotypes of blacks, therefore, we need to go beyond their conventional use in film narratives (e.g., themes and characters) to the manner in which they represent points of view and value judgments.[1267] The key in analyzing racial images, according to Pines, is in making a formal distinction between "denotation" and "connotation." The former deals with a literal explanation; the latter, with an interpretative explanation. Clearly, separating the two different levels of assessment is difficult. "The concept-image, 'black', is heavily value-loaded," Pines explains, "because of the dominant assumptions about blacks held in the society, and the sharp racial divisions that exist." He goes on to say that "The emotional load of the racial image is therefore pre-eminent, it immediately influences one's perception at all cognitive levels."[1268] Consequently, studying racial images requires that we examine why something is done as well as how it is done.

A third link between the politics of entertainment and African-American stereotypes is the debate about "realism" in film. To summarize what was said earlier, movies operate as a middle ground between "objective reality" and the intentions of specific filmmakers. Through the use of cameras, lighting, editing, and other cinematic techniques, the product created for mass consumption represents a limited world view that gives a false impression of society. That is, what we see or hear in the movie is not the same as if it were shown or heard independent of the filmmaking process. More to the point, filmmakers shape their products to satisfy the mass audience's presumed desires. During the process, the culture also influences the codes, signs, languages, images, and messages embedded or "stitched" into the film. For example, Hollywood films made during the sixties have few young black males wearing mustaches. On the other hand, movies made by black independent filmmakers during the same period present strong black protagonists having a mustache. Since a man's appearance relates to his self-image and feelings about masculinity, his appearance on screen is not a trivial matter. The broader picture of the transformation from "objective reality" to "screen reality" is evident in the conventions found in film genres. For example, when did westerns begin to feature black cooks, cowhands, outlaws, and heroes? When did police films start to include blacks as department chiefs, bureau heads, and squad leaders? Why these changes occurred is a source of controversy. Was it because of the filmmaker's integrity or because of box-office pressure? And what role did audiences play in the process? Had their encrusted notions about issues, images, and interpretations changed or had they been ignored?

Clearly, white audiences that grew up in the twenties and thirties generally have a more negative image of the intellectual capabilities of African-Americans than those growing up in the sixties and seventies. Did the movies of the seventies help bring about the change in attitudes or follow the lead set by other forces in society? In fact, the evidence suggests that Hollywood's preoccupation with the box office makes it both a follower and a leader. As Siegfried Kracauer explains,

[1266] Jim Pines, "The Study of Racial Images: A Structural Approach," SCREEN EDUCATION 23 (Summer 1977):24.

[1267] For good examples of the relationship among race, ideology, and propaganda, see Thomas R. Cripps, "Movies, Race, and World War II: TENNESSEE JOHNSON as an Anticipation of the Strategies of the Civil Rights Movement," JOURNAL OF THE NATIONAL ARCHIVES 14:2 (Summer 1982):49-67; and Clayton R. Koppes and Gregory D. Black, "Blacks, Loyalty, and Motion Picture Propaganda in World War II," JOURNAL OF AMERICAN HISTORY 73 (September 1986):383-406.

[1268] Pines, p.25.

Hollywood's attitude toward the presentation of any given piece of information ultimately depends on its estimate of how the masses of moviegoers respond to the spread of that information through fiction films . . . [thus] Films help change mass attitudes on condition that these attitudes have already begun to change.[1269]

More to the point, movie messages tend to reinforce traditional values rather than to challenge them. Suffice it to say that by using a "seamless narrative," producers present the illusion of a realistic experience that misleads many people into thinking that what they see on the screen is a "slice of life."

Nowhere was this "realistic" illusion created and maintained more persuasively than in film's repeated glorification of the antebellum South. From the first film version of UNCLE TOM'S CABIN (1903), through THE BIRTH OF A NATION (1915), GONE WITH THE WIND (1939), SONG OF THE SOUTH (1946), and into the sixties with films like THE ALAMO (1960) and SHENANDOAH (1965),[1270] film audiences around the world were inundated with the myth of Southern gentlemen, beautiful belles, and happy slaves. Except for an occasional film like JEZEBEL (1938) that explored degradation in the Old South,[1271] the pre-World War II emphasis was on "moonlight, mint julips, and magnolias." Why generation after generation of viewers encouraged the release and re-release of this movie myth goes beyond the simple explanation of escapism. According to Edward D. C. Campbell, Jr.,

Movies reflect the way we are. ROOTS or MANDINGO would have been as dismally out of place in the 1930s as say THE LITTLE REBEL now. And of course the failure cannot be attributed to differences in technology. We return to some films because they reveal so much about the society which so avidly supported them. Just as UNCLE TOM'S CABIN of 1903 exposes much of America at the turn of the century, so too does its remake in 1965 reveal vast cultural assumptions. That is why films are important cultural history, for each production was concerned--often intentionally--with lessons for the present viewed through a contemporary interpretation of the past . . . The film industry accepted beliefs as readily as it created them. The movies of the antebellum South with their increasingly familiar settings and characters reinforced an image shaped cinematically since 1903. However, in the subtle variations and the public responses over seventy years and in the more recent reversals of stereotypes rest many revelations about how Americans perceived themselves and their racial and economic problems: therein lies the importance of a film genre too often remembered only for its luminaries or technical achievements.[1272]

[1269] "National Types as Hollywood Presents Them," p.260.

[1270] Warren French argues that "the legendary South gave way to the legendary West; and from 1915 to the end of the 1960s the screen's principal contribution to our native mythology was the Western rather than the 'Southern.'" Warren French, "Introduction--'The Southern': Another Lost Cause," THE SOUTH AND FILM, ed. Warren French (Jackson: University Press of Mississippi, 1981), p.3. For more information on the Western film genre, see Chapters 2 and 5.

[1271] Ida Jeter, "JEZEBEL and the Emergence of the Hollywood Tradition of a Decadent South," THE SOUTH AND FILM, pp.31-46. See also Kenneth O'Brien, "The Southern Heroine in the Films of the 1930's," JOURNAL OF POPULAR FILM AND TELEVISION 14:1 (Spring 1986):23-32.

[1272] Edward D. C. Campbell, Jr., THE CELLULOID SOUTH: HOLLYWOOD AND THE SOUTHERN MYTH (Knoxville: The University of Tennessee Press, 1981), pp.4-5. For more information about history on film and history in film, see Chapter 2.

Clearly, the film industry did not initiate the myth of the romanticized South. Its complex roots go back to the literary and stage traditions of the eighteenth century. The evolution of those traditions and their impact on film history have been documented by a host of writers such as Edward D. C. Campbell, Jr., Warren French, Jack Temple Kirby, Ida Jeter, J. P. Telotte, Michael Adams, Jeffrey J. Folks, Fred Chappell, and Peter Soderburgh. Here we need only note that the cinematic romantic image of the antebellum South not only popularized a distorted view of African-American history, but also became a cornerstone of the film industry.

Ever since the post-WWII period and the advent of neo-realism, film scholars have been trying to demystify, deconstruct, and re-write film narratives in order to make audiences more sensitive to the use of films as a social and political force in society. To offset the romantic myths of the South,[1273] a new generation of filmmakers produced an alternative picture in movies like TAMANGO (1957), SLAVES (1969), BUCK AND THE PREACHER (1972), MANDINGO (1975), and THE DRUM (1976). In addition, the reconstructed Hollywood, tapping the writings of Erskine Caldwell, William Faulkner, Lillian Hellman, Harper Lee, Carson McCullers, and Tennessee Williams, has taken issue with the image of the South as an American Eden. In place of Southern chivalry, we are presented with images of Gothic nightmares in movies like TOBACCO ROAD, THE LITTLE FOXES (both in 1941), THE MEMBER OF THE WEDDING (1952), BABY DOLL (1956), CAT ON A HOT TIN ROOF, GOD'S LITTLE ACRE (both in 1958), SUDDENLY LAST SUMMER (1959), SANCTUARY (1961), TO KILL A MOCKINGBIRD (1962), THE HEART IS A LONELY HUNTER (1968), and THE REIVERS (1969).

Here again, the degree to which viewers are taken in by the "seamless narratives" as well as by critical strategies designed to sensitize them to the ideological implications of film texts is very problematic. There is no reason to believe that the Southern Gothic is any more realistic than the films of the Old South. In the view of Robert Stam and Louise Spence, "While posing legitimate questions concerning narrative plausibility and mimetic accuracy, negative stereotypes and positive images, the emphasis on realism has often betrayed an exaggerated faith in the possibilities of verisimilitude in art in general and the cinema in particular, avoiding the fact that films are inevitably constructs, fabrications, representations."[1274] For our purposes, the question is whether we should focus on the conflict between the illusion of reality and objective reality, or concentrate instead on the nature of the stereotype in relation to character analysis and on how meanings and images are created, to what end, and with what effect.

A fourth link between the politics of entertainment and African-American stereotypes is the relationship between the Jewish-dominated film industry and the black community, a relationship that reveals a great deal about the history of racism and anti-Semitism in America. For example, Ben Halpern identifies blacks and Jews as the "classic" minorities:

> . . . both share a tragic past; both have been persecuted at the hands of a Christian majority. Both have a sense of separateness and racial different-ness at the hands of a Christian white majority. Both consider themselves "Biblical people." In many ways, there are striking similarities and a sense of kinship. Yet, in their vastly different life-styles, mutual envy and fear, economic and political competition, and in their relationship to a

[1273] Fred Chappell, "The Image of the South in Film," SOUTHERN HUMANITIES REVIEW 12 (Fall 1978):303-11. For a good discussion of how the mass media approach race relations in modern times, see Floyd Watkins, THE DEATH OF ART (Chicago: University of Chicago Press, 1970).

[1274] Robert Stam and Louise Spence, "Colonialism, Racism and Representation: An Introduction," SCREEN 24:2 (1983):3.

non-Jewish, non-black power structure, there are antagonisms that run deep. While the triad may be at times more intricate, it is usually the "mean" Christian on top, politically and economically, the "stingy" Jew in the middle, and the "lazy" black on the bottom.[1275]

The point worth remembering is that the controversial relationship between blacks and Jews is centuries old.

One intriguing sidelight to the relationship between Jews and African-Americans is the tendency of progressive filmmakers to translate a Jewish problem into a black problem. For example, a Georgia jury in 1913 sentenced a Jew to death for murdering a teenage girl. The crucial evidence was provided by a black janitor. Southern anti-Semitism of the period was so intense that enraged citizens lynched the Jew when they learned that the state's governor had commuted the Jew's sentence. That incident, fictionalized in Ward Greene's novel, DEATH IN THE DEEP SOUTH (1936), became the basis for the 1937 film THEY WON'T FORGET, only this time considerable attention was paid to the welfare of the black janitor (Clinton Rosemond).[1276] To cite other examples, Cripps claims that in creating THE GREEN PASTURES on stage and screen, Marc Connelly consciously tried to have "modern blacks . . . inherit the great history of Jews. . . ."[1277] Just over a decade later in 1949, Arthur Laurents's Broadway play HOME OF THE BRAVE (1945) about the problems of a Jewish soldier suffering from the racist actions of his fellow GI's was translated to the screen as the problems of a black soldier.[1278] In comparing the two black "problem" films to the post-WWII anti-Semitic films, Walter Goodman comments that "The whiteness of the early black victims [in PINKY and LOST BOUNDARIES] was akin to the gentile-ness of the victim of anti-Semitism in GENTLEMAN'S AGREEMENT."[1279]

In terms of how the Jewish-dominated film industry characterized African-American culture, Arun Kumar Chaudhuri provides a good summary up to the post-WWII era:

A chronological overview of the Negro in the motion picture reveals that from its inception it has used the Negro in a stereotyped derogatory manner or as a means of "poking fun" and giving the general public incorrect ideas on the life and character of the group. Picturization of the Negro, for the most part, has been represented by the following stereotyped personalities up to World War II: clown, clod-hopper, scarecrow, stupid individual, devoted slave who "knows his place," and an "Uncle Tom"--submissive, servile. White actors, at first, were "made up" to perform the role of these types of characterization. After World War I Negro actors were employed to portray roles which represented them as being afraid of the dark, ghosts, police, and animals; or either as lazy or greedy individuals.[1280]

[1275] Cited in Jack Nusan Porter, "John Henry and Mr. Goldberg: The Relationship Between Blacks and Jews," THE JOURNAL OF ETHNIC STUDIES 7:3 (Fall 1979):75.

[1276] For more details, see BLACKS IN FILMS, pp.51-3.

[1277] THE GREEN PASTURES, p.18.

[1278] For examples of other cases, see BLACKS IN FILMS, p.64.

[1279] Walter Goodman, "Ethnic Humor Bubbles to the Surface of the Melting Pot," NEW YORK TIMES B (April 27, 1986):17.

[1280] Arun Kumar Chaudhuri, "A Study of the Negro Problem in Motion Pictures," (Unpublished Master's thesis, University of Southern California, 1951), pp.92-3.

No one denies that such derogatory images have been used or that their influence is still being felt in the 1980s. What is not generally understood is the reasons why such stereotypes evolved, why they persist, and the effects they have had. Since it is the effect and not the reality that matters in the film industry, it is useful to trace the evolution of African-American screen images from the past to the present.[1281] Although the discussion that follows focuses almost exclusively on Hollywood feature films, a similar overview of documentary and foreign films would also yield invaluable information. Those who wish to delve further will find the resources for such a study in the following pages.

Interestingly, at a time when America was both seeking reconciliation with the South and institutionalizing its racial fears, the first primitive films in the 1890s pictured black people in a variety of roles: dancing, doing menial jobs, serving in the military, and boxing. Among the popular titles were THE CORBETT-JACKSON

[1281] My broad overview of African-American images in film has been shaped by the following material: *James Baldwin, THE DEVIL FINDS WORK (New York: The Dial Press, 1976), pp.35-92; Daisy F. Balsley, A DESCRIPTIVE STUDY OF REFERENCES MADE TO NEGROES AND OCCUPATIONAL ROLES REPRESENTED BY NEGROES IN SELECTED MASS MEDIA (Unpublished Ph.D. dissertation, University of Denver, 1959); *Donald Bogle, TOMS, COONS, MULATTOES, MAMMIES, AND BUCKS: AN INTERPRETIVE HISTORY OF BLACKS IN AMERICAN FILMS (New York: The Viking Press, 1973); ___, "'B' . . . for Black: No Business Like Micheaux Business," FILM COMMENT 21:5 (September/October 1985):29-38; Singer Alfred Buchanan, A STUDY OF THE ATTITUDES OF WRITERS OF THE NEGRO PRESS TOWARD THE DEPICTION OF THE NEGRO IN PLAYS AND FILMS: 1930-1965. (Unpublished Ph.D. dissertation, University of Michigan, 1968); William Lee Burke, THE PRESENTATION OF THE AMERICAN NEGRO IN HOLLYWOOD FILMS, 1946-1961: AN ANALYSIS OF A SELECTED SAMPLE OF FEATURE FILMS, (Unpublished Ph.D. dissertation, Northwestern University, 1965); Royal D. Colle, THE NEGRO IMAGE AND THE MASS MEDIA (Unpublished Ph.D. dissertation, Cornell University, 1967); *Thomas Cripps, BLACK FILM AS GENRE (Bloomington: Indiana University Press, 1978); *___, SLOW FADE TO BLACK: THE NEGRO IN AMERICAN FILM, 1900-1942 (New York: Oxford University Press, 1977); ___, "Black Films and Film Makers: Movies in the Ghetto, B. P. (Before Poitier)," NEGRO DIGEST 18:4 (February 1969):21-48, Rpt. in the Bobbs-Merrill Reprint Series in Black Studies BC-55; Langston Hughes and Milton Meltzer, BLACK MAGIC: A PICTORIAL HISTORY OF THE NEGRO IN AMERICAN ENTERTAINMENT (Englewood Cliffs, N.J.: Prentice-Hall, 1967); *Daniel J. Leab, FROM SAMBO TO SUPERSPADE: THE BLACK EXPERIENCE IN MOTION PICTURES (Boston: Houghton Mifflin Company, 1975); ___, "A Pale Black Imitation: All-Colored Films, 1930-60," JOURNAL OF POPULAR FILM 4:1 (1975):56-76; Carlton Moss, "The Negro in American Films," FREEDOMWAYS 3:2 (Spring 1963):134-42; *Jim Pines, BLACKS IN FILMS: A SURVEY OF RACIAL THEMES AND IMAGES IN THE AMERICAN FILM (London: Studio Vista, 1975); *Henry T. Sampson, BLACKS IN BLACK AND WHITE: A SOURCE BOOK ON BLACK FILMS (Metuchen: The Scarecrow Press, 1977); Peter A. Soderbergh, "Hollywood and the South, 1930-1960," MISSISSIPPI QUARTERLY 19:1 (Winter 1965-66):1-19; Terry Theodore, "The Negro in Hollywood: A Critical Study of Entertainment Films Containing Negro Themes" (Master's thesis, University of Southern California, 1951); Armond White, "Telling It on the Mountain: Black Filmmakers Are Outside, . . . " FILM COMMENT 21:5 (September/October 1985):39-46; Gladstone L. Yearwood, "The Hero in Black Film: An Analysis of the Film Industry and Problems in Black Cinema," WIDE ANGLE 5:2 (1982):42-9; Stephen F. Zito, "The Black Film Experience," THE AMERICAN FILM HERITAGE: IMPRESSIONS FROM THE AMERICAN FILM INSTITUTE ARCHIVES (Washington, D.C.: Acropolis Books, 1972), pp.61-9; and "The Last 'Special Issue' on Race?" SCREEN 29:4 (Autumn 1988).

[1282] Peter Jackson was a black fighter who boxed James Corbett, the heavyweight champion, for the Kinetoscope Exhibition Company in 1894. For more information,

FIGHT,[1282] THE PICKANINNIES (both in 1894), THE EDISON MINSTRELS, DANCING DARKIES (both in 1897), and COLORED TROOPS DISEMBARKING (1898). The question today is whether these early films portrayed a negative or neutral image of African-Americans. For example, Pines writes that

> The black image was inherently useful not just in terms of its entertainment value, though this played a highly important part overall, but also, and more dynamically, in terms of its iconic-cultural recognizability. Thus, while the newsreel image tended to assume a mystifying dimension BECAUSE OF the seemingly magical nature of motion pictures, the movie process merely reinforced traditional myths and images of black life. Such largely experimental movies . . . signalled the beginning of the historic relationship between technological innovation in the American film and racism.[1283]

On the other hand, Cripps finds the first black images neutral:

> In their day, the films were black only in the sense that they thrust a heretofore invisible image upon general American viewers. Their roots emerged from a faddish popular anthropology . . . Therefore many early black figures on the screen were no more than the subjects of a quest for the legendary, the curious, and the bizarre, through darkest Africa and Carib isle.[1284]

The debate between scholars like Pines and Cripps recalls the arguments raised earlier by Janet Staiger about the canonization of films. She is particularly disturbed about pluralistic points of view that isolate the film experience from our moral and political lives. Moreover, she argues that we should focus on how films affect people and what they do to their lives and not just examine the image as an aesthetic experience.

In practical terms, the issue of how the first films portrayed African-Americans might best be seen against the backdrop of the 1904 Niagara meeting, when leading black intellectuals gathered to discuss the future of African-Americans in terms of direction (assimilation or cultural pluralism) and strategy (cooperation or militancy). If you were a black living at the turn of the century and saw these films, how would you have felt about yourself, the status of your people, and America's claim of life, liberty, and the pursuit of happiness? According to Stephen F. Zito, "the blackness of the black man was both his badge of character and his comic fate."[1285] Whatever the truth about the early images, it is clear that the sheer novelty of moving pictures allowed the film pioneers simply to record any scenes that exploited movement.

But very soon the filmmakers discovered that to maximize profits, novelty had to be combined with formula products. That discovery, as noted earlier, was predicated on the filmmakers' predictions and predilections toward their audiences. Not only were the movies tied to seasonal and cyclical fluctuations but also to well-established patterns in literature and on the stage. In terms of black images, the tradition relied heavily on the "Sambo" approach: comic characters who were stupid, eager to please, always grinning, and ready to sing and dance at the slightest

see Gordon Hendricks, THE KINETOSCOPE: AMERICA'S FIRST COMMERCIALLY SUCCESSFUL MOTION PICTURE EXHIBITOR (New York: The Beginnings of the American Film, 1966), pp.97-109.

[1283] BLACKS IN FILMS, p.7.

[1284] BLACK FILM AS GENRE, p.13.

[1285] Zito, p.62.

[1286] For a good chronicle of the stereotype, see *Joseph Boskin, SAMBO: THE RISE AND DEMISE OF AN AMERICAN JESTER (New York: Oxford University Press, 1986).

encouragement.[1286] While other socially conscious groups exercised considerable influence in discouraging offensive portrayals and anachronistic values, African-Americans found their objections totally ignored by the free-wheeling film industry. Unlike Jews or women, they had neither creative nor financial influence in the burgeoning movie business. In fact, at the outset and following the traditions established by the stage and vaudeville, the key film roles, performed by white actors in blackface,[1287] institutionalized stereotypes like Uncle Tom figures, loyal servants, bizarre clowns, and dangerous knife-wielding gamblers. As black performers slowly became assimilated into films, they almost always appeared in grotesque parodies of their race. Examples of the racial types are evident in film titles like UNCLE TOM'S CABIN (1903), THE WOOING AND WEDDING OF A COON (1905), THE MASHER (1907), RASTUS IN ZULULAND (1910), and FOR MASSA'S SAKE (1911).

One noteworthy aspect of the early black stereotypes was the excessive and sensational interest in interracial mixing that the filmmakers had inherited from the stage. Ever since Shakespeare's OTHELLO, popular playwrights had exploited the dramatic possibilities of sexual conflicts between the races. A case in point was Dion Boucicault's THE OCTOROON (1859) and the problems of "the tragic mulatto." Focusing on the plantation era, the play deals with a female slave of mixed blood who must be sold by her lover to a person they both despise. The "tragedy" is that her "blackness" prevents her from enjoying the benefits of being "white."[1288] Plays like THE OCTOROON were quite popular in the early 1900s, and even spawned other dramas on the tragic mulatto theme. For example, Edward Sheldon's THE NIGGER (1909) treated the problems of a state governor who discovers that he has black blood and thus has to forget about a future in politics. The time-worn plot, as Leab explains, was to have the stage mulatto "reinforce popular notions about white superiority."[1289] "Black" was synonymous with weakness and despair; "white," with strength and optimism. Among the more notable plays dealing with interracial mixing in the silent era were ALL GOD'S CHILLUN GOT WINGS (1924) and IN ABRAHAM'S BOSOM (1926).

American filmmakers adapted, without reservations, the stage traditions regarding racial values in society. This type of racial hierarchy, as Cripps documents, had a strong appeal to the competitive and race-conscious employees of the white-dominated film industry where one's job, advancement, and social circle operated as a microcosm of the race-conscious society. "The important difference,"

[1287] For a good introduction to the blackface tradition, see *Robert C. Toll, BLACKING UP: THE MINSTREL SHOW IN NINETEENTH-CENTURY AMERICA (New York: Oxford University Press, 1974).

[1288] The term "tragic mulatto," as applied to film history, functions equally as a form of contrast and as a concept. According to Rosalind Cash, ". . . black women in American movies have been divided into two categories. They either play the tragic mulatto or the mammy. The mammy was always the very big, very dark black woman and she was really de-sexed. Hattie McDaniel played mammies, and so did Louise Beavers. And there's even a touch of that in Claudia McNeill's performance in A RAISIN IN THE SUN. The idea was that no black woman could really be sensual or erotic." Cash then goes on to say that "what happens to the light-skinned woman in American movies is that she does get a chance at leading roles, but she always ends up tragically. She's really a white woman with a little bit of that Negro blood, which just destroys her." See Heywood Hale Broun, "Is it Better to Be Shaft than Uncle Tom?" NEW YORK TIMES B (October 26, 1973):11.

[1289] Leab, p.10.

Cripps points out, "was that in Hollywood such arrangements became the premise upon which moviegoing Americans reinforced their racial values."[1290]

The first significant appearance of the tragic mulatto on screen was in THE DEBT (1912), when a young woman's life is ruined by the discovery that her mother was black. From that film on, including two movie versions of IMITATION OF LIFE (1934 and 1959) and three versions of SHOW BOAT (1929, 1936, and 1951), filmmakers presented sensational and sentimental stereotypes of people agonizing over what to do with their "racial impurity." On the one hand, despicable characters like Lydia Brown in THE BIRTH OF A NATION (1915) used their positions as a means of revenging themselves on the white race. On the other hand, sympathetic protagonists like Philip Morrow in THE NIGGER (1915) accepted their "tragic" destinies with courage and dignity. In both instances, however, people with mixed blood underwent considerable crises of self-confidence.

As the film industry moved from a state of "pure competition" to an oligopoly in the teens, African-Americans struggled to gain a foothold in the market. The Foster Photoplay Company, the first black production firm to operate in Chicago, formed by William Foster with the help of Peter P. Jones, didn't surface until 1910, and a limited number of black-owned theaters strove to satisfy the needs of local black audiences. While men like Foster and Jones led the way in opening up the film market for "race productions" (movies targeted for black audiences),[1291] these enterprising attempts had neither the strength nor the stature of their white counterparts. For example, black audiences faced considerable obstacles in seeing films with all-black casts. Until the forties, the number of black-owned theaters never exceeded twenty-five, and these houses showed predominantly Hollywood films. The one advantage to black audiences was that ticket prices were cheaper than at the white theaters. Among the many disadvantages was that the low ticket scale limited the price that the black exhibitor paid for "race productions." This affected not only the number of black films seen, but also the number made. White houses rarely showed "race" films. Furthermore, in the South, white theaters were segregated and many remained so into the 1960s. On occasion, the white theaters opened for special matinees or midnight showings for black audiences, who otherwise were dispatched to the balconies (infamously referred to as "Nigger Heaven"). DE FACTO segregated theaters followed similar patterns in the North. In addition, producers interested in all-black-cast films faced three major business problems: the market for race movies was extremely limited, distribution depended on a theater-by-theater arrangement, and very few people were willing to put any pre-production money into such ventures. Thus, black filmmakers and performers had great difficulty in forming a strong, cohesive voice.

The most derogatory treatment of blacks in silent films occurs in THE BIRTH OF A NATION (1915). Griffith's technical masterpiece is the work of a white supremacist who tried to show that black people, unless they had paternal white leaders, were incapable of governing themselves or of controlling their passions.[1292] Lewis Jacobs accurately lists the naive and ignorant images that Griffith projected in 1915:

The film was a passionate and persuasive avowal of the inferiority of the Negro. In viewpoint it was surely narrow and prejudiced. Griffith's Southern upbringing made him completely sympathetic toward [Thomas] Dixon's exaggerated ideas, and the fire of his convictions gave the film rude strength. At one point in the picture a title bluntly editorialized that the South must be

[1290] SLOW FADE TO BLACK, p.95.

[1291] For a useful overview, see Pearl Bowser, "The Boom Is Really an Echo," BLACK CREATION 4 (Winter 1973):32-5.

[1292] For a more detailed discussion of Griffith, see Chapter 6.

made "safe" for the whites. The entire portrayal of the Reconstruction days showed the Negro, when freed from white domination, as arrogant, lustful, villainous. Negro congressmen were pictured drinking heavily, coarsely reclining in Congress with bare feet upon their desks, lustfully ogling the white women in the balcony. Gus, the Negro servant, is depicted as a renegade when he joins the emancipated Negroes. His advances to Flora, and Lynch's proposal to Elsie Stoneman, are overdrawn to make the Negro appear obnoxious and audacious. The Negro servants who remain with the Camerons, on the other hand, are treated with patronizing regard for their faithfulness. The necessity for the separation of Negro from white, with the white as the ruler, is passionately maintained throughout the film.[1293]

These stereotypes are not only the outgrowth of isolated incidents in the Reconstruction period; they also appear on the screen and in the minds of the audience as "historical" evidence about life in the South and how ex-slaves behaved when they were given authority between 1865 and 1873.[1294] Much of Griffith's "historical evidence" was derived from the followers of the Columbia University history professor William A. Dunning. But there was more to Griffith's conservative and sympathetic portrait of the South than found in the Dunning school of thought. As Jack Temple Kirby explains,

Griffith's Dixie was homey in the highlands, decadent in the tide- water, but virtuous, courageous, and rather violent throughout. It was a useful South. Imperialists, reactionary paternalists, reformer-segregators, nature-lovers--all found something pertinent and reinforcing. But in an age of eugenics, racial separatism, xenophobia, and the "new" immigration of Catholics and Jews, Griffith's, Dunning's and their contemporaries' use of the South was only one key to reconciling the past with the new world. Ethnicity--the larger sense of what Professor Dunning called "the great face of race"--was the matrix of pluralistic society's identity; and contrary to Israel Zangwill's myth of a harmonious "melting pot," most Americans seemed to understand that sensible social history explained white dominance and permanent ethnic separation and hostility.[1295]

To a large degree, therefore, THE BIRTH OF A NATION popularized on a national scale the current vogue in academic circles about the "truth" of the antebellum era, the Civil War, and the Reconstruction period that followed.

There can be little doubt of the influence that the film had on future portrayals of African-Americans. Ralph Ellison, for example, writes:

In the struggle against Negro freedom, motion pictures have been one of the strongest instruments for justifying some white Americans' anti-Negro attitudes and practices. Thus the South, through D. W. Griffith's genius, captured the enormous myth-making potential of the film form almost from the beginning. While the Negro stereotypes by no means made all white men Klansmen the

[1293] Jacobs, p.177.

[1294] For a more liberal interpretation of the Reconstruction period, consult *Kenneth M. Stampp, THE ERA OF RECONSTRUCTION 1865-1877 (New York: Alfred A. Knopf, 1965). Also helpful is Charles L. Hutchins, A CRITICAL EVALUATION OF THE CONTROVERSIES ENGENDERED BY D. W. GRIFFITH'S BIRTH OF A NATION (Master's thesis, University of Iowa, 1961).

[1295] *Jack Temple Kirby, MEDIA-MADE DIXIE: THE SOUTH IN THE AMERICAN IMAGINATION (Baton Rouge: Louisiana State University Press, 1978), pp.16-7.

cinema did, to the extent that audiences accepted its image of Negroes, make them participants in the South's racial ritual of keeping the Negro "in his place."[1296]

Walter Lippmann also comments upon the film's negative effect:

Historically it may be the wrong shape, morally it may be a pernicious shape, but it is a shape, and I doubt whether anyone who has seen the film and does not know more about the Ku Klux Klan than Mr. Griffith, will hear the name again without seeing these white horsemen.[1297]

Both points of view are reinforced by the findings of Ruth Peterson and L. I. Thurstone,[1298] who report that children develop negative attitudes toward African-Americans as a result of seeing THE BIRTH OF A NATION.

The more immediate effect of the film's characters is revealed in the stereotypes of black people in Hollywood movies during the twenties. This was the time when black theater was enjoying its greatest popularity. Across the country, from the Great White Way, Harlem, and Greenwich Village, to college campuses like Howard University, African-American performers, dramatists, and scholars were working through repertory groups like the Lafayette Players, Gilpin Players, and the Ethiopian Players to educate and enlighten audiences about the rich heritage of African-American culture. Indifferent to such stirrings, Hollywood carried forward the plantation traditions legitimized in THE BIRTH OF A NATION. The standard tack was to use blacks (primarily men) as comic relief. A typical example is demeaning image of blacks in film shorts like the Rolin Comedies featuring Frederick Ernest Morrison as Pickaninny Sammy. Overall, explains Leab,

American films generally depicted blacks in a menial capacity. According to a survey based on films viewed by VARIETY between 1915 and 1920, over 50 percent of the black characters were maids, stableboys, and the like. And during the 1920s more than 80 percent were some kind of subordinate help.[1299]

Equally disturbing was the depiction of blacks as slaves or jungle barbarians. An example is Griffith's THE IDOL DANCER (1920), where a white heroine literally faints at the mere sight of a native, who symbolizes danger and destruction. These types of motion pictures, in which African-Americans were systematically kept in servile positions or depicted as clods and brutes, helped impress the white audience, as Peter Noble puts it, with the general idea that blacks belonged in African jungles "and certainly not in 'civilized' America, where they could count themselves lucky to be tolerated by the whites."[1300]

[1296] Ralph Ellison, "Shadow and Act," *SHADOW AND ACT (New York: Random House, 1964), p.276. Another excellent analysis of the effect is Thomas R. Cripps, "Reaction of the Negro to the Motion Picture BIRTH OF A NATION," THE HISTORIAN 25:3 (May 1963):344-62; Rpt., the Bobbs-Merrill Reprint Series in Black Studies BC-57; and *Fred Silva, ed. FOCUS ON "THE BIRTH OF NATION" (Englewood Cliffs: Prentice-Hall, 1971), pp..

[1297] Lippmann, p.92.

[1298] Peterson and Thurston, p.166.

[1299] Leab, p.42.

[1300] Peter Noble, THE NEGRO IN FILMS (London: Skelton Robinson, 1950), p.44. New York: Arno Press, 1970.

Of course, there were exceptions to Hollywood's distortions of African-American culture. For example, Hal Roach's OUR GANG series made black children like "Sunshine Sammy," "Pineapple," and "Farina" an integral part of the action as well as the comedy. The question today is why black audiences patronized such films. Was it because they felt that the films improved race relations or because such films gave much needed employment to black performers?

THE BIRTH OF A NATION did more than perpetuate racist values. It also stimulated black organizations like the National Association for the Advancement of Colored People (NAACP) to lead nationwide protests against the film as well as to increase America's sensitivity to race relations. In addition, a number of independent black production companies came into existence to counteract racist attitudes and, at the same time, provide black performers with demanding roles as well as giving black audiences a more meaningful film experience. The Lincoln Motion Picture Company, established in 1916 and run and operated by George and Noble Johnson, was the first black film organization to produce and distribute films with all-black casts to a national audience. Its initial film, THE REALIZATION OF A NEGRO'S AMBITION (1916), focused on the career of James Burton, a fictional graduate of Tuskegee. The depiction of his commercial success and happy home life is radically different from the racist images of the period. Here, in many respects, is a black person with the same middle-class values and goals as white people. The question that surfaced later about these types of all-black movies mirroring values in white movies is whether these positive black images symbolized the black filmmakers' desires to imitate white Christian values at the expense of an African-American heritage. That issue aside, the commercial success of THE REALIZATION OF A NEGRO'S AMBITION resulted in Lincoln's producing several more feature films before going out of business in 1923.

Another important contribution to independent black productions was the Oscar Micheaux Film and Book Company founded in 1918. Micheaux, often referred to as "the Father of the Black Cinema," was the only black filmmaker who began in the WWI era and continued operating throughout the next three decades.[1301] His first film, THE HOMESTEADER (1919), foreshadowed many of his future productions. Based upon a semi-autobiographical novel Micheaux had written, the story deals with black pride and true love. A sense of the author's flair for show business is evident in the book's cover:

A novel that can be called truly great in its sweep and immensity, a tale of the great Northwest Country in the making; in its tense mystery and strange intrigue--a courageous Negro youth in the toils of a hypocritical minister of the gospel; in its web of cross-purposes and contrasted types strangely linked together, THE HOMESTEADER makes up a story replete with conquest, mystery and intrigue but with a theme intensely human, a story of love, high resolve and ultimate achievement.

While copies of the book are still available, no print exists of the film. Nonetheless, the success of the screen adaptation eventually led Micheaux to leave his Sioux City, Iowa, headquarters and to set up operations on 135 Street in Harlem. From there, as Madubuko Diakite points out, Micheaux continued to produce dramas and melodramas around two basic themes: (1) the everyday difficulties of middle- and lower-class black people--e.g., BIRTHRIGHT (1924), THIRTY YEARS LATER (1928), THE EXILE (1931), THE BETRAYAL (1948)--and (2) issues related to racial identity

[1301] For a good overview, see Richard Grupenhoff, "The Rediscovery of Oscar Micheaux, Black Film Pioneer," JOURNAL OF FILM AND VIDEO 40:1 (Winter 1988):40-8; Bernard L. Peterson, Jr., "The Films of Oscar Michaeux: America's First Fabulous Black Filmmaker," THE CRISIS 86 (April 1979):136-41; and Pearl Bowser, "Oscar Micheaux: Pioneer Filmmaker," CHAMBA NOTES (Winter 1979):5.

and class differences--e.g., BODY AND SOUL (1925), BROKEN VIOLIN (1926), THE WAGES OF SIN (1928), and TEMPTATION (1936).[1302] No matter which theme Micheaux pursued, he seemed committed to offering an alternative to the stereotypes cataloged in THE BIRTH OF A NATION. Whatever his technical or artistic failings, and they were many, Micheaux led the way in teaching future independent filmmakers the pitfalls of being an outsider in a highly competitive industry.

Other efforts to offset Griffith's insidious images were made by a mixed collection of black and white race production companies like the Reol Production Company (white-owned), the Unique Film Company (black-owned), the Colored and Indian Film Company (black-owned), the Ebony Film Company (white-owned), the Democracy Film Corporation (white-owned), and the Frederick Douglas Company (black-owned). As Bogle explains, they sprung up all over America, "often using the abandoned studios of mainstream film companies that had fled to California."[1303] The shenanigans they pulled on the public and exhibitors are every bit as entertaining today as the legendary stories attributed to the Hollywood moguls. Eventually, an alert press, a more discriminating black audience, and a growing list of cynical exhibitors caught on to the wheeler-dealer values of the post-WWI race companies. By the end of the silent era, nearly 150 organizations had appeared and disappeared. Most of them produced forgettable films. In fact, there is the possibility that the proliferation of so many inferior companies and inept films soured the black community on race productions in general.

One film that failed was particularly notable because it was produced by Emmett J. Scott, Booker T. Washington's secretary at Tuskegee.[1304] Although not in the same class as the films made by the Johnson brothers or Micheaux, THE BIRTH OF A RACE (1919) testifies to the growing concern that prominent African-Americans felt about the power of film to influence the nation's values and attitudes. Originally titled LINCOLN'S DREAM, the ambitious project had the initial backing of Washington, the NAACP, and Carl Laemmle, the head of Universal Pictures. Unfortunately Washington died, the NAACP got bogged down with internal problems, and Laemmle dropped his support. Determined to continue, Scott took up with a fly-by-night Chicago operation; and the film, retitled THE BIRTH OF A RACE, became a good illustration of the problems faced by early independent black filmmakers in the white-dominated film industry. Conceived in 1916, the twelve-reel movie, shot in Florida and Chicago, took three years to finish. And as Norman Kagan explains, Scott had to abandon his initial plans.

Needing completion money, he was forced to deal with white backers who demanded major changes in story and company organization. The final film which resulted had beautiful sets next to shabby backdrops, enormous live battle scenes cut into cheap and obvious stock footage. The theme was lost, and THE BIRTH OF A RACE was a terrible failure.

But a failure with important lessons. Black producers had learned about runaway shooting costs, about attainable production goals, and about the importance of control of white technicians--and white backers.[1305]

[1302] Madubuko Diakite, FILM, CULTURE, AND THE BLACK FILMMAKER: A STUDY OF FUNCTIONAL RELATIONSHIPS AND PARALLEL DEVELOPMENTS (New York: Arno Press, 1980), p.67. Interestingly, the only two Micheaux films still in existence are WITHIN OUR GATES (1920) and BODY AND SOUL (1924).

[1303] "'B' . . . for Black," p.31.

[1304] According to Cripps, Washington and Scott were both involved in the project. Regrettably, the former died a month before a contract was signed with a Chicago firm. See, SLOW FADE TO BLACK, pp.74-5.

[1305] Norman Kagan, "Black American Cinema: A Primer," CINEMA 6:2 (Fall 1970):2-7.

Kagan's analysis quite correctly stresses the aspirations that well-meaning but crudely constructed organizations like the Birth of a Race Photoplay Corporation offered to black audiences in the silent era. Kagan's analysis also covers up what Cripps calls the "chicanery and mismanagement" that plagued the poorly conceived black undertaking.[1306]

Although Kagan's oversimplification of black-white relationships downplays the complexities of the film industry, it does suggest that in many respects early black filmmakers ran into the same problems faced by producers of Yiddish films. That is, shoestring productions operating outside the mainstream of the commercial film industry had difficulty in securing adequate capital and technical skill to produce films competitive with those of the emerging film studios. Furthermore, the lack of an adequate distribution system coupled with limited exhibition outlets only increased the obstacles to reaching an already limited audience. To their credit, however, both groups stressed many positive cultural aspects of their race. Like the Yiddish filmmakers, the "race" filmmakers gambled that their purpose would mask their technical and business failings. As Bogle points out, they were not entirely wrong. Films like THE BULL DOGGERS (1923), THE FLAMING CRISIS (1924), THE FLYING ACE (1926), and THE SCAR OF SHAME (1927) did provide many black audiences with characters who "were walking embodiments of black assertion and aggression, and, of course, they gave the lie to America's notions of a Negro's place."[1307] Jane Gaines feels that early melodramatic productions like SCAR OF SHAME did more than skew the world in favor of black heritage. She believes that black audiences seeing this "domestic melodrama would have made the cruel irrationality of social and political disenfranchisement seem manageable; cast in personal terms, injustice could almost seem to be dealt with finally and absolutely. Ideals of fairness and equality could appear to win out at least temporarily over bigotry, heartlessness, and malevolence."[1308]

What is being debated today is whether the films made by these individuals were protest movies, attacking the second-class citizenship blacks had in a racist American society. For example, Sampson rejects the notion that the first wave of independent black films (1916-1930) directly challenged the values and attitudes of a segregated nation:

> The early producers made no direct effort through their films to glorify and amplify the scientific, political and cultural contributions made by blacks. The themes of these early pictures tended to reflect the life style and social customs of the Black bourgeoisie of the period. In an indirect sense, these early productions can be viewed as a protest against the demeaning stereotypes portrayed by the majors. Almost always, the central characters in pioneer black-cast films were portrayed as well-educated, with high moral values, and strongly motivated to achieve success.[1309]

On the other hand, Diakite insists that the first black films were neither offshoots of white-film genres nor ordinary reflections of a racist society. "If the values reflected in Black made films are seen as mere reflections of a white culture," he points out, "then the realities of Black life, hopes, aspirations are justly being overlooked, an occurrence which white Hollywood has refused to deal with, but one

[1306] SLOW FADE TO BLACK, p.74.

[1307] "'B' . . . for Black," p.31.

[1308] Jane Gaines, "The Scar of Shame: Skin Color and Caste in Black Silent Melodrama," CINEMA JOURNAL 26:4 (Summer 1987):17.

[1309] Sampson, pp.87-8.

that Black filmmakers dealt with in spite of handicaps, whenever possible.[1310] Bogle concurs, particularly in relation to the films made by Micheaux. "Intertwined in all his films," insists the popular historian, "is the consciousness of how race is a force in black life."[1311] Cripps offers still another perspective by attacking the absence of a black aesthetic in the early films:

> Already middle-class blacks and whites were more like each other than were middle- and lower-class blacks. Thus merely to bronze white images and make them stand for black would make them ludicrous. The agonies of turning to Mother Africa for inspiration had already been demonstrated by Garvey, the South still encouraged flight rather than inspiration, and the ghetto was too bitter to contemplate; thus there always shimmered the temptation to make mirror images of white movies. Therefore success itself might be a false god for Negroes.[1312]

In one notable respect, Cripps's comments suggest a striking similarity between African-Americans seeking to imitate white behavior and Jewish immigrants striving to assimilate into a white, Christian world. Both groups found films an important classroom for learning and transmitting "the rules of the game."

The issue over what constitutes a "black aesthetic" continues to surface in debates about the past and the present. Typical is Gladstone L. Yearwood's assertion that "A black cinema must be based on a demythification and demystification of institutionalized cinema."[1313] Beginning with the question of what constitutes "a black cinema," the astute Ohio University professor attacks the standard definitions: e.g., "iconic" (you see a black face, you recognize a black film), "indexical" (black films are made by black filmmakers), and "intentional" (I want to make a black film; it is a black film). Arguing that art is not judged on who the artist is, where the artist was born, the artist's intentions or targeted audience, Yearwood suggests the following tentative definition:

> Any film whose signifying practices or whose making of symbolic images emanates from an essential cultural matrix deriving from a collective black socio-cultural and historical experience and uses black expressive traditions as a means through which artistic languages are mediated.[1314]

From this perspective, the critic focuses of the movie itself and the process it took to produce it. What makes black films different from Hollywood films is that the former arises out of different historical and production processes.

Whatever the truth of the debate over black protest films, it is evident that race movies (productions owned primarily by whites with black men fronting for their bosses) found a welcome audience in the late teens and early 1920s. For example, a 1921 survey reported that over 305 movie houses catered to black audiences and that five black distributing firms were operating nationwide.[1315] It is also evident that

[1310] Diakite, p.51

[1311] "'B' . . . for Black," p.32.

[1312] SLOW FADE TO BLACK, pp.171-2.

[1313] Gladstone L. Yearwood, "Towards a Theory of a Black Cinema Aesthetic," BLACK CINEMA AESTHETICS, p.67.

[1314] Yearwood, pp.70-1.

[1315] Sampson, p.9. Bogle claims that by 1923, there were approximately 600 theaters showing race movies. See, "'B' . . . for Black," p.33.

race producers were following the lead set by the emerging white movie moguls. Black picture palaces like the Dunbar, Globe, and Star theaters in Georgia, and the Regal Theatre in Chicago were clear signs of the growing recognition for first-run houses. So too was the growing black star system featuring celebrities like Noble Johnson and Paul Robeson. Looking back at the decade, J. Hoberman writes

> The boom years of the '20s saw scores of black-owned or oriented film studios, operating out of New York, Philly, Chicago, and K. C., producing screen versions of black novels, films that dealt with black newsreels, parodies and imitations of Hollywood, and a great many melodramas with the powerful theme of upward mobility or the tragic consequence of "passing" for white. These films were shown in America's 700 or so ghetto movie houses, as well as in schools, churches, and revival meetings and at special "midnight" shows in white theatres.[1316]

No doubt, much of the black film prosperity of the twenties was tied to the creative energies generating from the Jazz Age and the cultural importance of the Harlem Renaissance. The contributions of the African-American community to the cultural life of the nation was not lost on the film moguls who began luring prominent black performers to Hollywood. Among the more noted personalities associated with the film capital by the end of the decade were Josephine Baker, Willie Best, James B. Lowe, Clarence Muse, Lincoln (Stepin Fetchit) Perry, Jerry Peterson, Bessie Smith, and Ethel Waters.

Unfortunately, the black film boom was not destined to last. Among the first negative signs were the increasing censorship battles. For example, the teens had witnessed the nationwide hysteria among whites resulting from Jack Johnson's becoming the first black boxer to win the heavyweight crown (1908). The newsreels of suceeding fights by "great white hopes" to get back the title eventually resulted in Congress passing legislation in 1912 forbidding the interstate traffic of newsreels showing boxing between the races. By the start of the twenties, film censorship in general was on the rise across the nation and having a notable impact on black filmmakers. For example, Micheaux's WITHIN OUR GATES (1920), dealing with the slave era and including a lynching scene, was banned by a number of white Louisiana theater owners. Ohio banned the Blackburn Velde Productions' FOR HIS MOTHER'S SAKE (1922), because it featured Jack Johnson, who had been convicted (some say framed) of white slavery. Furthermore, the industry, as we shall see, established regulations where filmmakers were forbidden to deal with miscegenation and offensive racial stereotyping. Hollywood's response was to play it safe and limit the roles African-Americans could play. Even in films dealing with Africa or the South Seas, blacks functioned as background material rather than as an integral part of the plot or action.

In addition, economic and technical problems began forcing many black producers out of business. As Carlton Moss explains,

> The Negro producers, operating with extremely limited funds and the barest necessities of equipment, found that all the facilities for making and processing films were in the hands of the white producers. With no experienced colored technicians available, he had to hire such white personnel as were available to him--the most inefficient, least skilled and inexperienced in the industry, whom he could only equip with the cheapest and most inadequate production facilities. As though these handicaps were not sufficent--the colored producer found himself running counter to what his very organizations were fighting--namely, an end to jim crow. For the white theatres would not buy his product, and

[1316] J. Hoberman, "A Forgotten Black Cinema Surfaces," VILLAGE VOICE 20:46 (November 17, 1975):85.

his films were, of necessity, limited only to jim crow houses. To add insult to injury, the content of his films had to conform to what the status quo approved, for any film which portrayed Negro Americans in any context of militancy would have been challenged by the police and other arms of the government.[1317]

Thus every aspect of the film industry worked against outsiders. It carried over, as Moss describes, into owning real estate and film laboratories. It became an insurmountable obstacle in social and business contacts. The one exception was in the performance category. There you could earn a living, but only if you accepted the rules.[1318]

Those race producers who survived, like Micheaux, resorted to extraordinary methods. According to Lorenzo Tucker, one of Micheaux's most enduring stars, the filmmaker had a unique way of financing his films:

He would write a script and take pictures of his stars; then he would make a tour of the theaters in the black neighborhoods throughout the South and East asking the theater managers for an advance against the film booking.
By summer he would be back in New York with enough money to shoot the film. He'd edit in the fall and by winter he would be back on the road distributing one or two motion pictures in less than a year after he had been given the advances.[1319]

Not surprisingly, few black filmmakers demonstrated Micheaux's talent for survival. What is surprising is that the film industry had changed little in terms of racial values since the turn of the century. If anything, Americans had become more conservative rather than less. Their fears about "Others" had been exacerbated by World War I and the Russian Revolution. Equally troublesome to white America in the late 1920s was the growing racial unrest in northern cities as a result of great masses of blacks migrating to major industrial centers. Crowded conditions, unequal pay, job discrimination, and segregated housing pitted one minority against another. Consequently, stories about the Old South with its genteel leaders and loyal servants became far more reassuring than problem films about urban crimes and family conflicts. "In film," as Campbell points out, "the South especially appeared as a region of similar desires, staunch conservatism, and white, Protestant isolationism."[1320] Thus by the end of the silent era, blacks were breaking down their isolation in American society, while on screen it remained muddled.

With the coming of sound, the status of black performers and producers became even more complex and controversial. As discussed earlier, the technological revolution concentrated the industry's economic and social power into the grip of a handful of white movie moguls. It also made their products seem more "realistic." You not only saw what people were like, but also heard what they said. Ironically, the decision by the movie moguls to capitalize on the appeal that "blackface" music, images, and traditions had for mass audiences (and thereby open many new jobs for African-Americans) also reinforced many of the negative stereotypes of the silent era. For example, the film that set Hollywood on its radically new technological course was THE JAZZ SINGER (1927), featuring Al Jolson in blackface in several crucial scenes. Whether the blackface scenes added or detracted from the image of black

[1317] Moss, p.138.

[1318] Moss, pp.138-9.

[1319] George Davis, "Black Motion Pictures: The Past," N. Y. AMSTERDAM NEWS 61:38 D (September 18, 1971):13.

[1320] Campbell, p.71.

people is not the issue here. What is important is that the convention gave new life to the minstrel tradition in film.

Among the first attempts at all-talking, all-singing movies were HEARTS IN DIXIE and HALLELUJAH! (both in 1929). The former was produced by Fox and included among its cast an actor destined to epitomize the most controversial aspects of race comedy: Stepin Fetchit. Seen by some as an excuse for updating the minstrel tradition in the era of sound movies and by others as an attempt to upgrade the image of blacks in Hollywood films, HEARTS IN DIXIE was more than a series of comic and musical sketches and less than an inspirational portrait of Southern black life. It was, however, a modest critical and box-office success. HALLELUJAH! not only reaffirmed the commercial potential of black films, but also surpassed it in terms of critical acclaim. Where the MGM production ran into problems with its critics was over the temptations that country folk face in the big cities. Unlike the Fox film, which centered all the action in a rural setting, the more ambitious MGM project attempted to capture the problems of black migration away from the farms and into urban areas. The message Hollywood was receiving, however, was to keep simple black folk down on the farm. The popularity of both films with black and white audiences confirmed the fact that movies about and with African-American performers had become primarily the responsibility of mainstream white filmmakers.

Of particular interest is the female typecasting in HALLELUJAH!. It followed a tradition, explains Gary Null, that lasted well into the seventies:

> Dark-skinned women were seen as sexless; they were usually fat, good-natured servant figures such as would become well known in the thirties like Hattie McDaniel and Louise Beavers. Only light-skinned black women who represented a basically white style of beauty were shown as sexually desirable. The character portrayed by Nina Mae McKinney in HALLELUJAH! is seen as having no moral character at all, and this again is seen as typical. In films, as in "real life," those of too obviously mixed blood were especially the objects of contumely.[1321]

What makes Null's comments so intriguing is that they not only identify the typecasting occurring in the independent ethnic market, but they also remind us that in all the feminist accounts of film history almost nothing has been written about the mistreatment of minority women during the first fifty years of American film.[1322]

Director King Vidor claims that his primary concern in HALLELUJAH! was to present an objective treatment of the black. Just how much his aim missed is pointed out by Jacobs: "The film turned out to be a melodramatic piece replete with all the conventionalities of the white man's conception of the spiritual-singing, crap-shooting Negro."[1323] Paul Rotha comments that "The Negro was portrayed in a vacuum. Because his position in white society was never referred to, his behavior appeared to arise from his own nature rather than from environmental pressures."[1324] As for those who claimed that Vidor's intentions were honorable, if ineffectual, in portraying black culture, the PITTSBURGH COURIER had an answer: "With all due

[1321] *Gary Null, BLACK HOLLYWOOD: THE NEGRO IN MOTION PICTURES (Secaucus: The Citadel Press, 1975), p.36.

[1322] For a brief overview of the one-dimensional treatment of black female characterizations, see Pearl Bowser, "Sexual Imagery and the Black Woman in American Cinema," BLACK CINEMA AESTHETICS, pp.42-51.

[1323] Jacobs, p.458.

[1324] Paul Rotha and Richard Griffith, THE FILM TILL NOW (New York: Vision Press, 1960), p.471.

respects to King Vidor's good intentions in bringing about the talking movie, HALLELUJAH, and his knowledge of the Negro, the thinking Negro in Chicago . . does not like the picture." The unsigned article went on to say, "The bubbling over emotions, the happiness and the suffering, the low life and loose morals, the queer habits of manner and dress, are all facets of the picture which the Chicago Negro would have destroyed."[1325]

In fairness to Vidor, many members of the black community in 1929 praised not only Hollywood's new focus but also the presumed benefits it offered to the ethnic independent filmmakers. For example, on the same page that carried the PITTSBURGH COURIER's attack on Vidor's film was an article praising the performance of Nina Mae McKinney.[1326] Furthermore black writer Geraldyn Dismond spoke for many people when she wrote that

it must be conceded by the most skeptical that the Negro has at last become an integral part of the Motion Picture Industry. And his benefits will be more than monetary. Because of the Negro movie, many a prejudiced white who would not accept a Negro unless as a servant will be compelled to admit that at least he can be something else; many an indifferent white will be beguiled into a positive attitude of friendliness; many a Negro will have his race-consciousness and self-respect stimulated. In short, the Negro movie actor is a means of getting acquainted with Negroes and under proper direction and sympathetic treatment can easily become a potent factor in our great struggle for better race relations.[1327]

Arguments such as Dismond's would appear periodically throughout the history of films. Whether discussing the simplistic pro-black images of the fifties or the "blaxploitation" movies of the early seventies, the defenders of "breakthrough" trends dwell on the gains being made by a wider variety of roles for black performers and by the opportunities for mass audiences to witness more "realistic" images of African-American culture. Cynics point out that such claims illustrate what the ethnic community could expect in terms of "proper direction and sympathetic treatment" from a profit-motivated film industry. More sympathetic observers stress the complexity of the system and applaud the growing power of black leaders and organizations to effect positive changes and remove demeaning themes and stereotypes.

That issue aside, films like HEARTS IN DIXIE and HALLELUJAH! rarely questioned the traditional images of blacks or the racist society that created them. What's especially revealing is that an industry that prides itself on making sequels, remakes, and spin-offs from successful ventures showed no interest in following up the box-office success of these two all-black cast films. Instead, the filmmakers continued to employ their talented African-American entertainers in short subjects exploiting black music.[1328] When it came to theatrical feature films, the strategy called for antebellum Southern stereotypes of servants, slaves, and happy entertainers. Within a few years, Hollywood's negative traditions carried over into many of its cartoons and genre movies. For example, the Tarzan series and offshoots like TRADER HORN (1931), KING KONG (1933), and SHE (1935) reinforced the dishonest image of African-Americans as dangerous savages. Horror films like ISLAND

[1325] "King Vidor's Play Fails to Go Over," PITTSBURGH COURIER 21:6 (February 8, 1930):16.

[1326] "Nina Mae McKinney Is Big Hit At Lafayette," ibid., p.16.

[1327] Geraldyn Dismond, "The Negro Actor and the American Movies," CLOSE UP 5:2 (August 1929):96-7, New York: Arno Press, 1971; and BLACK FILMS AND FILM-MAKERS: A COMPREHENSIVE ANTHOLOGY FROM STEREOTYPE TO SUPERHERO, pp.117-21.

[1328] For more information, see SLOW FADE TO BLACK, Chapter 10.

OF LOST SOULS and WHITE ZOMBIE (both in 1932) contributed to the portrait of blacks as mindless killing machines.

Generally overlooked in histories dealing with black stereotypes is the way in which the cartoons which formed part of the standard weekly film program from the 1930s to the 1950s reinforced the film industry's racist perspectives. But as Irene Kotlarz points out, the cartoons, in maintaining their own codes and conventions, created some black images that are "among the clearest expressions of national and corporate racism produced by modern mass media."[1329] Not surprisingly, the major studios followed the same stereotypes institutionalized in the "live action" films: i.e., servants, entertainers, clowns, and dangerous knife-wielding savages. What is surprising, Kotlarz discovers, is the degree to which the 1930s filmmakers fashioned racist stereotypes around nineteenth-century traditions and caricatures.[1330] Thus cartoons like Disney's TRADER MICKEY (1932), Columbia's KANNIBAL KAPERS (1935), and Warner Bros.'s BOSKO AND THE CANNIBALS (1937) have their roots in popular illustrations of the 1880s that stressed the "differences" between Western civilization and the "Otherness" of African cultures.[1331]

As Hollywood continued to adapt the gross stereotypes of the past to the sound era, black journalists continued to face a perennial dilemma. Writing mainly for the black middle class, they perceived themselves as advocates for the black share of the American Dream. It was a formidable task, particularly since many blacks apparently preferred Hollywood movies to the ghetto productions by black and white independents. Consequently, the journalists often had to balance their columns with both praise for the progress African-American performers were making in the film capital, and condemnation for the plantation stereotypes in mainstream film genres. Attacking the racist films made by white men lost jobs for black writers, editors, performers, and assistant directors. Supporting the demeaning films as excuses for racial pride or interracial fellowship encouraged the film industry to continue with its insulting racial stereotypes.

At the heart of the problem was the need to define for black audiences a black aesthetic. A case in point is the controversy over Marc Connelly's screen adaptation of his Broadway hit THE GREEN PASTURES (1936). Although many members of the black press praised the production, one that didn't found its story reported in VARIETY:

> Baltimore Afro-American, nation's largest Negro newspaper, this week carries a story claiming Marc Connelly drew what the sheet describes as a "color line" in casting his play, "Green Pastures," for a Warner pic. Paper says this "has greatly incensed the entire theatrical fraternity of Harlem." The "color line," in the Afro's vernacular, means that Connelly has chosen only very dark complected actors for screen version of "Pastures"; with the paper bluntly announcing "Pullman porters and stevedores get leads.[1332]

[1329] Irene Kotlarz, "The Birth of a Notion," SCREEN 24:2 (1983):21.

[1330] Worth noting is that Charles F. Altman feels that many historians tend to overlook the most obvious instances of direct influence on film from older arts. For example, he points out that "The costume drama of the thirties needs to be related to nineteenth-century European book illustrations and painting; the late forties and early fifties are strongly influenced by early American painters, thanks to the lead of Minnelli and Mamoulian." Cf. Charles F. Altman, "Towards a Historiography of American Film," CINEMA JOURNAL 16:2 (Spring 1977):9-10.

[1331] Kotlarz, p.24.

[1332] "Colored Paper Pans Connelly's 'Pastures' Cast," VARIETY 121:2 (March 4, 1936):3.

Whether black journalists should have pressed more for building better audiences for more intelligent films, demanding more equality for black artists, and leading boycotts against racial distortions in mainstream films and cartoons is a debatable issue. What is clear is that a considerable amount of newsprint was expended on the number of blacks finding work in the industry, on biographical hype of individual performers, and on the money being made by black stars.

No actor personified more the problems of an individual caught in the crossfire between two worlds, one black and the other white, than Paul Robeson.[1333] As Cripps writes,

> More than any single figure, Paul Robeson accepted as a personal responsibility the problem of bridging the gap between the race movies and the commercial movies of Hollywood. In a dozen films, most of them produced outside of Hollywood, he attempted to create strong black characters who provided important elements of plots rather than merely backgrounds for predominant white stories. That he eventually failed is a testament to the intransigence of the system of commercial movies rather than a sign of his own lack of will or effort.[1334]

Richard Dyer approaches Robeson's cross-over star status from another perspective. Stressing the importance filmmakers give to a performer's body and the use of the body, he points out that ultimately Robeson appeared as a figure

> whose body could be in sport, in feats of strength, in sculpturable muscularity, in sheer presence, in a voice the correlative of manly power, but whose body finally does nothing, contained by frames, montage, narrative, direction, vocal restraint. He was a cross-over star because (and as long as) he so hugely em-body-ed, in-corpo-rated this historical functioning of black people in Western representation and economy.[1335]

Scholar, All-American athlete, lawyer, entertainer, and visionary, Robeson appeared to be the ideal African-American that the movie moguls could have promoted in any vehicle they chose to merchandize. And yet, in a film career that spanned two decades, his greatest successes were in race movies.

An excellent example of his strengths and his problems is the actor's third film, THE EMPEROR JONES (1933), which also featured Fredi Washington. Based upon Eugene O'Neill's revolutionary drama of a black anti-hero who briefly dominates whites and then degenerates into a tragic figure, the low-budget, independent screen adaptation was made by three white men: the producers John Krimsky and Gifford Cochran and the director Dudley Murphy. There was much cause for optimism at the outset. A well-know black personality was going to star in a relatively hands-off film based upon a famous play by a great American dramatist (who encouraged the production) and the finished product would be distributed by a powerful organization (United Artists). Conceptually, the production had much to recommend it: e.g., an

[1333] For information on Paul Robeson, see Arnold Schlosser, PAUL ROBESON: HIS CAREER IN THE THEATRE, IN MOTION PICTURES, AND ON THE CONCERT STAGE (Ph.D. dissertation, New York University, 1970). For a superb discussion of his star image, see *Richard Dyer, HEAVENLY BODIES: FILM STARS AND SOCIETY (New York: St. Martin's Press, 1986), pp.67-139. Also useful is *Jeffrey Richards, "Paul Robeson: The Black Man as Film Hero," ALL OUR YESTERDAYS: 90 YEARS OF BRITISH CINEMA, ed. Charles Barr (London: British Film Institute, 1986), pp.334-40.

[1334] Thomas Cripps, "Paul Robeson and Black Identity in American Movies," MASSACHUSSETS REVIEW 11:3 (Summer 1970):469.

[1335] HEAVENLY BODIES, p.139.

excellent cast, a powerful performance by Robeson, a new prologue by DuBose Heyward, and a creditable musical score by J. Rosamond Johnson.[1336]

How well the film did commercially is a matter of debate. For example, Cripps argues that it did well wherever it played, including the South.[1337] Norman Kagan supports Cripps up to a point (noting that censors in the South excised two murder scenes and a shot of a woman smoking), but goes on to add that the film "lost money in the North, and it was quite successful in Europe."[1338] Most film historians agree that the film was sympathetically reviewed by members of the press. Outside of those who were annoyed with the shoestring production values, the criticisms generally fell into two categories: either there was too much repetition of Hollywood racist stereotypes, or the additional urban scenes (the original play took place solely in the jungle) distracted from the meaning of the original O'Neill work. In addition, some white audiences rejected the movie on the grounds that it made the Robeson character too powerful and too arrogant. Some black audiences attacked the film for its stereotypical gambling scenes, knife-wielding villain, and voodoo-drumming natives.

Despite the film's periodic regional censorship problems, its modest box-office success encouraged more white men to try the "race market," but discouraged black filmmakers from pursuing naturalistic stories about lower-class black society. Moreover, as Yearwood notes, the film career of Robeson highlighted an important aspect of film signification: "meaning arises not so much in what precedes the film as in the concrete circumstances or the process of production governing the making of the film."[1339]

The few remaining black production companies in the 1930s decided to accept the demeaning Hollywood images as mandatory box-office requirements and thus turned their attention to making movies that imitated white standards and perspectives. Not surprisingly, light-skinned blacks got the best roles.

For its part, Hollywood continued to expand the opportunties for black performers. Not only could they work in racially oriented films like IMITATION OF LIFE (1934) and SHOW BOAT (1936), but they also could act in non-racial films like I AM A FUGITIVE FROM A CHAIN GANG (1932), FURY,[1340] and THE PETRIFIED FOREST (both in 1936). There was, however, a difference between the early and late 1930s. As Cripps comments, the first half of the decade saw black performers in "largely ceremonial roles," thereby reinforcing the minstrel traditions of the past. But once Hollywood became politicized in the mid-1930s, black roles took on a more left-wing orientation.[1341] That is, they could indirectly make subtle pitches for racial justice. If one examines the period closely, the scholarly impression is that progress toward a more rounded image of African-American life had been made as a result of an increasing number of urban film dramas. Taking a more populist view, one can

[1336] In addition to the black film histories, see Tom Shales, "THE EMPEROR JONES," THE AMERICAN FILM HERITAGE: IMPRESSIONS FROM THE AMERICAN FILM INSTITUTE ARCHIVES (Washington, D.C.: Acropolis Books, 1972), pp.70-4.

[1337] SLOW FADE TO BLACK, p.217.

[1338] Norman Kagan, "Across the Awareness Divide: Reviving THE EMPEROR JONES (2)," VILLAGE VOICE 16:26 (July 1, 1971):57.

[1339] Yearwood, p.47.

[1340] Fritz Lang, the director of FURY, claims that Louis B. Mayer cut various scenes with blacks from the film on the grounds that "Colored people can only be used as shoeshine people or as porters in a railroad car." See *Peter Bogdanovich, FRITZ LANG IN AMERICA (New York: Praeger, 1967), p.32.

[1341] THE GREEN PASTURES, pp.25-6.

claim that the traditions of the antebellum South, with its servile characters and racial hierarchy, were alive and well. Even further, it is clear that only in the racial films were blacks accorded any true recognition. The outstanding example was Hattie McDaniel's Oscar for Best Supporting Actress in GONE WITH THE WIND (1939).[1342]

The 1930s also are noted for some of Hollywood's finest and most controversial black film actors: Eddie "Rochester" Anderson, Louise Beavers, Willie Best, Teresa Harris, Rex Ingram, Hattie McDaniel, "Butterfly" McQueen, Mantan Moreland, Clarence Muse, Lincoln ("Stepin Fetchit") Perry, Paul Robeson, Bill "Bojangles" Robinson, Libby Taylor, and Fredi Washington. What distinguished the majority of these black stars from their predecessors of past decades was their longevity as film actors. In the twenties, for example, performers like Charles Gilpin and James B. Lowe had been brought to Hollywood to do a particular film. If they stayed, and Gilpin didn't, they functioned as "outsiders." In the thirties, however, personalities like Beavers and Muse were part, albeit low down on the pecking order, of the establishment. They could justifiably point to their status as a sign that blacks were moving up the film ladder. On the other hand, critics of the industry objected to these black troopers' apologetic and accommodationist attitudes and values.

Clearly the most controversial actor was Fetchit with his shuffling routines. Those who defend him point to his enormous popularity in a white-dominated industry and to the fact that conditions dictated his characterizations. According to Joseph McBride, Fetchit, as well as McDaniel, were performers PAR EXCELLENCE:

What made Step and Hattie McDaniel outclass all the other black character actors of bygone Hollywood was their subtle communication of superiority to the whole rotten game of racism. They played the game--it was the only game in town--but they were, somehow, above it: Step with his other worldly eccentricities and Hattie McDaniel with her air of bossy HAUTEUR.[1343]

Those who attack Fetchit, as Peter Noble points out, focus on the drawbacks in the stereotypes created by Fetchit and his imitators (e.g., "Snowball," and "Sleep n' Eat") in that they reinforced the racist image that

the American Negro was a happy, laughing, dancing imbecile with permanently rolling eyes and widespread, empty grin. In films too numerous to mention, actors like Fetchit demeaned themselves, bringing Negro dignity to its lowest common denominator.[1344]

By the end of the 1930s, Hollywood had more than its share of racial critics, not the least of which were organizations like the NAACP and the Urban League. Such groups routinely attacked the demeaning stereotypes found in films like SO RED THE ROSE (1935), THE GREEN PASTURES (1936), and GONE WITH THE WIND (1939). But these futile efforts, as Pines explains, were doomed from the start because the racial protestors failed to understand the Hollywood system. That is, they took aim at trees instead of the forest, "their reciprocal and (therefore predictable) responses

[1342] Stanley O. Williford claims that after McDaniel received her Oscar, "She did not get much more work and she remained in roles as mammy and maid." He then goes on to quote Hedda Hopper, who states that the star "went for a 21-month period recently without getting a day's work in pictures." See Stanley O. Williford, "Blacks and the Academy Awards; Can We Get Them?" SOUL (April 10, 1972):12.

[1343] Joseph McBride, "Stepin Fetchit Talks Back," FILM QUARTERLY 14:4 (Summer 1971):21.

[1344] Peter Noble, THE NEGRO IN FILMS (London: Skelton Robinson, 1948, New York: Arno Press, 1970), p.49. All quotations cited in this chapter are from the 1948 edition.

[were] to specific, and usually prominent, racial films and characterizations, as opposed to, say, maintaining an overall strategy toward Hollywood and media racial processes."[1345]

Again to be fair, not everyone viewed these films as containing completely negative images. For example, Cripps finds THE GREEN PASTURES important "not only as a monument to a lost past and as a prophecy but also as a cinematic accomplishment. . . ."[1346] Moreover, critics like Cripps argue that what was being overlooked was the progress being made as a result of hundred of films employing black performers in a variety of roles. With so many black faces in so many different films it was hard to convince audiences nationwide that the old silent film stereotypes were still creditable.

The late 1930s also saw the emergence of a second wave of successful independent black films, different in content and perspective from the silent era. The transition to sound had removed almost every black filmmaker, except Micheaux, from race productions. And even though white producers like Jack and Bert Goldberg continued to showcase African-American entertainers in movies aimed at black audiences, the race movies had few redeeming qualities. Even Micheaux's efforts and questionable practices eventually wore thin, finally putting him on the outskirts of the market that he had helped create. What was unusual about the new wave, beginning in 1937, was the cooperation between black and white producers. The emphasis this time was on adapting Hollywood's genres (e.g., musicals, gangster films, and westerns) to black interests.

In effect, the ethnic market had learned that box-office success depended on two particular aspects of a theatrical film: (1) the cast and the stars, and (2) the story and the plot. The movie that started the new cycle was a gangster film, DARK MANHATTAN (1937), featuring the black performers George Randol and Ralph Cooper and the white agent Ben Rinaldo. Despite the film's many production flaws, black audiences were genuinely pleased by the chance to see black heroes in action.

Almost immediately, white entrepreneurs like Harry and Leo Popkin, the Goldberg brothers, Ted Toddy, Alfred Sack, Robert Levy, Jed Buell, and Dudley Murphy jumped on the bandwagon. With well-known performers like Fetchit and Moreland, as well as newcomers like Herb Jeffries and Ralph Cooper, the strategy this time was for escapist entertainment, not message movies. In short, race productions became carbon copies of the Hollywood formula, with the race producers having even less regard for the intelligence of their audiences than did the cynical Hollywood moguls. Minimal attention was paid to intelligent scripts, polished performances, or technical virtuosity. The emphasis was on fast footwork and spirited fun.

Even with such low expectations, the odds against the race producers were too formidable to overcome. Not only did the filmmakers lack adequate distribution and exhibition outlets, but they also made two serious errors. First, they were out of step with the times. While more and more movies were pointing to the growing dangers from overseas, race films looked backward to trivial events and focused on frivolous stories. Second, the race producers relied too heavily on white technicians. In most of their productions, the key cinematographers and editing personnel consisted of white men moonlighting from Hollywood studio jobs. As a result, the production expertise necessary for upgrading the technical quality of ethnic films and, not insignificantly, for depicting a black aesthetic remained outside their grasp.

[1345] BLACKS IN FILMS, p.29.

[1346] *Thomas Cripps, ed., THE GREEN PASTURES (Madison: The University of Wisconsin Press, 1979), p.11.

Not until future black artists like Harry Belafonte, Ossie Davis, Melvin Van Peebles,[1347] and Sidney Poitier took a hand in training a cadre of minority technicians would that miscalculation be corrected. In the meantime, the new black wave ended before America's involvement in WWII. Not only had race productions suffered a devastating blow, but also the future of a black aesthetic once more rested primarily on the attitudes of the white-controlled film industry.

Beginning in the early 1940's, with the nation's need for a united front against the Axis powers, Hollywood moved into another transitional stage and again slightly adjusted its attitudes toward African-American themes. That is not to say that studios stopped producing jungle movies with savage warriors or that the Southern plantation myth disappeared from view. They didn't. Whether in Charlie Chan movies, Tarzan films, or popular melodramas, there were always the standard comic, dangerous, or servile black images. It is to say that at the urging of powerful advocates like the NAACP the studios were persuaded to provide blacks with more sympathetic and dignified roles: e.g., Leigh Whipper in THE OX-BOW INCIDENT (1943) and Kenneth Spencer in BATAAN (1943). At the same time, mainstream studios began building a cadre of black female stars who would appeal to black audiences. Among those gaining national attention were Lena Horne,[1348] Ethel Waters,[1349] and Hazel Scott. There was a big difference, however, between image and reality. As Horne wrote years later, "For all the publicity I was receiving I was still just a very minor figure in Hollywood."[1350]

The role of the NAACP throughout this period is a fascinating study in the problems facing reformers in the film industry. One incident worth mentioning involves a spring 1942 Hollywood luncheon given for Walter White, the NAACP's executive secretary. Held on the 20th Century-Fox lot, the occasion provided the opportunity for White, as well as Wendell Willkie, the industry's counsel, to confront directly seventy of Hollywood's most influential producers. White stated in his speech to the film executives that while conditions in the industry "had improved immeasurably in the past few years," there still needed to be a "fairer representation of the Negro in pictures." The reason, he explained, was not that "Hollywood should make a hero of the Negro, because not many Negroes are heroes, just as not many white people are heroes. However, we do wish films would give the Negro his normal place in the world."[1351] Willkie followed with a strong reminder that the fate of the free world was hanging in the balance and that "many of the persons responsible for Hollywood films belonged to a racial and religious group which had been the target of Hitler, and they should be the last to be guilty of doing to another minority the things which had been done to them."[1352]

[1347] Horace W. Coleman, "Melvin Van Peebles," JOURNAL OF POPULAR CULTURE 5:2 (Fall 1971):368-84.

[1348] *Lena Horne and Richard Schickel, LENA (New York: Signet Books, 1965); and Dan Abramson, "Lena Horne," FILMS IN REVIEW 37:3 (March 1986):142-8.

[1349] *Ethel Waters with Charles Samuels, HIS EYE IS ON THE SPARROW: AN AUTOBIOGRAPHY (New York: Doubleday and Company, 1951).

[1350] Horne, p.130.

[1351] "Negroes Ask for Better Shade in Pictures," VARIETY 147:2 (June 17, 1942):5. Cited in Leonard Courtney Archer, THE NATIONAL ASSOCIATION FOR THE ADVANCEMENT OF COLORED PEOPLE AND THE AMERICAN THEATRE: A STUDY OF RELATIONSHIPS AND INFLUENCES, Volume 1 (Unpublished Ph.D. dissertation, Ohio State University, 1951), p.378.

[1352] Walter White, A MAN CALLED WHITE (New York: The Viking Press, 1948), p.201. Cited in Archer, p.379.

The immediate upshot of these public talks was an agreement signed by the producers and the NAACP in the summer of 1942. Whether it really led to any significant changes is still a matter of much debate. In fact, a year later Dalton Trumbo was writing in THE CRISIS that "The movie Negro is a humorous, lazy, lying fellow because so many Americans have fallen victim to the racial myths of fascism." He then added, "And both movie moguls and scenario writers are guilty of perpetuating this stereotype."[1353] For those who doubted that the stereotype was bad, Lawrence D. Reddick, three years into WWII, cataloged nineteen different versions, including savage African, corrupt politican, sexual superman, natural-born cook, superstitious churchgoer, chicken and watermelon eater, razor and knife "toter," and mental inferior.[1354]

The obvious question is why these demeaning images continued. The standard answers relate to the myth of the Southern box office, the film industry as a microcosm of society, and movies as a business and not a school. There was, however, another issue related to the problems that reform groups like the NAACP faced within the industry itself. It pertains to the attitudes of the performers who worried about job security. They had grave reservations about the NAACP setting up shop in Hollywood without any input from the artists themselves, and lobbying for changes that affected black artists.

Simply put, the NAACP WWII campaign against the film capital split the Hollywood black community into rival factions. Pro-industry performers like Clarence Muse, Ethel Waters, and Louise Beavers objected not only to White's strategy, but also to the endorsement by newcomers like Lena Horne of the NAACP's views.[1355] Stars like McDaniel tried to explain to the young star how much had preceded the NAACP drive and what was at stake for those black performers who had worked in Hollywood for the past decades. Nonetheless, Horne never felt part of the film community.[1356] In fairness to all of the black Hollywood insiders, they admired the NAACP's goals but disagreed strongly with the methods of achieving them. In hindsight, both sides had a point.

Except for the knockout punch dealt race productions by the national crisis, World War II demonstrated that an integrationist approach to African-American culture was possible and profitable. One reason is that musicals proved especially popular at home and abroad. Given the times and the availability of black artists, it seemed sensible to cast African-Americans in mainstream musicals. The strategy, however, was to isolate the performer or group from the white cast. Still operating on the myth of the Southern box office, the filmmakers assured their Southern exhibitors that any objectionable "racial number" could be edited from the print without hurting the quality of the film. In theory, the savvy filmmakers were right. In practice, the Southern censors were intractable. As more and more protests about black characterizations came from Southern exhibitors, the conservative film industry backstepped and began reducing black roles in mainstream feature films. In the interim, two popular musicals with all-black casts were made: STORMY WEATHER and CABIN IN THE SKY (both in 1943).

[1353] Dalton Trumbo, "Blackface, Hollywood Style," THE CRISIS (December 1943):365.

[1354] Lawrence D. Reddick, "Educational Programs for the Improvement of Race Relations: Motion Pictures, Radio, the Press and Libraries," JOURNAL OF NEGRO EDUCATION 13:3 (Summer 1944):369-89; Rpt., "Of Motion Pictures," BLACK FILMS AND FILM MAKERS, p.4.

[1355] FROM SAMBO TO SUPERSPADE, pp.129-35.

[1356] Horne, p.108.

A second reason for the shift in status of Hollywood's African-American performers is that blacks serving their country expected and deserved positive reinforcement that the nation they were willing to die for perceived them as worthy citizens. It should be pointed out that Hollywood did not change its approach purely for profit or for moral reasons. Once America entered World War II, the federal government took steps to insure that the entertainment world in general and movies in particular reinforced the notion that we were one nation fighting against a common enemy. The bottom line was that the mass media had to sanitize their racial imagery. To make certain that no one failed to understand the message, the government established the Office of War Information and its Bureau of Motion Picture Affairs.[1357] Meanwhile, the armed forces circulated a handful of films designed to improve race relations, including the highly regarded training film, THE NEGRO SOLDIER (1943), scripted by the young black screenwriter Carlton Moss.

For its part, Hollywood cast more black performers in dignified and courageous roles in major motion pictures, including box-office favorites like CASABLANCA (1942), SAHARA (1943), and LIFEBOAT (1944). But appearing in films was not the same as populating them. Thus Dooley Wilson is the only black personality in CASABLANCA, Rex Ingram is alone in SAHARA, and Canada Lee raises the banner single-handedly in LIFEBOAT. This tokenism continued until the late 1940s. And there was a price. Because the public was becoming sensitive about black images, the filmmakers avoided additional problems by eliminating, whenever possible, any subsidiary roles for black actors. Thus the number of black extras working dropped dramatically between 1940 and 1946.[1358]

The debate today is about the cause of the changes that occurred: Were they the result of pressure from groups like the NAACP and powerful black presences like Beavers, Horne, Ingram, Lee, McDaniel, and Muse; or did they occur because of government interference and box-office profits? Both sides in the debate not only claim the credit, but also accuse the other of the rollbacks that took place by the end of the war.

By the middle of the decade, the few surviving black independent filmmakers like Oscar Micheaux and Spencer Williams[1359] were in trouble. Financially exhausted and isolated from any meaningful distribution outlet, Micheaux lingered on until his death in 1951, while Williams eventually bowed out of production and found work elsewhere.

Only the white producers of race movies like Ted Toddy were satisfied with stressing the Hollywood values in their all-black films. Staying afloat in the film business through the early 1970s, he relied on a philosophy reported in a 1947 issue of the MOTION PICTURE HERALD: "Negro audiences do not care for heavy emotional dramas. The choice in film entertainment is the picture which features light comedy, outdoor adventures, musical comedies with an abundance of singing and dancing, and comedy romances."[1360] Toddy's attitude was shared completely by his white counterparts. A case in point is Jack and Bert Goldberg, who had been around since the 1920s, running such ghetto production companies as International Roadshows, Hollywood Productions, and Herald Pictures. As far as Jack was concerned, the more

[1357] For more information, see Chapter 2.

[1358] According to one source, the number of black extras dropped by fifty percent (145 against 300) in the six year period, while the last two years saw no interest in "any of the 100 Negro singers or 60 dancers." At one point in film history (1926), the number of black extras exceeded 6,800. Cited in Floyd C. Covington, "The Negro Invades Hollywood," BLACK FILMS AND FILM-MAKERS, p.123.

[1359] In addition to the books on the history of African-American films, see Greg Tate, "Smiley the Redeemer," VILLAGE VOICE (January 10, 1989):61.

[1360] Cited in THE AMERICAN FILM INDUSTRY: A HISTORICAL DICTIONARY, p.349.

ethnic films featured singing and dancing and drama, the more black audiences enjoyed the race movies.[1361] Before dismissing the race productions, it's important to note that they not only gave work to stars like Lena Horne, Dorothy Dandridge, and Bill "Bojangles" Robinson, but they also provided showcases for ethnic stars who didn't fit into the Hollywood mold: e.g., Jackie "Moms" Mabley, Dusty "Open the Door" Richard, Dewey "Pigmeat" Markham, and Louis Jordan.[1362]

The debate today is whether the failure of these independent entrepreneurs occurred because they lacked talent and resources, or because the times just passed them by. For example, Null believes that "even if he had lived in another era, in which prejudice was less blatant and the expression of black culture and expression considered valid, Ted Toddy would not have made great films."[1363] On the other hand, Bogle argues that the race productions of the forties succeeded "as fundamental celebrations of cultural roots and communal spirits--and also as pure, undiluted celebrations of black style."[1364]

It was in the postwar period that progressives in the American film industry began taking serious steps to alter the distorted and demeaning image of African-Americans that persisted in films from SARATOGA TRUNK (1945) and SONG OF THE SOUTH (1946), to the early 1950s with GLORY ALLEY (1952) and THE EGYPTIAN (1954). A case in point is BODY AND SOUL (1947). The sensitive boxing film has Canada Lee playing an ex-champ suffering from brain damage but forced into a fatal bout with an upcoming contender. Even though Lee's part is a secondary role, it underscores the continuing shift in the treatment of black images. Those actors cast in major Hollywood films found that their roles were being integrated into the dramatic fabric of the narrative. The important difference between this step and those that ended the decade was that Hollywood was not yet ready to make the problems of African-Americans the central issue of a mainstream theatrical release.

BODY AND SOUL also underscored another shift in the course of black screen images: the increasing influence of left-wing directors, actors, and writers. As will be discussed in detail in Chapter 5, Hollywood had been embroiled in internal ideological conflicts since the mid-thirties. The labor struggles and the political divisions that had errupted during the thirties and been left simmering during WWII boiled over in the postwar period. Lines were clearly drawn between the left and the right. Within a few years, the conservatives would triumph and dominate the industry throughout the fifties. Before that happened, however, a number of left-wing artists would alter the treatment of blacks on the screen. BODY AND SOUL was the work of such men who were destined to be blacklisted: the producer Abraham Polonsky, the director Robert Rossen, and the actors John Garfield and Canada Lee. After BODY AND SOUL, but before the blacklisting era, Hollywood began exploring the difficulties that African-Americans faced in the land of the free.

In 1949, four films were released that suggested the scope of the problem: HOME OF THE BRAVE,[1365] LOST BOUNDARIES,[1366] INTRUDER IN THE DUST, and PINKY.

[1361] Cited in "A Pale Black Imitation," p.69.

[1362] "'B' . . . for Black," p.34.

[1363] Null, p.111.

[1364] "'B' . . . Black," p.34.

[1365] For a useful look at the effect of the film on audiences, see Samuel W. Bloom, A SOCIAL PSYCHOLOGICAL STUDY OF MOTION PICTURE AUDIENCE BEHAVIOR: A CASE STUDY OF THE NEGRO IMAGE IN MASS COMMUNICATION (Unpublished Ph.D. dissertation, University of Wisconsin, 1956).

[1366] For a good study of the presumed effects of the film, see Daniel M. Wilner,

Representative of the transformation was the updated image of the "tragic mulatto." The characters of mixed blood in films like PINKY and LOST BOUNDARIES no longer were forced to sacrifice themselves to an ignoble future. True, they still agonized over their "shameful" plight; but now they willingly used their ethnic identity crises to improve the lot of less fortunate members of their race. Of course, their simple human choices meant "sacrificing" the benefits of living with successful whites. For the most part, as Ralph Ellison argues, these movies represent the white man's changing attitude toward the black, as evidenced by the fact that the motion pictures manifest basic and uncomfortable negative attitudes toward the latter:

> Are Negroes cowardly soldiers? (HOME OF THE BRAVE); are Negroes the real polluters of the South? (INTRUDER IN THE DUST); have mulatto Negroes the right to pass as white, at the risk of having black babies, or if they have white-skinned children of having to kill off their "white" identities by revealing to them that they are, alas, Negroes? (LOST BOUNDARIES); and finally, should Negro girls marry white men or-- wonderful non sequitur--should they help their race (PINKY)?[1367]

As Ellison rightly points out, these films are about what white people think of blacks, and not about blacks themselves.

 The effort by Hollywood to revise negative black stereotypes increased in the fifties. As Cripps puts it, "The story of Negroes in American films . . . is not only the story of the death of Rastus, or Sambo, or Uncle Tom, but the rebirth of a complete man as yet unnamed."[1368] At a time when the film industry was undergoing major changes due to the PARAMOUNT Decree, the influx of foreign films, and a revolution in leisure time activities, filmmakers fashioned a simplistic but positive image of African-Americans that white audiences could feel comfortable with as neighbors and buddies. For example, James Edwards in BRIGHT VICTORY (1951) and MEN IN WAR (1957) symbolized what a good friend blacks could be. The unstated strategy in fifties' films was to have black characters exhibit the same liberal values and noble goals that had become associated with the Jew in World War II movies.[1369] Both groups are presented not only as having more moral fortitude than their WASP associates, but also as serving as gadflies for the conscience of the group. In fact, the screen treatment of blacks in fifties' films employed many of the techniques pioneered in the evolving screen image of Jews: (1) demonstrate that blacks are responsible members of society; (2) show the self-identity crises they face in resolving conflicts between ethnic traditions and assimilationist desires; and (3) identify the external problems they encounter in being accepted in a racist society.

 In at least two significant areas, however, the pattern for African-American images differed from that of white minorities. First, non-whites had no creative role in the production, distribution, and exhibition of racial problem films. A slight indication of how large a problem that was is given by Gerald Weales in his description of the problems films like LOST BOUNDARIES, PINKY, and INTRUDER IN THE DUST faced in Atlanta, Georgia, in the early 1950s:

ATTITUDE AS A DETERMINANT OF PERCEPTION IN THE MASS MEDIA OF COMMUNICATION: REACTIONS TO THE MOTION PICTURE "HOME OF THE BRAVE" (Unpublished Ph.D. dissertation, University of California, Los Angeles, 1951).

[1367] Ellison, p.277.

[1368] Thomas R. Cripps, "The Death of Rastus: Negroes in American Films Since 1945," PHYLON 23:3 (Fall 1967):271. Rpt. in Bobbs-Merrill Reprint Series in Black Studies BC-56 and BLACK FILMS AND FILMMAKERS, pp.53-64.

[1369] For more information of the image of Jews in World War II, see Chapter 2.

Of Atlanta's first-run houses, only two, the Roxy and the Fox, had facilities for Negroes. PINKY is the only one of the racial films that played either of those houses. A large number of Negroes will not attend segregated movie theaters, just as they will not attend other segregated events . . . Many of these Negroes will not attend Negro houses either. For many years one booker handled all the Negro houses and the film fare was extremely cheap. The majority of pictures in Negro theaters are still the cheap and the sensational ones . . . The physical condition of some of these houses, the dirt and the noise, have kept people away. Many Negroes go to see films, if they see them at all, only when they visit some city in which they are free to enter any theater and sit in any section of it.[1370]

Clearly, non-whites had a more difficult job improving their screen image than did whites. Second, African-American characters, like their counterparts among Asians, Hispanics, and Native Americans, always appeared to need the aid of a white benefactor in solving their problems. For example, films dealing with the South (e.g., INTRUDER IN THE DUST) generally provided help to blacks through the intervention of elderly white women or young white children. Films set outside the South and overseas (e.g., HOME OF THE BRAVE) generally provided much-needed support to blacks through a compassionate white man. In short, Hollywood's liberal forces always kept a close eye on the predominantly white-controlled box office. By the mid-1950s, that concern translated into films radically different from what could be shown on TV.

Humanizing black film images took many forms. One approach reworked the theme of the tragic mulatto. For example, the remake of SHOW BOAT (1951) reminded audiences how sad it was to be born with mixed blood. Only now Jerome Kern's music substituted more prominently for the detailed racial background of the earlier versions. Not only were racial issues glossed over, but the tragic Julie also performed more noble sacrifices. BAND OF ANGELS (1957) took Robert Penn Warren's 1955 novel about the Civil War and its story of a reformed slave trader in love with an octoroon and tried unsuccessfully to turn it into another GONE WITH THE WIND. By the mid-fifties, however, audiences found the plot ludicrous, the acting incredible, and the conventions silly. ISLAND IN THE SUN (1957) exposed the "horrors" of mixed blood in the midst of a black versus white political struggle in the British West Indies. The remake of IMITATION OF LIFE (1959) made certain to show that "passing for white" can lead to a number of personal problems but not necessarily to any social awareness about black-white relationships. Another approach was to take interracial mixing out of the present and into the future. THE WORLD, THE FLESH AND THE DEVIL (1959) told the story of the sole surviving black person alive in New York City after a catastrophic germ war. So long as the hero remains alone, the film presents him as a highly skilled and totally self-sufficent human being. Once the black man is joined by two white survivors (first a woman and then a man), the story resorts to the predictable, sentimental conflicts arising out of interracial sex relationships. In analyzing films like ISLAND IN THE SUN, IMITATION OF LIFE, and THE WORLD, THE FLESH AND THE DEVIL, Albert Johnson concludes that the theme of interracialism is "vague, inconclusive and undiscussed."[1371]

Hollywood also marketed the inspirational "problem" film in the form of the black sports genre. For example, Jackie Robinson, the first great black baseball star to break the "color barrier" in the major leagues, played himself in a low-budget movie THE JACKIE ROBINSON STORY (1950). With all its many technical drawbacks and

[1370] Gerald Weales, ""Pro-Negro Films in Atlanta," FILMS IN REVIEW 3:9 (November 1952):455-62; Rpt., BLACK FILMS AND FILM-MAKERS, pp.44-52.

[1371] Albert Johnson, "Beige, Brown or Black," FILM QUARTERLY 13:1 (Fall 1959):43; Rpt., BLACK FILMS AND FILM MAKERS, pp.36-43.

stilted script, the story of the magnificent Brooklyn Dodger star exposed many white youngsters (living in urbanized ghettos and studying about "Sambo" in their public school history books) to the racial struggle of black athletes. Joe Louis, the remarkable heavyweight champion, had his brilliant career depicted in THE JOE LOUIS STORY (1953). Although the boxer had no acting role in the film, Coley Wallace as his stand-in provided a good transitional image as the film made excellent use of actual footage of the champ's boxing glory. While the movie failed to attract widespread distribution, it did, as Bogle writes, become a film that "many a ghetto kid was to cherish. . . ."[1372]

Except for these types of "problem" films, Hollywood mainly used African-American performers as secondary characters operating primarily in a white world. Among the more notable examples are William Marshall in LYDIA BAILEY (1952), Ethel Waters in THE MEMBER OF THE WEDDING (1952), Louis Armstrong in THE GLENN MILLER STORY (1954), Pearl Bailey in THAT CERTAIN FEELING (1956), Woody Strode in THE TEN COMMANDMENTS (1956), Nat "King" Cole in CHINA GATE (1957),[1373] and Eartha Kitt in THE MARK OF THE HAWK (1958).[1374]

As this rich array of performers struggled to make breakthroughs, a number of industry observers cheered the results and predicted the demise of Hollywood's ignoble stereotypes. Typical of the times was Sidney Harmon's opinion that "Without even a ripple of notice from the public, the hyphenated American has happily passed into extinction."[1375] He points to the fact that as late as the mid-fifties films like ANNA LUCASTA (1958) could not have been made. "For the first time in history," Harmon predicts, "we will be able to . . . push back that last frontier of apartness that makes us differentiate between Americans on the basis of colour . . . not on the do-good basis of visionary Utopianism, but realistically through the awakening public insight into true human values."[1376]

There were three black artists, however, who broke out of the supporting mode and personified the dilemma of black film stars: Harry Belafonte, Dorothy Dandridge, and Sidney Poitier. Although significantly different personalities, each performer illustrated the changes taking place in the post-PARAMOUNT Decree era. For example, Belafonte in films like BRIGHT ROAD (1953), CARMEN JONES (1954), and ISLAND IN THE SUN (1957) proved that black personalities could be romantic leads. Of course, they had to be light-skinned like Belafonte and not dark like Poitier. Belafonte also proved that top-flight personalities could do something about the types of roles offered them. Insulted by the demeaning characterizations and dishonest treatment of black men in social situations, he formed his own company, Harbel Productions. The two films he helped produce and star in were ODDS AGAINST TOMORROW and THE WORLD, THE FLESH AND THE DEVIL (both in 1959). Whatever their limitations as art or box-office successes, they showed that strong black characterizations could be incorporated into the genre conventions of the gangster and science fiction films.[1377]

[1372] TOMS, p.185.

[1373] For more information on the star, see James Haskins with Kathleen Benson, NAT KING COLE (New York: Stein and Day, 1984).

[1374] Eartha Kitt, ALONE WITH ME: A NEW AUTOBIOGRAPHY (Chicago: Henry Regnery Company, 1976).

[1375] Sidney Harmon,"How Hollywood is Smashing the Colour Bar," FILMS AND FIMING 5:6 (March 1959):7.

[1376] Harmon, p.30.

[1377] For more information, see Arnold Shaw, BELAFONTE: AN UNAUTHORIZED BIOGRAPHY (Philadelphia: Chilton Company, 1960).

Dandridge, on the other hand, demonstrated just how difficult it was for a talented actress to work in Hollywood. Although she had been performing in films since the mid-1930s, the beautiful actress couldn't gain a foothold in the industry until after she had first established herself as a popular singer in nightclubs. Beginning with the leading role in BRIGHT ROAD, through CARMEN JONES, ISLAND IN THE SUN, TAMANGO (1957), and including PORGY AND BESS (1959), she finally proved that a black woman could do more than sing a torch song and serve meals.[1378] Regrettably, her progress up the ladder had more than its share of humiliating experiences. For example, Earl Mills, Dandridge's personal manager, tells of the visit Louis B. Mayer made to the set of BRIGHT ROAD to see his "sexy, sultry, satin night club singer" playing a conservative school teacher:

"All I ask from you," he said, "is a good performance. I don't care about sex appeal. I don't ask for anything more than devotion to duty."

But he patted her on the fanny when he left.[1379]

By the mid-fifties, she was working for 20th Century-Fox. When she refused to play a demeaning Tuptin in THE KING AND I (1956), the studio decided not to pick up her option. Soon she found herself in the center of a controversy between blacks and whites over the production of PORGY AND BESS. From her point of view, the story

is an accurate picture of the harsh, terrorized lives of Negroes forced to live in ghettoes. There are Catfish Rows all over America. The ghettoes of the North are large Catfish Rows, where the strain of living, the terror, the tragedy, and disease shorten lives. That is what the fighting is all about, to change that.

But the thinking of many Negro civil rights leaders is that the impoverished conditions of Negroes should not be pictured in song or story, cinema or television. These advocates hold that you should show the "positive" side of black living, show the white man we could be as good and respectable and smug as is he. Show the whites we are nice American humans, and don't let them see the squalor in which nine-tenths of us live.[1380]

The outcome of her strong positions was that by 1960 no one was offering her any more film scripts. Thus the first black woman to win an Oscar nomination for Best Actress (Carmen in CARMEN JONES) found herself an outcast in the Hollywood rat race and at the age of forty-two committed suicide.

Without question, however, Poitier led the way in creating the new liberal image of the noble black.[1381] Thanks to the success of films like HOME OF THE BRAVE, LOST BOUNDARIES, and INTRUDER IN THE DUST, Hollywood was looking for black

[1378] Dorothy Dandridge and Earl Conrad, EVERYTHING AND NOTHING: THE DOROTHY DANDRIDGE TRAGEDY (New York: Abelard-Schuman, 1970); and *Earl Mills, DOROTHY DANDRIDGE: A PORTRAIT IN BLACK (Los Angeles: Holloway House Publishing Company, 1970).

[1379] Mills, p.155.

[1380] Dandridge, p.187.

[1381] For more information, see *Carolyn H. Ewers, THE LONG JOURNEY: A BIOGRAPHY OF SIDNEY POITIER (New York: Signet, 1969); William Hoffman, SIDNEY (New York: Lyle Stuart, 1971); Samuel Lawrence Kelley, THE EVOLUTION OF CHARACTER PORTRAYALS IN THE FILMS OF SIDNEY POITIER: 1950-1978 (New York: Garland Publishing, 1983); *Alvin H. Marill, THE FILMS OF SIDNEY POITIER, Introduction Frederick O'Neal

performers who could portray traditional American (translate that into WASP) values without threatening white audiences. Poitier fit the bill for the times. He was, in his words, "an average Joe Blow Negro."[1382] Charming and talented, the twenty-five year-old actor was an assimilationist's dream and the black nationalist's nightmare. As Samuel Lawrence Kelley points out, "The dominant ideology of the times promoted the complete assimilation and integration of blacks into the American mainstream, thus working against the proliferation of the all-black film and the black arts as they had flourished during the Harlem Renaissance and prior to 1950."[1383] For the next two decades, Poitier nearly monopolized the screen image of black males. How he did it and at what price has been told effectively by others. What is instructive here is a glimpse at the process and the problems to remind us of the links among entertainment, profits, politics, and stereotypes.

According to Kelley, the merchandizing of the actor underwent three stages. The first period covered 1950 to 1963, when Poitier appears as the ideal black hero for mass consumption: humane, intelligent, and non-militant. Dangerous only when aroused. In NO WAY OUT (1950), he plays the skillful physician who fights back against a bigoted and criminally insane patient and wins. In THE BLACKBOARD JUNGLE (1955), he portrays a bright but cynical ghetto youth who is made civilized by a crusading white teacher. In SOMETHING OF VALUE (1957), he reveals the soul-searching torment that black African nationals undergo in order to gain independence from colonial authorities. In THE DEFIANT ONES (1958), he depicts a proud and rebellious convict who learns that he has more in common with his racially intolerant white escapee than anyone realizes. In LILIES OF THE FIELD (1963), he becomes the complete integrationist, demonstrating to immigrant nuns that what counts most in the world is brotherhood and humanity.

Poitier's film roles were more than just acting assignments. Like any African-American actor, he first had to be a black performer and only afterwards an actor. "It is his destiny," explains Andrew Sarris, "to be forbidden the individuality to say 'I' instead of 'we.'"[1384] Nevertheless, Kelley points out, the star felt he had a dual responsibility: to upgrade the image of blacks on screen and, at the same time, to elevate his audiences worldwide.[1385] Thus, whatever role Poitier took became a problem. For example, to act in Zoltan Korda's CRY, THE BELOVED COUNTRY (1951), Poitier actually had to become the producer-director's slave. According to Alvin H. Marill, "It was the only way he'd be allowed to work in South Africa, which permitted only 'indentured' blacks to enter the country."[1386] The question was whether the film's attacks on apartheid were more important than his dignity. From the vantage point of the seventies, Poitier looked back and said, "Were I as politically aware then as I grew to be, I wouldn't have gone, even though I

(Secaucus: Citadel Press, 1978); and *Sidney Poitier, THIS LIFE (New York: Alfred A. Knopf, 1980).

[1382] Dennis John Hall, "Pride Without Prejudice: Sidney Poitier's Career," FILMS AND FILMING 18:3 (December 1971):40.

[1383] Kelley, p.225.

[1384] Sidney Poitier, "Dialogue on Film," AMERICAN FILM 1:10 (September 1976) pp.33-48; Rpt. in edited form in *Joseph McBride, ed., FILMMAKERS ON FILMMAKING: THE AMERICAN FILM INSTITUTE SEMINARS ON MOTION PICTURES AND TELEVISION (Los Angeles: J. P. Tarcher, 1983), pp.71-81.

[1385] Kelley, p.240.

[1386] Marill, p.21.

needed the bread."[1387] To star in PORGY AND BESS (1959), he had to wrestle with his conscience over the storm of black protests against the demeaning racial stereotypes. Poitier's defense in 1959 was that

> Porgy is a beautiful character [sic], He's a cripple, he's a beggar, he's uneducated and he's superstitious, but he still has a lasting faith in the essential goodness of people, and in his ability to cope with misfortune and overcome it.[1388]

Years later, the actor who wrote that he "couldn't be happier . . . [if] Porgy is the . . . [role] I may be remembered by" was telling people that he was coerced into making the film, that it represented the low point in his career, and that he "hated" the entire experience.[1389]

The second phase in Poitier's screen career, according to Kelley, was from 1964 to 1968, when the films he made--e.g., THE LONG SHIPS (1964), THE BEDFORD INCIDENT, DUEL AT DIABLO, A PATCH OF BLUE (all in 1965), IN THE HEAT OF THE NIGHT and GUESS WHO'S COMING TO DINNER? (both in 1967)--were offshoots of his superstar status. "In these films," writes Kelly, "the hero was found to be nonracial, intergrationist/assimilationist, likable and not disturbing to whites . . . [in short] just another human being."[1390] The strategy was to make the Poitier stereotype more complex rather than permit him to explore the racial unrest gripping the nation in the mid-sixties. It was as if his nobility and humanity were offering indirectly to troubled Americans assurances that, given their inalienable rights, blacks posed no threat either to "our" way of life or to "our" traditions.

What is especially revealing, Kelley explains, is that the highly successful actor and personally attractive male was kept relatively asexual and uninvolved emotionally with women. Even when he plans to marry, as in GUESS WHO'S COMING TO DINNER?, Poitier's intimacy with the opposite sex is severely curtailed, and the happy couple remain sexually passionless. Equally revealing is that no filmmaker thought it advisable or valuable to team Poitier with a female star. That is, except for Diahann Carroll in PARIS BLUES (1961), Poitier worked primarily with unknown actresses.[1391]

The period after 1968, according to Kelley, reveals the superstar's "transitions and adjustments to the economic realities of the black box office and the social and political changes which have taken place during this period."[1392] No longer content to align himself solely with the general population (whites and blacks), he alters the settings and situations that his noble heroes encounter. In films like THE LOST MAN (1969), THEY CALL ME MR. TIBBS (1970), THE ORGANIZATION, and BROTHER JOHN (both in 1971), he struggles to convince black audiences that assimilated black heroes are just as effective as black militants in fighting racial injustice. His major

[1387] Gill Noble, "Entertainment, Politics, and the Movie Business," CINEASTE 8:3 (Winter 1977-8):21.

[1388] Sidney Poitier, "They Call Me a Do-It-Yourself Man," FILMS AND FILMING 5:12 (September 1959):33.

[1389] FROM SAMBO TO SUPERSPADE, p.208; Hoffman, pp.123-4; Marill, p.28; and Ewers, pp.88-9.

[1390] Kelley, p.227.

[1391] Kelley, pp.228-9. Cripps makes a similar point, arguing that there is an "absence of adult sexual behavior in the films of Sidney Poitier." See "The Death of Rastus," p.275.

[1392] Kelley, p.226.

problem is that he still clings to a formula that has lost its appeal. That is, Poitier still wants to make films in which "Audiences found people they could like . . . not negative, antihuman symbols of mankind."[1393] The fact that the four films are critical and commercial flops gives added weight to Vincent Canby's argument that by 1970 Poitier had become "obsolete." This would not have happened, explains the NEW YORK TIMES critic,

> had not Poitier, over the last two decades, in a series of often bad but never insignificant movies, insinuated his blackness, and the blackness of a large number of other Americans, into the consciousness of a white majority that will never be quite as blind again. Now, however, in one way or another, the revolution has gotten ahead of its leader.[1394]

In effect, Poitier's original audience had stopped going regularly to the movies and been replaced by young people with a new racial consciousness. That is not to say, however, that the star no longer appealed to a segment of the black population. He still had many fans. For example, in response to Canby's charges of Poitier's being obsolete, a woman from Oaks Bluffs, Massachussets, wrote in the Letters to the Editor section, "What is wrong with representing these people without a constant reference to race? Does this representation make him obsolete?"[1395] The problem was that the woman didn't represent the majority of black people going to the movies.

Thus, it was clear by 1971 that the superstar had to alter his style and direction if he were going to remain a box-office favorite. To insure greater control of his film product, Poitier joined with fellow superstars Barbra Streisand, Paul Newman, and Steve McQueen in forming First Artists Corporation. Over the next six years, the stars agreed to make three films each. In addition, Poitier formed E & R Productions to make films exclusively released by Columbia Pictures. The latter arrangement enabled Poitier to make his directorial debut, as well as to co-produce and co-star with Belafonte, in BUCK AND THE PREACHER (1972). From Poitier's perspective,

> It was . . . important that he and Belafonte "establish ourselves as producers. If you work only as an actor, you can only ask producers to hire one or two of your friends. As a producer you are then able to effectuate the employment of literally hundreds of people. One of the things that concerns Belafonte and myself is that, with the exception of Melvin Van Peebles, there are no black film-makers working in the commercial arena of the world film market."[1396]

During the remainder of the decade, the committed actor explored stories directly aimed at black audiences: e.g., A WARM DECEMBER (1973), UPTOWN SATURDAY NIGHT (1974), THE WILBY CONSPIRACY (1975), LET'S DO IT AGAIN (1975), and A PIECE OF THE ACTION (1977). Although commercially successful and deliberately divorced from the drug, sex, and violence milieu of the "blaxploitation" formula, these mostly lighthearted comedies added to Poitier's screen problems. As Kelley reports, the actor had no personal flair for comedy, and each successive film came to rely

[1393] Guy Flatley, "Sidney Poitier as Black Militant," NEW YORK TIMES D (November 10, 1968):15.

[1394] Vincent Canby, "Milestones Can Be Millstones," NEW YORK TIMES B (July 19, 1970):1.

[1395] Muriel Dallard, "Poitier Represents Millions of Negroes," NEW YORK TIMES D (September 13, 1970):11.

[1396] Louie Robinson, "The Expanding World of Sidney Poitier: Superstar, Director, Producer Eyes Future," EBONY 27:1 (November 1971):106.

more and more on other actors to carry the bulk of the comedy.[1397] Eventually, Poitier retired from acting for a period of ten years, making a return in 1988 with LITTLE NIKITA.[1398] In the interim, he directed several films, including STIR CRAZY (1980), HANKY PANKY (1982), and FAST FORWARD (1985).

Poitier's story is more than just the list of breakthroughs in particular films over a thirty-year period. It is more than just the fact that his success not only created new opportunities for black performers but also convinced the money-conscious executives that black audiences constituted a new and profitable market for Hollywood films. His story is also about the price that a courageous and successful black actor has to pay in a complex social and economic environment. A quick survey of articles from a variety of periodicals underscores a number of issues related to black images. For example, in November, 1950, Al Hine winds up his glowing review of Poitier's first film with the comment that "Hollywood has absorbed brickbats aplenty, many of them justified, but when it can produce pictures like NO WAY OUT . . . it's time to put away the crying towel and do a little cheering."[1399] Not much changed, however, when it came to profits for films featuring blacks. Ten years later, Howard Thompson profiled Poitier. Taking inventory of his career, the actor talks about the mistakes he made, the parts he took for the money, and the fact that he won't go down that road again. Ending on an optimistic note, Poitier claims that black performers have more opportunities than ever before: "My own career couldn't have happened otherwise."[1400] A week later, Bosley Crowther reviews the plight of blacks in Hollywood movies, making particular mention of the reception of key Poitier films. He points out that THE DEFIANT ONES (1957) couldn't be shown in downtown Atlanta, that EDGE OF THE CITY (1957) failed at the box office "partly because it could get no bookings in the South, partly because it repelled people with its forthright integrationist theme," and that PORGY AND BESS (1959) had to be temporarily taken out of distribution because of ugly protests involving pickets and burning crosses.[1401] Lest anyone believe that great progress has been made since NO WAY OUT, the superstar states in a 1965 interview that "I'm the only Negro actor earning a living in movies, the only one. It's a hell of a responsibility."[1402]

Seventeen years after Poitier's debut, six years after the most successful black performer in film history was opening doors to Jim Crow theaters across the country, three years after he became the first and only black actor to date to win an Oscar for Best Actor, the critical tide turned against him. Suddenly the "ebony saint" was a PERSONA NON GRATA to the African-American community. Epitomizing the new mood was Clifford Mason's stinging attack on the actor's assimilationist-integrationist image. Mason sets up two Poitiers: the idealist intent on rectifying the film industry's racist stereotypes versus "the Negro movie star all white America loves."[1403]

[1397] Kelley, p.235.

[1398] Aljean Harmetz, "After a Decade, Poitier Returns as an Actor to a Changing Hollywood," NEW YORK TIMES C (May 4, 1987):15.

[1399] Al Hine, "Film Review: NO WAY OUT," HOLIDAY 8 (November 1950):8.

[1400] Howard Thompson, "Focus on a Peregrinating Poitier," NEW YORK TIMES B (March 26, 1961):9.

[1401] Bosley Crowther, "Negroes in Films," NEW YORK TIMES B (April 2, 1961):1.

[1402] Cited in Howard Thompson, "'Why Is Sidney Poitier the Only One?'" NEW YORK TIMES B (June 13, 1965):13.

[1403] Clifford Mason, "Why Does White America Love Sidney Poitier So?" NEW YORK TIMES B (September 10, 1967):1; Rpt. THE BLACK MAN ON FILM, pp.75-9.

According to the author, the second one demeans the first. Rather than helping change stereotypes through films like THE BEDFORD INCIDENT, LILIES OF THE FIELD, A PATCH OF BLUE, DUEL AT DIABLO, and TO SIR WITH LOVE, Poitier becomes "a showcase nigger who is given a clean suit and a complete purity of motivation so that, like a mistreated puppy, he has all the sympathy on his side and all those mean whites are just so many Simon Legrees."[1404] At the core of Mason's disgust is Poitier's accommodationist attitude, his refusal to make films that show black people in a black environment, and the perception that for seventeen years he's been "playing the same role, the antiseptic, one-dimensional hero."[1405]

Attacks like Mason's continued for the next few years, resulting in a mixed bag of reactions from white and black critics alike.[1406] For example, Crowther dismisses demands for a color-blind cinema as being unrealistic given the times. "The very

[1404] Mason, pp.1, 21.

[1405] Mason, p.21.

[1406] Dr. Laura Fishman, a colleague in the Department of Sociology at the University of Vermont, helped shape my ideas in this section of the manuscript. Her comments are worth quoting in full:

"Clifford Mason's attack on Sidney Poitier's assimilationist/integrationist image can be more clearly appreciated by placing it within the framework of the new black militant ideology which received significant acceptance among blacks during the mid-sixties. Attacks like Mason's, directed at numerous black political and cultural heroes, emerged during a time of racial turmoil and hope within black communities throughout the United States. This period can best be described as a time of black protest, non-violent demonstrations, rebellions and cries of Black Power. The ghetto uprisings had an impact on the development of a new black ideology which sought to encourage blacks to undo their state of powerlessness, helplessness and dependency under American racism. As an alternative to the popularly accepted assimilationist/integrationist model, the new black militant ideology encouraged blacks to break the yoke of their oppression by developing a new sense of identity that was not white-oriented but reflective of blacks' own racial identity. Within this context, it sponsored black pride and awareness, identification with Africa, Black Power (blacks should run and control their own communities) and a rejection of integration as a goal for the black freedom struggle.

"In response to this new ideology, black militant analysts began to examine many traditional notions concerning black culture: e.g., black lifestyles, the black family as well as black leadership structure and cultural heroes. Particular attention was paid to exposing and opposing those black political and cultural heroes who ascribed to the assimilationist/integrationist model. Subsequently the exact black political heroes who earlier were lauded by the black community as success stories because they had gained prominence within the white dominated system were now under attack for subscribing to a model which black militants perceived as 'selling out' the masses of blacks.

"Black militant analysts thus contended that blacks who had achieved national recognition were too oriented toward integration and thus were untrustworthy for the following reasons: (1) These heroes had denied their black identity, their heritage and their own culture; they were ashamed of their blackness; (2) In order to interact with whites, these black heroes behaved like 'good niggers,' a condition characterized by docility, passivity, submissiveness and non-aggressiveness. By stressing these traits, argued black analysts, these heroes exemplified blacks striving to be middle-class caricatures of white

fact," he points out, "that films about Negroes have been so low on the popularity scale is all the more reason for delighting in the emergence of Mr. Poitier to the eminence he has as an artist and as an exponent of his race."[1407] On the other hand, James Baldwin makes a distinction between films like CRY, THE BELOVED COUNTRY, THE BLACKBOARD JUNGLE, THE DEFIANT ONES, and GUESS WHO'S COMING TO DINNER? and Poitier the actor. The former he dislikes and finds a waste of time. The latter he finds moving and honest. In the late sixties, however, Baldwin sees Poitier's superstar status working against his ability to reflect accurately the predicament of black people in America. In fact, given the priorities of the movie and TV industries to perpetuate the fantasy of the American Dream, it is impossible for any creative black person to truthfully reflect Afro-American culture because "the black face . . . is not only not part of that dream, it is antithetical to it."[1408] What makes Poitier important, therefore, is not what he has done in the past but what his presence can produce for him and other African-Americans in the future. That is, being preeminent gives one "the power to change things."[1409] And in 1989, Michael E. Ross points out that Poitier has witnessed a lot of changes in the forty years since he made his debut in NO WAY OUT. The actor who has starred in or directed forty-two films and twice been named the top box-office star of the year has created some of the screen's "most memorable and enduring roles . . . [embodying] the experience of many black Americans: an abiding faith in the country's institutions, coupled with frustration and anger directed at these institutions."[1410]

people. (3) And lastly, the attack focused upon black heroes' identification with the traditional goals and values of white institutions as well as with their concomitant maintenance of established white society as it presently functioned.

"Thus, black critics, who espoused the new ideology, contended that traditional heroes were no more than pawns of the white power structure and in turn no longer represented the interests of the mass of blacks: their 'going white' was resented and thus accused of becoming the 'white man's nigger.'

"This new militant spirit encouraged a radical ideology and a new set of political and cultural heroes, emphasizing a fresh agenda for black participation in American life. To devise these new rules, the black community needed models of leadership who espoused the following: pride in blacks' African heritage; a new sense of identity that was not white-oriented but reflective of their own racial development; and priorities which emphasized the type of work needed to free blacks from the economic and cultural domination of white American values and institutions.

"Since Sidney Poitier portrayed the 'old' as opposed to the 'new' notion of a black hero and captured the old vs. the new agenda of black activism, film criticism of this time period reflects this tension. And this is the context within which these critiques should be framed." A Letter to the Author, June 5, 1987.

[1407] Bosley Crowther, "The Significance of Sidney," NEW YORK TIMES B (August 6, 1967):1; Rpt. *Richard A. Maynard, THE BLACK MAN ON FILM: RACIAL STEREOTYPING (Rochelle Park: Hayden Book Company, 1974), pp.73-5.

[1408] James Baldwin, "Sidney Poitier," LOOK 32:15 (July 23, 1968):56.

[1409] "Sidney Poitier," p.58.

[1410] Michael E. Ross, "Sidney Poitier on 40 Years of Change," NEW YORK TIMES C (February 28, 1989):18.

Poitier's problems were directly linked to the new Hollywood that was emerging after TV became America's chief source of popular entertainment. The film image of African-Americans in the sixties reflects the sweeping social, political, and economic changes taking place within and without Hollywood: e.g., the civil rights movement, the Vietnam War, and the power of federal legislation to restructure the industry. Studios now found it necessary to increase dramatically the number of blacks on the payroll. Films like ALL THE YOUNG MEN (1960), TAKE A GIANT STEP, and A RAISIN IN THE SUN (both in 1961) continued to fight for racial tolerance in the movies. Whether in the armed forces or in domestic melodramas, the message was upbeat: blacks were on the march. As the decade progressed, black performers discovered not only that they had a greater variety of roles open to them, but also that they had more opportunities to work than ever before.[1411] Of course, the African-Americans in film understood that progress is a relative concept. Compared to the treatment of Native Americans, Orientals, and Hispanics, they were making great strides. Compared to white Christian Americans, blacks were still in the Reconstruction era. For example, as racial violence erupted in the South during the early sixties, blacks, except for Poitier, were still relegated to secondary roles. In fact, the number of films dealing with black characterizations from 1962 to 1966 changed noticeably in only two of those five years: i.e., 1963, ten films about blacks; 1964, fourteen films. The other three years found black performers almost exclusively in supporting roles.[1412] What was so unusual was that black rage against the film and television industry had exploded in 1963. As Albert Johnson points out, the demands of groups like the Congress of Racial Equality (CORE) and the Student Non-Violent Coordinating Committee (SNCC) resulted in film and television producers' casting black performers into a number of unprecedented roles as "doctors, nurses, lawyers, teachers, pilots, business executives, and, in a stroke of wildly off-beat but authentic casting, COWBOYS.[1413]

As racial violence erupted in America during the mid-sixties, black personalities gained greater visibility on the screen. For example, in 1964, Jim Brown, Nat "King" Cole, and Brock Peters were playing noticeable roles in films like RIO CONCHOS, CAT BALLOU, and MAJOR DUNDEE respectively. The following year saw meaty parts for Ossie Davis in THE HILL, Cab Calloway in THE CINCINNATI KID, and Brock Peters in THE PAWNBROKER.

It wasn't until 1967, however, that African-American characterizations began being integrated more closely into the fabric of mainstream film narratives. For example, Geoffrey Holder rules the mythical floating island in DR. DOLITTLE; James Earl Jones, Roscoe Lee Browne, Cicely Tyson, and Raymond St. Jacques figure prominently in the political turmoil in Haiti in THE COMEDIANS; Jim Brown fights heroically in THE DIRTY DOZEN; and Godfrey Cambridge plays the traumatized government agent in THE PRESIDENT'S ANALYST. In addition, 1967 also featured two of the decade's most discussed black-oriented films: GUESS WHO'S COMING TO

[1411] Martin Dworkin, "The New Negro on the Screen," PROGRESSIVE 24:10 (October, November, December 1960):39-41, 33-6, 34-6.

[1412] Edward Mapp, BLACKS IN AMERICAN FILMS: TODAY AND YESTERDAY (Metuchen: The Scarecrow Press, 1972), pp.54, 69, 83, 105, 122.

[1413] Albert Johnson, "The Negro in American Films: Some Recent Works," FILM QUARTERLY 18:4 (Summer 1965):15; Rpt. in BLACK FILMS AND FILM-MAKERS, pp.153-81. For more information on the role of blacks in the development of the West, see John M. Carroll, ed., THE BLACK MILITARY EXPERIENCE IN THE AMERICAN WEST (New York: Liveright, 1971); *Philip Durham and Everett L. Jones, THE NEGRO COWBOYS (New York: Dodd, Mead & Company, 1965); *William Loren Katz, THE BLACK WEST (Garden City (Doubleday & Company, 1971); and *William H. Leckie, THE BUFFALO SOLDIERS: A NARRATIVE OF THE NEGRO CAVALRY IN THE WEST (Norman: University of Oklahoma Press, 1967).

DINNER? and IN THE HEAT OF THE NIGHT. Significantly, it was also the year that
DUTCHMAN by LeRoi Jones (Imamu Amiri Baraka) came to the screen, starring Al
Freeman, Jr., and Shirley Jones.

By the end of the decade, it was evident that the standard Hollywood genres
had undergone considerable changes in terms of the African-American image. No
longer did movies about the South or the West ignore the presence of powerful black
characters, thanks, in part, to films like SERGEANT RUTLEDGE, WILD RIVER (both
in 1960), THE MAN WHO SHOT LIBERTY VALANCE (1962), TO KILL A MOCKINGBIRD
(1962), NOTHING BUT A MAN (1964), MAJOR DUNDEE (1965), 100 RIFLES, THE
SCALPHUNTERS (both in 1968), THE LIBERATION OF L. B. JONES, and SLAVES
(both in 1969). It was also evident by the end of the decade that filmmakers were
exploiting violence and sex. Here was a combination that television couldn't touch.
As discussed earlier, the appearance of a more liberal Motion Picture Code in the
mid-sixties made possible a a number of radical screen conventions, including a
reevaluation of the treatment of blacks. Evidence of the radical changes could be
found in Jim Brown films like THE SPLIT (1968) and RIOT (1969), as well as in
PUTNEY SWOPE and THREE IN THE ATTIC (both in 1969).

The major breakthroughs, however, came from independent makers of black films
like John Cassavetes, Shirley Clarke, Herbert Danska, Jonas Mekas, Gordon Parks,
Larry Pearce, Melvin Van Peebles, Michael Roemer, and Robert Young. Cassavetes
started things off with SHADOWS (1960), a novel film about a woman who falls in love
with a white man but neglects to tell him that she is black. The revolutionary twist
to the traditional "tragic mulatto" theme is that her color is insignificant. Pearce
followed with ONE POTATO TWO POTATO (1964), a disturbing look at interracial
marriage and the problems it creates for children. That same year, Roemer and Young
released NOTHING BUT A MAN (1964), a story of the plight of an itinerant worker
trying to lead a normal life. Still in 1964, Clarke unveiled THE COOL WORLD, an
account of troubles among Harlem's adolescents. About the same time, Mekas came
out with GUNS OF THE TREES (n.d.), a portrayal of the black in urban society.
Van Peebles got his break with STORY OF A THREE DAY PASS (1967), a film made
in France, followed by a satiric Hollywood film, WATERMELON MAN (1970), and then
the independent film, SWEET SWEETBACK'S BAADASSSSS SONG (1971). Danska's
SWEET LOVE, BITTER (1967) introduced black militancy to film characterizations.
And Parks made news with his autobiographical film, THE LEARNING TREE (1968).

What critics are debating is whether the new atmosphere of liberalism made any
meaningful changes in the treatment of black characterizations and themes. For
example, Albert Johnson doesn't see anything "brave" about what was achieved in
the film industry's attempts to change the image of blacks. "Actually," he writes,
"it is harder than ever before to truthfully dramatize the American Negro's dilemmas
on stage and screen, because the angers are too intense."[1414] In arguing his case,
he points to a number of films that he feels demonstrate American filmmakers'
"uncertainty" over black themes and characterizations: PARIS BLUES (1961), an
account of American expatriate jazzmen; PRESSURE POINT (1962), a story of a
pseudo-intellectual struggle between a Negro psychiatrist in a Federal prison and a
white prisoner; LILIES OF THE FIELD (1963), an overrated attempt to show the black
as "he really is"; ONE POTATO, TWO POTATO (1964), a story of miscegenation,
again. In evaluating these films, Johnson attacks the tired themes and argues for
more positive subject matter: e.g., biographies of outstanding black intellectuals
ahead of their time, documentaries on the paradoxical relationships existing between
blacks and whites, and black film roles that are more sophisticated.[1415] Pines
approaches the debate from the perspective of integration versus cultural pluralism.

[1414] Johnson, p.14. See also Lerone Bennett, Jr., "The Emancipation Orgasm: Sweetback
in Wonderland," EBONY 26:11 (September 1971):98-101.

[1415] Johnson, p.30.

He wonders "whether the quality of assimilation achieved [in American films of the sixties] is morally correct.[1416] James Baldwin takes a more sardonic approach in comparing IN THE HEAT OF THE NIGHT with Griffith's 1915 history of the Civil War:

> In THE BIRTH OF A NATION, the sheriff would have been an officer of the Klan. The widow would, secretly, have been sewing the Klan insignia. The murdered man (whether or not he was her husband) would have been a carpetbagger. Sam would have been a Klan deputy. The troublesome poor whites would have been mulattoes. And Virgil Tibbs would have been the hunted, not the hunter. It is impossible to pretend this state of affairs has really altered: a black man, in any case, had certainly best not believe everything he sees in the movies.[1417]

And Campbell writes that "The films of the Old South actually clung to old precepts, and the sordid films of the New South were often more exciting entertainment than revealing examinations."[1418]

The end of the sixties was also notable for the push by talented blacks to increase their off-camera work. The slump that the film industry experienced in 1969-1970 added to the frustration over minorities' being the last hired and the first fired. As Murray reports, a 1969 investigation by the Los Angeles Equal Employment Opportunity Commission resulted a year later in an agreement among the three major networks, the film industry, and the craft guilds to increase minority hirings:

> Specifically, the plan called for the establishment of a minority pool for craft jobs; permanent craft jobs to be based on a 20 percent ratio of minority to white members; referral for daily craft employment to be at a specified ratio of minority pool personnel to general labor now on the roster; and finally, a program aimed at training minority group members for complicated craft jobs.[1419]

Over the next decade, the issue of minority representation continued to be fought in the courts and in the guilds.[1420] It was just one more manifestation of the growing black impatience with second-class citizenship and the incredibly slow pace of reforming American society.

For better or worse, the seventies gave rise to the third boom in African-American films. This time, the changes were more controversial; the effects, more dramatic. Heading the list were the "blaxploitation" films, action-packed, violent, and sexy stories blending gritty reality with extreme racial fantasies and targeted at urban black audiences. As Pauline Kael explains the cycle,

> the black-MACHO movies have exploited retaliatory black fantasies. The heroes sleep with gorgeous white girls, treating them with casual contempt. They can have any white women they want, but they have no attachment to them; they have steady black girls to count on in time of trouble. They act out the white man's worst fears: fully armed and sexually as indomitable as James Bond, they take the white men's women and cast them off.

[1416] BLACKS IN FILMS, p.117.

[1417] THE DEVIL FINDS WORK, p.57.

[1418] Campbell, p.171.

[1419] Murray, p.128.

[1420] See David Robb, "SAG Vows Redoubled Effort to End Inequitable Minority Hiring," VARIETY (April 27, 1983):42.

The black superstud has very different overtones for the black audience from what Bond or Matt Helm has for mixed audiences, because the black movies are saying to the black audience, "See we really ARE what the whites are afraid of; they have reason to be afraid of our virility."[1421]

What was not widely understood at the time was that most of the "blaxploitation" movies were made by white men using the talents of black artists and by the revenge fantasies of black audiences to bolster the sagging white-dominated film coffers. Capitalizing on the artistic freedom provided by the Revised Motion Picture Code and the recognition that big city theaters had been taken over by black youths, Hollywood filmmakers produced inexpensive race movies that milked the black market for almost five years. In the meantime, a number of creative African-American performers, directors, screenwriters, and crews received invaluable training in front of and behind the camera.

If one film can be singled out for igniting the "blaxploitation" phase of the seventies, it is COTTON GOES TO HARLEM (1970). Starring Godfrey Cambridge and Raymond St. Jacques, and adapted from a novel by the black author Chester Himes, it was the first successful black film directed by a black director (Ossie Davis) that was released by a major studio (MGM).[1422] According to United Artists' sales vice president James Velde, the film's domestic success was linked to the fact "that 70% of that coin has come from black audiences."[1423] Translated into industry terms, the time was ripe for producing more pictures for urban blacks and expecting bigger profits. "'In a way,'" one trade observer explains, "'the negro market is like the youth market. A substantially higher percentage of this group can be counted on as regular moviegoers. And if you can find pictures specially geared to their tastes, you can make a pot of money.'"[1424] What distinguishes COTTON GOES TO HARLEM from its recent racial predecessors like IN THE HEAT OF THE NIGHT, GUESS WHO'S COMING TO DINNER? (both in 1967), and THEY CALL ME MR. TIBBS (1970) is COTTON's emphasis on racial characteristics rather than on racial conflicts. Or, as Ronald Gold reports, "COTTON may be described as the first motion picture with 'Soul.'"[1425]

One way "Soul" appears in the new black films is in the form of cynicism, violence, and sexual promiscuity. Among the more controversial examples are SWEET SWEETBACK'S BAADASSSSS SONG, SHAFT (both in 1971), BLACK CAESAR, BLACULA, SLAUGHTER, ACROSS 110th STREET, TROUBLE MAN, MELINDA (all in 1972), FIVE ON THE BLACK SIDE, SLAUGHTER'S BIG RIP-OFF, COFFY, GORDON'S WAR, CLEOPATRA JONES, and THE SPOOK WHO SAT BY THE DOOR (all in 1973). As W. I. Scobie points out, films like SWEET SWEETBACK'S BAADASSSSS SONG split the black community. It

[1421] Pauline Kael, "Notes on Black Movies," NEW YORKER 48:41 (December 2, 1972):159. Rpt. Pauline Kael, REELING (Boston: Little, Brown and Company, 1976), pp.60-8; and BLACK FILMS AND FILM-MAKERS, pp.258-67.

[1422] The first black director to get his film produced and distributed by a Hollywood studio (Warner Bros.-7 Arts) was Gordon Parks. The film was THE LEARNING TREE (1969).

[1423] Quoted in Ronald Gold, "Director Dared Use Race Humor; 'Soul' As Lure For 'Cotton's' B. O. Bale," VARIETY 260:7 (September 30, 1970):1.

[1424] Gold, p.1.

[1425] Gold, p.62.

is symptomatic of the black ideology gap: those who've Made It on EBONY's instant acceptability scale hate the film. It defies all their values, devalues their lives. But down there in darkest Watts, the brothers thought it was Right On . . . Did you see how he?!!! . . . in-vid-iously i-dent-ified those white mothers?! . . . shit.[1426]

Unlike the easily identifiable and highly ingratiating integrated heroes of Poitier and Belafonte, "blaxploitation" movie performers like Jim Brown, Rosalind Cash, Tamara Dobson, Pam Grier, Yaphet Kotto, Calvin Lockhart, and Fred Williamson made socially conscious audiences squirm in their seats as black audiences cheered the downfall of vicious "Honkies." As Kael points out, "Except when we were at war, there has never been such racism in American films."[1427]
 The discomfort was not reserved for whites alone. Many black performers themselves felt bad about the roles they were forced to take in the film industry if they were to make it as performers. For example, Alan Ebert writes that Pam Grier, "Known in the industry as 'Tits-and-ass' . . . [couldn't be hired] for her acting ability. No one expected that of her. Just carnal sexuality. That always sold."[1428] Many black leaders and educators felt the "blaxploitation" movies offended their sense of propriety and jeopardized their social relations with non-blacks. According to Alvin Poussaint, the superspade heroes, "rooted in American racism, have contributed to the white paranoia that maintains racial discrimination and segregation."[1429] Moreover, as Murray indignantly observes, improving racial images is important, "But infinitely more significant is exposing the illicit affection being expressed by some artistically immoral blacks for pieces of green paper."[1430] Ellen Holly takes issue with the film content, arguing that "Half the time, the material not only isn't black, it isn't even original, as white material ready for the boneyard is given a hasty backwash and sent on one last creaking go-round."[1431] Emma Darnell, an Atlanta attorney representing a group of concerned parents in that city, points out that she favors a campaign "to educate the community to the harm these movies spread among our children. We are talking about the life and death of black children, dope, prostitution, and so on . . . We want the filth out of our community."[1432]
 On the other hand, supportive viewers saw only good guys, who happened to be black, knocking the daylights out of vicious crooks, who happened to be white. Sympathetic audiences insisted that such scenes were "cathartic," that they enabled frustrated black youths to release their violent emotions in a safe and non-threatening environment. Moreover, the best women in the "blaxploitation" films, who happened to be black, were great with their guns and out-of-sight in the sack. "If they're going to put the damper on John Shaft," explains James Earl Jones in defense of the all-black films, "let them put it on John Wayne too and they'll find out that there

[1426] W. I. Scobie, "Black Cinema: Supernigger Strikes," LONDON MAGAZINE 12:1 (April-May 1972):113.

[1427] "Notes on Black Films," p.161.

[1428] Alan Ebert, "Pam Grier: Coming into Focus," ESSENCE (January 1979):43.

[1429] Alvin Poussaint, "Cheap Thrills That Degrade Blacks," PSYCHOLOGY TODAY 7:9 (February 1974):32.

[1430] James P. Murray, "The Subject is Money," BLACK FILMS AND BLACK-FILMMKERS, p.257.

[1431] Ellen Holly, "Where Are the Films About Real Black Men and Women?" NEW YORK TIMES B (June 2, 1974):11.

[1432] Quoted in Barbara Morrow Williams, "Filth Vs. Lucre: The Black Community's Tough Choice," PSYCHOLOGY TODAY 7:9 (February 1974):112.

are a lot of people who need those fantasies."[1433] On a more positive note, Mary E. Membane ("Liza") argues that films like GORDON'S WAR and CLEOPATRA JONES "are remarkably accurate in reflecting the mood, the ambiance, the sensibility of the seventies in black communities across the nation."[1434] Moreover, Mark A. Reid believes that the new wave of black film activity, "which surfaced from the ashes of riot-torn ghettos, rejected art that tried to appeal to white America's morality."[1435] Although attempts at providing a black aesthetic through the commercial cinema were controlled and manipulated by white producers, films like SWEET SWEETBACK'S BAADASSSSS SONG and SHAFT did present an image of angry black heroes who symbolically undermined white institutions that oppress the heroes. "Despite the flaws that can be criticized," Reid concludes, "black action films, for a period of three years, proved to be a popular genre which focused on black themes and provided opportunities for blacks in the American film industry."[1436]

For a while, the public accepted the "blaxploitation" movies as mere entertainment. After all, they not only added a new dimension to gangster and spy films, but also "modernized" black stereotypes. In particular, they effectively captured the contemptuous ghetto dialogue, with its unsettling profanity and vivid metaphors.[1437] Eventually, however, the religious leaders, psychiatrists, politicians, and socially conscious critics made the public realize that the white-dominated film industry had no commitment to upgrading the image of blacks or of allowing them an equal footing in the business of filmmaking. The public also came to realize, as Poussaint explains, how these movies perpetuate negative myths about black women, impede the movement for African-American unity, and misdirect young people by encouraging anti-social behavior.[1438] Even more disturbing to the Howard University dean Tony Brown was the complicity of black filmmakers themselves:

> "The blaxploitation films . . . are a phenomenon of self-hate. Look at the image of SUPER FLY. Going to see yourself as a drug dealer when you're oppressed is sick. Not only are blacks identifying with him, they're paying for the identification."[1439]

[1433] Charles Michener, "Black Movies," NEWSWEEK 130:17 (October 23, 1972):77; Rpt. BLACK FILMS AND FILM-MAKERS, pp.235-46, and THE BLACK MAN ON FILM, pp.96-103.

[1434] Mary E. Mebane ("Liza"), "At Last--Brother Caring for Brother," NEW YORK TIMES D (September 23, 1973):13.

[1435] Mark A. Reid, "The Black Action Film: The End of the Patiently Enduring Black Hero," FILM HISTORY: AN INTERNATIONAL JOURNAL 2:1 (Winter 1988):24.

[1436] Reid, pp.32, 34.

[1437] Interestingly, "blaxploitation" films did not work in European markets. According to one film executive, the reason was that "Europeans are simply more prejudiced than American audiences . . . [and] Inherent prejudice blends with the relatively small black population in Europe's main burgs . . . [thereby severely limiting] the market potential for such pix." See "U. S. Black Films Failing in Europe," VARIETY (May 8, 1974):54.

[1438] Poussaint, p.98.

[1439] Michener, p.77.

Brown went on to say that blacks who make such films "are guilty of nothing less than 'treason.'"[1440]

Another way "Soul" enters the mainstream of the American film industry in the seventies is by expanding the image of black life and history. Films like THE GREAT WHITE HOPE (1970), SHAFT, THE SKIN GAME, KONGI'S HARVEST (all in 1971), SOUNDER, BUCK AND THE PREACHER, BLACK GIRL, LADY SINGS THE BLUES (1972), GANJA AND HESS (1973), CLAUDINE (1974), LEADBELLY, and COOLEY HIGH (Both in 1975) add a new, albeit two-- rather than three-dimensional image of blacks on screen. For the first time, independent black filmmakers under the structure of the new Hollywood were producing mainstream films about African-American culture. How good they were is another question. According to black screenwriter Lonne Elder III, he was told by a big studio executive, "'They want s_ _ _ and we're giving them s _ _ _.'"[1441]

The issue then and now is what characters like Richard Roundtree's Shaft, Ron O'Neal's Super Fly, and Melvin Van Peebles's Sweetback symbolize in the evolution of black film stereotypes. Do they in fact signal a new direction or, more likely, a co-optation of black culture? Part of the answer may lie, as Gladstone L. Yearwood suggests, in looking more closely at the image of the contemporary black hero. As discussed earlier, Americans routinely turn to their consistent roster of role models for direction in personal behavior. Now there are black choices as well as the traditional white selections. A key element in how those role models are used by people is related to the way in which the heroes or villains satisfy the spectator's desires and needs. If contemporary black film heroes offend middle-class dignity, imagine the rage that created such heroes. Put differently, the way representatives of virtue or evil are symbolized aids in the public's comprehension of complex and difficult ideas. At this stage in the twentieth century, it is axiomatic that the more governments and social institutions seek to forge a consensus, the more they resort to popular stereotypes of heroes and villains. Yearwood argues that given the central role that film heroes play in the film continuum, a detailed analysis of the modern Hollywood black hero would reveal the problems of black artists trying to work in mainstream films:

> Since the popular cinema is itself an economic institution in a system of exchange, its heroes (stars) are marketable commodities. The black hero in film is by nature a subversive, and is thus unable to take a place in the system of exchange on the same basis as traditional heroes. The traditional hero in film represents a particular social order within which blacks are positioned as a subordinate underclass. With the emergence of a black hero, traditional social relations and positions are challenged. It is difficult to conceive of a black hero in film within traditional consumerist terms.[1442]

More to the point, so long as Hollywood operates as a microcosm of society, so long will African-American heroes remain "reflective of the unequal relations between dominant social classes and subordinate socio-cultural groups."[1443]

What makes Yearwood's attack on Hollywood's contemporary black heroes especially interesting is his emphasis on "pleasure" and "positioning." As discussed earlier, many feminist critics believe that films are geared to our unconscious ways of seeing and our pleasure in viewing "private worlds." The scopophilia engages our desire for pleasure in looking and the camera's ability to reproduce the world

[1440] Michener, p.77.

[1441] Michener, p.80.

[1442] Yearwood, p.43.

[1443] Yearwood, p.43.

encourages us to accept uncritically what is projected as the "truth." This voyeuristic tradition periodically operates as a means of "ordering" our existence. Assuming for the moment the validity of that assertion, we can appreciate Yearwood's claim that modern movies are politicizing black heroes to the advantage of conservative rather than subversive groups. That is, black heroes like Shaft, Super Fly, and Sweetback appear powerless against the dominant political system. These "street-heroes" operate primarily as wish-fulfillment figures for escapist-minded audiences. If anything, they tell us more about white society than about African-American culture. And as Yearwood points out, "In contrast to this 'street hero,' the middle-class black hero, portrayed for example, by Sidney Poitier in many of his roles before the seventies, is principally an accomodationist type who in no significant manner challenges the dominant system of political relations in the cinema."[1444] Juanita R. Howard puts the matter differently, worrying most about the impact of all-black films with super black heroes. "They turn out," she writes, "however unintentionally, to be the same soil in which seeds of alienation have always grown."[1445]

While there is much scepticism in Yearwood's and Howard's assertions about progress in the treatment of black film images, it should be pointed out that white liberals, independent black filmmakers, and a number of industry critics have successfully begun to chip away at many of the derogatory and demeaning aspects of the minstrel and plantation traditions.[1446] But the obstacles still facing black talent need to be understood. Gordon Parks, the director of THE LEARNING TREE and SHAFT, explains that

> It is true that there were many so-called exploitation films that were bad. I didn't see many of them, but I saw one or two and they were really bad. What you must remember is that those black directors were getting their first chance. They were given money to make the film, otherwise they never would have been able to set their foot through the door and say, "Here I am, and here's what I want to make . . ." Even some of the black businessmen who put money up decided that they wanted this kind of film in order to secure their money up there. You don't particularly care about morality and this or that. What you want to do is protect your half million dollars or whatever money you put in the film. That's the problem.[1447]

Given the integral, complex nature of the film continuum, the changes in the range of roles open to black performers, the increased opportunities for black directors, and the number of talented black people working in film today are no small achievement.

It should also be noted that changes in the film image of blacks often affect negatively the very personalities who helped make progress possible. A major example is Sidney Poitier. Over a thirty-year period, almost single-handedly, he forced a white-dominated film industry and audience to reevaluate the role of the black performer in films. Yet it was Poitier who found himself a pariah with the black

[1444] Yearwood, p.44. See also Theophilus Green, "The Black Man as Movie Hero," EBONY 27:10 (August 1972):144-8.

[1445] Juanita R. Howard, "Sittin, Eating Popcorn as Alienation Grows," NEW YORK TIMES C (August 12, 1975):29.

[1446] For another perspective, see Eugenia Collier, "Once Again, the White Liberal to the Rescue," NEW YORK TIMES B (April 21, 1974):11.

[1447] Thom Shepard, "Gordon Parks: Beyond Black Film," *THE CINEASTE INTERVIEWS ON THE ART AND POLITICS OF THE CINEMA, eds. Dan Georgakas and Lenny Rubenstein, Foreword Roger Ebert (Chicago: Lake View Press, 1983), pp.178-9.

community once the "blaxploitation" market erupted. "I was a perfect target," he
writes, "but there wasn't anything I could do."[1448] He came to symbolize Hollywood's
"one-dimensional, middle-class imagery"; his pervasive screen image became the
illogical reason why other black actors couldn't get roles; and his films illustrated
the reasons why America remained rooted in its racist past. It seemed as if the film
industry could tolerate either a middle-class black or his angry counterpart, but not
both at the same time. Equally revealing is that once the "blaxploitation" era ended,
the stars of those films virtually disappeared from the screen. Gone was the mass
interest in either black stars or films. "There were occasional exceptions," points
out Canby, "but mostly it was business as before. Blacks continued to turn up in
major movies, but in subsidiary if not just token roles."[1449]

As a result of the changes taking place in Hollywood from the post-WWII era to
the end of the seventies, black artists not only increased their ranks off-camera and
in the unions, but also black performers gained a greater visbility. If nothing else,
audiences became more familiar with a host of key personalities such as Sidney Poitier,
Harry Belafonte, Gordon Parks, Richard Roundtree, Godfrey Cambridge, Ossie Davis,
Jim Brown, Ron O'Neal, Diana Ross, Diahann Carroll, Ruby Dee, Diana Sands, Ivan
Dixon, Melvin Van Peebles, Sammy Davis, Jr., James Earl Jones, Roscoe Lee Browne,
and Woody Strode.

Outside the established system, independent filmmakers and those just starting
out in ghetto film workshops across the nation offered signs of a strong, healthy
cinema. The most visible aspect of their work is a non-traditional approach to
filmmaking. In describing films like Charles Burnett's KILLER OF SHEEP, Larry
Clark's PASSING THROUGH, and Haile Gerima's BUSH MAMA (all in 1977), Yearwood
stressed the new dimension being added to the politics of film:

> These films are not what one may term ADVOCACY FILMS, or simple
> propagandistic work. There is a centrality of the artistic expression of ideas
> through the medium of film. Without a doubt, these filmmakers deal with explicit
> political themes in contrast to the general direction of the first phase [of
> independent black filmmaking]. These films contain a political commitment to the
> liberation struggles of black and other oppressed people.[1450]

Moreover, these new filmmakers are not willing to limit their audiences to
African-Americans. They aim their films at a larger segment of the population, hoping
not only to get their message across to more people than just blacks but also refining
the nature of popular entertainment. Armond White also is concerned with the efforts
of filmmakers like Charles Burnett, Charles Lane, Ailie Sharon Larkin, Henry Miller,
and Bill Woodberry to offer black alternatives to mainstream filmmaking. Each of these
individuals, in his own way, "move[s] away from authoritative conventions of popular
culture."[1451] Unlike independents of the past, they are reaching targeted audiences
through museums, festivals, and a variety of Public Broadcasting formats.[1452] "These

[1448] "Walking the Hollywood Color Line," p.24.

[1449] Vincent Canby, "America Rediscovers Its Black Actors," NEW YORK TIMES 2 (December
16, 1984):1.

[1450] Gladstone L. Yearwood, "Introduction: Issues in Independent Black Filmmaking,"
BLACK CINEMA AESTHETICS, pp.11-2. See also *Mbye B. Cham and Claire
Andrade-Watkins, eds. BLACKFRAMES: CRITICAL PERSPECTIVES ON BLACK INDEPENDENT
CINEMA (Cambridge: The MIT Press, 1988).

[1451] "Telling It on the Mountain," p.40.

[1452] For a good overview of independent black filmmakers, see Pearl Bowser and Valarie
Harris, eds., INDEPENDENT BLACK AMERICAN CINEMA (New York: Third World Newsreel,

independents," writes White, "who may simply be too good, too smart for their chosen careers, have reached a point that requires a specific recording of love, humor, pain, and anger--emotions that decades of black caricature have obscured, rendered unrecognizable."[1453]

Particular inroads were also made by film and television artists like Madeleine Anderson, St. Claire Bourne, William Greaves, Ben Land, and Carlton Moss. For example, Greaves, who was executive producer of the Emmy-Award winning TV news show BLACK JOURNAL and is the holder of numerous awards for films like FROM THESE ROOTS (1974) and FREDERICK DOUGLAS: AN AMERICAN LIFE (1985), confidently told the interviewer James Murray that "because of the commercial factor and candor that are becoming increasingly popular, black filmmakers, who are more candid and speak from areas that the wider community has little contact with, will probably flourish in this country."[1454] St. Claire Bourne told the same interviewer, "I think we can make it if we prove we are honest and competent."[1455] But even with such optimism, many of these independent producers were unable significantly to affect the image of blacks in TV, a medium that increasingly determines the content of theatrical films. As Cripps points out, bad ratings for the works of these artists resulted in television programming that steered clear of racial matters.[1456] Moreover, the NAACP, angry over what it perceived as the continuing "gross underemployment of blacks, both behind and in front of the camera," threatened a boycott against the film industry in 1982.[1457] As a result, minority hiring took a periodic upswing.

Perhaps the most interesting news of the late 1970s was that a marketing and distribution executive, Ashley Boone, along with Sandy Lieberson, helped run 20th Century-Fox for nearly half of 1979.[1458] Boone is African-American, the first and only black persion ever to operate a major film studio. Those who worked with him, like Alan Ladd, Jr., and George Lucas, not only praise his talent but also credit him with some of the major marketing strategies of the last ten years, including the campaigns for STAR WARS (1977) and GHOSTBUSTERS (1984). Today, however, his connection with 20th Century-Fox has been deleted from the studio-sanctioned-chronology of its history.[1459]

By the mid-1980s, the treatment of African-Americans had once again become muddled. On the one hand, films like A SOLDIER'S STORY, THE COTTON CLUB, BEVERLY HILLS COP, and THE BROTHER FROM ANOTHER PLANET (all in 1984) indicated that a decade after the "blaxploitation" films had died away a new black interest cycle was in the making. Not only were audiences supporting these films at the box office, but the themes and characterizations were showing sides of black culture previously untouched.[1460] Even a new low-budgeted but flawed film version

1981). This program guide to the black film retrospective contains comments on over forty films and videos.

[1453] White, p.41.

[1454] Murray, p.94.

[1455] Murray, p.105.

[1456] BLACK FILM AS GENRE, p.57.

[1457] Michael Dempsey and Udayan Gupta, "Hollywood's Color Problem," AMERICAN FILM 7:6 (April 1982):66-70.

[1458] Joy Horowitz, "Hollywood's Dirty Little Secret," PREMIERE 2:7 (March 1989):56.

[1459] Horowitz, p.56.

[1460] See C. Gerald Fraser, "Black Woman's Outlook in Whitney Film Series," NEW YORK

of NATIVE SON (1986) contained fresh insights into the old Chicago neighborhoods of Wright's 1940 novel.[1461] Spike Lee's SHE'S GOTTA HAVE IT (1985), a low-budget film made for $175,000, grossed $7,000,000 at the box office. "For an independent shoestring production," Stuart Mieher explains, "this was remarkable. For an independent shoestring production by a black man about black people, it was astounding."[1462] Moreover, a film like GARDENS OF STONE (1987) ignores completely issues of race, showing James Earl Jones and Lotte McKee as vibrant and intelligent human beings who function as well if not better than their white counterparts. Other African-American stars joining Poitier and Jones included Morgan Freeman, Lou Gossett, Jr., Danny Glover, Whoopi Goldberg, Gregory Hines, Eddie Murphy, Richard Pryor, and Denzel Washington. Even further, Robert Townsend's HOLLYWOOD SHUFFLE (1987), which he produced, directed, wrote, and starred in, encourages many viewers to believe that independent black filmmakers now have unprecedented opportunities to present alternative life-styles on the screen.[1463] And in box-office terms, the biggest draw of the decade is Eddie Murphy, whose films "have generated more than $1 billion worldwide--more than any other actor's in history."[1464]

TIMES 1 (December 28, 1986):56; and Eric Pace, "Blacks in the Arts: Evaluating Recent Success," ibid., A (June 14, 1987):1, 38.

[1461] See Aljean Harmetz, "Problems of Filming NATIVE SON," NEW YORK TIMES C (December 23, 1986):14; and Vincent Canby, "Screen: NATIVE SON, Based on Wright's Novel," ibid., C (December 24, 1986):14.

[1462] Stuart Mieher, "Spike Lee's Gotta Have It," NEW YORK TIMES MAGAZINE (August 9, 1987), p.26. Lee's next film, SCHOOL DAZE (1988), a six million dollar venture, ran into considerable critical and commercial problems, some of which he claimed were race-related. See Spike Lee, "Letters: SCHOOL DAZE Days," NEW YORK TIMES C (March 6, 1988):21; and Jennet Conant and Karen Springer, "A Question of Class and Color: Spike Lee Takes a Hard Look at Black College Life," NEWSWEEK (February 15, 1988):62. See also Vincent Canby, "Spike Lee Raises the Movies' Black Voice," NEW YORK TIMES H (May 28, 1989):11, 14; Michael T. Kaufman, "In a New Film, Spike Lee Tries to Do the Right Thing," ibid., H (June 25, 1989):1, 20; Michel Marriott, "Raw Reactions to a Film on Racial Tensions," ibid., B (July 3, 1989):21, 23; Thulani Davis, "We've Gotta Have It: Spike Lee and a New Black Cinema," VILLAGE VOICE (June 20, 1989):67-8, 70; Renee Tajima, "Say the Right Thing," ibid., p.68; James Earl Hardy, "Do the Sty Thing," ibid., p.70; Donald Suggs, "Standing Still," ibid., p.70; Stanley Crouch, "Do the Race Thing: Spike Lee's Afro-Fascist Chic," ibid., pp.73-4, 76; Lisa Kennedy, "And Then There Was Nunn," ibid., p.74; Guy Trebay, "Rosie the Riveting," ibid., p.74; Samir Hachem, "Journey Into Fear," ibid., p.76; Brent Staples, "Spike Lee's Blacks: Are They Real People?" ibid., H (July 2, 1989):9, 26; "DO THE RIGHT THING: Issues and Images," ibid., H (July 9, 1989):1, 23; "Letters: Spike Lee," ibid., H (July 16, 1989):3; "Letters: Spike Lee," ibid., H (July 23, 1989):3; Betsy Sharkey, "Knocking on Hollywood's Door: Black Filmmakers Like Spike Lee's Struggle to See and Be Seen," AMERICAN FILM 14:9 (July-August 1989):22-7, 52, 54; and Thulani Davis, "Local Hero: Workin' 40 Acres and a Mule in Brooklyn," ibid., pp.26-7.

[1463] For a sample of optimistic reactions, see Janet Maslin, "Film: HOLLYWOOD SHUFFLE, Satire by Robert Townsend," NEW YORK TIMES C (March 20, 1987):8; Esther B. Fein, "Robert Townsend Has Fun at Hollywood's Expense," ibid., H (April 19, 1987):18, 35; C. Gerald Fraser, "A Film Maker Reflects on a 12-Year Project," ibid., C (February 4, 1988):26; and Duane Byrge, "HOLLYWOOD SHUFFLE," HOLLYWOOD REPORTER (April 3, 1987):3, 67.

[1464] Horowitz, p.59.

On the other hand, the conservative issues and racial fears that had plagued filmmakers since the turn of the century were back in vogue. In movie theaters across the country, on TV screens, and on shelves of countless videocassette stores were films sentimentalizing the Old South: e.g., GONE WITH THE WIND, SONG OF THE SOUTH, and THE COLOR PURPLE (1985). New black stars like Whoopi Goldberg, Richard Pryor, and Eddie Murphy were starring in films as the black comic who functions primarily in a white world: e,g., JUMPING JACK FLASH, THE GOLDEN CHILD (both in 1986), CRITICAL CONDITION, BURGLAR, and BEVERLY HILLS COP II (all in 1987). Lou Gossett, Jr., Gregory Hines, and Danny Glover were playing tough guys helping out their white friends in action-packed melodramas like IRON EAGLES, RUNNING SCARED (both in 1986), and LETHAL WEAPON (1987).[1465] Once again, black personalities were adding the key ingredients to run-of-the-mill movies and making the films click at the box office.[1466]

The question was "Why?" What made these once-discredited traditions popular again? Was it merely a longing for the past or a desire to reinstate the notion of movies as merely entertainment?[1467] And how accurate were Angela M. Salgado's comments that "The new movement is not simply to discuss and focus on relations of black people and black community . . . Films are now talking about the dynamics of the black community in the context of the larger society."[1468]

Adding to the dilemma over changing times is a 1987 commentary by Michael Blowen of the BOSTON SUNDAY GLOBE. Starting with the premise that we should stop designating movies starring black performers as black movies, he argues that

> Except to convey the obvious--the idea that a movie probably features a predominantly black cast and, in some cases, a black director--the term is misleading. Instead of opening up our experience of a movie and the world, it closes it down, eliminating much of the richness and variety of many of the films designated as black. It implies that the films deal primarily with issues and situations pertinent only to black people, thus eliminating the larger implications and audiences.[1469]

Blowen also points out an alleged unfairness to the performers who get typecast as "black" actors and thus are used sparingly because of their presumed limited range. Examples cited are Woody Strode, Richard Roundtree, Ron O'Neal, William Marshall,

[1465] Horowitz points out (p.59) that a number of key roles in important box-office films--e.g., AN OFFICER AND A GENTLEMAN (1982), BEVERLY HILLS COP (1984), and LETHAL WEAPON (1987)--had been written for white actors but played by black performers--Lou Gossett, Jr., Eddie Murphy, and Danny Glover respectively.

[1466] Michael E. Ross, "Black and White Buddies: How Sincere Is the Harmony?" NEW YORK TIMES H (June 14, 1987):23-4.

[1467] Daniel Goleman reports that researchers investigating the staying power of prejudice are finding not only "that people tend to seek and remember situations that reinforce stereotypes, while avoiding those that do not," but also that "Much of the recent work on prejudice has moved from a psychoanalytic view to a cognitive one, in which most prejudice is seen as the byproduct of the normal processes whereby people perceive and categorize one another." See Daniel Goleman, "'Useful' Modes of Thinking Contribute to the Power of Prejudice," NEW YORK TIMES C (May 12, 1987):1, 10.

[1468] Crystal Nix, "Changes in Black Films," NEW YORK TIMES C (October 25, 1985):8.

[1469] Michael Blowen, "Abolish Term 'Black Films,'" BOSTON SUNDAY GLOBE B (January 11, 1987):1,6.

Cicely Tyson, and Diana Ross. To further prove his point, he includes comments from a number of prominent film personalities. For example, Steven Spielberg denies that his film, THE COLOR PURPLE (1985) is primarily about "race."[1470] Paul Robeson, Jr., insists that black films no longer refer specifically to black-oriented issues. Norman Jewison notes that neither of his important films involving black performers--IN THE HEAT OF THE NIGHT (1967) and A SOLDIER'S STORY (1984)--are black films. And Sidney Poitier sums up the editorial by stating that "people should approach movies starring black people the way they approach any other movie and evaluate it in that manner."[1471]

On the other hand, the frustration in the film capital still runs high. "Mention Black Power in Hollywood," Donna Britt reports, "and many blacks will tell you it's a romantic notion, at best, a dream deferred." She goes on to point out that "Less than 1 percent of about 1,100 executives at major movie studios here are black; a 1987 Writers Guild study found black writers 'significantly' less likely to be employed than blacks."[1472] Joy Horowitz points out that in 1988, the film industry's two leading black executives--Stanley Robertson and Ashley Boone--were both fired as a result of managerial changes at Columbia Pictures (Robertson) and a corporate takeover at Lorimar Telepictures (Boone).[1473]

That is not to say that everything is bleak. It isn't. Britt shares some of Blowen's optimism about the growing number of black screenwriters, directors, and producers. She does, however, close her observations with a quote from Tony Brown, the host of PBS's TONY BROWN'S JOURNAL: "The only color of freedom in America is green."[1474] Horowitz does acknowledge that affirmative action programs like the one at 20th Century-Fox (one minority will be hired for every two new employments) portend positive signs for the future."[1475] And Lou Gossett, Jr., claims that ever since his success in AN OFFICER AND A GENTLEMAN (1982) the public appears colorblind and sees him in his screen roles "as a person--not as a race or a color."[1476]

Reading DeWayne Wickham's syndicated column about minorities reminds us anew that battle is far from over. Decrying the persistent use of white Anglo-Saxons playing prominent roles in depicting the struggles of African-Americans, the outraged writer attacks not only the distortions in the screen studies, but also the film industry's profit-orientation in recent films like CRY FREEDOM (1987) and MISSISSIPPI BURNING (1988). "It is axiom of filmmaking," he argues, "that [in] movies about the suffering and struggles of Afro-American history . . . whites are always cast in the starring roles." To further develop his argument, Wickham describes the treatment of a civil war unit, soldiered by blacks and commanded by whites, in a yet-to-be-released film GLORY. In fact, the only member of the famous

[1470] For useful perspectives, see Jacqueline Bobo, "Black Women's Responses to THE COLOR PURPLE," JUMP CUT 33 (February 1988):43-51; and Ed Guerrero, "The Slavery Motif in Recent Popular Cinema: THE COLOR PURPLE and THE BROTHER FROM ANOTHER PLANET," ibid., pp.52-9.

[1471] Blowen, p.6.

[1472] Donna Britt, "Blacks Flex Muscles in Film and TV," USA TODAY D (December 18, 1987):1-2.

[1473] Horowitz, p.59.

[1474] Britt, p.D2.

[1475] Horowitz, p.64.

[1476] Cited in Glenn Collins, "Lou Gossett Jr. Battles the Hollywood Stereotype," NEW YORK TIMES H (February 19, 1989):33.

Fifty-fourth Massachussets army regiment awarded the Medal of Honor is William H. Carney. In the film, however, his role is relegated to the background, putting the emphasis on the commanding officer who leads the brave soldier back to the fort and comforts him during his final moments. Ignored is the fact that Carney survived the battle. Thus, for Wickham, these three films collectively represent "the latest addition to a new genre of 'blaxploitation' movies."[1477]

The point to glean from this general overview is that the battle for intelligent black images is far from over. Many of the same issues, related to different but no less demeaning images, are still being debated by liberal critics and black intellectuals. For example, Stephen Holden, discussing Wesley Brown's 1987 historical drama BOOGIE WOOGIE AND BOOKER T., points out that

> Underlying the heated political arguments and personal battles that erupt, one hears the same profound questions about race and American society that are still being asked today. They are questions of policy (accomodation vs. confrontation), identity (assimilation vs. exclusivity), and moral survival (how to understand and live with the evils of racism and social injustice).[1478]

What is so frustrating about the history of African-Americans in film is that there is no progress in the iconography. It seems as if every breakthrough has more than its share of setbacks. For those who measure the pace in terms of glacial shifts, the progress from UNCLE TOM'S CABIN (1903) to THE COLOR PURPLE (1985) is considerable. For those who still wonder why we can't treat minorities with respect and intelligence, the current situation is demoralizing.

At the center of the controversy is a growing awareness that the public influences the kinds of film images that movies project. There is also, at long last, an understanding that movies contain important social data about our values and attitudes, and that they are a business in which the survival rate for any filmmaker, black or white, is miniscule. Moreover, the survival rate in mainstream films is tied to the philosophy that movies are first and foremost entertainment. That is not to say that movies don't educate or advocate causes. They do. But, as Poitier points out,

> You cannot make a message picture. A message picture is a statement, a preachment, a speech without entertainment values unless you make some laughs as you go along. People are listening for the political content of it or the point of view. We are not accustomed to that in America and until such time as the motion picture is no longer the domain of the profit-seekers, you have to principally entertain people. That goes for black people as well as white people.[1479]

At the same time, it is imperative that we understand that the escapist emphasis of American theatrical films requires the cultural suppression of minorities and outsiders in order to validate the values of the dominant groups in American culture. The result is that African-Americans have been and continue to be demeaned on the screen because an apathetic and prejudiced audience remains visually illiterate about the

[1477] DeWayne Wickham, "Latest Films Show 'Blaxploitation,'" BURLINGTON FREE PRESS A (January 13, 1989):14.

[1478] Stephen Holden, "Black Dramatists Offer New Visions of Old Icons," NEW YORK TIMES C (March 6, 1987):1.

[1479] "Entertainment, Politics, and the Movie Business," p.17. See also David Ansen, "A Superstar Returns to the Screen: Sidney Poitier at 60," NEWSWEEK (February 22, 1988):73.

derogatory images presented and the effects such stereotypes have on our imagination, attitudes, and values. Consequently, black filmmakers need to do more than condemn the Hollywood system. They must work toward transforming the role of film in our society, while also documenting the range and richness of the African-American experience.[1480]

BOOKS

GENERAL

Boskin, Joseph. SAMBO: THE RISE AND DEMISE OF AN AMERICAN JESTER. New York: Oxford University Press, 1986. Illustrated. 252pp.

Campbell, Edward D. C., Jr. THE CELLULOID SOUTH: HOLLYWOOD AND THE SOUTHERN MYTH. Knoxville: The University of Tennessee Press, 1981. Illustrated. 212pp.
 The leading work on the subject, this chronological survey on the image of the South on film examines the curious fascination that the American public has had with the complex issues of history and race. As Campbell explains, "The impact of this cinematic antebellum culture was enormous, its mystique always evident." Unlike his peers, the author moves cautiously in drawing any conclusions about what specific films tell us about audience values or social commentary. For example, he notes the limitations of information gleaned from studio publicity records, but observes that the material accurately reflects what the film executives "thought the public wanted and even how the industry intended the public to act." Campbell also cites the value of local newspapers as a source of information in determining the reactions of a region, rather than relying too heavily on national popularity as the major barometer of a film's success. The end result is a study of how movies reflected popular perceptions in their conventions, film techniques, and critical reactions; and how our understanding of those perceptions may have used the South to satisfy our desires and expectations. In fact, he concludes, "The mythology which surrounds and shrouds the South is revealed on the screen as not uniquely Southern but distinctly American in origin, use, and appeal."
 In the first of the book's five scholarly chapters, the author raises the issue of why a modern industrial nation once ripped asunder by a Civil War over slavery became so enamored of positive images of its vanquished agrarian foes. In providing the answer, Campbell shows us why movies are important historical documents. At the very least, he argues, they show us our values. For those viewers who wanted to deny their complicity in acts of inequality, the Old South became a convenient whipping boy. For those viewers who romanticized their magnificent cultural heritage, the antebellum South offered an idealistic image of gracious landowners, beautiful belles, and faithful servants. To prove his theory, Campbell first traces the literary history of the South in fiction. Within a few richly detailed pages he summarizes the important novels, stories, and theatricals that collectively rehabilitated the South in the eyes of the nation. The popularity of those efforts understandably caught the attention of the new visual entertainment medium. Here was subject matter that ideally suited the needs of film; it was brief, easily identifiable, and escapist rather than serious fare. The confining nature of the large industrial centers made stories about pastoral settings especially appealing, and thus came into being the romantic and sentimental tales so dear to the hearts of American film audiences. Rather than focus

[1480] For a useful source of information on African-American films, see C. Gerald Fraser, "Group Celebrates a Decade of Distributing Black Films," NEW YORK TIMES C (June 7, 1989):20.

on specific films, Campbell wisely explains the differences between fact and legend in the myth of the antebellum South on screen. That is, he contrasts the actual geographical boundaries between the Old South and those of the Confederacy, reviews the plot conventions of the film genre, and explains why most American filmmakers prefer to use tried and tested stereotypes rather than create new ones. According to Campbell, films operate on several levels. One approach is to make certain that the movie's image of the South jibes with the public's preconceptions of the Old South. A second approach is to convince the audience that the film honestly represents the past. In other words, "film versions of the slave South functioned far more as agents of reinforcement than as agents of change." After the fifties, when Hollywood finally began altering its racial stereotypes, it signaled, according to Campbell, not a more liberal Hollywood but instead a more informed public perception. Thus the attacks on the evils of the antebellum South were little more than the efforts of a business to make as much money as possible.

Chapter 2 takes a look at silent films from 1903 to 1927. Dividing stories about the Old South into two romantic extremes (preserving values threated by an industrial society and characterizing blacks as the ardent defenders of a slave culture), the movies functioned as "a popular and simplistic apologia for the South." The carefully developed thesis explores how time, sympathy, and manipulation worked to the filmmakers' advantage. Dozens of films testify to the public's willingness not only to forgive the evils of a bygone age, but also to transfer the blame away from Southern plantation owners to Northern overseers and carpetbaggers. Even more astonishing is the ability of filmmakers like Griffith to persuade viewers that the disruptive force in the Old South was the slave, not the slave owner. Perceptively, Campbell reminds us that the importance of THE BIRTH OF A NATION was not its racial views, but the fact that Griffith's image of the stereotyped South became respectable in middle-class circles and unified Northern and Southern whites in what one advertisement claimed was a "common defense of their Aryan birthright." By the time THE JAZZ SINGER (1927) sounded the end of silent films, not much had changed in the values first expressed in UNCLE TOM'S CABIN (1903). Conservatism, racial fears, and Southern apologists still determined the screen's outlook on the Old South. In effect, the South's stock rose as race relations fell.

Chapter 3 analyzes Hollywood's famous studio system from 1928 to 1939. Starting with the reasons why the South remained a popular movie topic in the 1930s, Campbell dwells on how the cinematic images emphasized the region's ambivalence toward economic upheaval. What is interesting is the gap between what appeared on screen and in books. The former gave us the Old South as a paragon of strength against hard times, while the latter stressed the hardship of poor farmers and ignorant country people. Unlike other authors on the subject, Campbell is not interested in mere plot summaries or superficial labels. He prefers to ask difficult questions and to offer tentative answers. For example, in speculating on the influence of revisionist writers (e.g., Ellen Glasgow, William Faulkner, and Erskine Caldwell) on the image of the South in film, Campbell wonders why the impact was so insignificant. After all, he notes, "the movies adhered in part to the spirit of the Agrarians." The answer the author comes up with relates more to the emotional rather than to the intellectual needs of the audience. What is especially satisfying about Campbell's analyses is their evenhandedness. After severely criticizing the studios for their reactionary messages, he can still acknowledge the enormous value of the celluloid South as an invaluable genre for maintaining the public's morale during the Depression. Moreover, he makes it clear that Hollywood survived more on catering to public opinion than on molding it.

Regrettably, the remaining two chapters lack the balance so valuable to our understanding of how the nation responded to the evolution of the celluloid South through film history. While Chapter 4, devoted almost exclusively to Margaret Mitchell's GONE WITH THE WIND (1936) and David Selznick's screen version (1939), effectively summarizes previously published material, there is little new information. More disappointing, however, is Campbell's decision to include in his final chapter almost forty years (1941-1980) of tightly compressed film history. The result is more

a listing of film titles than a reflective account of how the sentimental traditions of the Old South turned into stories of Gothic horrors. That is not to say that Campbell ignores how changing times altered the types of films that were produced or the pressures that motivated Hollywood's pro-black attitudes during and after WWII. There are occasional analyses, like that of SONG OF THE SOUTH (1946), which illustrate the dilemmas filmmakers faced with an audience basically out of touch with contemporary literature. It is to say that Campbell in this chapter is more willing to settle for labeling rather than for analyzing events. We want to know more about Hollywood's internal problems and how they related to an emphasis on "titillation" rather than on "reevaluation." Moreover, the author's artistic judgments appear more fallible here than in earlier sections. A case in point is his assertion that "The films of the 1930s earned money largely by providing entertaining stories. The film business after 1945 survived in part by providing excitement not to be seen on television. After 1965, the business made profits by reflecting audience desires to an even greater extent." Just as telling is the fact that while he deplores films that sensationalize the Old and New South, Campbell spends more time discussing movies like SLAVES (1969) and MANDINGO (1975) than he does SOUNDER (1972) or NORMA RAE (1979). To his credit, however, Campbell offers important leads into the extreme positions taken by Hollywood in dealing with the South. In addition to raising the issue of whether the filmmakers were insincere or eager to take their place in revisionist film history, he demonstrates the value of checking the publicity for each contemporary film to see if its liberal intentions match its market rhetoric. And in summarizing the oversimplifications made by nearly eighty years of film history, the astute historian reminds us that "The survival of the South in the popular imagination owes more to the cinema than any other force."

In his "afterword," the author reviews what made the romantic themes so popular, calling attention to the importance of a conservative strain within the public at large. He notes that protests and violence did more to change Hollywood's attitudes than did reason and information. He points out that while the old racial conflicts appear to be ebbing in contemporary films, the myths about Southern independence and individualism are thriving. Thus, Campbell concludes that "The mythology survives, only the trappings have changed."

Anyone exploring the hundreds of films treating the Old and New South should begin with this detailed and informative study. Whatever its drawbacks, it remains a primary source of rich material on the issues and events. A filmography, bibliography, and index are included. Recommended for special collections.

Diakite, Madubuko. FILM, CULTURE, AND THE BLACK FILMMAKER: A STUDY OF FUNCTIONAL RELATIONSHIPS AND PARALLEL DEVELOPMENTS. New York: Arno Press, 1980. Illustrated. 184pp.

"The purpose of this work," writes Diakite, "is to examine and describe how select black filmmakers maintained a relationship with select black socio-cultural communities." The filmmakers discussed are Oscar Micheaux, Melvin Van Peebles, and Ousmane Sembene. The focus is on demonstrating what these three individuals considered significant to their targeted audiences and the style in which those perceptions were presented. To that end, Diakite defines and discusses issues related to black culture. "Black" is defined as "(1) a social and ethnic community whose major ethnic population is heavily dominated by people of African descent; (2) the social community (ethnic minority) of the United States who are also commonly referred to as Afro or African-Americans, or black Americans." After acknowledging the near impossibility of defining "black film," he then concludes that in this study it means "the finished film that was inspired and directed by a black filmmaker, regardless of the amount of non-black assistance, money or censorship involved." Regrettably, very little time was spent proofreading one of the most poorly typed manuscripts in recent memory. More than one-third of this labored doctoral study done for the Department of Film Studies at Stockholm University is filled with spelling, punctuation, usage, and grammatical errors.

The first of the book's seven erratic chapters is devoted to a tedious discussion of issues related to perception-reflection theories and black film-art debates. Central to understanding Diakite's perspective are his explanations of terms like "functional interdependence" and "persistence of social systems." These anthropological concepts underscore how African-American culture emerged and developed in various stages, including in its social luggage values drawn from Africa, slavery, Southern society, Emancipation, northern migration, and racism. In the author's view, African-American culture is dynamic rather than static, heterogeneous rather than homogeneous. Where Diakite blunders badly is in making sweeping political, social, and cultural comparisons between the Republic of Senegal in the 1970s and communities in America in two different periods (1918 to 1948 and the late 1960s). Too much space is devoted to assertions and too little to persuasive documentation.

Chapter 2 attempts to set up a model whereby commercial feature films by black filmmakers can be analyzed from an anthropological point of view: e.g., examine the cultural influences on the film content, study their value to the socio-cultural community, and describe the filmmakers' intentions and the manner in which they appear in the films. The model requires that we differentiate between "objective" and "expressive" meanings. That is, we first must identify and describe the self-contained content in the work ("objective" meanings) and then objectify the "psychic" content that involves values and attitudes associated with the filmmaker and the culture from which the film emerged ("expressive" meanings). A major problem is that the author encompasses too many issues in his surveys of the parallel developments of film art of two black cultural worlds and the ritual relationships the filmmakers created with their socio-cultural communities. Thus Diakite never successfully demonstrates that the black films cited proved "a source of important socio-cultural meanings that remain misinterpreted by critics and historians"; that the three filmmakers consciously "incorporated values and ideas familiar to black audiences in the development of a film aesthetic of their own"; and that the films cited "are important in communicating socio-cultural values and orientation to black audiences."

Chapter 3 turns its attention to the cultural features and social development of black films. Diakite first looks at the functions films perform, relying heavily on Bronislaw Malinowski's view that every feature of a socio-cultural community operates as an integral part of the biological and psychological workings of the entire community. Also alluded to in this superficial overview of functionalism are the ideas of A. R. Radcliffe-Brown, Robert K. Merton, Dorothy M. Emmet, and J. S. R. Goodlad. Neither the discussion nor the limited citations add any information to what common sense already provides.

Chapter 4 asserts that a study of black art is the same as studying "the essence of communication, the method of communication, and the function of communication." Following a disappointing overview of the history of black arts, the author proceeds to offer a brief summary of black filmmakers in American film history. His best sections stress a justifiable pride in the accomplishments of black independent filmmakers and a predictable outrage over Hollywood's distortion of black culture. His least effective comments, dealing with black films from the sixties on, result from his misunderstanding of the changes taking place in the production and distribution of films following the PARAMOUNT case in 1948, the shift in exhibition from urban to rural areas, and the major role taken by independents in the new Hollywood. Diakite does offer, however, a useful overview of filmmaking in Africa south of the Sahara. Asserting that African audiences have a long history of filmgoing, he argues that the weakness in African movies stems from the absence of a sophisticated film industry. The chapter then concludes with uneven summaries of the careers of Micheaux, Van Peebles, and Sembene. The most useful comments relate to his strong defense of the first two men as protesters against Hollywood's "models of black reality," pointing out in the case of Micheaux that film critics have failed to value him for his unique qualities and have instead "compared his filmmaking technology with Hollywood standards." On the other hand, Van Peebles, the first African-American given a Hollywood contract to make three films, is discussed almost

exclusively in relation to a non-Hollywood studio film: SWEET SWEETBACK'S BAADASSSSS SONG (1971).

Chapter 5 describes the cultural and aesthetic phenomena that are relevant to two widely separated black communities. The characteristics applicable and theoretically appropriate to both are found in the functions of style and theme. For example, the author explains that "Style has the capacity to reflect the types of action the forces of evolutionary change are involved in, such as psychological, economic, political, or physical." That is, style functions as a means of orienting the public to the STATUS QUO and/or introducing new ideas. The major drawback to style, according to Diakite, is its tendency to be coopted by the establishment and used to maintain residual values. To distinguish the two contrasting functions, he labels one "DYNAMIC" (reflecting emerging values) and the other "NON-DYNAMIC" (reflecting the STATUS QUO). An example of the former is Van Peebles's SWEET SWEETBACK'S BAADASSSSS SONG. An example of the latter is Micheaux's THE GIRL FROM CHICAGO (1932). In each instance, Diakite provides an intriguing analysis of the filmmakers' style in scripting, directing, cinematography, sound, and editing techniques. The emphasis throughout is on how the filmmakers reflect basic values embedded in their socio-cultural environments. Although the analyses are too brief to be persuasive, they do indicate the possibilities for richer investigation.

Chapter 6 explores the "documentary phenomena in black films." Here the author makes a number of sweeping generalizations about the works of his three filmmakers. For example, Micheaux's films are described as reflecting more than the ambitions of a black entrepreneur. They also are alleged to reflect "the wider issues that were expressive of the militancy of black and white struggles for the improvement of everyone's lot in the United States." The only supporting sources for this conclusion are V. J. Jerome's writings in MASSES AND MAINSTREAM. The works of Van Peebles and Sembene are described as having "parallel--not similar--characteristics." That is, the former gives vent to changes in black culture wrought by the radical ideology of the sixties; the latter, albeit operating in an ethos that Diakite claims is too "new and incomplete" to evaluate, reflects the ideological struggle of "'pure' versus the 'mongolized' remnants of African culture as affected by colonialism." To his credit, the author lists the problems in discussing an artist's intentions, but still insists that it is possible to analyze how experience functions as the basis for describing an artist's intentions.

Chapter 7 summarizes Diakite's research and offers suggestions for further study. Although mainly a restatement of the obvious, he calls attention to what the filmmakers communicated rather than why they made the films they did. To defend his thesis, he relies on a circular model of a socio-cultural community (e.g., values and ideologies, public opinion, economic processes, filmmaker, reflected concept, and audience). His oversimplified explanations stress "the centrifugal force of audience responses to black film-art." Popularity is seen as linked to the filmmakers' "approach" and "style" to their respective perceptions of "reality" and "the living world of experience." In particular, he isolates three common categories: "THE OUTCAST or OUTLAW THEME," "THE MORALITY THEME," and "THE IDEALIST THEME." These three themes, according to the author, are used by the artists as a means of orienting their respective audiences to new and revolutionary aspects of black culture. In addition to explaining how his approach could apply to other media studies, Diakite argues that his analyses and explanations prove that black film demonstrates how African-American filmmakers use their black conventions as a form of unique communication to African-American audiences, how these conventions reveal values and ideologies unique to black communities at a specific time and place, and how the commercial failure of African-American filmmakers is more the result of socio-economic factors than of alleged artistic weaknesses.

Despite the book's many glaring errors, it is worth examining for its positive attitude toward black filmmakers working against formidable odds. A weak bibliography and filmography are included. Approach with caution.

French, Warren, ed. THE SOUTH AND FILM. Jackson: University Press of Mississippi, 1981. Illustrated. 258pp.

Originally published in the Spring-Summer 1981 issue of THE SOUTHERN QUARTERLY: A JOURNAL OF THE ARTS IN THE SOUTH, the twenty-two essays of varying quality collectively provide a more in-depth look on specific topics and films than is available in either the Campbell or Kirby works on Hollywood's treatment of the Old South. Individually, however, many of the articles lack the cohesiveness and impact of a well-thought out study. For example, in the editor's introduction he succinctly summarizes the film chronology, but makes some incredible statements. On the one hand, there is the intriguing assertion that the Western superseded the Southern. On the other hand, there is the astonishing comment that "Even THE BIRTH OF A NATION and GONE WITH THE WIND have been attacked on racial and social grounds." That alternating pattern of perceptive observations and naive comments catches the spirit of the opening essay as well as the book itself. Best of all, there is the element of surprise. Who would suspect that an opening history on the celluloid South would focus primarily on two years (1969-70) and argue that a watershed film on the treatment of that controversial region would be EASY RIDER (1969)?

The first of the book's five major sections deals with four film "classics": THE BIRTH OF A NATION (1915), JEZEBEL (1938), GONE WITH THE WIND (1939), and THE SOUTHERNER (1945). Robert A. Armour's essay on the Griffith epic focuses on the "Realistic South" versus the "Romantic South." While he provides a good summary of previously published research, the author's apologetic tone and weak critical judgments undermine the article's value to scholars. Joan L. Silverman's comments on the film as "prohibition propaganda," while interesting, are too brief to be impressive research. On the other hand, Ida Jeter's excellent discussion of JEZEBEL includes a wealth of information and insights. For example, she points out that between 1929 and 1941 there were approximately seventy-five theatrical films about the South, most of which followed two themes: (1) "the North as commercial and egalitarian and the South as agrarian and aristocratic"; and (2) "a Gothic portrait of decadence and depravity in the South, old and new." Trisha Curran's terse but stimulating comments on GONE WITH THE WIND tie the film to its Depression-roots. The disappointing section ends with Hart Wegner's lackluster analysis of Jean Renoir's THE SOUTHERNER.

The second major section, focusing on genres, opens with Evelyn Ehrlich's valuable discussion of Civil War film conventions. She not only touches on the models drawn from drama and popular literature, but also traces the evolution of Civil War themes in silent films. Most interesting is her intelligent analysis of the similarities between stage and film treatments of the era. Wade Austin's general comments on the "Real Beverly Hillbillies" provides entertaining future research possibilities on the "local yokel" movies between 1935 and 1955. Martin F. Norden's skillful approach to business and love in the much-ignored film BRIGHT LEAF (1950) offers another perspective on films about the post-Reconstruction period, its economy, and the values of its industrial leaders. Edward D. C. Campbell's brisk overview is little more than a reworking of parts of his final chapter in THE CELLULOID SOUTH.

The third major section, discussing AUTEURS, begins with J. P. Telotte's superb essay on "The Human Landscape of John Ford's South." In discussing the famous director's eleven "Southern" films (four silent), Telotte stresses the differences between Ford's characteristic manner of relating individuals to their physical environment in Westerns, and the almost total lack of emphasis on setting in the Southern films. Equally interesting is the theory that Ford's reliance on racial stereotypes resulted from his lack of personal experience in the South. Gerald Plecki, on the other hand, provides few revelations on Robert Altman's Southern films. Except for a general reminder that the director's image of the region is a catch-all for America's best and worst traits, we get little more than a once-over lightly of films like BREWSTER MCCLOUD (1970), THIEVES LIKE US (1974), and NASHVILLE (1975). Michael Adams's insightful comments on Martin Ritt's Southern films serve as an excellent summary of Hollywood's attitude toward the region over a

twenty-five-year period. From EDGE OF THE CITY (1957) through BACK ROADS (1981), as Adams points out, the noted director's views have remained relatively constant on the effect that outsiders have on a tightly knit community, the isolation of people in the South, and the nature of close family ties. Particularly impressive is the evenhanded way in which Adams evaluates the films and then concludes that Ritt's major weakness may be that "he does not give us the insights an artist would."

The fourth major section, "Women," contains two brief, minor essays on Southern heroines. Victoria O'Donnell, taking a cue from Alfred Korzybski's theory that symbols enable us to span time, attempts to analyze the celluloid image of Southern women as an example of "time-binding." She comes up with the following types: "The Feminine Woman" (Vivien Leigh's Scarlett O'Hara); "The Real Lady" (Olivia De Havilland's Melanie Wilkes); The Fallen Woman" (Vivien Leigh's Blanche DuBois); "The Sexual Woman" (Elizabeth Taylor's Maggie the Cat); "The Unfulfilled Sexual Woman" (Joanne Woodward's Rachel); "The Rich, Spoiled Woman (Cybill Shepherd's Jacy Farrow); and "The New Female Woman" (Cicely Tyson's Rebecca). What hurts O'Donnell's case is not only the superficial definitions, but also her unwillingness to delve very deeply into the subject. For example, she doesn't even bother to list Shepherd's screen name in THE LAST PICTURE SHOW (1971). Lenora Clodfelter Stephens's essay on black women may be the book's weakest contribution. Her title is particularly misleading since she seems to spend more time looking at black males in modern films than at the changing images of black actresses.

The fifth major section, "William Faulkner and Film," contains a praiseworthy essay by Jeffrey J. Folks on Faulkner's own reactions in his writings to silent film. The scholarly investigation into the great writer's first three novels and early short stories reveals a man very much taken with Hollywood's form of entertainment. While Jack Barbera's "Tomorrow and Tomorrow and TOMORROW" lacks the scope of the Folks's piece, it does a good job of tracing the history of the 1972 Faulkner adaptation.

The sixth and final section, "Regionalism," contains a potpourri of five disappointing essays, ranging from Gorham Kindem's slight "Southern Exposure: KUDZU and IT'S GRITS" to H. Wayne Schuth's superficial comments on "The Image of New Orleans on Film." The one high point is David D. Lee's intriguing "Appalachia on Film: The Making of SERGEANT YORK."

Given the quality of these essays and the fact that the book was published at the same time that the 1981 issue of THE SOUTHERN QUARTERLY appeared, one wonders why it was necessary to include the weaker essays at all. Overall, the handful of strong contributors justifies the book's place in specialized libraries, but only after more important works on the subject have been consulted. A flimsy "Chronology on the Evolution of 'The Southern,'" a weak bibliography, a trivial filmography, a brief film title index, and an adequate general index conclude the book. Approach with caution.

*Kirby, Jack Temple. MEDIA-MADE DIXIE: THE SOUTH IN THE AMERICAN IMAGINATION. Baton Rouge: Louisiana State University Press, 1979. Illustrated. 203pp.

Using academic historiography from roughly 1900 as his focal point, the ambitious author sets out to write an analysis of the "popular historical images of the South since the birth of film and annual best sellers." In other words, Kirby wants us to know how Southern apologists reworked the grotesque and distorted images that once epitomized the region and its "peculiar institutions." Unfortunately, the attempt is more interesting than the results, mainly because the history professor prefers scope to substance. He defines the "South" as the white majority, since that is the way Kirby believes most Americans perceive the region. He does, of course, stress the presence of a "black South" and periodically points to its role in the shaping of a white consciousness. His objectives are "first simply to survey this [popular historical] imagery in the mass communications media: films, best-selling fiction, documentary books and films, popular (i.e. nonacademic) histories, school texts, music, and television." He also offers some breezy observations on "radio, drama,

sports, and . . . advertising through the printed and television media." His criteria for inclusion are tied to the box office and TV ratings rather than to artistic or scholarly praise. The result is more space for Erskine Caldwell than for William Faulkner, more attention to Robert Altman's NASHVILLE (1975) than to Jean Renoir's THE SOUTHERNER (1945). The problem is not with Kirby's methodology but with his analyses. For example, he finds NASHVILLE "a three-hour long bore," but considers WHITE LIGHTNING (1973) a "good drama which reveals a maturing treatment of several traditional southern themes." That's about as complex as the survey gets. But given the book's historical progression, Kirby feels compelled to point out how artistically significant works affected the rise and fall of popular works in specific genres: e.g., Ellen Glasgow's BARREN GROUND (artistic) to Caldwell's TOBACCO ROAD (popular). Why the authors wrote as they did and what their books meant to their readers are never pursued. Nor is there ever any attempt to explain why the region itself produced such distorted polarities as the pastoral plantation and the racist redneck country traditions. Lest we worry that scholars have been responsible for the false images, Kirby reassures us that ever since the mid-1930s, academic historians have stayed at least one decade "ahead" of the popular mass media. That is, the scholarly community years ago abandoned its former sentimental attachments to antebellum Southern myths and adapted a neoabolitionist attitude toward the Old South "and the human rights cause since 1958, along with sympathetic portrayals of the white poor as well." The problem here, as Walter Sullivan explains, is that "Kirby's study suffers from his own bias in favor of the school of revisionism. He devotes one embarrassed paragraph to Fogel and Engerman. Genovese's name does not appear in the book. No reference is made to Floyd Watkins's THE DEATH OF ART Nor does Kirby mention Richard Weaver's IDEAS HAVE CONSEQUENCES [and he] is unequipped to deal with literature critically . . . and there is no mention of the impact of black music on southern culture."[1481]

How well Kirby succeeds in demonstrating the links between popular imagery and public values is illustrated in the opening of his seven chronologically arranged chapters, "Griffith, Dunning, and 'the Great Fact of Race.'" He first establishes the negative image of the South in the second half of the nineteenth century. Perceived as brutal and backwoods, the region appears incompatible with other American institutions and thus has to have its face lifted if it is to achieve reconciliation with the nation at large. Among its more famous publicists in the early 1900s is D. W. Griffith. To Kirby's credit, he provides a useful overview of the filmmaker's values and historical sources in dealing with film versions of the antebellum South. Particular attention is paid to the 1901 ATLANTIC MONTHLY articles on the history of Southern Reconstruction written by Professor William A. Dunning of Columbia University. From that pro-Southern reinterpretion of the Civil War and its aftermath emerges a conservative and sympathetic account of the Old South known as 'the Dunning School." Thus Griffith's THE BIRTH OF A NATION (1915) is described not only as part of that school, but also as in step with the times. Regrettably, Kirby is not as skillful in identifying Griffith's other sources. For example, he repeats the commonly held notion that Thomas Dixon's novel THE CLANSMAN was the source for THE BIRTH OF A NATION and omits Anita Loos from the list of people who wrote scenarios for Griffith. In quoting material attributed to President Woodrow Wilson's secretary, Kirby fails to footnote his source.

A second section especially relevant to film history is Chapter 3, "The Embarrassing New South." Writing about the prolonged lull (1916-1928) in the appearance of books or films about the South (with the exception of Buster Keaton's 1926 masterpiece, THE GENERAL), Kirby describes the emergence in the late twenties of a new genre loosely called "sharecropper social realism." Among the films it generated was CABIN IN THE COTTON (1931), "a typical 'issue' picture of the Hoover

[1481] Walter Sullivan, "In Search of the Real South," SEWANEE REVIEW 86:3 (Summer 1978):xc, c.

and early New Deal years." Predictably, no real insights are provided on the film itself or on its value to interpreting the times. The only sensitive comment is that the virtually all-white film deals with the problems of a group that was in reality almost all black. In addition, Kirby offers some casual comments on I AM A FUGITIVE FROM A CHAIN GANG (1932).

Chapter 4, "The Grand Old South," surveys the presumed reasons why films about the sentimental South and Confederacy proved so popular during the thirties. Here again, Kirby's value is in outlining the variety of mass media steps that gave rise to the fluctuating image of the "South." While his pop treatment of films like HEARTS IN DIXIE and HALLELUJAH! (both in 1929) add little to our understanding of the films or art, he does link them to similar themes in popular literature.

Probably the greatest value of Kirby's study is in listing and labeling the participants in the popular culture battle between pro- and anti-Southern mythmakers. Endnotes, an essay on sources, and an index conclude the exercise. Worth browsing.

*Maynard, Richard A., ed. THE BLACK MAN ON FILM: RACIAL STEREOTYPING. Rochelle Park: Hayden Book Company, 1974. Illustrated. 134pp.

A useful anthology aimed at secondary school teachers, this resource book is designed to aid in the analysis of films, old and new, that stereotype blacks. Maynard's four basic objectives are (1) to analyze movies as a "MIRROR of our social attitudes"; (2) to chronicle the "social impact of films on American race relations"; (3) to make the public aware of why blacks have a legitimate grievance against the film industry's historical distortion of African-Americans; and (4) "to attempt to determine why unrealistic images of minorities persist in our mass media and how we are able to change them for the future." Most of the material contained in the book's six major sections attack the history of black stereotyping. Each of the chronologically arranged sections focuses on a specific problem, pointing out how the stereotypes become increasing more complex with time.

Part 1, on the history of black film stereotypes, begins with an excerpt from Ossie Davis's explanation of why he wrote PURLIE VICTORIOUS (released on film as GONE ARE THE DAYS). To illustrate his thesis of how demeaning stereotypes emerged and were perpetuated, Davis analyzes the screen image of Stepin Fetchit and emphasizes its roots to slaves who deceived their owners into thinking that blacks were "dumb and lazy." Thus, Fetchit's form of "protest" humor represents a respectable tradition. The next essay is Lawrence D. Reddick's seminal 1944 essay on movies, including reviews of films like HALLELUJAH! (1929), IMITATION OF LIFE (1934), and GONE WITH THE WIND (1939). The excellent section concludes with Thomas Cripps's important essay, "The Death of Rastus: Negroes in American Films Since 1945," stressing the importance of film censorship in the perpetuation of racial stereotypes.

Part 2, on THE BIRTH OF A NATION, demonstrates the impact that the film had on American society. Following an excerpt from Lewis Jacob's superb THE RISE OF THE AMERICAN FILM, which summarizes the movie's plot and controversial nature, the editor cleverly threads together three reprints from the 1915, 1916, and 1965 publications of THE CRISIS to reveal how the NAACP battled to get the movie banned. To offer an alternative point of view, Maynard includes a reprint of James Agee's strong 1948 defense of the film (and eulogy for D. W. Griffith). "I don't entirely agree with him," writes the famous critic, "nor can I be sure that the film won't cause trouble and misunderstanding, especially as advertised and exacerbated by contemporary abolitionists; but Griffith's absolute desire to be fair, and understandable, is written all over the picture; so are degrees of understanding, honesty, and compassion far beyond the capacity of his accusers." The section concludes (as do the later chapters) with a number of thought-provoking discussion questions.

Part 3, on opinions relating to topics from Stepin Fetchit to CARMEN JONES (1954), covers nearly thirty years of film history. The opening reprints are two valuable 1929 essays from OPPORTUNITY (published by the National Urban League)

in which Floyd C. Covington details the employment status of African-Americans in the early days of sound and Robert Benchley reviews HEARTS IN DIXIE. Other essays taken from OPPORTUNITY, VARIETY, NEW YORK AMSTERDAM NEWS, THE REPORTER, THE DAILY WORKER, and COMMENTARY critique films like IMITATION OF LIFE (1934), THE LITTLEST REBEL (1935), CABIN IN THE SKY (1943), INTRUDER IN THE DUST (1949), and CARMEN JONES (1954).

Part 4, on a "New" look for blacks in film, concentrates on the significance of Sidney Poitier and UP TIGHT (1968) to black film history. Bosley Crowther's 1967 defense of Poitier represents the typical critical perspective prior to the mid-1960s, stressing the actor's distinguished achievements as well as the film, IN THE HEAT OF THE NIGHT (1967). Clifford Mason, on the other hand, represents the extreme anger felt by militant blacks against Poitier in the late 1960s. The final two essays in the section discuss the critical reactions to UP TIGHT, considered by many people to be the first major treatment of black protest in mainstream films. Lindsay Patterson's "It's Gonna Blow Whitey's Mind" argues that the remake of THE INFORMER (1935) constitutes in 1968 "the most 'daring' film ever to be in production," while Reneta Adler's "Critic Keeps Her Cool on UP TIGHT" claims the film doesn't work because neither the ideology or characterizations of the new version fit into the patterns of the John Ford classic.

Part 5, "Beyond Sidney Poitier," changes direction away from the distortions of black culture toward what can be done about it. William Grant Still, writing in 1945 in OPPORTUNITY, examines what happened to blacks in Hollywood during WWII and comes to the conclusion that protesters should understand that films are a business that can be hurt by boycotts against undesirable products. Harold Cruse's extract from THE CRISIS OF THE NEGRO INTELLECTUAL also advocates boycotting undesirable films not because of disdain for a specific product but because of long-term patterns. That is, blacks should maintain a black ethos: "Without a literay and cultural critique of his own, the Negro can not fight for and maintain a position in the cultural world." The last essay in this section is Charles Michener's insightful 1972 NEWSWEEK article "Black Movies," summarizing the issues and personalities that made up up the bulk of the "blaxploitation" era.

Part 6, on parallel studies in stereotyping, contains two analyses of minority stereotyping other than that of blacks. Vine Deloria, Jr.,'s excerpt from her book, WE TALK, YOU LISTEN examines the mistreatment of Native Americans in the movies. Making the point that racist stereotypes result more from ignorance than from malicious intent, she argues for new perspectives that symbolize a balance among differing interpretations about our nation's history and objectives. Gary Carey's "The Long, Long Road to Brenda Patimkin" gives a valuable overview of the film image of Jews in Hollywood films. Arguing that almost all of the decisions pertaining to the film image of Jews were linked directly to commercial concerns, Carey concludes that by the time GOODBYE, COLUMBUS (1969) was released, film Jews were "in" and were deemed "worthy of taking it on the nose with the worst and the best of us."

It would be a serious mistake to overlook this splendid anthology. Not only are many of the essays important and difficult to locate, but collectively they are an excellent resource for classroom study. The three significant drawbacks are the absence of any information about race productions, the lack of a much-needed bibliography, and the failure to include an index. On the other hand, Carey includes a worthwhile filmography. Well worth browsing.

AFRICAN STUDIES

Cyr, Helen W. A FILMOGRAPHY OF THE THIRD WORLD: AN ANNOTATED LIST OF 16mm FILMS. Metuchen: The Scarecrow Press, 1976. 319pp.

A valuable compilation of short subjects and feature-length movies, this worthwhile study defines its topic very broadly, including in the Third World "all non-Western nations--that is, all except the United States, Europe, and the Soviet Union--and the ethnic minorities of North America and Europe." The majority of entries have release dates from the late 1960s, testifying to the increasing interest that filmmakers have in Third World topics. Cyr makes it clear that a film's quality is not a prerequisite for inclusion. Rather, she is concerned with topic representation and availability. For example, all the films cited are distributed in America and/or Canada or available from university film depositories. Each film entry provides the following information: title, alternative title when appropriate, producer, release or copyright date, running time, color, name of distributor, and a brief annotation. Feature-length film entries also contain information on subtitles (if a foreign language film), as well as technical and cast credits. A distributors' directory is provided at the end of the book. An index is also included. Worth browsing.

Cyr, Helen W. A FILMOGRAPHY OF THE THIRD WORLD: AN ANNOTATED LIST OF 16mm FILMS. Metuchen: The Scarecrow Press, 1985. 275pp.
 A useful supplement to the 1976 edition, this filmography repeats the basic features of the first book, including an emphasis on African-American movies. More nations are included here than in the past and the over 1300 new titles increase the overall value of the entire project. Worth browsing.

Gabriel, Teshome H. THIRD CINEMA IN THE THIRD WORLD: THE AESTHETICS OF LIBERATION. Ann Arbor: UMI Research Press, 1982. 147pp.
 A thoughtful but demanding analysis of the changes in Third World cinema beginning in the early 1960s, this revised 1979 UCLA doctoral thesis discusses how the new cinematic movement "was built on the rejection of the concepts and propositions of traditional cinema, as represented by Hollywood." Third World filmmakers begin by immersing themselves into the day-to-day lives and struggles of Third World people. The products that result focus on political and social relevancies and underscore the inescapable importance of cinematic style and ideology. Consequently, the films themselves capture the traumatas affecting Third World people everywhere. The filmmakers view their work as political statements operating as political acts to bring about positive changes in the way films are seen and made. Chapter 1 provides a concise overview of the pioneering efforts to establish Third World cinema. Chapters 2 and 3 discuss the theoretical foundations of the movement, relying heavily on the teachings of scholars like Amilcar Cabral, who stresses the need for analyzing films in a socio-aesthetic context and Franz Fanon, who identifies five basic themes Gabriel relates to Third World cinema: class, culture, religion, sexism, and armed struggle. The intent is to demonstrate how each of the themes requires action both by the filmmakers and their audiences. Chapter 4 explains what is meant by a "revolutionary film," stressing the importance of fresh approaches to style and ideological perspectives. Chapter 5 applies the theory to specific films, emphasizing a three-pronged strategy: (1) a comparison of two films--the NBC American movie, BAY OF PIGS (1964) and the Cuban feature film, PLAYA GIRON (1973)--dealing with the same subject matter; (2) a comparison of five films, two from South Africa--JOURNEY TO THE SUN and LAST GRAVE AT DIMBAZA (both in 1975)--and three films on the Mexican Revolution--the Italian feature film, DUCK, YOU SUCKER, and the Argentine documentary, MEXICO: THE FROZEN REVOLUTION (both in 1971), and the semi-documentary, REED: INSURGENT MEXICO (1972)--demonstrating the importance of analyzing acts of omission; and (3) a comparison of two films--THE YOUNG AND THE DAMNED/LOS OLVIDADOS (1950) and EL CHACAL DE NAHUELTORO (1969)--illustrating the value of analyzing films on the basis of style and ideology. Chapter 6 concludes the scholarly investigation by examining the differences between cultural and ideological codes. Gabriel makes a persuasive case that culture plays a pivotal role in determining a film's ideological content.

what makes this otherwise complex study valuable to some beginning students is the author's systematic approach to the subject. He is more concerned with educating rather than with advocating a particular point of view. Moreover, his sensitive insights into the controversial topics often add to our understanding of the political aims of Third World filmmakers. Especially useful are his introductions to the thinking and work of artists like Ousmane Sembene, Jorge Sanjines, Miguel Littin, Fernando Solanas, and Octavio Getino. Particularly intriguing are his explanations of why Chinese intellectuals object to Michelangelo Antonioni's CHUNG KUO/CHINA (1972).

There are, however, some drawbacks to this first serious study in English of Third World cinema. Uppermost is the book's price, which puts it on library shelves rather than in students' personal libraries. Next is the fact that Gabriel's useful bibliography regrettably ignores non-English studies on this much-neglected topic. Third, many of the explanations require more information than is permitted by the perimeters of a doctoral study. And finally, there are problems when comparisons are made between different types of films (feature-length movies and documentaries) with different audiences and goals in mind.

These limitations notwithstanding, the publication is one more important reminder of what major film schools are doing to upgrade film scholarship, the quality of a new generation of film academicians, and the valuable service provided by publishers like the UMI Research Press. The book concludes with three significant appendexes--a copy of "Filmmakers and the Popular Government: A Political Manifesto," the Resolutions of the Third World Filmmakers Meeting in Algiers in 1973, and an interview with Ousmane Sembene--and a filmography, bibliography, and index. Recommended for special collections.

*Maynard, Richard A. AFRICA ON FILM: MYTH AND REALITY. Rochelle Park: Hayden Book Company, 1974. Illustrated. 84pp.

If your knee-jerk reaction to the term "Africa" is "Dark Continent," "savage," "jungle," Tarzan," and "mysterious," then you're probably forty years of age and over and would enjoy reading this imaginative and well-organized anthology debunking the pervasive mythology that muddles America's thinking about African culture. The book is another in a series of secondary school compilations edited by the film reviewer for SCHOLASTIC TEACHER MAGAZINE. Like the other works, this one is primarily interested in why we persist in retaining degrading stereotypes long after they have been discredited by scholars.

Part 1, on Africa itself, surveys the continent and provides a factual overview of the geography, history, and political development. Although too brief to satisfy serious students, the anthropologist Paul Bohannan's excerpt from his book AFRICA & AFRICANS offers a good introduction to what Africans are up against as they emerge from their enslaving colonial past. Among the false myths that the author debunks are simple ones like lions don't live in the jungle--(a) because they exist in the grasslands, and (b) because the entire continent contains only five percent jungle--to complex myths like the fact that African nations since the 1960s are polarized in their attitudes toward the United States--in fact, they are not so much against any nation as they are strongly for Africa. The historian Philip D. Curtin's "Investigating Africa's Past" reminds us that a study of African history expands not only our understanding of the continent's rich diversity and cultural accomplishments, but also our methodology for the study of the past in general. The section ends, as do the other three, with a number of useful discussion questions.

Part 2, on the origins of myths about Africa, suggests how cultural conflicts often determine our perceptions about each other, regardless of evidence to the contrary. The historian Winthrop Jordon's excerpt from his book, WHITE OVER BLACK, explains how the myth of the "savage" originated, making clear that British racial and religious biases in the the sixteenth century are responsible for the stereotypes about black Africans being pagans and barbarians. "The discovery of

savages overseas," Jordon points out, "enabled them to . . . move from miracles to verifiable monstrosities, from heaven to earth." Moreover, he adds, "By forging a sexual link between Negroes and apes . . . Englishmen were able to give vent to their feelings that Negroes were a lewd, lascivious, and wanton people." Curtin's second contribution, an excerpt from his book, THE IMAGES OF AFRICA, discusses how British prejudice in the eighteenth century perpetuated the false myths about the "dark continent." Building on the fact that English unfamiliarity with the area often ran "the gauntlet of disease and death," those explorers and settlers perpetuated the notion that a tropical society was not a Edenic paradise but rather a dangerous environment that created savages. One outcome, as Curtin reports, was a popular theory that "African indolence came directly or indirectly from the climate, or from basic racial endowment. . . ." The remedy the British devised was slavery.

Part 3, on the intimate relationship between the African myths and the media, contains a wealth of excerpts surveying nearly fifty years of distortions about African culture. Beginning with an excerpt from Edgar Rice Burrough's first of his twenty-seven novels about the "jungle man," TARZAN OF THE APES (1912), we see how the sixteenth-, seventeenth-, and eighteenth-century myths about black savages were institutionalized in American pop fiction. Other stimulating examples include an excerpt from H. Rider Haggard's best-selling book, KING SOLOMON'S MINES (three times made into a feature film, 1937, 1950, 1985), the 1932 NEW YORK TIMES film review of Johnny Weissmuller's debut in TARZAN, THE APE MAN, studio publicity material for the MGM film TRADER HORN (1931), and excerpts from the film script of THE NUN'S STORY (1959).

Part 4, on repudiating the myth, allows three angry black authors to decribe their reactions to Hollywood's distorted version of African history and culture. Harold Cruze, one-time film critic for THE DAILY WORKER, explains in a November 1950 review what he finds most objectionable about the 1950 MGM version of KING SOLOMON'S MINES. Next, the Nigerian academician Oladipo Onipege describes why he feels that the American film industry has "engaged in an unrelenting propaganda war against the African, the South Sea Islander, and the American Red Indian." Finally, the film critic Lindsay Patterson reviews the effects that Hollywood's racial distortions have had on black people around the world.

For fast-reading, stimulating issues, and first-rate selections, this concise anthology is tops. Regrettably, the brevity of the extracts and the non-scholarly orientation of the series in general remain obstacles in expanding the series' wider distribution to major libraries and college classrooms. A filmography is included, but no index or bibliography are provided. Well worth browsing.

Pfaff, Francoise. THE CINEMA OF OUSMANE SEMBENE: A PIONEER OF AFRICAN FILM. Foreword Thomas Cripps. Westport: Greenwood Press, 1984. Illustrated. 207pp.

An invaluable overview to black Africa's most prominent filmmaker, this highly complimentary study is divided into two major parts. The first section covers Sembene's pre-cinematic background, his role as a modern GIROT (a storyteller, genealogist, musician, and oral reporter), and how he uses the medium to reflect a dynamic African society. The second major section analyzes his important films: BOROM SARRET (1963), BLACK GIRL (1966), MANDABI (1968), EMITAI (1971), XALA (1974), and CREDO (1976). Throughout this lucid examination of a complex artist, Pfaff manages not only to hold the reader's attention with perceptive comments about his work habits, but she also reminds us of the enormous obstacles faced by African filmmakers who lack adequate studio and editing facilities. In addition, she provides three appendexes--a biographical sketch of Sembene, his screen credits, and his impact on filmmaking--along with a useful bibliography and helpful index. Recommmended for special collections.

AMERICAN STUDIES

Bogle, Donald. BROWN SUGAR: EIGHTY YEARS OF AMERICA'S BLACK FEMALE SUPERSTARS. New York: Harmony Books, 1980. Illustrated. 208pp.
 A delightful overview of America's best-known (and not so-well known) black female performers, this popular history is lavishly illustrated and briskly written. Bogle explains in his introduction to his seven enjoyable chapters that throughout his youth he was "troubled and haunted by . . . the personal difficulties [of the actresses]." Rather than concentrate on all the women who dominated the entertainment world, he decides to focus on the stars--"those women who captured the imagination of millions and became bona fide legends." The personalities profiled include Ma Rainey, Ethel Waters, Josephine Baker, Lena Horne, Dorthy Dandridge, Billie Holiday, Marian Anderson, Donna Summer, Cicely Tyson, Diana Ross, and Eartha Kitt. If possible, read the book as an addendum to viewing the valuable four-part 1986 TV series based on the study, starring Billy Dee Williams and containing rare footage of the stars in action. A bibliography and index are included. Well worth browsing.

*Bogle, Donald. TOMS, COONS, MULATTOES, MAMMIES, AND BUCKS: AN INTERPRETIVE HISTORY OF BLACKS IN AMERICAN FILMS. New York: The Viking Press, 1973. Illustrated. 260pp. New York: Crossroads/Ungar/Continuum, 1989. Expanded Edition. Illustrated. 322pp.
 Concerned more with attacking the film industry than with critical analyses of race productions and Hollywood films, this highly subjective but extremely entertaining study performs a cheerleading function for some of the most memorable black artists in motion picture history. Bogle's preface outlines the importance of films in his life and why he felt compelled as a twenty-five-year-old black to write a book about the work of his "cultural ancestors." He cavalierly dismisses Noble's pioneering work as "the typical, unintentionally patronizing, white liberal 'tasteful' approach" and asserts that it is the black actors that "have elevated KITSCH or trash and brought to it arty qualities if not pure art."
 Chapter 1, on films from UNCLE TOM'S CABIN (1903) to THE BIRTH OF A NATION (1915), identifies Bogle's strengths as a popular critic and his weaknesses as a scholar. Although he gives a valuable summary of the five basic African-American film stereotypes, the author never once acknowledges his debt to literary and theatrical critics who almost a century earlier had started cataloging stereotypes of racial minorities, nor does he credit black critics like Lawrence D. Reddick with listing nineteen black stereotypes in 1944. Bogle also makes numerous assertions that are highly debatable. For example, he claims that Sam Lucas's role in UNCLE TOM'S CABIN (1914) marks the first time that a black man had a leading role in film. In addition to there being no proof provided, Bogle ignores the race films made by William Foster in 1910. Moreover, the author's discussions of the Jack Johnson era vastly oversimplify events between 1908 and 1915. Consider his false assertion that after Johnson became heavyweight champ in 1908, "black boxers in films were invariably defeated by their white opponents." In fact, blacks had always been defeated UNTIL Johnson beat Burns. The succession of "great white hopes" that followed also were defeated and resulted in a racist Congress finally outlawing interstate boxing films primarily because white boxers were losing to black fighters. Those oversimplifications aside, the author's biting evaluation of THE BIRTH OF A NATION effectively captures nuances of the film's racial bigotry that escape the eye of most white critics.
 Chapter 2, on the 1920s, makes the false assumption that negative images of blacks had been almost completely replaced by an emphasis on jesters. Thus most of the chapter dwells on "coon" imagery, while ignoring the other notable images of the decade. Bogle does a good job, however, of outlining the career of Allen Clayton Hoskins ("Farina") within the context of Hal Roach's justly praised OUR GANG

comedies, pointing out that, for the most part, race was not a factor in the stories about the children of working-class people. Among other highlights are his observations about HEARTS IN DIXIE (1929) as an example of the "blackface fixation" (i.e., black performers masking their heritage in order to satisfy the perceptions of a white-oriented film industry and audience) and the performance of Stepin Fetchit being a model of how gifted black entertainers "played the game." Equally stimulating are Bogle's comments about HALLELUJAH! (1929), which he finds, on the one hand, "the finest record of black grief and passion to reach a movie screen" and, on the other hand, "an unreal universe and consequently divorced . . . from real issues confronting blacks and whites in America." Also noteworthy is his perceptive biographical sketch of Nina Mae McKinney.

Chapter 3, on servile roles in the 1930s, discusses the changes in black stereotypes. "No other period in motion-picture history," writes Bogle, "could boast of more black faces carrying mops and pails or lifting pots and pans than the Depression years." Jocular and buoyant, black artists became synonymous with optimism and pluck. In the process, the period is seen by the author as "a Golden Age" for black performers. Where other historians and critics cite the negative aspects of Stepin Fetchit, Bill "Bojangles" Robinson, Clarence Muse, Louise Beavers, Fredi Washington, Rex Ingram, Eddie "Rochester" Anderson, Hattie McDaniel, "Butterfly" McQueen, and Paul Robeson, Bogle argues impressively that they achieved what was considered impossible: "They proved single-handedly that the mythic types could be individualized and made, if not into things of beauty, than at least into things of joy." The one major drawback is the author's insistence on making unsubstantiated claims about who was the first to do this or that. For example, Fetchit was hardly the first black to receive feature billing, the Mae West films were not the first to show humanized black domestics, and Robeson was a "symbol of black confidence and self-fulfillment" long before the film version of THE EMPEROR JONES (1933).

Chapter 4, on independent race productions, begins four years late with Bert Williams's DARKTOWN JUBILEE (1914) and extends into the 1940s with a brief epitaph for Oscar Micheaux and his final film, THE BETRAYAL (1948). Throughout, Bogle stresses the efforts by the race producers to keep faith with their black audiences. For example, where Robert Levy's Reol Motion Picture Corporation is severely criticized by other authors for its weak and opportunistic productions, Bogle points out that it was one of the first companies to film black classics. Although he attacks the "idiotic" movies of Octavus Roy Cohen, in which the white producer had his black actors in blackface, Bogle quickly reminds us that white race producers in general contributed to black film history with such movies as TEN NIGHTS IN A BARROOM (1926) and THE SCAR OF SHAME (1927). And where other commentators emphasize the poor production qualities of race films and the depressing conditions of ghetto theaters, the author reminds us that it was in these battered and broken-down theaters that many black audiences felt most at home with images of their own people.

Chapter 5, on the innovations of the 1940s, starts by describing the new entertainers who replaced the jesters and villains of yesteryear, and then concludes with a discussion of how the entertainers were themselves replaced by a unique set of people depicting race problems in America. The material on the singers and dancers is more a collection of tributes than an analysis of personalities. Performers like Ethel Waters, Hazel Scott, and Lena Horne emerge as important figures in black film history as much for what they meant to contemporary audiences, as for their enduring acting skills. For example, Bogle acknowledges that Scott appears to modern audiences as "appallingly bourgeois and terribly affected," but he defends her screen image on the grounds that she intended her behavior to be refined and tasteful as a justification of her race. His comments on Horne are unusually elliptical, pointing out how she lost important roles in the remake of SHOW BOAT (1951), BRIGHT VICTORY (1953), and CARMEN JONES (1954), but never telling why. The impression is that talent was not the issue. CABIN IN THE SKY and STORMY WEATHER (both in 1943) get good rather than great reviews, mainly because the black entertainers had to overcome the slick content. SONG OF THE SOUTH (1946) is described as the death knell for blacks as comic servants or loyal entertainers, esssentially because "Neither

the songs nor the servants had worked." That may have been true for Bogle, but late in the 1980s lots of white people were still singing the songs and telling the tales of Uncle Remus. In between the popular entertainers and those blacks who called attention to American racism were performers Bogle labels the "New Negroes": actors who glorified the American way and became mouthpieces for liberal statements about social issues. Among the more memorable actors were Leigh Whipper, Ernest Anderson, Canada Lee, and Kenneth Spencer. Regrettably, the author adds little to our understanding of the period or the performers, although he wisely admits that the "New Negro" had been around since the early 1930s and ARROWSMITH (1931). The chapter ends with stimulating discussions on the five 1949 problem films, pointing out how they not only met the needs of their time, but also served as important showcases for black artists like James Edwards, Ethel Waters, and Juano Hernandez.

Chapter 6, on black stars of the 1950s, calls attention to three major personalities: Ethel Waters ("Earth Mother for an Alienated Age"), Dorothy Dandridge ("Apothesis of the Mulatto"), and Sidney Poitier ("Hero for an Integrationist Age"). In each instance, Bogle emphasizes their unique personalities and the contributions they made to advancing black film imagery. For example, where other historians are fond of pointing out Waters's temperamental nature, Bogle argues that "Overwork, exhaustion, exploitation, and personal unhappiness had made her 'difficult' and chronically suspicious of everyone." As a result, he stresses the importance of Waters's performance in THE MEMBER OF THE WEDDING (1952). In profiling Dandridge's life, the author never denies her self-destructive personality problems. Rather, he argues that her problems were a key factor in her success on screen. Interestingly, he fails to mention the tragic star's autobiography in his analysis of her career. Poitier is given mixed reviews, with the actor being credited for his superstar status but attacked for perpetuating "Tom" roles. Although I find it unfair and unconvincing to characterize Poitier as falling "into the tradition of the dying slave content that he has well served the massa," I recognize where the young Bogle was coming from in the early 1970s. Another problem in the book is that the author periodically makes embarrassing factual errors. For example, Dots Johnson, a male, is erronously credited with playing Poitier's wife in NO WAY OUT (1950).[1482] The remainder of the chapter summarizes the contributions made by nonactors like Richard Wright, Jersey Joe Wolcott, Althea Gibson, and Woody Strode. What is most disappointing is the short shrift given to Harry Belafonte, Pearl Bailey, and Ruby Dee.

Chapter 7, on the militant movies of the 1960s, overstates the images of anger and insolence that characterized a number of black films and personalities. Part of the problem is that Bogle fails to anchor his analyses in the context of what was taking place in the film industry. Thus he argues that the decade was more noted for its "so-called significant films rather than great personalities." A careful study of the circumstances might persuade him that it was black personalities like Sidney Poitier, Ruby Dee, Diana Sands, and Gordon Parks, as well as white directors like John Cassavetes, Shirley Clarke, and Michael Roemer who made the films possible. Informed readers might be surprised by Bogle's classifying films like ONE POTATO, TWO POTATO and NOTHING BUT A MAN (both in 1964) as militant movies. The biggest surprises, however, are Bogle's harsh criticism of Ossie Davis and GONE ARE THE DAYS (1964), claiming that they represent "a step backward"; and the author's caustic baiting of Sammy Davis, Jr., as "curiously reminiscent of Harold Lloyd's little black sidekick Sunshine Sammy." On the other hand, the terse profiles of Roscoe Lee Browne, Brock Peters, and Al Freeman, Jr., underscore the need for more information about these much-neglected actors. The remainder of the chapter is a slapdash overview of the late 1960s, doing a disservice to performers like Jim Brown and Raymond St. Jacques, while missing almost completely the relationship between the black-oriented films and the box office.

[1482] Mildred Joanne Smith plays the role of Cora Brooks.

Bogle's "Epilogue: 1970 Onward" raises a number of important issues, but in a very superficial manner. He impressively condemns the disparity between the rise of black studies and the decline of black film content, wonders aloud why black audiences seem more in tune with the times than are directors like Ossie Davis (COTTON GOES TO HARLEM) and William Wyler (THE LIBERATION OF L. B. JONES), predictably praises SWEET SWEETBACK'S BAADASSSSS SONG while foolishly extolling the dismal production WATERMELON MAN, and underestimates the box-office appeal and social significance of films like SHAFT and SUPER FLY. In fairness to Bogle, he senses what are the important films, knows about the contributions of performers like Calvin Lockheart, Cicely Tyson, Robert Hooks, Ron O'Neal, and Richard Roundtree, and understands how far black artists have come since 1902. At this stage, he just seems to lose interest in the book and races to a simplistic conclusion.

If candid and articulate impressions of black film history are what you're after, this book is a good buy. The author's perceptions are fresh, controversial, and fun reading. Serious students, however, should approach with extreme caution. An index is included. Well worth browsing.

*Cripps, Thomas. BLACK FILM AS GENRE. Bloomington: Indiana University Press, 1978. Illustrated. 184pp.

The first of the book's two major sections opens with a definition of "black film" as "those motion pictures made for theater distribution that have a black producer, director, and writer, or black performers; that speak to black audiences or, incidentally, to white audiences possessed of preternatural curiosity, attentiveness, or sensibility toward racial matters; and that emerge from self-conscious intentions, whether artistic or political, to illuminate the Afro-American experience." Immediately, Cripps modifies the definition to include those films made after the forties, to include TV film and programs, regardless of their origins, which also relate to African-American concerns. Then he qualifies his perspective even further by telling us that in the strictest sense, "every black film, from production through distribution, was affected by whites." In short, Cripps sees the critiquing of black films as a major problem. To date, he argues, the methodology appears to be either literary or political. That is, art becomes an adversary against racism, or art is judged as art and not as a bullet for justice. Moreover, there is a problem in using Hollywood liberalism as a measuring rod, since almost every attempt to improve the film capital's iconography has distracted black filmmakers from creating an indigenous black cinema. Thus Cripps argues for an approach that views black films as a genre, "as a RITUAL celebrating a MYTH. . . ." Among the conventions he identifies are folk idioms, a tone of urgency, and heroic black figures. Equally important are the distinctions between genre films and exploitation movies. For example, the former prize authenticity; the latter, sensationalism.

In the second part of the opening section, Cripps reworks much of the material on race productions published in SLOW FADE TO BLACK. The new research carries the evolution of black film imagery beyond the WWII period to the present. After pointing out the blending of black film identity with the general American identity in the fifties, he makes special note of important trends set by international productions like NATIVE SON (1951) in Argentina, DUTCHMAN (1967) in England, and BLACK ORPHEUS/ORFEU NEGRO (1960) in Brazil. Especially interesting are the distinguished film historian's views on the "blaxploitation" movies. Preferring to label them "crossover" films, he stresses the gains made by the subgenre and draws distinctions between important works like SWEET SWEETBACK'S BAADASSSSS SONG (1971) and THE BOOK OF NUMBERS (1972) and "counterfeits of white films" like COOL BREEZE (THE ASPHALT JUNGLE) (1972) and ABBY (THE EXORCIST) (1975). The section ends with a useful overview of black experiences in the history of television, and the author's judgment that "The experience of TV leads to the . . . conclusion: the smaller, uncelebrated public television programs allow for small-group control, which results in viable genre offerings."

In the second of the book's major sections, "A Brief Analysis of Six Black Genre Films," Cripps offers stimulating discussions on THE SCAR OF SHAME (1927), THE ST. LOUIS BLUES (1929), THE BLOOD OF JESUS (1941), THE NEGRO SOLDIER (1943), NOTHING BUT A MAN (1964), and SWEET SWEETBACK'S BAADASSSSS SONG (1971). What makes the analyses so interesting is his emphasis on context. For example, in discussing THE SCAR OF SHAME, he talks about middle-class dramas as a staple of American movies. In critiquing THE ST. LOUIS BLUES, he calls attention to the missed opportunities by Hollywood for developing a black aesthetic during the transition from silent to sound films because of a penchant for short subjects rather than feature length musicals starring top black entertainers. THE BLOOD OF JESUS gives him the opportunity to discuss the importance of religious themes in the development of a black genre. THE NEGRO SOLDIER serves as a chance to explore the outlines of black documentaries. NOTHING BUT A MAN reminds readers that at the very moment filmmakers in the sixties were searching for the heroism of picaresque black outlaws audiences overlooked the importance of the urban pastoral hero. Finally, SWEET SWEETBACK'S BAADASSSSS SONG puts the revolutionary film in the context of older black traditions that focus on the sexual outlaw.

The final brief section, "Criticsm and Scholarship," serves as an opportunity for the premiere scholar in the field to comment on the development of a critical tradition on black films and the work of his peers. It is a model of tact and restraint. Rather than dwell on the shortcomings of plagiarists and cheerleaders exposed by his impeccable research, Cripps choses to emphasize the contributions made by authors like Donald Bogle, V. J. Jerome, Daniel J. Leab, Kenneth MacPherson, James P. Murray, Peter Noble, Lindsay Patterson, Charles D. Peavy, and Lawrence D. Reddick. Attention is also given to the role played by the black press and organizations like the NAACP in the evolution of black films. For example, he points out that black newspapers in the formative period from 1916 to the 1930s rarely were critical of race movies since so many of the reviewers also doubled as theatrical bookers for the films and the papers sought advertising revenue.

Although BLACK FILM AS GENRE lacks the force of SLOW FADE TO BLACK as a comprehensive and detailed study, it stands as an invaluable pioneering effort to put in perspective the history of black film criticism. Whatever reservations one may have about the selection of films or the terse analyses the author provides, it is clear that Cripps has outlined the nature of a genre deserving serious discussion and refinement. The book concludes with a fine bibliography, a list of credits for the six films analyzed, a disappointing black filmography, and a helpful index. Recommended for special collections.

*Cripps, Thomas. SLOW FADE TO BLACK: THE NEGRO IN AMERICAN FILM, 1900-1942. New York: Oxford University Press, 1977. Illustrated. 447pp.

A brilliant analysis of black film stereotypes, this scholarly study reflects two basic perspectives on social history: (1) race relations in America have resulted in the exploitation of a visible black minority by a white majority; and (2) popular culture contains invaluable social data that reveal the nation's deep-seated values and attitudes. The book itself is preoccupied with "the PRE-conditions of strong black interests in movies, the growth of power sufficient to alter movie images, and the growth of a cadre of black film creators." To explain how those events occurred, Cripps's succinct introduction to his thirteen detailed chapters categorizes his four major themes: "the survival of black performers within the motion picture industry; the growth of black protest against the worst Hollywood racism; the fitful underground movement to create an independent black cinema; and the movement to make the art of the film speak forthrightly to issues generated by a dualistic American racial system." Interestingly, he observes that the early movies capitalized on the great traditions in American popular culture (e.g., westerns, melodramas, and slapstick comedy) but never acknowledges the importance of sports. In quickly reviewing the transition from the plantation images of the twenties, to the breakthough roles of WWII, the author emphasizes how Hollywood led rather than

followed specific changes in American society. Credit is given more to liberal whites than to black enterprise. However, Cripps values highly the efforts of the black press to establish an aesthetic for an indigenous black cinema. The shrewdest journalists sensed that "race productions" maintained a Jim Crow mentality and divided the races not only from without, but also from within. Summing up his project, the author wants us to see his chronicle as a study of "a race in tension with white society, in conflict with itself and its own ideals, in a quest to overcome historic disabilities, and moving slowly toward a viable cinema identity and an honest contribution to Hollywood movies."

Chapter 1, "The Unformed Image: The Afro-American in Early American Movies," discusses developments from the turn of the century to 1915. The author is superb at blending the evolution of film images with the controversial changes occurring in society. Not only do we see divisions between races, but also divisions among blacks themselves. Surprisingly, no mention is made of the role boxing films played in the penny arcade days, or the controversy over Peter Jackson's staged bout with Jim Corbett. When Cripps finally gets to prize fights and Jack Johnson, he acknowledges the importance of the black champion in terms of racial pride. Yet it is the absence in the first decade of films of any black boxers winning fights that undercuts Cripps's argument of a neutral cinema. For his part, Cripps concentrates on the new medium's being merely a toy. He points out the ways in which blacks were excluded from almost both ends of the film continuum, emphasizing the fact that white businessmen and audiences preferred black images that drew on the plantation myths and the minstrel tradition. Nevertheless, Cripps argues that in relation to the treatment of blacks in other media, the image of blacks in early film was "boundless." The shift to a more controversial treatment of blacks, according to Cripps, occurs with the rise of the Trust. That is, heavy investments made radical departures from popular and traditional stereotypes difficult. Thus the more control of the industry was concentrated in the hands of a few, the more black fortunes dropped. The most conspicuous examples were in films depicting African life and adventure. Cripps is at his best when reflecting on why the change occurred, refusing to blame it on the rise of ghettos or of the semicentennial of the Civil War. In trying to determine what effects the nation's love for pastoral themes or the desire for reconciliation with the South had on a growing negativism toward blacks, Cripps introduces the subject of D. W. Griffith and his extensive influence on the future treatment of blacks. Considerable space is also given to the types of Civil War films between 1910 and 1915, as well as to a comparison between the depictions of black characters and those of Orientals and Native Americans. The major debatable issue is Cripps's assertion that by 1915, the only racial minority able to take on the film industry was the African-American community.

Chapter 2 focuses almost exclusively on THE BIRTH OF A NATION (1915). Starting first with the black perspective, the author recounts the options open to, and exercised by, people outraged over the racist film. For example, the black press is credited with pushing for a black aesthetic. The NAACP is noted for its lobbying efforts and nationwide guidance in protesting the film's demeaning images. At that point, Cripps reviews the history of the film, from its links to Frank Woods and Thomas Dixon to Griffith's traditional Southern values. A fine analysis of Dixon's literary and stage efforts in bringing the story of the Civil War and the Reconstruction period to the film takes us back to the storms of protest over the movie in 1915. Excellent comparisons are made of the tactics to ban the film in Boston and New York and the effect that the NAACP's failure to win in either city had on the release of the movie across the country. The point, as Cripps forcefully argues, is that by 1915, black leaders knew that "blind advocacy of censorship was a dead end." Much more meaningful would be the development of a black aesthetic. The problem is that Cripps makes the choice simpler than it was. One needs to explain more clearly where the money, material, and distribution outlets were to come from and how the released films would find their way to a sizable audience able to encourage and support further efforts toward an indigenous black cinema.

Chapter 3, "Two Early Strides Toward a Black Cinema," explores the first major efforts to challenge the white film oligopoly. Both the Tuskegee group and the Lincoln Motion Picture Company shared a common optimism over the burgeoning black urban audience and an emerging black economic nationalism. Both elements, in Cripps's judgment, were prerequisites for a black film aesthetic. Both provided the basis for a shift away from censorship and toward an alternative cinema. Under the leadership of Booker T. Washington and Emmett J. Scott, the Tuskegee group considered several film projects as a means of building a black-controlled movie company. Cripps remains the only researcher to date who not only describes the background of Washington and Scott vis-a-vis film, but also explains the depth of Washington's involvement in the process that eventually led to the production of THE BIRTH OF A RACE (1919). Equally impressive is the author's candor in attacking the film and listing the setbacks it inflicted on race films. One positive aspect was the incentive it gave to the Johnson brothers to fight on with their work. Cripps makes an intriguing case for the Lincoln Motion Picture Company's being the impetus for the black aesthetic as a social force. In addition to putting the enterprise in the context of a western rebirth of black culture, he surveys the problems the brothers faced as businessmen, the steps they took to avoid the mistakes of the Tuskegee group, and the unique qualities of the organization itself. Curiously, Cripps blames the rise of fly-by-night race companies after WWI for the black film market's being overextended and overproduced. The argument could be made that the worse companies like Fredrick Douglas and Ebony were, the better should have been the fortunes of the Lincoln Motion Picture Company. In fairness to Cripps, he makes the case that black filmmakers demanded what white filmmakers never got or expected--blind communal support--and that an overzealous black press had praised race films indiscriminately to the point where the public had trouble knowing what to believe.

Chapter 4 examines what the shift from East to West Coast production meant for the treatment of blacks in American movies. Working on the assumption that Hollywood was isolated and insulated, Cripps insists that whites over the next two decades thought of African-Americans primarily as "court jesters." That is, they were relegated to ghetto status, exploited by whites, and remained essentially powerless. The most conspicuous contact between blacks and whites was in the area of employer-employee. Cripps is especially effective in describing the hateful conditions that made black performers more victims than peers of their fellow actors. In short, he concludes, "a whole black world grew up south of Hollywood, remote, oppressed, and yet in the twenty years between the wars incapable of well-focused response to racism in the movies." One of the few problems with the book is very noticeable in this section. In back-to-back visual illustrations, Cripps refers to a specific actor, but the captions never clearly identify the actor. The most interesting material, however, refers to the author's attitude toward performers like Clarence Muse, Willie Best, and Stepin Fetchit. For example, he labels Muse a conservative and then dismisses him as a man with impressive credentials who wound up fighting for the STATUS QUO. On the other hand, Cripps is extremely sympathetic to all the regular Hollywood blacks, stating that they lived on the fringe of the industry and could work only if they kept their mouths shut.

Chapter 5, "The Silent Hollywood Negro," scrutinizes why the major gains made by urban blacks had a mixed effect on screen images of African-Americans. Part of the answer, the ingenious author explains, lies with a comparison between social and screen reality. The more blacks moved up in the professions, took strong political stances, and demanded their constitutional rights, the more the absence of positive black images became an irritant to them. On the positive side, the anger over the racial stereotypes set in motion forces that would eventually change the system by the end of the thirties: e.g., a more discriminating black press and the rise of liberal Jewish filmmakers. On the negative side, the movie moguls worked to play down the radical changes in society by emphasizing traditional values and images. Cripps next describes how blacks tried to build a powerful voice in black communities. The strategy was to support race movies and to encourage strong casting and positive roles in Hollywood films. How well this tactic worked is very debatable. Cripps thinks

it laid the groundwork for eventually undermining the antebellum Southern stereotypes. In the mid-1920s it surely encouraged black performers to be more aggressive in their dealings with studio bosses. An especially intriguing thesis relates not to racial slurs, but rather to the decision to ignore blacks altogether, i.e., the Tarzan movies. That is, the format and its clones are not objectionable because of the manner in which they treat blacks, but because of the way blacks are omitted. Cripps follows the thesis through industry efforts to limit demeaning images of blacks mainly to jungle roles, servants, and extras. While authors like Daniel J. Leab and Jim Pines rail against the period, Cripps insists on seeing it in terms of progress for blacks, particularly in comparison to the gains made by Orientals and Native Americans.

Chapter 6, "Uncle Tom Was a 'Bad Nigger,'" analyzes why the 1927 adaptation of the Stowe work epitomized the changes occurring within and without Hollywood. Starting with the assertion that changes in black urban life had made the antebellum Southern myths untenable, Cripps describes the dilemma of white screenwriters who didn't know enough to create new images of black culture but who were embarrassed to use the old stereotypes. UNCLE TOM'S CABIN (1927) seemed a good middle ground. On the one hand, the new production allowed the maturing black press to demonstrate its growing influence with the black community, the production underscored the increasing number of minor roles for blacks, and the story itself seemed ideal for a modern update of black-white relations. Cripps views such film ventures as steps leading away from race productions to Hollywood films featuring positive and entertaining black performers. On the other hand, the plight of black actors was reinforced by the circumstances of the production itself. Cripps does an exceptional job of humanizing "Hollywood's cupidity." He describes not only the "problems" with Charles Gilpin, but also Universal's mismanagement of the project. Nonetheless, the author's "silver-lining" perspective dutifully identifies the advantages gained by blacks as a result of the 1927 release. Special note is made of the fact that contrary to standard operating procedures for the industry, the filmmakers made no attempt to follow up the film's box-office success. Instead, Cripps lists the moves toward the assimilation of blacks in silent and early sound films. By the end of the twenties, he contends that blacks had made only a slight improvement in mainstream films, predominantly "as furniture and atmosphere."

Chapter 7, "The Black Underground," considers the reasons why white films held little attraction for blacks and why all-black films failed to fill in the vacuum. Cripps's benchmark is Oscar Micheaux. Unlike the majority of companies producing all-black films, Micheaux's was the only one completely controlled by blacks. Eventually that would change, but during the silent era his "paternal racial chauvinism" operated as an alternative to Hollywood's racist imagery. Before discussing the filmmaker's strengths and weaknesses, Cripps surveys the black independent movement through WWI, explaining why the better race movies were made on the East rather than on the West Coast. The crucial years are the early twenties, during which black businessmen, journalists, filmmakers, and audiences joined forces to shape a black film aesthetic. What went wrong is exquisitely detailed by Cripps, who segregates the dedicated producers from the opportunistic entrepreneurs. Special praise is given to particular journalists who spearheaded the need for an indigenous black cinema. The problem, as Cripps concludes, was that the post-WWI era found race movies caught in the middle between disarming Hollywood comedies and discerning black critics. The fact that black filmmakers devoted their efforts to an exclusive black culture, in the author's judgment, was absurd because all the signs of the time linked corporate and personal success to integration and assimilation. Equally disturbing, all-black films forced the filmmakers to make blacks the villains, clods, and fools in the melodramatic and comic plots patterned after popular Hollywood genres. It's in this context that Cripps makes his case for Micheaux as "the dean of black producers." What is most impressive about the analyses of films like THE BRUTE (1920) and BODY AND SOUL (1925) is the manner in which the author balances critical standards and social commentary. With all of his admiration for Micheaux's struggle, Cripps reserves his highest accolades for the Colored Players' film, THE SCAR OF SHAME (1927). Although he does not find it an important film

commercially or technically, he admires its unconcious depiction of black aspirations. In the end, however, Cripps faults even the best race films for the confusion their all-black casts and stories created in the minds of black audiences. With no whites to blame, black protagonists always got the blame for their problems. Thus, the failure of silent race films to compete with Hollywood products could be seen as much the fault of misguided and outdated values, as an inability to fund technological changes.

Chapter 8, "Two Cheers for the Indies," probes one of the richest and most ironic periods in the history of black films. According to Cripps, the transition from silent to sound films resulted in a random group of white independent producers' getting the chance to experiment with film content and technique. Their efforts represent for the author "among the finest depictions of Negro life and style." To demonstrate his thesis, he focuses on the three best-known independents who worked with primarily black casts: the Meschrabpom Company of the Soviet Union, Kenneth Macpherson's Pool Films in Switzerland, and Dudley Murphy in America. Murphy, the most successful of the three, was responsible for the Bessie Smith short THE ST. LOUIS BLUES (1929), the Duke Ellington short BLACK AND TAN (1930), and the Paul Robeson feature film, THE EMPEROR JONES (1933). Cripps's major contribution is a first-rate discussion of the barriers that Europe posed to black film production.

Chapter 9, "Better Than White Voices," considers the initial impact of sound technology on blacks at the end of the twenties. Once again Cripps does a marvelous job of laying out the reasons for Hollywood's erratic behavior. Where other commentators remain content to acknowledge the plethora of black two-reelers spawned by the competing sound systems, Cripps inundates us with data about grosses, specific performers, individual race producers, and social comparisons. While others are quick to dismiss the failure of race movies to enter the sound era, Cripps explores the reasons why, at first, there was no cause for alarm. Not only were actors like Clarence Muse arguing that it was a question of quality not racism that was keeping black material out of mainstream movies, but also other black opinion makers were extolling the quality of the black two-reelers and the value of the black voice to the talkies. Care is taken, however, to distinguish between the musical shorts and the racist elements in cartoons like FELIX THE CAT, the OUT OF THE INKWELL series, and the TOM AND JERRY series. Throughout, the author subtly stresses the dilemma of supporting a white-dominated process that spoke so pervasively for African-American culture.

Chapter 10, "Black Music White Voices," attempts to build a sympathetic case for HEARTS IN DIXIE and HALLELUJAH! (both in 1929), and THE GREEN PASTURES (1936). Consistent with Cripps's commitment to proving that the evolution of black films in Hollywood represents a consistent struggle to establish a black cinema aesthetic, he sees the two early sound musicals as making important contributions to dignifying the image of blacks, humanely interpretating black Southern culture, and increasing white awareness of African-American life. In fact, he finds the films the impact of these films so powerful that they become the "litmus test of the quality, and even the progress, of black cinema imagery." THE GREEN PASTURES he sees as illustrating Hollywood's search for "a bland, happy vehicle" that "brought black Southern folk religion to a wide and appreciative audience." Here again, Cripps's aesthetic judgments run contrary to recent assessments, while his scholarly treatments of the production process are unrivaled. Thus evidence at the time justifies his upbeat judgments but hindsight suggests that the handful of contemporary black critics who were put off by HALLELUJAH!'s scenes of urban vice and rural piety may have been more objective than the compassionate author. On the other hand, Cripps shows no patience at all with race movies of the period. Dismissing them as exploitative and out-of-touch with the original intentions of race producers, he makes no attempt to find any contribution that the now mostly white-run race companies made to the development of a black aesthetic.

Chapter 11, "The Hollywood Negro Faces the Great Depression," traces how the tenor of the times appeared in films. At the outset, the author establishes the clash between the black press and the black Hollywoodians' accommodationist positions. The former attack the complaisance of the later, who in turn defend their traditional roles as "symbols of success and adulation to the race while preparing the way for favorable social change by disarming white fears." In the process, Cripps builds a strong case for the importance of a small black star system in shaping the emerging black aesthetic. Considerable care is taken to show how familiar black stereotypes are subtly revised, thereby allowing audiences to witness a more mocking, flippant, and casual black image in Hollywood. The author boldly declares that the residential black performers boosted the merit of any serious Hollywood film they were in. Particularly impressive is the data on why the black Hollywoodians wanted no part of the NAACP's attack on Hollywood. In a few tightly packed paragraphs, Cripps convincingly lists why black performers feared for their jobs, the conservatism of the major studios, and the stranglehold that the studio bosses had on people's lives. Our attention is drawn to the positive changes occurring in the conventions of sports movies and prison films, while we are reminded that "vestigial racism" remained in the jungle films. Especially challenging are Cripps's curious assessments of Fetchit and Muse. He praises their successes, stresses their limitations, and acknowledges the constraints under which they worked. At the end, you're still not clear on where the author stands. What is clear is that Cripps finds the quantity of film work done by blacks in the thirties responsible for diluting the antebellum Southern movie myths.

Chapter 12, "Meanwhile Far Away from the Movie Colony," probes the options black Hollywoodians faced in the late 1930s: either change the way things work in the film capital or look elsewhere for an indigenous black cinema. Neither choice was practical or profitable. As Cripps points out, "race nationalism" depended too heavily on matching black interests with white ones. Hopes for a European solution were decimated by inadequate production and distribution systems. To illustrate his case, the author reviews the ties between Paul Robeson and British films. Although Cripps hedges on the reasons why Robeson's English movies failed to connect with American black audiences, he strongly suggests that there was a connection between Hollywood's liberal shift and the actor's misguided optimism over racial honesty in European movies. The status of race movies in America is portrayed as another misguided hope. Once again, Cripps focuses on Micheaux to explain the problems associated with developing an all-black cinema. And again in evaluating prominent black personalities, the author finds Micheaux symbolizing both the best and the worst of his type. Cripps next turns his critical eye on the escapist trend in race productions beginning in 1937, with a special focus on Ralph Cooper, and ending in disarray by 1940. Almost in rage, Cripps lashes out at the faults of the new wave of black films, citing them for failing to aid a black aesthetic, blindly adhering to distorted white production values, ignoring the needs of black audiences, and obstructing opportunities to build bridges between independent and mainstream filmmakers. Even the black press gets scolded for its misguided assumptions that one doesn't carp at a brother in public. Interestingly, Cripps's failure to include sports movies in his initial discussion about the roots of black film conventions becomes noticeable again, as he argues that two small films--THE SPIRIT OF YOUTH (1937) and KEEP PUNCHING (1939)--were among the few race films to provide black audiences with heroic figures without exploiting race.

Chapter 13, "The Politics of Art," brings this outstanding research effort to a splendid conclusion. Focusing on the shift from independent race producers to a more liberal Hollywood pressured by the NAACP, the author summarizes left-wing attempts to liberate the film industry from its racist values. Part of the problem, according to Cripps, was the black audience itself. They apparently appreciated Tarzan movies as much as they did Lena Horne and Hattie McDaniel. Part of the solution was finding a strong advocate to take the issue away from isolated complaints about specific films and to direct it squarely at the film continuum itself. Central to Cripps's thesis is his analysis of GONE WITH THE WIND (1939). First he describes the changes that occurred off camera, being particularly hard on the antics of Oscar Polk. Next, he attacks both Mitchell's "overblown novel" and Selznick's "grand romance." From here,

Cripps faults both the liberal and black press for their blindness toward the film's confused ideology. But the watershed is McDaniel's Oscar for Best Supporting Actress. It was at that point, the scholar insists, that blacks came into their own. Racial arrangements were never the same. Some credit is given to the black Hollywood stalwarts who in December, 1939 met to shape their demands for reform. More credit is given to the NAACP (led by Walter White) and its influence with Hollywood producers during the crucial spring months of 1942. In the end, Cripps points out the progress that had been made toward a black aesthetic but states emphatically that the insolvable problem was that control of black images still remained in the hands of whites.

No book in this area, or for that matter in the history of books on film, is more impressively researched or better argued. The nearly 100 illustrations, scholarly footnotes, and intriguing facts combine to make this study a model for researchers. The flaws that bother me--e.g., highly subjective and unconvincing film aesthetics and lack of attention to the importance of sports in black film history--are trivial in comparison to the insights that Cripps provides into the humiliation blacks experienced in the evolution of film stereotypes. A film title and subject index are included. Recommended for all libraries.

*Cripps, Thomas, ed. THE GREEN PASTURES. Madison: The University of Wisconsin Press, 1979. Illustrated. 206pp.

Controversial from the day Marc Connelly's play first appeared, THE GREEN PASTURES (1936) became an even more problematic work as a Warner Bros. film. Both play and film were seen either as spurs to racial pride and important cultural events or as simplistic and anachronistic portrayals of black life. Cripps's major task is to demonstrate that both the play and the film "must be seen as two points along the continuum of American social and political life." That assignment he justifies with relative ease. In an informative and straightforward introduction, the Morgan State University history professor explains how Connelly, a middle-class Yankee columnist, author, and celebrity, got the idea for his 1930 Pultzer Prize-winning play from Roark Bradford's regional stories on Southern blacks, OL' MAN ADAM AN' HIS CHILLUN: BEING THE TALES THEY TELL ABOUT THE TIME WHEN THE LORD WALKED THE EARTH LIKE A NATURAL MAN (1928). Connelly's strategy for adapting the book to the stage, the steps he took to insure its "authenticity," the acts of omission concerning black culture, and the problems that the playwright encountered with producers and critics are impressively documented and discussed. The five year gap between the Broadway opening and the start of the Warner Bros. production provides Cripps with an opportunity to discuss the goals and values of the black press vis-a-vis white productions on stage and screen. The section on the production of the film catches the flavor of Connelly's problems with the studio, highlights the reasons why the film retained its theatrical orientation, and demonstrates why studio press books function as vital historical artifacts for scholars. The final section on reactions to the film neatly summarizes why both the film and play remain controversial works.

Overall, however, there is something disappointing about this contribution to the generally excellent Wisconsin/Warner Bros. script series under Tino Balio's able leadership. One problem relates to my reactions to the film following Cripps's introductory essay. In the case of other studies, I wanted to get the film and see it anew from the perspective of the scholar. That doesn't happen here. Nothing Cripps tells me stirs any interest in the film. In fact, the intriguing issues are those outside the play and the film. And that's the second problem. Having gotten more involved in side issues than the film, I'm not given enough information to delve more deeply into the various topics. For example, the comments about the black press and its attitudes toward white liberal theatrical productions deserve amplification. The footnote about the NAACP leader Walter White's starting a WWII campaign to expand the roles of black film performers challenges the standard film history accounts of Hollywood's change of heart toward black films and actors. It would be

nice to know more about the matter. The press accounts of Rex Ingram's hyperbolic autobiography leaves the reader unclear about what the truth was about the actor's life. In this instance, Cripps doesn't bother to document where pertinent information can be found. In the end, these types of fascinating tidbits work against the book's case for THE GREEN PASTURES. Either too much time is spent on the background or too little time is devoted to analyzing the film. A case in point is the film production process. All we get about why the film retained its theatrical roots is Connelly's perspective. All we know about the production is what Connelly tells Cripps in an interview. Surely there's more to the story than the accounts of a playwright disturbed by the way the studio treated him.

These quibbles aside, the book remains a worthwhile contribution to our understanding of the past. The adequate collection of stills, the complete screenplay, and the useful endnotes are entertaining and educational. Well worth browsing.

Grupenhoff, Richard. THE BLACK VALENTINO: THE STAGE AND SCREEN CAREER OF LORENZO TUCKER. Methuen: The Scarecrow Press, 1988. Illustrated. 188pp.

*Jerome, V. J. THE NEGRO IN HOLLYWOOD FILMS. New York: Masses and Mainstream, 1952. 64pp.

A Marxist analyst of the first major post-WWII films on black problems in society, Jerome subjectively takes filmmakers to task for the shoddy way in which their films treat their racial themes. He argues that the movies are a box-office concession to a socially conscious public, but that they distort the problems involved. As a result, the slim book offers an interesting perspective on films (all in 1949) like HOME OF THE BRAVE, "the most meaningful American picture emanating from the war"; LOST BOUNDARIES, "a pseudo-documentary . . . [whose] teeth are rotten to the core"; PINKY, a Hollywood solution to the problems of blacks that is "A reformist, segregationist, paternalistic solution"; and INTRUDER IN THE DUST, a film that concludes "that there is no Negro question--that the problem of the Negro is really the problem of the white man, his 'moral' problem." Well worth browsing.

Hyatt, Marshall, ed. THE AFRO-AMERICAN CINEMATIC EXPERIENCE: AN ANNOTATED BIBLIOGRAPHY & FILMOGRAPHY. Wilmington: Scholarly Resources, 1983. 260pp.

A valuable resource, this skillfully executed reference book offers a sweeping coverage of black film history. The format is straightforward. Bibliographical entries are alphabetically arranged, with each containing a useful annotation. The index provides name and subject headings, expediting searches for material on particular topics covered in the bibliography. The one major drawback is that volume numbers and pages are not consistently provided, thereby making inter-library loans more difficult. The filmography portion arranges films by category and indicates additional information on specific films related to the black movies. The annotations used for the bibliography derive from academic journals, daily newspapers, and popular journals. Well worth browsing.

Klotman, Phyllis Rauch. FRAME BY FRAME: A BLACK FILMOGRAPHY. Bloomington: Indiana University Press, 1979. 700pp.

A valuable compendium of over 3,000 film items, this impressive resource provides information on movie titles, cast and technical credits, plot synopses, technical information, distributor (or archive), date, and country of origin. The entries include productions by American and foreign companies made between 1900 and 1977. Unlike other recent filmographies that limit themselves almost exclusively to American feature and independent releases, this enterprise includes anthropological, documentary, experimental, and Third World movies. To be included, the themes or subject matter have to relate to blacks, have blacks making a

substantial contribution to the production, or have blacks "in ancillary or walk-on roles." The author defines "Black" as broadly as possible; thus it encompasses Afro-American/Black American (U. S.), Black Latin America (Mexico, Central America, South America), Black African (mainly sub-Saharan), and Afro-Caribbean. Klotman's one serious error is in not providing a subject index, thus making it difficult to locate films by genre, period, or national origin. Other problems in the extensive alphabetical listings by titles relate to omissions and labeling. In addition, there are four inadequate indexes related to black screenwriters, directors, producers, and authors. Well worth browsing.

Landay, Eileen. BLACK FILM STARS. New York: Drake Publishers, 1973. Illustrated. 194pp.
 A glossy and superficial look at black film history, this coffee table publication contains many intriguing illustrations and a number of entertaining anecdotes about black film personalities. Landay begins her fifteen chapters dealing with seventy years of movie distortions with the observation that "Mr. Edison's 'flickers' were to have a profound effect on all Americans--black and white, audience and performers" and then explains that she is going "to trace the path of the black in movies, marking the milestones, tragedies, ironies, and humor of the journey." Moreover, the overly ambitious author indicates in hyperbolic journalistic prose that her book is also "a social history, a diary, a study in human behavior, a lesson in economics, a counterpoint of talent wasted and talent triumphant--one which might lead us to wonder if we have reached the journey's end or have taken only the first few halting steps along the way." Needless to say, the pages that follow, containing over 200 black-and-white photographs, fail to fulfill such grandiose designs.
 In Landay's defense, the book offers a delightful visual summary of many memorable moments in black film history, along with a synthesis of film tales. For example, we're told that Sam Lucas's performance in UNCLE TOM'S CABIN (1914), in which he dove into an icy river to rescue Little Eva, led to a lingering illness that caused his death. In 1967, "Butterfly" McQueen was offered expenses but no salary to make personal appearances tied to the rerelease of GONE WITH THE WIND and she refused. In the forties, when Lena Horne was the first black pinup, she did a stint at New York's Savoy-Plaza hotel, where she was provided a day-room to dress and rest in, but asked to lodge elsewhere for the evenings.
 Anyone interested in a nostalgic but sensitive look at the past should find this work enjoyable fare. The attractive format and the journalistic survey compensate for the shallow reviews and simplistic survey. A bibliography and index are also included. Worth browsing.

Leab, Daniel J. FROM SAMBO TO SUPERSPADE: THE BLACK EXPERIENCE IN MOTION PICTURES. Boston: Houghton Mifflin Company, 1975. Illustrated. 301pp.
 Based upon a study of more than 2000 films, this informative analysis helps pioneer new perspectives on the evolution of film stereotypes from the plantation imagery of the silent era, to the virile heroes and heroines of the 1970s. The tone for the book's ten chapters on social history is set in Leab's introductory comments: "Even though black has become box office, the Negro is not often presented on screen 'just like other folks.' The old Sambo caricature has simply been replaced by a new one, dubbed 'Superspade' . . . Yet whether Sambo or Superspade, the black image on screen has always lacked the dimension of humanity." The problem for the author, and for anyone comparing and contrasting the works of independent filmmakers and minority groups with the films made by mainstream filmmakers, is how to balance aesthetic and social judgments. It is a problem particularly evident in this scholarly examination.
 Chapter 1, "The Gamut From A to B," illustrates Leab's dilemma. In describing how literary and stage traditions since before the Civil War fixed the image of blacks in the American consciousness as ludicrous figures, he makes no effort to point out

exceptions to the popular perception. In setting the stage for the birth of film, he argues that contemporary standards only reinforced the gross stereotypes of the past. In explaining film's absorption of the literary and stage traditions, Leab states that "The movies readily picked up, and improved on, the same caricatures, which soon reached more people than ever." Once we come to terms with the author's moral outrage, his explanations of why certain things were done offer intriguing speculations. For example, he rejects the notion that actors in blackface portraying black roles in film were merely following stage traditions, or that such impersonations were used to prevent white audiences from objecting violently to interracial mixing on screen. For Leab, the real reason why white actors were used is "because the filmmakers of the time, a crude and pragmatic lot on the whole, accepted the prevailing beliefs about the limited abilities of the black and proceeded accordingly." Where his sensitive reflections get him into more controversial judgments is in the evaluations of black performers and films. A case in point is Bert Williams. While Leab acknowledges the star as a great stage performer, he dismisses Williams's 1916 film shorts as the work of a "victim of cruel racism." When early black performers like Bert Murphy, Frank Montgomery, and Florence McClain are rescued from obscurity by the resourceful author, he feels compelled to point out that at least one outraged black critic attacked the performers' films by referring to them as "'what is commonly called crap.'" The negative scholarly paradigm continues throughout the book. New information about personalities, films, and events is introduced, briefly discussed, and then critically analyzed. Moreover, Leab enjoys taking on his peers. For example, he takes issue with Cripps's position that the primitive film years contained an "unformed image" of blacks. Maybe so, says Leab, but it is clear to him that "Between the 1890s and 1915 the movie black--whether played by a white or not, and whether presented as an uneasy menace, a dancing machine, a comic stooge, a faithful retainer, a cheerful flunky, a tainted unfortunate, or an ignorant savage--was presented as a composite of qualities that were the opposite of the values treasured by white American society."[1483]

Chapter 2 is devoted exclusively to THE BIRTH OF A NATION (1915). It offers a brief biography of Griffith, general comments about censorship fights, and a smattering of critical reactions to the film. The most interesting sections relate to the assessment of Griffith as a product of his time. For example, Leab reminds us that the filmmaker, who epitomized a "Victorian idealist" always fighting for the downtrodden, never thought of himself as "antiblack." He points out how Griffith "toned down" Dixon's "inherent racism." But, in the end, Leab argues, THE BIRTH OF A NATION clearly demonstrated that Griffith "was a racist, a firm believer in the inferiority of the black." Among the more intriguing items the author provides is the fact that Griffith continued to employ white actors in black roles even after his peers in the industry began discontinuing the practice.

Chapter 3, "The Freezing of an Image," explores the impact of the changing economic structure of the film industry in the 1920s on black stereotypes. Although the treatment ranges from jungle roles to jazz musicians, the predominant characterizations functioned as comic relief. Leab provides numerous examples of how racism pervaded the screen: e.g., title cards, publicity gags, two-reel comedy shorts, newsreels, and the racist names ("Smoke" and "Molasses") that black

[1483] The debate carried over into Thomas Cripps's review of the book. While praising Leab's honesty and scholarship, he reacts to the "A to B" comment with the following: "Putting aside the question of historical accuracy, such a historical model tends to blur fragile, subtle, sporadic deviations from norms. In order to distill the best of black creativity, Leab focuses on the arcane, the private, the mythic, as though to say anything black that is created, if it is available to whites or financed by them, cannot be truly black. Unfortunately, this view minimizes ambiguity and variety in favor of a narrow concept of black culture. . . ." See Thomas Cripps, "Fresh Light on Racial Themes: On Blacks in American Films," AMERICAN FILM 1:1 (October 1975):86.

characters had in films. Particularly interesting are the examples of black protest against the demeaning film images, succinct biographies of white performers who played black film roles, and the obstacles that black performers faced in the film world.

Chapter 4, "'All-Colored'--But Not Very Different," is one of Leab's major contributions to the study of African-American film history. No longer are we given just thumbnail accounts of black showmen like William Foster, Emmett J. Scott, Noble Johnson, Clarence Brooks, and Oscar Micheaux. Thanks to hard work and resourceful scholarship, the author introduces the problems, the personalities, and the behind-the-scenes machinations that went into the creation of organizations like the Foster Photoplay Company, the Birth of a Race Photoplay Corporation, and the Lincoln Motion Picture Company. Almost as important as the discussion are the sources that Leab provides for future research. Where he raises the hackles of race-conscious critics is in his critical reactions to the "race movies" themselves. In evaluating Micheaux's work, for example, Leab praises him for the progress he made in popularizing all-black movies, but concludes that the silent films were not "outstanding," they "were not designed to uplift or to enlighten," and they "suffered by comparison" with white products.

Chapter 5, "Shufflin' Into Sound," adds to the book's negative perspective on the evolution of black film images. HEARTS IN DIXIE (1929) is described as "designed to delight white audiences only"; HALLELUJAH! (1929) is credited as being a technically "impressive film" but "actually a lumpy mixture of naive sentimentality and hackneyed sentimentality"; and THE GREEN PASTURES (1936) is seen as a "condescendingly sentimentalized white view of blacks." In Leab's defense, he makes his case boldly and with ample documentation from both the white and black press. He is not willing to sacrifice his liberal values for token progress or superficial excuses about good intentions. On the other hand, he ignores the realities of the film continuum, minimizes the difficulties faced by black performers as they struggled to change the "system," and fails to account for the popularity of Hollywood's "race" films with many black audiences in the 1930s. Given the subtle shifts that occurred in the film capital after 1935, his conclusion that "blacks gained little from the introduction of sound" seems unwarranted.

Chapter 6, "A Limited Response," underscores the book's strengths and weaknesses. On the positive side, Leab continues his unrelenting attack on Hollywood's snail-like pace in reforming its negative racial stereotypes. For example, he points to the differences between what film executives from MGM, RKO, Universal, and 20th Century-Fox promised and delivered. He pays particular attention to the battles among black performers who were for and against the NAACP attacks on the film industry's racial themes and characterizations. While presenting a good summary of the 1942 Hollywood luncheon for Walter White and the comments made by him and the industry counsel Wendell Willkie, Leab clearly disagrees with the NAACP's approach to resolving the mistreatment of blacks in the film industry. Where the chapter confirms the book's weaknesses is in its reluctance to credit White and his followers with any significant achievements. In fact, every time Leab points to a presumed step forward, he quickly musters data to show the opposite effect. Thus when he tells us that WWII opened up more positive roles for black performers, he points out that it resulted in an overall net decline of jobs for black extras. When he quotes a current critic lauding the film CABIN IN THE SKY (1943), Leab tells us that a more accurate review was by a critic writing at the time of the film's release who described it as "'a stale insult.'"

Chapter 7, "Glimmers of Change," takes aim at the "racially aware" films of 1949 and 1950. Beginning with the false assumption that TV, rather than a host of variables including a dramatic shift away from urban areas and into the suburbs, was causing a drop in Hollywood profits, Leab reiterates that profits, not purpose, are at the core of film productions like HOME OF THE BRAVE, LOST BOUNDARIES, PINKY, INTRUDER IN THE DUST (1949), and NO WAY OUT (1950). Useful plot summaries are followed by a sampling of contemporary critical reasons and a critical evaluation of each film. Leab's negative reactions are by now understandable but also

predictable and therefore lose some of their force. For example, Sidney Poitier's debut in NO WAY OUT is characterized "as the percursor of a new stereotype: the ebony saint." True, the image carried with it an obvious accommodation to white middle-class fears about sexual and social mores. But it is also true that for the times both the role and the personality were extraordinary. The question again is what measuring rod the critic is using. What Leab does contribute to film history is an important set of attacks that continue to remind readers of the problems black protesters faced in their uphill battle with the studios.

Chapter 8, "A Pale Black Imitation," is a hard-hitting examination of black independent films. Pulling no punches, the author labels the "race films" made by black and white filmmakers "sheer dreadfulness," while insisting that the "indigestible . . . is not necessarily the forgettable." That is, they function as historical artifacts of what certain segments of black society felt before the civil rights era about themselves and their dreams for integration into American life. It's not clear, however, just what Leab thinks the documents reveal. He sees almost all the productions driven by commercial considerations and imitating Hollywood genres: e.g. HARLEM IS TOPS (1932) and THE DUKE IS TOPS (1938) copy the conventions of the musical; HARLEM ON THE PRAIRIE (1938) and HARLEM RIDES THE RANGE (1939) combine the musical and western conventions; and DARK MANHATTAN (1937) and STRAIGHT FROM HEAVEN (1939) follow the gangster format. The author is especially hard on Mantan Moreland, Oscar Micheaux, and white producers of black films. For example, Micheaux is deemed important because of his pioneering efforts in "race productions"; but in the long run damned for his "parroting of the industry's demeaning image of the black." The same condemnation is reserved for white entrepreneurs like Jack (the "Abraham Lincoln of Harlem") and Bert Goldberg, Alfred Sack, and Robert Savini, all of whom specialized in racial caricatures of African-American culture. Whatever reservations one might have about Leab's film analyses, it is difficult to fault him for his excellent research on the status of black theaters, the way in which black producers operated in a difficult, white-controlled film industry, and the impact that budgetary concerns had on black performers. Particularly valuable is his thumbnail account of Ralph Cooper, one of the stars of 1930s' "race movies."

Chapter 9, "Toward a New Image," is probably Leab's most positive section. While still lambasting Hollywood for its timidity and foolishness in holding to outworn racial traditions, the author finds almost as much to praise as to condemn. Thus, he can attack THE INTRUDER (1961) as a "corny melodrama" but view it as "a movie that deserves to be remembered." He can even identify movies with minimal flaws: e.g., NOTHING BUT A MAN and ONE POTATO, TWO POTATO (both in 1964). In the process, Leab also enjoys himself. For example, his dismissal of THE NIGHT OF THE QUARTER MOON (1959) gives him a chance to ask: "Why did white men who fell in love with black women always seem to have domineering mothers?" The core of the chapter, however, consists of sensitive and thoughtful analyses of three major black film stars: Dorothy Dandridge, Harry Belafonte, and Sidney Poitier. Each represents a different direction taken in the 1950s and 1960s. While Dandridge's biographical review relies too much on plot summaries, Belafonte's overemphasizes his setbacks. Both critiques, however, outline the subtle changes occurring within the film industry: i.e., the revision of the code, the growing importance of independent producers, and the impact of foreign films on Hollywood movie content. Leab's most balanced analysis is given to Poitier's career. No quarter is given to the criticisms surrounding the actor's "sexless" and "one-dimensional" roles. No chance is missed to point out where more stinging reviews can be found. At the same time, Leab takes pains to show the inroads "the Ebony saint" made in awakening the conscience and consciousness of hundreds of millions of moviegoers over a twenty-year period.

Chapter 10, "Black is Box Office," offers Leab an ideal chance to summarize his rage against the white-dominated film industry. While pointing out the advances in employment made by black males since the sixties, he notes the paucity of roles for black women during the same time frame. While describing how Jim Brown and Raymond St. Jacques offered significant alternatives to Poitier's "ebony saint" image, he explains that Brown was not a critical success or a favorite of his Hollywood

bosses, and that St. Jacques was more important for the changes he symbolized than for the films he made. The one exception in St. Jacques's case was COTTON GOES TO HARLEM (1970). The remainder of the book gives a general overview of the significance of Richard Roundtree, Melvin Van Peebles, and Gordon Parks. In summing up, Leab states that "Except for a few notable exceptions like SOUNDER, THE LEARNING TREE, and NOTHING BUT A MAN, the film image of the black is as condescending and defamatory as it has ever been."

Anyone searching for a lucid, well-researched, and fast-reading history of the mistreatment of blacks in American films should include this book as must reading. The negative slant may not give us the more reflective perspective of Cripps, but it's difficult to find a more honest approach to the subject. Over eighty handsomely produced illustrations, plus endnotes, a bibliography, and an index add to the value of this very important study. Recommended for special collections.

Mapp, Edward. BLACKS IN AMERICAN FILMS: TODAY AND YESTERDAY. Metuchen: The Scarecrow Press, 1972. Illustrated. 278pp.

An updated and expanded version of Mapp's 1970 doctoral thesis at NYU, the disappointing publication promises more than it delivers. "The objective of this book," writes the author, "is to ascertain, by the use of informal qualitative content analysis, the portrayal of the Negro as a major character in . . . recent American films . . . [of the 1960s]." Although the focus is on movies made by American companies worldwide, Mapp, for questionable reasons, refuses to consider films made by black producers. These race productions "were aimed at black audiences, denied wide distribution and are therefore atypical." The value of this study lies in its chronological comments on over 200 films, occasional notes on specific characterizations, and periodic references to specific black personalities. The book's major drawbacks are its simplistic perspectives and weak scholarship.

The first five of the book's fifteen chapters provide a superficial introduction to previous scholarship, the era of silent films, the thirties, WWII, and the transition from the postwar period to the advent of the sixties. A scissors and paste methodology plus minimal footnotes and limited references characterize the trite exercise.

The next nine chapters offer a year-by-year summary of the major films and events related to black film history. Each chapter begins with a perfunctory account of issues relating to black life in America: e.g., riots, civil rights legislation, and prominent activists. Mapp then tries unsuccessfully to connect these events to the films produced, characters created, and traditional themes revised. Although his conclusions are neither original nor insightful, he deserves credit for maintaining a log of information about the flawed attempts to bring black-oriented films into the movie houses of mainstream America.

Chapter 15 presents Mapp's conclusions on the evolution of black film images in America. Among the predictable points he makes is that black males are more visible than black females, that the visibility of blacks in general is on the upswing, and that future films will no doubt include heretofore ignored areas of black history and culture.

In fairness to Mapp, he was one of the first authors since Noble and the latter's pioneering work to investigate black film history. Thus, his extensive bibliography, respectable collection of stills, and useful index served as a guide to later researchers, who quickly surpassed his poorly developed material. Worth browsing.

Murray, James P. TO FIND AN IMAGE: BLACK FILMS FROM UNCLE TOM TO SUPER FLY. Indianapolis: The Bobbs-Merrill Company, 1973. Illustrated. 205pp.

Arguing sensitively for a black aesthetic, this emotional commentary is weak on history but strong on theory. In the introduction to the book's seventeen brisk chapters, Murray, the editor for BLACK CREATION, defines black films as "any cinema in which blacks exert significant influence, either by direct input (such as writing the screenplay, starring in, producing, or directing the film) or by indirect

participation (such as accepting roles in which no creative involvement is permitted, but in which a black theme has a decided effect). Three specific goals of black films are correcting false film images, reflecting black reality, and creating (i.e., propagandizing) a positive black image. Given the times, Murray predicts that corrections will remain the major preoccupation of black films for the foreseeable future.

Chapter 1 summarizes the place movies hold in the lives of black people. Murray makes no attempt here or throughout the book to document his passionate perspective. We're asked to take his word that blacks for years identified with white heroes, yearned for white heroines, and despaired because of blacks' status in films. He points with pride to the attempts by African-Americans throughout film history to fight the false images of blacks in Hollywood movies, to the rise of black theaters where one could sit in the orchestra, to the emergence of race production companies, and to the contributions of men like Oscar Micheaux and Paul Robeson. The only critical note is directed toward white producers of race movies like the Goldberg brothers and Ted Toddy for their "purely commercial and inherently exploitative" films. Jumping back and forth through film history, he sketches in the key films and personalities that shaped Hollywood's racial stereotypes. He mentions numerous objections to the film industry's treatment of blacks, occasionally giving credit to a critic like Lawrence Reddick but providing no footnotes or bibliography.

Chapter 2 takes a look at the black actor. Mixing history with theory, he quickly summarizes the problems all black performers face. In deciding what roles to take, they should, he argues, set dignity above profit and shape whatever parts they play into intelligent images that enhance race consciousness. He rails against the studio practice of hiring black athletes and entertainers first and black actors last. A series of stars--e.g., Harry Belafonte, Sammy Davis, Jr., and James Edwards--serve as examples of past practices.

Chapter 3 concentrates on Sidney Poitier, making certain to list every important achievement of the superstar throughout his film career. As a rebuttal to the actor's critics, Murray builds a case for Poitier's contributions to black films and quotes the star on the pride he feels from seeing so many black peers working in films during the 1970s. While Murray includes Clifford Mason's reactions to Poitier, he immediately counters with William Marshall's defense.

The next three chapters turn into thumbnail essays on various topics. For example, Chapter 4 touches on the work of Diahann Carroll, Barbara McNair, Dionne Warwick, and Judy Pace to illustrate the problems of black actresses who, in order to survive, must also "double as nightclub and concerned singers." Chapter 5 indicates the number of athletes from Woody Strode to Jim Brown who worked in movies. Surprisingly, there is no mention of either Paul Robeson or Kenny Washington. Chapter 6 offers a whirlwind commentary on black comedians.

Thankfully, Chapter 7 devotes more than two pages to the topic of social issues in films. In one of the book's more reflective sections, Murray becomes more than a cheerleader for films like NOTHING BUT A MAN (1964) and UP TIGHT (1968) and takes on the role of a critic. He refers to the reactions of Stirling Silliphant to "blaxploitation" films, the contributions of independent filmmakers like Shirley Clarke and Richard Quine, and defends Stepin Fetchit.

The next five chapters concentrate on important black film and television directors. Chapter 8 offers a very good interview-discussion account of Gordon Parks, the first black to direct and script a Hollywood feature, and focuses primarily on his intentions in making SHAFT (1971). Chapter 9 profiles Melvin Van Peebles, emphasizing reactions to SWEET SWEETBACK'S BAADASSSSS SONG (1971). Chapter 10 talks about Ossie Davis, stressing the problems related to the American reception of KONGI'S HARVEST (1972). Chapter 11 gives a good introduction to the work of actor-director-producer William Greaves, a much-neglected filmmaker. Chapter 12 offers several useful insights into St. Claire Bourne, the founder of Chamba Productions.

With Chapter 13, Murray explores how the hard times in Hollywood at the end of the sixties affected the future of black films. He points to the decline in film production, the increase in film unemployment, and the search for investment dollars

as indications that television was becoming a more important outlet for black talent. He is particularly effective in discussing how black audiences and black exhibitors are impacting on the film industry in general.

Chapter 15, the book's best chapter, points to the rise of more independent black film companies and the training that they are providing for a black cadre of technicians. Among the major stars credited with helping the process are Sidney Poitier, Harry Belafonte, Ossie Davis, and Bill Cosby. Particularly useful is Murray's reliance on dates and figures to document the battle by groups in the early 1970s to increase minority representation in the Hollywood guilds. Also adding to the general understanding of Ossie Davis's difficulties with his Third World company is a useful summary of the fight to produce a film biography of Billie Holiday and the race with the Motown-Paramount production of LADY SINGS THE BLUES (1972). Murray concludes the noteworthy section with several fascinating twists. For example, in a highly unusual tone for the author he takes a swipe at James Earl Jones's performance in THE MAN (1972), calling it "oddly dull, docile, and racially unconscious." Not so surprising, the critic then lowers John Wayne's stock with quotations from a 1971 PLAYBOY interview in which the legendary actor talks about quota systems for blacks and the fact that he thinks the studios are going too far.

Chapter 15 turns our attention to the decline in black newspapers, the rise in black journals, and the effect both are having on black film criticism. Among the writers singled out for praise are Walter Burrell, Jr., and Clayton Riley. Murray also comments on the growing importance of New York City as a focus for black films and television productions, while describing a number of problems black performers and filmmakers are facing in Hollywood.

The concluding two chapters briskly highlight the difficulties blacks face in the film industry. Chapter 16 reminds us that as of the early 1970s, there were only twenty black-owned movie houses out of 14,000 nationwide; black performers still did not have financial parity with their white peers; and black filmmakers were encountering severe difficulties in making films of their choosing. Chapter 17 regretfully concludes that the role of the independent black filmmaker remains tenuous at best. Nevertheless, Murray insists that the day of black cinema is not too far off.

Whatever difficulties Murray's non-academic style poses for serious students, it has the advantage of providing a first-hand impression of what popular black film critics were looking for in the 1970s. Moreover, his chapters on behind-the-camera breakthroughs and vital black independent filmmakers provide leads found in few other sources. A good filmography, a list of blacks nominated for Oscars, and an index add to the book's value. Well worth browsing.

Noble, Peter. THE NEGRO IN FILMS. London: Skelton Robinson, 1948. New York: Arno Press, 1970. Illustrated. 288pp.

The first comprehensive analysis of black film history, this unsophisticated but influential study set the parameters for the more insightful analyses by scholars in the sixties. Noble's introduction to his nine impressionistic chapters hammers away at the mistreatment of blacks in film. Arguing that it is necessary to evaluate one of film's "more sinister aspects of influence," he points out that "Film propaganda has, in fact, wrought great dis-service to the Negro cause, and the manner in which coloured actors are shown on the screen has affected to a truly remarkable extent the reaction of audiences all over the world to coloured people in their own country and elsewhere."

Chapters 2 and 3 provide a quick survey of the African-American on the stage and in silent films. The theatrical overview covers from the early days of slavery to the end of WWII, concluding with the observation that Jim Crow is alive and well in the American theater. Noble's history of the silent era begins with the French film OFF TO BLOOMINGDALE ASYLUM (1902), quickly moves on to American products like THE MASHER (1907) and a slew of "Rastus" and "Sambo" films made between 1910 and 1914, and insists that the early films all reinforced the theme that blacks were "subhuman." Special attention is given to film versions of UNCLE TOM'S CABIN

(although here and elsewhere the author has difficulty with exact dates) and to the importance of THE BIRTH OF A NATION (1915). The post-WWI period is characterized as one in which black actors replaced whites in blackface, but the roles remained basically those of "inferiors of every description."

Chapter 4, on the transition to sound, emphasizes the initial optimism of black entertainers toward a career in "talkies." Noble is especialy hard on Fetchit, claiming the popular actor brought "Negro dignity to its lowest common denominator." HEARTS IN DIXIE (1929) is credited with being an ambitious, well-meaning film that only has the dignified performance of Clarence Muse to rescue it from oblivion. HALLELUJAH! (1929) fares as badly, with Noble quoting Paul Robeson's denunciation of the film's religious scenes as "sheer blasphemy." The Warner Bros. production of THE GREEN PASTURES (1936), however, gets a more balanced assessment, since Noble claims that the debate over its merits is endemic to black images on the screen. That is, "On one side there are those who assert that a Negro playing ANY part on the screen is better that no Negroes on the screen at all, and on the other side there are those who believe that the Negro should appear only in films which show his correct relationship to a white community and not in fairy-tales, fantasies or films treating the subject lightly and unrealistically." Mervyn LeRoy is credited with being a director sensitive to the problems of blacks, especially in films like I AM A FUGITIVE FROM A CHAIN GANG (1932) and THEY WON'T FORGET (1937). Moreover, the independent production of THE EMPEROR JONES (1933) is touted as one of the most original movies up to the post-WWII period. Particularly interesting are the author's accounts of the controversies surrounding IMITATION OF LIFE (1934), the way in which Bill Robinson's career epitomized the dilemma faced by most black performers, and the reasons why Daniel Haynes was so indignant about his role in SO RED THE ROSE (1935). The engrossing section ends with a stinging evaluation of GONE WITH THE WIND (1939), claiming that it was a "prime example of how a moving picture can incite racial hatred."

The next five chapters explore a Hollywood genre, independent and government films, the role of the African-American in European films, important black entertainers in Hollywood, and the effect that WWII had on Hollywood. The material on song and dance offers a useful commentary on Katherine Dunham, while the disappointing section on the independents is interesting primarily for its data on black theaters. The chapter on Europe is misleading since it focuses primarily on Paul Robeson and Robert Adams, analyzing a dozen films the men made collectively, with only a passing comment on continental cinema. Chapter 8 is devoted exclusively to black performers, leading off with more information on Robeson, followed by biographical essays on Rex Ingram, Lena Horne, Clarence Muse, and concluding with shorter profiles on artists like Ethel Waters, "Butterfly" McQueen, Kenneth Spencer, Louise Beavers, Hattie McDaniel, and Robert Adams. The material on WWII provides some intriguing observations on films like TALES OF MANHATTAN (1942), THE OX-BOW INCIDENT, BATAAN, CABIN IN THE SKY, STORMY WEATHER (all in 1943), and LIFEBOAT (1944).

The final chapter summarizes the efforts of organized groups to alter the patterns established for black jobs and roles in the film industry. At the outset is a long overdue tribute to the efforts of protest groups like the NAACP and the International Film and Radio Guild (IFRG) to change the image of blacks on screen. Among their victories, according to the author, is getting 20th Century-Fox to change the title of Rene Clair's film TEN LITTLE NIGGERS to TEN LITTLE INDIANS, released in America as AND THEN THERE WERE NONE (1945). Noble also stresses what needs to be done to implement the changes advocated by the pressure groups. Uppermost on his list is the recommendation that Hollywood be understood as a business that needs to be persuaded that black-oriented films not only are good for the industry's reputation, but also for its pocketbook. The chapter ends with Lawrence Reddick proposing seven recommendations for pressuring Hollywood in improving racial relations.

Although much of the data in this book is more accurately reported in subsequent analyses, Noble's outrage over the treatment of blacks over a fifty-year history serves as a valuable reminder of a time and attitude that significantly shaped the

future of black film history. The four appendexes covering a brief history of African-Americans, a bibliography, a filmography, and Griffith's defense of THE BIRTH OF A NATION provide a perspective on how far we have come in the last forty years, while the helpful index functions as a good reference tool. Well worth browsing.

*Null, Gary. BLACK HOLLYWOOD: THE NEGRO IN MOTION PICTURES. Secaucus: The Citadel Press, 1975. Illustrated. 254pp.

This coffee table book is a poorly written but handsomely illustrated survey of African-American film history. Seven simplistic chapters serve as the excuse for the best collection of photographs on the subject. By way of determining the book's strengths and weaknesses, one need only examine the first chapter, which covers in ten pages of limited prose and heavily illustrated, beautifully reproduced pictures the beginning of films to the mid-twenties. Null strikes the right opening note by stating that "the depiction of black people on the screen has not only reinforced and sharpened some of the prejudices of the white majority, but it has also to a great extent shaped the often negative image blacks have had of themselves." He then goes on to offer a standard interpretation of how blacks were mistreated on screen, but offers almost no reflective comments. Even more disappointing is that within a span of three pages on early film history no mention is made of the fact that movies inherited a fifty-year stage tradition of UNCLE TOM shows; Oscar Micheaux is mistakenly credited with filming THE WAGES OF SIN and BROKEN VIOLIN (both in 1914) four years before he actually began in films; and Thomas Dixon's novel THE CLANSMAN is falsely given as the single source of THE BIRTH OF A NATION (1915). On the other hand, Lester Glassner's superb taste (albeit unacknowledged) is reflected in the judicious selection of shots and images of the period. A brief index in included, but no filmography or bibliography. Well worth browsing.

Oshana, Maryann. WOMEN OF COLOR: A FILMOGRAPHY OF MINORITY AND THIRD WORLD WOMEN. New York: Garland Publishing Company, 1985. Illustrated. 338pp.

A novel compendium dealing with over 900 feature films, this resource limits itself to movies in English that portray leading or supporting nonwhite female characters pivotal to the plot. What is fascinating about the entries covering the years from 1930 to 1983 is that most of the minority roles have been played by white women. Oshana thus reinforces the fact that minority women have been extremely limited in the roles they could get in American and English sound films. Time and space, explains the author, are the reasons why she declined to include silent movies. The entries include the following: production company, running time, year of release, production and cast credits, and a minority/Third World classification (i.e., Native American, black, or Hispanic). In addition, brief plot summaries are provided, along with information about the parts played by minority women. The filmography concludes with indexes on actresses (in minority roles), directors, and minority/Third World classifications. The one glaring omission relates to race productions, an area important to serious film students. Recommended for special collections.

Patterson, Lindsay, ed. BLACK FILMS AND FILM-MAKERS: A COMPREHENSIVE ANTHOLOGY FROM STEREOTYPE TO SUPERHERO. New York: Dodd, Mead, & Company, 1975. Illustrated. 298pp.

The best collection of previously published articles on the development of black films and of the values of those who make them, this welcome anthology is a treasure chest of overlooked and hard-to-get essays. Patterson does a splendid job of dividing his nearly thirty works into six intriguing sections. In a sensitive introduction, he explains his views on the topic by addressing an open letter to his son. The tone of the letter and its warnings about the effect of films on the minds of the impressionable reveals a great deal about the editor's selection of contributors. That

is, Patterson detests almost all of the "blaxploitation" movies, a fact that accounts for his imbalance of essays attacking the seventies' cycle of films. His fondness for the battles of the past to improve the lot of black performers foreshadows the number of conflicting essays on specific films and the insights that accrue from publishing them together in one volume. And his moral indignation that black talent has never had the luxury of being able to practice its craft in a reasonable setting accounts for the preponderance of angry essays assailing the white-dominated film industry.

Section 1--"Nigger to Supernigger"--gets the anthology off to an excellent start. Lawrence Reddick's significant 1944 essay, "Of the Movies," not only catches the flavor of the WWII push to improve the treatment of blacks in American film, but also provides a succinct summary of the degrading stereotypes up to the mid-1940s. Unfortunately, the editor, throughout the book, chooses to ignore incorrect dates and facts. Alain Locke and Sterling A. Brown's "Folk Values in a New Medium" provides a good counterbalance to Reddick, because it reminds us that in 1930 many white liberal and black intellectuals felt very positive about movies like HEARTS IN DIXIE and HALLELUJAH! (both in 1929). Arthur Draper's 1936 essay, "Uncle Tom Will Never Die!" brings us back to black rage with a strong attack on King Vidor's SO RED THE ROSE (1935). Albert Johnson's highly regarded 1959 essay, "Beige, Brown or Black," takes us into the liberal fifties, but from the perspective of an astute critic who saw through the industry's shallow attempts at integrating the black into mainstream filmmaking. Gerald Weales's foolishly ignored 1952 essay, "Pro-Negro Films in Atlanta," offers an invaluable look at film censorship and attitudes during the height of Hollywood's 1949-1950 cycle of black "problem" films. Thomas R. Cripps's often-quoted 1967 article, "The Death of Rastus: Negroes in American Films Since 1945," is reprinted with its impressive insights, valuable footnotes, and surprising errors in film dates. And Richard Wesley's 1973 attack on "blaxploitation" films, "Which Way the Black Film," rounds out the subtle historical overview from the early sound days to the mid-1970s.

Section 2, "Movie Milestones," goes back over the same general terrain, only with a closer look at specific films. Bosley Crowther's 1965 piece, "The Birth of BIRTH OF A NATION," covers much of the same material that Cripps does in his 1963 pioneering essay, "The Reaction of the Negro to THE BIRTH OF A NATION," but without the scope or depth of the noted film historian. Robert Benchley's 1929 essay, "HEARTS IN DIXIE (The First Real Talking Picture)," may be, given its brief three and a half pages, the shallowest essay of its kind. Not only does the author talk in hyperboles about the future of movies depending upon African-American voices, but he also makes veiled anti-Semitic remarks about the film being butchered to "make a Jewish holiday" and claims that movies will never be art "so long as they are in the hands of the present group of financiers." We can be grateful he didn't refer to the movie moguls as "moneylenders." On the other hand, James Baldwin's 1955 film analysis in "CARMEN JONES: The Dark Is Light Enough," should be required reading for anyone interested in what segments of the black community objected to in the liberal films about blacks in the 1950s. In the first of three back-to-back essays from 1969 to 1970, "It's Gonna Blow Whitey's Mind," Patterson goes behind-the-scenes of UP TIGHT (1968) to discuss how the veiled remake of John Ford's THE INFORMER (1935) captures not only Hollywood's myopic goals, but also the optimism (in hindsight, misplaced) of the cast and director Jules Dassin. Patterson's second essay ("In Harlem, James Bond With a Soul?") tells us more about the difficulty of making meaningful inroads in minority apprenticeship programs than it does about the production of the film, COTTON GOES TO HARLEM (1970). The third Patterson essay ("SOUNDER--A Hollywood Fantasy?") attacks Martin Ritt's production for its unrealistic depiction of black sharecroppers in the 1930s. Having grown up in such surroundings, the author identifies a number of errors, while, at the same time, lamenting that black activists are willing to settle for "positive" images of blacks rather than honest portrayals. Maurice Petterson's 1973 essay, "Book of Numbers," concludes the movie milestones with an upbeat review of Raymond St. Jacques's film about the numbers racket during the Depression. Specific attention is paid to the problems of black women in film, especially the difficulties faced by the actress Freda Payne.

Section 3--focusing on the experiences of early black performers--begins with Geraldyn Dismond's 1929 UP CLOSE article, "The Negro Actor and the American Movies." Her brief but effective overview highlights the reaction that members of the black community had to the emerging role of African-Americans in the first stages of talking films. Floyd C. Covington's 1929 piece, "The Negro Invades Hollywood," takes a closer look at the activities of Charles E. Butler, the black man responsible for "cattle calls" for African-American entertainers in the movies of the late twenties (and on into succeeding decades). William Harrison's 1939 article, "The Negro and the Cinema," takes a critical look at Paul Robeson's acting, the limited roles available to black performers, and the lack of social vision in the independent black films of the 1930s. William Thomas Smith's 1945 "Hollywood Report" confirms the plight of black performers up to the end of WWII, pointing out that character actor Jesse Graves, known for his butler roles, appeared in nearly fifty films in 1944, "but earned only seven thousand dollars." A selection from LENA, the 1965 autobiography written by Lena Horne with the help of Richard Schickel, synthesizes what it was like to be the only black glamor queen in Hollywood during the forties.

Section 4 explores the status of the black performer in the 1960s. Albert Johnson's excellent 1965 essay, "The Negro in American Films: Some Recent Works," offers a perceptive overview of the 1960s and its controversial approaches to black themes. Catherine Sugy's 1970 article, "Black Men or Good Niggers?" is a challenging look at whether traditional formulas for mistreating black culture have been altered significantly by the films about and with blacks in the 1960s. Michael Mattox's 1973 commentary, "The Day Black Movie Stars Got Militant," is a valuable summary of the goals of the Black Artists Alliance (BAA), a pressure group working inside the entertainment world and consisting of black talent in film, TV, and the theater. Edward Mapp's 1973 essay, "Black Women in Films: A Mixed Bag of Tricks," relates the sexist treatment of black actresses to the fact that their screen roles result from white male fantasies rather than from input by black female screenwriters and directors.

Section 5, "Establishing Your Own," contains three essays, each relating to the production of black films. James Asendio's 1940 essay, "History of Negro Motion Pictures," focuses on George Randol, his years in Hollywood during the 1930s, and the joint effort with Ralph Cooper and Ben Rinaldo in producing DARK MANHATTAN (1937). Patterson's 1971 article, "In Movies Whitey Is Still King," identify different places around the world where Hollywood's demeaning treatment of blacks has produced new areas of racism. Melvin Van Peebles's 1971 excerpts from his journal on the making of SWEET SWEETBACK'S BAADASSSSS SONG not only suggest a raunchy approach to getting your creative juices popping, but also explains what the producer-director-actor was trying to accomplish with his revolutionary project.

In Section 6, "The Seventies: Only the Heroes Have Changed!" concludes the invaluable anthology with three 1972 articles on "blaxploitation" films. Charles Michener's first-rate NEWSWEEK story, "Black Movies," gives a good synopsis of the key films, stars, and groups related to the controversial film cycle. James P. Murray's concise 1972 essay, "The Subject Is Money," explains what's involved in financing films by or with blacks and how much African-Americans are at a disadvantage in the process. Pauline Kael's much-praised 1972 commentary, "Notes on Black Movies," pulls no punches in denigrating white and black filmmakers for their racist values in the "blaxploitation" films.

Overall, the collection paints a negative picture of the evolution of black films. It makes no real attempt to credit stars, producers, or groups with waging an uphill but successful battle against a white-dominated film industry, nor does it show any real interest in silent films. The focus is on reminding us how often black artists dream that this time "it would be different" and more often got shafted. Despite the editor's pessimistic tone, however, the book suggests that changes have been made, creative personnel are sensitive to the types of changes required and know about the pitfalls to be avoided. Moreover, it's a pleasure to have many of the articles cited in numerous studies conveniently collected in one valuable anthology. A selected

filmography, brief bibliography, and adequate index add to the book's value as a good overview of black film history. Recommended for special collections.

*Pines, Jim. BLACKS IN FILMS: A SURVEY OF RACIAL THEMES AND IMAGES IN THE AMERICAN FILM. London: Studio Vista, 1975. Illustrated. 143pp.

Thought-provoking and lucid, this concise history does a first-rate job of blending film facts with intelligent observations on racial stereotyping. Eight well-balanced chapters explore the evolution of the black film image from the first Kinetoscope movies to the early 1970s and the "blaxploitation" era. Two strategies distinguish Pines's efforts from those of his peers. On the positive side, he offers a stimulating set of original observations on Hollywood's historical images of blacks and how they affected America's social attitudes toward blacks. On the negative side, his clever analyses make almost no attempt to tie the screen transformations to crises and changes in the film industry or in American society.

Chapter 1 begins by speculating on the links between turn of the century entertainment and the roots of "racial plasticization" in film: e.g., the popularity of ethnic music and dance, white people's perception of blacks as being visually exotic, the impression that "blacks symbolized the quintessence of ICONIC motion," and the importance of the Southern plantation myth in the emerging film industry. Pines then describes how stage traditions dominated the first film decade of the twentieth century, resulting in three basic racial motifs throughout the silent period: the faithful servant, the comic buffoon, and the savage buck. These motifs mainly alternated between comic and grotesque images. Among Pines's many useful observations are those relating to the reformist overtones of "progressivism" in almost every social area but race relations.

Chapter 2 reviews the ideological connection between the advent of sound movies and the "racial image/myth-making process." The focus is on showing how the "talkies" increased the audience's belief in the "realistic" nature of the movies. Unfortunately, no evidence is provided to substantiate his cause-and-effect assertions. Starting with Al Jolson's use of blackface in films like THE JAZZ SINGER (1927) and THE SINGING FOOL (1928), Pines draws a useful distinction between the film conventions of the minstrel tradition and Hollywood's move toward modernism. Curiously, his discussion of stage origins omits the fact that George Jessel, not Jolson, was the original choice for the lead in the film and that the movie itself is based on a popular stage play of the day. Pines goes on to describe why filmmakers eventually lost interest in minstrel entertainment, but not in antebellum Southern mythology. His discussions of films like HEARTS IN DIXIE and HALLELUJAH! (both in 1929) explain why many of the silent era's racial stereotypes continued through the 1940s. Of particular interest are the author's explanations of why the by-now growing protest movements against Hollywood were ineffective and why many racial protesters were willing to accept "toned-down versions of derogatory films as an alternative to getting them banned altogether." The critics came from within as well as outside the film capital. Citing Robeson as a classic example of the internal protester, Pines argues that the standard pattern was to have the performer exploited by the movies, then become critical of the system, and finally abandon it forever. On the other hand, those outside the industry attacked it on moral and literal issues.

Chapter 3 looks at the evolution of race films from the silent era through the succeeding four decades. Pines's well-meaning but flawed discussion of personalities and groups testifies to the importance of the later scholarly efforts by Cripps, Leab, and Sampson. For example, he omits any mention of William Foster and Peter P. Jones, credits Oscar Micheaux as the first important black producer, and claims that Micheaux began operating in Harlem in 1918 instead of 1923. To his credit, Pines provides a good overview of the general circumstances that gave rise to a viable black ethnic market. In particular, he delineates the importance of the black community in the film continuum, the ethnic market's fascination with "black nocturnal culture," and the independent filmmaker's negative portrayal of the urban black social milieu. His treatment of Micheaux includes a provocative look at the producer's "ethnic realism" and the use of "light-skinned" performers and characterizations. Pines is

especially effective when dealing with the use of white technicians in the black film market, pointing out why blacks failed to develop technical expertise and thus lost ground in gaining artistic independence in the highly complex film industry.

Chapter 4 returns to the 1930s and surveys its specific reactionary black images through World War II. Following a useful contrast between the progress made by black performers on stage as compared to their alleged stagnation in Hollywood, the author explores mainstream racial films of the Depression: e.g., THE EMPEROR JONES (1933), IMITATION OF LIFE (1934), THE GREEN PASTURES (1936), and GONE WITH THE WIND (1939). His perceptive comments are marred slightly by mistaking Margaret Mitchell's book as a product of the "late twenties" and by ignoring the fact that the film version of O'Neill's play was an independent production. Especially interesting are Pines's reasons why "racial movies" like PRESTIGE (1932), SO RED THE ROSE, THE LITTLEST REBEL (both in 1935), and THE PRISONER OF SHARK ISLAND (1936) were far more representative of the period than the better known studio hits. Also noteworthy are his intriguing comments about the treatment of black images in "social message" films like I AM A FUGITIVE FROM A CHAIN GANG (1932) and THEY WON'T FORGET (1937). Moving on to Hollywood's moral ambiguity toward the depiction of black characters by the mid-1930s--e.g., THE PETRIFIED FOREST (1936), JEZEBEL (1938)--Pines reiterates the importance of radical sound technology on black stereotyping. The war years are given short shrift, with Pines only commenting on the fact that an increasing number of black personalities--e.g., Hazel Scott, Ethel Waters, Katherine Dunham, and Lena Horne--fought against appearing in demeaning roles and derogatory movies. On the other hand, his comments on films like SEWANEE RIVER (1940), TALES OF MANHATTAN (1942), CABIN IN THE SKY, and THE OX-BOW INCIDENT (both in 1943) add to our understanding of how Hollywood responded to the nation's need for a united front against the Axis powers.

Chapter 5 provides a number of insights into Hollywood's postwar liberalizing of racial themes. Starting with the links between a new and powerful black middle class and demands that the armed forces be integrated, the narrative surveys the relevant factors that led to Hollywood's pro-black movies: e.g., the link between the industry and social developments, the influence of an influential left-wing Hollywood cadre. As Pines points out, although "progressives" like Herbert J. Biberman, Jules Dassin, Carl Foreman, Joseph Losey, Abraham Polonsky, Robert Rossen, and Nedrick Young were not able to work in Hollywood during the the 1950s and early 1960s, "it is obvious that it was really their initial efforts which inspired liberal radical developments generally." He also sheds light on why black film personalities followed the "integration" rather than the "ethnic identity" route, noting that black performers nationwide took their cue from organizations like the American Negro Theatre (ANT) and the Committee for the Negro in Arts (CNA). Among the more obvious casualties in such an orientation was the independent black filmmaker, who lost his audience for ethnic-centered films. The emphasis screen-wide was on solidifying the ties between black artists and socially conscious white filmmakers. The evidence is found in mainstream racial problem films like HOME OF THE BRAVE, INTRUDER IN THE DUST, PINKY, and LOST BOUNDARIES (all in 1949). Typical of Pines's insightful commentary is the observation that psychological groupings like those found in HOME OF THE BRAVE reveal how the black problem motif was treated: "it shows how, within the liberal pro-Negro genre, the Negro predominates as a character devoid of a genuine sense of individuality who is 'positively functional' ONLY in the terms dictated by liberal racial concepts." The standard practice had the black protagonist overly dependent on a paternal white character.

Chapter 5 discusses the evolution of radical liberalism in the fifties. Noting that it is difficult to identify specific steps by the film industry that led directly from the integrationist approach begun before WWII to the escapist mood in the seventies, Pines explains that the standard practice in the Cold War era was to place a clear-cut black hero in a "social-racial predicament." According to the author, the pattern in which the black hero finds himself face-to-face with racial conflict was set in HOME OF THE BRAVE. From that film on, Hollywood pursued the notion of "the liberal racial character with a definite and seemingly 'positive' sense of social purpose." Among

the films analyzed in terms of the "liberal-image dynamic" are INTRUDER IN THE DUST (1949), NO WAY OUT (1950), NATIVE SON (1951), THE BLACKBOARD JUNGLE (1955), EDGE OF THE CITY, SOMETHING OF VALUE (both in 1957), THE WORLD, THE FLESH AND THE DEVIL, TAKE A GIANT STEP, THE DEFIANT ONES (all in 1958), and ODDS AGAINST TOMORROW (1959). Where Pines excels is in distinguishing among a variety of Hollywood approaches to humanizing black characters. For example, NO WAY OUT shows the value in upgrading the importance of the white racist figure; THE DEFIANT ONES explores the possibilities of taking black and white characters through an equal learning experience in order to achieve racial tolerance; and SOMETHING OF VALUE illustrates (albeit in Kenya rather than in the United States) the self-identity crisis that idealistic and rebellious black men face. Pines also deserves recognition for a good summary of the racial films shepherded by Martin Ritt: e.g., EDGE OF THE CITY (1957), PARIS BLUES (1961), and SOUNDER (1972). The only strained note is in claiming that THE GREAT WHITE HOPE (1970) relegates "racial conflict" to a secondary level and advances "the idea of humanism-under-pressure" as the major focus. Another concern is in Pines's many acts of omission. Why, for example, downplay the tragic career of Dorothy Dandridge, dismiss with almost no comment, ISLAND IN THE SUN (1957), and ignore the influential effect of black athletes-turned-actors and inspirational black sports movies? Still another problem relates to Pines's assertion that a powerful literary figure like Bigger Thomas in Richard Wright's novel, NATIVE SON, "can not be effectively reincarnated in cinematic terms." A more defensible position would be that such literary figures have yet to make it intact to the screen, certainly not in either the 1951 or 1987 screen adaptations of NATIVE SON.

Chapter 6 considers the maturing of Hollywood's treatment of black images, and, in the process, crystalizes Pines's considerable strengths and noticeable weaknesses. He writes persuasively of the gains made in the liberal racial genre of the sixties, but makes no meaningful references to the sweeping social, political, and economic changes taking place within and without Hollywood. The omission is particularly glaring given the author's valuable approach to the decade's multi-faceted African-American characterizations and diversified social situations. For example, Pines divides the evolving treatment of the post-WWII liberalized black image into three admittedly overlapping categories. First comes a look at familiar genres like the western--e.g., SERGEANT RUTLEDGE (1960), MAJOR DUNDEE (1965), and 100 RIFLES (1968)--and the Southern drama--THE INTRUDER (1961), TO KILL A MOCKINGBIRD (1963), NOTHING BUT A MAN (1964), IN THE HEAT OF THE NIGHT (1967), SLAVES (1969), and THE LIBERATION OF L. B. JONES (1970). Each of the succinct but extremely stimulating analyses stresses how the traditional American milieu was infiltrated by a civil rights movement. What is intriguing is why Pines fails to note which films were independent productions, why the films became more controversial as the decade proceeded, and what effect the reorganization of the Hollywood system had on the content of social problem films. Clearly, 100 RIFLES and SLAVES could not have been made in 1960. The second category critiques racial themes in non-southern settings: e.g., A RAISIN IN THE SUN (1961), THE COOL WORLD, ONE POTATO, TWO POTATO (both in 1964), DUTCHMAN (1967), GUESS WHO'S COMING TO DINNER? (1967), and THE LOST MAN (1969). These types of sixties' films more clearly demonstrate Pines's theories on the main thrust of the sixties' racial problem genre. For example, A RAISIN IN THE SUN is admired for its archetypal portrait of ethnic conflicts; THE COOL WORLD is praised as the best interpretation of social-racial experiences in film history up to the mid-sixties. What is uncharacteristic of Pines is his outrage against sixties' filmmakers' dealing with the theme of miscegenation. For example, he dismisses Larry Peerce's ONE POTATO, TWO POTATO as "another flash in the pan" because of its oversentimentality; and he attacks Stanley Kramer's GUESS WHO'S COMING TO DINNER? as "sheer idiocy" because it proves "the fundamental impotence of the black man in the Hollywood meat grinder." The third and final category of the sixties' racial film genre, racial understatement, touches on the assimilation of African-American characters into Hollywood and society proper. Although Pines claims that the category "reveals a major evolution in racial characterization," he does little more than tick off a dozen

films--e.g., LILIES OF THE FIELD (1963), THE PAWNBROKER, and THE SLENDER THREAD (both in 1965)--and avoids any attempt at analyzing why black characterizations proliferate in so many late 1960s' films.

Chapter 8 concludes the book with a sensitive but faulty commentary on the early seventies and "blaxploitation" movies in Hollywood. Part of the problem is the author's failure to distinguish between the old and new structure of the film industry. For example, in discussing the significance of COTTON GOES TO HARLEM (1970), Pines talks about the "Hollywood idiom" but never explains why it has undergone its "remarkable transformations" following the post-WWII era. In dealing with the film capital's "entrenched historical-ideological determinants," he insists that middle-class blacks can never hope to usurp such "a bigoted and exploitive system." Once again Pines ignores the fact that not only has television opened up new channels of distribution, but also independent production has gained greater prominence. He is right, however, in stressing the enormity of the undertaking. His thoughtful comments on why films like COTTON GOES TO HARLEM and SHAFT (1971) opened the doors for black-oriented films and Hollywood's "ethnic adjustment" summarize why well-intentioned plans go astray. For example, his comments on the integration of black characters and themes into the traditions of the gangster genre illustrate how certain filmmakers exploited ethnic issues for personal profits. In summing up the history of black images in American films, Pines expresses his anger by paraphrasing a line from SUPER FLY (1972) in which several Black Power activists refuse to side with the film's hero, a drug dealer, and exclaim, "'I'll join once you get it together, until then go fuck yourselves. . . .' or something to that effect."

Anyone interested in reading a reflective introduction to the humiliating history of African-Americans in Hollywood films should get a copy of this book. It has few peers in its field. In addition to a slight bibliography and endnotes, Pines provides a useful chronological filmography and a helpful index. Recommended for special collections.

Powers, Anne, ed. BLACKS IN AMERICAN MOVIES: A SELECTED BIBLIOGRAPHY. Metuchen: The Scarecrow Press, 1974. 157pp.

Lacking the scope and depth of the Hyatt bibliography, this earlier work nonetheless provides a valuable listing of books, articles, and related material on black film history. The opening section contains general observations and a listing of non-periodical references (e.g., indexes, bibliographies, general reference works, dissertations, excerpts, books, biographies, and autobiographies). The major section groups its periodical listings under fourteen categories: e.g., the history of blacks in film; blacks in Hollywood; blacks and whites; the black image; comments and criticism; film and black athletes; actors and actresses; black music and musicians; blacks, films, and politics; and blacks, films, and social themes. Regrettably, the citations are listed by article title rather than by author. A few terse annotations accompany some of listings. In addition, there are two other bibliographical listings: an alphabetical compilation of articles by the title of the journal they appeared in; and a chronological arrangement of articles from the 1920s to the seventies. The informative book concludes with a filmography of black films up to 1930 and an author-subject index. Worth browsing.

*Sampson, Henry T. BLACKS IN BLACK AND WHITE: A SOURCE BOOK ON BLACK FILMS. Metuchen: The Scarecrow Press, 1977. Illustrated. 333pp.

"The basic objective of this book," explains Sampson, "is to present relatively little known facts concerning all-black cast films that were independently produced between 1910 and 1950." This enterprising history of those small American companies traces the activities of pioneer black filmmakers, black- and white-owned movie companies, and the black casts and technical crews that have been basically overlooked by more traditional surveys. In compiling and organizing his study, Sampson reviewed over ten thousand issues of black weeklies covering a forty-year

period. He also relied extensively on the often flawed but intriguing memories of the participants themselves, giving us not so much a definitive account of the events as an invaluable black perspective on the mood and difficulties involved in bringing black themes and values to a white-dominated movie industry. Since no claims are made for the study's being a critical or interpretive commentary on the evolution, development, and demise of the black film industry, the unsubstantiated assertions by a number of the black performers pose no serious problems to the book's unquestionable contribution to film scholarship. In fact, Sampson's documentation of film titles, production companies, and cast credits proves very reliable.

The first of the book's seven chapters provides a terse historical overview of forty years of independent black film activities prior to 1950. It begins with a reminder that civil rights organizations, black artists, and black newspapers continuously protested before and after the birth of the movies the negative stereotypes perpetuated by the entertainment world. Sampson then continues with cursory comments about initial black participation in the film industry, starting with William Foster's pioneering efforts in Chicago in 1910, followed later by the Lincoln Motion Picture Company in Los Angeles (1916), and the Oscar Micheaux Film and Book Company in Chicago (1918). Of the more than 150 independent companies organized expressly for producing films for black audiences up to 1950, only thirty-four percent were owned and run by blacks. More to the point, Sampson explains that the forty-year span saw only three peak periods for black productions: the early 1920s, the late 1930s, and the immediate post-WWII era. At the same time, he briefly notes reasons why the black film industry had frequent setbacks. For example, it declined in the mid- and late 1920s because of limited markets, chaotic distribution policies, and risky financial backing. Not surprisingly, black film companies suffered a high mortality rate during the silent era. Many did not even survive the release of their first productions. One reason why black film production increased prior to WWII "was the opening of balconies in Southern theatres to black trade." Once blacks began patronizing white theaters in great numbers, black theater owners fought back by booking more black films. Interestingly, almost every black film company in the forties was operated by white producers like Ted Toddy, Jack and Bert Goldberg, Robert Salvani, Arthur Dreifuss, and Richard Kahn. The three notable exceptions were George Randol, Eddie Green, and William Alexander. Sampson makes the point, however, that of the 370 black films made before 1950, "approximately ten per cent were produced by one black man--Oscar Micheaux." A particularly noteworthy section of this chapter is devoted to a chronological highlighting of black film production, allowing readers to get a thumbnail synopsis of black film history. Also included are three tables listing theaters catering mainly to blacks between 1910 and 1950, black theaters in America up to 1939, and theaters catering mainly to blacks in 1944.

The next two chapters are devoted to the activities of the Lincoln Motion Picture Company and the Micheaux Film Corporation. The former gives an important account of the first movie company to produce and distribute nationally films made by blacks and starring all-black casts. Among the pictures discussed are THE REALIZATION OF A NEGRO'S AMBITION and THE TROOPER OF COMPANY K (both in 1916), and THE LAW OF NATURE (1917). Information is also provided on the relationship between Noble Johnson and the Lincoln Motion Picture Company, as well as the contributions of George Johnson, Tony Langston, and Clarence Brooks. The chapter on Micheaux covers his twenty-one years in the film industry (1918-1940) when he produced films based primarily on his novels. The emphasis is on demonstrating the overlooked filmmaker's skills as an entrepreneur and black showman attuned to the values of a black audience. Especially interesting is the case Sampson makes for many of Micheaux's films' being protest vehicles for black rage. For example, WITHIN OUR GATES (1920) involved a controversial scene relating to the lynching of a Southern black man. Despite the fact that a number of movie houses in the South boycotted the film, the undaunted Micheaux followed up with THE GUNSAULUS MYSTERY (1921), a story based upon the Leo Frank murder case in which a black woman was killed and her assailant convicted because of the testimony of a black janitor. Other movies reviewed in this chapter include THE DUNGEON (1922), BIRTHRIGHT (1924), A DAUGHTER OF THE CONGO (1930), THE EXILE (1931), TEMPTATION,

UNDERWORLD (both in 1936), GOD'S STEPCHILDREN (1938), and THE BETRAYAL (1948).

Chapter 4 offers a good overview of the white independents, including early production organizations like the Ebony Film Company (set up in Illinois in 1915), The Birth of a Race Photoplay Corporation (chartered in Delaware in 1917), and the Democracy Film Corporation (incorporated in California in 1919). Other important companies reviewed are the Reol Production Company, the Colored Players Film Corporation, the Dunbar Film Corporation, Million Dollar Productions, Associated Features, Hollywood Productions, Jubilee Pictures, International Roadshows, Astor Pictures, and Sack Amusement Enterprises. Highlighted in this brief chronicle are the activities of Bert and Jack Goldberg, Swan Micheaux, Ralph Cooper, and Ted Toddy.

Chapter 5 briefly examines the activities of independent black filmmakers who organized, operated, and financed movies targeted for black audiences nationally from 1912 to 1950. Starting with William Foster's pioneering efforts between 1910 and 1916, the survey includes thumbnail comments on ventures like the Unique Film Company, the Leigh Whipper Film Company, the Colored and Indian Film Company, Cooper-Randol Productions, and Harlem Productions. In all, the number of companies averaged out a little better than one a year over the forty-year period, although factually ninety percent of the ventures occurred during the silent era.

Although the primary focus of Chapter 6 is concerned with presenting in chronological order synopses of over 125 black films produced between 1910 and 1950, the author begins with a valuable introduction to the problems blacks and whites faced in making the "underground" films that varied considerably in terms of artistic and commercial success. Almost all were in the "C" category. The reasons for their lack of quality, Sampson explains, were related not only to poor resources and limited distribution outlets, but also to the impact that inadequate facilities and shooting schedules had on the performers employed. To prove his point, the author includes extensive quotations from black periodicals like the CHICAGO DEFENDER, the PITTSBURGH COURIER, and the Baltimore AFRO-AMERICAN to illustrate the problems the filmmakers faced from within and without the film industry. As a result, the efforts of organizations like the Lincoln Motion Picture Company, the Micheaux Film Corporation, and the Colored Players Film Corporation appear remarkable for their time. A major disappointment in this important section is that no information is provided on lost or destroyed movies.

The book's last chapter offers brief biographical sketches in alphabetical order of over seventy black performers. For the most part, Sampson explains in his introductory remarks, these actors and actresses came from black dramatic stock companies, as well as from musical comedies, vaudeville, and the nightclub circuit. Among the more notable performers cited are Clarence Brooks, Anita Bush, Ralph Cooper, Dorothy Dandridge, Herb Jeffries, Noble M. Johnson, Lena Horne, Mantan Moreland, and Lillian Randolph. Regrettably, Sampson makes no effort to be critical in his sketches and thus produces lackluster and intellectually vapid summaries of aggressive and articulate black artists such as Charles Gilpin, Rex Ingram, Clarence Muse, and Lincoln Perry (Stepin Fetchit). A notable omission is any information on Paul Robeson, although the noted actor's role in BODY AND SOUL (1925) is documented in the book.

In addition to the more than sixty well-chosen and reproduced illustrations (including pictures of businessmen and film posters), there are three appendexes. The first lists over 380 all-black films produced by independent filmmakers between 1904 and 1950. The second provides a partial listing of 167 (including sixty-five black) individuals and corporations organized to produce black-cast films from 1915 to 1950. The third provides film credits for featured performers in black-cast films from 1915 to 1950, with asterisks identifying biographical information reported in Chapter 7. A useful index concludes this helpful resource. Recommended for special collections.

*Yearwood, Gladstone L., ed. BLACK CINEMA AESTHETICS: ISSUES IN INDEPENDENT BLACK FILMMAKING. Athens: Ohio University, 1982. Illustrated. 120pp.

A critical and scholarly monograph discussing the dimensions of a black film aesthetic, this publication pays particular attention to an interdisciplinary approach to the problems of an African-American cinema as distinguished from a black-oriented cinema modeled after the standard Hollywood fare. The essays themselves represent perspectives from historians, theorists, critics, and filmmakers. Yearwood makes clear in his stimulating introduction, that an alternative to the Hollywood model is mandatory for independent black filmmakers. "What one finds," the editor explains, "is that the best black cinema is that which explores cinematic models and content which lie outside traditional cinema." The problem for the filmmakers is that they must work in mainstream cinema if they are going to transform the expectations of the industry and the audience. SHAFT (1971) is a case in point. Not only does it illustrate the parameters that Hollywood places on black expression, but it also demonstrates how the film industry utilizes black consciousness and militant themes to bolster its profits. Thus, for Yearwood, the difference between an exploitation film and a black film is that the former "portrays thoughtless anger, mad vengeance, and portrays miserable types in romantic terms" whereas a movie like SWEET SWEETBACK'S BAADASSSSS SONG (1971) "refuses to glorify the violence of social oppression and the low-comic masquerade of a castrated existence." In essence, exploitation films mock black consciousness; black films acknowledge and describe it.

Thomas Cripps's "New Black Cinema and Uses of the Past" is the first of the anthology's nine essays. Stressing the importance of history to modern filmmakers, the distinguished author cites the period between 1968 and 1973 as an example of how naive black artists were about the past, present, and future. They failed to see how the film and television industries fragmented large producing units into smaller and more competitive entities that eventually made black filmmakers lose touch with their audiences and financiers. What is needed, Cripps argues, is a "critical canon of past black filmmaking." For example, he points out that a study of the problems Emmett J. Scott encountered during the making of THE BIRTH OF A RACE (1919) "provides the earliest single opportunity to study in great detail the combination of social and economic forces that conspire to affect the content of black films." In other words, Cripps advocates studying film as sensitive document about and by blacks.

Each of the other eight essays adds to Cripps's perspective. Vattel T. Rose's "Afro-American Literature as a Cultural Resource for a Black Cinema Aesthetic" is another argument for the importance of tradition in the lives of independent black filmmakers. After making it clear that the uniqueness of African-American literature is its "folk or oral tradition of black American culture," the series editor notes that the "inherited past" benefits black filmmakers through examples, but warns them not to limit their films to protests alone. He stresses the need to explore the entire black experience. Pearl Bowser's "Sexual Imagery and the Black Woman in American Cinema" contrasts briefly the Hollywood stereotypes identified as "mulatto mistress, faithful soul, sultry singer, mammy, high yallar, chocolate dandy, foxy, chick" with the counter images portrayed by black independent filmmakers. Yearwood's edited version of a colloquy on the relationship of SWEET SWEETBACK'S BAADASSSSS SONG to the contemporary black film movement highlights the reactions of Melvin Van Peebles, St. Claire Bourne, Haile Gerima, and Pearl Bowser to the controversial 1971 film. Yearwood's "Towards a Theory of Black Cinema Aesthetic" explores the reasons why it is important for black filmmakers to gain economic control over their films. Harold Weaver's "The Politics of African Cinema" compares and contrasts African with American filmmakers. In addition to pointing out the obvious differences in the areas of production, distribution, and exhibition, the author stresses the adversary relationship of African artists like Ousmane Sembene, who view films primarily as a weapon in the struggle for political, social, and economic liberation. St. Clair Bourne's "The Development of the Contemporary Black Film Movement," provides an inside look at the goals and problems of an important independent black filmmaker. Haile Gerima's "On Independent Black Cinema," eloquently echoes Cripps's insistence on the importance of history as a means to achieving artistic freedom. "A sense of

history," Gerima writes, "provides a context and a meaning for one's world; and struggle must play a central role in the course of this history." He therefore insists that black filmmakers reject the idea of film as entertainment and instead view it as a means of questioning the STATUS QUO and raising important questions about what is needed to make society better. Tony Gittens's "Cultural Restitution and Independent Black Cinema" concludes the collection with a plea that independent black filmmakers become spokespeople for reinforcing black cultural pride in the ethnic and national pride of African-Americans.

The value of this slim volume goes beyond the fact that it remains one of the few books to explore an interdisciplinary approach to a black cinema aesthetic. Not only are the essays stimulating reading and thought-provoking experiences, but they also summarize ideas more pedantically argued in other works. Hopefully, future symposia will follow and result in publications of this quality. When that occurs, editors should include bibliographical information and take time to proofread the material carefully. Recommended for special collections.

HARRY BELAFONTE

Shaw, Arnold. BELAFONTE: AN UNAUTHORIZED BIOGRAPHY. Philadelphia: Chilton Company, 1960. Illustrated. 338pp.

DOROTHY DANDRIDGE

Dandridge, Dorothy, and Earl Conrad. EVERYTHING AND NOTHING: THE DOROTHY DANDRIDGE TRAGEDY. New York: Abelard-Schuman, 1970). Illustrated. 215pp.

*Mills, Earl. DOROTHY DANDRIDGE: A PORTRAIT IN BLACK. Los Angeles: Holloway House Publishing Company, 1970. Illustrated. 250pp.

SAMMY DAVIS, JR.

*Davis, Sammy, Jr. HOLLYWOOD IN A SUITCASE. New York: William Morrow and Company, 1980. Illustrated. 288pp.

*Davis, Sammy, Jr. et al. WHY ME? THE SAMMY DAVIS STORY. New York: Farrar, Straus & Giroux, 1989. Illustrated. 374pp.

*Davis, Sammy, Jr., et al. YES I CAN: THE STORY OF SAMMY DAVIS, JR. New York: Farrar, Straus and Giroux, 1965. Illustrated. 630pp.

LENA HORNE

*Horne, Lena, and Richard Schickel. LENA. New York: Signet, 1965. Illustrated. 224pp.

EARTHA KITT

Kitt, Eartha. ALONE WITH ME: A NEW AUTOBIOGRAPHY. Chicago: Henry Regnery Company, 1976. Illustrated. 276pp.

SIDNEY POITIER

*Ewers, Carolyn H. THE LONG JOURNEY: A BIOGRAPHY OF SIDNEY POITIER. New York: Signet, 1969. Illustrated. 126pp.

Hoffman, William. SIDNEY. New York: Lyle Stuart, 1971. Illustrated. 175pp.

Kelley, Samuel Lawrence. THE EVOLUTION OF CHARACTER PORTRAYALS IN THE FILMS OF SIDNEY POITIER: 1950-1978. New York: Garland Publishing, 1983. 279pp.

*Marill, Alvin H. THE FILMS OF SIDNEY POITIER. Introduction Frederick O'Neal. Secaucus: Citadel Press, 1978. Illustrated. 224pp.

*Poitier, Sidney. THIS LIFE. New York: Alfred A. Knopf, 1980. Illustrated. 374pp.

PAUL ROBESON

*Duberman, Martin Bauml. PAUL ROBESON. New York: Alfred A. Knopf, 1988. Illustrated. 804pp.

Seaton, Marie. PAUL ROBESON. London: Denis Dobson, 1958. Illustrated. 254 pp.

DIANA ROSS

*Berman, Connie. DIANA ROSS: SUPREME LADY. New York: Popular Library, 1978. Illustrated. 174pp.

*Taraborrelli, J. Randy. DIANA. Garden City: Doubleday and Company, 1985. Illustrated. 246pp.

ETHEL WATERS

Waters, Ethel, with Charles Samuels. HIS EYE IS ON THE SPARROW: AN AUTOBIOGRAPHY. Garden City: Doubleday and Company, 1951. Illustrated. 278pp.

FILMS

THE GREEN PASTURES (Warner--16mm: 1936, 93 mins., b/w, sound, R-MGM)
 Marc Connelly scripted and co-directed with William Keighley, this adaptation of Connelly's Broadway fantasy about a black heaven and De Lawd's visit to earth. The differences between the play, its original source (Roark Bradford's OL' MAN ADAM AN' HIS CHILLUN), and the film are discussed in detail in Thomas Cripps's analysis of the screenplay. A study of the film provides an excellent introduction not only to the controversial stereotypes of the period, but also to the problems of depicting an important aspect of black culture and racial relations. The fine cast

includes Rex Ingram (De Lawd, Adam, Hezdrel), Oscar Polk (Gabriel), and Eddie Anderson (Noah).[1484]

HOME OF THE BRAVE (United Artists--16mm: 1949, 88 mins., b/w, sound, R-BUD, CHA, FCE, FDC, FNC, IVY, KPF, VCI, WCF, WHO, WIL: S-A)

A transformation of Arthur Laurents's play about anti-Semitism, the Stanley Kramer production was scripted by Carl Foreman and directed by Mark Robson. James Edwards stars as the black soldier whose hysterical paralysis is the result of racial incidents during a reconnaissance mission on an enemy-held island. Jeff Corey plays the sympathetic white physician who finally brings about Edwards's cure, which includes calling him, strictly for medical reasons, "a dirty nigger." The film illustrates not only Hollywood's approach to "race problems" in the late 1940s, but also whether much progress had been made since the early days of movies.

LILIES OF THE FIELD (United Artists--16mm: 1963, 97 mins., b/w, sound, R-BUD, FNC, MGM, ROA, TWY, WES, WHO)

Directed by Ralph Nelson, the James Poe screenplay (based on William E. Barrett's novel) shows what happens to Homer Smith (Sidney Poitier) when he accidentally encounters a handful of nuns trying to breathe life into their Arizona desert homestead. Not knowing much about farming, the five East German refugees come to rely heavily on the ex-WWII soldier to repair and to restore the farm left to them by their Holy Order. The internal struggle that Smith wages over his responsibility to the nuns highlights as well as any film the types of roles Poitier took up to the mid-1960s. If for no other reason, the film deserves viewing to discover what Hollywood considers the only black performance in the history of motion pictures to win an Oscar for Best Actor. Nominated for four Oscars, including Best Film, Best Screenplay Based on Material from Another Medium, and Best Cinematography (Ernest Haller), it won only for Best Actor.

NOTHING BUT A MAN (Cinema V--16mm: 1963, 92 mins., b/w, sound, R-CAL, FNC, MAC, SUF)

Produced by Michael Roemer and directed by Robert Young, this was the first important film by white artists operating in the commercial cinema to dare portray in sensitive and humane terms, the struggle of a young black couple in a segregated society. The film is somewhat dated by the absence of any statement of the militant black position at the end of the sixties, but Ivan Dixon and Abbey Lincoln give two of the strongest black performances in the history of African-American screen images.[1485]

PAUL ROBESON: TRIBUTE TO AN ARTIST (Sunrise--16mm: 1979, 29 mins., color, sound, R-FNC, TWY)

[1484] In addition to Cripps's study, see "Cinema: The New Pictures," TIME 27:26 (June 29, 1936):38-40.

[1485] BLACK FILM AS GENRE, pp.115-27; Frank Manchel, "Film Study: NOTHING BUT A MAN," MEDIA AND METHODS 4:2 (October 1967):10-3; ___, "Movies and Man's Humanity," TEACHING THE HUMANITIES: SELECTED READINGS, ed. Sheila Schwartz (New York: Macmillan Company, 1970), pp.192-200; and Saul B. Cohen, "Michael Roemer and Robert Young: Film Makers of NOTHING BUT A MAN," FILM COMMENT 3:2 (Spring 1965):8-13.

Narrated by Sidney Poitier and directed by James Earl Jones, this useful documentary traces Robeson's career through filmed interviews, newsclips, and stills. The focus is on his outspoken attacks on racism and intolerance and the reactions they produced.

SWEET SWEETBACK'S BAADASSSSS SONG (Van Peebles--16mm: 1971, 97 mins., color, sound, R-DCL)

Written, directed, and scored by Melvin Van Peebles, the story deals with a ghetto brothel boy who grows into an angry man who fights a corrupt white police force and survives. Van Peebles gives a strong performance as a superstud who turns on his oppressors and then finds help in the black community as he flees from the white man's law. [1486]

FILM AND CENSORSHIP

A major conclusion to be drawn from what has been discussed so far is that ever since the birth of American movies powerful and influential people and institutions have viewed the medium as a threat to the social, political, and economic values of traditional culture. No matter where we have turned--the role of celebrities in our lives, the nature of the film continuum, or the stereotyping of minorities--we have come face-to-face with the fear that the movies do irreparable damage to individuals, groups, and national interests. It is appropriate, therefore, that we conclude this chapter with a reminder of how Hollywood responds to the attempts from inside and outside of the film industry to control and to manipulate movies for purposes other than entertainment. Our concern is with identifying a few of the problems that filmmakers face in a conservative industry that is constantly under attack from well-meaning but often naive critics. No attempt is made to deal in depth with any one issue, except to point out the ties between censorship and stereotyping. At the outset, it is useful to remember that not only are movies part of a large entertainment network that continues to shape American values, attitudes, and national policies, but also that our understanding of the process remains limited. The exercise that follows represnts the hope that others will explore more fully the relationship between what is seen and how and why it is produced.

The threat of censorship is undoubtedly a factor in film stereotyping. Fear about what will be rejected at the box office is directly tied to fear about what will be projected on the screen. As discussed earlier, the self-styled guardians of American values and customs have always tried to control the types of information available to the general public, because of fears that the wrong type of message or image would distract the young, impressionable, or criminal elements in society from adhering to the social structure determined by those in positions of power. Almost from the birth of the movies, politicians, reformers, and religious leaders sensed the power of the medium to alter the STATUS QUO. One only had to go to the movies to see how the working classes could use the medium as a means for comparing their status with that of the middle and upper classes. Assimilationists found the movies an ideal classroom for learning how to integrate into American society. If people were to be "persuaded" to accept the teachings of their "betters," it was imperative to the preservers of tradition that the movies be controlled. Otherwise, there was no way "to protect" the masses from the dangers of the "immoral" and "politically dangerous" mass medium.

[1486] In addition to Diakite's comments (pp.106-13), see *Melvin Van Peebles, SWEET SWEETBACK'S BAADASSSSS SONG (New York: Lancer Books, 1971); BLACK FILM AS GENRE, pp.128-40; Murray, pp.72-82; "Sweet, Sweetback's Baadasssss Song and the Development of the Contemporary Black Film Movement," BLACK CINEMA AESTHETICS, pp.55-66; and Gladstone L. Yearwood, "Towards a Theory of a Black Cinema Aesthetic," ibid., pp.67-81.

The pioneering filmmakers intuitively understood their ability to aid in making America a new nation, conceived in liberty and dedicated to the proposition that only the most modern and clever people will become successful. What added to the lifelong struggle between the traditionalists and the filmmakers was the fact that those who made the movies so powerful didn't fit into the traditional robes of authority. It didn't matter that they hungered to be accepted by the "right" people. It didn't matter that their films were the best possible propaganda for the Melting Pot philosophy. It didn't matter that they preferred accommodation to confrontation. What counted most, as will be discussed in Chapter 5, is that the men who rose to become the titans of the movie business were mostly Jewish immigrants and their assimilated offspring who spoke, dressed, and behaved differently from the guardians of traditions. In effect, film moguls symbolized everything America's religious and social elite found objectionable in the twentieth century. And because the film industry built its fortunes on the premise that formula filmmaking was the most productive means to maximizing profits, film stereotypes of American life were accused of formenting almost every social, political, and economic problem the country experienced.

The more the industry relied on stereotypes, the more it was attacked. Humanists claimed stereotypes were incompatible with art, social reformers claimed that stereotypes weakened our values, and political leaders felt that stereotypes undermined their ability to govern. Of course, the filmmakers, with their tawdry values and racist conventions, contributed mightily to their own problems. Ignorance and arrogance are not the best defenses against centuries of claims of moral and social superiority.

It is small wonder then that there have been so many attempts to coerce the industry into producing only certain types of films, and those only in prescribed ways. The story of the movies' battles with censors is an old tale, going as far back as 1907 when Chicago's political pundits enacted legislation empowering the police chief to edit or to prevent any film from being shown, even before anyone had seen it. A year later New York's mayor closed all the nickelodeons in town "because of the serious opposition by the rectors and pastors of practically all the Christian denominations in the city and because of the further objection of the Society for the Prevention of Crime."[1487] The theaters reopened only after they had promised that no films would be shown that tended to degrade the morals of society.

The conservative filmmakers got the message: Clean up your act or go out of business. By now the Trust was in power and, as discussed earlier, dominated the industry. Although the members of the Trust were responsible for manufacturing and distributing most of the products of the cheap, popular form of amusement, they were not foreigners nor were they considered outsiders. Thus it was decided that the industry and the traditionalists could work together to form a censorship group that could "police" the movies and retain the values of the institutions supported by the white reformers, religious leaders, and ambitious politicians. Enter the New York Board of Motion Picture Censorship (renamed in 1915 THE National Board of Review of Motion Pictures), the forerunner of schemes by filmmakers to maintain the STATUS QUO and to ensure that profits would not be impeded by local censors and federal legislation. The idea was to have a seal of approval granted to acceptable films. Its motto was "selection, not censorship."[1488] How the board operated is described in many books. We need only note here that it contained within its operation a series of fatal flaws. First, it relied on volunteers for its decisions. Second, it depended

[1487] Mauritz Hallgren, LANDSCAPE OF FREEDOM (New York: Howell Soskin and Company, 1941), p.339.

[1488] THE PUBLIC RELATIONS OF THE MOTION PICTURE INDUSTRY (New York: Department of Research and Education, Federal Council of the Churches of Christ in America, 1931). Cited in Donahue, p.37.

on the good offices of the Trust for support and cooperation. And third, the standards for giving its approval were never defined.

Despite its pitiful credentials and simplistic ideals, the board became the prototype for similar bodies across the country. More significantly, well-organized pressure groups, working through such bodies, were successful in helping to get laws passed to ban certain films as indecent. Ordinances were enacted that gave the police the right to shut movie houses that showed "harmful films"; and when the exhibitors appealed, the high courts, such as the Supreme Court of Illinois, ruled that the ordinances were necessary "to secure decency and morality in the moving-picture business, and that the purpose falls within the police power."[1489] In 1915, the U. S. Supreme Court, in MUTUAL FILM CORPORATION V. INDUSTRIAL COMMISSION OF OHIO, 236 U. S. 230, ruled unanimously that states had the power to censor movies, even before they had public screenings. The justification for prior restraint was based on the assumption that the movies' potential for causing harm far outweighed any other issues of justice or fair trade. The decision remained in effect until the early 1950s.

The history of the movie industry's fight with the censors revolves around an age-old debate. In simplified terms, the basic issue seems to be whether or not film as an art has the right to create whatever images, stereotyped or not, it wants. The philosophical question can be seen in the contrasting positions on freedom and art taken by Susanne Langer and Mortimer Adler. As discussed earlier, Langer's pragamtic position is that society and the individual must be allowed to interact. The artist gives form to reality, and the communication between the artist and the audience is the basis of the creative experience. Therefore, artists need their freedom.[1490] Adler, on the other hand, takes the position that there should be an absolute value by which the work of art has to be measured. Things are either right or wrong in relation to the ideal. Thus, there must be some standards for artists outside the work of art, and hence the need for censorship.[1491] In spite of their differences, both of the authors recognize the importance of art as a channel for the individual's self-realization.

The struggle by Hollywood to resolve those two positions tells us as much about the history of America's social and political values as it does about film stereotyping. For our purposes, we need to realize that the most powerful form of film censorship is the self-regulation created by the producers and distributors themselves. It was clear by the end of the teens that outside censoring bodies like the National Review Board were powerless to regulate the actions of the film industry. It was also clear that Hollywood, as will be discussed in Chapter 5, had become in a few short years the symbol for traditionalists of a modern Sodom and Gomorrah. As a last resort, "foreigners" like Carl Laemmle, Marcus Loew, and Adolph Zukor went in search of a respectable Gentile to head some form of industry self-regulation that would appease the bastions of respectability. Started in 1922 under the direction of Will Hays, and with the intention of protecting the industry against outside interference, the MPPAA has for more than sixty-seven years been the most formidable censor in filmmaking.

[1489] James Jackson Kilpatrick, THE SMUT PEDDLERS (Garden City, N.Y.: Doubleday and Company, 1960), p.171.

[1490] For more information, see Langer's two major works, PHILOSOPHY IN A NEW KEY: A STUDY IN THE SYMBOLISM OF REASON, RITE AND ART and *FEELING AND FORM: A THEORY OF ART DEVELOPED FROM "PHILOSOPHY IN A NEW KEY."

[1491] For more information see Adler's ART AND PRUDENCE: A STUDY IN PRACTICAL PHILOSOPHY.

It operated, at least up to November 1, 1968, mainly through a motion picture code, that prescribed what could and could not be shown in films.[1492]
Lest anyone dismiss too quickly Hays's influence or power during his twenty-three-year reign as "czar" of the motion picture industry, let me comment briefly on what followed his taking office in 1922. By the end of the year, over thirty states that had bills calling for the creation of some form of film censorship decided to let Hays handle the movies as he saw fit. Banks that had refused to underwrite theater expansion, film production, and corporate acquisitions now became friendly. Within three years, the tide had turned against the traditionalists and in favor of the film industry. It wasn't that Hays's code had really reformed movies. It was the fact that a highly respected Christian statesman, suitably connected to Washington insiders, was at the helm. By the middle of the decade, however, Hays's pronouncements were no longer acceptable to reformers. Nearly all of the states were threating once again to enact legislation against films. To protect the industry, Hays forced the filmmakers to agree to a "formula" for self-regulation of the movies. All original screenplays had to be approved by Hays prior to beginning production. When that idea failed, a second "formula" was enacted in 1927: "The Don'ts and Be Carefuls" Code. Although the edict had no teeth, it briefly affected how films were made. Consider, for example, Rule 21 of the Code:

Resolved, that those things which are included in the following list shall not appear in pictures produced by the members of this association irrespective of the manner in which they are treated;
1. Pointed Profanity--by either title or lip--this includes the four words, "God," "Lord," "Jesus," "Christ," (unless they be reverently used in connection with proper religious ceremonies), "hell," "damn," "Gawd," and every other profane and vulgar expression however it is spelled;
2. Any licentious or suggestive nudity--in fact or in silhouette and any lecherous or licentious notice thereof by other characters in the picture;
3. The illegal traffic of drugs
4. Any reference to sex perversion
5. White slavery
6. Miscegenation (sex relationships between white and black races)
7. Sex hygiene and venereal disease
8. Scenes of actual childbirth--in fact or silhouette
9. Children's sex organs
10. Ridicule of the clergy
11. Willful offense to any nation, race, or creed
And be it further resolved, that special care be exercised in the manner in which the following subjects be treated, to the end that vulgarity and suggestiveness be eliminated and that good taste be emphasized:
1. The use of the flag
2. International relations (avoiding picturizing in an unfavorable light another country's religion, history, institutions, prominent people, and citizenry);
3. Arson
4. The use of firearms
5. Theft, robbery, safe-cracking, and dynamiting of trains, mines, buildings, etc. (having in mind the effect which a too-detailed description of these may have upon the moron);

[1492] See Appendix III for the 1927 section of the Code, often listed as "The Don'ts and Be Carefuls.

 6. Brutality and possible gruesomeness
 7. Techniques of committing murder by whatever method
 8. Methods of smuggling
 9. Third degree methods
10. Actual hangings or electrocutions as legal punishment for crime
11. Sympathy for criminals
12. Attitude toward public characters and institutions
13. Sedition
14. Apparent cruelty to children and animals
15. Branding of people or animals
16. The sale of women, or of a woman selling her virtue
17. Rape or attempted rape
18. First night scenes
19. Man and woman in bed together
20. Deliberate seduction of girls
21. Surgical operations
22. The institution of marriage
23. The use of drugs
24. Titles or scenes having to do with law enforcement or law-enforcing officers;
25. Excessive or lustful kissing, particularly when one character or the other is a "heavy."

Each of these restrictions helped shape film stereotypes in the twenties.

Using these guidelines, think back on what minorities faced as they struggled to gain a foothold in the film industry, on the pressures of filmmakers to make profitable products, on the needs and desires of audiences for entertainment and information, on the demands of artists to create a revolutionary new art form, and on the aspirations of socially conscious groups to use the medium as a source of enlightenment and education. No wonder social historian Robert Sklar writes that "To speculate about the cultural messages of movies en masse is to display one's skill at fantasy, philosophy or metaphor."[1493]

Hays's most difficult time came during the height of the Depression, when almost no one in the nation doubted the power and influence of the movies for maintaining the country's myths and morale. For a while, Hays was able to weather the attacks by traditionalists over the sexual promiscuity and immorality in the gangster films starring Edward G. Robinson, James Cagney, and Paul Muni; the sensational melodramas featuring Marlene Dietrich, Joan Crawford, and Greta Garbo; and the uproarious comedies of Mae West and the Marx brothers. Even when the Payne Fund studies reported their negative conclusions, as discussed earlier, Hays was able to insist that movies had the power to heal the nation's wounds and divert the people from their problems. But there was no way he could ignore the toll that the Depression was taking at the box office.

Adding to the decline in profits was the best organized and most powerful censoring body in America: the Roman Catholic church. In 1933, it had created the National Legion of Decency, an organization that made it possible for over twenty million Catholics to be encouraged to boycott any film that the church disapproved of. Furthermore, the church completely endorsed the new Motion Picture Production Code that had been written by their "representatives" Martin I. Quigley and Father Daniel A. Lord in 1929-1930. In an effort to protect profits and to assure the Roman Catholic clergy that Hollywood would honor the new Code,[1494] Hays persuaded the Jewish-dominated industry to accept a Production Code Administrator recommended by the Catholic hierarchy, Joseph I. Breen. In the spring of 1934, Breen was

[1493] MOVIE-MADE AMERICA, p.87.

[1494] See Appendix IV for a copy of the Code.

empowered to accept, censor, or reject any film made by Hollywood. No film could be shown in theaters controlled by the MPPDA unless it had a "seal of approval." Filmmakers who released their films without that seal were fined $25,000. The no-nonsense Breen took his job quite seriously. Together with Hays, the PCA exercised somewhat negotiable but absolute power over film content for the next two decades.[1495] What made Hays and Breen so powerful was the fact that they were practical men. They knew that the successful relationship between profits and purpose was predicated on satisfying both traditionalists and the public. The ingenious way they resolved the dilemma was to sanction almost any reasonable risque or violent act as long as the film concluded with "sinful" people being punished and traditional values being vindicated. Moreover, the Breen Office functioned as it did and for as long as it did because the movie moguls found it both profitable and prestigious to see themselves as the keepers of the flame.

It is undeniable that the code severely limited what could and could not be depicted about the human condition. As we have seen, it affected language, dress, behavior, and specific events. What is generally ignored is what the code allowed the filmmakers to achieve in solidifying and/or reshaping national values. Once that is understood, we will have a better understanding of the role of censorship in film history. For example, how effective was the code in providing a national forum for the problems related to class struggles? How accurately did it reflect the national will in the 1930s and 1940s? Most intriguing, what role did Breen play on a daily basis in the way minorities, topical issues, and sensitive matters were put on screen?

Between 1934 and the mid-1950s, social critics waged an uphill battle against the film industry. While there were many individuals and groups that questioned film motives and images, they remained, as we have seen, relatively powerless to alter film conventions. When changes did occur, as in the case of minority stereotypes, they were achieved not only by federal pressure but also by the organized efforts of articulate leaders appealing to the filmmakers as responsible guardians of national values. Shame, not sin, appeared to motivate a growing body of liberal filmmakers who guided Hollywood through the war years. From the vantage point of today, their efforts seem weak and superficial; their values, overly sentimental and naive. But anyone who studies the era is quickly sensitized to the enormous worldwide power that the movies attained over the emotions of their audiences. They gained and maintained that power by appealing to the fantasies and values of generations steeped in racial bigotry and massive ignorance. If changes were to be accomplished, the filmmakers first had to gain the trust and loyalty of their patrons. Then through the manipulation of conventions, as discussed in Chapter 2, there was a possibility of introducing new values and doing away with old prejudices. In short, reform could follow only profitable formulas.

Between 1941 and 1954, Hollywood underwent a number of crises that forced a restructuring of the industry and led inevitably to a weakening of self-regulation vis-a-vis the Breen Office and the code. To summarize earlier discussions, political battles within the industry divided the filmmakers, created powerful guilds, and weakened the authority of producers. Federal legislation forced a restructuring of the industry itself. New styles of filmmaking like FILM NOIR and the temporary influence of progressive artists rekindled debates over what was permissible film content. Alternative forms of recreation plus mass migrations of white people away from big cities to suburban areas dramatically changed the size and nature of the moviegoing public. TV's displacement of the movies as the major form of entertainment resulted in the industry's reevaluating its methods and policies. These were but a few of the reasons why the conservative leaders of the film industry acquiesced to

[1495] Two of the most famous cases involved GONE WITH THE WIND (1939), when Selznick agreed to pay $5,000 to let Gable give the famous line, "Personally Scarlett, I don't give a damn"; and Hughes's release of THE OUTLAW (1943) without the seal of approval and then being forced to withdraw the film.

the demands that the old forms of self-regulation had to go. The new "realism" on the screen required more freedom in treating social and political issues. Liberal filmmakers demanded more latitude in what they created if they were going to appeal to a more socially aware audience. Even the traditionalists found they could no longer depend on the support of their constituencies. For example, Otto Preminger's THE MOON IS BLUE (1953), denied a Seal of Approval by Breen, not only did well at the box office and won its legal battle before the Supreme Court but also led to Breen's retirement from the film industry. Breen's successor, Geoffrey Shurlock, tried to mollify everyone by liberalizing what films his office would approve. But Elia Kazan's BABY DOLL (1956) proved that neither Shurlock nor the Legion of Decency held much influence with the public. By the early sixties, the days of powerful self-regulation were over. Social, political, and economic conditions had rendered the modern code meaningless.[1496]

A new approach was necessary to put the film industry even more in touch with the times. Ever since Eric Johnston replaced Hays and changed the name of the MPPDA to the Motion Picture Association of America (MPAA) in 1945, the industry was searching for some way to prevent the erosion of self-regulation. Its failure to control film content, effectively, and thus stem the increase of explicit sex and violence in films, had multiplied the industry's critics. And once attendance started its steep decline in the late 1940s, the film industry became bewildered by its inability to gauge what the public wanted and what was responsible filmmaking. Johnston's death in 1964 and the industry's increasingly miserable box-office performance (except for 1964) intensified the search for a solution to the self-regulation problem. After two years of floundering, the industry's leaders settled on Jack Valenti as their new spokesperson. That same year, as Donahue points out, the Supreme Court ruled in GINSBERG V. NEW YORK, "that material which was not obscene for adults might be obscene for children. That day (April 22, 1966) INTERSTATE CIRCUIT V. DALLAS declared that a classification system for films could be constitutional if guidelines were clearly defined."[1497] Almost immediately, Valenti scrapped the code concept and adopted a ratings system.

The new labeling game began in 1968. Films are now designated G, PG (formerly M, later GP), PG-13, R and X. G means that it's safe to take anyone to the film. PG says pretty much the same thing, except the producers feel that it's best to have parents give their permission before an adolescent hears a four-letter word or empathizes with a promiscuous line of thought. The catch is that no proof of parental permission is required at the box office. PG-13, introduced in 1986 as a reaction to the gratuitous use of drugs in teenage films like SIXTEEN CANDLES (1984), alerts parents to the fact that the filmmakers may have inserted enough objectionable material to make the movie questionable to traditionalists but not to the six anonymous Californians who serve on the ratings board overseen by Valenti, Richard Fox (the head of the National Association of Theater Owners),[1498] and Richard D. Heffner (Chairperson of the Ratings Board). R steps up the admission price because it theoretically requires the adolescent to be accompanied by an adult. And X means no one under seventeen admitted.[1499]

[1496] See Appendix IV: The Motion Picture Code in the sixties.

[1497] Donahue, p.40.

[1498] William F. Kartozian was elected the new president of NATO in September, 1988.

[1499] For a useful discussion read, Bruce A. Austin, "The Influence of the MPAA's Film-Rating System on Motion Picture Attendance: A Pilot Study," JOURNAL OF PSYCHOLOGY 106 (1980):91-9; Vincent Canby, "Are the Ratings Just Alphabet Soup?" NEW YORK TIMES 2 (April 20, 1986):19, 33; Patricia Robertus and Rita James Simon, "The Movie Code: A View from Parents and Teenagers," JOURNALISM QUARTERLY 47 (Autumn 1970):568-9, 629; Gene Shalit, "The Rating Game," LOOK 34:22 (November

The effect of Valenti's plan is to allow filmmakers greater freedom in film content, but, at the same time, to alert parents to the nature of controversial movies. In that way, exhibitors who like to take advantage of the public's voyeuristic desires are limited in whom they can appeal to. In essence, greater flexibility for the filmmaker, more information for the public, and less freedom for the exhibitor. In fact, as Walter Goodman observes, "only 5 percent of the 7,000 movies rated up to January 1986 received an X . . . [and] not a single X was issued in all of 1985."[1500]

Contrary to public opinion, the biggest money-makers are not the X films. As Fletcher Knebel points out in 1970:

> VARIETY'S year-end survey shows that of the seven films that yielded $11 million or more in rental fees to distributors in 1969, only one, MIDNIGHT COWBOY, was an alienated-youth influx thing. The rest were "family" pictures, returning millions to the distributors last year--THE LOVE BUG $17 [million]; FUNNY GIRL, $16.5; BULLITT, $16.4; BUTCH CASSIDY AND THE SUNDANCE KID, $15; ROMEO AND JULIET, $14.5; and TRUE GRIT, $11.5. COWBOY ranked seventh at $11. (In movie parlance, a "family" film can include scores of instant corpses, done in murder, slaughter, war, perfidity, accident or more domestic annoyance, but positively no action by live human reproductive organs between the killing.)[1501]

Knebel's observations appeared premature in the decade that followed. Thanks to hit films like DEEP THROAT (1972), pornography soared and became big business, accenting America's hypocrisy over what it outlawed in public and supported in private. But by 1986, the novelty of explicit sex had worn off. As Nicholas D. Kristof discovered, the pornography industry had fallen on hard times. Partly because of legal challenges, political pressures, and health concerns, partly because of a growing awareness of how such products demean those who watch and support them, and partly because of the public having grown tired of the pedestrian productions themselves, Kristof reports that while the X-rated film industry still believes that a market exists for "adult" videocassettes, the pornographic film industry is headed for bad times.[1502]

Nevertheless, the hue and cry against violence in the mass media continues to attract concerned broadcasters and self-appointed reformers. The National Coalition on Television Violence (NCTV), for example, claims that "horror, slasher, and violent science fiction movies have gone from 6 percent of box office receipts in 1970 to 30 percent of box office receipts [in 1984]."[1503] They further claim that their 950 studies and reports from the United States and from nearly twenty-five other nations over a half century of research prove that violence in the media is on the rise. Joining the NCTV in their crusade is Pat Collins, the arts and entertainment editor of "CBS

3, 1970):82, 86-9; Jack Valenti, "The Movie Ratings System," THE MOVIE BUSINESS BOOK, pp.362-72; and Donahue, pp.40-7.

[1500] Walter Goodman, "Grading Hollywood's Ratings System," NEW YORK TIMES 2 (July 27, 1986):19.

[1501] Fletcher Knebel, "Hollywood: Broke--And Getting Rich," LOOK 34:22 (November 3, 1970):52.

[1502] Nicholas D. Kristof, "X-Rated Industry in a Slump," NEW YORK TIMES F (October 5, 1986):1, 6. See also Stuart Taylor, Jr., "Justices, in 6-3 Ruling, Ease Curb on Seizure of X-Rated Materials," ibid., A (April 28, 1986):11; and "Defeated by Pornography," ibid., A (June 2, 1986):16.

[1503] Georgette Gouveia, "Editor Fights Violence in Movies," THE BURLINGTON FREE PRESS A (May 13, 1985):10.

Morning News." She has four suggestions for those who share her concerns. First, they should lobby the MPPA for a new film rating: "R-SV for excessive sex and violence." Second, state legislators should pass laws prohibiting people under eighteen years of age from renting or buying R-rated video tapes or discs. Third, the public should pressure broadcasters who feel compelled to show excessively violent and sexually oriented programs to do so only after nine o'clock in the evening, and not advertise them during the day. Fourth, everyone who agrees with her should boycott both violent Hollywood films and also the products of corporations that own the film studios that make such harmful movies.[1504]

Another recent concern is the fact that many young people can rent numerous R-rated films at the local videocassette store. Often parents don't know that their children are watching violent films like HALLOWEEN (1978), DRESSED TO KILL (1980), and SANTA (1981). "The R-rated 'Slasher' movies which feature brutal acts of violence against women," Jenny Pomeroy, president of the Junior League of Bronxville, N. Y., points out, "are ones more likely to get into the hands of children than the sexually obscene ones.[1505] As a result of aroused citizens' groups like the Westchester organization, a number of states are taking legislative action to require videocassette stores to display prominently the MPAA ratings and to ban the rental or sale of films rated R or X. According to Jon Nordheimer, "Legal experts said the flurry of legislation might help provide parents with a better idea of what materials their children are renting, but most felt the law would not be upheld on constitutional grounds if challenged in court."[1506]

Finally, the attorney general's Commission on Pornography reported in 1986, that the nation needed to fight the pornography industry aggressively through the combined efforts of vigorous law enforcement and vigilant citizens' groups.[1507] The strategies should include pressuring local prosecutors, scrutinizing judicial decisions, and, when necessary, boycotting merchants selling objectionable material. Although the eleven members disagree on some of the ninety-two recommendations made by the committee, there was general agreement that "a causal relationship" existed between pornography and criminal behavior. For example, in discussing sexually violent material, the Report specified certain types of scenes as objectionable:

Whether in magazine or motion picture form, the woman eventually becomes aroused and ecstatic about the intially forced sexual activity, and usually is portrayed as begging for more. There is also a large body of material, more "mainstream" in its availability, that portrays sexual activity or sexually suggestive nudity coupled with extreme violence, such as disfigurement or murder. The so-called "slasher" films fit this description, as does some material, both in films and in magazines, that is less or more sexually explicit than the prototypical "slasher" film.[1508]

[1504] Gouveia, p.10.

[1505] Cited in Jon Nordheimer, "New Issue as VCR's Expand: Violent Films and the Young," NEW YORK TIMES A (May 18, 1987):1.

[1506] Nordheimer, p.B9.

[1507] For a summary, see Philip Shenon, "2 on U. S. Commission Dissent on Pornography Link to Violence," NEW YORK TIMES A (May 19, 1986):17; Robert Pear, "Panel Calls on Citizens to Wage National Assault on Pornography," ibid., A (July 10, 1986):1, B7; Barbara Gamarekian, "Report Draws Strong Praise and Criticism," ibid., B7; "Excerpts From Final Report of Attorney General's Panel on Pornography," ibid., p.B7.

[1508] Ibid.

The fact that a majority of the eleven members of a national Commission believe that there is a causal relationship between pornography and criminal acts is one more example of the way in which the battle between art and censorship has discolored the history of films.

Indicative of the current mood toward obscenity was a 1987 ruling by the U. S. Supreme Court reaffirming the Court's prior decisions on First-Amendment restraints on government attempts to outlaw the sale of obscene material.[1509] By a vote of 5 to 4, the justices decreed that "judges and juries deciding whether sexually explicit material is legally obscene must assess the social value of the material from the standpoint of a 'reasonable person,' rather than applying community standards."[1510] The narrow vote, however, called attention to the deeply divided opinions on the subject. As Stuart Taylor, Jr., points out, the minority group attacks the ruling as "too vague" and claim that it "might have the same effect that the majority had found unconstitutional in the community standards yardstick--allowing jurors to find books and other materials obscene simply because they were deemed without value by the majority of the local population."[1511] The reason is that the high court overturned the community standards yardstick in MILLER V CALIFORNIA (1973) is because it was too sweeping a measurement. Community standards should be applied, the majority ruled, only to such works that "appeal to the prurient interest in sex, which portray sexual conduct in a patently offensive way, and which . . . do not have serious literary, artistic, political, or scientific value."[1512] Whether the new 5-4 decision addresses the basic issue of what is "reasonable" is debatable. Moreover, as Associate Justice Byron White notes, the fact that a limited segment of the nation finds a work with redeeming value in no way precludes the fact that a "reasonable person" would dismiss it.

To try to resolve here what has not been resolved for centuries would be foolish. I do not believe there will ever be an end to censorship and the controversy about how movies should function in a free society. The nature of the film industry is such that it will continue to represent society's fears and aspirations through a succession of images relying on formulas linked to the nation's values and history. The enormous diversity of opinion and cultures within America will always put the medium at odds with one group or another over the interpretation of specific events and people. Nevertheless, champions of free speech and artistic freedom will persist in defending the right of filmmakers to state, as Justice William J. Brennan, Jr., argued in ROTH v. UNITED STATES, 354 U.S. 476 (1957), that the CONSTITUTION protects "unorthodox ideas, controversial ideas, even ideas hateful to the prevailing climate of opinion."

BOOKS

*Barker, Martin, ed. THE VIDEO NASTIES: FREEDOM AND CENSORSHIP IN THE MEDIA. Winchester: Unwin Hyman, 1985. 131pp.

[1509] For a recent example of the Justice Department labeling films as "political propoganda," see "Label on 3 Films Backed by Court," NEW YORK TIMES 1 (June 21, 1986):7.

[1510] Stuart Taylor, Jr., "High Court Refines Standard on Obscenity Cases," NEW YORK TIMES B (May 5, 1987):13

[1511] Taylor, p.13.

[1512] Taylor, p.13.

Beman, Lamar Taney, ed. SELECTED ARTICLES ON CENSORSHIP OF THE THEATER AND MOVING PICTURES. New York: Jerome S. Ozer, Publisher, 1971. 385pp.

Originally published in 1931, this superb collection deals with many quotations and essays from the various pressure groups of the 1920s and 1930s who vigorously attacked the film industry. The book also contains an extremely useful bibliography covering the estimated effects that movies have had on the American public. Well worth browsing.

Carmen, Ira H. MOVIES, CENSORSHIP AND THE LAW. Ann Arbor: University of Michigan Press, 1966. 339pp.

In this valuable book, Carmen covers the history of American motion picture censorship beginning in 1915 when the Supreme Court denied the freedom of the press to films and traces the various changes of thought that have occurred up to 1965. "This study," the author writes, "is, in an elemental sense, an examination of the public's gradual acceptance of the most significant technical advancement in the development of the mass media in the past generation, the motion picture." Carmen divides his examination of the clashes between the film industry and the censors into four major sections: "The Supreme Court and the Right of Free Speech for Motion Pictures under the Constitution: The 'Early Period,' 1915-52," "Motion Pictures and the Right of Free Expression under the Constitution: The 'Modern Period,' 1953-65," "State Censorship of Motion Pictures," and "Local Censorship of Motion Pictures." A concluding section summarizes the issues relating to the enforcement of the "Supreme Law" and whether motion picture censorship should be abolished. Most fascinating about the legal history is the arbitrary way that state and local censors interpret the law. Seven appendexes reveal the nature of a questionnaire used for evaluating how censorship boards operate. A bibliography and index are included. Well worth browsing.

*Crowther, Bosley. MOVIES AND CENSORSHIP. New York: Public Affairs Committee, 1961. 28pp.

A very simplified, short pamphlet describing some basic ideas about censorship. It offers some sensible, practical, and useful ideas for public meetings at which discussion stays mainly on a superficial level. Worth browsing.

*De Grazia, Edward and Roger K. Newman. BANNED FILMS: MOVIES, CENSORS, AND THE FIRST AMENDMENT. New York: R. R. Bowker Company, 1982. Illustrated. 455pp.

An informative and entertaining history of First Ammendment issues relating to motion pictures, this journalistic survey explores the nation's reactions to the shifting images and values that Hollywood portrayed from the turn of the century to the start of the 1980s. De Grazia and Newman do a nice balancing act in highlighting over 120 specific censorship battles and the role of the Supreme Court in defining political ideologies and social agendas. The material is divided into two major sections: the history of film censorship in America, and the cases dealing with the films. The most useful information is found in section 2, where the authors review the individual cases, providing details on the date and place of censorship, year of film release, significant cast and technical credits, rating and awards, plot summary, and the issues debated in the actual banning of the film. Although the comments are brief, they are extremely interesting and useful. A bibliography and index are included. Recommended for special collections.

Ernst, Morris, and Pare Lorentz. CENSORED: THE PRIVATE LIFE OF THE MOVIES. New York: Jerome S. Ozer, Publishers, 1971. Illustrated. 199pp.

Originally published in 1930, this work by the famed attorney and the great documentary filmmaker chronicles the legal decisions made by local and state censorship bodies and makes a persuasive argument against any form of legislative control of movies. Well worth browsing.

Facey, Paul W. THE LEGION OF DECENCY: A SOCIOLOGICAL ANALYSIS OF THE EMERGENCE AND DEVELOPMENT OF A SOCIAL PRESSURE GROUP. New York: Arno Press, 1974. 206pp.
Originally written in 1945 as a doctoral dissertation at Fordham University, this useful study of the Catholic group formed to monitor "immoral" Hollywood activities provides a general overview of the organization's history and methods of operation. The book's five informative chapters offer a helpful comparison between the Legion of Decency and other like-minded pressure groups in society. A bibliography is included, but no index is provided. Well worth browsing.

*Farber, Stephen. THE MOVIE RATING GAME. Washington, D. C.: Public Affairs Press, 1972. 128pp.
Here is one of the most complete and useful discussion of the meaning and purpose of the controversial rating symbols. In nine informative chapters, Farber provides historical background, inside information, and specific recommendations for improvement. "The study," the author reminds us, "developed out of firsthand experience and knowledge." Having been appointed to a one-year fellowship in 1970, Farber resigned six months later as a result of his frequent clashes with more conservative members of the group. The discussions concerning the board's values and behavior thus reveal the author's hostility to its controversial criteria for evaluating films. Also included are a number of valuable appendexes about studio contract stipulations, typical objections of the rating board, and types of censorship restrictions. No index or bibliography is provided. Well worth browsing.

Feldman, Charles Matthew. THE NATIONAL BOARD OF CENSORSHIP (REVIEW) OF MOTION PICTURES, 1909-1922. New York: Arno Press, 1977. 231pp.

Gardner, Gerald. THE CENSORSHIP PAPERS: MOVIE CENSORSHIP LETTERS FROM THE HAYS OFFICE, 1934-1948. New York: Dodd and Mead, 1987. 226pp.

*Hart, Harold H., ed. CENSORSHIP: FOR AND AGAINST. New York: Hart Publishing Company, 1971. Illustrated. 255pp.
"This book," Hart explains, "is addressed to those who would like to unravel the tangled threads of our laws and mores. Does the open presence of salacious magazines on our newstands lead to depravity? Do the photographs of what were hitherto considered private parts corrupt the young? Since four-letter words have become part and parcel of cinema dialogue, has the moral fiber of the community weakened? In what manner have peep-shows and blue movies affected the welfare of society?" The twelve contributors debating the issues are Hollis Alpert, Judith Crist, Nat Hentoff, Charles Keating, Arthur Lelyveld, Max Lerner, Eugene McCarthy, Carey McWilliams, Charles Rembar, Ernest Van Den Haag, and Rebecca West. Although this interesting mixture of critics, attorneys, politicans resolves nothing, they do raise useful points about the control the mass media and government documents. An index is included. Well worth browsing.

Hunnings, Neville March. FILM CENSORS AND THE LAW. Foreword Frede Castberg. London: George Allen & Unwin, 1967. Illustrated. 474pp.

In updating and expanding his articles on censorship from SIGHT AND SOUND, Hunnings gives a lengthy and remarkably good documentation on censorship in Britain since the Cinematograph Act of 1909. Although problems of other nations are dealt with, it is mainly in Britain that the story of ignorance, arrogance, and apathy is best described. Moreover, as Pofessor Castberg comments in his Foreword, the book not only provides information on "varying attitudes to the problems of film censorship . . . [but also valuable descriptions] of the fundamental difference between the political system of England, which is based on no Constitution, and the political sytem of the United States, where freedom of speech is guaranteed by Constitutional provision and sustained by the federal courts against all federal, legislative and administrative authorities, and since the GITLOW decision of the Supreme Court in 1925, also against the states." Hunnings divides his material into four major parts: (1) the history of censorship in England from 1896 to the mid-1960s, (2) a comparison of four federal countries (America, India, Canada, and Australia), (3) three European countries (Denmark, France, and the Soviet Union), and (4) a summary on the nature of film censorship. In addition, Hunnings offers considerable information about censorship in England in his five appendexes, along with tables of cases, statutes, decrees and territorial ordinances, and films. An extensive bibliography and a useful index are included. Well worth browsing.

Inglis, Ruth A. FREEDOM OF THE MOVIES: A REPORT ON SELF-REGULATION FROM THE COMMISSION ON FREEDOM OF THE PRESS. Chicago: The University of Chicago Press, 1947. 241pp.

More of a historical document than a relevant study to today's censorship problems, this chronological analysis of how industrial film censorship evolved works to enlighten the post-WWII public to how the Breen Office operated and the problems that Hollywood's self-regulation posed to filmmakers and audiences. Six fact-filled chapters explore topics like the social role of movies, history and economics, early attempts to control film, how self-regulation functions, and specific recommendations for the late-1940s. Among the people serving on the commission are Robert M. Hutchins, William E. Hocking, Harold D. Lasswell, Archibald MacLeish, Reinhold Niebuhr, Arthur M. Schlesinger, and George N. Shuster. In addition to an appendix reprinting the Motion Picture Production Code, the editor provides a bibliographical essay and an index. Well worth browsing.

Martin, Olga J. HOLLYWOOD'S MOVIE COMMANDMENTS: A HANDBOOK FOR MOTION PICTURE WRITERS AND REVIEWERS. New York: Arno Press, 1970. 301pp.

Originally published in 1937, this invaluable commentary on the taboos of the American production code offers a stimulating background to the ingenious attempts by Hollywood producers and directors to present realism and humor in their films. There is also a useful section explaining the censorship of U. S. films by other countries in the early thirties. No index is included. Well worth browsing.

McClelland, Doug. THE UNKINDEST CUTS: THE SCISSORS AND THE CINEMA. South Brunswick: A. S. Barnes and Company, 1972. Illustrated. 220pp.

This pioneering study of the arbitrary editing of specific Hollywood and imported films discusses what happens to movies once the shooting is done but before the film is released to the public or considered for an Oscar. The unusual aspect of of McClelland's study is that he concentrates on the decisions made by the directors, producers, and performers rather than by the censors. The classic cases involving works by Huston, von Stroheim, and Welles are discussed, along with accounts of dozens of less well known examples. Sixteen entertaining and informative chapters, relying on interviews with key figures, highlight not only the reasons for the cuts, but also the problems connected with the process. Regrettably, the author fails to balance his study with examples of why certain decisions were necessary or to offer clear standards for how to evaluate the excisions. The book's appeal is limited,

therefore, to general audiences rather than to serious students. No footnotes or bibliography is provided. An index is included. Worth browsing. 266pp.

Moley, Raymond. THE HAYS OFFICE. New York: The Bobbs-Merrill Company, 1945. New York: Jerome S. Ozer, 1971.

This sympathetic but very useful portrait of the controversial Indiana film czar is an invaluable document on the origination of the Motion Picture Producers and Distributors of America in 1922, and the subsequent years up to 1944. Five detailed chapters provide important insights into how the Hays Office operated at home and abroad. All of the major resolutions are carefully appendixed at the end, and Moley's lucid prose and apt quotations suggest one side, an important one, of self-regulation.[1513] An index is included. Recommended for special collections.

Nizer, Louis. NEW COURTS OF INDUSTRY: SELF-REGULATION UNDER THE MOTION PICTURE CODE, INCLUDING AN ANALYSIS OF THE CODE. New York: Jerome S. Ozer, 1971. 344pp.

Originally published in 1935, this carefully written and detailed account of the motion picture code attacks the problems inherent in the Hays Office and describes the methods used by the industry to resolve its difficulties. Well worth browsing.

Oboler, Eli. M. THE FEAR OF THE WORD: CENSORSHIP AND SEX. Metuchen: The Scarecrow Press, 1974. 370pp.

A fast-moving, detailed look at censorship related to human sexuality, this interesting study takes a historical look at the reasons why censors seek to prevent the general public from learning about sexual behavior in society. Oboler, a librarian who has encountered the problem firsthand, describes his experiences and his attitude toward the process and its underpinnings in fifteen lively chapters. Four valuable appendexes on censorship documents, endnotes, a bibliography, and an index are included. Well worth browsing.

*Philips, Baxter. CUT: THE UNSEEN CINEMA. New York: Bounty Books, 1975. Illustrated. 111pp.

A good overview of film censorship that visually borders on the sensational, this commercial publication tries to be popular both with serious students and film buffs. The author's four fact-filled chapters on how censorship evolved in films over an eighty-year period, starting first with an emphasis on sex in the cinema, going through the eras of the production code and political censorship, and concluding with an emphasis on violence and sex in the seventies. Nearly every page of the interesting text presents illustrative matter that graphically presents images of sexual behavior in motion picture history. For those who read PLAYBOY just for the interviews, this study is worth examining. Regrettably, no footnotes, bibliography, or index is included. No doubt, some readers won't even notice. Well worth browsing.

[1513] In this connection, the following articles suggest the problems Hays faced when he took office: DeWitt Bodeen, "Wallace Reid," FILMS IN REVIEW 18:3 (April 1966):205-30; and Aydelott Ames, "Mary Miles Minter," ibid., 20:8 (October 1969):473-95, 501. Also useful are Herbert M. Levy, "The Case Against Film Censorship," ibid., 1:3 (April 1950):1-2, 38-42; and Frederick M. Wirt, "To See or Not to See: The Case Against Censorship," FILM QUARTERLY 13:1 (Fall 1959): 26-31.

*Randall, Richard S. CENSORSHIP OF THE MOVIES: THE SOCIAL AND POLITICAL CONTROL OF A MASS MEDIUM. Madison: The University of Wisconsin Press, 1968. 280pp.

This is one of the most valuable books on the changing practices of film censorship up to the mid-1960s. The libertarian author works on the assumption that before public policy can be made and properly evaluated, we need to understand the circumstances out of which the law was conceived. That is, "Before we know what to do about government prior censorship in law, for example, we must know what government prior censors do. Before we know what the limits of free speech should be, we need to know what the condition of free speech is." Randall's purpose is to educate readers to the complexities of the First Amendment. The material is divided into four major sections. Part 1 briefly discusses the relationship between censorship and the movies. Part 2 examines in detail the clashes between the law and film, highlighting important cases and explaining procedural and substantive issues. Part 3 describes the ins and outs of government prior censorship, relying heavily on interviews with state and local censors, film exhibitors, and lawyers. Part 4 analyzes the wider milieu of film censorship, delving into the variety of methods used to control film through "criminal prosecution, extra-legal action by officials, the pressures of private groups, and the film industry's efforts at self-regulation." Part 5 concludes with Randall critiquing the state of free speech in film in the mid-1960s. The author's training in political science helps considerably in making the implications of his important research applicable to modern battles with film censors. Endnotes, a table of cases, and an index are provided. Recommended for special collections.

Robertson, James C. THE BRITISH BOARD OF CENSORS: FILM CENSORSHIP IN BRITAIN, 1896-1950. Dover: Croom Helm, 1985. Ilustrated. 213pp.

A study of seventy years of British film censorship, this detailed analysis is filled with interesting information and statistical data. The author, a British historian, uses six chapters to examine not only the events and cases that shaped the British Board of Censor's operating principles, but also the political and social climates that nurtured the board's effectiveness between 1913 and 1950. Particularly impressive is Robertson's insightful account of the relationship between American and British perspectives from the turn of the century to the post-WWII period. Three appendexes offer details on the Board's 1926 Codification and the films banned from 1913 to 1950. Endnotes, a bibliography, an index of film titles, and a general index are included. Recommended for special collections.

*Schumach, Murray. THE FACE ON THE CUTTING ROOM FLOOR: THE STORY OF MOVIE AND TELEVISION CENSORSHIP. New York: William Morrow and Company, 1964. Illustrated. 305pp.

Although Schumach remains neutral, he presents a worthwhile lucid survey of personalities and events over the past forty years, including very good reports on the political pressures for censorship and the consequences resulting. "The first law of censorship--and probably the only one not inscribed on the statute books--," Schumach writes, "is this: in a democracy, the more popular the art form, the greater the demands for censorship of it. This theorem has two corollaries. First, the quality of the art has little to do with the matter. Second, those who arrogate to themselves the privilege of exercising censorship may or may not be cultured, unbiased and/or sincere." Taking those lessons as the cornerstones of his lively study, he provides eight informal, nonchronological chapters on nudity and censorship, mammary fixations, religious pressure groups, the blacklisting era, sexual exploitation, censorship and the courts, censorship on TV, and the future of censorship from the mid-1960s on. Although Schumach offers no evidence for his intriguing revelations, he makes a good case for thinking seriously about undocumented assertions. Two appendexes offer valuable information on foreign film censorship, along with one appendix containing the Motion Picture Code. An index is included. Well worth browsing.

*Vizzard, Jack. SEE NO EVIL: LIFE INSIDE A HOLLYWOOD CENSOR. New York: Simon and Schuster, 1970. 381pp.

Written by a man who for a quarter of a century was on the inside of the Hollywood Code Office, this book provides some interesting and sobering anecdotes about movie censorship. Vizzard is more concerned with being entertaining than with being factual. Thus, he begins his book with the observation that "Being a censor is like being a whore; everyone wants to know how you got into the business." Once we discover that his Jesuit training eventually led to his employment by Joseph I. Breen, the author regales us with outrageous tales about clashes between filmmakers and the self-regulation arm of the film industry. No documentation supports his often tasteless and upsetting stories. Nevertheless, the fact that Vizzard served as long as he did compels one to read carefully his twenty-one chapters of recollections and to savor the mood and practices of the Breen Office. A set of appendexes provides copies of the Motion Picture Code and of other documents. No bibliography or index is included. Well worth browsing.

*Williams, Bernard, ed. OBSCENITY AND FILM CENSORSHIP: AN ABRIDGEMENT OF THE WILLIAMS REPORT. New York: Cambridge University Press, 1981. 166pp.

In 1979, the Williams Report on Obscenity and Film Censorship created a storm of controversy in England. The commission was appointed two years earlier "to review the laws concerning obscenity, indecency and violence in publications, displays and Entertainments in England and Wales, except in the field of broadcasting, and to review the arrangements for film censorship in England and Wales; and to make recommendations." This publication offers the commission's findings, omitting only the extensive appendexes. Williams, who headed the commission and edited the book, explains in his preface that the group worked primarily "to clarify the issues and to developed some shared understanding of such things as the nature of pornography . . . and to direct our discussions toward a workable law, and to make recommendations that would be practical for this society at this time." Thirteen chapters help considerably in upgrading the level of understanding regarding pornography, with two of the chapters devoted exclusively to film. Well worth browsing.

AFTERWORD

The preceding discussion of stereotypes and their relationship to film has only suggested a range of issues involved in a social history of film. No one topic has been resolved. For example, It seems clear that there is no one-to-one relationship between film content and audience behavior. It also seems clear that there is a complex relationship between movies and young people. There is even the possibilty that moviegoing is more socially significant than moviewatching. Despite this chapter's length, it is not possible to explain the advantages and disadvantages of the various approaches to studying the intricate interaction between film and society. The purpose of this chapter, however, was to explore five specific assumptions: (1) movies are both a business and an art, and that duality has emerged over the past ninety years; (2) movies are part of an evolving mass entertainment network catering to the needs and desires of a vast audience; (3) a systematic analysis of the conventions of film reveals significant data about ourselves and our nation; (4) audiences identify with characters and conflicts in films; and (5) films do not operate in a vacuum.

Thanks to the research provided by hundreds of film scholars, it is evident that movies play a crucial role in the symbolic life of society. Although the medium has more than its share of critics who attack its values and products, there is good reason to believe not only that film is undervalued in certain circles, but also that its critics may be railing more against the public's values than the medium's representation of those values. That is, the film industry functions within society, not independent of it. Thus, as Emanuel Levy points out,

demographic changes (size and structure of the population), historical events (World War II), political circumstances (the McCarthy era), and the prevailing dominant culture (conservatism versus liberalism, patriotism versus self-criticism) have been some of the most basic factors to affect the kinds of movies made and their reception by audiences.[1514]

It is these factors that have shaped the kinds of stereotypes that the film industry uses to maintain its strength. The resulting stereotypes are the direct responses to fickle market conditions. Moreover, the economic conservatives who control the production end of the business stress the need for formulas designed to minimize financial risks and to maximize audience identification.

The stereotypes, or conventions, used in those formulas add, detract, or reinforce the collective perceptions of a large segment of society, thereby providing us with a representation not only of the time in which they flourished but also a perspective on the spiritual and social growth of a nation. By understanding these film conventions, we can learn about the need for more heterogeneous movies as well as appreciate the obstacles faced by commercial artists. The key elements always to keep in mind are that profit takes precedence over purpose, that education and entertainment are intertwined in the movies, and that no meaningful discussion of film stereotypes is useful outside of historical and social contexts. Given those guidelines, it appears reasonable to assert that movies are more than escapist entertainment. They are also a form of social control and a forum for understanding ourselves and the world around us. In discussing their multiple roles in society, we must recognize that it is the effects movies produce, not the reality of their images and sounds, that most command our attention.

[1514] Levy, p.xv.